The Feminism and Visual Culture Reader

Feminism is one of the most important perspectives from which visual culture has been theorized and historicized over the past thirty years. Challenging the notion of feminism as a unified discourse, *The Feminism and Visual Culture Reader* assembles a wide array of writings that address art, film, architecture, popular culture, new media, and other visual fields from a feminist perspective.

The Feminism and Visual Culture Reader combines classic texts with six newly commissioned pieces, all by leading feminist critics, historians, theorists, artists, and activists. Articles are grouped into thematic sections, each of which is introduced by the editor. Providing a framework within which to understand the shifts in feminist thinking in visual studies, as well as an overview of major feminist theories of the visual, this Reader also explores how issues of race, class, nationality, and sexuality enter into debates about feminism in the field of the visual.

Contributors: Judith Barry, John Berger, Janet Bergstrom, Rosemary Betterton, Lisa Bloom, Susan Bordo, Rosi Braidotti, Judith Butler, Camera Obscura Collective, Sue-Ellen Case, Meiling Cheng, Judy Chicago, Hélène Cixous, Mary Ann Doane, Mary Douglas, Jennifer Doyle, Ann duCille, Andrea Dworkin, Deborah Fausch, María Fernández, Sandy Flitterman-Lewis, Susan Leigh Foster, Coco Fusco, Moira Gatens, Ann Eden Gibson, Sander L. Gilman, Jennifer González, Elizabeth Grosz, The Guerrilla Girls, Harmony Hammond, Donna Haraway, N. Katherine Hayles, bell hooks, Luce Irigaray, Amelia Jones, Mary Kelly, Julia Kristeva, Leslie Labowitz, Suzanne Lacy, Sharon Lehner, Elisabeth Lyon, Judith Mayne, Trinh T. Minh-ha, Tania Modleski, Patricia Morton, Laura Mulvey, José Esteban Muñoz, Linda Nochlin, Lorraine O'Grady, Pratibha Parmar, Constance Penley, Peggy Phelan, Adrian Piper, Sadie Plant, Griselda Pollock, Irit Rogoff, Christine Ross, Miriam Schapiro, Mira Schor, Lynn Spigel, Sandy Stone, Klaus Theweleit, VNS Matrix, Faith Wilding, Judith Wilson, Monique Wittig, Janet Wolff, and Kathleen Zane.

Amelia Jones is Professor of Art History at the University of California, Riverside. She has organized exhibitions including *Sexual Politics: Judy Chicago's Dinner Party in Feminist Art History* at the UCLA/Armand Hammer Art Museum (1996), and her publications include the co-edited anthology *Performing the Body/Performing the Text* (1999), *Body Art/Performing the Subject* (1998), and *Postmodernism and the En-Gendering of Marcel Duchamp* (1994).

In Sight: Visual Culture
Series Editor: Nicholas Mirzoeff

This series promotes the consolidation, development and thinking-through of the exciting inter-disciplinary field of visual culture in specific areas of study. These will range from thematic questions of ethnicity, gender and sexuality to examinations of particular geographical locations and historical periods. As visual media converge on digital technology, a key theme will be to what extent culture should be seen as specifically visual and what that implies for a critical engagement with global capital. The books are intended as resources for students, researchers and general readers.

The Feminism and Visual Culture Reader
Edited by Amelia Jones

Forthcoming titles:

Nineteenth-Century Visual Culture Reader
Edited by Vanessa Schwartz and Jeannene Przyblyski

Multicultural Art in America
Nicholas Mirzoeff

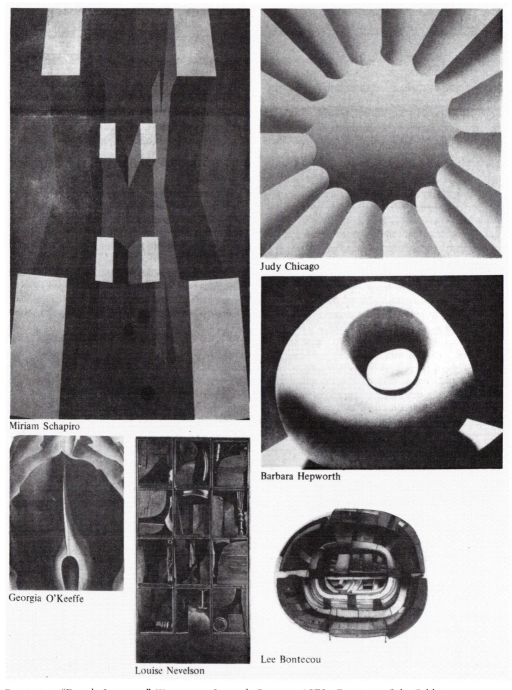

Judy Chicago

Miriam Schapiro

Barbara Hepworth

Georgia O'Keeffe

Louise Nevelson

Lee Bontecou

Frontispiece "Female Imagery," *Womanspace* Journal, Summer 1973. Courtesy of the Schlesinger Library, Radcliffe Institute, Harvard University.

The Feminism and
Visual Culture Reader

Edited by

Amelia Jones

Routledge
Taylor & Francis Group

LONDON AND NEW YORK

First published 2003
by Routledge
11 New Fetter Lane, London EC4P 4EE

Simultaneously published in the USA and Canada
by Routledge
29 West 35th Street, New York, NY 10001

Routledge is an imprint of the Taylor & Francis Group

Selection and editorial matter © 2003 Amelia Jones;
individual chapters © 2003 the contributors

Typeset in Perpetua and Bell Gothic
by Florence Production Ltd, Stoodleigh, Devon
Printed and bound in Great Britain
by TJ International Ltd, Padstow, Cornwall

British Library Cataloguing in Publication Data
A catalogue record for this book is available from the British Library

Library of Congress Cataloging in Publication Data
A catalog record for this book has been requested

ISBN 0–415–26705–6 (hbk)
ISBN 0–415–26706–4 (pbk)

Contents

List of figures xi
Notes on contributors xiii
Acknowledgments xxv
Permissions xxvi

Amelia Jones
INTRODUCTION: CONCEIVING THE INTERSECTION OF FEMINISM
AND VISUAL CULTURE 1

PART ONE
Provocations

Amelia Jones
INTRODUCTION TO PART ONE 9

1 Rosemary Betterton
 FEMINIST VIEWING: VIEWING FEMINISM 11

2 Jennifer Doyle
 FEAR AND LOATHING IN NEW YORK: AN IMPOLITE ANECDOTE
 ABOUT THE INTERFACE OF HOMOPHOBIA AND MISOGYNY 15

3 Lisa Bloom
 CREATING TRANSNATIONAL WOMEN'S ART NETWORKS 18

4 Judith Wilson
 ONE WAY OR ANOTHER: BLACK FEMINIST VISUAL THEORY 22

5 Faith Wilding
 NEXT BODIES 26

6 Meiling Cheng
THE UNBEARABLE LIGHTNESS OF SIGHT 29

PART TWO
Representation

Amelia Jones
INTRODUCTION TO PART TWO 33

7 John Berger
FROM WAYS OF SEEING 37

8 Judy Chicago and Miriam Schapiro
FEMALE IMAGERY 40

9 Laura Mulvey
VISUAL PLEASURE AND NARRATIVE CINEMA 44

10 Judith Barry and Sandy Flitterman-Lewis
TEXTUAL STRATEGIES: THE POLITICS OF ART-MAKING 53

11 Mary Ann Doane
FILM AND THE MASQUERADE: THEORIZING THE FEMALE SPECTATOR 60

12 Mary Kelly
DESIRING IMAGES/IMAGING DESIRE 72

13 Griselda Pollock
SCREENING THE SEVENTIES: SEXUALITY AND REPRESENTATION
IN FEMINIST PRACTICE – A BRECHTIAN PERSPECTIVE 76

14 bell hooks
THE OPPOSITIONAL GAZE: BLACK FEMALE SPECTATORS 94

15 Peggy Phelan
BROKEN SYMMETRIES: MEMORY, SIGHT, LOVE 105

PART THREE
Difference

Amelia Jones
INTRODUCTION TO PART THREE 115

16 Luce Irigaray
ANY THEORY OF THE "SUBJECT" HAS ALWAYS BEEN APPROPRIATED
BY THE "MASCULINE" 119

17 Harmony Hammond
LESBIAN ARTISTS 128

18 Monique Wittig
THE STRAIGHT MIND 130

19 Sander L. Gilman
BLACK BODIES, WHITE BODIES: TOWARD AN ICONOGRAPHY OF
FEMALE SEXUALITY IN LATE NINETEENTH-CENTURY ART,
MEDICINE, AND LITERATURE 136

20 Trinh T. Minh-ha
DIFFERENCE: "A SPECIAL THIRD WORLD WOMEN ISSUE" 151

21 Lorraine O'Grady
OLYMPIA'S MAID: RECLAIMING BLACK FEMALE SUBJECTIVITY 174

22 Sandy Stone
A POSTTRANSSEXUAL MANIFESTO 187

23 Ann Eden Gibson
COLOR AND DIFFERENCE IN ABSTRACT PAINTING: THE ULTIMATE
CASE OF MONOCHROME 192

24 Coco Fusco
THE OTHER HISTORY OF INTERCULTURAL PERFORMANCE 205

25 José Esteban Muñoz
"THE WHITE TO BE ANGRY": VAGINAL CREME DAVIS'S
TERRORIST DRAG 217

PART FOUR
Disciplines/Strategies

Amelia Jones
INTRODUCTION TO PART FOUR 225

26 Linda Nochlin
WHY HAVE THERE BEEN NO GREAT WOMEN ARTISTS? 229

27 Camera Obscura Collective
FEMINISM AND FILM: CRITICAL APPROACHES 234

28 Adrian Piper
THE TRIPLE NEGATION OF COLORED WOMEN ARTISTS 239

29 Mira Schor
 PATRILINEAGE 249

30 Hélène Cixous
 BATHSHEBA OR THE INTERIOR BIBLE 256

31 Irit Rogoff
 GOSSIP AS TESTIMONY: A POSTMODERN SIGNATURE 268

32 Patricia Morton
 THE SOCIAL AND THE POETIC: FEMINIST PRACTICES IN
 ARCHITECTURE, 1970–2000 277

PART FIVE
Mass Culture/Media Interventions

Amelia Jones
INTRODUCTION TO PART FIVE 283

33 Pratibha Parmar
 HATEFUL CONTRARIES: MEDIA IMAGES OF ASIAN WOMEN 287

34 Tania Modleski
 THE SEARCH FOR TOMORROW IN TODAY'S SOAP OPERAS 294

35 Suzanne Lacy and Leslie Labowitz
 FEMINIST MEDIA STRATEGIES FOR POLITICAL PERFORMANCE 302

36 Amelia Jones
 FEMINISM, INCORPORATED: READING "POSTFEMINISM" IN AN
 ANTI-FEMINIST AGE 314

37 Lynn Spigel
 THE SUBURBAN HOME COMPANION: TELEVISION AND THE
 NEIGHBORHOOD IDEAL IN POSTWAR AMERICA 329

38 Ann duCille
 BLACK BARBIE AND THE DEEP PLAY OF DIFFERENCE 337

39 The Guerrilla Girls
 INTRODUCTION AND CONCLUSION TO THE GUERRILLA GIRLS'
 BEDSIDE COMPANION TO THE HISTORY OF WESTERN ART 349

40 Kathleen Zane
 REFLECTIONS ON A YELLOW EYE: ASIAN I(\EYE/)CONS AND
 COSMETIC SURGERY 354

41 Judith Mayne
FEAR OF FALLING 364

PART SIX
Body

Amelia Jones
INTRODUCTION TO PART SIX 369

42 Mary Douglas
EXTERNAL BOUNDARIES 373

43 Klaus Theweleit
STREAMS/ALL THAT FLOWS and WOMAN: TERRITORY OF DESIRE 375

44 Andrea Dworkin
PORNOGRAPHY 387

45 Julia Kristeva
APPROACHING ABJECTION 389

46 Judith Butler
PERFORMATIVE ACTS AND GENDER CONSTITUTION: AN ESSAY IN
PHENOMENOLOGY AND FEMINIST THEORY 392

47 Sue-Ellen Case
TOWARD A BUTCH–FEMME AESTHETIC 402

48 Janet Wolff
REINSTATING CORPOREALITY: FEMINISM AND BODY POLITICS 414

49 Deborah Fausch
THE KNOWLEDGE OF THE BODY AND THE PRESENCE OF HISTORY:
TOWARD A FEMINIST ARCHITECTURE 426

50 Susan Leigh Foster
THE BALLERINA'S PHALLIC POINTE 434

51 Susan Bordo
NEVER JUST PICTURES 454

52 Moira Gatens
EPILOGUE TO IMAGINARY BODIES: ETHICS, POWER AND CORPOREALITY 466

PART SEVEN
Technology

Amelia Jones
INTRODUCTION TO PART SEVEN 471

53 Donna Haraway
 A CYBORG MANIFESTO: SCIENCE, TECHNOLOGY, AND
 SOCIALIST-FEMINISM IN THE LATE TWENTIETH CENTURY 475

54 N. Katherine Hayles
 VIRTUAL BODIES AND FLICKERING SIGNIFIERS 497

55 Elizabeth Grosz
 BODIES–CITIES 507

56 Christine Ross
 TO TOUCH THE OTHER: A STORY OF CORPO-ELECTRONIC SURFACES 514

57 María Fernández
 POSTCOLONIAL MEDIA THEORY 520

58 Sadie Plant
 FEMINISATIONS: REFLECTIONS ON WOMEN AND VIRTUAL REALITY 528

59 VNS Matrix
 CYBERFEMINIST MANIFESTO 530

60 Rosi Braidotti
 CYBERFEMINISM WITH A DIFFERENCE 531

61 Jennifer González
 THE APPENDED SUBJECT: RACE AND IDENTITY AS DIGITAL
 ASSEMBLAGE 534

62 Sharon Lehner
 MY WOMB, THE MOSH PIT 545

 Index 551

Figures

Note: The following were reproduced with kind permission. While every effort has been made to trace copyright holders and obtain permission, this has not been possible in all cases. Any omissions brought to our attention will be remedied in future editions.

Frontispiece "Female Imagery," *Womanspace* Journal, 1973

3.1	Taro Ito, *Me Being Me*, 2000	20
3.2	Zhang Xin, *Climate No. 6*, 2000	21
10.1	Hannah Wilke, *S.O.S. Starification Object Series*, 1974–5	55
10.2	Mary Kelly, *Documentation III*, from *Post-Partum Document*, 1975	58
12.1	Mary Kelly, *Documentation VI*, from *Post-Partum Document*, 1977–8	74
13.1	Yve Lomax, *Open Rings and Partial Lines*, 1983–4	86
19.1	Edouard Manet, *Olympia*, 1863	138
19.2	*The Hottentot Venus*, 1817	141
19.3	*The "Hottentot Apron,"* 1834	143
19.4	*The Hottentot Venus*, popular engraving, *c.* 1850	145
20.1	Trinh T. Minh-ha, still from film *Surname Viet Given Name Nam*, 1989	152
21.1	Lorraine O'Grady, *Gaze 3*, 1991	179
22.1	Sandy Stone, *Self-portrait*, *c.* 2002	188
23.1	Clyfford Still, *1950 M, No. 1*, 1955	193
23.2	Marcia Hafif, *Cadmium Red*, 1982	195
23.3	Barbara Kruger, *"Heart" (Do I have to give up me to be loved by you?)*, 1988	196
23.4	Marcia Hafif, *Roman Painting XVIII*, 1988	197
24.1	Coco Fusco and Guillermo Gómez-Peña, *Two Undiscovered Amerindians Visit Madrid*, 1992	207
24.2	Maximo and Bartola, "The Last Aztec Survivors of a Mysterious Jungle City Called Ixinaya," *c.* 1853–1901	212
25.1	Vaginal Davis as the Bad Seed	218
25.2	Vaginal Davis	223
29.1	Hannah Wilke, *Of Radishes and Flowers*, 1972	251

30.1	Rembrandt, *Bathsheba Bathing*, 1654	257
30.2	Rembrandt, *The Slaughtered Ox*, 1655	266
35.1	Suzanne Lacy and Leslie Labowitz, with assistance from the Women's Building and its artists, from *Three Weeks in May*, 1977	303
35.2	Leslie Labowitz in collaboration with Women Against Violence Against Women and the National Organization for Women, *Record Companies Drag Their Feet*, 1977	307
35.3	Suzanne Lacy and Leslie Labowitz, with assistance from Biba Lowe, *In Mourning and In Rage*, 1977	308
35.4	Leslie Labowitz, Nancy Angelo, and Nancy Taylor, Coordinators, *The Incest Awareness Project*, cosponsored by Ariadne and the Gay and Lesbian Community Service Center, 1979–81	311
36.1	Barbara Bush posing in *Women's Day*, 30 October 1990	317
36.2	Advertisement from *Time*, 29 October 1990, for *Time* special issue on women	319
36.3	*Good Housekeeping* advertisement from *Los Angeles Times Magazine*, December 1988	320
37.1	Motorola television advertisement, 1952	334
37.2	Television advertisement, *Colliers*, 1953	335
40.1	Tran T. Kim-Tran, still from video, *Operculum*, 1993	359
47.1	Peggy Shaw and Lois Weaver in *Split Britches Cabaret*, c. 1981–2	411
51.1	Kate Moss from *People*	461
51.2	Scarlett and Mammy from *Gone with the Wind*, 1939	464
54.1	David Cronenberg's *The Fly*, 1986	503
56.1	Mona Hatoum, *Corps étranger*, 1994	517
57.1	Lee Bul, *Cyborg Blue*, 1997–8	521
61.1	UNDINA screen grab, c. 2002	537
61.2	Bodies© INC screen grab, c. 2002	543
62.1	Replication by Tina La Porta, c. 2000	546

Notes on contributors

Judith Barry is an artist and writer who works in a variety of media: installation, sculpture, film and video, performance, photography. Her work has been exhibited widely in the U.S., Europe, and Asia. In 2000, she was the second recipient of the Freidrich and Lillian Kiesler Prize for Architecture and Art. In 2001 she represented the U.S. at the Cairo Biennale where she was awarded Best Pavilion for her two-channel video installation "Voice-Off." Her books include *Public Fantasy* (1991) and *Projections* (1997).

John Berger is an art historian, painter, and novelist whose publications in the field of art and visual culture include *The Success and Failure of Picasso* (1965) and *Ways of Seeing* (1972). Berger's works of fiction include *G.* (1972), winner of the Booker Prize and the James Tait Black Memorial Prize. His art has been exhibited at the Wildenstein, Redfern, and Leicester galleries in London.

Janet Bergstrom teaches film history and theory at U.C.L.A. A founding editor of *Camera Obscura*, she has published on émigré directors Jean Renoir, Fritz Lang and F.W. Murnau, as well as Chantal Akerman, Claire Denis and Asta Nielsen. She is editor of *Endless Night: Cinema and Psychoanalysis, Parallel Histories* (1999), author of a monograph on Chantal Akerman (forthcoming), and is currently engaged in a study of Murnau's films from *Sunrise* to *Tabu*.

Rosemary Betterton teaches in the Institute for Women's Studies at Lancaster University. She has published widely in the area of feminist visual cultural theory and practice, including her book, *An Intimate Distance: Women, Artists and the Body* (1996), and the collection, *Unframed: The Practices and Politics of Women Painting* (2002).

Lisa Bloom is the author of *Gender on Ice: American Ideologies of Polar Expeditions* (1993) and the editor of *With Other Eyes: Looking at Race and Gender in Visual Culture* (1999). Her most recent book project, *Ghosts of Ethnicity: Negotiating Jewish Identities in U.S. Feminist Art and Video*, revisits feminist art and video practices from the 1970s and 1980s. She is an Associate Professor in women's studies and visual culture at Josai International

University in Japan (Chiba Prefecture) and is currently a visiting Associate Professor in Visual Arts at the University of California, San Diego.

Susan Bordo is Professor of English and Women's Studies and holds the Otis A. Singletary Chair in the Humanities at the University of Kentucky. She is the author of many critically acclaimed books and articles on feminism and visual culture, including *Unbearable Weight: Feminism, Western Culture, and the Body* (1993), *Twilight Zones: The Hidden Life of Cultural Images from Plato to O.J.* (1997), and *The Male Body: A New Look at Men in Public and Private* (1999).

Rosi Braidotti is Professor of Women's Studies at the University of Utrecht. Her books include *Nomadic Subjects: Embodiment and Sexual Difference in Contemporary Feminist Thought* (1994), and *Between Monsters, Goddesses and Cyborgs: Feminist Confrontations with Science, Medicine and Cyberspace* (1996).

Judith Butler is Maxine Elliot Professor in the Departments of Rhetoric and Comparative Literature at the University of California, Berkeley. She is the author of *Subjects of Desire: Hegelian Reflections in Twentieth-Century France* (1987), *Gender Trouble: Feminism and the Subversion of Identity* (1993), *Bodies That Matter: On the Discursive Limits of "Sex"* (1993), *The Psychic Life of Power: Theories of Subjection* (1997), and *Excitable Speech* (1997), as well as numerous articles on philosophy and feminist and queer theory. Her most recent work is *Antigone's Claim: Kinship Between Life and Death* (2000). Her new project is a critique of ethical violence in relation to modernist philosophical and literary texts.

Camera Obscura Collective: See entries for Janet Bergstrom, Sandy Flitterman-Lewis, Elisabeth Lyon, and Constance Penley.

Sue-Ellen Case is Chair of Critical Studies in the Department of Theater at U.C.L.A. Her book, *Feminism and Theater* (1988), was the first to be published in that field. Her later book, *The Domain-Matrix: Performing Lesbian at the End of Print Culture* (1997), extends the gender critique in theater studies into the area of technology and performance. She is the editor of several anthologies and numerous articles in the field of performance, gender, and lesbian critical theory.

Meiling Cheng is Associate Professor and Director of Theater Studies at the School of Theater, University of Southern California. A practicing poet and performance artist, she has published essays on feminism and performance. Her book, *In Other Los Angeleses: Multicentric Performance Art* (2002), studies contemporary performance in relation to community and intersectional structures of identity.

Judy Chicago is an artist, author, and educator, and one of the founders of the feminist art movement that began in the U.S. in the late 1960s. In 1970 she established the Feminist Art Program at California State University at Fresno and, in 1974, she began the execution of the *Dinner Party*, a multimedia, large-scale installation piece that examines the history of women in Western civilization. Completed in 1979, the project was exhibited internationally; it will be permanently installed at the Brooklyn Museum starting in 2003. Chicago is the

creator of innumerable other visual art works and the author of eight books including *Through the Flower: My Struggle as a Woman Artist* (1982) and *The Birth Project* (1985).

Hélène Cixous has published more than thirty full-length works of poetic fiction, several major plays and collections of critical work, as well as innumerable shorter pieces. She was instrumental in founding Paris VIII University in 1968, and has been Director of the Centre d'Études Féminines there since 1974, when she created a French doctoral program in Women's Studies (the first and still the only one in France). Since 1995 she has also served as Distinguished Visiting Professor at Northwestern University. Her publications in English translation include her doctoral thesis *The Exile of James Joyce* (1976), *Inside* (1988), *The Newly Born Woman* (1986), *Coming to Writing and Other Essays* (1991), *The Book of Promethea* (1991), *Three Steps on the Ladder of Writing* (1994), *Manna* (2000), *The Hélène Cixous Reader* (1994), *Rootprints* (1997), *Stigmata* (1998), *First Days of the Year* (1998), and *The Third Body* (1999).

Mary Ann Doane is George Hazard Crooker Professor of Modern Culture and Media and of English at Brown University. She is the author of *The Desire to Desire: The Woman's Film of the 1940s* (1987) and *Femmes Fatales: Feminism, Film Theory, Psychoanalysis* (1991). In addition, she has published a wide range of articles on feminist film theory, sound in the cinema, psychoanalytic theory, and sexual and racial difference in film, melodrama, and television. She is currently completing a book on technologies of representation and temporality in modernism.

Mary Douglas is an anthropologist who performed her early fieldwork in the Belgian Congo. She is the author of numerous influential works on human culture, including *The Lele of the Kasai* (1963), *Purity and Danger* (1966), *Natural Symbols* (1970), *Implicit Meanings* (1970), *Risk and Culture* (1982 with Aaron Wildavsky), *How Institutions Think* (1986), *Thought Styles* (1996), *Missing Persons* (1998 with Stephen Ney), and *Leviticus as Literature* (1999). Her academic career has included appointments in Great Britain at Oxford University, University College London, University of London, and in the U.S. at Northwestern University, Princeton University, and the Russell Sage Foundation, where she served as Director for Research on Culture. She remains an active researcher as a Professor Emeritus at University College London.

Jennifer Doyle teaches in the English Department at the University of California, Riverside, and works in the areas of nineteenth-century American art and literature, and gender and visual culture. Her current project, "Sex Objects," explores the work of writers and artists who deploy sex to destabilize the distinction between art and everyday life (Herman Melville, Thomas Eakins, Andy Warhol, and contemporary artists such as Vaginal Davis and Tracey Emin). She is co-editor of *Pop Out: Queer Warhol* (1996) and the author of "Sex, Scandal, and Thomas Eakins's *Gross Clinics*," *Representations* (Fall 1999).

Ann duCille is the William R. Kenan, Jr. Professor of the Humanities at Wesleyan University, where she chairs the African American Studies Program. She is the author of *The Coupling Connection: Sex, Text, and Tradition in Black Women's Fiction* (1993) and *Skin Trade* (1996).

Andrea Dworkin is the radical feminist author of *Pornography: Men Possessing Women* (1981), *Intercourse* (1987), and the novels *Mercy* (1991) and *Ice and Fire* (1986). She co-authored legislation recognizing pornography as a violation of the civil rights of women.

Deborah Fausch teaches architectural history and theory at the University of Illinois at Chicago. The editor, with Paulette Singley, Rodolphe el-Khoury, and Svi Efrat, of *Architecture: In Fashion* (1995), she has published essays on contemporary architectural theory in the journals *ANY, Perspecta, archithese, Daidalos*, as well as in several anthologies. She is writing a book on the urban theories of Robert Venturi and Denise Scott Brown.

María Fernández is an art historian whose interests center on post-colonial studies, electronic media theory, Latin American colonial and modern art, and the intersections among these fields. She has published essays on these topics in the journals *Third Text, Art Journal, n.paradoxa, Fuse*, and *Mute*. Fernández has taught at various institutions, including the University of Pittsburgh, Carnegie Mellon University, the University of Connecticut, and Vermont College.

Sandy Flitterman-Lewis is the author of *To Desire Differently: Feminism and the French Cinema* (1996) and co-author of *New Vocabularies in Film Semiotics* (1992) and was founding co-editor of *Camera Obscura: A Journal of Feminism and Film Theory* and of *Discourse: Studies in Media and Culture*. She has published chapters in numerous anthologies and is a Professor in the English department and Cinema Studies program at Rutgers University. In 1998 she organized a conference at Columbia University on material culture and daily life in Occupied France called *Hidden Voices: Childhood, the Family and Anti-Semitism*, the topic of which is the subject of her current work.

Susan Leigh Foster, a choreographer and writer, founded the eminent Dance Ph.D. program at the University of California, Riverside, and is currently a Professor at the University of California, Los Angeles. She is the author of *Reading Dancing, Choreography and Narrative* (1987) and *Dances That Describe Themselves* (2002). She has also edited *Choreographing History* (1995) and *Corporealities* (1996).

Coco Fusco is a New York-based interdisciplinary artist, and Associate Professor at the School of Arts of Columbia University. She has performed, lectured, exhibited, and organized exhibitions throughout North and South America, Europe, South Africa, Australia, New Zealand, Korea, and Japan. She is the author of *English is Broken Here* (1995), *The Bodies That Were Not Ours and Other Writings* (2001), and the editor of *Corpus Delecti: Performance Art of the Americas* (1999).

Moira Gatens is Professor and Chair of Philosophy at the University of Sydney. She is author of *Feminism and Philosophy* (1991), *Imaginary Bodies* (1996), and, with Genevieve Lloyd, *Collective Imaginings: Spinoza, Past and Present* (1999). She is editor of *Feminist Ethics* (1998) and co-editor of *Gender and Institutions* (1999) and *The Oxford Companion to Australian Feminism* (1999).

Ann Eden Gibson writes on contemporary art and theory and is Chair of the Art Department of the University of Delaware. She is the author of *Issues in Abstract Expressionism: The*

Artist-Run Periodicals (1990), and *Abstract Expressionism: Other Politics* (1997). She organized the exhibitions *Judith Godwin: Style and Grace* (1997) and, with Daniel Veniciano, *Norman Lewis: The Black Paintings, 1945–1977* (1998). Her book *Seeing Through Theory: Intention, Identity and Agency* is forthcoming from the University of Chicago Press.

Sander L. Gilman is Distinguished Professor of Liberal Arts and Sciences and Medicine at the University of Illinois at Chicago. He is a cultural and literary historian and the author or editor of over fifty books including *Seeing the Insane* (1982), *Jewish Self-Hatred* (1986), *Love + Marriage = Death* (1998), and *Making the Body Beautiful* (1999).

Jennifer González is Assistant Professor of Art History and Visual Culture at the University of California at Santa Cruz. Her writing has appeared in *Frieze, World Art, Diacritics, Inscriptions*, and in anthologies such as *The Cyborg Handbook* (1995), *Prosthetic Territories* (1995), *Race in Cyberspace* (2000), and *With Other Eyes: Looking at Race and Gender in Visual Culture* (1999).

Elizabeth Grosz teaches feminist theory in the Department of Women's Studies at Rutgers University. She has published widely in the areas of contemporary French philosophy, feminist theory and architectural theory, including the crucial feminist texts, *Jacques Lacan: A Feminist Introduction* (1990), *Volatile Bodies: Towards a Corporeal Feminism* (1994), *Space, Time, Perversion: Essays on the Politics of Bodies* (1995), and, most recently, *Architecture from the Outside: Essays on Virtual and Real Space* (2001).

The Guerrilla Girls are a group of women artists, writers, performers, and filmmakers who fight discrimination. Dubbing themselves the conscience of culture, they declare themselves feminist counterparts to the mostly male tradition of anonymous do-gooders like Robin Hood, Batman, and the Lone Ranger. They wear gorilla masks to shift the focus to the issues rather than their personalities. They use humor to convey information, provoke discussion, and show that feminists can be funny. Since 1985 they have produced over eighty posters, printed projects, and actions that expose sexism, racism, and hypocrisy in culture and politics. Their work has been passed around the world by kindred spirits who consider themselves Guerrilla Girls too. The mystery surrounding their identities has attracted attention and support. They could be anyone; they are everywhere.

Harmony Hammond is a New Mexico-based artist, writer and independent curator. She was a founding member of A.I.R. gallery (1972) and a co-founder and editor of *Heresies: A Feminist Publication on Art and Politics* (1976). She is the author of *Wrappings: Essays on Feminism, Art and the Martial Arts* (1984) and *Lesbian Art in America: A Contemporary History* (2000).

Donna Haraway is a Professor in the History of Consciousness Department at the University of California at Santa Cruz, where she teaches feminist theory, science studies, and women's studies. She is the author of *Crystals, Fabrics and Fields: Metaphors of Organicism in Twentieth-Century Developmental Biology* (1976), *Primate Visions: Gender, Race, and Nature in the World of Modern Science* (1989), *Simians, Cyborgs, and Women: The Reinvention of Nature* (1991), and *Modest_Witness@Second_Millennium.FemaleMan©_Meets_OncoMouse™*

(1997). Her present project, *Birth of the Kennel*, analyzes webs of action in dog–human cultures.

N. Katherine Hayles, Professor of English and Design/Media Arts at U.C.L.A., writes and teaches on the relations of literature, science, and technology in the twentieth and twenty-first centuries. Her most recent book, *How We Became Posthuman: Virtual Bodies in Cybernetics, Literature, and Informatics* (1999), won the René Wellek Prize for the best book in literary theory for 1998/9 and the Eaton Award for the best book in science-fiction theory and criticism for 1998/9. She is currently working on a new book, *Literature for Posthumans*, scheduled to appear in the MediaWorks Pamphlet series at M.I.T. Press.

bell hooks is Distinguished Professor of English at City College in New York. She is the author of many books on race and feminism, including *Outlaw Culture: Resisting Representation* (1994), *Black Looks, Teaching To Transgress* (1994), *Killing Rage* (1996), and *Feminism is for Everybody* (2000).

Luce Irigaray is a leading philosopher and feminist thinker, best known for her epochal feminist interventions into philosophy and psychoanalysis in the books *Speculum of the Other Woman* (1990) and *This Sex Which Is Not One* (1990). She is also the author of *Je, Tu, Nous* (1992), *I Love to You* (1994), *To Be Two* (2000), and *To Speak is Never Neutral* (2001).

Amelia Jones is Professor of Art History at the University of California, Riverside. She has written numerous articles in anthologies and journals and has organized exhibitions including *Sexual Politics: Judy Chicago's Dinner Party in Feminist Art History* (1996), for which she also edited and contributed to a catalogue by the same title. She co-edited the anthology, *Performing the Body/Performing the Text* with Andrew Stephenson (1999) and has published the books *Postmodernism and the En-Gendering of Marcel Duchamp* (1994) and *Body Art/Performing the Subject* (1998). She received N.E.H. and Guggenheim fellowships to complete her current project, a book tentatively entitled *Irrational Modernism*, rethinking the early twentieth-century historic avant-garde.

Mary Kelly is Professor of Art and Critical Theory at U.C.L.A. She is the creator of the important feminist multimedia installation art work, *Post-Partum Document* (1973–9), and numerous other feminist art works. She has published essays on feminism and contemporary art, many of which are pulled together in her book, *Imaging Desire* (1996). Publications on her artwork include *Mary Kelly* (1997) and *Rereading Post-Partum Document* (1999).

Julia Kristeva, internationally known psychoanalyst and critic, is Professor of Linguistics at the Université de Paris VII. She has hosted a French television series and is the author of many critically acclaimed books, including *Revolution in Poetic Language* (1974/English translation 1984), *About Chinese Women* (1974/English translation 1977), *Desire in Language* (English translation 1980), and *Étrangers à nous-mêmes* (1988). *The Kristeva Reader* (1986) and *The Portable Kristeva* (1997) collect a number of her most important texts.

Leslie Labowitz is an American artist who studied in Germany with Joseph Beuys and organized the first Feminist Artists Group there; she brought Beuys' concept of art as a social tool to California in 1977, when she returned to the U.S. and began collaborating with Suzanne Lacy. Her collaborative performances with Lacy include *Three Weeks in May* (1977), *In Mourning and In Rage* (1977), and *From Reverence to Rape to Respect* (1978).

Suzanne Lacy is an artist, writer, and video producer whose work includes large-scale performances on urban themes (see Labowitz entry) and the edited volume *Mapping the Terrain: New Genre Public Art* (1995). A theorist of public art and a pioneer in community development through art, Lacy is currently artist-in-residence for Oakland's strategic planning organization, *Oakland Sharing the Vision*, and is a founding faculty member of the Visual and Public Art Program at California State University at Monterey Bay. She has been Dean of Fine Arts at the California College of Arts and Crafts in Oakland, California, since the mid-1980s.

Sharon Lehner holds an M.A. from the department of performance studies at N.Y.U. She works as an archivist — most recently at the Brooklyn Academy of Music.

Elisabeth Lyon teaches film studies and comparative literature at Hobart and William Smith Colleges in Geneva, New York. She is a co-founder and was co-editor of *Camera Obscura* from 1975 to 1997. Besides her academic work, from 1995 to 1998 she was Director of Development for Bona Fide Productions in Los Angeles, where she produced two feature films, *Election* and *The Wood* (Bona Fide/MTV/Paramount productions, 1999).

Judith Mayne is Professor of French and Women's Studies at Ohio State University. She is the author of several books on feminism and film studies, including *Cinema and Spectatorship* (1993) and, most recently, *Framed: Lesbians, Feminists, and Media Culture* (2000).

Trinh T. Minh-ha is a writer, filmmaker, and composer. Her work includes a collaborative multimedia installation, *Nothing But Ways* (1999); seven books, of which the most recent are *Cinema Interval* (1999) and, in collaboration with Jean-Paul Bourdier, *Drawn from the African Dwellings* (1996); and six feature-length films, including *The Fourth Dimension* (2001) and *A Tale of Love* (1996), which have been honoured in twenty-seven retrospectives around the world. She is Professor of Women's Studies, Film Studies, and Rhetoric at the University of California, Berkeley.

Tania Modleski is Professor of English at the University of Southern California, and is the author of several books on feminism, film, and popular culture, including *Feminism Without Women: Culture and Criticism in a "Post-Feminist Age"* (1991) and *Old Wives' Tales and Other Women's Stories* (1999).

Patricia Morton is Associate Professor at the University of California, Riverside. She has published widely on architectural history and issues of race, gender, and marginality in such journals as *Art Bulletin*, *Casabella*, and the *Journal of Architectural Education*, and in her book on the 1931 Colonial Exposition in Paris, *Hybrid Modernities* (2000). Her current research focuses on primitivism in modern architecture.

Laura Mulvey is Professor of Film and Media Studies at Birkbeck College, University of London, and Director of the A.H.R.B. Centre for British Film and Television Studies. She has been writing about film and film theory since the mid-1970s. She has published *Visual and Other Pleasures* (1989), *Fetishism and Curiosity* (1996), and *Citizen Kane* (1996). In the late 1970s and early 1980s, she co-directed six films with Peter Wollen including *Riddles of the Sphinx* (1978) and *Frida Kahlo and Tina Modotti* (1980). In 1994, she co-directed a documentary with artist/filmmaker Mark Lewis entitled *Disgraced Monuments*, which was broadcast on Channel 4.

José Esteban Muñoz is Associate Professor in the Department of Performance Studies at Tisch School of the Arts, New York University. He is the co-editor of *Pop Out: Queer Warhol* (1996) and *Everynight Life: Culture and Music in Latin/o America* (1997) as well as special issues of the journals *Social Text* and *Women and Performance*. He is the author of *Disidentifications: Queers of Color and the Performance of Politics* (1999) and is currently completing two manuscripts titled *Feeling Brown: Ethnicity, Affect and Performance* and *Cruising Utopia*.

Linda Nochlin is the Lila Acheson Wallace Professor of Modern Art at the Institute of Fine Arts, New York University. She specializes in the art of the nineteenth and twentieth centuries, with a particular interest in the work of Gustave Courbet and the Impressionists. She is the author of *Representing Women* (1999), *Realism* (1997), *Women in the 19th Century: Categories and Contradictions* (1997), *The Jew in the Text* (1995), and *Florine Stettheimer: Manhattan Fantastica* (1995), and co-author of *Andy Warhol: Nudes* (1997), *The First 38 Years* (1997), and *Renoir's Portraits: Impressions of an Age* (1997).

Lorraine O'Grady, Associate Professor of Studio Art and African American Studies at the University of California at Irvine, is a performance and installation artist who has exhibited nationally and internationally. Her awards have included the Bunting Fellowship in Visual Art at Harvard University and the Vera List Senior Fellowship in Art and Politics at the New School for Social Research, and her writings have appeared in such publications as *Artforum* and *Afterimage*.

Pratibha Parmar is an internationally acclaimed filmmaker and writer whose documentary credits include *Khush* (1991), *A Place of Rage* (1991), *Warrior Marks* (1993; with Alice Walker), and *Righteous Babes* (1998). She has directed a number of films, including *Memsahib Rita* (1994), *Wavelengths* (1997), and *Sita Gita* (2000). She is a published author and editor of several books, including (with Alice Walker) *Warrior Marks: Female Genital Mutilation and the Sexual Blinding of Women* (1993).

Constance Penley is Professor of Film Studies at the University of California, Santa Barbara. She is one of the founding editors of *Camera Obscura* and a member of the G.A.L.A. committee. She is the author of *The Future of an Illusion: Film, Feminism, and Psychoanalysis* (1989) and *NASA/TREK: Popular Science and Sex in America* (1997). She is the editor of *Feminism and Film Theory* (1988) and *The Analysis of Film by Raymond Bellour* (2000). She is the co-editor of several collections, including *Male Trouble* (1989), *Technoculture* (1991), and *Imaging Technologies: Gender and Science* (1988), and recently wrote the libretto for *Biospheria: An Environmental Opera*.

Peggy Phelan is currently Professor of Performance Studies, Tisch School of the Arts, New York University, and Visiting Professor of Drama, Stanford University. She is the author of *Unmarked: The Politics of Performance* (1993), *Mourning Sex: Performing Public Memories* (1997), and, with Helena Reckitt, *Art and Feminism* (2001). From 1997 to 1999 she was a fellow of the Open Institute's project on Death in America.

Adrian Piper is an artist, theorist, philosopher, and critic whose research publications are in metaethics and Kant's metaphysics. She is a Professor of Philosophy at Wellesley College and exhibits her work at the John Weber and Paula Cooper Galleries in New York. Her collected writings about art and culture have been published in a two-volume set entitled *Out of Order, Out of Sight* (1996).

Sadie Plant received her Ph.D. from the University of Manchester, and is the author of *The Most Radical Gesture: The Situationist International in the Postmodern Age* (1992), *Zeros and Ones: Digital Women and the New TechnoCulture* (1997), and *Writing on Drugs* (2001). She has been a lecturer in cultural studies at the University of Birmingham and research fellow at the University of Warwick.

Griselda Pollock is Professor of Social and Critical Histories of Art and Director of the Transdisciplinary (A.H.R.B.) Centre for Cultural Analysis, Theory and History at the University of Leeds. She has written extensively on feminist cultural theory and the analysis of the historical and contemporary visual arts. Her most recent books are *Differencing the Canon: Feminist Desire and the Writing of Art's Histories* (1999) and *Looking Back to the Future: Essays on Art, History and Death* (2000). She is also preparing a monograph on Van Gogh, a book entitled *Time, Space and the Archive: Towards the Virtual Feminist Museum*, and a critical study of *Leben oder Theater* by Charlotte Salomon.

Irit Rogoff holds a University Chair in Art History/Visual Culture at Goldsmith's College, London University. Rogoff writes on German modernism, feminism, and issues of diaspora; she is author of *Terra Firma: Geography's Visual Culture* (2000), editor of *The Divided Heritage: Themes and Problems in German Modernism* (1991), and co-editor, with Daniel Sherman, of *Museum Culture: Histories/Theories/Spectacles* (1994).

Christine Ross is Associate Professor and Chair of the Department of Art History and Communication Studies at McGill University. A regular contributor to *Parachute*, she is the author of *Images de surface: l'art vidéo considéré* (1996). Recent publications extending her feminist exploration of video installation include essays on the work of Pipilotti Rist and Rosemary Trockel and on contemporary video art in relation to performativity in the journals *Paradoxa*, *October*, and *Art Journal*.

Miriam Schapiro, awarded the 2001 Distinguished Artist Award for Lifetime Achievement by the College Art Association, is an artist whose work, incorporating elements of stitchery, needlework, sewing and quiltmaking, was central to the Pattern and Decoration movement in the 1970s and 1980s. Schapiro ran the California Institute of the Arts version of the Feminist Art Program with Judy Chicago in the early 1970s and took part in the women's collective which founded *Heresies* magazine. Her works are held by major museums worldwide, including

the National Museum of American Art, the Museum of Modern Art, and the Whitney Museum of American Art.

Mira Schor is a painter and writer living in New York. She was the co-publisher and co-editor, with Susan Bee, of *M/E/A/N/I/N/G*, a journal of contemporary art, between 1986 and 1996. Schor and Bee co-edited a volume of the journal's highpoints entitled *M/E/A/N/I/N/G: An Anthology of Artists' Writings, Theory and Criticism* (2000). A collection of Schor's essays, *Wet: On Painting, Feminism, and Art Culture*, was also published by Duke University Press (1997). She is the recipient of a 1992 Guggenheim Fellowship in Painting and also of the 1999 College Art Association Frank Jewett Mather Award in Art Criticism. She teaches in the M.F.A. Program in Visual Art in the Fine Arts Department of Parsons School of Design in New York City and exhibits her art work nationally.

Lynn Spigel is a Professor in the School of Cinema – Television at the University of Southern California. She is the author of *Make Room for TV: Television and the Family Ideal in Postwar America* (1992) and *Welcome to the Dreamhouse: Popular Media and Postwar Suburbs* (2001). She has also co-edited numerous anthologies, including *Feminist Television Criticism* (1997) and *The Revolution Wasn't Televised* (1997).

Sandy Stone is Associate Professor at and Founding Director of the Advanced Communication Technologies Laboratory (ACTLab) and the Convergent Media program of the University of Texas at Austin, Senior Artist at the Banff Centre for the Arts, and Fellow of the Humanities Research Institute, University of California, Irvine. In various incarnations she has been a filmmaker, rock'n'roll engineer, neurologist, social scientist, cultural theorist, and performer. She is the author of numerous publications, including "The Empire Strikes Back: A Post-transsexual Manifesto" (*Camera Obscura*, 1992) and the book, *The War of Desire and Technology at the Close of the Mechanical Age* (1996).

Klaus Theweleit is a lecturer in sociology at the University of Freiberg. His publications include *Male Fantasies* vols 1 and 2 (1987 and 1989), *Gormley/Theweleit* (2002), and *Object Choice: All You Need is Love* (1994).

VNS Matrix – Josephine Starrs (http://sysx.org/starrs), Julianne Pierce (http://sysx.org/jules), Francesca da Rimini (http://sysx.org/gashgirl), and Virginia Barratt. From 1991 to 1997 they created installations, events, and public art works in Australia and internationally. With backgrounds in photography, film, video, music, performance, writing, feminism, and cultural theory, VNS Matrix coined the term "cyberfeminism" along with Sadie Plant in the early 1990s. The impetus for VNS Matrix was to investigate and decipher the narratives of domination and control that surround high technological culture, and explore the construction of social space, identity, and sexuality in cyberspace.

Faith Wilding, a feminist cultural producer active since the early 1970s, currently works with Subrosa, a cyberfeminist collective, to explore and critique the intersections of the new information and bio-technologies in women's bodies, lives, and work. She is a Fellow at the STUDIO for Creative Inquiry, Carnegie Mellon University, and Graduate Faculty in the M.F.A. Visual Arts program, Vermont College.

Judith Wilson is an assistant Professor of African-American Studies and Art History at the University of California, Irvine. A former *Ms.* Magazine editor (1975–77), *Essence* contributing editor (1978–81), and *Village Voice* art critic (1979–81), she is currently a member of the international council of *Third Text*, the editorial board of *American Art*, and a general editor of *The Encyclopedia of African-American Art and Architecture* (forthcoming). She has published widely on issues of feminism and race in the history of art.

Monique Wittig, Professor of Women's Studies and French at the University of Arizona, is an internationally recognized author of several experimental novels, including *The Lesbian Body* (first English translation 1975), and of plays, literary criticism, and theoretical essays, a number of which are collected in *The Straight Mind* (published in English in 1992). Her works have been translated into many languages and she is a recipient of the prestigious French national literary award, the Prix Médicis. Employing a materialist feminist approach she combines political activism and philosophical inquiry, cultural critique and creativity to abolish the mark of gender.

Janet Wolff is Associate Dean for Academic Affairs in the School of the Arts at Columbia University. She taught for a number of years at the University of Leeds and from 1991 to 2001 she was Director of the Visual and Cultural Studies Program at the University of Rochester. Her books include *The Social Production of Art* (1981), *Aesthetics and the Sociology of Art* (1983), *Feminine Sentences: Essays on Women and Culture* (1990), and *Resident Alien: Feminist Cultural Criticism* (1995). Her latest book, *AngloModern: Painting and Modernity in England and the U.S.,* will be published in 2003.

Kathleen Zane was born and raised in Hawaii, and educated in New York City. She has been a Professor of Literature, American Studies, and Women's Studies in the Northeast U.S., Mexico, Spain, and Japan. While she continues her research and writing on visual and popular cultures, focused on the Asian body, the culture of travel, and the Hawaiian-theme "Hello Kitty" products, she is currently in training to be a psychotherapist.

Acknowledgments

First and foremost I would like to thank the authors of the previously published texts in this volume for generously granting permission for their essays to be reprinted here. And a special thanks goes to those who wrote insightful new essays in response to my invitation and cheerfully accepted my editorial interventions: Rosemary Betterton, Lisa Bloom, Meiling Cheng, Jennifer Doyle, Faith Wilding, and Judith Wilson. In addition, I am grateful to the many colleagues who offered advice to me on which essays on this topic they have found the most useful in their teaching and research: Nancy Barton, Gavin Butt, Whitney Chadwick, Dorit Cypis, Jennifer Doyle, Ann Gibson, Caroline Jones, Liz Kotz, Peter Lunenfeld, Kathleen McHugh, Marsha Meskimmon, Tania Modleski, Caroline Murphy, Kathy O'Dell, Griselda Pollock, Hilary Robinson, Irit Rogoff, Moira Roth, Mira Schor, Vivian Sobchack, Abigail Solomon-Godeau, Andrew Stephenson, Kristine Stiles, Carole-Anne Tyler, Janet Wolff, and Lynn Zelevansky. I often followed their excellent advice; any lacunae in the collection should be attributed to space limitations rather than to any gaps in their knowledge. Other friends (you know who you are) kept me in balance with margaritas and gossip....

Marita Sturken and Nicholas Mirzoeff provided valuable editorial input for the introductory sections of the book. Needless to say, without Mirzoeff's initial prompting and intelligent guidance this volume would not have come to fruition. Rebecca Barden, Chris Cudmore, and Katherine Ahl at Routledge offered indispensable advice and aid at every step. And my Research Assistants, Mitra Abbaspour and Robert Summers, funded in part by my supportive and generous home campus, University of California, Riverside, provided much needed bibliographic – and Xeroxing – labor.

My deepest gratitude goes to Tony Sherin, one of those rare, truly feminist men whose support is infinite but whose patience is, thankfully, finite and so guides me to acknowledge my own limits. Finally, this book, which I hope provides a record (suggestive, rather than fixed) of the potential of feminism to change the way we see, is dedicated to my children, Evan and Vita, burgeoning feminists both; their world, thanks to the insights offered in such texts as these, will surely be a more just and thoughtful one.

Permissions

We gratefully acknowledge permission to reproduce the following essays:

Barry, Judith, and Sandy Flitterman, "Textual Strategies: The Politics of Art-Making," *Screen* 21, n. 2, Summer 1980.

Berger, John, *Ways of Seeing*, Penguin Books, Harmondsworth, 1972. Copyright ©1972 John Berger.

Bordo, Susan, "Never Just Pictures," *Twilight Zones: The Hidden Life of Cultural Images from Plato to O.J.*, University of California Press, Berkeley, 1997. Copyright ©1997 The Regents of the University of California.

Braidotti, Rosi, "Cyberfeminism with a Difference," online, available: <http://www.let.uu.nl/womens.studies/rosi/cyberfem.htm//July 2001>.

Butler, Judith, "Performative Acts and Gender Constitution: An Essay in Phenomenology and Feminist Theory," *Theatre Journal* 40, n. 4, December 1988.

Camera Obscura Collective, "Feminism and Film: Critical Approaches," *Camera Obscura* 1, December 1976.

Case, Sue-Ellen, "Toward a Butch–Femme Aesthetic," *Making a Spectacle: Feminist Essays on Contemporary Women's Theatre*, University of Michigan Press, Ann Arbor, 1989.

Chicago, Judy, and Miriam Schapiro, "Female Imagery," *Womanspace Journal*, 1973.

Cixous, Hélène, "Bathsheba or the Interior Bible," *New Literary History* 24, n. 4, 1993, 820–37. Copyright © The University of Virginia. Reprinted by permission of the Johns Hopkins University Press. ["Bathsabée ou la Bible intérieure" was first published in *FMR* 43, April 1993, 14–18; this translation (of a different version) appeared in *New Literary History* 24, n. 4, 1993: 820–37.]

Doane, Mary Ann, "Film and the Masquerade," *Femmes Fatales: Feminism, Film Theory, Psychoanalysis*, Routledge, New York, 1991. Reprinted by permission of Routledge, an imprint of Taylor & Francis Books Ltd. [Originally published in *Screen* 23, n. 3/4, 1982.]

Douglas, Mary, "External Boundaries," *Purity and Danger: An Analysis of Concepts of Pollution and Taboo*, Frederick Praeger, New York and Washington, 1966.

duCille, Ann, "Black Barbie and the Deep Play of Difference," *Skin Trade*, Harvard University Press, Cambridge MA, 1996.

Dworkin, Andrea, "Pornography," *Pornography: Men Possessing Women*, E. P. Dutton, New York, 1989. Copyright ©1979, 1980, 1981 Andrea Dworkin. Reprinted by permission of Dutton, a division of Penguin Putnam Inc., and Elaine Markson Literacy Agency.

Fausch, Deborah, "The Knowledge of the Body and the Presence of History," in *Architecture and Feminism*, Debra Coleman et al. (eds), Princeton Architectural Press, New York, 1996.

Fernández, María, "Postcolonial Media Theory," *Art Journal* 58, n. 3, Fall 1999.

Foster, Susan, "The Ballerina's Phallic Pointe," *Corporealities*, Susan Foster (ed.), Routledge, London, 1996. Reprinted by permission of Routledge, an imprint of Taylor & Francis Books Ltd.

Fusco, Coco, "The Other History of Intercultural Performance," *English is Broken Here: Notes on Cultural Fusion in the Americas*, The New Press, New York, 1995. Copyright ©1995 Coco Fusco. Reprinted by permission of The New Press. [Originally published in *The Drama Review* 38, n. 1, Spring 1994.]

Gatens, Moira, "Epilogue," *Imaginary Bodies*, Routledge, London, 1996. Reprinted by permission of Routledge, an imprint of Taylor & Francis Books Ltd.

Gibson, Ann Eden, "Color and Difference in Abstract Painting," *Genders* 13, Spring 1992.

Gilman, Sander L., "Black Bodies, White Bodies: Toward an Iconography of Female Sexuality in Late Nineteenth-Century Art, Medicine, and Literature," in *Race, Writing and Difference*, Henry Louis Gates Jr (ed.), The University of Chicago Press, Chicago, 1986. [Originally published in *Critical Inquiry* 12, n. 1, Autumn 1985.]

González, Jennifer, "The Appended Subject," in *Race in Cyberspace*, Beth K. Kolko et al. (eds), Routledge, New York, 2000. Reprinted by permission of Routledge, an imprint of Taylor & Francis Books Ltd.

Grosz, Elizabeth, "Bodies–Cities," in *Sexuality and Space*, Beatriz Colomina (ed.), Princeton Architectural Press, New York, 1992.

Guerrilla Girls, "Introduction" and "Conclusion," *The Guerrilla Girls' Bedside Companion to the History of Western Art*, Penguin Books, New York, 1998. Copyright ©1998 The Guerrilla Girls. Used by permission of Viking Penguin, a division of Penguin Putnam Inc.

Hammond, Harmony, "Lesbian Artists," in *Our Right to Love*, Ginny Vida (ed.), Prentice Hall, New York, 1978. Reprinted by permission of Pearson Educational Publishers Inc. [Originally published in *Our Right to Love*, ed. Ginny Vida, Prentice-Hall, 1978.]

Haraway, Donna, "A Cyborg Manifesto: Science, Technology, and Socialist-Feminism in the Late Twentieth Century," *Simians, Cyborgs and Women: The Reinvention of Nature*, Routledge, New York, 1991. Reprinted by permission of Routledge, an imprint of Taylor & Francis Books Ltd. [Originally published in *Socialist Review* 80, 1985.]

O'Grady, Lorraine, "Olympia's Maid: Reclaiming Black Female Subjectivity," *Afterimage* 20, n. 1, Summer 1992. [The first part of this article was published in *Afterimage* 20, n. 1, Summer 1992.]

Parmar, Pratibha, "Hateful contraries: Media Images of Asian Women," *Ten.8* 16, 1984. [From *Ten.8* 16 (1984).]

Phelan, Peggy, "Broken Symmetries: Memory, Sight, Love," *Unmarked*, Routledge, London, 1993. Reprinted by permission of Routledge, an imprint of Taylor & Francis Books Ltd.

Piper, Adrian, "The Triple Negation of Colored Women Artists," *Out of Order, Out of Sight Vol. II: Selected Writings in Art Criticism*, MIT Press, Cambridge MA, 1996. [Originally published in *Next Generation: Southern Black Aesthetic*, University of North Carolina, Chapel Hill, 1990.]

Plant, Sadie, "Feminisations: Reflections on Women and Virtual Reality," in *Clicking In: Hot Links to a Digital Culture*, Lynn Hershman Leeson (ed.), Bay Press, Seattle, 2000.

Pollock, Griselda, "Screening the Seventies," *Vision and Difference*, Routledge, London and New York, 1988. Reprinted by permission of Routledge, an imprint of Taylor & Francis Books Ltd.

Rogoff, Irit, "Gossip as Testimony," in *Generations & Geographies in the Visual Arts*, Griselda Pollock (ed.), Routledge, London, 1996. Reprinted by permission of Routledge, an imprint of Taylor & Francis Books Ltd.

Ross, Christine, "To Touch the Other," *Public* 13, 1996, Public Access, Toronto.

Schor, Mira, "Patrilineage," *Wet: On Painting, Feminism and Art Culture*, Duke University Press, Durham, 1997. Copyright ©1997 Duke University Press. All rights reserved. Reprinted with permission. [Originally published in *Art Journal* 50, n. 2, Summer 1991.]

Spigel, Lynn, "The Suburban Home Companion," in *Sexuality and Space*, Beatriz Colomina (ed.), Princeton Architectural Press, New York, 1992.

Stone, Sandy, "A Posttranssexual Manifesto," from "The Empire Strikes Back," *Camera Obscura* 29, May 1992.

Theweleit, Klaus, "Streams/All that Flows" and "Women: Territory of Desire," *Male Fantasies, Vol. I: Women, Floods, Bodies, History*, University of Minnesota Press, Minneapolis, 1987. Translated by Stephen Conway. [Originally published in German, 1977.]

VNS Matrix, "Cyberfeminist Manifesto," online, available: <http://sysx.org/vns/manifesto.html>.

Wittig, Monique, "The Straight Mind," *The Straight Mind and Other Essays*, Beacon Press, Boston, 1992. Copyright ©1992 Monique Wittig. Reprinted by permission of Beacon Press, Boston. [Originally published in *Feminist Issues* 1, n. 1, Summer 1980.]

Wolff, Janet, "Reinstating Corporeality: Feminism and Body Politics," *Feminine Sentences: Essays on Women and Culture*, University of California Press, Berkeley, 1990. Copyright ©1990 Janet Wolff, The University of California Press, Berkeley.

Zane, Kathleen, "Reflections on a Yellow Eye," in *Talking Visions: Multicultural Feminism in a Transnational Age*, Ella Shohat (ed.), The MIT Press, Cambridge MA, 1998.

AMELIA JONES

INTRODUCTION
Conceiving the intersection of feminism and visual culture

THE INTERSECTION OF FEMINISM AND VISUAL CULTURE, two modes of thinking, making, doing, or strategizing which have their own historical trajectories and political reasons for being, is a volatile and immensely rich one. Feminism, in most of its forms, proposes or demands a political and/or ethical stance towards cultural experience; academic versions of feminism theorize the ways in which all forms of culture condition, and are conditioned by, gender or "sexual difference." In its most recent forms, feminism insists on broadening models of analyzing the role of gender in cultural experience to accommodate the coextensivity of gender and other modes of subjectivity – including aspects of sexual orientation, racial and ethnic identifications, nationality, class, and so on.

Visual culture is a rubric and a model of critical thinking about the world of images saturating contemporary life. Visual culture was initially developed by scholars frustrated by the limitations of art historical analysis (which insists upon the separation of "high" from "low" cultural forms) and the separation of models of visual analysis according to disciplines (for example film theory and television studies). Visual culture, from the beginning, has been aimed at breaking down disciplinary limitations defining what and how visual imagery is to be analyzed within a critical visual practice.

Both modes of thinking – feminism and visual culture – are, in this way, driven by political concerns and focus primarily on cultural forms as informing subjective experience. While feminism is a broader initiative encompassing all levels of cultural experience, its insights have become so central to our understanding of the world that it informs most modes of visual culture analysis at this point, whether this dependence is acknowledged or not. At the same time, feminism has long acknowledged that visuality (the conditions of how we see and make meaning of what we see) is one of the key modes by which gender is culturally inscribed in Western culture. Feminism and visual culture, then, deeply inform one another.

This volume offers a selection of key texts that, in one way or another, theorize and historicize visual imagery and the issue of visuality through a feminist lens. The volume is intended to be suggestive, leading the reader to further exploration, rather than definitive; it *conceives* (of) this complex intersection both in the sense of imagining or putting it into form and in the sense of attempting to understand it through the inclusion of numerous prepublished, and six newly commissioned, essays.

Definitions

Feminism is, of course, not a singular discourse to be easily defined or pinned down. Although its emergences (from the burgeoning of the suffragette movements in the late nineteenth and early twentieth centuries to the rise of women's lib in the 1960s and beyond) can be loosely mapped, its parameters and positions are under continual negotiation. This book takes feminism seriously but does not seek to patrol its borders by, for example, labeling authors or producers of images "feminist" or "not feminist." This kind of strategy is antithetical to the best impulses of what I take to be feminism, which in some forms at least argues against attributing inherent meaning or value to people, texts, or objects in the world. In organizing this anthology, I worked from the logic that any argument (whether visual or verbal, embodied, virtual, or textual) which takes an interest in, or can be deployed to explore, the ways in which subjects take on, perform, or project gendered identities is, to some extent, feminist, or at least is useful for a feminist study of visual or other kinds of culture.

Having arisen as a critical rubric relatively recently, visual culture is at once a clearer and a more elusive category, though as a body of objects it has existed as long (at least) as the human eye. The simplest place in which to situate visual culture is in relation to the rise of cultural studies in England in the 1950s and beyond. Informed by the rise of the New Left in late 1950s Britain (itself sparked by the Soviet incursion into Hungary in 1956), cultural studies drew from myriad disciplines and methods of analysis but was most deeply marked, according to one of its foundational figures, Stuart Hall, by an abiding link to Marxism, with its commitment to analyze the deep structures of society and to focus on historical and cultural specificity. Cultural studies, Hall has insisted, is a "discursive formation" rather than a discipline (Hall 1992, 278). It is a set of ideas articulating new models of analysis in response to the forms of culture it seeks to address – it "draws from whatever fields are necessary to produce the knowledge required for a particular project" (Grossberg et al. 1992, 2).

While cultural studies is a mode of thinking about culture of all kinds, until the rise of the specific discourse of visual culture in the 1980s, its bias was towards textual analysis. This bias related to the fact that it took much of its theoretical impetus not only from Marx but from the fields of linguistics and semiotics, where the most sophisticated textual analyses were being done in the 1950s by scholars such as Roland Barthes. Through a semiotics inflected by Marxist and psychoanalytic theory, British scholars Raymond Williams and then Hall thus developed cultural studies in 1964, the center for which was the cross- (or even anti-)disciplinary Centre for Contemporary Cultural Studies in Birmingham.

Cultural studies, then, developed with the strong motivation to break down the conventional distinctions defining disciplines and privileging certain kinds of culture over those deemed "popular" or "mass" oriented. Visual culture takes this democratizing impulse, but focuses on visual imagery and on the problem of visuality. Like cultural studies, visual culture draws from several complementary models for examining sign systems, institutions, and other aspects of lived cultural experience – such as Marxism, semiotics, psychoanalysis – but visual culture, having developed as a mode of analysis somewhat later, also takes much of its defining political impetus from feminism and the other rights discourses, including anti-racist and postcolonial theory and gay/lesbian or queer theory. Visual culture, naturally enough, is also deeply informed as well by the critical models of visual analysis developed in the disciplines of art history (including photography history and theory) and film studies. Through these latter influences and pressures, visual culture has developed far beyond its initial connection to cultural studies alone.

While visual culture shares the impulse of cultural studies to reject disciplinary hierarchies (conceptions, for example, of "high" vs. "low" culture) and to explore the uses and meanings of images *across* disciplines, its even more important offering, as Nicholas Mirzoeff and others have pointed out, is in its revision of the conception of how meaning takes place in the visual relation (Mirzoeff 1999, 3–4). In his epochal 1972 study of popular and fine art images, *Ways of Seeing*, John Berger[1] (Chapter 7) noted "[t]he way we see things is affected by what we know or what we believe" (Berger 1972, 3). Berger (among others) opened the way for conceiving the meaning of visual images as taking place in a process of exchange between the image (with its proposed "way of seeing") and the viewer, whose beliefs inform the way she or he interprets the work. Visual culture, then, cuts through the conventional art-historical notion of meaning as inherent in an image, as presumably embedded there in perpetuity by the willful intentions of the artist; as Keith Moxey has put it, "[t]he sign systems of the past are invested with meaning by those of the present" (Bryson et al. 1994, xxvii).

Along with Berger's *Ways of Seeing*, one of the key moments in the articulation of a critical discourse of visual culture studies was the publication in 1975 of Laura Mulvey's "Visual Pleasure and Narrative Cinema" (Chapter 9) in the important British film journal, *Screen*. The publication of this essay and Berger's emphasis on a feminist critique of visual culture mark the centrality of feminism to the study of visual culture. Both authors marshal aspects of psychoanalysis, Marxism, semiotics, and feminist theory to argue compellingly that visual images not only narrativize power relations (through the reiterative portrayal of naked women) but bear these relations within their very formal structure and in their conditions of distribution; both authors explore at some length how these relations are explicitly gendered.

As Mulvey's and Berger's texts suggest, feminism and visual culture have a reciprocally weighted relationship. Feminism has had a central role in the development of critical models of reading visual imagery in visual culture and its related disciplines of art history, film theory, television studies, and the visually oriented arms of media, new media, and cultural studies. Visual culture as a category of objects or images, or as a mode or strategy of interpretation, is always already determined in and through relations of sexual difference; it has offered some of the most useful possibilities for the development of a feminist model of critical cultural analysis.

At the same time, cultural studies has not always embraced or even acknowledged the theoretical and political pressures of feminism in its critical practices (see Shiach 1999, 3). This volume counters this tendency within the cultural or media studies approach to relegate feminism to the sidelines as simply one way of thinking about textual or visual meaning.[2]

It is the premise of this volume that feminism is not an adjunct to, or one critical model within, a larger umbrella of cultural or visual culture studies. Rather, feminism is one of the ways in which we can most usefully come to an understanding of the image culture in which we are suspended – not the least because feminism is one of the myriad discourses that arose in symbiotic relation to the rise of modernity – itself coincident with the development of the camera, media imagery, and, in short, modern image culture. This collection makes clear, in addition, that the insights of feminism provided crucial impetus for the opening up of disciplines which ultimately resulted in the formation of new interdisciplinary strategies of interpretation such as visual culture studies. And it points to the fact that, since around 1970, it has been feminist responses and approaches to visual images that have provided some of the strongest, most polemical, and most productive theories and critical strategies to come out of any of the disciplines or modes of analysis associated with visual culture.

Inclusion/exclusion: the logic of the Reader

Far from pretending to be comprehensive, *The Feminism and Visual Culture Reader* must admit its own partialities, the crucial political impulse behind feminism itself being a refusal of any claims of omnipotence, universalism, or comprehensiveness of point of view. The inevitable exclusions in this project are too many to name. My choices are marked by my own particular position within this intersecting field: I was trained in the U.S. as an art historian (with a Ph.D. minor in film studies) and I came of age as a feminist scholar in the late 1980s and early 1990s, when U.S./English feminism dominated the scene.

The logic of inclusion plays along several lines, all of which relate to my desire for the Reader to serve both as an introduction to feminism and visual culture for non-specialists and students and as a resource for those who have immersed themselves in its complex debates over the past thirty years. In order to provide a useful compendium for both types of audiences, I was motivated by the following premises:

(1) I wanted to try to include at least most of the now canonical texts put to work in feminist studies of visual imagery – such as Mulvey's "Visual Pleasure and Narrative Cinema" and Donna Haraway's epochal "Cyborg Manifesto" (Chapter 53). My logic was that without these crucial essays the Reader would be incomplete for teaching purposes; the non-specialist reader would simply be forced to find them elsewhere. In addition, this Reader is intended to provide a historiography of feminist approaches to visual culture by tracing a trajectory through the various shifts in feminist visual theory; without the major texts, the story would be incomplete.

(2) Another primary criterion for selection was that the included essay offer a new theoretical model of analysis or interpretation or critique – a model that breaks (or broke, if it is an older work) new ground in some way.

(3) Finally, I wanted to represent as many theoretical and political points of view as possible: a certain (though inevitably not broad enough, as noted) geographical scope covering an array of primarily Anglophone writers; as wide an array of positions within (and sometimes even oblique to) feminism as possible, including the voices of those critiquing the limitations of feminist visual theory; and as wide an array of visual culture examples as possible – including photographs, advertisements, architecture, magazine imagery, toys, television shows, movies, dance, video, performance/theater, and the Internet.

This breadth is necessarily somewhat biased towards those kinds of visual culture addressed by the field of art history, since I am trained in this discipline. At the same time, of course, my desire for breadth meant that I had to eliminate many important essays that overlapped other arguments already represented by essays written from a similar point of view. Even within art history, then, extensive debates are often only represented by the point of view offered in a single essay; in order more fully to follow debates within disciplines, the reader is urged to consult other anthologies focusing more specifically on art history (see Robinson 2001) or other disciplines related to visual culture. The lists of additional readings at the end of each section of the anthology point the reader in the direction of some of these additional sources.

It is also in the spirit of inclusion (but with the knowledge of the inevitable exclusions that all inclusions entail) that I commissioned the six new essays in the first section of the

book. Each is written by a feminist with a particular, strongly articulated point of view; the writers are working from different disciplinary locations, but all are interested in visual culture. Each of the six new essays stages a polemical opening for the various shifts marked by the articles grouped in historically and/or conceptually determined categories, in the rest of the book. These interventions are meant both to emphasize the urgency of focusing a feminist critique on the field of visual culture and, as they are posed by writers trained in different disciplines, to point to the specificity of different kinds of visuality.

Another logic: tracing a history of theory

In addition to providing the reader with a number of exemplary, rigorous feminist models for understanding how visual images function and come to have meaning, and how disciplines have accommodated various kinds of visual culture, the volume seeks to offer one historiography of feminist theories of the visual (only "one" because, indeed, the histories that could be told would be infinitely variable depending on the teller).

Contrary to the views of some conservative art historians, whose anxieties about the opening signaled by visual culture take the form of hysterical denunciations of its putative ahistoricism (the questionnaire and many of the responses in a 1996 special section on "Visual Culture" in the art journal *October* being exemplary of this reactionism),[2] this volume takes visual culture as offering the potential for a deeply, if differently, historical understanding of the visual images of past and present. Rather than confirming social art history's conception of the image as superstructural – as conveying through its own formal logic and subject matter the economic and/or social "facts" of its context of making – the cross-disciplinary concept of visual culture and its newly broadened field of objects provides an alternative, less instrumentalist, model of thinking historically.

Feminism, of course, has its own stake both in interrogating outmoded models of historicizing visual imagery and in articulating new ways of understanding the complex connections between images and the cultures and individuals they touch. Hence, as the essays in this volume attest, feminist examinations of visual culture and visuality have their own historical investments and connections and, thus, their own explicit politics that, in the most convincing cases, go beyond the instrumentalism of social art history altogether.

It is with this impulse in mind – an impulse that, through a feminist lens, views visual culture as producing its own kind of politics and history – that each section of the anthology is designed to trace one trajectory of developments within a broad area of conceptual and theoretical concern in the feminist analysis of visual culture. Each of the thematic categories – Representation, Difference, Disciplines/Strategies, Mass Culture/Media Interventions, Body, and Technology – addresses a major aspect of feminist visual culture analysis, a node of debate where specific concerns have been highlighted and debated in complex ways. Each category marks a constellation of arguments that historiographically defines the intersection between feminism and visual culture – a constellation, further, that conditions the way in which we understand the image culture in which we are immersed. Within each section, essays are arranged chronologically in order best to convey the flow of debate. The reader is pointed to the introductions of each section for a more extensive discussion of the logic of each section category.

Conclusion

The old battles – still being fought as late as 1996 with the discipline-guarding arguments in *October* – no longer make sense. Visual culture is here to stay. Like those of film, television, cultural studies, and other modes of analysis, the tools of art history will inevitably serve this new, voraciously appropriative, cross-disciplinary mode of seeing, interpreting, and understanding our image-saturated culture. Feminism is already built into the way we look at images of women as well as of men – so much is clear in the way in which articles written over the last fifteen years can assume the reader knows the Mulveyan argument about the gaze, as well as in the way in which one's students (even those in their first year of university) already look at the world through eyes that recognize a fetish when they see one. The ideas included in this volume – representing the groundbreaking feminist work of writers from Mulvey, Griselda Pollock, and Judy Chicago to Klaus Theweleit, bell hooks, Peggy Phelan, Sandy Stone, María Fernández, and beyond – comprise a particular history of feminist visual culture theory that, I hope, will provoke further debate as well as provide a basis for the teaching and intellectual exploration of this vital topic.

Notes

1 The typical logic of cultural studies is to ghettoize feminism into a separate category of "gaze theory" or some such thing; this occurs in the strange volume *Visual Culture: The Reader*, edited by Jessica Evans and Stuart Hall, the latter, of course, the "father" of institutionalized cultural studies. Aside from the problem of separating off most of the feminist articles (as well as the articles theorizing race, which – as is typical of this kind of project – go into a separate category as well), the book is flawed by its exclusive attention to photography (as if pre-, or for that matter, post-photographic images are not visual culture).

2 See the forum on "Visual Culture" in *October* 77 (Summer 1996), which opens with a ludicrously biased questionnaire pompously intoning about the dangers of visual culture ("It has been suggested that the interdisciplinary project of 'visual culture' is no longer organized on the model of history" (25)). Thomas Crow expresses most directly the anxiety about visual culture's destruction of the boundaries formerly differentiating art from popular culture (and thus the art historian from the populist): "To surrender that discipline [philosophy, which he stages as analogous to art history] to a misguidedly populist impulse would universally be regarded as the abrogation of a fundamental responsibility" (34). Douglas Crimp writes a sharp, and elegant, attack on this rather fatuous debate among Octoberists, noting, among other things, their tendency to rail against an imagined, and vaguely defined, visual culture studies – one that becomes the very kind of "illusory, phantasmatic, oneiric, hallucinatory" object of their own projections that they accuse capitalism of purveying and visual culture of shoring up. This brilliant article argues for the crucial role in visual culture or cultural studies in insisting on the political and socially over-determined dimensions of every interpretation. Douglas Crimp, "Getting the Warhol We Deserve," *Social Text* 59 (Summer 1999), 53.

 Art history seems to have the biggest stake of all the related disciplines in warding off the incursion of visual culture as a rubric and mode of understanding visuality. It is a conservative field to begin with, staging its boundaries in relation to what can be considered art, and what cannot, and is deeply invested (as the *October* survey makes lamentably clear) in a very limited conception of what constitutes history.

References and further reading

Barthes, Roland. *Mythologies* (1957). Tr. Annette Lavers. New York: Hill & Wang, 1972.

Berger, John. *Ways of Seeing*. Harmondsworth: Penguin Books and London: BBC, 1972.

Betterton, Rosemary, ed. *Looking On: Images of Femininity in the Visual Arts and Media*. London and New York: Pandora, 1987.

Bloom, Lisa, ed. *With Other Eyes: Looking at Race and Gender in Visual Culture*. Minneapolis: University of Minnesota Press, 1999.

Bordo, Susan. *Twilight Zones: The Hidden Life of Cultural Images from Plato to O.J.* Berkeley: University of California Press, 1997.

Bryson, Norman, Holly, Michael Ann, and Moxey, Keith, eds. *Visual Culture: Images and Interpretations*. Hanover, NH: Wesleyan University Press, 1994.

Carson, Fiona and Pajaczkowska, Claire, eds. *Feminist Visual Culture*. New York: Routledge, by arrangement with Edinburgh University Press, 2001

Cherry, Deborah, *Beyond the Frame: Feminism and Visual Culture, Britain 1850–1900*. London and New York: Routledge, 2000.

Evans, Jessica and Hall, Stuart, eds. *Visual Culture: The Reader*. London, Thousand Oaks, New Delhi: Sage Publications, 1999.

Grossberg, Lawrence, Nelson, Cary, and Treichler, Paula A. "Cultural Studies: An Introduction." *Cultural Studies*. Lawrence Grossberg, Cary Nelson, and Paula A. Treichler, eds. New York and London: Routledge, 1992.

Hall, Stuart. "Cultural Studies and its Theoretical Legacies." *Cultural Studies*. Lawrence Grossberg, Cary Nelson, and Paula A. Treichler, eds. New York and London: Routledge, 1992.

Hall, Stuart, ed. *Representation: Cultural Representations and Signifying Practices*. London and Thousand Oaks, CA: Sage in association with The Open University Press, 1997.

hooks, bell. *Art on My Mind: Visual Politics*. New York: The New Press, 1995.

Jenks, Christopher, ed. *Visual Culture*. London and New York: Routledge, 1995.

Lippard, Lucy. *The Pink Glass Swan: Selected Feminist Essays on Art*. New York: The New Press, 1995.

Meyers, Marian, ed. *Mediating Women: Representations in Popular Culture*. Cresskill, NJ: Hampton Press, 1999.

Mirzoeff, Nicholas, ed. *The Visual Culture Reader*. London and New York: Routledge, 1998.

Mirzoeff, Nicholas. *An Introduction to Visual Culture*. London and New York: Routledge, 1999.

Morris, Meaghan. *The Pirate's Fiancé: Feminism, Reading, Postmodernism*. London and New York: Verso, 1988.

October 77 (Summer 1996), "Questionnaire on Visual Culture," 25–70.

Perry, Gill, ed. *Gender and Art*. New Haven and London: Yale University in association with The Open University, 1999.

Pollock, Griselda, ed. *Generations and Geographies in the Visual Arts: Feminist Readings*. London and New York: Routledge, 1996.

Robertson, George, Mash, Melinda, and Tickner, Lisa, eds. *The Block Reader in Visual Culture*. London and New York: Routledge, 1996.

Robinson, Hilary, ed. *Feminism/Art/Theory 1968–1999*. London: Blackwell, 2001.

Rogoff, Irit. *Terra Infirma: Geography's Visual Culture*. London and New York: Routledge, 2000.

Shiach, Morag, ed. *Feminism and Cultural Studies*. Oxford: Oxford University Press, 1999.

Shohat, Ella, ed. *Talking Visions: Multicultural Feminism in a Transnational Age*. Cambridge, MA and London: MIT Press, 1998.

Sturken, Marita and Cartwright, Lisa. *Practices of Looking: An Introduction to Visual Culture*. Oxford: Oxford University Press, 2001.

PART ONE

Provocations

"**P**ROVOCATIONS" INCLUDES SIX ORIGINAL ESSAYS commissioned especially for this volume. Written by scholars trained in different disciplines, these polemical pieces intervene strategically in current debates about gender and visuality, with an emphasis on complicating the understanding of gender identity by acknowledging its intersectionality with other kinds of identification – in particular racial, ethnic, class, national, and that of sexual orientation.

Rosemary Betterton and Lisa Bloom (Chapters 1 and 3), both trained in art history and visual culture, engage the intersection of feminism and visual culture by addressing the politics of feminism within the art world and art history as an international discipline – Betterton via an argument about new issues that arise in teaching feminist approaches to visual culture to students today in England; Bloom, with cross-cultural experience teaching in the U.S. as well as in Japan, through a polemical call for the creation of "transnational" feminist art communities to forge links across cultures. Both Betterton and Bloom argue their points with great sensitivity to the difficulties of translation – feminism cannot mean the same thing to different students, artists, and theorists in different cultures or of different ages. For feminism to remain viable and relevant, then, in relation to the study of visual culture, it must both retain a certain political edge and make itself flexible enough to accommodate international, racial, ethnic, class, and generational differences.

Jennifer Doyle and Judith Wilson (Chapters 2 and 4), with passion and moxie, open out the heterosexism and racism still lingering in the fabric of the intricately woven relationship between feminism and visual culture. While trained in completely different disciplines (Doyle in English, Wilson in art history), each focuses on a different aspect of visual culture and deploys the insights of feminism to expose the hidden assumptions about gender, sexuality, and race still informing even the presumably "liberated" discourses and institutions attached to an analysis of visual culture. Doyle and Wilson map the complex interrelations among different kinds of oppression that continue to inform our experience and understanding of visual culture. Doyle offers a passionate feminist defense of the *queer* as opening out both visual practice and theories of visuality. While her essay notes the various pitfalls of intersecting feminism and anti-racist theory, Wilson ends by arguing, convincingly, for an expansion of "black feminist visual culture."

Faith Wilding (Chapter 5), an artist and writer at the forefront of feminist art theory and practice since her role as a founding member of the epochal Feminist Art Program at California State University, Fresno, in 1970, has turned her creative energies and insights to new technologies – making art and crafting cyberfeminist theory to intervene in the troubling, still capitalist and masculinist, assumptions motivating and justifying biotechnological scientific "advances." Here, she offers a cyberfeminist manifesto that presents a feminist model for how to negotiate this hazardous new image world.

Meiling Cheng (Chapter 6), trained in theater studies, here offers a poetic rumination on feminism and visuality that points to the absurdity of assuming we can "see" or "know" what is in front of our eyes but also to the importance of trying to make sense of the pool of colors that surrounds us – to the dangers of fixing an approach but also to the horrors of refusing to take a position at all.

Cheng's lyrical intervention sets the stage for us to imagine a final dissolution of boundaries (disciplinary and otherwise), while retaining a sense of mission in order to move feminism and visual culture studies in new directions.

ROSEMARY BETTERTON

FEMINIST VIEWING:
VIEWING FEMINISM

"**B**UT I DON'T KNOW WHAT I am supposed to think!"
As I attempt to explain to a first-year women's studies class how a Pre-Raphaelite painting might be open to different feminist readings, I begin to think again about the gap between feminist art history and its potential audiences.[1] While these students can offer sophisticated and critical readings of cinematic, literary, and televisual texts, when faced with a figurative painting, they have neither the critical vocabulary nor the cultural capital with which to analyze it. For these young women, understanding fine art, whether past or present, has nothing whatever to do with their own feminist agendas and they cannot see the point of it. Several explanations could be offered for this lack of engagement with feminist analyses of visual art, from generational differences to a general visual illiteracy, but any such generalized assumptions about responses tend to focus on the students' failure to be "expert" feminist readers, rather than on any inadequacy in the models of critical analysis they are invited to adopt. And yet, the same students engaged with enthusiasm in discussions of black lesbian identity and autobiography in the 1970s and of contemporary feminist cinema.

Feminist art criticism is no longer the marginalized discourse that it once was; indeed it has produced some brilliant and engaging writing over the last decade and in many ways has become a key site of academic production.[2] But, as feminist writers and teachers, we need to address ways of thinking through new forms of social engagement between feminism and the visual, and of understanding the different ways in which visual culture is currently inhabited by our students.

The current shift from a discipline-based study of sexual difference in the visual arts to the interdisciplinary analysis of visual culture entails rethinking epistemological and methodological issues of what constitutes our knowledge corpus and its practices. Here I want to focus on my sense of the disruptive potential of feminist visual culture for the disciplinary procedures of feminist art history and the subversive question posed by my students: why should we bother to reinterpret visual culture of the past from a contemporary feminist perspective? I will first return to an earlier moment of feminist critical practice, which I think is productive for beginning to think through these questions.

In a trenchant and polemical essay entitled "Feminist Art and Avant-Gardism" (1987), Angela Partington addresses the question of the gendered pleasures of consumption for a female audience. Writing in the mid-1980s in the context of feminist debates about visual pleasure, Partington argued against the idea of a "correct" feminist textual strategy, suggesting, rather, that feminist critics "need to prioritize feminine knowledges and competences, since these are the means by which objects can signify and be meaningful for women and

represent their relation to, or interests in the world." While she recognizes the difficulty of defining "feminine experience" and insists on its unfixity, arguing that '[g]endering processes never end; a feminine subject is never completely 'formed,'" she only partially addresses the questions of the differences of interest between women, and of *whose* interests are being represented by feminism.[3]

Partington's attention to gender power relations, her insistence that femininity can be active and productive in generating meanings, and her interest in taking "women-as-an-audience" seriously, however, offered a welcome counterpart to the tendency, then dominating British feminist art practice, to focus on deconstructive critical strategies.

In describing a circuit from feminine investment to desire to the developments of specific knowledges and competences in the female viewer in her essay, Partington drew on a model of consumption derived from feminist cultural studies of television, one that in turn brought its own theoretical and methodological problems, to inform her approach.[4] At the time, her insistence on the importance of feminine (as well as feminist) reading skills was not widely acknowledged. I want to pursue some of these issues in relation to the study of feminist visual culture by examining what kinds of cultural skills and competences feminism has given to women students today.

While students may still engage with feminism as a critical and empowering set of discourses, they are more likely to encounter it first, not as a form of politics but as part of their studies, legitimized *by* rather than outside the academy. It is clear that students today have many of the cultural skills that feminism has taught us: ways of seeing, being in, and representing the world in terms of sexual difference. In the study of visual culture, these skills are connected to the ways of making and reading images that are only possible as a result of thirty years of feminist struggles around representation. They include, in no particular order:

- an awareness of how gender shapes looking and the "gaze"
- an understanding of terms like "gender" and "patriarchy"
- a certain reflexivity in the representation of self
- a willingness to explore issues of identity and difference
- an interest in and engagement with body politics
- an ability to read "against the grain" of a given text.

While remaining at the level of potential feminist knowledge unless consciously theorized or analyzed historically, most students in women's studies, cultural studies, and the social sciences have a fair degree of competence in these sorts of cultural skills. So why do they find reading works of art, as opposed to television or advertising, so difficult? Why are they often disappointed when works claimed to be feminist do not sustain such meanings for them or, conversely, when feminist scholarly readings of works of art do not correspond to their own? What is foreclosed in the labeling of such responses as culturally incompetent by feminist 'experts' are the epistemological and ontological questions Griselda Pollock has suggested might be raised in such cases: "What am I looking at and for? What knowledge does my look desire? Who am I when I look at this?"[5]

These questions become particularly complex when issues of self and identity are at stake, as is the case in representations of embodiment and sexuality when images may have an intense personal resonance. I want to take as an example a difference in reading between Pollock herself and one made by a former student of mine. What happens when a woman reads "against the grain" of a feminist reading? In Pollock's recent book, *Differencing the Canon: Feminist Desire and the Writings of Art's Histories*, she offers a witty, psychoanalytically informed

reading of Toulouse-Lautrec's work as "psychically impotent," including an analysis of his series of representations of *maisons closes*, the regulated brothels of late-nineteenth-century Paris, which she notes are "hard to look at" in that they "make women's sexual pleasure and intimacy yet another voyeuristic commodity."[6]

Pollock describes a visual economy that is dependent on three looks, those of the male artist and the heterosexual male voyeur, and that of the feminist critic who refuses to align herself with the other two. But can a different visual economy be envisaged, or other ways of looking be made possible that do not reproduce such structures of identification and dis-identification? In an essay written in 1999 on the same images, a student read them very differently. She saw Lautrec's paintings as validating her own lesbian identity in a rare and sympathetic representation of active lesbian sexuality, which she could not easily find else-where. I am not making a comparison of these two readings in terms of their levels of sophistication or "correctness," but in order to suggest that they proceed from different positionings and knowledges, a difference that opens up a productive space in which to explore questions of *how* meanings are made and *for* whom.

The implications of this comparison for the theorization of feminist visual culture would be a shift away from the traditional concerns of art history with producers and texts towards a model of reading in which greater attention would be paid to the multiple inscriptions of women in and through visuality. Such a model would enable us to understand how those texts are mobilized and made meaningful in different ways by their different women readers, allowing for and legitimating differences in reading as well as interrogating the relations of power between the authoritative text and its interpretation, between teachers and students, and between theories and practices of reading.

If, as Nicholas Mirzoeff describes it, the study of visual culture is not so much a discipline, but "a tactic . . . a fluid interpretative structure, centered on the response to visual media of both individuals and groups,"[7] then there is some urgency in thinking about the processes through which individuals and groups are empowered to respond or not. The notion of visual culture, then, opens up a key question that has been to some extent displaced from recent feminist art criticism: how to theorize affect, identification, and investment in images by women and other social groups.

There were valid political and strategic reasons for Laura Mulvey's call in the early 1970s for a feminist avant-garde film practice that would break with the past and privilege new kinds of visual language, especially within the context of Hollywood cinema with its powerful realist tradition.[8] Equally, deconstructive strategies that emphasized a concern with reading practices that were dis-identificatory and distanciating were central to feminist art practices in the 1970s and 1980s as a way of breaking with the dominant modes of viewing and understanding art. Such critical practices and strategies were, and are, crucial in analyzing the processes through which meaning is produced within texts, but they have little to say about how social readers, positioned in multiple relations of desire, power and difference, may make meanings from them.

This issue of making meaning, it seems to me, is important for current theorizations in visual culture, in spite of an obvious risk of a return to untheorized accounts of visual pleasure – such a return is not by any means what I am advocating. Questions of the relations between embodied spectatorship and the sensory encounter with film and video are already being theorized in feminist studies.[9] Laura Marks' account of "intercultural cinema," drawing on postcolonial theory and phenomenology, for example, offers a critique of the dominant western episteme in film studies and emphasizes the situated nature of knowledges and competences involved in the making and viewing of work by culturally located, as well as gender specific, producers and audiences.[10]

Such arguments suggest that the changes already occurring within postmodern culture cannot be addressed adequately by earlier models of feminist critique. To take one example, mainstream Hollywood cinema has already absorbed many of the deconstructive and distanciating techniques of avant-garde cinema in complicated ways that are partly a response to the "successes" of feminism as well as part of a backlash against it. Dominant regimes of the visual in twenty-first-century global culture are mobile and constantly seeking new sites to colonize; a feminist analysis that seeks to engage critically with them must in turn be equally flexible and quick on its feet. Visual culture for our students is less likely to reside in still images seen in isolation, than in multi-layered text and image complexes: television, cinema, and video, digital media and the Internet, or even books with pictures. To ask them, as I did, to make sense of a painting cut off from any interpretative context, and to assume that they did not already possess many of the cultural skills of reading visual culture from a feminist viewpoint, was an enterprise marked by my failure to recognize the multiple ways through which feminism has already informed our viewing practices in the twenty-first century.

Notes

1 An early version of this argument appeared as "Why Can't We Look at More Work by Men? Feminism in the Classroom," in John and Jackie Swift, eds, *Disciplines, Fields and Change in Art Education*, Vol. 2 *Aesthetics and Art Histories* (Birmingham: ARTicle Press, 2000).
2 For example, the presence of feminist scholars in the academy, of gender studies within the curriculum, and the explosion of feminist research and publication over the last three decades, which have made possible a collection such as this one.
3 Angela Partington, "Feminist Art and Avant-Gardism," in Hilary Robinson, ed., *Visibly Female* (London: Camden Press, 1987), 245.
4 For a brilliant analysis of some of the problems of audience research, see Ellen Seiter, "Making distinctions in audience research," *Cultural Studies* 4:1 (1990), 61–84. There is a need for further analysis of the use of the terms "spectator," "viewer," "reader," "consumer," and "audience" as well as "object," "artifact," and "text" in studies of visual culture.
5 Richard Kendall and Griselda Pollock, eds, *Dealing with Degas: Representations of Women and the Politics of Vision* (London: Pandora Press, 1992).
6 Griselda Pollock, *Differencing the Canon: Feminist Desire and the Writing of Art's Histories* (London: Routledge, 1999), 88.
7 Nicholas Mirzoeff, *An Introduction to Visual Culture* (London: Routledge, 1999), 4.
8 Laura Mulvey, "Film, Feminism, and the Avant-Garde," in *Visual and Other Pleasures* (London: Macmillan, 1989), 111–26.
9 See Amelia Jones and Andrew Stephenson, eds, *Performing the Body/Performing the Text* (London and New York: Routledge, 1999).
10 Laura Marks, *The Skin of the Film: Intercultural Cinema, Embodiment, and the Senses* (Durham and London: Duke University Press, 2000).

JENNIFER DOYLE

FEAR AND LOATHING IN NEW YORK
An impolite anecdote about the interface of homophobia and misogyny

AS A FEMINIST INTELLECTUAL WITH A passion for visual culture, I love challenging the habits of thought that surround the subject of sex, not only as they are embalmed for us by historically important paintings, but also as they appear in more ordinary settings – like television, advertisement, homes, sidewalks, and, even, in conversation. I'm fully committed to the importance of expanding our focus beyond museums and textbooks, in order to interrogate the politics of the ordinary. The status quo is maintained, after all, by the very little things people say and do everyday, most of the time, quite unconsciously.

And so, in thinking about what feminist approaches to visual culture mean for me, my mind settles not on a scholarly moment, but a social one. In recounting the anecdote that follows, I have tried to make it more polite, but I can't. In fact, in telling this story, I claim my right, as a feminist, to be impolite.

It's December and I'm at a posh club in New York City, listening to a pack of young, straight white male artists complain that they can't get anywhere in the art world because they "don't suck dick." They all seem unable to reconcile the grandiosity of their hopes for themselves as artists against the banality of their lot (artists going nowhere). In one sense, the conversation could not be more ordinary: an effect of the postmodern condition is the erosion of white men's sense of privilege. Unfortunately, this effect is not often accompanied by a revision of their sense of entitlement.

A ready-made narrative offers itself as an explanation for their sense of exclusion: a blend of the classic paranoid fantasy for a heterosexual man of the dangers that adhere to being the object of another man's desire, the equation of commercial success with prostitution, and the popular sense that "political correctness" puts quantity (politics) over quality (aesthetics). This cluster of notions protected these men from their fear of failure by dismissing those on the "inside" as having had to compromise their virtue in order to get there. The straight-identified men imagined that their true worth would surely be recognized if only the art world weren't populated by (gay) men whose judgment is mediated by politics and sexual desire while theirs is supposedly objective, untainted by such contingencies.

The ease with which these well-heeled and well-educated men reproduced the phobic fantasy that homosexuality is what's wrong with the art world took me aback. Even more disturbing was the ease with which this observation was made in front of me, as if its wisdom were self evident, and my own place in such conversations ornamental.

"I suck dick," I interjected, "and it isn't getting me anywhere." The conversation paused for a beat, and then rolled along as if I'd said nothing, as if I'd belched, and the only polite response was to act as if no one had noticed.

In speaking up, I wanted to unveil the overlapping assumptions about homosexuality and women that structure the complaint that you can't get anywhere in the art world (as a man) if you "don't suck dick" (because you're straight). This complaint hides, for instance, the fact that, if you are a woman, you can't get anywhere in the art world even if you do. If a willingness to go down got you anywhere, more of us would know the names of Picasso's lovers.

Take this scenario from another perspective, and imagine a lesbian saying "I can't get anywhere in the art world because I don't suck dick." In many ways, she'd be right. She can't "get anywhere" by the usual routes because she has to hurdle both homophobia and misogyny. If she does get anywhere, she's probably very smart about the sexual politics embedded in art institutions and has worked her way in from the outside (for example, photographer Catherine Opie or painter Linda Bessemer – hardly, however, household names). A gay man who says he can't get anywhere because he doesn't might be speaking to the burden of expectations on him as a "gay artist" – if he's open about his sexuality, he may feel a pressure to make sexuality the subject of his work, to market his sexuality as part of his artistic persona (exiling himself officially to the margins). He may experience this as limiting. These scenarios, however, strike me as unlikely: no artist who belongs to a sexual minority is likely to reduce the difficulties they face to the question of whether or not they suck dick.

This anecdote does not reveal much about the art we encounter in textbooks, museums, or academic journals. It speaks more nearly to how people think about artists, to the attitudes we have about art itself and how art fits in the world. I am dwelling on it in order to raise questions about the kind of social work performed by a group of ostensibly heterosexual men, who want to be artists, when they invoke homosexuality as something they feel the art world (whatever that is) "expects" from them, and what happens when they make this kind of speech act in front of an ostensibly heterosexual woman. And what happens, too, when she announces something like "I suck dick" in return.

My attempt at a joke failed because I, from their perspective, merely re-stated their point: I'm not getting anywhere because I'm straight. My point, from my perspective, was that dick sucking doesn't give gay men or straight women access to social or political power. In general, the identification of a person with a sex act nearly always results in that person's abjection (the negative value assigned to sex is so strong that even the President isn't immune from its stain).

There is a huge difference between their sentence and mine: They distanced themselves from sex in general, and homosexuality in particular, in order to assert their virtue as (heterosexual, male) artists. They bonded together over the fear of being made the object of other men's sexual interests. When I made my remark, I, in essence, confessed that I was exactly what they were afraid of becoming (a woman). I had wanted to assert, in as simple and vulgar a sentence as I could manage, the ridiculousness of the narrative they were producing about homosexuality and power. Instead, as the words came out of my mouth, as they fell on deaf ears, I felt that I merely appeared to them as living proof of the dangers of becoming a sex object. I also felt the ridiculousness of my presumption that they would respond to me as a colleague – I was, after all, in a bar, where, as the lone "girl" at the table, my input as an "intellectual" was most unwanted.

I had wanted to explain to them that the sex politics of the "art world" (for them, that meant the gallery system in New York) is complicated. I wanted to say that they were using a bigoted idea about homosexuality to mask the dynamics of exclusion that define art institutions (it's about power, culture, class). I wanted them to understand, furthermore, that the

irrelevance of women to the economy they were describing is not an effect of the presence of gay men in the art world. When women (like the marvelous painter Grace Hartigan) get left out of art-historical narratives about, say, American painting (whose official story is unusually macho) it's not a "velvet mafia" that's keeping them out, it's straight-up sexism. In any case, the art world (here I mean museums, media coverage of art, and art history as a discipline) has at best a vexed relationship to the topic of homosexuality. Take a look at the career of any major gay artist and you'll find that his or her sexuality (if it is even acknowledged) hasn't made the reception of his or her work any easier.

I don't want to socialize with people who imagine that gay men are what's wrong with art: the homoerotic possibilities embedded within bohemian circles is one of the things that have always been right with the world that surrounds art-making. Those possibilities have long been life-sustaining to queer men and women – meaning not only men and women whose sexual desires are same-sex organized, but women and men who simply can't live happily within the hetero-normative matrix. The weird and acrobatic discourse about art and sex that we encounter in ordinary social spaces attempts to contain the queerness of decisions that people make every day to make art – to start punk rock bands, make performance art, paint, move to the city, hang out with poets and hustlers, with drag queens and intellectuals.

A wide range of people writing criticism and theory today are thinking about the social spaces that surround art – about how some spaces nurture, and how other spaces police and censor people who don't fit or belong anywhere else. We are asking questions like: What power relations are masked by popular narratives about art? What kind of stories do visual images tell us about sex and desire? What kinds of relationships do they foster between the people who admire them? What kind of story has art history told about sex and desire? What kinds of things can't art history account for? What's the difference between pornography and art? Between art and advertisement? Where do our attitudes about sex figure into those distinctions?

In attempting to answer these kinds of questions, in challenging the ordinary ways that people think about art and each other, we honor this simple truth: the queerness of the worlds that emerge around art is worth fighting for.

LISA BLOOM

CREATING TRANSNATIONAL WOMEN'S ART NETWORKS

WHEN I BEGAN FORMULATING MY IDEAS for this article, I was grappling with the challenges of conducting a professional life in Japan and the U.S. From 1998 to 2001 I taught in the first Women's Studies Ph.D. program in Japan at Josai International University (Chiba Prefecture); I am currently visiting faculty at the University of California, San Diego, in the Visual Arts Department. It was my experience of traveling between cultures that made me confront the question of whether or not feminist theories and ways of framing questions in feminist visual culture emanating from the U.S. – be these strictly feminist, or with a queer or postcolonial inflection – have any significance in other contexts outside of the U.S., and more especially outside the North Atlantic region.

This experience pushed me beyond where I had been when I edited the anthology *With Other Eyes: Looking at Race and Gender in Visual Culture*, published in English (1999) and Japanese (2000);[1] here, I argue in my introduction that multiculturalist and postcolonialist ways of seeing have expanded English-language feminisms' frame of reference within the context of European and North American art history. When I wrote this introduction, I was unable to address how different feminist theories worked in different transnational locations outside of that limited regional context. Given my experience of traversing the Japanese and U.S. feminist contexts, it seems to me that it is crucial at this point to think about how feminist theorists in visual cultural studies in the U.S. might create international alliances, not in the sense of constructing universally valid analytical frameworks, but rather in the sense of creating a space to articulate transnationalist feminist visual cultural practices through, for example, traveling exhibitions, curatorial practices, university hirings, as well as the organization of artists' and critics' speaker series and conferences.

It is in the spirit of thinking about how such transnational practices in the arts work outside the U.S. that I became intrigued by a remarkable exhibition catalogue from Singapore. Entitled *Text-Subtext: International Contemporary Asian Women Artists Exhibition* (2000), the catalogue focuses on the history of women's art both locally and internationally within the Asia Pacific Region.[2] I was particularly attracted to it because it is one of the first catalogues in English by prominent women artists, critics, and curators from various countries within the Asia Pacific region, all of whom express their discontent with the existing system and stress the need for political participation and social empowerment through the development of adequate international networking structures for women artists and critics. The big metropolitan cities in Asia such as Singapore, Seoul, Tokyo, Osaka, Beijing, among others, have seen over the years the growth of a critical core of articulate, educated, bilingual women art

critics, artists, and curators who, endowed with the ability to analyze critically their marginalized situations within a highly patriarchal global art world, are now making informed choices about the roles they want to adopt and arguing for access to positions of power in the art world.

This catalogue is both about documenting the growth of Asian women's art and art criticism in countries such as Japan, China, the Philippines, Korea, Taiwan, India, Indonesia, Vietnam, Australia, and Singapore, and about theorizing its significance. It also draws attention to how the system of gender inequality for Asian women has developed in the arts in these various countries and how defining features of Western feminism do not always neatly translate from one context to another. For example, the term "feminist" has different meanings and was not often used by the Asian women critics and artists in the catalogue. Presumably, this is in part because the term "feminist" is sometimes seen as a Western concept, and one that is often used pejoratively by Asian men to construct Asian women as outsiders to the nation.

Because many women are negotiating for rights and responsibilities from within strong patriarchal familial contexts in Asia, it is worth noting as well that Western notions of "individualism" and "self-determination" also do not resonate in Asia in the same way these concepts might in the U.S. or the U.K. The performance piece by the Japanese artist, Taro Ito, entitled *Me Being Me*, exemplifies this difference. As the only lesbian "coming out" performance piece in the exhibition and catalogue, it resembles a Western-style feminism in its emphasis on a bodily centered liberation. Yet, the piece explores less the artist's own individual autonomy but a relational selfhood, situated in the context of intimate relationships with her mother and grandmother [Figure 3.1].

Other pieces in the exhibit, however, posit community and national group formations and relations, without an emphasis on the autobiographical or the familial. How this is done varies significantly. For example, the Chinese artist Zhang Xin's piece *Climate No. 6* explores how the process of women's self-performance generally takes place in China in relation not so much to familial structures but to economic, national, and social ones. The two parts of the installation present simultaneously the same image of the Chinese socialist heroine, Liu Hulan, who was killed by the Chinese Nationalists' army and then idolized in the Chinese media during the 1950s as representing the "spirit" of socialism of that time. One part of the installation presents a video image of a heroic bust that was constructed of Liu Hulan during this period, which provides the background to a free-standing ice sculpture that represents the same bust of Hulan, now in the process of melting and being bottled into drinking water [Figure 3.2]. This process of transformation from a bust made out of marble to one that is now marketed and consumed as drinking water is meant in part to represent the commodification of China's past within its new market economy. Yet, the artist sees both past and present representations of Liu Hulan as incomplete. Thus Zhang Xin leaves the viewer to contemplate actively how Chinese women could reconsider their relationship to Liu Hulan outside of Marxist economic theories, which are often blind to gender issues.

Given the concern with inter-Asian diversity in this exhibition, how the word "Asian" is used is significant since it is a term that does not always neatly translate from one context to another. Binghui Huangfu, the exhibition's curator, uses the term "Asian" very differently from how the Japanese might have used it as a form of cultural hegemony (in the past, the Japanese, as representatives of an old colonial power in Asia, used the term "Asian art" in the same spirit as Western critics would deploy "art" in general: inevitably in each case the broad definition would pretend to be inclusive but in practice would refer only to the art of the

Figure 3.1 Taro Ito, *Me Being Me*, 2000, performance, Singapore.

dominant culture using the term). Huangfu also uses the term differently from how Westerners might see it as merely a homogenizing description of a large group of people that live east of the Middle East and in an area bounded by the Indian and Pacific Oceans. For Huangfu,

> [t]he word Asian carries with it many interpretations . . . Firstly Asian women are not a single group. Asia is made up of many different national components. Each one having differing causal and cultural conditions affecting the state of women. It is not even possible to make subgroupings as the cultural and economic environment in each country is different . . . When Asians use the term 'Asian' . . . it does have a similar point of collective departure from the west but contains a subtle unifying understanding of the diversity of the cultural practice[s] contained within its various borders.[3]

There is a lot that U.S.-based artists and critics can learn from a catalogue such as this one that documents and theorizes new women's art and critical practices in the Asia Pacific Region.[4] Such a resource enables the English-speaking feminist audience to see the connections between influential practices in various countries within Asia and more local practices by the diaspora artists and feminist cultural critics in the U.S., the U.K., Australia, and Canada; the authors and artists included in the catalogue elaborate a new kind of feminist art theory and practice in relation to issues of postcolonialism and transnationalism.

Figure 3.2 Zhang Xin, *Climate No. 6*, 2000, sculpture and video installation. Ice, stainless steel, glass, water cooler, drinking water. 200 × 85 × 40 cm.

This is not to suggest, however, an easy commonality between the Asian women writers and artists in this catalogue and the diaspora feminist theorists such as Gayatri Spivak and Trinh T. Minh-ha whom it cites, theorists who work in the West and choose to subvert the dominant intellectual paradigm of the "first world" from within. Rather, what I am trying to suggest is that it is important to acknowledge the ways in which these different feminisms are being brought into dialogue with one another, in different cultural contexts outside of the West. This exhibition catalogue provides an example of such an inter-Asian exchange that puts women artists and critics working in the margins of various patriarchal nation-states (in the West as well as Asia) in a feminist dialogue with one another. In doing so, catalogues such as this one deserve attention for opening up the field of feminist visual cultural studies, which has otherwise been long constrained by a "grand narrative" of feminism that is restricted to the story of art within the West, relegating the experience of non-Western women artists working in other regional contexts to the margins of feminist art discourse.

Notes

1 Lisa Bloom, ed., *With Other Eyes: Looking at Race and Gender in Visual Culture* (Minneapolis: University of Minnesota Press, 1999); the Japanese translation has the same title (Tokyo: Saiki-sha, 2000).
2 *Text-Subtext: International Contemporary Asian Women Artists Exhibition* (Singapore: Earl Lu Gallery, LASALLE-SIA College of the Arts, 2000); for inquiries e-mail: earllugallery@lasallesia.edu.sg. The exhibition catalogue has two parts: one includes the contributions of art critics, curators, and art historians, and the other consists of statements made by the artists in the exhibition.
3 Binghui Huangfu, "Contemporary Art and Asian Women," *Text-Subtext,* 158.
4 It is significant that the curator Binghui Huangfu credits her interest in postcolonial and feminist theory to the influence of Trinh T. Minh-ha and Lydia Liu among others. Note that the only feminist critic from the North Atlantic Region included in the catalogue of *Text-Subtext* is Katy Deepwell, a British art historian who is the editor of the British journal, *n.Paradoxa: International Feminist Art Journal*, one of the few international feminist forums in English. It is available on-line at <http://web.ukonline.co.uk/n.paradoxa/index.htm>, and in print, through KT press, 38 Bellot Street, London SE10 0AQ, U.K.

Chapter 4

JUDITH WILSON

ONE WAY OR ANOTHER[1]
Black feminist visual theory

IN THIS ESSAY I WANT TO consider some of the reasons for, and consequences of, the embryonic state of what we might call "black feminist visual theory."[2] In the process, I also hope to suggest at least some of what this discourse has the potential to be or do. I write dogged, however, by a rude mental chorus:

"*We* who?"
"The f-word! She used the f-word!"
"The road to racial/class/gender subordination is paved with theory . . ."
"Everybody knows that *visual* is synonymous with *superficial*. Get a (socially responsible intellectual) life!"

Because such protests have been addressed in depth elsewhere, I will respond only briefly here:[3]

1 By "we" I mean myself and this text's readers, a self-selected audience that shares at least a curiosity about, or willingness to consider, the results of a conjunction between black and feminist ideas about the visual.

2, 3, and 4 I have been a feminist since my senior year in college, when a close friend and black political comrade dashed across the campus lawn with the news "We were wrong about feminism! You have to read *The Second Sex*!"

It was 1973 and having already read Frantz Fanon's *Black Skin, White Masks*, I was struck by the parallel role of vision in Simone de Beauvoir and Fanon's respective ontologies of gender and race. It would be another decade before their shared references to Lacan's "mirror stage" meant anything to me, and I have only recently learned the difference between the Lacanian "gaze" and the Sartrean "look" with which they were preoccupied.[4] Meanwhile, I seized the "f-word" gladly – not only because de Beauvoir's insights illuminated so many of my own experiences as a daughter, sister, student, worker, and lover. The breathtaking depth and range of her thinking was as important to me as its ideological content.

Like Fanon, by sheer intellectual force de Beauvoir blew out the jambs of mental prisons I'd grown up squirming inside. That she was white and European bothered me no more than Fanon's having been male. Both were "Others" who'd stolen white patriarchal fire to blaze liberatory trails. While each has been usefully critiqued in recent years, their radical impact remains my benchmark for the critical potential of "theory."[5]

Having come to believe that race, gender, and the visual structure one another in a complex set of interlocking, epistemological feedback loops, I have lost faith in the explanatory power of singular approaches to these cultural constructs. Yet, I am also acutely aware that linking the words "black," "feminist," "visual," and "theory" poses difficult problems. To be intelligible, terminology must be shared by members of discursive communities. As such, it reveals collective horizons of thought. The adjectives "feminist" and "visual," for example, can each be used to modify the noun "theory" in ways that will make sense to most readers of this essay. But "black theory," what is that? Theory practiced by black people? (If so, who is black? And how is theory produced by such people different from theory produced by other kinds of people?) Theory about blackness? (Then what is blackness? A category, a quality, an ideology, an experience, or some combination of these?)

Similarly, if we link the adjectives in sets of two, some pairings "work," others do not: the coherence of "black feminist theory" stems from the term's use for more than a decade as much as from the elaboration of its project during that time. Less familiar and less clearly defined, "feminist visual theory" and "black visual theory" nonetheless sound feasible. But reversing the modifiers ("feminist black theory," "visual feminist theory," "visual black theory"), in each case yields cognitive dissonance, stranding us at the limit of contemporary thought.

This, of course, is a function of the differential statuses of theoretical discourses around race, gender, and the visual – a situation, in turn, rooted in material relations of cultural privilege and institutionalized power. But it also reflects the fundamental incommensurability of the terms "black," "feminist," and "visual" – the first a social category, the second a political orientation, while the third can be (both/and, either/or) a mode of sensory perception, a category of cultural phenomena. I belabor these semantic points because they remind us of factors easily overlooked or forgotten in the rush to be intellectually inclusive or included: without discursive communities – groups whose members share values, interests, goals – new knowledges cannot thrive. And, while disparate discourses may be usefully combined, their tendency to function unevenly – in dynamic tension with one another, rather than isomorphically – must be taken into account.

So far, black feminist and visual theory have intersected at two primary sites: the black female body and the gaze.[6] Focusing on the former has made plain the futility of attempts to

theorize the role of a racially unspecified female body in visual representation. Focusing on the latter has demonstrated the complex interplay of race and gender in processes of identity formation and, thus, the construction of race and gender-based power relations at the most intimate levels of consciousness. It is possible to imagine a dense, intricately woven fabric of ideas suspended between these two poles. But, at present, we have only tantalizing fragments – scattered essays (in some cases, a decade or more old), manuscripts in press, unpublished theses, rumors of work in progress – to suggest how far-reaching and multi-faceted black feminist theories of the visual might be.[7]

Preoccupation with the body and the gaze stems from the heady exchanges of feminists and poststructuralists and the emergence of visual theory in Europe and the U.S. during the 1970s and 1980s. Black feminist interventions in these developments, which began surfacing in the early 1990s, were launched mainly from two disciplinary locales: literary criticism and film studies.[8] As a result, black feminist theoretical engagements with the body generally assumed its textuality, while the gaze was addressed mainly in terms of psychic and social viewing relations. Left aside were questions arising from phenomenological accounts of the visual as eluding logocentric capture or genealogies of race as a branch of post-Enlightenment developments that also gave rise to modern aesthetics and art history.[9] Similarly, while black feminist interrogations of dominant culture theory insisted upon historical specificity with respect to race and gender, they were not as vigorous in asserting or exploring the cultural relativity of vision.[10]

Here, I contend, black women artists have stolen a march on both visual theory and art criticism. Having emerged in record numbers and gained unprecedented visibility in the past two decades, they have frequently engaged aspects of current body/gaze discourses.[11] But in doing so, they often push these preoccupations into unfamiliar territory – invoking the intricate, aesthetic and social histories of black "hair politics," for instance, or exhuming a Hegelian master/slave dialectic that subtends racialized viewing relations in the U.S. context.[12] At such moments, their art points to another universe of questions around black self-esteem, cultural heritage, and aesthetic preferences for which the links between black female bodies, dominant scopic regimes, and black visual practices have not been adequately theorized.

But if we have learned anything from the furor over Kara Walker's mordant burlesques of plantation stereotypes and Betye Saar's subsequent resurrection of the Black Power-era visual trope of the "revolutionary mammy" in response, it is that artists aren't infallible guides to critical Nirvana. Lost in that war over the "correct" way to treat stereotypes was a history of black women artists' strategically varied attempts to redeem themselves from the combined stigma of pre- and post-emancipation economic and sexual servitude. This lineage stretches back to nineteenth-century neoclassical sculptor Edmonia Lewis and down through Elizabeth Catlett and Betye Saar, then on to Kara Walker and Renee Cox – each of them haunted by pop cultural ghosts of Aunt Jemima, Topsy, and Jezebel. A nexus of race, class, and gender representation that begs for black feminist visual analysis, this history of black female visual production and representation takes us well beyond preoccupations with the Hottentot Venus and Josephine Baker, which have been the twin poles of visual theory about the black female body until now.

So what's "wrong" with black feminist visual theory, what's holding it back? (1) It needs to mine the growing corpus of history and criticism devoted to black visual culture in all its forms – elite, popular, and vernacular.[13] (2) It needs to break out of U.S. imperialist mental prisons that make us simultaneously complicitous with an oppressive international status quo and unnecessarily isolated in our own counter-hegemonic struggles.[14] (3) It needs to risk venturing deeper into the forests of theory, armed with the knowledge that women like

Jamaican philosopher Sylvia Wynter and African-American literary critic Hortense Spillers have already cleared space there.[15] (4) But, above all, there needs to be *more* black feminist visual theory!

Notes

1 My title is a reference to Sara Gómez Yera's 1974 film *De Cierta Manera* (English title: *One Way or Another*), which employs three disparate cinematic modes – newsreel, neo-realist, and Hollywood romance – to expose sexism and racism as impediments to social change in post-revolutionary Cuba.

2 Although allied to the "Black feminist art project" urged by artist/art historian Frieda High Tesfagiorgis over a decade ago, "black feminist visual theory" includes "a discourse that would center Black women artists" in art history, criticism, and theory, but also extends beyond such a discourse to frame all of visual culture in a raced and gendered theoretical perspective. Tesfagiorgis, "In Search of a Discourse and Critique/s That Center the Art of Black Women Artists," in *Theorizing Black Feminisms: The Visionary Pragmatism of Black Women* (New York: Routledge, 1993), 236.

3 On the problems of premature or ill-considered solidarities, see Janet Henry, "WACtales: A Downtown Adventure," in *Talking Visions: Multicultural Feminism in a Transnational Age*, ed. by Ella Shohat (New York: New Museum of Contemporary Art, 1998), 261–271. On contemporary black women's resistance to and need for feminism, see Joan Morgan, "Hip-hop Feminist," in *When Chickenheads Come Home to Roost: A Hip-Hop Feminist Breaks It Down* (New York: Simon & Schuster, 1999), 49–62. On the hazards and utility of "theory," see Carole Boyce Davies, *Black Women, Writing and Identity: Migrations of the Subject* (New York: Routledge, 1994), 35–58. On the central role of the visual in the construction of "modern European racism," see Clyde Taylor, *The Mask of Art: Breaking the Aesthetic Contract – Film and Literature* (Bloomington: Indiana University Press, 1998), 27–28, 31–52.

4 Simone de Beauvoir, *The Second Sex* (New York: Bantam, 1970), 251, note 2. Frantz Fanon, *Black Skin White Masks: The Experiences of a Black Man in a White World* (New York: Grove Press, 1967), 161, note 25.

5 See, for example, Judith Butler's critique of de Beauvoir in *Gender Trouble: Feminism and the Subversion of Identity* (New York: Routledge, 1990), 9–12, and Rey Chow's critique of Fanon in *Ethics After Idealism: Theory – Culture – Ethnicity – Reading* (Bloomington: University of Indiana Press, 1998), 55–73.

6 Examples range from Michele Wallace's 1990 "Modernism, Postmodernism and the Problem of the Visual in Afro-American Culture," in *Out There: Marginalization and Contemporary Culture*, eds Russell Ferguson, et al. (New York: New Museum of Contemporary Art, 1990), 39–50; to Andrea Douglas's "The Metaphysics of Identity," in *Exploring Identity: Contemporary Work by African-American Women* (Lynchburg, VA: Randolph-Macon Woman's College, Maier Museum of Art, 2001), 4–22.

7 For example, the pioneer essays by Frieda High Tesfagiorgis ("Afrofemcentrism in the Art of Elizabeth Catlett and Faith Ringgold," *Sage* 4, no. 1 (Spring 1987), 25–32) and Lowery Stokes Sims ("Aspects of Performance in the Work of Black American Women Artists," in *Feminist Art Criticism: An Anthology*, ed. by Arlene Raven, Cassandra Langer, Joanna Frueh (Ann Arbor, MI: UMI Research Press, 1988), 207–225); and the books by Lisa Gail Collins (*The Art of History: African American Women Artists Engage the Past* (New Brunswick, NJ: Rutgers University Press, 2002)), Deborah Willis and Carla Williams (*The Black Female Body* (Philadelphia: Temple University Press, 2002)), and Lisa Farrington (*Art On Fire: The Politics of Race and Sex in the Paintings of Faith Ringgold* (New York: Millennium Fine Arts Publishing, 1999)); as well as recent dissertations by Phyllis Jackson (Northwestern, 1996), Margaret Vendryes (Princeton, 1997), Kellie Jones (Yale, 1998), and Gwendolyn DuBois Shaw (Stanford, 2000).

8 In periodizing my account in this way, I do not mean to discount the foundational 1970s' work of black feminist literary critics like Toni Cade Bambara, Barbara Smith, Barbara Christian, Hortense Spillers, and Mary Helen Washington, and historians and social scientists including Sharon Harley, Rosalyn Terborg-Penn, and Joyce Ladner. But I do want to mark the emergence of a specific strain of black feminist theory that, because of its engagements with poststructuralism and poststructuralist-inflected feminisms, seems especially compatible with the new types of visual theory that emerged in the 1980s.

Here I must add that I do not view black feminist theory as the exclusive province of feminists who are black. Thus, feminists who are not black, like Jane Gaines and Mary Ann Doane in film studies and Ann Gibson in art history, as well as thinkers who are not women, like Frantz Fanon and Sander Gilman, have contributed to black feminist visual discourse, however controversially.

9 On the shared genealogies of race, aesthetics, and art history, see Taylor, *The Mask of Art*, 38–66, and Martin Bernal, *Black Athena: The Afroasiatic Roots of Classical Civilization*, Vol. I: *The Fabrication of Ancient Greece 1785–1985* (New Brunswick, NJ: Rutgers University Press, 1987), 212–223.

10 For an ethnographic perspective on the cultural relativity of vision, see Marshall H. Segall, Donald T. Campbell, and Melville J. Herskovits, *The Influence Of Culture On Visual Perception* (Indianapolis: Bobbs-Merrill, 1966). For evidence from gestalt psychology, see Taylor, *The Mask of Art*, 32–33.

11 Examples of this new prominence include the 1998–99 mainstream museum-based traveling retrospectives of Alma Thomas, Elizabeth Catlett, and Adrian Piper; major museum shows throughout the decade for Lorna Simpson, Carrie Mae Weems, Faith Ringgold, and the mother–daughter pair of Betye and Alison Saar; monographs on Catlett and Lois Mailou Jones, a two-volume collection of Piper's meta-art and criticism, and catalogs for two group shows, *Bearing Witness: Art by Contemporary African American Women* and *Three Generations of African American Women Sculptors: A Study in Paradox*, that placed this black female creative upsurge in larger, collective, and historical contexts.

12 See my essay "Beauty Rites: Towards an Anatomy of Culture in African American Women's Art," *International Review of African American Art* 11, no. 3 (1994), 11–17, 47–55; and Saidiya Hartman, "Excisions of the Flesh," *Lorna Simpson: For the Sake of the Viewer* (Chicago: Museum of Contemporary Art, 1992), 55–67.

13 Tesfagiorgis, "In Search of a Discourse and Critique/s," 231–233, 248–256.

14 Davies, *Black Women, Writing and Identity*, 25–27, 31–32.

15 See Wynter, "Rethinking 'Aesthetics': Notes Towards a Deciphering Practice," *Ex-Iles: Essays on Caribbean Cinema*, ed. Mbye B. Cham (Trenton, NJ: Africa World Press, 1992), 236–279; and Spillers, "All the Things You Could Be By Now, If Sigmund Freud's Wife Was Your Mother," in *Female Subjects in Black and White: Race, Psychoanalysis, Feminism*, eds Elizabeth Abel, Barbara Christian, Helene Moglen (Berkeley: University of California Press, 1994), 135–158.

Chapter 5

FAITH WILDING

NEXT BODIES

A T THE BEGINNING OF THE TWENTY-FIRST century, the advancing global hegemonies of corporate biotechnology and digital information and communication technologies (ICT) present radically new challenges for feminist cultural theorists and visual art practitioners. An eclectic emergent cyberfeminism that engages feminist theory and practices in the digital environment has opened the territory of the Internet as a strategic field of artistic production and political intervention. Wired feminists recognize that the instantaneous global circulation of images and texts in the networks of cyberspace is introducing large new audiences both to new feminist representations, and to feminist critiques of the gender relations and capitalist market ideologies that drive ICT.

Feminist initiatives supported by international electronic networks have already emerged in some African countries, in India, and in other developing countries. In developed countries, the relatively low cost of digital production and distribution offers younger women artists

working with new media important new avenues of visibility and action. In the last ten years, cyberfeminist web sites, participatory electronic art projects, and electronic networking groups have increased from a handful in the early 1990s to over two thousand in 2001. Cyberfeminism has adopted many of the tactics of earlier avant-garde feminisms, including strategic separatism (women-only lists, self-help groups, chat groups, networks, and technological training); feminist cultural and social theory relating to women and technology; creation of new images of women to counter rampant sexist stereotyping (feminist avatars, cyborgs, trans- or non-gendered figures); and feminist Internet critique.

The question of how to negotiate the link of cyberfeminism to other feminisms is crucial to understanding the often-contradictory contemporary positions of women working with the new technologies.[1] Cyberfeminism began with strong techno-utopian expectations that the new electronic media would offer women a fresh start to create new languages, programs, platforms, images, fluid identities and even subjectivities in cyberspace and that women could recode, redesign, and reprogram information technology to help change the female condition.[2] In much the same way as 1970s' and 1980s' feminist artists appropriated non-traditional media, technologies, and forms – such as performance, installation, video, and media interventions – in order to present a new feminist content in art, wired women – while often ambivalent about their relationship to early feminisms – are now beginning to appropriate digital technologies that do not yet have an established aesthetic history. This is an exciting moment in which to reinvent a radical feminist visual culture.

Distinctions can be made between two overlapping waves of cyberfeminism: an initial wave (roughly 1990–5) celebrated a cyborg consciousness and the innate affinities of women and machines. A second wave (1997–present) critiques the (relatively) a-political stance of previous theorists and practitioners and advocates the development of an embodied and politically engaged cyberfeminism.[3] Current debates among "new" cyberfeminists are beginning to emphasize the crucial importance of differences within feminism, and of postcolonial discourses and representations, to an engaged feminist Internet theory, politics, and practice. In this regard, the central issue of the invisibility of embodied difference in the virtual or "post-corporeal" media remains primary.

Cyberfeminist artists with the technological skills and access must join with other feminists to strategize a visible resistance to authoritarian ICT and biotech industries. Drawing on feminist cultural and postcolonial theory and strategies from past activist practices, they can initiate models for direct action, subversion, and coalition building among different groups of women. Effective tactics for such visual culture projects will: (1) employ collective production and performative action in a specific social context; (2) combine feminist critiques of technology as it relates to differences of gender, race, and class; and (3) engage in cross-disciplinary research in biotechnology, biopolitics, feminist and postcolonial art and theory.

1 The relationship between theory and practice in feminist visual culture needs rethinking. Past feminist art practices – such as those formulated by the Feminist Art Programs in California in the 1970s – sprang up in the context of an international political feminist movement. They employed activist strategies and tactics synthesized from avant-garde movements, feminist theory, and practices of everyday life. Insights gained from consciousness-raising were put to use in generating activist performances and public visual work. Political conditions have changed, however; today there is no cohesive, collective feminist movement to provide a context in which artists, students, and cultural workers can formulate and situate their practices. Most feminist artists work alone and most prominent women artists have gained recognition as individual art stars in much the same manner as the prominent men.

The blatant sexism and racism of many of the Internet and biotech art works exhibited at major electronic media venues point to a pressing need for critical feminist interventions in the representational domains of electronic media and biotech.[4] Art projects that seek to create critical discourses around biotech and ICT call for collective or collaborative interventions based on interdisciplinary research, shared expertise, and participatory performative practices. Transnational electronic networking can also be immensely productive for such projects.

2 Far from being obsolete, feminist political philosophy and gender theory have crucial bearing on the new working and living conditions (for women) created by the global deployment of ICT. Worldwide, women's lives are being profoundly altered – particularly in the areas of production and reproduction – in ways that often lead to extreme physical and mental health problems. This is as true for highly educated professional women (including artists) in academia, the sciences, and the medical and computer industries, as it is for women clerical and factory workers in the just-in-time telecommunications and home-work industries, and for rural and urban women working in electronic chip factories and in assembly sweat-shops. A crucial concern for cyberfeminist artists is to address and counter the increased economic and political stratification and exclusion reinforced by global capital and ICT.

Since most women still work a "double shift" of production and reproduction of labor, the demands and pressures of the high-speed consumer economy affect us differently from (most) men. Increasing levels of Chronic Fatigue Syndrome, depression, and stress disorders among professional women (the most documented group), not to mention the myriad social and personal stresses faced by pink- and blue-collar women workers, attest to the high human costs of late capitalist economies of production. In strategizing cyberfeminist projects relating to women's productive and reproductive labor, we must contest the unquestioned value placed on speed and efficiency and the concomitant failure to heed the limits and needs of the organic body.

3 Feminist theorists have shown how the new biotech reproductive order colonizes the female body as a pre-eminent laboratory and tissue mine for a lucrative medical/pharmaceutical industry.[5] Moving beyond the strictures of conventional academic feminist theory, cyberfeminist artists must develop activist practices that educate and engage a wide public directly, and instigate informed debate about the far-reaching repercussions of these technologies in women's lives. Disturbing developments in bio/genetic technologies such as Assisted Reproductive Technologies (ART), transgenics, and genetic modification of plants are profoundly affecting human genetic futures and the environment worldwide. Cultural critiques of corporate biotech industries should therefore be a major focus of feminist action and artistic intervention.

Organic bodies and bodily processes – particularly those of women and fetuses – are being invaded at the molecular level and re-engineered to meet the cyborgian and eugenic requirements of a rationalized global workforce and consumer market. Feminists working with these technologies – scientists, researchers and technicians, as well as non-specialist but informed activist artists – are in a critical position to work together to devise interventions into these increasingly naturalized technological discourses and practices. As informed amateurs, artists can often operate in a wider field of discursive debate and engage in more radical projects than is possible for most professionals. Cyberfeminist artists can combine visual media and scientific research in performative projects that raise consciousness, educate audiences, and model interventionist tactics. Critical practices can expose the profit motives and neo-colonial ideologies driving many of the new flesh, reproductive, and genetic industries, helping audiences to assess their political, economic, social, and eugenic implications.

In conclusion, it is time to call on cyberfeminist artists to create a radical new visual culture that critiques and resists the patriarchal and authoritarian ideologies driving corporate biotech and ICT; and to produce critical art works and cultural theory based on an informed analysis of the risks as well as the benefits of digital technologies. With such tools in cyber-feminist hands, it might be possible to create a new international feminist front!

Notes

I thank María Fernández for her permission to adapt portions of this essay from our article "Situating Cyberfeminisms" (see note 3).

1 See Faith Wilding, "Where is the Feminism in Cyberfeminism?" *n.paradoxa* 2 (1998) 6–12; and Critical Art Ensemble and Faith Wilding, "Notes toward the Political Condition of Cyberfeminism," *Art Journal* 57, no. 2 (Summer 1998), 47–59.
2 See VNS Matrix web pages, online, available <http://sysx.org/artists/vns/>.
3 See María Fernández and Faith Wilding, "Situating Cyberfeminisms," *Domain Errors: Cyberfeminist Practices*, an anthology edited by the subRosa collective (New York: Autonomedia Books, 2002).
4 For example: ARS Electronica's "Next Sex" (September 2000), Exit Art's "Paradise Now" (November 2000), and ISEA's "Beyond the Screen" (December 2000). Enthralled by the promissory spectacle of biogenetic technologies, many artists are unthinkingly producing projects that promote corporate inter-ests and eugenic ideology.
5 For a bibliography on feminism and biotech see <http://www.cyberfeminism.net>.

Chapter 6

MEILING CHENG

THE UNBEARABLE LIGHTNESS OF SIGHT

HOW DO FEMINISM AND VISUAL culture intersect?
 It is easier to pose an analogy than to answer a complicated question straight on: a set of colors is infused into an undulating pond, a pond of suspended visions. The colors, viscous (in oil-based paint), offer a certain vibrancy to the visions, coating them with an addi-tional texture and seemingly making the phantasmatic floating sights more focused, hence more "materialized," especially at the earlier moments when the colors are first introduced to the pond one by one. The visions are gradually awash with yellow, white, pink, green, red, brown, blue, purple, black, and multiple other colors, to the extent that these visions

are both reshaped and disguised by the colors and the colors also generate their own floating images. We see a plenitude upon plenitude: their intersection is splendor in disorientation.

How is feminism a set of colors?

Feminism started out as a simple impulse: to question the patriarchal status quo that presupposed gender inequality. The methods used by feminists in the 1970s to put this re-dressive impulse into action varied. Some challenged the constraining effects of gender conditioning; some advocated for women's self-determination, economic independence, and political liberation; some attacked the hegemony of masculocentric representations; some asserted the materiality of sexual difference, while pursuing women's right to full citizenship. Each method may be likened to a prime color, with its unique agenda and objectives similar to the particular density and distribution of pigment in each color. As a color tends to saturate and coordinate the surface of an image, so the set of ideological programs associated with feminism functions to orient the words, attitudes, and actions of a feminist.

These "prime colors," however, soon proved inadequate matches to the complexity of life. Within feminism, the confrontation with gender oppression alone proved insufficient when the interlocking effects of race, ethnicity, class, age, physical ability, and sexuality were laid open and critiqued. This shift toward greater complexity is not antithetical to the femi-nist ethos, for its inclusive tendency has prepared most feminists to welcome the intersubjective mandate of self-revision. All-inclusiveness, however, has its side effect of loose proliferation. After three decades' popular dissemination of the term, feminism now becomes a mutable label open to multiple, and often contradictory, censures and applications. A movement that began by exposing the specificity of variegated experiences of subjugation grows to subsume a multiplicity of causes, some of which have little to do with its formative, interventionist impulse. Imagine more and more colors are added to the pond in such rapid intervals that we can no longer discern individual patterns, and least of all evaluate their discord in abstrac-tion. If we, as feminists, desire to tell more stories about the floating visions in our own voices, this may be the moment that we must pause and select more carefully the colors on our palette. Limitation offers us the freedom to intervene with sophisticated clarity.

How do we compare visual culture to an undulating pond of visions?

Visual culture assembles diverse accesses to a phenomenal world that sustains and envelops us primarily through our senses, especially through our optical sense, which extends the reach of our sensory body. The condition of sensory extension is a plus, but also a necessity, as distance is prerequisite for vision. We are capable of seeing only that which stands apart from our eyes. This state of apartness entails that the majority of sights are foreign to, or other than, our being. A dispossessed endowment, our vision can neither own nor transfix the object of its gaze, even though the object under surveillance may feel threatened by this gaze. A certain liquidity distances our act of seeing from the seen; we approach visible sights as if through a watery screen, a pond of visions that keep undulating. Indeed, the saying "seeing is believing" comments on the impossibility, for us, of verifying a sight purely through seeing, for a belief is born/e precisely to defer the uncertainty of (a) being. We believe what we see in order not to lose (sight of) that to which our visual desire clings. Being unverifiable, the object of our visual desire – as a floating sight in our optical pond – dangles in indetermi-nacy, glowing in a surfeit of free-ranging signification that resists semantic fixity. But we enact our desire by investing our belief in the visual object, encrypting certain meanings and projecting them onto the image to stop its rippling into invisibility, a disappearance that would register our inability to access the field beyond visuality. Pouring colors onto the floating visions is, then, one way to pre-empt the disappearance of the visible and thus to put in abeyance our mourning for the lost sight.

Like an optical pond that gathers floating images by random accretion, the field of visual culture tends to expand in its inventory of study objects, which are, theoretically, a collection of any visible sight invested with a perceiver's desire. Visual culture, given inherently to multiplicity, triggers the interest in finding ways of comprehending and deciphering the existing images manufactured by contemporary culture. The conundrum hidden in this scenario is the discrepancy of intentionality between the subject of inquiry and the inquiring subject: the image seized for view, however deliberately designed, exists in a state of indifference, whereas the viewer is most likely already overdetermined by her/his interpretive desire. Perhaps the best we can do is to bypass the conundrum by pursuing the liberating potential of that discrepancy, recognizing the being of an image as light/intangible and the core of a desire as heavy/matter-producing. We allow the heavy to impinge upon the light, not to deaden the light, but to turn it into a certain illuminating matter.

Heavy like a set of colors, feminism seeks to produce significant matters that redress the myopia of phallocentric culture. As feminists, we may regard visual culture as a system of commodification heavily encoded with phallocentric values, or simply as a floating gallery of aggregating images phantasmatic in their void of values. The former requires our critique as we challenge the masculinist hegemony that has processed visual representations surreptitiously for its own perpetuation. The latter yields a vast productive space for us to play with subversive colors, those that engender our own narratives, allowing them to radiate from the undulating visions in the pond. When we heed the lightness of sight, we gain the potential of making its lightness as heavy as a commitment.

PART TWO

Representation

T HE MODERN PERIOD (roughly the nineteenth up through the mid to late twentieth centuries) is often characterized as having taken shape, precisely, through the rise of a particular kind of image culture. Modernity, in this view, *is* the culture of photographic reproduction. While the photographic camera mimics the structure of Renaissance single-point perspective, paradoxically, because of its production of copies, its development signaled the end of the ideology of individualism aligned with this very Renaissance method of defining how we see and make images (see John Berger 1972, 11–23). With the rise of image culture, the scramble to shore up the boundaries between so-called art and popular culture imagery became more frantic, culminating – in the immediate post-WWII period in the U.S. in particular – with the reductivist modernist formalist arguments of Clement Greenberg and his followers. Key to Greenberg's method was the neo-Kantian argument that art works were autonomous from the political or social realm: their meaning was inherent to their structure and content, and inevitably aligned in some way with the assumed initiating intentionality of the artists who produced them.

Feminism and visual culture, of course, both (and especially both together) have had a great stake in overturning the assumptions of the modernist formalist model of determining meaning and value for visual images. By the 1960s, with the rise of the rights, the student, and the anti-war movements and the burgeoning of global capitalism, new generations of artists and visual theorists drew on semiotic theory to question the viability of the notion of the image as autonomous, as containing within itself an inherent meaning and value. Coming to the fore during this period and after was the issue of *representation*; theorists began to interrogate the structures, psychic and social, motivating representation rather than accepting it as a given. Through the dismantling of the modernist concept of representation (which poses the image or text as having an unmediated, transparent relationship to the real), theorists with a stake in critiquing dominant canons and definitions of the "genius" and the "masterpiece" were given a space to assert alternative modes of making, seeing, and interpreting visual culture and its institutions (see Linda Nochlin (Chapter 26); Chadwick 1988).

As well, the insights of rapidly expanding theories of subjectivity and power, developed out of philosophy and semiotics by poststructuralist theorists (primarily from France) furthered this impulse to question the underlying motivations behind the autonomy argument (see Luce Irigaray (Chapter 16)). Psychoanalysis, in particular, provided a model for unhinging the

assumptions built into its hidden system of assigning privilege: Jackson Pollock's drip painting wasn't *intrinsically* better than the abstract painting of his female partner Lee Krasner. It was produced as superior by a system motivated by the desire to continue to support white male subjects and to protect their domains in order to mask the fact that there is no inherent value (in psychoanalytic terms: the penis isn't a phallus; it can be castrated, and the male subject, like the female, is fundamentally based on lack not plenitude).

Unconscious desires motivate every cultural expression; by uncovering these, the visual theorist could psychoanalyze, as it were, not only the institutional and discursive privileges of the art world and image culture but the artist himself (viz., Mulvey's wonderful psycho-analytical account of Alan Jones's castration-envy-palliating female phalli in "Fears, Fantasies and the Male Unconscious"). Alternatively, living in a psychoanalytically informed culture could support the contention that women necessarily tend to make a different kind of imagery, based on our particular psychic, and largely unconscious, experience of embodiment (this is the general idea behind the arguments about central core imagery; see Judy Chicago and Miriam Schapiro (Chapter 8)).

These psychoanalytic models of identity and meaning formation in relation to represen-tation were linked as well to a growing awareness of the effects of living in an increasingly image-saturated culture, as theorized by writers such as Jean Baudrillard and Guy Debord. Debord's 1967 book *Society of the Spectacle* offered a Marxist critique of the West's image culture of simulation (a postmodern term for representation, stressing its constructedness and opaqueness in relation to the "real," whatever that could be understood to be). The authority of the Renaissance to Enlightenment concept of the encyclopedic view (the single point from which the world could be seen and known) was thrown into question from these two direc-tions: the rights movements (born, of course, out of the Enlightenment itself) and the destabilizing effects of media-saturated image culture, chronicled in Debord's Marxist critique.

The essays collected under the rubric "Representation" in this volume represent one aspect of this trajectory intertwining the insights of semiotics, Marxism, and psychoanalysis with the critical, feminist approach to image culture (or in Debord's terms, the "society of the spec-tacle"). I have chosen to include here a series of crucial essays written in the context of early to recent feminist debates about the relations of looking and empowerment proposed by the dominant regime of visuality in western culture. A number of these essays, written by some of the major figures in feminist art and film theory (John Berger (Chapter 7), Laura Mulvey (Chapter 9), Mary Ann Doane (Chapter 11)) and by the important cultural theorist bell hooks (Chapter 14), offer explicit critiques of the culture of the "gaze" (aligned with masculine subjectivity, the gaze produces women and other dominated subjects as fetishes to palliate male castration anxiety) or rework this model that defines representations of women's bodies as necessarily participating in the regime of fetishism, and assumes these bodies to be white. hooks ends by arguing for "critical black female spectators," who, identifying neither with the phallocentric gaze nor with the "construction of white womanhood as lack," construct a theory of looking relations that turns their delight in looking at films into "the pleasure of interrogation."

Other essays draw on more loosely psychoanalytic notions of the self in relation to repre-sentation in order to argue for alternative strategies of intervening in this representational regime through the production of new kinds of images or theories of visuality (see Chicago and Schapiro, Judith Barry and Sandy Flitterman-Lewis (Chapter 10), Mary Kelly (Chapter 12), and Griselda Pollock (Chapter 13)).

While Chicago and Schapiro claim the possibility of creating and identifying a specifically "female" type of imagery, Kelly, Barry and Flitterman-Lewis, and Pollock argue strongly against such an assumed connection. Drawing on Freud's model of fetishism, Barry and Flitterman-Lewis and Pollock insist that "textual strategies" or avant-gardist, distancing tactics must be adopted by feminist artists who wish to counteract the invidious, and seemingly inevitable, effects of the male gaze. This argument about representation was extremely important in the development of feminist models for critiquing visual culture; it became dominant in the 1980s.

Kelly, whose artwork is often argued to be the most successful at attaining such distancing strategies, here contributes an essay arguing for a nuanced view of these debates. Still making use of a Freudian model of analysis, Kelly insists on complicating the idea that "fetishism is an exclusively male perversion." She counters the tendency to focus on critical strategies of resisting the male gaze, raising the issue of the *female* spectator.

Peggy Phelan's (Chapter 15) observation that "if representational visibility equals power, then almost-naked young white women should be running Western culture" (112) shifts the debate away from the model of the male gaze to a new way of thinking gendered identity as referenced partly through visual cues but ultimately functioning beyond a simple model of visual power and visibility. Theories of representation, following the lead of Phelan and other recent feminist scholars, have begun to move us in entirely new directions.

References and further reading

Adams, Parveen. *The Emptiness of the Image: Psychoanalysis and Sexual Differences*. London and New York: Routledge, 1996.

Berger, John. *Ways of Seeing*. Harmondsworth: Penguin Books and London: BBC, 1972.

Bergstrom, Janet and Doane, Mary Ann, eds. "The Spectatrix." Special issue on Female Spectatorship. *Camera Obscura* 20–1 (1990).

Chadwick, Whitney. "Women Artists and the Politics of Representation." *Feminist Art Criticism*. Arlene Raven, Cassandra Langer, Joanna Frueh, eds. New York: Harper & Row, 1988.

Cowie, Elizabeth. "Women, Representation and the Image." *Screen Education* n. 23 (Summer 1977).

Debord, Guy. *Society of the Spectacle* (1967). Detroit: Black and Red Press, 1977.

Deepwell, Katy, ed. "Desire and the Gaze." Special issue. *n. Paradoxa* 6 (July 2000).

Diawara, Manthia. "Black Spectatorship: Problems of Identification and Resistance." *Screen* 29, n. 4 (Autumn 1988), 66–76.

Freud, Sigmund. "Fetishism" (1927). Tr. Joan Rivière. *Sexuality and the Psychology of Love*. New York: Macmillan, 1963.

Friedberg, Ann. *Window Shopping: Cinema and the Postmodern*. Berkeley and Los Angeles: University of California Press, 1993.

Fuss, Diana. "Fashion and the Homospectatorial Look" (1992). *Identities*. Kwame Anthony Appiah and Henry Louis Gates, Jr, eds. Chicago: University of Chicago Press, 1995.

Jay, Martin. *Downcast Eyes: The Denigration of Vision in Twentieth-Century French Thought*. Berkeley: University of California Press, 1994.

Kaplan, E. Ann. "Is the Gaze Male?" *Women in Film: Both Sides of the Camera*. London and New York: Methuen, 1983.

Kuhn, Annette. *The Power of the Image: Essays on Representation and Sexuality*. London: Routledge and Kegan Paul, 1985.

Linker, Kate. "Representation and Sexuality" (1983). *Art after Modernism: Rethinking Representation*. Brian Wallis, ed. New York: New Museum of Contemporary Art, 1984.

Lippard, Lucy. "What is Female Imagery?" (1975). *From the Center: Feminist Essays on Women's Art*. New York: Dutton, 1976.

Mayne, Judith. *Cinema and Spectatorship*. London and New York: Routledge, 1993.

Moore, Suzanne. "Here's Looking at You Kid!" *The Female Gaze: Women as Viewers of Popular Culture*. Lorraine Gamman and Margaret Marshment, eds. Seattle: Real Comet Press, 1989.

Mulvey, Laura. "Fears, Fantasies and the Male Unconscious *or*, 'You Don't Know What is Happening, Do You Mr Jones?'" (1972). *Visual and Other Pleasures*. Bloomington: Indiana University Press, 1989.

Pollock, Griselda. "What's Wrong with Images of Women?" *Screen Education* n. 24 (Autumn 1977), 25–33.

Raven, Arlene. "Feminist Content in Current Female Art." *Sister* 6, n. 5 (October/November 1975), 10.

Rose, Jacqueline. "Sexuality in the Field of Vision." *Difference: On Representation and Sexuality*. New York: New Museum of Contemporary Art, 1984.

Silverman, Kaja. *The Subject of Semiotics*. Oxford: Oxford University Press, 1983.

Silverman, Kaja. *The Threshold of the Visible Word*. New York: Routledge, 1996.

Tyler, Carole-Anne. "The Feminine Look." *Theory Between the Disciplines: Authority/Vision/Politics*. Martin Kreiswirth and Mark Cheetham, eds. Ann Arbor: University of Michigan Press, 1990.

Williamson, Judith. "Images of 'Women'." *Screen* 24, n. 6 (November–December 1983): 102–16.

"Women and Representation: A Discussion with Laura Mulvey." Collective project by Jane Clarke, Sue Clayton, Joanna Clelland, Rosie Elliott, and Mandy Merck. *Wedge* 2 (Spring 1979).

JOHN BERGER

FROM *WAYS OF SEEING*

ACCORDING TO USAGE AND CONVENTIONS which are at last being questioned but have by no means been overcome, the social presence of a woman is different in kind from that of a man. A man's presence is striking. If it is small or incredible, he is found to have little presence. The promised power may be moral, physical, temperamental, economic, social, sexual – but its object is always exterior to the man. A man's presence suggests what he is capable of doing to you or for you. His presence may be fabricated, in the sense that he pretends to be capable of what he is not. But the pretence is always towards a power which he exercises on others.

By contrast, a woman's presence expresses her own attitude to herself, and defines what can and cannot be done to her. Her presence is manifest in her gestures, voice, opinions, expressions, clothes, chosen surroundings, taste – indeed there is nothing she can do which does not contribute to her presence. Presence for a woman is so intrinsic to her person that men tend to think of it as an almost physical emanation, a kind of heat or smell or aura.

To be born a woman has been to be born, within an allotted and confined space, into the keeping of men. The social presence of women has developed as a result of their ingenuity in living under such tutelage within such a limited space. But this has been at the cost of a woman's self being split into two. A woman must continually watch herself. She is almost continually accompanied by her own image of herself. Whilst she is walking across a room or whilst she is weeping at the death of her father, she can scarcely avoid envisaging herself walking or weeping. From earliest childhood she has been taught and persuaded to survey herself continually.

And so she comes to consider the *surveyor* and the *surveyed* within her as the two constituent yet always distinct elements of her identity as a woman.

She has to survey everything she is and everything she does because how she appears to others, and ultimately how she appears to men, is of crucial importance for what is normally thought of as the success of her life. Her own sense of being in herself is supplanted by a sense of being appreciated as herself by another.

Men survey women before treating them. Consequently how a woman appears to a man can determine how she will be treated. To acquire some control over this process, women must contain it and interiorize it. That part of a woman's self which is the surveyor treats the part which is the surveyed so as to demonstrate to others how her whole self would like to be treated. And this exemplary treatment of herself by herself constitutes her presence. Every woman's presence regulates what is and is not "permissible" within her presence. Every one of her actions – whatever its direct purpose or motivation – is also read as an indication of how she would like to be treated. If a woman throws a glass on the floor, this is an example of how she treats her own emotion of anger and so of how she would wish it to be treated

by others. If a man does the same, his action is only read as an expression of his anger. If a woman makes a good joke this is an example of how she treats the joker in herself and accordingly of how she as a joker-woman would like to be treated by others. Only a man can make a good joke for its own sake.

One might simplify this by saying: *men act* and *women appear*. Men look at women. Women watch themselves being looked at. This determines not only most relations between men and women but also the relation of women to themselves. The surveyor of woman in herself is male: the surveyed female. Thus she turns herself into an object – and most particularly an object of vision: a sight.

In one category of European oil painting women were the principal, ever-recurring subject. That category is the nude. In the nudes of European painting we can discover some of the criteria and conventions by which women have been seen and judged as sights.

The first nudes in the tradition depicted Adam and Eve. It is worth referring to the story as told in Genesis:

> And when the woman saw that the tree was good for food, and that it was a delight to the eyes, and that the tree was to be desired to make one wise, she took of the fruit thereof and did eat; and she gave also unto her husband with her, and he did eat.
>
> And the eyes of them both were opened, and they knew that they were naked; and they sewed fig-leaves together and made themselves aprons. . . . And the Lord God called unto the man and said unto him, "Where are thou?" And he said, "I heard thy voice in the garden, and I was afraid, because I was naked; and I hid myself. . . .
>
> Unto the woman God said, "I will greatly multiply thy sorrow and thy conception; in sorrow thou shalt bring forth children; and thy desire shall be to thy husband and he shall rule over thee".

What is striking about this story? They became aware of being naked because, as a result of eating the apple, each saw the other differently. Nakedness was created in the mind of the beholder.

The second striking fact is that the woman is blamed and is punished by being made subservient to the man. In relation to the woman, the man becomes the agent of God.

In the medieval tradition the story was often illustrated, scene following scene, as in a strip cartoon.

During the Renaissance the narrative sequence disappeared, and the single moment depicted became the moment of shame. The couple wear fig-leaves or make a modest gesture with their hands. But now their shame is not so much in relation to one another as to the spectator. Later the shame becomes a kind of display.

When the tradition of painting became more secular, other themes also offered the opportunity of painting nudes. But in them all there remains the implication that the subject (a woman) is aware of being seen by a spectator. She is not naked as she is. She is naked as the spectator sees her.

Often – as with the favourite subject of Susannah and the Elders – this is the actual theme of the picture. We join the Elders to spy on Susannah taking her bath. She looks back at us looking at her. In another version of the subject by Tintoretto, Susannah is looking at herself in a mirror. Thus she joins the spectators of herself.

The mirror was often used as a symbol of the vanity of woman. The moralizing, however, was mostly hypocritical. You painted a naked woman because you enjoyed looking at her,

you put a mirror in her hand and you called the painting *Vanity*, thus morally condemning the woman whose nakedness you had depicted for your own pleasure.

The real function of the mirror was otherwise. It was to make the woman connive in treating herself as, first and foremost, a sight.

The Judgement of Paris was another theme with the same inwritten idea of a man or men looking at naked women. But a further element is now added. The element of judgement. Paris awards the apple to the woman he finds most beautiful. Thus Beauty becomes competitive. (Today The Judgement of Paris has become the Beauty Contest.) Those who are not judged beautiful are *not beautiful*. Those who are, are given the prize.

The prize is to be owned by a judge – that is to say to be available for him. Charles the Second commissioned a secret painting from Lely. It is a highly typical image of the tradition. Nominally it might be a *Venus and Cupid*. In fact it is a portrait of one of the King's mistresses, Nell Gwynne. It shows her passively looking at the spectator staring at her naked. This nakedness is not, however, an expression of her own feelings; it is a sign of her submission to the owner's feelings or demands. (The owner of both woman and painting.) The painting, when the King showed it to others, demonstrated this submission and his guests envied him.

It is worth noticing that in other non-European traditions – in Indian art, Persian art, African art, Pre-Columbian art – nakedness is never supine in this way. And if, in these traditions, the theme of a work is sexual attraction, it is likely to show active sexual love as between two people, the woman as active as the man, the actions of each absorbing the other.

We can now begin to see the difference between nakedness and nudity in the European tradition. In his book on *The Nude* Kenneth Clark maintains that to be naked is simply to be without clothes, whereas the nude is a form of art. According to him, a nude is not the starting point of a painting, but a way of seeing which the painting achieves. To some degree, this is true – although the way of seeing "a nude" is not necessarily confined to art: there are also nude photographs, nude poses, nude gestures. What is true is that the nude is always conventionalised – and the authority for its conventions derives from a certain tradition of art.

What do these conventions mean? What does a nude signify? It is not sufficient to answer these questions merely in terms of the art-form, for it is quite clear that the nude also relates to lived sexuality.

To be naked is to be oneself. To be nude is to be seen naked by others and yet not recognized for oneself. A naked body has to be seen as an object in order to become a nude. (The sight of it as an object stimulates the use of it as an object.) Nakedness reveals itself. Nudity is placed on display.

To be naked is to be without disguise. To be on display is to have the surface of one's own skin, the hairs of one's own body, turned into a disguise which, in that situation, can never be discarded. The nude is condemned to never being naked. Nudity is a form of dress.

In the average European oil painting of the nude the principal protagonist is never painted. He is the spectator in front of the picture and he is presumed to be a man. Everything is addressed to him. Everything must appear to be the result of his being there. It is for him that the figures have assumed their nudity. But he, by definition, is a stranger – with his clothes still on.

[. . .]

JUDY CHICAGO AND MIRIAM SCHAPIRO

FEMALE IMAGERY

O'KEEFFE BEGAN, SHE PAINTED A HAUNTING mysterious passage through the black portal of an iris, making the first recognized step into the darkness of female identity. That step moved her out of the reference points of art-making as it had been defined by men, throughout history. She painted out of an urgency to understand her own being and to communicate as yet unknown information about being a woman.

What does it feel like to be a woman? To be formed around a central core and have a secret place which can be entered and which is also a passageway from which life emerges? What kind of imagery does this state of feeling engender? There is now evidence that many women artists have defined a central orifice whose formal organization is often a metaphor for a woman's body. The center of the painting is the tunnel; the experience of female sexuality. In the case of O'Keeffe, the metaphor is extended into a world of life and death. In "Black Iris" the forms suggest and then transcend womanliness to metamorphose into an image of death and resurrection. [See Frontispiece.]

There is a contradiction in the experience of a woman who is also an artist. She feels herself to be "subject" in a world which treats her as "object". Her works often become a symbolic arena where she establishes her sense of personal, sexual identity.

She asks: "Who am I? Am I active or passive? How does the vulnerable center inside me affect my perception of reality? How does my own sense of interior space and receptivity differ from the sense of being outside and thrusting inward? Where is the mirror in the world to reveal who I am? If I repeat the shape of my question many times, will that shape be seen?"

In answering these questions she often defines a sculptural or pictorial image which is central and, in doing so, she gives out her own information about who she is, often to a world that doesn't listen, doesn't look, and certainly doesn't care.

When women began to speak about themselves, they were not understood. Men had established a code of regulations for the making and judging of art which derived from their sense of what was or was not significant. Women, thought to be inferior to men, obviously could not occupy center stage unless they concerned themselves with the ideas men deemed appropriate. If they dealt with areas of experience in the female domain, men paid no attention because they were not used to women making their experience visible. In fact those women whose work was built on their own identity in terms of female iconography have been treated by men as if they were dealing with masculine experience. This is a false assumption since the cultural experience of women has differed greatly from that of men. For centuries, women were educated to different tasks and remained outside of the scientific and mechanical culture built by men. Now that women are beginning to recognize their right to display their own symbology, they find themselves met with a mask of non-comprehension on the part of the male art critics.

The best example of this is the case of Georgia O'Keeffe. Here is a woman of major stature who appears in the 20th century.

In 1923, a year before she married Stieglitz, O'Keeffe painted a 48″ × 30″ oil on canvas called "Grey Line with Black, Blue and Yellow". In this painting, which resembles a watercolor more than an oil in its transparent paint quality, we see a central image constructed like the labia of the vagina, opening into a thin, black, membranous cavity. The entire central orifice is surrounded on each side by a white, sheltering form which rises and moves out from the center to embrace another space beyond the flesh of the flower-like orifice, a space which suggests infinity. Describing the central opening are a series of delicately painted folds, which suggest nothing less than orgiastic throbbing or contractions of labor. There is in the uppermost regions of the orifice, a dark movement towards a peak where again the sensuous perception is that of the highly focused feeling of clitoral sensation.

In 1946, the year Stieglitz died, she painted an oil on paper, 30″ × 24″, called "In the Patio 1." The essential motif of this painting as well as others, is the patio of her house in the southwest. Again the central image appears. Here in opposition to the repeated oval and/or circular motions in the last painting discussed, we find the central image in the shape of a rectangle, actually housed within the space of a larger rectangle (perhaps a door frame or a window frame). Seen through the space of the central image are several more rectangular, periscoping spaces. In order to understand the preoccupation with building structure, one has to read it as a metaphor for a housing or casing of the soul or the body. Once we acknowledge this proposition, then the opening in the middle of the picture provides an insight into the mystery of black and white forms intertwining in the Yin/Yang manner; we see a complexity of meaning stemming from O'Keeffe's preoccupation with life and death. There are light motifs in the painting, such as the two darts in the large framework and the curve upwards of the framework itself, as well as the ambivalent floor opening on the left-hand side of the painting. All of this iconography seems to subordinate itself to the larger issue of looking through the window or door into infinity; or discovering the view of the soul; or tunnelling forward into infinity or backwards to the past which now becomes black and white or "clear".

In 1964 she painted an oil on canvas, 24¼″ × 30⅛″, "Road Past the View". Here we see other aspects of O'Keeffe's femininity. The painting is a landscape which conveys the curves of flesh in the quietness of a dream. The color is as soft as has ever been seen in abstract painting, not just pale, but soft like a cloud or a light caress. As a woman, O'Keeffe has no taboo (as in the case with men) about allowing herself to be gentle and tender. Women in our society are allowed to retain this aspect of themselves – the expression of softness inside themselves which has been acculturated into the mothering aspect of the female role. For men, conditioned to the role of toughness, fragility is associated with womanliness and men cannot allow those feelings in themselves lest they risk the fantasy of emasculinization. Because O'Keeffe doesn't have this problem, the range of expression in her work is far greater than one ordinarily sees in the lifetime of a man's work.

O'Keeffe's oeuvre opens up the possibility of human expressiveness heretofore unavailable, particularly to men. Implicit in this is a suggestion that just as women have suffered when measured by male standards, so men might be found lacking when measured by the standards of that work by women which asserts softness, vulnerability and self-exposure.

Better to deny, obscure or mystify the achievements of women than to have to be measured by those achievements. The structure of male personality has led to an artmaking that aggrandizes abstract ideas, formal innovation, and concern with materials and tools. This reflects the conditioning of men towards manipulation of reality and away from exposure of

vulnerability and dependency. It is with this conditioning that men approach the work of women, and whatever expressiveness lies outside the possibilities of their own acculturated perception, remains unseen. If the emperor's new clothes are really the vestments of women's feelings, then the men are unprepared to see them, because they have not been perceptually educated to accept the language of female form.

Let us examine the work of a number of women artists from the point of view that we are suggesting, and see what we discover. Remember, we are looking for the ways in which these artists' femaleness shapes both the form and context of their work. The central image is frequently used by these artists, either alone or in repetition, which asserts the identity of the form by repeating it.

1 In Emily Carr's "Forest of British Columbia" an ominous landscape becomes the metaphor for the murky, unknown female interior. The winding and binding forms sometimes cavern, sometimes womb, sometimes forest, reiterates, as in O'Keeffe, the mysterious and infinite life process.

2 J. de Feo's "White Rose" is composed of layer upon layer upon layer of paint applied, then scraped off, over a period of several years, finally encrusting the canvas with memories of the now hidden manifestations of female sensuality. This voyage conveys an almost frightening process of revealing and obscuring self.

3 Lee Bontecou's drawing "Unknown" is part of a series of work that made a profound contribution to an understanding of female identity through imagery. In Lee Bontecou we find the essential answer to one of the perplexing questions about the nature of female identity. The question is: Is woman passive or active? Society defines women's vaginas and hence women as passive, receptive, responsive and acceptant; yet women know that their vaginas expand in childbirth, contract in orgasm, rip, bleed, want, assert, and in doing so define their nature in defiance of the society's narrow definition. The large, velvet lined cores of Bontecou's work deal exclusively with defining the central cavity of the female and thus the female herself. Bontecou establishes definitely that female identity is both active and passive.

4 In Deborah Remington's painting "Ansonia", the red egg recalls early Mother cult symbology and floats in a landscape of a machine culture. The deification of the egg, respondent in its place of honor, clearly in the center of the painting, speaks for itself.

5 In Barbara Hepworth's "Nesting Stones" of 1937, we see not only a repeat of the pregnant rock form used by O'Keeffe in her "Black Rock with Blue 3" but also an unmistakable mother and child nesting image and a centralized hollow, which reveals Hepworth's stated belief in a female sensibility in art.

6 In "Ox" 1969 by Miriam Schapiro, central imagery and the nature of female identity appear in their clearest forms. Body form which can be penetrated in its soft flesh center becomes an insignia for the assertion of self that all female artists search for, a female counterpart to Vetruvial Man. The image, which seems to be a mechanical, formalized structure, houses a soft and inviting tunnel.

7 Nevelson's boxes become the containers, the voids, the empty spaces of self and of life which must be filled, replenished and satisfied. Again, Nevelson is the artist who reveals a woman's need to fill and be filled, and in so doing attests to the simultanity of giving and being given to.

8 In "Desert Fan" 1971, by Judy Chicago, the central core image reveals the merging of flesh and landscape. The surrounding forms echo and repeat the assertion of the central core which invites penetrability and implies self-expansion. The softness of the color

enhances the delicate vulnerable depth of the interior space, which is shown to be vibrant and beautiful.

The visual symbology that we have been describing must not be seen in a simplistic sense as "vaginal or womb art". Rather, we are suggesting that women artists have used the central cavity which defines them as women as the framework for an imagery which allows for the complete reversal of the way in which women are seen by the culture. That is, to be a woman is to be an object of contempt, and the vagina, stamp of femaleness, is devalued. The woman artist, seeing herself as loathed, takes that very mark of her otherness and by asserting it as the hallmark of her iconography, establishes a vehicle by which to state the truth and beauty of her identity.

One of the reasons that this work by women has been either misunderstood or ignored is that it asserts a set of values that differ from the mainstream of culture. It seems obvious that a woman artist who goes into her studio every day and sees the clear evidence of her abilities will see that the values of the society which define her as passive and inferior, cannot be right. If she challenges those values, she will inevitably challenge others as she discovers in her creative journey that most of what she has been taught to believe about herself is inaccurate and distorted. It is with this differing self perception that the woman artist moves into the world and begins to define all aspects of experience through her own modes of perception which, at their very base, differ from the society's, inasmuch as her self-definition is in direct conflict with the definition of woman held by the society at large.

Perhaps the paradoxes of life which define the human condition have another dimension. If women are not what we have assumed them to be, what about other assumptions we have made? If to be female is, in Bontecou's metaphorical structures, active as well as passive, what is it to be male? Does that alter the definition of the male as well? If vulnerability is asserted as something to accept, as in Chicago's open, exposed imagery, does that suggest that we might question our fear of our own softness? If Nevelson reveals to us the simultaneous, yet seemingly contradictory, essence of self, as giver and as receiver, does that mean that men, as well as women can nurture and be nurtured, fill, and be filled? O'Keeffe's flower houses both life and death, and Remington's egg is both portal and protuberance. In Schapiro's "Ox", femaleness turns out to be the other side of maleness, with a hard outside and a soft inside. The central image assumes universality in these works because it is used to define first, the nature of female identity and then, the nature of human identity and the human dilemma. The sense of double identity, both male and female, has allowed these artists to reveal all of the contradictions of life, unified within the image of female self which becomes the house of life. These women, who have made art in solitude and in anguish, rather than being honoured for their unique vision of reality, have seen their imagery lost in the plethora of culture. It is our hope that female perception of reality, as it is beginning to be described, will enrich our language, expand our perceptions and enlarge our humanity.

LAURA MULVEY

VISUAL PLEASURE AND NARRATIVE CINEMA

I Introduction

A *A political use of psychoanalysis*

THIS PAPER INTENDS TO USE PSYCHOANALYSIS to discover where and how the fascination of film is reinforced by pre-existing patterns of fascination already at work within the individual subject and the social formations that have moulded him. It takes as its starting-point the way film reflects, reveals and even plays on the straight, socially established interpretation of sexual difference which controls images, erotic ways of looking and spectacle. It is helpful to understand what the cinema has been, how its magic has worked in the past, while attempting a theory and a practice which will challenge this cinema of the past. Psychoanalytic theory is thus appropriated here as a political weapon, demonstrating the way the unconscious of patriarchal society has structured film form.

The paradox of phallocentrism in all its manifestations is that it depends on the image of the castrated woman to give order and meaning to its world. An idea of woman stands as linchpin to the system: it is her lack that produces the phallus as a symbolic presence, it is her desire to make good the lack that the phallus signifies. Recent writing in *Screen* about psychoanalysis and the cinema has not sufficiently brought out the importance of the representation of the female form in a symbolic order in which, in the last resort, it speaks castration and nothing else. To summarise briefly: the function of woman in forming the patriarchal unconscious is twofold: she firstly symbolises the castration threat by her real lack of a penis and secondly thereby raises her child into the symbolic. Once this has been achieved, her meaning in the process is at an end. It does not last into the world of law and language except as a memory, which oscillates between memory of maternal plenitude and memory of lack. Both are posited on nature (or on anatomy in Freud's famous phrase). Woman's desire is subjugated to her image as bearer of the bleeding wound; she can exist only in relation to castration and cannot transcend it. She turns her child into the signifier of her own desire to possess a penis (the condition, she imagines, of entry into the symbolic). Either she must gracefully give way to the word, the name of the father and the law, or else struggle to keep her child down with her in the half-light of the imaginary. Woman then stands in patriarchal culture as a signifier for the male other, bound by a symbolic order in which man can live out his fantasies and obsessions through linguistic command by imposing them on the silent image of woman still tied to her place as bearer, not maker, of meaning.

There is an obvious interest in this analysis for feminists, a beauty in its exact rendering of the frustration experienced under the phallocentric order. It gets us nearer to the roots of our oppression, it brings closer an articulation of the problem, it faces us with the ultimate challenge: how to fight the unconscious structured like a language (formed critically at the moment of arrival of language) while still caught within the language of the patriarchy? There is no way in which we can produce an alternative out of the blue, but we can begin to make a break by examining patriarchy with the tools it provides, of which psychoanalysis is not the only but an important one. We are still separated by a great gap from important issues for the female unconscious which are scarcely relevant to phallocentric theory: the sexing of the female infant and her relationship to the symbolic, the sexually mature woman as non-mother, maternity outside the signification of the phallus, the vagina. But, at this point, psychoanalytic theory as it now stands can at least advance our understanding of the *status quo*, of the patriarchal order in which we are caught.

B Destruction of pleasure as a radical weapon

As an advanced representation system, the cinema poses questions about the ways the unconscious (formed by the dominant order) structures ways of seeing and pleasure in looking. Cinema has changed over the last few decades. It is no longer the monolithic system based on large capital investment exemplified at its best by Hollywood in the 1930s, 1940s and 1950s. Technological advances (16mm and so on) have changed the economic conditions of cinematic production, which can now be artisanal as well as capitalist. Thus it has been possible for an alternative cinema to develop. However self-conscious and ironic Hollywood managed to be, it always restricted itself to a formal *mise en scène* reflecting the dominant ideological concept of the cinema. The alternative cinema provides a space for the birth of a cinema which is radical in both a political and an aesthetic sense and challenges the basic assumptions of the mainstream film. This is not to reject the latter moralistically, but to highlight the ways in which its formal preoccupations reflect the psychical obsessions of the society which produced it and, further, to stress that the alternative cinema must start specifically by reacting against these obsessions and assumptions. A politically and aesthetically avant-garde cinema is now possible, but it can still only exist as a counterpoint.

The magic of the Hollywood style at its best (and of all the cinema which fell within its sphere of influence) arose, not exclusively, but in one important aspect, from its skilled and satisfying manipulation of visual pleasure. Unchallenged, mainstream film coded the erotic into the language of the dominant patriarchal order. In the highly developed Hollywood cinema it was only through these codes that the alienated subject, torn in his imaginary memory by a sense of loss, by the terror of potential lack in fantasy, came near to finding a glimpse of satisfaction: through its formal beauty and its play on his own formative obsessions. This article will discuss the interweaving of that erotic pleasure in film, its meaning and, in particular, the central place of the image of woman. It is said that analysing pleasure, or beauty, destroys it. That is the intention of this article. The satisfaction and reinforcement of the ego that represent the high point of film history hitherto must be attacked. Not in favour of a reconstructed new pleasure, which cannot exist in the abstract, nor of intellectualised unpleasure, but to make way for a total negation of the ease and plenitude of the narrative fiction film. The alternative is the thrill that comes from leaving the past behind without simply rejecting it, transcending outworn or oppressive forms, and daring to break with normal pleasurable expectations in order to conceive a new language of desire.

II Pleasure in looking/fascination with the human form

A The cinema offers a number of possible pleasures. One is scopophilia (pleasure in looking). There are circumstances in which looking itself is a source of pleasure, just as, in the reverse formation, there is pleasure in being looked at. Originally, in his *Three Essays on Sexuality*, Freud isolated scopophilia as one of the component instincts of sexuality which exist as drives quite independently of the erotogenic zones. At this point he associated scopophilia with taking other people as objects, subjecting them to a controlling and curious gaze. His particular examples centre on the voyeuristic activities of children, their desire to see and make sure of the private and forbidden (curiosity about other people's genital and bodily functions, about the presence or absence of the penis and, retrospectively, about the primal scene). In this analysis scopophilia is essentially active. (Later, in "Instincts and Their Vicissitudes", Freud developed his theory of scopophilia further, attaching it initially to pregenital auto-eroticism, after which, by analogy, the pleasure of the look is transferred to others. There is a close working here of the relationship between the active instinct and its further development in a narcissistic form.) Although the instinct is modified by other factors, in particular the constitution of the ego, it continues to exist as the erotic basis for pleasure in looking at another person as object. At the extreme, it can become fixated into a perversion, producing obsessive voyeurs and Peeping Toms whose only sexual satisfaction can come from watching, in an active controlling sense, an objectified other.

At first glance, the cinema would seem to be remote from the undercover world of the surreptitious observation of an unknowing and unwilling victim. What is seen on the screen is so manifestly shown. But the mass of mainstream film, and the conventions within which it has consciously evolved, portray a hermetically sealed world which unwinds magically, indifferent to the presence of the audience, producing for them a sense of separation and playing on their voyeuristic fantasy. Moreover the extreme contrast between the darkness in the auditorium (which also isolates the spectators from one another) and the brilliance of the shifting patterns of light and shade on the screen helps to promote the illusion of voyeuristic separation. Although the film is really being shown, is there to be seen, conditions of screening and narrative conventions give the spectator an illusion of looking in on a private world. Among other things, the position of the spectators in the cinema is blatantly one of repression of their exhibitionism and projection of the repressed desire onto the performer.

B The cinema satisfies a primordial wish for pleasurable looking, but it also goes further, developing scopophilia in its narcissistic aspect. The conventions of mainstream film focus attention on the human form. Scale, space, stories are all anthropomorphic. Here, curiosity and the wish to look intermingle with a fascination with likeness and recognition: the human face, the human body, the relationship between the human form and its surroundings, the visible presence of the person in the world. Jacques Lacan has described how the moment when a child recognises its own image in the mirror is crucial for the constitution of the ego. Several aspects of this analysis are relevant here. The mirror phase occurs at a time when children's physical ambitions outstrip their motor capacity, with the result that their recognition of themselves is joyous in that they imagine their mirror image to be more complete, more perfect than they experience in their own body. Recognition is thus overlaid with misrecognition: the image recognised is conceived as the reflected body of the self, but its misrecognition as superior projects this body outside itself as an ideal ego, the alienated subject

which, reintrojected as an ego ideal, prepares the way for identification with others in the future. This mirror moment pre-dates language for the child.

Important for this article is the fact that it is an image that constitutes the matrix of the imaginary, of recognition/misrecognition and identification, and hence of the first articulation of the I, of subjectivity. This is a moment when an older fascination with looking (at the mother's face, for an obvious example) collides with the initial inklings of self-awareness. Hence it is the birth of the long love affair/despair between image and self-image which has found such intensity of expression in film and such joyous recognition in the cinema audience. Quite apart from the extraneous similarities between screen and mirror (the framing of the human form in its surroundings, for instance), the cinema has structures of fascination strong enough to allow temporary loss of ego while simultaneously reinforcing it. The sense of forgetting the world as the ego has come to perceive it (I forget who I am and where I was) is nostalgically reminiscent of that pre-subjective moment of image recognition. While at the same time, the cinema has distinguished itself in the production of ego ideals, through the star system for instance. Stars provide a focus or centre both to screen space and screen story where they act out a complex process of likeness and difference (the glamorous impersonates the ordinary).

C Sections A and B have set out two contradictory aspects of the pleasurable structures of looking in the conventional cinematic situation. The first, scopophilic, arises from pleasure in using another person as an object of sexual stimulation through sight. The second, developed through narcissism and the constitution of the ego, comes from identification with the image seen. Thus, in film terms, one implies a separation of the erotic identity of the subject from the object on the screen (active scopophilia), the other demands identification of the ego with the object on the screen through the spectator's fascination with and recognition of his like. The first is a function of the sexual instincts, the second of ego libido. This dichotomy was crucial for Freud. Although he saw the two as interacting and overlaying each other, the tension between instinctual drives and self-preservation polarises in terms of pleasure. But both are formative structures, mechanisms without intrinsic meaning. In themselves they have no signification, unless attached to an idealisation. Both pursue aims in indifference to perceptual reality, and motivate eroticised phantasmagoria that affect the subject's perception of the world to make a mockery of empirical objectivity.

During its history, the cinema seems to have evolved a particular illusion of reality in which this contradiction between libido and ego has found a beautifully complementary fantasy world. In *reality* the fantasy world of the screen is subject to the law which produces it. Sexual instincts and identification processes have a meaning within the symbolic order which articulates desire. Desire, born with language, allows the possibility of transcending the instinctual and the imaginary, but its point of reference continually returns to the traumatic moment of its birth: the castration complex. Hence the look, pleasurable in form, can be threatening in content, and it is woman as representation/image that crystallises this paradox.

III Woman as image, man as bearer of the look

A In a world ordered by sexual imbalance, pleasure in looking has been split between active/male and passive/female. The determining male gaze projects its fantasy onto the female figure, which is styled accordingly. In their traditional exhibitionist role women are simultaneously looked at and displayed, with their appearance coded for strong visual and erotic impact so that

they can be said to connote *to-be-looked-at-ness*. Woman displayed as sexual object is the *leitmotif* of erotic spectacle: from pin-ups to strip-tease, from Ziegfeld to Busby Berkeley, she holds the look, and plays to and signifies male desire. Mainstream film neatly combines spectacle and narrative. (Note, however, how in the musical, song-and-dance numbers interrupt the flow of the diegesis.) The presence of woman is an indispensable element of spectacle in normal narrative film, yet her visual presence tends to work against the development of a story-line, to freeze the flow of action in moments of erotic contemplation. This alien presence then has to be integrated into cohesion with the narrative. As Budd Boetticher has put it:

> What counts is what the heroine provokes, or rather what she represents. She is the one, or rather the love or fear she inspires in the hero, or else the concern he feels for her, who makes him act the way he does. In herself the woman has not the slightest importance.

(A recent tendency in narrative film has been to dispense with this problem altogether; hence the development of what Molly Haskell has called the "buddy movie", in which the active homosexual eroticism of the central male figures can carry the story without distraction.) Traditionally, the woman displayed has functioned on two levels: as erotic object for the characters within the screen story, and as erotic object for the spectator within the auditorium, with a shifting tension between the looks on either side of the screen. For instance, the device of the show-girl allows the two looks to be unified technically without any apparent break in the diegesis. A woman performs within the narrative; the gaze of the spectator and that of the male characters in the film are neatly combined without breaking narrative verisimilitude. For a moment the sexual impact of the performing woman takes the film into a no man's land outside its own time and space. Thus Marilyn Monroe's first appearance in *The River of No Return* and Lauren Bacall's songs in *To Have and Have Not*. Similarly, conventional close-ups of legs (Dietrich, for instance) or a face (Garbo) integrate into the narrative a different mode of eroticism. One part of a fragmented body destroys the Renaissance space, the illusion of depth demanded by the narrative; it gives flatness, the quality of a cut-out or icon, rather than verisimilitude, to the screen.

B An active/passive heterosexual division of labour has similarly controlled narrative structure. According to the principles of the ruling ideology and the psychical structures that back it up, the male figure cannot bear the burden of sexual objectification. Man is reluctant to gaze at his exhibitionist like. Hence the split between spectacle and narrative supports the man's role as the active one of advancing the story, making things happen. The man controls the film fantasy and also emerges as the representative of power in a further sense: as the bearer of the look of the spectator, transferring it behind the screen to neutralise the extra-diegetic tendencies represented by woman as spectacle. This is made possible through the processes set in motion by structuring the film around a main controlling figure with whom the spectator can identify. As the spectator identifies with the main male protagonist, he projects his look onto that of his like, his screen surrogate, so that the power of the male protagonist as he controls events coincides with the active power of the erotic look, both giving a satisfying sense of omnipotence. A male movie star's glamorous characteristics are thus not those of the erotic object of the gaze, but those of the more perfect, more complete, more powerful ideal ego conceived in the original moment of recognition in front of the mirror. The character in the story can make things happen and control events better

than the subject/spectator, just as the image in the mirror was more in control of motor co-ordination.

In contrast to woman as icon, the active male figure (the ego ideal of the identification process) demands a three-dimensional space corresponding to that of the mirror recognition, in which the alienated subject internalised his own representation of his imaginary existence. He is a figure in a landscape. Here the function of film is to reproduce as accurately as possible the so-called natural conditions of human perception. Camera technology (as exemplified by deep focus in particular) and camera movements (determined by the action of the protagonist), combined with invisible editing (demanded by realism), all tend to blur the limits of screen space. The male protagonist is free to command the stage, a stage of spatial illusion in which he articulates the look and creates the action. (There are films with a woman as main protagonist, of course. To analyse this phenomenon seriously here would take me too far afield. Pam Cook and Claire Johnston's study of *The Revolt of Mamie Stover* in Phil Hardy (ed.), *Raoul Walsh* (Edinburgh, 1974), shows in a striking case how the strength of this female protagonist is more apparent than real.)

C1 Sections III A and B have set out a tension between a mode of representation of woman in film and conventions surrounding the diegesis. Each is associated with a look: that of the spectator in direct scopophilic contact with the female form displayed for his enjoyment (connoting male fantasy) and that of the spectator fascinated with the image of his like set in an illusion of natural space, and through him gaining control and possession of the woman within the diegesis. (This tension and the shift from one pole to the other can structure a single text. Thus both in *Only Angels Have Wings* and in *To Have and Have Not*, the film opens with the woman as object of the combined gaze of spectator and all the male protagonists in the film. She is isolated, glamorous, on display, sexualised. But as the narrative progresses she falls in love with the main male protagonist and becomes his property, losing her outward glamorous characteristics, her generalised sexuality, her show-girl connotations; her eroticism is subjected to the male star alone. By means of identification with him, through participation in his power, the spectator can indirectly possess her too.)

But in psychoanalytic terms, the female figure poses a deeper problem. She also connotes something that the look continually circles around but disavows: her lack of a penis, implying a threat of castration and hence unpleasure. Ultimately, the meaning of woman is sexual difference, the visually ascertainable absence of the penis, the material evidence on which is based the castration complex essential for the organisation of entrance to the symbolic order and the law of the father. Thus the woman as icon, displayed for the gaze and enjoyment of men, the active controllers of the look, always threatens to evoke the anxiety it originally signified. The male unconscious has two avenues of escape from this castration anxiety: preoccupation with the re-enactment of the original trauma (investigating the woman, demystifying her mystery), counterbalanced by the devaluation, punishment or saving of the guilty object (an avenue typified by the concerns of the *film noir*); or else complete disavowal of castration by the substitution of fetish object or turning the represented figure itself into a fetish so that it becomes reassuring rather than dangerous (hence overvaluation, the cult of the female star).

This second avenue, fetishistic scopophilia, builds up the physical beauty of the object, transforming it into something satisfying in itself. The first avenue, voyeurism, on the contrary, has associations with sadism: pleasure lies in ascertaining guilt (immediately associated with castration), asserting control and subjugating the guilty person through punishment or forgiveness. This sadistic side fits in well with narrative. Sadism demands a story, depends on making

something happen, forcing a change in another person, a battle of will and strength, victory/defeat, all occurring in a linear time with a beginning and an end. Fetishistic scopophilia, on the other hand, can exist outside linear time as the erotic instinct is focused on the look alone. These contradictions and ambiguities can be illustrated more simply by using work by Hitchcock and Sternberg, both of whom take the look almost as the content or subject matter of many of their films. Hitchcock is the more complex, as he uses both mechanisms. Sternberg's work, on the other hand, provides many pure examples of fetishistic scopophilia.

C2 Sternberg once said he would welcome his films being projected upside-down so that story and character involvement would not interfere with the spectator's undiluted appreciation of the screen image. This statement is revealing but ingenuous: ingenuous in that his films do demand that the figure of the woman (Dietrich, in the cycle of films with her, as the ultimate example) should be identifiable; but revealing in that it emphasises the fact that for him the pictorial space enclosed by the frame is paramount, rather than narrative or identification processes. While Hitchcock goes into the investigative side of voyeurism, Sternberg produces the ultimate fetish, taking it to the point where the powerful look of the male protagonist (characteristic of traditional narrative film) is broken in favour of the image in direct erotic rapport with the spectator. The beauty of the woman as object and the screen space coalesce; she is no longer the bearer of guilt but a perfect product, whose body, stylised and fragmented by close-ups, is the content of the film and the direct recipient of the spectator's look.

Sternberg plays down the illusion of screen depth; his screen tends to be one-dimensional, as light and shade, lace, steam, foliage, net, streamers and so on reduce the visual field. There is little or no mediation of the look through the eyes of the main male protagonist. On the contrary, shadowy presences like La Bessière in *Morocco* act as surrogates for the director, detached as they are from audience identification. Despite Sternberg's insistence that his stories are irrelevant, it is significant that they are concerned with situation, not suspense, and cyclical rather than linear time, while plot complications revolve around misunderstanding rather than conflict. The most important absence is that of the controlling male gaze within the screen scene. The high point of emotional drama in the most typical Dietrich films, her supreme moments of erotic meaning, take place in the absence of the man she loves in the fiction. There are other witnesses, other spectators watching her on the screen, their gaze is one with, not standing in for, that of the audience. At the end of *Morocco*, Tom Brown has already disappeared into the desert when Amy Jolly kicks off her gold sandals and walks after him. At the end of *Dishonoured*, Kranau is indifferent to the fate of Magda. In both cases, the erotic impact, sanctified by death, is displayed as a spectacle for the audience. The male hero misunderstands and, above all, does not see.

In Hitchcock, by contrast, the male hero does see precisely what the audience sees. However, although fascination with an image through scopophilic eroticism can be the subject of the film, it is the role of the hero to portray the contradictions and tensions experienced by the spectator. In *Vertigo* in particular, but also in *Marnie* and *Rear Window*, the look is central to the plot, oscillating between voyeurism and fetishistic fascination. Hitchcock has never concealed his interest in voyeurism, cinematic and non-cinematic. His heroes are exemplary of the symbolic order and the law – a policeman (*Vertigo*), a dominant male possessing money and power (*Marnie*) – but their erotic drives lead them into compromised situations. The power to subject another person to the will sadistically or to the gaze voyeuristically is turned onto the woman as the object of both. Power is backed by a certainty of legal right and the

established guilt of the woman (evoking castration, psychoanalytically speaking). True perversion is barely concealed under a shallow mask of ideological correctness – the man is on the right side of the law, the woman on the wrong. Hitchcock's skilful use of identification processes and liberal use of subjective camera from the point of view of the male protagonist draw the spectators deeply into his position, making them share his uneasy gaze. The spectator is absorbed into a voyeuristic situation within the screen scene and diegesis, which parodies his own in the cinema.

In an analysis of *Rear Window*, Douchet takes the film as a metaphor for the cinema. Jeffries is the audience, the events in the apartment block opposite correspond to the screen. As he watches, an erotic dimension is added to his look, a central image to the drama. His girlfriend Lisa had been of little sexual interest to him, more or less a drag, so long as she remained on the spectator side. When she crosses the barrier between his room and the block opposite, their relationship is reborn erotically. He does not merely watch her through his lens, as a distant meaningful image, he also sees her as a guilty intruder exposed by a dangerous man threatening her with punishment, and thus finally giving him the opportunity to save her. Lisa's exhibitionism has already been established by her obsessive interest in dress and style, in being a passive image of visual perfection; Jeffries' voyeurism and activity have also been established through his work as a photo-journalist, a maker of stories and captor of images. However, his enforced inactivity, binding him to his seat as a spectator, puts him squarely in the fantasy position of the cinema audience.

In *Vertigo*, subjective camera predominates. Apart from one flashback from Judy's point of view, the narrative is woven around what Scottie sees or fails to see. The audience follows the growth of his erotic obsession and subsequent despair precisely from his point of view. Scottie's voyeurism is blatant: he falls in love with a woman he follows and spies on without speaking to. Its sadistic side is equally blatant: he has chosen (and freely chosen, for he had been a successful lawyer) to be a policeman, with all the attendant possibilities of pursuit and investigation. As a result, he follows, watches and falls in love with a perfect image of female beauty and mystery. Once he actually confronts her, his erotic drive is to break her down and force her *to tell* by persistent cross-questioning.

In the second part of the film, he re-enacts his obsessive involvement with the image he loved to watch secretly. He reconstructs Judy as Madeleine, forces her to conform in every detail to the actual physical appearance of his fetish. Her exhibitionism, her masochism, make her an ideal passive counterpart to Scottie's active sadistic voyeurism. She knows her part is to perform, and only by playing it through and then replaying it can she keep Scottie's erotic interest. But in the repetition he does break her down and succeeds in exposing her guilt. His curiosity wins through; she is punished.

Thus, in *Vertigo*, erotic involvement with the look boomerangs: the spectator's own fascination is revealed as illicit voyeurism as the narrative content enacts the processes and pleasures that he is himself exercising and enjoying. The Hitchcock hero here is firmly placed within the symbolic order, in narrative terms. He has all the attributes of the patriarchal superego. Hence the spectator, lulled into a false sense of security by the apparent legality of his surrogate, sees through his look and finds himself exposed as complicit, caught in the moral ambiguity of looking. Far from being simply an aside on the perversion of the police, *Vertigo* focuses on the implications of the active/looking, passive/looked-at split in terms of sexual difference and the power of the male symbolic encapsulated in the hero. Marnie, too, performs for Mark Rutland's gaze and masquerades as the perfect to-be-looked-at image. He, too, is on the side of the law until, drawn in by obsession with her guilt, her secret, he longs to see her in the act of committing a crime, make her confess and thus save her. So he, too, becomes

complicit as he acts out the implications of his power. He controls money and words; he can have his cake and eat it.

IV Summary

The psychoanalytic background that has been discussed in this article is relevant to the pleasure and unpleasure offered by traditional narrative film. The scopophilic instinct (pleasure in looking at another person as an erotic object) and, in contradistinction, ego libido (forming identification processes) act as formations, mechanisms, which mould this cinema's formal attributes. The actual image of woman as (passive) raw material for the (active) gaze of man takes the argument a step further into the content and structure of representation, adding a further layer of ideological significance demanded by the patriarchal order in its favourite cinematic form – illusionistic narrative film. The argument must return again to the psychoanalytic background: women in representation can signify castration, and activate voyeuristic or fetishistic mechanisms to circumvent this threat. Although none of these interacting layers is intrinsic to film, it is only in the film form that they can reach a perfect and beautiful contradiction, thanks to the possibility in the cinema of shifting the emphasis of the look. The place of the look defines cinema, the possibility of varying it and exposing it. This is what makes cinema quite different in its voyeuristic potential from, say, striptease, theatre, shows and so on. Going far beyond highlighting a woman's to-be-looked-at-ness, cinema builds the way she is to be looked at into the spectacle itself. Playing on the tension between film as controlling the dimension of time (editing, narrative) and film as controlling the dimension of space (changes in distance, editing), cinematic does create a gaze, a world and an object, thereby producing an illusion cut to the measure of desire. It is these cinematic codes and their relationship to formative external structures that must be broken down before mainstream film and the pleasure it provides can be challenged.

To begin with (as an ending), the voyeuristic-scopophilic look that is a crucial part of traditional filmic pleasure can itself be broken down. There are three different looks associated with cinema: that of the camera as it records the pro-filmic event, that of the audience as it watches the final product, and that of the characters at each other within the screen illusion. The conventions of narrative film deny the first two and subordinate them to the third, the conscious aim being always to eliminate intrusive camera presence and prevent a distancing awareness in the audience. Without these two absences (the material existence of the recording process, the critical reading of the spectator), fictional drama cannot achieve reality, obviousness and truth. Nevertheless, as this article has argued, the structure of looking in narrative fiction film contains a contradiction in its own premises: the female image as a castration threat constantly endangers the unity of the diegesis and bursts through the world of illusion as an intrusive, static, one-dimensional fetish. Thus the two looks materially present in time and space are obsessively subordinated to the neurotic needs of the male ego. The camera becomes the mechanism for producing an illusion of Renaissance space, flowing movements compatible with the human eye, an ideology of representation that revolves around the perception of the subject; the camera's look is disavowed in order to create a convincing world in which the spectator's surrogate can perform with verisimilitude. Simultaneously, the look of the audience is denied an intrinsic force: as soon as fetishistic representation of the female image threatens to break the spell of illusion, and the erotic image on the screen appears directly (without mediation) to the spectator, the fact of fetishisation, concealing as it does castration fear, freezes the look, fixates the spectator and prevents him from achieving any distance from the image in front of him.

This complex interaction of looks is specific to film. The first blow against the mono-lithic accumulation of traditional film conventions (already undertaken by radical film-makers) is to free the look of the camera into its materiality in time and space and the look of the audience into dialectics and passionate detachment. There is no doubt that this destroys the satisfaction, pleasure and privilege of the "invisible guest", and highlights the way film has depended on voyeuristic active/passive mechanisms. Women, whose image has continually been stolen and used for this end, cannot view the decline of the traditional film form with anything much more than sentimental regret.

Chapter 10

JUDITH BARRY AND SANDY FLITTERMAN-LEWIS

TEXTUAL STRATEGIES
The politics of art-making

IN ORDER TO DEVELOP A FEMINIST ARTISTIC practice that works towards productive social change, it is necessary to understand representation as a polit-ical issue and to have an analysis of women's subordination within patriarchal forms of representation. This article emerges from the need for a feminist re-examination of the notions of art, politics, and the relations between them, an evaluation which must take into account how "femininity" itself is a social construct. We have come together, a feminist film theorist and a feminist artist, to discuss these issues, and more specifically to consider the limitations of current definitions of art as a political activity.

Initially in the women's movement feminists emphasised the importance of giving voice to personal experiences; the expression and documentation of women's oppression as well as their aspirations provided women's art with a liberating force. However, a radical reconcep-tualisation of the personal to include more broadly social and even unconscious forces has made a more analytical approach to these personal experiences necessary. The experiential must be taken beyond consciously felt and articulated needs of women if a real transforma-tion of the *structures of* women's oppression is to occur.

While we recognise the value of certain forms of radical political art, concerned to high-light feminist issues generally submerged by dominant cultural discourse, this kind of work, if untheorised, can only have limited results. More militant forms of feminist art such as agit-prop, body art, and ritualised violence, can produce immediate results by allowing the expression of rage, for example, or by focusing on a particular event or aspect of women's

oppression. But these results may be shortlived. A more theoretically informed art can contribute to enduring changes by addressing itself to structural and deep-seated causes of women's oppression rather than to its effects. A radical feminist art would include an under-standing of how women are constituted through social practices in culture; once this is understood it would be possible to create an aesthetics designed to subvert the production of "woman" as commodity. We see a need for theory that goes beyond the personal into the questions of ideology, culture, and the production of meaning.

To understand better the point at which theory and art intersect it might be useful to consider women's cultural production in four categories.[1] Our attempt here is to describe a typology rather than criticise these positions or their shortcomings. In evaluating these types of women's art, our reference point will be the recognition of the need for a theory of cultural production. When we talk about culturally constructed meaning we are referring to a system of heterogeneous interacting codes. The meaning we derive from any interaction is depen-dent on our knowledge of a set of conventions affecting every aspect of our lives, from the food we eat to the art we like. Every act (eating an orange, building a table, reading a book) is a social act; the fundamentally human is social. Theory both enables us to recognise this and permits us to go beyond individual, personally liberating solutions to a *socially* liberated situation. The culture of any society will impose a certain selection or priority of meaning upon the multiplicity of meanings inherent in a given situation creating an apparently given and enduring ensemble. A theoretical approach, systematically considering the range of cultural phenomena, can produce the means for examining the political effectiveness of feminist art work.

Each of the four categories in our typology of women's art-making implies a specific strategy. Through examination of each of the categories we can ascertain the assumptions that characterise these relations. From doing this it should be clear that sets of assumptions do not constitute a theory, although they may be sufficient to establish a particular type of artistic practice. When we speak of the political in discussing art work we must ask the question, "Action, by whom, and for what purpose?" Each of the four categories will propose different answers to these questions, because they each have different goals and strategies.

I

One type of women's art can be seen as the glorification of an essential female power. This power is viewed as an inherent feminine artistic essence which could find expression if allowed to be explored freely. This is an essentialist position because it is based on the belief in a female essence residing somewhere in the body of women. It can be found in the emphasis on "vaginal" forms in painting and sculpture; it is sometimes associated with mysticism, ritual and the idea of a female mythology. It is possible to see this type of art which valorises the body as reversing the traditional Western hierarchy of mind over matter. This form of art could be seen as an aesthetics of simple inversion. Feminist essentialism in art simply reverses the terms of dominance and subordination. Instead of the male supremacy of patriarchal culture, the female (the essential feminine) is elevated to primary status.

Much of the art work in this category has as its aim the encouragement of women's self-esteem through valorisation of female experiences and bodily processes. This art seeks to reinforce satisfaction in being a woman in a culture that does the opposite. By glorifying the bodies of women in art work, an identificatory process is set up so that the receivers of the art work (the women for whom the work is intended) will validate their own femaleness. This type of art work is sometimes concerned to redefine motherhood as the seat of female

creativity. In a society which isolates women and inspires competition it seeks to encourage solidarity amongst women through emotional appeal, ritual form, and synaesthetic effects in performance.

One such example is the work of Gina Pane, the French body artist whose performances for the last ten years have involved self-mutilation and the ritualised drawing of her own blood. She defines the incision of her face with a razor blade in one performance as a "transgression of the taboo of the sore through which the body is opened, and of the canons of feminine beauty". At least one critic has praised her work because it "privileges the signifier on the side of pain". Complications arise, however, when the assumptions underlying this type of art are examined. To counterpose an aesthetics of pain to the assumed pleasurable discourse of dominant artistic practice, already accepts as given a pleasure/pain dichotomy. By confronting one half of the dichotomy with its opposite, Pane's work offers an act of artistic contestation, but within the dualistic tradition of Western metaphysics.

By elevating pain to the status of an oppositional artistic force, it would seem that Pane is simply reinforcing a traditional cliché about women. Even if women are assumed to be outside the patriarchal discourse, would the first rumble of self-expression take the form of pain or self-mutilation? Pane's comments about her work seem to indicate that she feels that in wounding herself she is wounding society. However, because her wounds exist in an art context, they are easily absorbed into an artworld notion of pain as beautiful. The solidarity in suffering that this work seems to want to promote is actually a form of solidarity that has been imposed on women for centuries. It is bondage rather than bonding.

Hannah Wilke, an artist based in New York, adopts a related strategy of body art in creating an art work that has as its aim "that women allow their feelings and fantasies to

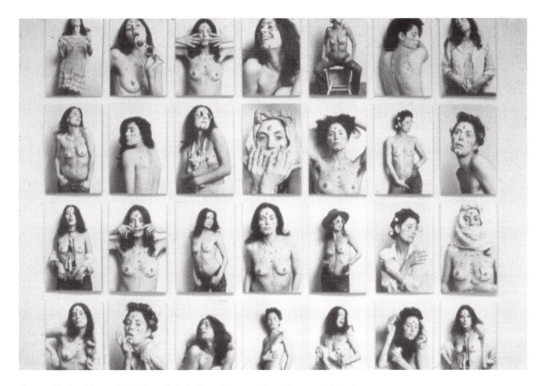

Figure 10.1 Hannah Wilke, *S.O.S. Starification Object Series*, 1974–5.

emerge, so that this could lead to a new type of art".[2] In her "SOS Starification Object Series" (1974–5) she says, "I am my art. My art becomes me" [Figure 10.1]. She sets up an equivalency between her body's poses and its alteration after vaginally shaped pieces of chewing gum are attached to the exposed areas on the one hand, and language, where the meaning of a word or series of words is transformed by a slight change or modification in the letters composing it, on the other. Scarification becomes starification. Wilke explains "my art is seduction". Often her poses take on the characteristics of a centrefold, her eyes directed to the assumed male spectator of nude paintings and *Playboy* magazine. In *Ways of Seeing*, John Berger points out "Men look at women. Women watch themselves being looked at. The surveyor of the woman in herself is male; the surveyed female. Thus, she turns herself into an object." In objectifying herself as she does, in assuming the conventions associated with a stripper (as someone who will reveal all), Wilke seems to be teasing us as to her motives. She is both the stripper and the stripped bare. She does not make her own position clear; is her art work enticing critique or titillating enticement? It seems her work ends up by reinforcing what it intends to subvert. In using her own body as the content of her art, in calling her art "seduction", she complicates the issues and fails to challenge conventional notions of female sexuality. Consequently it permits statements like the following from male critics: "By manipulating the image of a sex kitten (female sex object), Wilke manages to avoid being trapped by it without having to deny her own beauty to achieve liberation."

Wilke's and Pane's work represent two, very divergent, types of women's art in our first category. Yet they enable us to draw some conclusions about this type of art-making. because this kind of art has no theory of the representations of women, it presents images of women as unproblematic. It does not take into account the social contradictions involved in "femininity". In much of this art, women are proposed as the bearers of culture, albeit an alternative one. In this way what is assumed to be a progressive position is actually retrograde. Being-a-woman is the essential presupposition underlying this art work: what this notion entails is assumed to be generally accepted, uncontradictory, and immutable. Whether the art focuses on pain (immolation) or pleasure (eroticism), it does not challenge a fixed and rigid category of "femininity".

II

A second strategy in feminist artistic practice views women's art as a form of sub-cultural resistance. It presents a kind of artisanal work, often overlooked in dominant systems of representation, as the "unsung province" of women's art activity. An example of this type of work is the valorisation of crafts, such as patch-work quilts, and the activities of women in the home. It proposes the development of a feminist counter-tradition in the arts, reconstructing a "hidden history" of female productivity. This strategy has the effect of stimulating women's creativity to discover new areas of expression. By redefining art to include crafts and previously neglected skills, it avoids the ideological distinction between "high" and "low" cultural forms. In so doing, it emphasises that this patriarchal distinction has served to restrict creative avenues for women.

However, this is also an essentialist position in as much as it views women as having an inherent creativity that simply goes unrecognised by mainstream culture. It therefore has limited ability to transform the structural conditions which both produce definitions of "art" and oppress women. This is not to say that this kind of art-making is unimportant, but simply to point out the limitations of an untheorised strategy.

[. . .]

III

Our third category of women's art derives also from this aspect of potential isolationism. It views the dominant cultural order as a monolithic construction in which women's cultural activity is either submerged or placed entirely outside its limits. This position can be regarded as an antidote to feminist essentialism in that it recognises that what has traditionally been known as the "form" and the "content" of culture both carry meaning. However, ironically, it is also the basis of *both* "separatist" (artists who do not identify with the artworld) and non-feminist (women artists who maintain that they are people who "happen" to be women) discussion. Thus this category includes two groups of women at opposite ideological poles. The strategy of the first group is to establish their own society, so women will be able to combat the patriarchy. However, it fails to theorise how women are produced as a category within the social complex, or how femininity is a social construction.

The example of Los Angeles artist Terry Wolverton presents both the advantages and the limitations of the separatist strategy. As co-director of the Lesbian Art Project (which provides a programme of Sapphic Education) and producer–co-director of a feminist science fiction theatre, Wolverton's art work is informed with the desire to shape an alternative female culture. This takes the form of validating craft projects such as bread-dough sculptures and costumed happenings because they are produced by lesbians in the community. One positive consequence is that this type of art allows women to explore their feelings and attitudes, enabling them to develop self-esteem and pride in the discovery of their love and trust for one another. The productive result is an attack on the destructive *dis*satisfaction with being a woman that patriarchal culture fosters. However, the separatist position seems to be an example of this self-validation gone awry: the very notion of positive (lesbian) images of women relies on the already constituted meaning of "woman". Again, this unproblematic notion of "femaleness" does not take into account that meaning is a dialectical process which involves an interaction between images and viewers. By failing to theorise how this meaning is produced within the social complex, this art considers the notion of femininity as unprob-lematic and positions women's culture as separate and different from mainstream culture. This can produce very disturbing results, as in the case of some of the art work validated by Wolverton, in which the prominence given to the exposed breasts of the subjects of the art work is strikingly similar to that in the photography of Les Krims, an artist noted for his particularly virulent expressions of misogyny.

The second group of women within our third category cannot be said to have a feminist strategy because they do not view themselves as artists engaged in the feminist struggle. Women who have been favoured through more strident forms of careerism make the asser-tion that women's art has outgrown its need for feminism. For these women, feminism is no longer useful, primarily because it is seen as a means to an end. Artists falling into this cate-gory, such as Rosalyn Drexler ("I don't object to being called a woman artist as long as the word woman isn't used to define the kind of art I create") and Elaine de Kooning ("We're artists who happen to be women or men among other things we happen to be – tall, short, blonde, dark, mesomorph, ectomorph, black, Spanish, German, Irish, hot-tempered, easy-going – that are in no way relevant to our being artists")[3] simply deny that their work is embedded in a social context, or that art-making is a form of social practice.

IV

A final type of artistic practice situates women at a crucial place in patriarchy which enables them to play on the contradictions within it. This position regards artistic activity as a *textual*

practice which exploits existing social contradictions. This position intersects with other social practices foregrounding many of the issues involved in the representation of women. In these works the image of women is not accepted as an already produced given, but is constructed in and through the work itself. This has the result of emphasising that meanings are socially constructed and demonstrates the importance and function of discourse in the shaping of social reality.

In discussing our fourth category of feminist art-making, we can clarify the issue of theory by underlining the difference between women making art in a male-dominated society and feminist art working against patriarchy. Activism in itself in women's art has limited effects because it does not examine the representation of women in culture or the production of women as a social category. We are suggesting that a feminist art evolves from a theoretical reflection on representations: how the representation of women is produced, the way it is understood, and the social conditions in which it is situated. In addition to specific artistic practices that fall into this category we should point out that important critical work is being done in theoretical journals such as *m/f*, *Camera Obscura* and *Discourse*, all of which contain articles analysing cultural production from a feminist perspective.

In *Post-Partum Document* Mary Kelly deconstructs the assumed unity of the mother/child dyad in order to articulate the mother's fantasies of possession and loss. By mapping the exploration of psychic processes, she indicates the ways in which motherhood is constructed rather than biologically given. One section (*Documentation III*), displayed in a series of transparent boxes, is a record of "conversations" between mother and son at the point when the

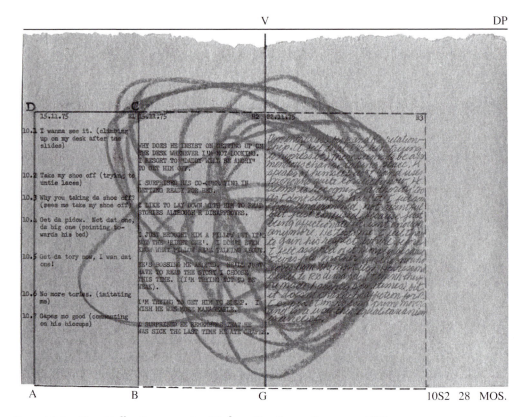

Figure 10.2 Mary Kelly, *Documentation III*, from *Post-Partum Document*, 1975.

child is leaving the family to enter school [Figure 10.2]. Each box contains a drawing done by the child, remarks by the child, the mother's reaction, and the mother's diary. This information is supplemented by a Lacanian psychoanalytic text describing the constitution of the mother's subjectivity under "motherhood" (patriarchy). This method allows the spectator to construct several positions simultaneously.

In a September 1976 press release Mary Kelly described her work in the following way:

> I am using the "art object" explicitly as a fetish object in order to suggest the operations of the unconscious that underlie it. The stains, markings and word imprints have a minimum sign value in themselves, but a maximum affective value in relation to my lived experience. In psychoanalytic terms, they are visual representations of cathected memory traces. These traces, in combination with the diaries, time-tables and feeding charts, constitute what I would call a discourse which "represents" my lived experience as a mother, but they are consciously set up in an antagonistic relationship with the diagrams, algorithms and footnotes, thereby constituting another discourse which "represents" my analysis as a feminist, of this lived experience.
>
> [. . .]

An important aim of the art in this [fourth] category is the critical awareness (both on the part of the spectator, and informing the work) of the construction of femininity. For it is only through a critical understanding of "representation" that a *re*presentation of "women" can occur. We do not want to simply posit a definition of "good women's art", for at this historical moment such a definition would foreclose the dialectical play of meaning that we are calling for; our intention is to be suggestive rather than prescriptive. One strategy of this fourth type of art transforms the spectator from a passive consumer into an active producer of meaning by engaging the spectator in a process of discovery rather than offering a rigidly formulated truth. Moreover, the art work strives to produce a critical perspective that questions absolute or reified categories and definitions of women. Both the social construction of femininity and the psychoanalytic construction of sexual difference can be foregrounded if the art work attempts to rupture traditionally held and naturalised ideas about women. Finally, a theoretical approach implies a break with the dominant notion of art as personal expression, instead connecting it with the social and the political and placing the artist as producer in a new situation of responsibility for her images.

Notes

1 An initial formulation of these categories has been made by Laura Mulvey in an interview in *Wedge*, no. 2, Spring 1978.
2 *Flash Art*, May 1975, pp. 54–55.
3 *Art and Sexual Politics: Why Have There Been No Great Women Artists?* edited by Thomas Hess and Elizabeth C. Baker, Collier, New York 1973, both quotes from p. 57.

MARY ANN DOANE

FILM AND THE MASQUERADE
Theorizing the female spectator

I Heads in hieroglyphic bonnets

IN HIS LECTURE ON "FEMININITY," Freud forcefully inscribes the absence of the female spectator of theory in his notorious statement, "to those of you who are women this will not apply – you are yourselves the problem."[1] Simultaneous with this exclusion operated upon the female members of his audience, he invokes, as a rather strange prop, a poem by Heine. Introduced by Freud's claim concerning the importance and elusiveness of his topic – "Throughout history people have knocked their heads against the riddle of the nature of femininity" – are four lines of Heine's poem:

> Heads in hieroglyphic bonnets,
> Heads in turbans and black birettas,
> Heads in wigs and thousand other
> Wretched, sweating heads of humans . . .[2]

The effects of the appeal to this poem are subject to the work of overdetermination Freud isolated in the text of the dream. The sheer proliferation of heads and hats (and hence, through a metonymic slippage, minds), which are presumed to have confronted this intimidating riddle before Freud, confers on his discourse the weight of an intellectual history, of a tradition of interrogation. Furthermore, the image of hieroglyphics strengthens the association made between femininity and the enigmatic, the undecipherable, that which is "other." And yet Freud practices a slight deception here, concealing what is elided by removing the lines from their context, castrating, as it were, the stanza. For the question over which Heine's heads brood is not the same as Freud's – it is not "What is Woman?," but instead, "What signifies Man?" The quote is taken from the seventh section (entitled "Questions") of the second cycle of *The North Sea*. The full stanza, presented as the words of "a young man. / His breast full of sorrow, his head full of doubt," reads as follows:

> O solve me the riddle of life,
> The teasingly time-old riddle,
> Over which many heads already have brooded,
> Heads in hats of hieroglyphics,
> Turbaned heads and heads in black skull-caps,
> Heads in perrukes and a thousand other

Poor, perspiring human heads –
Tell me, what signifies Man?
Whence does he come? Whither does he go?
Who lives up there upon golden stars?[3]

The question in Freud's text is thus a disguise and a displacement of that other question, which in the pre-text is both humanistic and theological. The claim to investigate an otherness is a pretense, haunted by the mirror-effect by means of which the question of the woman reflects only the man's own ontological doubts. Yet what interests me most in this intertextual misrepresentation is that the riddle of femininity is initiated from the beginning in Freud's text as a question in masquerade. But I will return to the issue of masquerade later.

More pertinently, as far as the cinema is concerned, it is not accidental that Freud's eviction of the female spectator/auditor is copresent with the invocation of a hieroglyphic language. The woman, the enigma, the hieroglyphic, the picture, the image – the metonymic chain connects with another: the cinema, the theater of pictures, a writing in images of the woman but not *for* her. For she *is* the problem. The semantic valence attributed to a hieroglyphic language is two-edged. In fact, there is a sense in which the term is inhabited by a contradiction. On the one hand, the hieroglyphic is summoned, particularly when it merges with a discourse on the woman, to connote an indecipherable language, a signifying system which denies its own function by failing to signify anything to the uninitiated, to those who do not hold the key. In this sense, the hieroglyphic, like the woman, harbors a mystery, an inaccessible though desirable otherness. On the other hand, the hieroglyphic is the most readable of language. Its immediacy, its accessibility are functions of its status as a *pictorial* language, a writing in images. For the image is theorized in terms of a certain *closeness*, the lack of a distance or gap between sign and referent. Given its iconic characteristics, the relationship between signifier and signified is understood as less arbitrary in imagistic systems of representation than in language "proper." The intimacy of signifier and signified in the iconic sign negates the distance which defines phonetic language. And it is the absence of this crucial distance or gap which also, simultaneously, specifies both the hieroglyphic and the female. This is precisely why Freud evicted the woman from his lecture on femininity. Too close to herself, entangled in her own enigma, she could not step back, could not achieve the necessary distance of a second look.[4]

Thus, while the hieroglyphic is an indecipherable or at least enigmatic language, it is also and at the same time potentially the most universally understandable, comprehensible, appropriable of signs.[5] And the woman shares this contradictory status. But it is here that the analogy slips. For hieroglyphic languages are *not* perfectly iconic. They would not achieve the status of languages if they were – due to what Todorov and Ducrot refer to as a certain nongeneralizability of the iconic sign:

Now it is the impossibility of generalizing this principle of representation that has introduced even into fundamentally morphemographic writing systems such as Chinese, Egyptian, and Sumerian, the phonographic principle. We might also conclude that every logography (the graphic system of language notation) grows out of *the impossibility of a generalized iconic representation*; proper nouns and abstract notions (including inflections) are then the ones that will be noted phonetically.[6]

The iconic system of representation is inherently deficient – it cannot disengage itself from the "real," from the concrete; it lacks the gap necessary for generalizability (for Saussure, this

is the idea that, "Signs which are arbitrary realize better than others the ideal of the semiotic process"). The woman, too, is defined by such an insufficiency. My insistence upon the congruence between certain theories of the image and theories of femininity is an attempt to dissect the *episteme* which assigns to the woman a special place in cinematic representation while denying her access to that system.

The cinematic apparatus inherits a theory of the image which is not conceived outside of sexual specifications. And historically, there has always been a certain imbrication of the cinematic image and the representation of the woman. The woman's relation to the camera and the scopic regime is quite different from that of the male. As Noël Burch points out, the early silent cinema, through its insistent inscription of scenarios of voyeurism, conceives of its spectator's viewing pleasure in terms of that of the Peeping Tom, behind the screen, reduplicating the spectator's position in relation to the woman as screen.[7] Spectatorial desire, in contemporary film theory, is generally delineated as either voyeurism or fetishism, as precisely a pleasure in seeing what is prohibited in relation to the female body. The image orchestrates a gaze, a limit, and its pleasurable transgression. The woman's beauty, her very desirability, becomes a function of certain practices of imaging – framing, lighting, camera movement, angle. She is thus, as Laura Mulvey has pointed out, more closely associated with the surface of the image than its illusory depths, its constructed three-dimensional space which the man is destined to inhabit and hence control.[8] In *Now Voyager* (1942), for instance, a single image signals the momentous transformation of the Bette Davis character from ugly spinster aunt to glamorous single woman. Charles Affron describes the specifically cinematic aspect of this operation as a "stroke of genius":

> The radical shadow bisecting the face in white/dark/white strata creates a visual phenomenon quite distinct from the makeup transformation of lipstick and plucked eyebrows. . . . This shot does not reveal what we commonly call acting, especially after the most recent exhibition of that activity, but the sense of face belongs to a plastique pertinent to the camera. The viewer is allowed a different perceptual referent, a chance to come down from the nerve-jarring, first sequence and to use his eyes anew.[9]

A "plastique pertinent to the camera" constitutes the woman not only as the image of desire but as the desirous image – one which the devoted cinéphile can cherish and embrace. To "have" the cinema is, in some sense, to "have" the woman. But *Now Voyager* is, in Affron's terms, a "tear-jerker," in others, a "woman's picture," i.e. a film purportedly produced for a female audience. What, then, of the female spectator? What can one say about her desire in relation to this process of imaging? It would seem that what the cinematic institution has in common with Freud's gesture is the eviction of the female spectator from a discourse purportedly about her (the cinema, psychoanalysis) – one which, in fact, narrativizes her again and again.

II A lass but not a lack

Theories of female spectatorship are thus rare, and when they are produced, seem inevitably to confront certain blockages in conceptualization. The difficulties in thinking female spectatorship demand consideration. After all, even if it is admitted that the woman is frequently the object of the voyeuristic or fetishistic gaze in the cinema, what is there to prevent her from reversing the relation and appropriating the gaze for her own pleasure? Precisely the

fact that the reversal itself remains locked within the same logic. The male striptease, the gigolo – both inevitably signify the mechanism of reversal itself, constituting themselves as aberrations whose acknowledgment simply reinforces the dominant system of aligning sexual difference with a subject/object dichotomy. And an essential attribute of that dominant system is the matching of male subjectivity with the agency of the look.

The supportive binary opposition at work here is not only that utilized by Laura Mulvey – an opposition between passivity and activity, but perhaps more importantly, an opposition between proximity and distance in relation to the image.[10] It is in this sense that the very logic behind the structure of the gaze demands a sexual division. While the distance between image and signified (or even referent) is theorized as minimal, if not non-existent, that between the film and the spectator must be maintained, even measured. One need only think of Noël Burch's mapping of spectatorship as a perfect distance from the screen (two times the width of the image) – a point in space from which the filmic discourse is most accessible.[11]

But the most explicit representation of this opposition between proximity and distance is contained in Christian Metz's analysis of voyeuristic desire in terms of a kind of social hierarchy of the senses: "It is no accident that the main socially acceptable arts are based on the senses at a distance, and that those which depend on the senses of contact are often regarded as 'minor' arts (= culinary arts, art of perfumes, etc.)."[12] The voyeur, according to Metz, must maintain a distance between himself and the image – the cinéphile *needs* the gap which represents for him the very distance between desire and its object. In this sense, voyeurism is theorized as a type of meta-desire:

> If it is true of all desire that it depends on the infinite pursuit of its absent object, voyeuristic desire, along with certain forms of sadism, is the only desire whose principle of distance symbolically and spatially evokes this fundamental rent.[13]

Yet even this status as meta-desire does not fully characterize the cinema for it is a feature shared by other arts as well (painting, theater, opera, etc.). Metz thus adds another reinscription of this necessary distance. What specifies the cinema is a further reduplication of the lack which prompts desire. The cinema is characterized by an illusory sensory plenitude (there is "so much to see") and yet haunted by the absence of those very objects which are there to be seen. Absence is an absolute and irrecoverable distance. In other words, Noël Burch is quite right in aligning spectatorial desire with a certain spatial configuration. The viewer must not sit either too close or too far from the screen. The result of both would be the same – he would lose the image of his desire.

It is precisely this opposition between proximity and distance, control of the image and its loss, which locates the possibilities of spectatorship within the problematic of sexual difference. For the female spectator there is a certain overpresence of the image – she *is* the image. Given the closeness of this relationship, the female spectator's desire can be described only in terms a kind of narcissism – the female look demands a becoming. It thus appears to negate the very distance or gap specified by Metz and Burch as the essential precondition for voyeurism. From this perspective, it is important to note the constant recurrence of the motif of proximity in feminist theories (especially those labeled "new French feminisms") which purport to describe a feminine specificity. For Luce Irigaray, female anatomy is readable as a constant relation of the self to itself, as an autoeroticism based on the embrace of the two lips which allow the woman to touch herself without mediation. Furthermore, the very notion of property, and hence possession of something which can be constituted as other, is antithetical to the woman: "*Nearness* however, is not foreign to woman, a nearness so close that

any identification of one or the other, and therefore any form of property, is impossible. Woman enjoys a closeness with the other that is *so near she cannot possess it any more than she can possess herself*."[14] Or, in the case of female madness or delirium, "women do not manage to articulate their madness: they suffer it directly in their body."[15] The distance necessary to detach the signifiers of madness from the body in the construction of even a discourse which exceeds the boundaries of sense is lacking. In the words of Hélène Cixous, "More so than men who are coaxed toward social success, toward sublimation, women are body."[16]

This theme of the overwhelming presence-to-itself of the female body is elaborated by Sarah Kofman and Michèle Montrelay as well. Kofman describes how Freudian psychoanalysis outlines a scenario whereby the subject's passage from the mother to the father is simultaneous with a passage from the senses to reason, nostalgia for the mother henceforth signifying a longing for a different positioning in relation to the sensory or the somatic, and the degree of civilization measured by the very distance from the body.[17] Similarly, Montrelay argues that while the male has the possibility of displacing the first object of desire (the mother), the female must become that object of desire:

> Recovering herself as maternal body (and also as phallus), the woman can no longer repress, "lose," the first stake of representation . . . From now on, anxiety, tied to the presence of this body, can only be insistent, continuous. This body, so close, which she has to occupy, is an object in excess which must be "lost," that is to say, repressed, in order to be symbolized.[18]

This body so close, so excessive, prevents the woman from assuming a position similar to the man's in relation to signifying systems. For she is haunted by the loss of a loss, the lack of that lack so essential for the realization of the ideals of semiotic systems.

Female specificity is thus theorized in terms of spatial proximity. In opposition to this "closeness" to the body, a spatial distance in the male's relation to his body rapidly becomes a temporal distance in the service of knowledge. This is presented quite explicitly in Freud's analysis of the construction of the "subject supposed to know." The knowledge involved here is a knowledge of sexual difference as it is organized in relation to the structure of the look, turning on the visibility of the penis. For the little girl in Freud's description seeing and knowing are simultaneous – there is no temporal gap between them. In "Some Psychological Consequences of the Anatomical Distinction Between the Sexes," Freud claims that the girl, upon seeing the penis for the first time, "makes her judgement and her decision in a flash. She has seen it and knows that she is without it and wants to have it."[19] In the lecture on "Femininity" Freud repeats this gesture, merging perception and intellection: "They [girls] at once notice the difference and, it must be admitted, its significance too."[20]

The little boy, on the other hand, does not share this immediacy of understanding. When he first sees the woman's genitals he "begins by showing irresolution and lack of interest; he sees nothing or disowns what he has seen, he softens it down or looks about for expedients for bringing it into line with his expectations."[21] A second event, the threat of castration, is necessary to prompt a rereading of the image, endowing it with a meaning in relation to the boy's own subjectivity. It is in the distance between the look and the threat that the boy's relation to knowledge of sexual difference is formulated. The boy, unlike the girl in Freud's description, is capable of a re-vision of earlier events, a retrospective understanding which invests the events with a significance which is in no way linked to an immediacy of sight. This gap between the visible and the knowable, the very possibility of disowning what is seen,

prepares the ground for fetishism. In a sense, the male spectator is destined to be a fetishist, balancing knowledge and belief.

The female, on the other hand, must find it extremely difficult, if not impossible, to assume the position of fetishist. That body which is so close continually reminds her of the castration which cannot be "fetishized away." The lack of a distance between seeing and understanding, the mode of judging "in a flash," is conducive to what might be termed an "over-identification" with the image. The association of tears and "wet wasted afternoons" (in Molly Haskell's words)[22] with genres specified as feminine (the soap opera, the "woman's picture") points very precisely to this type of over-identification, this abolition of a distance, in short, this inability to fetishize. The woman is constructed differently in relation to processes of looking. For Irigaray, this dichotomy between distance and proximity is described as the fact that:

> The masculine can partly look at itself, speculate about itself, represent itself and describe itself for what it is, whilst the feminine can try to speak to itself through a new language, but cannot describe itself from outside or in formal terms, except by identifying itself with the masculine, thus by losing itself.[23]

Irigaray goes even further: the woman always has a problematic relation to the visible, to form, to structures of seeing. She is much more comfortable with, closer to, the sense of touch.

The pervasiveness, in theories of the feminine, of descriptions of such a claustrophobic closeness, a deficiency in relation to structures of seeing and the visible, must clearly have consequences for attempts to theorize female spectatorship. And, in fact, the result is a tendency to view the female spectator as the site of an oscillation between a feminine position and a masculine position, invoking the metaphor of the transvestite. Given the structures of cinematic narrative, the woman who identifies with a female character must adopt a passive or masochistic position, while identification with the active hero necessarily entails an acceptance of what Laura Mulvey refers to as a certain "masculinization" of spectatorship:

> [A]s desire is given cultural materiality in a text, for women (from childhood onwards) trans-sex identification is a *habit* that very easily becomes *second Nature*. However, this Nature does not sit easily and shifts restlessly in its borrowed transvestite clothes.[24]

The transvestite wears clothes which signify a different sexuality, a sexuality which, for the woman, allows a mastery over the image and the very possibility of attaching the gaze to desire. Clothes make the man, as they say. Perhaps this explains the ease with which women can slip into male clothing. As both Freud and Cixous point out, the woman seems to be *more* bisexual than the man. A scene from Cukor's *Adam's Rib* (1949) graphically demonstrates this ease of female transvestism. As Katherine Hepburn asks the jury to imagine the sex role reversal of the three major characters involved in the case, there are three dissolves linking each of the characters successively to shots in which they are dressed in the clothes of the opposite sex. What characterizes the sequence is the marked facility of the transformation of the two women into men in contradistinction to a certain resistance in the case of the man. The acceptability of the female reversal is quite distinctly opposed to the male reversal which seems capable of representation only in terms of farce. Male transvestism is an occasion for laughter; female transvestism only another occasion for desire.

Thus, while the male is locked into sexual identity, the female can at least pretend that she is other – in fact, sexual mobility would seem to be a distinguishing feature of femininity

in its cultural construction. Hence, transvestism would be fully recuperable. The idea seems to be this: it is understandable that women would want to be men, for everyone wants to be elsewhere than in the feminine position. What is not understandable within the given terms is why a woman might flaunt her femininity, produce herself as an excess of femininity, in other words, foreground the masquerade. Masquerade is not as recuperable as transvestism precisely because it constitutes an acknowledgment that it is femininity itself which is constructed as mask – as the decorative layer which conceals a non-identity. For Joan Riviere, the first to theorize the concept, the masquerade of femininity is a kind of reaction-formation against the woman's trans-sex identification, her transvestism. After assuming the position of the subject of discourse rather than its object, the intellectual woman whom Riviere analyzes felt compelled to compensate for this theft of masculinity by overdoing the gestures of feminine flirtation.

> Womanliness therefore could be assumed and worn as a mask, both to hide the possession of masculinity and to avert the reprisals expected if she was found to possess it – much as a thief will turn out his pockets and ask to be searched to prove that he has not the stolen goods. The reader may now ask how I define womanliness or where I draw the line between genuine womanliness and the "masquerade." My suggestion is not, however, that there is any such difference; whether radical or super-ficial, they are the same thing.[25]

The masquerade, in flaunting femininity, holds it at a distance. Womanliness is a mask which can be worn or removed. The masquerade's resistance to patriarchal positioning would there-fore lie in its denial of the production of femininity as closeness, as presence-to-itself, as, precisely, imagistic. The transvestite adopts the sexuality of the other – the woman becomes a man in order to attain the necessary distance from the image. Masquerade, on the other hand, involves a realignment of femininity, the recovery, or more accurately, simulation, of the missing gap or distance. To masquerade is to manufacture a lack in the form of a certain distance between oneself and one's image. If, as Moustafa Safouan points out, "to wish to include in oneself as an object the cause of the desire of the Other is a formula for the struc-ture of hysteria,"[26] then masquerade is anti-hysterical for it works to effect a separation between the cause of desire and oneself. In Montrelay's words, "the woman uses her own body as a disguise."[27]

The very fact that we can speak of a woman "using" her sex or "using" her body for partic-ular gains is highly significant – it is not that a man cannot use his body in this way but that he doesn't have to. The masquerade doubles representation; it is constituted by a hyperboliza-tion of the accoutrements of femininity. *A propos* of a recent performance by Marlene Dietrich, Silvia Bovenschen claims, "we are watching a woman demonstrate the representation of a woman's body."[28] This type of masquerade, an excess of femininity, is aligned with the *femme fatale* and, as Montrelay explains, is necessarily regarded by men as evil incarnate: "It is this evil which scandalizes whenever woman plays out her sex in order to evade the word and the law. Each time she subverts a law or a word which relies on the predominantly masculine struc-ture of the look."[29] By destabilizing the image, the masquerade confounds this masculine structure of the look. It effects a defamiliarization of female iconography. Nevertheless, the preceding account simply specifies masquerade as a type of representation which carries a threat, disarticulating male systems of viewing. Yet, it specifies nothing with respect to female spectatorship. What might it mean to masquerade as spectator? To assume the mask in order to see in a different way?

III "Men seldom make passes at girls who wear glasses"

The first scene in *Now Voyager* depicts the Bette Davis character as repressed, unattractive, and undesirable or, in her own words, as the spinster aunt of the family. ("Every family has one.") She has heavy eyebrows, keeps her hair bound tightly in a bun, and wears glasses, a drab dress, and heavy shoes. By the time of the shot discussed earlier, signaling her transformation into beauty, the glasses have disappeared, along with the other signifiers of unattractiveness. Between these two moments there is a scene in which the doctor who cures her actually confiscates her glasses (as a part of the cure). The woman who wears glasses constitutes one of the most intense visual clichés of the cinema. The image is a heavily marked condensation of motifs concerned with repressed sexuality, knowledge, visibility and vision, intellectuality, and desire. The woman with glasses signifies simultaneously intellectuality and undesirability; but the moment she removes her glasses (a moment which, it seems, must almost always be *shown* and which is itself linked with a certain sensual quality), she is transformed into spectacle, the very picture of desire. Now, it must be remembered that the cliché is a heavily loaded moment of signification, a social knot of meaning. It is characterized by an effect of ease and naturalness. Yet, the cliché has a binding power so strong it indicates a precise moment of ideological danger or threat – in this case, the woman's appropriation of the gaze. Glasses worn by a woman in the cinema do not generally signify a deficiency in seeing but an active looking, or even simply the fact of seeing as opposed to being seen. The intellectual woman looks and analyzes, and in usurping the gaze she poses a threat to an entire system of representation. It is as if the woman had forcefully moved to the other side of the specular. The overdetermination of the image of the woman with glasses, its status as a cliché, is a crucial aspect of the cinematic alignment of structures of seeing and being seen with sexual difference. The cliché, in assuming an immediacy of understanding, acts as a mechanism for the naturalization of sexual difference.

But the figure of the woman with glasses is only an extreme moment of a more generalized logic. There is always a certain excessiveness, a difficulty associated with women who appropriate the gaze, who insist upon looking. Linda Williams has demonstrated how, in the genre of the horror film, the woman's active looking is ultimately punished. And what she sees, the monster, is only a mirror of herself – both woman and monster are freakish in their difference – defined by either "too much" or "too little."[30] Just as the dominant narrative cinema repetitively inscribes scenarios of voyeurism, internalizing or narrativizing the film-spectator relationship (in films like *Psycho* [1960], *Rear Window* [1954], *Peeping Tom* [1960]), taboos in seeing are insistently formulated in relation to the female spectator as well. The man with binoculars is countered by the woman with glasses. The gaze must be dissociated from mastery. In *Leave Her to Heaven* (John Stahl, 1945), the female protagonist's (Gene Tierney's) excessive desire and overpossessiveness are signaled from the very beginning of the film by her intense and sustained stare at the major male character, a stranger she first encounters on a train. The discomfort her look causes is graphically depicted. The Gene Tierney character is ultimately revealed to be the epitome of evil – killing her husband's crippled younger brother, her unborn child, and ultimately herself in an attempt to brand her cousin as a murderess in order to insure her husband's future fidelity. In *Humoresque* (Jean Negulesco, 1946), Joan Crawford's problematic status is a result of her continual attempts to assume the position of spectator – fixing John Garfield with her gaze. Her transformation from spectator to spectacle is signified repetitively by the gesture of removing her glasses. Rosa, the character played by Bette Davis in *Beyond the Forest* (King Vidor, 1949), walks to the station every day simply to *watch* the train departing for Chicago. Her fascination with

the train is a fascination with its phallic power to transport her to "another place." This character is also specified as having a "good eye" – she can shoot, both pool and guns. In all three films the woman is constructed as the site of an excessive and dangerous desire. This desire mobilizes extreme efforts of containment and unveils the sadistic aspect of narrative. In all three films the woman dies. As Claire Johnston points out, death is the "location of all impossible signs,"[31] and the films demonstrate that the woman as subject of the gaze is clearly an impossible sign. There is a perverse rewriting of this logic of the gaze in *Dark Victory* (Edmund Goulding, 1939), where the woman's story achieves heroic and tragic proportions not only in blindness, but in a blindness which mimes sight – when the woman pretends to be able to see.

IV Out of the cinema and into the streets: the censorship of the female gaze

This process of narrativizing the negation of the female gaze in the classical Hollywood cinema finds its perfect encapsulation in a still photograph taken in 1948 by Robert Doisneau, "*Un Regard Oblique.*" Just as the Hollywood narratives discussed above purport to center a female protagonist, the photograph appears to give a certain prominence to a woman's look. Yet, both the title of the photograph and its organization of space indicate that the real site of scopophilic power is on the margins of the frame. The man is not centered; in fact, he occupies a very narrow space on the extreme right of the picture. Nevertheless, it is his gaze which defines the problematic of the photograph; it is his gaze which effectively erases that of the woman. Indeed, as subject of the gaze, the woman looks intently. But not only is the object of her look concealed from the spectator, her gaze is encased by the two poles defining the masculine axis of vision. Fascinated by nothing visible – a blankness or void for the spectator – unanchored by a "sight" (there is nothing "proper" to her vision – save, perhaps, the mirror), the female gaze is left free-floating, vulnerable to subjection. The faint reflection in the shop window of only the frame of the picture at which she is looking serves merely to rearticulate, *en abyme*, the emptiness of her gaze, the absence of her desire in representation.

On the other hand, the object of the male gaze is fully present, there for the spectator. The fetishistic representation of the nude female body, fully in view, insures a masculinization of the spectatorial position. The woman's look is literally outside the triangle which traces a complicity between the man, the nude, and the spectator. The feminine presence in the photograph, despite a diegetic centering of the female subject of the gaze, is taken over by the picture as object. And, as if to doubly "frame" her in the act of looking, the painting situates its female figure as a spectator (although it is not clear whether she is looking at herself in a mirror or peering through a door or window). While this drama of seeing is played out at the surface of the photograph, its deep space is activated by several young boys, out-of-focus, in front of a belt shop. The opposition out-of-focus/in-focus reinforces the supposed clarity accorded to the representation of the woman's "non-vision." Furthermore, since this out-of-focus area constitutes the precise literal center of the image, it also demonstrates how the photograph makes figurative the operation of centering – draining the actual center point of significance in order to deposit meaning on the margins. The male gaze is centered, in control – although it is exercised from the periphery.

The spectator's pleasure is thus produced through the framing/negation of the female gaze. The woman is there as the butt of a joke – a "dirty joke" which, as Freud has demonstrated, is always constructed at the expense of a woman. In order for a dirty joke to emerge in its specificity in Freud's description, the object of desire – the woman – must be absent

and a third person (another man) must be present as witness to the joke – 'so that gradu-
ally, in place of the woman, the onlooker, now the listener, becomes the person to whom
the smut is addressed."[32] The terms of the photograph's address as joke once again insure a
masculinization of the place of the spectator. The operation of the dirty joke is also inextri-
cably linked by Freud to scopophilia and the exposure of the female body:

> Smut is like an exposure of the sexually different person to whom it is directed. By
> the utterance of the obscene words it compels the person who is assailed to imagine
> the part of the body or the procedure in question and shows her that the assailant is
> himself imagining it. It cannot be doubted that the desire to see what is sexual exposed
> is the original motive of smut.[33]

From this perspective, the photograph lays bare the very mechanics of the joke through its
depiction of sexual exposure and a surreptitious act of seeing (and desiring). Freud's descrip-
tion of the joke-work appears to constitute a perfect analysis of the photograph's orchestration
of the gaze. There is a "voice-off" of the photographic discourse, however – a component of
the image which is beyond the frame of this little scenario of voyeurism. On the far left-hand
side of the photograph, behind the wall holding the painting of the nude, is the barely detectable
painting of a woman imaged differently, in darkness – *out of sight* for the male, blocked by
his fetish. Yet, to point to this almost invisible alternative in imaging is also only to reveal
once again the analyst's own perpetual desire to find a not-seen that might break the hold of
representation. Or to laugh last.

There is a sense in which the photograph's delineation of a sexual politics of looking is
almost uncanny. But, to counteract the very possibility of such a perception, the language of
the art critic effects a naturalization of this joke on the woman. The art-critical reception
of the picture emphasizes a natural but at the same time "imaginative" relation between
photography and life, ultimately subordinating any formal relations to a referential ground:
"Doisneau's lines move from right to left, directed by the man's glance; the woman's gaze
creates a line of energy like a hole in space . . . The creation of these relationships from life
itself is imagination in photography."[34] "Life itself," then, presents the material for an "artistic"
organization of vision along the lines of sexual difference. Furthermore, the critic would have
us believe that chance events and arbitrary clicks of the shutter cannot be the agents of a
generalized sexism because they are particular, unique – "Kertész and Doisneau depend entirely
upon our recognition that they were present at the instant of the unique intersection of
events."[35] Realism seems always to reside in the streets and, indeed, the out-of-focus boy
across the street, at the center of the photograph, appears to act as a guarantee of the "chance"
nature of the event, its arbitrariness, in short – its realism. Thus, in the discourse of the art
critic the photograph, in capturing a moment, does not construct it; the camera finds a natur-
ally given series of subject and object positions. What the critic does not consider are the
conditions of reception of photography as an art form, its situation within a much larger
network of representation. What is it that makes the photograph not only readable but
pleasurable – at the expense of the woman? The critic does not ask what makes the photo-
graph a negotiable item in a market of signification.

V The missing look

The photograph displays insistently, in microcosm, the structure of the cinematic inscription
of a sexual differentiation in modes of looking. Its process of framing the female gaze repeats

that of the cinematic narratives described above, from *Leave Her to Heaven* to *Dark Victory*. Films play out scenarios of looking in order to outline the terms of their own understanding. And given the divergence between masculine and feminine scenarios, those terms would seem to be explicitly negotiated as markers of sexual differences. Both the theory of the image and its apparatus, the cinema, produce a position for the female spectator – a position which is ultimately untenable because it lacks the attribute of distance so necessary for an adequate reading of the image. The entire elaboration of femininity as a closeness, a nearness, as present-to-itself is not the definition of an essence but the delineation of a *place* culturally assigned to the woman. Above and beyond a simple adoption of the masculine position in relation to the cinematic sign, the female spectator is given two options: the masochism of over-identification or the narcissism entailed in becoming one's own object of desire, in assuming the image in the most radical way. The effectivity of masquerade lies precisely in its potential to manufacture a distance from the image, to generate a problematic within which the image is manipulable, producible, and readable by the woman. Doisneau's photograph is not readable by the female spectator – it can give her pleasure only in masochism. In order to "get" the joke, she must once again assume the position of transvestite.

It is quite tempting to foreclose entirely the possibility of female spectatorship, to repeat at the level of theory the gesture of the photograph, given the history of a cinema which relies so heavily on voyeurism, fetishism, and identification with an ego ideal conceivable only in masculine terms. And, in fact, there has been a tendency to theorize femininity and hence the feminine gaze as repressed, and in its repression somehow irretrievable, the enigma constituted by Freud's question. Yet, as Michel Foucault has demonstrated, the repressive hypothesis on its own entails a very limited and simplistic notion of the working of power.[36] The "no" of the father, the prohibition, is its only technique. In theories of repression there is no sense of the productiveness and positivity of power. Femininity is produced very precisely as a position within a network of power relations. And the growing insistence upon the elaboration of a theory of female spectatorship is indicative of the crucial necessity of understanding that position in order to dislocate it.

Notes

1 Sigmund Freud, "Femininity," *The Standard Edition of the Complete Psychological Works of Sigmund Freud*, vol. 22, ed. James Strachey (London: Hogarth and the Institute of Psychoanalysis, 1964) 113.
2 This is the translation given in a footnote in *The Standard Edition*, vol. 22, 113.
3 Heinrich Heine, *The North Sea*, trans. Vernon Watkins (New York: New Directions, 1951) 77.
4 In other words, the woman can never ask her own ontological question. The absurdity of such a situation within traditional discursive conventions can be demonstrated by substituting a "young woman" for the "young man" of Heine's poem.
5 As Oswald Ducrot and Tzvetan Todorov point out in *Encyclopedic Dictionary of the Sciences of Language*, trans. Catherine Porter (Baltimore and London: Johns Hopkins UP, 1979) 195, the potentially universal understandability of the hieroglyphic is highly theoretical and can only be thought as the unattainable ideal of an imagistic system: "It is important of course not to exaggerate either the resemblance of the image with the object – the design is stylized very rapidly – or the 'natural' and 'universal' character of the signs: Sumerian, Chinese, Egyptian and Hittite hieroglyphics for the same object have nothing in common."
6 Ducrot and Todorov 194. Emphasis mine.
7 See Noël Burch's film, *Correction Please, or How We Got Into Pictures*, Great Britain, 1979.
8 Laura Mulvey, "Visual Pleasure and Narrative Cinema," *Screen* 16.3 (Autumn 1975): 12–13. The essay is also reprinted in Mulvey, *Visual and Other Pleasures* (Bloomington: Indiana UP, 1989) 14–28 and in *Feminism and Film Theory*, ed. Constance Penley (New York: Routledge; London: British Film Institute, 1988) 57–68. [Reprinted in this volume, Chapter 9.]

9 Charles Affron, *Star Acting: Gish, Garbo, Davis* (New York: E. P. Dutton, 1977) 281–82.

10 This argument focuses on the image to the exclusion of any consideration of the soundtrack, primarily because it is the process of imaging which seems to constitute the major difficulty in theorizing female spectatorship. The image is also popularly understood as a metonymic signifier for the cinema as a whole and for good reason: historically, sound has been subordinate to the image within the dominant classical system. For more on the image/sound distinction in relation to sexual difference, see my article, "The Voice in the Cinema: The Articulation of Body and Space," *Yale French Studies* 60 (1980): 33–50.

11 Noël Burch, *Theory of Film Practice*, trans. Helen R. Lane (New York: Praeger, 1973) 35.

12 Christian Metz, "The Imaginary Signifier," *Screen* 16.2 (Summer 1975): 60. See Metz, *The Imaginary Signifier: Psychoanalysis and the Cinema*, trans. Celia Britton et al. (Bloomington: Indiana UP, 1982). Excerpts from the essay are included in *Narrative, Apparatus, Ideology*, ed. Philip Rosen (New York: Columbia UP, 1986) 244–78.

13 Metz 61.

14 Luce Irigaray, *This Sex Which Is Not One*, trans. Catherine Porter with Carolyn Burke (Ithaca: Cornell UP, 1985) 31.

15 Luce Irigaray, "Woman's Exile," *Ideology and Consciousness* I (May 1977): 74.

16 Hélène Cixous, "The Laugh of the Medusa," *New French Feminisms*, ed. Elaine Marks and Isabelle de Courtivron (Amherst: University of Massachusetts Press, 1980) 257.

17 Sarah Kofman, "Ex: The Woman's Enigma," *Enclitic* 4.2 (Fall 1980): 20.

18 Michèle Montrelay, "Inquiry into Femininity," *m/f* I (1978): 91–92.

19 Freud, "Some Psychological Consequences of the Anatomical Distinction Between the Sexes," *Sexuality and the Psychology of Love*, ed. Philip Rieff (New York: Collier, 1963) 187–88.

20 Freud, "Femininity" 125.

21 Freud, "Some Psychological Consequences . . ." 187.

22 Molly Haskell, *From Reverence to Rape* (Baltimore: Penguin, 1974) 154.

23 Irigaray, "Women's Exile" 65.

24 Laura Mulvey, "Afterthoughts on 'Visual Pleasure and Narrative Cinema' inspired by *Duel in the Sun*," *Framework* 6.15–17 (Summer 1981): 13. The essay is also reprinted in Mulvey, *Visual and Other Pleasures* 29–38 and in *Feminism and Film Theory* 69–79.

25 Joan Riviere, "Womanliness as a Masquerade," *Psychoanalysis and Female Sexuality*, ed. Hendrik M. Ruitenbeek (New Haven: College and UP, 1966) 213. The essay was originally published in *The International Journal of Psychoanalysis* 10 (1929). My analysis of the concept of masquerade differs markedly from that of Luce Irigaray. See *Ce sexe qui n'en est pas un* (Paris: Les Éditions de Minuit, 1977) 131–32 (*This Sex Which Is Not One* 133–34). It also diverges to a great extent from the very important analysis of masquerade presented by Claire Johnston in "Femininity and the Masquerade: Anne of the Indies," *Jacques Tourneur* (London: British Film Institute, 1975) 36–44. I am indebted to her for the reference to Riviere's article.

26 Moustafa Safouan, "Is the Oedipus Complex Universal?," *m/f* 5–6 (1981): 84–85.

27 Montrelay 93.

28 Silvia Bovenschen, "Is There a Feminine Aesthetic?," *New German Critique* 10 (Winter 1977): 129.

29 Montrelay 93.

30 Linda Williams, "When the Woman Looks . . .," in *Re-vision: Essays in Feminist Film Criticism*, ed. Mary Ann Doane, Patricia Mellencamp and Linda Williams (Frederick, MD: U Publications of America and the American Film Institute, 1984).

31 Johnston 40.

32 Freud, *Jokes and Their Relation to the Unconscious*, trans. James Strachey (New York: Norton, 1960) 99.

33 Freud, *Jokes* 98.

34 Weston J. Naef, *Counterparts: Form and Emotion in Photographs* (New York: E. P. Dutton and the Metropolitan Museum of Art, 1982) 48–49.

35 Naef 48–49.

36 Michel Foucault, *The History of Sexuality*, Vol. I: *An Introduction*, trans. Robert Hurley (New York: Pantheon, 1978).

MARY KELLY

DESIRING IMAGES/IMAGING DESIRE

"**IN THIS MATTER OF THE VISIBLE,**" said Lacan, "everything is a trap."[1] The field of vision is ordered by the function of images; at one level, quite simply by linking a surface to a geometric point by means of a path of light; but at another level, this function seems more like a labyrinth. Since the fascination in looking is founded on separation from what is seen, the field of vision is also, and most appropriately, the field of desire. Here the viewer enters the realm of lost objects, of vanishing points determined, not by geometry, but by what is real for the subject; linked, not to a surface, but to a place – the unconscious; not by means of light, but by the laws of primary process.

In the matter of images of women then, it would seem that everything is doubly labyrinthine. Desire is embodied in the image which is equated with the woman who is reduced to the body which in turn is seen as the site of sexuality and the locus of desire . . . a familiar elision, almost irresistible it would seem, judging from the outcome of so many conference panels and special issues devoted to this theme. Nevertheless, it is a dangerous and circuitous logic that obscures a certain "progress," a progression of strategies, of definitions made possible within feminist theory by the pressure of a political imperative to formulate the "problem" of images of women as a question: how to change them. The legacy is not a through-route, but a disentangling of paths that shows more clearly their points of intersection and draws attention to the fact that it is not obligatory to start over again at the beginning.

Discourses of the body and of sexuality, for instance, do not necessarily coincide. Within the modernist paradigm, it is not the sexual body, but the phenomenological (Husserlian) body that takes precedence; what belongs to me, my body, the body of the self-possessing subject whose guarantee of artistic truth is grounded in "actual experience," often deploying the "painful state" as a signature for that ephemeral object. Thus, the contribution of feminists in the field of performance has been, exactly, to pose the question of sexuality across the body in a way which focuses on the construction of the sexed subject, and at the same time problematizes the notion of the artist/*auteur*. The body is decentered, radically split, positioned; not simply my body, but his body, her body. Here, no third term emerges to salvage a transcendental sameness for aesthetic reflection. Yet these artists continue to counterpose a visible form and a hidden content; excavating a different order of truth – the "truth" of the woman, her original feminine identity. Although the body is not perceived as the repository of this truth, it is seen as a hermeneutic image; the enigma of femininity is formulated as a problem of imagistic misrepresentation which is subsequently resolved by discovering a true identity behind the patriarchal facade.

The enigma, however, only seems to encapsulate the difficulty of sexuality itself and what emerges is more in the order of an underlying contradiction than an essential content. The woman artist sees her experience as a woman particularly in terms of the "feminine position,"

that is, as the object of the look. But she must also account for the "feeling" she experiences as the artist, occupying what could be called the "masculine position," as subject of the look. The former she defines as the socially prescribed position of the woman, one to be questioned, exorcized, or overthrown, while the implication of the latter – that there can be only one position with regard to active looking and that is masculine – cannot be acknowledged and is construed instead as a kind of psychic truth: a natural instinctual, pre-existent, and possibly unrepresentable femininity.[2] Often, the ambivalence of the feminist text seems to repudiate its claim to essentialism; it testifies instead to what extent masculine and feminine identities are never finally fixed, but are continually negotiated through representations. This crisis of positionality, this instability of meaning revolves around the phallus as the term which marks the sexual division of the subject in language. Significantly, Lacan describes the woman's relation to the phallic term as a disguise, a masquerade.[3] In being the phallus for the other, she actively takes up a passive aim, becomes a picture of herself, erects a facade. Behind the facade, finally, there is no "true" woman to be discovered. Yet, there is a dilemma: the impossibility of being at once both subject and object of desire.

Clearly, one (so-called post-feminist) response to this impasse has been to adopt a strategy of disavowal. It appears in the guise of a familiar visual metaphor: the androgene. She *is* a picture; an expressionistic composite of looks and gestures which flaunts the uncertainty of sexual positioning. She refuses the lack, but remains the object of the look. In a sense, the fetishistic implications of not-knowing merely enhance the lure of the picture, effectively taming the gaze, rather than provoking a de-construction. Another (and perhaps more politically motivated) tactic has been to self-consciously assume the "patriarchal facade"; to make it an almost abrasive and cynical act of affirmation. By producing a representation of femininity in excess of conventional codes, it shatters the narcissistic structure which would return the woman's image to her as a moment of completion. This can induce the alienating effect of a mis-recognition, but the question persists: how can she represent herself as subject of desire?

The (neo-)feminist alternative has been to refuse the literal figuration of the woman's body, creating significance out of its absence. But this does not signal a new form of iconoclasm. The artist does not protest against the "lure" of the picture. In another way, however, her practice could be said to be blasphemous in so far as she seeks to appropriate the gaze behind it (the place of gods, of *auteurs*, and evil eyes). In her field of vision femininity is not seen as a pre-given entity, but as the mapping-out of sexual difference within a definite terrain, a moment of discourse, a fragment of history. With regard to the spectator, it is a tactic of reversal, attempting to produce the woman, through a different form of identification with the image, as the subject of the look.

A further consequence of this reversal is that it queries the tendency of psychoanalytic theory to complement the division of the visual field into sexually prescribed positions by rhyming repression/perversion, hysteria/obsession, body/word . . . with the heterosexual couplet seer/seen. Yet, this division does not seem to be sustained in Freud's work itself. According to Freud, sexual identity is said to be the outcome of a precarious passage called the Oedipus complex; a passage which is in a certain sense completed by the acceptance of symbolic castration. But castration is also inscribed at the level of the imaginary, that is, in fantasy, and this is where the fetishistic scenario originates and is continually replayed. The child's recognition of difference between the mother and the father is above all an admission that the mother does not have the phallus. In this case seeing is not necessarily believing, for what is at stake for the child is really the question of his or her own relation to having or being. Hence the fetishist, conventionally assumed to be male, postpones that moment of

recognition, although certainly he has made the passage – he knows the difference, but denies it. In terms of representation, this denial is associated with a definite iconography of pornographic images where the man is reassured by the woman's possession of some form of phallic substitute or alternatively by the shape, the complete arrangement, of her body.

The question of masculine perversions is an important one. But it would be a mistake to confine women to the realm of repression, excluding the possibility, for example, of female fetishism. For the woman, in so far as the outcome of the Oedipal moment has involved at some point a heterosexual object choice (that is, she has identified with her mother and has taken her father as a love object), will also postpone the recognition of lack in view of the promise of having the child. In having the child, in a sense she has the phallus. So the loss of the child is the loss of that symbolic plenitude – more exactly the ability to represent lack.[4]

When Freud describes castration fears for the woman, this imaginary scenario takes the form of losing her loved objects, especially her children; the child is going to grow up, leave her, reject her, perhaps die. In order to delay, disavow, that separation she has already in a way acknowledged, the woman tends to fetishize the child: by dressing him up, by continuing to feed him no matter how old he gets, or simply by having another "little one." So perhaps in place of the more familiar notion of pornography, it is possible to talk about the mother's memorabilia – the way she saves things – first shoes, photographs, locks of hair, or

Figure 12.1 Mary Kelly, *Documentation VI* from *Post-Partum Document*, 1977–8.

school reports. A trace, a gift, a fragment of narrative; all of these can be seen as transitional objects, not in Winnicott's sense, as surrogates, but in Lacan's terms, as emblems of desire. The feminist text proceeds from this site; not in order to valorize the potential fetishism of the woman, but to create a critical distance from it – something which has not been possible until now because it has not been generally acknowledged.[5] Here the problem of images of women can be re-formulated as a different question: how is a radical, critical, *and* pleasurable positioning of the woman as spectator to be done?

Desire is caused not by objects, but in the unconscious, according to the peculiar structure of fantasy. Desire is repetitious, it resists normalization, ignores biology, disperses the body. Certainly, desire is not synonymous with images of desirable women; yet, what does it mean, exactly, to say that feminists have refused the "image" of the woman? First, this implies a refusal to reduce the concept of the image to one of resemblance, to figuration, or even to the general category of the iconic sign. It suggests that the image, as it is organized in that space called the picture, can refer to a heterogeneous system of signs – indexical, symbolic, and iconic. And thus, that it is possible to invoke the non-specular, the sensory, the somatic, in the visual field; to invoke, especially, the register of the invocatory drives (which, according to Lacan, are on the same level as the scopic drives, but closer to the experience of the unconscious), through "writing." Secondly, it should be said that this is not a hybrid version of the "hieroglyph" masquerading as a "heterogeneity of signs." The object is not to return "the feminine" to a domain of pre-linguistic utterance; but rather, to mobilize a system of *imaged discourse* capable of refuting a certain form of "culturally overdetermined" scopophilia. But why? Would this release the "female spectator" from her hysterical identification with the male voyeur?

Again, the implications of suggesting that women have a privileged relation to narcissism or that fetishism is an exclusively male perversion should be re-considered. Surely, the link between narcissism and fetishism is castration. For both the man and the woman this is the condition for access to the symbolic, to language, to culture; there can be no privileged relation to madness. Yet there *is* difference. There is still that irritating asymmetry of the Oedipal moment. There is Freud's continual emphasis on the importance of the girl's attachment to her mother. And there is Dora.[6] What *did* she find so fascinating in the picture of the Sistine Madonna? Perhaps, above all, it was the possibility of seeing the woman as subject of desire without transgressing the socially acceptable definition of her as the mother. To have the child as phallus; to be the phallic mother; to have the pleasure of the child's body; to have the pleasure of the maternal body experienced through it; perhaps, in the figure of the Madonna, there was a duplication of identification and desire that only the body of another woman could sustain.

For both the man and the woman, the maternal body lines the seductive surface of the image, but the body *he* sees is not the same one *she* is looking at. The woman's relation to the mother's body is a constant source of anxiety. Montrelay claims that this relation is often only censored rather than repressed. As a consequence the woman clings to a "precocious femininity," an archaic oral-anal-vaginal or *concentric* organization of the drives which bar her access to sublimated pleasure (phallic *jouissance*).[7] Similarly, with regard to the artistic text, and if pleasure is understood in Barthes' sense of the term as a loss of preconceived identity, rather than an instance of repletion, then it *is* possible to produce a different form of pleasure for the woman by representing a specific loss – the loss of her imagined closeness to the mother's body. A critical, perhaps disturbing sense of separation is effected through the visualization of exactly that which was assumed to be outside of seeing; precocious, unspeakable, unrepresentable. In the scopic register, she is no longer at the level of concentricity,

of repetitious demand, but of desire. As Lacan points out, even the eye itself belongs to this archaic structure since it functions in the field of vision as a lost object.[8] Thus, the same movement which determines the subject's appearance in language, that is, symbolic castration, also introduces the gaze. And the domain of imaged discourse.

Until now the woman as spectator has been pinned to the surface of the picture, trapped in a path of light that leads her back to the features of a veiled face. It is important to acknowledge the masquerade that has always been internalized, linked to a particular organization of the drives, represented through a diversity of aims and objects; but at the same time, to avoid being lured into looking for a psychic truth beneath the veil. To see this picture critically, the viewer should be neither too close nor too far away.

Notes

1 Jacques Lacan, "The Line and Light," in *The Four Fundamental Concepts*, ed. M. Masud, trans. R. Khan (London: Hogarth Press, 1977), p. 93.
2 Mary Kelly, "Re-Viewing Modernist Criticism," *Screen* 22, no. 3 (1981), pp. 53–56.
3 See Jacques Lacan, "The Signification of the Phallus" (1958), in *Feminine Sexuality*, ed. Juliet Mitchell and Jacqueline Rose (London: The Macmillan Press, 1982).
4 See Sigmund Freud, "The Dissolution of the Oedipus Complex" (1924), *Standard Edition*, vol. 19, trans. James Strachey (London: Hogarth Press, 1968).
5 See Mary Kelly, *Post-Partum Document* (London: Routledge & Kegan Paul, 1983).
6 See Sigmund Freud, "Fragment of an Analysis of a Case of Hysteria" (1901), *Standard Edition*, vol. 7, trans. James Strachey (London: Hogarth Press, 1968).
7 Michèle Montrelay, "Inquiry into Femininity," *m/f*, no. 1 (1978): 86–99.
8 Jacques Lacan, "What is a Picture?" in *The Four Fundamental Concepts*, p. 118.

Chapter 13

GRISELDA POLLOCK

SCREENING THE SEVENTIES

Sexuality and representation in feminist practice – a Brechtian perspective

You should have a practice in art that actually looks forward to a moment that will be different. I think that's the point that we haven't actually grasped. Critics look at a work and they say, "That's only a negative deconstructive understanding of personal experience", without seeing what the work as a whole represents in terms of a positive view of social change and what art could be in the future.

Mary Kelly interviewed by Monika Gagnon, *C Magazine*, 1986 (10), 24

I

IN SEPTEMBER 1985 AN EXHIBITION entitled *Difference On Representation and Sexuality* opened at the Institute of Contemporary Arts in London. It was undoubtedly a major feminist event and the show featured work by women and men: Ray Barrie, Victor Burgin, Hans Haacke, Mary Kelly, Silvia Kolbowski, Barbara Kruger, Sherrie Levine, Yve Lomax, Jeff Wall and Marie Yates.[1] Supported by a film and video programme, this exhibition had first been seen at the New Museum of Contemporary Art in New York in December 1984. Curator Kate Linker opened her foreword to the catalogue with this statement:

> Over the past ten years, a significant body of work has explored the complex terrain triangulated by the terms of sexuality, meaning and language. In literature, the visual arts, criticism, and ideological analysis, attention has focused on sexuality as a cultural construction, opposing a perspective based on a natural or "biological" truth. This exhibition charts this territory in the visual arts. It presents work by its main participants. And it explores the radical implications of this approach. Its thesis – the continuous production of sexual difference – offers possibilities for change, for it suggests that this need not entail reproduction, but rather a revision of our conventional categories of opposition.[2]

The *Difference* exhibition sustained a critical concept of artistic practice and cultural politics generated during the 1970s in contest with the crumbling hegemony of American modernism and the New York galleries and institutions at the centre of the capitalist west's art industry. In the current climate of what has been termed the "postmodernism of reaction" these practices have been marginalized. The show itself was a statement of refusal to permit such obliteration of the critical project of the 1970s in the present financial and curatorial celebrations of born again painting and expressionism.[3] For not only does the new expressionism reintroduce the unquestioning sense of the Grand Tradition, it significantly defines art and its creative processes and materials as exclusively masculine. Witness the total exclusion of women from the celebratory event housed in London at the Royal Academy in 1981, *The New Spirit in Painting*.[4]

Although the work presented in the *Difference* exhibition could only be read as in conflict with such traditionalist revivals of painting and its expressive ethos, there are some radical critics who have expressed reservations about the theoretical resources and strategies of representation employed by artists such as Burgin, Kelly, Barrie, Lomax and Yates. It is precisely the triangulation of sexuality, language and meaning through the use of Lacanian psychoanalysis which has become contentious.[5] For instance in the introduction to a series of his essays on contemporary art and culture Hal Foster worries that "due to its adversarial stress on the Lacanian definition of the Oedipus complex in terms of the Name-of-the-father, the specificity of patriarchy as a social formation and as an everyday practice is sometimes lost".[6] This then leads to a potential contradiction between "its political desire to transform social institutions and its historical pessimism regarding patriarchy. . . . This art does indeed demonstrate that the subject is produced socially, but it is not enough to say that its patriarchal structures are thus 'subject to change' when no strategies for change are offered and when these structures are presented as all but transhistorical and urpsychological".[7] Admitting none the less the importance of this area of work Foster adds one final caveat. He is worried about the "fascination with the representations it impugns" and further that feminist insistence on the social construction of sexual difference and the role of "woman as sign" has been overargued.

There clearly is a political worry about the use of psychoanalysis, the deconstructive work on representations and feminist cultural politics involved. But what is missing from the way in which these issues are being discussed in the 1980s is a historical understanding of the political motivation for these strategies grounded in specific developments in the 1970s. One major omission from the current terms of analysis of these British practices is the recirculation in the early 1970s of the theories and practices of the German dramatist, film-maker and cultural theorist Bertolt Brecht through the pages of the British film magazine *Screen*.

II Screening the seventies

I want to start with boys. In 1980 *Screen* magazine made a foray into art history, inviting T. J. Clark to publish one of the versions of his study of the painting *Olympia* (1863) by Edouard Manet. The polemical orientation of his arguments about the founding practices of modernism were made explicit in the final sections. He projected from what he took to be Manet's failure to sustain a radical critique of bourgeois ideologies what would be necessary for a painting to accomplish such a position.[8] In the following issue the film-maker and theorist Peter Wollen published a reply to the Clark essay in terms which openly suggested a rematch of the famous debate between Bertolt Brecht and George Lukacs in the 1930s on the political merits of realism versus modernism.[9] Wollen accused Clark of negating the modernist project in all its guises by seemingly calling for a return to realism. (Clark later refuted this.) None the less the misunderstanding occasioned from Wollen a defence of contemporary artists working within a radical or political modernism, taking its cues from the theories of Bertolt Brecht. Wollen attacked Clark's argument as "an attempt to undermine the whole paradigm of modernism and, specifically, the aesthetics of its radical avant-garde sector. This surely is to turn one's back on the whole history of political art this century."[10]

Wollen also took Clark to task for ignoring feminist theorizations of sexual difference and their use of psychoanalytical analysis of the look and subject positions which were being so productive in British critical culture at that date. In a significant passage Wollen makes indirect reference to two of the major projects of this cultural fraction, *Riddles of the Sphinx*, 1977, a film by Laura Mulvey and Peter Wollen, and *Post-Partum Document*, 1973–9, by Mary Kelly.

> There is a passage in Timothy Clark's essay where he imagines a picture in which "the production of a sexual subject" would be depicted in a "particular class formation". This is indeed *the* picture (if it is a picture rather than some more complex form of art) which it is important to think about. Within my terms this is a picture about, not Woman, but the production of woman as a fetish in a particular conjunction of capitalism and patriarchy. . . . Such a picture would not identify "Woman" or any particular woman but would confront the underlying mechanisms which produce the sexual discourse within which women are placed. Consequently when Timothy Clark asks "Do dis-identificatory practices matter?" the answer must be "yes".[11]

Dis-identificatory practices refer to the strategies for displacing the spectator from identifying with the illusory fictional worlds offered in art, literature and film disrupting the "dance of ideology" which engages us on behalf of oppressive regimes of class, sexist, heterosexist and racist classifications and placements. Although such strategies were associated with *Screen* theories deriving from semiotics and psychoanalysis Wollen clearly made the link with Brecht and

he saw Clark invoking realism as the opposition to the modernism associated exclusively with American and Greenbergian definitions rather than looking to the political deployment of another modernism associated with Brecht.

This little exchange may seem somewhat dated when the postmodern is so much to the forefront of our critical debates and a defence of modernism, Brechtian or otherwise, may seem, if not quaint, positively reactionary. However much we may concede that the post-modern condition is now our inescapable horizon, the issues raised by our recent history in the 1970s are not thus superseded. Indeed specific historical knowledge is a vital defence against postmodernist suspension of history. Even in radical critical circles this takes the form of an over-emphasis for instance on the psychoanalytic theory used by certain artists at the expense of an understanding of the political reasons for its strategic use in the struggle against sexual oppression.

But what has this debate to do with feminism?

The site of the debate was the representation of the body of woman. Clark addressed, as a canonical modernist painting, *Olympia*, without a serious pause to question why modernism is installed upon the territory of a commodified female body let alone consider the sexual politics of his position as a writer.[12] Wollen was easily able to dismiss Clark's obstinate puzzlement about the inconsistencies of the painting's signifying systems in relation to the signification of sexuality, but he was able to do so by referring to feminist work on psychoanalysis, to feminist theses about the representation of woman, fetishism and the gaze. (It is important to note that neither deal with the dimension of race, so central to the sexual representation and meanings within *Olympia*.) The central text articulating this problematic is of course by Laura Mulvey, *Visual Pleasure and Narrative Cinema*,[13] which identifies as a major trope of the cinematic apparatus an active mastering gaze subjecting the passive image of woman, fragmented, or dismembered, fetishized and above all silenced. Although widely used, Mulvey's argument has never been fully developed in relation to modernist representation in the visual arts. Why do the canonical works articulate precisely these power relations, a monological masculine discourse conjuring up the fetish of a female bodily presence and vocal absence? Think not only of *Olympia* but *The Demoiselles d'Avignon* (Picasso) and de Kooning's series *Woman*. In Carol Duncan's and Alan Wallach's substantial essay on the itinerary to which the visitor to the Museum of Modern Art (MOMA), New York, was subjected by the lay-out of the galleries exhibiting the permanent collection of modern art, they suggested it functioned as a ritual and an ordeal based upon an encounter with the great goddess or Mother Earth repeatedly conjured up by the grand works of the modern tradition.[14] Their insight needs to be reformulated to recognize modernist painting not exclusively as the heroic struggle for individual expression or the equally painful discipline of purification and stylistic innovation but as a more fundamental discourse around the paradoxes and anxieties of masculinity which hysterically and obsessionally figures, debases and dismembers the body of woman. As Angela Carter said, "Picasso liked cutting up women".

Modernism is to art history and practice what the classic realism of Hollywood cinema is to film theory. We need a similarly comprehensive theorization of the sexual politics which it inscribes. To produce this we need to engage with theories whose primary object is the manufacture of sexual difference. Going beyond offering feminist readings of individual modernist paintings or oeuvres we need to analyse the systems which generated them. Modernism is structured around sexual politics but these are displaced by the manifest content of modernist discourse, the celebration of creative masculine individualism. The figure of the artist always assumed to be masculine in critical and economic practices around art is matched

by the sign woman which is its signifier within representational systems. This is as pertinent in figurative art as in those works that claim to investigate nature or the cosmic void – the polarities are always gendered and hierarchical.

What I have been suggesting might well imply that feminism must automatically be anti-modernist. There have been feminist critics who argue just this. For instance writing in the *Art Journal* in 1980 the leading American feminist critic Lucy Lippard claimed that feminism's greatest contribution to the future vitality of art precisely lay in its lack of contribution to modernism and she claimed that

> [f]eminist method and theories have instead offered a socially concerned alternative to the increasingly mechanised evolution of art about art. The 1970s might not have been pluralist at all if women had not emerged during the decade to introduce the multicolored threads of female experience into the male fabric of modern art.[15]

At the conference held in Vancouver in 1982 Nicole Dubreuil Blondin addressed the antipathy between modernism and feminism by analysing Lucy Lippard's trajectory as a critic. She concluded that while feminism was anti-modernist it provided in some senses the para-digm for postmodern art. She suggested that the woman paradigm in art could be seen as the model of rupture, the total other that would finally reconcile aesthetics and politics. Yet there was a common link between feminism and other practices: "Is not the avant-garde under-going profound changes in its postmodernist phase, its new configurations corresponding exactly to the problematic of women's art?"[16]

Cutting right across the modernist/anti-modernist and the modernist/postmodernist axes was an article published in *Screen* in 1981. Mary Kelly offered a complex analysis of several major aspects of modernist criticism and practice but crucially positioned feminist practices as a dialectical force breaking through the paradoxes of the late modernist field of which they were in part an effect. Kelly identified three critical areas which had become characteristic of later modernist discourses and were the territory for a feminist intervention across that terrain: materiality, sociality and sexuality.

Materiality: a doctrine of "truth to materials", or the Greenbergian claims that the character of painting for instance should be determined by the nature of its material med-ium, represent a modernist stress on materiality. Analysing art from a *historical* materialist position involves admission of the social character of artistic activity taking place within specifiable conditions of production and consumption. Meanings are furthermore considered as being generated through social and historically variable signifying systems. In place of the utopian claims for personal expression and universal understanding by means of the power of the material or medium of artforms typical of modernist theory, feminist mater-ialism recognizes a textual politics – an interrogation of representation as a social site of ideological activity.

Sociality: indicates an emphasis on the contexts of artistic production. During the 1970s there were various attempts to explore the limits of art institutions, such as galleries which defined what is and what is not art. While attempting to defy the consumption of art as commodities in the art market, new forms of art such as performance, land art, conceptual art, body art and so forth were of limited effectivity. They lacked analysis of art as an insti-tutional practice. While museums, owners' homes, forecourts of banks and big corporations are merely seen as contexts of use which come after the discrete moment of private creation in the studio, artists continue to dream of some means of protecting their art from these "abuses".[17] But the studio and the gallery are not separate. They form interdependent moments

in the circuits of production and consumption of culture under capitalism. Therefore Mary Kelly argues that the sociality of art is "a question of institutions which determine the reading of artistic texts and the strategies which would be appropriate for interventions".[18] Feminist interventions are moreover empowered because they will place art and its institutions on a continuum with other economic, social and ideological practices. Founded in the political struggle of the women's movement with its comprehensive social critique, feminist cultural practices index artistic activity to the social world in which culture is becoming an increasingly significant level of social regulation and ideological consumption.

Sexuality: this item is paramount within feminist theory but there are distinctions to be made between different uses of the term. Since the 1960s sexuality has been a privileged issue in libertarian politics. This legacy informs one thread of feminist culture in which women's claims for an autonomous and self-defined sexuality have almost become a metaphor for our total struggle for personal liberation. In the works of Judy Chicago, for instance, the woman's sexualized body functions as the sign of the reclaiming of women's essential identity and integrity. Sexuality is understood within this tradition as a quality or attribute, innate, essential and liberating; in Foucault's phrase, "the truth of our being".

Countering this discourse is a notion of sexuality compositely fashioned from the Lacanian rereadings of Freud by Lacan and the historical project of Michel Foucault in which the potentially oppressive socio-psychic production of sexuality is stressed. Sexuality is perceived as an effect of social discourses and institutions (Foucault).[19] Artistic practices have also been implicated in the manufacture and repetition of sexual positions in the way that they manage desire and pleasure, fuel fantasies and situate the viewer. Feminist practices have insisted upon the recognition of gender specificity in art as elsewhere but selected practices have addressed precisely the way in which the sexing of subjects and the production of sexual difference are effected and renegotiated in the ceaseless circulation of visual and other representations.

Thus we are back with psychoanalysis, language and meaning and Hal Foster's criticism. But the interrelations of the three levels Kelly identifies indicates an artistic practice of some complexity. At once the social is redefined in terms of textual practices through which both meanings and the positions from which we find those meanings normal are manufactured. Yet the textual is also discovered as material, existing not as a discrete, spiritual phenomenon (e.g. the embodiment of creativity or the human spirit as in many conventional art theories) but functioning within economic and social institutions productive of both commodities and ideologies. Within and across both these axes the question of the production of sexual difference insists, demanding varied forms of analysis which seemingly direct us away from the concrete social into the realms of theory and psychoanalysis. But the political purpose is paramount with the intention to expose critical areas wherein we are being produced according to the sexual hierarchies and social divisions constitutive of patriarchal and capitalist social relations.

Screen magazine was a major resource for critical cultural practices in Britain in the 1970s far beyond the confines of film-making and film studies. Indeed the appearance of Clark's article on its pages signalled a momentary alliance with radical sectors of art history and the visual arts. Mary Kelly was put on to the editorial board in 1979 and Griselda Pollock in 1980. The magazine is typically associated with the dissemination of European developments in the theory of semiotics (Saussure), of ideology (Althusser) and of the subject (Lacan).[20] The strong interest in Brecht is often overlooked. Through the example of Brecht many political artists found an Archimedian point outside proliferating postmodernist pilferings of other moments of art's history by providing access to a modernism erased from history by the selective tradition peddled by the Museum of Modern Art, New York, and modernist art

history. The legacy of Brecht moreover qualified the uses of post-structuralism, psychoanalysis and semiotics by providing a bridge between political engagement and a commitment to develop artistic strategies which could have a political effectivity within the sphere of culture. As a result of Marxist and post-structuralist arguments the cultural level broadly defined was being recognized as strategically significant in the late capitalist world.

At the same time there can be no doubt that Brecht was being re-read in terms of the contemporary theorizations of ideology, language and subjectivity. Yet Brechtian theory and practice insisted upon a political baseline to debates. This explains why politicized artists in this period could negotiate the play between materiality, sociality and sexuality.

The interest in Brecht was fuelled by translations into English of a number of key texts which had only recently come to light, such as the essay "Against George Lukacs" which first appeared in English in *New Left Review* in 1974. *Screen* devoted two issues to Brecht and Cinema.[21] In his paper to the Brecht event in Edinburgh in 1975 Stephen Heath stated:

> The problem, the political problem, for artistic practice in its ideological interven-
> tion, could be precisely the transformation of relations of subjectivity in ideology.[22]

How does one get from Brecht to that formulation?

Perhaps one of the most well-known of Brecht's strategies is that of "distanciation" or "defamiliarization", one of the foundations of "dis-identificatory practices". The point was to liberate the viewer from the state of being captured by illusions of art which encourages passive identification with fictional worlds. For Brecht the viewer was to become an active participant in the production of meanings across an event which was recognized as represen-tation but also as referring to and shaping understanding of contemporary social reality. Distanciation is not a style or aesthetic gambit but an erosion of the dominant structures of cultural consumption which as Heath ingeniously pointed out in another article in *Screen* are classically fetishistic.

> Fetishism describes as we have seen, a structure of representation and exchange and
> the ceaseless confirmation of the subject in that perspective . . . which is that of the
> spectator in a theatre – or a movie-theatre – in an art of representation. It is this
> fixed position of separation-representation-speculation (the specularity of reflection
> and its system of exchange) that Brecht's distanciation seeks to undermine. . . . In
> Brecht's own words, it is a question of "creating new contact between stage and the
> auditorium and thus giving a new basis to artistic pleasure".[23]

In the fetishistic regime the viewer is at once separated from what he/she is seeing but enthralled into identification with an imaginary world in which threatening knowledge is allayed by beautiful images.[24] Brechtian distanciation aims to make the spectator an agent in cultural production and activate him or her as an agent in the world. The double edge of distanciation theory feeds at once into structuralist insistence on the active role of the spectator-viewer[25] and into post-structuralist semiotics which stresses that meanings are produced for, and secure, subject positions.[26] The formalist issues may seem far from Brecht's project of political mobilization. The bridge was built out of the theory of ideology advanced by Althusser.[27]

According to his formulation our sense of who and what we are – i.e. as subjects in the philosophical sense – is not innate and does not precede our access to language and thus society. Subjectivity is constructed through representations circulated by society's major

institutions of social reproduction, the family, the school, the church, advertising, culture, i.e. the ideological state apparatuses. These are systematically but independently organized to hail us as their subjects. The word subject has a double meaning. We are subjects in the grammatical sense of being an agent, but we are also subjects in the legal sense, for example subjects of the Queen, i.e. subjected to an authority or system of meanings. Thus political struggle must engage both these social practices which constitute us as social individuals, subject of and for a social system.[28] The relations of subjectivity in ideology have to be transformed at the points of their production. Cultural representations are a significant site.

> We come back here to our discussion of ideology; ideology is not to be replaced by some area of pure knowledge; rather, from within ideology, art, as realism in Brecht's sense, attempts to displace those formations of ideology by posing the specific relations of those formations in the mode of production.[29]

In addition to distanciation Brecht signifies a critique of realism. As Marxists both Brecht and Lukacs were committed to epistemological realism, the premiss that social being determines social consciousness.[30] But they diverged radically over tactics for a mode of representation adequate to provide politically effective knowledge of that social reality. Lukacs privileged forms of literary realism associated with the realist tradition of Balzac and Tolstoy, specifying what Brecht saw as an anachronistic formula. For Brecht each historical movement and social group had to discover its own appropriate strategies and these must be of a complexity adequate to their critical and instructional project.

> Thus Brecht stands against the Lukacsian vision of modernism as *decadence* – the breaking up of traditional forms as barbarism – in the interest of an avant-garde activity of the exploration of reality in the production of new forms of its definition.[31]

Against literary realism, Brecht turned to modernist defiance of the traditional forms and encouraged the use of montage, disruption of narrative, refusal of identifications with heroes and heroines, the intermingling of modes from high and popular culture, the use of different registers such as the comic, tragic as well as a confection of songs, images, sounds, film and so forth. Complex seeing and complex multilayered texts were the project. Distanciation is therefore the theoretical and practical result of this critique of realist representation and a device for achieving a different form of realist knowledge actively involving the spectator in its production and its translation into action.

III

What is feminism's relation to this debate? Necessarily alienated from MOMA's modernism, but also challenging dominant modes of realist representation which naturalize bourgeois hierarchies and service masculine fantasy, feminism is nonetheless committed, epistemologically, to realism. Political change must come through concrete social struggle in the real world. Much feminist cultural activity was, however, initially realist in an uncritical way. The concern to speak about, document and investigate women's lives, experience and perspectives found immediate expression in documentary films and photography projects, as well as in figurative imagery in the visual arts.[32] There is no doubt a tactical importance in the construction of women's lives and histories with which the alienated woman spectator can enthusiastically identify as part of a political process known as consciousness-raising. But as feminists soon

discovered, the desire to make visible could not of itself produce knowledge. Vision may only conform ideologically sanctioned perceptions of the world or at best simply invert them; as Heath says: "Reality is to be grasped not in the mirror of vision but in the distance of analysis, the displacement of the ideology that vision reflects and confirms."[33]

Thus feminist artists concerned to explicate the character of women's oppression within classed and racially divided patriarchal societies cannot be content to describe its appearances and symptoms. Structural determinations need to be excavated and tracked through their articulation in representation. Brechtian notions of radical art as non-unity, as a many-faceted collage/montage which is open to the play of contradictions inspired new ways of making art works, in performance and time-based works, installations, videos, scripto-visual multiple projects.

> Hence art – art as specific intervention – is not unity but contradiction, not reflection but construction, not meaning but interrogation, is lesson and action . . . in short must pose questions which render action possible.[34]

One of the most telling feminist products of that theoretical and political conjuncture was the *Post-Partum Document* by Mary Kelly made over the period 1973–9 and comprising six parts and 135 units [see Figures 10.2, 12.1]. Currently this work is almost exclusively positioned in relation to feminist interest in psychoanalytic theory. Although this was a major resource and, it must be stressed, point of critique in the work, the conditions of its production and the nature of its intervention will be seriously misunderstood without reference to the historical conjunction out of which the project came.

It needs, therefore, to be placed within its own history. In the period 1970–2 Mary Kelly took part in the making of *The Nightcleaners*, a Brechtian film partly made in support of the unionizing of low-paid women workers in contract office cleaning and partly made as a critique of the campaign and of documentary.[35] Interest in unionization led to involvement with the newly founded Artists' Union. In May 1972 Mary Kelly was elected its first chairperson. Women in the Union established an active Women's workshop out of which a major project emerged. *Women and Work*, 1975, was a collaboration between Margaret Harrison, Kay Hunt and Mary Kelly to investigate the impact of the Equal Pay Act of 1970 on the workers in a Metal Box factory in Southwark, London. This Act, which had taken over one hundred years of campaigning to get on the statute books, had specified a five-year period for its implementation. The project was to investigate the real effects of the legislation for working women.

The exhibition defied the conventions for both documentary representation and art exhibitions. It was an installation composed of photographic panels, statistical tables, split screen films, talking phones, copies of recent legislation and official reports and so forth. This graphically revealed not a steady progress towards equality, but a calculated restructuring of the workforce and redefinition of skills whose effect was to segregate women more rigidly into low-paid, low-skill categories. Still and moving photography were skilfully juxtaposed to make visible these structural differences. Women's jobs could be adequately represented statically by showing nothing more than hands at work at a machine while men's jobs typically involved movement within a complex and changing spatial environment.

In one section men and women had been asked to provide accounts of a typical working day. The results were juxtaposed on a large panel. For women, work was what happened around the dead time of paid employment; it had no limits and there was no real division between labour and leisure. But this time and work clearly mattered. The revelation of a sexual division of labour as something happening in the home as well as the factory was

nothing new for feminist analysis. But the emotional investment of women in the areas of work associated with child care had not been acknowledged or analysed. Indeed it tended to be dismissed as the major source of women's oppression. The *Post-Partum Document* (hereafter *PPD*) was generated as an investigation of that interface between what is conventionally accepted as the social and the hitherto unexplored psychic realities structured through the social division of labour in the so called private spaces.

In 1974 *Psychoanalysis and Feminism* by Juliet Mitchell introduced into anglophone communities an interest in psychoanalysis typical of French feminist groups. The book was both a symptom of and a major force behind the revision of the feminist slogan, "the personal is political". From the initial affirmation of subjective experience reported in consciousness-raising groups, feminist theorization of the personal elaborated an analysis of the formation of the subject through social institutions, the family for instance, mediated by the most pervasive of all social institutions, language. Sexual positionality was therefore posed as a simultaneous effect of social and psychic induction in the order of culture, enshrined in language.

The question raised therefore was not only how are human infants made subjects of and to their culture but what is happening to women in their overdetermined relation to the privileged site of that process – child care. While the major but not exclusive theoretical framework of the *PPD* was a revision of the psychoanalytic schemata of Lacan, the representational strategies were informed by the Brechtian uses of montage, text, objects in a sequence of sections which actively invent the spectator as someone who will engage, remember, reflect and reconstitute the traces of the relationship between mother and child which is the document's material. The end product is a new understanding of the passage of the mother and the child through the reciprocal process of socialization as feminine and, in this case, masculine subjects.

The mother and child relation in its social and psychic interplay cannot be pictured for it is a process, like the dream or a fantasy of which we can have knowledge only through its traces, its coded signs. Thus present in the document are objects such as nappy liners, comforters, casts of tiny hands, gifts, words. Like fetishes these are the inanimate signs of the social relation which produced them and for which they bear symbolic meaning. They become therefore clues to that unspoken and hitherto unrepresented realm of meaning and fantasy of the feminine. The physical presence of woman fetishized in modern western art is thereby replaced by another order of presences accompanied by the discourse of and from the place of the traditionally silenced feminine. In place of the exclusively masculine theorization of fetishism, Kelly explored aspects of feminine fetishization of the child and its substitutes.

Secondary discourses are necessary to relocate the meaning of these signs in the production of the mother, the making of the maternal feminine which is the piece's major revelation. Therefore the spectator confronts the materiality of the mother's discourse (often inscribed in handwriting), in transcribed conversations, diaries and commentaries. These texts are not a unifying narrative. There is no one authorial voice but interventions and reworkings, even parodies of several modes of discourse. These are fissured and traversed by desire, anxiety, fear of loss, disavowal and fetishization.

Far from being a piece of conceptual art which refuses the figurative in favour of text as substitute, the document images discourse, not words but speech and statements, as the site of subjective and ideological activity. This necessarily reverses the bodily presence and vocal absence which typifies the representation of woman as sign in masculine representation. It produces a voice from the position of the feminine and makes the spectator study the initiation of the child into a language which is the symbolic system of a patriarchal order. The dialogues between mother and child are circumscribed by the meanings structured in a

Figure 13.1 Yve Lomax, *Open Rings and Partial Lines*, 1983–4.

patriarchal system which is exposed precisely at the points when discourse fails and the mother has no words for the feminine placed outside representation, positioned as the pathological or procreative body. Finally writing is presented as inscription and a site which we must analyse symptomatically, not so much for what is literally spoken or written but for what those markings figure at other registers, such as fantasy, where the meanings are not totally defined by the dominant culture but slide and shift revealing what the symbolic order represses. Writing is a scene for the mother in which the child is retraced, a potential moment of feminine fetishism. Equally, as the final section "On the insistence of the letter" suggests, "the child's alphabet is an anagram of the maternal body".[36]

Although the *PPD* was produced within the spaces and discourses of the visual arts, its procedures echo Brecht's almost cinematic conception of the interplay of text, image, object, as well as his encouragement to use several registers of representation such as, in this case, the scientific, medical, autobiographical, educational, theoretical and so forth. The *PPD* fulfils Wollen's projection of a complex work of art confronting not Woman or women but the underlying mechanisms which produce the sexual discourses within which women are positioned in contemporary western patriarchal societies. Distanciated from passive consumption of the ideological category of the natural mother or the voyeuristic exploitation of an autobiographical account of one woman's experience as a mother, the spectator is offered a quite new understanding of the intersection between the social organization of domestic labour on the one hand, and on the other, the consolidation of femininity as prescribed within a patriarchal system.

The *PPD* is to be understood as a text, working its materials to produce meanings, not merely to picture already formed meanings. Thus as Stephen Heath stated, art as realism in Brecht's sense attempts to displace the formation of ideology by making strange, by defamiliarizing, the relations of subjectivity in ideology – i.e. the making of the feminine and its socio-economic and psychic positions. In addition the Brechtian model proposes a strategic artistic practice which does not operate from some imagined point outside the dominant culture. As practice it seeks to context the hegemony of the dominant culture(s) by intervening in the relevant territories of production and consumption.

> From then on, the struggle is, as it were, on the very ground of representation – on the very ground of the interpellations of the subject in reality by ideology; art as *displacement* in so far as it holds representation at a distance – the distance, precisely, of politics.[37]

IV

A secondary result of the Brechtian critique of bourgeois realism in the pursuit of a critical realism is the insistence upon the ideological character of the terms of representation. Realist modes of representation present the world as if total knowledge is possible through empirical observation. Readers and viewers are posed as mere witnesses or observers. Yet it can be shown that specific devices are deployed which sustain this effect, positioning the viewer/reader in a specular relation, as if in a mirror, to what is seemingly revealed by its transparent textual devices. Denying the fact of being a construction, being produced, the realist text offers itself as merely a picture of the world which does not depend for its sense on any other texts, references or information.[38]

Critical practices, strategies of subversion, must inevitably involve a critique of dominant realist modes which "naturalize" bourgeois and masculinist ideologies as fact or common sense. Stephen Heath called this decolonization of the ideologically loaded languages and modes of

representation "*depropriation*".[39] The term was taken up by Mary Kelly in her essay introducing the exhibition she curated at the Riverside Studios in London, *Beyond the Purloined Image*, August 1983. The works on show were made by Mitra Tabrizian, Ray Barrie, Karen Knorr, Olivier Richon, Marie Yates, Yve Lomax, Susan Trangmar and Judith Krowle. This diverse body of work was produced within what could be called a politics of representation and they addressed the codes and conventions of much media imagery, specifically those which perpetuate sexual (and in some cases racial) positionalities within the present regime of sexual (and racial) difference.

The enterprise could be compared to a more widespread phenomenon associated with "appropriation" and media critique which formed the basis of American exhibitions such as *Image Scavengers* (1982) and *The Stolen Image and its Uses* (1983).[40] Kelly intended however to distinguish the British artists from their American counterparts who take their images from the fine arts of media and re-present them in visual quotation marks, and who are perhaps more influenced by the situationists and the writings of Jean Baudrillard.[41] The strategy of depropriation takes its cues from Brecht and Godard while utilizing more recent theorizations of representation and subjectivity.

In the Riverside exhibition Mitra Tabrizian showed *On Governmentality* which analysed the institution of advertising.[42]

> The work presented here is a fiction placed within a documentary frame, it is at the intersection of two discursive practices: that of documentary photography and that of the discourse of advertising from which representative textual fragments are taken.[43]

Each of the seventeen panels offers us a posed and constructed photograph of an employee within the industry, a caption designating types of professional employed but not necessarily describing the pictured employee, and a quotation from pages of the *Journal of Advertising*. The conventional overlaying and reinforcing characteristic of realist modes of representation are unsettled by the disparities between image, caption and text. They do not add up to provide that appearance of truth revealed. Instead the mechanics of that kind of suturing process are simply broken down. None the less, each element acquires a new signifying capacity. The photographs unsettle a viewer expecting the normal position of dominance and socially sanctioned voyeurism associated with documentary photography. The subjects are seated at a table, screened off or otherwise barricaded against the viewer. They are so obviously posed, so "frozen", that the usual staying of time by which the photograph "captures life" is unpleasurably exceeded. Finally the subjects stare back at the viewer defying the usual hierarchy of looking and being looked at. The terms extracted from their point of production and consumption are to be read symptomatically so that we recognize the discourse of advertising, which constructs the consuming subject, possessive, desiring, competitive. In an accompanying introduction to the piece, Mitra Tabrizian gives a Brechtian gloss:

> We should therefore not ask whether advertising informs or represents or misrepresents existing values but should rather open up the question of its effects. Definitions of reality are created within different discursive practices (e.g. advertising) at a particular time in a society. Struggles within ideology are struggles to change these definitions which have to be shifted if we are to create other "forms of subjectivity".[44]

Yve Lomax exhibited sections of a continuing project titled *Open Rings and Partial Lines* [Figure 13.1] which is composed of a series of large triptych photographic panels. Two images confront

each other across a third, a divider which does not provide the link or middle term to resolve the relation between or meanings of the flanking pair. The format itself is a protest against the binary oppositions which underpin the heterosexist regime of sexual difference. Montage is used here to refuse wholeness either of woman or in a binary pairing of man/woman.[45]

> What more difference is there than between boys and girls. The difference, obviously. And what could be less than this difference. And being less, how could it ever be more. What more difference is there than between boys and girls – a difference, obviously between more than two. More and no more. . . .
>
> The difference between two reduces everything to the same. No more and yet always more. And even though I may say with much resonance that *I am a woman*, even though I may resonantly speak of *we* don't expect me to remain the same; don't expect that we are all *The Same*, many of the same, a plurality reducible to one.[46]

The tripartite panels jarringly expose diverse images of women which relay us off to major sites for the production and circulation of "truths" about "woman" – advertising, film noir, melodrama, fashion photography, television and so forth. Extracting the codes and rhetorics of these modes of representation reveals their unexpected menace. Those images which we recognize as not being quotes or parodies figure woman against the grain of dominant representations. They manage to suggest that their women subjects are not available to the viewer's controlling, possessing or fantasizing gaze. This process negotiates a thin line between presenting woman as mysterious enigma, fascinatingly other and creating a quality of reserve, a state of sufficiency, "otherwise engaged", articulating a subjectivity and a non fetishized sexuality of and for women.

Since 1978 when she exhibited at the *Three Perspectives of Photography* (Arts Council, London, Hayward Gallery,) Yve Lomax has been investigating the relation between the (so-called) enigma of femininity and truth in the territory of photographic representation. Photography promises power by offering to make truth visible – all is knowable in its gaze. It unites the visible and the invisible, a presence and an absence. Woman is obsessively caught not only as the silenced object of that possessing and empowering gaze, but as its very sign. So how can we represent women unless we work against the contradiction of woman as enigma functioning as sign of truth for man?[47]

Lomax's quotations and reconstructions do not correspond, for instance, with early work by Cindy Sherman in which she reconstructs the codes of the representation of femininity in cinema.[48] Much more than an exposé of the feminine as masquerade, Lomax's work explodes the binary oppositions in which the feminine is trapped as Other, as difference, as much in evidence in feminist as in patriarchal ideologies. For Lomax the point is not to seek another site for feminine truth, some essence or wholeness. In the fragments which refuse to be reunited or even imagined as parts of an original whole, difference and heterogeneity are postulated in more radical terms. In 1982 she wrote:

> Will we search for that which makes the whole? Searching, searching, searching – what a sad search! Will the desire to seek the whole work against women's multiplicity and become a reductionist exercise, building up to a neat, well secured whole, all the diverse and particular parts which women are and make?[49]

In the case of Yve Lomax depropriation goes beyond critique. It involves a double process – a refusal of the dominant hierarchy of sexualized binary oppositions and a preliminary articulation

of meanings and desire for female subjects. Thus in the musings which accompany the visual texts Lomax voices irreverent feminist questions about theorizations of representation and the sexual order it underpins. Parodying the psychoanalytical theories of sexual difference Lomax uses irony to expose its phallocentricity.

Lack's last laugh

Fearing the lack of the whole we journey to seek its presence.

Between two elements we search for a link – surely this will allow us to arrive at the whole.

What is it we fear we lack and how shall we exactly know when we arrived, wholly satisfied?

Around and around we go.

Desire only comes when Something goes. Yes but also no.

The whole withdraws itself, it goes into hiding and creates a telling lack. By way of all absence all is set in motion for the whole to be brought back. In the name of absence the whole totalises the parts. It forms a constellation of which it is a non-part. Representation hinges upon lack and this makes all the difference.

If we no longer play that game of hide and seek.

Laughter with a thousand edges.

No part can ever stand alone; it takes many lines to make a specific part.

The title, the head – that too is an open part. A part which constantly rings with other parts.

There is no sovereign or whole meaning; no one message going down the line.[50]

Feminist art and argument often oppose dominant representations as stereotypical, false, inadequate, and offer instead a positive, alternative imagery valorizing what "real" women are "really like". This can, however, merely replace one myth of woman with another, presupposing some essence or common identity in place of a radical recognition of multiple differences, class, race, sexuality, culture, religion, age and so forth. Lomax's work recalls a telling refusal of oversimplification by Italian writer Anne Marie Sauzeau Boetti, writing in 1976 of feminist strategies:

This kind of project offers the only means of objectivising feminine existence: not a positive avant-garde subversion but a process of differentiation. Not the project of fixing meanings, but of breaking them up and multiplying them.[51]

We are not seeking a new meaning for Woman but rather a total dissolution of the system by which sex/gender is organized to function as the criterion upon which differential and degrading treatment is assigned and naturalized.

The importance of this position hardly needs to be stressed in the present context when so many different groups across the world are revolting against their enforced submission to imperializing classifications and claiming recognition of their specificity and diversity.

[. . .]

Notes

1 For discussion of this strategy against the "biological" canon of "all women" shows see Mary Kelly, "Beyond the purloined image", *BLOCK*, 1983 (9), 68.

2 Kate Linker, "Foreword", *Difference – On Sexuality and Representation*, New York, New Museum of Contemporary Art, 1984, 5.

3 Hal Foster, "Post modernism: a preface", in *The Anti-Aesthetic – Essays on Post Modern Culture*, Port Townsend, Bay Press, 1983, reprinted as *Post Modern Culture*, London, Pluto Press, 1985, xii.

4 The ideology of art which neo-expressionist criticism recirculates is simply articulated in this text: "The artists' studios are full of paint pots again and an abandoned easel in an art school has become a rare sight. Wherever you look in Europe or America you find artists who have rediscovered the sheer joy of painting. . . . In short, artists are involved in painting again, it has become crucial to them, and this new consciousness of the contemporary significance of the oldest form of their art is in the air, tangibly, wherever art is being made. This new concern with painting is related to a certain subjective vision, a vision that includes both an understanding of the artist himself as an individual engaged in a search for self-realisation and as an actor on a wider historical stage." Christos M. Joachimides. "A new spirit in painting", in the catalogue of the title, London, Royal Academy of Arts, 1981, 14.

5 For a fuller account of this see Kate Linker, "Representation and sexuality", *Parachute*, 1983 (32), reprinted in Brian Wallis (ed.), *Art After Modernism: Rethinking Representation*, New York, New Museum of Contemporary Art, and Boston, David R. Godine, 1984. For another site of critical address to psychoanalytically based theories of sexual difference see the issue of *Screen* 1987, 28 (1), "Deconstructing difference".

6 Hal Foster, "Introduction", *Recodings, Art, Spectacle, Culture Politics*, Port Townsend, Bay Press, 1985, 9.

7 Ibid., 9–10.

8 T. J. Clark, "Preliminaries to a possible treatment of *Olympia* in 1865", *Screen*, 1980, 21 (1) 38–41.

9 See *Aesthetics and Politics: Debates Between Ernst Bloch, George Lukacs, Bertolt Brecht, Walter Benjamin, Theodor Adorno*, translation editor Ronald Taylor, London, New Left Books, 1977.

10 Peter Wollen, "Manet: modernism and avant-garde", *Screen*, 1980, 21 (2), 25.

11 Ibid., 23.

12 In his later work on this topic published in *The Painting of Modern Life, Paris in the Art of Manet and His Followers*, New York, Knopff, and London, Thames & Hudson, 1984, Clark does position the prostitute as central to the discourses of modernity but still he attempts to fix this figure in terms of class and not gender relations, see 78, 117.

13 Laura Mulvey, "Visual pleasure and narrative cinema", *Screen*, 1975, 16 (3). [Chapter 9 in this volume.]

14 Carol Duncan and Alan Wallach, "The Museum of Modern Art as late capitalist ritual: an iconographic analysis", *Marxist Perspectives*, 1978, 1.

15 Lucy Lippard, "Sweeping exchanges: the contribution of feminism to the art of the seventies", *Art Journal*, 1980, 41 (1/2), 362.

16 Nichole Dubreuil-Blondin, "Feminism and modernism: some paradoxes", in *Modernism and Modernity. The Vancouver Conference Papers*, edited by Benjamin Buchloh, Halifax, Nova Scotia College of Art and Design Press, 1984, 197.

17 For an example of this attitude see Eva Cockcroft, "Abstract expressionism: weapon of the cold war", *Artforum*, June 1984.

18 Mary Kelly, "Re-viewing modernist criticism", *Screen*, 1981, 22 (3) 45.

19 It should be pointed out that these two formulations are not necessarily compatible and indeed Foucault's analysis implicated psychoanalysis in the historical construction of social regulation of persons via the constructions of sexuality. See Michel Foucault, *The History of Sexuality*, Vol. 1, *An Introduction* (1976) translated by Robert Hurley, London, Allen Lane, 1979. Also see Stephen Heath, *The Sexual Fix*, London, Macmillan, 1982.

20 Anthony Easthope, "The trajectory of *Screen* 1970–79", in Francis Barker (ed.), *The Politics of Theory*, Colchester, University of Essex, 1983.

21 See *Screen*, 1974, 15 (2), "Brecht and a revolutionary cinema" and 1975/6, 16 (4), transcript of the Edinburgh Film Festival Brecht Event.

22 Stephen Heath, "From Brecht to film: theses: problems", *Screen*, 1975/6, 16 (4), 39.

23 Stephen Heath, "Lessons from Brecht", *Screen*, 1974, 15 (2), 108–9.

24 Ibid., 107–8. It is relevant to note the parallels between Heath's arguments and those mounted in the previous chapter. For instance: "Think in this respect of the photograph, which seems to sustain exactly this fetishistic structure. The photograph places the subject in a relation of specularity – the glance –, holding him pleasurably in the safety of disavowal; at once knowledge – this exists – and a perspective of reassurance – but I am outside this existence . . . the duality rising to the fetishistic category *par excellence*, that of the beautiful", 107.

25 See Roland Barthes, "The death of the author", in Stephen Heath (ed.) *Image-Music-Text*, London, Fontana, 1977.

26 Julia Kristeva, "The system and the speaking subject", reprinted in Toril Moi, *The Kristeva Reader*, Oxford, Basil Blackwell, 1986.

27 Louis Althusser, "Ideology and ideological state apparatuses" in *Lenin and Philosophy and Other Essays*, translated by Ben Brewster, London, New Left Books, 1971.

28 Brecht himself was quite adamant about the historically varying forms of social individuality and because these changed at different stages and epochs of capitalism, cultural practices must be specific to their moments.

29 Heath, "Lessons from Brecht", 1974, 124.

30 See Terry Lovell, *Pictures of Reality. Aesthetics, Politics and Pleasure*, London, British Film Institute, 1980.

31 Heath, "Lessons from Brecht", 1974, 123.

32 See Annette Kuhn, *Women's Pictures: Feminism and Cinema*, London, Routledge & Kegan Paul, 1982; Rozsika Parker and Griselda Pollock, *Framing Feminism: Art and the Women's Movement 1970–85*, London, Pandora Press, 1987.

33 Heath, "From Brecht to film", 38.

34 Ibid., 35.

35 Claire Johnstone and Paul Willemen, "Brecht in Britain: the independent political film (on *The Nightcleaners*)", *Screen*, 1975/6, 16 (4).

36 Mary Kelly, *Post-Partum Document*, London, Routledge & Kegan Paul, 1983, 188.

37 Heath, "Lessons from Brecht", 124.

38 Colin MacCabe, "Realism and the cinema: some Brechtian theses", *Screen*, 1974, 15 (2), 12. The point is clearly made in John Tagg, "Poser and photography", *Screen Education*, 1980, 36, 53, where he writes that realism "works by the controlled and limited recall of a reservoir of similar 'texts', by a constant repetition, a constant cross-echoing".

39 Heath, "Lessons from Brecht", 120.

40 See Paula Marincola, *Image Scavengers: Photography*, Philadelphia Institute of Contemporary Art, 1982, and Abigail Solomon Godeau, *The Stolen Image and Its Uses*, Syracuse, New York, 1983. Also Abigail Solomon Godeau, "Winning the game when the rules have been changed: art, photography and post-modernism", *Screen*, 1984, 25 (6).

41 Jean Baudrillard, *For A Critique of the Political Economy of the Sign*, St Louis, Telos Press, 1981 and "The Precession of the simulacra", reprinted in Brian Wallis (ed.), *Art After Modernism: Rethinking Representation*, New York, The New Museum of Contemporary Art, 1984.

42 The panels are reproduced in *Screen*, 1983, 24 (4–5). Other work by Mitra Tabrizian has been published as follows: *College of Fashioning Model Course* in *Screen Education*, 1982 (40), *Women In Iran* in *Feminist Review*, 1982 (12), *Correct Distance, Part I* in *Screen*, 1984, 25 (3–4), *Correct Distance, Part II*, in *Feminist Review*, 1984 (28).

43 Ibid., 155.

44 Ibid., 155.

45 Yve Lomax, "The politics of montage", *Camerawork*, 1982, 9.

46 *Broken Lines: More and No More Difference*, text and photographs by Yve Lomax, *Screen*, 1987, 28 (1).

47 See *Three Perspectives on Photography*, London, Arts Council, 1978, 52–5, for Yve Lomax's text "Some stories which I have heard: some questions which I have asked".

48 Judith Williamson, "Images of 'woman' – the photographs of Cindy Sherman", *Screen*, 1983, 24 (6).

49 Reprinted in *Sense and Sensibility in Feminist Art Practice*, Nottingham Midland Group, 1982. This was a catalogue for an exhibition curated by Carol Jones and introduced by Griselda Pollock.

50 Quoted from a wall panel in the exhibition *Difference On Representation and Sexuality*, London Institute of Contemporary Art, 1985. Reading this text requires some familiarity with the current of psycho-analytical theory in which representation is premissed on absence, i.e. Freud observed little children playing a game of constantly throwing a toy which was repeatedly returned. Vocalization accompanied this play which Freud read as the beginning of symbolization used to "cover" the absence of the mother. At the Oedipal moment the gap or lack concerns the mother's phallus which becomes the signifier of lack and the primary signifier in a language system which institutionalizes lack – words are substitutes for absent things and persons. This schema is mapped on to the production of sexual difference in which this play of presence, absence, lack and wholeness produces the binary opposition of man, and woman being lack.

51 Anne Marie Sauzeau Boetti, "Negative capability as practice in women's art", *Studio International*, 1976, 191 (979), reprinted in Rozsika Parker and Griselda Pollock, *Framing Feminism, Art and the Women's Movement 1970–85*, London, Pandora Press, 1987.

BELL HOOKS

THE OPPOSITIONAL GAZE
Black female spectators

W HEN THINKING ABOUT BLACK FEMALE spectators, I remember being punished as a child for staring, for those hard intense direct looks children would give grown-ups, looks that were seen as confrontational, as gestures of resistance, challenges to authority. The "gaze" has always been political in my life. Imagine the terror felt by the child who has come to understand through repeated punishments that one's gaze can be dangerous. The child who has learned so well to look the other way when necessary. Yet, when punished, the child is told by parents, "Look at me when I talk to you." Only, the child is afraid to look. Afraid to look, but fascinated by the gaze. There is power in looking.

Amazed the first time I read in history classes that white slave-owners (men, women, and children) punished enslaved black people for looking, I wondered how this traumatic relationship to the gaze had informed black parenting and black spectatorship. The politics of slavery, of racialized power relations, were such that the slaves were denied their right to gaze. Connecting this strategy of domination to that used by grown folks in southern black rural communities where I grew up, I was pained to think that there was no absolute difference between whites who had oppressed black people and ourselves. Years later, reading Michel Foucault, I thought again about these connections, about the ways power as domination reproduces itself in different locations employing similar apparatuses, strategies, and mechanisms of control. Since I knew as a child that the dominating power adults exercised over me and over my gaze was never so absolute that I did not dare to look, to sneak a peep, to stare dangerously, I knew that the slaves had looked. That all attempts to repress our/black peoples' right to gaze had produced in us an overwhelming longing to look, a rebellious desire, an oppositional gaze. By courageously looking, we defiantly declared: "Not only will I stare. I want my look to change reality." Even in the worse circumstances of domination, the ability to manipulate one's gaze in the face of structures of domination that would contain it, opens up the possibility of agency. In much of his work, Michel Foucault insists on describing domination in terms of "relations of power" as part of an effort to challenge the assumption that "power is a system of domination which controls everything and which leaves no room for freedom." Emphatically stating that in all relations of power "there is necessarily the possibility of resistance," he invites the critical thinker to search those margins, gaps, and locations on and through the body where agency can be found.

Stuart Hall calls for recognition of our agency as black spectators in his essay "Cultural Identity and Cinematic Representation." Speaking against the construction of white representations of blackness as totalizing, Hall says of white presence: "The error is not to conceptualize this 'presence' in terms of power, but to locate that power as wholly external to us — as

extrinsic force, whose influence can be thrown off like the serpent sheds its skin." What Frantz Fanon reminds us, in *Black Skin, White Masks*, is how power is inside as well as outside:

> the movements, the attitudes, the glances of the Other fixed me there, in the sense in which a chemical solution is fixed by a dye. I was indignant; I demanded an explanation. Nothing happened. I burst apart. Now the fragments have been put together again by another self. This "look," from – so to speak – the place of the Other, fixes us, not only in its violence, hostility and aggression, but in the ambivalence of its desire.

Spaces of agency exist for black people, wherein we can both interrogate the gaze of the Other but also look back, and at one another, naming what we see. The "gaze" has been and is a site of resistance for colonized black people globally. Subordinates in relations of power learn experientially that there is a critical gaze, one that "looks" to document, one that is oppositional. In resistance struggle, the power of the dominated to assert agency by claiming and cultivating "awareness" politicizes "looking" relations – one learns to look a certain way in order to resist.

When most black people in the United States first had the opportunity to look at film and television, they did so fully aware that mass media was a system of knowledge and power reproducing and maintaining white supremacy. To stare at the television, or mainstream movies, to engage its images, was to engage its negation of black representation. It was the oppositional black gaze that responded to these looking relations by developing independent black cinema. Black viewers of mainstream cinema and television could chart the progress of political movements for racial equality *via* the construction of images, and did so. Within my family's southern black working-class home, located in a racially segregated neighborhood, watching television was one way to develop critical spectatorship. Unless you went to work in the white world, across the tracks, you learned to look at white people by staring at them on the screen. Black looks, as they were constituted in the context of social movements for racial uplift, were interrogating gazes. We laughed at television shows like *Our Gang* and *Amos 'n' Andy*, at these white representations of blackness, but we also looked at them critically. Before racial integration, black viewers of movies and television experienced visual pleasure in a context where looking was also about contestation and confrontation.

Writing about black looking relations in "Black British Cinema: Spectatorship and Identity Formation in Territories," Manthia Diawara identifies the power of the spectator: "Every narration places the spectator in a position of agency; and race, class and sexual relations influence the way in which this subjecthood is filled by the spectator." Of particular concern for him are moments of "rupture" when the spectator resists "complete identification with the film's discourse." These ruptures define the relation between black spectators and dominant cinema prior to racial integration. Then, one's enjoyment of a film wherein representations of blackness were stereotypically degrading and dehumanizing co-existed with a critical practice that restored presence where it was negated. Critical discussion of the film while it was in progress or at its conclusion maintained the distance between spectator and the image. Black films were also subject to critical interrogation. Since they came into being in part as a response to the failure of white-dominated cinema to represent blackness in a manner that did not reinforce white supremacy, they too were critiqued to see if images were seen as complicit with dominant cinematic practices.

Critical, interrogating black looks were mainly concerned with issues of race and racism, the way racial domination of blacks by whites overdetermined representation. They were rarely concerned with gender. As spectators, black men could repudiate the reproduction of

racism in cinema and television, the negation of black presence, even as they could feel as though they were rebelling against white supremacy by daring to look, by engaging phallocentric politics of spectatorship. Given the real life public circumstances wherein black men were murdered/lynched for looking at white womanhood, where the black male gaze was always subject to control and/or punishment by the powerful white Other, the private realm of television screens or dark theaters could unleash the repressed gaze. There they could "look" at white womanhood without a structure of domination overseeing the gaze, interpreting, and punishing. That white supremacist structure that had murdered Emmet Till after interpreting his look as violation, as "rape" of white womanhood, could not control black male responses to screen images. In their role as spectators, black men could enter an imaginative space of phallocentric power that mediated racial negation. This gendered relation to looking made the experience of the black male spectator radically different from that of the black female spectator. Major early black male independent filmmakers represented black women in their films as objects of male gaze. Whether looking through the camera or as spectators watching films, whether mainstream cinema or "race" movies such as those made by Oscar Micheaux, the black male gaze had a different scope from that of the black female.

Black women have written little about black female spectatorship, about our moviegoing practices. A growing body of film theory and criticism by black women has only begun to emerge. The prolonged silence of black women as spectators and critics was a response to absence, to cinematic negation. In "The Technology of Gender," Teresa de Lauretis, drawing on the work of Monique Wittig, calls attention to "the power of discourses to 'do violence' to people, a violence which is material and physical, although produced by abstract and scientific discourses as well as the discourses of the mass media." With the possible exception of early race movies, black female spectators have had to develop looking relations within a cinematic context that constructs our presence as absence, that denies the "body" of the black female so as to perpetuate white supremacy and with it a phallocentric spectatorship where the woman to be looked at and desired is "white." (Recent movies do not conform to this paradigm but I am turning to the past with the intent to chart the development of black female spectatorship.)

Talking with black women of all ages and classes, in different areas of the United States, about their filmic looking relations, I hear again and again ambivalent responses to cinema. Only a few of the black women I talked with remembered the pleasure of race movies, and even those who did, felt that pleasure interrupted and usurped by Hollywood. Most of the black women I talked with were adamant that they never went to movies expecting to see compelling representations of black femaleness. They were all acutely aware of cinematic racism – its violent erasure of black womanhood. In Anne Friedberg's essay "A Denial of Difference: Theories of Cinematic Identification" she stresses that "identification can only be made through recognition, and all recognition is itself an implicit confirmation of the ideology of the status quo." Even when representations of black women were present in film, our bodies and being were there to serve – to enhance and maintain white womanhood as object of the phallocentric gaze.

Commenting on Hollywood's characterization of black women in *Girls on Film*, Julie Burchill describes this absent presence:

> Black women have been mothers without children (Mammies – who can ever forget the sickening spectacle of Hattie MacDaniels waiting on the simpering Vivien Leigh hand and foot and enquiring like a ninny, "What's ma lamb gonna wear?") . . . Lena Horne, the first black performer signed to a long term contract with a major

(MGM), looked gutless but was actually quite spirited. She seethed when Tallulah Bankhead complimented her on the paleness of her skin and the non-Negroidness of her features.

When black women actresses like Lena Horne appeared in mainstream cinema most white viewers were not aware that they were looking at black females unless the film was specifically coded as being about blacks. Burchill is one of the few white women film critics who has dared to examine the intersection of race and gender in relation to the construction of the category "woman" in film as object of the phallocentric gaze. With characteristic wit she asserts: "What does it say about racial purity that the best blondes have all been brunettes (Harlow, Monroe, Bardot)? I think it says that we are not as white as we think." Burchill could easily have said "we are not as white as we want to be," for clearly the obsession to have white women film stars be ultra-white was a cinematic practice that sought to maintain a distance, a separation between that image and the black female Other; it was a way to perpetuate white supremacy. Politics of race and gender were inscribed into mainstream cinematic narrative from *Birth of A Nation* on. As a seminal work, this film identified what the place and function of white womanhood would be in cinema. There was clearly no place for black women.

Remembering my past in relation to screen images of black womanhood, I wrote a short essay, "Do you remember Sapphire?" which explored both the negation of black female representation in cinema and television and our rejection of these images. Identifying the character of "Sapphire" from *Amos 'n' Andy* as that screen representation of black femaleness I first saw in childhood, I wrote:

> She was even then backdrop, foil. She was bitch – nag. She was there to soften images of black men, to make them seem vulnerable, easygoing, funny, and unthreatening to a white audience. She was there as man in drag, as castrating bitch, as someone to be lied to, someone to be tricked, someone the white and black audience could hate. Scapegoated on all sides. *She was not us.* We laughed with the black men, with the white people. We laughed at this black woman who was not us. And we did not even long to be there on the screen. How could we long to be there when our image, visually constructed, was so ugly. We did not long to be there. We did not long for her. We did not want our construction to be this hated black female thing – foil, backdrop. Her black female image was not the body of desire. There was nothing to see. She was not us.

Grown black women had a different response to Sapphire; they identified with her frustrations and her woes. They resented the way she was mocked. They resented the way these screen images could assault black womanhood, could name us bitches, nags. And in opposition they claimed Sapphire as their own, as the symbol of that angry part of themselves white folks and black men could not even begin to understand.

Conventional representations of black women have done violence to the image. Responding to this assault, many black women spectators shut out the image, looked the other way, accorded cinema no importance in their lives. Then there were those spectators whose gaze was that of desire and complicity. Assuming a posture of subordination, they submitted to cinema's capacity to seduce and betray. They were cinematically "gaslighted." Every black woman I spoke with who was/is an ardent moviegoer, a lover of the Hollywood film, testified that to experience fully the pleasure of that cinema they had to close down critique,

analysis; they had to forget racism. And mostly they did not think about sexism. What was the nature then of this adoring black female gaze – this look that could bring pleasure in the midst of negation? In her first novel, *The Bluest Eye*, Toni Morrison constructs a portrait of the black female spectator; her gaze is the masochistic look of victimization. Describing her looking relations, Miss Pauline Breedlove, a poor working woman, maid in the house of a prosperous white family, asserts:

> The onliest time I be happy seem like was when I was in the picture show. Every time I got, I went, I'd go early, before the show started. They's cut off the lights, and everything be black. Then the screen would light up, and I's move right on in them picture. White men taking such good care of they women, and they all dressed up in big clean houses with the bath tubs right in the same room with the toilet. Them pictures gave me a lot of pleasure.

To experience pleasure, Miss Pauline sitting in the dark must imagine herself transformed, turned into the white woman portrayed on the screen. After watching movies, feeling the pleasure, she says, "But it made coming home hard."

We come home to ourselves. Not all black women spectators submitted to that spectacle of regression through identification. Most of the women I talked with felt that they consciously resisted identification with films – that this tension made moviegoing less than pleasurable; at times it caused pain. As one black woman put it, "I could always get pleasure from movies as long as I did not look too deep." For black female spectators who have "looked too deep" the encounter with the screen hurt. That some of us chose to stop looking was a gesture of resistance, turning away was one way to protest, to reject negation. My pleasure in the screen ended abruptly when I and my sisters first watched *Imitation of Life*. Writing about this experience in the "Sapphire" piece, I addressed the movie directly, confessing:

> I had until now forgotten you, that screen image seen in adolescence, those images that made me stop looking. It was there in *Imitation of Life*, that comfortable mammy image. There was something familiar about this hard-working black woman who loved her daughter so much, loved her in a way that hurt. Indeed, as young southern black girls watching this film, Peola's mother reminded us of the hardworking, church-going, Big Mamas we knew and loved. Consequently, it was not this image that captured our gaze; we were fascinated by Peola.

Addressing her, I wrote:

> You were different. There was something scary in this image of young sexual sensual black beauty betrayed – that daughter who did not want to be confined by black-ness, that "tragic mulatto" who did not want to be negated. "Just let me escape this image forever," she could have said. I will always remember that image. I remem-bered how we cried for her, for our unrealized desiring selves. She was tragic because there was no place in the cinema for her, no loving pictures. She too was absent image. It was better then, that we were absent, for when we were there it was humiliating, strange, sad. We cried all night for you, for the cinema that had no place for you. And like you, we stopped thinking it would one day be different.

When I returned to films as a young woman, after a long period of silence, I had devel-oped an oppositional gaze. Not only would I not be hurt by the absence of black female

presence, or the insertion of violating representation, I interrogated the work, cultivated a way to look past race and gender for aspects of content, form, language. Foreign films and U.S. independent cinema were the primary locations of my filmic looking relations, even though I also watched Hollywood films.

From "jump," black female spectators have gone to films with awareness of the way in which race and racism determined the visual construction of gender. Whether it was *Birth of A Nation* or Shirley Temple shows, we knew that white womanhood was the racialized sexual difference occupying the place of stardom in mainstream narrative film. We assumed white women knew it to. Reading Laura Mulvey's provocative essay, "Visual Pleasure and Narrative Cinema," from a standpoint that acknowledges race, one sees clearly why black women spectators not duped by mainstream cinema would develop an oppositional gaze. Placing ourselves outside that pleasure in looking, Mulvey argues, was determined by a "split between active/male and passive/female." Black female spectators actively chose not to identify with the film's imaginary subject because such identification was disenabling.

Looking at films with an oppositional gaze, black women were able to critically assess the cinema's construction of white womanhood as object of phallocentric gaze and choose not to identify with either the victim or the perpetrator. Black female spectators, who refused to identify with white womanhood, who would not take on the phallocentric gaze of desire and possession, created a critical space where the binary opposition Mulvey posits of "woman as image, man as bearer of the look" was continually deconstructed. As critical spectators, black women looked from a location that disrupted, one akin to that described by Annette Kuhn in *The Power of the Image*:

> the acts of analysis, of deconstruction and of reading "against the grain" offer an additional pleasure – the pleasure of resistance, of saying "no": not to "unsophisticated" enjoyment, by ourselves and others, of culturally dominant images, but to the structures of power which ask us to consume them uncritically and in highly circumscribed ways.

Mainstream feminist film criticism in no way acknowledges black female spectatorship. It does not even consider the possibility that women can construct an oppositional gaze via an understanding and awareness of the politics of race and racism. Feminist film theory rooted in an ahistorical psychoanalytic framework that privileges sexual difference actively suppresses recognition of race, reenacting and mirroring the erasure of black womanhood that occurs in films, silencing any discussion of racial difference – of racialized sexual difference. Despite feminist critical interventions aimed at deconstructing the category "woman" which highlight the significance of race, many feminist film critics continue to structure their discourse as being about "women" when in actuality it speaks only about white women. It seems ironic that the cover of the recent anthology *Feminism and Film Theory* edited by Constance Penley has a graphic that is a reproduction of the photo of white actresses Rosalind Russell and Dorothy Arzner on the 1936 set of the film *Craig's Wife* yet there is no acknowledgement in any essay in this collection that the woman "subject" under discussion is always white. Even though there are photos of black women from films reproduced in the text, there is no acknowledgment of racial difference.

It would be too simplistic to interpret this failure of insight solely as a gesture of racism. Importantly, it also speaks to the problem of structuring feminist film theory around a totalizing narrative of woman as object whose image functions solely to reaffirm and reinscribe patriarchy. Mary Ann Doane addresses this issue in the essay "Remembering Women: Psychical and Historical Constructions in Film Theory":

This attachment to the figure of a degeneralizible Woman as the product of the apparatus indicates why, for many, feminist film theory seems to have reached an impasse, a certain blockage in its theorization . . . In focusing upon the task of delineating in great detail the attributes of woman as effect of the apparatus, feminist film theory participates in the abstraction of women.

The concept "Woman" effaces the difference between women in specific socio-historical contexts, between women defined precisely as historical subjects rather than as *a* psychic subject (or non-subject). Though Doane does not focus on race, her comments speak directly to the problem of its erasure. For it is only as one imagines "woman" in the abstract, when woman becomes fiction or fantasy, can race not be seen as significant. Are we really to imagine that feminist theorists writing only about images of white women, who subsume this specific historical subject under the totalizing category "woman," do not "see" the whiteness of the image? It may very well be that they engage in a process of denial that eliminates the necessity of revisioning conventional ways of thinking about psychoanalysis as a paradigm of analysis and the need to rethink a body of feminist film theory that is firmly rooted in a denial of the reality that sex/sexuality may not be the primary and/or exclusive signifier of difference. Doane's essay appears in a very recent anthology, *Psychoanalysis and Cinema* edited by E. Ann Kaplan, where, once again, none of the theory presented acknowledges or discusses racial difference, with the exception of one essay, "Not Speaking with Language, Speaking with No Language," which problematizes notions of orientalism in its examination of Leslie Thornton's film *Adynata*. Yet in most of the essays, the theories espoused are rendered problematic if one includes race as a category of analysis.

Constructing feminist film theory along these lines enables the production of a discursive practice that need never theorize any aspect of black female representation or spectatorship. Yet the existence of black women within white supremacist culture problematizes, and makes complex, the overall issue of female identity, representation, and spectatorship. If, as Friedberg suggests, "identification is a process which commands the subject to be displaced by an other; it is a procedure which breaches the separation between self and other, and, in this way, replicates the very structure of patriarchy." If identification "demands sameness, necessitates similarity, disallows difference" – must we then surmise that many feminist film critics who are "over-identified" with the mainstream cinematic apparatus produce theories that replicate its totalizing agenda? Why is it that feminist film criticism, which has most claimed the terrain of woman's identity, representation, and subjectivity as its field of analysis, remains aggressively silent on the subject of blackness and specifically representations of black womanhood? Just as mainstream cinema has historically forced aware black female spectators not to look, much feminist film criticism disallows the possibility of a theoretical dialogue that might include black women's voices. It is difficult to talk when you feel no one is listening, when you feel as though a special jargon or narrative has been created that only the chosen can understand. No wonder then that black women have for the most part confined our critical commentary on film to conversations. And it must be reiterated that this gesture is a strategy that protects us from the violence perpetuated and advocated by discourses of mass media. A new focus on issues of race and representation in the field of film theory could critically intervene on the historical repression reproduced in some arenas of contemporary critical practice, making a discursive space for discussion of black female spectatorship possible.

When I asked a black woman in her twenties, an obsessive moviegoer, why she thought we had not written about black female spectatorship, she commented: "we are afraid to talk about ourselves as spectators because we have been so abused by 'the gaze'." An aspect of

that abuse was the imposition of the assumption that black female looking relations were not important enough to theorize. Film theory as a critical "turf" in the United States has been and continues to be influenced by and reflective of white racial domination. Since feminist film criticism was initially rooted in a women's liberation movement informed by racist practices, it did not open up the discursive terrain and make it more inclusive. Recently, even those white film theorists who include an analysis of race show no interest in black female spectatorship. In her introduction to the collection of essays *Visual and Other Pleasures*, Laura Mulvey describes her initial romantic absorption in Hollywood cinema, stating:

> Although this great, previously unquestioned and unanalyzed love was put in crisis by the impact of feminism on my thought in the early 1970s, it also had an enormous influence on the development of my critical work and ideas and the debate within film culture with which I became preoccupied over the next fifteen years or so. Watched through eyes that were affected by the changing climate of consciousness, the movies lost their magic.

Watching movies from a feminist perspective, Mulvey arrived at that location of disaffection that is the starting point for many black women approaching cinema within the lived harsh reality of racism. Yet her account of being a part of a film culture whose roots rest on a founding relationship of adoration and love indicates how difficult it would have been to enter that world from "jump" as a critical spectator whose gaze had been formed in opposition.

Given the context of class exploitation, and racist and sexist domination, it has only been through resistance, struggle, reading, and looking "against the grain," that black women have been able to value our process of looking enough to publicly name it. Centrally, those black female spectators who attest to the oppositionality of their gaze deconstruct theories of female spectatorship that have relied heavily on the assumption that, as Doane suggests in her essay, "Woman's Stake: Filming the Female Body," "woman can only mimic man's relation to language, that is assume a position defined by the penis-phallus as the supreme arbiter of lack." Identifying with neither the phallocentric gaze nor the construction of white womanhood as lack, critical black female spectators construct a theory of looking relations where cinematic visual delight is the pleasure of interrogation. Every black woman spectator I talked to, with rare exception, spoke of being "on guard" at the movies. Talking about the way being a critical spectator of Hollywood films influenced her, black woman filmmaker Julie Dash exclaims, "I make films because I was such a spectator!" Looking at Hollywood cinema from a distance, from that critical politicized standpoint that did not want to be seduced by narratives reproducing her negation, Dash watched mainstream movies over and over again for the pleasure of deconstructing them. And of course there is that added delight if one happens, in the process of interrogation, to come across a narrative that invites the black female spectator to engage the text with no threat of violation.

Significantly, I began to write film criticism in response to the first Spike Lee movie, *She's Gotta Have It*, contesting Lee's replication of mainstream patriarchal cinematic practices that explicitly represents woman (in this instance black woman) as the object of a phallocentric gaze. Lee's investment in patriarchal filmic practices that mirror dominant patterns makes him the perfect black candidate for entrance to the Hollywood canon. His work mimics the cinematic construction of white womanhood as object, replacing her body as text on which to write male desire with the black female body. It is transference without transformation. Entering the discourse of film criticism from the politicized location of resistance, of not wanting, as a working-class black woman I interviewed stated, "to see black women in the

position white women have occupied in film forever," I began to think critically about black female spectatorship.

For years I went to independent and/or foreign films where I was the only black female present in the theater. I often imagined that in every theater in the United States there was another black woman watching the same film wondering why she was the only visible black female spectator. I remember trying to share with one of my five sisters the cinema I liked so much. She was "enraged" that I brought her to a theater where she would have to read subtitles. To her it was a violation of Hollywood notions of spectatorship, of coming to the movies to be entertained. When I interviewed her to ask what had changed her mind over the years, led her to embrace this cinema, she connected it to coming to critical conscious-ness, saying, "I learned that there was more to looking than I had been exposed to in ordinary (Hollywood) movies." I shared that though most of the films I loved were all white, I could engage them because they did not have in their deep structure a subtext reproducing the narrative of white supremacy. Her response was to say that these films demystified "white," since the lives they depicted seemed less rooted in fantasies of escape. They were, she suggested, more like "what we knew life to be, the deeper side of life as well." Always more seduced and enchanted with Hollywood cinema than me, she stressed that unaware black female spectators must "break out," no longer be imprisoned by images that enact a drama of our negation. Though she still sees Hollywood films, because "they are a major influence in the culture" – she no longer feels duped or victimized.

Talking with black female spectators, looking at written discussions either in fiction or academic essays about black women, I noted the connection made between the realm of repre-sentation in mass media and the capacity of black women to construct ourselves as subjects in daily life. The extent to which black women feel devalued, objectified, dehumanized in this society determines the scope and texture of their looking relations. Those black women whose identifies were constructed in resistance, by practices that oppose the dominant order, were most inclined to develop an oppositional gaze. Now that there is a growing interest in films produced by black women and those films have become more accessible to viewers, it is possible to talk about black female spectatorship in relation to that work. So far, most discussions of black spectatorship that I have come across focus on men. In "Black Spectatorship: Problems of Identification and Resistance" Manthia Diawara suggests that "the components of 'difference'" among elements of sex, gender, and sexuality give rise to different readings of the same material, adding that these conditions produce a "resisting" spectator. He focuses his critical discussion on black masculinity.

The recent publication of the anthology *The Female Gaze: Women as Viewers of Popular Culture*, edited by Lorraine Gamman and Margaret Marshment, excited me, especially as it included an essay, "Black Looks" by Jacqui Roach and Petal Felix, that attempts to address black female spectatorship. The essay posed provocative questions that were not answered: Is there a black female gaze? How do black women relate to the gender politics of representation? Concluding, the authors assert that black females have "our own reality, our own history, our own gaze – one which sees the world rather differently from 'anyone else.'" Yet, they do not name/describe this experience of seeing "rather differently." The absence of definition and explanation suggests they are assuming an essentialist stance wherein it is presumed that black women, as victims of race and gender oppression, have an inherently different field of vision. Many black women do not "see differently" precisely because their perceptions of reality are so profoundly colonized, shaped by dominant ways of knowing. As Trinh T. Minh-ha points out in "Outside In, Inside Out": "Subjectivity does not merely consist of talking about oneself . . . be this talking indulgent or critical."

Critical black female spectatorship emerges as a site of resistance only when individual black women actively resist the imposition of dominant ways of knowing and looking. While every black woman I talked to was aware of racism, that awareness did not automatically correspond with politicization, the development of an oppositional gaze. When it did, individual black women consciously named the process. Manthia Diawara's "resisting spectatorship" is a term that does not adequately describe the terrain of black female spectatorship. We do more than resist. We create alternative texts that are not solely reactions. As critical spectators, black women participate in a broad range of looking relations, contest, resist, revision, interrogate, and invent on multiple levels. Certainly when I watch the work of black women filmmakers Camille Billops, Kathleen Collins, Julie Dash, Ayoka Chenzira, Zeinabu Davis, I do not need to "resist" the images even as I still choose to watch their work with a critical eye.

Black female critical thinkers concerned with creating space for the construction of radical black female subjectivity, and the way cultural production informs this possibility, fully acknowledge the importance of mass media, film in particular, as a powerful site for critical intervention. Certainly Julie Dash's film *Illusions* identifies the terrain of Hollywood cinema as a space of knowledge production that has enormous power. Yet, she also creates a filmic narrative wherein the black female protagonist subversively claims that space. Inverting the "real-life" power structure, she offers the black female spectator representations that challenge stereotypical notions that place us outside the realm of filmic discursive practices. Within the film she uses the strategy of Hollywood suspense films to undermine those cinematic practices that deny black women a place in this structure. Problematizing the question of "racial" identity by depicting passing, suddenly it is the white male's capacity to gaze, define, and know that is called into question.

When Mary Ann Doane describes in "Woman's Stake: Filming the Female Body" the way in which feminist filmmaking practice can elaborate "a special syntax for a different articulation of the female body," she names a critical process that "undoes the structure of the classical narrative through an insistence upon its repressions." An eloquent description, this precisely names Dash's strategy in *Illusions*, even though the film is not unproblematic and works within certain conventions that are not successfully challenged. For example, the film does not indicate whether the character Mignon will make Hollywood films that subvert and transform the genre or whether she will simply assimilate and perpetuate the norm. Still, subversively, *Illusions* problematizes the issue of race and spectatorship. White people in the film are unable to "see" that race informs their looking relations. Though she is passing to gain access to the machinery of cultural production represented by film, Mignon continually asserts her ties to black community. The bond between her and the young black woman singer Esther Jeeter is affirmed by caring gestures of affirmation, often expressed by eye-to-eye contact, the direct unmediated gaze of recognition. Ironically, it is the desiring objectifying sexualized white male gaze that threatens to penetrate her "secrets" and disrupt her process. Metaphorically, Dash suggests the power of black women to make films will be threatened and undermined by that white male gaze that seeks to reinscribe the black female body in a narrative of voyeuristic pleasure where the only relevant opposition is male/female, and the only location for the female is as a victim. These tensions are not resolved by the narrative. It is not at all evident that Mignon will triumph over the white supremacist capitalist imperialist dominating "gaze."

Throughout *Illusions*, Mignon's power is affirmed by her contact with the younger black woman whom she nurtures and protects. It is this process of mirrored recognition that enables both black women to define their reality, apart from the reality imposed upon them by structures of domination. The shared gaze of the two women reinforces their solidarity. As the

younger subject, Esther represents a potential audience for films that Mignon might produce, films wherein black females will be the narrative focus. Julie Dash's recent feature-length film *Daughters of the Dust* dares to place black females at the center of its narrative. This focus caused critics (especially white males) to critique the film negatively or to express many reservations. Clearly, the impact of racism and sexism so over-determine spectatorship – not only what we look at but who we identify with – that viewers who are not black females find it hard to empathize with the central characters in the movie. They are adrift without a white presence in the film.

Another representation of black females nurturing one another *via* recognition of their common struggle for subjectivity is depicted in Sankofa's collective work *Passion of Remembrance*. In the film, two black women friends, Louise and Maggie, are from the onset of the narrative struggling with the issue of subjectivity, of their place in progressive black liberation movements that have been sexist. They challenge old norms and want to replace them with new understandings of the complexity of black identity, and the need for liberation struggles that address that complexity. Dressing to go to a party, Louise and Maggie claim the "gaze." Looking at one another, staring in mirrors, they appear completely focused on their encounter with black femaleness. How they see themselves is most important, not how they will be stared at by others. Dancing to the tune "Let's get Loose," they display their bodies not for a voyeuristic colonizing gaze but for that look of recognition that affirms their subjectivity – that constitutes them as spectators. Mutually empowered they eagerly leave the privatized domain to confront the public. Disrupting conventional racist and sexist stereotypical representations of black female bodies, these scenes invite the audience to look differently. They act to critically intervene and transform conventional filmic practices, changing notions of spectatorship. *Illusions*, *Daughters of the Dust*, and *Passion of Remembrance* employ a deconstructive filmic practice to undermine existing grand cinematic narratives even as they retheorize subjectivity in the realm of the visual. Without providing "realistic" positive representations that emerge only as a response to the totalizing nature of existing narratives, they offer points of radical departure. Opening up a space for the assertion of a critical black female spectatorship, they do not simply offer diverse representations, they imagine new transgressive possibilities for the formulation of identity.

In this sense they make explicit a critical practice that provides us with different ways to think about black female subjectivity and black female spectatorship. Cinematically, they provide new points of recognition, embodying Stuart Hall's vision of a critical practice that acknowledges that identity is constituted "not outside but within representation," and invites us to see film "not as a second-order mirror held up to reflect what already exists, but as that form of representation which is able to constitute us as new kinds of subjects, and thereby enable us to discover who we are." It is this critical practice that enables production of feminist film theory that theorizes black female spectatorship. Looking and looking back, black women involve ourselves in a process whereby we see our history as counter-memory, using it as a way to know the present and invent the future.

References

Burchill, Julie. *Girls on Film*. New York: Pantheon, 1986.

de Lauretis, Teresa. *Technologies of Gender: Essays on Theory Film, and Fiction*. Bloomington, IN: Indiana University Press, 1987.

Diawara, Manthia. "Black British Cinema: Spectatorship and Identity Formation in Territories." *Public Culture*, Vol. 1, No. 3 (Summer 1989).

—— "Black Spectatorship: Problems of Identification and Resistance." *Screen*, Vol. 29, No. 4 (1988).

Doane, Mary Ann. "Remembering Women: Psychical and Historical Constructions in Film Theory." In *Psychoanalysis & Cinema*, edited by E. Ann Kaplan. London: Routledge, 1990.

—— "Woman's Stake: Filming the Female Body." In *Feminism and Film Theory*, edited by Constance Penley, New York: Routledge, 1988.

Fanon, Frantz. *Black Skin, White Masks*. New York: Monthly Review, 1967.

Foucault, Michel. *Language, Counter-memory, Practice: Selected Essays and Interviews*. Edited by Donald F. Bouchard, translated by Bouchard and Sherry Simon. Ithaca, NY: Cornell University Press, 1977.

—— *Power/Knowledge: Selected Interviews and Other Writings*. Edited by Colin Gordon, translated by Gordon et al. New York: Pantheon, 1980.

Friedberg, Anne. "A Denial of Difference: Theories of Cinematic Identification." In *Psychoanalysis & Cinema*, edited by E. Ann Kaplan. London: Routledge, 1990.

Gamman, Lorraine and Margaret Marshment. *Female Gaze: Women as Viewers of Popular Culture*. Seattle, WA: Real Comet Press, 1989.

Hall, Stuart. "Cultural Identity and Cinematic Representation." *Framework*, 36 (1989): 68–81.

hooks, bell. *Ain't I A Woman: Black Women and Feminism*. Boston: South End Press, 1981.

—— *Feminist Theory: From Margin to Center*. Boston: South End Press, 1984.

—— *Talking Back: Thinking Feminist, Thinking Black*. Boston: South End Press, 1989.

—— *Yearning: Race, Gender, and Cultural Politics*. Boston: South End Press, 1990.

Kaplan, E. Ann, ed. *Psychoanalysis & Cinema: AFI Film Readers*. New York: Routledge, 1989.

Kuhn, Annette. *Power of the Image. Essays on Representation and Sexuality*. New York: Routledge, 1985.

Minh-ha, Trinh. "Outside In, Inside Out." In *Questions of Third World Cinema*, edited by Jim Pines. London: British Film Institute, 1989.

Morrison, Toni. *The Bluest Eye*. New York: Holt, Rinehart and Winston, 1970.

Mulvey, Laura. *Visual and Other Pleasures*. Bloomington, IN: Indiana University Press, 1989.

Penley, Constance. *Feminism and Film Theory*. New York: Routledge, 1988.

Chapter 15

PEGGY PHELAN

BROKEN SYMMETRIES
Memory, sight, love

[B]elief is in itself the image: both arise out of the same procedures and through the same terms: *memory, sight, and love.*

(Julia Kristeva[1])

THE QUESTION OF BELIEF ALWAYS enters critical writing and perhaps never more urgently than when one's subject resists vision and may not be "really there" at all. Like the fantasy of erotic desire which frames love, the distortions of forgetting which

infect memories, and the blind spots laced through the visual field, a believable image is the product of a negotiation with an unverifiable real. As a representation of the real the image is always, partially, phantasmatic. In doubting the authenticity of the image, one questions as well the veracity of she who makes and describes it. To doubt the subject seized by the eye is to doubt the subjectivity of the seeing "I." These words work both to overcome and to deepen the provocation of that doubt.

As Jacques Lacan repeatedly argued, doubt is a defense against the real.[2] And as basketball players know, sometimes the most effective offense is a good defense. Doubt can be temporarily overcome by belief, that old and slightly arthritic leap of faith. Like Jacob's struggle with the Angel who will not give him a proper name, *Unmarked* attempts to find a theory of value for that which is not "really" there, that which cannot be surveyed within the boundaries of the putative real.

By locating a subject in what cannot be reproduced within the ideology of the visible, I am attempting to revalue a belief in subjectivity and identity which is not visibly representable. This is not the same thing as calling for greater visibility of the hitherto unseen. *Unmarked* examines the implicit assumptions about the connections between representational visibility and political power which have been a dominant force in cultural theory in the last ten years. Among the challenges this poses is how to retain the power of the unmarked by surveying it within a theoretical frame. By exposing the blind spot within the theoretical frame itself, it may be possible to construct a way of knowing which does not take surveillance of the object, visible or otherwise, as its chief aim.

Employing psychoanalysis and feminist theories of representation, I am concerned with marking the limit of the image in the political field of the sexual and racial other. I take as axiomatic the link between the image and the word, that what one can see is in every way related to what one can say. In framing more and more images of the hitherto under-represented other, contemporary culture finds a way to name, and thus to arrest and fix, the image of that other. Representation follows two laws: it always conveys more than it intends; and it is never totalizing. The "excess" meaning conveyed by representation creates a supplement that makes multiple and resistant readings possible. Despite this excess, representation produces ruptures and gaps; it fails to reproduce the real exactly. Precisely because of representation's supplemental excess and its failure to be totalizing, close readings of the logic of representation can produce psychic resistance and, possibly, political change. (Although rarely in the linear cause-effect way cultural critics on the Left and Right often assume.)

Currently, however, there is a dismaying similarity in the beliefs generated about the political efficacy of visible representation. The dangerous complicity between progressives dedicated to visibility politics and conservatives patroling the borders of museums, movie houses, and mainstream broadcasting is based on their mutual belief that representations can be treated as "real truths" and guarded or championed accordingly. Both sides believe that greater visibility of the hitherto under-represented leads to enhanced political power. The progressives want to share this power with "others"; conservatives want to reserve this power for themselves. Insufficient understanding of the relationship between visibility, power, identity, and liberation has led both groups to mistake the relation between the real and the representational.

As Judith Butler points out, the confusion between the real and the representational occurs because "the real is positioned both before and after its representation; and representation becomes a moment of the reproduction and consolidation of the real" ("Force of Fantasy": 106). The real is read through representation, and representation is read through the real.

Each representation relies on and reproduces a specific logic of the real; this logical real promotes its own representation. The real partakes of and generates different imagistic and discursive paradigms. There is, for example, a legal real in which concepts such as "the image" and "the claimant" are defended and decided through recourse to pre-established legal concepts such as copyright, trademark, property, the contract, and individual rights.[3] Within the physical universe, the real of the quantum is established through a negotiation with the limitations of the representational possibilities of measuring time and space. To measure motion that is not predictable requires that one consider the uncertainty of both the means of measurement and the energy that one wants to measure. Within the history of theatre the real is what theatre defines itself against, even while reduplicating its effects.[4] Within Lacanian psychoanalysis the Real is full Being itself. Freud's mapping of the unconscious, as Lacan consistently insisted, makes the Real forever impossible to realize (to make real) within the frame of the Symbolic.[5] Within the diverse genre of autobiography the real is considered the motivation for self-representation.[6] Each of these concepts of the real contains within it a meta-text of exclusionary power. Each real believes itself to be the Real-real. The discourse of Western science, law, theatrical realism, autobiography, and psychoanalysis are alike in believing their own terms to be the most comprehensive, the most basic, the most fundamental route to establishing or unsettling the stability of the real. By employing each of them in *Unmarked* I hope to demonstrate that the very proliferation of discourses can only disable the possibility of a Real-real.

I know this sounds oh-so-familiar to the ears of weary poststructuralists. But what is less familiar is the way in which the visible itself is woven into each of these discourses as an unmarked conspirator in the maintenance of each discursive real. I want to expose the ways in which the visible real is employed as a truth-effect for the establishment of these discursive and representational notions of the real. Moreover, I want to suggest that by seeing the blind spot within the visible real we might see a way to redesign the representational real. If the visible real is itself unable to constitute a reliable representational real its use-value must lie elsewhere.

The pleasure of resemblance and repetition produces both psychic assurance and political fetishization. Representation reproduces the Other as the Same. Performance, insofar as it can be defined as representation without reproduction, can be seen as a model for another representational economy, one in which the reproduction of the Other *as* the Same is not assured.[7]

The relationship between the real and the representational, between the looker and the given to be seen, is a version of the relation between self and other. Cultural theory has thus far left unexamined the connection between the psychic theory of the relationship between self and other and the political and epistemological contours of that encounter. This relationship between self and other is a marked one, which is to say it is unequal. It is alluring and violent because it touches the paradoxical nature of psychic desire; the always already unequal encounter nonetheless summons the hope of reciprocity and equality; the failure of this hope then produces violence, aggressivity, dissent. The combination of psychic hope and political-historical inequality makes the contemporary encounter between self and other a meeting of profound romance and deep violence. While cultural theorists of the colonial subject and revisionary meta-anthropologists have thrown welcome light on the historical pattern of the violence of this encounter, we still have relatively little knowledge of the romance nestled within it.

Unmarked concerns the relationship between the self and the other as it is represented in photographs, paintings, films, theatre, political protests, and performance art. While the notion of the potential reciprocal gaze has been considered part of the "unique" province of live

performance, the desire to be seen is also activated by looking at inanimate art. Examining the politics of the exchange of gaze across these diverse representational mediums leads to an extended definition of the field of performance. The "politics" of the imagined and actual exchange of gaze are most clearly exposed in relation to sexual difference. At once an attempt to stabilize "difference" and an attempt to repress the "sexual" itself, cultural representation seeks both to conceal and reveal a real that will "prove" that sexual difference is a real difference.

I

Psychoanalysis imagines a primal scene that is profoundly formative for the subject. The fundamental power of this primal scene is not mitigated by the difference between actually witnessing the scene or "only" imagining it. An imagined history and a history of a real ocular experience have similarly weighted consequences for the psychic subject. Given this concept of psychic history, the familiar argument that psychoanalysis is ahistorical can be seen as a mistaking of the notion of history which psychoanalysis employs. A noncontinuous psychic subject *cannot* be adequately reflected in a continuous historiography. In refusing to believe that the empirical real is more impressive than the imagined or fantasized (a belief fundamental to Western historiography), psychoanalysis is incompatible with histories that seek to demonstrate the "weight of empirical evidence," if that which is labeled empirical excludes that which is immaterial and phantasmatic.[8]

The primal scene is remembered and (re)visited through the dream and the symptom – through the imaginative attempt of the unconscious to replay the (past) scene on the stage of the present. Self-identity needs to be continually reproduced and reassured precisely because it fails to secure belief. It fails because it cannot rely on a verifiably continuous history. One's own origin is both real and imagined. The formation of the "I" cannot be witnessed by the "eye." The primal scene itself is (probably) a screen memory for the always-lost moment of one's own conception. Moreover, within the logic of psychic displacement, the memory of the primal scene also functions as a rehearsal for one's own death. The primal scene is a psychic revisiting and anticipation of the world without oneself. This vision is devastating and liberating; but it cannot be endured very long. One prefers instead to see oneself more or less securely situated. The process of self-identity is a leap into a narrative that employs seeing as a way of knowing. Mimetic correspondence has a psychic appeal because one seeks a self-image within the representational frame. Mimetic representation requires that the writer/speaker employs pronouns, invents characters, records conversations, examines the words and images of others, so that the spectator can secure a coherent belief in self-authority, assurance, presence.[9] Memory. Sight. Love. All require a witness, imagined or real.

But what would it take to value the immaterial within a culture structured around the equation "material equals value?" As critical theories of cultural reproduction become increasingly dedicated to a consideration of the "material conditions" that influence, if not completely determine, social, racial, sexual, and psychic identities, questions about the immaterial construction of identities – those processes of belief which summon memory, sight, and love – fade from the eye/I.[10] Pitched against this fading, the words I have lined up here attempt to (re)develop the negative, not in order to produce a clearer print, but rather to see what it would mean to use the negative itself as a way of securing belief in one's self-image.

II

As Lacanian psychoanalysis and Derridean deconstruction have demonstrated, the epistemological, psychic, and political binaries of Western metaphysics create distinctions and evaluations across two terms. One term of the binary is marked with value, the other is unmarked. The male is marked with value; the female is unmarked, lacking measured value and meaning. Within this psycho-philosophical frame, cultural reproduction takes she who is unmarked and re-marks her, rhetorically and imagistically, while he who is marked with value is left unremarked, in discursive paradigms and visual fields. He is the norm and therefore unremarkable; as the Other, it is she whom he marks.

The reproduction of the cultural unconscious proceeds, as Lacan has argued, by taking two terms and forming one: the one they become is gendered male. Sexual difference in this way remains hidden and cultural (re)production remains *hommo-sexual*.[11] Unable to bear (sexual) difference, the psychic subject transforms this difference into the Same, and converts the Other into the familiar grammar of the linguistic, visual, and physical body of the Same. This process of conversion is what Freud called fetishization. Lacan calls it the function of metaphor.

For Lacan: "The sexual relation cannot be written. Everything that is written is based on the fact that it will be forever impossible to write the sexual relation as such. This gives way to a certain effect of discourse called *écriture*" (in Reynaud: 31). Writing re-marks the hole in the signifier, the inability of words to convey meaning exactly. The intimacy of the language of speech and the language of vision extends to their mutual impossibilities. The failure to represent sexual difference within visual representation gives way to a certain effect of the positive/negative, the seen and the unseen, which frames the visual perception of the Woman, and leads to her conversion into, more often than not, a fetish – a phallic substitute. This fetishization of the image is the risk of representational visibility for women. It secures the gap between the real and the representational and marks her as Other.[12]

Within the realm of the visible, that is both the realm of the signifier and the image, women are seen always as Other; thus, *The Woman* cannot be seen. Yet, like a ubiquitous ghost, she continues to haunt the images we believe in, the ones we remember seeing and loving. *Unmarked* is part of this ghost story – the story of the woman as immaterial ghost. It takes place within the haunted house of the cultural unconscious and it shakes the graves of the restless spirits of psychoanalysis, Freud and Lacan, and follows their feminist familiar – Luce Irigaray, Jacqueline Rose, Juliet MacCannell, and Joan Copjec. Attentive to the political field in which the real and the representational are the reproductive couple *par excellence*, I want to see which of their offspring are draped and which are raped by the psychic and discursive terms of "the visible."

The current contradiction between "identity politics" with its accent on visibility, and the psychoanalytic/deconstructionist mistrust of visibility as the source of unity or wholeness needs to be refigured, if not resolved.[13] As the Left dedicates ever more energy to visibility politics, I am increasingly troubled by the forgetting of the problems of visibility so successfully articulated by feminist film theorists in the 1970s and 1980s. I am not suggesting that continued invisibility is the "proper" political agenda for the disenfranchised, but rather that the binary between the power of visibility and the impotency of invisibility is falsifying. There is real power in remaining unmarked; and there are serious limitations to visual representation as a political goal.

Visibility is a trap ("In this matter of the visible, everything is a trap": Lacan, *Four Fundamental Concepts*: 93); it summons surveillance and the law; it provokes voyeurism,

fetishism, the colonialist/imperial appetite for possession. Yet it retains a certain political appeal. Visibility politics have practical consequences; a line can be drawn between a practice (getting someone seen or read) and a theory (if you are seen it is harder for "them" to ignore you, to construct a punitive canon); the two can be reproductive. While there is a deeply ethical appeal in the desire for a more inclusive representational landscape and certainly under-represented communities can be empowered by an enhanced visibility, the terms of this visibility often enervate the putative power of these identities. A much more nuanced relationship to the power of visibility needs to be pursued than the Left currently engages.[14]

Arguing that communities of the hitherto under-represented will be made stronger if representational economies reflect and see them, progressive cultural activists have staked a huge amount on increasing and expanding the visibility of racial, ethnic, and sexual "others." It is assumed that disenfranchised communities who see their members within the representational field will feel greater pride in being part of such a community *and* those who are not in such a community will increase their understanding of the diversity and strength of such communities. Implicit within this argument are several presumptions which bear further scrutiny:

1 Identities are visibly marked so the resemblance between the African-American on the television and the African-American on the street helps the observer see they are members of the same community.
2 The relationship between representation and identity is linear and smoothly mimetic. What one sees is who one is.
3 If one's mimetic likeness is not represented, one is not addressed.
4 Increased visibility equals increased power.

Each presumption reflects the ideology of the visible, an ideology which erases the power of the unmarked, unspoken, and unseen.

Adrian Piper, the visual artist and philosopher, has demonstrated that part of the meaning of race resides in the perpetual choice to acknowledge or ignore its often invisible markings. In the United States the history of slavery, and its relation to reproduction and rape, has meant that a "pure" match between race and skin color is relatively rare. In her potent video *Cornered*, Piper addresses the "white" so fundamental to the performance of racist ideology in the United States.[15] Since race is thought to be "carried" by blood and the history of slavery for African-American women is also the history of rape, the belief that one is "purely" white or black is difficult to sustain. Piper, dressed in blue and draped in pearls, calmly constructs a decision tree for her "white" spectator. First she demonstrates that the statistical probability that the spectator is actually black is extremely high. Then she asks how that knowledge will change, or not change, one's identifications. (Will you tell some of your friends? Will you tell your boss? Will you keep it a secret?) Gradually, as the trellis gets more and more intricate, the logic it is upholding begins to slip. What is the distinction between "blackness" and "whiteness" based on? If "racial identification" is a choice, what motivates it? Who gets to make that choice? In unhooking racial identity from the realm of the visible and making it a matter of "choice," Piper exposes the enormous consequences of racial difference while exposing the utter insignificance of the ground which legislates these differences – gene arrangement, the odd biology of blood.

Installed in "The Windows on Broadway," at The New Museum in New York, Piper's video spilled out onto the street and captivated a whole range of "non-traditional" museum-goers. The video monitor was installed against the rear wall of the window; in the foreground of the window was a large, upended and overturned brown table. On the side wall, birth

certificates with the word "race" highlighted were displayed. Within the video frame, Piper herself sat behind a table very much like the one overturned in the window. A series then of mimetic frames opens up as one tries to "locate" the event. The window replicates the video screen: on video, Piper sits at a table; in the window, the video monitor (placed on another similar table) represents her image from behind an overturned table, calmly speaking. The double framing, the marked reproduction of the real production via the return of the tables, make the notion of apprehending the elusive, invisible properties of "race-blood" seem absurd. Piper's representational frame-up corners the spectator and disables the habitual notion that race is visibly marked on skin.

The decision to "identify" as an African-American or to "pass" as white – a question Piper poses for her "white" spectator in *Cornered* – is part of an ongoing performance of identity. The same physical features of a person's body may be read as "black" in England, "white" in Haiti, "colored" in South Africa, and "mulatto" in Brazil. More than indicating that racial markings are read differently cross-culturally, these variations underline the psychic, political, and philosophical impoverishment of linking the color of the physical body with the ideology of race. Race-identity involves recognizing something other than skin and physical inscriptions. One cannot simply "read" race as skin-color. The tendency to do so leads to the corollary proposition that all people with the same skin color believe the same thing, and that there is, for example, such a thing as a coherent African-American community. The fiery debate in 1991 over Clarence Thomas, President George Bush's nominee to the Supreme Court, makes plain the diversity of the African-American community in the United States. The "visibility" of black skin is not, and cannot be, an accurate barometer for identifying a community of diverse political, economic, sexual, and artistic interests.

The focus on skin as the visible marker of race is itself a form of feminizing those races which are not white. Reading the body as the sign of identity is the way men regulate the bodies of women. Lorene Cary tells a West Indian folk tale in *Black Ice*. A woman drapes her skin across a chair in the bedroom she shares with her husband and slips out through a window to enjoy the night. Night after night she leaves their bed. (Indigenous dream interpreters, as against Freudian ones, would say she is walking with The Invisible.) She is always careful to return before her husband wakes. She slips back into her skin and then back into their bed. But one night her husband wakes and sees her skin across the chair. He is distraught. He seeks the advice of "an old woman in the village." She tells him to take some salt and rub the inside of the empty skin with it. A few nights later, the woman leaves again and the husband applies the salt to her skin. When she returns to her skin it will not yield: "Skin, skin, ya na know me?" she screams (Cary, *Black Ice*: 131). Caught between her body and her spirit, her insides keep her out. The husband who believes he has the right to the entrances and exists of her body can coat the inside of her skin with salt but he cannot keep her home. His failure to hold her in their bed prompts him to make her skin unable to house her spirit. Both exiled, her question hangs in the air: "Skin, skin, ya na know me?" The woman's voice cannot reanimate her skin. And she remains lost to her own body because of his desire to mark it as his.

In conflating identity politics with visibility, cultural activists and some theorists have also assumed that "selves" can be adequately represented within the visual or linguistic field. The "hole in the signifier," "the Real-impossible" which is unsayable, unseeable, and therefore resistant to representation, is ignored in the full fling forward into representation.[16] The danger in staking all on representation is that one gains only re-presentation. *Pace* Baudrillard, the real continues to exert its allure and provoke our frustration despite the pervasiveness of "the precession of simulacra," despite our inability to recover it independent of its representation.[17]

If representational visibility equals power, then almost-naked young white women should be running Western culture. The ubiquity of their image, however, has hardly brought them political or economic power. Recognizing this, those who advance the cause of visibility politics also usually call for "a change" in representational strategies. But so far these proposals are rather vague. What is required in order to advance a more ethical and psychically rewarding representational field, one that side-steps the usual traps of visibility: surveillance, fetishism, voyeurism, and sometimes, death? How are these traps more or less damning than benign neglect and utter ignorance? There is an important difference between willfully failing to appear and never being summoned.

Given capitalism's continual degradation of women's reproductive value – from the crude ideology of the familiar feminization of poverty which matter-of-factly turns up as a 59 to 63 cent wage differential in the U.S., to the failure to recognize human reproduction itself as labor, except in the case of surrogacy – that is, through the agency of the biological other and under the hood of capitalism's fellow, the contract – it is imperative that those interested in women as subjects find other ways of thinking about the relation between representation and reproduction. This requires attention to that which eludes both reproduction and representation. It is not enough to dismiss "the negative status of what cannot be seen" (Sue-Ellen Case, "Introduction," *Performing Feminisms*: 13) without considering what that negative negates.

Visibility politics are additive rather than transformational (to say nothing of revolutionary). They lead to the stultifying "me-ism" to which realist representation is always vulnerable. Unable to see oneself reflected in a corresponding image of the Same, the spectator can reject the representation as "not about me." Or worse, the spectator can valorize the representation which fails to reflect her likeness, as one with "universal appeal" or "transcendent power."

Visibility politics are compatible with capitalism's relentless appetite for new markets and with the most self-satisfying ideologies of the United States: you are welcome here as long as you are productive. The production and reproduction of visibility are part of the labor of the reproduction of capitalism. I am trying here to remember the traps of the visible and to outline, however speculatively, a different way of thinking about the political and psychic relationship between self and other, subject and object, in cultural reproduction. The psychoanalytic dimensions of the encounter between who one is and who one sees, an encounter most comprehensively explained by Lacan's reading of Freud, can be employed as a departure point for a more emphatic accenting of the political dimensions of the encounter between self and other.

[. . .]

Identity cannot [. . .] reside in the name you can say or the body you can see – your own or your mother's. Identity emerges in the failure of the body to express being fully and the failure of the signifier to convey meaning exactly. Identity is perceptible only through a relation to an other – which is to say, it is a form of both resisting and claiming the other, declaring the boundary where the self diverges from and merges with the other. In that declaration of identity and identification, there is always loss, the loss of not-being the other and yet remaining dependent on that other for self-seeing, self-being.

[. . .]

Notes

1 Julia Kristeva, "Ellipsis on Dread and the Specular Seduction," quoted in Jacqueline Rose, *Sexuality in the Field of Vision*: 141.
2 The best discussion of Lacanian doubt can be found in Joan Copjec, "Vampires, Breast-Feeding and Anxiety."

3 The two most relevant meditations on the contemporary legal real in the United States are Jane Gaines' fascinating essay, "Dead Ringer: Jacqueline Onassis and the Look-alike" which examines a case of a model, Barbara Reynolds, who appears in an ad for Christian Dior. The model's "art" is her ability to look like Onassis. Onassis sued Dior and the ad agency for using her image without permission. Gaines formulates the questions raised by this case in terms of the "right" to appropriate/exploit/protect what both Onassis and Reynolds already own – their image. Patricia Williams' provocative book *The Alchemy of Race and Rights* examines the legal real in terms of the historical force of racist marks defining citizenry. While there are serious problems with Williams' work as "legal theory," hers is an extraordinarily enabling book. Williams reimagines the categories and interests by which the legal real is constituted and maintained.

4 The best essay on feminism and the theatrical real is Elin Diamond's "Mimesis, Mimicry and the True-Real." She re-reads Irigaray's re-reading of Plato and suggests that there is no original without a notion of a mimetic copy – including the "original" Mother. Lynda Hill's "Staging Hurston's Life and Work" considers the tricky politics of race and representation in relation to Zora Neale Hurston's attempt to reproduce "authentic folk" community and contemporary drama's attempt to restage the story of her life and work "authentically."

5 The best discussion of the Lacanian Real can be found in *October* 58: "Rendering the Real A Special Issue," guest editor Parveen Adams. Also see Slavoj Žižek, *The Sublime Object of Ideology*. Throughout this chapter, the Lacanian Real shall be distinguished from other versions of the real by use of the upper-case R.

6 In the vast library of autobiographical criticism see Phillip Lejeune, *On Autobiography* and Bella Brodzki and Celeste Schenck (eds), *Life/Lines*, for preliminary discussions of how the real defines the autobiographical.

7 Slavoj Žižek tells the tale of the reception of *Rashomon* (1950). Kurosawa's film was hailed as the "classic" Japanese film throughout the United States and Europe and won the 1951 Golden Lion in Venice. But it failed terribly in Japan because it was considered "too European." Each culture employed the frame of the Other to define its relation to the representational text – not surprisingly the frame of the Other brought these others to opposite conclusions about the "same" representational text. Slavoj Žižek, "Lacan's Return to the Cartesian *Cogito*," a talk delivered in the English Department, New York University, December 1991.

8 This notion of the importance of the phantasmatic, however, also led Freud to abandon the seduction theory in favor of the Oedipal complex. In other words, the fantasy was ascribed to the child – despite "evidence" that the adult was indeed seducing the child. In abandoning the seduction theory, Freud was favoring the phantasmatic over the "evidence of the senses." For him the "evidence of the senses" (sensuality) is inferior to abstract and immaterial reasoning (intellectuality). In other words, the Oedipal complex, insofar as it remains phantasmatic, reproduces patriarchal reasoning in which "abstraction" is superior to visible evidence. The consequences of this shift, however, also perpetuated the idea that women (who were usually the patients recalling these seductions) were neurotics – while Oedipus remained a hero, however tragic.

9 Roy Schafer has clearly set this process forth in his essay "Narration in the Psychoanalytic Dialogue."

10 For an excellent discussion of the philosophical underpinnings of political identities see Diana Fuss, *Essentially Speaking*.

11 This term is borrowed from Luce Irigaray who develops it in *Speculum of the Other Woman*.

12 To the degree that the ethnic or racial "other" (not the norm and thus remarkable) is also always already feminized, the same risk is encountered. Visibility reproduces the self-same and converts the other into a fetish, a phallic substitute. The other is a metaphor understood within the pre-existing grammar and frame of the given to be seen.

13 Fuss sees this problem as the result of "an essentialist/constructivist" divide. I see it as a mistrust of the immaterial, a deep doubt about the "real" power of the unconscious and the unseen. Lynda Hart's essay "Identity and Seduction: Lesbians in the Mainstream" is a powerful analysis of the distinction between identity and (symbolic) identification. She constructs her argument around *Anniversary Waltz*, a dense performance by Peggy Shaw and Lois Weaver, which in every way collapses the distinctions between the real (it "really" was their anniversary that motivated the performance) and the representational (who is the couple they show?)

14 It is worth accenting, however, the real success of visibility politics. Curriculums from kindergarten to college are undergoing revision to reflect more adequately the achievements of non-European and non-white contributions to history and culture, largely because of the political-academic pressure

brought to bear on "white" education by progressives. In addition, more attention and money have been given to HIV research, largely because ACT-UP (AIDS Coalition To Unleash Power) has made itself a visible force to be reckoned with. Pro-choice rallies draw more members from more diverse communities as the Supreme Court whittles reproductive rights down to a tiny nub, largely because feminists have identified abortion as the most visible arena for political struggle in the US.

While these are not in any way pragmatic achievements to belittle, neither are they all one could hope for. To take just one example, the epistemological structure of white, European power-knowledge is able to incorporate at the level of content a certain amount of "new information" about non-whites and non-Europeans. But the model by which this information is represented contains within it an implicit system of evaluation and way of perceiving which remains intact.

15 Piper's *Cornered* (1989), a video tape, is available from Visual Data Bank, Chicago.
16 The phrase "the Real impossible" is Žižek's who develops it in *The Sublime Object of Ideology*.
17 See Baudrillard's *Simulations*; the phrase "the precession of simulacra" is the title of an essay excerpted from that book and reprinted in *Art After Modernism*, ed. Brian Wallis.

References

Adams, Parveen (guest ed.) (1991) "Rendering the Real A Special Issue," *October* 58 (Fall).
Baudrillard, Jean (1983) *Simulations*, tr. Paul Foss, Paul Patton and Philip Beitchman, New York: Semiotext(e) Inc.
Brodzki, Bella and Schenck, Celeste (eds) (1988) *Life/Lines: Theorizing Women's Autobiography*, Ithaca, NY and London: Cornell University Press.
Butler, Judith (1990) "The Force of Fantasy: Feminism, Mapplethorpe and Discursive Excess," *Differences* 2(2) (Summer): 105–25.
Cary, Lorene (1991) *Black Ice*, New York: Knopf.
Case, Sue-Ellen (ed.) (1990) "Introduction," in *Performing Feminisms*, Baltimore, MD: Johns Hopkins University Press.
Copjec, Joan (1991) "Vampires, Breast-Feeding and Anxiety," in "Rendering the Real a Special Issue," guest ed. Parveen Adams, *October* 58 (Fall): 25–44.
Diamond, Elin (1989) "Mimesis, Mimicry and the True-Real," *Modern Drama* 32(1): 59–72.
Fuss, Diana (1989) *Essentially Speaking: Feminism, Nature and Difference*, New York: Routledge.
Gaines, Jane (1989) "Dead Ringer: Jacqueline Onassis and the Look-Alike," *South Atlantic Quarterly* 88(2) (Spring): 461–86.
Hart, Lynda (1993) "Identity and Seduction: Lesbians in the Mainstream," in *Acting Out: Feminist Performances*, ed. Lynda Hart and Peggy Phelan, Ann Arbor, Mich.: University of Michigan Press.
Hill, Lynda (1993) "Staging Hurston's Life and Work," in *Acting Out: Feminist Performances*, ed. Lynda Hart and Peggy Phelan, Ann Arbor, Mich.: University of Michigan Press.
Irigaray, Luce (1985) *Speculum of the Other Woman*, tr. Gillian C. Gill, Ithaca, NY: Cornell University Press.
Kristeva, Julia (1979) "Ellipsis on Dread and the Specular Seduction," tr. Delores Burdick, *Wide Angle* 3(3): 42–7.
Lacan, Jacques (1978) *Four Fundamental Concepts of Psycho-Analysis*, ed. Jacques-Alain Miller, tr. Alan Sheridan, New York: Norton.
Lejeune, Phillip (1989) *On Autobiography*, ed. Paul Eakin, tr. Katherine Leary, foreword Paul Eakin, Minneapolis, Minn.: University of Minnesota Press.
Piper, Adrian (1989) *Cornered*, a video tape available from Visual Data Bank, Chicago, Ill.
——— (1992) "Cornered" (text of video), *Movement Research Performance Journal*, 4 (Winter/Spring): 10.
Reynaud, Berenice (1990) "Impossible Projections," in *The Films of Yvonne Rainer*, Bloomington, Ind.: University of Indiana Press: 24–35.
Rose, Jacqueline (1986) *Sexuality in the Field of Vision*, London and New York: Verso.
Schafer, Roy (1981) "Narration in the Psychoanalytic Dialogue," in *On Narrative*, ed. W. T. J. Mitchell, Chicago, Ill.: University of Chicago Press: 25–49.
Wallis, Brian (ed.) (1984) *Art after Modernism: Rethinking Representation*, New York: New Museum of Contemporary Art.
Williams, Patricia (1991) *The Alchemy of Race and Rights*, Cambridge, Mass.: Harvard University Press.
Žižek, Slavoj (1989) *The Sublime Object of Ideology*, London and New York: Verso.

PART THREE

Difference

THE RIGHTS MOVEMENTS – AND FEMINISM in particular – gave impetus in the mid-1970s and beyond to critiques of the institutional, discursive, and psychic structures by which difference is enacted and experienced by subjects living in the patriarchal West. Developing out of the examination of the structures of representation, and loosely based on the Hegelian model of the master–slave dialectic (whereby the "difference" and inevitable power differential between two subjects is constituted relationally), the critique of sexual difference spearheaded by feminist scholars from the mid-1970s on provided a basis for the burgeoning theoretical, artistic, and personal exploration of difference that was to become the lynchpin of cultural identity politics. The essays in this section are still, by and large, heavily indebted to psychoanalysis (see Heath), and also to the feminist critique of the master–slave dialectic articulated in Simone de Beauvoir's epochal 1949 book *The Second Sex*.

Almost all of the essays in this section implicitly or explicitly accept the loosely Freudian–Marxist conception of fetishism, itself drawn from anthropological studies of "primitive" cultures, as the explanatory model for the objectification of women in modern or postmodern image culture. Fetishism is the dynamic whereby the woman's body is repetitively, even obsessively, objectified in patriarchy because it then can function (as a fetish) to palliate the unconscious castration anxiety that threatens male dominance. In order to disavow his fear that he could potentially lose his penis, this theory goes, the man creates or looks at images of naked women – producing them as signs of *sexual difference* – as a means of convincing himself that he is dominant (strictly speaking, in the Freudian model, he constructs them as objects, as fetishes, so that they can act as substitutes for his potentially "lost" organ; or, in Hegel's earlier terms, he identifies himself as master by producing the woman as slave). Luce Irigaray's essay (Chapter 16) takes apart just such mechanisms, pointing to their patriarchal foundations by ironicizing, in a poetic language of metaphor, the sticking points of the obsessive focusing on the visual in psychoanalysis. (Irigaray acerbically offers the speculum not as a tool for seeing but as an abyss, a concave mirror that burns a hole in the "convex" eye that probes it.) Such fetishistic images, in the Marxist model, also serve as illusory signs of the alienated exchange of the capitalist market. (As noted, the fetish is also intimately linked to primitivism – fantasies of the "primitive" other as lacking – and thus the model of fetishism can be useful for analyzing colonialist desires; see Sander L. Gilman (Chapter 19) and Coco Fusco (Chapter 24).)

How do we experience our own and others' sexual difference? How is sexual difference manifested in and through visual imagery, even if that visual "imagery" is the body itself (Ann Eden Gibson (Chapter 23), José Esteban Muñoz (Chapter 25))? How do we interpret the difference(s) conveyed or suggested through images? The essays included in this section point to both the articulation of a model of sexual difference based on, but also critical of, a psychoanalytic model (Irigaray) and the simultaneous critique of the notion that gender could ever be experienced or theorized as being discrete from other differences such as those of sexual orientation (Harmony Hammond (Chapter 17), Monique Wittig (Chapter 18)); of class, race or ethnicity, and nationality (Gilman, Trinh T. Minh-ha (Chapter 20), Lorraine O'Grady (Chapter 21), Fusco, Muñoz); and even of levels of lived or virtual experience (Sandy Stone (Chapter 22)). Difference is, in these essays, resolutely expanded beyond the tendency in 1970s' identity politics to focus on singular categories of identity (within feminism, to stress sexual difference or gender as separable and as uniquely constitutive of one's identity).

The theoretical acknowledgment of the complexity of notions of sexual difference and female identity, an acknowledgment that has become more and more pronounced in the 1990s and beyond, marks the breakdown of the 1960s' and 1970s' notion of coalitional identity politics, wherein the importance of proclaiming one's allegiance to a particular (and usually singular) identity category, of making oneself "visible" to the dominant culture, was deemed to be unassailable. This earlier notion of identity politics had hugely important and productive effects, of course. But as feminists such as Trinh, O'Grady, and Fusco argue in their essays here, its disadvantages were multiple: it enacted the same kind of damaging universalizing logic that had excluded women from dominant cultural activities in the first place (now acting to exclude women other than the norm promoted by the veiled assumption of a white middle-class feminist subject); it assumed that visibility equals power (see Peggy Phelan (Chapter 15)); it does not coincide with the complexities of lived experience and, in particular, with the intricacies of how power functions in the image-saturated culture of global capitalism.

Finally, it is only very recently that theorists such as Stone and Muñoz have aggressively overturned the very founding concept of difference theory itself – the notion that subjects can be, even phantasmagorically, sustained in positions of absolute difference in relation to one another. We can no longer believe that gender is easily determinable, static, or fixable through visual or other cues. Difference, the work of Judith Butler (1990) tells us, is performative. As Sandy Stone insists here, thinking within the old system of sexual difference makes us complicit with it; rather, "we can seize upon the textual violence inscribed in the transsexual body and turn it into a reconstructive force." Vaginal Davis, the performative cross-gendered drag superstar discussed by Muñoz, provides perhaps the most up-to-date comment on the limitations of sexual difference theory. Her racially and sexually overdetermined body, as Stone's theorization suggests, perpetrates a kind of violence on our desire to fix difference, even for feminist means.

References and further reading

Abel, Elizabeth, Christian, Barbara, and Moglen, Helene, eds. *Female Subjects in Black and White: Race, Psychoanalysis, Feminism*. Berkeley and Los Angeles: University of California Press, 1997.

Anzaldúa, Gloria, and Moraga, Cherríe, eds. *This Bridge Called My Back: Writings by Radical Women of Color*. New York: Kitchen Table/Women of Color Press, 1981.

Beauvoir, Simone de. *The Second Sex* (1949). H. M. Parshley, tr. and ed. New York: Alfred A. Knopf, 1953.

Bennett, David, ed. *Multicultural States: Rethinking Difference and Identity*. London and New York: Routledge, 1998.

Bergstrom, Janet. "Enunciation and Sexual Difference." *Camera Obscura* 3–4 (Summer 1979): 32–69.

Bloom, Lisa, ed. *With Other Eyes: Looking at Race and Gender in Visual Culture*. Minneapolis: University of Minnesota Press, 1999.

Butler, Judith. *Gender Trouble: Feminism and the Subversion of Identity*. London and New York: Routledge, 1990.

Cheng, Meiling. *In Other Los Angeleses: Multicentric Performance Art*. Berkeley and Los Angeles: University of California Press, 2002.

Collins, Lisa Gail. *The Art of History: African American Women Artists Engage the Past*. New Brunswick, NJ: Rutgers University Press, 2002.

de Lauretis, Teresa. "Sexual Indifference and Lesbian Representation." *Theatre Journal* 40, n. 2 (May 1988): 155–77.

Doane, Mary Ann. "Dark Continents: Epistemologies of Racial and Sexual Difference in Psychoanalysis and the Cinema." *Femmes Fatales: Feminism, Film Theory, Psychoanalysis*. London and New York: Routledge, 1991.

duCille, Ann. "The Occult of True Black Womanhood: Critical Demeanor and Black Feminist Studies." *Signs* 19, n. 3 (Spring 1994): 591–629.

Edmondson, Belinda. "Black Aesthetics, Feminist Aesthetics, and the Problems of Oppositional Discourse." *Cultural Critique* n. 22 (Fall 1992): 75–98.

Gaines, Jane. "White Privilege and Looking Relations: Race and Gender in Feminist Film Theory." *Cultural Critique* n. 4 (Fall 1986): 59–79.

Heath, Stephen. "Difference." *Screen* 19, n. 3 (Autumn 1978): 51–112.

Horne, Peter, and Lewis, Reina, eds. *Outlooks: Lesbian and Gay Sexualities and Visual Cultures*. London and New York: Routledge, 1996.

Iginla, Biodun. "Black Feminist Critique of Psychoanalysis." *Feminism and Psychoanalysis: A Critical Dictionary*. Elizabeth Wright, ed. London: Blackwell, 1992.

Jones, Amelia. "Negotiating Difference(s) in Contemporary Art." *Theories of Contemporary Art*, 2nd Edition. Richard Hertz, ed. Englewood Cliffs, New Jersey: Prentice Hall, 1993.

Jones, Lisa. *Bulletproof Diva: Tales of Race, Sex, and Hair*. New York: Doubleday, 1994.

Mohanty, Chandra, Russo, Ann, and Torres, Lourdes, eds. *Third World Women and the Politics of Feminism*. Bloomington: Indiana University Press, 1991.

Morgan, Joan. *When Chickenheads Come Home to Roost: A Hip-Hop Feminist Breaks It Down*. New York: Simon & Schuster, 1999.

Morrison, Toni, ed. *Race-ing Justice, En-gendering Power: Essays on Anita Hill, Clarence Thomas, and the Construction of Social Reality*. New York: Pantheon, 1992.

Penley, Constance. "A Certain Refusal of Difference: Feminist Film Theory." *Art after Modernism: Rethinking Representation*. Brian Wallis, ed. New York: New Museum of Contemporary Art, 1984.

"Racism is the Issue." Special issue. *Heresies: A Feminist Publication on Art and Politics* 4, n. 3, issue 15 (1982).

"Representing Lesbian Subjectivities." Special issue. *Art Papers* 18, n. 6 (November/December 1994).

Roth, Moira. *Difference/Indifference*. Amsterdam: G + B Arts International, 1998.

Shohat, Ella, ed. *Talking Visions: Multicultural Feminism in a Transnational Age*. New York: New Museum of Contemporary Art, 1998.

Spivak, Chakravorty Gayatri. *In Other Worlds: Essays in Cultural Politics*. London and New York: Routledge, 1988.

Taylor, Clyde. *The Mask of Art: Breaking the Aesthetic Contract – Film and Literature*. Bloomington: Indiana University Press, 1998.

Tesfagiorgis, Freida High W. "In Search of a Discourse and Critique/s That Center the Art of Black Women Artists." *Theorizing Black Feminisms: The Visionary Pragmatism of Black Women*. Stanlie M. James and Abena P. A. Busia, eds. London and New York: Routledge, 1993.

Wallace, Michele. "Modernism, Postmodernism, and the Problem of the Visual in Afro-American Culture." *Out There: Marginalization and Contemporary Culture*. Russell Ferguson, Martha Gever, Trinh T. Minh-Ha, Cornel West, eds. Cambridge, Massachusetts: MIT Press, 1990.

Weinstock, Jane. "Sexual Difference and the Moving Image." *Difference: On Representation and Sexuality.* New York: New Museum of Contemporary Art, 1984.

Wilson, Judith. "Beauty Rites: Towards an Anatomy of Culture in African-American Women's Art." *The International Review of African-American Art* 11, n. 3 (1994): 11–17, 47–55.

Wolverton, Terry. "Lesbian Art Project." *Heresies* 2, n. 3 (1979): 14–19.

LUCE IRIGARAY

ANY THEORY OF THE "SUBJECT" HAS ALWAYS BEEN APPROPRIATED BY THE "MASCULINE"

WE CAN ASSUME THAT ANY THEORY of the subject has always been appropriated by the "masculine." When she submits to (such a) theory, woman fails to realize that she is renouncing the specificity of her own relationship to the imaginary. Subjecting herself to objectivization in discourse – by being "female." Re-objectivizing her own self whenever she claims to identify herself "as" a masculine subject. A "subject" that would re-search itself as lost (maternal-feminine) "object"?

Subjectivity denied to woman: indisputably this provides the financial backing for every irreducible constitution as an object: of representation, of discourse, of desire. Once imagine that woman imagines and the object loses its fixed, obsessional character. As a bench mark that is ultimately more crucial than the subject, for he can sustain himself only by bouncing back off some objectiveness, some objective. If there is no more "earth" to press down/repress, to work, to represent, but also and always to desire (for one's own), no opaque matter which in theory does not know herself, then what pedestal remains for the ex-sistence of the "subject"? If the earth turned and more especially turned upon herself, the erection of the subject might thereby be disconcerted and risk losing its elevation and penetration. For what would there be to rise up from and exercise his power over? And in?

The Copernican revolution has yet to have its final effects in the male imaginary. And by centering man outside himself, it has occasioned above all man's ex-stasis within the transcendental (subject). Rising to a perspective that would dominate the totality, to the vantage point of greatest power, he thus cuts himself off from the bedrock, from his empirical relationship with the matrix that he claims to survey. To specularize and to speculate. Exiling himself ever further (toward) where the greatest power lies, he thus becomes the "sun" if it is around him that things turn, a pole of attraction stronger than the "earth." Meanwhile, the excess in this universal fascination is that "she" also turns upon herself, that she knows how to re-turn (upon herself) but not how to seek outside for identity within the other: nature, sun, God . . . (woman). As things now go, man moves away in order to preserve his stake in the value of his representation, while woman counterbalances with the permanence of a (self)recollection which is unaware of itself as such. And which, in the recurrence of this re-turn upon the self – and its special economy will need to be located – can continue to support the illusion that the object is inert. "Matter" upon which he will ever and again return to plant his foot in order to spring farther, leap higher, although he is dealing here with a nature that is already self-referential. Already fissured and open. And which, in her circumvolutions

upon herself, will also carry off the things confided to her for re-presentation. Whence, no doubt, the fact that she is said to be restless and unstable. In fact it is quite rigorously true that she is never exactly the same. Always whirling close or farther from the sun whose rays she captures and sends curving to and fro in turn with her cycles.

Thus the "object" is not as massive, as resistant, as one might wish to believe. And her possession by a "subject," a subject's desire to appropriate her, is yet another of his vertiginous failures. For where he projects a something to absorb, to take, to see, to possess . . . as well as a patch of ground to stand upon, a mirror to catch his reflection, he is already faced by another specularization. Whose twisted character is her inability to say what she represents. The quest for the "object" becomes a game of Chinese boxes. Infinitely receding. The most amorphous with regard to ideas, the most obviously "thing," if you like, the most opaque matter, opens upon a mirror all the purer in that it knows and is known to have no reflections. Except those which man has reflected there but which, in the movement of that concave speculum, pirouetting upon itself, will rapidly, deceptively, fade.

And even as man seeks to rise higher and higher – in his knowledge too – so the ground fractures more and more beneath his feet. "Nature" is forever dodging his projects of representation, of reproduction. And his grasp. That this resistance should all too often take the form of rivalry within the hom(m)ologous, of a death struggle between two consciousnesses, does not alter the fact that at stake here somewhere, ever more insistent in its deathly hauteur, is the risk that the subject (as) self will crumble away. Also at stake, therefore, the "object" and the modes of dividing the economy between them. In particular the economy of discourse. Whereby the silent allegiance of the one guarantees the auto-sufficiency, the auto-nomy of the other as long as no questioning of this mutism as a symptom – of historical repression – is required. But what if the "object" started to speak? Which also means beginning to "see," etc. What disaggregation of the subject would that entail? Not only on the level of the split between him and his other, his variously specified alter ego, or between him and the Other, who is always to some extent *his* Other, even if he does not recognize himself in it, even if he is so overwhelmed by it as to bar himself out of it and into it so as to retain at the very least the power to promote his own forms. Others who will always already have been in the service of the same, of the presuppositions of the same logos, without changing or prejudicing its character as discourse. Therefore not really others, even if the one, the greatest, while holding back his reserves, perhaps contains the threat of otherness. Which is perhaps why he stands off-stage? Why he is repressed too? But high up, in "heaven"? Beyond, like everything else? Innocent in his exorbited empire. But once you get suspicious of the reasons for extrapolation, and at the same time interpret the subject's need to re-duplicate himself in a thought – or maybe a "soul"? – then the function of the "other" is stripped of the veils that still shroud it.

Where will the other spring up again? Where will the risk be situated which sublates the subject's passion for remaining ever and again the same, for affirming himself ever and again the same? In the *duplicity* of his speculation? A more or less conscious duplicity? Since he is only partially and marginally where he reflects/is reflected? Where he knows (himself)? As likeness whose price can be maintained by the "night" of the unconscious? The Other, lapsed within, disquieting in its shadow and its rage, sustaining the organization of a universe eternally identical to the self. The backside of (self)representation, of the visual plane where he gazes upon himself? Therefore, resemblance proliferates all the more in a swarm of analogues. The "subject" henceforth will be multiple, plural, sometimes di-formed, but it will still

postulate itself as the cause of all the mirages that can be enumerated endlessly and therefore put back together again as one. A fantastic, phantasmatic fragmentation. A destruc(tura)tion in which the "subject" is shattered, scuttled, while still claiming surreptitiously that he is the reason for it all. Is reason feigned perhaps? Certainly, it is *one*. For this race of signifiers spells out again the solipsism of him who summons them, convokes them, even if only to disperse them. The "subject" plays at multiplying himself, even deforming himself, in this process. He is father, mother, and children). And the relationships between them. He is masculine and feminine and the relationships between them. What mockery of generation, parody of copulation and genealogy, drawing its *strength* from the same model, from the mode of the same: the subject. In whose sight everything *outside* remains forever a condition making possible the image and the reproduction of the self. A faithful, polished mirror, empty of altering reflections. Immaculate of all auto-copies. Other because wholly in the service of the same subject to whom it would present its surfaces, candid in their self-ignorance.

When the Other falls out of the starry sky into the chasms of the psyche, the "subject" is obviously obliged to stake out new boundaries for his field of implantation and to re-ensure – otherwise, elsewhere – his dominance. Where once he was on the heights, he is now entreated to go down into the depths. These changes in position are still postulated in terms of verticality, of course. Are phallic, therefore. But how to tame these uncharted territories, these dark continents, these worlds through the looking glass? How to master these devilries, these moving phantoms of the unconscious, when a long history has taught you to seek out and desire only clarity, the clear perception of (fixed) ideas? Perhaps this is the time to stress *technique* again? To renounce for the time being the sovereignty of thought in order to forge *tools* which will permit the exploitation of these resources, these unexplored mines. Perhaps for the time being the serene contemplation of empire must be abandoned in favor of taming those forces which, once unleashed, might explode the very concept of empire. A detour into *strategy, tactics, and practice* is called for, at least as long as it takes to gain vision, self-knowledge, self-possession, even in one's decenteredness. The "subject" sidles up to the truth, squints at it, obliquely, in an attempt to gain possession of what truth can no longer say. Dispersing, piercing those metaphors – particularly the photological ones – which have constituted truth by the premises of Western philosophy: virgin, dumb, and veiled in her nakedness, her vision still naively "natural," her viewpoint still resolutely blind and unsuspecting of what may lie beneath the blindness.

Now is the time to operate, before all is lost. That is, plow again those fields which had been assumed cultivated once and for all, but which now turn out to have merely lain fallow, capable of products that choke anything growing in their soil. The "subject" must dig his foundations deeper, extend the underground passages which assured the edifice of his determination, further dig out the cellars upon which he raises the monument of his identification, in order to prop up more securely his "dwelling": the system of his relationship to self, the closure of his auto-representations, focus of his lonely exile as "subject." Man's home has indeed become these/his theoretical elaborations, by means of which he has sought to reconstruct, in an impossible metaphorization, the matrix and the way that would lead to or back to it. But by wishing to reverse the anguish of being imprisoned within the other, of being placed inside the other, by making the very place and space of being his own, he becomes a prisoner of effects of symmetry that know no limit. Everywhere he runs into the walls of his palace of mirrors, the floor of which is in any case beginning to crack and break up. This in turn serves, of course, to sublate his activity, leading him to new tasks which for a time will distract him again from his specular imprisonment. A diversion from the depths of his madness,

pretext for an increase in attentiveness, vigilance, mastery. The reason for the quakes must be sought out, these seismic convulsions in the self must be interpreted.

But man only asks (himself) questions that he can already answer, using the supply of instruments he has available to assimilate even the disasters in his history. This time at any rate he is prepared to lay odds again, and, give or take a few new weapons, he will make the unconscious into a property of his language. A disconcerting property, admittedly, which confuses everything he had long since assigned meaning to. But that, it seems, is not the most important thing at stake. The really urgent task is to ensure the colonization of this new "field," to force it, not without splintering, into the production of the same discourse. And since there can be no question of using the same plan/e for this "strange" speech, this "barbarous" language with which it is impossible to conduct a dialogue – read, monologue – the discovery will be set out hierarchically, in stages. Will be brought to order. By giving here a little more play to the system, here a little less. The forms of arrangement may vary, but they will all bear the paradox of forcing into the same representation – the representation of the self/same – that which insists upon its *heterogeneity*, its *otherness*.

Yet the fact that the dream can be interpreted only as a "rebus" should have persuaded the "reader" to turn it in all directions and positions, and not favor one type of inscription that would already prescribe a meaning to it: a linear, teleologically horizontal or vertical displacement, over a surface as yet unwritten, which it brands by cutting it up according to rules of repetition and recurrence, obeying processes that already paralyze the "body's" system of gestures within a given graphic order, etc. Why not rather have recalled those "pictures" made for children, pictographs in which the hunter and hunted, and their dramatic relationships, are to be discovered *between* the branches, *made out* from *between* the trees. From the spaces between the figures, or stand-in figures. Spaces that organize the scene, blanks that sub-tend the scene's structuration and that will yet not be read as such. Or not read at all? Not seen at all? Never in truth represented or representable, though this is not to say that they have no effect upon the present scenography. But fixed in oblivion and waiting to come to life. Turning everything upside down and back to front. If, that is, the interpreter-subject did not desire "this" (the id) to continue sustaining the proliferation of images (of self), as a trompe-l'oeil backcloth for the same's show, for a theater of the identical.

Dreams are also riddles in that – during "sleep," and in order to "keep" asleep – they recast the roles that history has laid down for "subject" and "object." Mutism that says without speech, inertia that moves without motion, or else only with the motions of another language, another script. Dream pictography, dream choreography, phonography, and pornography which compensate for the present *paralysis* of the sleeper. Who will/would awake – perhaps? – only if the "child," faced with such "riddles," did not have the overweening desire to "see" an other and same figure and form than the one that is already present for him. If it were enough for him to be entranced, let us say, by a *double syntax*, without claiming to regulate the second by the standard of representation, of re-presentation, of the first. If he were not "wounded," threatened by "castration," by anything he cannot see directly, anything he cannot perceive as like himself. Did not feel, as a result, the need to invent a new "theory," yet another in the series of optical instruments which, by means of the second – or hundred and second – sighting, moves in around the "manifestations" of the unconscious, under the protection of technological distance. Prosthesis, which assists the horrified gaze to construct, laboriously, "consciously," concept by concept, the rationality of his repression. His established good. Session after session, in a procedure that is also regulated by visual – rememorative – laws, he repeats the same gesture reestablishing the bar, the barred. While all the while

permissive, listening with benevolent neutrality, collecting, on a carefully circumscribed little stage, the inter-dict. The lines between the lines of discourse. But he restricts himself to reframing, remarking, or "analyzing" its contours, re-stratifying its stage, so that order, good "conscious" order, may prevail. Elsewhere.

Now, let us imagine – for what else is there to do when rereading Freud but imagine a response, or else admit one's inability to survey such an imagination – let us imagine that man (Freud in the event) had discovered that the rarest thing – the most exciting as well as the most scientifically rigorous, the most faithful to factual materiality and the most historically curative – would be to articulate directly, *without catacombs*, what we are calling these two syntaxes. Irreducible in their strangeness and eccentricity one to the other. Coming out of different times, places, logics, "representations," and economics. In fact, of course, these terms cannot fittingly be designated by the number "two" and the adjective "different," if only because they are not susceptible to com-parison. To use such terms serves only to reiterate a movement begun long since, that is, the movement to speak of the "other" in a language already systematized by/for the same. Their distribution and demarcation and articulation necessitate operations as yet nonexistent, whose complexity and subtlety can only be guessed at without prejudicing the results. Without a teleology already in operation somewhere. But had the man Freud preferred the play, or even the clash, of those two economies rather than their disposition in hierarchical stages by means of one barrier (or two), one censorship (or two), then perhaps he would not finally have cracked his head against all that remains irreducibly "obscure" to him in his speculations. Against the non-visible, therefore not theorizable nature of woman's sex and pleasure. Whatever the explorations he attempts and which tempt him concerning this "dark continent," he always refers back to some still blind and incomprehensible "horizon" of investigation. And there, in what he recognizes as outside the range of his systematic prospecting (beyond the self?), Freud is in fact indicating a way off the historico-transcendental stage, at the very moment when his theory and his practice are perpetuating, in the mode of enunciation and the drama of enunciating, that very same stage, which we may now call the *hysterico*-transcendental. Announcing by this re-mark, by this effect of repetition – re-petitio principii – of recapitulation and, without his knowledge, of mimicry, that his breath is privileged. And he is out of breath.

For, when Freud reaffirms the incest taboo, he simply reannounces and puts back in place the conditions that constitute the speculative matrix of the "subject." He reinforces his positions in a fashion yet more "scientific," more imperious in their "objectivity." A demonstration he clearly needed himself if he is to "sublimate" in more universal interests his own desire for his/the mother. But as a result of using psychoanalysis (his psychoanalysis) only to scrutinize the history of his subject and his subjects, without interpreting *the historical determinants of the constitution of the "subject" as same*, he was restoring, yet again, that newly pressed down/repressed earth, upon which he stands erect, which for him, following tradition though in more explicit fashion, will be the body/sex of the mother/nature. He must challenge her for power, for productivity. He must resurface the earth with this floor of the ideal. Identify with the law-giving father, with his proper names, his desires for making capital, in every sense of the word, desires that prefer the possession of territory, which includes language, to the exercise of his pleasures, with the exception of his pleasure in trading women – fetishized objects, merchandise of whose value he stands surety – with his peers. The ban upon returning, regressing to the womb, as well as to the language and dreams shared with the mother, this is indeed the point, the line, the surface upon which the "subject" will

continue to stand, to advance, to unfold his discourse, even to make it whirl. Though he has barely escaped the ring, the vault, the snare of reconciling his end and his archives, those calls, resurgent, of his beginnings. Though that he-who-is-the-cause is barely keeping his balance. But since he now knows the reason for his wobbling. . . . And, after all, the acquisition of new riches is certainly part of this? Overdetermination, deferred action, dreams, fantasies, puns. . . . Language, by adopting its/these "annexes" – also ocular, uterine, embryonic – adds to its wealth, gains "depth," consistency, diversity, and multiplication of its processes and techniques. Was language once believed threatened? Here it is dancing, playing, writing itself more than ever. It is even claimed that language is "truer" than in the past, reimpregnated with its childhood. A consciousness yet more consciously pregnant with its relationship with the mother.

Whereas "she" comes to be unable to say what her body is suffering. Stripped even of the words that are expected of her upon that stage invented to listen to her. In an admission of the wear and tear on language or of its fetishistic denial? But hysteria, or at least the hysteria that is the privileged lot of the "female," *now has nothing to say*. What she "suffers," what she "lusts for," even what she "takes pleasure in," all take place upon another stage, in relation to already codified representations. Repression of speech, inter-dicted in "hieroglyphic" symptoms – an already suspicious designation of something prehistoric – which will doubtless never again be lifted into current history. Unless it be by making her enter, in contempt of her sex, into "masculine" games of tropes and tropisms. By converting her to a discourse that denies the specificity of her pleasure by inscribing it as the hollow, the intaglio, the negative, even as the censured other of its phallic assertions. By hom(m)osexualizing her. By perversely travestying her for the pederastic, sodomizing satisfactions of the father/husband. She shrieks out demands too innocuous to cause alarm, that merely make people smile. Just the way one smiles at a child when he shouts aloud the mad ambitions adults keep to themselves. And which one knows he can never realize. And when she also openly displays their power fantasies, this serves as a re-creation to them in their struggle for power. By setting before them, keeping in reserve for them, in her in-fancy, what they must of course keep clear of in their pursuit of mastery, but which they yet cannot wholly renounce for fear of going off course. So she will be the Pythia who apes induced desires and suggestions foreign to her still hazy consciousness, suggestions that proclaim their credibility all the louder as they carry her ever further from her interests. By resubmitting herself to the established order, in this role of delirious double, she abandons, even denies, the prerogative historically granted her: unconsciousness. She prostitutes the unconscious itself to the ever present projects and projections of masculine consciousness.

For whereas the man Freud – or woman, were she to set her rights up in opposition – *might have been able* to interpret what the overdetermination of language (its effects of deferred action, its subterranean dreams and fantasies, its convulsive quakes, its paradoxes and contradictions) owed to the repression (which may yet return) of maternal power – or of the matriarchy, to adopt a still prehistorical point of reference – whereas he might have been able also to interpret the repression of the history of female sexuality, we shall in fact receive only confirmation of the discourse of the same, through comprehension and extension. With "woman" coming once more to be embedded in, enclosed in, impaled upon an architectonic more powerful than ever. And she herself is sometimes happy to request a recognition of consciousness thereby, even an appropriation of unconsciousness that cannot be hers. Unconsciousness she is, but not for herself, not with a subjectivity that might take cognizance of it, recognize it as her own. Close to herself, admittedly, but in a total ignorance (of self).

She is the reserve of "sensuality" for the elevation of intelligence, she is the matter used for the imprint of forms, gage of possible regression into naive perception, the representative representing negativity (death), dark continent of dreams and fantasies, and also eardrum faithfully duplicating the music, though not all of it, so that the series of displacements may continue, for the "subjects." And she will serve to assure his determination only if she now seeks to reclaim his property from him: this (of his) elaborated as same out of this (of hers) foreclosed from specula(riza)tion. The same thing will always be at stake. The profiteering will barely have changed hands. A barter solution that she would adopt out of the void of her desire. And always one step behind in the process, the progress of history.

But if, by exploits of her hand, woman were to reopen paths into (once again) a/one logos that connotes her as castrated, especially as castrated of words, excluded from the work force except as prostitute to the interests of the dominant ideology – that is of hom(m)osexuality and its struggles with the maternal – then a certain sense, which still constitutes the sense of history also, will undergo unparalleled interrogation, revolution. But how is this to be done? Given that, once again, the "reasonable" words – to which in any case she has access only through mimicry – are powerless to translate all that pulses, clamors, and hangs hazily in the cryptic passages of hysterical suffering-latency. Then. . . . Turn everything upside down, inside out, back to front. *Rack it with radical convulsions*, carry back, reimport, those crises that her "body" suffers in her impotence to say what disturbs her. Insist also and deliberately upon those *blanks* in discourse which recall the places of her exclusion and which, by their *silent plasticity*, ensure the cohesion, the articulation, the coherent expansion of established forms. Reinscribe them hither and thither *as divergencies*, otherwise and elsewhere than they are expected, in *ellipses* and *eclipses* that deconstruct the logical grid of the reader-writer, drive him out of his mind, trouble his vision to the point of incurable diplopia at least. *Overthrow syntax* by suspending its eternally teleological order, by snipping the wires, cutting the current, breaking the circuits, switching the connections, by modifying continuity, alternation, frequency, intensity. Make it impossible for a while to predict whence, whither, when, how, why . . . something goes by or goes on: will come, will spread, will reverse, will cease moving. Not by means of a growing complexity of the same, of course, but by the irruption of other circuits, by the intervention at times of short-circuits that will disperse, diffract, deflect endlessly, making energy explode sometimes, with no possibility of returning to one single origin. A force that can no longer be channeled according to a given *plan/e:* a projection from a single source, even in the secondary circuits, with retroactive effects.

All this already applies to words, to the "lexicon" (as it is called), which is also connected up, and in the same direction. But we must go on questioning words as the wrappings with which the "subject," modestly, clothes the "female." Stifled beneath all those eulogistic or denigratory metaphors, she is unable to unpick the scams of her disguise and indeed takes a certain pleasure in them, even gilding the lily further at times. Yet, ever more hemmed in, cathected by tropes, how could she articulate any sound from beneath this cheap chivalric finery? How find a voice, make a choice strong enough, subtle enough to cut through those layers of ornamental style, that decorative sepulcher, where even her breath is lost. Stifled under all those airs. She has yet to feel the need to get free of fabric, reveal her nakedness, her destitution in language, explode in the face of them all, words too. For the imperious need for her shame, her chastity – duly fitted out with the belt of discourse – , of her decent modesty, continues to be asserted by every man. In every kind of tone, form, theory, style, with the exception of a few that in fact rouse suspicion also by their pornographically, hom(m)osexual excess. Common stock, one may assume, for their production.

The (re)productive power of the mother, the sex of the woman, are both at stake in the proliferation of systems, those houses of ill fame for the subject, of fetish-words, sign-objects whose certified truths seek to palliate the risk that values may be recast into/by the other. But no clear univocal utterance, can in fact, pay off this mortgage since all are already trapped in the same credit structure. All can be recuperated when issued by the signifying order in place. It is still better to speak only in riddles, allusions, hints, parables. Even if asked to clarify a few points. Even if people plead that they just don't understand. After all, they never have understood. So why not double the misprision to the limits of exasperation? Until the ear tunes into another music, the voice starts to sing again, the very gaze stops squinting over the signs of auto-representation, and (re)production no longer inevitably amounts to the same and returns to the same forms, with minor variations.

This disconcerting of language, though anarchic in its deeds of title, nonetheless demands patient exactitude. The symptoms, for their part, are implacably precise. And if it is indeed a question of breaking (with) a certain mode of specula(riza)tion, this does not imply renouncing all mirrors or refraining from analysis of the hold this plan/e of representation maintains, rendering female desire aphasic and more generally atonic in all but its phallo-morphic disguises, masquerades, and demands. For to dodge this time of interpretation is to risk its freezing over, losing hold, cutting back. All over again. But perhaps through this specular surface which sustains discourse is found not the void of nothingness but the dazzle of multifaceted speleology. A scintillating and incandescent concavity, of language also, that threatens to set fire to fetish-objects and gilded eyes. The recasting of their truth value is already at hand. We need only press on a little further into the depths, into that so-called dark cave which serves as hidden foundation to their speculations. For there where we expect to find the opaque and silent matrix of a logos immutable in the certainty of its own light, fires and mirrors are beginning to radiate, sapping the evidence of reason at its base! Not so much by anything stored in the cave – which would still be a claim based on the notion of the closed volume – but again and yet again by their indefinitely rekindled hearths.

But which "subject" up till now has investigated the fact that a *concave mirror* concentrates the light and, specifically, that this is not wholly irrelevant to woman's sexuality? Any more than is a man's sexuality to the convex mirror? Which "subject" has taken an interest in the anamor-phoses produced by the conjunction of such curvatures? What impossible reflected images, maddening reflections, parodic transformations took place at each of their articulations? When the "it is" annuls them in the truth of a copula in which "he" still forever finds the resources of his identification as same. Not one subject has done so, on pain of tumbling from his ex-sistence. And here again, here too, one will rightly suspect any perspective, however surreptitious, that centers the subject, any autonomous circuit of subjectivity, any system-aticity hooked back onto itself, any closure that claims for whatever reason to be metaphysical – or familial, social, economic even –, to have rightfully taken over, fixed, and framed that concave mirror's incandescent hearth. If this mirror – which, however, makes a *hole* – sets itself up pompously as an authority in order to give shape to the imaginary orb of a "subject," it thereby defends itself phobically in/by this inner "center" from the fires of the desire of/for woman. Inhabiting a securing morphology, making of its very structure some comfortable sepulcher from whence it may, possibly, by some hypothetical survival, be able to look out. (Re)g(u)arding itself by all sorts of windows-on-wheels, optical apparatuses, glasses, and mirrors, from/in its burning glass, which enflames all that falls into its cup.

But, may come the objection – defending again the objective and the object – the speculum is not necessarily a mirror. It may, quite simply, be an instrument to *dilate* the lips, the orifices, the walls, so that the eye can penetrate the *interior*. So that the eye can enter, to see, notably with speculative intent. Woman, having been misinterpreted, forgotten, variously frozen in show-cases, rolled up in metaphors, buried beneath carefully stylized figures, raised up in different idealities, would now become the "object" to be investigated, to be explicitly granted consideration, and thereby, by this deed of title, included in the theory. And if this center, which fixed and immobilized metaphysics in its closure, had often in the past been traced back to some divinity or other transcendence invisible as such, in the future its ultimate meaning will perhaps be discovered by tracking down what there is to be *seen* of female sexuality.

Yes, man's eye – understood as substitute for the penis – will be able to prospect woman's sexual parts, seek there new sources of profit. Which are equally theoretical. By doing so he further fetishizes (his) desire. But the desire of the mystery remains, however large a public has been recruited of late for "hysteroscopy." For even if the place of origin, the original dwelling, even if not only the woman but the mother can be unveiled to his sight, what will he make of the exploration of this mine? Except usurp even more the right to look at everything, at the whole thing, thus reinforcing the erosion of his desire in the very place where he firmly believes he is working to reduce an illusion. Even if it should be a transcendental illusion. What will he, what will they, have *seen* as a result of that dilation? And what will they get out of it? A disillusion quite as illusory, since the transcendental keeps its secret. Between empirical and transcendental *a suspense will still remain inviolate*, will escape prospection, then, now, and in the future. The space-time of the risk that fetishes will be consumed, catch fire. In this fire, in this light, in the optical failure, the impossibility of gazing on their encounters in flame, the split (schize) founding and structuring the difference between experience and transcendental (especially phallic) eminence will burn also. *Exquisite/exschizoid crisis of ontico-ontological difference*. What manner of recasting all economy will ensue? To tell the truth, no one knows. And, to stay with truth, you can only fear the worst. For you may fear a general crisis in the value system, a foundering of the values now current, the devaluation of their standard and of their regimen of monopolies.

The copulative effusion, and fusion, melts down the mint's credit with each moment of bliss. Renews and redistributes the accepted stakes: between two crises, two explosions, two incandescences of fetish mineral. And it is no easy matter to foresee whether, in that game, the one – the man? – who has recouped the biggest pile of chips will be the winner. It is equally possible to imagine that the one – the woman – who has spent her time polishing her mine will carry the day. Since the abrasion of the stores entrusted to the reflecting surface renders that surface more likely to set aflame the supplies and capitalizations of the one who, under cover and pretext of seduction, puts his riches on display.

But, will come the objection once again – in the name of some other objectality – we are not fed by fire and flames. Maybe. But then neither are we by fetishes and gazes. And when will they cease to equate woman's sexuality with her reproductive organs, to claim that her sexuality has value only insofar as it gathers the heritage of her maternity? When will man give up the need or desire to drink deep in all security from his wife/mother in order to go and show off to his brothers and buddies the fine things he formed while suckling his nurse? And/or when will he renounce (reversing roles so as better to retain them) the wish to preserve his wife/child in her inability, as he sees it, to produce for the marketplace? With

"marriage" turning out to be a more or less subtle dialectization of the nurturing relationship that aims to maintain, at the very least, the mother/child, producer/consumer distinction, and thereby perpetuate this economy?

To return to the gaze, it will be able to explore all the inner cavities. Although, in the case of the most secret, it will need the help of ancillary light and mirror. Of appropriate sun and mirrors. The instrumental and technical exploitation of sun and mirror will have shown the gaze, proved to it, that those mines contained no gold. Then the gaze, aghast at such bareness, will have concluded that at any rate all brilliance was its own preserve, that it could continue to speculate without competition. That the childish, the archaic credit accorded to the all-powerful mother was nothing, was but fable. But how is one to desire without fiction? What pleasure is there in stockpiling goods without risks, without expenditures?

You will have noted, in fact, that what polarizes the light for the exploration of internal cavities is, in paradigmatic fashion, *the concave mirror*. Only when that mirror has concentrated the feeble rays of the eye, of the sun, of the sun-blinded eye, is the secret of the caves illumined. Scientific technique will have taken up the condensation properties of the "burning glass," in order to pierce the mystery of woman's sex, in a new distribution of the power of the scientific method and of "nature." A new despecularization of the maternal and the female? Scientificity of fiction that seeks to exorcise the disasters of desire, that mortifies desire by analyzing it from all visual angles, but leaves it also intact. Elsewhere. Burning still.

[*Translated by Gillian C. Gill.*]

Chapter 17

HARMONY HAMMOND

LESBIAN ARTISTS

WHAT CAN I TELL YOU EXCEPT the truth? We do not have a history. We are not even visible to each other. Many well-known women artists of the twentieth century have been lesbians, but if they are famous as artists, it is never mentioned that they are lesbians, or how that might have affected the way they live, their work, or work processes. The best we have is Romaine Brooks, but she was rich and ensconced in villas, surrounded by monocled countesses. As wonderful as this sounds, it is unrealistic on my $360 a month. Rosa Bonheur lived with her Natalie for forty years and dressed in pants, but she didn't think that other women should.

In my search for contemporary lesbian artists, I spend much energy wondering and fantasizing about women who rejected passive female roles and committed themselves to art. After

all, they did have young women as assistants and companions. But there is a space between us – time . . . a silence, as large as the desert, because history has ignored lesbian visual artists. The patriarchy has taken them.

The silence, the words omitted from the biographies of lesbian artists, have denied us role models and the possibility of developing work that acknowledges lesbian experience as a creative source for art-making and a context in which to explore it. I refuse to let them dispose of me in this way – to obliterate my existence as a lesbian and as an artist. I refuse to be quiet; I want lesbian artists to be visible.

Art not only reflects but creates and transforms cultural reality. Cultural reality is a whole, made up of individual realities. I first came out as a lesbian through my work. I knew and identified myself as a lesbian before ever sleeping with a woman. My work is the place where I confronted myself, gave form to my thoughts, fears, fantasies, and ideas. I had been drawing on a tradition of women's creativity in my work, so it was only natural to acknowledge my feelings and desires for women. My work is a lover, a connection between creativity and sexuality. Since I came out as a lesbian through my work, I came out as a lesbian artist – meaning the two are connected and affect each other. This was relatively easy, perhaps as a matter of evolution. As lesbians we have the possibility of the utmost creative freedom to make the strongest, most sensitive statements. Passion gives substance.

I believe that there is something as yet indefinable in my work, and other work that we might call "lesbian sensibility," but for the most part it is hidden. As our work becomes more visible recurring themes and approaches will emerge and we can examine and develop them. How can lesbian sensibility exist in the context of patriarchal art? In some works, lesbian imagery is overt – at least to other lesbians. In others, it is hidden or perhaps less important. That is okay; it's there and will come out. We do not need to define or limit it.

I feel that we are at a very important time, with new creative energy coming from political consciousness in our work. To be a lesbian artist is not a limitation or a box any more than being a feminist is, unless you make it so. It is a statement of commitment, energy, interest, and priority. As a feminist, and as a lesbian, I can express myself in any medium, and I can use any technique or approach to art-making. But whatever I do, be it overt lesbian imagery or a more covert statement, it will come from a consciousness of myself as a lesbian and an artist. It is a question of where you get your support and whom you give your energy to and not just a matter of whom you sleep with, nor your life-style. Where I put my creative energy is a political decision. It is important that we identify ourselves as lesbians as well as artists. No one is going to give us space or visibility. We must take it. Since we have no history, we can begin to paint, draw, weave, and write our own. In sisterhood. . . .

MONIQUE WITTIG

THE STRAIGHT MIND[1]

IN RECENT YEARS IN PARIS, language as a phenomenon has dominated modern theoretical systems and the social sciences, and has entered the political discussions of the lesbian and women's liberation movements. This is because it relates to an important political field where what is at play is power, or more than that, a network of powers, since there is multiplicity of languages which constantly act upon the social reality. The importance of language as such as a political stake has only recently been perceived.[2] But the gigantic development of linguistics, the multiplication of schools of linguistics, the advent of the sciences of communication, and the technicality of the metalanguages that these sciences utilize, represent the symptoms of the importance of that political stake. The science of language has invaded other sciences, such as anthropology through Lévi-Strauss, psychoanalysis through Lacan, and all the disciplines which have developed from the basis of structuralism.

The early semiology of Roland Barthes nearly escaped from linguistic domination to become a political analysis of the different systems of signs, to establish a relationship between this or that system of signs – for example, the myths of the petit bourgeois class – and the class struggle within capitalism that this system tends to conceal. We were almost saved, for political semiology is a weapon (a method) that we need to analyze what is called ideology. But the miracle did not last. Rather than introducing into semiology concepts which are foreign to it – in this case Marxist concepts – Barthes quickly stated that semiology was only a branch of linguistics and that language was its only object.

Thus, the entire world is only a great register where the most diverse languages come, to have themselves recorded, such as the language of the Unconscious,[3] the language of fashion, the language of the exchange of women where human beings are literally the signs which are used to communicate. These languages, or rather these discourses, fit into one another, interpenetrate one another, support one another, reinforce one another, auto-engender, and engender one another. Linguistics engenders semiology and structural linguistics, structural linguistics engenders structuralism which engenders the Structural Unconscious. The ensemble of these discourses produces a confusing static for the oppressed, which makes them lose sight of the material cause of their oppression and plunges them into a kind of ahistoric vacuum.

For they produce a scientific reading of the social reality in which human beings are given as invariants, untouched by history and unworked by class conflicts, with a psyche identical for each one of them because genetically programmed. This psyche, equally untouched by history and unworked by class conflicts, provides the specialists, from the beginning of the twentieth century, with a whole arsenal of invariants: the symbolic language which very advantageously functions with very few elements, since like digits (0–9) the symbols "unconsciously" produced by the psyche are not very numerous. Therefore, these symbols are very easy to impose, through therapy and theorization, upon the collective and individual unconscious. We

are taught that the unconscious, with perfectly good taste, structures itself upon metaphors, for example, the name-of-the-father, the Oedipus complex, castration, the murder-or-death-of-the-father, the exchange of women, etc. If the unconscious, however, is easy to control, it is not just by anybody. Similar to mystical revelations, the apparition of symbols in the psyche demands multiple interpretations. Only specialists can accomplish the deciphering of the unconscious. Only they, the psychoanalysts, are allowed (authorized?) to organize and interpret psychic manifestations which will show the symbol in its full meaning. And while the symbolic language is extremely poor and essentially lacunary, the languages or metalanguages which interpret it are developing, each one of them, with a richness, a display, that only logical exegeses (?) have equalled.

Who gave the psychoanalysts their knowledge? For example, for Lacan, what he calls the "psychoanalytic discourse," or the "analytical experience," both "teach" him what he already knows. And each one teaches him what the other one taught him. But who will deny that Lacan scientifically acknowledged, through the "analytical experience" (somehow an experiment) the structures of the Unconscious? Who will be irresponsible enough to disregard the discourses of the psychoanalyzed people lying on their couches? In my opinion, there is no doubt that Lacan found in the unconscious the structures he said he found there, since he had previously put them there. People who did not fall into the power of the psychoanalytical institution may experience an immeasurable feeling of sadness in front of the degree of oppression (of manipulation) that the psychoanalyzed discourses show. In the analytical experience there is an oppressed person, the psychoanalyzed, whose need for communication is exploited and who (in the same way as the witches could, under torture, only repeat the language that the inquisitors wanted to hear) has no other choice (if s/he does not want to destroy the implicit contract which allows her/him to communicate and which s/he needs), than to attempt to say what s/he is supposed to say. They say that this can last for a lifetime – cruel contract which constrains a human being to display her/his misery to an oppressor who is directly responsible for it, who exploits her/him economically, politically, ideologically and whose interpretation reduces this misery to a few figures of speech.

But can the need to communicate that this contract implies only be satisfied in the psychoanalytical situation, in being cured or "experimented" with? If we believe recent testimonies[4] by lesbians, feminists, and gay men, this is not the case. All their testimonies emphasize the political significance of the impossibility that lesbians, feminists, and gay men face in the attempt to communicate in heterosexual society, other than with a psychoanalyst. When the general state of things is understood (one is not sick or to be cured, one has an enemy) the result is for the oppressed person to break the psychoanalytical contract. This is what appears in the testimonies along with the teaching that the psychoanalytical contract was not a contract of consent but a forced one.

The discourses which particularly oppress all of us, lesbians, women, and homosexual men, are those discourses which take for granted that what founds society, any society, is heterosexuality.[5] These discourses speak about us and claim to say the truth in an apolitical field, as if anything of that which signifies could escape the political in this moment of history, and as if, in what concerns us, politically insignificant signs could exist. These discourses of heterosexuality oppress us in the sense that they prevent us from speaking unless we speak in their terms. Everything which puts them into question is at once disregarded as elementary. Our refusal of the totalizing interpretation of psychoanalysis makes the theoreticians say that we neglect the symbolic dimension. These discourses deny us every possibility of creating our own categories. But their most ferocious action is the unrelenting tyranny that they exert upon our physical and mental selves.

When we use the overgeneralizing term "ideology" to designate all the discourses of the dominating group, we relegate these discourses to the domain of Irreal Ideas, we forget the material (physical) violence that they directly do to the oppressed people, a violence produced by the abstract and "scientific" discourses as well as by the discourses of the mass media. I would like to insist on the material oppression of individuals by discourses, and I would like to underline its immediate effects through the example of pornography.

Pornographic images, films, magazine photos, publicity posters on the walls of the cities, constitute a discourse, and this discourse covers our world with its signs, and this discourse has a meaning: it signifies that women are dominated. Semioticians can interpret the system of this discourse, describe its disposition. What they read in that discourse are signs whose function is not to signify and which have no *raison d'être* except to be elements of a certain system or disposition. But for us this discourse is not divorced from the real as it is for semioticians. Not only does it maintain very close relations with the social reality which is our oppression (economically and politically), but also it is in itself real since it is one of the aspects of oppression, since it exerts a precise power over us. The pornographic discourse is part of the strategies of violence which are exercised upon us: it humiliates, it degrades, it is a crime against our "humanity." As a harassing tactic it has another function, that of a warning. It orders us to stay in line and it keeps those who would tend to forget who they are in step; it calls upon fear. These same experts in semiotics, referred to earlier, reproach us for confusing, when we demonstrate against pornography, the discourses with the reality. They do not see that this discourse *is* reality for us, one of the facets of the reality of our oppression. They believe that we are mistaken in our level of analysis.

I have chosen pornography as an example, because its discourse is the most symptomatic and the most demonstrative of the violence which is done to us through discourses, as well as in the society at large. There is nothing abstract about the power that sciences and theories have, to act materially and actually upon our bodies and our minds, even if the discourse that produces it is abstract. It is one of the forms of domination, its very expression, as Marx said. I would say, rather, one of its exercises. All of the oppressed know this power and have had to deal with it. It is the one which says: you do not have the right to speech because your discourse is not scientific and not theoretical, you are on the wrong level of analysis, you are confusing discourse and reality, your discourse is naive, you misunderstand this or that science.

If the discourse of modern theoretical systems and social science exert a power upon us, it is because it works with concepts which closely touch us. In spite of the historic advent of the lesbian, feminist, and gay liberation movements, whose proceedings have already upset the philosophical and political categories of the discourses of the social sciences, their categories (thus brutally put into question) are nevertheless utilized without examination by contemporary science. They function like primitive concepts in a conglomerate of all kinds of disciplines, theories, and current ideas that I will call the straight mind. (See *The Savage Mind* by Claude Lévi-Strauss.) They concern "woman," "man," "sex," "difference," and all of the series of concepts which bear this mark, including such concepts as "history," "culture," and the "real." And although it has been accepted in recent years that there is no such thing as nature, that everything is culture, there remains within that culture a core of nature which resists examination, a relationship excluded from the social in the analysis – a relationship whose characteristic is ineluctability in culture, as well as in nature, and which is the heterosexual relationship. I will call it the obligatory social relationship between "man" and "woman." (Here I refer to Ti-Grace Atkinson and her analysis of sexual intercourse as an institution.[6]) With its ineluctability as knowledge, as an obvious principle, as a given prior to any science,

the straight mind develops a totalizing interpretation of history, social reality, culture, language, and all the subjective phenomena at the same time. I can only underline the oppressive character that the straight mind is clothed in in its tendency to immediately universalize its production of concepts into general laws which claim to hold true for all societies, all epochs, all individuals. Thus one speaks of *the* exchange of women, *the* difference between the sexes, *the* symbolic order, *the* Unconscious, desire, *jouissance*, culture, history, giving an absolute meaning to these concepts when they are only categories founded upon heterosexuality or thought which produces the difference between the sexes as a political and philosophical dogma.

The consequence of this tendency toward universality is that the straight mind cannot conceive of a culture, a society where heterosexuality would not order not only all human relationships but also its very production of concepts and all the processes which escape consciousness, as well. Additionally, these unconscious processes are historically more and more imperative in what they teach us about ourselves through the instrumentality of specialists. The rhetoric which expresses them (and whose seduction I do not underestimate) envelops itself in myths, resorts to enigma, proceeds by accumulating metaphors, and its function is to poeticize the obligatory character of the "you-will-be-straight-or-you-will-not-be."

In this thought, to reject the obligation of coitus and the institutions that this obligation has produced as necessary for the constitution of a society, is simply an impossibility, since to do this would mean to reject the possibility of the constitution of the other and to reject the "symbolic order," to make the constitution of meaning impossible, without which no one can maintain an internal coherence. Thus lesbianism, homosexuality, and the societies that we form cannot be thought of or spoken of, even though they have always existed. Thus, the straight mind continues to affirm that incest, and not homosexuality, represents its major interdiction. Thus, when thought by the straight mind, homosexuality is nothing but heterosexuality.

Yet, straight society is based on the necessity of the different/other at every level. It cannot work economically, symbolically, linguistically, or politically without this concept. This necessity of the different/other is an ontological one for the whole conglomerate of sciences and disciplines that I call the straight mind. But what is the different/other if not the dominated? For heterosexual society is the society which not only oppresses lesbians and gay men, it oppresses many different/others, it oppresses all women and many categories of men, all those who are in the position of the dominated. To constitute a difference and to control it is an "act of power, since it is essentially a normative act. Everybody tries to show the other as different. But not everybody succeeds in doing so. One has to be socially dominant to succeed in it."[7]

For example, the concept of difference between the sexes ontologically constitutes women into different/others. Men are not different, whites are not different, nor are the masters. But the blacks, as well as the slaves, are. This ontological characteristic of the difference between the sexes affects all the concepts which are part of the same conglomerate. But for us there is no such thing as being-woman or being-man. "Man" and "woman" are political concepts of opposition, and the copula which dialectically unites them is, at the same time, the one which abolishes them.[8] It is the class struggle between women and men which will abolish men and women.[9] The concept of difference has nothing ontological about it. It is only the way that the masters interpret a historical situation of domination. The function of difference is to mask at every level the conflicts of interest, including ideological ones.

In other words, for us, this means there cannot any longer be women and men, and that as classes and as categories of thought or language they have to disappear, politically,

economically, ideologically. If we, as lesbians and gay men, continue to speak of ourselves and to conceive of ourselves as women and as men, we are instrumental in maintaining hetero-sexuality. I am sure that an economic and political transformation will not dedramatize these categories of language. Can we redeem *slave*? Can we redeem *nigger, negress*? How is *woman* different? Will we continue to write *white, master, man*? The transformation of economic rela-tionships will not suffice. We must produce a political transformation of the key concepts, that is of the concepts which are strategic for us. For there is another order of materiality, that of language, and language is worked upon from within by these strategic concepts. It is at the same time tightly connected to the political field where everything that concerns language, science and thought refers to the person as subjectivity and to her/his relationship to society.[10] And we cannot leave this within the power of the straight mind or the thought of domination.

If among all the production of the straight mind I especially challenge structuralism and the Structural Unconscious, it is because: at the moment in history when the domination of social groups can no longer appear as a logical necessity to the dominated, because they revolt, because they question the differences, Lévi-Strauss, Lacan and their epigones call upon neces-sities which escape the control of consciousness and therefore the responsibility of individuals.

They call upon unconscious processes, for example, which require the exchange of women as a necessary condition for every society. According to them, that is what the unconscious tells us with authority, and the symbolic order, without which there is no meaning, no language, no society, depends on it. But what does women being exchanged mean if not that they are dominated? No wonder then that there is only one unconscious, and that it is hetero-sexual. It is an unconscious which looks too consciously after the interests of the masters[11] in whom it lives for them to be dispossessed of their concepts so easily. Besides, domination is denied; there is no slavery of women, there is difference. To which I will answer with this statement made by a Rumanian peasant at a public meeting in 1848: "Why do the gentlemen say it was not slavery, for we know it to have been slavery, this sorrow that we have sorrowed." Yes, we know it, and this science of oppression cannot be taken away from us.

It is from this science that we must track down the "what goes-without-saying" hetero-sexual, and (I paraphrase the early Roland Barthes) we must not bear "seeing Nature and History confused at every turn."[12] We must make it brutally apparent that structuralism, psychoanalysis, and particularly Lacan have rigidly turned their concepts into myths – Difference, Desire, the Name-of-the-father, etc. They have even "over-mythified" the myths, an operation that was necessary for them in order to systematically heterosexualize that personal dimension which suddenly emerged through the dominated individuals into the historical field, particularly through women, who started their struggle almost two centuries ago. And it has been done systematically, in a concert of interdisciplinarity, never more harmonious than since the heterosexual myths started to circulate with ease from one formal system to another, like sure values that can be invested, in anthropology as well as in psychoanalysis and in all the social sciences.

This ensemble of heterosexual myths is a system of signs which uses figures of speech, and thus it can be politically studied from within the science of our oppression; "for-we-know-it-to-have-been-slavery" is the dynamic which introduces the diachronism of history into the fixed discourse of eternal essences. This undertaking should somehow be a political semi-ology, although with "this sorrow that we have sorrowed" we work also at the level of language/manifesto, of language/action, that which transforms, that which makes history.

In the meantime in the systems that seemed so eternal and universal that laws could be extracted from them, laws that could be stuffed into computers, and in any case for the

moment stuffed into the unconscious machinery, in these systems, thanks to our action and our language, shifts are happening. Such a model, as for example, the exchange of women, reengulfs history in so violent and brutal a way that the whole system, which was believed to be formal, topples over into another dimension of knowledge. This dimension belongs to us, since somehow we have been designated, and since, as Lévi-Strauss said, we talk, let us say that we break off the heterosexual contract.

So, this is what lesbians say everywhere in this country and in some others, if not with theories at least through their social practice, whose repercussions upon straight culture and society are still unenvisionable. An anthropologist might say that we have to wait for fifty years. Yes, if one wants to universalize the functioning of these societies and make their invariants appear. Meanwhile the straight concepts are undermined. What is woman? Panic, general alarm for an active defense. Frankly, it is a problem that the lesbians do not have because of a change of perspective, and it would be incorrect to say that lesbians associate, make love, live with women, for "woman" has meaning only in heterosexual systems of thought and heterosexual economic systems. Lesbians are not women.[13]

Notes

1 This text was first read in New York at the Modern Language Association Convention in 1978 and dedicated to the American lesbians.
2 However, the classical Greeks knew that there was no political power without mastery of the art of rhetoric, especially in a democracy.
3 Throughout this paper when Lacan's use of the term "the unconscious" is referred to it is capitalized, following his style.
4 For example see Karla Jay, Allen Young, eds., *Out of the Closets* (New York: Links Books, 1972).
5 Heterosexuality: a word which first appears in the French language in 1911.
6 Ti-Grace Atkinson, *Amazon Odyssey* (New York: Links Books, 1974), pp. 13–23.
7 Claude Faugeron and Philippe Robert, *La Justice et son public et les représentations sociales du système pénal* (Paris: Masson, 1978).
8 See for her definition of "social sex" Nicole-Claude Mathieu, "Notes pour une définition sociologique des categories de sexe," *Epistemologie Sociologique* 11 (1971); translated in Nicole-Claude Mathieu, *Ignored by Some, Denied by Others: The Social Sex Category in Sociology* (pamphlet), Explorations in Feminism 2 (London: Women's Research and Resources Centre Publications, 1977), pp. 16–37.
9 In the same way as for every other class struggle where the categories of opposition are "reconciled" by the struggle whose goal is to make them disappear.
10 See Christine Delphy, "Pour un Féminisme Matérialiste," *l'Arc* 61, *Simone de Beauvoir et la lutte des femmes*, which will appear in a forthcoming number of *Feminist Issues*.
11 Are the millions of dollars a year made by the psychoanalysts symbolic?
12 Roland Barthes, *Mythologies* (New York: Hill and Wang, 1972), p. 11.
13 No more is any woman who is not in a relation of personal dependency with a man.

SANDER L. GILMAN

BLACK BODIES, WHITE BODIES
Toward an iconography of female sexuality in late nineteenth-century art, medicine, and literature

HOW DO WE ORGANIZE OUR PERCEPTIONS of the world? Recent discussions of this age-old question have centered around the function of visual conventions as the primary means by which we perceive and transmit our understanding of the world about us.[1] Nowhere are these conventions more evident than in artistic representations, which consist more or less exclusively of icons. Rather than presenting the world, icons represent it. Even with a modest nod to supposedly mimetic portrayals it is apparent that, when individuals are shown within a work of art (no matter how broadly defined), the ideologically charged iconographic nature of the representation dominates. And it dominates in a very specific manner, for the representation of individuals implies the creation of some greater class or classes to which the individual is seen to belong. These classes in turn are characterized by the use of a model which synthesizes our perception of the uniformity of the groups into a convincingly homogeneous image. The resulting stereotypes may be overt, as in the case of caricatures, or covert, as in eighteenth-century portraiture. But they serve to focus the viewer's attention on the relationship between the portrayed individual and the general qualities ascribed to the class.

Specific individual realities are thus given mythic extension through association with the qualities of a class. These realities manifest as icons representing perceived attributes of the class into which the individual has been placed. The myths associated with the class, the myth of difference from the rest of humanity, is thus, to an extent, composed of fragments of the real world, perceived through the ideological bias of the observer. These myths are often so powerful, and the associations of their conventions so overpowering, that they are able to move from class to class without substantial alteration. In linking otherwise marginally or totally unrelated classes of individuals, the use of these conventions reveals perceptual patterns which themselves illuminate the inherent ideology at work.

While the discussion of the function of conventions has helped reveal the essential iconographic nature of all visual representation, it has mainly been limited to a specific sphere – aesthetics. And although the definition of the aesthetic has expanded greatly in the past decade to include everything from decoration to advertising, it continues to dominate discussions of visual conventions. Patterns of conventions are established within the world of art or between that world and parallel ones, such as the world of literature, but they go no farther. We maintain a special sanctity about the aesthetic object which we deny to the conventions of representation in other areas.

This essay is an attempt to plumb the conventions (and thus the ideologies) which exist at a specific historical moment in both the aesthetic and scientific spheres. I will assume the existence of a web of conventions within the world of the aesthetic – conventions which have elsewhere been admirably illustrated – but will depart from the norm by examining the synchronic existence of another series of conventions, those of medicine. I do not mean in any way to accord special status to medical conventions. Indeed, the world is full of over-lapping and intertwined systems of conventions, of which the medical and the aesthetic are but two. Medicine offers an especially interesting source of conventions since we do tend to give medical conventions special "scientific" status as opposed to the "subjective" status of the aesthetic conventions. But medical icons are no more "real" than "aesthetic" ones. Like aesthetic icons, medical icons may (or may not) be rooted in some observed reality. Like them, they are iconographic in that they represent these realities in a manner determined by the histor-ical position of the observers, their relationship to their own time, and to the history of the conventions which they employ. Medicine uses its categories to structure an image of the diversity of mankind; it is as much at the mercy of the needs of any age to comprehend this infinite diversity as any other system which organizes our perception of the world. The power of medicine, at least in the nineteenth century, lies in the rise of the status of science. The conventions of medicine infiltrate other seemingly closed iconographic systems precisely because of this status. In examining the conventions of medicine employed in other areas, we must not forget this power.

One excellent example of the conventions of human diversity captured in the iconog-raphy of the nineteenth century is the linkage of two seemingly unrelated female images – the icon of the Hottentot female and the icon of the prostitute. In the course of the nine-teenth century, the female Hottentot comes to represent the black female *in nuce*, and the prostitute to represent the sexualized woman. Both of these categories represent the creation of classes which correspondingly represent very specific qualities. While the number of terms describing the various categories of the prostitute expanded substantially during the nineteenth century, all were used to label the sexualized woman. Likewise, while many groups of African blacks were known to Europeans in the nineteenth century, the Hottentot remained repre-sentative of the essence of the black, especially the black female. Both concepts fulfilled an iconographic function in the perception and the representation of the world. How these two concepts were associated provides a case study for the investigation of patterns of conven-tions, without any limitation on the "value" of one pattern over another.

Let us begin with one of the classic works of nineteenth-century art, a work which records the idea of both the sexualized woman and the black woman. Edouard Manet's *Olympia*, painted in 1862–63 and first exhibited in the Salon of 1865, assumes a key position in docu-menting the merger of these two images [Figure 19.1]. The conventional wisdom concerning Manet's painting states that the model, Victorine Meurend, is "obviously naked rather than conventionally nude,"[2] and that her pose is heavily indebted to classical models such as Titian's *Venus of Urbino* (1538), Francisco Goya's *Naked Maja* (1800), and Eugène Delacroix's *Odalisque* (1847), as well as other works by Manet's contemporaries, such as Gustave Courbet.[3] George Needham has shown quite convincingly that Manet was also using a convention of early erotic photography in having the central figure directly confront the observer.[4] The black female attendant, based on a black model called Laura, has been seen as a reflex of both the classic black servant figure present in the visual arts of the eighteenth century as well as a repre-sentation of Baudelaire's *Vénus noire*.[5]

[. . .]

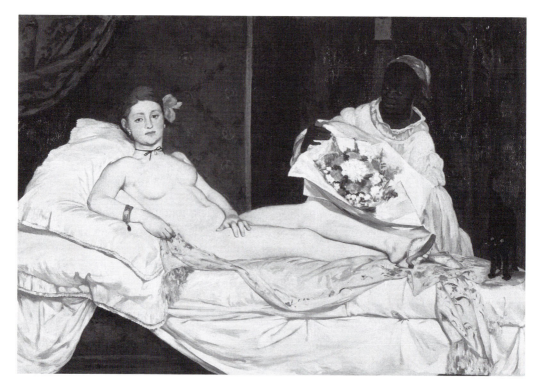

Figure 19.1 Edouard Manet, *Olympia*, 1863. Paris, Musée d'Orsay.

The figure of the black servant in European art is ubiquitous. Richard Strauss knew this when he had Hugo von Hofmannsthal conclude their conscious evocation of the eighteenth century, *Der Rosenkavalier* (1911), with the mute return of the little black servant to reclaim the Marschallin's forgotten gloves.[6] But Hofmannsthal was also aware that one of the black servant's central functions in the visual arts of the eighteenth and nineteenth centuries was to sexualize the society in which he or she is found. The forgotten gloves, for instance, mark the end of the relationship between Octavian, the Knight of the Rose, and the Marschallin: the illicit nature of their sexual relationship, which opens the opera, is thereby linked to the appearance of the figure of the black servant, which closes the opera. When one turns to the narrative art of the eighteenth century – for example, to William Hogarth's two great cycles, *A Rake's Progress* (1733–34) and *A Harlot's Progress* (1731) – it is not very surprising that, as in the Strauss opera some two centuries later, the figures of the black servants mark the presence of illicit sexual activity. Furthermore, as in Hofmannsthal's libretto, they appear in the opposite sex to the central figure. In the second plate of *A Harlot's Progress*, we see Moll Hackabout as the mistress of a Jewish merchant, the first stage of her decline as a sexualized female; also present is a young, black male servant. In the third stage of Tom Rakewell's collapse, we find him in a notorious brothel, the Rose Tavern in Covent Garden.[7] The entire picture is full of references to illicit sexual activity, all portrayed negatively; present as well is the figure of a young female black servant.

The association of the black with concupiscence reaches back into the Middle Ages. The twelfth-century Jewish traveler Benjamin of Tudela wrote that

at Seba on the river Pishon . . . is a people . . . who, like animals, eat of the herbs that grow on the banks of the Nile and in the fields. They go about naked and have not the intelligence of ordinary men. They cohabit with their sisters and anyone they can find. . . . And these are the Black slaves, the sons of Ham.[8]

By the eighteenth century, the sexuality of the black, both male and female, becomes an icon for deviant sexuality in general; as we have seen, the black figure appears almost always paired with a white figure of the opposite sex. By the nineteenth century, as in the *Olympia* [. . .] the central female figure is associated with a black female in such a way as to imply their sexual similarity. The association of figures of the same sex stresses the special status of female sexuality.

[. . .]

The relationship between the sexuality of the black woman and that of the sexualized white woman enters a new dimension when contemporary scientific discourse concerning the nature of black female sexuality is examined.

Buffon commented on the lascivious, apelike sexual appetite of the black, introducing a commonplace of early travel literature into a "scientific" context.[9] He stated that this animallike sexual appetite went so far as to lead black women to copulate with apes. The black female thus comes to serve as an icon for black sexuality in general. Buffon's view was based on a confusion of two applications of the great chain of being to the nature of the black. Such a scale was employed to indicate the innate difference between the races: in this view of mankind, the black occupied the antithetical position to the white on the scale of humanity. This poly-genetic view was applied to all aspects of mankind, including sexuality and beauty. The antithesis of European sexual mores and beauty is embodied in the black, and the essential black, the lowest rung on the great chain of being, is the Hottentot. The physical appearance of the Hottentot is, indeed, the central nineteenth-century icon for sexual difference between the European and the black – a perceived difference in sexual physiology which puzzled even early monogenetic theoreticians such as Johann Friedrich Blumenbach.

Such labeling of the black female as more primitive, and therefore more sexually inten-sive, by writers like the Abbé Raynal would have been dismissed as unscientific by the radical empiricists of late eighteenth- and early nineteenth-century Europe.[10] To meet their scientific standards, a paradigm was needed which would technically place both the sexuality and the beauty of the black in an antithetical position to that of the white. This paradigm would have to be rooted in some type of unique and observable physical difference; they found that differ-ence in the distinction they drew between the pathological and the normal in the medical model. William Bynum has contended that nineteenth-century biology constantly needed to deal with the polygenetic argument. We see the validity of his contention demonstrated here, for the medical model assumes the polygenetic difference between the races.[11]

It was in the work of J. J. Virey that this alteration of the mode of discourse – though not of the underlying ideology concerning the black female – took place. He was the author of the study of race standard in the early nineteenth century and also contributed a major essay (the only one on a specific racial group) to the widely cited *Dictionnaire des sciences médicales* [*Dictionary of medical sciences*] (1819).[12] In this essay, Virey summarized his (and his contemporaries') views on the sexual nature of black females in terms of acceptable medical discourse. According to him, their "voluptuousness" is "developed to a degree of lascivity unknown in our climate, for their sexual organs are much more developed than those of whites." Elsewhere, Virey cites the Hottentot woman as the epitome of this sexual

lasciviousness and stresses the relationship between her physiology and her physiognomy (her "hideous form" and her "horribly flattened nose"). His central proof is a discussion of the unique structure of the Hottentot female's sexual parts, the description of which he takes from the anatomical studies published by his contemporary, Georges Cuvier.[13] According to Cuvier, the black female looks different. Her physiognomy, her skin color, the form of her genitalia label her as inherently different. In the nineteenth century, the black female was widely perceived as possessing not only a "primitive" sexual appetite but also the external signs of this temperament – "primitive" genitalia. Eighteenth-century travelers to southern Africa, such as François Le Vaillant and John Barrow, had described the so-called Hottentot apron, a hypertrophy of the labia and nymphae caused by the manipulation of the genitalia and serving as a sign of beauty among certain tribes, including the Hottentots and Bushmen as well as tribes in Basutoland and Dahomey.[14]

The exhibition in 1810 of Saartjie Baartman, also called Sarah Bartmann or Saat-Jee and known as the "Hottentot Venus," caused a public scandal in a London inflamed by the issue of the abolition of slavery, since she was exhibited "to the public in a manner offensive to decency. She . . . does exhibit all the shape and frame of her body as if naked" [Figure 19.2]. The state's objection was as much to her lewdness as to her status as an indentured black. In France her presentation was similar. Sarah Bartmann was not the only African to be so displayed: in 1829 a nude Hottentot woman, also called "the Hottentot Venus," was the prize attraction at a ball given by the Duchess du Barry in Paris. A contemporary print emphasized her physical difference from the observers portrayed.[15] After more than five years of exhibition in Europe, Sarah Bartmann died in Paris in 1815 at the age of twenty-five. An autopsy was performed on her which was first written up by Henry de Blainville in 1816 and then, in its most famous version, by Cuvier in 1817.[16] Reprinted at least twice during the next decade, Cuvier's description reflected de Blainville's two intentions: the comparison of a female of the "lowest" human species with the highest ape (the orangutan) and the description of the anomalies of the Hottentot's "organ of generation." It is important to note that Sarah Bartmann was exhibited not to show her genitalia but rather to present another anomaly which the European audience (and pathologists such as de Blainville and Cuvier) found riveting. This was the steatopygia, or protruding buttocks, the other physical characteristic of the Hottentot female which captured the eye of early European travelers. Thus the figure of Sarah Bartmann was reduced to her sexual parts. The audience which had paid to see her buttocks and had fantasized about the uniqueness of her genitalia when she was alive could, after her death and dissection, examine both, for Cuvier presented to "the Academy the genital organs of this woman prepared in a way so as to allow one to see the nature of the labia."[17]

Sarah Bartmann's sexual parts, her genitalia and her buttocks, serve as the central image for the black female throughout the nineteenth century. And the model of de Blainville's and Cuvier's descriptions, which center on the detailed presentation of the sexual parts of the black, dominates all medical description of the black during the nineteenth century. To an extent, this reflects the general nineteenth-century understanding of female sexuality as pathological: the female genitalia were of interest partly as examples of the various pathologies which could befall them but also because the female genitalia came to define the female for the nineteenth century. When a specimen was to be preserved for an anatomical museum, more often than not the specimen was seen as a pathological summary of the entire individual. Thus, the skeleton of a giant or a dwarf represented "giantism" or "dwarfism"; the head of a criminal represented the act of execution which labeled him "criminal."[18] Sarah

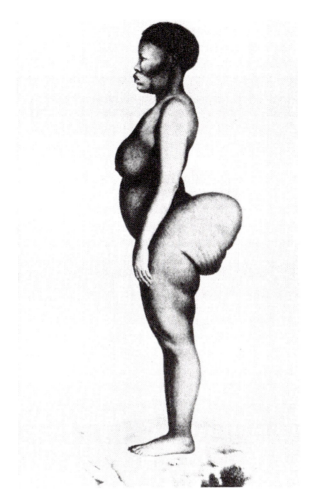

Figure 19.2 The Hottentot Venus, from Georges Cuvier, "Extraits d'observations faites sur le cadavre d'une femme connue à Paris et à Londres sous le nom de Vénus Hottentote," 1817.

Bartmann's genitalia and buttocks summarized her essence for the nineteenth-century observer, or, indeed, for the twentieth-century one, as they [were, until 2002, when they were returned to South Africa] still on display at the Musée de l'homme in Paris. Thus when one turns to the autopsies of Hottentot females in the nineteenth century, their description centers about the sexual parts. De Blainville (1816) and Cuvier (1817) set the tone, which is followed by A. W. Otto in 1824, Johannes Müller in 1834 [Figure 19.3], William H. Flower and James Murie in 1867, and Luschka, Koch, and Görtz in 1869.[19] These presentations of Hottentot or Bushman women all focus on the presentation of the genitalia and buttocks. Flower, the editor of the *Journal of Anatomy and Physiology*, included his dissection study in the opening volume of that famed journal. His ideological intent was clear. He wished to provide data "relating to the unity or plurality of mankind." His description begins with a detailed presentation of the form and size of the buttocks and concludes with his portrayal of the "remarkable development of the labia minoria, or nymphae, which is so general a characteristic of the Hottentot and Bushman race." These were "sufficiently well marked to distinguish these parts

at once from those of any of the ordinary varieties of the human species." The polygenetic argument is the ideological basis for all the dissections of these women. If their sexual parts could be shown to be inherently different, this would be a sufficient sign that the blacks were a separate (and, needless to say, lower) race, as different from the European as the prover-bial orangutan. Similar arguments had been made about the nature of all blacks' (and not just Hottentots') genitalia, but almost always concerning the female. Edward Turnipseed of South Carolina argued in 1868 that the hymen in black women "is not at the entrance to the vagina, as in the white woman, but from one-and-a-half to two inches from its entrance in the inte-rior." From this he concluded that "this may be one of the anatomical marks of the non-unity of the races."[20] His views were seconded in 1877 by C. H. Fort, who presented another six cases of this seeming anomaly.[21] In comparison, when one turns to the description of the autopsies of black males from approximately the same period, the absence of any discussion of the male genitalia whatsoever is striking. For example, William Turner, in his three dissec-tions of male blacks in 1878, 1879, and 1896, makes no mention at all of the genitalia.[22] The uniqueness of the genitalia and buttocks of the black is thus associated primarily with the female and is taken to be a sign solely of an anomalous *female* sexuality.

By mid-century the image of the genitalia of the Hottentot had assumed a certain set of implications. The central view is that these anomalies are inherent, biological variations rather than adaptions. In Theodor Billroth's standard handbook of gynecology, a detailed presenta-tion of the "Hottentot apron" is part of the discussion of errors in development of the female genitalia (*Entwicklungsfehler*). By 1877 it was a commonplace that the Hottentot's anomalous sexual form was similar to other errors in the development of the labia. The author of this section links this malformation with the overdevelopment of the clitoris, which he sees as leading to those "excesses" which "are called 'lesbian love.'" The concupiscence of the black is thus associated also with the sexuality of the lesbian.[23] In addition, the idea of a congenital error incorporates the disease model applied to the deformation of the labia in the Hottentot, for the model of degeneracy presumes some acquired pathology in one genera-tion which is the direct cause of the stigmata of degeneracy in the next. Surely the best example for this is the concept of congenital syphilis as captured in the popular conscious-ness by Henrik Ibsen's drama of biological decay, *Ghosts*. Thus Billroth's "congenital failure" is presupposed to have some direct and explicable etiology as well as a specific manifestation. While this text is silent as to the etiology, we can see the link established between the ill, the bestial, and the freak (pathology, biology, and medicine) in this view of the Hottentot's genitalia.

At this point, an aside might help explain both the association of the genitalia, a primary sexual characteristic, and the buttocks, a secondary sexual characteristic, in their role as the semantic signs of "primitive" sexual appetite and activity. Havelock Ellis, in volume 4 of his *Studies in the Psychology of Sex* (1905), provided a detailed example of the great chain of being as applied to the perception of the sexualized Other. Ellis believed that there is an absolute scale of beauty which is totally objective and which ranges from the European to the black. Thus men of the lower races, according to Ellis, admire European women more than their own, and women of lower races attempt to whiten themselves with face powder. Ellis then proceeded to list the secondary sexual characteristics which comprise this ideal of beauty, rejecting the "naked sexual organ[s]" as not "aesthetically beautiful" since it is "fundamentally necessary" that they "retain their primitive characteristics." Only people "in a low state of culture" perceive the "naked sexual organs as objects of attraction."[24] The list of secondary sexual characteristics which Ellis then gives as the signs of a cultured (that is, not primitive)

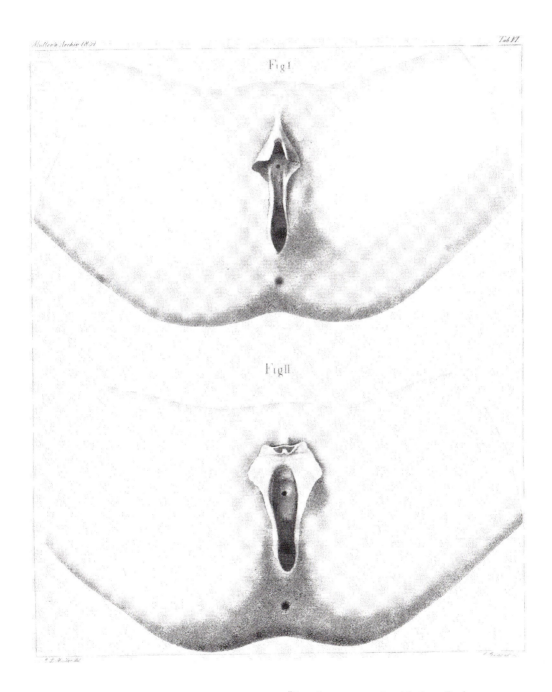

Fig I

Fig II

Figure 19.3 The "Hottentot Apron," Johannes Müller, "Über die äusseren Geschlechtsteile der Buschmänninnen," 1834.

perception of the body – the vocabulary of aesthetically pleasing signs – begins with the buttocks. This is, of course, a nineteenth-century fascination with the buttocks as a displacement for the genitalia. Ellis gives it the quality of a higher regard for the beautiful. His discussions of the buttocks ranks the races by size of the female pelvis, a view which began with Willem Vrolik's claim in 1826 that a narrow pelvis is a sign of racial superiority and is echoed by R. Verneau's study in 1875 of the form of the pelvis among the various races.[25] Verneau uses the pelvis of Sarah Bartmann to argue the primitive nature of the Hottentot's anatomical structure. Ellis accepts this ranking, seeing the steatopygia as "a simulation of the large pelvis of the higher races," having a compensatory function like face powder in emulating white skin. This view places the pelvis in an intermediary role as both a secondary as well as a primary sexual sign. Darwin himself, who held similar views as to the objective nature of human beauty, saw the pelvis as a "primary [rather] than as a secondary . . . character" and the buttocks of the Hottentot as a somewhat comic sign of the primitive, grotesque nature of the black female.[26]

When the Victorians saw the female black, they saw her in terms of her buttocks and saw represented by the buttocks all the anomalies of her genitalia. In a mid-century erotic caricature of the Hottentot Venus, a white, male observer views her through a telescope, unable to see anything but her buttocks [Figure 19.4].[27] This fascination with the uniqueness of the sexual parts of the black focuses on the buttocks over and over again. In a British pornographic novel, published in 1899 but set in a mythic, antebellum Southern United States, the male author indulges his fantasy of flagellation on the buttocks of a number of white women. When he describes the one black, a runaway slave, being whipped, the power of the image of the Hottentot's buttocks captures him:

> She would have had a good figure, only that her bottom was out of all proportion.
> It was too big, but nevertheless it was fairly well shaped, with well-rounded cheeks
> meeting each other closely, her thighs were large, and she had a sturdy pair of legs,
> her skin was smooth and of a clear yellow tint.[28]

The presence of exaggerated buttocks points to the other, hidden sexual signs, both physical and temperamental, of the black female. This association is a powerful one. Indeed Freud, in *Three Essays on Sexuality* (1905), echoes the view that female genitalia are more primitive than those of the male, for female sexuality is more anal than that of the male.[29] Female sexuality is linked to the image of the buttocks, and the quintessential buttocks are those of the Hottentot.

[. . .]

In the nineteenth century, the prostitute is perceived as the essential sexualized female. She is perceived as the embodiment of sexuality and of all that is associated with sexuality – disease as well as passion.[30] Within the large and detailed literature concerning prostitution written during the nineteenth century (most of which documents the need for legal controls and draws on the medical model as perceived by public health officials), the physiognomy and physiology of the prostitute are analyzed in detail. We can begin with the most widely read early nineteenth-century work on prostitution, that of A. J. B. Parent-Duchatelet, who provides a documentation of the anthropology of the prostitute in his study of prostitution in Paris (1836).[31] Alain Corbin has shown how Parent-Duchatelet's use of the public health model reduces the prostitute to yet another source of pollution, similar to the sewers of Paris. Likewise in Parent-Duchatelet's discussion of the physiognomy of the prostitute, he believes

Figure 19.4 The Hottentot Venus, popular engraving, *c.*1850.

himself to be providing a descriptive presentation of the appearance of the prostitute. He presents his readers with a statistical description of the physical types of the prostitutes, the nature of their voices, the color of their hair and eyes, their physical anomalies, and their sexual profile in relation to childbearing and disease. Parent-Duchatelet's descriptions range from the detailed to the anecdotal. His discussion of the *embonpoint* of the prostitute begins his litany of external signs. Prostitutes have a "peculiar plumpness" which is attributed to "the great number of hot baths which the major part of these women take" – or perhaps to their lassitude, since they rise at ten or eleven in the morning, "leading an animal life." They are fat as prisoners are fat, from simple confinement. As an English commentator noted, "the grossest and stoutest of these women are to be found amongst the lowest and most disgusting classes of prostitutes."[32] These are the Hottentots on the scale of the sexualized female.

[. . .]

The perception of the prostitute in the late nineteenth century [. . .] merged with the perception of the black. Both categories are those of outsiders, but what does this amalgamation imply in terms of the perception of both groups? It is a commonplace that the primitive was associated with unbridled sexuality. This was either condemned, as in Thomas Jefferson's discussions of the nature of the black in Virginia, or praised, as in the fictional supplement

written by Denis Diderot to Bougainville's voyages. It is exactly this type of uncontrolled sexuality, however, which is postulated by historians such as J. J. Bachofen as the sign of the "swamp," the earliest stage of human history. Blacks, if both G. W. F. Hegel and Arthur Schopenhauer are to be believed, remained at this most primitive stage, and their presence in the contemporary world served as an indicator of how far mankind had come in establishing control over his world and himself. The loss of control was marked by a regression into this dark past – a degeneracy into the primitive expression of emotions in the form of either madness or unrestrained sexuality. Such a loss of control was, of course, viewed as pathological and thus fell into the domain of the medical model. For the medical model, especially as articulated in the public health reforms of the mid- and late nineteenth century, had as its central preoccupation the elimination of sexually transmitted disease through the institution of social controls; this was the project which motivated writers such as Parent-Duchatelet and Tarnowsky. The social controls which they wished to institute had existed in the nineteenth century but in quite a different context. The laws applying to the control of slaves (such as the 1685 French *code noir* and its American analogues) had placed great emphasis on the control of the slave as sexual object, both in terms of permitted and forbidden sexual contacts as well as by requiring documentation as to the legal status of the offspring of slaves. Sexual control was thus well known to the late eighteenth and early nineteenth centuries.

The linkage which the late nineteenth century established between this earlier model of control and the later model of sexual control advocated by the public health authorities came about through the association of two bits of medical mythology. The primary marker of the black is his or her skin color. Medical tradition has a long history of perceiving this skin color as the result of some pathology. The favorite theory, which reappears with some frequency in the early nineteenth century, is that the skin color and attendant physiognomy of the black are the result of congenital leprosy.[33] It is not very surprising, therefore, to read in the late nineteenth century – after social conventions surrounding the abolition of slavery in Great Britain and France, as well as the trauma of the American Civil War, forbade the public association of at least skin color with illness – that syphilis was not introduced into Europe by Christopher Columbus' sailors but rather that it was a form of leprosy which had long been present in Africa and had spread into Europe in the Middle Ages.[34] The association of the black, especially the black female, with the syphilophobia of the late nineteenth century was thus made manifest. Black females do not merely represent the sexualized female, they also represent the female as the source of corruption and disease. It is the black female as the emblem of illness who haunts the background of Manet's *Olympia*.

For Manet's *Olympia* stands exactly midway between the glorification and the condemnation of the sexualized female. She is the antithesis of the fat prostitute. Indeed, she was perceived as thin by her contemporaries, much in the style of the actual prostitutes of the 1860s. But Laura, the black servant, is presented as plump, which can be best seen in Manet's initial oil sketch of her done in 1862–63. Her presence in both the sketch and in the final painting emphasizes her face, for it is the physiognomy of the black which points to her own sexuality and to that of the white female presented to the viewer unclothed but with her genitalia demurely covered. The association is between these hidden genitalia and the signifier of the black. Both point to potential corruption of the male viewer by the female.

[. . .]

It is [. . .] uncleanliness, [. . .] disease, which [form] the final link between two images of woman, the black and the prostitute. Just as the genitalia of the Hottentot were perceived as parallel to the diseased genitalia of the prostitute, so too the power of the idea of corruption

links both images. [. . .] Miscegenation was a fear (and a word) from the late nineteenth-century vocabulary of sexuality. It was a fear not merely of interracial sexuality but of its results, the decline of the population. Interracial marriages were seen as exactly parallel to the barrenness of the prostitute; if they produced children at all, these children were weak and doomed. Thus Ellis, drawing on his view of the objective nature of the beauty of man-kind, states that "it is difficult to be sexually attracted to persons who are fundamentally unlike ourselves in racial constitution" (*SPS*, p. 176). He cites Abel Hermant to substantiate his views:

> Differences of race are irreducible and between two beings who love each other they cannot fail to produce exceptional and instructive reactions. In the first superficial ebullition of love, indeed, nothing notable may be manifested, but in a fairly short time the two lovers, innately hostile, in striving to approach each other strike against an invisible partition which separates them. Their sensibilities are divergent; every-thing in each shocks the other; even their anatomical conformation, even the language of their gestures; all is foreign.[35]

It is thus the inherent fear of the difference in the anatomy of the Other which lies behind the synthesis of images. The Other's pathology is revealed in anatomy. It is the similarity between the black and the prostitute – as bearers of the stigmata of sexual difference and, thus, pathology – which captured the late nineteenth century. [. . .]

The "white *man's* burden" thus becomes his sexuality and its control, and it is this which is transferred into the need to control the sexuality of the Other, the Other as sexualized female. The colonial mentality which sees "natives" as needing control is easily transferred to "woman" – but woman as exemplified by the caste of the prostitute. This need for control was a projection of inner fears; thus, its articulation in visual images was in terms which described the polar opposite of the European male.

The roots of this image of the sexualized female are to be found in male observers, the progenitors of the vocabulary of images through which they believed themselves able to capture the essence of the Other. Thus when Freud, in his *Essay on Lay Analysis* (1926), discusses the ignorance of contemporary psychology concerning adult female sexuality, he refers to this lack of knowledge as the "dark continent" of psychology (*SE*, 20: 212).[36] In using this phrase in English, Freud ties the image of female sexuality to the image of the colonial black and to the perceived relationship between the female's ascribed sexuality and the Other's exoticism and pathology. It is Freud's intent to explore this hidden "dark continent" and reveal the hidden truths about female sexuality, just as the anthropologist-explorers (such as Lombroso) were revealing the hidden truths about the nature of the black. Freud continues a discourse which relates the images of male discovery to the images of the female as object of discovery. The line from the secrets possessed by the "Hottentot Venus" to twentieth-century psycho-analysis runs reasonably straight.

Notes

1 The debate between E. H. Gombrich, *The Image and the Eye* (Ithaca, N.Y., 1982) and Nelson Goodman, *Ways of Worldmaking* (Hassocks, 1978) has revolved mainly around the manner by which conventions of representation create the work of art. Implicit in their debate is the broader question of the function of systems of conventions as icons within the work of art itself. On the limitation of the discussion of

systems of conventions to aesthetic objects, see the extensive bibliography compiled in Ulrich Weisstein, "Bibliography of Literature and the Visual Arts, 1945–1980," *Comparative Criticism* 4 (1982): 324–34, in which the special position of the work of art as separate from other aspects of society can be seen. This is a holdover from the era of *Geistesgeschichte* in which special status was given to the interaction between aesthetic objects.

 This can be seen in the alternative case of works of aesthetic provenance which are, however, part of medical discourse. One thinks immediately of the anatomical works of Leonardo or George Stubbs or of paintings with any medical reference such as Rembrandt's *Dr. Tulp* or Théodore Géricault's paintings of the insane. When the literature on these works is examined, it is striking how most analysis remains embedded in the discourse of aesthetic objects, i.e., the anatomical drawing as a "subjective" manner of studying human form or, within medical discourse, as part of a "scientific" history of anatomical illustration. The evident fact that both of these modes of discourse exist simultaneously in the context of social history is lost on most critics. An exception is William Schupbach, *The Paradox of Rembrandt's "Anatomy of Dr. Tulp,"* Medical History, supp. 2 (London, 1982).

2 George Heard Hamilton, *Manet and His Critics* (New Haven, Conn., 1954), p. 68. I am ignoring here George Mauner's peculiar position that "we may conclude that Manet makes no comment at all with this painting, if by comment we understand judgment or criticism" (*Manet: Peintre-Philosophie: A Study of the Painter's Themes* [University Park, Pa., 1975], p. 99).

3 For my discussion of Manet's works, I draw especially on Theodore Reff, *Manet: "Olympia"* (London, 1976), and Werner Hofmann, *Nana: Mythos und Wirklichkeit* (Cologne, 1973); neither of these studies examines the medical analogies. See also Eunice Lipton, "Manet: A Radicalized Female Imagery," *Artforum* 13 (Mar. 1975): 48–53.

4 See George Needham, "Manet, *Olympia* and Pornographic Photography," in *Woman as Sex Object*, ed. Thomas Hess and Linda Nochlin (New York, 1972), pp. 81–89.

5 See Philippe Rebeyrol, "Baudelaire et Manet," *Les Temps modernes* 5 (Oct. 1949): 707–25.

6 See my *On Blackness without Blacks: Essays on the Image of the Black in Germany* (Boston, 1982). On the image of the black, see Ladislas Bugner, Jean Vereoutter, *l'Image du noir dans l'art occidental*, 4 vols. (Paris, 1976–1991).

7 See the various works on Hogarth by Ronald Paulson, such as *Hogarth: His Life, Art, and Times*, 2 vols. (New Haven, Conn., 1971) and *Hogarth's Graphic Works*, 2 vols. (New Haven, Conn., 1970); and see Ross E. Taggert, "A Tavern Scene: An Evening at the Rose," *Art Quarterly* 19 (Autumn 1956): 320–23.

8 M. N. Adler, trans., *The Itinerary of Benjamin of Tudela* (London, 1907), p. 68.

9 See John Herbert Eddy, Jr., "Buffon, Organic Change, and the Races of Man" (Ph.D. diss., University of Oklahoma, 1977), p. 109. See also Paul Alfred Erickson, "The Origins of Physical Anthropology" (Ph.D. diss., University of Connecticut, 1974) and Werner Krauss, *Zur Anthropologie des achtzehnten Jahrhunderts: Die Frühgeschichte der Menschheit im Blickpunkt der Aufklärung*, ed. Hans Kortum and Christa Gohrisch (Munich, 1979).

10 See Guillaum-Thomas Raynal, *Histoire philosophique et politique des établissements et du commerce des Européens dans les deux Indes*, 10 vols. (Geneva, 1775), 2: 406–7.

11 See William F. Bynum, "The Great Chain of Being after Forty Years: An Appraisal," *History of Science* 13 (1975): 1–28, and "Time's Noblest Offspring: The Problem of Man in British Natural Historical Sciences" (Ph.D. diss., Cambridge, 1974).

12 See J. J. Virey, "Négre," *Dictionnaire des sciences médicales*, 41 vols. (Paris, 1819), 35: 398–403.

13 See Virey, *Histoire naturelle du genre humaine*, 2 vols. (Paris, 1824), 2: 151.

14 See George M. Gould and Walter L. Pyle, *Anomalies and Curiosities of Medicine* (Philadelphia, 1901), p. 307, and Eugen Holländer, *Aeskulap und Venus: Eine Kultur – und Sittengeschichte im Spiegel des Arzles* (Berlin, 1928). Much material on the indebtedness of the early pathologists to the reports of travelers to Africa can be found in the accounts of the autopsies I will discuss below.

 One indication of the power which the image of the Hottentot still possessed in the late nineteenth century can be found in George Eliot, *Daniel Deronda*, ed. Barbara Hardy (1876: Harmondsworth, 1967). On its surface the novel is a hymn to racial harmony and an attack on British middle-class bigotry. Eliot's liberal agenda is nowhere better articulated than in the ironic debate concerning the nature of the black in which the eponymous hero of the novel defends black sexuality (see p. 376). This position is attributed to the hero not a half-dozen pages after the authorial voice of the narrator introduced the description of this very figure with the comparison: "And one man differs from another,

as we all differ from the Bosjesman" (p. 370). Eliot's comment is quite in keeping with the under-
lying understanding of race in the novel. For just as Deronda is fated to marry a Jewess and thus avoid
the taint of race mixing, so too is the Bushman, a Hottentot surrogate in the nineteenth century,
isolated from the rest of mankind. The ability of Europeans to hold simultaneously a polygenetic view
of race and a liberal ideology is evident as far back as Voltaire. But in Eliot's novel the Jew is contrasted
to the Hottentot, and, as we have seen, it is the Hottentot who serves as the icon of pathologically
corrupted sexuality. Can Eliot be drawing a line between outsiders such as the Jew or the sexualized
female in Western society and the Hottentot? The Hottentot comes to serve as the sexualized Other
onto whom Eliot projects the opprobrium with which she herself was labeled. For Eliot, the Hottentot
remains beyond the pale; even in the most whiggish text, the Hottentot remains the essential Other.

15 Paul Edwards and James Walvin, *Black Personalities in the Era of the Slave Trade* (Baton Rouge, La.,
1983), pp. 173, 175. A print of the 1829 ball in Paris with the nude "Hottentot Venus" is reproduced
in *Illustrierte Geschichte der Medizin*, ed. Richard Toellner, 9 vols. (Salzburg, 1980), 4: 1319; this is a
German reworking of Jacques Vie et al., *Histoire de la médecine*, 8 vols. (Paris, 1977).

16 See Henri de Blainville, "Sur une femme de la race hottentote," *Bulletin des sciences par la société philo-
matique de Paris* (1816): 183–90. This early version of the autopsy seems to be unknown to William
B. Cohen, *The French Encounter with Africans: White Response to Blacks, 1530–1880* (Bloomington, 1980),
esp. pp. 239–45. See also Stephen Jay Gould, "The Hottentot Venus," *Natural History* 91 (1982):
20–27.

17 Georges Cuvier, "Extraits d'observations faites sur le cadavre d'une femme connue à Paris et à Londres
sous le nom de Vénus Hottentote," *Mémoires du Museum d'histoire naturelle* 3 (1817): 259–74; rpt. with
plates in Geoffrey Saint-Hilaire and Frédéric Cuvier, *Histoire naturelle des mammifères avec des figures orig-
inales*, 2 vols. (Paris, 1824), 1: 1–23. The substance of the autopsy is reprinted again by Flourens in
the *Journal complémentaire du dictionnaire des sciences médicales* 4 (1819): 145–49, and by Jules Cloquet,
Manuel d'anatomie de l'homme descriptive du corps humaine (Paris, 1825), pl. 278. Cuvier's presentation
of the "Hottentot Venus" forms the major signifier for the image of the Hottentot as sexual primitive
in the nineteenth century.

18 See, e.g., Walker D. Greer, "John Hunter: Order out of Variety," *Annals of the Royal College of Surgeons
of England* 28 (1961): 238–51. See also Barbara J. Babiger, "The *Kunst- und Wunderkammern*: A *cata-
logue raisonné* of Collecting in Germany, France and England, 1565–1750" (Ph.D. diss., University of
Pittsburgh, 1970).

19 See Adolf Wilhelm Otto, *Seltene Beobachtungen zur Anatomie, Physiologie, und Pathologie gehörig* (Breslau,
1816), p. 135; Johannes Müller, "[Ü]ber die äusseren Geschlechtseile der Buschmänninnen," *Archiv
für Anatomie, Physiologie, und Wissenschaftliche Medizin* (1834), pp. 319–45; W. H. Flower and James
Murie, "Account of the Dissection of a Bushwoman," *Journal of Anatomy and Physiology* 1 (1867): 189–208;
and Hubert von Luschka, A. Koch, and E. Görtz, "Die äusseren Geschlechtsteile eines Busch-
weibes," *Monatsschrift für Geburtskunde* 32 (1868): 343–50. The popularity of these accounts can be seen
by their republication in extract for a lay audience. These extracts also stress the sexual anomalies
described. See *Anthropological Review* 5 (July, 1867): 319–24, and *Anthropological Review* 8 (Jan., 1870):
89–318.

20 Edward Turnipseed, "Some Facts in Regard to the Anatomical Differences between the Negro and
White Races," *American Journal of Obstetrics* 10 (1877): 32, 33.

21 See C. H. Fort, "Some Corroborative Facts in Regard to the Anatomical Difference between the Negro
and White Races," *American Journal of Obstetrics* 10 (1877): 258–59. Paul Broca was influenced by similar
American material (which he cites from the *New York City Medical Record*, 15 Sept., 1868) concern-
ing the position of the hymen; see his untitled note in the *Bulletins de la société d'anthropologie de
Paris* 4 (1869): 443–44. Broca, like Cuvier before him, supported a polygenetic view of the human
races.

22 See William Turner, "Notes on the Dissection of a Negro," *Journal of Anatomy and Physiology* 13 (1878):
382–86; "Notes on the Dissection of a Second Negro," *Journal of Anatomy and Physiology* 14 (1879):
244–48; and "Notes on the Dissection of a Third Negro," *Journal of Anatomy and Physiology* 31 (1896):
624–26. This was not merely a British anomaly. Jefferies Wyman reports the dissection of a black
suicide (originally published in *Proceedings of the Boston Society of Natural History*, 2 Apr., 1862 and 16
Dec., 1863) and does not refer to the genitalia of the male Hottentot at all; see *Anthropological Review*
3 (1865): 330–35.

23 H. Hildebrandt, *Die Krankheiten der äusseren weiblichen Genitalien*, in *Handbuch der Frauenkrankheiten*, ed. Theodor Billroth, 3 vols. (Stuttgart, 1885–86), 11–12. See also Thomas Power Lowry, ed., *The Classic Clitoris: Historic Contributions to Scientific Sexuality* (Chicago, 1978).

24 Havelock Ellis, *Studies in the Psychology of Sex*, vol. 4, *Sexual Selection in Man* (Philadelphia, 1920), p. 158; all further references to this work, abbreviated *SPS*, will be included in the text.

25 See Willem Vrolik, *Considerations sur la diversité du bassin des différentes races humaines* (Amsterdam, 1826) and R. Verneau, *Le bassin dans les sexes et dans les races* (Paris, 1875), pp. 126–29.

26 Charles Darwin, *The Descent of Man and Selection in Relation to Sex* (Princeton, N.J., 1981), 2: 317, and see 2: 345–46.

27 See John Grand-Carteret, *Die Erotik in der französischen Karikatur*, trans. Cary von Karwarth and Adolf Neumann (Vienna, 1909), p. 195.

28 [Hughes Rebell?], *The Memories of Dolly Morton: The Story of a Woman's Part in the Struggle to Free the Slaves: An Account of the Whippings, Rapes, and Violences That Preceded the Civil War in America with Curious Anthropological Observations on the Radical Diversities in the Conformation of the Female Bottom and the Way Different Women Endure Chastisement* (Paris, 1899), p. 207.

29 See Sigmund Freud, *The Standard Edition of the Complete Psychological Works of Sigmund Freud*, ed. and trans. James Strachey, 24 vols. (London, 1953–74), 7: 186–87, esp. n. 1; all further references to this work, abbreviated *SE* and with volume and page numbers, will be included in the text.

30 The best study of the image of the prostitute is Alain Corbin, *Les filles de noce: Misère sexuelle et prostitution (dix-neuvième et vingtième siècles)* (Paris, 1978). On the black prostitute, see Khalid Kishtainy, *The Prostitute in Progressive Literature* (London, 1982), pp. 74–84. On the iconography associated with the pictorial representation of the prostitute in nineteenth-century art, see Hess and Nochlin, *Woman as Sex Object;* Nochlin, "Lost and Found: Once More the Fallen Woman," *Art Bulletin* 60 (Mar., 1978): 139–53; and Lynda Nead, "Seduction, Prostitution, Suicide: *On the Brink* by Alfred Elmore," *Art History* 5 (Sept., 1982): 310–22. On the special status of medical representations of female sexuality, see the eighteenth-century wax models of female anatomy in the Museo della Specola, Florence, and reproduced in Mario Bucci, *Anatomia come arte* (Florence, 1969), esp. pl. 8.

31 See A. J. B. Parent-Duchatelet, *De la prostitution dans la ville de Paris*, 2 vols. (Paris, 1836), 1: 193–244.

32 Parent-Duchatelet, *On Prostitution in the City of Paris*, (London, 1840), p. 38. It is exactly the passages on the physiognomy and appearance of the prostitute which this anonymous translator presents to his English audience as the essence of Parent-Duchatelet's work.

33 See Winthrop D. Jordan. *White over Black: American Attitudes toward the Negro, 1550–1812* (New York, 1977), pp. 3–43.

34 See Iwan Bloch, *Der Ursprung der Syphilis; Eine medizinische und kulturgeschichtliche Untersuchung*, 2 vols. (Jena, 1901–11).

35 Abel Hermant, quoted in Ellis, *Studies in the Psychology of Sex*, 4: 176 n. 1.

36 See Renate Schlesier, *Konstruktion der Weiblichkeit bei Sigmund Freud* (Frankfurt, 1981), pp. 35–39.

TRINH T. MINH-HA

DIFFERENCE
"A special third world women issue"

It is thrilling to think – to know that for any act of mine, I shall get twice as much praise or twice as much blame. It is quite exciting to hold the center of the national stage, with the spectators not knowing whether to laugh or weep.

> Zora Neale Hurston, "How It Feels to Be Colored Me"

It must be odd
to be a minority
he was saying.
I looked around
and didn't see any.
So I said
Yeah
it must be.

> Mitsuye Yamada, "Looking Out"
> in *Camp Notes*

WORDS EMPTY OUT WITH AGE. Die and rise again, accordingly invested with new meanings, and always equipped with a secondhand memory. In trying to tell something, a woman is told, shredding herself into opaque words while her voice dissolves on the walls of silence. Writing: a commitment of language. The web of her gestures, like all modes of writing, denotes a historical solidarity (on the understanding that her story remains inseparable from history). She has been warned of the risk she incurs by letting words run off the rails, time and again tempted by the desire to gear herself to the accepted norms. But where has obedience led her? At best, to the satisfaction of a "made-woman," capable of achieving as high a mastery of discourse as that of the male establishment in power. Immediately gratified, she will, as years go by, sink into oblivion, a fate she inescapably shares with her foresisters. How many, already, have been condemned to premature deaths for having borrowed the master's tools and thereby played into his hands? Solitude is a common pre-requisite, even though this may only mean solitude in the immediate surroundings. Elsewhere, in every corner of the world, there exist women who, despite the threat of rejection resolutely work toward the unlearning of institutionalized language, while staying alert to every deflection of their body compass needles. *Survival*, as Audre Lorde comments, "*is not an academic skill. . . . It is learning how to take our differences and make them strengths. For the master's tools will never dismantle the master's house. They may allow us temporarily to beat him at his*

own game, but they will never enable us to bring about genuine change."[1] The more one depends on the master's house for support, the less one hears what he doesn't want to hear. Difference is not difference to some ears, but awkwardness or incompleteness. Aphasia. Unable or unwilling? Many have come to tolerate this dissimilarity and have decided to suspend their judgments (only) whenever the other is concerned. Such an attitude is a step forward; at least the danger of speaking for the other has emerged into consciousness. But it is a very small step indeed, since it serves as an excuse for their complacent ignorance and their reluctance to involve themselves in the issue. You who understand the dehumanization of forced removal-relocation-reeducation-redefinition, the humiliation of having to falsify your own reality, your voice – you know. And often cannot *say* it. You try and keep on trying to unsay it, for if you don't, they will not fail to fill in the blanks on your behalf, and you will be said.

The policy of "separate development"

With a kind of perverted logic, they work toward your erasure while urging you to keep your way of life and ethnic values *within the borders of your homelands*. This is called the policy of "separate development" in apartheid language. Tactics have changed since the colonial times and indigenous cultures are no longer (overtly) destroyed (preserve the form but remove the content, or vice versa). You may keep your traditional law and tribal customs among your-selves, as long as you and your own kind are careful not to step beyond the assigned limits.

Figure 20.1 Trinh T. Minh-ha, still from film *Surname Viet Given Name Nam*, 1989.

Nothing has been left to chance when one considers the efforts made by the White South African authorities to distort and use the tools of Western liberalism for the defense of their racialistic-ally indefensible cause. Since no integration is possible when terror has become the order of the day, I (not you) will give you freedom. I will grant you autonomy – not complete autonomy, however, for "it is a liberal fallacy to suppose that those to whom freedom is given will use it only as foreseen by those who gave it."[2] (Confidentially, I live in a state of intense fear, knowing that Western education has taught you aggression in equality. Now I sleep with a gun under my pillow and lock the gate at the top of my stairway; a single second of care-lessness may cost me my life – for life and domination are synonyms to me – and I tremble at the slightest movement of my servants. Better intern you "for your own good" than be interned or "driven to the sea" by you.) Self-determination begins with the division of the land (on condition that I cut the cake), and I will make sure each of you gets the part s/he *deserves*. The delimitation of territories is my answer to what I perceive as some liberals' dream for "the inauguration, namely, of a system in which South Africa's many peoples would resolve themselves unreluctantly into one."[3] The governed do not (should not) compose a single people; this is why I am eager to show that South Africa is not one but ten separate nations (of which the White nation is the only one to be skin-defined; the other nine being deter-mined largely on the basis of language – the Zulu nation, the Swazi nation, and so on). This philosophy – I will not call it "policy" – of "differentiation" will allow me to have better control over my nation while looking after yours, helping you thereby to gradually stand on your own. It will enable you to return to "where you belong" whenever you are not satis-fied with my law and customs or whenever you are no longer useful to me. Too bad if you consider what has been given to you as the leftovers of my meals. Call it "reserves of cheap labor" or "bantustans" if you wish; "separate development" means that each one of us minds her/his own business (I will interfere when my rights are concerned since I represent the State) and that your economical poverty is of your own making. As for "the Asiatic cancer, which has already eaten so deeply into the vitals of South Africa, [it] ought to be resolutely eradicated."[4] Non-white foreigners have no part whatsoever in my plans and I "will under-take to drive the coolies [Indians] out of the country within four years."[5] My "passionate concern for the future of a European-type white society, and . . . that society's right to self-preservation" is not a question of color feeling, but of nationalism, the "Afrikaner nationalism [which] is a form of collective selfishness; but to say this is simply to say that it is an authentic case of nationalism."[6]

Words manipulated at will. As you can see, "difference" is essentially "division" in the under-standing of many. It is no more than a tool of self-defense and conquest. You and I might as well not walk into this semantic trap which sets us up against each other as expected by a certain ideology of separatism. Have you read the grievances some of our sisters express on being among the few women chosen for a "Special Third World Women's Issue" or on being the only Third World woman at readings, workshops, and meetings? It is as if everywhere we go, we become Someone's private zoo. Gayatri Chakravorty Spivak spoke of their remarking "the maids upstairs in the guest quarters were women of color" in a symposium;[7] Gloria Anzaldúa, of their using her as a token woman and her friend Nellie Wong as a "purveyor of resource lists";[8] Mitsuye Yamada, of having to start from scratch each time, as if she were "speaking to a brand new audience of people who had never known an Asian Pacific woman who is other than the passive, sweet, etc., stereotype of the 'Oriental' woman";[9] Audre Lorde, of the lack of interracial cooperation between academic feminists whose sole explanation for the issue remains: "We did not know who to ask";[10] and Alice Walker, of

the necessity of learning to discern the true feminist – "for whom racism is inherently an impossibility" – from the white female opportunist – "for whom racism, inasmuch as it assures white privilege, is an accepted way of life."[11] The decision you and I are called upon to make is fraught with far-reaching consequences. On the one hand, it is difficult for us to sit at table with them (the master and/or his substitute) without feeling that our presence, like that of the "native" (who happens to be invited) among the anthropologists, serves to mask the refined sexist and/or racist tone of their discourse, reinforcing thereby its pretensions to universality. Given the permanent status of "foreign workers," we – like the South African blacks who are allowed to toil on white territories as "migrants," but are gotten rid of and resettled to the homeland area as soon as they become unprofitable labor units – continue in most cases to be treated as "temporary sojourners," even though we may spend our whole lifetime by their side pleading a common cause.

> [T]he white rancher told Chato he was too old to work for him any more, and Chato and his old woman should be out of the shack by the next afternoon because the rancher had hired new people to work there. That had satisfied her. To see how the white man repaid Chato's years of loyalty and work. All of Chato's fine-sounding English didn't change things.[12]

The lines are an excerpt from Leslie Marmon Silko's "Lullaby." From the South African reserve to the American Laguna Pueblo Reservation, the story changes its backdrops but remains recognizable in the master's indifference to the lot of his non-European workers. Yet, on the other hand, you and I acquiesce in reviving the plot of the story, hoping thereby that our participation from the inside will empower us to act upon the very course of its events. Fools? It all depends on how sharply we hone ourselves on the edge of reality; and, I venture to say, we do it enough to never lose sight of our distinct actualities. Silence as a refusal to partake in the story does sometimes provide us with a means to gain a hearing. It is voice, a mode of uttering, and a response in its own right. Without other silences, however, my silence goes unheard, unnoticed; it is simply one voice less, or more point given to the silencers. Thus, no invitation is declined except in particular circumstances where we feel it is necessary to do so for our own well-being. What does it matter who the sponsor is? Every opportunity is fitted for consciousness raising; to reject it is almost tantamount to favoring apartheid ideology. White and black stand apart (armed legislation versus tribal law) and never the twain shall meet. There the matter rests. Crossed fears continue to breed wars, for they feed endlessly on each other until no conversation can possibly be carried out without heaping up misunderstandings. It is, indeed, much easier to dismiss or eliminate on the pretext of difference (destroy the other in our minds, in our world) than to live fearlessly with and within difference(s).

"What's the difference?" as if I cared? Or yes, I mean it, help me see? Shall I quench my thirst gazing at the plums while waiting for my helper to come by and pluck them off the branches for me? Do I really ask for difference or am I just saying it's not worth trying to find out? One of the classical questions our male world leaders used to throw out in interviews with feminists was: "If women are to be men's equals, how is it that history remains so short of female leaders' names?" (In other words, "Tell me, what is women's contribution to History?") Yes, and I also remember Virginia Woolf's bishop who convincingly declared in the papers that it was impossible for any woman, past, present, or to come, to have the genius of Shakespeare.[13] From the male reader-leader's standpoint, again, the great male

writer-leader is matchless. Such a narrow-mindedness may sound quite outmoded today, for sexism no longer expresses itself as blatantly as it once did . . . and one somehow "feels sorry" for these men whose power extends well beyond the frontiers of their territories but whose field of vision ends at the fence of their own yard. Yet, it is this same ignorance and narrow-mindedness that lie behind answers similar to the one quoted above from academic feminists on the scarcity of Third World women's voices in debates: "We didn't know who to ask." Historians have, for several decades now, been repeating that History with a capital H does not exist and that it has never constituted the *a priori* reasoning of their discussion but, rather, its result. Like the anthropological study whose information may always be reordered, refuted, or completed by further research, the historical analysis is nothing other than the recon-struction and redistribution of a pretended order of things, the interpretation or even transformation of documents given and frozen into monuments. The re-writing of history is therefore an endless task, one to which feminist scholars have devoted much of their energy. The more they dig into the maze of yellowed documents and look into the non-registered facts of their communities, the more they rejoice upon discovering the buried treasures of women's unknown heritage. Such findings do not come as a godsend; they are gained through genuine curiosity, concern, and interest. Why not go and find out for yourself when you don't know? Why let yourself be trapped in the mold of permanent schooling and wait for the delivery of knowledge as a consumer waits for her/his suppliers' goods? The understanding of difference is a shared responsibility, which requires a minimum of willingness to reach out to the unknown. As Audre Lorde says:

> Women of today are still being called upon to stretch across the gap of male ignor-ance, and to educate men as to our existence and our needs. This is an old and primary tool of all oppressors to keep the oppressed occupied with the master's concerns. Now we hear that it is the task of black and third world women to educate white women, in the face of tremendous resistance, as to our existence, our differ-ences, our relative roles in our joint survival. This is a diversion of energies and a tragic repetition of racist patriarchal thought.[14]

One has to be excessively preoccupied with the master's concerns, indeed, to try to explain why women cannot have written, "the plays of Shakespeare in the age of Shakespeare," as Virginia Woolf did. Such a waste of energy is perhaps unavoidable at certain stages of the struggle; it need not, however, become an end point in itself.

"Why do we have to be concerned with the question of Third World women? After all, it is only one issue among many others." Delete "Third World" and the sentence immediately unveils its value-loaded clichés. Generally speaking, a similar result is obtained through the substitution of words like *racist* for *sexist*, or vice versa, and the established image of the *Third World Woman* in the context of (pseudo-)feminism readily merges with that of the *Native* in the context of (neo-colonialist) anthropology. The problems are interconnected. Here, a plural, angry reply may be expected: what else do you wish? It seems as if no matter what We do We are being resented. Now, "in response to complaints of exclusionary practices, special care is always taken to notify minority organizations and women of color of conferences, plan-ning meetings, job openings, and workshops."[15] Once again, re-read the statement with the master's voice and with "woman" in place of "minority." Much remains to be said about the attitude adopted in this "special care" program and its (unavowed or unavowable) intent. Viewing the question through the eyes of a white sister, Ellen Pence thus writes:

> Gradually, I began to realize the tremendous gap between my rhetoric about soli-
> darity with Third World women and my gut feelings. . . . Our idea of including
> women of color was to send out notices. We never came to the business table as
> equals. Women of color joined us on our terms. . . . I started seeing the similarities
> with how men have excluded the participation of women in their work through
> Roberts Rules of Order, encouraging us to set up subcommittees to discuss *our* prob-
> lems but never seeing sexism as their problem. It became clear that in many ways I
> act the same way toward women of color, supporting them in dealing with *their*
> issues. . . . I'm now beginning to realize that in many cases men do not understand
> because they have never committed themselves to understanding and by under-
> standing, choosing to share their power. The lessons we've learned so well as women
> must be the basis for our understanding of ourselves as oppressive to the Third World
> women we work with.[16]

No matter which side i belong to, once i step down into the mud pit to fight my adversary,
i can only climb out from it stained. This is the story of the duper who turns her/himself
into a dupe while thinking s/he has made a dupe of the other. The close dependency that
characterizes the master–servant relationship and binds the two in each other for life is an
old, patent fact one can no longer deny. Thus, insofar as I/i understand how "sexism dehu-
manizes men," I/i shall also see how "my racism must dehumanize me" (Pence). The inability
to relate the two issues and to feel them in my bones, has allowed me to indulge in the
illusion that I will remain safe from all my *neighbors' problems* and can go on leading an un-
disturbed, secure life of my own. Hegemony and racism are, therefore, a pressing feminist
issue; "as usual, the impetus comes from the grassroots, activist women's movement."
Feminism, as Barbara Smith defines it, "is the political theory and practice that struggles to
free *all* women. . . . Anything less than this vision of total freedom is not feminism, but
merely female self-aggrandizement."[17]

The sense of specialness

One gives "special care" to the old, to the disabled, and to all those who do not match the stereo-
type of the real wo/man. It is not unusual to encounter cases where the sense of specialness,
which comes here with being the "first" or the "only" woman, is confused with the conscious-
ness of difference. One cannot help feeling "special" when one figures among the rare few to
emerge above the anonymous crowd and enjoys the privilege of preparing the way for one's
more "unfortunate" sisters. Based on what other women are not (capable of) doing, such a
reward easily creates a distance – if not a division – between I-who-have-made-it and You-who-
cannot-make-it. Thus, despite my rhetoric of solidarity, I inwardly resist your entrance into the
field, for it means competition, rivalry, and sooner or later, the end of my specialness. I shall,
therefore, play a double game: on the one hand, I shall loudly assert my right, as a woman, and
an exemplary one, to have access to equal opportunity; on the other hand, I shall quietly main-
tain my privileges by helping the master perpetuate his cycle of oppression. The reasoning holds
together only as long as he does not betray me in my own game; and for that . . . I am bound
to breathe the same air he breathes, no matter how polluted it turns out to be. My story, yours
perhaps, that of Mitsuye Yamada, who describes herself as:

> An Asian American woman thriving under the smug illusion that I was *not* the stereo-
> typic image of the Asian woman because I had a career teaching English in a community

college. I did not think anything assertive was necessary to make my point . . . it was so much my expected role that it ultimately rendered me invisible . . . contrary to what I thought, I had actually been contributing to my own stereotyping. . . . When the Asian American woman is lulled into believing that people perceive her as being different from other Asian women (the submissive, subservient, ready-to-please, easy-to-get-along-with Asian woman), she is kept comfortably content with the state of things.[18]

and that of Adrienne Rich, who perceives her specialness as follows:

My own luck was being born white and middle-class into a house full of books, with a father who encouraged me to read and write. So for about twenty years I wrote for a particular man, who criticized and praised me and made me feel I was indeed "special." The obverse side of this, of course, was that I tried for a long time to please him. . . .

We seem to be special women here, we have liked to think of ourselves as special, and we have known that men would tolerate, even romanticize us as special, as long as our words and actions didn't threaten their privilege of tolerating or rejecting us and our work according to *their* ideas of what a special woman ought to be.[19]

There is more than one way to relate the story of specialness. I may orient myself toward the same end by choosing a reasoning completely opposite to the one mentioned above. Not only do I like to think of myself as special but also as having a free hand. We all have the potential to be special, I say, why not work for it? Let me *select* those with whom I would like to share my blessings. Thus weaving my cocoon and closing myself snugly, I then turn to my sisters and kindly urge them to proceed alike: Weave your own cocoon; let it tie you in, in comfort, and I shall help to gain that special, oh so special, recognition. Have you read Zora Neale Hurston's "The 'Pet' Negro System?" The policy of "separate development" means that we may all bloom in our garden. It also means that i am *tolerated* in my difference as long as i conform with the established rules. Don't overstep the line. Considered both a "dangerous" species (remember the Yellow Peril in politicians' discourses and the descriptions of warlike savages in colonial reports. More subtly expressed today, the fear re-surfaces only when some Third World representatives become too outspoken), and an "endangered" species (suffering pathetically from a "loss of authenticity"), i am to remain behind the safety grille for the visitor's security and marvel. Specialness as a soporific soothes, anaesthetizes my sense of justice; it is, to the wo/man of ambition, as effective a drug of psychological self-intoxication as alcohol is to the exiles of society. Now, i am not only given the permission to open up and talk, i am also encouraged to express my difference. My audience expects and demands it; otherwise people would feel as if they have been cheated: We did not come to hear a Third World member speak about the First (?) World, we came to listen to that voice of difference likely to bring us *what we can't have* and to divert us from the monotony of sameness. They, like their anthropologists whose specialty is to detect all the layers of my falseness and truthfulness, are in a position to decide what/who is "authentic" and what/who is not. No uprooted person is invited to participate in this "special" wo/man's issue unless s/he "makes up" her/his mind and paints her/himself thick with authenticity. Eager not to disappoint, i try my best to offer my benefactors and benefactresses what they most anxiously yearn for: the possibility of a difference, yet a difference or an otherness that will not go so far as to question the foundation of their beings and makings. Their situation is not unlike

that of the American tourists who, looking for a change of scenery and pace in a foreign land, such as, for example, Japan, strike out in search of what they believe to be the "real" Japan – most likely shaped after the vision of Japan as handed to them and reflected in television films like "Shogun" – or that of the anthropologists, whose conception of "pure" anthropology induces them to concentrate on the study of "primitive" ("native," "indigenous," or to use more neutral, technical terms: "non-state," "non-class") societies. Authenticity in such contexts turns out to be a product that one can buy, arrange to one's liking, and/or preserve. Today, the "unspoiled" parts of Japan, the far-flung locations in the archipelago, are those that tourism officials actively promote for the more venturesome visitors. Similarly, the Third World representative the modern sophisticated public ideally seeks is the *unspoiled* African, Asian, or Native American, who remains more preoccupied with her/his image of the *real* native – the *truly different* – than with the issues of hegemony, racism, feminism, and social change (which s/he lightly touches on in conformance to the reigning fashion of liberal discourse). A Japanese actually looks more Japanese in America than in Japan, but the "real" type of Japanism ought to be in Japan. The less accessible the product "made-in-Japan," the more trustworthy it is, and the greater the desire to acquire and protect it.

MIRROR MIRROR

People keep asking me where I come from
says my son.
Trouble is I'm american on the inside
 and oriental on the outside
 No Doug
Turn that outside in
THIS is what America looks like.

 Mitsuye Yamada,
 Camp Notes and Other Poems

The question of roots and authenticity

"I was made to feel," writes Joanne Harumi Sechi, "that cultural pride would justify and make good my difference in skin color while it was a constant reminder that I was different."[20] Every notion in vogue, including the retrieval of "roots" values, is necessarily exploited and recuperated. The invention of needs always goes hand in hand with the compulsion to help the needy, a noble and self-gratifying task that also renders the helper's service indispensable. The part of the savior has to be filled as long as the belief in the problem of "endangered species" lasts. To persuade you that your past and cultural heritage are doomed to eventual extinction and thereby keeping you occupied with the Savior's concern, inauthenticity is condemned as a *loss* of *origins* and a whitening (or faking) of non-Western values. Being easily offended in your elusive identity and reviving readily an old, racial charge, you immediately react when such guilt-instilling accusations are leveled at you and are thus led to stand in need of defending that very ethnic part of yourself that for years has made you and your ancestors the objects of execration. Today, planned authenticity is rife; as a product of hegemony and a remarkable counterpart of universal standardization, it constitutes an efficacious means of silencing the cry of racial oppression. We no longer wish to erase your difference, We demand, on the contrary, that you remember and assert it. At least, to a certain extent. Every path I/i take is edged with thorns. On the one hand, i play into the Savior's hands by

concentrating on authenticity, for my attention is numbed by it and diverted from other, important issues; on the other hand, i do feel the necessity to return to my so-called roots, since they are the fount of my strength, the guiding arrow to which i constantly refer before heading for a new direction. The difficulties appear perhaps less insurmountable only as I/i succeed in making a distinction between difference reduced to identity-authenticity and difference understood also as critical difference from myself. The first induces an attitude of temporary tolerance – as exemplified in the policy of "separate development" – which serves to reassure the conscience of the liberal establishment and gives a touch of subversiveness to the discourse delivered. "That we may each have our due" or "that we may all have more" should, in *reality*, be read: "that I may not have any less." Hence, the (apartheid's) need to lay down (the) pass laws which restrict the "outsiders" freedom of movement as well as their choice of participation (only those whose discourse squares with that of the dominant are eligible), forcing them thereby to live in the reserves/ations. (Hence also, the widespread resistance against passes or "reference books" led by the black women, and their massive jailing in South Africa.) All "temporary sojourners," as observed in the more blatantly manifested case of South Africa, run the risk of being sent back to their homelands no matter how long they have been settled in the areas the Savior appropriates to her/himself. Differences that cause separation and suspicion therefore do not threaten, for they can always be dealt with as fragments. Mitsuye Yamada, a second-generation Asian American, relevantly remarks:

> our white sisters . . . should be able to see that political views held by women of color are often misconstrued as being personal rather than ideological. Views critical of the system held by a person in an "outgroup" are often seen as expressions of personal angers against the dominant society. (If they hate it so much here, why don't they go back?). . . .
>
> Many of us are now third and fourth generation Americans, but this makes no difference: periodic conflicts involving Third World peoples can abruptly change white Americans' attitudes towards us. . . . We found our status as true-blooded Americans was only an illusion in 1942 when we were singled out to be imprisoned for the duration of the war by our own government. . . . When I hear my students say, "We're not against the Iranians here who are mindful of their own business. We're just against those ungrateful ones who overstep our hospitality by demonstrating and badmouthing our government," I know they speak about me.[21]

Infinite layers: I am not i can be you and me

A critical difference from myself means that I am not i, am within and without i. I/i can be I or i, you and me both involved. We (with capital W) sometimes include(s), other times exclude(s) me. You and I are close, we intertwine; you may stand on the other side of the hill once in a while, but you may also be me, while remaining what you are and what i am not. The differences made *between* entities comprehended as absolute presences – hence the notions of *pure origin* and *true* self – are an outgrowth of a dualistic system of thought peculiar to the Occident (the "onto-theology" which characterizes Western metaphysics). They should be distinguished from the differences grasped *both between* and *within* entities, each of these being understood as multiple presence.[22] Not One, not two either. "I" is, therefore, not a unified subject, a fixed identity, or that solid mass covered with layers of superficialities one has gradually to peel off before one can see its true face. "I" is, itself, *infinite layers*. Its complexity can hardly be conveyed through such typographic conventions as I, i, or I/i.

Thus, I/i am compelled by the will to say/unsay, to resort to the entire gamut of personal pronouns to stay near this fleeing *and* static essence of Not-I. Whether I accept it or not, the natures of *I, i, you, s/he, We, we, they*, and *wo/man* constantly overlap. They all display a necessary ambivalence, for the line dividing *I* and *Not-I*, *us* and *them*, or *him* and *her* is not (cannot) always (be) as clear as we would like it to be. Despite our desperate, eternal attempt to separate, contain, and mend, categories always leak. Of all the layers that form the open (never finite) totality of "I," which is to be filtered out as superfluous, fake, corrupt, and which is to be called pure, true, real, genuine, original, authentic? Which, indeed, since all interchange, revolving in an endless process? (According to the context in which they operate, the superfluous can become the real; the authentic can prove fake; and so on.) *Authenticity* as a need to rely on an "Undisputed origin," is prey to an obsessive *fear:* that of *losing a connection.* Everything must hold together. In my craving for a logic of being, I cannot help but loathe the threats of interruptions, disseminations, and suspensions. To begin, to develop to a climax, then, to end. To fill, to join, to unify. The order and the links create an illusion of continuity, which I highly prize for fear of nonsense and emptiness. Thus, a clear origin will give me a connection back through time, and I shall, by all means, search for that genuine layer of myself to which I can always cling. To abolish it in such a perspective is to remove the basis, the prop, the overture, or the finale – giving thereby free rein to indeterminacy: the result, forefeared, is either an anarchic succession of climaxes or a de(inex)pressive, uninterrupted monotony – and to enter into the limitless process of interactions and changes that nothing will stop, not even death. In other words, things may be said to be what they are, not exclusively in relation to what was and what will be (they should not solely be seen as clusters chained together by the temporal sequence of cause and effect), but also in relation to each other's immediate presences and to themselves as non-presences. The *real*, nothing else than a *code of representation*, does not (cannot) coincide with the lived or the performed. This is what Vine Deloria, Jr accounts for when he exclaims: "Not even Indians can relate themselves to this type of creature who, to anthropologists, is the 'real' Indian."[23] A realistic identification with such a code has, therefore, no reality whatsoever: it is like "stopping the ear while trying to steal the bell" (Chinese saying).

WOMAN

It is a being somewhat like a well.
When you drop a well bucket
you will find
restlessness deep in the well. . . .

That she is herself
is more difficult than water is water
just as it's difficult for water to go beyond water
she and I are linked in mutual love
who once betrayed each other
two mirrors who reflected each other

When I escape from her, I incessantly
am forced to be her and when I confront her
instead I become him . . .

 Korā Kumiko[24]

The female identity enclosure

Difference as uniqueness or special identity is both limiting and deceiving. If identity refers to the whole pattern of sameness within a human life, the style of a continuing me that permeates all the changes undergone, then difference remains within the boundary of that which distinguishes one identity from another. This means that *at heart*, X must be X, Y must be Y, and X *cannot* be Y. Those who run around yelling that X is not X and X *can* be Y usually land in a hospital, a "rehabilitation" center, a concentration camp, or a res-er-va-tion. All deviations from the dominant stream of thought, that is to say, the belief in a permanent essence of wo/man and in an invariant but fragile identity, whose "loss" is considered to be a "specifically human danger," can easily fit into the categories of the "mentally ill" or the "mentally underdeveloped." It is probably difficult for a "normal," probing mind to recognize that to seek is to lose, for seeking presupposes a separation between the seeker and the sought, the continuing me and the changes it undergoes. What if the popularized story of the identity crisis proves to be only a story and nothing else? Can identity, indeed, be viewed other than as a by-product of a "manhandling" of life, one that, in fact, refers no more to a consistent "pattern of sameness" than to an inconsequential process of otherness? How am I to lose, maintain, or gain an (fe/male) identity when it is impossible to me to take up a position outside this identity from which I presumably reach in and feel for it? Perhaps a way to portray it is to borrow these verses from the *Cheng-tao-ke*:

> You cannot take hold of it,
> But you cannot lose it.
> In not being able to get it, you get it.
> When you are silent, it speaks;
> When you speak, it is silent.[25]

Difference in such an insituable context is *that which undermines the very idea of identity*, deferring to infinity the layers whose totality forms "I." It subverts the foundations of any affirmation or vindication of value and cannot, thereby, ever bear in itself an absolute value. The difference (within) between *difference* itself and *identity* has so often been ignored and the use of the two terms so readily confused, that claiming a female/ethnic identity/difference is commonly tantamount to reviving a kind of naïve "male-tinted" romanticism. If feminism is set forth as a demystifying force, then it will have to question thoroughly the belief in its own identity. To suppose, like Judith Kegan Gardiner, that "the concept of female identity provides a key to understanding the *special qualities* of contemporary writing by women . . ., the diverse ways in which writing by women *differs* from writing by men," and to "propose the preliminary metaphor 'female identity is a process' for the most fundamental of these differences" does not, obviously, allow us to radically depart from the master's logic. Such a formulation endeavors to "reach a theory of female identity . . . that *varies from the male model*," and to demonstrate that:

> primary identity for women is more flexible and relational *than for men*. Female gender identity is *more* stable *than male gender identity*. Female infantile identifications are *less* predictable *than male ones* . . . the *female counterpart* of the male identity crisis may occur more diffusely, at a different stage, or not at all. (my italics)

It seems quite content with reforms that, at best, contribute to the improvement and/or enlargement of the identity enclosure, but do not, in any way, attempt to remove its fence. The

constant need to refer to the "male model" for comparisons unavoidably maintains the subject under tutelage. For the point is not to carve one's space in "identity theories that ignore women" and describe some of the faces of female identity, saying, like Gardiner: "I picture female identity as typically less fixed, less unitary, and more flexible than male individuality, both in its primary core and in the entire maturational complex developed from this core,"[26] but patiently to dismantle the very notion of core (be it static or not) and identity.

Woman can never be defined. Bat, dog, chick, mutton, tart. Queen, madam, lady of pleasure. MISTRESS. *Belle-de-nuit*, woman of the streets, fruitwoman, fallen woman. Cow, vixen, bitch. Call girl, joy girl, working girl. Lady and whore are both bred to please. The old Woman image-repertoire says She is a Womb, a mere baby's pouch, or "nothing but sexuality." She is a passive substance, a parasite, an enigma whose mystery proves to be a snare and a delusion. She wallows in night, disorder, and immanence and is at the same time the "disturbing factor (between men)" and the key to the beyond. The further the repertoire unfolds its images, the more entangled it gets in its attempts at capturing Her. "Truth, Beauty, Poetry – she is All: once more all under the form of the Other. All except heself,"[27] Simone de Beauvoir wrote. Yet, even with or because of Her capacity to embody All, Woman is the lesser man, and among male athletes, to be called a woman is still resented as the worst of insults. "Wo-" appended to "man" in sexist contexts is not unlike "Third World," "Third," "minority," or "*color*" affixed to *woman* in pseudo-feminist contexts. Yearning for universality, the generic "woman," like its counterpart, the generic "man," tends to efface difference within itself. Not every female is "a real woman," one knows this through hearsay . . . Just as "man" provides an example of how the part played by women has been ignored, undervalued, distorted, or omitted through the use of terminology presumed to be generic, "woman" more often than not reflects the subtle power of linguistic exclusion, for its set of referents rarely includes those relevant to Third World "female persons." "All the Women Are White, All the Blacks are Men, But Some of Us Are Brave" is the title given to an anthology edited by Gloria T. Hull, Patricia Bell Scott, and Barbara Smith. It is, indeed, somehow devious to think that WOMAN also encompasses the Chinese with bound feet, the genitally mutilated Africans, and the one thousand Indians who committed *suttee* for one royal male. Sister Cinderella's foot is also enviably tiny but never crooked! And, European witches were also burnt to purify the body of Christ, but they do not pretend to "self-immolation." "Third World," therefore, belongs to a category apart, a "special" one that is meant to be both complimentary and complementary, for First and Second went out of fashion, leaving a serious Lack behind to be filled.

Third World?

To survive, "Third World" must necessarily have negative *and* positive connotations: negative when viewed in a vertical ranking system – "underdeveloped" compared to over-industrialized, "underprivileged" within the already Second sex – and positive when understood sociopolitically as a subversive, "non-aligned" force. Whether "Third World" sounds negative or positive also depends on *who* uses it. Coming from you Westerners, the word can hardly mean the same as when it comes from Us members of the Third World. Quite predictably, you/we who condemn it most are both we who buy in and they who deny any participation in the bourgeois mentality of the West. For it was in the context of such mentality that "Third World" stood out as a new semantic finding to designate what was known as "the savages" before the Independences. Today, hegemony is much more subtle, much more pernicious than the form of blatant racism once exercised by the colonial West. I/i always find myself asking, in this

one-dimensional society, where I/i should draw the line between tracking down the oppressive mechanisms of the system and aiding their spread. "Third World" commonly refers to those states in Africa, Asia and Latin America which called themselves "non-aligned," that is to say, affiliated with neither the Western (capitalist) nor the Eastern (communist) power blocs. Thus, if "Third World" is often rejected for its judged-to-be-derogative connotations, it is not so much because of the hierarchical, first-second-third order implied, as some invariably repeat, but because of the growing threat "Third World" consistently presents to the Western bloc the last few decades. The emergence of repressed voices into the worldwide political arena has already prompted her (Julia Kristeva) to ask: "How will the West greet the awakening of the 'third world' as the Chinese call it? Can we [Westerners] participate, actively and lucidly, in this awakening when the center of the planet is in the process of moving toward the East?"[28] Exploited, looked down upon, and lumped together in a convenient term that denies their individualities, a group of "poor" (nations), having once sided with neither of the dominating forces, has slowly learned to turn this denial to the best account. "The Third World to Third World peoples" thus becomes an empowering tool, and one which politically includes all non-whites in their solidarist struggle against all forms of Western dominance. And since "Third World" now refers to more than the geographically and economically determined nations of the "South" (versus "North"), since the term comprises such "developed" countries as Japan and those which have opted for socialist reconstruction of their system (China, Cuba, Ethiopia, Angola, Mozambique) as well as those which have favored a capitalist mode of development (Nigeria, India, Brazil), there no longer exists such a thing as a unified unaligned Third World bloc. Moreover, Third World has moved West (or North, depending on where the dividing line falls) and has expanded so as to include even the remote parts of the First World. What is at stake is not only the hegemony of Western cultures, but also their identities as unified cultures. Third World dwells on diversity; so does First World. This is our strength and our misery. The West is painfully made to realize the existence of a Third World in the First World, and vice versa. The Master is bound to recognize that His Culture is not as homogeneous, as monolithic as He believed it to be. He discovers, with much reluctance, He is just an other among others.

Thus, whenever it is a question of "Third World women" or, more disquietingly, of "Third World Women in the U.S.," the reaction provoked among many whites almost never fails to be that of annoyance, irritation, or vexation. "Why Third World in the U.S.?" they say angrily; "You mean those who still have relatives in South East Asia?" "Third World! I don't understand how one can use such a term, it doesn't mean anything." Or even better, "Why use such a term to defeat yourself?" Alternatives like "Western" and "non-Western" or "Euro-American" and "non-Euro-American" may sound a bit less charged, but they are certainly neither neutral nor satisfactory, for they still take the dominant group as point of reference, and they reflect well the West's ideology of dominance (it is as if we were to use the term "non-Afro-Asian," for example, to designate all white peoples). More recently, we have been hearing of the Fourth World which, we are told, "is a world populated by indigenous people who still continue to bear a spiritual relationship to their traditional lands." The colonialist creed "Divide and Conquer" is here again, alive and well. Often ill at ease with the outspoken educated natives who represent the Third World in debates and paternalistically scornful of those who remain reserved, the dominant thus decides to weaken this term of solidarity, both by invalidating it as empowering tool and by inciting divisiveness within the Third World – a Third World within the Third World. Aggressive Third World (educated "savages") with its awareness and resistance to domination must therefore be classified apart from gentle

Fourth World (uneducated "savages"). Every unaligned voice should necessarily/consequently be either a personal or a minority voice. The (impersonal) majority, as logic dictates, has to be the (aligned) dominant.

> It is, apparently, inconvenient, if not downright mind stretching [notes Alice Walker], for white women scholars to think of black women as women, perhaps because "woman" (like "man" among white males) is a name they are claiming for themselves, and themselves alone. Racism decrees that if they are now women (years ago they were ladies, but fashions change) then black women must, perforce, be something else. (While they were "ladies" black women could be "women" and so on.)[29]

Another revealing example of this separatist majority mentality is the story Walker relates of an exhibit of women painters at the Brooklyn Museum: when asked "Are there no black women painters represented here?" (none of them is, apparently), a white woman feminist simply replies "It's a *women's* exhibit!"[30] Different historical contexts, different semantic contents . . .

"Woman" and the subtle power of linguistic exclusion

What is *woman?* Long ago, during one of the forceful speeches she delivered in defense of her people, Sojourner Truth was asked by a threatened white doctor in the audience to prove to all those present that she was truly a woman:

> "There are those among us," he began in a tone characteristic of institutional training, "who question whether or not you are a woman. Some feel that maybe you are a man in a woman's disguise. To satisfy our curiosity, why don't you show your breasts to the women [*sic*] in this audience?"[31]

It seemed, indeed, profoundly puzzling for this man-child doctor's mind to see the Woman (or Breasts) in someone who had "never been helped into carriages, lifted over ditches, nor given the best places everywhere," who had "plowed, and planted, and gathered into barns," and who, beyond measure, triumphantly affirmed elsewhere: "Look at me! Look at my arm! . . . and no man could head me – and *ar'nt I a woman!*"[32] Definitions of "*woman*," "woman-hood," "femininity," "femaleness," and, more recently, of "female identity" have brought about the arrogance of such a sham anatomical curiosity – whose needs must be "satisfied" – and the legitimation of a shamelessly dehumanizing form of Indiscretion. Difference reduced to sexual identity is thus posited to justify and conceal exploitation. The Body, the most visible difference between men and women, the only one to offer a secure ground for those who seek the permanent, the feminine "nature" and "essence," remains thereby the safest basis for racist and sexist ideologies. The two merging themes of Otherness and the Identity-Body are precisely what Simone de Beauvoir discussed at length in *The Second Sex*, and continued until the time of her death to argue in the French journal she edited, *Questions Féministes*. The lead article written by the Editorial Collective under the title of "Variations on Common Themes" explains the purpose of the journal – to destroy the notion of differences between the sexes, "which gives a shape and a base to the concept of 'woman'":

> Now, after centuries of men constantly repeating that *we* were different, here are women screaming, as if they were afraid of not being heard and as if it were an excit-ing discovery: "We are different!" Are you going fishing? No, I am going fishing.

The very theme of difference, whatever the differences are represented to be, is useful to the oppressing group. . . . any allegedly natural feature attributed to an oppressed group is used to imprison this group within the boundaries of a Nature which, since the group is oppressed, ideological confusion labels "nature of oppressed person" . . . to demand the right to Difference without analyzing its social character is to give back the enemy an effective weapon.[33]

Difference as the Editorial Collective of *Questions Féministes* understands and condemns it is bound to remain an integral part of naturalist ideology. It is the very kind of colonized-anthropo-logized difference the master has always happily granted his subordinates. The search and the claim for an essential female/ethnic identity-difference today can never be anything more than a move within the male-is-norm-divide-and-conquer trap. The malady lingers on. As long as words of difference serve to legitimate a discourse instead of delaying its authority to infinity, they are, to borrow an image from Audre Lorde, "noteworthy only as *decorations*." In "An Open Letter to Mary Daly," Lorde reproaches Daly (whose vision of non-European women in *Gyn/Ecology* mainly results from her insistence on universalizing women's oppression) with utilizing Lorde's words "only to testify against myself as a woman of color." She further expands this comment by specifying:

I feel you do celebrate differences between white women as a creative force towards change, rather than a reason for misunderstanding and separation. But you fail to recognize that, as women, those differences expose all women to various forms and degrees of patriarchal oppression, some of which we share, some of which we do not. . . . The oppression of women knows no ethnic nor racial boundaries, true, but that does not mean it is identical within those boundaries.

In other words,

to imply . . . that all women suffer the same oppression simply because we are women, is to lose sight of the many varied tools of patriarchy.[34]

Here you probably smile, for none of us is safe from such a critique, including I who quote Lorde in my attempts at disentangling Difference. The process of differentiation, however, continues, and speaking nearby or together with certainly differs from speaking for and about. The latter aims at the finite and dwells in the realm of fixed oppositions (subject/object difference; man/woman sexual difference), tending thereby to valorize the privileged father-daughter relationship.

Should you visit San Francisco one day, be sure to be there sometime in late January or February, for you will be witnessing one of the most spectacular festivals celebrated in America. Chinatown, which until recently was the "wickedest thoroughfare in the States," the taint of "America's dream town," a vice-ridden and overcrowded ghetto where tourists rarely venture, is now the not-to-be-missed tourist attraction, an exotica famed for its packed restaurants, its Oriental delicacies, its glittering souvenir-crammed shops and, above all, its memorable Chinese New Year celebration. Over and over again, the (off-)scene repeats itself as if time no longer changes. How is the parade born? Where and in what circumstances was it invented? "Back home" — whose spirit this parade pretends to perpetuate — did the Chinese celebrate their New Year squeezed up along the sidewalks with several dozen hefty policemen (American and Chinese looking almost alike) on foot, on horseback, and on motor bikes (no Chinese policeman, however, has been seen on horseback or on a motor bike) to guard (what is supposed to be)

their parade, shoo them, push them back, or call them to order if they happen to get off the line while watching *the procession? What do you think the motives are behind such an ostentatious display of folk-lore, or arrogance and coercive power (besides the invariable it-is-for-your-own-good answer Order usually provides you with)? For I myself fail to see any sign of "celebration" in this segregated masquerade, where feasters are forcibly divided into actors and spectators, while participation exclusively consists in either exhibiting oneself exotically on the scene or watching the object of exhibition distantly off the scene. Chinese New Year thus takes on a typical dualistic Western face. Preserve the form of the old in the context-content of the new; this is what* decoration *means. Power arrogates to itself the right to inter-fere in every mass event that takes place, and the feast no longer belongs to the people, whose joint merrymaking cannot be viewed other than as a potential threat to Power. Tell me, where are those public celebrations described in tourist guides, that "spill onto every street in Chinatown and transform the squares into fairgrounds"?*

Subject-in-the-making

"In 'woman'," says Julie Kristeva, "I see something that cannot be represented, something that is not said, something above and beyond nomenclatures and ideologies."[35] Since there can be no social-political r-evolution without a r-evolution of subjects, in order to shatter the social codes, women must assume, in every (non-dualist) sense of the word, "a *negative* func-tion: reject everything . . . definite, structured, loaded with meaning, in the existing state of society." Such a responsibility does not exclusively devolve upon women, but it is women who are in a better position to accept it, "because in social, sexual and symbolic experiences being a woman has always provided a means to another end, to becoming something else: a subject-in-the-making, a subject on trial."[36] In a book written after her visit to China, Kristeva remarks how little Chinese women differ from Chinese men – these woman "whose ances-tors knew better than anyone the secrets of erotic art, now so sober and so absorbed in their gray-blue suits, relaxed and austere . . . stand[ing] before their lathes or in the arms of their children . . . the 'pill' in their pockets":

> One can say that they "censure the sexual difference" . . . what if this reproach, insofar as it is one, were to have no meaning except in our framework of paternal dominance, where any trace of a "central mother figure" is completely lost? What if their tradition, on condition one could strip it of its hierarchical-bureaucratic-patriarchal weight, allowed no more separation between two metaphysical entities (Men and Women); no more symbolic difference, that is, outside the biological differ-ence, except *a subtle differentiation on both sides of the biological barrier, structured by the recognition of a social law to be assumed in order ceaselessly to be contested?* . . .
>
> If . . . one considered the family, women, and the sexual difference in the way they determine a social ethic, one could say. . . . that the basic question there is the building of a society whose active power is represented by no one . . . not even women.[37] (my italics)

The point raised by this apparent indifference to a physical distinction between men and women is not simple repression of a sexual difference, but a *different* distribution of sexual *difference*, therefore a challenge to the notion of (sexual) identity as commonly defined in the West and the entire gamut of concepts that ensues: femininity-femaleness-feminitude-woman-womanhood/masculinity-maleness-virility-man-manhood, and so on. In other words, sexual difference has no absolute value and is interior to the praxis of every subject. What is known

as the "Phallic principle" in one part of the world (despite the dominance this part exerts over the rest) does not necessarily apply to the other parts. A thorough undermining of all power-based values would require the dismantling of the sovereign, authority-claiming subject, without which it is bound to be co-opted by power. "On a deeper level," observes Kristeva, "a woman cannot 'be'; it is something which does not even belong in the order of *being*. It follows that a feminist practice can only be negative ['our negativity is not Nietzschean anger'], at odds with what already exists so that we may say 'that's not it' and 'that's still not it.'"[38]

Ethnicity or womanhood: whose duality?

Voices of theories. Unlike Kristeva, while understanding the necessity of a "negative" feminist practice which continuously reminds us that "woman cannot be" or that we can no more speak about "woman" than about "man," I would not "try to go against metaphysical theories that censure what [she] just labeled 'a woman'" and to "dissolve identity."[39] Although these statements belong to a context of active questioning of the search for a woman's identity (and by extension, of a straight celebration of ethnic identity), they tend to invite accusations of privileging "woman" as attitude over "woman" as sex. One does not go without the other, and "woman," with its undefinable specificity (the difference, as mentioned above, both between and within entities), cannot exclusively be apprehended in relation to an apparently unsexed or supposedly beyond-the-sex "negative function." The perception of sex as a secondary attribute – a property or an adjective that one can add or subtract – to woman is a perception that still dwells in the prevailing logic of acquisition and separation. Difference understood not as an irreducible quality but as a drifting apart within "woman" articulates upon the infinity of "woman" as entities of inseparable "I's" and "Not-I's." In any case, "woman" here is not interchangeable with "man"; and to declare provocatively, as Kristeva does, that one should dissolve "even sexual identities" is, in a way, to disregard the importance of the shift that the notion of identity has undergone in woman's discourses. That shift does not lead to "a theory of female identity . . . that varies from the male model" (Gardiner), as mentioned earlier, but rather to identity as points of re-departure of the critical processes by which I have come to understand how the personal – the ethnic me, the female me – is political. Difference does not annul identity. It is beyond and alongside identity. Thus, there is simply no point outside Kristeva's "sexual identities" from which to take up a position ("When you are silent, it speaks; / When you speak, it is silent"). The same holds true for the choice many women of color feel obliged to make between ethnicity and womanhood: how can they? You never have/are one without the other. The idea of two illusorily separated identities, one ethnic, the other woman (or more precisely female), again, partakes in the Euro-American system of dualistic reasoning and its age-old divide-and-conquer tactics. Triple jeopardy means here that whenever a woman of color takes up the feminist fight, she immediately qualifies for three possible "betrayals": she can be accused of betraying either man (the "man-hater"), or her community ("people of color should stay together to fight racism"), or woman herself ("you should fight first on the women's side"). The pitting of anti-racist and anti-sexist struggles against one another allows some vocal fighters to dismiss blatantly the existence of either racism or sexism within their lines of action, as if oppression only comes in separate, monolithic forms. Thus, to understand how pervasively dominance operates via the concept of hegemony or of absent totality in plurality is to understand that the work of decolonization will have to continue within the women's movements.

 Other voices of theories. Attempts have been made recently, for example, by some women anthropologists and, more noisily, by Ivan Illich to distinguish *sex* from *gender*. The implications borne by these two notions are, indeed, far- and wide-reaching, and their

differentiation certainly provides one more useful tool to inquire into this oppressor–oppressed, First World–Third World relationship. As representative terms, sex and gender point to two irreducible (although easily overlapping) systems of values, two distinct ways of perceiving the male and female dynamics. Blindness to the difference and non-interchangeability of these systems had induced the social sciences to treat native wo/men as nothing but "economic neuters" of fe/male sex. "Sex and gender," writes Illich, "are unfit to cohabit the same conceptual universe. The attempt to marry the two necessarily leads to the scientific sexism of anthropology, be it of macho or of a fem brand." Anthropology, like all the science of *man*, is, therefore, male-biased not only because "we who are ourselves men study men" (male investigators feed their own models to local male informants who, while rendering an account of their customs, feed them back with some native adaptations and with the best intentions, to the inquisitors from whom they first come), but also because it is gender-blind in its pretensions to science. "Its scientific logic makes it an analytical tool that studies men and women as 'anthropoi,' reduces gender to sex, and makes of a metaphorical complementarity . . . a system of two homogeneous opposites."[40] Illich's distinction between gender and sex clarifies, in many ways, the reserved attitude non-Western women maintain toward all anthropological or anthropologically reinforced feminist interpretations of their conditions. It calls attention to possibly one of the most pernicious hegemonic distortions on which nearly every anthropologist's study of the so-called sex division of labor among the "non-literate" people (and by extension, the "bi-cultural" natives) has rested: the fundamental assumption that gender is only a (primitive, underdeveloped) form of sex role.

"By social gender," Illich specifies, "I mean the eminently local and timebound duality that sets off men and women under circumstances and conditions that prevent them from saying, doing, desiring, or perceiving 'the same thing.' By economic, or social, sex I mean the duality that stretches toward the illusory goal of economic, political, legal, or social equality between women and men." What stands out in these two definitions is the tentative exploration of a difference within duality itself. The duality Illich sees in gender and names "ambiguous," "asymmetric complementarity is *opposed* to the polarization of homogeneous characteristics that constitutes social sex" (my italics).[41] Since each culture has its own interweaving of genders, the first kind of duality remains undefinable and *is* a goal in itself. The second works towards an *objectivist* (or objectified, hence "illusory") goal and can therefore easily be determined according to a set of established criteria for equality. With such a differentiation in mind, the concept of gender may be said to be alive, open enough to deal with both differences between and differences within entities, while the concept of sex reduces the interactions between men and women to an even exchange or a mere opposition of identities. Gender as a "complementarity" is only ambiguous to the Positivistic analytical mind. In its local perspective, the gender divide is always crystal clear, even though this clarity does not result from any consistent rule that scientific reasoning may invent to salvage it and is better conveyed through myths, stories or sayings than through analyses whose necessity for order calls forth the parades of police rationalities. Thus, to simply denounce Third World women's oppression with notions and terms made to reflect or fit into Euro-American women's criteria of equality is to abide by ethnographic ideology, which depends on the representation of a coherent cultural subject as source of scientific knowledge to explain a native culture and reduces every gendered activity to a sex-role stereotype. Feminism in such a context may well mean "westernization." A fundamentally "pure" (unmediated) export of or import from the dominant countries, it indirectly serves the cause of tradition upholders and provides them with a pretext for muddling all issues of oppression raised by Third World women. Standardization continues its relentless

course, while Tradition remains the sacred weapon oppressors repeatedly hold up whenever the need to maintain their privileges, hence to impose the form of the old on the content of the new, arises. One can say that fear and insecurity lie behind each attempt at opposing modernism with tradition and, likewise, at setting up ethnicity against womanhood. There was a time when being a feminist meant lacking "femininity," therefore running counter to the law of womanhood; today, it is more convincing to reject feminism as a whitewashed notion and a betrayal of roots values, or vice versa, to consider the promotion of ethnic identity treacherous to that of female identity or feminism. Exchanges like the following, related by Alice Walker, are indeed very common:

> *White student feminist:* "But if you say that black women should work in the black community, you are saying that race comes before sex. What about black *feminists?* Should *they* be expected to work in the black community? And if so, isn't this a betrayal of their feminism? Shouldn't they work with women?"
>
> *Our Mother [Walker's voice]:* "But of course black people come in both sexes."[42]

One bounces back and forth from one extreme to another, as if races of color annul sex, as if woman can never be ethnic.

The Gender controversy

Gender, as Illich presents it, bespeaks a fundamental social polarity that varies with times and places and is never the same. It is inherent in men's and women's acts, their speeches, gestures, grasps of reality, their spaces, patterns of living, and the objects in their surroundings; it reigns in non-industrialized societies as a regulative force that renders inevitable the collective, mutual dependence of men and women, setting thereby limits to dominion, exploitation, and defeat. "Vernacular culture is a truce between genders," Illich affirms, and "while under the reign of gender women might be subordinate, under *any* economic regime they are *only* the second sex."[43] However assertive, extremist, and nostalgic such a statement may sound, it does not, in fact, run counter to the opinions voiced by a number of Third World feminists and woman anthropologists. The latter have, for the last decade, devoted their energy to denouncing the male scholar's androcentrism, which prevents him from admitting or even recognizing the full impact of women's participation in the creation of society. They have begun challenging his limited descriptions of social reality by reinterpreting data to redefine power, influence, and status and to demonstrate that only within a male-biased perspective does the subjugation of women take on a universal face. Women from various Third World countries have concentrated their efforts on dispelling ideas popularly held about their so-called inferior status. Such was, for example, the main intent of a group of women who gathered in Abidjan (July 3–8, 1972) to speak around the theme of "The Civilization of the Woman in African Tradition." The meeting, organized by the Society of African Culture, opened with a few statements which set the tone for the entire colloquium:

> we can only deplore the mechanism which favours the transfer to Africa of problems and their solutions, of certain institutions which result from a purely Western historical process. Organizations for the promotion of women's rights . . . tend naturally to extend identical activities into Africa, and, in so doing, to assimilate us into a strictly European mentality and historic experience.
>
> Hardly anything has been written about African women that has not presented them as minor elements.[44]

The African woman, at least in the precolonial society, is neither a reflection of man, nor a slave. She feels no need whatsoever to imitate him in order to express her personality.[45]

Jacqueline Ki-Zerbo emphasized the conception of *woman* as *home*. The hearth of the joint family, the needle sewing its different members together, She is *woman* in relation not only to her husband, but also to all the men of her husband's family, to her brothers, her cousins, and their friends. She is equally mother of her children and mother of all the children of the family, as well as of those belonging to her husband's friends. Thelma Awori condemned the long-lived myth of the inferiority of the African women and, in her attempts at explaining these women's conditions, raised the question of *etiquette* in social relations. Observance of the rules of etiquette, which she considered to be intrinsic to African culture, is a necessity for the survival of the community, not just an empty form with which individuals comply from mere habit. Delphine Yeyet insisted on the elevated status of women in the traditional non-state societies of Gabon. She aimed, through her speech, at destroying the myth according to which women, oppressed in primitive communes, are being liberated in today's monetary societies where men dominate. "In a subsistence economy," Yeyet observed, "men are obliged to earn their livelihood in cooperation with women without exploiting them. In a monetary economy, however, the thirst for comfort and profit pushes men to exploit women and chase them from the domains of political and social action";[46] hence, the advent, in present-day Gabon, of numerous secret and closed women's defense societies that seek to inspire respect and fear in "capitalist" men. The list of women voicing similar opinions at the colloquium is impressively long, but these three examples suffice to give an idea of the refusal of many African women to see themselves through imported words that identify them as minors with little or no rights, little or no independence, subject to the omni-authority of men. The notion of *woman* not as sexed individual but as *home*, of *etiquette* as *communal survival*, the idea of attributing women's oppression to the advent of a monetary economy, and Illich's concept of *gender* converge in many aspects. A gendered life-style implies that non-interchangeable men and women work together for the survival of their community. The contrary may be said of life under the regime of industrial economics, where genderless hands – in search of their fe/male identities – produce commodities in exchange for pay and where the law of the jungle happily prevails: Power belongs to s/he who succeeds, in the rat-(extermination)race, to consume most before(/while) being consumed.

Proceeding from one opposition to another can, however, be very limiting. It all depends on the way one renders these limits visible and succeeds in letting oppositions annul themselves by constantly annulling each other. Concepts are bound, by their linguistic nature, to yield a plural interpretation. The more this linguistic reality is taken into consideration, the less reductive prove to be the issues raised and the position adopted by the writing or speaking subject. The reign of gender Illich sets up against the regime of economic sex and the three exemplary arguments by African women mentioned above may denote a sincere effort to probe into the question of oppression, but they may also denote a form of highly reactionary thinking rising from a deep-seated chauvinism-sexism. They may lead to a radical change in one's outlook on Third World women's struggles, as they may lead to the backwardness of "hard-core" conservatism, a conservatism that spouts out of opportunism, of the irrational fear of *losing*.[47] (Losing what? That is the question. A quick answer will run flatly as follows: losing either the master's favor or the master's position itself.) The notion of gender is pertinent to feminism as far as it denounces certain fundamental attitudes of imperialism and as long

as it remains unsettled and unsettling. Illich's continual build-up of opposition between gender and sex does not, however, lead to such an opening. It tends, on the contrary, to work toward separation and enclosure. The universe in which his theories circulate – whether they relate to schooling, medical, religious, or feminist institutions – is a fixed universe with a definite contour. One can call it the uncompromising hatred of industrial economics or the cult of a subsistence-oriented mode of living; whatever the name, the aim pursued remains the same. The concept of gender is thus elaborated to fit into this perspective, hence his insistence on the irremediable *loss* of gender. Sexism postulated as a *sine qua non* of economic growth does not leave any room for gendered activities, and the two as duality are absolutely incompatible. Such a clear, irreversible division is, at times, very useful. It sheds another convincing light on the fact that sexism is no more inherent in the masculine gender (although it has been initially and predominantly practiced by men) than in the feminine gender, and when we say, for example, that the subjugation of women takes on a universal face only within a "male-biased" perspective, we are aware that we still judge this perspective in a sexist (not gendered) perspective. Recognizing one's limit and situating one's view in the realm of sexism and genderlessness certainly helps one to avoid "imputing sex to the past," reducing or distorting the realities of "native" cultures; but this does not necessarily imply that what Illich sees as a gender-bound style of perception is lost, dead, or irrecuperable. One cannot speak about the loss of a concept without at the same time knowing it can be spoken of as a gain. That vernacular speech is fading away and that industrialized language enforces the genderless perspective are borne out of Illich's own speech and writing, which, despite their careful avoidance or redefinition of key words (are bound by his own reasoning to), offer a genderless look at gender, and address a genderless *man*. Such a contradiction invites, however, further probing into the concept of gender. One wonders, indeed, whether Illich's attempts at defining gender and his persistence in dwelling on its supposed finiteness have not somehow blinded him to some of the most radical (not to be understood merely as excessive or extreme) trends in feminism today. No matter how relevant and incisive the statement may prove to be in his conceptual context, to declare that "under *any* economic regime [women] are *only* the second sex" is to oversimplify the issue. It is also willingly to ignore the importance of women's achievements in dismantling the differences within this "second-sex" as well as those between First, Second, and Third. The master is too bent on proving his point to allow for any deflection. One may say of the rigid line of his reasoning that it connotes a strong nostalgia for the past and for a purity of self-presence in life, a purity he does not hesitate to defend by crushing or crossing out all obstacles standing in his way. The place of (Illich-)the male investigator/speaker/writer remains unquestioned.

Perhaps, for those of us who have never known what life in a vernacular culture is/was and are unable to imagine what it can be/could have been, gender simply does not exist otherwise than grammatically in language. (Vernacular, as Illich uses it, denotes autonomous, non-market-related actions, or "sustenance derived from reciprocity patterns imbedded in every aspect of life, as distinguished from sustenance that comes from exchange or from vertical distribution.")[48] Attempts at reviving this notion (gender) through a genderless, industrialized language will then appear vain, for they will only be interpreted as a sophisticated – therefore most insidious – plea for a return to tradition, a tradition carried on for the benefit of men and legally (not equitably) reinforced by laws invented, brought into operation, and distorted by men for men. Such an interpretation is not totally unfounded, and there are many tradition upholders in the Third World today who would readily make use of Illich's theory of gender to back up their anti-feminist fight. Having always maintained that

there should be nothing like equality and rights for women because traditionally these simply did not exist, they would turn his arguments to account and continue confidently to preach the absence of women's oppression in traditional societies. Like the Society of African Culture at the colloquium in Abidjan, they will loudly extol women's "splendid initiative, the maturity of their action," as well as their aptitude to uphold "autonomy vis-à-vis men . . . without neglecting their duties to their children or to their husbands [sic]."[49] If it is deplorable to think of women solely as sex and equal rights, it is also lamentable to see in the notion of woman-hearth-home only the cook-wife-mother whose activities should remain centered on the home despite the roles she may perform in the outside world. "The African woman today," says Simi Afonja, "is seen as intruding into realms which are exclusively for men. Hence we hear too often that the woman's place traditionally is in the home. . . . She should not therefore be found in jobs specifically meant for men."[50] When removed from its survival content, etiquette in social relations disintegrates to become mere form. Gender, reduced to a sex-determined behavior, serves to promote inequality in a system of production, exchange, and consumption where "the woman," according to Jeanne Nzaou-Mabika, "has little opportunity to take the initiative and to exercise her creative ability. The least manifestations of a desire for change in ancient practices is regarded as an intolerable rebellion."[51] Here, Illich's theory shows, again, that distinctions need to be made both (1) between the transgression or infraction of gender in a gendered society and the deviation from a sex-determined behavior in a society where gender has disappeared and (2) between gender infringement and the fading of the gender line itself. Violations of the gender divide, which have occurred in all times and places, mostly result from technological discovery, public calamity, private misfortune, or occasional emergencies. Having always been experienced as a terrifying force when carried out collectively, they also constitute an effective means of redressing a power imbalance or defying the established order, and they aim, not at effacing the gender line, but at *confirming it through change*. Gender thus understood approximates Julia Kristeva's earlier definition of that which characterizes the relation between women and men in China: "a subtle differentiation on both sides of the biological barrier, structured by the recognition of a social law to be assumed in order ceaselessly to be contested." A social regulator and political potential for change, gender, in its own way, baffles definition. It escapes the "*diagnostic* power" of a sex-oriented language/sex-identified logic and coincides thereby with *difference*, whose inseparable temporal and spatial dynamics produces the illusion of identity while undermining it relentlessly. In today's context, to defend a gendered way of living is to fight for difference, a difference that postpones to infinity and subverts the trend toward unisex behavioral patterns. The story of gender-as-difference is, therefore, not "the story of what has been lost" (Illich), but the story of that which does not readily lend itself to (demonstrative) narrations or descriptions and continues to mutate with/beyond nomenclature.

Notes

Our special thanks go to Mitsuye Yamada for the authorization to quote her poems in this book.

1 Audre Lorde, "The Master's Tools Will Never Dismantle the Master's House," *This Bridge Called My Back: Writings by Radical Women of Color*, ed. C. Morraga & G. Anzaldúa (Watertown, Mass.: Persephone Press, 1981), p. 99.
2 Charles A. W. Manning, "In Defense of Apartheid," *Africa Yesterday and Today*, ed. C.D. Moore & A. Dunbar (New York: Bantam, 1968), p. 287.
3 Ibid., p. 289.

4 Jan Christiaan Smuts, quoted in Louis Fischer, *Gandhi: His Life and Message for the World* (New York: New American Library, 1954), p. 25.

5 General Louis Botha, quoted in ibid.

6 Manning, p. 287.

7 Gayatri Chakravorty Spivak, "The Politics of Interpretations," *Critical Inquiry* 9, no. 1 (1982), p. 278.

8 Gloria Anzaldúa, "Speaking in Tongues: A Letter to 3rd World Women Writers," *This Bridge*, pp. 167–68.

9 Mitsuye Yamada, "Asian Pacific American Woman and Feminism," *This Bridge*, p. 71.

10 Lorde, "The Master's Tools . . .," p. 100.

11 Alice Walker, "One Child of One's Own: A Meaningful Digression Within the Work(s)," *The Writer on Her Work*, ed. J. Sternburg (New York: W. W. Norton, 1980), p. 137.

12 Leslie Marmon Silko, "Lullaby," *The Ethnic American Woman*, ed. E. Blicksilver (Dubuque, Iowa: Kendall/Hunt, 1978), p. 57.

13 Virginia Woolf, *A Room of One's Own* (New York: Harcourt Brace Jovanovich, 1929), p. 48.

14 "The Master's Tools . . .," p. 100.

15 Ellen Pence, "Racism – A White Issue," *But Some of Us Are Brave*, ed. G. T. Hull, P. B. Scott, & B. Smith (Old Westbury, N.Y.: Feminist Press, 1982), p. 46.

16 Ibid., pp. 46–47.

17 Barbara Smith, "Racism and Women's Studies," *But Some of Us Are Brave*, p. 49.

18 Mitsuye Yamada, "Invisibility Is An Unnatural Disaster: Reflections of an Asian American Woman," *This Bridge*, pp. 36–37.

19 Adrienne Rich, *On Lies, Secrets and Silence* (New York: W. W. Norton, 1979), pp. 38–39.

20 Joanne Harumi Sechi, "Being Japanese-American Doesn't Mean 'Made in Japan,'" *The Third Woman, Minority Women Writers of the United States*, ed. D. Fisher (Boston: Houghton Mifflin Cie., 1980), p. 444.

21 "Asian Pacific . . .," pp. 74–75.

22 I have discussed at length the notions of non-dualistic thinking and of multiple presence in Trinh T. Minh-ha, *Un Art sans oeuvre. L'Anonymat dans les arts contemporains* (Troy, Mich.: International Books, 1981).

23 Vine Deloria, Jr., *Custer Died for Your Sins* (New York: Avon Books, 1969), p. 86.

24 Excerpts in *Women Poets of Japan*, ed. Kenneth Rexroth and Ikuko Atsumi (New York: New Directions Books, 1977), p. 123.

25 Quoted in Alan W. Watts, *Nature, Man, and Woman* (1958, rpt. New York: Vintage Books, 1970), p. 121.

26 "On Female Identity and Writing by Women," *Critical Inquiry* 8 (Special Issue on *Writing and Sexual Difference*, ed. E. Abel), no. 2 (1981), pp. 348–49, 354, 353.

27 Simone de Beauvoir, *The Second Sex* (1952, rpt. New York: Bantam, 1970), p. 223.

28 Julia Kristeva, "Woman Can Never Be Defined," trans. Marilyn A. August, *New French Feminism*, ed. E. Marks & I. De Courtivon (Amherst: Univ. of Massachusetts Press, 1980), p. 139.

29 "One Child of One's Own . . .," pp. 133–34.

30 Ibid., p. 136.

31 Quoted in *Sturdy Black Bridges. Visions of Black Women in Literature*, ed. R. P. Bell, B. J. Parker, & B. Guy-Sheftall (Garden City, N.Y.: Anchor/Doubleday, 1979), p. xxv.

32 Sojourner Truth, "Speech of Woman's Suffrage," *The Ethnic American Woman*, p. 335.

33 In *New French Feminism*, pp. 214, 219.

34 In *This Bridge*, pp. 95, 97.

35 "Woman Can Never Be Defined," p. 137.

36 Kristeva in an interview with Xavière Gauthier, "Oscillation between Power and Denial," *New French Feminism*, pp. 166–67.

37 Julia Kristeva, "On the Women of China," tr. E. Conroy Kennedy, *Signs* 1, no. 1 (1975), pp. 79, 81.

38 "Woman Can Never Be Defined," p. 137.

39 Ibid., p. 138.

40 Ivan Illich, *Gender* (New York: Pantheon Books, 1982), pp. 128, 131–32.

41 Ibid., p. 20.

42 "One Child of One's Own . . .," p. 133.

43 *Gender*, p. 178.

44 *La Civilisation de la femme dans la tradition africaine* (Paris: Présence Africaine, 1975), English introduction, p. 15.

45 Ibid., French introduction, p. 13 (my translation).

46 Ibid., p. 68. For Ki-Zerbo & T. Awori, see pp. 22, 31–39.

47 See *Feminist Issues* 3, no. 1 (Spring 1983), an issue devoted to a symposium organized by the Women's Studies Program at UC-Berkeley in response to the lectures Illich gave on his concept of gender in 1982 at the University. Of particular interest here is Barbara Christian's paper on "Alternate Versions of the Gendered Past: African Women Writers vs. Illich," which draws attention to the nostalgic undertones of the concept. Although I agree with the paper and do not view it as being in any way incompatible with what has been discussed in this chapter concerning the question of gender, I would rather emphasize the controversial nature of the concept, its very potential to raise issues and to draw attention to aspects of cultural and sexual description that have until recently been minimized if not ignored in many sociological/anthropological analyses. Difference, as pointed out all along in this chapter, should neither be defined by the dominant sex nor by the dominant culture. As another possibly useful tool to unsettle the notion of difference as division or opposition, gender-differentiated-from-sex should therefore not be simply dismissed or denied but problematized, re-contextualized, and re-appropriated or re-affirmed in women's own terms.

48 Ivan Illich, *Shadow Work* (London: Marion Boyars, 1981), p. 57.

49 *La Civilisation*, p. 15.

50 Ibid., p. 369.

51 Ibid., p. 287.

Chapter 21

LORRAINE O'GRADY

OLYMPIA'S MAID
Reclaiming black female subjectivity

THE FEMALE BODY IN THE WEST is not a unitary sign. Rather, like a coin, it has an obverse and a reverse: on the one side, it is white; on the other, not-white or, prototypically, black. The two bodies cannot be separated, nor can one body be understood in isolation from the other in the West's metaphoric construction of "woman." White is what woman is; not-white (and the stereotypes not-white gathers in) is what she had better not be. Even in an allegedly postmodern era, the not-white woman as well as the not-white man are symbolically and even theoretically excluded from sexual difference.[1] Their function continues to be, by their chiaroscuro, to cast the difference of white men and white women into sharper relief.

A kaleidoscope of not-white females, Asian, Native American, and African, have played distinct parts in the West's theatre of sexual hierarchy. But it is the African female who, by

virtue of color and feature and the extreme metaphors of enslavement, is at the outermost reaches of "otherness." Thus she subsumes all the roles of the not-white body.

The smiling, bare-breasted African maid, pictured so often in Victorian travel books and *National Geographic* magazine, got something more than a change of climate and scenery when she came here.

Sylvia Ardyn Boone, in her book *Radiance from the Waters* (1986), on the physical and metaphysical aspects of Mende feminine beauty, says of contemporary Mende: "Mende girls and women go topless in the village and farmhouse. Even in urban areas, girls are bare-breasted in the house: schoolgirls take off their dresses when they come home, and boarding students are most comfortable around the dormitories wearing only a wrapped skirt."[2]

What happened to the girl who was abducted from her village, then shipped here in chains? What happened to her descendants? Male-fantasy images on rap videos to the contrary, as a swimmer, in communal showers at public pools around the country, I have witnessed black girls and women of all classes showering and shampooing with their bathing suits *on*, while beside them their white sisters stand unabashedly stripped. Perhaps the progeny of that African maiden feel they must still protect themselves from the centuries-long assault which characterizes them, in the words of the *New York Times* ad placed by a group of African-American women to protest the Clarence Thomas–Anita Hill hearings, as "immoral, insatiable, perverse; the initiators in all sexual contacts – abusive or otherwise."[3]

Perhaps they have internalized and are cooperating with the West's construction of not-white women as not-to-be-seen. How could they/we not be affected by that lingering structure of invisibility, enacted in the myriad codicils of daily life and still enforced by the images of both popular and high culture? How not get the message of what Judith Wilson calls "the legions of black servants who loom in the shadows of European and European-American aristo-cratic portraiture,"[4] of whom Laura, the professional model that Edouard Manet used for Olympia's maid, is in an odd way only the most famous example? [See Figure 19.1.] Forget euphemisms. Forget "tonal contrast." We know what she is meant for: she is Jezebel *and* Mammy, prostitute and female eunuch, the two-in-one. When we're through with her in-exhaustibly comforting breast, we can use her ceaselessly open cunt. And best of all, she is not a real person, only a robotic servant who is not permitted to make us feel guilty, to accuse us as does the slave in Toni Morrison's *Beloved* (1987). After she escapes from the room where she was imprisoned by a father and son, that outraged woman says: "You couldn't think up what them two done to me."[5] Olympia's maid, like all the other "peripheral Negroes,"[6] is a robot conveniently made to disappear into the background drapery.

To repeat: castrata and whore, not madonna and whore. Laura's place is outside what can be conceived of as woman. She is the chaos that must be excised, and it is her excision that stabilizes the West's construct of the female body, for the "femininity" of the white female body is ensured by assigning the not-white to a chaos safely removed from sight. Thus only the white body remains as the object of a voyeuristic, fetishizing male gaze. The not-white body has been made opaque by a blank stare, misperceived in the nether regions of TV.

It comes as no surprise, then, that the imagery of white female artists, including that of the feminist avant-garde, should surround the not-white female body with its own brand of erasure. Much work has been done by black feminist cultural critics (Hazel Carby and bell hooks come immediately to mind) that examines two successive white women's movements, built on the successes of two black revolutions, which clearly shows white women's inability to surrender white skin privilege even to form basic alliances.[7] But more than politics is at stake. A major structure of psychic definition would appear threatened were white women to acknowledge and embrace the sexuality of their not-white "others." How else explain the

treatment by that women's movement icon, Judy Chicago's *Dinner Party* (1973–78), of Sojourner Truth, the lone black guest at the table? When thirty-six of thirty-nine places are set with versions of Chicago's famous "vagina" and recognizable slits have been given to such sex bombs as Queen Elizabeth I, Emily Dickinson, and Susan B. Anthony, what is one to think when Truth, the mother of four, receives the only plate inscribed with a face?[8] Certainly Hortense Spillers is justified in stating that "the excision of the genitalia here is a symbolic castration. By effacing the genitals, Chicago not only abrogates the disturbing sexuality of her subject, but also hopes to suggest that her sexual being did not exist to be denied in the first place."[9]

And yet, Michele Wallace is right to say, even as she laments further instances of the disempowerment of not-white women in her essay on *Privilege* (1990), Yvonne Rainer's latest film, that the left-feminist avant-garde "in foregrounding a political discourse on art and culture" has fostered a climate that makes it "hypothetically possible to publicly review and interrogate that very history of exclusion and racism."[10]

What alternative is there really – in creating a world sensitive to difference, a world where margins can become centers – to a cooperative effort between white women and women and men of color? But cooperation is predicted on sensitivity to differences among ourselves. As Nancy Hartsock has said, "We need to dissolve the false 'we' into its real multiplicity."[11] We must be willing to hear each other and to call each other by our "true-true name."[12]

To name ourselves rather than be named we must first see ourselves. For some of us this will not be easy. So long unmirrored in our true selves, we may have forgotten how we look. Nevertheless, we can't theorize in a void, we must have evidence. And we – I speak only for black women here – have barely begun to articulate our life experience. The heroic recuperative effort by our fiction and nonfiction writers sometimes feels stuck at the moment before the Emancipation Proclamation.[13] It is slow and it is painful. For at the end of every path we take, we find a body that is always already colonized. A body that has been raped, maimed, murdered – that is what we must give a healthy present.

It is no wonder that when Judith Wilson went in search of nineteenth-century nudes by black artists, she found only three statues of nonblack children – Edmonia Lewis's *Poor Cupid*, 1876; her *Asleep* (1871); and one of the two children in her *Awake* (1872)[14] (though Wilson cautions that, given the limits of current scholarship, more nudes by nineteenth-century blacks may yet surface).[15] Indeed, according to Wilson, the nude, one of high art's favorite categories, has been avoided during most of "the 200-year history of fine art production by North American blacks."[16] Noting exceptions that only prove the rule, i.e., individual works by William H. Johnson and Francisco Lord in the 1930s and Eldzier Cortor's series of Sea Island nudes in the 1940s, she calls "the paucity of black nudes in U.S. black artistic production prior to 1960 . . . an unexamined problem in the history of Afro-American art."[17] And why use 1960 as a marker of change? Because, says Wilson, after that date there was a confluence of two different streams: the presence of more, and more aggressive, black fine artists such as Bob Thompson and Romare Bearden, and the political use of the nude as a symbol of "Black Is Beautiful," the sixties slogan of a programmatic effort to establish black ethnicity and achieve psychic transformation.[18]

Neither of these streams, however, begins to deal with what I am concerned with here: the reclamation of the body as a site of black female subjectivity. Wilson hints at part of the problem by subtitling a recent unpublished essay "Bearden's Use of Pornography." An exterior, pornographic view, however loving, will not do any more than will the emblematic "Queen of the Revolution." But though Wilson raises provisional questions about Bearden's montaging of the pornographic image, her concerns are those of the art historian, while

mine must be those of the practitioner.[19] When, I ask, do we start to see images of the black female body by black women made as acts of auto-expression, the discrete stage that must immediately precede or occur simultaneously with acts of auto-critique? When, in other words, does the present begin?

Wilson and I agree that, in retrospect, the catalytic moment for the subjective black nude might well be Adrian Piper's *Food for the Spirit* (1971), a private loft performance in which Piper photographed her physical and metaphysical changes during a prolonged period of fasting and reading Immanuel Kant's *Critique of Pure Reason*.[20] Piper's performance, unpublished and unanalyzed at the time (we did not have the access then that we do now), now seems a paradigm for the willingness to look, to get past embarrassment and retrieve the mutilated body, as Spillers warns we must if we are to gain the clearsightedness needed to overthrow hierarchical binaries: "Neither the shameface of the embarrassed, nor the not-looking-back of the self-assured is of much interest to us," Spillers writes, "and will not help at all if rigor is our dream."[21]

It is cruelly ironic, of course, that just as the need to establish our subjectivity in preface to theorizing our view of the world becomes most dire, the idea of subjectivity itself has become "problematized." But when we look to see just whose subjectivity has had the ground shifted out from under it in the tremors of postmodernism, we find (who else?) the one to whom Hartsock refers as "the transcendental voice of the Enlightenment" or, better yet, "He Who Theorizes."[22] Well, good riddance to him. We who are inching our way from the margins to the center cannot afford to take his problems or his truths for our own.

Though time may be running out for such seemingly marginal agendas as the establishment of black female subjectivity (the headlines remind us of this every day) and we may feel pressured to move fast, we must not be too conceptually hasty. This is a slow business, as our writers have found out. The work of recuperation continues. In a piece called *Seen* (1990) by the conceptual artist Renee Greene, two of our ancestresses most in need, Saartjie Baartman ("the Hottentot Venus") and Josephine Baker, have been "taken back." Each in her day (early nineteenth and twentieth century, respectively) was the most celebrated European exhibit of exotic flesh. Greene's piece invites the viewer to stand on a stage inscribed with information about the two and, through a "winkie" of eyes in the floor and a shadow screen mounted on the side, to experience how the originals must have felt, pinned and wriggling on the wall. The piece has important attributes: it is above all cool and smart. But from the perspective being discussed here – the establishment of subjectivity – because it is addressed more to the other than to the self and seems to deconstruct the subject just before it expresses it, it may not unearth enough new information.

The question of to whom work is addressed cannot be emphasized too strongly. In the 1970s, African-American women novelists showed how great a leap in artistic maturity could be made simply by turning from their male peers' pattern of "explaining *it* to *them*," as Morrison once put it, to showing how it feels to *us*.[23]

Besides, pleading contains a special trap, as Gayatri Spivak noted in her discussion of the character Christophine in Jean Rhys's *Wide Sargasso Sea*: "No perspective *critical* of imperialism can turn the Other into a self, because the project of imperialism has always already historically refracted what might have been the absolutely Other into a domesticated Other that consolidates the imperialist self."[24] Critiquing *them* does not show who *you* are; it cannot turn you from an object into a subject of history.

The idea bears repeating: self-expression is not a stage that can be bypassed. It is a discrete moment that must precede or occur simultaneously with the deconstructive act. An example may be seen in the work of the painter Sandra Payne. In 1986, at the last show of the now

legendary black avant-garde gallery Just Above Midtown in SoHo, Payne presented untitled drawings of joyously sexual and sublimely spiritual nudes. The opening reception was one of those where people speak of everything but what is on the walls. We do not yet have the courage to look.

Understandably, Payne went into retreat. Three years later, she produced attenuated mask drawings that, without the hard edge of postmodernism, are a postmodern speech act in the dialogue of mask and masquerade. Without the earlier subjective nudes, she may not have arrived at them.

A year ago, as a performance artist in a crisis of the body (how to keep performing without making aging itself the subject of the work?), I opted for the safety of the wall with a show of photomontages. My choice of the nude was innocent and far from erotic; I wanted to employ a black self stripped of as many layers of acculturation as possible. The one piece in the show with explicitly represented sexuality, *The Clearing*, a diptych in which a black female engaged with a white male, was to me less about sex than it was about culture. It was not possible to remain innocent for long, however. I soon encountered an encyclopedia of problematics concerning the black body: age, weight, condition, not to mention hair texture, features, and skin tone. Especially skin tone. Any male and female side by side on the wall are technically married. How to arrange a quadriptych such as *Gaze*, composed of head and shoulder shots of differently hued black men and women? Should I marry the fair woman to the dark man? The dark woman to the fair man? What statements will I be making about difference if I give them mates matching in shade? What will I be saying about the history of class?

There was another problematic, as personal as it was cultural. Which maimed body would be best retrieved as the ground of my biographic experience? Young, or middle-aged? Jezebel, or Mammy? The woman I was, or the woman I am now? And, which body hue should I use to generalize my upper-middle-class West Indian-American experience? A black-skinned "ancestress," or the fairer-skinned product of rape? I hedged. In the end, I chose an African-British high-fashion model, London-born but with parents from Sierra Leone. For me, she conveyed important ambiguities: she was black-skinned, but her nude body retained the aura of years of preparation for runway work in Europe. In *The Strange Taxi: From Africa to Jamaica to Boston in 200 Years*, where the subject was hybridism itself, my literal ancestresses, who to some may have looked white, sprouted from a European mansion rolling on wheels down the African woman's back. Although they may have been controversial, I liked the questions those beautifully dressed, proudly erect, ca. World War I women raised, not least of which was how the products of rape could be so self-confident, so poised.

As I wrestled with ever shifting issues regarding which black woman to shoot, I came to understand and sympathize with Lorna Simpson's choice of a unified response in such montages as *Guarded Conditions* (1989), in which a brown-skinned woman in a shapeless white shift is shot from behind – with every aspect of subjectivity both bodily and facial occluded, except the need to cover up itself – and then multiplied. No doubt about it. This multiple woman showers and shampoos in her shift.

But, I tell myself, this cannot be the end. First we must acknowledge the complexity, and then we must surrender to it. Of course, there isn't any final answering of the question, "What happened to that maid when she was brought here?" There is only the process of answering it and the complementary process of allowing each answer to come to the dinner party on its own terms. Each of these processes is just beginning, but perhaps if both continue, the nature of the answers will begin to change and we will all be better off. For if the female body in the West is obverse and reverse, it will not be seen in its integrity – neither side will know itself – until the not-white body has mirrored herself fully.

Postscript

The paragraphs above were drafted for delivery before a panel of the College Art Association early in 1992.[25] Rereading them, I can see to how great an extent they were limited by the panel's narrowly feminist brief. The topic assigned was "Can the naked female body effectively represent women's subjectivity in contemporary North American media culture, which regularly presents women's bodies as objects for a voyeuristic and fetishizing male gaze?"

I think I was invited because I was the only black female artist employing the nude anyone on the panel had heard of. I felt like the extra guest who's just spilt soup on the tablecloth when I had to reject the panel's premise. The black female's body needs less to be rescued from the masculine "gaze" than to be sprung from a historic script surrounding her with signification while at the same time, and not paradoxically, it erases her completely.

Figure 21.1 Lorraine O'Grady, *Gaze 3*, 1991, black and white photomontage.

Still, I could perhaps have done a better job of clarifying "what it is I think I am doing anyway."[26] Whether I will it or not, as a black female artist my work is at the nexus of aggravated psychic and social forces as yet mostly uncharted. I could have explained my view, and shown the implications for my work, of the multiple tensions between contemporary art and critical theory, subjectivity and culture, modernism and postmodernism, and, especially for a black female, the problematic of psychoanalysis as a leitmotif through all of these.

I don't want to leave the impression that I am privileging representation of the body. On the contrary: though I agree, to alter a phrase of Merleau-Ponty, that every theory of subjectivity is ultimately a theory of the body,[27] for me the body is just one artistic question to which it is not necessarily the artistic answer.

My work in general deals with what Gayatri Spivak has called the "'winning back' of the position of the questioning subject."[28] To win back that position for the African-American female will require balancing in mental solution a subversion of two objects which may appear superficially distinct: on the one hand, phallocentric theory; and on the other, the lived realities of Western imperialist history, for which all forms of that theory, including the most recent, function as willing or unwilling instruments.

It is no overstatement to say that the greatest barrier I/we face in winning back the questioning subject position is the West's continuing tradition of binary, "either:or" logic, a philosophic system that defines the body in opposition to the mind. Binaristic thought persists even in those contemporary disciplines to which black artists and theoreticians must look for allies. Whatever the theory of the moment, before we have had a chance to speak, we have always already been spoken and our bodies placed at the binary extreme, that is to say, on the "other" side of the colon. Whether the theory is Christianity or modernism, each of which scripts the body as all-nature, *our* bodies will be the most natural. If it is poststructuralism/postmodernism, which through a theoretical sleight of hand gives the illusion of having conquered binaries, by joining the once separated body and mind and then taking this "unified" subject, perversely called "fragmented," and designating it as all-culture, we can be sure it is *our* subjectivities that will be the most culturally determined. Of course, it is like whispering about the emperor's new clothes to remark that nature, the other half of the West's founding binary, is all the more powerfully present for having fallen through a theoretical trapdoor.

Almost as maddening as the theories themselves is the time lag that causes them to overlap in a crazy quilt of imbrication. There is never a moment when new theory definitively drives out old. Successive, contradictory ideas continue to exist synchronistically, and we never know where an attack will be coming from, or where to strike pre-emptively. Unless one understands that the only constant of these imbricated theories is the black body's location at the extreme, the following statements by some of our more interesting cultural theorists might appear inconsistent.

Not long ago, Kobena Mercer and Isaac Julien felt obliged to argue against the definition of the body as all-nature. After noting that "European culture has privileged sexuality as the essence of the self, the innermost core of one's 'personality,'" they went on to say: "This 'essentialist' view of sexuality . . . *already contains racism*. Historically, the European construction of sexuality coincides with the epoch of imperialism and the two interconnect. [It] is based on the idea that sex is the most basic form of naturalness which is therefore related to being *uncivilized* or *against* civilization."[29]

Michele Wallace, on the other hand, recently found herself required to defend the black body against a hermeneutics of all-culture. "It is not often recognized," she commented, "that bodies and psyches of color have trajectories in excess of their socially and/or culturally

constructed identities."[30] Her statement is another way of saying: now that we have "proved" the personal is political, it is time for us to reassert that the personal is not *just* political.

Wallace and Mercer and Julien are all forced to declare that subjectivity belongs to *both* nature *and* culture. It's true, "both:and" thinking is alien to the West. Not only is it considered primitive, it is now further tarred with the brush of a perceived connection to essentialism. For any argument that subjectivity is partly natural is assumed to be essentialist. But, despite the currency of antiessentialist arguments, white feminists and theorists of color have no choice: they must develop critiques of white masculinist "either:or-ism," even if this puts them in the position of appearing to set essentialism up against antiessentialism. This inherent dilemma of the critique of binarism may be seen in Spivak's often amusing ducking and feinting. To justify apparent theoretical inconsistencies, Spivak once explained her position to an interviewer as follows: "Rather than define myself as specific rather than universal, I should see what in the universalizing discourse could be useful and then go on to see where that discourse meets its limits and its challenge within that field. I think we have to choose again strategically, not universal discourse but essentialist discourse. I think that since as a deconstructivist – see, I just took a label upon myself – I cannot in fact clean my hands and say, 'I'm specific.' In fact I must say I am an essentialist from time to time. There is, for example, the strategic choice of a genitalist essentialism in anti-sexist work today. How it relates to all of this other work I am talking about, I don't know, but *my search is not a search for coherence*."[31] Somebody say Amen.

If artists and theorists of color were to develop and sustain our critical flexibility, we could cause a permanent interruption in Western "either:or-ism." And we might find our project aided by that same problematic imbrication of theory, whose disjunctive layers could signal the persistence of an unsuspected "both:and-ism," hidden, yet alive at the subterranean levels of the West's constructs. Since we are forced to argue both that the body is more than nature, and *at the same time* to remonstrate that there is knowledge beyond language/culture, why not seize and elaborate the anomaly? In doing so, we might uncover tools of our own with which to dismantle the house of the master.[32]

Our project could begin with psychoanalysis, the often unacknowledged linchpin of Western (male) cultural theory. The contradictions currently surrounding this foundational theory indicate its shaky position. To a lay person, postmodernism seems to persist in language that opposes psychoanalysis to other forms of theoretical activity, making it a science or "truth" that is not culturally determined. Psychoanalysis's self-questioning often appears obtuse and self-justifying. The field is probably in trouble if Jacqueline Rose, a Lacanian psychologist of vision not unsympathetic to third world issues, can answer the question of psychoanalysis's universality as follows: "To say that psychoanalysis does not, or cannot, refer to non-European cultures, is to constitute those cultures in total 'otherness' or 'difference'; to say, or to try to demonstrate, that it can, is to constitute them as the 'same.' This is not to say that the question shouldn't be asked."[33]

The implication of such a statement is, that no matter how many times you ask the question of the universality of psychoanalysis or how you pose it, you will not arrive at an answer. But the problem is not the concept of "the unanswerable question," which I find quite normal. The problem is the terms in which Rose frames the question in the first place: her continuing use of the totalizing opposition of "otherness" and "sameness" is the sign of an "either:or" logic that does not yet know its own name.

If the unconscious may be compared to that common reservoir of human sound from which different peoples have created differing languages, all of which are translated more or less easily, then how can any of the psyche's analogous products be said to constitute *total*

"otherness" or "difference"? It's at this point that one wants, without being *too* petulant, to grab psychoanalysis by the shoulders and slap it back to a moment before Freud's Eros separated from Adler's "will-to-power," though such a moment may never have existed even theoretically. We need to send this field back to basics. The issue is not whether the unconscious is universal, or whether it has the meanings psychoanalysis attributes to it (it is, and it does), but rather that, in addition, it contains contradictory meanings, as well as some that are unforeseen by its current theory.

Meanwhile, psychoanalysis and its subdisciplines, including film criticism, continue having to work overtime to avoid the "others" of the West. Wallace has referred to "such superficially progressive discourses as feminist psychoanalytic film criticism which one can read for days on end without coming across any lucid reference to, or critique of, 'race.'"[34]

But that omission will soon be redressed. We are coming after them. In her most brilliant theoretical essay to date, "The Oppositional Gaze," bell hooks takes on white feminist film criticism directly.[35] And Gayatri Spivak brooks no quarter. She has declared that non-Western female subject constitution is the main challenge to psychoanalysis and counter-psychoanalysis and has said: "The limits of their theories are disclosed by an encounter with the materiality of that other of the West."[36]

For an artist of color, the problem is less the limits of psychoanalysis than its seeming binarial *rigidity*. Despite the field's seeming inability to emancipate itself from "either:or-ism," I hope its percepts are salvageable for the non-West. Psychoanalysis, after anthropology, will surely be the next great Western discipline to unravel, but I wouldn't want it to destruct completely. We don't have time to reinvent that wheel. But to use it in our auto-expression and auto-critique, we will have to dislodge it from its narrow base in sexuality. One wonders if, even for Europeans, sexuality as the center or core of "personality" is an adequate dictum. Why does there have to be a "center:not-center" in the first place? Are we back at that old Freud–Adler crossroad? In Western ontology, why does somebody always have to win?

"Nature:culture," "body:mind," "sexuality:intellect," these binaries don't begin to cover what we "sense" about ourselves. If the world comes to us through our senses – and however qualified those are by culture, no one would say culture determines *everything* – then even they may be more complicated than their psychoanalytic description. What about the sense of balance, of equilibrium? Of my personal *cogito*'s, a favorite is "I dance, therefore I think." I'm convinced that important, perhaps even the deepest, knowledge comes to me through movement, and that the opposition of materialism to idealism is just another of the West's binarial theorems.

I have not take a scientific survey, but I suspect most African-Americans who are not in the academy would laugh at the idea that their subjective lives were organized around the sex drive and would feel that "sexuality," a conceptual category that includes thinking about it as well as doing it, is something black people just don't have time for. This "common sense" is neatly appropriated for theory by Spillers in her statement: "Sexuality describes another type of discourse that splits the world between the 'West and the Rest of Us.'"[37]

Not that sex isn't important to these folks; it's just one center among many. For African-American folk wisdom, the "self" revolves about a series of variable "centers," such as sex and food; family and community; and a spiritual life composed sometimes of God or the gods, at others of esthetics or style. And it's not only the folk who reject the concept of a unitary center of the "self." Black artists and theorists frequently refer to African-Americans as "the first postmoderns." They have in mind a now agreed understanding that our inheritance from the motherland of pragmatic, "both:and" philosophic systems, combined with the historic

discontinuities of our experience as black slaves in a white world, have caused us to construct subjectivities able to negotiate between "centers" that, at the least, are double.[38]

It is no wonder that the viability of psychoanalytic conventions has come into crisis. There is the gulf between Western and non-Western quotidian perceptions of sexual valence, and the question of how psychic differences come into effect when "cultural differences" are accompanied by real differences in power. These are matters for theoretical and clinical study. But for artists exploring and mapping black subjectivity, having to track the not-yet-known, an interesting question remains: Can psychoanalysis be made to triangulate nature and culture with "spirituality" (for lack of a better word) and thus incorporate a sense of its own limits? The discipline of art requires that we distinguish between the unconscious and the limits of its current theory, and that we remain alive to what may escape the net of theoretical description.

While we await an answer to the question, we must continue asserting the obvious. For example, when Elizabeth Hess, a white art critic, writes of Jean-Michel Basquiat's "dark, frantic figures" as follows, she misses the point: "There is never any one who is quite human, realized; the central figures are masks, hollow men . . . It can be difficult to separate the girls from the boys in this work. *Pater* clearly has balls, but there's an asexualness throughout that is cold."[39] Words like "hot" and "cold" have the same relevance to Basquiat's figures as they do to classic African sculpture.

The space spirituality occupies in the African-American unconscious is important to specu-late upon, but I have to be clear. My own concern as an artist is to reclaim black female agency. Subjectivity for me will always be a social and not merely a spiritual quest.[40] To para-phrase Brecht, "It is a fighting subjectivity I have before me," one come into political consciousness.[41]

Neither the body nor the psyche is all-nature or all-culture, and there is a constant leakage of categories in individual experience. As Stuart Hall says of the relations between cultural theory and psychoanalysis, "Every attempt to translate the one smoothly into the other doesn't work; no attempt to do so can work. Culture is neither just the process of the unconscious writ large nor is the unconscious simply the internalisation of cultural processes through the subjective domain."[42]

One consequence of this incommensurability for my practice as an artist is that I must remain wary of theory. There have been no last words spoken on subjectivity. If what I suspect is true, that it contains a multiplicity of "centers" and all the boundaries are fluid, then most of what will interest me is occurring in the between-spaces. I don't have a prayer of locating these by prescriptively following theoretical programs. The one advantage art has over other methods of knowledge, and the reason I engage in it rather than some other activity for which my training and intelligence might be suited, is that, except for the theoretical sciences, it is the primary discipline where an exercise of calculated risk can regularly turn up what you had not been looking for. And if, as I believe, the most vital inheritance of contemporary art is a system for uncovering the unexpected, then programmatic art of any kind would be an oxymoron.

Why should I wish to surrender modernism's hard-won victories, including those of the Romantics and Surrealists, over classicism's rear-guard ecclesiastical and statist theories? Despite its "post-ness," postmodernism, with its privileging of mind over body and culture over nature, sometimes feels like a return to the one-dimensionality of the classic moment. That, more than any rapidity of contemporary sociocultural change and "fragmentation," may be why its products are so quickly desiccated.

Because I am concerned with the reclamation of black female subjectivity, I am obliged to leave open the question of modernism's demise. For one thing, there seems no way around the fact that the method of reclaiming subjectivity precisely mirrors modernism's description of the artistic process. Whatever else it may require, it needs an act of will to project the inside onto the outside long enough to see and take possession of it. But, though this process may appear superficially *retardataire* to some, repossessing black female subjectivity will have unforeseen results both for action and for inquiry.

I am not suggesting an abandonment of theory: whether we like it or not, we are in an era, postmodern or otherwise, in which no practitioner can afford to overlook the openings of deconstruction and other poststructural theories. But as Spivak has said with respect to politics, practice will inevitably norm the theory instead of being an example of indirect theoretical application: "Politics is assymetrical [*sic*]," Spivak says, "it is provisional, you have broken the theory, and that's the burden you carry when you become political."[43]

Art is, if anything, more asymmetrical than politics, and since artistic practice not only norms but, in many cases, self-consciously produces theory, the relation between art and critical theory is often problematic. Artists who are theoretically aware, in particular, have to guard against becoming too porous, too available to theory. When a well-intentioned critic like bell hooks says, "I believe much is going to come from the world of theory-making, as more black cultural critics enter the dialogue. As theory and criticism call for artists and audiences to shift their paradigms of how they see, we'll see the freeing up of possibilities,"[44] my response must be: Thanks but no thanks, bell. I have to follow my own call.

Gayatri Spivak calls postmodernism "the new proper name of the West," and I agree. That is why for me, for now, the postmodern concept of *fragmentation*, which evokes the mirror of Western illusion shattered into inert shards, is less generative than the more "primitive" and active *multiplicity*. This is not, of course, the cynical *multi* of "multiculturalism," where the Others are multicultural and the Same is still the samo. Rather, paradoxically, it is the *multi* implied in the best of modernism's primitivist borrowings, for example in Surrealism, and figured in Éluard's poem: "Entre en moi toi ma multitude/Enter into me, you, my multitude."[45] This *multi* produces tension, as in the continuous equilibration of a *multiplicity of centers*, for which dance may be a brilliant form of training.

Stuart Hall has described the tensions that arise from the slippages between theory development and political practice and has spoken of the need to live with these disjunctions without making an effort to resolve them. He adds the further caveat that, in one's dedication to the search for "truth" and "a final stage," one invariably learns that meaning never arrives, being never arrives, we are always only becoming.[46]

Artists must operate under even more stringent limitations than political theorists in negotiating disjunctive centers. Flannery O'Connor, who in her essays on being a Catholic novelist in the Protestant South may have said most of what can be said about being a strange artist in an even stranger land, soon discovered that though an oppositional artist like herself could choose what to write, she could not choose what she could make live. "What the Southern Catholic writer is apt to find, when he descends within his imagination," she wrote, "is not Catholic life but the life of this region in which he is both native and alien. He discovers that the imagination is not free, but bound."[47] You must not give up, of course, but you may have to go below ground. It takes a strong and flexible will to work both with the script and against it at the same time.

Every artist is limited by what concrete circumstances have given her to see and think, and by what her psyche makes it possible to initiate. Not even abstract art can be made in a social or psychic vacuum. But the artist concerned with subjectivity is particularly constrained

to stay alert to the tension of differences between the psychic and the social. It is her job to make possible that dynamism Jacqueline Rose has designated as "medium subjectivity" and to avert the perils of both the excessively personal and the overly theoretical.

The choice of *what* to work on sometimes feels to the artist like a walk through a minefield. With no failproof technology, you try to mince along with your psychic and social antennae swivelling. Given the ideas I have outlined here, on subjectivity and psychoanalysis, modernism and multiplicity, this is a situation in which the following modest words of Rose's could prove helpful: "I'm not posing what an ideal form of medium subjectivity might be; rather, I want to ask where are the flashpoints of the social and the psychic that are operating most forcefully at the moment."[48]

I would add to Rose's directive the following: the most interesting social "flashpoint" is always the one that triggers the most unexpected and suggestive psychic responses. This is because winning back the position of the questioning subject for the black female is a two-pronged goal. First, there must be provocations intense enough to lure aspects of her image from the depths to the surface of the mirror. And then, synchronously, there must be a probe for pressure points (which may or may not be the same as flashpoints). These are places where, when enough stress is applied, the black female's aspects can be reinserted into the social domain.

I have only shadowy premonitions of the images I will find in the mirror, and my perception of how successfully I can locate generalizable moments of social agency is necessarily vague. I have entered on this double path knowing in advance that, as another African-American woman said in a different context, it is more work than all of us together can accomplish in the boundaries of our collective lifetimes.[49] With so much to do in so little time, only the task's urgency is forcing me to stop long enough to try and clear a theoretical way for it.

Notes

1 Hortense J. Spillers, "Interstices: A Small Drama of Words," in Carole S. Vance, ed., *Pleasure and Danger: Exploring Female Sexuality* (Boston: Routledge and Kegan Paul, 1984), p. 77.
2 Sylvia Ardyn Boone, *Radiance from the Waters: Ideals of Feminine Beauty in Mende Art* (New Haven: Yale University Press, 1986), p. 102.
3 "African American Women in Defense of Ourselves," advertisement, *New York Times*, Nov. 17, 1991, p. 53.
4 Judith Wilson, "Getting Down to Get Over: Romare Bearden's Use of Pornography and the Problem of the Black Female Body in Afro-U.S. Art," in *Black Popular Culture*, ed. Gina Dent (Seattle: Bay Press, 1992), p. 114.
5 Toni Morrison, *Beloved* (New York: Alfred A. Knopf, 1987), p. 119.
6 George Nelson Preston, quoted in Wilson, *Getting Down*, p. 114.
7 For an examination of the relationship of black women to the first white feminist movement, see Hazel V. Carby, *Reconstructing Womanhood: The Emergence of the Afro-American Woman Novelist* (New York: Oxford University Press, 1987), Chs. 1 and 5, and bell hooks, *Ain't I a Woman: Black Women and Feminism* (Boston: South End Press, 1981), *passim*. For insights into the problems of black women in the second white feminist movement, see Audre Lorde, "Age, Race, Class, and Sex: Women Redefining Difference," in Russell Ferguson, Martha Gever, Trinh T. Minh-ha, Cornel West, eds., *Out There: Marginalization and Contemporary Cultures* (New York: The New Museum of Contemporary Art, 1990), and Bernice Johnson Reagon, "Coalition Politics: Turning the Century," in Barbara Smith, ed., *Home Girls: A Black Feminist Anthology* (New York: Kitchen Table: Women of Color Press, 1983). For problems of women of color in a white women's organization at the start of the third feminist movement, see Lorraine O'Grady on WAC, "Dada Meets Mama," *Artforum*, 31, 2 (Oct. 1992): 11–12.
8 See Judy Chicaco, *The Dinner Party: A Symbol of Our Heritage* (New York: Anchor/Doubleday, 1979).
9 Spillers, p. 78.
10 Michele Wallace, "Multiculturalism and Oppositionality," in *Afterimage* 19, 3 (Oct. 1991): 7.

11 Nancy Hartsock, "Rethinking Modernism: Minority vs. Majority Theories," in *Cultural Critique* 7, special issue: "The Nature and Context of Minority Discourse II," edited by Abdul R. JanMohamed and David Lloyd, p. 204.

12 See the title story by Merle Hodge in Pamela Mordecai and Betty Wilson, eds., *Her True-True Name* (London: Heinemann Caribbean Writers Series, 1989), pp. 196–202. This anthology is a collection of short stories and novel extracts by women writers from the English, French, and Spanish-speaking Caribbean.

13 The understanding that analysis of the contemporary situation of African-American women is dependent on the imaginative and intellectual retrieval of the black woman's experience under slavery is now so broadly shared that an impressive amount of writings have accumulated. In fiction, a small sampling might include, in addition to Morrison's *Beloved*, Margaret Walker, *Jubilee* (New York: Bantam, 1966); Octavia E. Butler, *Kindred* (1979; reprint, Boston: Beacon Press, 1988); Sherley A. Williams, *Dessa Rose* (New York: William Morrow, 1986); and Gloria Naylor, *Mama Day* (New York: Ticknor and Fields, 1988). For the testimony of slave women themselves, see Harriet A. Jacobs, edited by Jean Fagan Yellin, *Incidents in the Life of a Slave Girl* (Cambridge: Harvard University Press, 1987); *Six Women's Slave Narratives*, The Schomburg Library of Nineteenth Century Black Women Writers (New York: Oxford University Press, 1988), and Gerda Lerner, ed., *Black Women in White America: A Documentary History* (New York: Vintage Books, 1972). For a historical and sociological overview, see Deborah Gray White, *Ar'n't I a Woman?: Female Slaves in the Plantation South* (New York: W.W. Norton, 1985).

14 Wilson, p. 121, note 13.

15 Ibid., p. 114.

16 Ibid.

17 Ibid.

18 Judith Wilson, telephone conversation with the author, Jan. 21, 1992.

19 Wilson, op. cit., pp. 116–18.

20 Adrian Piper, "Food for the Spirit, July 1971," in *High Performance* 13 (Spring 1981). This was the first chronicling of "Food" with accompanying images. The nude image from this performance first appeared in Piper's retrospective catalogue, Jane Farver, *Adrian Piper: Reflections 1967–87* (New York: Alternative Museum, April 18–May 30, 1987).

21 Hortense J. Spillers, "Mama's Baby, Papa's Maybe: An American Grammar Book," in *Diacritics* 17, 2 (Summer 1987): 68.

22 Hartsock, "Rethinking Modernism," pp. 196, 194.

23 Toni Morrison, in Charles Ruas, "Toni Morrison's Triumph," an interview, in *Soho News*, March 11–17, 1981, p. 12.

24 Gayatri Chakravorty Spivak, "Three Women's Texts and a Critique of Imperialism," in Henry Louis Gates, Jr., ed., *"Race," Writing, and Difference* (Chicago: University of Chicago Press, 1986), p. 272.

25 "Carnal Knowing: Sexuality and Subjectivity in Representing Women's Bodies," a panel of the College Art Association, 80th Annual Conference, Chicago, February 15, 1992.

26 A riff on Barbara Christian's title, "But What Do We Think We're Doing Anyway: The State of Black Feminist Criticism(s)," in Cheryl A. Wall, ed., *Changing Our Own Words: Essays on Criticism, Theory, and Writing by Black Women* (New Brunswick, N.J.: Rutgers University Press, 1989), which is itself a riff on Gloria T. Hull's title, "What It Is I Think She's Doing Anyhow: A Reading of Toni Cade Bambara's *The Salt Eaters*," in Smith, ed., *Home Girls*, which is in turn a riff on Toni Cade Bambara's autobiographical essay, "What It Is I Think I'm Doing Anyhow," in Janet Sternberg, ed., *The Writer on Her Work* (New York: W.W. Norton, 1980).

27 "But by thus remaking contact with the body, and with the world, we shall also discover ourselves, since, perceiving as we do with our body, the body is a natural self and, as it were, the subject of perception." Quoted by Edward R. Levine, unpublished paper delivered at College Art Association, 80th Annual Conference, Chicago, February 13, 1992.

28 Gayatri Chakravorty Spivak, "Strategy, Identity, Writing," in *The Post-Colonial Critic: Interviews, Strategies, Dialogues,* ed. Sarah Harasym (New York: Routledge, 1990), p. 42.

29 Kobena Mercer and Isaac Julien, "Race, Sexual Politics and Black Masculinity: A Dossier," in Rowena Chapman and Jonathan Rutherford, eds., *Male Order: Unwrapping Masculinity* (London: Lawrence and Wishart, 1987), pp. 106–7.

30 Wallace, op. cit., p. 7.

31 Spivak, "Criticism, Feminism, and The Institution," in *The Post-Colonial Critic* [see note 28], p. 11 (italics mine).

32 See the oft-quoted phrase, "For the master's tools will never dismantle the master's house," in Lorde, "Age, Race," p. 287.

33 Jacqueline Rose, "Sexuality and Vision, Some Questions," in Hal Foster, ed., *Vision and Visuality*, Dia Art Foundation, Discussions in Contemporary Culture no. 2 (Seattle: Bay Press, 1988), p. 130.

34 Wallace, op. cit., p. 7.

35 bell hooks, *Black Looks: Race and Representation* (Boston: South End Press, 1992), pp. 115–31. [Chapter 14 in this volume.]

36 Spivak, op. cit., p. 11.

37 Spillers, "Interstices," p. 79.

38 See the famous description of African-American "double-consciousness" in W. E. B. DuBois, *The Souls of Black Folk* (New York: New American Library, 1982), p. 45.

39 Elizabeth Hess, "Black Teeth: Who Was Jean-Michel Basquiat and Why Did He Die?" in *Village Voice*, Nov. 3, 1992, p. 104.

40 "The expressionist quest for immediacy is taken up in the belief that there exists a content beyond convention, a reality beyond representation. Because this quest is spiritual not social, it tends to project metaphysical oppositions (rather than articulate political positions); it tends, that is, to stay within the antagonistic realm of the Imaginary." Hal Foster, *Recordings: Art, Spectacle, Cultural Politics* (Seattle: Bay Press, 1985), p. 63.

41 Teresa de Lauretis, *Feminist Studies/Critical Studies* (Bloomington: Indiana University Press, 1986), p. 17.

42 Stuart Hall, "Theoretical Legacies," in Lawrence Grossberg, Cary Nelson, Paula Treichler, eds., *Cultural Studies* (New York and London: Routledge, 1992), p. 291.

43 Spivak, op. cit., p. 47.

44 bell hooks, interviewed by Lisa Jones, "Rebel Without a Pause," in the *Voice Literary Supplement*, Oct. 1992, p. 10.

45 Paul Éluard, quoted in Mary Ann Caws, *The Poetry of Dada and Surrealism: Aragon, Breton, Tzara, Éluard, and Desnos* (Princeton: Princeton University Press, 1970), p. 167.

46 Hall, *passim*.

47 Flannery O'Connor, *Mystery and Manners: Occasional Prose*, selected and edited by Sally and Robert Fitzgerald (New York: Farrar, Straus and Giroux, 1961), p. 197.

48 Rose, op. cit., p. 129.

49 Deborah E. McDowell, "Boundaries," in Houston A. Baker, Jr., and Patricia Redmond, eds., *Afro-American Literary Study in the 1990s* (Chicago: University of Chicago Press, 1989), p. 70.

Chapter 22

SANDY STONE

A POSTTRANSSEXUAL MANIFESTO

To ATTEMPT TO OCCUPY A PLACE as speaking subject within the traditional gender frame is to become complicit in the discourse that one wishes to deconstruct. Rather, we can seize upon the textual violence inscribed in the transsexual body and turn it into a reconstructive force. Le me suggest a more familiar example. Judith Butler points out that the lesbian categories of "butch" and "femme" are not simple assimilations of lesbianism

back into the terms of heterosexuality. Rather, Butler introduces the concept of *cultural intel-ligibility*, and suggests that the contextualized and resignified "masculinity" of the butch, seen against a culturally intelligible "female" body, invokes a dissonance that both generates a sexual tension and constitutes the object of desire. She points out that this way of thinking about gendered objects of desire admits of much greater complexity than the example suggests. The lesbian butch or femme both recall the heterosexual scene but simultaneously displace it. The idea that butch and femme are "replicas" or "copies" of heterosexual exchange underestimates the erotic power of their internal dissonance.[1] In the case of the transsexual, the varieties of performative gender, seen against a culturally intelligible gendered body *which is itself a medically constituted textual violence*, generate new and unpredictable dissonances that implicate entire spectra of desire. In the transsexual as text we may find the potential to map the refigured body onto conventional gender discourse and thereby disrupt it, to take advantage of the dissonances created by such a juxtaposition to fragment and reconstitute the elements of gender in new and unexpected geometries. I suggest we start by taking Raymond's accusa-tion that "transsexuals divide women" beyond itself, and turn it into a productive force to multiplicatively divide the old binary discourses of gender – as well as Raymond's own monistic discourse. To foreground the practices of inscription and reading that are part of this delib-erate invocation of dissonance, I suggest constituting transsexuals not as a class or problematic "third gender," but rather as a *genre* – a set of embodied texts whose potential for *productive* disruption of structured sexualities and spectra of desire has yet to be explored.

Figure 22.1 Sandy Stone, *Self-portrait*, c. 2002.

In order to effect this, the genre of visible transsexuals must grow by recruiting members from the class of invisible ones, from those who have disappeared into their "plausible histories." The most critical thing a transsexual can do, the thing that constitutes success, is to "pass."[2] Passing means to live successfully in the gender of choice, to be accepted as a "natural" member of that gender. Passing means the denial of mixture. One and the same with passing effacement of the prior gender role, or the construction of a plausible history. Considering that most transsexuals choose reassignment in their third or fourth decade, this means erasing a considerable portion of their personal experience. It is my contention that this process, in which both the transsexual and medicolegal/psychological establishment are complicit, forecloses the possibility of a life grounded in the *intertextual* possibilities of the transsexual body.

To negotiate the troubling and productive multiple permeabilities of boundary and subject position that intertextuality implies, we must begin to rearticulate the foundational language by which both sexuality and transsexuality are described. For example, neither the investigators nor the transsexuals have taken the step of problematizing "wrong body" as an adequate descriptive category. In fact "wrong body" has come, virtually by default, to *define* the syndrome.[3] It is quite understandable, I think, that a phrase whose lexicality suggests the phallocentric, binary character of gender differentiation should be examined with deepest suspicion. So long as we, whether academics, clinicians, or transsexuals, ontologize both sexuality and transsexuality in this way, we have foreclosed the possibility of analyzing desire and motivational complexity in a manner that adequately describes the multiple contradictions of individual lived experience. We need a deeper analytical language for transsexual theory, one that allows for the sorts of ambiguities and polyvocalities that have already so productively informed and enriched feminist theory.

Judith Shapiro points out that "to those . . . who might be inclined to diagnose the transsexual's focus on the genitals as obsessive or fetishistic, the response is that they are, in fact, simply conforming to *their culture's* criteria for gender assignment" (emphasis mine). This statement points to deeper workings, to hidden discourses and experiential pluralities within the transsexual monolith. They are not yet clinically or academically visible, and with good reason. For example, in pursuit of differential diagnosis a question sometimes asked of a prospective transsexual is: "Suppose that you could be a man [or woman] in every way except for your genitals; would you be content?" There are several possible answers, but only one is clinically correct.[4] Small wonder, then, that so much of these discourses revolves around the phrase "wrong body." Under the binary phallocratic founding myth by which Western bodies and subjects are authorized, only one body per gendered subject is "right." All other bodies are wrong.

As clinicians and transsexuals continue to face off across the diagnostic battlefield that this scenario suggests, the transsexuals for whom gender identity is something different from *and perhaps irrelevant* to physical genitalia are occulted by those for whom the power of the medical/psychological establishments, and their ability to act as gatekeepers for cultural norms, is the final authority for what counts as a culturally intelligible body. This is a treacherous area, and were the silenced groups to achieve voice we might well find, as feminist theorists have claimed, that the identities of individual, embodied subjects were far less implicated in physical norms, and far more diversely spread across a rich and complex structuration of identity and desire, than it is now possible to express.[5] And yet in even the best of the current debates, the standard mode is one of relentless totalization. Consider [a] most perspicuous example [. . .], Raymond's stunning "all transsexuals rape women's bodies" (what if she had said, for example, "all blacks rape women's bodies"): For all its egregious and inexcusable bigotry, the language of her book is only marginally less totalizing than, for example,

Gary Kates's "transsexuals . . . take on an exaggerated and stereotypical female role," or Ann Bolin's "transsexuals try to forget their male history." Both Kates's and Bolin's studies are in most respects fine work, and were published in the same collection as an earlier version of this essay;[6] but still there are no subjects in these discourses, only homogenized, totalized objects – fractally replicating earlier histories of minority discourses in the large. So when I speak the forgotten word, it will perhaps wake memories of other debates. The word is *some*.

Transsexuals who pass seem able to ignore the fact that by creating totalized, monistic identities, forgoing physical and subjective intertextuality, they have foreclosed the possibility of authentic relationships. Under the principle of passing, denying the destabilizing power of being "read," relationships begin as lies – and passing, of course, is not an activity restricted to transsexuals. This is familiar to the person of color whose skin is light enough to pass as white, or to the closet gay or lesbian, or to anyone who has chosen invisibility as an imperfect solution to personal dissonance. Essentially I am rearticulating one of the arguments for solidarity that has been developed by gays, lesbians, and people of color. The comparison extends further. To deconstruct the necessity for passing implies that transsexuals must take responsibility for *all* of their history, to begin to rearticulate their lives not as a series of erasures in the service of a species of feminism conceived from within a traditional frame, but as a political action begun by reappropriating difference and reclaiming the power of the refigured and reinscribed body. The disruptions of the old patterns of desire that the multiple dissonances of the transsexual body imply produce not an irreducible alterity but a myriad of alterities, whose unanticipated juxtapositions hold what Donna Haraway has called the promises of monsters – physicalities of constantly shifting figure and ground that exceed the frame of any possible representation.[7]

The essence of transsexualism is the act of passing. A transsexual who passes is obeying the Derridean imperative: "Genres are not to be mixed. I will not mix genres."[8] I could not ask a transsexual for anything more inconceivable than to forgo passing, to be consciously "read," to read oneself aloud – and by this troubling and productive reading, to begin to *write oneself* into the discourses by which one has been written – in effect, then, to become a (look out – dare I say it again?) posttranssexual.[9] Still, transsexuals know that silence can be an extremely high price to pay for acceptance. I want to speak directly to the brothers and sisters who may read/"read" this and say: I ask all of us to use the strength that brought us through the effort of restructuring identity, and that has also helped us to live in silence and denial, for a re-visioning of our lives. I know you feel that most of the work is behind you and that the price of invisibility is not great. But, although *individual* change is the foundation of all things, it is not the end of all things. Perhaps it is time to begin laying the groundwork for the next transformation.

Afterword

In the brief time, or so it seems, since this essay was first written, the situation both on the street with regard to articulating a specifically transgendered positionality and within the academy vis-à-vis theory has deeply changed, and continues to evolve. Whether the original *"Empire"* paper had the privilege of being a fortunately timed bellwether or whether it successfully evoked the build-it-and-they-will-come principle is unknown, but the results are no less gratifying for lack of that knowledge. Transgender (or for that matter, posttransgender) theory would appear to be successfully engaging the nascent discourses of Queer Theory in a number

of graceful and mutually productive respects, and this is reason for guarded celebration. Needless to say, however, beginnings are most delicate and critical periods in which, while the foundation stones are still exposed, it is necessary to pay exquisite attention to detail. For this author, it is a most promising and interesting time in which to be alive and writing.

Notes

1 Judith Butler, *Gender Trouble: Feminism and the Subversion of Identity* (New York: Routledge, 1990).

2 The opposite of passing, being *read*, provocatively invokes the inscription practices to which I have referred.

3 I am suggesting a starting point, but it is necessary to go much further. We will have to question not only how *body* is defined in these discourses, but to more critically examine who gets to say *what "body" means*.

4 In case the reader is unsure, let me supply the clinically correct answer: "No."

5 It is useful as well as gratifying to note that since the first version of this essay appeared in 1991, several coalition groups, one of which is appropriately named *Transgendered Nation*, have begun actively working to bring the rich diversity within transgendered communities to public attention. Their action at the 1993 conference of the American Psychological Association, which was debating the appropriateness of continuing to include transsexuality in the next edition of the official diagnostic manual (*DSM*), appeared brave and timely. Of course, several arrests (of transgendered demonstrators, not psychologists) ensued.

6 These essays appeared in Straub and Epstein in *Body Guards: the Cultural Politics of Gender Ambiguity*, ed. Kristina Straub and Julia Epstein (New York: Routledge, 1991).

7 For an elaboration of this concept, see Donna Haraway, "The Promises of Monsters: A Regenerative Politics of Gender for Inappropriate/d Others," in *Cultural Studies*, ed. Lawrence Grossberg, Cary Nelson, and Paula Treichler (New York: Routledge, 1990).

8 Jacques Derrida, "La loi du genre/The Law of Genre," trans. Avital Ronell, in *Glyph*, vol. 7 (1980): 176 (French), 202 (English).

9 I also call attention to Gloria Anzaldúa's theory of the Mestiza, an illegible subject living in the borderlands between cultures, capable of partial speech in each but always only partially intelligible to each. Working against the grain of this position, Anzaldúa's "new mestiza" attempts to overcome illegibility partly by seizing control of speech and inscription and by writing herself into the discourse. The stunning "Borderlands" is a case in point; Gloria Anzaldúa, *Borderlands/La Frontera: The New Mestiza* (San Francisco: Spinsters/Aunt Lute, 1987).

ANN EDEN GIBSON

COLOR AND DIFFERENCE IN ABSTRACT PAINTING
The ultimate case of monochrome

MONOCHROME PAINTING, AND RECENTLY the development in monochrome called radical painting (one-color painting about painting's body and the supports that hold it up), has been peculiarly vulnerable to shifts in interpretation.[1] The thought that interpretations vary with interpreters' needs and experiences is not a new idea. But the idea that gender studies might have a contribution to make to abstraction *is* new, especially in art where there are no images of men or women to look at. Because of its makers' emphasis on its body as the source of its meaning, monochrome painting responds in striking ways to gendered readings and, in particular, to those that have been gendered as female.

In making this assertion I may appear to have embarked on a perverse course. Describing radical painting's "feminism" could appear as an attempt to salvage the core of patriarchal modernism by claiming for it a degree of womanliness. A review of monochrome's history, from Rodchenko to Reinhardt and Klein, for instance, and from there to artists like Brice Marden and Olivier Mosset, seems more than likely to reinforce its identity as a masculinist bulwark than to yield anything that could be given a positive feminist reading. *One surface– one color* painting, as Carter Ratcliffe called it[2] – painting of the sort exemplified by *1950 M, No. 1*, the blue painting by Clyfford Still in Figure 23.1 (done in 1955), or the deep red *Perhaps/Vermilion Rose* (1987–1990) by Frederic Thursz – has been widely understood as a most persuasive metaphor for a history of art seen as a progressive hierarchy of purifications. As Clement Greenberg wrote in 1962:

> Under the testing of modernism more and more of the conventions of the art of painting have shown themselves to be dispensable, unessential. But now it has been established, it would seem, that the irreducible essence of pictorial art consists in but two constitutive conventions or norms: flatness and the delimitation of flatness, and that the observance of merely these two norms is enough to create an object that can be experienced as a picture; thus a stretched or tacked up canvas already exists as a picture – though not necessarily as a successful one.[3]

The modernist thinking represented by Greenberg's theoretical positioning of monochrome, however, has also been seen by feminists as an expression of the paternal metaphor, a bastion of patriarchal privilege. "Modernism is structured around sexual politics," wrote Griselda Pollock, "but these are displaced by the manifest content of modernist discourse, the celebration

Figure 23.1 Clyfford Still, *1950 M, No. 1*, 1955; Hirshhorn Museum and Sculpture Garden, Smithsonian Institute, Washington D.C.

of creative masculine individualism. The figure of the artist always assumed to be masculine in critical and economic practices around art is matched by the sign woman which is its signifier within representational systems."⁴ Modernist painting, then, painting that kept the surface flat and single-colored, while delimiting (that is, articulating, testing) the limits of the paint's viscosity, its character as plastic color as Still's and Thursz's may be seen to do, would be "male."

[. . .]

Understood this way, monochrome has served as the icon of unitary, that is, a single-track, modernist humanism. I am referring here to the aspect of modernism called "shepherding" by Heidegger, in which man "has to guard the truth of Being, of his own and other beings." Heidegger insisted that "man's essential worth is *not* in his being the tyrannical 'Subject' to other being's 'Object.'"⁵ But as Pollock points out, this shepherding implies a control that has historically been most often assumed by men. As I am not the first to point out, "in its own eyes, Western humanism is the love of humanity, but to others it is merely the custom and institution of a group of men, their password, and sometimes their battle-cry."⁶ In regard to the recruitment of monochrome painting into an implicitly male humanist history of art, the point isn't that there is anything intrinsically "male" about monochrome paint surfaces; the point is

that as the epitome of a modernism that has been a male preserve, monochrome painting has appeared as its apex. As a modernist icon, monochrome paintings appeared to *be*, as well as to stand for, "testing" of painting's limits that isolated the essential and discarded the inessential. Read this way, their spartan self-sufficiency posited monochrome as somehow objectively, universally recognizable as painting's essence – as paradigmatic *painting*.

Now to say that monochrome painting is iconic modernism is to say that monochrome both represents modernism and performs it. As Frederic Thursz (who feels that "monochrome" is a reductively inadequate term for his work)[7] wrote of his painting. "It is a manifestation of Painting," adding "and an icon unto itself."[8] This suggests and in fact names as iconic, the kind of self-sufficiency, with its remove from social functions, that has become associated with the Greenbergian version of modernism discussed above.

In calling his work also a "manifestation of Painting," however, Thursz suggested also a second figure. Other writers more recent than Greenberg have seen the index as an important tool with which artists could break out of the isolation from the everyday world that the iconization of their work as "art" produced. An indexical sign, as opposed to an icon, is one that refers to the process that brought it into being, as blood might seem to refer to a wound and smoke to a fire.[9] So the index has been seen as a semiotic strategy by which painting refused to settle for modernist self-sufficiency. Rosalind Krauss suggested that Duchamp's late work represented a crisis in signification in its simultaneous presentation in the same piece of these two modes, the icon and the index, arguing that works that disrupt modernist pictorial conventions were often indexical.[10] Richard Shiff has modified the idea that there is any intrinsically transgressive character in indexicality as such by noting that what is read as transgressively indexical [. . .] by one generation has been read as iconic (that is, as standing for, as opposed to enacting transgression) by artists who followed.[11] Nor did indexical resistance to painting's iconic isolation break its masculinist spell. In fact, the prime sign of modernism for feminist artist/theorist Mary Kelly was the autographic stroke, whose indexicality guaranteed the painting's authenticity by serving to connect the maker to the painting. In Pollock's work, she has remarked, the indexicality of his strokes refers not only to the motion of his arm but also constructs the myth of a one-to-one correspondence between the painter's sincerity and the gestural marks on the canvas. The perception of Jackson Pollock's existential authenticity has been aided by his viewer's belief that there is an indexical connection between his subjective impulses and the placement of the skeins of color he poured on the surface of canvasses.[12] You may be thinking now that I am going to associate Pollock's macho bravado, etc., with that indexicality, as a number of scholars have done rather persuasively.[13] But I want to discuss something else: how color has been used to elude *both* iconic and indexical figuration.

In her claim that it is gesture – not the color plane – that best characterizes modernism, Mary Kelly called attention to color's resistance to signification. Color – like that in the painting by Clyfford Still in the first illustration of this essay – is harder than gesture to reduce to a figure; it is too elusive; it "never really," as Kelly put it, "accedes to the signifier." Kelly's reference for this observation is Jean-Louis Schefer's "Split colour/blur." Significantly, the passage she quoted was the one in which Schefer refers to color as "the difference in the field where 'it' is found."[14] Monochrome interested Kelly at the point where it registered as "difference," providing a disruption of modernism's linear progressivism. Even when color's effect is linked with perceptible gesture (as it is, to one degree or another, in much "monochrome" painting – in Still, for instance, and in Phil Sims' as well as Howard Smith's and Marcia Hafif's paintings), the dominance of color impression has tended to reduce viewers' interest in the gestural (i.e., indexical) reference to the work's maker. Red can stand for fire or blood or your lover's passion (I will come back to your lover). While it can be restrained by context

(I can paint or talk about a red robe, for instance), as soon as I unhook color as a signifier from the image of an object to which it must refer, it is free to go back to figuring anything the viewer may imagine, as well as being simply what covers a particular canvas. Jeremy Gilbert Rolfe argued that color's function in painting is inherently ambiguous because of the impurity of visual experience.[15] Unhinged color, Kelly argued, color freed in monochrome painting, for instance, from the mimetic necessity of describing the color of draperies or trees, seems to be less susceptible than comparably nonmimetic line to being recruited for the task of referring to the painter's authority. It is this truant quality of color, its opposition to form and its distance from the mimetic, that has prompted painters to use it to figure what is not yet figured. This, in other words, is why some painters have tended to use monochrome or near-monochrome fields to escape figuration altogether.

[. . .]

Contemporary artists have responded to the modern commodification of the body in different ways. Consider, for instance, *Cadmium Red* (1982), by Marcia Hafif [Figure 23.2] versus *"Heart" (Do I have to give up me to be loved by you?)* (1988), by Barbara Kruger

Figure 23.2 Marcia Hafif, *Cadmium Red*, 1982. Photo by Allan Finklestein.

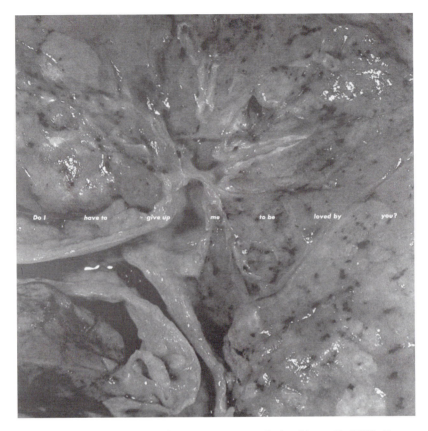

Figure 23.3 Barbara Kruger, *"Heart" (Do I have to give up me to be loved by you?)*, 1988. Courtesy Mary Boone Gallery, New York.

[Figure 23.3]. At first impression this comparison might appear to be one in which Hafif's monochrome, drained of social implications, is confronted by Kruger's photo and text. Kruger has quite effectively reversed the camera's control of its object that Laura Mulvey so influentially gendered as male.[16] The ocular domination that in Mulvey's early work gendered *all* spectators as male is turned around here, and we are interrogated. In this photosilk-screen work, nearly 12 × 12 feet, Kruger has embedded in an image of pulsing tissue the caption, "Do I have to give up me to be loved by you?" This crucial question about the relationship of love and possession labels a picture of flesh, reproduced in voluptuous, carnal tones of red. The flesh in question, however, despite the title, *Heart*, looks more like (in fact, is) lung tissue;[17] what's more, the tissue is spotted. It looks polluted, like the pictures of smoke-damaged lungs displayed in American health clinics for the purpose of scaring tobacco addicts into quitting. Kruger's riveting conjunction of written text and mimetic image rhymes the kind of economic colonization of the body exercised by tobacco industries with the emotional exchange of the body's autonomy for love. This is a metaphor of economic and emotional coercion that may affect either sex, but the text across the tissue places it in a register that has historically been more frequently demanded of the female partner. Both of these works, like Pollock's poured paintings, do index the body. Kruger's photographic image records the action of light reflected by human tissue. Hafif, closer to Pollock, indexically recorded in *Cadmium Red* the pressure and direction of each brushstroke. "In a one-color painting," she

wrote in 1981, "the strokes carry a major load of significance."[18] They inflect her field of red with a reference to the physical act of her making, becoming "a part of the subject matter of the painting as a whole."[19] Like Pollock's skeins of paint, her facture reads as the traces of her body's actions. In her choice of this device to advertise her agency and the connection between her own corporeality and that of the painting she differed from certain other monochromists. Yves Klein's *Requiem, Blue (RE 20)*, for instance, from 1960, is punctuated by raised circular forms that read as eruptions from within; the apparent products of an autonomous force beneath the surface, rather than – as with Hafif – an index of an agency outside it.

Some of Hafif's work has been even more specifically connected with her body. The panels in *Roman Painting XVIII* [Figure 23.4], named for its evocation of the color of light in Rome, are approximately her own size and her own color (Hafif is "white," or, more descriptively, pink). Here a reference to the body may be inferred that is metaphoric as well as indexical. Its metaphor may be read in a substitution of similar qualities: Her body's height, upright proportion, and color are recalled by her canvas. Like the skin of the human body, the color of one "monochrome" painting may be quite different from another and may even differ in tone from one part of the same painting to another. But its relegation of both stroke and color variation to secondary status tends to maintain its insistence on itself – canvas covered with closely modulated hues of a single color – as a unified and particular surface: a particular place. Hafif's more recent enamel on wood paintings, in which the message of the stroke is nearly erased in favor of a reflective luminosity, heighten the insistence on color as the dominant element.[20] This reading (color/pigment as the vehicle of monochrome's insistence on itself as a specific, independent, nonreferring entity) is absolutely in conflict with historic interpretations

Figure 23.4 Marcia Hafif, *Roman Painting XVIII*, 1988. Photo by Ivan Dalla Tana, New York.

of it, that is, to monochrome painting as an index of the acts of its make and as an icon of modernism; and this is to say nothing of the references to religion, medicine, and commerce that now adhere to it due to the critique of its position in institutionalized art history performed by monochrome's more conceptual versions.

This dichotomy is more extreme in Hafif than in Pollock, where gesture dominates place. Gesture in Pollock functions as a screen, dominating the spaces between the lines. In Hafif, gesture becomes the whole surface. Monochrome painting thus brings several extremes together: It is just about as abstract – and by that in this context I mean nonmimetic – as you can get, and just about as real – as concrete – as it is possible to be; paint on a flat surface. At the same time it may be both programmatically or subjectively referential.

Painting as a vehicle for "non-objective" abstraction and painting as a concrete art are hardly new ideas (as noted earlier in this essay, Rodchenko exemplified these positions for monochrome early in the twentieth century), but as demonstrated in the fall of 1988, "Color Alone," the international survey of radical painting held in Lyon,[21] this seemingly limited prac-tice displays a remarkable vitality. I believe that one reason for this is radical painting's occupation of an intersection where its semiotic position is congruent with concerns about the body felt by many of us, both men and women. These are concerns that have been most often voiced by women. I will explain what I mean in a moment. But first I want to say why this matters.

It's true that although a number of women have worked in or near monochrome (not only Hafif, but also painters such as Jo Baer, Beth Brenner, Carmengloria Morales, Pat Passlof, and Susanne Tanger), most attention to this mode has centered around its male practitioners. The fact of men's public domination of this mode is the ideological counterpart of a modernist reading of the history of painting, where the best painting is that which most successfully refers only to itself, a self implicitly male but characterized as universal. Paintings like those done by Robert Ryman and Joe Marioni for instance, may be seen in this frame as retrac-tions of the medium of painting to its own (male) territory, a territory increasingly understood by feminists as that realm of patriarchal aesthetics where the self-sufficient art object is its own referent. In this scenario, monochrome painting's surface, devoid of image, silently, onanistically corresponds to itself, thus ruling out any intercourse with the Other. It is a visual analogy of that aspect of the id that Gilles Deleuze and Felix Guattari characterized as the body with no organs; fearfully self-sufficient, refusing congress with the world.[22]

I want to argue here, however, that although this characterization of monochrome is an accurate assessment of some readings and even of the intentions of some painters (suggesting the essentialist potential of this mode), we as viewers are entitled to read these paintings *against that grain*, placing them in another kind of story. That story is the history of attempts to escape the phallocentrism of language, the violence of representation, and the control of bodies marked as different.

Mark C. Taylor has called attention to a provocative precedent for this reading of radical painting in an essay on Maurice Merleau-Ponty, who conflated the silence of the flesh with the perception of color in an extravagant use of the feminine body as metaphor for his purposes. He reminded readers that the body is the condition necessary for perceptual experience. When you go to the theatre or look at a painting, your body becomes that "*in front of which* precise beings, figures, and points can come to light."[23] Your body, in other words, is the living tissue in which meaning at other sites is realized. It is not just a ground, a receptor, but an active participant, "the formative medium of the object and the subject."[24] The philos-opher characterized this body as an interlace, an inversion of clauses one into the other, that *exposes* a "lining," or "hollow,"[25] where meaning comes into being. What is notable here for

this discussion is Merleau-Ponty's suggestion that ideas do not exist wholly either inside or outside but that, rather, they span our perceptions of what is exterior and interior to our bodies,[26] and that in the experience of the visible world, no less than in literature, music, and the passions, we experience "the exploration of an invisible and the disclosure of a universe of ideas." The difference between these ideas and those of science, suggests Merleau-Ponty, is that they "cannot be detached from the sensible appearances and be erected into a second positivity." With these, "there is no vision without the screen: the ideas we are speaking of would not be better known to us if we had no body and no sensibility."[27] Merleau-Ponty has been particularly interested in these observations as regards not only the seat of perception in the body, but the opportunity for its exercise provided by colors seen in light. Colors change with the color of the light within which they are seen; in addition, "a colour is never merely a colour," he observed, "but the colour of a certain object, and the blue of a carpet would never be the same blue were it not a woolly blue."[28] This may at first sound as if it opposes Mary Kelly's observation, cited earlier, that color "never really accedes to the signifier." But Merleau-Ponty is not speaking here about blue *signifying* a carpet. He refers, rather, to the particular aspect of color, its inseparability from a particular material, a particular body with all its specificities, upon which monochrome painters have concentrated. This is the aspect of color that has historically resisted the bridle of verbal signification, appearing again and again as an often fugitive agent (one that often cannot even be securely named) that resists the regulation of systems and methods. In the history of European art, the study of color has been marginal, in part for this reason. It is important to note that this does not mean that color does not signify, as John Gage, for instance, has demonstrated in his extensive publications on color in the history of art. Quite to the contrary, colors can be shown "to have held quite antithetical connotations in different periods and cultures, and even at the same time and in the same place."[29] Nor am I suggesting that color itself is, or should be, limited to being merely the sign for that which refuses certain systems of signification, although it has been used that way, too. As Gage concluded in a recent essay, "Color seems to me to be of special importance to the art historian precisely because it obliges her to engage with so many other areas of human experience. Because it is almost invariably itself, and very rarely a representation of itself, and because it is the stuff from which representations are made, color must be experienced concretely in artefacts."[30]

This is the aspect of color upon which Merleau-Ponty so usefully insisted. He in fact at one point conflated the body and paintings as sites where meaning is engendered: "The body is to be compared, not to a physical object, but rather to a work of art" in that "in a picture or a piece of music the idea is incommunicable by means other than the display of colours and sounds."[31] I am suggesting that in their emphasis on the materiality of the perceptions they provide, monochrome paintings like Ryman's *Director* or Marioni's *Red Painting* are not only *embodied* sites of meaning (this would be true of many kinds of painting and music) but that in their insistence on their physical being, in what has been presented as their alogocentricity, one might say, their *silence*, they accomplish something else. This something else is hardly an escape from figuration, since monochrome is eminently open to an array of figural interpretations. It has to do, rather, with monochrome's *jouissance*, with its play with figurations. Since color may be perceived but is not easily fixed in language, it does not reduce very securely to the kind of stable signification demanded of it either by most histories of modernist painting or by Marxist, socialist, or even feminist criticism. In its resistance to either reading, its preservation of its own *différance*, it has, however, embodied itself as an Other that will not consent to being defined, hierarchized, placed. There is an aspect of monochrome that might be said to speak mainly from the body to the body. This aspect

of monochrome, of color, qualifies a staple of postmodern thinking by making *words'* control of representation as contingent as the meanings of bodies *in* systems of representation.[32] Like Merleau-Ponty's receptive body, monochrome paintings disable the distinction not only between foreground and background but also between viewer and object, becoming exemplary sites for the production of the kinds of meaning where options remain open for longer than usual. They are exemplary of a kind of meaning that some feminists have called for.

But in what way, and according to whose terms, is such meaning feminist? After all, neither Merleau-Ponty nor most monochrome painters are even women, let alone feminists, even though their productions lend themselves to a feminist reading. To answer this it is important to identify the essentialism of Merleau-Ponty's "feminizing" description of somatic sensibility as characteristic of a male idea of feminine "difference" that some feminists reject. The strikingly feminine valence of Merleau-Ponty's "strange domain of carnality" offered by Mark Taylor provides a vivid example of the traditional association of the body and the feminine. The body-as-feminine functions here as both site and agent of the disruption of the univocality of Symbolic language, the Law of the Father. In this guise, not only men – like Jacques Lacan – but also women have valorized its poetic agency. Julia Kristeva, for instance, has characterized its disruption of the binarity of subject-object positions, which generates multiple potentials and is best analysed in a semiotic system that maps such disruptions as relations of continuity and contiguity, as "the maternal body." Aspects of meaning not easily reduced to Symbolic language – like tone of voice, facial expression, gesture, rhythm, and even the physical disposition of type on a page – suggested for Kristeva heterogeneous options whose multiplicity is opposed by the repression of the Symbolic. For Kristeva, Jacques Lacan's Law of the Father, as it is expressed in Symbolic language, tries to reduce the plurality of the maternal body to a univocal signifying function. In the binary system this contest establishes, the signified is a discrete object of desire, presupposing a defining subject. The maternal body is most in evidence, according to Kristeva, when language's operations (or, for the purposes of this essay, painting's operations) fail to have a clear meaning, when meaning is unsettled and questionable as a result of non-language factors.[33]

The problem with Kristeva's characterization of somatic disruptions of paternally sanctioned systems as "maternal" is, first, that it confirms the essentialist association of the feminine with the body (echoing the female:nature::male:culture dichotomy). And second, although it engages in a kind of guerrilla warfare, it leaves the prohibitive paternal law in place as the foundation of culture. The failure of Kristeva's maternal soma to dislodge gender-linked essentialisms is paralleled by the failure of Rodchenko's *Pure Yellow*, *Pure Red*, and *Pure Blue* to put an end to either painting as the representor of things outside itself or as a fetishized commodity.[34] Although as Yve-Alain Bois has pointed out, the monochrome panels did deconstruct painting's "pretense to reach the realm of the real," they hardly destroyed – in fact, they reaffirmed – painting's identity as a representational art.[35] Did Taylor sense similar problems with this association of unchanneled or "wild" meaning with the feminine? "Merleau-Ponty describes the gaping wound, dark hole, open gap, central cavity, inaccessible hollow in the midst of the chiasmus, formed by a process of folding and unfolding," he wrote, "with a term usually associated with Derrida's texts: *invagination*."[36] Taylor did not pursue the critical potential of his own remark; but some of the feminists who attended the Columbia University Theory of Literature seminar in 1978 saw Derrida's use of the term, at least, as problematic. In his lecture Derrida described Maurice Blanchot's *La Folie du jour* as an "invaginated text." A feminist familiar with French theory asked him why he chose that particular term. Derrida answered only that he expected the question, but not from her – not from a feminist who understood, in other words, what Derrida saw as the necessity of the *neutering* of the

feminine that results from treating it as a metaphoric term only, divorced from the political facts that accompany feminine "difference."[37] Rather amazingly, I think, both Merleau-Ponty and Derrida maintained that this "strange domain," this "invagination" (for Derrida one of the terms of *différance*), was neuter.[38]

It could be argued, then, that monochrome's resistance to language, like Merleau-Ponty's and Derrida's neutering of the feminine, has in the end only enabled femaleness to serve as a sign of the continuing oppositional stance of what is really the (paternal) avant-garde and as an aid to its historical cohesion. Merleau-Ponty's understanding of difference is more useful here than his problematic feminization of the flesh. Difference is subordinated, he wrote, "as soon as [it] ceases being experience and becomes *signification*, something spoken."[39] This is what has happened to monochrome in the story of Greenbergian modernism and to gesture painting in Kelly's account. The description of the religious, cultural, and economic experiences that have filled the absence created by this deprivation of experiences is what Serrano's and McCollum's work is about. Monochrome stands in these works for painting's emptiness in its historically ultimate state – as a sign of the univocality of high modernism, serving interests other than its own.

I would like to argue, however, for another possibility. Merleau-Ponty likened this *flesh*, this "naked color," as he called it, in which meaning becomes visible, to "a sort of straits between exterior horizons and interior horizons ever gaping open . . . less a color or a thing, therefore, than a difference between things and colors."[40] Like Merleau-Ponty's "straits," between exterior and interior, monochrome may be understood not as a sign (only) but, rather, as a site of difference. And not only as "*a site for the inscription of sexual difference*," as Griselda Pollock characterized the practice of painting,[41] and not only as Merleau-Ponty's feminized flesh, with its connotations of lack, but as *human* flesh, with its broader differences of class, color, gender, age, and nationality. As Michele Wallace has remarked, Griselda Pollock's suggestion of a third position beyond (white) feminist struggles for equality and difference suggests the possibility of investigating the interdependency of issues of ethnicity and sex.[42] Following Wallace's suggestions, a related but distinct analysis revolving around the body and monochrome's color in regard to issues of ethnicity and "race" opens another arena of difference. The point of departure for the analysis of monochrome in this article are white feminisms in France, Great Britain, and the United States; but African-American studies and African-American feminisms offer other (and sometimes conflicting) forms of difference for provocative readings of "color" yet to be explored.[43]

In that aspect of monochrome to which I would like to call attention, the viewer is confronted with explicit, distinct differences from painting to painting and sometimes within a painting. The differences between these two versions of monochrome (and I am talking about *readings*, not production) are somewhat similar to the differences between the idea that humanity is best represented by one perfect specimen and the idea that there is no one best representative of humanity since people's differences from one another present themselves in many stimulating and satisfying varieties. Most criticism of monochrome painting has tended to discuss it either as a sign of painting's materiality or has taken it into the realm of metaphysics. Either way, a tradition has been invoked in which discussion must be about something else than a particular painting. Criticism of the idea of monochrome has elided the body; elided the specific. This is the grain against which monochrome paintings must be read if they are to produce an arena of difference rather than generalizations in the service of an idea. In this kind of reading the bodies of monochrome paintings become places where the viewer's desire for one kind of color, value, facture, opacity, translucence, weight, light becomes weighted with association, played with and played out in different ways in different

paintings. It becomes apparent that the languages of different paintings are as different as the movements and textures of different bodies and their appeal is as varied. When a viewer responds to these differences, each painting will be open to some different interpretations but not to all interpretations, somewhat as the "subjective plurality" ascribed to the black woman by Mae Gwendolyn Henderson allows her "to become an expressive site for a dialectics/dialogics of identity and difference."[44] This is how, as I am arguing, monochrome can function as a site where perception remains open to difference.

[. . .]

Notes

1 The term *monochrome* can be misleading if it is taken literally. Monochrome painting frequently relies on *many* colors to produce a fluctuating and vivid impression of colored light. The term *radical painting* has been applied to the work of painters who intended to start from painting's materialist roots, to rebuild it from what they see as painting's foundations: object and color. (See Marcia Hafif, "True Colors", *Art in America* 77 [June 1989]: 192–193.) Unlike the steady focus on the object alone demonstrated earlier by more "analytic" approaches (i.e., Robert Ryman's), "radical" painters such as American Joseph Marioni and German Gunter Umberg have established a phenomenalist interest in the relation between the viewer and the painting. See Henry Staten, "Joseph Marioni, Painting beyond Narrative," in *Joseph Marioni, Painter* (Aalst, Belgium: Galerij S65, 1986), n.p. In the painting I am discussing here, though, whether analytic or radical in the intention of the artist, one color usually dominates, and any "figure" introduced by variation in paint application usually *serves* that impression rather than the other way around. This is what produces the impression of "one-color," or monochrome, painting.
2 Carter Ratcliffe, "Mostly Monochrome," *Art in America* (April 1981): 115.
3 Clement Greenberg, "After Abstract Expressionism," *Art International*, October 25, 1962, 30.
4 Griselda Pollock, *Vision and Difference, Femininity, Feminism, and the Histories of Art* (London and New York: Routledge, 1988), 159. This statement brings up two vexed areas, that of the definition of modernism and of modernism's relation to feminism. While this essay is not about either of these issues per se, it is important to situate this argument in relation to them. The term *modernism* is currently used in two rather distinct ways, following two aspects of the modernist enterprise, as described by Peter Wollen, "The Two Avant-Gardes," in *Readings and Writings, Semiotic Counter-Strategies* (London: Verso Editions and NLB, 1982). One is the aspect of modernism that did not reject all vestiges of mimetic reference, intending its formal strategies to serve greater social and political goals. This modernism would include certain Dadaists. German Expressionists, many Surrealists, as described by Peter Burger in his *Theorie der Avantgarde* (Frankfurt: Suhrkamp Verlag, 1974). The other modernism in some individual cases began as an attempt to produce socially effective work but in its concentration on the relation of signifier and signified within the sign itself forgot or gave up on the possibility of immediate social effectiveness. Artists who worked in this mode (Abstract Expressionists and Minimalists, for instance) often abjured mimetic strategies. This approach is familiar to many in the United States in the writing of Clement Greenberg. Rodchenko's monochrome *Red, Yellow, Blue* of 1921 shows the connection between formal and socially grounded modernisms. Not only did Rodchenko aim to eliminate from consideration all figure-ground relationships and all chromatic relationships in favor of color's pure materiality, but he also wanted to rid color of the spiritual, emotional, and psychological associations, that is, transcendental associations in general, that clung to painting as signifiers of aristocratic privilege. See Benjamin Buchloh: "The Primary Colors for the Second Time," *October* (Summer 1986), 43. (See also Yve-Alain Bois, "Malevich, le carré, le degré zéro," *Macula* 1 [1978]: 28–49.) But the theatre of revolutionary social concern in which this painting was registered enabled it to make an antimaterialist, antielitist statement that it has not been possible for subsequent monochrome activities to repeat. The attempt to strip art of spirit, emotion, and psychological association – especially in increasingly "purist" or "essentialist" readings of modern art – has been characterized by feminists as one of the strategies that establish and maintain patriarchal power. See Nichole Dubreuil-Blondin, "Feminism and Modernism: Paradoxes," in *Modernism and Modernity*, ed. Benjamin H. D. Buchloh, Serge Guilbaut, and David Solkin (Halifax, Nova Scotia: Press of the Nova Scotia College of Art and Design, 1983), 195–212; Carol Duncan, "The MoMA's Hot Mamas," *Art Journal* 48 (Summer 1989): 171–178; and Anna Chave, "Minimalism and the Rhetoric of Power," *Arts* 64 (January 1990): 44–63.

5 Martin Heidegger, "Letter on Humanism," in *Basic Writings*, ed. David Farrell Krell (New York: Harper and Row, 1977), 221, 210. In addition to Heidegger's "shepherding," humanism has frequently been considered to preserve values considered universal such as individual freedom, equality, the dignity of the human person, and freedom of expression. The universality of these values has been under fire for some time, not only from feminists such as Griselda Pollock but from socialists. See also L. Goldman, "Socialism and Humanism," in *Socialist Humanism*, ed. E. Fromm (Anchor, 1966), 40.

6 James Clifford quoted this passage from Maurice Merleau-Ponty's *Humanisme et terreur* (Paris: Gallimard, 1947), 182 in his "On Ethnographic Surrealism," in *The Predicament of Culture* (Cambridge, Mass.: Harvard University Press, 1988), 145.

7 Frederick Thursz, "Interview F. M. Thursz," in Bernard Ceysson, *Frederic Matys Thursz* (Saint-Etienne: Musée d'Art Moderne, 1989), 9.

8 Frederic Thursz, in "Monochrome: Definitions, Amplifications, Repercussions and More . . . ," *Art in America* (December 1981): 155.

9 Charles Saunders Peirce, *Collected Papers*, ed. Charles Hartshorne, Paul Weiss, and Arthur W. Burks, 8 vols. (Cambridge, Mass.: Harvard University Press, 1958–60), vol. 2, 143–144, 156–173.

10 Rosalind Krauss, "Notes on the Index, Part 1 and Part 2," in *The Originality of the Avant-Garde and Other Modernist Myths* (Cambridge: MIT University Press, 1985), 206, 217.

11 Richard Shiff, "Performing an Appearance: On the Surface of Abstract Expressionism," in *Abstract Expressionism: The Critical Developments*, ed. Michael Auping (Buffalo, N.Y.: Albright-Knox Art Gallery, 1987), 94–123, esp. 116.

12 Mary Kelly, "Re-Viewing Modernist Criticism," *Screen* 22: 3 (1981): 44. For Richard Shiff on this issue, see his "Performing on Appearance," 113.

13 Including, most recently, Ellen Landau. See her "The Wild One," chap. 1 of *Jackson Pollock* (New York: Harry N. Abrams, 1989).

14 Kelly, "Re-Viewing Modernist Criticism," 44. Her reference is to Jean-Louis Schefer's "Split colour blur" as it appeared in *20th Century Studies* 15–16 (December 1976).

15 Jeremy Gilbert-Rolfe, "Color as metaphor," *Res* 2 (Autumn 1981): 104.

16 Laura Mulvey, "Visual Pleasure and Narrative Cinema," *Screen* 16 (Autumn 1975): 6–18. Reprinted in Brian Wallis ed., *Art after Modernism* (New York: New Museum of Contemporary Art, 1984), 361–373. [Chapter 9 in this volume.]

17 Barbara Kruger, telephone conversation with the author, 9 February 1989.

18 Marcia Hafif, "Getting on with Painting," *Art in America* (April 1981): 132.

19 Ibid.

20 At the same time the plywood edges left exposed on the *Enamel on Wood* series emphasize the materiality of the painting as an object, counteracting the tendency of Hafif's shiny, nearly strokeless application of paint to read as disembodied color.

21 The catalog for the exhibition is *la couleur seule: l'expérience du monochrome*, 7 octobre–5 décembre 1988. Commissaire de l'exposition, Maurice Besset; réalisée par l'équipe due Musée Saint Pierre Art Contemporain, Thierry Raspail et al. Ville de Lyon, avec la collaboration des Musées de France. Centre National des arts plastiques.

22 Deleuze and Guattari quote Antonin Artaud: "Le corps est le corps/il est seul/et n'a pas besoin d'organe/le corps n'est jamais un organisme/les organismes sont les ennemis du corps" (*L'Anti-Oedipe* [Paris: Les Editions de Minuit, 1972], 9).

23 Maurice Merleau-Ponty, *Phénoménologie de la perception* (Paris: Editions Gallimard, 1945), 117. Discussion by Mark C. Taylor in *Altarity* (Chicago: University of Chicago Press, 1987), 70. My attention was drawn to Taylor's work by Joseph Marioni.

24 Merleau-Ponty, *Le Visible et l'invisible* (Paris: Editions Gallimard, 1964), 193.

25 Ibid., 193, 249.

26 Ibid., 193–194.

27 Ibid., 195–198. It is notable that Merleau-Ponty was working out the earlier formation of these ideas, published in 1945 in the *Phénoménologie de la perception*, during the German occupation of France in World War II, when the bodies in which occurred many individual "spirits" and "ideas" were destroyed. Perhaps his ideas about the inseparability of idea and flesh seem achingly familiar now, nearly half a century later, in the intensification of issues surrounding the mortality of particular bodies in the later 1980s and early 1990s: AIDS, the antagonism of the "pro-life" and "pro-choice" movements in the United States, the right to self-determination of people formerly and still in the Soviet Eastern Bloc, the internal colonization of people of color in developed countries like the United States and

Great Britain and the heritage of external colonization in the countries of Africa and India, and the escalation of decisions about who will live and who will not in the areas around the Persian Gulf.

28　Merleau-Ponty, *Phénoménologie*, 360–361.

29　John Gage, "Color in Western Art: An Issue?" *Art Bulletin* 72 (December 1990): 539, 518.

30　Ibid., 539.

31　Merleau-Ponty, *Phénoménologie*, 176.

32　I think one could say that the idea that the meanings of objects in our visual culture are determined by the systems of representation in which they appear, driven home by writers such as Brian Wallis in his indispensable essay, "What's Wrong with This Picture? An Introduction," in *Art after Modernism*, ed. Wallis, xi–xviii, has achieved the status of a "given" in high culture circles.

33　Julia Kristeva, *Desire in Language*, ed. Leon S. Roudiez, trans. Thomas Gorz, Alice Jardine, and Leon S. Roudiez (New York: Columbia University Press, 1980), 134–136.

34　For problems with Kristeva, see Judith Butler, *Gender Trouble, Feminism and the Subversion of Identity* (New York: Routledge, 1990), 80–86. For an estimate of the abridgment of the revolutionary potential of Rodchenko's paradigmatic *Red, Yellow, Blue* in the history of art production, see Benjamin Buchloh, "The Primary Colors for the Second Time," *October* 37 (Summer 1986): 43–44.

35　Yve-Alain Bois, "Painting The Task of Mourning," in *Endgame* (Boston: Institute of Contemporary Art and MIT Press, 1986), 41.

36　Taylor, *Altarity*, 72.

37　Alice Jardine, *Gynesis, Configurations of Woman and Modernity* (Ithaca: Cornell University Press, 1985), 34–35.

38　See Taylor, *Altarity*, 70, 277. For Merleau-Ponty the body, like lighting, is anterior to perception and, thus, despite the feminine terms he uses to describe it, "it tends to become 'neutral' for us" (*Phénoménologie*, 359). Derrida's "invagination" is one of the terms of the neologism, *différance*, that implies, among other things, the necessity of taking issue with totalizing views. He characterized this as a "middle voice," an "intransivity" ("Différance," in *Théorie d'ensemble* [Paris: Editions du Seuil, 1968]).

39　Maurice Merleau-Ponty, "Philosophy and Non-Philosophy since Hegel," trans. J. H. Silverman, *Telos* 29 (1976): 79.

40　Merleau-Ponty, *Le Visible et l'invisible*, 175.

41　Pollock, *Vision and Difference*, 81. Emphasis is in the original.

42　Pollock's suggestion was in her "Differencing the Canon," delivered at the CAA "Firing the Canon" panel, chaired by Linda Nochlin, New York City, 16 February 1990. Michele Wallace, "Modernism, Postmodernism and the Problem of the Visual in Afro-American Culture," in *Out There, Marginalization and Contemporary Cultures* (New York: New Museum and MIT Press, 1990), 46.

43　African-American painters Norman Lewis and Faith Ringgold both painted series of black paintings. The social implications of these works in relation to the modernist understanding of monochrome painting that informed their reception is one of the investigations of the tradition of monochrome painting that promises to bear important results.

44　Mae Gwendolyn Henderson, "Speaking in Tongues: Dialogics, Dialectics, and the Black Woman Writer's Literary Tradition," in *Changing Our Own Words: Essays on Criticism, Theory, and Writing by Black Women*, ed. Cheryl A. Wall (New Brunswick: Rutgers University Press, 1989), 36–37.

COCO FUSCO

THE OTHER HISTORY OF
INTERCULTURAL PERFORMANCE

IN THE EARLY 1900S, FRANZ KAFKA wrote a story that began, "Honored members of the Academy! You have done me the honor of inviting me to give your Academy an account of the life I formerly led as an ape."[1] Entitled "A Report to an Academy," it was presented as the testimony of a man from the Gold Coast of Africa who had lived for several years on display in Germany as a primate. That account was fictitious and created by a European writer who stressed the irony of having to demonstrate one's humanity; yet it is one of many literary allusions to the real history of ethnographic exhibition of human beings that has taken place in the West over the past five centuries. While the experiences of many of those who were exhibited is the stuff of legend, it is the accounts by observers and impresarios that constitute the historical and literary record of this practice in the West. My collaborator, Guillermo Gómez-Peña, and I were intrigued by this legacy of performing the identity of an Other for a white audience, sensing its implications for us as performance artists dealing with cultural identity in the present. Had things changed, we wondered? How would we know, if not by unleashing those ghosts from a history that could be said to be ours? Imagine that I stand before you then, as did Kafka's character, to speak about an experience that falls somewhere between truth and fiction. What follows are my reflections on performing the role of a noble savage behind the bars of a golden cage.

Our original intent was to create a satirical commentary on Western concepts of the exotic, primitive Other; yet, we had to confront two unexpected realities in the course of developing this piece: 1) a substantial portion of the public believed that our fictional identities were real ones; and 2) a substantial number of intellectuals, artists, and cultural bureaucrats sought to deflect attention from the substance of our experiment to the "moral implications" of our dissimulation, or in their words, our "misinforming the public" about who we were. The literalism implicit in the interpretation of our work by individuals representing the "public interest" bespoke their investment in positivist notions of "truth" and depoliticized, ahistorical notions of "civilization." This "reverse ethnography" of our interactions with the public will, I hope, suggest the culturally specific nature of their tendency toward a literal and moral interpretation.

When we began to work on this performance as part of a counter-quincentenary project, the [first] Bush administration had drawn clear parallels between the "discovery" of the New World and his "New World Order." We noted the resemblance between official quincentenary celebrations in 1992 and the ways that the 1892 Columbian commemorations had served as a justification for the United States' then new status as an imperial power. Yet, while we anticipated that the official quincentenary celebration was going to form an imposing backdrop,

what soon became apparent was that for both Spain and the United States, the celebration was a disastrous economic venture, and even an embarrassment. The Seville Expo went bankrupt; the U.S. Quincentenary Commission was investigated for corruption; the replica caravels were met with so many protestors that the tour was canceled; the Pope changed his plans and didn't hold mass in the Dominican Republic until after October 12; American Indian Movement activist Russell Means succeeded in getting Italian Americans in Denver to cancel their Columbus Day parade; and the film super-productions celebrating Columbus – from *1492: The Discovery* to *The Conquest of Paradise* – were box office failures. Columbus, the figure who began as a symbol of Eurocentrism and the American entrepreneurial spirit, ended up being devalued by excessive reproduction and bad acting.

As the official celebrations faded, it became increasingly apparent that Columbus was a smokescreen, a malleable icon to be trotted out by the mainstream for its attacks on "political correctness." Finding historical justification for Columbus's "discovery" became just another way of affirming Europeans' and Euro-Americans' "natural right" to be global cultural consumers. The more equitable models of exchange proposed by many multiculturalists logically demanded a more profound understanding of American cultural hybridity, and called for redefinitions of national identity and national origins. But the concept of cultural diversity fundamental to this understanding strikes at the heart of the sense of control over Otherness that Columbus symbolized, and was quickly cast as un-American. Resurrecting the collective memory of colonial violence in America that has been strategically erased from the dominant culture was described consistently throughout 1992 by cultural conservatives as a recipe for chaos. More recently, as is characterized by the film *Falling Down*, it is seen as a direct threat to heterosexual, white male self-esteem. It is no wonder that contemporary conservatives invariably find the focus on racism by artists of color "shocking" and inappropriate, if not threatening to national interests, as well as to art itself.

Out of this context arose our decision to take a symbolic vow of silence with the cage performance, a radical departure from Guillermo's previous monologue work and my activities as a writer and public speaker. We sought a strategically effective way to examine the limits of the "happy multiculturalism" that reigned in cultural institutions, as well as to respond to the formalists and cultural relativists who reject the proposition that racial difference is absolutely fundamental to aesthetic interpretation. We looked to Latin America, where consciousness of the repressive limits on public expression is far more acute than it is here, and found many examples of how popular opposition has for centuries been expressed through the use of satiric spectacle. Our cage became the metaphor for our condition, linking the racism implicit in ethnographic paradigms of discovery with the exoticizing rhetoric of "world beat" multiculturalism. Then came a perfect opportunity: In 1991, Guillermo and I were invited to perform as part of the Edge '92 Biennial, which was to take place in London and also in Madrid as part of the quincentennial celebration of Madrid as the capital of European culture. We took advantage of Edge's interest in locating art in public spaces to create a site-specific performance for Columbus Plaza in Madrid, in commemoration of the so-called Discovery.

Our plan was to live in a golden cage for three days, presenting ourselves as undiscovered Amerindians from an island in the Gulf of Mexico that had somehow been overlooked by Europeans for five centuries. We called out homeland Guatinau, and ourselves Guatinauis. We performed our "traditional tasks," which ranged from sewing voodoo dolls and lifting weights to watching television and working on a lap-top computer. A donation box in front of the cage indicated that, for a small fee, I would dance (to rap music), Guillermo would

tell authentic Amerindian stories (in a nonsensical language), and we would pose for Polaroids with visitors. Two "zoo guards" would be on hand to speak to visitors (since we could not understand them), take us to the bathroom on leashes, and feed us sandwiches and fruit. At the Whitney Museum in New York we added sex to our spectacle, offering a peek at authentic Guatinaui male genitals for $5. A chronology with highlights from the history of exhibiting non-Western peoples was on one didactic panel and a simulated Encyclopedia Britannica entry with a fake map of the Gulf of Mexico showing our island was on another. After our three days in May 1992, we took our performance to Covent Garden in London. In September, we presented it in Minneapolis, and in October, at the Smithsonian's National Museum of Natural History. In December, we were on display in the Australian Museum of Natural History in Sydney, and in January 1993, at the Field Museum of Chicago. In early March, we were at the Whitney for the opening of the biennial, the only site where we were recognizably contextualized as artwork. Prior to our trip to Madrid, we did a test run under relatively controlled conditions in the Art Gallery of the University of California, Irvine.

Our project concentrated on the "zero degree" of intercultural relations in an attempt to define a point of origin for the debates that link "discovery" and "Otherness." We worked within disciplines that blur distinctions between the art object and the body (performance), between fantasy and reality (live spectacle), and between history and dramatic reenactment (the diorama). The performance was interactive, focusing less on what we did than on how people interacted with us and interpreted our actions. Entitled *Two Undiscovered Amerindians Visit . . .*, we chose not to announce the event through prior publicity or any other means,

Figure 24.1 Coco Fusco and Guillermo Gómez-Peña, *Two Undiscovered Amerindians Visit Madrid*, 1992.

when it was possible to exert such control; we intended to create a surprise or "uncanny" encounter, one in which audiences had to undergo their own process of reflection as to what they were seeing, aided only by written information and parodically didactic zoo guards. In such encounters with the unexpected, people's defense mechanisms are less likely to operate with their normal efficiency; caught off guard, their beliefs are more likely to rise to the surface.

Our performance was based on the once popular European and North American practice of exhibiting indigenous people from Africa, Asia, and the Americas in zoos, parks, taverns, museums, freak shows, and circuses. While this tradition reached the height of its popularity in the nineteenth century, it was actually begun by Christopher Columbus, who returned from his first voyage in 1493 with several Arawaks, one of whom was left on display at the Spanish Court for two years. Designed to provided opportunities for aesthetic contemplation, scientific analysis, and entertainment for Europeans and North Americans, these exhibits were a critical component of a burgeoning mass culture whose development coincided with the growth of urban centers and populations, European colonialism, and American expansionism.

In writing about these human exhibitions in America's international fairs from the late nineteenth and early twentieth centuries, Robert W. Rydell (author of *All the World's a Fair; Visions of Empire at American International Exhibitions, 1876–1916*) explains how the "ethnological" displays of nonwhites – which were orchestrated by impresarios but endorsed by anthropologists – confirmed popular racial stereotypes and built support for domestic and foreign policies.[2] In some cases, they literally connected museum practices with affairs of state. Many of the people exhibited during the nineteenth century were presented as the chiefs of conquered tribes and/or the last survivors of "vanishing" races. Ishi, the Yahi Indian who spent five years living in the Museum of the University of California at the turn of the century, is a well-known example. Another lesser-known example comes from the U.S.–Mexico War of 1836, when Anglo-Texan secessionists used to exhibit their Mexican prisoners in public plazas in cages, leaving them there to starve to death. The exhibits also gave credence to white supremacist worldviews by representing nonwhite peoples and cultures as being in need of discipline, civilization, and industry. Not only did these exhibits reinforce stereotypes of "the primitive" but they served to enforce a sense of racial unity as whites among Europeans and North Americans, who were divided strictly by class and religion until this century. Hence, for example, at the Columbian Exhibition of 1893 in Chicago, ethnographic displays of peoples from Africa and Asia were set up outside "The White City," an enclosed area celebrating science and industry.

Intercultural performance

Performance Art in the West did not begin with Dadaist "events." Since the early days of European "conquest," "aboriginal samples" of people from Africa, Asia, and the Americas were brought to Europe for aesthetic contemplation, scientific analysis, and entertainment. Those people from other parts of the world were forced first to take the place that Europeans had already created for the savages of their own Medieval mythology; later with the emergence of scientific rationalism, the "aborigines" on display served as proof of the natural superiority of European civilization, of its ability to exert control over and extract knowledge from the "primitive" world, and ultimately, of the genetic inferiority of non-European races. Over the last 500 years, Australian Aborigines, Tahitians, Aztecs, Iroquois, Cherokee, Ojibways, Iowas, Mohawks, Botocudos, Guianese, Hottentots, Kaffirs, Nubians, Somalis, Singhalese, Patagonians, Tierra del Fuegans, Kahucks, Anapondans, Zulus, Bushmen, Japanese, East Indians, and

Laplanders have been exhibited in the taverns, theaters, gardens, museums, zoos, circuses, and world's fairs of Europe, and the freak shows of the United States.

[. . .]

In most cases, the human beings that were exhibited did not choose to be on display. More benign versions continue to take place these days in festivals and amusement parks with the partial consent of those on exhibit. The contemporary tourist industries and cultural ministries of several countries around the world still perpetrate the illusion of authenticity to cater to the Western fascination with Otherness. So do many artists.

Emerging at a time when mass audiences in Europe and America were barely literate and hardly cognizant of the rest of the world, the displays were an important form of public "education." These shows were where most whites "discovered" the non-Western sector of humanity. I like to call them the origins of intercultural performance in the West. The displays were living expressions of colonial fantasies and helped to forge a special place in the European and Euro-American imagination for nonwhite peoples and their cultures. Their function, however, went beyond war trophies, beyond providing entertainment for the masses and pseudoscientific data for early anthropologists. The ethnographic exhibitions of people of color were among the many sources drawn on by European and American modernists seeking to break with realism by imitating the "primitive." The connection between West African sculpture and Cubism has been discussed widely by scholars, but it is the construction of ethnic Otherness as essentially *performative* and located in the body that I here seek to stress.

The interest that modernists and postmodernists have had in non-Western cultures was preceded by a host of references to "exotics" made by European writers and philosophers over the past five centuries. The ethnographic shows and the people brought to Europe to be part of them have been alluded to by such writers as William Shakespeare, Michel Montaigne, and William Wordsworth. In the eighteenth century, these shows, together with theatre and popular ballads, served as popular illustrations of the concept of the Noble Savage so central to Enlightenment philosophy. Not all the references were positive; in fact, the nineteenth-century humanist Charles Dickens found that the Noble Savage as an idea hardly sufficed to make an encounter with Bushmen in the Egyptian Hall in 1847 a pleasurable or worthwhile experience:

> Think of the Bushmen. Think of the two men and the two women who have been exhibited about England for some years. Are the majority of persons – who remember the horrid little leader of that party in his festering bundle of hides, with his filth and his antipathy to water, and his straddled legs, and his odious eyes shaded by his brutal hand, and his cry of "Qu-u-u-u-aaa" (Bosjeman for something desperately insulting I have no doubt) – conscious of an affectionate yearning towards the noble savage, or is it idiosyncratic in me to abhor, detest, abominate, and abjure him? I have never seen that group sleeping, smoking, and expectorating round their brazier, but I have sincerely desired that something might happen to the charcoal therein, which would cause the immediate suffocation of the whole of noble strangers.[3]

Dickens's aversion does not prevent him from noting, however, that the Bushmen possess one redeeming quality: their ability to break spontaneously into dramatic reenactment of their "wild" habits. By the early twentieth century, the flipside of such revulsion – in the form of fetishistic fascination with exotic artefacts and the "primitive" creativity that generated them – had become common among the members of the European avant-garde. The Dadaists, often thought of as the originators of performance art, incuded several imitative gestures in their

events, ranging from dressing up and dancing as "Africans," to making "primitive-looking" masks and sketches. Tristan Tzara's dictum that "Thought is made in the mouth," a performative analog to Cubism, refers directly to the Dadaist belief that Western art tradition could be subverted through the appropriation of the perceived orality and performative nature of the "non-Western." In a grand gesture of appropriation, Tzara anthologized African and Southern Pacific poetry culled from ethnographies into his book, *Poèmes Nègres*, and chanted them at the infamous Cabaret Voltaire in Zurich in 1917. Shortly afterward, Tzara wrote a hypothetical description of the "primitive" artist at work in *Notes on Negro Art*, imputing near-shamanistic powers to the Other's creative process:

> My other brother is naive and good, and laughs. He eats in Africa or along the South Sea Islands. He concentrates his vision on the head, carves it out of wood that is hard as iron, patiently, without bothering about the conventional relationship between the head and the rest of the body. What he thinks is: man walks vertically, everything in nature is symmetrical. While working, new relationships organize themselves according to degree of necessity; this is how the expression of purity came into being. From blackness, let us extract light. Transform my country into a prayer of joy or anguish. Cotton wool eye, flow into my blood. Art in the infancy of time, was prayer. Wood and tone were truth . . . Mouths contain the power of darkness, invisible substance, goodness, fear, wisdom, creation, fire. No one has seen so clearly as I this dark grinding whiteness.[4]

Tzara is quick to point out here that only he, as a Dadaist, can comprehend the significance of the "innocent" gesture of his "naive and good" brother. In *The Predicament of Culture*, James Clifford explains how modernists and ethnographers of the early twentieth century projected coded perceptions of the black body – as imbued with vitalism, rhythm, magic, and erotic power, another formation of the "good" versus the irrational or bad savage.[5] Clifford questions the conventional mode of comparison in terms of affinity, noting that this term suggests a "natural" rather than political or ideological relationship. In the case of Tzara, his perception of the "primitive" artist as part of his metaphorical family conveniently recasts his own colonial relation to his imaginary "primitive" as one of kinship. In this context, the threatening reminder of difference is that the original body, or the physical and visual presence of the cultural Other, must be fetishized, silenced, subjugated, or otherwise controlled to be "appreciated." The significance of that violent erasure is diminished – it is the "true" avant-garde artist who becomes a better version of the "primitive," a hybrid or a cultural transvestite. Mass culture caged it, so to speak – while artists swallowed it.

This practice of appropriating and fetishizing the primitive and simultaneously erasing the original source continues into contemporary "avant-garde" performance art. In his 1977 essay "New Models, New Visons: Some Notes Toward a Poetics of Performance," Jerome Rothenberg envisioned this phenomenon in an entirely celebratory manner, noting correlations between Happenings and rituals, meditative works and mantric models, Earthworks and Native American sculptures, dreamworks and notions of trance and ecstasy, bodyworks and self-mutilation, and performance based on several other variations of the shamanistic premise attributed to non-Western cultures. Rothenberg claims that unlike imperialism's models of domination and subordination, avant-garde performance succeeded in shifting relations to a "symposium of the whole," an image strikingly similar to that of the world-beat multiculturalism of the 1980s. Referring to Gary Snyder's story of Alfred Kroeber and his (unnamed) Mojave informant in 1902, Rothenberg notes Snyder's conclusion that "The old man sitting in the sand house telling

his story is who we must become – not A. L. Kroeber, as fine as he was."[6] Rothenberg goes on to claim that artists are to critics what aborigines are to anthropologists, and therefore suffer from the same misrepresentation. "The antagonism of literature to criticism," he writes, "is, for the poet and artist, no different from that to anthropology, say, on the part of the Native American militant. It is a question in short of the right to self-definition."[7]

Redefining these "affinities" with the primitive, the traditional, and the exotic has become an increasingly delicate issue as more artists of color enter the sphere of the "avant-garde." What may be "liberating" and "transgressive" identification for Europeans and Euro-Americans is already a symbol of entrapment within an imposed stereotype for Others. The "affinity" championed by the early moderns and postmodern cultural transvestites alike is mediated by an imagined stereotype, along the lines of Tzara's "brother." Actual encounters could threaten the position and supremacy of the appropriator unless boundaries and concomitant power relations remain in place. As a result, the same intellectual milieus that now boast Neoprimitive body piercers, "nomad" thinkers, Anglo *comadres*, and New Age earth worshippers continue to evince a literal-minded attitude toward artists of color, demonstrating how racial difference is a determinant in one's relation to notions of the "primitive." In the 1987 trial of minimalist sculptor Carl Andre – accused of murdering his wife, the Cuban artist Ana Mendieta – the defense continually suggested that her earthworks were indicative of suicidal impulses prompted by her "satanical" beliefs; the references to Santería in her work could not be interpreted as self-conscious. When Cuban artist José Bedia was visited by the French curators of the Les Magiciens de la Terre exhibition in the late 1980s, he was asked to show his private altar to "prove" that he was a true Santería believer. A critically acclaimed young African American poet was surprised to learn last year that he had been promoted by a Nuyorican Poet's Cafe impresario as a former L.A. gang member, which he never was. And while performing *Border Brujo* in the late 1980s, Gómez-Peña encountered numerous presenters and audience members who were disappointed that he was not a "real shaman" and that his "tongues" were not Nahuatl but a fictitious language.

Our cage performances forced these contradictions out into the open. The cage became a blank screen onto which audiences projected their fantasies of who and what we are. As we assumed the stereotypical role of the domesticated savage, many audience members felt entitled to assume the role of the colonizer, only to find themselves uncomfortable with the implications of the game. Unpleasant but important associations have emerged between the displays of old and the multicultural festivals and ethnographic dioramas of the present. The central position of the white spectator, the objective of these events as a confirmation of their position as global consumers of exotic cultures, and the stress on authenticity as an aesthetic value, all remain fundamental to the spectacle of Otherness many continue to enjoy.

The original ethnographic exhibitions often presented people in a simulation of their "natural" habitat, rendered either as an indoor diorama, or as an outdoor recreation. Eyewitness accounts frequently note that the human beings on display were forced to dress in the European notion of their traditional "primitive" garb, and to perform repetitive, seemingly ritual tasks. At times, nonwhites were displayed together with flora and fauna from their regions, and artefacts, which were often fakes. They were also displayed as part of a continuum of "outsiders" that included "freaks," or people exhibiting physical deformities. In the nineteenth and early twentieth centuries, many of them were presented so as to confirm social Darwinist ideas of the existence of a racial hierarchy. Some of the more infamous cases involved individuals whose physical traits were singled out as evidence of the bestiality of nonwhite people. For example, shortly after the annexation of Mexico and the publication of John Stephens's account of travel in the Yucatan, which generated popular interest in pre-Columbian cultures, two

Figure 24.2 Maximo and Bartola, "The Last Aztec Survivors of a Mysterious Jungle City Called Ixinaya," *c.*1853–1901. Photo by Charles Eisenman. Courtesy of the Becker Collection, Syracuse University Library, Department of Special Collections.

microcephalics (or "pinheads") from Central America, Maximo and Bartola, toured the United States in P.T. Barnum's circus; they were presented as Aztecs. This set off a trend that would be followed by many other cases into the twentieth century. From 1810–1815, European audiences crowded to see the Hottentot Venus, a South African woman whose large buttocks were deemed evidence of her excessive sexuality [see Figure 19.2]. In the United States, several of the "Africans" exhibited were actually black Americans, who made a living in the nineteenth century by dressing up as their ancestors, just as many Native Americans did dressing up as Sioux whose likenesses, thanks to the long and bloody Plains Wars of the late nineteenth century, dominate the American popular imagination.

For Gómez-Peña and myself, the human exhibitions dramatize the colonial unconscious of American society. In order to justify genocide, enslavement, and the seizure of lands, a "naturalized" splitting of humanity along racial lines had to be established. When rampant miscegenation proved that those differences were not biologically based, social and legal systems were set up to enforce those hierarchies. Meanwhile, ethnographic spectacles circulated and reinforced stereotypes, stressing that "difference" was apparent in the bodies on display. Thus they naturalized fetishized representations of Otherness, mitigating anxieties generated by the encounter with difference.

In his essay, "The Other Question" Homi Bhabha explains how racial classification through stereotyping is a necessary component of colonialist discourse, as it justifies domination and masks the colonizer's fear of the inability to always already know the Other.[8] Our experiences in the cage suggested that even though the idea that America is a colonial system is met with resistance – since it contradicts the dominant ideology's presentation of our system as a democracy – the audience reactions indicated that colonialist roles have been internalized quite effectively.

The stereotypes about nonwhite people that were continuously reinforced by the ethnographic displays are still alive in high culture and the mass media. Imbedded in the unconscious, these images form the basis of the fears, desires, fantasies about the cultural Other. In "The Negro and Psychopathology," Frantz Fanon discusses a critical stage in the development of children socialized in Western culture, regardless of their race, in which racist stereotypes of the savage and the primitive are assimilated through the consumption of popular culture: comics, movies, cartoons, and so forth.[9] These stereotypical images are often part of myths of colonial dominion (for example, cowboy defeats Indian, conquistador triumphs over Aztec Empire, colonial soldier conquers African chief, and so on). This dynamic also contains a sexual dimension, usually expressed as anxiety about white male (omni)potence. In *Prospero and Caliban: The Psychology of Colonization*, Octave Mannoni coined the term "Prospero complex" to describe the white colonial patriarch's continuous fear that his daughter might be raped by a nonwhite male.[10] Several colonial stereotypes also nurture these anxieties, usually representing a white woman whose "purity" is endangered by black men with oversized genitals, or suave Latin lovers, or wild-eyed Indian warriors; and the common practice of publicly lynching black men in the American South is an example of a ritualized white male response to such fears. Accompanying these stereotypes are counterparts that humiliate and debase women of color, mitigating anxieties about sexual rivalry between white and nonwhite women. In the past, there was the subservient maid and the overweight and sexless Mammy; nowadays, the hapless victim of a brutish or irrational dark male whose tradition is devoid of "feminist freedoms" is more common.

[. . .]

While the human exhibition exists in more benign forms today – that is, the people in them are not displayed against their will – the desire to look upon predictable forms of Otherness from a safe distance persists. I suspect after my experience in the cage that this desire is powerful enough to allow audiences to dismiss the possibility of self-conscious irony in the Other's self-presentation; even those who saw our performance as art rather than artifact appeared to take great pleasure in engaging in the fiction, by paying money to see us enact completely nonsensical or humiliating tasks. A middle-aged man who attended the Whitney Biennial opening with his elegantly dressed wife insisting on feeding me a banana. The zoo guard told him he would have to pay $10 to do so, which he quickly paid, insisting that he be photographed in the act. After the initial surprise of encountering caged beings, audiences invariably revealed their familiarity with the scenario to which we alluded.

We did not anticipate that our self-conscious commentary on this practice could be believable.

[. . .]

In Spain there were many complaints that our skin was not dark enough for us to be "real" primitives. The zoo guards responded by explaining that we live in a rain forest without must exposure to the sun. At the Whitney, a handful of older women also complained that we were too light-skinned, one saying that the piece would only be effective if we were "really dark." These doubts, however, did not stop many from taking advantage of our apparent inability to understand European languages; many men in Spain made highly charged sexual comments about my body, coaxing others to add more money to the donation box to see my breasts move as I danced. I was also asked out on dates a few times in London. Many other people chose a more discreet way of expressing their sexual curiosity, by asking the zoo guards if we mated in public in the cage. Gómez-Peña found the experience of being continually objectified more difficult to tolerate than I did. By the end of our first three days in Madrid, we began to realize not only that people's assumptions about us were based upon gender stereotypes, but that my experiences as a woman had prepared me to shield myself psychologically from the violence of public objectification.

I may have been more prepared, but during the performances, we both were faced with sexual challenges that transgressed our physical and emotional boundaries. In the cage we were both objectified, in a sense, feminized, inviting both male and female spectators to take on a voyeuristic relationship to us. This might explain why women as well as men acted upon what appears to be the erotic attraction of a caged primitive male. In Sydney, our sponsoring institution, the Australian Museum of Natural History, was approached by a female reporter from a soft-porn magazine who wanted to do a photo spread in which she would appear topless, feeding us bananas and watermelon. She was refused by the museum publicist. Interestingly, women were consistently more physical in their reactions, while men were more verbally abusive. In Irvine, a white woman asked for plastic gloves to be able to touch the male specimen, began to stroke his legs, and soon moved toward his crotch. He stepped back, and the woman stopped – but she returned that evening, eager to discuss our feelings about her gesture. In Chicago, another woman came up to the cage, grabbed his head and kissed him. Gómez-Peña's ex-wife had lawsuit papers delivered to him while we were in the cage at Irvine, and subsequently appeared in a mask and bizarre costume with a video camera and proceeded to tape us for over an hour. While men taunted me, talked dirty, asked me out, and even blew kisses, not one attempted physical contact in any of our performances.

As I presented this "reverse ethnography" around the country, people invariably asked me how I felt inside the cage. I experienced a range of feelings from panic to boredom. I felt exhilarated, and even playful at times. I've also fallen asleep from the hot sun and been irritable because of hunger or cold. I've been ill, and once had to be removed from the cage to avoid vomiting in front of the crowd. The presence of supportive friends was reassuring, but the more aggressive reactions became less and less surprising. The night before we began in Madrid, I lay awake in bed, overcome with fear that some demented phalangist might pull a gun on us and shoot before we could escape. When nothing of that sort happened, I calmed down and never worried about our safety again. I have to admit that I liked watching people on the other side of the bars. The more we performed, the more I concentrated on the audience, while trying to feign the complete bewilderment of an outsider. Although I loved the intentional nontheatricality of this work, I became increasingly aware of how engaging in

certain activities can trigger audience reactions, and acted on that realization to test our spectators. Over the course of the year, I grew fond of the extremists who verbalized their feelings and interacted with us physically, regardless of whether they were hostile or friendly. It seemed to me that they had a certain braveness, even courage, that I don't know I would have in their place. When we came upon Tiny Teesha in Minnesota, I was dumbstruck at first. Not even my own performance had prepared me for the sadness I saw in her eyes, or my own ensuing sense of shame.

One memory in particular came to the forefront of my mind as we traveled with this performance. It involved an encounter I had over a decade ago, when I was finishing college in Rhode Island, where I had studied film theory. I had met an internationally known French ethnographic filmmaker in his sixties at a seminar he was giving, and told him I planned to spend time in France after graduation. A year later, I received a phone call from him while I was in Paris. He had found me with the help of a student from my alma mater. He told me he was going to begin production on a feature and might be able to offer me a job. After having spent part of the summer as a translator-salesgirl at a department store, I was excited by the prospect of film-related work. We arranged to meet to discuss his project.

Even though we were conversing in a language I had not mastered, it didn't take long for me to sense that the filmmaker's interests might be more than professional. I was not exactly prepared to deal with sexual advances from a man who could have been my grandfather. I thought I had protected myself by arranging to meet in a public place, but he soon explained that we had to leave the cafe to meet with the producers for a reading of the script. After fifteen minutes in his car, I began to suspect that there was no meeting planned. We eventually arrived at what looked like an abandoned house in a rural area, without another soul in sight. He proudly announced that this was the house he had grown up in and that he wanted to show it to me. I was by this time in a mild state of shock, furiously trying to figure out where I was and how to get away safely.

The filmmaker proceeded to go into a shed next to the house and remove all his clothes except his underwear. He emerged with a manual lawn mower and went to work on his garden. At one point he ran up to me and exclaimed that he wished he could film me naked there; I did not respond. At another point, he handed me a basket and told me to gather nuts and berries. While my anger mounted, my fears slowly subsided as I realized that he was deeply immersed in his own fantasy world, so self-involved that he hardly needed my participation. I waited for him to finish his playacting, and then told him to take me to the closest train station, which he did, but not without grabbing me and ripping my shirt as I got out of his car.

I got back to my apartment safely. I was not physically harmed, but I was profoundly disturbed by what I had witnessed. The ethnographic filmmaker whose fame rested on his depictions of "traditional" African societies had projected his racist fantasies onto me for his own pleasure. What I thought I was, how I saw myself – that was irrelevant. Never had I seen so clearly what my physical presence could spark in the imagination of an aging colonialist pervert.

The memory of that ethnographic filmmaker's gaze haunted me for years, to the point that I began to wonder if I had become paranoid. But I, having watched behavior only slightly more discreet than his from behind the bars of our cage, can reassure myself that I am not. Those are the moments when I am glad that there are real bars. Those are also the times when, even though I know I can get out of the cage, I can never quite escape.

AMERINDIANS: 1) *A mythical people of the Far East, connected in legendary history with Seneca and Amerigo Vespucci.*

Although the term Amerindian suggests that they were the original inhabitants of this continent, the oldest authorities (e.g., Christopher Columbus in his diaries, and more recently, Paul Rivette) regarded them as Asian immigrants, not Americans. Other explanations suggested are *arborindians*, "tree people," and *amerindians*, "brown people." The most that can be said is that *amerindians* may be the name of an indigenous American stock that the ancients knew no more about than ourselves.

AMERINDIANS: 2) One of the many English terms for the people of Guatinau. In their language, the Guatinaui people's word for themselves signifies "outrageously beautiful" or "fiercely independent." They are a jovial and playful race, with a genuine affection for the debris of Western industrialized popular culture. In former times, however, they committed frequent raids on Spanish ships, disguised as British pirates, whence comes their familiarity with European culture. Contemporary Guatinauis have only recently begun to travel outside their island.

The male and female specimens here on display are representatives of the dominant tribe from their island, having descended from the Mintomani stock. The male weighs seventy-two kilos, measures 1.77 meters, and is approximately thirty-seven years of age. He likes spicy food, burritos, and Diet Coke, and his favorite cigarette brand is Marlboro. His frequent pacing in the cage leads experts to believe that he was a political leader on his island.

The female weighs sixty three kilos, measures 1.74 metres, and appears to be in her early thirties. She is fond of sandwiches, pad thai, and herb tea. She is a versatile dancer, and also enjoys showing off her domestic talents by sewing voodoo dolls, serving cocktails, and massaging her male partner. Her facial and body decorations indicate that she has married into the upper caste of her tribe.

Both of the Guatinauis are quite affectionate in the cage, seemingly uninhibited in their physical and sexual habits despite the presence of an audience. Their animist spirituality compels them to engage in periodic gestural prayers, which they do with great enthusiasm. They like to massage and scratch each other, enjoy occasional long embraces, and initiate sexual intercourse on the average of twice a day.

Anthropologists at the Smithsonian observed (with the help of surveillance cameras) that the Guatinauis enjoy gender role playing together after dark, transforming many of their functional objects in the cage into makeshift sex toys by night. Visitors who get close to them will note that they often seek to fondle strangers while posing for photographs. They are extremely demonstrative with children.

[. . .]

Notes

1 Franz Kafka, *The Basic Kafka* (New York: Washington Square Press, 1979), 245.
2 Robert Rydell, *All the World's a Fair, Visions of Empire at American International Exhibitions, 1876–1916* (Chicago: University of Chicago Press, 1984).
3 Richard D. Altwick, *The Shows of London* (Cambridge, Mass.: Belknap Press, 1978).
4 Tristan Tzara, *Seven Dada Manifestors and Lampisteries*, trans. Barbara Wright (London: J. Calder, 1992), 57–58.
5 James Clifford, *The Predicament of Culture* (Cambridge, Mass.: Harvard University Press, 1988).
6 Jerome Rothenberg, "New Models, New Visions: Some Notes Towards a Poetics of Performance," in *Performance in Postmodern Culture*, ed. Michel Benamou and Charles Caramello (Madison, Wisconsin: Coda Press, 1977), 15.

7 Ibid.
8 Homi Bhabha, "The Other Question: Difference, Discrimination and the Discourse of Colonialism," in *Out There: Marginalization and Contemporary Culture*, ed. Russell Ferguson, Martha Gever, Trinh T. Minh-ha, and Cornel West (Cambridge, Mass.: MIT Press, 1990), 71–88.
9 Frantz Fanon, "The Negro and Psychopathology," in *Black Skin, White Masks*, trans. Charles Lam Markmann (New York: Grove Press, 1967), 141–209.
10 Octave Mannoni, *Prospero and Caliban: The Psychology of Colonization*, trans. Pamela Powesland (Ann Arbor: University of Michigan Press, 1990).

Chapter 25

JOSÉ ESTEBAN MUÑOZ

"THE WHITE TO BE ANGRY"
Vaginal Creme Davis's terrorist drag

THE YEAR 1980 SAW THE DEBUT of one of the L.A. punk scene's most critically acclaimed albums, the band X's *Los Angeles*. X was fronted by John Doe and Exene Cervenka, who were described by one writer as "poetry workshop types,"[1] who had recently migrated to Los Angeles from the East Coast. They used the occasion of their first album to describe the effect that city had on its white denizens. The album's title track, "Los Angeles," narrates the story of a white female protagonist who had to leave Los Angeles because she started to hate "every nigger and Jew, every Mexican who gave her a lot of shit, every homosexual and the idle rich." Today, the song reads for me like a fairly standard tale of white flight from the multiethnic metropolis. Yet, I would be kidding myself if I pretended to have had access to such a reading back then, for I had no contexts or reading skills for any such interpretation.

When I contemplate these lyrics today, I am left with a disturbed feeling. When I was a teenager growing up in South Florida, X occupied the hallowed position of favorite band. When I attempt to situate my relation to this song and my own developmental history, I remember what X meant to me back then. Within the hermetic Cuban-American community I came of age in, punk rock was not yet the almost routine route of individuation and resistance that it is today. Back then it was the only avant-garde that I knew; it was the only cultural critique of normative aesthetics available to me. Yet, there was a way in which I was able to escape the song's interpellating call. Although queerness was already a powerful polarity in my life and the hissing pronunciation of "Mexican" that the song produced felt very much like the epithet "spic" that I had a great deal of experience with, I somehow found a way to resist these identifications. The luxury of hindsight lets me understand that I needed X and the possibility of subculture they promised at that moment to withstand the identity-eroding

Figure 25.1 Vaginal Davis as the Bad Seed. Photo by Rick Castro.

effects of normativity. I was thus able to enact a certain misrecognition that let me imagine myself as something other than queer or racialized. But such a misrecognition takes a certain toll. The toll is one that subjects who attempt to identify with and assimilate to dominant ideologies pay every day of their lives. The price of the ticket is this: to find self within the dominant public sphere, we need to deny self. The contradictory subjectivity one is left with is not just the fragmentary subjectivity of some unspecified postmodern condition; it is instead the story of the minoritarian subject within the majoritarian public sphere. Fortunately, this story does not end at this difficult point, this juncture of painful contradiction. Sometimes

misrecognition can be *tactical*. Identification itself can also be manipulated and worked in ways that promise narratives of self that surpass the limits prescribed by the dominant culture.

In this chapter, I will discuss the cultural work of an artist who came of age within the very same L.A. punk scene that produced X. The L.A. punk scene worked very hard to whitewash and straighten its image. Although many people of color and queers were part of this cultural movement, they often remained closeted in the scene's early days. The artist whose work I will be discussing came of age in that scene and managed to resist its white-washing and heteronormative protocols.

The work of drag superstar Vaginal Creme Davis, or, as she sometimes prefers to be called, Dr Davis, spans several cultural production genres. It also appropriates, terroristic-ally, both dominant culture and different subcultural movements. Davis first rose to prominence in the Los Angeles punk scene through her infamous 'zine *Fertile La Toyah Jackson* and her performances at punk shows with her Supremes-like backup singers, the Afro Sisters. *Fertile La Toyah Jackson*'s first incarnation was as a print 'zine that presented scandalous celebrity gossip. The 'zine was reminiscent of *Hollywood Babylon*, Kenneth Anger's two-volume tell-all history of the movie industry and the star system's degeneracy. The hand-stapled 'zine even-tually evolved into a video magazine. At the same time, as the 'zine became a global subcultural happening, Davis's performances in and around the L.A. punk scene, with the Afro Sisters and solo, became semilegendary. She went on to translate her performance madness to video, starring in various productions that include *Dot* (1994), her tribute to Dorothy Parker's acerbic wit and alcoholism, *VooDoo Williamson – The Doña of Dance* (1995), her celebration of modern dance and its doyennes, and *Designy Living* (1995), a tribute to Noël Coward's *Design for Living* and Jean-Luc Godard's *Masculin et féminin*.

According to Davis's own self-generated legend, her existence is the result of an illicit encounter between her then forty-five-year-old African-American mother and her father, who was, at the time, a twenty-one-year-old Mexican-American. Davis has often reported that her parents only met once, when she was conceived under a table during a Ray Charles concert at the Hollywood Palladium in the early 1960s.

Although the work with the Afro Sisters and much of her 'zine work deals with issues of blackness, she explores her Chicana heritage with one of her musical groups, ¡Cholita! – a band that is billed as the female Menudo. This band consists of both men and women in teenage Chicana drag who sing Latin American bubblegum pop songs with titles like "Chicas de hoy" (Girls of today). ¡Cholita! and Davis's other bands all produce socially interrogative performances that complicate any easy understanding of race or ethnicity within the social matrix. Performance is used by these theatrical musical groups to, borrowing a phrase from George Lipsitz, "rehearse identities"[2] that have been rendered toxic within the dominant public sphere but are, through Davis's fantastic and farcical performance, restructured (yet not cleansed) so that they present newly imagined notions of the self and the social. This chapter focuses on the performance work done through *The White to Be Angry*, a live show and a CD produced by one of Davis's other subculturally acclaimed musical groups, Pedro, Muriel, and Esther. (Often referred to as PME, the band is named after a cross section of people that Davis met when waiting for the bus. Pedro was a young Latino who worked at a fast-food chain and Muriel and Esther were two senior citizens.) This chapter's first section will consider both the compact disc and the live performance. The next section interrogates questions of "passing," and its specific relation to what I am calling the cultural politics of *disidentification*. I will pursue this thread, "passing," in relation to both mainstream drag and a queerer modality of performance that I call Davis's "terrorist drag." The final section considers Davis's relation to the discourse of "antigay."

Who's that girl?

Disidentification is a performative mode of tactical recognition that various minoritarian subjects employ in an effort to resist the oppressive and normalizing discourse of dominant ideology. Disidentification resists the interpellating call of ideology that fixes a subject within the state power apparatus. It is a reformatting of self within the social. It is a third term that resists the binary of identification and counteridentification. Counteridentification often, through the very routinized workings of its denouncement of dominant discourse, reinstates that same discourse. In an interview in the magazine *aRude*, Davis offers one of the most lucid explications of a modality of performance that I call disidentificatory. Davis responds to the question "How did you acquire the name Vaginal Davis?" with a particularly elucidating rant:

> It came from Angela Davis – I named myself as a salute to her because I was really into the whole late '60's and early '70's militant Black era. When you come home from the inner city and you're black you go through a stage when you try to fit the dominant culture, you kinda want to be white at first – it would be easier if you were white. Everything that's negrified or black – you don't want to be associated with that. That's what I call the snow period – I just felt like if I had some cheap white boyfriend, my life could be perfect and I could be some treasured thing. I could feel myself projected through some white person, and have all the privileges that white people get – validation through association.[3]

The "snow period" Davis describes corresponds to the assimilationist option that minoritarian subjects often choose. Although sanctioned and encouraged by the dominant culture, the "snow period" is not a viable option for people of color. More often than not, for the person of color, snow melts in the hands of the subject who attempts to acquire privilege through associations (be they erotic, emotional, or both) with whites. Davis goes on to describe her next phase.

> Then there was a conscious shift, being that I was the first one in my family to go to college – I got militant. That's when I started reading about Angela and the Panthers, and that's when Vaginal emerged as a filtering of Angela through humor. That led to my early 1980's a capella performance entity, Vaginal Davis and the Afro Sisters (who were two white girls with Afro wigs). We did a show called "we're taking over" where we portrayed the Sexualese Liberation Front which decides to kidnap all the heads of white corporate America so we could put big black dildos up their lily white buttholes and hold them for ransom. It really freaked out a lot of the middle-class post-punk crowd – they didn't get the campy element of it but I didn't really care.[4]

Thus the punk-rock drag diva elucidates a stage or temporal space where the person of color's consciousness turns to her or his community after an immersion in white culture and education. The ultramilitant phase that Davis describes is typically a powerful counteridentification with the dominant culture. At the same time, though, Davis's queer sexuality, her queerness *and* effeminacy, kept her from fully accessing Black Power militancy. Unable to pass as heterosexual black militant through simple counteridentification, Vaginal Davis instead disidentified with Black Power by selecting Angela and *not* the Panthers as a site of self-fashioning and political formation. Davis's deployment of disidentification demonstrates that it is, to employ Kimberlé William Creshaw's term, an *intersectional strategy*.[5] Intersectionality insists on critical

hermeneutics that register the copresence of sexuality, race, class, gender, and other identity differentials as particular components that exist simultaneously with one another. Vintage Black Power discourse contained many homophobic and masculinist elements that were toxic to queer and feminist subjects. Davis used parody and pastiche to remake Black Power, opening it up via disidentification to a self that is simultaneously black and queer. (With her group ¡Cholita! she performs a similar disidentification with Latina/o popular culture. As Graciela Grejalva, she is not an oversexed songstress, but instead a teenage Latina singing sappy bubblegum pop.)

Davis productively extends her disidentificatory strategy to her engagement with the performative practice of drag. With the advent of the mass commercialisation of drag evident in suburban multiplexes that program such films as *To Wong Foo, Thanks for Everything! Julie Newmar* and *The Bird Cage*, or VH-1's broadcasts of RuPaul's talk show, it seems especially important at this point to distinguish different modalities of drag. Commercial drag presents a sanitized and desexualized queer subject for mass consumption. Such drag represents a certain strand of integrationist liberal pluralism. The sanitized queen is meant to be enjoyed as an entertainer who will hopefully lead to social understanding and tolerance. Unfortunately, this boom in filmic and televisual drag has had no impact on hate legislation put forth by the New Right or on homophobic violence on the nation's streets. Indeed, this "boom" in drag helps one understand that a liberal-pluralist mode of political strategizing only eventuates a certain absorption and nothing like a productive engagement with difference. Thus, although RuPaul, for example, hosts a talk show on VH-1, one only need click the remote control and hear about new defenses of marriage legislation that "protect" the family by outlawing gay marriage. Indeed, the erosion of gay civil rights is simultaneous with the advent of higher degrees of queer visibility in the mainstream media.

But while corporate-sponsored drag has to some degree become incorporated within the dominant culture, there is also a queerer modality of drag that is performed by queer-identified drag artists in spaces of queer consumption. Félix Guattari, in a discussion of the theatrical group the Mirabelles, explains the potential political power of drag:

> The Mirabelles are experimenting with a new type of militant theater, a theater separate from an explanatory language and long tirades of good intentions, for example, on gay liberation. They resort to drag, song, mime, dance, etc., not as different ways of illustrating a theme, to "change the ideas" of spectators, but in order to trouble them, to stir up uncertain desire-zones that they always more or less refuse to explore. The question is no longer to know whether one will play feminine against masculine or the reverse, but to make bodies, all bodies, break away from the representations and restraints on the "social body."[6]

Guattari's take on the Mirabelles, specifically his appraisal of the political performance of drag, assists in the project of further evaluating the effects of queer drag. I do not simply want to assign one set of drag strategies and practices the title of "bad" drag and the other "good." But I do wish to emphasize the ways in which Davis's *terroristic drag* "stirs up desires" and enables subjects to imagine a way of "break[ing] away from the restraint of the 'social body,'" while sanitized corporate drag and even traditional gay drag are unable to achieve such effects. Davis's political drag is about creating an uneasiness, an uneasiness in desire, which works to confound and subvert the social fabric. The "social body" that Guattari discusses is amazingly elastic and it is able to accommodate scripts on gay liberation. Drag like Davis's, however, is not easily enfolded in that social fabric because of the complexity of its intersectional nature.

There is a great diversity within drag performance. Julian Fleisher's *The Drag Queens of New York: An Illustrated Field Guide to Drag*, surveys underground drag and differentiates two dominant styles of drag, "glamour" and "clown."[7] New York drag queens such as Candis Cayne or Girlina, whose drag is relatively "real," rate high on the glamour meter.[8] Other queens, such as Varla Jean Merman (who bills herself as the love child of Ethel Merman and Ernest Borgnine) and Miss Understood, are representative of the over-the-top parody style of drag known as "clown." Many famous queens, such as Wigstock impresario and mad genius The "Lady" Bunny, appear squarely in the middle of Fleisher's scale.[9] On first glance, Vaginal, who is in no way invoking glamour or "realness," and most certainly does not *pass* (in a direct sense of the word), seems to be on the side of clown drag. I want to complicate this system of evaluation and attempt a more nuanced appraisal of Vaginal Davis's style.

Vaginal Davis's drag, while comic and even hilarious, should not be dismissed as just clowning around. Her uses of humor and parody function as disidentificatory strategies whose effect on the dominant public sphere is that of a counterpublic terrorism. At the center of all of Davis's cultural productions is a radical impulse toward cultural critique. It is a critique that, according to the artist, has often escaped two groups who compose some of drag's most avid supporters: academics and other drag queens.

> I was parodying a lot of different things. But it wasn't an intellectual type of thing
> – it was innate. A lot of academics and intellectuals dismissed it because it wasn't
> smart enough – it was too homey, a little too country. And gay drag queens hated
> me. They didn't understand it. I wasn't really trying to alter myself to look like a
> real woman. I didn't wear false eyelashes or fake breasts. It wasn't about the real-
> ness of traditional drag – the perfect flawless makeup. I just put on a little lipstick,
> a little eye shadow and a wig and went out there.[10]

It is the "innateness," and "homeyness," and the "countryness" of Davis's style that draws this particular academic to the artist's work. I understand these characteristics as components of the artist's guerrilla style, a style that functions as a ground-level cultural terrorism that fiercely skewers both straight culture and reactionary components of gay culture. I would also like to link these key words, *innateness, homeyness,* and *countryness,* that Vaginal calls on, with a key word from the work of Antonio Gramsci that seems to be a partial cognate of these other terms: *organic.*

Gramsci attempted to both demystify the role of the intellectual and reassert the signifi-cance of the intellectual's role to a social movement. He explained that "Every social group, coming into existence on the original terrain of an essential function, creates together with itself, organically, one or more strata of intellectuals which give it homogeneity and an aware-ness of its own function not only in the economic but also in the social and political fields."[11] Davis certainly worked to bolster and cohere the L.A. punk scene, giving it a more signifi-cant "homogeneity" and "awareness."[12] At the same time, her work constituted a critique of that community's whiteness. In this way, it participated in Gramsci's project of extending the scope of Marxist analysis to look beyond class as the ultimate social division and consider *blocs.* Blocs are, in the words of John Fiske, "alliance[s] of social forces formed to promote common social interests as they can be brought together in particular historical conditions."[13] The Gramscian notion of bloc formation emphasizes the centrality of class relations in any critical analysis, while not diminishing the importance of other cultural struggles. In the life-world of mostly straight white punks, Davis had, as a black gay man, a strongly disidentifica-tory role within that community. I suggest that her disidentifications with social blocs are

Figure 25.2 Vaginal Davis. Photo by Rick Castro.

productive interventions in which politics are destabilized, permitting her to come into the role of "organic intellectual." Vaginal Davis did and did not belong to the scene but nonetheless did forge a place for herself that is not *a* place, but instead the still important *position* of intellectual.

[. . .]

"Queerness" and "blackness" need to be read as ideological discourses that contain contradictory impulses within them – some liberatory, others reactionary. These discourses also require hermeneutics that appraise the intersectional and differential crosscutting currents with individual ideological scripts. Davis's work is positioned at a point of intersection between various discourses (where they are woven together), and from this point she is able to enact a parodic and comedic demystification; the potential for subversion is planted.

Disidentification, as a mode of analysis, registers subjects as constructed and contradictory. Davis's body, her performances, all her myriad texts, labor to create critical uneasiness,

and, furthermore, to create desire within uneasiness. This desire unsettles the strictures of class, race, and gender prescribed by what Guattari calls the "social body." A disidentificatory hermeneutic permits a reading and narration of the way in which Davis clears out a space, deterritorializing it and then reoccupying it with queer and black bodies. The lens of disidentification allows us to discern seams and contradictions and ultimately understand the need for a war of positions.

Notes

1 Barney Hoskyns, *Waiting for the Sun: Strange Days, Weird Scenes and the Sound of Los Angeles* (New York: St. Martin's Press, 1996), p. 307.
2 George Lipsitz, *Dangerous Crossings: Popular Music, Postmodernism and the Poetics of Space* (New York and London: Verso, 1994), p. 17.
3 Tommy Gear and Mike Glass, "Supremely Vaginal," *aRude* 1:2 (Fall 1995): 42.
4 Ibid.
5 Kimberlé William Crenshaw, "Beyond Racism and Misogyny: Black Feminism and 2 Live Crew," in *Words That Wound: Critical Race Theory, Assaultive Speech, and the First Amendment*, ed. Mari J. Matsuda et al. (Boulder, Colo.: Westview Press, 1993), pp. 111–32.
6 Félix Guattari, *Soft Subversions*, ed. Sylvère Lotringer, trans. David L. Sweet and Chet Wiener (New York: Semiotext[e], 1996), p. 37.
7 Julian Fleisher, *The Drag Queens of New York: An Illustrated Field Guide to Drag* (New York: Riverhead Books, 1996).
8 "Realness" is mimetic of a certain high-feminine style in standard realist terms.
9 Many of the performers I have just mentioned appear in the film documentation of New York's annual drag festival, *Wigstock: The Movie*.
10 Gear and Glass, "Supremely Vaginal," p. 77.
11 Antonio Gramsci, "The Formation of Intellectuals," in *The Modern Prince and Other Writings*, trans. Louis Marks (New York: International Publishers, 1959), p. 181.
12 Here I do not mean homogeneity in its more quotidian usage, the opposite of heterogeneous, but instead in a Gramscian sense that is meant to connote social cohesion.
13 John Fiske, "Opening the Hallway: Some Remarks on the Fertility of Stuart Hall's Contribution to Critical Theory," in *Stuart Hall: Critical Dialogues in Cultural Studies*, ed. David Morley and Kuan-Hsing Chen (New York: Routledge, 1996), pp. 213–14. Also, for an analysis that uses what is in part a Gramscian lens to consider group formations, see Dick Hebdige's classic analysis of subcultures, *Subculture: The Meaning of Style* (London: Routledge, 1979).

PART FOUR

Disciplines/Strategies

F ROM THE BEGINNING OF SECOND WAVE feminism, institutional critiques
accompanied the semiotic analysis of images and texts. Hence, the section "Disciplines/
Strategies" includes a number of essays across visually oriented disciplines – each of which
critically examines dominant disciplinary structures or offers suggestions for interventionist
strategies of making or interpreting that aim to dismantle such structures. All of these essays
critique previous "ways of seeing," as Berger would put it, while also offering new models for
understanding the relations sustained between viewing subjects and their institutional environ-
ments. While Linda Nochlin (Chapter 26) – in an epochal 1971 essay that jump-started the
feminist critique of the notion of the "great artist" – Adrian Piper (Chapter 28), Mira Schor
(Chapter 29), and Irit Rogoff (Chapter 31) intervene specifically in the disciplinary logic of art
history and criticism, pointing to its lacunae and excavating its patriarchal and racial biases; the
other essays in this section address film studies (Camera Obscura Collective [Chapter 27]) and
architecture (Patricia Morton [Chapter 32]).

Piper mounts an extended attack on the art world for excluding and denigrating the work
of "colored women artists," while Schor, a founding member of the early 1970s' Southern
Californian Feminist Art Program and a practicing artist as well as writer, explicitly addresses
the tendency in art history and criticism to position women, as well as men, artists within a
"patrilineage" – a strategy that legitimates male artists at the expense of important female
artistic influences. Rogoff intervenes in traditional art history by proposing to introduce gossip
into the art historical record as a means of "destabilizing the historiography of Modernism";
the overt acknowledgment of gossip as a kind of historical "evidence" parallels the integra-
tion of, as she puts it, "mass and popular culture into the study of high and privileged culture."
Both incursions have important political effects that support the feminist desire to intervene
in canonical narratives of visual culture history, narratives whose insidious effects were earlier
explored by scholars such as Griselda Pollock (1980).

The Camera Obscura Collective piece, written collectively by Janet Bergstrom, Sandy
Flitterman-Lewis, Elizabeth Hart Lyon, and Constance Penley for the founding issue of the
important feminist film journal *Camera Obscura*, articulates a precise polemic for addressing
the oppression of women through "the very forms of reasoning, signifying and symbolical
exchange of our culture." This articulation points to the extreme usefulness of the insights

of semiotics, where the "forms" rather than simply the message of a cultural text or image were understood to convey ideological effects.

Patricia Morton offers a rigorous and specific disciplinary argument. Morton addresses architectural practice and theory, which are often produced by the same creative thinkers, and traces a brief trajectory of feminist thought in this overlapping arena as well as examining the institutional oppressions that constrain feminists working in the field of architecture. Alternatively, Hélène Cixous's (Chapter 30) feminist intervention is a writerly one. Cixous, an Algerian-French feminist poet, playwright, and theorist and one of the best known of the highly influential "French Feminists" and the key articulator of the notion of "écriture feminine" (feminine writing) here adopts this strategy, writing in a poetic, and specifically non-academic style (thus "feminizing" the authoritarianism of conventional art historical language). Cixous interprets Rembrandt's images in a highly charged embodied exchange, refusing the kind of "critical distance" argued to be necessary for an "objective" critical analysis in traditional art history.

The disciplinary critiques and strategies of intervention articulated by these essays mark a crucial aspect of the feminist intersection with visual culture and its histories. As these writers clearly recognize, it is only through such interventions that new modes of thinking – and seeing – can be effectively developed.

References and further reading

Barzman, Karen-Edis. "Beyond the Canon: Feminists, Postmodernism, and the History of Art." *The Journal of Aesthetics and Art Criticism* 52, n. 3 (Summer 1994).

Berger, John. *Ways of Seeing*. Harmondsworth: Penguin Books and London: BBC, 1972.

Brunsdon, Charlotte, D'Acci, Julie and Spigel, Lynn, eds. *Feminist Television Criticism: A Reader*. Oxford: Oxford University Press, 1997.

Coleman, Debra, Danze, Elizabeth and Henderson, Carol, eds. *Architecture and Feminism*. Princeton: Princeton Architectural Press, 1996.

Colomina, Beatriz, ed. *Sexuality and Space*. Princeton: Princeton Architectural Press, 1992.

Deepwell, Katy, ed. *New Feminist Art Criticism: Critical Strategies*. Manchester and New York: Manchester University Press, 1995.

Duncan, Carol. *The Aesthetics of Power: Essays in Critical Art History*. Cambridge and New York: Cambridge University Press, 1993.

Erens, Patricia, ed. *Issues in Feminist Film Criticism*. Bloomington: Indiana University Press, 1990.

Erlemann, Christiane. "What is Feminist Architecture?" (1983), tr. Harriet Anderson. *Feminist Aesthetics*. Gisela Ecker, ed. Boston: Beacon Press, 1983.

Foster, Susan Leigh, ed. *Corporealities: Dancing, Knowledge, Culture, and Power*. London: New York: Routledge, 1996.

Gouma-Peterson, Thalia and Mathews, Patricia. "The Feminist Critique of Art History." *The Art Bulletin* 69, n. 3 (September 1987).

Haralovich, Mary Beth and Rabinovitz, Lauren, eds. *Television, History, and American Culture: Feminist Critical Essays*. Durham, North Carolina: Duke University Press, 1999.

Hart, Lynda and Phelan, Peggy, eds. *Acting out: Feminist Performances*. Ann Arbor: University of Michigan Press, 1993.

Johnstone, Claire. "The Subject of Feminist Film Theory/Practice." *Screen* 21, n. 2 (1980).

Kelly, Mary. "Re-Viewing Modernist Criticism" (1981). *Imaging Desire*. Cambridge, Massachusetts: MIT Press, 1996.

Mavor, Carol. *Becoming: The Photographs of Clementina, Viscountess Hawarden*. Durham: Duke University Press, 1999.

Nead, Lynda. "Feminism, Art History and Cultural Politics." *The New Art History*, A.L. Rees, Frances Borzello, eds. Atlantic Highlands, New Jersey: Humanities Press, International, 1988.

Partington, Angela. "Feminist Art and Avant-Garde." *Visibly Female/Feminism and Art: An Anthology*, Hilary Robinson, ed. New York: Universe Books, 1988.

Pollock, Griselda. "Artists Mythologies and Media Genius, Madness and Art History." *Screen* 21, n. 3 (1980).

Pollock, Griselda, ed. *Generations and Geographies in the Visual Arts: Feminist Readings*. London and New York: Routledge, 1996.

Shapiro, Sherry B., ed. *Dance, Power and Difference: Critical and Feminist Perspectives on Dance Education*. Champaign, IL: Human Kinetics Publications, 1998.

Salomon, Nanette. "The Art Historical Canon: Sins of Omission." *(En)Gendering Knowledge: Feminists in Academe*. Joan Harman and Ellen Messer-Davidow, eds. Knoxville: University of Tennessee Press, 1991.

Thornham, Sue, ed. *Feminist Film Theory: A Reader*. New York: New York University Press, 1999.

Tickner, Lisa. "Feminism, Art History, and Sexual Difference." *Genders* 3 (Fall 1988).

LINDA NOCHLIN

WHY HAVE THERE BEEN NO GREAT WOMEN ARTISTS?

WHILE THE RECENT UPSURGE OF FEMINIST activity in this country has indeed been a liberating one, its force has been chiefly emotional – personal, psychological, and subjective – centered, like the other radical movements to which it is related, on the present and its immediate needs, rather than on historical analysis of the basic intellectual issues which the feminist attack on the status quo automatically raises.[1] Like any revolution, however, the feminist one ultimately must come to grips with the intellectual and ideological basis of the various intellectual or scholarly disciplines – history, philosophy, sociology, psychology, etc. – in the same way that it questions the ideologies of present social institutions. If, as John Stuart Mill suggested, we tend to accept whatever *is* as natural, this is just as true in the realm of academic investigation as it is in our social arrangements. In the former, too, "natural" assumptions must be questioned and the mythic basis of much so-called fact brought to light. And it is here that the very position of woman as an acknowledged outsider, the maverick "she" instead of the presumably neutral "one" – in reality the white-male-position-accepted-as-natural, or the hidden "he" as the subject of all scholarly predicates – is a decided advantage, rather than merely a hindrance or a subjective distortion.

In the field of art history, the white Western male viewpoint, unconsciously accepted as *the* viewpoint of the art historian, may – and does – prove to be inadequate not merely on moral and ethical grounds, or because it is elitist, but on purely intellectual ones. In revealing the failure of much academic art history, and a great deal of history in general, to take account of the unacknowledged value system, the very *presence* of an intruding subject in historical investigation, the feminist critique at the same time lays bare its conceptual smugness, its meta-historical naïveté. At a moment when all disciplines are becoming more self-conscious, more aware of the nature of their presuppositions as exhibited in the very languages and structures of the various fields of scholarship, such uncritical acceptance of "what is" as "natural" may be intellectually fatal. Just as Mill saw male domination as one of a long series of social injustices that had to be overcome if a truly just social order were to be created, so we may see the unstated domination of white male subjectivity as one in a series of intellectual distortions which must be corrected in order to achieve a more adequate and accurate view of historical situations.

It is the engaged feminist intellect (like John Stuart Mill's) that can pierce through the cultural-ideological limitations of the time and its specific "professionalism" to reveal biases and inadequacies not merely in dealing with the question of women, but in the very way of formulating the crucial questions of the discipline as a whole. Thus, the so-called woman question, far from being a minor, peripheral, and laughably provincial sub-issue grafted onto

a serious, established discipline, can become a catalyst, an intellectual instrument, probing basic and "natural" assumptions, providing a paradigm for other kinds of internal questioning, and in turn providing links with paradigms established by radical approaches in other fields. Even a simple question like "Why have there been no great women artists?" can, if answered adequately, create a sort of chain reaction, expanding not merely to encompass the accepted assumptions of the single field, but outward to embrace history and the social sciences, or even psychology and literature, and thereby, from the outset, can challenge the assumption that the traditional divisions of intellectual inquiry are still adequate to deal with the meaningful questions of our time, rather than the merely convenient or self-generated ones.

Let us, for example, examine the implications of that perennial question (one can, of course, substitute almost any field of human endeavor, with appropriate changes in phrasing): "Well, if women really *are* equal to men, why have there never been any great women artists (or composers, or mathematicians, or philosophers, or so few of the same)?"

"Why have there been no great women artists?" The question tolls reproachfully in the background of most discussions of the so-called woman problem. But like so many other so-called questions involved in the feminist "controversy," it falsifies the nature of the issue at the same time that it insidiously supplies its own answer: "There are no great women artists because women are incapable of greatness."

The assumptions behind such a question are varied in range and sophistication, running anywhere from "scientifically proven" demonstrations of the inability of human beings with wombs rather than penises to create anything significant, to relatively open-minded wonderment that women, despite so many years of near-equality – and after all, a lot of men have had their disadvantages too – have still not achieved anything of exceptional significance in the visual arts.

The feminist's first reaction is to swallow the bait, hook, line and sinker, and to attempt to answer the question as it is put: that is, to dig up examples of worthy or insufficiently appreciated women artists throughout history; to rehabilitate rather modest, if interesting and productive careers; to "rediscover" forgotten flower painters or David followers and make out a case for them; to demonstrate that Berthe Morisot was really less dependent upon Manet than one had been led to think – in other words, to engage in the normal activity of the specialist scholar who makes a case for the importance of his very own neglected or minor master. Such attempts, whether undertaken from a feminist point of view, like the ambitious article on women artists which appeared in the 1858 *Westminster Review*,[2] or more recent scholarly studies on such artists as Angelica Kauffmann and Artemisia Gentileschi,[3] are certainly worth the effort, both in adding to our knowledge of women's achievement and of art history generally. But they do nothing to question the assumptions lying behind the question "Why have there been no great women artists?" On the contrary, by attempting to answer it, they tacitly reinforce its negative implications.

Another attempt to answer the question involves shifting the ground slightly and asserting, as some contemporary feminists do, that there is a different kind of "greatness" for women's art than for men's, thereby postulating the existence of a distinctive and recognizable feminine style, different both in its formal and its expressive qualities and based on the special character of women's situation and experience.

[. . .]

The fact of the matter is that there have been no supremely great women artists, as far as we know, although there have been many interesting and very good ones who remain insufficiently investigated or appreciated; nor have there been any great Lithuanian jazz pianists, nor Eskimo tennis players, no matter how much we might wish there had been. That this

should be the case is regrettable, but no amount of manipulating the historical or critical evidence will alter the situation; nor will accusations of male-chauvinist distortion of history. There *are* no women equivalents for Michelangelo or Rembrandt, Delacroix or Cézanne, Picasso or Matisse, or even, in very recent times, for de Kooning or Warhol, any more than there are black American equivalents for the same. If there actually were large numbers of "hidden" great women artists, or if there really should be different standards for women's art as opposed to men's – and one can't have it both ways – then what are feminists fighting for? If women have in fact achieved the same status as men in the arts, then the status quo is fine as it is.

But in actuality, as we all know, things as they are and as they have been, in the arts as in a hundred other areas, are stultifying, oppressive, and discouraging to all those, women among them, who did not have the good fortune to be born white, preferably middle class and, above all, male. The fault lies not in our stars, our hormones, our menstrual cycles, or our empty internal spaces, but in our institutions and our education – education understood to include everything that happens to us from the moment we enter this world of meaningful symbols, signs, and signals. The miracle is, in fact, that given the overwhelming odds against women, or blacks, that so many of both have managed to achieve so much sheer excellence, in those bailiwicks of white masculine prerogative like science, politics, or the arts.

[. . .]

The question "Why have there been no great women artists?" is simply the top tenth of an iceberg of misinterpretation and misconception; beneath lies a vast dark bulk of shaky *idées reçues* about the nature of art and its situational concomitants, about the nature of human abilities in general and of human excellence in particular, and the role that the social order plays in all of this. While the "woman problem" as such may be a pseudo-issue, the misconceptions involved in the question "Why have there been no great women artists?" points to major areas of intellectual obfuscation beyond the specific political and ideological issues involved in the subjection of women. Basic to the question are many naïve, distorted, uncritical assumptions about the making of art in general, as well as the making of great art. These assumptions, conscious or unconscious, link together such unlikely superstars as Michelangelo and van Gogh, Raphael and Jackson Pollock under the rubric of "Great" – an honorific attested to by the number of scholarly monographs devoted to the artist in question – and the Great Artist is, of course, conceived of as one who has "Genius"; Genius, in turn, is thought of as an atemporal and mysterious power somehow embedded in the person of the Great Artist.[4] Such ideas are related to unquestioned, often unconscious, meta-historical premises that make Hippolyte Taine's race-milieu-moment formulation of the dimensions of historical thought seem a model of sophistication. But these assumptions are intrinsic to a great deal of art-historical writing. It is no accident that the crucial question of the conditions *generally* productive of great art has so rarely been investigated, or that attempts to investigate such general problems have, until fairly recently, been dismissed as unscholarly, too broad, or the province of some other discipline, like sociology. To encourage a dispassionate, impersonal, sociological, and institutionally oriented approach would reveal the entire romantic, elitist, individual-glorifying, and monograph-producing substructure upon which the profession of art history is based, and which has only recently been called into question by a group of younger dissidents.

Underlying the question about woman as artist, then, we find the myth of the Great Artist – subject of a hundred monographs, unique, godlike – bearing within his person since birth a mysterious essence, rather like the golden nugget in Mrs. Grass's chicken soup, called Genius or Talent, which, like murder, must always out, no matter how unlikely or unpromising the circumstances.

[. . .]

As far as the relationship of artistic occupation and social class is concerned, an interesting paradigm for the question "Why have there been no great women artists?" might well be provided by trying to answer the question "Why have there been no great artists from the aristocracy?" One can scarcely think, before the antitraditional nineteenth century at least, of any artist who sprang from the ranks of any more elevated class than the upper bourgeoisie; even in the nineteenth century, Degas came from the lower nobility – more like the haute bourgeoisie, in fact – and only Toulouse-Lautrec, metamorphosed into the ranks of the marginal by accidental deformity, could be said to have come from the loftier reaches of the upper classes. While the aristocracy has always provided the lion's share of the patronage and the audience for art – as, indeed, the aristocracy of wealth does even in our more democratic days – it has contributed little beyond amateurish efforts to the creation of art itself, despite the fact that aristocrats (like many women) have had more than their share of educational advantages, plenty of leisure and, indeed, like women, were often encouraged to dabble in the arts and even develop into respectable amateurs, like Napoleon III's cousin, the Princess Mathilde, who exhibited at the official Salons, or Queen Victoria, who, with Prince Albert, studied art with no less a figure than Landseer himself. Could it be that the little golden nugget – genius – is missing from the aristocratic makeup in the same way that it is from the feminine psyche? Or rather, is it not that the kinds of demands and expectations placed before both aristocrats and women – the amount of time necessarily devoted to social functions, the very kinds of activities demanded – simply made total devotion to professional art production out of the question, indeed unthinkable, both for upper-class males and for women generally, rather than its being a question of genius and talent?

When the right questions are asked about the conditions for producing art, of which the production of great art is a subtopic, there will no doubt have to be some discussion of the situational concomitants of intelligence and talent generally, not merely of artistic genius. Piaget and others have stressed in their genetic epistemology that in the development of reason and in the unfolding of imagination in young children, intelligence – or, by implication, what we choose to call genius – is a dynamic activity rather than a static essence, and an activity of a subject *in a situation*. As further investigations in the field of child development imply, these abilities, or this intelligence, are built up minutely, step by step, from infancy onward, and the patterns of adaptation-accommodation may be established so early within the subject-in-an-environment that they may indeed *appear* to be innate to the unsophisticated observer. Such investigations imply that, even aside from meta-historical reasons, scholars will have to abandon the notion, consciously articulated or not, of individual genius as innate, and as primary to the creation of art.[5]

The question "Why have there been no great women artists?" has led us to the conclusion, so far, that art is not a free, autonomous activity of a super-endowed individual, "influenced" by previous artists, and, more vaguely and superficially, by "social forces," but rather, that the total situation of art making, both in terms of the development of the art maker and in the nature and quality of the work of art itself, occur in a social situation, are integral elements of this social structure, and are mediated and determined by specific and definable social institutions, be they art academies, systems of patronage, mythologies of the divine creator, artist as he-man or social outcast.

[. . .]

Conclusion

I have tried to deal with one of the perennial questions used to challenge women's demand for true, rather than token, equality, by examining the whole erroneous intellectual substructure upon which the question "Why have there been no great women artists?" is based; by questioning the validity of the formulation of so-called problems in general and the "problem" of women specifically; and then, by probing some of the limitations of the discipline of art history itself. [. . .] I have suggested that it was indeed *institutionally* made impossible for women to achieve artistic excellence, or success, on the same footing as men, *no matter what* the potency of their so-called talent, or genius. The existence of a tiny band of successful, if not great, women artists throughout history does nothing to gainsay this fact, any more than does the existence of a few superstars or token achievers among the members of any minority groups. And while great achievement is rare and difficult at best, it is still rarer and more difficult if, while you work, you must at the same time wrestle with inner demons of self-doubt and guilt and outer monsters of ridicule or patronizing encouragement, neither of which have any specific connection with the quality of the art work as such.

What is important is that women face up to the reality of their history and of their present situation, without making excuses or puffing mediocrity. Disadvantage may indeed be an excuse; it is not, however, an intellectual position. Rather, using as a vantage point their situation as underdogs in the realm of grandeur, and outsiders in that of ideology, women can reveal institutional and intellectual weaknesses in general, and, at the same time that they destroy false consciousness, take part in the creation of institutions in which clear thought – and true greatness – are challenges open to anyone, man or woman, courageous enough to take the necessary risk, the leap into the unknown.

Notes

1 Kate Millett's *Sexual Politics*, New York, 1970, and Mary Ellman's *Thinking About Women*, New York, 1968, provide notable exceptions.
2 "Women Artists," Review of *Die Frauen in die Kunstgeschichte* by Ernst Guhl in *The Westminster Review* (American Edition), LXX, July 1858, pp. 91–104. I am grateful to Elain Showalter for having brought this review to my attention.
3 See, for example, Peter S. Walch's excellent studies of Angelica Kauffmann or his unpublished doctoral dissertation, "Angelica Kauffmann," Princeton University, 1968, on the subject; for Artemisia Gentileschi, see R. Ward Bissell, "Artemisia Gentileschi – A New Documented Chronology," *Art Bulletin* 1 (June 1968): 153–68.
4 For the relatively recent genesis of the emphasis on the artist as the nexus of esthetic experience, see M.H. Abrams, *The Mirror and the Lamp: Romantic Theory and the Critical Tradition*, New York, 1953, and Maurice Z. Shroder, *Icarus: The Image of the Artist in French Romanticism*, Cambridge, Massachusetts, 1961.
5 Contemporary directions – earthworks, conceptual art, art as information, etc. – certainly point *away* from emphasis on the individual genius and his salable products; in art history, Harrison C. and Cynthia A. White's *Canvases and Careers: Institutional Change in the French Painting World*, New York, 1965, opens up a fruitful new direction of investigation, as did Nikolaus Pevsner's pioneering *Academies of Art*. Ernst Gombrich and Pierre Francastel, in their very different ways, always have tended to view art and the artists as part of a total situation rather than in lofty isolation.

CAMERA OBSCURA COLLECTIVE

FEMINISM AND FILM
Critical approaches

I Context

THE JOURNAL *CAMERA OBSCURA* HAS EVOLVED from the recognition of a need for theoretical study of film in this country from a feminist and socialist perspective. This kind of analysis recognizes that women are oppressed not only economically and politically, but also in the very forms of reasoning, signifying and symbolical exchange of our culture. The cinema is a privileged place for an examination of this kind in its unique conjuncture of political, economic and cultural codes.

A feminist film analysis recognizes that film is a specific cultural product, and attempts to examine the way in which bourgeois and patriarchal ideology is inscribed in film. This involves a process of investigation and theoretical reflection on the mechanisms by which meaning is produced in film. A theoretical examination of films in terms of their signifying process means understanding that depictions of social "reality" are mediated by a signifying mode with its own specific structures and determinations. It locates analysis at the intersection of the process of construction of the text and the social context which determines and is represented in that text. This dialectical interaction is the process of signification. The study of film as a signifying practice (through rigorous analysis of films as texts) contributes to an understanding of how ideology determines and is determined by the mode of representation.

It is important to know where to locate ideology and patriarchy within the mode of representation in order to intervene and transform society, to define a praxis for change. Crucial to the feminist struggle is an awareness that any theory of how to change consciousness requires a notion of how consciousness is formed, of what change is and how it occurs.

In the last few years, there has been, for the first time, theoretical work in the area of feminist analysis of film. Some of the most significant contributions have come out of work done in England and published in the journal *Screen*, or in conjunction with it; for example, Pam Cook and Claire Johnston's texts on Tourneur, Arzner and Walsh, and Laura Mulvey's "Visual Pleasure and Narrative Cinema". The work of Kari Hanet and Jacqueline Rose has extended methods of textual analysis for the study of film within a feminist context through critical analyses of the structuring activity of films seen as texts and the production of meaning through textual operations. We see our activity on *Camera Obscura* within the context of such theoretical work, and want the journal to provide a locus for other work of this kind. Toward this end we are publishing translations of some of the most important work on film theory currently being done in France. We want to encourage theoretical work on cinematic representation and the signifying function of woman within this system.

II Texts

We are presenting in this issue our analyses of two films made by women. The film-texts we have chosen, in their specific textual operations, their mode of structuration, offer a critique of cinematic representation in general, and more specifically of the representation of woman in classical cinema. They contribute to the development of a feminist counter-cinema both by having as their central concern a feminist problematic, and by operating specific challenges to cinematic codes and narrative conventions of illusionist cinema.

Yvonne Rainer's *Film about a woman who* . . . explores problems of sexual relationships and the formation of the woman's self-image from the point of view of a generalized "she". Disjunctive sequences echo each other thematically while exploiting formal possibilities for dislocating and relocating sound, image, subject and spectator. The film is organized to engage the viewer in a dynamic, or even in a dialectical, relationship with the "story", such as it is or might be. In the interview with Rainer, which took place in February 1975 and was subsequently modified and expanded both by Rainer and ourselves, we argue that the analytical style which she uses in both *Lives of Performers* and *Film about a woman who* . . . is more effective in provoking an awareness in the viewer of the general and social nature of the sexual problematic she is dealing with than is, to cite Rainer's counter-example, an illusionist film like *The Mother and the Whore*.

Raynal's film offers a critique of the notion of woman as a spectacle in classical narrative cinema. Her film poses the problem of the place of woman within the dominant representational mode and enacts transgressions on the structure of that representation. In its deconstruction of woman as object for erotic contemplation, the film examines the mechanisms of voyeuristic pleasure which are implied not only in the film-viewing situation itself but also in the patriarchal mode which defines it. Because *Deux Fois* is not widely known and is rarely seen, we have provided extensive documentation of the film, including a shot commentary, shot chart and photogrammes.

In neither film do the materials depicted determine or have precedence over the materials of depiction; the "meaning" of the film is to be grasped in the process of their interaction. Both films, in their narrative organization or subversion of it, provoke reflection on the signifying process, on representation, and on the figure and function of the woman image. These films are useful for a feminist analysis because they open up a space of contradiction which engages the spectator in the production of meaning; they force the spectator to participate in a dialectical process with the images before her or him, the process by which consciousness is formed and transformed. The emphasis in these films on contradiction, production, work on the part of the spectator, serves to demonstrate a concept important for feminism – that social "reality" is a changeable construct.

In our analysis of these films, we are hoping to provide a theoretical base for feminist film practice. In our attempt to encourage feminist filmmaking activity, we are including in this issue a section which makes information available on current film practice by women. We feel it is important to give encouragement and exposure to women working and to provide a theoretical context for their work.

III Methodology

A methodology which has already proven useful for a feminist analysis of film is textual analysis which brings to the study of film analytical tools derived from recent advances in areas such

as semiology and psychoanalysis. Textual analysis considers the text (the film) as a dynamic process of the production of meanings, inscribed within the larger context of social relations. The text is seen not as a closed work, but as a discourse, a play of signification, dynamism and contradiction. This definition of text displaces the spectator as fixed receiver of meaning; and implies an unfixing and unsettling of the spectator–screen relationship. Textual analysis examines the status of the text as production, in which both the originator of the text (film-maker) and the spectator actively participate in the production of meaning. It emphasizes the aesthetic object as a social phenomenon which is created and understood through language. The text is recognized as the material organization of signifiers and not as the simple expression of an interiority of a personality, or of a reality already constituted outside of language. Rather than seeing cinematic language as a transparent instrument of expression, textual analysis emphasizes the materiality of language. The text is thus seen as a social space through which various languages (social, cultural, political, aesthetic) circulate and interact.

Semiology treats film as a discourse, a text which is structured by various signifying systems. One of the most useful aspects of semiological analysis for a feminist analysis of film, is that it reminds us that an image is a construction, that an image has signification only according to the socially conventionalized possibilities of its being read or understood. Both the image and the way it is read are culturally determined. Semiology attempts to deconstruct the assumption of the naturalness of the iconic image; this deconstruction is the beginning of an understanding that ideology is inscribed in representation, and that our perceptions, which seem natural, are actually culturally determined.

Another useful methodology for a feminist analysis of film concerns an area which is only beginning to be explored in its relation to an understanding of cinematic meaning – psychoanalysis. The ways in which the dominant patriarchal view conditions us at the levels of psychic structures is one of the most important areas for theoretical work.

A space in which the mechanisms of the unconscious and the construction of the human subject can be seen is opened by the breaks, dislocations and deformations in the conscious text – the remembered dream, the film. Utilizing the French psychoanalyst Jacques Lacan's theory that the unconscious is structured like a language, film theorists are seeking to combine psychoanalysis and semiology in an investigation into the mechanisms and processes of cinematic signification. Particularly important to these concerns are articles such as Jean-Louis Baudry's "The Apparatus", which analyses the conjuncture of the cinematic and the psychic apparatus in the film-viewing situation.

IV Production

This first issue was produced collectively by four women. We chose to produce it this way in order to give the journal a political and theoretical coherence and focus. For two years, we have seen films, studied, lectured and written together. The journal was seen as a place to bring together this shared work and to encourage others to work in the area of feminism and film theory.

Collective intellectual activity is difficult and contradictory in a social milieu that requires its members to represent themselves individualistically. We were attempting to break with the notion of writing as an individual representation or expression, in an effort to incorporate the objective fact of sociality into the act of writing itself. This extends the notion of political commitment beyond an analysis of filmmaking activity to the very process of production of this analysis: we see both our theory and our practice as a struggle within ideology.

Although this first issue was produced by the present collective, in the future we want to both enlarge the collective and to publish the work of others.

The camera obscura provides a useful model for a discussion of a feminist theory of film because it emphasizes the points of convergence of ideology and representation, of ideology as representation. The camera obscura, as an apparatus which renders an image of the "real", is both reproducer of ideology and metaphor for its functioning. On the one hand bourgeois ideology is embedded in the very mechanism of the camera obscura, the prototype of the camera and therefore of cinematic representation. On the other hand, the camera obscura is used as a metaphor for the functioning of ideology by Marx and for the process of the unconscious by Freud. Yet the camera obscura is neither an apparatus nor a metaphor which is outside of ideology; both in its mode of operation and its conceptual dichotomy, it is its instrument. Because the camera obscura is an ambiguous image itself, it is a locus of contradiction and must be grasped in a dialectical process. In this sense the feminist struggle, like the camera obscura, is not only an overturning of capitalist relations of production and patriarchal society, but involves a critical understanding of its mode of functioning, a dialectical analysis. Rather than positing the camera obscura as a fixed symbol, we are presenting it as an image of implicit contradiction, one that includes process and the possibility of transformation.

The camera obscura was used extensively by Leonardo da Vinci and Leone Battista Alberti in their studies on perspective in the fifteenth century. Because it reproduces the illusion of depth on a flat surface and reduces the image of the object viewed in exact proportions, the camera obscura was seen as a mechanism which could imitate nature. The apparent objectivity of the camera obscura made the elimination of subjectivism from graphic representation seem possible. A more reliable eye – a mechanical one – was substituted for the human eye. With this implicit equation of monocular perspective and objectivity, the codes of Renaissance perspective were introduced. However, the camera obscura both reproduces and is determined by a specific system of ideological assumptions. Bourgeois ideology posits a universal eternal human essence; monocular perspective, which implies a harmonious order, a universe created for man with man at the center as the pivot of experience, reproduces this ideology in visual terms. Implicit in monocular perspective is the assumption that the world is created, unified and homogeneous, by a superior determination. The camera obscura was seen as an eye without a point of view, the eye of God on the universe.

In the nineteenth century the camera obscura was used as a metaphor for the processes of the unconscious by Freud and a theory of ideology by Marx. Freud substitutes a photographic model for the camera obscura in his theory of the unconscious, a theory of the constitution of the psychoanalytic subject. He uses the optical metaphor to describe psychical locale (topographical location of the conscious-preconscious/unconscious), the functioning of the unconscious, and the relation of the conscious/unconscious. When Freud describes how unconscious representations pass over into the conscious sphere, the optical model becomes a spatial metaphor; the camera obscura is seen as a series of dark chambers which function to filter psychic materials to "attract the eye of consciousness". Evoking relations of position and screen, Freud describes consciousness as a "spectator at the end of the second room".

> The unconscious system may therefore be compared to a large anteroom, in which the various mental excitations are crowding upon one another, like individual beings. Adjoining this is a second, smaller apartment, a sort of reception-room, in which consciousness resides. But on the threshold between the two there stands a personage with the office of door-keeper, who examines the various mental excitations, censors them, and denies them admittance to the reception-room when he disapproves of

them . . . The excitations in the unconscious, in the ante-chamber, are not visible to consciousness . . . they can only become so if they succeed in attracting the eye of the consciousness.[1]

Marx uses the metaphor of the camera obscura as an image of ideological inversion and mystification. Rather than accepting the existence of an autonomous history of ideas, Marx explains the formation of ideas from material practice.

> Men are the producers of their conceptions, ideas, etc. – real, active men, as they are conditioned by a definite development of their productive forces . . . Conscious-ness can never be anything else than conscious existence, and the existence of men is their actual life-process. If in all ideology men and their circumstances appear upside-down as in a *camera obscura*, this phenomenon arises just as much from their historical life process as the inversion of objects on the retina does from their phys-ical life-process . . . we do not set out from what men say, imagine, conceive, nor from men as narrated, thought of, imagined, conceived in order to arrive at men in the flesh. We set out from real, active men, and on the basis of their real-life process we demonstrate the development of the ideological reflexes and echoes of this life-process, which is empirically verifiable and bound to material premises. Morality, religion, metaphysics, all the rest of ideology and their corresponding forms of consciousness, thus no longer retain the semblance of independence. They have no history, no development; but men, developing their material production and their material intercourse, alter, along with this their real existence, their thinking and the products of their thinking.[2]

The metaphor of the camera obscura as Marx uses it indicates that the ideological inver-sion is a hierarchical one that substitutes an imaginary basis for a real one. It implies that ideology is something fantasmagoric, insubstantial, illusory. Marx uses the model of the camera obscura to describe how ideology is a reflection cut off from its source, and how this reflec-tion necessarily masks, conceals, mystifies real relations.

However, the fact that the camera obscura model relies on a system of simple opposi-tions – real/imaginary, light/darkness – indicates the limitations of the specular metaphor for a description of the way in which ideology functions. The camera obscura, like other spec-ular metaphors, implies not only the existence of the "real" but a specific relation to it: a given which is always projected in inversion. The notion that there is an originating source of meaning apart from human practice and consciousness that pre-exists ideological distor-tion, implies that there can be such a thing as pure, unmediated "truth". The camera obscura mechanism as a metaphor for the functioning of ideology does not account for the mecha-nisms by which consciousness is produced or generated; it describes the *effects* of ideological mystification (an inverted reflection of human activity) but is incapable of accounting for the processes of transformation which produce these effects.

The optical model is thus insufficient as a metaphor for ideology because its presupposi-tion of an anterior reality which is inverted in its representation denies the materiality of ideology. As a mechanism which operates on the basis of direct reproduction, the model implies that ideology is a simple transposition of human relations.

Rather than illusory conscious ideas or beliefs, ideology is a material force which plays an objective historical role in social formations: as a system of representations (images, myths, conceptions about the world) it is a structuring of experience; a structure which informs and

is embedded in practical activity. The notion of reciprocity, which is implicit in an understanding of ideology as lived relations, is not present in Marx's early model of the camera obscura, where the relation of the object to its representation proceeds in a single direction. The materiality of ideology implies interconnectedness, a dynamic reciprocity of determinations – social, economic, political, cultural.

Like the camera obscura, the cinematic apparatus is not ideologically neutral, but reproduces specific ideological predispositions: codes of movement, of iconic representation, and perspective. The notion that "reality" can be reflected in film negates any awareness of the intervention, the mediation of the cinematic apparatus. The impression of reality in the cinema is not necessarily due to its capacity for verisimilitude, its ability to reproduce faithfully a copy of an object, but rather to the complex process of the basic cinematic apparatus itself, which in its totality includes the spectator.

Camera obscura: locus of representation, ideology, the unsconscious. A feminist theory of film must examine the ideological effects of the cinematic apparatus on the spectator/subject, understanding the spectator as a social subject, a locus of ideological determinations. Though the metaphor of the camera obscura can be critiqued in its modes of functioning, it is precisely because it is an image which includes contradiction that it represents an important conjuncture for a feminist theory of film.

Notes

1 Sigmund Freud, *Introduction to Psychoanalysis* (Pocket Books, New York, 1975), pp. 305–6.
2 Karl Marx and Frederick Engels, *The German Ideology, Part I* (International Publishers, New York, 1970), p. 47.

Chapter 28

ADRIAN PIPER

THE TRIPLE NEGATION OF COLORED WOMEN ARTISTS

THESE ARE INTERESTING TIMES in which to be a colored woman artist (henceforth a CWA).[1] Forces of censorship and repression in this country are gathering steam and conviction as those same forces in other countries are being overturned or undermined. No one should be surprised at these inverse parallel developments. Sociologists know

that groups tend to increase the internal pressures toward conformity and homogeneity in order to maintain their identities against external pressures forcing dissolution into a larger whole. And just as American society is now imposing a Euroethnic, Christian, heterosexual male ethos on all of us in order to maintain a uniquely American identity against the incursion of other, emerging democracies in Russia and Central Europe, similarly the art world is reasserting a Euroethnic, heterosexual male aesthetic on all of us in order to resist the incursion of gays, coloreds, and practitioners of outlaw sexuality into its inner sanctum.[2] In particular, I will argue that the ideology of postmodernism functions to repress and exclude CWAs from the art-historical canon of the Euroethnic mainstream. Correctly perceiving the artefacts produced by CWAs as competitors for truth and a threat to the cultural homogeneity of the Euroethnic tradition, it denies those artefacts their rightful status as innovations relative to that tradition through ad hoc disclaimers of the validity of concepts such as "truth" and "innovation."

Item, 1982: NEA funding for the Washington Women's Art Center ceases after congressional protest over their "Erotic Art Show." Item, 1983: Rosalind Krauss explains to her fellow symposiasts at the NEA Art Criticism Symposium that she doubts that there is any unrecognized African-American art of quality because, if it doesn't bring itself to her attention, it probably doesn't exist. Item, as of this writing: No CWA is invited to show in any Whitney Biennal, ever. Item, 1987: Donald Kuspit publishes in his vanity journal a seven-page essay devoted to the thesis that my writing is a symposium of mental illness and my work is not worth discussing.[3] Item, 1988: an unusually strong group show of the work of colored women artists opens at the Intar Gallery in Manhattan and receives no attention from the local Euroethnic press, with the exception of Arlene Raven's intelligent review in *The Village Voice*.[4] Item, 1989: Christina Orr-Cahall cancels a retrospective of the photography of Robert Mapplethorpe at the Corcoran Galley. Item, 1989: Jesse Helms protests public funding of Andres Serrano's work by the Southeast Center for Contemporary Art's Awards in the Visual Arts. Item, 1989: Roberta Smith explains to film interviewer Terry McCoy that the real problem with the art of African-Americans is that it just isn't any good, that it would be in mainstream galleries if it were, that she's been up to the Studio Museum a couple of times and hasn't seen anything worthwhile, that it's all too derivative, and so on.[5] Item, 1990: The National Endowment for the Arts withdraws funding from an exhibition catalog about AIDS at Artists' Space. Item, 1990: Hilton Kramer devotes two essays in the *New York Observer* to protesting the current interest in issues of race and gender that, he claims, leaves quality by the wayside.[6]

In a more intellectually sophisticated environment, these howlers would be accorded exactly the weight they deserve, that is, none. In this decade's art world – as we can see, a world not exactly overpopulated by mental giants[7] – they are dangerously repressive in effect. Instead of being recognized and ridiculed for what they are, namely, obscene theatrical gestures without redeeming social content, they legitimate and encourage further such obscenities among those who are naturally inclined to them, and intimidate the naturally docile into self-censorship. We can expect these repressive measures to increase in number, severity, and ugliness as those relegated to the margins succeed in greater numbers in gaining access to unjustly withheld social and economic advantages within the mainstream Euroethnic art world.[8]

At the same time, on the other hand, a few CWAs recently have begun to receive some modest measure of attention from the Euroethnic art world. We have been invited to show in previously all-Euroethnic group exhibitions, galleries, or museums, and we have received some critical attention for work that for decades was largely passed over in silence, as though it did not exist. No protest against the de facto censorship of CWAs has ever been mounted

of the sort that has rightly greeted the recent attempted censorship of the work of male artists Robert Mapplethorpe, Andres Serrano, or David Wojnarowicz. Until very recently, CWAs were ignored as a matter of course.[9] In the last few years, CWAs have begun to exist in the consciousness of the more progressive, intellectually oriented circles of the Euroethnic artworld.

Certain factors can be cited to explain the recent visibility of CWAs. In 1987, without fanfare and at considerable professional risk to himself, Michael Brenson began to review the work of African-American artists in the *New York Times* on a regular basis. The appearance of these reviews, backed by Brenson's authority and that of the *New York Times*, effected a profound change in the conventions of Euroethnic art writing. By approaching African-American art with the same attention, respect, and critical standards he applied to Euroethnic art, Brenson singlehandedly exposed the tacit racism of ignoring African-American art that had prevailed among virtually all other Euroethnic art critics.[10] The same year, Howardena Pindell compiled and published "Art World Racism: A Documentation," which was excerpted for broader art-world consumption in the *New Art Examiner* in 1989.[11] This work documented the hard statistics of African-American exclusion from Euroethnic galleries, museums, and publications for all to see. The statistics were so incriminating and inexcusable that they effectively foreclosed further disingenuity or rationalization of practices now clearly identifiable as racist. Both of these efforts have sparked energetic and conscientious attempts at reparation in many quarters.[12] Because racism and sexism often go together, amelioration of both together can be achieved by showcasing the work of CWAs.

I am encouraged by this recent development, but I am also suspicious of its long-term significance. It coincides too neatly with an interest in difference and otherness in other fields such as comparative literature, history, and anthropology, *in which the main subject of investigation is the person, not the artifact*. Euroethnic preoccupation with these issues in the art world forces a level of social and political self-criticism and scrutiny of entrenched conventions of aesthetic evaluation that is altogether salutary, and needed. But the object of preoccupation defined by these issues is not the artifact but rather its producer as "other." Not the work of art, but rather the artist often provides the content and themes of interviews, photoimages, conferences, and critical essays. This means substituting social relations for works of art as an object of investigation. And in an arena as ill-equipped to investigate social relations as the art world, this means imposing only slightly more sophisticated racial and gender stereotypes rather than looking at art.

For example, a CWA who expresses political anger or who protests political injustice in her work may be depicted as hostile or aggressive; or a CWA who deals with gender and sexuality in her work may be represented as seductive or manipulative. Or a CWA who chooses to do her work rather than cultivate political connections within the art world may be seen as exotic or enigmatic. These are all familiar ways of stereotyping the African-American "other." When the art itself stymies the imposition of such stereotypes, the Euroethnic viewer is confronted with a choice: either to explore the singular significance of the art itself – which naturally requires a concerted effort of discernment and will for most Euroethnics – or to impose those tired stereotypes on the artist instead. For two-cylinder intellects, the latter alternative is the most popular.[13]

Of course this tendency to focus on the artist at the expense of the work may be explained differently, as a reflexive by-product of a self-protective, general reaction to most mainstream contemporary Euroethnic art, which compels its viewers to focus on the artist out of sheer desperation, because the art itself is so boring. But for CWAs, this focus on the person rather than the art is particularly troublesome, first, because it turns the artist into little more than

a cryptic, exotic object that provides the occasion for Euroethnic self-analysis. I am, after all, not an "other" to *myself*; that is a category imposed on me by Euroethnics who purport to refer to me but in fact denote their own psychosociological constructs. If I choose to explore those constructs in my work, I am investigating Euroethnic psychosociology, not myself, which merely compounds the blunder of withdrawing the focus from the work and turning it instead onto me. This is the blunder of a bad conscience that seeks to deflect self-scrutiny, by re-directing it onto the artist, at the expense of full attention to the sociocultural meaning of *that artist's chosen form of self-expression*, namely, art. This tack, of changing the subject, is just another way to silence those for whom artistic censorship has been a way of life. Euroethnics who have a genuine interest in the forms of self-expression of artists from a different culture do not dwell intellectually on the otherness of the artists for long. They get to work doing the necessary research into that culture, and achieving the necessary familiarity with it, that will yield the insights into those alien forms of cultural expression they purport to seek.[14]

Second, focusing on the otherness of the artist rather than the meaning of the art falsely presupposes a background of Euroethnic homogeneity against which the person can be iden-tified as an "other." This perpetuates the ideological myth of minority status on which racists rely to exercise their strategies of disempowerment. Politically concerned Euroethnics would do better to reflect on their collusion in those strategies – for example, isolating a few token coloreds to exhibit in predominantly Euroethnic group shows, or to write about in predom-inantly Euroethnic art publications – against the reality of their constituting 15 percent of the world's population while consuming or stockpiling 85 percent of its resources.

Third, CWAs in particular suffer from this focus because they have to battle gender and race stereotypes simultaneously. Well-meaning critics and curators who think it is possible to make meaningful generalizations about the art of all women, all African-Americans, all Central Europeans, Italians, or gay men are depriving themselves and their audiences of the paradigm experience art is supposed to provide: to heighten one's appreciation of the singular and orig-inal qualities of an individual artifact in cultural relation to its producer, its viewer, and its social environment.[15] Whenever someone deflects attention from my work to my identity as a CWA, I start to get nervous about whether they are actually seeing my work at all.

For these reasons, the remainder of this discussion is going to be devoted to a system-atic analysis of the Euroethnic art world's negation of CWAs along three dimensions: as coloreds, as women, and as artists. I want to offer a systematic analysis that can explain why, for example, no one feels the need even to defend or justify Betty Saar's exclusion from the "Magiciens de la Terre" exhibit; why the exhibition "Autobiography: In Her Own Image" went virtually unremarked by the Euroethnic press; why the repression and artistic censorship of PWAs[16] is seen as so much more urgent and threatening than that of CWAs; and why, in general, I am not yet convinced that the repression and artistic censorship of CWAs is a thing of the past.

Artistic success in the contemporary Euroethnic art world is perceived by all as the payoff of a zero-sum game, in which one player's win is another player's loss.[17] For example, not everyone can show her work at MOMA. So, it is reasoned, if you show yours there, you decrease my chances of showing mine there. So in order for me to increase my chances of showing mine there, I must, first of all, work actively to decrease yours – through professional back-stabbing, bad-mouthing, covert manipulation, dishonesty, false and loudly trumpeted I-was-there-first self-aggrandizement, etc. Second, I must work actively to increase my chances: by tailoring my work according to trends established by those already exhibited at MOMA,[18] courting the powerful, offering bribes in a variety of currencies, and censoring my impulse to protest when witnessing injustice, so as not to antagonize *anyone* who might eventually

help me to get my work shown at MOMA. I must deploy similar strategies for obtaining gallery representation, selling work, or getting critical attention for work. This means that individual artists and their allies see one another as professional competitors, and the assets of others as threats to the ability of each to achieve maximal professional success.

"Maximal professional success," in turn, is defined by admission into a circumscribed set of art institutions – museums, galleries, collections, and art publications – that constitute the Euroethnic mainstream. The ideological content of that mainstream changes with fluctuations of intellectual fashion in other fields (such as Englightenment aesthetics, analytic philosophy, or continental poststructuralism). But the underlying ideological commitment of the Euroethnic mainstream is to its own perpetuation, in whatever guise. In the Renaissance, this commitment was manifested as a belief in the ability of men creatively to transform the sensuous and material in the service of the intellectual and spiritual; that is, to transcend the natural physical realm associated with the secular female. In modernism, this same commitment was manifested as a belief in the progression of art made by men from the concretely representational to the intellectual and abstract. In postmodernism, it is manifested in a dissolution of faith in intellectual progress, and a corresponding attitude of mourning for the past glories and achievements of all previous stages of Euroethnic art history, which are memorialized and given iconic status through appropriation into contemporary art-world artifacts.

In virtually every field to which women have gained entry in significant numbers, the status of that field and its perception as providing significant social opportunity has diminished: If a woman can do it, the reasoning goes, then what is there to feel superior about? Therefore the first line of defense is to protest roundly that a woman can't do it. The second, when that doesn't work, is to conclude that it's not worth doing. Thus it is no accident that the advent of postmodernism coincides with the acceptance of Euroethnic women artists into the inner sanctum of that tradition. Their success forces a choice of inference: Either women are just as capable of intellectual transcendence as men, and just what is needed to bring that progression to its next stage, or else their presence undermines the very possibility of further progression altogether. It is quite clear which inference has been chosen. Not coincidentally, Euroethnic postmodernism expresses a newly pessimistic, nihilistic, and self-defeated view of the social and intellectual status of art at just the moment that women have begun to join its major ranks in significant numbers.

Euroethnic postmodernism's attitude of mourning assumes our arrival at the end of the art-historical progression, and therefore the impossibility of further innovation indigenous to it. This means, in particular, that innovations that occur outside of that progression, or by those who are not accepted into it, cannot be acknowledged to exist as innovations at all. Accordingly, the normative category or originality against which art within the Euroethnic tradition was judged is replaced by the purportedly descriptive categories of anomaly, marginality, and otherness. These aesthetically noncommittal categories can be deployed to acknowledge the existence of such innovations without having to credit them normatively as innovations at all.

Relative to the commitment of the Euroethnic mainstream to its own self-perpetuation and its rejection of any further innovation indigenous to it, the very different concerns that may find expression in the art of CWAs – identity, autobiography, selfhood, racism, ethnic tradition, gender issues, spirituality, etc. – constitute a triple-barreled threat. First, this work has no halcyon past to mourn. Instead, it offers an alternative art-historical progression that narrates a history of prejudice, repression, and exclusion, and looks, not backward, but forward to a more optimistic future. It thereby competes with Euroethnic art history as a candidate for truth. Second, it refutes the disingenuous Euroethnic postmodern claim that there *is* no

objective truth of the matter about anything, by presenting objective testimony of the truth of prejudice, repression, and exclusion.[19] Third, it belies the Euroethnic postmodern stance that claims the impossibility of innovation, by presenting artifacts that are, in fact, innovative relative to the Euroethnic tradition – innovative not only in the range and use of media they deploy but also in the sociocultural and aesthetic content they introduce. In all of these ways, the art of CWAs is an innovative threat to the systemic intellectual integrity and homogeneity of the Euroethnic art tradition. And so, because artistic success is defined within that tradition as a zero-sum game, these threats must be eliminated as quickly and completely as possible. Thus are CWAs negated as artists by the Euroethnic art world.

The Euroethnic postmodernist stance of mourning, in combination with its negation of CWAs as artists, provides the surest proof (in case we needed it) that the Euroethnic art world is fueled primarily by a spirit of entrepreneurship, not one of intellectual curiosity, and that its definition of professional success is skewed accordingly. Only a field that defined professional success in economic rather than intellectual terms could seriously maintain that the art of CWAs had nothing new to teach it. Whereas history, literature, anthropology, sociology, psychology, etc. have been scrambling for almost two decades to adjust or modify their canons so as to accommodate the new insights and information to be culled from the life experience of those previously excluded from them, only the Euroethnic art world is still having trouble acknowledging that those insights and information actually exist. In this field, if they don't exist at auctions or in major collections, they don't exist at all. Critics and curators who collaborate in this ideology sacrifice their intellectual integrity for the perquisites of market power. This is the payoff that the zero-sum game of Euroethnic artistic success ultimately offers all its players.

The Euroethnic contemporary art world is administered primarily by Euroethnic men. As in all walks of life, there are good men and there are bad men. In this arena, the bad ones are blessedly easy to detect. Their behavior and their pronouncements indicate that they evaluate works of art according to their market value rather than according to their aesthetic value. For example, they may refuse even to acknowledge the aesthetic value of work that is not for sale in a major gallery, or they may select artifacts to exhibit or write about solely from those sources. Or they may defend the aesthetic values of very expensive artifacts at great length but on visibly shaky conceptual grounds. Or they may be more visibly impressed by the aesthetic value of a work as its market value increases. Indeed, lacking any broader historical or sociocultural perspective, they may even believe that aesthetic value is nothing but market value. And, believing that only artifacts produced by other Euroethnic men can safeguard the intellectual integrity and homogeneity of the Euroethnic tradition, they distribute payoffs, in proportion to the exercise of the winning zero-sum game strategies earlier described, primarily to other Euroethnic men.

Some women and coloreds collude in the perpetuation of this game, by playing according to its prescribed rules. Euroethnic women who compete with one another and with colored women for its payoffs divide themselves from CWAs and ally themselves with the Euroethnic men who distribute those payoffs and who are their primary recipients. They thereby ally themselves with the underlying ideological agenda of perpetuating the tradition of Euroethnic art as an intellectually homogeneous, systemic whole. This is to concur and collaborate with the Renaissance, modernist, and postmodernist agenda of implicitly denying the legitimacy – indeed, the very possibility – of intellectually and spiritually transcendent artifacts produced by women.

Put another way: By accepting payoffs for playing the zero-sum game of artistic success according to its prescribed rules, some Euroethnic women collaborate in the repression of

the alternative art history to which the art of women in general, as well as that of CWAs, often gives expression. Thus CWAs are negated as women not only through the more brutal, overt attempts at eradication by some Euroethnic male art-world administrators but *whenever* a Euroethnic woman abnegates her connection as a woman to CWAs, in order to receive the payoffs available for repressing them. It is painfully humiliating to witness a Euroethnic woman simultaneously prostituting herself and betraying us in this way.

Similarly for colored men and their connection with CWAs. All colored artists bear the burden of reflexive eradication from the Euroethnic mainstream, and of the reflexive devalu-ation of their work as a result.[20] Much has been written about this recently, and I will not rehearse those arguments here.[21] My point, here as earlier, is the same. To the extent that colored artists compete for positioning, attention, and the payoffs of winning the zero-sum game of Euroethnic artistic success, they abide by the rules of that game. In so doing, they compound their reflexive repression by the Euroethnic mainstream, by dividing themselves from one another and negating themselves and their historical tradition for the sake of the payoffs that game promises.

This has nothing to do with what kind of artifact – abstract or representational, in tradi-tion media or new genres – any such artist produces. An unusually dimwitted defense of the repression of colored artists has it that African-Americans are naturally most adept at expressing themselves creatively in music rather than in the visual arts, and that therefore their attempts in the latter media are invariably derivative, superficial, or disappointing. No one who has studied the artifactual strategies of survival and flourishing of colonialized peoples under hege-monic rule anywhere could take such an argument seriously. But then of course no one who would offer such an argument would be capable of the minimal intellectual effort of research necessary to disprove it. The fact of the matter is that, like other colonialized peoples, African-Americans must master two cultures, not just one, in order to survive as whole individuals, and master them they do. They contribute fresh styles and idioms to the visual arts just as abundantly as they do – and have always done – to music, literature, and film.

The Euroethnic tradition has always needed these extrinsic creative resources in order to flourish, and in the past has simply expropriated and used them without permission or acknow-ledgment.[22] Had that tradition long since invited their producers into the Euroethnic main-stream, it might have been better armed, with creative strategies of cohesion and survival, for withstanding the censorship attacks that continue to issue from within its own fundamentalist ranks. It is not surprising that blind reviewing is virtually inconceivable in contemporary Euroethnic art, whereas it is the norm in other areas of higher education. As an intellectually integral and homogeneous system, the Euroethnic art tradition could not possibly survive a convention of evaluation that ignored the racist, sexist, and aesthetically irrelevant social and political connections that hold it together. That is why it rewards all of us so richly for follow-ing the rules of the zero-sum game.

It is very difficult for any of us not to play this game, as it often seems to be the only game in town. But in fact that is not true. It is not true that Euroethnic payoffs of the zero-sum game are the only measures of artistic success, nor the most important over the long term, nor even the most satisfying ones. There is great satisfaction in affecting or transforming the audience to one's work, and in making those personal connections that enable the work to function as a medium of communication. There is great satisfaction in learning to see what-ever resources are freely available in one's environment as grist for the mill of artistic imagination, and indeed, in seeing one's environment in general in that way. There is satis-faction in giving work away, and in avoiding or refusing the corrupting influences of those payoffs, and in reaping the rewards of authentic interpersonal relationships as a consequence.

And there is very great satisfaction in not caring enough for those payoffs to be willing to follow the rules in order to receive them: in not caring enough to tailor one's work accordingly, or offer bribes, or curry favor, or protect one's position by remaining silent in the face of injustice, or by undercutting others.

In fact the very conception of artistic success as the payoff of a zero-sum game is faulty, because the price of playing by those rules is the de facto deterioration, over the long term, of the aesthetic integrity of the artifacts produced in accordance with them.[23] Those who play that game according to the rules and win the perquisites of market power may, indeed, achieve artistic success in the Euroethnic art world. But the price they pay is alienation from their own creative impulses and from their own work as a vehicle of self-expression; addiction to the shallow, transitory material and political reassurances of worth that are recruited to take their place; sycophancy and betrayal from those they temporarily view as allies; and mistrust and rejection from those who might otherwise have been friends. It hardly seems worth it.

Because commitment to that game is so self-defeating and divisive for all who try to play it, I do not believe the triple negation of colored women artists will come to an end until that game itself is over. It will come to an end, that is, when the Euroethnic art world stops trying to negate them as players, and when women and coloreds and Euroethnics stop trying to negate themselves and one another in order to gain entry to it.

I have suggested that Euroethnic postmodernism is finally an attempt to change a few of the rules, hastily, in order to preserve intact the stature of the winners and their payoffs. I neglected to add that that attempt is clearly failing. While larger and larger quantities of money, power and inflated prose are being invested in more and more desiccated and impotent caricatures of Euroethnic art, those who have been excluded from that system have been inventing and nurturing their own idioms, visions, and styles of expression out of that greatest of all mothers, namely, Necessity. That is our strength and our solace. That is why the Euroethnic art world needs our resources and strategies – as it always has – in order to progress to the next stage of development. But we are no longer so preoccupied with other matters as to overlook backdoor expropriation of those resources, nor to take comfort in being the invisible powers behind the throne. As we come to feel the strength of our numbers and the significance of our creative potentialities, we approach a readiness to drop out of the zero-sum game and claim our roles as players in a very different kind of game, in which the payoffs are not competitive but, rather, cooperative. In this kind of game, no one has to lose in order for someone else to win, because the payoffs – self-expression, personal and creative integrity, freedom, resourcefulness, friendship, trust, mutual appreciation, connectedness – are not scarce resources over which any player must be attacked, negated, or sacrificed. Nor are the rules of this game – mutual support, honesty, dialogue, sharing of resources, receptivity, self-reflectiveness, acceptance – of such a kind as to butcher the self and cheapen one's central commitments. It does seem, in so many respects, to be a more appealing game to play. The only question is whether we are all wise enough to be willing to play it.

Notes

1 Let's begin with a word about terminology. I do not like the currently fashionable phrase "people of color" for referring to Americans of African, Asian, Native American, or Hispanic descent. It is syntactically cumbersome. It also has an excessively genteel and euphemistic ring to it, as though there were some ugly social fact about a person we needed to simultaneously denote and avoid, by performing elaborate grammatical circumlocutions. Moreover, discarding previous phrases, such as "Negro," "black," "colored," or "Afro-American," as unfashionable or derogatory implies that there is some neutral, politically correct phrase that can succeed in denoting the relevant group without taking on the derogatory

and insulting connotations a racist society itself attaches to such groups. There is no such phrase. As long as African-Americans are devalued, the inherently neutral words coined to denote them will themselves eventually become terms of devaluation. Finally, the phrase is too inclusive for my purposes in this essay. I want to talk specifically about women artists of African descent, in such a way as to include those Hispanic-Americans, Asian-Americans, and Native Americans who publicly acknowledge and identify with their African-American ancestry, and exclude those who do not. The term *colored* seems both etiologically and metaphorically apt.

2 Needless to say, this explanation is compatible with self-interested attempts of conservative congressmen and senators to find some local scapegoat to substitute for foreign communism, in order to divert attention away from their ineffectuality in simply representing their constituencies.

3 Donald Kuspit, "Adrian Piper: Self-Healing through Meta-Art," *Art Criticism* 3, no. 3 (September 1987), pp. 9–16.

4 Arlene Raven, "Colored," *The Village Voice*, May 31, 1988, p. 92. The title of the exhibition was "Autobiography: In Her Own Image," curated by Howardena Pindell.

5 Telephone conversation between the author and Terry McCoy, Fall 1989.

6 Dennis Szakacs, of the Southeastern Center for Contemporary Art (SECCA), provided the following statement: "Attempts were made to obtain copies of Kramer's articles from the *New York Observer* as well as from Kramer himself. An *Observer* staff person explained that they were not equipped to handle such requests while Kramer, in a telephone conversation, acknowledged that the articles existed and agreed to send copies. After many weeks and several unreturned messages, the Kramer articles have yet to arrive."

7 I am not an intellectual elitist, but I do believe that racism, sexism, homophobia, and intolerance generally involve cognitive deficits and elementary errors in reasoning and judgment. [. . .]

8 It's so amusing how arguments that there are no more margins always seem to come from those in the center. Just as it's amusing how arguments that there is no more avant garde always seem to come from those who have gotten the greatest economic mileage from being a part of it. In general, it's immensely entertaining to watch the keepers of the brass ring start to deny that it exists just when they notice that the disenfranchised are about to grab it. No doubt this is pure coincidence.

9 My personal experience is of having been included in "definitive" major museum shows of conceptual art in the late 1960s, until the art-world contacts I made then met me face-to-face, found out I was a woman, and disappeared from my life; and in "definitive" major museum shows of Body Art and women's art in the early 1970s, until the contacts I made then found out I was colored and similarly disappeared from my life. Although I have had virtually no contact with major museums since those years, I fully expect the situation to improve as all those individuals die off and are replaced by smarter ones.

10 An attempt to sully Brenson's achievement by portraying him as moved by professional self-interest recently appeared in *Spy* magazine (J.J. Hunsecker, "Naked City: The *Times*," *Spy* [April 1990], p. 48). This uncommonly ugly and snide article backfires, by revealing the author's own inherent racism. That the very choice to treat Brenson's decision to write about African-American artists as cause for ridiculing him itself demeans those artists doesn't seem to have occurred to Hunsecker. Whatever Brenson's actual motives were, they do not undermine the cultural and historical importance of his actions and their consequences. But as described in *Spy*, they at least provide a refreshing contrast to those sterling motives, so frequently professed by the politically correct, that nevertheless fail to spark any effective political action at all.

11 Howardena Pindell, "Art World Racism: A Documentation," *The New Art Examiner* 16, no. 7 (March 1989), pp. 32–36.

12 And brazenly arrogant bullet biting in others, as some of the previous items suggest.

13 And make no mistake about it: For the two-cylinder intellect, these are *mutually* exclusive alternatives. An identifying feature of such cognitive malfunctions is the absence of any sustained attention to the work itself. Thus, for example, Robert Morgan, in "Adrian Piper," *Arts Magazine* 63, no. 10 (Summer 1989), p. 99, does not bother describing the content of the work at all. Instead he generously concentrates on offering free career advice as to how, by doing a different work that "told us more about Adrian Piper and how she as a person had personally suffered from racial prejudice and abuse (if this is indeed the case)," I could have avoided hurting the feelings of "anyone who has worked in ghettos and has read what black activist writers have written, and has tried to put into practice some positive methods for ending bigotry on a day-to-day basis." To all of you out there who satisfy this description, I want to take this opportunity to apologize to you for hurting your feelings, for failing to devote

my work to "autobiographical ideas and constructs" that confirm how much I "personally [have] suffered from racial prejudice and abuse," and for failing more generally to just plain mind my own business. *Tant pis!*

14 Christopher Isherwood's lifelong involvement with the translation, exposition, and practice of Vedanta philosophy would provide a paradigmatic example of this, as would Robert Farris Thompson's involvement with African and African-American culture.

15 "All-black" shows are in this respect unlike, for example, all-Russian or all-Italian shows. Whereas all-Russian shows function unproblematically, to showcase the singularity of artifacts for an interested and enthusiastic public, all-African-American shows often function controversially to demonstrate, to a resistant and defensive public, that original and singular artifacts produced by African-American artists actually exist. I am proud to have shown in the company chosen for the all-African-American shows in which I have participated. But clearly, the necessity of these shows has been more didactic than aesthetic, regardless of the valuable aesthetic qualities that inhere in the artifacts shown, or even the motives and interests of their curators. That the charge of "ghettoization" is thus asymmetrically applied only to all-African-American shows signals the inability of the accuser to perceive and appreciate this work on its own terms. (To see this, one need only consider the likely reaction to a *mostly* African-American show, mounted in a major Euroethnic museum, including just a small sample of Euroethnic artists. The very concept boggles the mind.)

16 People With AIDS. This phrase was coined in the gay community a few years ago so as to avoid the dehumanizing and victimizing connotations of phrases such as "HIV-positives" and "AIDS victims."

17 The classic text in game theory still seems to me to be the best. See R. Duncan Luce and Howard Raiffa, *Games and Decisions* (New York: John Wiley and Sons, 1957), especially chapter 4.

18 I discuss this phenomenon at greater length in "Power Relations within Existing Art Institutions," reprinted in my *Out of Order, Out of Sight*, vol. II. There I treat it as a matter of institutional suasion. But anyone with a talent for market analysis and a few months of careful study of major New York gallery exhibitions can figure out what kind of work to produce in order to elicit market demand, if that is one's motive for producing the work.

19 Colored proponents of poststructuralist discourse often seem not to grasp the self-negating implications of advocating the view that objective truth doesn't exist and that all discourses are suspect, nor the self-defeating implications of adopting what amounts to an unintelligible private language discourse in order to defend these views. But I believe that most Euroethnic poststructuralists grasp these implications quite clearly. That's why they welcome their colored cohorts into the academy so enthusiastically.

20 See note 9.

21 Patricia Failing, "Black Artists Today: A Case of Exclusion?" *Art News* (March 1989), pp. 124–131; Michael Brenson, "Black Artists: A Place in the Sun," *The New York Times*, March 12, 1989, C1; Lowery Sims, "The Mirror the Other," *Artforum* 28, no. 7 (March 1990), pp. 111–115.

22 A recent example of this depredation is the treatment of graffiti art by the Euroethnic mainstream. Unlike other media of expression in hip-hop culture, such as rap music, which has received sustained attention and encouragement by the music establishment, graffiti art was off the streets, on the walls of major galleries, in the work of various young up-and-coming Euroethnic painters, and out the art-world door within two seasons. Now that its idioms have been furtively incorporated into the Euroethnic canon, it is once again safe to minimize its originality and significance as an independent movement.

23 See note 18; also see "A Paradox of Conscience," in my *Out of Order, Out of Sight*, vol. II.

MIRA SCHOR

PATRILINEAGE

ARTISTS WORKING TODAY, particularly those who have come of age since 1970, belong to the first generation that can claim artistic matrilineage, in addition to the patrilineage that must be understood as a given in a patriarchal culture.

The past two decades have given rise to the systematic research and critical analysis of work by women artists, beginning with the goal of retrieving them from obscurity and mis-attribution, inserting such artists into an already constituted, "universal" – white male – art history, and, more recently, focusing on a critique of the discipline of art history itself. A second historical and critical system has grown in discursive relation to the first, as well as a substantial body of significant work by women artists contemporaneous with this rethinking of the gender of art discourse. Even if insertion into a predetermined system is no longer an unqualified goal, communication between systems remains unsatisfactory, incomplete.

One indicator of the separate but unequal status of this latter system, and the lack of communication between these systems of discourse and art practice, is the degree to which, despite the historical, critical, and creative practice of women artists, art historians, and cultural critics, current canon formation is still based on male forebears, even when contemporary women artists – even contemporary feminist artists – are involved. Works by women whose paternity can be established and whose work can safely be assimilated into art discourse are privileged, and every effort is made to assure this patrilineage.

In a sense it is simply stating the obvious that legitimation is established through the father. It must be noted that, in this historical moment, some fathers are better than others. Optimal patrilineage is a perceived relationship to such mega-fathers as Marcel Duchamp, Andy Warhol, Joseph Beuys, and mega-sons such as Jasper Johns and Robert Rauschenberg. Irony, coolness, detachment, and criticality are favored genetic markers. Picasso is not a favored father in our time, and no one would claim more "feminine" fathers – Bonnard or even Matisse fall into this gendered category. The mega-fathers for the 1960s, 1970s, and 1980s have tended not to be painters; Johns is the exception to this, but his insertion of found objects into his paintings and his iconography of cultural emblems assures his patrilineage to Duchamp.

Legitimation is also found through the invocation of the names of a particular group of authors: six Bs spring to mind – Baudelaire, Benjamin, Brecht, Beckett, Barthes, and Baudrillard. Jacques Derrida, Sigmund Freud, Michel Foucault, and Jacques Lacan are other frequent sires for the purposes of art-historical legitimation. The preponderance of thin lips and aquiline profiles among these gentlemen suggests a holdover of Victorian ideas about phrenology. The game is still afoot for Sherlock Holmes, apparently the prototypical mega-father.

To fully analyze the persistence of patrilineage, one would have to develop a methodology to study a vast number of contemporary artists, male and female, white and non-white,

straight and gay, exhibiting and being written about, to trace their artistic family trees, and then read through critical texts to see how their work is referenced to male or female artists and authors. Further controls would establish how various male and female authors undertake this process of legitimation via referencing.

This is a daunting project and not one that I can at present undertake. This essay can only offer a scattershot survey of incidences of patrilineal legitimation, and raise questions about matrilineage within contemporary art practice, critical discourse, and teaching. I will examine texts from several stages of career construction: the exhibition review, the art-magazine feature article, the catalogue essay, and the essay anthology. The scope of my examples is by necessity limited, given the seemingly infinite applicability of the system of patrilineal validation at issue.

The exhibition review is one of the most basic, routine, preliminary elements in canon formation. Reviews at the back of the major, mainstream, international art magazines are generally short texts that usually refer to at least one other artist or author to offer context and validation for the artist being considered. Almost without exception men are always referenced to men; with few exceptions, women artists are also referenced to men. Such references do not usually involve serious efforts at comparison and analysis but rather function as subliminal mentions. Just the appearance of the name of the sire on the same page as that of the artist under discussion serves the purpose of legitimation, even if it is in a sentence, that begins "Unlike" Examples proliferate. One can start and end anywhere, anytime. An *Artscribe* review by Claudia Hart of Louise Lawler's work notes the number of "refined colour photographs of culturally mythological paintings – a Jasper Johns flag, drips by Pollock, a Miró . . . Her mock displays nevertheless set up a mannered Borgesian labyrinth." Her work is then related to that of Dan Graham, and of course, Duchamp.[1] An *ArtForum* review by charles Hagen of Rebecca Purdum's work references her to J.M.W. Turner, Claude Monet, and Henry Moore, while a review by Lois E. Nesbitt of the painter Judy Ledgerwood's work references her to Mark Rothko, Johns, Peter Halley, and finally, to April Gornik, although a reference to Purdum seems called for by Ledgerwood's hazy, painterly surface.[2]

Women artists are rarely legitimating references for male artists – or should one say that women artists are rarely legitimated by the mention of their work in the contextualization of a male artist, even when significant visual and iconographic elements link a male artist's work to that of a female forebear or contemporary? For example, an *ArtForum* review of a Robert Morris exhibition, by Donald Kuspit, discusses the eroticism and spirituality of a work such as *House of the Vetti* (1983), described by the curator Pepe Karmel as "a central slit enclosed by narrow labial folds of pink felt."[3] Kuspit fails to note the obvious reference by both Morris and Karmel to the multitude of "labial" works done by women artists in the 1970s, which preceded and informed this work by Morris. The description of the work and the work itself, reproduced with the review, particularly recall Hannah Wilke's "labial" latex wall sculptures from the early seventies [Figure 29.1].

Feature articles in the major art publications also yield a preponderance of references to fathers. A February 1990 *ArtForum* feature article by Christopher Lyons on Kiki Smith is a case in point. Smith's work, as Lyons immediately notes, is very much about the body, representing inner organs, "humors," egg and sperm, flayed skin, tongues, and hands. It is often made out of materials such as rice paper or glass, whose delicacy is a metaphor for the fragility of the living body. Smith is of the first generation of artists whose education could have included an awareness of art by women and of issues of gender and the role of the body in gender discussion. Her works on rice paper particularly recall the work of Nancy Spero, while certain other works recall Eva Hesse. Lyons seems aware of the problematics of tradition. He begins his article

Figure 29.1 Hannah Wilke, *Of Radishes and Flowers*, 1972. Latex and snaps, 76 × 32 in. Courtesy Robert Feldman Fine Arts, New York.

by stating that "much celebrated art comes at the end of a tradition, and is recognized in terms defined by it. But certain artists appear to rediscover, under the pressure of new conditions, a lost or buried concern. . . . Smith's is a timely subject – the body has become a political battleground, as the various organs of social control fight over it."[4] However, he does not define what these "new conditions" are or what the nature of the "political battleground" might be, although the feminist component of these questions appears obvious.

Instead, Smith is almost instantly given a mega-patrilineage: "The concept of self-empowerment, *Selbstverwaltung*, at the heart of Joseph Beuys' political activity is also, in a quieter way, a goal of Smith's emblematic employment of the body's elements."[5] Note that Smith's way is "quieter," that is, more feminine. This daughterhood (the term implies both relationship to a parent and good, filial behavior) is reinforced three paragraphs later when

Smith's actual patrilineage is invoked; her father, the sculptor Tony Smith, is mentioned. Once Smith's patrilineage is safely (and doubly) established, Lyons briefly mentions that Smith follows "the path of Nancy Spero rather than Andy Warhol."[6]

Catalogues by curators deeply involved with trend setting and career production also reveal a view of art history and lineage remarkably untouched by developments in feminist art and analysis. *Pre/Pop Post/Appropriation* is the exhibition catalogue by Collins and Milazzo for a show they curated at the Stux Gallery in New York in November 1989.[7] In this exhibition the younger artists showcased by Collins and Milazzo and Stux – Annette Lemieux, the Starn Twins, and Nancy Shaver, among others – are given historical context and legitimacy by the inclusion in the show of works by Rauschenberg and Johns. The catalogue goes further, listing, in elegant boldface, italic headings, Cézanne, Duchamp ("and the Meta-Game of Desire"), Rauschenberg, and Johns. Despite the frequent references to the "Body" and "Desire" (as in, "The 'Body,' 'originally' coded for desire, is frozen in Cézanne, and meta-conceptualized and meta-eroticized in Duchamp"),[8] the catalogue essay betrays no awareness of the vast amount of available materials on sophisticated theorization of the body in works by artists, such as Mary Kelly, or philosophers, such as Luce Irigaray. The contextualization system of legitimation is extended to the statements on each individual artist. The men are of course referenced to men (the Starn Twins to "Rembrandt, Picasso and the Mona Lisa"). And so are the women: "The 'Body' has always figured prominently in Suzan Etkin's work." In her early work, a "process of objectification had to do with reclaiming her own body as a woman, and historically, repossessing the body of the Woman as an object of desire, on a symbolic level, not only from the male artist in general, but specifically, from an artist whose work she, in fact, still very much admires: Yves Klein."[9] Does one need to be reminded at this juncture of Klein's piece, in which naked women, covered in pigment, rolled around a piece of paper on the floor in front of bemused onlookers?

Holt Quentel's "world literally sewn, patched together, wilfully, intentionally; torn and then stitched back together; then worn away" is the world of the other male artists in the exhibition. But what of quilts by women, which gained legitimacy as aesthetic artifacts through the agency of the feminist art movement? What on Sonia Delaunay? What of Lee Bontecou? Betsy Ross does get a mention in the section on Lemieux, but Lemieux's use of autobiography, female anonymous biography, receives no other historical context than that of modernism and postmodernism.

Meg Webster's "concrete effort to reassert immediacy in the work of art, to bring (back) to consciousness the radical content and process of Nature, and to reassign Value to the element itself" is referenced in this catalogue and in an individual show catalogue by Collins and Milazzo (Scott Hanson Gallery, January 1990) to Rauschenberg, Ross Bleckner, and Robert Gober. Ana Mendieta, Michelle Stuart, Nancy Holt, Alice Aycock, and the many women artists represented in Lucy Lippard's *Overlay* who use earth to work on the concept of Nature have been occulted by the exclusivity of Collins and Milazzo's use of patrilineage to further their system of art-star production.

Critics and dealers may prefer to legitimate women artists whose very real self-referencing to male artists makes it possible for them to be inserted and then resubsumed to patriarchy. Clearly, all women are inculcated with patriarchal values and all women artists are taught about a male art history. Clearly, many women artists participate in the perpetuation of patrilineage by consciously associating their work with that of male forebears. Why link one's work and career to a weaker, less prestigious line? It seems likely that male critics in particular chose to write about women artists who conform best to this system. But this generation of artists, critics, and curators cannot pretend that there have been no women

artists or writers. And yet, the elision of women is so seamless that, reading through a Collins and Milazzo catalogue essay or an *ArtForum* review, one forgets that there *are* women.

This seamless persistence of patrilineage is most frustrating at the intersection of post-modernist and feminist discourse. *Art After Modernism: Rethinking Representation*, edited by Brian Wallis, is an anthology positioned at just this intersection.[10] In the front of the book, the contents lists essays by Rosalind Krauss, Abigail Solomon-Godeau, Mary Kelly, Lucy Lippard, Laura Mulvey, Constance Penely, Kate Linker, and Kathy Acker (nine out of the twenty-four authors). But in the back of the book, the index reveals a pattern of referencing consistent with patrilineage. The index references at least eighty-three male visual artists, writers, and critics, with multiple page references of Duchamp, Warhol, Adorno, Baudelaire, Benjamin, and Brecht. Twenty-seven women are referenced; of these, fewer are writers and theorists, and the overall number of page references is smaller. This survey is unscientific but reveals something of the underlying persistence of male referencing in the process of art-historical construction.

Perhaps most disturbing is the use of patrilineal legitimation in noteworthy feminist texts, such as Griselda Pollock's *Vision & Difference*, one of the most substantial exercises in feminist revision of art-historical practice. Her essay "Screening the Seventies: Sexuality and Representation in Feminist Practice – a Brechtian Perspective" reveals its basic reliance on patrilineage in its title. Pollock charmingly begins one early section of the essay, by writing, "I want to start with boys,"[11] but in fact she never ends her use of the "boys." In order to position artists such as Silvia Kolbowski, Barbara Kruger, Sherrie Levine, Yve Lomax, Marie Yates, and, principally, Mary Kelly at the forefront of the critical avant-garde, Pollock rates their success in effectively intervening in patriarchal systems of representation by the degree of their adherence to Brechtian principles of "distanciation," as formulated by Brecht and promoted by Peter Wollen and Stephen Heath (the latter two, by publishing essays in *Screen* magazine).

Pollock first outlines the Brechtian program and its scripto-visual practices and techniques, then repeatedly inscribes Kelly's work into this context:

> While the major but not exclusive theoretical framework of the *PPD* [*Post-Partum Document*] was a revision of the psychoanalytical schemata of Lacan, the representational strategies were informed by the Brechtian uses of montage, texts, objects in a sequence of sections. . . .
>
> Although the *PPD* was produced within the spaces and discourses of the visual arts, its procedures echo Brecht's almost cinematic conception of the interplay of text, image, object. . . . The *PPD* fulfills Wollen's projection of a complex work of art confronting not Woman or women but the underlying mechanisms which produce the sexual discourses within which women are positioned in contemporary western patriarchal societies. . . . But in terms of artistic practice the questions of subjectivity and sexual difference need to be developed in relation to Brechtian strategies and their political priorities.[12]

The usefulness of Brechtian strategies to intervene in patriarchal representation should not, however, vitiate at least some discussion on the ambiguities and ironies of relying so heavily on a male system to validate a feminist practice. In this significant example of feminist avant-garde canon formation, the woman artist is still subsumed to her mega-father.

These samplings in the published material of mainstream art culture turn one into a de facto Guerrilla Girl: there are so few features on women artists, so few reviews – and

those are so often placed further back in the review sections – so few references to women artists, writers, and theorists. Hence the significance of a 1989 Guerrilla Girls poster listing all the works by women artists that could be purchased for the price of one Jasper Johns. There *are* mothers. Matrilineage and sorority, though constantly re-occulted by patriarchy, exist now as systems of influence and ideology. In addition to the wealth of fathers that no sane woman could deny, as a painter and a critic, I place myself in a matrilineage and a sisterhood: Frida Kahlo, Charlotte Salomon, Florine Stettheimer, Miriam Schapiro, Pat Steir, Ida Applebroog, Elizabeth Murray, Ana Mendieta, Louise Bourgeois, Charlotte Brontë, Jane Austen, Louisa May Alcott, Emily Carr, Luce Irigaray, Griselda Pollock, Mary Kelly, Simone de Beauvoir, Simone Weil – all artists and writers whose works have influenced, informed, and, perhaps most important, challenged my visual and critical practice.[13] It is by now a vestigial cliché that the male art system offers me resistance as water does to the swimmer; at present I am most challenged by resistance within the present of feminist thought. To hone one's critical understanding by a vigorous debate with other women offers more hope for a revitalized art discourse than does the endless reinscription of a stale patrilineal system.

All studio art and art history students should know the names listed on the Guerrilla Girls poster. They should be aware of the multiplicity of feminist art history, practice, and theory. If there is a resolution or a solution to the persistence of patrilineage, it must be at the level of education. At the end of a semester survey course on the history of women artists one student, an art history major, asked, "Why do we have to have this course? Why didn't we learn about these artists and these issues before?"

Why indeed? Feminist art programs and women's art history courses had barely developed and been reinforced with a minimum of slides when the rightist backlash of the Reagan years intervened, cutting funds, attacking the ideal of affirmative action. In the art world, movements based on process, concept, and performance – not linked to the market – were replaced by art movements based on critiques, often collaborationist, of capitalism. Schools followed, or rather slipped back. Curricula lost courses on women; women faculty lost energy for teaching such courses. Slides of works by women artists were lost. Most art schools do not provide enough information on women artists, and what little material they do offer is often without a pedagogic and theoretical framework. Combined with the patrilineal tendencies of art writing and canon formation noted in this essay, the art student, female or male, has few tools for disrupting patrilineage.

To cause such a disruption is not a question of creating a Marceline Duchamp: it is exactly the opposite. The end game of postmodernism turns on the eternal ritual killing and resurrection of a limited type of father. Other models might provide a path to a new art history and a different system of validation and legitimation. And maybe some bastards and orphaned daughters (and the entire Third World) could find homes and genetic placement.

Postscript: Summer 1992

[. . .]

If women are denied access to their own past they always occur in history as exceptions, that is to say as freaks (Sue Williams's "self-destructive" personal history is useful to this type of mythmaking), and they are forced to rediscover the same wheel over and over, always already losing their place in the growth of culture. They are denied the critical mass of a history, with ancestors and even with Oedipal battles between generational rivals. If women themselves deny association with feminism, they are likely to be subsumed to male history no matter how exceptional they are. Women may feel they risk a lot by linking themselves

to women progenitors as well as to men, but while the magazine review linking a woman artist to a male progenitor, either through a positive – or even negative – reference, may bring short-term career benefits, in the long term, experience shows that the art history text-book will name only the mega-father, and the artists who were described as "like" or "unlike" him will become simply, "and followers," among which women will be the last to be named.

It is a commonplace of history that it is written by the victors. Western civilization is so much a male "hommologue"[14] that it will always privilege a man's failure over a woman's success. It can barely consider accomplishments of women. They don't compute. To undo that process requires constant vigilance. Women must reexamine the very notions of success and failure in the light of their basis in a patriarchal value system. Yet women's fear of asso-ciation with a "weaker" position remains a powerful force in the maintenance of patrilineage *by* women. Comments by individual women working in the new abstract painting suggest a distrust of any word beginning with *fem-*, rejecting the marginalization *fem-* might entail but, by the same token, rejecting the specificity of political/personal experience that might enliven their work and prevent its absorption into yet another "universalist," that is to say male, move-ment.

In "Patrilineage" I insist on the importance of a new, more gender-conscious form of studio-art and art-historical education. Patrilineage can only be dismantled by the conscious will to do so by women and men involved in the process of art production, criticism, and history. Women artists must identify women artists whom they admire, were influenced by, or even those they dislike or feel competitive with, revealing the *woman's world* many women artists now occupy in their daily aesthetic lives. An effort must be made by critics to not only be aware of those influences, but even to search for them, and further, to posit the issue of gendered influence as a problematic of art. What does it mean for a woman to claim to be doing "universalist" work? Or to be clearly influenced by male artists, including, in some cases, misogynist ones? These questions must be critically addressed.

Patriarchy has a lot invested in the notion of universality and in the process of patri-lineage. Property is what is inherited through legitimate lineage, and the possession of property – be it culture, history, or philosophy – is ultimately what is at the core of this art-historical mechanism. Artists and art writers, women in particular, have a stake in undermining tradi-tional notions of property, value, and lineage. The method is really very simple: it will always be a man's world unless one seeks out and values the women in it.

Notes

1 Claudia Hart, "Reviews: Louise Lawler," *Artscribe International*, no. 67 (January–February 1988): 70.
2 Charles Hagen, "Reviews: Rebecca Purdum," *ArtForum* 28, no. 5 (January 1990): 134; Lois E. Nesbitt, "Reviews: Judy Ledgerwood," *ArtForum* 28, no. 3 (November 1989): 151.
3 Quoted in Donald Kuspit, "Reviews: Robert Morris," *ArtForum* 28, no. 1 (September 1989): 140.
4 Christopher Lyons, "Kiki Smith: Body and Soul," *ArtForum* 28, no. 6 (February 1990): 102.
5 Ibid.
6 Ibid., 105.
7 Tricia Collins and Richard Milazzo, *Pre/Pop Post/Appropriation*, exhibition catalogue (New York: Stux Gallery, 1989), unpaginated.
8 Ibid.
9 Ibid.
10 Brian Wallis, ed., *Art After Modernism: Rethinking Representation* (New York: New Museum of Contemporary Art; Boston: David R. Godine, 1984).
11 Griselda Pollock, *Vision & Difference: Femininity, Feminism and the Histories of Art* (New York: Routledge, 1988), 157. [Chapter 13 in this volume is an extract from this work.]

12 Ibid., 169, 170, 199.
13 When I first wrote this essay, my wish was to choose names of women that were very well known, in order to establish their seemingly obvious availability as spiritual mothers to a woman artist, indeed to any artist. In order to be dispassionate, I did not place myself in the most personally relevant matrilineage and sorority: my mother, Resia Schor, is an artist whose answer to widowhood was to further develop her own art and her capacity to support herself and her family rather than seeking the help of a man; my sister, Naomi Schor, a distinguished feminist scholar, laid a path for me to follow, through "women's lib" and French feminist theory. Beyond these two most important female models, I live in a sisterhood of artists, former students, colleagues, friends all, whose work is of primary concern to me: Maureen Connor, Nancy Bowen, Susanna Heller, Susan Bee, Ingrid Calame, Robin Mitchell, Faith Wilding, Portia Munson, Rona Pondick, Jeanne Silverthorne, among too many others to list.
14 Luce Irigaray, *Speculum of the Other Woman* (Ithaca: Cornell University Press, 1985), 240. Irigaray speaks of the "phallosensical hommologue" of Western civilization.

Chapter 30

HÉLÈNE CIXOUS

BATHSHEBA OR THE INTERIOR BIBLE

I'VE TAKEN TWENTY-FOUR STEPS in the direction of Bathsheba.

1. To what degree is it not about "a nude," behold why, between all the magic ones, I first said that one.

From her, I want to receive the secret message.

This female nude is not a nude.

She is not made – not painted – to be seen nude. Precisely her – Bathsheba. She who was seen. Should not have been seen. She who is perceived. From afar.

She whom we see is not the mortal object.

Not the object of desire, and of murder.

It is Bathsheba in truth.

The non-nude nudity. Not denuded. Not undressed. Clean, characteristic.

Absolute Bathsheba. Without a man. Can we imagine seeing her: "David and Bathsheba"? (The name Bathsheba invokes David – but not this woman, here, no.)

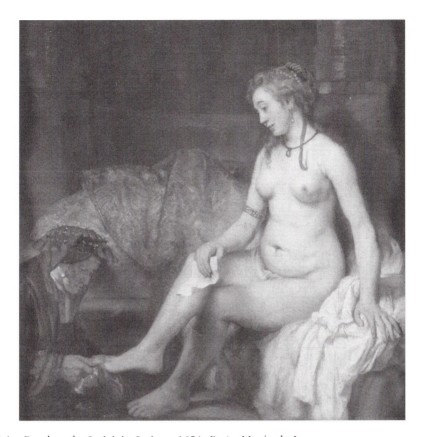

Figure 30.1 Rembrandt, *Bathsheba Bathing*, 1654. Paris, Musée du Louvre.

2. This is Bathsheba. The dark surroundings must be what's left of David. This sort of blackness? . . . If there is a couple, a pair in the painting, indeed it would be day and night.

(I say blackness, and not: black. Blackness isn't black. It is the last degree of reds. The secret blood of reds. There are so many blacks . . . Twenty-four, they say.)

I said "without a man." I mean to say without a "visible" man. I mean to say without an interior man. Inside herself. Without . . . preparation, without rigidity. This woman is not erect.

(And Rembrandt? – Ah! Rembrandt's sex –
Nothing to do with Rubens's sex of flourishes, nothing to do with da Vinci's mirror. Rembrandt is without ostentation.

The Rembrandt('s) sex is matrical.)

3. Why wouldn't Freud have anything to say about Rembrandt? Because there is no family scene, one sees no menace, no transference, no projection, there's no dependence, no authority, no cruel attachment.

Look at Titus. Titus is not "a son," he's a boy. This is a young man. This young man is.

This old woman is not maternalized. This old man is not venerabilized. The old man is old.

The wars of appurtenance, of appropriation, that rage in families: no. No violence. Only insistence and profundity. And to each, his or her profound destinal mission: becoming human.

4. What there is not in Rembrandt: there is no da Vinci.
Not the smile. Not the look that takes or the smile that flees.
There is no smile: no exterior. No face that lets itself be looked at. That knows it is looked at. No face. No surface. No scene. Everything is in the interior. No representation.

The passivity of Bathsheba. The despondency.
The imminence. Drooping over her somber heart.

5. There is no Vermeer.
No walls, no painting on the walls, no window, no panes, no curtain, no nautical map on the wall, no cupboard.
In Vermeer, light enters by the window on the left and draws. Everything is in the cell. The outside knocks on the windowpanes. The exterior enters the interior.
(The camera obscura, the machine for seeing gives us: photographic vision, from foreground to background.)
Here: no objects in the foreground, no fruits. No spools of thread. Here, no exterior, no era, no city.
Vermeer takes us to Delft. To the Lacemaker's. Eternal Reconstitution.
Where does Rembrandt take us? To a foreign land, our own.
A foreign land, our other country.
He takes us to the Heart.

6. One must penetrate into the country (– says Van Gogh – stay in the Midi, until, by penetration, you become it).
Sharpen one's eye on the land.
Cézanne being absolutely from the very land, he knows it so intimately, one must make the same calculation internally in order to arrive at tones like this (Firm tones).[1]
Rembrandt's very land? Neither the city, nor the countryside. The interior land: "the landscape of the interior Bible." I say the Bible, that is to say, the land of the most ancient passions, it is a land without landscape, without monuments. But not without form and without inhabitants.
How to get there? How to get inside a star, Van Gogh wondered? The fastest method of transportation is not the train, it's death.
And to get inside the interior Bible? One must take the stairs, and plunge into the flesh. Down to the farthest memory.

7. It's dark here. We're down below. We're here.
In the breast. Immediately. Such an absence of exterior!
The country is a room of palpitating folds.
What I feel: this obscurity. It is the troubled air of our secrets, those that govern us and that we're not really aware of. We (Bathsheba) are in the secret. The secret surrounds us. Bathsheba is seated in our room, in our breast, like a luminous heart. She contains the light. The light doesn't spill out.
The Body: bread of light.

I verify: where is the light coming from? The shadow of the ribbon on Bathsheba's skin tells us that a strong light is coming from the left. But the pearly luster of the triangular lining under the servant's cap tells us that a stream of light must be rising up from the right.

The source of the light is cut off. The light remains. The secret fire that emanates from the flesh.

8. Of what secret lights are we made?

Of what densities?

What Rembrandt gives back to us: the dough, the depth, the tactile, that which we lose, which we have lost, we who live flat, without density, in silhouettes on a screen: the interior radiance.

– A scene of Rembrandt (let's take a family scene, or a scene like this one, a scene of "corporation"), what gives it its force – by which it takes us, pushes us, pinches us, caresses us, is, beyond courtly war exhanges – beyond pretenses, codes . . .

– that it always occurs at the same time in the cellar in the cave or in the forest, in these great and somber prehistoric cathedrals where our colors, our drawings stir, where attraction and repulsion shine, like lanterns in our obscurity. It is there (to the bottom) that Rembrandt leads us. Taking the red staircase, down to the bottom of ourselves, under the earth's crust.

This world is full of night and of golden stuff. The stuff of night is a clay. A mud. It is still moving, imperceptibly.

No landscape and no "furniture" either. Instead of furniture, "shelving," "shelves" of color. Bands, brush strokes. What do you see, there?

A man said to me, here's a cupboard. With linens piled up.

Another man, this one a painter: an architectural background, a pilaster.

A commentator said to me: the curtain has been drawn aside.

We have such a need of cupboards, of curtains, such a need to furnish.

The interior world is full of night and of golden stuff, of the stuff of night. Spools of nights.

Curtains? The curtains have been drawn aside? The stuff, the linens, the dark golds, the white golds, border on, play in major and minor, the body's blond gold.

The entire room is flesh. Sex.

The "curtains" have raised themselves like eyelids, uncovering the clear pupil: the luminous body of Bathsheba.

I notice: "the sensation of curtains drawn aside." As if our naïveté were thinking: this, this light in the cup of flesh, only exists hidden, preserved. It's *intimacy*. We can never see it, except by indiscretion.

(See the incredible Holy Family at the Curtain: it's about magic: how to make us feel the intimacy of intimacy, the *intimitude*?[2] We are graced with being shown what is hidden behind the curtain: same gesture as for gazing at a baby in its cradle: we lean over, pull the sheet aside, the veil, the curtain, taking care not to tear it from its intimacy. Bathsheba in the cradle, sleeps before us, very near, very far from us.)

It's about the discrete sensation of "revelation."

We see a mixture of slowness and agitation. The moment "just afar" – not yet. It does not yet have a name.

9. With what is she painted?

Van Gogh said that Delacroix said that Veronese painted white blond naked women with a color which, by itself, greatly resembles street mud.

Van Gogh wants to paint with the earth. To mould.

With what mud is Bathsheba painted? With what earth?

With the flesh's butter. With ghee. That rosy blond butter.

Libations.

Bathsheba nude.

I see Rembrandt painting the veil (that doesn't hide a thing) on her groin.

Rembrandt grazing Bathsheba's groin with a veil.

The veil, a nothing that creates the nudity.

Without this transparent nothing we would forget she is nude.

Bathsheba is in person. In a dressing gown. In body.

It is the body that is the face.

10. She does not look at us. She is of those who do not look at us. I mean to say: those women, Bathsheba, Mary, Hendrickje, don't look at us, don't stop living, (that is to say dreaming, that is to say leaving) in order to look at us.

They withdraw, they take their leave slow, a thought carries them toward the unknown, far away. We hear – barely – the call from afar –

And we, looking at them, we see though taking its leave. We see thought. It is a portrait of thought, according to Rembrandt. Thought is not the weighty thinker seated. It passes, inside, distracted, traveling, it is the foreigner, the stranger.

He paints the foreigner, the stranger in me, in you.

The times when under the letter's sway –

we suddenly become the stranger, the foreigner in ourselves. We separate ourselves from ourselves. We lose ourselves. From sight also.

He catches, paints, the point of departure. The hour, when destiny slips from our eyes.

Everything seems domestic. And yet such a strangeness wells up in our eyes, like tears. It's that she is already gone, she who is called Bathsheba. But the body remains. That much more body, that much more flesh, that much heavier here, now that she-Bathsheba is elsewhere.

The face is traveling: a great silence resigns in the painting.

"What are you thinking about?" we wonder.

11. A nude woman thinking. "Thoughtful body."

On the other hand the thoughtfulness accentuates the nudity: naked nudity. Nudity un-thought. Un-attended to, un-kept. Given.

(What does a naked woman think about – her rapport to her body, always the slight attention, like a veil, the glance or the gaze. Whenever I'm naked, I don't look at myself, I cast a glance my way (– the glance of the other, of you/me at me) – But no, Bathsheba does not look at her body. She is not before herself. She is not here. She is gone, behind her eyelids.)

On the other hand, the person who thinks in front of us, abandons us. A very slight betrayal rouses us: we miss her a little, she who is (only a little bit here) absent.

Distracted, she is abstracted from us.

"He doesn't paint great Historical subjects (said a contemporary). He paints thoughts . . ." (Roger de Piles, 1699, Paris).

(He paints thoughtfulness. This absence in the body. This leave-taking by the soul that leaves the body deserted like a living tomb. We think: we're parting.

12. The older woman further down at the bottom is a remainder. She comes back to us from this drawing [see "Fragment of a drawing," London: Victoria and Albert Museum].

Bathsheba is also then this other woman.

The woman with the cap is: Bathsheba's strange foreignness, her exoticism, Asia.
Nude with a cap! Extravagance: something aberrant in the coifed nudity.
And the coif: oriental . . .

This nude cut in two: the body is Bathsheba's
　　　　　　　　　　　the coif is the older woman's . . . The cap! is at work.
The "servant's" gaze moves off toward the future in the East.
Bathsheba's gaze withdraws toward the occidental future.
The two gazes descend slowly, toward the bottom.
Cross each other, don't see each other. Are on two parallel planes.
The two women withdraw from the scene thoughtfully.
The "servant" wipes Bathsheba's feet distractedly. She is elsewhere. They are elsewhere. In soul they are elsewhere. The body, left, weighs more heavily.
What is the "servant" thinking about? These two women are daydreaming of the end of the year. At the end of the year, a path will have been lost,
The end of the year . . .

At first glance, at tenth glance, this is the face that at first I see. I should say: this demi-face. We call this: profile. In fact it is a side, a half, a demi-star. The other side belongs to the night. I will never know then but half of Bathsheba, the illuminated part.

13. Something unreadable catches my eye. Maybe this, I tell myself, after a long time: it is something that glides from head to toe. A motionless movement, a transformation. Now I see it, it is time, and even: it is time's writing, it is age. From the young head, the body goes forward, aging imperceptibly. Ah! So that's what was gripping my heart. This young woman is in the process of aging. The future is spreading through her limbs. Her breasts are still childlike, already her pelvis, her thighs, her legs are in the hands of age.

What? I mustn't say this? But this is nonetheless what Rembrandt paints: the passion (the suffering) of Bathsheba, starts here, in the body, between the knees,
where floats . . . the letter.

14. The Violence of the Letter.
At first I didn't see it. The Letter.

Little by little the letter captures the gazes.
At first I looked at the body.
This body that lets itself fall into itself.
That weighs. Weighing. For? Against?

I looked at the body's dough. The flesh furnishes. Without muscles. (See the muscled thighs of the *Woman Bathing*.)

A despondency, a prostration. Of an animal that knows itself promised. To the sacrifice.
"The body lowers its head."
(It seems there has been a *pentimento*[3] of the head.)
(Whereas all the women rise, in one way or another. Even the modest ones, even Hendrickje. They have muscles or a cap.)
Bathsheba is drooping. Slightly.
Chin drooping.
An indolence has seized her.
Dejection? Resignation?

How she holds the letter: Weariness. She might drop it.

15. (N.B. the victory of the letter: the slow rise to the surface, the insistence.)
So there is a letter.
There is always a letter.
The letter, what violence! How it seeks us out, how it aims at us!
Us.
Especially women.
And more often than joy, it is some death it brings to us.
I don't know why I hadn't seen it. And you?
What's a letter, next to a big body full of buttered light? a crumpled paper, next to these unctuous linens?
Suddenly I am letterstruck. And I see only it.[4] This letter! No, it's a hole in the body of the painting, the rent, the tear in the night. If I see the letter, I no longer see Bathsheba. And now that I have my eyes on the letter, I see that it's the letter that spills this shadow on to Bathsheba's left leg. This letter is in opposition. To the veil. To the linen.
To the reading. It is a letter from the back. It turns its back to us. When I wanted to read it: forever forbidden. To paint a letter seen from the back! The Door is closed. It is David, an old tale whispers to me.
David is the outsider. The outside. The arranger.[5] Invisible.
"David and Bathsheba," that's it: it is Bathsheba to the letter . . . The letter resounds throughout the entire painting.
Form
This painting is divided more or less into two triangles.
Shadow of gold and (carnal) light of flesh.
In the center, the stroke of the letter.

16. The letter has just been read.
The two women are under the letter's sway.

The letter has taken their breath away. Has dispatched them over there into the closed time, before the closed doors to the future.

Here in the painting, in the tent, they have already past, the present already past falls in heavy folds toward the bottom.

How white the letter is in the middle of the painting. Of a shadowy rosy whiteness. The letter is within the scale, so it is a part of Bathsheba's colors.

Letter one neither holds on to nor drops. Holds the entire painting under the indecipherable charm of its breath.

And how red the stain is at the corner of the letter.

Like a signature. The mark on the shoulder. A touch of purple on the white. Sign or signature. Piece of red seal? A bit of wax. So is it realistic? No, it is red. It is an element. Incarnadine.

Portrait of Sadness: presentiment of mourning.

Bathsheba's sadness:

She becomes sad under the insistence of our gaze.

The mouth made for smiling, the mouth doesn't droop.

The sadness is in the brow: the brow slightly rises like thought slightly rises as it attempts to think farther.

17. I've just seen, in the collection: *The Lacemaker*, *The Astronomer* by Vermeer. The *Erasmus* by Holbein.

The Lacemaker is a *sublime still life*. I remained in contemplation before the light and shadow of the lacemaker's fingers. The sculptured aspect of the light. *The Lacemaker* is a Cézanne by its ridges. *The Lacemaker* is perfect. In its every detail. It is a treasure chest full of precious colors. It isn't lacking in anything. We feel a great satisfaction. Like before the perfection of a doll's house: everything is there, down to the smallest cooking pot. And into the bargain there are those yellows. Everything is in order in the house.

Erasmus hasn't changed. It's really him, today as three centuries ago, the same dry, thin-lipped man. Erasmus's appearance hasn't changed in three centuries. It is a photograph. There is no interior. Holbein is the master of the genial splendor of realism. I imagine the surprise of his contemporaries. Such a resemblance!

(It seems that certain buyers would complain about the lack of resemblance in Rembrandt's portraits. What must resemblance resemble?)

18. Why do I place Rembrandt above, elsewhere, apart? Since forever? No realism: what he paints is a woman hidden under the appearance of Bathsheba. He paints the precise passing instant, the instant that is the door to eternity. In the instant is the eternity.

In Rembrandt truly no realism. To what degree it is the soul he paints, the soul in flesh and in light, can be seen by the indifference he manifests for the "realistic description" of the body. The position is impossible. I tried. But this is of no importance. It is the soul that presses the thighs together.

He paints a woman struck by a letter, carried outside of herself and whom he calls – we call – Bathsheba.

He paints the bruised heart of Bathsheba. He paints the slight and uncertain intensity.

Rembrandt paints the secret: the trace of what escapes us: he always paints what escapes us: what has just happened, what is going to happen, and which traverses us suddenly, pierces us, turns us upside down, escapes – beyond the painting, beyond thought, and leaves us there painting, suspended, grazed, he paints the body that remains, maybe the skin, maybe the cadaver.

The painting is the place of passage.

19. And in order to paint this, one must be dead.

He paints like a dead man. Like a poet. Like a dead man.

See why Van Gogh places Rembrandt apart, elsewhere:

"Rembrandt remains faithful to nature, even when, there too and still, he goes to the heights, the highest heights, infinite heights, but just the same, Rembrandt could still do otherwise when he didn't feel the need to remain faithful, in the literal sense of the word, like in the portrait, when he could be poet, that is to say creator."

"That is what he is in the *Jewish Bible*."

"– What an immensely profound, noble sentiment. One must die several times in order to paint like this, now this is a remark one could apply to him."

"Rembrandt penetrates so far into the mystery that he says things no language can express. It is just of us to say of Rembrandt: the Magician . . . This is not an easy craft."[6]

The craft of death isn't easy. What does that mean?

For example this: it isn't with the appetite of desire that Rembrandt paints Bathsheba. It is with attentive love for the creature, for the miracle of existing. The profound amazement, joyous without splendor, almost pious before this invention: the human being. Nothing royal. Nothing extraordinary. The sober splendor of the ordinary. What is marvellous: the ordinary metamorphosis: these people are subject to alteration, to time. Time is at work. And not just time. Everything that endlessly paints us from the inside. All the blows and messages that knock at the door to the heart, and paint from the inside the troubled nervous agitation we call soul. (The soul, our capacity to suffer, said Tsvetaeva.)

That which wells up in Bathsheba, that which the letter has poured into her body, into her organs, into her brain, and which is working on her body, her face, her brow, from the inside.

She's listening to this: this transformation in herself. Which is still new, mobile, momentary. She doesn't know who, shortly, she'll be.

Traversed.

Traversed, St Matthew too? Transfixed. Cocked. All ears.

He paints us listening to ourselves change.

On the one hand he paints.
The heavy
Silence
of Bathsheba

On the other he paints *the Voice that causes writing*.
– The Voice – How to paint the Voice?
– We don't see the voice.
Rembrandt paints the voice we do not see.
 paints what we do not see.

see?
paints what speaks inside . . .
 the word The Angel

20. I see *St Matthew and the Angel*

What I love is: the proximity of the invisible.

And the hand on the shoulder. The voice's hand. Because the mystery of the voice is this: it is that it touches us. And also this angel so close, so flesh – who is but a head and a hand: (The body . . . we imagine it.) The angel, I mean to say the voice, the body is: "on tiptoe." It is the tension. Toward the ear we're aiming for.

I approach: the truth is that the angel is a part of St Matthew. This man has an enormous square build. He radiates force, ruggedness, the wind. He passes from the road and the forest to the writing table. His cheeks are struck by the air. Colored by intemperate weather. One would think an earthly sailor, a woodcutter, a giant tamed by tenderness. A heavy handsome man touched by grace. The angel is his grace. Rembrandt paints to the letter: that which was metaphor is made flesh. The voice comes from very far, very near. With all his weight, with his whole forehead, his whole mane, the man listens. The voice (of the angel) passes through his throat.

Rembrandt paints this mysterious thing that mobilizes the body: the state of creation. Writing, thinking, is being in a state of waiting for what is yet to come, but proclaims itself – Proclamation and imminence – a force stronger than myself comes up behind me. And – I guess – painting is the same way, with the angel at your shoulder and eyes that listen and do not see.

This is also the attitude of the *Philosopher Meditating*.[7] The philosopher is "listening." He is nothing but an ear. All is audition. Slightly turned away from the light, from the book – and from the bust. Hence pointed toward the mouth – obscure ear . . .

What is "a philosopher meditating"?

A somber conch.

Meditation takes place at the bottom of the staircase.

21. We, we have lost our heads a bit?

For we are on the road to our most violent, most foreign fellow-creature.

The Ox. The Hermit. The Turned Upside Down. The Acrobat. The Paralyzed. The Ancient Choir. The Truth. You, as I see you when I see you as you really are: and to do this I have to draw the curtains aside, to slaughter you, to open you up – (with my gaze only). And then, naturally, it is me that I see, it is us, nude, it is our nuditude,[8] magnificent, our power bound, our shining blindness.

Why do we adore *The Slaughtered Ox*? [See Figure 30.2.] Because without our knowing it or wanting it, it is our anonymous humanity. We are not Christ, never, Christ . . . no I will not speak of this.

We are this creature, which even turned upside down and decapitated and hung beneath the earth – when it is seen with those eyes that don't reject the below, that don't prefer the above –

maintains its majesty.

Behold the portrait of our mortality. The being hung (by its shins), turned upside down, twice decapitated.

What we become under the ax and the slicer.

There is a butcher shop on our life's path. As children we would pass trembling before the butcher's window. Later on we want to forget death. We cut the dead one up into pieces and we call it meat.

22. And the Curtain? Or the frame?

To see the ox we must enter into the painting. The ox is framed. The frame is in the interior of the painting.

The painting has two doors. One in front. One in back. Let's enter. We enter by the front door. We're standing in the cellar. The ox is a lamp, an enormous hanging lamp. It is the aster of this night. It irradiates.

The ox is beautiful.

The ox shines in the darkness. Where? Back of a shop? Cellar? Tomb? The ox is a gigantic ingot of flesh.

The ox is bound. The ox is nude.

Who are we contemplating? Samson's truth, or Rembrandt's. The blind, the freed, the powerful slaughtered. The gazed upon. Who by their magnificent helplessness fill us with wonder.

The vanquished sparkles. (Vanquished but Strong)

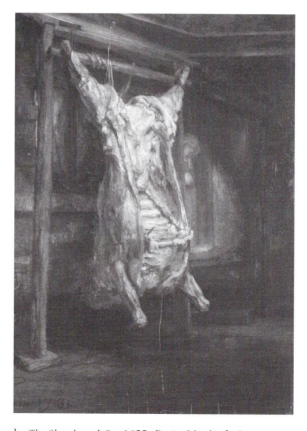

Figure 30.2 Rembrandt, *The Slaughtered Ox*, 1655. Paris, Musée du Louvre.

Nothing less "realistic." To paint this. With what admiration. What love.

The ox is hurled to the bottom. And there are no angels. The huge body is sideways. Everything adds to the impression that someone has left it all alone.

All of a sudden I see: it's about our captivity.

23. The ox is dazzling. The ox is pregnant with light.

To the extent that we don't see the woman's head – advancing prudently, in a halo of weak light.

The light seems to be the luminous shadow projected by the flesh.

In "reality" it is doubtless coming from behind the door.

The woman pokes her head in through the doorway, to see? Furtiveness. As if she were looking at what mustn't be looked at.

Clandestine glance: curiosity wonders: is it there? Who's there? What's hidden there?

To one side the powerful body, the incarnation of slaughtered power, hung by its feet. Why is the ox hung "head down" (the absence of a head down there)?

On the other the small head without a body, the question.

But we don't see her. The shining of the ox attracts my entire gaze. Attracts us. We are attracted by the open ox as by the illuminated carriage opening of a palace.

The light calls. We advance. Let's enter.

Here all is gold and purple.

We are in the breast.

24. Before me spreads the agitated space with its somber thicknesses of fatty haunted gold, so it seems, in the purple distances of the canvas, of flayed scarlet stairs in the geologic matter, the ground sheer like a deep hanging, past upon past, my mines, my reserve difficult to access, but overflowing if I arrive, with thoughts, with passions, with kin, before me my personal foreign land: everything in the nearby over there is mine, everything is strangely foreign to me: everything that, in its night dough, I discern for the first time, I recognize. The world, before me, so great, is inside, it is the immense limitless life hidden behind restricted life.

Do you see the steps? To the right, some somber steps tell us we are down below, in the cellar. Somber descending steps.

But here we climb up. These steps here, the interior gold and purple steps lead us toward the heights, toward the heart of the temple.

What are we present at? At a mystery. At a solemn representation.

This is not the crucifixion.

This is the Passion according to Rembrandt. Mourning and Transfiguration of the Ox.

It is there in the cellar, that I divine:

What does he seek to paint of Bathsheba?

Her solitude of slaughtered ox.

Bathsheba or the slaughtered ox.

P.S. Reading the big catalogues, I look for *The Slaughtered Ox*. For example in Gerson's beautiful volume of Rembrandt.[9] I flip through the index. The author has classified the work according to rubrics; Portraits: Self-portraits, Portraits of men, Portraits of Women, Portraits of Children; Groups . . . (I'm looking for the Ox), Landscapes . . . Finally I find it: it is in Interiors, keeping company with the *Philosopher Meditating*.

Translator's notes

Translated by Catherine A.F. MacGillivray.

1 Vincent Van Gogh, *Lettres à son frère Théo* (Paris: Grasset, 1937), p. 181.
2 Neologism formed by Cixous from neologisms like *negritude* etc.
3 From the Italian. This painterly term means an alteration, an artistic second thought, which can sometimes still be discerned in the finished work. In French, the word for this is *repentir*, which also means "repentance," thus producing a double meaning I found impossible to render in English: of the depiction of the head as having been slightly altered during the act of painting, and of the head's drooping position as indicating a feeling of repentance on the part of Bathsheba. For a further discussion of the notion of *repentir* in painting, see Hélène Cixous, "Without end, no, State of drawingness, no, rather: the Executioner's taking off," *Stigmata: Escaping Texts* (London: Routledge, 1998), pp. 20–31.
4 In French, the following passage plays with the "femininity" of the letter (*la lettre*) in a complicated intertwining of feminine pronouns that refer at times to the letter, at others to Bathsheba. Unfortunately, this proximity and even confusion between the two is lost in English.
5 In French: *David est l'hors. Le hors. L'ordonnateur.* This complex sentence, impossible to render precisely in English, plays with the French word for "outside." The word for "arranger" can also be heard as *l'hors donnateur* (the giver of the outside), thus referring back to what comes before, and so on.
6 Vincent Van Gogh, *Lettres à son frère Théo* (Paris: Grasset, 1937), p. 123.
7 In order for the rest of the passage to make sense, I have translated the title of this painting by Rembrandt directly from the French. In English, this same painting is called *Scholar in a Room with Winding Stair*.
8 See n. 2.
9 Horst Gerson, *Rembrandt's Paintings*, trans. H. Norden, ed. G. Schwantz (London: Weidenfeld and Nicholson, 1968).

Chapter 31

IRIT ROGOFF

GOSSIP AS TESTIMONY
A postmodern signature

Knowledge as surreptitious appropriation

IN THE STRUGGLE TO LOCATE and articulate new structures of knowing and alternative epistemologies which are actually informed by the conjunctions of subjectivities, pleasures, desires and knowledges, gossip deserves serious consideration. As gossip is invariably located in the present and avoids any imposition of, to quote Foucault, "an origin of hidden meaning", gossip turns the tables on conventions of both "history" and "truth" by externalizing and making overt its relations to subjectivity, voyeuristic pleasure and the communicative circularity of story-telling. For feminist theory and feminist practices of producing counter-historical narratives, gossip provides some opportunities for a gender-specific variant on Foucault's notion of genealogy. The disruptive claims he made for genealogy, such as:

> if interpretation is the violent or surreptitious appropriation of a system of rules, which in itself has no essential meaning, in order to impose a direction, to bend it to a new will, to force its participation in a new game, and to subject it to secondary rules, then the development of humanity is a series of interpretations[1]

have been imperative for a feminist epistemology which does not pursue a broadening of existing categories to include female subjects but revises those very categories, questions the historical narrative structures which produced them and dares to imagine alternative narratives. So many of the struggles of feminist history and theory – to contemporize history and to insist on its constitution from the perspective of the present, the efforts to unyoke it from the authority of empirically sanctified "experts" and the effort to write the subjectivities of both writers and readers into the text through perceived and imagined structures of identification, as well as the perception of "community" that coheres around these identifications – already exist within the very definition of gossip.

Unauthored, untraceable and unfixed in historical time, gossip can offer a troubling of simple faith in historical and political representation. Gossip within trajectories of historical evidence exemplifies in Derrida's words "a principle of contamination, a law of impurity, a parasitical economy . . . a law of abounding, of excess, a law of participation without membership". Reviled in relation to empirical and verifiable factualities, relegated to the recesses of femininity or feminized masculinity and moralized as a reprehensible activity, gossip seems to bear a multiple burden.

The categories which structure and inform much of scholarly literature on gossip are reflective of the need to contain that "unruly contamination" Derrida speaks of. In the first of these arenas, which I think of as "anthropologizing", gossip is studied as the discourse of "others", the strange communicative habits prevalent in remote communities of distant exotic tribes who exist outside the structured knowledges of western civilization. Another dominant tenet, which I think of as "moralizing", is one which makes exhaustive efforts to vindicate gossip from its morally inferior position and earnestly tries to find some purpose in its activity. In these studies authors seem to attempt to decouple gossip from two of its apparently constitutive and locative components: "idleness" and "maliciousness". In such moralizing discourses on gossip, authors seem to pay little attention to the fact that both of these terms are highly feminized in culture and to discount the fact that they may in fact serve for the inscription of subjectivities or as the sites of defiance or resistance.[2] The third form, stemming from sociology, deals with "celebrity" and assumes that gossip is a by-product of mass culture and that it is the distance between celebrities and audiences refracted through the apparatuses of mass, popular culture that produces the activity of gossip in lieu of proximity.[3]

My argument is markedly different from these scholarly discourses as I do not wish to cleanse gossip of its negative associations (of distinctly feminized communicative activity) and turn it into an acceptable cultural artefact, but rather to argue that we can find in it a radical mode of postmodern knowledge which would serve us well in the reading and rewriting of gendered historical narratives.

To this end I shall read through a couple of research situations in which I was engaged in efforts to narrate highly gendered histories within visual culture, in order to locate and characterize the implications of knowledge which circulates as gossip. The first of these concerns bohemian circles in the pre-First World War avant-garde in Munich. In trying to substantiate and narrate the lives of women artists, collaborators and household members within the unconventional ménages of bohemia, we keep coming across persistent rumours speculating on illicit love affairs and illegitimate children and domestic arrangements, none

of which can be substantiated. Their presence speaks of the investment we have in the imaginary concepts of bohemia as linked to radically innovative art and to heroic artistic agents.

The second example has to do with the media sensationalization of the death of Cuban artist Ana Mendieta in New York in 1985. The unclear circumstances of her death and her position within third world feminist politics in relation to the New York art world produced an immensity of gossip and speculation which assumed the form of response to the critical positions Mendieta represented.

But to open up the discourse of gossip as radical knowledge is to take on the dangers of the same ridicule which is visited on the activity of gossip itself, for it negates the scholarly distanciation between what is said, who it is said by and who is being addressed. Thus my friend Abigail, deeply knowledgeable in the perils of feminist academic investigations, is extremely worried about me. She wonders why I keep going off to conferences with papers on such topics as nagging, embarrassment, ambition, and now, gossip. She is concerned that I get the reputation of someone whose work is somehow not quite respectable, who writes about issues that no one takes very seriously, that I will become another variant of the dotty woman, the female eccentric, like Bella Abzug with her hats.

Initially I thought that the project I was engaged in was a reassessment of these marginal, empirically unquantifiable and not-quite-respectable emotions and activities and the attempt to theorize them. For as long as they remain outside theoretical activity, as long as they are not critically activated and mobilized, they remain in the form of essentialized, feminized "human frailties". At some level I thought that these might come together into an alternative, feminist, sexual history of Modernism, an alternative history in which the concept of Modernism gets undone not by a parallel cultural heroism gendered female, but by a set of small-scale actions and receptions taking place at the margins: the pleasures of conversations, the conflicts of domesticity, the agony of rejection and failed love, the spreading of rumours, the support systems that promote ideas and make activity in the public sphere feasible. All the low moments which invariably precede and follow the high moments. All of the moments and all of the emotions which make up the fabric of Modernism just as surely as the great drama of "the birth of Cubism" ever did. So conditioned are we by the hierarchical values of what constitutes serious cultural endeavour, that we either co-opt these small-scale narratives into the grand schemes of heroic activity or we allow them to slip into a kind of domesticated netherworld. But if one is to work theoretically and historically as a feminist, then one of the tasks is to bring into theory, by which I mean to bring into critical consciousness, that which has always languished outside it, which has remained untheorized for very good reasons: because the very act of acknowledging its legitimacy begins to undo the lofty categories in which we have all been working. I am sure everyone remembers the opening of Michel Foucault's *The Order of Things*, in which he quotes Borges' short story about the Chinese encyclopaedia and its odd categories. After enumerating the categories, Foucault says:

> In wonderment of this taxonomy, the thing we apprehend in one great leap, the thing that by means of the fable, is demonstrated as the exotic charm of another system of thought, is the *limitations of our own*, the stark impossibility of thinking *that*.[4]

For me that is the point of theoretical activity, to locate that which is outside theoretical frameworks – or as Derrida says when speaking of telepathy, "everything in our conception of knowledge is so constructed that telepathy is impossible, unthinkable, unknowable"[5] – to understand why it is situated outside the paradigms and to activate that condition of exile as a form of critical, political mobilization. The politics of this particular critical, theoretical activity address the

gendered, racialized and sexualized exclusions and discriminations which come into being in the *choices* of what is of sufficient importance to be theorized. It is not exclusively in establishing an alternative set of cultural values that this activity's importance lies but also in the making strange and apparent the very seamlessness of these choices, and by reference, attempting to figure out what they exclude which we are not necessarily aware of.

Equally it is the very concept of investigation which is interrogated through my inquiry, the statuses of gendered knowledge and of how it is arrived at. I call as a witness Lord Peter Wimsey, Dorothy Sayers' detective hero and for many years, my ideal fantasy of worldly masculinity: here he is in conversation with a police inspector, a representative of official investigation and officially structured knowledge, while he himself represents, as all private investigators do, the realm of oblique and unsanctioned knowledge; he is speaking of an elderly gentlewoman he has enlisted for his investigations:

> "Miss Climpson" said Lord Peter "is a manifestation of the wasteful ways in which this country is run. Look at electricity, look at water power, look at the tides. Millions of power units being given off into space every minute. Thousands of old maids, simply bursting with useful energy, forced by our stupid social system into hotels and communities and hostels and posts as companions, where their magnificent gossip powers and units of inquisitiveness are allowed to dissipate themselves or even become harmful to the community, while the ratepayers' money is spent on getting work, for which these women are providentially fitted, inefficiently carried out by ill-equipped policemen like you."[6]

This is one reason for my choice of subjects. The other is the necessity so many of us feel of integrating the study of mass and popular culture with the study of high and privileged culture. One of the ways in which we do this is to integrate in one study high cultural images and popular cultural discourses and claim for both the immense power of constituting identities. Another way, one which interests me at present, is to take up issues like gossip, or complaining, or spectatorship and to use them as a model through which to track an examine some narratives in visual culture. Part of the attraction of trying to work in this way is that the use of a common term as investigative tool works to undo the divisions between high/low, materially present/electronically mediated and bring them into a proximity of sorts.

Thus if gossip, by its troubled relation to historical realism, has been postmodern all along, it can serve to destabilize the historiography of Modernism. If the rewriting of the histories and theories of modern visual culture can be geared towards an investigation of narrativity and of the structures of spectatorship, then gossip can be inscribed into these as the voices of numerous cultural unconsciouses.

To recap, gossip which is unauthored, untraceable and unfixed in historical time can offer a troubling of simple faith in historical and political representation. Gossip within trajectories of historical evidence exemplifies Derrida's "principle of contamination".[7] In the arena of "scientific study" gossip is reviled in relation to empirical and verifiable factualities. It does not arise out of the structures of knowledge which connect notions of truth with empirical, verifiable evidence and with the scientific researcher's moral obligation to assume personal responsibility for a truth. "I don't know, but I heard at the café last night that . . ." absolutely does not fit in with those concepts of truth, research and responsibility. Rather it falls within the domain of what Louise Collins calls "excessively thin accounts of moral personhood".[8]

Furthermore, gossip as a form of social or cultural activity is relegated to the recess of femininity or feminized masculinity and moralized as a reprehensible activity. It is interesting

to note that social scientists who theorize or analyse gossip rely primarily on interviews with women and with gay men. There is some tacit understanding here that "men of the world", men busy making the world in their own form, do not gossip, that gossip is for those "who have nothing better to do".[9]

Thus gossip seems to bear a multiple burden: in Foucauldian terms it serves the purpose, through negative differentiation, of constituting a category of respectable knowledge, "trivial" discourse allowing for the emergence of "serious" discourse, etc. In Derridean terms gossip allows for the constitution of the formal boundaries of the genre and its outlawed, excessive and uncontainable narratives. We are all aware of the mysterious power and mobility of gossip as it winds its way through subterranean and unacknowledged channels and continuously constitutes communities within its listeners. (This is being used strategically within current Queer Theory, as in the film *L is for the Way You Look* by Jean Carlomusto, in which gossip about Fran Leibowitz and about Dolly Parton constitutes a community of alliance between a group of young women wandering through the night-spots of New York city one summer night.) Finally, in Freudian terms a serious examination of gossip opens a possibility for the intersections of psychic narratives with historical narratives. In refuting his earlier theory of infantile seduction and yet allowing it to maintain its narrative (as opposed to factual) hold on the patient, Freud acknowledges that it is not necessarily *what* specifically happened, or even whether the seduction of the female infant had actually taken place, that is of such importance, but the certainty of the subject that it had, and the centrality that this certainty assumes within the subject's narrative. In terms of gossip and audience reception dynamics, which is what I am preoccupied with here, Freud's argument opens up possibilities for reading gossip as a projection of various desires by the audience onto narratives in culture.

Romancing visual culture

I would like to take these thoughts through a few examples from specific moments, moments perceived as those of historical romance, in the academic work of studying twentieth-century art, revisiting in the process some work I have done recently in a different vein. The first of these occurred recently, while I was working in Munich on a study of women's artistic production at the margins of Modernism's historical avant-garde and in which hearsay as evidence arose in a startling manner. I had become interested in the unconventional households of the pre-war avant-garde in which an economy of desire between an official wife, an equally official and acknowledged mistress, usually herself an artist, and a housekeeper-cum-model/lover revolved around the male artists positioned at their centre, a new economy of bohemian desire. My research assistant, vastly knowledgeable in the labyrinthine ways of local Munich histories, burst into the office one day with the following news. She had just heard that Paul Klee might have had an illegitimate child with the woman who worked as a maid within his household. Where had she heard the news? I asked. At one of the local Schwabing cafés which had been at the centre of bohemian life for more than a century, was the reply. I remarked about the fact that the event, if true, had taken place more than eighty years ago. She replied that I had no idea of how to go about historical research. Certainly the time lag and ephemeral nature of the evidence seemed to make no difference to the seriousness with which such a rumour was to be taken, and she immediately set out to research it through personal interviews and correspondences, outside the official archival structure, where, needless to say, no such evidence existed.

In trying to substantiate and narrate the lives of women artists, collaborators and household members within the unconventional ménages of bohemia, we keep coming across

persistent rumours which speculate on illicit love affairs with men, on lesbian love affairs and on illegitimate children and domestic arrangements, none of which can be substantiated. Their presence speaks of the investment we have in the imaginary concepts of bohemia as linked to radically innovative artistic gestures and to heroic artistic agents. The greater the depression suffered by Gabriele Munther after Wassily Kandinsky left her, the more illicit lovers taken by Franciska von Reventlow, "the fabulous countess" of Munich bohemia, the more extravagant the homosexual culture of the photographic studio Elvira presided over by the lesbian couple Sophia Goudstikker and Anita Augsburg, the greater our faith in the tumultuous and operatic arena of innovative creativity and in the bohemian transgressions which allow its full release.[10] The dull and conventional middle-class domesticity of the Klee household, if that is how it really was, becomes an irritating opaque surface which needs to be disturbed if we are to read the period and its activities in the ways we have been accustomed to doing in order to meet with our expectations. Thus gossip serves as an area for the cathexis of phantasmic projections by audiences which can alert us to the way in which we shape narratives through our own desire. The hours my research colleague and I spent in our office and the nearby café speculating about the nature of the Klee household were as important as the archivally substantiated facts we unearthed. We had decided for once to let our imagination run away with us and follow the rumours with verve and audacity. We constructed scenarios involving wives, and lovers and maids who were both and neither, with shameless abandon, which probably said a great deal more about our investments in cultural histories and our structures of identification than it did about our historical subjects. It was clear to us that a kind of counter-transference had taken place within our emergent art-historical discourse, an unconscious projection of the investigator's feelings and conflicts onto the lives of the subjects being studied. In the process we understood something about gendered historical specificity we had not understood before, about the possibility of hearing gossip as a way of alerting us to the specificity of our own subject positionality. In historical realism, as Diane Elam says,

> [h]istory is preserved from fantasy and its anachronisms, only by the becoming-fantastic of the female. The fantastic returns as the gendered complement of the real historical male that sought to exclude it. Woman that is, may permit the past to be represented as romance, but the price of this is that she herself cannot be adequately represented.[11]

Gossip, then, is one of the main tools by which the past can be represented as romance.

The questions which this episode has raised go far beyond the limitation of the archives as the sources for historical evidence, the categories by which they order their materials, the periodization and historical and generic nominalism by which documents and facts are marshalled.[12] Instead, I would like to pose a series of questions regarding subject positionality, desire and historical narrative as well as the gendered relation between historical realism and its accounts. Using Freud's original model of psychic fantasy in relation to the accounts of infantile seduction, I would like to understand what the persistent appearance and reappearance of gossip in close vicinity to master narratives, in particular to grandiose historical moments or achievements in Modernism, actually represents. If indeed it represents the possibility of giving articulated form to a series of unspeakable desires for which no narrative structures exist, as in Freud's model, then its ability to trouble the surface of historical factuality and narrative deserves some theoretical consideration.

Traditionally gossip is related to romance, to sexual activity and to sexual identity as well as the possibility of constructing what Patricia Spacks calls "a new oral artifact". Furthermore, she claims:

The relationship such gossip expresses and sustains *matters more* than the information it promulgates; and in the sustaining of that relationship, interpretation counts more than the facts or pseudo facts on which it works . . . gossip involves exchange not merely, not even mainly, of information, and not solely of understanding, but of *point of view*.[13]

In terms of cultural historiography and issues which theorize concepts of evidence, we have to ask ourselves, what does it mean to have evidence of someone's sexuality, of their intimate lives? Does it not shift the field from historical subjects to contemporary desiring subjects who, by constructing new oral artefacts and projecting their own desires onto the historical field, are in fact devising reading strategies, through which the arena of artistic activity is constantly reanimated? If we acknowledge that one of the main limitations to broadening the study of Modernism has been the singularly narrow and phallocentric narrative structure which has been available to us in recounting it, we can recognize some of the potential in theorizing gossip. "Gossip is not fictional, but both as oral and written form, it embodies the fictional . . . as subject matter gossip impels *plot* . . . while gossip's fascinations are; voyeurism, secrets, stories".

In looking at some accounts which have circulated around the official recorded lives of the main protagonists of the pre-war Munich avant-garde, accounts which are supposedly of little value because they shift the attention from the serious business of chronicling artistic production, I would like to try and shift the very nature of the historical account. I would not want to suggest, or even to speculate, that they be accepted as an alternative factuality, but rather that their persistent presence be used to destabilize the claims that art-historical discourse has made to historical realism. In her recent analysis of Romance as a model of postmodern discourse, Diane Elam states that "If real history belongs to men and women's history is merely the phantasy of historical romance, then postmodern cultural analysis of history and the 'real' offers a way of revaluing female discourse."[14] Thus if gossip, by its troubled relation to historical realism, has been postmodern all along, it can serve to destabilize the historiography of Modernism by pointing to both alternative economies inscribed in the business of cultural production as well as to the psychic fantasies whose constant dissatisfaction with existing accounts continues to generate unproven speculation.

Furthermore, since we have been arguing across the theoretical board for located and situated knowledge, we must recognize the degree to which gossip provides a mode of relational knowledge: who is speaking to whom about whom is part of the narrative structure, as is the conscious destabilization of a confident "knowing", since gossip is usually accompanied by certain qualifying frames.

My second example has to with the media sensationalization of the death of Cuban artist Ana Mendieta in New York in 1985. The unclear circumstances of her death (her husband the minimalist sculptor Carl Andre was twice accused and twice acquitted of hurling her to her death from the window of their 34th-floor apartment) and her own position within third world feminist politics in relation to the New York art world produced an immensity of scandalous gossip. The literature on the subject is immense and spans tabloids, art journals, feminist publications and academic research. It has even produced a 420-page tome of excruciating, laborious detail, five years in the making and luridly entitled *Naked by the Window – The Fatal Marriage of Carl Andre and Ana Mendieta*.[15] In the weeks following her death, burial and the trial of Andre the papers were full of descriptions of the pair as "wild, extravagant drunks" and as "virulent left wingers". He had "endless affairs with other women"; she "went into continuous jealous rages and bouts of despair". Their lives were described as a constant

orgy of drink, political activism, artistic creativity, endless rows, extravagant threats and equally extravagant reconciliations, all of which apparently took place in restaurants in the company of large numbers of invited friends. She was described as jealous of his position in the art world; the possibility of her having committed suicide was dismissed in *New York Magazine* with the words that "She was too pushy, too ambitious to do herself in". Her memorial service was described as "A demonstration by two hundred of the art world's dispossessed"; apparently no art world celebrities turned up since most of them seemed to think that this was a way of protesting the innocence of Carl Andre. One brave journalist said: "It's really coming down to this class thing and this race thing – He is museum class, she isn't. He is Anglo, she isn't".[16]

Within this hyped-up atmosphere of gossip and rumour, Mendieta's actual political and artistic activity played virtually no role. Her feminist activism, her co-founding of "Heresies", her third world politics, the constant contact with Cuba, her promotion of Cuban artists in the United States, none of these were mentioned.[17] Her work as an artist: earth works and burning banners, flimsy and transient objects located in remote regions, not commodifiable as objects for sale and known primarily through photographic representations, were seen as events taking place far from the New York art world with its narcissistic sense of its own centrality and importance. All of these certainly constituted an oppositional stance to the rules by which the New York art world existed in the 1980s. To address them, however, would have been the acknowledgement of another, alternative set of possibilities which were being followed by various groups involved with critical, oppositional practices. Instead Mendieta's entire world of art and of politics becomes gendered and racialized through vehement gossip to re-establish the operating rules by which the art world lived and to legitimate her death. "She was this loony Cuban, so what can you expect?" quotes one of the newspapers.

The complex drama of a third world woman's life in the heart of the West's art world becomes reduced to a saga of sex and violence. In the above-quoted feature article in *New York Magazine*, the subtitle of the cover page asks: "Did Carl Andre, the Renowned Minimalist Sculptor, Hurl His Wife, a Fellow Artist, to Her Death?" He has a name and a designated stylistic affiliation while she remains unnamed, without an artistic style, anchored in the art world as "his wife". The entire article is illustrated by grave simple images of Andre the man and of his grave simple minimalist work, while the numerous pictures of Mendieta show her with wine glasses, bottles of alcohol, plates piled up with food, or laughing an uproarious, open-mouthed laugh at various companions of the evening. In the same article her art work shows only those works which she did using her own naked body (rather than her more common use of a loose formal reference to the female figure) and which are directly related to sexual violence. The caption underneath these images reads "A Death Foretold?" and implies that her death was a result of some form of sexual violence, a claim for which there was absolutely no empirical basis. In all these images Mendieta is essentialized through an association with wild appetites and with unbounded female sexuality. She is racialized and sexualized as the "other" and the animating force of this narrative of doomed and wild passions.

Here again we can recognize the constitution of a discourse of gossip about artistic dissolution and unruly immigrants, at signalling the regrouping of a serious discourse on the subject of art, its demand for an attitude of responsibility, of commitment, of realism.

I want to revisit the site of the Mendieta narrative as told through the New York art world journalistic gossip with my earlier question: What does it mean to have evidence of someone's sexual activities? of their sexuality? How can one even begin the assumption of that kind of knowledge except through the structures of phantasmatic projection? Therefore I would need to ask, is it possible to have gossip function *simultaneously* as a policing action

for the reinstatement of contained and controllable genres *and* as the site for our most cherished fantasies about transgression and unruly excess?

In summary I want to go back to my original argument and repeat and expand on it. Undoubtedly gossip, by its troubled relation to historical realism, has been postmodern all along, and it can serve to destabilize the historiography of Modernism by pointing to both alternative economies inscribed in the business of cultural production as well as to the psychic fantasies whose constant dissatisfaction with existing accounts continues to generate unproven speculation. In addition, the moments at which we pause, listen, are affected and attempt to theorize gossip, are the moments of a "queering" of culture, in Alexander Doty's term; moments at which we not only distrust the false immutable coherence of master narratives but also perhaps the false, immutable coherence of our identities as subjects and tellers of those narratives.[18]

Notes

1 Michel Foucault: "If interpretation were the slow exposure of the meaning hidden in an origin, then only metaphysics could interpret the development of humanity. But if interpretation is the violent or surreptitious appropriation of a system of rules, which in itself has no essential meaning, in order to impose a direction, to bend it to a new will, to force its participation in a new game, and to subject it to secondary rules, then the development of humanity is a series of interpretations." ("Nietzsche, Genealogy, History" in *Language, Counter Memory, Practice*, Ithaca, Cornell University Press, 1977, pp. 151–2.)
2 See, for example, Robert F. Goodman and Aron Ben-Ze'ev (eds), *Good Gossip*, Lawrence, University of Kansas Press, 1994. Both of the editors' chapters in this volume exemplify such a laborious effort to address the "moralization" of gossip.
3 See, for example, Joshua Gamson, *Claims to Fame – Celebrity in Contemporary America*, Berkeley, University of California Press, 1995.
4 Michel Foucault, *The Order of Things – The Archaeology of the Human Sciences*, London, Tavistock, 1970, preface, p. xv.
5 Jacques Derrida, *Télépathie*, Paris, Éditions de Minuit, 1978, p. 216.
6 Dorothy L. Sayers, *An Unnatural Death*, London, New English Library, 1977, pp. 42–43.
7 Jacques Derrida "The Law of Genre", *Glyph* 7, 1980, pp. 206–7.
8 Louise Collins, "Gossip – A Feminist Defense," in *Good Gossip*, p. 109.
9 It is interesting to note that contemporary social scientists who study gossip, such as Patricia Spacks, Leo Braudy and Joshua Gamson, rely primarily on interviews with women and with gay men as the subjects of their interviews.
10 See Brigitte Bruns and Rudolph Herz, *Hof Atelier Elvira 1887–1928*, Munich, Stadtliches Museum, 1987.
11 Diane Elam, *Romancing the Post Modern*, London and New York, Routledge, 1992, pp. 14–15.
12 I have dealt with these limitations in a recent article on rewriting the relationship between women and Modernism in the historical avant-garde, "Tiny Anguishes – Reflections on Nagging, Scholarly Embarrassment and Feminist Art History", in *Differences* 4.3, 1993.
13 Patricia Spacks, *Gossip*, New York, Knopf, 1985, pp. 4, 7.
14 Diane Elam, *Romancing the Post Modern*, pp. 14–15.
15 Robert Katz, *Naked By the Window*, New York, Atlantic Monthly Press, 1990.
16 All the quotes reporting on the scandal and which I have included here are taken from Joyce Wadler's "A Death in Art – Did Carl Andre, the Renowned Minimalist Sculptor, Hurl His Wife, A Fellow Artist, To Her Death?" *New York Magazine*, 16 Dec. 1985, cover and feature article, pp. 38–46.
17 For a documentation and analysis of her work see *Ana Mendieta*, a retrospective catalogue, New York, The New Museum of Contemporary Art, 1987; Luis Camnitzer, "Ana Mendieta," in *Third Text*, no. 7, 1989, and Luis Camnitzer's recent book *New Art of Cuba*, Austin, University of Texas Press, 1994.
18 Alexander Doty, *Making Things Perfectly Queer*, Minneapolis, University of Minnesota Press, 1993.

PATRICIA MORTON

THE SOCIAL AND THE POETIC
Feminist practices in architecture, 1970–2000

FEMINIST PRACTICES IN ARCHITECTURE SINCE 1970 can be divided roughly into two directions, characterized by a dominating concern with "the social" and "the poetic," respectively. While the terms "social" and "poetic" reduce the complexity of thirty years' of feminist practice in architecture, they conveniently summarize themes in recent feminist theory and practice. There is no hard chronological or ideological split between the two tendencies and they coexist to this day. Within the "social" aspect of feminist architectural practice, feminist architects focused on women's experience of the built environment, institutional critiques of the architectural profession, and creation of alternative, feminist design methods. The "poetic" stage of feminist engagement in architecture has shifted interest to theories of the formation of sexual difference within architectural discourse and to design work that transgresses the gendered representational norms of architecture. Another way of stating this change is to contrast those women who consider themselves "feminist architects," as opposed to women who are architects foremost and eschew the label of "feminist."

In the 1960s and 1970s, feminist theorists such as Simone de Beauvoir and Kate Millet stimulated interest in the socially-constructed differences between men and women and the meanings associated with each sex. According to these theorists, the sexual binary male/female constructs a series of negative values; the female means passivity, powerlessness, death, the natural, irrationality, and the Other, whereas the male connotes activity, power, life, the cultural, rationality, and the Self. This is "phallogocentrism," the patriarchal value system that endorses a hierarchy of binary oppositions relating to sexual difference.

Under the influence of these theories of sexual difference, feminist architects and artists turned to their experiences as women for subjects and methods of creating their art. They used "women's crafts" such as needlework, weaving, embroidery, pottery, and rug-making to create works that demonstrated the value of these skilled, creative endeavors and that expressed women's lives. Rather than seeking to emulate men by becoming painters, sculptors, or architects, these women artists looked to women's traditions for a lineage and an alternative way of creating art that was based on feminist principles and practices. Certain feminist art of this period represented women's bodies and genitalia as a basic core of women's nature and experience. Judy Chicago's *Dinner Party*, for example, is an attempt to set the historical record straight and to announce the notable women of the past, as well as produce a new, feminist form of representation that features female genitalia. The 1972 *Womanhouse* project was a renovated house near downtown Los Angeles transformed into a feminist environment, with rooms in which the feminist participants critiqued the patriarchal oppression of women within the domestic sphere.

One of the central concerns of feminists has been the definition of the architect as a masterful, socially isolated individual whose genius and vision are imprinted on his designs. The architect's distance from manual labor and construction was established in the Renaissance with the shift from the architect as master mason or carpenter to the architect as professional designer who guided construction by means of drawings and models. It is precisely this model that has been rejected by feminist architects, who seek new models of identity and practice. This interrogation of the architect's role in society informed new practices founded on collaboration and cooperation rather than individual, competitive action. For example, the Women's Design Service was a technical aid agency providing a resource center, library, and consultation services on issues related to women and the design of the built environment in the greater London area. In the United States, the Women's Development Corporation was formed in 1980 in Providence, Rhode Island to design and develop rental housing for low-income women and children. Feminist architect Susana Torre curated a ground-breaking exhibition, "Women in Architecture" at the Brooklyn Museum, edited *Women In American Architecture: A Historic and Contemporary Perspective*, and established a private architectural practice with numerous collaborators.[1]

The Matrix Feminist Architectural Co-operative Limited, a non-profit women's architectural cooperative in London, was typical of these groups. It was founded in 1980 to help women's groups by finding and assessing potential building sites, aiding in obtaining funding for construction, and making models and giving workshops to help women's groups understand and take part in the design process. The cooperative wrote and published several books, including *Making Space: Women and the Man-Made Environment* (1986), *Building for Childcare: Making Better Buildings for the Under-5s* (1986), and *A Job Designing Buildings* (1986). Its projects involved traditional "woman's spaces" such as day care centers, nurseries, and housing, as well as the provision of technical aid, educational courses, lectures and informational publications.[2] Matrix explored "the ways in which the theory and practice of architecture could respond to and affect social relations. Its work was profoundly influenced by contemporary UK and US feminist theories and practices which were evolving outside the architectural world. . . . Working methods were developed which addressed women's inclusion in and exclusion from architectural processes and the built fabric of the city."[3]

The belief that architecture can affect social relations is part of the modernist credo; the use of architecture to create a new and better society dates back to the nineteenth century and the utopian politics of William Morris. Precisely this faith in architecture's ability to mold simultaneously the world and society has been rejected by postmodern and poststructuralist architects alike. In 1966, Robert Venturi stated:

> I make no attempt to relate architecture to other things. . . . The architect's ever diminishing power and his growing ineffectualness in shaping the whole environment can perhaps be reversed, ironically, by narrowing his concerns and concentrating on his own job. Perhaps then relationships and power will take care of themselves. I accept what seem to me architecture's inherent limitations, and attempt to concentrate on the difficult particulars within it rather than the easier abstractions about it.[4]

The evacuation of responsibility for the social consequences of design has dominated architectural practice and theory since the early 1980s, including feminism's association with architecture. Linked with the shift from social to poetic, or theoretical, concerns, feminist discourse in architecture has focused on the general category of the "feminine" rather than

explicitly feminist politics.[5] Just as male architects like Venturi discovered that they could not fulfill the traditional role of architect when too engaged by social issues, so women seem to have ascertained an oxymoron in the phrase "feminist architect."

Instead, women in architecture have turned to a critique of the masculinist underpinnings of architectural discourse, both written and formal. In her influential work, "Abodes of Theory and Flesh: Tabbles of Bower," Jennifer Bloomer states: "I am interested in how the pair ornament/structure has throughout the history of Western culture had an acritical relationship with the pair feminine/masculine and in the ramifications of this for architecture as cultural production."[6] Bloomer intertwines the deconstruction of masculinist architectural theory and design projects that posit an alternative practice. The British collaborative practice, muf, is founded on an "expansion of critical reflection upon the established practices of Architecture and Public Art" and a collaborative process of working that includes the client or user, experts in the area, multimedia designers, technical and cost consultants, graphic designers, and manufacturers.[7] Liquid Inc., Elizabeth Diller, Dagmar Richter, Nasrine Seraji-Bozorgzad, Karen Berman, and other women have dissected the conditions and norms of architectural discourse to found critical, interdisciplinary practices. Their emphasis on the "poetics" of architecture and its gendered representational systems has replaced the socially engaged work of an earlier generation, exemplified by Matrix.

During the twentieth century, increasing numbers of women have been trained as architects, but have remained largely outside the power hierarchies of the profession. As a reaction against their marginalization, women architects formed collectives and support groups that encouraged women's participation in the interpretation and production of the built environment. For example, the Association for Women in Architecture was founded in 1922 as Alpha Gamma, a national sorority for women architecture students in the United States. Women graduates of architectural schools formed the Association of Women in Architecture in 1934 for women practicing in the profession. In 1982 the AWA changed its name to the Association for Women in Architecture.

The continued marginalization of women in the profession is noted in the introductions of several recent anthologies on women and architecture. In her foreword to *The Sex of Architecture*, Patricia Conway gives a lucid account of the "obstacles created by gender prejudice" that confront women architects:

> [I]n 1995, only 8.9% of registered architects and 8.7% of tenured architecture faculty in the United States were women . . . almost no women are recognized as name partners in large commercial firms, nor has any woman in this country been commissioned to design a nationally significant building . . . the number of women holding top administrative positions and named chairs in American university architecture programs remains shockingly low . . . no woman has had a commanding voice as architecture critic for a major city newspaper or weekly newsmagazine . . . no woman has been awarded . . . the American Institute of Architects Gold Medal or the Pritzker Prize.[8]

In their collective introduction to the same volume, Diana Agrest, Conway and Leslie Kanes Weisman state: "almost all of the essays in this book identify, explicitly or implicitly, the female as 'other,' and it is from this marginalized position that women writing on architecture today are exploring history, the uses of public space, consumerism, and the role of domesticity in search of 'ways into' architecture, often through alternative forms of practice

and education."[9] In her introduction to *The Architect: Reconstructing Her Practice*, Francesca Hughes contends that "the absence of women from the profession of architecture remains, despite the various theories. . . . One simple and obvious reason for [the lack of feminist criticism on architecture] is the very small number of architects who might choose to apply feminist criticism to architecture: a constituency most easily identifiable as women architects."[10] This account, however, ignores the variety of subject positions and ideological stances possible within this supposedly self-identical category of women architects who apply feminist criticism to architecture.

These statements reinforce the marginal status of women in the profession and make it equal to their position "outside" architecture, without questioning the very definition of the female as "other." They ignore the importance of the feminine as the "other" of the masculine and "women architects" as the negative of "[male] architects." If women are "outside" the profession, we also provide the necessary limit of "architecture," which is assumed to be male, white, and "inside" the profession. This produces a double bind for women in architecture: declaring oneself a "woman" or "feminist architect" is to accept marginality within the profession and give tacit validity to the binary opposition of architect vs. woman architect; but to declare oneself "just an architect" is to ignore the reality of the exclusion of women from architecture's power structures. The problem with defining women in architecture as inherently, essentially, "marginal" is that it is a self-fulfilling definition and a vicious circle.

In 1979, feminist poet Adrienne Rich identified the conundrum facing women who seek acceptance within dominant power relations:

> There's a false power which masculine society offers to a few women who "think like men" on condition that they use it to maintain things as they are. This is the meaning of female tokenism: that power withheld from the vast majority of women is offered to few, so that it may appear that any truly qualified woman can gain access to leadership, recognition, and reward. . . . The token woman is encouraged to see herself as different from other women, as exceptionally talented and deserving; and to separate herself from the wider female condition; and she is perceived by "ordinary" women as separate also: perhaps even as stronger than themselves.[11]

Architecture has a few such token women architects with "name recognition" who are published in the same journals and books as male architects: Zaha Hadid is perhaps the most prominent. These women do not identify themselves as "women architects" or "feminists;" they are "just" architects. Most women in architecture shy away from identifying themselves with feminism or political critiques of gender relations in architecture, preferring to conform to the profession's masculine norms rather than be further marginalized as "feminist" architects. Thus, muf can quote Andy Beckett in *The Guardian* – "muf's playful piece by piece approach to reviving cities is becoming almost orthodox" – without irony or a sense that this statement may be indicative of their token status and appropriation within dominant discourse.[12]

The anthology *Architecture and Feminism* aspires to bridge the gap between socially engaged feminist architecture and theoretically sophisticated architecture by women. As the editors state in their introduction:

> *Architecture and Feminism* is, then, more of a proposal than a definition of the relationship between architecture and feminism. Instead of the prescriptives "architecture *if* feminism" or "architecture *plus* feminism," we suggest the strategic and speculative

"architecture *and* feminism." The link we have in mind would not assuage the inadequacies of architecture (nor, for that matter, feminism). Nor would it be limited to the character of an interdisciplinary crossover, with its focus on an exchange of concepts and the creation of "new" ideas. Rather we propose a connection forged out of the desire to produce intertextual work that contests an injust social order.[13]

The projects and articles in *Architecture and Feminism* consist of feminist critiques of work produced by male architects and histories of women architects' work, the intertextual work posited by its editors, framed within this contestation of existing social relations. This work does not consign women to a marginal role in a discipline dominated by male architects, but sees gender as a central issue for architectural discourse for both men and women.

The "outside" or margins of architecture – defined as women architects, feminism, the feminine – therefore circumscribes the "inside" of architecture, characterized as [male] architects, phallogocentrism, the masculine. Architecture's feminine outside cannot be theorized separate from its masculine inside because they are necessary to each other. It is this condition that is tested by the best work in architecture, whether "social" or "poetic."

Notes

1 Susana Torre, *Women In American Architecture: A Historic and Contemporary Perspective* (New York: Architectural League of New York, 1977). See <http://scholar2.lib.vt.edu/iawa/bio/torre.htm> at the International Archive of Women in Architecture Web site. This site lists biographies of women architects and documents large exhibitions and publications on women architects around the world.
2 See Ruth Owens, "Childcare Challenge," *Architect's Journal* 190, no. 9 (1989): 38–45.
3 Julia Dwyer and Anne Thorne, "Evaluating Matrix: Why was it important then? Why is it important now?", abstract, *Altérités: Interdisciplinarité et pratiques "féminines" de l'espace* conference, École des Beaux-Arts, Paris, June 4–5, 1999.
4 Robert Venturi, *Complexity and Contradiction in Architecture* (New York: Museum of Modern Art, 1966), 20–21.
5 See Jennifer Bloomer, ed. "Architecture and the Feminine: Mop-Up Work," special issue of *ANY Magazine*, vol. 1, n. 4 (January/February 1994).
6 Jennifer Bloomer, "Abodes of Theory and Flesh: Tabbles of Bower," *Assemblage* 17 (April 1992), 9.
7 muf, "Review of current work," abstract, *Altérités: Interdisciplinarité et pratiques "féminines" de l'espace.*
8 [In] Diana Agrest, Patricia Conway, and Leslie Kanes Weisman, eds., *The Sex of Architecture* (New York: Abrams, 1996), 10.
9 Ibid., 11.
10 Francesca Hughes, ed., *The Architect: Reconstructing Her Practice* (Cambridge, Mass.: MIT Press, 1996), x and xiv.
11 Adrienne Rich, *Ms magazine* (September 1979): 43.
12 muf, "Review of current work," abstract, *Altérités: Interdisciplinarité et pratiques "féminines" de l'espace.*
13 Debra Coleman, Elizabeth Danze, and Carol Henderson, eds., *Architecture and Feminism* (New York: Princeton Architectural Press, 1996), xiv.

Mass Culture/Media Interventions

A S T H E I N T R O D U C T I O N T O T H I S V O L U M E made clear, visual culture studies, so intimately linked to cultural studies, takes part of its cross-disciplinary impetus from its interest in mass media and popular culture. Feminism shares and adds a more precise political edge to this desire to break down the boundaries between so-called high art and mass culture. Women and other subjects conventionally excluded from the domains of high culture have everything to gain from the interrogation if not collapse of such ideological divisions which, as writers from Andreas Huyssen to Griselda Pollock and Rozsika Parker have argued, serve to marginalize the visual artwork and visual theory of women and minorities.

The essays in "Mass Culture/Media Interventions" trace this vital interest in interrogating the visual representation of women and other oppressed subjects in the mass media – an interest that has been increasingly central to the development of visual culture studies (and, as noted, marks one of its strongest links to cultural studies). The texts collected here address particular examples of mass media stereotypes (Pratibha Parmar (Chapter 33), Kathleen Zane (Chapter 40)), or specific kinds of media or media imagery addressed to or having particular salience for girls or women (Tania Modleski (Chapter 34), Lynn Spigel (Chapter 37)), intervene in specific examples of mass cultural propagandizing which attempt to limit the opportunities and identifications of female consumers (Amelia Jones (Chapter 36), Ann duCille (Chapter 38), Judith Mayne (Chapter 41)), or offer specific strategies of intervention using mass media venues or structures of address (Suzanne Lacy and Leslie Labowitz (Chapter 35), The Guerrilla Girls (Chapter 39)).

A number of the essays provide critical readings of popular media imagery, drawing on the strategies of cultural studies and feminist film theory. Thus, Parmar, a filmmaker and cultural theorist, articulates a feminist and anti-racist critique of media images of Asian women in Britain, while Kathleen Zane explores the broad, racially charged social pressures encouraging Asian women to obtain cosmetic eyelid surgery in order to look more "Western," looking at several films in order to turn a critical eye both on these pressures and on the white feminist assumptions about such "Asian mimic(wo)man" subjects.

In my 1992 essay, I look at the popular media's gleeful production of the "end" of feminism, proclaimed reiteratively in late 1980s' and early 1990s' stories in venues such as *Time* magazine. DuCille and Mayne, like Parmar and Zane, probe the limitations of a white, straight

feminist approach to mass culture, attending to the intersectional racial and sexual identifi-cations impacted in any cultural stereotype of femininity. DuCille provides an extended critique of the Mattel Corporation's Black Barbies, Mayne of the media representations of the "show-down" between skaters Nancy Kerrigan and Tonya Harding in the early 1990s, representations that surely took part of their frisson from the implication of a lesbo-erotic relationship between these two passionately warring antipodes of feminine comportment.

Eschewing a unilateral condemnation of the mass media or single-minded strategies of critique, Suzanne Lacy and Leslie Labowitz's and the Guerrilla Girls' pieces and Tania Modleski's and Lynn Spigel's essays make clear that the popular media are not (as earlier Marxist accounts would have it) simply and always sites of oppression and fetishization. They also provide venues – and strategies – for conveying pleasurable narratives of identification or explicitly feminist, visual messages about women's continuing oppressions. Lacy and Labowitz's essay describes their activist use of the mass media in "public informational campaigns" to promote a feminist critique of the social oppression of women through violence. The Guerrilla Girls' spread is exemplary of their highly successful appropriations of mass media forms and strategies to "advertise" the specific oppressions of women, gays and lesbians, and people of color within art discourse and institutions.

Modleski's important work on film and television is represented here with an excerpt from her classic argument about the empowering possibilities of soap operas – their capacity to provide "a unique narrative pleasure [for women] . . . adapted to the rhythms of women's lives in the home"; Spigel's crucial contribution to a feminist study of television by a section taken from her historical account of the rise of television and its crossing over of the private and public worlds, a crossing over that provoked intense anxieties about female power which were played out in the print media. These texts by Modleski and Spigel point to the useful-ness, for feminism, of addressing forms of mass media representation with a more sympathetic eye that allows for the pleasures women experience from engaging with them.

Together, the texts and projects in this section indicate the most fertile aspects of the intersection of feminism and visual culture. On the one hand, they point to the crucial impor-tance of introducing a feminist perspective into the cultural studies-type critique of popular culture. On the other hand, they show how feminist views of visual culture can be vivified by a more subtle approach to mass imagery that allows for, rather than disavows, its centrality to many women's lives.

References and further reading

Alloula, Malek. *The Colonial Harem* (1981), tr. Myrna Godzich and Wlad Godzich. Minneapolis: University of Minnesota Press, 1986.

Bordo, Susan. *Twilight Zones: The Hidden Life of Cultural Images from Plato to O.J.* Berkeley and Los Angeles: University of California Press, 1997.

Bright, Deborah. "Mirrors and Window Shoppers: Lesbians, Photography, and the Politics of Visibility." *Overexposed*. Carol Squiers, ed. New York: New Press, 1999.

Brunsdon, Charlotte. *Screen Tastes: Soap Opera to Satellite Dishes*. London and New York: Routledge, 1997.

Brunsdon, Charlotte. *The Feminist, the Housewife, and the Soap Opera*. Oxford: Oxford University Press, 2000.

Clover, Carol. *Men, Women, and Chainsaws: Gender in the Modern Horror Film*. Princeton, New Jersey: Princeton University Press, 1992.

de Lauretis, Teresa. *Technologies of Gender: Essays on Theory, Film, and Fiction*. Bloomington: Indiana University Press, 1987.

Dow, Bonnie J. *Prime-Time Feminism: Television, Media Culture, and the Women's Movement Since 1970*. Philadelphia: University of Pennsylvania Press, 1996.

Faludi, Susan. *Backlash: The Undeclared War Against American Women*. New York: Crown, 1991.

Gamman, Lorraine and Marshment, Margaret, eds. *The Female Gaze: Women as Viewers of Popular Culture*. Seattle: Bay Press, 1989.

Graham-Brown, Sarah. *Images of Women: The Portrayal of Women in Photography of the Middle East 1860–1950*. New York: Columbia University Press, 1988.

Griggers, Cathy. "Lesbian Bodies in the Age of (Post)Mechanical Reproduction." *Fear of a Queer Planet: Queer Politics and Social Theory*. Michael Warner, ed. Minneapolis: University of Minnesota Press, 1993.

Haskell, Molly. *From Reverence to Rape: The Treatment of Women at the Movies*. Chicago: University of Chicago Press, 1974/1987.

Huyssen, Andreas. "Mass Culture as Woman: Modernism's Other." *After the Great Divide: Modernism, Mass Culture, Postmodernism*. Bloomington: Indiana University Press, 1986.

Lumby, Catherine. *Bad Girls: The Media, Sex & Feminism in the 90s*. Leonards (N.S.W.): Allen & Unwin, 1997.

McHugh, Kathleen. *American Domesticity: From How-to Manual to Hollywood Melodrama*. Oxford: Oxford University Press, 1999.

Meyers, Marian, ed. *Mediated Women: Representations in Popular Culture*. Cresskill, N.J.: The Hampton Press, 1999.

Moore, Suzanne. *Looking for Trouble: On Shopping, Gender, and the Cinema*. London: Serpent's Tail Press, 1991.

Pollock, Griselda and Parker, Rozsika. "Crafty Women and the Hierarchy of the Arts." *Old Mistresses: Women, Art, and Ideology*. London: Routledge and Kegan Paul, 1981.

Pribram, E. Deirdre, ed. *Female Spectators: Looking at Film and Television*. London: Verso Books, 1989.

Projansky, Sarah. *Watching Rape: Film and Television in Postfeminist Culture*. New York: New York University Press, 2001.

Rosler, Martha. "In, around, and afterthoughts (on documentary photography)" (1982). *The Contest of Meaning: Critical Histories of Photography*. Richard Bolton, ed. Cambridge, Mass. and London: MIT Press, 1989.

Solomon-Godeau, Abigail. *Photography at the Dock*. Minneapolis: University of Minnesota Press, 1991.

Strinati, Dominic. "Feminism and Popular Culture." *An Introduction to Theories of Popular Culture*. London and New York: Routledge, 1995.

Treichler, Paula. "Beyond *Cosmo*: AIDS, Identity, and Inscriptions of Gender." *Camera Obscura* 28 (January 1992): 21–76.

Williams, Linda. *Hard Core: Power, Pleasure, and the Frenzy of the Visible*. Berkeley and Los Angeles: University of California Press, 1989.

Williamson, Judith. *Decoding Advertisements: Ideology and Meaning in Advertising*. London and New York: Marion Boyars, 1978.

Young, Lola. *Fear of the Dark: "Race," Gender, and Sexuality in the Cinema*. London and New York: Routledge, 1996.

PRATIBHA PARMAR

HATEFUL CONTRARIES
Media images of Asian women

A DISCUSSION OF THE IMAGERY of Asian women in the media has to start from a recognition of the multiple nature of Asian women's oppression and exploitation in British society. Images of Asian women will be explored within a framework which distances itself from discourses on representations which grant images an autonomy and independence, by bracketing them as separate entities.

The baseline of this article is that images of Asian women are very much rooted in, and locked into, the political and social systems of domination and cannot be divorced from the processes of struggle that Asian women are involved in.

While we will argue that the visual construction of Asian women in the television and newspaper media is sited in a particular ideology of power and control related directly to our race, gender, and class positions, this has to be grounded in a more general discussion of the shifts in representations of Asian people as a whole.

Images of Asian women intersect with and against a background of variety of "taken-for-granted" images of Asian people formed well before the 1950s and 1960s, when Asian migration to Britain was in any way significant; they have their historical roots equally in the encounters of the British Raj during the heyday of the British empire as well as in pre- and post-war Britain. Images of Asians which were created within imperialist social relations were those of Asians as "coolies", "servants", "ayahs" and "incompetent natives" on the one hand, and rich but childlike maharajahs eager to part with their jewels and wealth to the British royalty on the other.[1]

The British encounter with India meant that more than just images of "starving beggars" and servants and rich maharajahs were brought back; the British upper classes brought back Indian cooks and ayahs, while the Royalty indulged by adopting "poor little Indian princesses and princes". The circumstances in which East Indians were brought to England as domestics in the eighteenth century were very similar to those in which the majority of African blacks were imported from the Caribbean Islands.[2]

> The legal status of most Indian domestics corresponded exactly to that of the majority of Africans. They were completely at the disposal of their masters, and like Africans, they were bought and sold freely on the open market. Thus in *The Tatler* of 9–10 February 1709, the following advertisement appeared: "A Black Indian Boy, 12 years of age, fit to wait on a Gentleman, to be disposed of at Denis's Coffeehouse in Finch Lane near the Royal Exchange."[3]

The East India Company had provided wealth to many civil and military officials, who returned home to establish themselves in luxury and often brought over Indian servants with

them. The reason for this was often that the difficult and arduous journey by sea from India back to England was made less arduous by the ministrations of servants. Also, some of these officials had a desire to enjoy at home the same free labour that had been available abroad.

Many Indians were often abandoned once colonial families landed in Britain, and in 1786 the plight of the black poor escalated as many of them were forced to wander the streets and beg for food. There was public moral outrage at the existence of this "black problem" on the doorstep and the predictable response of charity and pity was evident in the newspapers of the day.

[. . .]

This [. . .] strongly resonates with the media's representation of Third-World people today, who are still mostly presented as picturesque exotica, as starving beggars, as natives fighting each other, or as perpetual victims of calamities, usually of their own making and incompetence. In the daily newspapers the Oxfam ads and photographs of people and events in the Third World incite a relationship to Third-World people of charity and pity. The problem of documentary-style photographs is that they are treated as a kind of evidence or testimony, which like a "window on the world" reveals the truth about the events or scenes depicted, and thereby reinforces the viewer's commonsense racist acceptance of poverty and under-development as expressions of a "natural state of affairs" rather than as the outcome of centuries of imperialism and colonial domination. Photography is a powerful instrument for depersonalising our relationship to the world, so when Sunday colour supplements carry reports of war, poverty, hunger and overcrowding in Third-World Countries, it is not seen or consumed as anything to do with "here and now" but "out there" – therefore unreal and distant. So while photography can arouse emotions, it can also often end up neutralising emotions depending on the mode in which it is represented.

This is in sharp contrast to the role the media has historically played in relation to the development and orchestration of the public's response to the black presence in Britain. However, the media do not merely reflect the objective reality of social relations but actively construct accounts which are deeply ideological in character. One general feature of this ideology, for instance, is the way the media produce a form of news which is in fact based on the values of drama, entertainment, and the spectacle of news photography.

[. . .]

However, while the amount of blatant racist reporting is often confined to crisis situations such as "The influx of Malawi Asians" and around dramatic events such as "Black mobs on the rampage", a more subtle and indirect racism is ever-present; an insidious kind of racism which tends to disappear from view into the taken-for-granted, naturalised world of "common sense". It is this commonsense racism which informs not only the reporting of major events but also the daily, more run-of-the-mill reporting, which, when articulated through the popular media, provides both fertile ground for the legitimisation of repressive state measures directed at the black communities and fodder for the growth of racist ideologues.

The media produces and reproduces certain types of representations and dominant frameworks of interpretation. In particular, reporting on Black people is impregnated with racist common sense. The processes by which such frameworks become naturalised and thereby institutionalised need to be challenged: "since (like gender) race appears to be given by nature, racism is one of the most profoundly naturalised of existing ideologies".[4]

Racist ideologies in the post-war period carried over and reworked these images of Asians as colonised people who previously were seen to be in need of Britain's civilising missionary zeal and, having been given independence, needed to be protected as children emerging into

adolescence. Between 1962 and 1981, the intense public debate on immigration produced a plethora of representations of Asians flooding the country in their millions and scrounging off the state. The year 1976, in particular, saw a concerted campaign by the politicians and the Press to pinpoint Asians as a problem group. For example, on 9 September of that year Alfred Sherman offered his views to readers of the *Daily Telegraph*. He saw "mass immigration as a symptom of the national death wish" and argued that even while "Britain was trying to cater for her own disadvantaged at a considerable cost, it simultaneously imports masses of poor, unskilled, uneducated, primitive and under-urbanised people into the stress areas of this country where they are bound to compete with the existing urban poor for scarce resources".

His argument was that black people brought the problems with them and because of their cultures were not able to overcome these difficulties. The real problem was seen as the growth within English society of alien communities with alien cultures.

The timing of this particular campaign was not accidental – it coincided with new immigration legislation. This particular campaign started with the revelation that a homeless Asian family expelled from Malawi was being housed in a four-star hotel at a cost of £600 per week to the British taxpayer. Not surprisingly, the number of attacks on Asians began to rise around this time. A detailed comment on the connection between Press comment and racial hostility was documented[5] but suffice it to say that every time the Press has sensationalised reports about Asians coming to Britain, there has been a corresponding rise in racist attacks on Asians.

Of all the black communities settled in Britain, it is Asians who are viewed as the most alien. The problems that Asians present to the British way of life and culture, this threat to Britishness, is encapsulated in their difference: their unwillingness to adapt, to change, their tendency to cling to their curries, their languages, their way of dressing, and above all their particular and peculiar patterns of household organisation and sex-gender relations.

The traditional Asian household, organised through the extended family kinship system, is held to be responsible for a number of problems that Asians face in the context of a British society ravaged by social and economic decline. Overcrowding is seen as a direct result of their tendency to breed like rabbits and their partiality for wanting to live together. Racist housing policies are not seen or acknowledged in any way. Asians are further handicapped by the strength of their culture which is depicted as unchanging, homogeneous, static and inflexible. The linchpin of this pathology of the Asian culture and family is the notion that within the family network, the women and girls are ruled by excessively patriarchal menfolk who force their daughters into arranged marriages and their wives into seclusion. Asian women are shown as meek and passive victims – voiceless puppets of Asian men, afflicted by language problems, extreme shyness and modesty.

The rise of the New Racism in recent years[6] has shifted the grounds on which debates around race and racism are publicly conducted. Proponents and theoreticians of this new racism, while continuing to duplicate the racist view of Asians as aliens at the source of Britain's present economic and social problems, are openly talking about the only solution to these problems being repatriation. The connections between common sense and right-wing theories of race which are able to command popular support have been comprehensively explored elsewhere,[7] but it is important to note here that this new racist ideology shares and follows similar lines of argument to the racist ideologies of the organised Fascist parties who have always openly propagated repatriation as the only solution to the alien wedge in Britain.

Correspondingly, while in the 1960s the dominant image was that of Asian immigration into the country, the present-day image has changed to that of black people fighting to stay in Britain.

[. . .]

Representation of Asian women in the visual media of cinema, television and film, or in the written media of books, literature and newspapers continues to use particular categories of definition to paint images of us. Depending on the political motivation and climate, specific images of Asian women are mobilised for particular arguments. The commonsense ideas about Asian female sexuality and femininity are based within, and determined by, a racist patriarchal ideology. Women are defined differently according to their race. The ideology of femininity is contradictorily constructed for all women: they are both mothers who service husbands and children, and also desirable sexual objects for men.

These two aspects of the construction of femininity for Asian women are racially specific, so whereas white women are visible through the imagery provided through mass advertising and the popular media, Asian women either remain invisible or appear within particular modes of discussions which utilise assumed and unquestioned racialised gender roles.

Asian women's femininity is very often linked to notions of fertility, and they are hardly ever seen as independent from their children. Images of Asian women subjected to virginity tests, estranged mothers who are fighting to be reunited with their children – Anwar Ditta and M. Patel for example – or others facing deportation threats with their British-born children, are common. The threat of their fertility is ever-present and ultimately they are held responsible for the growth of the black communities in Britain. There is a definite relationship between the commonsense notion of Asian women's secretive and private breeding, qualified and linked to the popular understandings of the esoteric practices of the *Kama Sutra*.

The shifts in imagery are often depending on shifts in state policies and debates on race. This was evident in the Press coverage of the virginity tests at Heathrow airport by immigration officials. The public outcry in the media over this is an instance of the racist and sexist assumption about Asian women who were represented as virtuous women whose sexuality is only confirmed through their marriage: "It is not in their culture for women to engage in sexual activity before marriage". This generalisation is based on the stereotype of the submissive, meek, and tradition-bound Asian woman.

This contradictory imagery of Asian women – represented on the one hand as sexually erotic creatures, full of Eastern promise, and on the other as completely dominated by their men, mute and oppressed wives and mothers – is explored through some examples which follow. They show how commonsense racism informs their representations as determined by racist gender constructions.

Asian women very frequently appear in the media as victims of arranged marriages. When the *Sunday Times Magazine* in June 1983 ran a "pictorial anatomy of six vastly different weddings" one of them was a Sikh wedding, which added a touch of the quaint and obligatory multiculturalism. The text accompanying the image reads:

> At 19, Rashpul Kaur has come thousands of miles to marry a stranger, Gurdal Singh Sahota. The couple has seen photos of each other but had not met till six weeks ago. With no close relatives in Bradford, Rashpul has been living with his family. She will live there after they are married too though, as nine people must share four bedrooms, they would prefer a house of their own.

Within a few sentences, the photograph of a young, unwilling bride being assembled for a wedding she so fatefully seems to accept, is reinforced by the text which mobilises racist commonsense notions of Asians living like rabbits in overcrowded houses.

Anthropological photography has a long and established tradition in European societies, and the process through which anthropological and pseudo-scientific photographs constructed "a particular genre of photography in which the image functions as empirical evidence of racial difference and identity" has been convincingly described elsewhere.[8] This tradition of using "photography to examine other races and fix them in place as dominated cultures" continues to this day, and the thorny but pertinent issue of who photographs whom and how is often neglected within socialist discourses of representation.

Critical self-examination of what constitutes oppositional photographic practice is very rare. Jo Spence, in an honest reappraisal of her role as a photographer, says:

> As a socialist and a feminist it has become untenable for me to work any longer as a professional photographer in order to support myself. After 27 years I have rejected my "right" to create and then sell the various fictions which I made about other people as I worked as an advertising, news and portrait photographer and later in so-called "community" and "alternative" projects. This is because the images I produced became part of an ideology which fixed and constructed people into particular class, race, and gender positions which were not always in their own interests.[9]

Alternative photographic practice rarely takes up such issues — indeed, many photographers who consider themselves to be "on the side of" (for instance) black people, continue to use their skills and power to represent "multi-ethnic" Britain in the belief that they are doing so in the interests of black people. But their photographs are constructed through a series of choices based on their race, class and gender positions and often complement the hegemonic system which used photographs as a way of representing, classifying and evaluating black people in particular ideological ways.

The use of photographs to construct exotic oppression images which are then presented as revelations for the viewer to gaze at with abject fascination and/or horror is very much the tradition in which Mary Ellen Mark's photographs of prostitutes in Falkland Road, Bombay, have to be situated.[10] Her photographs raise pertinent political questions about representations of oppressed groups by those in positions of control and power.

In May 1981, *The Sunday Times Magazine* ran a sultry close-up of a Bombay cage girl on its front cover. Inside, it carried a report on the American photographer Mary Ellen Mark who had spent three months taking photographs of the prostitutes of Falkland Road, Bombay. After 10 years of being haunted by their faces she set out to capture them visually.

The images in her book are very clear examples of western voyeurism and the photographer herself has no qualms about this aspect of her "mission": "The night before I left I had a vivid dream; I was a voyeur hiding behind a bed in a brothel on Falkland Road watching three transvestite prostitutes making love; I awoke amused and somewhat reassured. Perhaps my dream was a good sign."

The photograph [. . . of two people making love from Mark's project] illustrates this voyeurism in its starkest form. All the subjects in the photograph are totally unaware that they are being photographed, and even if they had been aware, it seems they had little power to do anything about it. As Mary Ellen says herself, the women's initial reaction to her was one of "hostility and aggression. The women threw garbage and water and pinched me." But like a pest she persisted because she was determined to enter a world no westerner had entered before — to be the first, in the true fashion of an explorer.

This photograph encapsulates the most intimate nature of the prostitute's trade, juxtaposed with an image of an old woman with her head in her arms, in a familiar gesture (to westerners) of helplessness portrayed in the charity posters. Here, the photographer's role is one of fly

on the wall, a peeping tom, unobserved but observing. And, given the nature of what is being observed, it panders quite explicitly to sexual voyeuristic fantasies. The old woman in the next cubicle reminds us that this is India after all, and triggers the associated imagery of poverty, hunger, disease and death.

However, in spite of her liberal guilt ("At first when I visited them I was embarrassed and felt like an intruder. (sic)") and in spite of being rejected ("Whenever I climbed the stairs, the women would run out of the hallways into their rooms and hide behind the curtains, and a madam would start screaming at me.") the urge to be a modern-day anthropologist made her persist for acceptance. Her final betrayal of these women is as a woman whom some of them had accepted as a sister. "One madam told me: 'We are sisters'."

As a white person documenting Indian women's sexuality, her vision is informed by her commonsense racism, but as a woman photographing other women, one would expect her to be more sensitive and aware of the contradictions of her project. However, she seems to have incorporated the white male's sexist interpretations of Asian female sexuality without question of qualms. Her photographs reveal and perpetuate the contradictory imagery that exists about Asian women. While the stark images show these women as passive victims economically and sexually vulnerable, they also echo the racist imagery of "uncivilised black animality".

It is because these women are prostitutes and not air hostesses, for example, that the seamier side of the exotic, alluring Asian female, ever ready to please the western executive (see Air India and Air Malaysia ads) is exposed for the western male to leer at and for the western female to look on with disgust.

Apart from such infrequent glossy exposés, Asian women are mostly invisible in the daily newspapers.

Even when Asian women are taking militant actions, the Press is so entrenched in its view of them as helpless and mild that they substitute anger with pain. So for instance, in July 1983, when Tamils living in Britain marched in a rally to protest against the violence in Sri Lanka, the front page of the *Observer* carried a report and a photograph of women leading the march, obviously angry and shouting, with the caption: "Women *weep* as Tamils in Britain demonstrate against racial butchery."

The lexicon of racism constrains and nuances many photographs that appear in the daily newspapers. There is a problem for those of us engaged in challenging such representations: there is the problem of how you represent the whole web of political relationships within which Asian people are enmeshed. How do you represent in images the resistance and strength of Asian women in their daily struggles to survive the onslaught of racism?

Asian women's political involvement in devising strategies for struggling against the objective reality of racism necessarily entails us in the process of creating our own imagery.

One illustration of producing self-images which reflect the experiences of Asian young women is the self-defence poster. This poster was produced together with a group of young Asian women and it is a clear instance of the text-image construction where the text doesn't attempt to explain but rather reinforces the representation of Asian young women taking control. The point that needs to be emphasised and cleared is that here we are not talking so much about creating "strong" or "positive" images which challenge racist stereotypes, but rather about the visceral understanding of the site of our oppression and thereby representing an aspect of the struggle against it.

Asian feminists, together with their African/Caribbean sisters in the black women's movement, are actively engaged in self-definition through our involvement in autonomous video and film collectives, publishing co-operatives and through writing which has begun the process of gaining control over our representation.

The year 1984 has seen a rise in the number of black groups either being set up, or consolidating previous projects in the area of film and video production. In April 1984, a group of black women organised a series of seminars and screenings on the theme of "Black women and Representation". The contributions through discussions and papers are currently being completed for publication in the near future.

One of the key problems for black women has been the lack of access to training and acquiring skills in film-making. Institutionalised racism of the mass media has prevented the black communities from gaining any significant access to the professional structures of the film industry. Several campaigns and pressure groups, such as the Black Media Workers Association, have campaigned for more black media professionals. However, such demands have to be linked to a critical assessment of the existing forms and content of films. While not denying that there is a legitimate struggle against the institutional racism of the mass media, many of us have felt that it is equally if not more important to concentrate on building our own alternatives.

In May 1984, there was a Black Women and the Media Conference, attended by more than 200 women from all over the country, where women gathered to learn and share media skills and discuss strategies for dealing with the distortion, racism and sexism of the mass media.

Another area where we have concentrated our energies is in organising and participating in courses on film-making. A positive outcome of one such course has been the formation of a film and video collective consisting of Asian and African/Caribbean women called the Late Start Film and Video Collective. This group is at present editing a video made about Audre Lorde, black feminist and lesbian poet from America. The latest development in the independent black film sector is the formation of the Black Film and Video Association.

As Asian women we have to place ourselves in the role of subjects creatively engaged in constructing our own images based both in our material and social conditions and in our visions and imaginations. The task of reconstituting the prevailing images of Asian women entails us in a struggle on several fronts. We have to begin by rescuing ourselves and our history from the colonial interpretations which have continued to dehumanise us and belittle us, and recast Asian women as active agents in the making of history. We have to begin to rescue the strands and threads of past and present experiences and future hopes into a tapestry whose hues and patterns will reflect us in our complexities and our contradictions, depicting us in our authenticity.

Notes

1 See Kusoom Vadgama, *Indians in Britain*, Madison Press, 1982, and also M. Alexander and S. Anand, *Queen Victoria's Maharajah; Duleep Singh 1838–93*, Weidenfeld & Nicolson, 1980.
2 Folarin Shyllon, *Black People in Britain, 1555–1833*, Oxford University Press, 1977.
3 Ibid., p. 122.
4 Stuart Hall, "The Whites of Their Eyes", in *Silver Linings*, Lawrence & Wishart, 1981, p. 32.
5 "Race and the Press", in *Race and Class*, vol. 18, 1976, Institute of Race Relations.
6 See Martin Baker, *The New Racism*, Junction Books, 1981.
7 See Errol Lawrence, "Just Plain Common Sense: The 'Roots' of Racism", in *The Empire Strikes Back*, Routledge & Kegan Paul, 1982.
8 See for an interesting discussion on this, David Green's article "Photography and Anthropology: The Technology of Power", in *Ten.8*, no. 14.
9 Jo Spence, "Feminism and Photography", in *Three Perspectives on Photography*, Arts Council of Great Britain, 1979.
10 Mary Ellen Mark, *Falkland Road: Prostitutes in Bombay*, Thames & Hudson, 1981.

TANIA MODLESKI

THE SEARCH FOR TOMORROW IN TODAY'S SOAP OPERAS

I

[. . .]

I PROPOSE [HERE] NOT TO IGNORE what is "feminine" about soap operas but to focus on it, to show how they provide a unique narrative pleasure which, while it has become thoroughly adapted to the rhythms of women's lives in the home, provides an alternative to the dominant "pleasures of the text" analyzed by Roland Barthes and others. Soap operas may be in the vanguard not just of T.V. art but of all popular narrative art.

II

Whereas the meaning of Harlequin Romances depends almost entirely on the sense of an ending, soap operas are important to their viewers in part because they never end. Whereas Harlequins encourage our identification with one character, soap operas invite identification with numerous personalities. And whereas Harlequins are structured around two basic enigmas, in soap operas, the enigmas proliferate: "Will Bill find out that his wife's sister's baby is really his by artificial insemination? Will his wife submit to her sister's blackmail attempts, or will she finally let Bill know the truth? If he discovers the truth, will this lead to another nervous breakdown, causing him to go back to Springfield General where his ex-wife and his illegitimate daughter are both doctors and sworn enemies?" Tune in tomorrow, not in order to find out the answers, but to see what further complications will defer the resolutions and introduce new questions. Thus the narrative, by placing ever more complex obstacles between desire and fulfillment, makes anticipation of an end an end in itself. Soap operas invest exquisite pleasure in the central condition of a woman's life: waiting – whether for her phone to ring, for the baby to take its nap, or for the family to be reunited shortly after the day's final soap opera has left *its* family still struggling against dissolution.

According to Roland Barthes, the hermeneutic code, which propounds the enigmas, functions by making "expectation . . . the basic condition for truth: truth, these narratives tell us, is what is *at the end* of expectation. This design implies a return to order, for expectation is a disorder."[1] But, of course, soap operas do not end. Consequently, truth for women is seen to lie not "at the end of expectation," but *in* expectation, not in the "return to order," but in (familial) disorder.

Many critics have considered endings to be crucial to narratives. Frank Kermode speculates that fictive ends are probably "figures" for death.[2] In his essay on "The Storyteller," Walter Benjamin comes to a similar conclusion:

The novel is significant . . . not because it presents someone else's fate to us, perhaps didactically, but because this stranger's fate by virtue of the flame which consumes it yields us the warmth which we never draw from our own fate. What draws the reader to the novel is the hope of warming his shivering life with a death he reads about.[3]

But soap operas offer the promise of immortality and eternal return – same time tomorrow. Although at first glance, soap opera seems in this respect to be diametrically opposed to the female domestic novels of the nineteenth century, which were preoccupied with death, especially the deaths of infants and small children, a second look tells us that the fantasy of immortality embodied in modern melodrama is not so very different from the fantasies expressed in the older works. In the latter, it is not the case that, in Benjamin's words, "the 'meaning' of a character's life is revealed only in his death";[4] rather, for women writers and readers, forced to endure repeatedly the premature loss of their children, it was the meaning of the character's death that had to be ascertained, and this meaning was revealed only in the afterlife, only in projections of eternity.

"[T]racts of time unpunctuated by meaning derived from the end are not to be borne," says Frank Kermode, confidently.[5] But perhaps for women (no doubt for men too) certain kinds of endings are attended by a sense of meaninglessness even less capable of being borne than limitless expanses of time which at least hold open the possibility that something may sometime happen to confer sense upon the present. The loss of a child was, for nineteenth-century women, an example of such an unbearable ending: it was, as Helen Papashvily has called it, "a double tragedy – the loss of a precious individual and the negation of her creativity,"[6] and it threatened, perhaps more than any other experience, to give the lie to the belief in a benevolent God and the ultimate rightness of the world order. And so, it was necessary to believe that the child would join a heavenly family for all eternity.

For twentieth-century woman, the loss of her family, not through death, but through abandonment (children growing up and leaving home) is perhaps another "ending" which is feared because it leaves women lonely and isolated and without significant purpose in life. The fear, as Barbara Easton persuasively argues, is not without foundation:

> With the geographical mobility and breakdown of communities of the twentieth century, women's support networks outside the family have weakened, and they are likely to turn to their husbands for intimacy that earlier generations would have found elsewhere.[7]

The family is, for many women, their only support, and soap operas offer the assurance of its immortality.[8] They present the viewer with a picture of a family which, though it is always in the process of breaking down, stays together no matter how intolerable its situation may get. Or, perhaps more accurately, the family remains close precisely because it is perpetually in a chaotic state. The unhappiness generated by the family can only be solved in the family. Misery becomes not, as in many nineteenth-century women's novels, the consequence and sign of the family's break-down, but the very means of its functioning and perpetuation. As long as the children are unhappy, as long as things *don't* come to a satisfying conclusion, the mother will be needed as confidante and adviser, and her function will never end.

One critic of soap opera remarks, "If . . . as Aristotle so reasonably claimed, drama is the imitation of a human action that has a beginning, a middle, and an end, soap opera belongs to a separate genus that is entirely composed of an indefinitely expandable middle."[9] It is not only that successful soap operas do not end, it is also that they cannot end. In *The Complete*

Soap Opera Book, an interesting and lively work on the subject, the authors show how a radio serial forced off the air by television tried to wrap up its story.[10] It was an impossible task. Most of the storyline had to be discarded and only one element could be followed through to its end – an important example of a situation in which what Barthes calls the "discourse's instinct for preservation" has virtually triumphed over authorial control.[11] Furthermore, it is not simply that the story's completion would have taken too long for the amount of time allotted by the producers. More importantly, I believe it would have been impossible to resolve the contradiction between the imperatives of melodrama – the good must be rewarded and the wicked punished – and the latent message of soap operas – everyone cannot be happy at the same time, no matter how deserving they are. The claims of any two people, especially in love matters, are often mutually exclusive.

John Cawelti defines melodrama as having

> at its center the moral fantasy of showing forth the essential "rightness" of the world order. . . . Because of this, melodramas are usually rather complicated in plot and character; instead of identifying with a single protagonist through his line of action, the melodrama typically makes us intersect imaginatively with many lives. Subplots multiply, and the point of view continually shifts in order to involve us in a complex of destinies. Through this complex of characters and plots we see not so much the working of individual fates but the underlying moral process of the world.[12]

It is scarcely an accident that this essentially nineteenth-century form continues to appeal strongly to women, whereas the classic (male) narrative film is, as Laura Mulvey points out, structured "around a main controlling figure with whom the spectator can identify."[13] Soap operas continually insist on the insignificance of the individual life. A viewer might at one moment be asked to identify with a woman finally reunited with her lover, only to have that identification broken in a moment of intensity and attention focused on the sufferings of the woman's rival.

If, as Mulvey claims, the identification of the spectator with "a main male protagonist" results in the spectator's becoming "the representative of power,"[14] the multiple identification which occurs in soap opera results in the spectator's being divested of power. For the spectator is never permitted to identify with a character completing an entire action. Instead of giving us one "powerful ideal ego . . . who can make things happen and control events better than the subject/spectator can,"[15] soap operas present us with numerous limited egos, each in conflict with the others, and continually thwarted in its attempts to control events because of inadequate knowledge of other peoples' plans, motivations, and schemes. Sometimes, indeed, the spectator, frustrated by the sense of powerlessness induced by soap operas, will, like an interfering mother, try to control events directly:

> Thousands and thousands of letters [from soap fans to actors] give advice, warn the heroine of impending doom, caution the innocent to beware of the nasties ("Can't you see that your brother-in-law is up to no good?"), inform one character of another's doings, or reprimand a character for unseemly behavior.[16]

Presumably, this intervention is ineffectual, and feminine powerlessness is reinforced on yet another level.

The subject/spectator of soap operas, it could be said, is constituted as a sort of ideal mother: a person who possesses greater wisdom than all her children, whose sympathy is

large enough to encompass the conflicting claims of her family (she identifies with them all), and who has no demands or claims of her own (she identifies with no one character exclusively). The connection between melodrama and mothers is an old one. Harriet Beecher Stowe, of course, made it explicit in *Uncle Tom's Cabin*, believing that if her book could bring its female readers to see the world as one extended family, the world would be vastly improved. But in Stowe's novel, the frequent shifting of perspective identifies the reader with a variety of characters in order ultimately to ally her with the mother/author and with God who, in their higher wisdom and understanding, can make all the hurts of the world go away, thus insuring the "essential 'rightness' of the world order." Soap opera, however, denies the "mother" this extremely flattering illusion of her power. On the one hand, it plays upon the spectator's expectations of the melodramatic form, continually stimulating (by means of the hermeneutic code) the desire for a just conclusion to the story, and, on the other hand, it constantly presents the desire as unrealizable, by showing that conclusions only lead to further tension and suffering. Thus soap operas convince women that their highest goal is to see their families united and happy, while consoling them for their inability to realize this ideal and bring about familial harmony.

[. . .]

III

Critics have speculated before now about why the narrative form of soap opera seems to have special appeal to women. Marcia Kinder, reviewing Ingmar Bergman's *Scenes from a Marriage*, suggests that the "open-ended, slow paced, multi-climaxed" structure of soap opera is "in tune with patterns of female sexuality."[17] While this is certainly a plausible explanation, it should be clear by now that soap opera as a narrative form also reflects and cultivates the "proper" psychological disposition of the woman in the home. Nancy Chodorow provides us with a nice description of women's work in the home and usefully contrasts it to work performed in the labor force:

> Women's activities in the home involve continuous connection to the concern about children and attunement to adult masculine needs, both of which require connection to, rather than separateness from, others. The work of maintenance and reproduction is characterized by its repetitive and routine continuity, and does not involve specified or progression. By contrast, work in the labor force – "men's work" – is likely to be contractual, to be more specifically delimited, and to contain a notion of defined progression and product.[18]

We have already seen ways in which soap operas encourage women to become involved in – "connected to" – the lives of the people on the screen. A comparison with *Dallas*, the popular nighttime serial, is instructive. There, the characters are highly glamorized, the difference between their world and that of the average viewer could not be greater, and the difference is continually emphasized. On soap operas, by contrast, glamour and wealth are played down. Characters are attractive enough so that their looks are not distracting, well off enough so that, as in a Henry James novel, they can worry about more exciting problems than inflation at the market. But glamour and wealth are not preoccupations as they are on *Dallas*. Obviously, the soap opera world is in reality no more like the average spectator's than the world of *Dallas*; yet the characters and the settings all connote, to use a Barthesian type of neologism, averageness. This accounts for the fans' frequent contention that soap opera

characters are just like them – whereas no one is likely to make such a claim about the Ewing family on *Dallas*. The consequent blurring of the boundaries between fantasy and life which sometimes occurs (as, for example, when fans write letters to the "characters," giving them advice about their problems) suggests that the psychological fusion which Chodorow says is experienced by the wife/mother applies in these instances to the *viewer's* experience of the characters.

Another way in which soap opera stimulates women's desire for connectedness is through the constant, claustrophobic use of close-up shots. Often only the audience is privileged to witness the characters' expressions, which are complex and intricately coded, signifying triumph, bitterness, despair, confusion – the entire emotional register, in fact. Soap operas contrast sharply with other popular forms aimed at masculine visual pleasure, which is often centered on the fragmentation and fetishization of the female body. In the most popular feminine visual art, it is easy to forget that characters even have bodies, so insistently are close-ups of faces employed. One critic significantly remarks, "A face in close-up is what before the age of film only a lover or a mother ever saw."[19] Soap operas appear to be the one visual art which activates the gaze of the mother – but in order to provoke anxiety about the welfare of others. Close-ups provide the spectator with training in "reading" other people, in being sensitive to their (unspoken) feelings at any given moment.

Chodorow stresses the "connectedness" of women's work in the home, but this is only half the picture. The wife's job is further complicated by the fact that she must often deal with several people with different, perhaps conflicting moods; and further she must be prepared to drop what she is doing in order to cope with various conflicts and problems the moment they arise. Unlike most workers in the labor force, the housewife must be aware of concentrating her energies exclusively on any one task – otherwise, the dinner could burn or the baby could crack its skull (as happened once on "Ryan's Hope" when the villainess became so absorbed in a love encounter that she forgot to keep an eye on her child). The housewife functions, as many creative women have sadly realized, by distraction. Tillie Olsen writes in *Silences*, "More than in any other human relationship, overwhelmingly more, motherhood means being instantly interruptable, responsive, responsible. . . . It is a distraction, not meditation, that becomes habitual: interruption, not continuity; spasmodic, not constant toil."[20] Daytime television plays a part in habituating women to distraction, interruption, and spasmodic toil.

These observations have crucial implications for current television theory. In his book *Television: Technology and Cultural Form* Raymond Williams suggests that the shifts in television programming from one type of show to another and from part of a show to a commercial should not be seen as "interruptions" – of a mood, of a story – but as parts of a whole. What at first appear to be discrete programming units in fact interrelate in profound and complex ways. Williams uses the term "flow" to describe this interaction of various programs with each other and with commercials. "The fact of flow," he says, defines the "central television experience."[21] Against Williams I would argue that the flow within soap operas as well as between soap operas and other programming units reinforces the very principle of interruptability crucial to the proper functioning of women in the home. In other words, what Williams calls "the central television experience" is a profoundly decentering experience.

"The art of being off center," wrote Walter Benjamin in an essay on Baudelaire, "in which the little man could acquire training in places like the Fun Fair, flourished concomitantly with unemployment."[22] Soap operas also provide training in the "art of being off center" (and we should note in passing that it is probably no accident that the nighttime "soap opera" *Dallas*

and its spinoffs and imitators are flourishing in a period of economic crisis and rising unemployment). The housewife, of course, is in one sense, like the little man at the Fun Fair, unemployed, but in another sense she is perpetually employed – her work, like a soap opera, is never done. Moreover, as I have said, her duties are split among a variety of domestic and familial tasks, and her television programs keep her from desiring a focused existence by involving her in the pleasures of a fragmented life.

Interruptions may be, as Benjamin thought, one of the fundamental devices of all art, but surely soap opera relies on them to a far greater extent than any other art.[23] Revelations, confrontations, and reunions are constantly being interrupted and postponed by telephone calls, unexpected visitors, counterrevelations, catastrophes, and switches from one plot to another. These interruptions are both annoying and pleasurable: if we are torn away from one exciting story, we at least have the relief of picking up the thread of an unfinished one. Like the (ideal) mother in the home, we are kept interested in a number of events at once and are denied the luxury of a total and prolonged absorption. Commercials constitute another kind of interruption, in this case from *outside* the diegesis. Commercials present the housewife with mini-problems and their resolutions, so after witnessing all the agonizingly hopeless dilemmas on soap operas, the spectator has the satisfaction of seeing something cleaned up, if only a stained shirt or a dirty floor.

Although daytime commercials and soap operas are both set overwhelmingly within the home, the two views of the home seem antithetical, for the chief concerns of commercials are precisely the ones soap operas censor out. The saggy diapers, yellow wax build-up and carpet smells making up the world of daytime television ads are rejected by soap operas in favor of "Another World," as the very title of one soap opera announces, a world in which characters deal only with the "large" problems of human existence: crime, love, death and dying. But this antithesis embodies a deep truth about the way women function in (or, more accurately, around) culture: as both moral and spiritual guides and household drudges: now one, now the other, moving back and forth between the extremes, but obviously finding them difficult to reconcile.[24]

Similarly, the violent mood swings the spectator undergoes in switching from quiz shows, the other popular daytime television fare, to soap operas also constitute a kind of interruption, just as the housewife is required to endure monotonous, repetitive work but to be able to switch instantly and on demand from her role as a kind of bedmaking, dishwashing automation to a large sympathizing consciousness. It must be stressed that while nighttime television certainly affords shifts in mood, notably from comedy to drama, these shifts are not nearly as extreme as in daytime programming. Quiz shows present the spectator with the same game, played and replayed frenetically day after day, with each game a self-contained unit, crowned by climactic success or failure. Soap operas, by contrast, endlessly defer resolutions and climaxes and undercut the very notion of success.

The formal properties of daytime television thus accord closely with the rhythms of women's work in the home. Individual soap operas as well as the flow of various programs and commercials tend to make repetition, interruption, and distraction pleasurable. But we can go even further and note that for women viewers reception itself often takes place in a state of distraction. According to Benjamin, "reception in a state of distraction . . . finds in the film its true means of exercise."[25] But now that we have television we can see that it goes beyond film in this respect, or at least the daytime programs do. For, the consumption of most films as well as of nighttime programs in some ways recapitulates the work situation in the factory or office: the viewer is physically passive, immobilized, and all his attention is

focused on the object before him. Even the most allegedly "mindless" program requires a fairly strong degree of concentration if its plot is to make sense. But since the housewife's "leisure" time is not so strongly demarcated, her entertainment must often be consumed on the job. As the authors of *The Complete Soap Opera Book* tell us:

> The typical fan was assumed to be trotting about her daily chores with her mop in one hand, duster in the other, cooking, tending babies, answering telephones. Thus occupied, she might not be able to bring her full powers of concentration to bear on *Backstage Wife*.[26]

This accounts, in part, for the "realistic" feel of soap operas. The script writers, anticipating the housewife's distracted state, are careful to repeat important elements of the story several times. Thus, if two characters are involved in a confrontation which is supposed to mark a final break in their relationship, that same confrontation must be repeated, with minor variations, a few times in order to make sure the viewer gets the point. "Clean breaks" – surely a supreme fiction – are impossible on soap operas.

Benjamin, writing of film, invoked architecture as the traditional art most closely resembling the new one in the kinds of response they elicit. Both are mastered to some extent in a state of distraction: that is, both are appropriated "not so much by attention as by habit."[27] It is interesting to recall in this connection the Dadaist Eric Satie's concept of furniture music, which would be absorbed while people went about their business or chatted with each other. Television is the literalization of the metaphor of furniture art, but it must be stressed that this art is more than simply background noise in the way, for example, that muzak is; soap operas are intensely meaningful to many women, as a conversation with any fan will immediately confirm.

Ironically, critics of television untiringly accuse its viewers of indulging in escapism. In other words, both high art critics and politically oriented critics, though motivated by different concerns, unite in condemning daytime television for *distracting* the housewife from her real situation. My point has been that a distracted or distractable frame of mind is crucial to the housewife's efficient functioning *in* her real situation, and at this level television and its so-called distractions, along with the particular forms they take, are intimately bound up with women's work.

Given the differences in the ways men and women experience their lives, it is not surprising to find that "narrative pleasure" can sometimes mean very different things to men and women. This is an important point. Too often feminist criticism implies that there is only one kind of pleasure to be derived from narrative and that it is an essentially masculine one. Hence, it is further implied, feminist artists must first of all challenge this pleasure and then out of nothing begin to construct a feminist aesthetics and feminist form. This is a mistaken position, in my view, for it keeps us constantly in an adversary role, always on the defensive, always, as it were, complaining about the family but never leaving home. Feminist artists don't have to start from nothing; rather, they can look for clues to women's pleasure which are already present in existing forms, even if this pleasure is currently placed at the service of patriarchy. Claire Johnston, a feminist film theorist, has argued for a strategy combining "both the notion of film as a political tool and film as entertainment":

> For too long these have been regarded as two opposing poles with little common ground. In order to counter our objectification in the cinema, our collective fantasies

must be released: women's cinema must embody the working through of desire: such an objective demands the use of the entertainment film. Ideas derived from the entertainment film, then, should inform the political film, and political ideas should inform the entertainment cinema: a two way process.[28]

Clearly, women find soap operas eminently entertaining, and an analysis of the pleasure these programs afford can provide feminists with ways not only to challenge this pleasure but to incorporate it into their own artistic practices.

[. . .]

[I]t is important to recognize that soap opera allays *real* anxieties, satisfies *real* needs and desires, even while it may distort them. The fantasy of community is not only a real desire (as opposed to the "false" ones mass culture is always accused of trumping up), it is a salutary one. As feminists, we have a responsibility to devise ways of meeting these needs that are more creative, honest, and interesting than the ones mass culture has supplied. Otherwise, the search for tomorrow threatens to go on, endlessly.

Notes

1 Roland Barthes, *S/Z*, p. 76.
2 Frank Kermode, *The Sense of an Ending*, p. 7.
3 Walter Benjamin, "The Storyteller," in his *Illuminations*, p. 101.
4 Benjamin, "The Storyteller," pp. 100–101.
5 Kermode, p. 162.
6 Helen Waite Papashvily, *All the Happy Endings*, p. 194.
7 Barbara Easton, "Feminism and the Contemporary Family," p. 30.
8 Not only can women count on a never ending story line, they can also, to a great extent, rely upon the fact that their favorite characters will never desert them. To take a rather extreme example: when, on one soap opera, the writers killed off a popular female character and viewers were unhappy, the actress was brought back to portray the character's twin sister. See Madeleine Edmondson and David Rounds, *From Mary Noble to Mary Hartman: The Complete Soap Opera Book*, p. 208.
9 Dennis Porter, "Soap Time: Thoughts on a Commodity Art Form," p. 783.
10 Edmondson and Rounds, pp. 104–110.
11 Barthes, *S/Z*, p. 135.
12 John G. Cawelti, *Adventure, Mystery and Romance*, pp. 45–46.
13 Laura Mulvey, "Visual Pleasure and Narrative Cinema," p. 420.
14 Mulvey, p. 420.
15 Mulvey, p. 420.
16 Edmondson and Rounds, p. 193.
17 Marsha Kinder, "Review of *Scenes from a Marriage*," p. 51.
18 Nancy Chodorow, *The Reproduction of Mothering*, p. 179.
19 Dennis Porter, "Soap Time", p. 786.
20 Tillie Olsen, *Silences*, pp. 18–19.
21 Raymond Williams, *Television: Technology and Cultural Form*, p. 95.
22 Benjamin, "On Some Motifs in Baudelaire," in *Illuminations*, p. 176.
23 Benjamin, "What is Epic Theater?" in *Illuminations*, p. 151.
24 See Sherry B. Ortner's brilliant discussion of women's position in culture, "Is Female to Male as Nature Is to Culture?"
25 Benjamin, "The Work of Art in the Age of Mechanical Reproduction," in *Illuminations*, p. 240.
26 Edmondson and Rounds, pp. 46–47.
27 Benjamin, "The Work of Art," in *Illuminations*, pp. 239–240.
28 Claire Johnston, "Women's Cinema as Counter-Cinema," p. 217.

Bibliography

Barthes, Roland. *S/Z*. Translated by Richard Miller. New York: Hill and Wang, 1974.

Benjamin, Walter. *Illuminations*. Translated by Harry Zohn. Edited by Hannah Arendt. New York: Schocken Books, 1969.

Cawelti, John G. *Adventure, Mystery, and Romance*. Chicago: University of Chicago Press, 1976.

Chodorow, Nancy. *The Reproduction of Mothering: Psychoanalysis and the Sociology of Gender*. Berkeley: University of California Press, 1978.

Easton, Barbara. "Feminism and the Contemporary Family." *Socialist Review* 8, no. 3 (1978), pp. 11–36.

Edmondson, Madeleine and Rounds, David. *From Mary Noble to Mary Hartman: The Complete Soap Opera Book*. New York: Stein and Day, 1976.

Johnston, Claire. "Women's Cinema as Counter-Cinema." In *Movies and Methods*. Edited by Bill Nichols. Berkeley: University of California Press, 1976.

Kermode, Frank. *The Sense of an Ending: Studies in the Theory of Fiction*. New York: Oxford University Press, 1967.

Kinder, Marsha. "Review of *Scenes from a Marriage*, by Ingmar Bergman." *Film Quarterly* 28, no. 2 (1976–75), pp. 48–53.

Mulvey, Laura. "Visual Pleasure and Narrative Cinema." In *Women and the Cinema*. Edited by Karyn Kay and Gerald Peary. New York: E.P. Dutton, 1977. [Chapter 9 in this volume.]

Olsen, Tillie. *Silences*. New York: Dell Publishing Co., 1979.

Ortner, Sherry B. "Is Female to Male as Nature Is to Culture?" In *Woman, Culture and Society*. Edited by Michelle Zimbalist Rosaldo and Louise Lamphere. Stanford, Ca.: Stanford University Press, 1974.

Papashvily, Helen Waite. *All the Happy Endings, A Study of the Domestic Novel in America, the Women Who Wrote It, the Women Who Read It, in the Nineteenth Century*. New York: Harper and Brothers, 1956.

Porter, Dennis. "Soap Time: Thoughts on a Commodity Art Form." *College English* 38 (1977): 782–788.

Williams, Raymond. *Television: Technology and Cultural Form*. New York: Schocken Books, 1975.

Chapter 35

SUZANNE LACY AND LESLIE LABOWITZ

FEMINIST MEDIA STRATEGIES FOR POLITICAL PERFORMANCE

IT WAS VIOLENCE – in the media and in society – that gave birth to feminist media art. By 1977 feminists had brought the subject of sexual violence into cultural dialogue; at the same time, an increased social permissiveness allowed more obviously violent and pornographic imagery to "leak" into the dominant culture through media. Across the country women formed groups to protest snuff films, one of the most shocking manifestations of glamorized violence. These groups did not focus on direct services to victims, as did rape centers formed earlier, but on the social effects of popular imagery. A natural liaison developed between activists who criticized violent images and artists who worked to expand their audience base with critical issues.

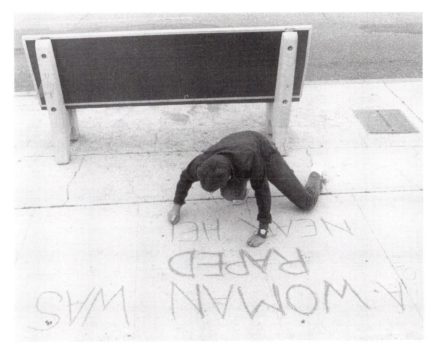

Figure 35.1 Suzanne Lacy and Leslie Labowitz, with assistance from the Women's Building and its artists, from *Three Weeks in May*, Los Angeles, 1977.

Each day the red stain spread further over the bright yellow map of Los Angeles. One red-stamped "rape" marked occurrences reported to the police department; around each of these, nine fainter markings represented unreported sexual assaults. Installed in the City Hall Mall, the twenty-five-foot map sat next to an identical one that listed where victims and their families could go for help.

This performance focused attention on the pervasiveness of sexual assault through a city-wide series of thirty events. Performances, speak-outs, art exhibits and demonstrations were amplified by media coverage. In one particularly striking series of street performances, Leslie Labowitz focused on myths of rape, men's role conditioning, and self-defense. Lacy's performance *She Who Would Fly* provided a ritual exorcism. Other artists included Barbara Smith, Cheri Gaulke, Anne Gaulden, Melissa Hoffman and Laurel Klick. *Three Weeks* brought together normally disparate groups – including artists, self-defense instructors, activists and city officials – in a temporary community that suggested future collaborative possibilities.

In 1978 we formed Ariadne: A Social Art Network, an exchange between women in the arts, governmental politics, women's politics, and media. The focus was sex-violent images in popular culture. Through Ariadne we developed a media strategy for performance artists, one applicable to a wide range of experiences, expertise and needs. For the three years of Ariadne's existence, we produced seven major public performance events dealing with advertising, news media, and pornography. From its inception, our work together combined performance and conceptual art ideas with feminist theory, community organizing techniques,

media analysis, and activist strategies. The first of these was *Three Weeks in May* (1977), a performance that laid the groundwork for a form we called the public informational campaign. Two other works followed quickly on its heels, each one developing our ideas about one-time media events (*Record Companies Drag Their Feet*, August 1977; *In Mourning and In Rage*, December 1977). In 1978 Ariadne took on San Francisco's Tenderloin district (*Take Back the Night*) and Las Vegas (*From Reverence to Rape to Respect*) with works that exercised but did not radically transform the strategies. In 1979 we worked independently of each other with core groups of women on two artworks that extended over long periods (*Making It Safe* and *The Incest Awareness Project*) in order to accomplish more than we could with a one-time media event. After Ariadne disbanded in 1980, we continued to use these media strategies in our individual performances.

In the past several years, activists among the Right and Left alike have become more sophisticated about obtaining media coverage, and corporations such as Mobil Oil have gone to great lengths to improve their public image through media manipulation. To the uninitiated, media intervention may appear overwhelming, a result in part of the mystification that surrounds mass communications. Although such work is time-consuming and often chancy (you compete with the unexpected for coverage), it is possible to learn certain basics of media strategy and, more important, to learn how to think creatively about media art. The following ideas on the application of such strategies to performance art should be taken as points of departure – not recipes – for artists who want to make media performances.

If you're considering media actions . . .

The first and most important question to ask is whether or not media coverage is even appropriate for your artwork (action). If so, what kind is most suited to your goals? The seductive power of publicity can overshadow the goals of social change, particularly among artists who have not had much direct political experience. We who understand so well the potential impact of images tend to forget that our particular artwork, placed before a mass audience, might not necessarily be the most effective way to evoke a change in viewers' attitudes, much less provoke them to responsible action on behalf of our issue. However, some performances need to be in the media by virtue of their subject matter and goals. For example, in the history of West Coast media artwork, feminist and otherwise, the most politically and aesthetically potent works have been those that critiqued or parodied media coverage itself; those that commented upon conventions maintained by the media (such as elections and economic forecasting); or those that addressed an issue of direct concern to a mass audience.

If you feel your issues as well as your art ideas demand a mass media format, clarify your goals to help decide what kinds of communication forms to use. Media can serve as an extended voice for politically powerless people and can, as well, be part of a networking effort that brings together various groups with an awareness of shared concerns. It can also be used to reveal information *about* oppression to a larger audience. However, you might find that posting a handbill, passing out leaflets door to door, holding a meeting, organizing a participatory ritual or a street theatre piece, or planning a potluck may be better ways to reach your audience. One form of communication is not necessarily better for artists than another; it all depends on what you want to accomplish.

Though the media would like to make "stars" out of a selected few, art for the media in the service of political goals is generally a collaborative effort. Artists who enter the political arena are advised to include political activists in their planning. Organizations that work with

the same issues you will address can provide an analytical framework, information, and often resources for your project. In the case of antiviolence feminist performance, Women Against Violence Against Women (WAVAW) and Women Against Violence and Pornography in the Media (WAVPM) provided us with a larger social context for our performances and the ongoing community organizing that would extend our effectiveness.

To understand how media operates, observe it – with detachment – and be pragmatic. It doesn't matter what you think the media *should* cover, the object of the game (and it is a game) is to get them to play it your way. Mass media time is not a public service; it is a highly valuable commodity that is purchased by corporations and individuals who promote products, ideas, attitudes and images. The stakes of this game are high, and as artists the best we can hope for is a kind of guerrilla foray into that system.

In your own community, learn everything you can about radio and television stations and the printed press. Who owns them? Are they local residents or part of a large network? What are the politics of the owners and managers, and how accessible are they to the public? Information about the points of view of news assignment editors and reporters, which can be gleaned from observation of their work, is invaluable in knowing who to approach when you want coverage.

A reporter in New Orleans once told me their news items had to be geared to the understanding of a seventh grader – or was it a seven-year-old? Reporters and their editors will spend very little time deciphering complicated messages; when you are depending upon news formats, in particular, it's important to be simple and clear. (This isn't the easiest thing to do; presenting new or countercultural ideas can't depend upon tried and true conventions.)

Never transgress the self-image of objectivity shared almost universally by reporters and documentary journalists. Whether you believe in this professional stance or not, act as if you do! Recently I was orchestrating a performance of 150 older women who were about to release helium balloons. Before giving the signal I asked a photojournalist if he would be able to capture the effect of all the balloons as they flew out of the women's hands. When he said the women were too spread out for that, I asked, "Should I group them closer together?" He looked at me in horror. "I can't tell you what to do!" I quickly agreed with him, then grouped them together for a stronger visual effect.

As you begin to look more closely at the media, its effectiveness in generating emotional responses and states of desire will become apparent. Once you have demystified the image-making process – how the messages one gets depend upon the arrangement of color, form, and content – you will be able to respond more objectively and critically to the bombardment of visual media in your daily life. Sensitivity to this is important for your analysis; once you pierce the manner in which meaning is conveyed through media, you can begin to generate your own meaning.

How are the images, narratives, and forms supportive of ideology? In the case of violent advertising, for example, how are colors, shapes, and sounds employed to seduce sexual response and/or fascination, dulling normal reactions to violence and establishing violation as an appropriate response to women? How do such attitudes tie into existing cultural mythology about the proper treatment of women? Which images instill passivity and which inspire participation and action? Pay as much attention to the form of your message as to its content, compromising between, on the one hand, the best way to capture the attention of both reporters and the public and, on the other, a newer way to educate people through participatory, rather

than authoritarian, communication. This isn't a simple matter, because there are few examples of this use of media. Our notion of what is suitable for television and newspapers is often shaped by the very forms that have manipulated our consciousness for so long. To introduce a more complex social analysis we need to defy certain conventions of news coverage.

For example, using the most obvious ideas and simplistic techniques of advertising may make coverage of your events more likely, but you may inadvertently generate meaning beyond your intentions, meaning directly at cross purposes to your goals. Graphics designer Sheila de Bretteville first called our attention to this issue by pointing out the coercive nature of billboard advertising. Because it is geared to split-second comprehension, it doesn't allow for design formats that reveal several points of view simultaneously, that share layered and complicated information about more complex subjects, and that allow participation from its viewers. In media performance, as well, the most convincing images with the most impact need to be monitored for implicit attitudes toward audiences: can viewers participate with the imagery and information, or are they being preached to and commanded?

Information about current events in the media is generally disconnected from potential analysis or action on the part of the viewers. Reporters discussing sexual violence, for example, present it as an unsolvable aberration of human nature and explain it in ways that mystify rather than promote understanding. In the case of the Hillside Strangler, for example, reporters keenly scrutinized the particular background of each victim, speculated wildly upon the history of the killer (speculations which were disturbingly similar to social mythology about men, women and sex), and never made the connections between these and other forms of sexual violence. Such connections, of course, are the basis for forming a political analysis. The questions we should have been asking were: How are these killings similar to the other mass murders of women? How are these murders related to entertainment violence? To our attitudes about the innate nature of male sexuality? To our expectations about women as victims? Even, how does sexual violence relate to the status of the economy?

Finally, monitor your own response to media imagery to determine which images and ideas motivate you. Only when you are objective about your own conditioning can you walk the line between images that reveal important information and images that overwhelm their viewers. During the airing and public controversy of "The Day After," a fictionalized television broadcast with graphic depictions of the horrors of nuclear holocaust, many activists criticized such imagery as inducing passivity. At what point do people throw up their hands in despair rather than take to the streets or the legislatures? Be aware of this point when creating images about problems that weigh heavily upon the lives of your viewers. You want to motivate people, not dull them further.

How to do a media performance

To create an effective media performance, you first need to ask yourselves three questions:

What is the problem? When communicating through the media, time is of the essence. The subtleties of your analysis simply won't be respected or recorded, and you must take great care to present your information in the clearest, most coherent fashion. The *art* is in making it compelling; the *politics* is in making it clear. To do this, you must first clarify your issue.

What is your goal? Simply getting people to *see* your art is not enough when you are working with serious and confrontational issues. What do you want to have happen as a result of your media campaign or event? This, perhaps the most difficult part of your analysis, needs to embody your best and most realistic projections. (Try not to fall into the self-delusive artist's stance about the "tremendous but unidentifiable impact" of your work!)

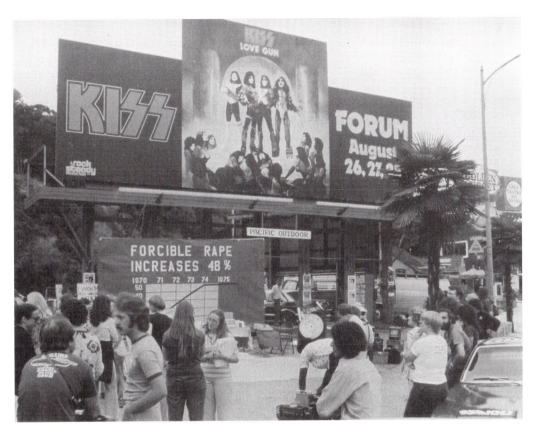

Figure 35.2 Leslie Labowitz in collaboration with Women Against Violence Against Women and the National Organization for Women, *Record Companies Drag Their Feet*, Los Angeles, 1977.

How do you bring attention to a national boycott? Working with Women Against Violence Against Women (WAVAW), Leslie Labowitz designed a performance specifically for television news coverage. A parody of the recording industry's greed, which enables it to ignore the effects of its violent advertising on women's lives, this performance was held on Sunset Boulevard, the symbolic heart of the industry. A mock executive's office was set up under a huge billboard for the latest album by the rock group KISS, along with a counter-billboard announcing rape statistics. Three record company moguls – portrayed by women dressed as roosters – arrived in a gold Cadillac, strutted into their "office" and began to count their "blood money." Women pleaded against, and protested their exploitation to no avail. The performance ended when twenty women draped the set with a banner that read, "Don't Support Violence – Boycott!"

Covered by all major television stations in the city and by *Variety*, a trade journal for the entertainment industry, the event launched a successful campaign against the record companies Warner, Atlantic and Electra for their use of violated images of women in their advertising. This performance was not only powerful as a one-time media event, but it also provides one example of how artists can collaborate effectively with an activist organization.

Figure 35.3 Suzanne Lacy and Leslie Labowitz, with assistance from Biba Lowe, *In Mourning and In Rage*, Los Angeles, 1977.

Ten seven-foot-tall, heavily veiled women stepped silently from a hearse. As reporters announced to cameras, "We are at City Hall to witness a dramatic commemoration for the ten victims of the Hillside Strangler," the women in black delivered an unexpected message. They did not simply grieve but attacked the sensationalized media coverage that contributes to the climate of violence against women. One at a time, the actresses broke their ominous silence to link these murders with *all* forms of sexual violence (an analysis missing from the media) and to demand concrete solutions.

City council members promised support to activists, Holly Near sang "Fight Back" (written especially for the performance), and news programs across the state carried reports of the performance and its activist message. *In Mourning and In Rage* was perhaps our most compelling example of a one-time media performance, staged as a guerrilla intervention to the conventions of sex crime reportage. Follow-up talk show appearances and activities by local rape hot line advocates created a much broader discussion of the issues than could be covered at the performance itself.

Who is your audience? Once you clarify who you want to reach, you may decide that the media form you have chosen is not appropriate to that audience. You probably won't reach children on the eleven o'clock news or working people on middle-of-the-afternoon talk shows. In a small community like Watts, California, word-of-mouth could be more effective than the *Los Angeles Times*, depending on your message. What does your audience already know about the topic at hand, and what do you want them to know? What is their attitude on the subject and how would you like to see them respond to your event?

Our media artworks fell into two categories: the media event and the public informational campaign. The first is a one-time event designed specifically for TV newscasts, choreographed to control the content as it is distributed through the media. These events cannot take the place of person-to-person contact through community organizing or long-term media education, but they serve as a very exciting and useful way to identify an issue or point of view about an issue for a large audience. A successful media event is one part of an overall strategy to influence public opinion, but it needs to be followed up with the in-depth information people will need to make knowledgeable choices.

The public informational campaign, a term used by public relations people, can do just that. Several different kinds of media coverage about a specific issue are placed over an extended period of time. More than a one-time media event, this kind of campaign can educate and organize a constituency. During such projects (*Three Weeks in May, Reverence to Rape to Respect, Making It Safe*, and *The Incest Awareness Project*) we reinforced radio interviews, talk shows, TV newscasts, and feature articles with activities that put us in direct contact with the public, such as street performances, lectures, demonstrations, and art exhibitions. Conceiving of the entire campaign as a conceptual performance, we paired art with informative events, designed talk show appearances as mini-performances, and used media opportunities to talk about performance art as well as the issues.

When you are staging a media event:

- The coordinating committee of your group should select the key images and the message. At least one member of this committee should be an artist who can design a format, create the visual images, and assist in the artistic production. Sometimes everyone's imagination will be captured by an exciting image that is evoked automatically or created by an individual in your group; other times a brainstorming session is needed. Your first images may be clichés accumulated from popular culture. Keep exploring your consciousness until strong and original ones come up. If you need a push, look at mythological images; in the case of women, for example, many images reflect positive expressions of power, even though they have accrued negative connotations in this culture. These images need to be reclaimed, and their continued existence in our collective mythology indicates a potentially strong audience response. For instance, *In Mourning and In Rage* took this culture's trivialized images of mourners as old, powerless women and transformed them into commanding seven-foot-tall figures angrily demanding an end to violence against women.
- To get the press to cover your event, establish its timeliness. Reporters come out for issues they think are current and topical; relate to news items already given airplay (if they don't feel the topic has burned out); have an element of sensationalism, high drama, or risk; and on an otherwise slow news day, have a "human interest" angle (although predicting what an assignment editor will deem to be humanly interesting is not always easy). It is important to determine whether your performance will fit preconceptions of what is newsworthy and at the same time maintain its integrity as art and as political

action. For example, the media's dramatization of the Hillside Strangler murders ensured coverage of our memorial performance by major local newscasters at the time. As a result, we were asked to appear on TV talk shows to discuss our alternatives to the media's highly sensationalized coverage of the murders.

- Don't fall into the trap of creating media gimmickry. Superficial images that don't go deep into the cultural symbols of society have less impact, particularly when compared to sophisticated and high-impact commercial images. News reporters react negatively to cute tricks aimed at obtaining coverage; they may manipulate, but they don't like to be manipulated. Events designed to express gut-level feelings and real community concerns do not come across as manipulation.

- Avoid overworked images. Activists fall into their own conventions, which may have the opposite effect than desired. For example, picket lines may establish such preconceptions in the mind of viewers that your meaning would be overlooked.

- Do your best to control the media's interpretation of your information, particularly when it is counter to prevailing attitudes. The press release, which will frame the media's perception of your planned action, is an art form in itself. It must be written simply, with enticing descriptions of visual opportunities and a clear political perspective on the issue. It should also include names of participating government officials and celebrities, if there are any, and give the impression that this will be the most important event of the day. Once your event is assigned to a reporter, that person becomes the next key in making sure your message remains relatively undistorted. To prepare for your contact with reporters, analyze television newscasts in your area: find out who the reporters are, how much time is allotted to your kind of issue, and, most important, how news footage is edited. How long is the average news slot? Does the newscaster stand in front of the image while describing the action? What is the ratio of visual-to-verbal information? Design your event to fit the normal newscast format in order to control its coverage as much as possible.

- Arrange the time of day, the day of the week, and the location to suit reporters' schedules. In Los Angeles, Tuesday or Wednesday morning (when news is usually slow) is considered the best time to call a press conference. Weekend news has already broken, and there is a better chance of getting on the evening news the same day. A strategic location will have effective "visuals" or provide a good background, be familiar to reporters, and have electrical outlets, parking, and other facilities. For example, Los Angeles City Hall was chosen as the site for *In Mourning and In Rage* because we were presenting demands to members of the city council, in session at that hour; we also knew the media would be likely to cover the session that day.

- Keep your event under twenty minutes and provide at least one high-impact visual image that is emblematic of your message. Both words and images should be easy to understand; anything ambiguous should be clarified by a speech during the performance or by a simply worded press release. The performance should be confined to a limited area so that the camera can frame the whole set without losing information. Sequences should be clear, logically connected, and few in number.

- Have one director for the performance and another for the reporters. Since the performers in these events are usually not professionals, an artist should supportively guide them through the piece and control the timing. The media director should greet reporters as they arrive, sign them in, hand out press kits and press statements (explaining the symbolism of each image), and give shot sheets (which break down the event's sequences) to the camera people. This director is also responsible for keeping reporters at the site for the entire event. Don't give out interviews or explicit information before the event

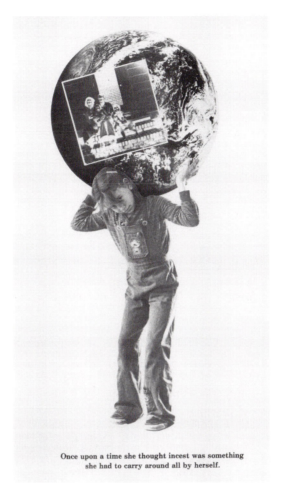

Once upon a time she thought incest was something
she had to carry around all by herself.

Figure 35.4 Leslie Labowitz, Nancy Angelo, and Nancy Taylor, Coordinators, *The Incest Awareness Project*, cosponsored by Ariadne and the Gay and Lesbian Community Service Center, 1979–1981.

The Incest Awareness Project's goal was to break the silence that surrounded the subject of incest, create positive images of women moving out of victimization, and effect social change through the development of prevention and recovery programs.

The year-long event included *Bedtime Stories*, an exhibition of performance and static artwork by women who had experienced incest; art therapy workshops for children; and a media campaign. In Nancy Angelo's *Equal Time and Equal Space*, the audience sat in a circle with video monitors, from which women who had been incest victims spoke to each other as if they were in a consciousness-raising session. Afterward, an experienced counsellor led the audience in a discussion. The prevention and recovery components – conceptualized by members of the art project with members of the Gay and Lesbian Community Service Center, and carried out by counsellors there – included a telephone referral service, counselling, a speakers bureau, and self-help groups. Many of these programs are still in existence.

is over, and brief everyone involved not to give out information but to direct all questions to the media director. Reporters love to "get the scoop" and leave for their next assignment.

[The project *Rape is Everyone's Concern* serves as an example of these strategies.] Las Vegas, glitter capital of the United States – with its high incidence of violent rape and its global image as the epitome of female objectification – was the perfect setting for a performance demonstrating the continuum between idolization and degradation of women. Modeled on *Three Weeks in May*, this campaign/performance created an exchange between women in Las Vegas and Los Angeles.

Ten days of events – including a talk by Margo St. James (founder of the prostitute's union COYOTE), an exchange exhibition on violence sponsored by women of Los Angeles and Las Vegas, a performance brought from Los Angeles by the Feminist Art Workers, and other collaborations between artists, humanist scholars, and women from the community – broke down the myth that Las Vegas has few rapes because sex is so available. Performances (by Suzanne Lacy, Kathy Kauffman, Nancy Buchanan and Leslie Labowitz) were held in galleries and on the streets. Two billboards, coverage in the local media, and a half-hour PBS documentary on rape created broad public exposure for the performance.

When you are planning a public informational campaign:

- Form a media committee to think through strategy, determine the overall image, build relationships with the press, develop press kits and write releases. The press kit should contain a general description, a schedule of events, background information on your issues and the people involved in your effort, press releases for each event, and photos and story-angle suggestions for feature articles. This information packet is sent out to contacts in the media, government, and community six weeks before the project begins. Separate releases are sent out several days before each individual event to news desks at local television and radio stations and newspapers.

- Follow up the press release with phone calls on the day of an important action. If coverage is still not confirmed, ask to speak to the station manager. Persist until you know at least two news teams are coming out. If they don't show up, reconsider your strategy and then make complaints to stations by phone or letter. In certain smaller communities, however, it is more effective to continue to alert reporters before and after the event rather than make complaints. One significant advantage of long-term campaigns is that media interest will build as people become more aware of your activities. In a sense you are developing your own history and context, something reporters look for.

- Develop a permanent log of media contacts: which reporters have covered past events and which reporters, feature writers, programs and columns you would like to involve in your project. Keep accurate records of your communications with media people to build trust and to plan your media strategy in a systematic manner. One person, or two in close communication, should be in charge of this.

- Choose individuals for media appearances who are accessible by phone, articulate, well informed, and who think quickly when confronted by reporters. Moderators have many ways of steering a dialogue in their own, often uninformed, direction. Your representative must know how to control the situation. Ask the moderator before the show what questions will be discussed, and prepare your answers accordingly. Some interviewers even like you to suggest questions to them, but be cautious as some take offense at such a

suggestion. Rehearse to prepare for negative as well as positive situations, decide which points you want to get across in the time allotted, and experiment with ways of turning every question to your advantage.

- Go in pairs to media presentations whenever possible, and see each appearance as an opportunity to train members of your group to speak out. It takes courage to speak publicly from one's experience as a woman, a minority or a supporter of a not-yet-popular cause, and those who do it need emotional support from the group. Moreover, by training each other you not only avoid the media's tendency to create stars, but you also empower each other.

Your final steps are to document and evaluate your artwork. Documentation, an essential tool for performance artists in general, takes on greater implications in media art. You can use it to analyze the success of your own strategies and to demonstrate approaches to others. Some museums and cable stations provide free to low-cost public access to equipment, and students in university broadcast departments will often record events for you. News stations will frequently release or sell their clips if you provide them with a blank videotape, although there are copyright restrictions on the use of this material.

Evaluating the results is your most important post-performance activity. Simply getting coverage is not an unqualified sign of your success; analyze the coverage and try to understand the message it actually communicated to its audience – not just the actual words that were spoken, but the slant given by the reporter's attitudes, the camera's focus, and the general appearance of your images. What makes it successful as art? As political action? What action did you inspire? What new perspectives did you reveal? Is there follow up needed, either in the community or in the media? Although the long-term effects on people's attitudes can only be projected, attempt to make these projections to keep your strategy evolving.

Media work has three ultimate purposes: first, to interrupt the incessant flow of images that supports the established social order with alternative ways of thinking and acting; second, to organize and activate viewers (media is not the only, nor necessarily most effective, way to do this); third, to create artful and original imagery that follows in the tradition of fine art, to help viewers see the world in a new way and learn something about themselves in relation to it. Long after reporters have lost interest in media art, long after our access is truncated due either to our effectiveness or lack thereof, our power to crystallize collective aspirations through art will continue, with or without television. As guerrilla media artists we must be fast on our feet, responding to the vicissitudes of media coverage, and ready to move on when we can no longer see the social change resulting from our efforts there.

AMELIA JONES

FEMINISM, INCORPORATED
Reading "postfeminism" in an anti-feminist age

W E LIVE IN A PARTICULAR CULTURAL and historical moment of highly charged sexual politics. Within the last year, supporters of women's rights have seen a number of disturbing public displays of these politics: the ridicule of a well-educated African American female lawyer by an all-white, male Senate commission for her exposure of sexual harassment by an African American male candidate for the Supreme Court; the media-fed rise of Camille Paglia, whose obscenely self-serving, pseudo-intellectual and anti-feminist pronouncements have established her as the Phyllis Schlafly of gender studies. We have consoled ourselves as women candidates for national and local offices emerge in large numbers; but this increase has been paralleled by spectacles of overt bigotry, sexism, and heterosexism such as the 1992 Republican convention. We have seen women professionals, both fictional and actual, become targets for reactionary rhetoric about "family values" and the "cultural elite." And we have become aware that freedom of choice for women is hanging by a judicial thread that the President's appointed hatchet men on the Supreme Court threaten to sever at any moment.

Intimately related to these epochal events in the history of American sexual politics is the onslaught of anti-feminist discourses that veil their agendas by proclaiming the demise of feminism through the supposedly inevitable development of "postfeminism." In the last ten years, as Susan Faludi points out in her book on the anti-feminist "backlash," feminism has become a dirty word.[1] I would like to explore the discursive means by which the death of feminism (its status as "post") has been promoted through photography and written texts, examining what is at stake – politically, culturally, and economically – in this promotion. Tracing various constructions of postfeminism, I analyze it on several different levels, each of which corresponds to a socio-cultural configuration of oppression against women that must he excavated in order to promote an effective understanding of postfeminist politics. I begin by introducing some examples of how feminism has been reduced to a unitary concept, then discursively and photographically executed (in both senses of the word) as postfeminist in the popular press in the last few years, and I follow this by tracing some of the ways in which discourses of postfeminism have permeated art criticism; and I ask, finally, what the constitution of postfeminism may mean for artists and art critics conscious of sexual and other differences.[2] As a coda to this critique I suggest ways of rethinking the dangerous double binds that threaten to destroy feminism both from within and from without by introducing several contemporary photographic practices that I interpret as providing sexually empowered constructions of female subjectivity.

I focus particularly on the photographic in tracing these effects because it is the photographic that, through its claims to truth, has most obediently served the consumerist, patriarchal, and heterosexist directives of the postfeminist logic at work in news magazine essays and advertisements. By opening this essay with examples of the construction of a so-called postfeminist subject in popular culture texts and images I want to emphasize the insidious and ideologically motivated role of representation in reinforcing, producing, and/or reproducing particular cultural ideologies. And, as many photography historians – from John Tagg to Abigail Solomon-Godeau – have pointed out, it is the photographic in western capitalist culture that is most often called upon to play this ideological role; the photographic functions centrally in the construction of bourgeois identities, determining norms of western subjectivity that subordinate people along the lines of gender, class, sexual, and racial difference.

Solomon-Godeau has persuasively argued, in particular, that photography has developed a special relationship to both the commodity and the feminine since its inception around 1840.[3] Photographs of women's bodies, which, since the nineteenth century, have comprised a large proportion of both art and advertising photography, instantiate a triple state of fetishism, or the "confluence of three fetishisms": "the psychic fetishism of patriarchy grounded in the specificity of the corporeal body; the commodity fetishism of capitalism . . . and the fetishizing properties of the photograph – a commemorative trace of an absent object"[4] Through the photographic image, femininity is constructed as locus of male desire and pleasure, embedded in the photographed and commodified female body via a system of fetishistic visual codes. The photographed female body operates as an object of exchange; in Luce Irigaray's terms: "The production of women, signs, and commodities is always referred back to men . . . wives, daughters, and sisters have value only in that they serve as the possibility of, and potential benefit in, relations among men . . . [the sexuality of men] is played out through the bodies of women, matter, or sign."[5] The woman, under this photographically reinforced system, can be a subject only by acting as a consumer, alienated from herself in her desire for commodities.

Notably, precisely because of its collusive role in reinforcing patriarchal structures of gender and sexual identity, the photographic has also been the primary site of feminist intervention in the postmodernist art practices that rely on strategies of appropriation of the last 15 years. In "feminist postmodernism" the insidiously objectifying, class- and race-bound effects of photographic images of women in both popular and so-called high art contexts are undermined through avant-gardist, Brechtian strategies that aim to disrupt the appropriated imagery through parody or textual intervention. The production of such imagery has come to be called, in much postmodernist critical discourse, "postfeminism."

What is behind these diverse applications of the term postfeminism? Do the apparently different contexts for its usage indicate distinct ideological positions, or do they belie a similar rhetoric, a similar purpose? What purpose does the rhetorical mobilization of postfeminism serve in each instance?

The enemies of the postfeminist backlash in the popular press are professional women in general, and feminism and its avatars in particular: especially those self-defined feminists who confuse and transgress previously accepted codes of domesticated femininity. The fantasized feminist enemy is a unitary figure – visually and textually coded as a professionally powerful and often excessively sexual woman. She is also limited to a specific race and class, not to mention sexual orientation; any identity deviating from the upper-class, anglo, straight imaginary of the American subconscious must be made unimaginable – must be transformed or homogenized into compliance with the normative American subject within this system of representation.

This symbolically limited yet still highly threatening feminist enemy of the status quo was recently exemplified by the fictional character Murphy Brown, whose repeated invocation and excoriation by the conservative right signals the strength of threat this contemporary feminist figure poses. By naming Murphy Brown the enemy of American "family values" because of her independence from men, the namer both denies the existence of single mothers who aren't as picturesque to the dominant mythos of femininity as Brown and hopes to negate the dramatic social and political shifts in American culture that undermine the paternalist ideology of the ideal family. The recent resuscitation of this patriarchal fantasy by the right – under the guise of "family values" – is a symptom of the massive anxiety of the patriarchal system, a reaction formation against the threatening incursion of women into the work force and, more recently, the political arena.[6] As innocuous (and fictional) as she may seem to those of us on the "radical" feminist edge and/or from the "cultural elite," the discursive category "Murphy Brown" can be read as functioning for the right as a means to diffuse their paranoid anxiety dream involving the rise of the self-sufficient, and potentially non-anglo, non-upper middle-class, female subject of the 1990s.

Murphy Brown is defined by the right as feminist and so antithetical to their postfeminist agenda. The contemporary female subject in the advertisements and news magazines I discuss here who is produced as "postfeminist" is still safely subordinate to the commodity system and to the circulation of normative, heterosexual male desire. The photographic images of the postfeminist woman perform particular forms of ideological work. With the cultural authority of anglo masculinity becoming increasingly bankrupt as gay, feminist, and non-white cultures insistently articulate counter-identifies to this imaginary norm, the patriarchal commodity system urgently seeks to reinforce predictable stereotypes of femininity.

The upper middle-class, white, postfeminist woman is produced to bolster a masculinist economy of social relations. For example, the images of Barbara Bush in a recent issue of the traditionalist magazine *Women's Day* produce an image of national womanhood that reinforces the death of the feminist subject [Figure 36.1]. Standing next to her well-known surrogate, Millie the dog, Barbara displays an eager subordination to patriarchal domesticity that is confirmed by her assertion, superimposed over the image, that "Women's Lib made me feel inadequate and useless."[7] The properly postfeminist woman shores up the crumbling infrastructure of conservative American ideology during a time of economic crisis and confirms the "rightness" of Republicanism, with its moralizing intervention in personal relations and destruction of the civil rights of women, lesbians, gays, blacks, and others. Barbara, smirking complacently within the presidential home funded by an ostensibly democratic tax system, and adorned in the pseudo-populist outfit of a string of pearls and silk dress, provides the assurance that nothing has changed: that in the 1990s it is still perfectly acceptable for men like George Bush [senior] to legislate for all American women. We know this is right because Barbara, nominally a woman although admittedly an anti-feminist, tells us it is; and, as the press insists, everyone loves Barbara.

Exemplifying the explosion of media interest in the volatile and changing nature of contemporary feminine identities, at least five issues of *Time* magazine have been devoted to this problem in the last three years.[8] Drawing on the powerful ideological effects of photography and text juxtapositions, each issue fabricates models of gender relations based on statistical information that Susan Faludi shows in *Backlash: The Undeclared War Against American Women* (1991) to be at best limited in application, and at worst entirely inaccurate; they manipulate popular conceptions of feminism through these spurious statistics and define feminism as "post" in advance of their analysis.

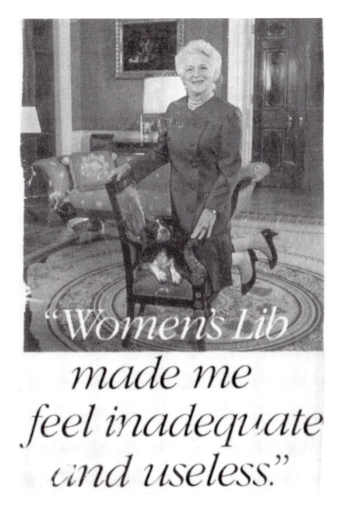

Figure 36.1 "Women's Lib made me feel inadequate and useless," Barbara Bush posing in *Women's Day*, 30 October 1990.

Two advertisements for the fall 1990 special issue of *Time* entitled "Women: The Road Ahead," for example, set the stage of this issue's overall anti-feminist orientation, juxtaposing cartoon images of women with the texts: "You've Come the Wrong Way, Maybe," and "Who says you *can* have it all?" [Figure 36.2]. Not surprisingly, the title page of the issue itself labels our current period unequivocally as "the postfeminist era." And, while containing several articles covering a variety of subjects, the special issue is sprinkled with postfeminist ads for its sponsor Sears; these work blatantly to reinforce profit-driven notions of "proper" femininity.[9] With photographs of glamorous, almost exclusively white women absorbed in frivolous, consumerist activities, the advertisements rely on texts to finalize their constructions of contemporary (post)femininity: "I don't like to go shopping, I like to go buying," and "I'm a senior partner in a very successful enterprise, my family," are two examples. The economic stakes and class implications subtending postfeminist ideologies are evident in these

advertisements: it is clearly the independently wealthy, stay-at-home postfeminist who makes the better consumer than the working feminist. The advertisements thus construct an unequivocal image of contemporary women as rich, white, non-professional, narcissistic, and profoundly materialistic. Along with the ambiguous but ultimately postfeminist contents of the issue itself, they work, in Althusserian terms, to interpellate a postfeminist subject.[10]

The cover story of *Time* from December 4, 1989 is unabashedly anti-feminist in tone and content.[11] In bold yellow letters, the cover text reads, "Women Face the '90s," continuing, less favorably: "In the '80s they tried to have it all. Now they've just plain had it. Is there a future for feminism?" The cover image, which features a crudely carved wooden sculpture of a woman in a business suit clutching a baby and a briefcase, created for *Time* by the feminist artist Marisol, can be read as a further warning sign of the insidious effects of postfeminist politics. *Time* here purchases the skills of an artist whose work is usually identified as exemplary of early 1970s' feminist art, with its reconfiguring of the traditionally devalued, feminine crafts media into art objects, to undermine modernist notions of purity; the magazine recontextualizes her piece into an icon of postfeminism by reproducing it under the aegis of illustrating the "news" of the death of feminism. Marisol's figure is made to signify not the empowering potential of having both career and family but the supposedly no-win dilemma of being a woman in the '90s (that is, once again, a white, upper middle-class woman).

The mutually supportive text and image construction of postfeminism continues inside the magazine. On the title page, a photograph of pro-choice advocates on the mall in Washington, D.C., trapped behind a chain link fence so that their banners and raised fists appear ineffectual, is captioned, "The superwomen are weary, the young are complacent. Is there a future for feminism?," and continues in smaller type, ". . . some look back wistfully at the simpler times before women's liberation. But very few would really like to turn back the clock" We must read to this last sentence in the smaller type to realize that perhaps the end of feminism – its lack of a "future" – is not as conclusive as the textual and visual codes suggest. The text resolves what is seemingly being questioned by prefacing its acknowledgment of the continuing relevance of feminism with the "weary" and "complacent" attitude of today's women. Furthermore, the assumption that the "pre-" feminist era was "simpler" goes unspecified and is doubly insidious by its casual placement.

Accompanied by a range of images of protesting feminists and feminist symbols on a time line (including a cartoon of a woman saying "I can't believe it. I forgot to have children," labeled explicitly by the magazine as postfeminist), the cover article, Claudia Wallis's "Onward Women," employs the term postfeminist in describing the rejection of feminism by younger generations of women as result of their realization that women can't have it all (as if "having it all" were the primary goal of the women's movement in the first place).[12] To make this rejection seem both natural and logical, the article confirms for us that "motherhood is back," explaining that younger women are turned off by feminism because, after all, "hairy legs haunt the feminist movement, as do images of being strident and lesbian. Feminine clothing is back; breasts are back . . . [and] the movement that loudly rejected female stereotypes seems hopelessly dated."[13] While the article appears to "ask" innocently if there is "a future for feminism," it effectively precludes any consideration of this future by using the term "postfeminist," inexorably linking feminism to the highly charged image of "being strident and lesbian," a state of "being" that is implicitly undesirable.

The *Time* article is one among innumerable examples of the popular construction of feminism as a unified attack on the mythologized American family. In order to ensure a return

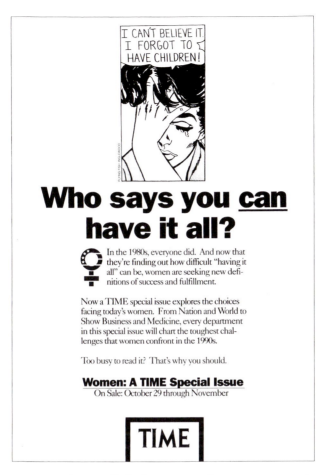

Figure 36.2 "Who says you *can* have it all?," advertisement from *Time*, 29 October 1990, for *Time* special issue on women.

to the ostensibly "simpler" family values of yore, this view of feminism, in turn, legitimates and in fact necessitates its obliteration. The image of the woman's responsibility to the family is most blatantly reinforced in the infamous *Good Housekeeping* "New Traditionalist" advertisements that have been displayed prominently at bus stops and in upscale magazines such as the *New York Times Magazine* in the last few years. In these ads, bold texts such as "she started a revolution – with some not-so-revolutionary ideals" and "more and more women have come to realize that having a contemporary lifestyle doesn't mean that you have to abandon the things that make life worthwhile – family, home, community, the timeless, enduring values" are accompanied by images of a beaming, yuppie mother in a sparkling domestic setting with one or two cherubic children [Figure 36.3].

The politics of postfeminism takes a violent and explicit turn in the recent spate of films exploring the deviance and ultimate expendability of women who are sexually and/or professionally powerful; examples include the notorious *Fatal Attraction* (1987) by Adrian Lyne, *Presumed Innocent* (1990) by Alan J. Pakula, *Single White Female* (1992) by Barbet Schroeder, *The Hand that Rocks the Cradle* (1992) by Curtis Hanson, and the recent, virulently misogynist

THE NEW TRADITIONALIST.

SHE STARTED A REVOLUTION — WITH SOME NOT-SO REVOLUTIONARY IDEALS.

She was searching for something to believe in – and look what she found. Her husband, her children, her home, herself.

She's the contemporary woman who has made a new commitment to the traditional values that some people thought were "old-fashioned."

She wasn't following a trend.

She made her own choices. But when she looked over the fence she found that she wasn't alone.

In fact, market researchers are calling it the biggest social movement since the sixties.

The quality of life she has chosen is the embodiment of everything that Good Housekeeping has stood for –

the Magazine, the Seal, the Institute.

Who else can speak to the New Traditionalist with that kind of authority and trust?

Who is more committed to helping her live the life she has chosen?

That's why there has never been a better time for Good Housekeeping.

AMERICA IS COMING HOME TO GOOD HOUSEKEEPING

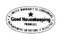

Figure 36.3 "She started a revolution – with some not-so-revolutionary ideals," *Good Housekeeping* advertisement from *Los Angeles Times Magazine*, December 1988.

and homophobic *Basic Instinct* (1992) by Paul Verhoeven, where the "strident lesbian"/bisexual becomes a man-killer with an ice pick/phallus.[14] These narratives produce the necessity of annihilating the non-domesticated contemporary woman in bloody orgies of human destruction, or reinscribing her into the family structure. With the termination of the contemporary professional woman comes the termination of feminism and its threatening anti-patriarchal goals. Needless to say, the dangerous women in these films are always, like Murphy Brown, pretty and anglo: one assumes that the Hollywood machine doesn't trust itself to contain successfully the exponentially greater threat posed to its system by working women of color (or, for that matter, lesbians or bisexual women who are feminists rather than psychopaths).

The other side of the postfeminist coin is the emergence of the so-called "men's movement." Inspired by Robert Bly's book *Iron John* (1990) the men's movement appropriates and perverts the rhetoric of feminism to urge the contemporary American male to "find a voice of [his] own" as a "Wild Man."[15] Bly laments the feminization of the American male at the hands of his female caretakers, and calls for the extirpation of this spineless femininity through primitivist histrionics and rituals of male bonding. The "Wild Man" immerses himself in mother nature and beats the appropriated drums of his "primitive" brothers with big sticks to prove to himself that, while he may be a "minority" – as one xenophobic *Time* article argues, referring to the competition for jobs from non-white, non-male workers in "Get Set: Here They Come! . . . White, U.S.-born males are a minority" – his ability to dominate is intact.[16] As with the frantic declarations of the supposed death of the feminist subject, the fact that masculinity (again, aggressively heterosexual and almost exclusively anglo and upper middle-class) needs to be shored up proves again how intense is the threat that the vast numbers of working women of all sexual, racial, and class identities currently pose to the patriarchal system (not to mention the threat posed by the increasingly powerful identity politics of the non-heterosexual male). As Russell Ferguson has argued, the "need to enforce values which are at the same time alleged to be 'natural' demonstrates the insecurity of a center which could at one time take its own power much more for granted."[17]

The popular deployment of the term "postfeminism" thus involves individiously redefining and recuperating femininity, feminism, and even masculinity into revitalized racist, class-bound, and patriarchal models of gender and sexual identity. The use of the term postfeminism in discourses on contemporary art appears, in contrast, to involve a significantly different project. In my view, however, the postmodern version of postfeminism similarly plays itself out through appropriative techniques that ultimately generalize and defuse feminist agendas. While artists such as Mary Kelly and Barbara Kruger who speak and work from a feminist political perspective have sometimes been labeled "postfeminist" by art historians and critics in order to distinguish their work from earlier, supposedly essentialist feminist art practices (as in Laura Mulvey's essay "Dialogue with Spectatorship: Barbara Kruger and Victor Burgin"), many critical texts on postmodernism have developed the concept of postfeminism toward ultimately anti-feminist ends.[18] While more subtle than the popular media's outright rejection of feminism as outmoded or expired, the discourses of postmodernism tend to address the relationship between feminism and postmodernism through modernist and ultimately masculinist models of interpretation – models that work to empower the postmodern critic through an "aesthetic terrorism" that hierarchizes art practices on the basis of avant-gardist categories of value, excluding those practices outside the boundaries they have determined for "radical" practice.[19]

The term postfeminism has been developed primarily within dominant discourses of postmodernism identified with New York City-based journals, art magazines, and institutions.[20] A central strategy within these discourses has been to claim radical value for postmodernism

in the visual arts by arrogating a certain kind of feminist practice and incorporating it into a universalist, "mainstream" postmodernism. Feminism is thus generalized as one radical strategy among many available to disrupt modernism's purities. Like the potentially problematic inclusion of women artists into the humanist canon, the incorporation of one particular kind of feminism into a broadly conceived, even universalizing radical project of postmodernist "cultural critique" accompanies the suppression of other kinds of, in this case, feminist practices and theories; it encourages the collapse of the specific claims of feminism into a "postfeminist" politics of supposed difference.

Since postfeminist discursive tactics in art writing often come from critics and scholars who position themselves on the left and are sympathetic to feminism, they are more difficult to recognize and negotiate than the overtly anti-feminist strategies of the popular media. However, it is crucial to recognize the stakes involved in incorporations of feminism as a useful tool for or subset of postmodernism. Within this strategic incorporation, for example, the two are merged via an exhausted political idealism, with feminism conflated with civil rights and other specific protests as merely a "jargon" or a pose taken up as a means of empowerment – such that a theorist of the postmodern such as Fredric Jameson can dismiss feminism as simply one among a number of examples of the "stupendous proliferation of social codes today into professional and disciplinary jargons, but also into the badges of ethnic, race, religious, and class-refraction adhesion."[21]

An instructive example of the subtle negation of the specificity of feminist politics is the sophisticated but still presumptuous appropriation of feminist theory as one postmodernist strategy among many in Craig Owens' important article "The Discourse of Others: Feminists and Postmodernism."[22] Owens presents in a concise and polemical way some of the major issues confronting feminist theory, astutely calling for a recognition of feminist art as explicitly disrupting modernist configurations of sexual difference, and taking issue, as I do here, with writers who "assimilat[e feminism] to a whole string of liberation or self-determination movements."[23] And yet, Owens' discussion, which begins seemingly innocently by placing feminism and postmodernism in the same space, describing "women's insistence on incommensurability" as "not only compatible with, but also an *instance of* postmodern thought,"[24] ends up by collapsing feminism entirely into the "postmodernist critique of representation": "th[e] feminist position is also a postmodern condition."[25] Owens takes up the empowering critical position he believes to be offered by feminism, reading strategies of the latter as part of the postmodernist critique of "the tyranny of the signifier."[26] In attempting to claim a radical agenda for feminism, Owens, like Jameson, reduces the feminist politic to simply another of the "voices of the conquered," including "Third World nations" and the "revolt of nature," that challenge "the West's desire for ever-greater domination and control."[27]

Owens' article, like many examples of texts discussing the intersection of feminism and postmodernism from the 1980s, ultimately references the potential of the "feminine" to disrupt modernist purity. Most marked in the work of French feminists such as Julia Kristeva and Hélène Cixous and in certain American and British cultural theories drawing from their work, the idealist conception of the disruptive potential of the "feminine" has a complex history. One tendency among writers on postmodernism such as Owens, then, has been to borrow from the philosophical and literary theories of French feminisms and to identify as radical precisely those art practices that undermine the phallocentric unified subject that subtends modernist ideologies. Collapsing the feminine into feminism, they then pose postmodernism as a radical, feminist alternative to the phallic closures of Greenbergian modernism.[28] Ironically and notably, this construction relies on the very type of oppositional logic constitutive of Clement Greenberg's own cultural theory: the opposition of a "progressive" to a "regressive"

artistic practice and the use of essentialism – in this case, an essentialist notion of femininity – to develop an authoritative critical position.

As Tania Modleski points out in her book *Feminism Without Women: Culture and Criticism in a "Postfeminist" Age* (1991), in this type of critical dynamic feminism is confused with feminization such that "feminist criticism [is] . . . becoming absorbed into the academy."[29] Interestingly, then, while the postfeminism of popular culture works to deny the continuing existence of feminisms and the sexually and professionally empowered female subject by constructing it as a threat that has been overcome, the postfeminism of academic criticism works to absorb feminist theory. As in Owens' article, postfeminism in art discourse is precisely this absorptive operation: the incorporation of feminism into postmodernism as postfeminism.

Exemplifying the effects of this incorporation, Dan Cameron employs postfeminism as the title of a recent article on postmodern art, using the term broadly to encompass all art by women in the 1980s that, in his terms, uses "structuralism to critique social patterns in terms of social domination."[30] Under the rubric of postfeminism, Cameron discusses women artists as diverse as Barbara Kruger and Susan Rothenberg, the latter of whom is not concerned in any direct way with feminist issues in her approach to object-making, while Kruger most certainly is. In fact, Cameron's "postfeminism" is increasingly confused as the article progresses. It appears any female can be (and, perhaps, necessarily is) "postfeminist" just by virtue of her sex. But Cameron also claims that "there is by no means a dearth of male artists working from [the] identical premises" of the female postfeminists.[31] So men are able to appropriate feminist radicality easily – by simply acknowledging the contingency of art as language; feminism becomes useful to masculinist artists and critics as postfeminism.

Cameron also discounts the explicitly feminist agendas of artists such as Kruger and Laurie Simmons by placing these artists in a masculinist genealogy of avant-garde critique: "following on the heels of Pop," they then become the "sources" for male artists Jeff Koons, Peter Halley, and Philip Taaffe, whose works, Cameron admits, are "more vociferously" collected than those of their supposed (maternal?) mentors, the "postfeminists."[32] We can hardly be surprised at this last discovery, given the modernist value systems and hierarchies still maintained even in Cameron's own ostensibly pro- but effectively anti-feminist argument.

It has, in fact, become quite common in art criticism to subsume feminist work under a broad framework of postmodernism. Kruger and Sherrie Levine, for example, are described by *New York Times Magazine* writer Richard Woodward in universalizing terms as simply using "photography conceptually to ask questions about the source and presentation of images in our culture."[33] Even the most explicitly feminist projects – such as Cindy Sherman's incisive critiques of the visual construction of the feminine – are submitted to this absorptive strategy. Sherman has posed herself as embodied object, photographically frozen within gendered positions of vulnerability in her "Untitled Film Stills" of the late 1970s, or as monstrously overblown in the very clichéd "darkness" of her sexual unknown, barely visible when covered with vomit or reflected in the lenses of sunglasses; in her most recent work, she has posed and photographed grotesque plastic female sex dolls, aggressively displaying their rigid female genitalia, dildos, and contorted artificial limbs. Sherman has been construed by Donald Kuspit as aiming toward the "universal" project of lamenting the condition of humanity:

> Sherman's work has been interpreted as a feminist deconstruction of the variety of female roles – *the lack of fixity of female, or for that matter any, identity*, although instability seems to have been forced more on women than men . . . But this interpretation

is a very partial truth. *Sherman shows the disintegrative condition of the self as such, the self before it is firmly identified as male or female.* This is suggested by the *indeterminate gender* of many of the faces and figures that appear in these pictures, and the presence of male or *would-be male* figures in some of them. *Female attributes* – for example, the woman's clothes in one untitled work . . . are just that, dispensable attributes, *clothes that can be worn by anyone.* The question is what the condition of the self is that will put them on . . . [my emphases].[34]

In this article – entitled, with disturbing and certainly unintentional irony, "Inside Cindy Sherman" – the stakes of postfeminist rhetoric are clear. Being "inside" Sherman, Kuspit constructs himself as knowing the artist better than she does herself. (How else could Kuspit "know" that what certainly do appear to be "female attributes" – women's clothing, a female authorial name, and even bloody women's underpants – are really things "that can be worn by anyone"?) Kuspit's fantasized penetration into this interior takes place via a probing set of metaphysical art historical tools such that Sherman's insistence on her otherness, as a "symptom" of masculinity's uncertainties about itself, is folded back into a narrative of (masculine) universality.

Kuspit concludes with the following argument: "It is this artistic use – her wish to excel with a certain aesthetic purity as well as to represent inventively – that reveals her wish to heal a more fundamental wound of selfhood than that which is inflicted on her by being a woman."[35] For Kuspit, the "true" meaning of this art is not feminist but moves beyond the narrow strictures that he perceives as delimiting feminism in the wide yet phallocentrically organized expanse of the universal, with its "fundamental wounds" and intrinsic "aesthetic purity." Whose "wishes" are being voiced here, anyway?

These incorporative disempowerments of feminist critiques are crucial to art criticism's maintenance of certain modernist and ultimately authoritative and masculinist models of artistic value even under the guise of postmodernism. As suggested earlier, these models draw from avant-gardist ideologies to construct oppositional categories of "progressive" versus "regressive" postmodern art practices – as in Hal Foster's argument in the article "(Post)modern Polemics," where he opposes "neoconservative" postmodernism to a radically avant-garde "poststructuralist" postmodernism.[36] Painting is doomed as always already "neoconservative" within this notion of properly radical postmodern practice. Photographic practices, particularly of an appropriative sort, are often assumed to be inherently deconstructive, which in turn implies that they have been wielded through an "intention" directed toward resisting the "male gaze" of visual pleasure.[37] Within currently dominant conceptions of postmodernism in the visual arts, then, contemporary art practices are either "good" or "bad," either "radical" and critical of all the now negatively viewed metaphysical elements of Greenbergian modernism, or "reactionary" – meaning, in this context, still modernist.

Underlying this dominant postmodern value system is the stipulation that the progressive art practice must follow Brechtian strategies of distanciation – working to displace and provoke the spectator to preclude his/her identification with the illusionary and ideological functions of representation. Brechtian distanciation requires, above all, a resistance to bourgeois pleasure – a prohibition of the object's seduction of the spectator as an embodied and desiring subject. In dominant conceptions of postmodernism, which tend to perpetuate modernism's hierarchies of taste disguised under terms of political rather than formal radicality, art that refuses visual pleasure is valued over more overtly seductive, sensual, or "decorative" work. The "dis-identificatory" or Brechtian practice is privileged for its

erosion of the dominant structures of cultural consumption which . . . are classically fetishistic . . . In the fetishistic regime the viewer is at once separated from what he/she is seeing but enthralled into identification with an imaginary world in which threatening knowledge is allayed by beautiful images. Brechtian distanciation aims to make the spectator an agent in cultural production and activate him or her as an agent in the world.[38]

The call for critical distance has also played an important role in the development of feminist theories of art practice and spectatorship. This is most strikingly evidenced in Laura Mulvey's call for a destruction of visual pleasure in her ubiquitous and formulative 1975 article, "Visual Pleasure and Narrative Cinema." Mulvey states her well-known polemic as follows: "It is said that analyzing pleasure, or beauty, destroys it. That is the intention of this essay."[39] According to Mulvey's argument, the construction of woman as objectified other through visual representation is inevitable, and feminists must work to refuse this objectification. Woman, Mulvey argues, stands "in patriarchal culture . . . as bearer . . . not maker of meaning," becoming object of scopophilic and inexorably male desire or the fetishizing male gaze, serving to palliate the male viewer's fear of lack.

The strategy of refusing male visual pleasure developed in Mulvey's article has been a central motivating force in the development of feminist cultural theory and of feminist art practices for the last two decades, including those practices now canonically inscribed as "feminist postmodernism" or "postfeminism" (from the works of Kruger and Sherman to those of Mary Kelly). The so-called postfeminists have operated within the Freudian terms of Mulvey's paradigm, working through psychoanalytic models of sexual difference to deconstruct the modernist conception of subjectivity as masculine and empowered through vision (the "male gaze"). In working to deconstruct modernism's reliance on the subject/object dichotomy, manipulating photographic imagery of the female body (or, in Kelly's case, working around or avoiding it) precisely in order to intervene in its propagandistic and psychically objectifying effects, these artists continue to work polemically within the terms of oppositional models of sexual difference.

While Mulvey's polemic has provided a space for the development of a feminist postmodernist practice, in view of its insistence on the refusal of pleasure (a pleasure that she defines as exclusively male and exclusively visual) it can also be seen to be aligned with art criticism's masculinist models of privileging bodily control. Central to the maintenance of masculinist critical models is the insistence on the impossibility of a work of art that is both sensual and conceptual, both corporeal and theoretical, both eroticized and politically critical at the same time. As sociologist Pierre Bourdieu has written of the psychic stakes of this refusal of pleasure in discourses of "high" culture,

> the object which "insists on being enjoyed" . . . neutralizes both ethical resistance and anaesthetic neutralization; it annihilates the distancing power of representation, the essentially human power of suspending immediate, animal attachment to the sensible and refusing submission to the pure affect . . . Pure pleasure – ascetic, empty pleasure which implies the renunciation of pleasure, pleasure purified of pleasure – is predisposed to become a symbol of moral excellence and the work of art a test of ethical superiority, an indisputable measure of the capacity for sublimation.[40]

According to Bourdieu, the aesthete's "disgust" toward the impure pleasures is the means by which he or she ensures "ethical superiority," performing his or her distance from the chaos of human corporeality and the stench of fully embodied desire: "disgust is the ambivalent

experience of the horrible seduction of the disgusting and of enjoyment, which performs a sort of reduction to animality, corporeality, the belly and sex"[41] The resistance to pleasure is above all a resistance to corporeal engagement motivated by a desire to control chaotic and unpredictable pleasure of the erotically engaged body. Only a pleasure purified or eroticism can elevate the aesthete or critic above the masses (which are, as scholars such as Tania Modleski, Andreas Huyssen, and Klaus Theweleit have pointed out, inexorably identified with the threat of femininity).[42] Within the hierarchical and eminently masculinist logic of criticism, the critic fears a collapse of the very hierarchizing boundaries of difference that enable the "male gaze."

As French feminists such as Irigaray have pointed out, the refusal of pleasure intersects with the prohibition of female agency and thus has ideological, and explicitly anti-feminist effects. Within the psychoanalytic map of bourgeois, western subjectivity, "woman has to remain a body without organs . . . The geography of feminine pleasure is not worth listening to. Women are not worth listening to, especially when they try to speak of their pleasure."[43] While it is the female body that elicits most directly the "disgusting" (clearly heterosexual and male) pleasure of which Bourdieu writes, and thus requires objectification as a means of controlling its potential threat, this very same body is conventionally refused to the female viewer as a locus of pleasure: "The fetishized feminine Imago, conforming to a commercialized ideal of what seduces the eye, is thus barred to the female spectator."[44]

There is no female pleasure in viewing under the Freudian (nor arguably, the Lacanian) system. In the Mulveyan "feminist anti-fetishism" or "Puritanism of the eye," where visual seduction is seen to be necessarily complicitous with male fetishism, female pleasure is simply ignored.[45] In this way, Mulvey's theoretical negation of female pleasure seems complicitous with its denial by patriarchy, the disempowering effects of which are described so vividly by Irigaray. Ironically, in overlooking the question of female pleasure, critical texts that privilege feminist appropriation art for its refusal of the desiring "male gaze" have maintained the boundaries of masculinist critical and viewing authority even as they have worked to celebrate practices that critique it. The postfeminist program, as it has been defined in postmodern art discourses, is complicit with both modernism's general refusal of pleasure, and with the Mulveyan focus on male pleasure (and its prohibition) at the expense of accounting for the possibility of a desiring female spectator.

[. . .]

One way of resisting the masculinist seduction that produces feminists as "post," or constructs feminism as subsumed within a critical postmodernist or ostensibly genderless and "universal" cultural project is to refuse what Jane Gallop calls "the prick" of patriarchy, which operates to remasculinize culture by reducing all subjectivity to the ostensibly "neutral subject . . . [itself] actually a desexualized, sublimated guise for the masculine sexed being."[46] The refusal of "the prick" of patriarchy can take place through recognizing and playing out the polymorphous female pleasures in feminist theory and artistic practice, through exacerbating the tenuousness of the boundaries between desire and repulsion. Flamboyantly asserting the [. . . disturbing effects of the female sex] at its most overtly indexical moment, [feminist photographic practices by artists such as Judie Bamber and Jeanne Dunning] perform what Freud describes as an uncanny effacing of "the distinction between imagination and reality,"[47] forcing fantasy to take responsibility for its ideological (in this case fetishizing) effects. The ideology of the falsely unifying claims of postfeminist discourses can be exposed through works like this – works that tread the borderlines between pleasure and disgust in the *representation* of female subjectivity, and through correlatively playful and overtly desiring interpretive texts that enact, rather than repress, the pleasure they take in images.

Notes

1 Susan Faludi, *Backlash: The Undeclared War Against American Women* (New York: Crown Publishers, 1991). Faludi's book is journalistic and anecdotal, but extremely useful for its polemical stance and the amount of information it marshals to debunk statistical "evidence" supporting anti-feminists in their determination of the death of feminism.

2 Some of the examples from popular culture that I examine in the following part of this essay initially appeared in a different form in my article "Post-Feminism – A Remasculinization of Culture?" *MEANING* 7 (1990), pp. 29–40. See also Laura Kipnis, "Feminism: The Political Conscience of Postmodernism?," *Universal Abandon? The Politics of Postmodernism*, Andrew Ross, ed., (Minneapolis: University of Minnesota Press, 1988), p. 164.

3 Abigail Solomon-Godeau, "The Legs of the Countess," *October* 39 (Winter 1986), pp. 65–107.

4 Ibid., pp. 67–68.

5 Luce Irigaray, "Women on the Market," *This Sex Which is Not One*, Catherine Porter, trans., (Ithaca: Cornell University Press, 1985), p. 172.

6 See Ruth Rosen's editorial "Column Left / 'Family Values' is a GOP Code for Meanness," *Los Angeles Time* (April 21, 1992), p. B7.

7 Cover, *Women's Day* (October 30, 1990).

8 *Time* ran the following issues: "Women Face the '90s. In the '80s they tried to have it all. Now they've just plain had it. Is there a future for feminism?" (December 4, 1989); "Special Issue, Women: The Road Ahead" (Fall 1990); "Why Are Men and Women Different? If it isn't just upbringing. New studies show they are born that way" (January 20, 1992); "Why Roe V. Wade is Already Moot" (May 4, 1992). For a slightly more pro-feminist note, see "Fighting the Backlash Against Feminism: Susan Faludi and Gloria Steinem sound the call to arms" (March 9, 1992); even here, the contents page tempers the seeming pro-feminist slant of this issue by asking, "Are women unhappy because feminism succeeded – or because it stalled?" Other popular press examples abound, as Faludi's book attests. A few recent local texts I have run across include Sally Quinn's editorial, "Feminists Have Killed Feminism," which is subtitled "For years, they shamed the majority who loved men, babies, family ties. Now their confessions reveal their hypocrisy," *Los Angeles Times* (January 23, 1992), p. B7; and Nina J. Easton's cover story, "I'm Not a Feminist but . . . ," *Los Angeles Times Magazine* (February 2, 1992).

9 The issue includes a critical examination of 1980s' anti-feminism by Barbara Ehrenreich, "Sorry, Sisters, This Is Not the Revolution," p. 15. In fact, the more pro-feminist slant of some of the articles indicates a split between the editorial staff (presumably responsible for the material on the cover and table of contents page, as well as the overall editorial slant of this issue), and some of the better-known feminist intellectuals, such as Ehrenreich, they commissioned to write articles.

10 Louis Althusser, "Ideology and Ideological State Apparatuses (Notes towards an Investigation)," in *Lenin and Philosophy*, B. Brewster, trans., (London and New York: New Left Books, 1971), pp. 127–186.

11 The "Special Issue" is far broader, carrying articles on women from other countries, including non-western ones, and addressing issues of race and class while discussing the role of women in the work place. In addition to these examinations of women's issues it also includes an essay by Sam Allis entitled, "What do Men Really Want?," with the byline, "Stoic and sensitive have been cast aside, leaving postfeminist males confused, angry and desperately seeking manhood."

12 Claudia Wallis, "Onward, Women," *Time* (December 4, 1989), pp. 80–82, 85–86, 89.

13 Ibid., p. 81.

14 I discuss the remasculinizing operations of recent Hollywood films in these terms in my article " 'She was bad news': Male Paranoia and the Contemporary New Woman," *Camera Obscura* 25–26 (January/ May 1991), pp. 297–320.

15 Popular press examinations of the "postfeminist male" include *Newsweek's* June 24, 1991 issue "Drums, Sweat and Tears: What Do Men Really Want? Now They Have a Movement of Their Own," with Jerry Adler, Anthony Duignan-Cabrera, and Jeanne Gordon's "Heading the Call of the Drums: All over America, the ancient, primal art of drumming is helping men find a voice of their own," pp. 52–53; *Esquire's* October 1991 Special Issue entitled, "Wild Men and Wimps," and Elizabeth Mehren's, "Now It's the Men's Turn," *Los Angeles Times Book Review* (September 1, 1991), p. 9.

16 Janice Castro, "Get Set: Here They Come! The 21st century work force is taking shape now. And guess what? White, U.S.-born men are a minority. . . . ," *Time* "Special Issue, Women: The Road Ahead" (Fall 1990), pp. 50–51. At least in the case of the "men's movement," the popular news magazines show appropriate sarcasm when "objectively" reporting this phenomenon (although such

sarcasm also allows them to have their men's movement and their ironic superiority, too). Postfeminist issues are taken much more seriously and discussed as "news," legitimating the determination of the death of feminism as a "fact."

17 Russell Ferguson, "Introduction: Invisible Center," *Out There: Marginalization and Contemporary Cultures*, Russell Ferguson, Martha Gever, Trinh T. Minh-ha, Cornel West, eds. (New York: New Museum of Contemporary Art, and Cambridge and London: MIT Press, 1990), p. 10.

18 Laura Mulvey, "Dialogue with Spectatorship: Barbara Kruger and Victor Burgin," *Visual and Other Pleasures* (Bloomington and Indianapolis: Indiana University Press, 1989), p. 134.

19 Mira Schor introduces this notion of "aesthetic terrorism" in her article "Figure/Ground," *MEANING* 6 (1989), p. 18.

20 I discuss this hegemonic postmodernism and its attendant modes of exclusionism and cultural domination at length in my book, *Postmodernism and the En-gendering of Marcel Duchamp* (Cambridge: Cambridge University Press, 1993).

21 Frederic Jameson, "Postmodernism or the Cultural Logic of Late Capitalism," *New Left Review* 46 (July–August 1984), p. 65. See also Andreas Huyssen, "Mass Culture as Woman," and "Mapping the Postmodern," *After the Great Divide: Modernism, Mass Culture, Postmodernism* (Bloomington: Indiana University Press, 1986), pp. 61, 220.

22 Craig Owens, "The Discourse of Others: Feminists and Postmodernism," *The Anti-Aesthetic: Essays on Postmodern Culture*, Hal Foster, ed. (Port Townsend, Washington: Bay Press, 1983), pp. 57–82.

23 Ibid., p. 62.

24 Ibid.

25 Ibid., pp. 59, 64.

26 Ibid., p. 59. There are feminist cultural theorists who examine the feminism/postmodernism intersection in ways that are more sensitive to the specificities of feminist theory. See Janet Lee, "Care to Join Me in an Upwardly Mobile Tango? Postmodernism and the 'New Woman'," *The Female Gaze: Women as Viewers of Popular Culture*, Lorraine Gamman and Margaret Marshment, eds., (Seattle: Real Comet Press, 1989), p. 172; Linda Hutcheon, "Postmodernism and Feminisms," *The Politics of Postmodernism* (London and New York: Routledge, 1989), pp. 142, 152; Shelagh Young, "Feminism and the Politics of Power: Whose Gaze is it Anyway," *The Female Gaze*, pp. 173–188; Susan Suleiman, "Feminism and Postmodernism: In Lieu of an Ending," *Subversive Intent: Gender, Politics, and the Avant-Garde* (Cambridge: Harvard University Press, 1990), pp. 181–205; Laura Kipnis, "Feminism: The Political Conscience of Postmodernism?"; the essays collected in *Feminism/Postmodernism*, Linda Nicholson, ed. (New York: Routledge, 1990); Barbara Creed, "From Here to Modernity: Feminism and Postmodernism," *Screen* 28, no. 2 (Spring 1987), pp. 47–67; Meaghen Morris, *The Pirate's Fiancée: Feminism, Reading, Postmodernism* (London and New York: Verso, 1988); and Elizabeth Wright, "Thoroughly postmodern feminist criticism," *Between Feminism and Psychoanalysis*, Teresa Brennan, ed. (London and New York: Routledge, 1989), pp. 141–152.

27 Craig Owens, "The Discourse of Others," p. 67.

28 Homi Bhabha has succinctly pinpointed the problematic nature of the privileging of a previously excluded other by contemporary theory. While Bhabha discusses this dynamic in relation to the ethnic and cultural other, his observations apply to the appropriation of the feminist other as well. See "The Other Question: Difference, Discrimination and the Discourse of Colonialism," *Out There: Marginalization in Contemporary Cultures*, p. 73.

29 Tania Modleski, *Feminism without Women: Culture and Criticism in a "Postfeminist" Age* (New York and London: Routledge, 1991), p. 3.

30 Dan Cameron, "Post-feminism," *FlashArt*, no. 132 (February/March, 1987), pp. 80–83.

31 Ibid., p. 80.

32 Ibid., p. 80, 82.

33 Richard B. Woodward, "It's Art, But is it Photography?" *New York Times Magazine* (October 9, 1988), p. 31.

34 Donald Kuspit, "Inside Cindy Sherman," *The New Subjectivism: Art in the 1980s* (Ann Arbor: UMI, 1988), p. 395.

35 Ibid., p. 396.

36 Hal Foster, "(Post)Modern Polemics," *Recodings: Art, Spectacle, Cultural Politics* (Seattle: Bay Press, 1985), pp. 121–138.

37 Thus, in Douglas Crimp's influential essay on the "Pictures" group of appropriation artists, including Sherrie Levine, Sherman, Robert Longo, and Jack Goldstein, he celebrates their work as radically postmodern (due to their "predominant sensibility" aimed toward "radical innovation"), while he rejects

"New Image Painting" as complicitous "with that art which strains to preserve the modernist aesthetic categories which museums themselves have institutionalized." In "Pictures," *Art after Modernism: Rethinking Representation*, Brian Wallis, ed. (New York: New Museum of Contemporary art, and Boston: David R. Godine, 1984), pp. 175, 187. Benjamin Buchloh's essay in this same anthology, "Figures of Authority, Cyphers of Regression," constructs a similar argument, linking contemporary European painting to the "inherent authoritarian tendency" of 1920s' artistic ideologies mythologizing a "new classicism," p. 111.

38 This is Griselda Pollock's description in her essay tracing the historical development of "Brechtian" strategies and their use for feminist art, "Screening the seventies: sexuality and representation in feminist practice – a Brechtian perspective," *Vision and Difference: Femininity, Feminism and the Histories of Art* (London and New York: Routledge, 1988), p. 163. [Chapter 13 in this volume.]

39 Laura Mulvey, "Visual Pleasure and Narrative Cinema," *Art after Modernism*, p. 363. [Chapter 9 in this volume.]

40 Pierre Bourdieu, *Distinction: A Social Critique of the Judgement of Taste*, Richard Nice, trans. (Cambridge: Harvard University Press, 1984), pp. 489, 490, 491.

41 Ibid., p. 489.

42 See Tania Modleski, *Loving with a Vengeance: Mass-Produced Fantasies for Women* (New York and London: Methuen, 1984); Andreas Huyssen, "Mass Culture as Woman," *After the Great Divide*, pp. 44–62; and Klaus Theweleit, *Male Fantasies*, vols. 1 and 2, Erica Carter, Chris Turner, Stephen Conway, trans. (Minneapolis: University of Minnesota Press, 1997 and 1989). See also Bourdieu's discussion of the intersection of class and gender in *Distinction*, p. 107.

43 Luce Irigaray, "Cosi Fan Tutti," *The Sex Which is Not One* (1977), Catherine Porter, trans. (Ithaca: Cornell University Press, 1985), p. 90. See also Johanna Drucker's "Visual Pleasure: A Feminist Perspective," *MEANING* 11 (May 1992), pp. 3–11.

44 Emily Apter, "Fetishism and Visual Seduction in Mary Kelly's *Interim*," *October* 58 (Fall 1991), p. 97.

45 Ibid., p. 101.

46 Jane Gallop, *The Daughter's Seduction: Feminism and Psychoanalysis* (Ithaca, New York: Cornell University Press, 1982), pp. 36, 58.

47 Sigmund Freud, "The Uncanny," *The Standard Edition of the Complete Psychological Works*, vol. 17, James Strachey, trans. (London: Hogarth Press, 1955), p. 244.

Chapter 37

LYNN SPIGEL

THE SUBURBAN HOME COMPANION
Television and the neighborhood ideal in postwar America

IN DECEMBER 1949, THE POPULAR RADIO comedy *Easy Aces* made its television debut on the DuMont network. The episode was comprised entirely of Goodman Ace and his wife Jane sitting in their living room, watching TV. The interest stemmed solely from the couple's witty commentary on the program they watched. Aside from that, there was no plot. This was television, pure and simple. It was just the sense of being with the

Aces, of watching them watch, and of watching TV with them, that gave this program its peculiar appeal.

The fantasy of social experience that this program provided is a heightened instance of a more general set of cultural meanings and practices surrounding television's arrival in postwar America. It is a truism among cultural historians and media scholars that television's growth after World War II was part of a general return to family values. Less attention has been devoted to the question of another, at times contradictory, ideal in postwar ideology – that of neighborhood bonding and community participation. During the 1950s, millions of Americans – particularly young white couples of the middle class – responded to a severe housing shortage in the cities by fleeing to new mass-produced suburbs. In both scholarly studies and popular literature from the period, suburbia emerges as a conformist-oriented society where belonging to the neighborhood network was just as important as the return to family life. Indeed, the new domesticity was not simply experienced as a retreat from the public sphere; it also gave people a sense of belonging to the community. By purchasing their detached suburban homes, the young couples of the middle class participated in the construction of a new community of values; in magazines, in films, and on the airwaves they became the cultural representatives of the "good life." Furthermore, the rapid growth of family-based community organizations like the PTA suggests that these neo-suburbanites did not barricade their doors, nor did they simply "drop out." Instead, these people secured a position of meaning in the *public* sphere through their new-found social identities as *private* landowners.

In this sense, the fascination with family life was not merely a nostalgic return to the Victorian cult of domesticity. Rather, the central preoccupation in the new suburban culture was the construction of a particular *discursive space* through which the family could mediate the contradictory impulses for the private haven on the one hand, and community participation on the other. By lining up individual housing units on connecting plots of land, the suburban tract was itself the ideal articulation of this discursive space; the dual goals of separation from and integration into the larger community was the basis of tract design. Moreover, as I have shown elsewhere, the domestic architecture of the period mediated the twin goals of separation from and integration into the outside world.[1] Applying principles of modernist architecture to the mass-produced housing of middle-class America, housing experts of the period agreed that the modern home should blur distinctions between inside and outside spaces. As Katherine Morrow Ford and Thomas H. Creighton claimed in *The American House Today* (1951), "the most noticeable innovation in domestic architecture in the past decade or two has been the increasingly close relationship of indoors to outdoors."[2] By far, the central design element used to create an illusion of the outside world was the picture window or "window wall" (what we now call sliding glass doors), which became increasingly popular in the postwar period. As Daniel Boorstin has argued, the widespread dissemination of large plate-glass windows for both domestic and commercial use "levelled the environment" by encouraging the "removal of sharp distinctions between indoors and outdoors" and thus created an "ambiguity" between public and private space.[3] This kind of spatial ambiguity was a reigning aesthetic in postwar home magazines which repeatedly suggested that windows and window walls would establish a continuity of interior and exterior worlds. As the editors of *Sunset* remarked in 1946, "Of all improved materials, glass made the greatest change in the Western home. To those who found that open porches around the house or . . . even [the] large window did not bring in enough of the outdoors, the answer was glass – the invisible separation between indoors and out."[4]

Given its ability to merge private with public spaces, television was the ideal companion for these suburban homes. In 1946, Thomas H. Hutchinson, an early experimenter in television

programming, published a popular book designed to introduce television to the general public, *Here is Television, Your Window on the World*.[5] As I have shown elsewhere, commentators in the popular press used this window metaphor over and over again, claiming that television would let people imaginatively travel to distant places while remaining in the comfort of their homes.[6]

Indeed, the integration of television into postwar culture both precipitated and was symptomatic of a profound reorganization of social space. Leisure time was significantly altered as spectator amusements – including movies, sports, and concert attendance – were increasingly incorporated into the home. While in 1950 only 9 percent of all American homes had a television set, by the end of the decade that figure rose to nearly 90 percent, and the average American watched about five hours of television per day.[7] Television's privatization of spectator amusements and its possible disintegration of the public sphere were constant topics of debate in popular media of the period. Television was caught in a contradictory movement between private and public worlds, and it often became a rhetorical figure for that contradiction. In the following pages, I examine the way postwar culture balanced these contradictory ideals of privatization and community involvement through its fascination with the new electrical space that television provided.

[. . .]

Television's promise of social interconnection has provided numerous postwar intellectuals – from Marshall McLuhan to Joshua Meyrowitz – with their own utopian fantasies. Meyrowitz is particularly interesting in this context because he had claimed that television helped foster women's liberation in the 1960s by bringing traditionally male spaces into the home, thus allowing women to "observe and experience the larger world, including all male interactions and behaviors." "Television's first and strongest impact," he concludes, "is on the perception that women have of the public male world and the place, or lack of place, they have in it. Television is an especially potent force for integrating women because television brings the public domain to women."[8] But Meyrowitz bases this claim on an essentialist notion of space. In other words, he assumes that public space is male and private space is female. However, public spaces like the office or the theater are not simply male; they are organized according to categories of sexual difference. In these spaces certain social positions and subjectivities are produced according to the placement of furniture, the organization of entrances and exits, the separation of washrooms, the construction of partial walls, and so forth. Thus, television's incorporation of the public sphere into the home did not bring "male" space into female space; instead it transposed one system of sexually organized space onto another.

Not surprisingly in this regard, postwar media often suggested that television would increase women's social isolation from public life by reinforcing spatial hierarchies that had already defined their everyday experiences in patriarchal cultures. The new family theatres were typically shown to limit opportunities for social encounters that women traditionally had at movie theaters and other forms of public entertainment. In 1951, a cartoon in *Better Homes and Gardens* stated the problem in humorous terms. On his way home from work, a husband imagines a night of TV wrestling while his kitchen-bound wife, taking her freshly baked pie from the oven, dreams of a night out at the movies.[9] Colgate dental cream used this dilemma of female isolation as a way to sell its product. A 1952 advertisement that ran in *Ladies' Home Journal* showed a young woman sitting at home watching a love scene on her television set, complaining to her sister, "All I do is sit and view. You have dates any time you want them, Sis! All I get is what TV has to offer."[10] Of course, after she purchased the Colgate dental cream, she found her handsome dream date. Thus, as the Colgate company so well understood, the imaginary universe that television offered posed its own set of female troubles. Even if television programs promised to transport women into the outside world,

it seems likely that women were critical of this, that they understood television's electrical space would never adequately connect them to the public sphere.

In 1955, the working-class comedy, *The Honeymooners*, dramatized this problem in the first episode of the series, "TV or Not TV." [11] The narrative was structured upon the contradiction between television's utopian promise of increased social life and the dystopian outcome of domestic seclusion. In an early scene, Alice Kramden begs her husband Ralph to buy a television set:

> I . . . want a television set. Now look around you, Ralph. We don't have any electric appliances. Do you know what our electric bill was last month? Thirty-nine cents! We haven't blown a fuse, Ralph, in ten years. . . . I want a television set and I'm going to get a television set. I have lived in this place for fourteen years without a stick of furniture being changed. Not one. I am sick and tired of this. . . . And what do you care about it? You're out all day long. And at night what are you doing? Spending money playing pool, spending money bowling, or paying dues to that crazy lodge you belong to. And I'm left here to look at that icebox, that stove, that sink, and these four walls. Well I don't want to look at that icebox, that stove, that sink and these four walls. I want to look at Liberace!

Significantly, in this exchange, Alice relates her spatial confinement in the home to her more general exclusion from the modern world of electrical technologies (as exemplified by her low utility bills). But her wish to interconnect with television's electrical spaces soon becomes a nightmare because the purchase of the set further engenders her domestic isolation. When her husband Ralph and neighbor Ed Norton chip in for a new TV console, the men agree to place the set in the Kramden's two-room apartment where Norton is given visitation privileges. Thus, the installation of the set also means the intrusion of a neighbor into the home on a nightly basis, an intrusion that serves to take away rather than to multiply the spaces which Alice can occupy. In order to avoid the men who watch TV in the central living space of the apartment, Alice retreats to her bedroom, a prisoner in a house taken over by television.

Social scientific studies from the period show that the anxieties expressed in popular representations were also voiced by women of the period. One woman in a Southern California study confessed that all her husband "wants to do is to sit and watch television – I would like to go out more often." Another woman complained, "I would like to go for a drive in the evening, but my husband has been out all day and would prefer to watch a wrestling match on television." [12]

A nationwide survey suggested that this sense of domestic confinement was even experienced by teenagers. As one respondent complained, "Instead of taking us out on date nights, the free-loading fellas park in our homes and stare at the boxing on TV." For reasons such as these, 80 percent of the girls admitted they would rather go to a B movie than stay home and watch television. [13]

If television was considered to be a source of problems for women, it also became a central trope for the crisis of masculinity in postwar culture. According to the popular wisdom, television threatened to contaminate masculinity, to make men sick with the "disease" of femininity. As other scholars have observed, this fear of feminization has characterized the debates on mass culture since the nineteenth century. Culture critics have continually paired mass culture with patriarchal assumptions about femininity. Mass amusements are typically thought to encourage passivity, and they have often been represented in terms of penetration,

consumption, and escape. As Andreas Huyssen has argued, this link between women and mass culture has, since the nineteenth century, served to valorize the dichotomy between "low" and "high" art (or modernism). Mass culture, Huyssen claims, "is somehow associated with women while real, authentic culture remains the prerogative of men."[14] The case of broadcasting is especially interesting because the threat of feminization was particularly aimed at men. Broadcasting quite literally was shown to disrupt the normative structures of patriarchal (high) culture and to turn "real men" into passive homebodies.

In the early 1940s, this connection between broadcast technology and emasculation came to a dramatic pitch when Philip Wylie wrote his bitter attack on American women, *Generations of Vipers*. In this widely-read book, Wylie maintained that American society was suffering from an ailment that he called "momism." American women, according to Wylie, had become overbearing, domineering mothers who turned their sons and husbands into weak-kneed fools. The book was replete with imagery of apocalypse through technology, imagery that Wylie tied to the figure of the woman. As he saw it, an unholy alliance between women and big business had turned the world into an industrial nightmare where men were slaves both to the machines of production in the factory and to the machines of reproduction – that is, women – in the home.

In his most bitter chapter, entitled "Common Women," Wylie argued that women had somehow gained control of the airwaves. Women, he suggested, made radio listening into a passive activity that threatened manhood, and in fact, civilization. As Wylie wrote:

> The radio is mom's final tool, for it stamps everyone who listens to it with the matriarchal brand – its superstitions, prejudices, devotional rules, taboos, musts, and all other qualifications needful to its maintenance. Just as Goebbels has revealed what can be done with such a mass-stamping of the public psyche in his nation, so our land is a living representation of the same fact worked out in matriarchal sentimentality, goo, slop, hidden cruelty, and the foreshadow of national death.[15]

In the annotated notes of the 1955 edition, Wylie updated these fears, claiming that television would soon take the place of radio and turn men into female-dominated dupes. Women, he wrote, "will not rest until every electronic moment has been bought to sell suds and every bought program censored to the last decibel and syllable according to her self-adulation – along with that (to the degree the mom-indoctrinated pops are permitted access to the dials) of her de-sexed, de-souled, de-cerebrated mate."[16] The mixture of misogyny and "telephobia" which ran through this passage was clearly hyperbolic; still, the basic idea was repeated in more sober representations of everyday life during the postwar period.

As popular media often suggested, television threatened to rob men of their powers, to usurp their authority over the image, and to turn them into passive spectators. This threat materialized in numerous representations that showed women controlling their husbands through television. Here, television's blurring of private and public space became a powerful tool in the hands of housewives who could use the technology to invert the sexist hierarchies at the heart of the separation of spheres. In this topsy turvy world, women policed men's access to the public sphere and confined them to the home through the clever manipulation of television technology. An emblematic example is a 1955 advertisement for *TV Guide* that conspires with women by giving them tips on ways to "Keep a Husband Home." As the ad suggests, "You might try drugging his coffee . . . or hiding all his clean shirts. But by far the best persuader since the ball and chain is the TV set . . . and a copy of *TV Guide*."[17]

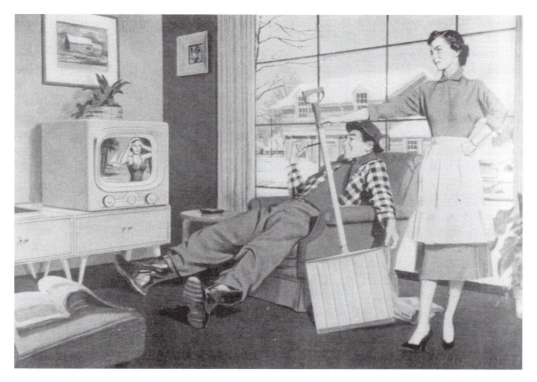

Figure 37.1 "Let's go, Mr Dreamer, that television set won't help you shovel the walk," Motorola television advertisement, 1952.

This inversion of the gendered separation of spheres was repeated in other representations that suggested ways for women to control their husbands' sexual desires through television. A typical example is a 1952 advertisement for Motorola television that showed a man staring at a bathing beauty on television while neglecting his real-life mate. The dilemma of "the other woman," however, was countered by the enunciative control that the housewife had in the representation. While the man is shown to be a passive spectator sprawled in his easy chair, his wife (who is holding a shovel) dominates the foreground of the image, and the caption, which speaks from her point of view, reads, "Let's Go Mr. Dreamer, that television set won't help you shovel the walk" [Figure 37.1]. Similarly, a 1953 RCA advertisement for a set with "rotomatic tuning" shows a male spectator seated in an easy chair while watching a glamorous woman on the screen. But the housewife literally controls and sanctions her husband's gaze at the televised woman because she operates the tuning dials.[18] Then too, numerous advertisements and illustrations depicted women who censored male desire by standing in front of the set, blocking the man's view of the screen [Figure 37.2].[19] Similarly, a cartoon in a 1949 issue of the *New York Times* magazine showed how a housewife could dim her husband's view of televised bathing beauties by making him wear sunglasses, while a cartoon in a 1953 issue of *TV Guide* suggested that the same form of censorship could be accomplished by putting window curtains on the screen in order to hide the more erotic parts of the female body.[20] Television, in this regard, was shown to contain men's pleasure by circumscribing it within the confines of domestic space and placing it under the auspices of women. Representations of television thus presented a position for male spectators that can best be described as passive aggression. Structures of sadistic and fetishistic pleasure

common to the Hollywood cinema were still operative, but they were sanitized and neutral-ized through their incorporation into the home.

In contemporary culture, the dream of social interconnection through antiseptic electrical space is still a potent fantasy. In 1989, in an issue entitled "The Future and You," *Life* maga-zine considered the new electronic space that the home laser holographic movie might offer in the twenty-first century. Not coincidentally, this holographic space was defined by male desire. As Marilyn Monroe emerged from the screen in her costume from *The Seven Year Itch*, a male spectator watched her materialize in the room. With his remote control aimed at the set, he policed her image from his futuristic La-Z-Boy Lounger. Although the scene was clearly coded as a science-fiction fantasy, this form of home entertainment was just the latest version of the older wish to control and purify public space. Sexual desire, transported to the home from the Hollywood cinema, was made possible by transfiguring the celluloid image into an electrical space where aggressive and sadistic forms of cinematic pleasure were now sanitized and made into "passive" home entertainment. The aggression entailed in watching Monroe was clearly marked as passive aggression, as a form of desire that could be contained within domestic space. But just in case the desire for this electronic fantasy woman could not be properly contained, the article warned readers to "fasten the seatbelt on your La-Z-Boy."[21]

As this example shows, the utopian dreams of space-binding and social sanitation that characterized television's introduction in the fifties is still a dominant cultural ideal. Electronic communications offer an extension of those plans as private and public spaces become increas-ingly intertwined through such media as home computers, fax machines, message units, and car phones. Before considering these social changes as a necessary part of an impending "elec-tronic revolution" or "information age," we need to remember the racist and sexist principles upon which these electrical utopias have often depended. The loss of neighborhood networks and the rise of electronic networks is a complex social phenomenon based on a series of contradictions that plague postwar life. Perhaps being nostalgic for an older, more "real" form

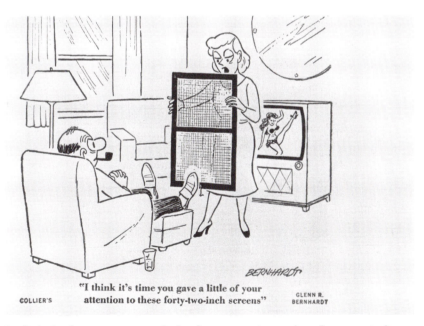

Figure 37.2 "I think it's time you gave a little of your attention to these forty-two-inch screens," television advertisement, *Colliers*, 1953.

of community is itself a historical fantasy. But the dreams of a world united by telecommunications seem dangerous enough to warrant closer examination. The global village, after all, is the fantasy of the colonizer, not the colonized.

Notes

1 See my article "Installing the Television Set: Popular Discourses on Television and Domestic Space, 1948–55," *Camera Obscura* 16 (March 1988): 11–47; and my dissertation, "Installing the Television Set: The Social Construction of Television's Place in the American Home" (University of California-Los Angeles, 1988).

2 Katherine Morrow Ford and Thomas H. Creighton, *The American House Today* (New York: Reinhold Publishing Co., 1951), p. 139.

3 Daniel J. Boorstin, *The Americans: The Democratic Experience* (New York: Vintage Books, 1973), pp. 336–345. Boorstin sees this "levelling of place" as part of a wider "ambiguity" symptomatic of the democratic experience.

4 *Sunset Homes for Western Living* (San Francisco: Lane Publishing Co., 1946), p. 14.

5 Thomas H. Hutchinson, *Here is Television, Your Window on the World* (1945; New York: Hastings House, 1948), p. ix.

6 For more on this, see my article "Installing the Television Set: Popular Discourses on Television and Domestic Space, 1948–55" and my dissertation, "Installing the Television Set: The Social Construction of Television's Place in the American Home."

7 The data on installation rates vary slightly from one source to another. These estimations are based on Cobbett S. Steinberg, *TV Facts* (New York: Facts on File, 1980), p. 142; "Sales of Home Appliances," and "Dwelling Units," *Statistical Abstract of the United States* (Washington, D.C., 1951–56); Lawrence W. Lichty and Malachi C. Topping, *American Broadcasting: A Source Book on the History of Radio and Television* (New York: Hastings House, 1975), pp. 521–522. Note, too, that there were significant regional differences in installation rates. Television was installed most rapidly in the Northeast; next were the central and western states, which had relatively similar installation rates; the South and southwest mountain areas were considerably behind the rest of the country. See "Communications," in *Statistical Abstract of the United States* (Washington, D.C., 1959); *U.S. Bureau of the Census, Housing and Construction Reports*, Series H-121, nos. 1–5 (Washington, D.C., 1955–58). Average hours of television watched is based on a 1957 estimate from the A. C. Nielsen Company printed in Leo Bogart, *The Age of Television: A Study of Viewing Habits and the Impact of Television on American Life* (1956; New York: Frederick Unger, 1958), p. 70.

8 Joshua Meyrowitz, *No Sense of Place: The Impact of Electronic Media on Social Behaviour* (New York: Oxford University Press, 1985), pp. 223–224.

9 *Better Homes and Gardens* (November 1951): 218.

10 *Ladies' Home Journal* (January 1962): 64.

11 *The Honeymooners* was first seen in 1951 as a skit in the live variety show *Cavalcade of Stars* on the DuMont network. The filmed half-hour series to which I refer aired during the 1955–56 season.

12 McDonagh et al., "Television and the Family," *Sociology and Social Research* 40, no. 4 (March–April 1956): pp 117, 119.

13 Cited in Betty Betz, "Teens and TV," *Variety*, January 7, 1953, p. 97.

14 Andreas Huyssen, *After the Great Divide: Modernism, Mass Culture, Postmodernism* (Bloomington: Indiana University Press, 1986), p. 47.

15 Philip Wylie, *Generation of Vipers* (New York: Holt, Rinehart and Winston, 1955), pp. 214–215.

16 Ibid., pp. 213–214.

17 *TV Guide*, January 29, 1955, back cover.

18 *Better Homes and Gardens* (February 1952): 154; *Better Homes and Gardens* (September 1953): 177.

19 See, for example, an advertisement for Durall window screens that shows a housewife blocking her husband's view of a bathing beauty on the television set in *Good Housekeeping* (May 1954): 187. A similar illustration appears in *Popular Science* (March 1953): 179. And an advertisement for Kotex sanitary napkins shows how a woman, by wearing the feminine hygiene product, can distract her husband's gaze at the screen: *Ladies' Home Journal* (May 1949): 30.

20 *New York Times*, December 11, 1949: magazine, p. 20; *TV Guide*, November 6, 1953, p. 14.

21 *Life* (February 1989): 67.

ANN DUCILLE

BLACK BARBIE AND THE DEEP
PLAY OF DIFFERENCE

[. . .]

Race and the real doll

"**R**EALISM IS PLAUSIBLE", Catherine Belsey writes, "not because it reflects
the world, but because it is constructed out of what is (discursively) familiar"[1] –
what we already know or think we know, that we readily recognize and instantly decode.
With its black, Hispanic, and Asian dolls and its Dolls of the World, Mattel attempts to repro-
duce a heterogeneous globe, in effect to produce multicultural meaning and market ethnic
diversity. It does so, of course, not by replicating the individual differences of real bodies but
by mass-marketing the discursively familiar – by reproducing stereotyped forms and visible
signs of racial and ethnic difference.

But could any doll manufacturer or other image maker – advertising and film, say –
attend to cultural, racial, and phenotypical differences without merely engaging the same
simplistic big-lips/broad-hips stereotypes that make so many of us – blacks in particular –
grit our (pearly white) teeth? What would it take to produce a line of dolls that would more
fully reflect the wide variety of sizes, shapes, colours, hairstyles, occupations, abilities, and
disabilities that African Americans – like all people – come in? In other words: what price
difference?

The cost of mass-producing dolls to represent the heterogeneity of the world would be
far greater than either corporation or consumer would be willing to pay.[2] Mattel and other
toy-makers have got around this problem by making the other at once different and the same.
In this sense, Mattel's play with mass-produced difference resembles the nation's uneasy play
with a melting-pot pluralism that both produces and denies difference. That is to say, while
professing colourblindness, the nation-state – faced with people rather than plastic – has never
quite known what to do with the other, how to melt down those who "look different". From
the Constitution's "three-fifths compromise" (1787) to California's Proposition 187 (1994),
what to do with the other – the other's history, language and literature, and especially body
– is a question that has upset the democratic applecart.[3]

The toy industry is only one of many venues where multiculturalism, posed as an answer
to critical questions about inclusion, diversity, and equality, has collapsed into an additive
campaign that augments but does not necessarily alter the Eurocentric *status quo*. Barbie "gone
ethnic" by way of dye jobs and costume changes seems to me but a metaphor for the way
multiculturalism has been used as a kind of quick fix by both liberal humanism and late capi-
talism. Made from essentially the same mould as what Mattel considers its signature doll –

the traditional, blonde, blue-eyed Barbie – tawny-tinted ethnic reproductions are both signs and symptoms of an easy pluralism that simply melts down and adds on a reconstituted other without transforming the established social order, without changing the mould.

So if today Barbie dolls do come in a rainbow coalition of colours, races, ethnicities, and nationalities, all of these dolls look remarkably like the stereotypical white Barbie, modified only by a dash of colour and a change of clothes. That multiple races and ethnicities issue from the same mould should surprise no one. From Colored Francie of the 1960s to Soul Train Shani of the 1990s, Mattel has seized every opportunity to profit from shifts in racial, cultural, and social politics. It may also be worth noting that it isn't only matters of race and ethnicity from which Mattel has sought to profit by, shall we say, diversifying its assets. Nor is Colored Francie the only *faux pas* the sales campaigns have produced.

Ken, Barbie's perennial escort, has never been as popular as his precious gal pal, leading Mattel to speculate that it might be time for Barbie to get a new boyfriend. A survey done in the early 1990s showed that, while little girls wanted Barbie to stand by her man, they wanted that man to have a more contemporary look. So in 1993 Mattel introduced a hip version of the traditionally strait-laced Ken doll. Dubbed Earring Magic Ken, this 1990s-kind-of-guy sports an earring in his left earlobe and a plastic version of two-toned, bleached-blonde hair. Having left his three-piece suit behind in the closet as he came out, Earring Magic Ken is dressed in black hip-hugger jeans, a purple fishnet tank top, a simulated leather vest, and faux Italian loafers. Dangling from a cord around his neck is a large faux-metal band, which some consumers – much to Mattel's chagrin – quickly claimed as a "cock ring", a sign of Ken's hitherto closeted queer identity.

A fashion accessory with a practical application, cock rings, which among gay males seem to have a symbolic meaning similar to wedding bands, are worn around the base of the penis. According to one source, such a ring slipped on a flaccid penis traps blood in the organ during an erection, thus increasing sensitivity and prolonging orgasm.[4] In addition, cock rings are commonly worn dangling from a chain around the neck, as in the case of Earring Magic a.k.a. Gay Ken.

The alleged cock ring and what some read as the doll's other stereotypical queer accoutrements – including the purple mesh tank top and the bleached, boy-toy hair – made this latest manifestation of Ken very popular, particularly among gay men and Barbie consumers with a keen eye for a collector's item. Mattel cried foul. It was not amused – or so it said – by these queer appropriations of its latest plaything. Ken is as straight as ever, the company protested; it's naughty-minded adults who are warped. But in the face of rising sales and virtual stampedes for "Queer Ken", Mattel initially seemed only moderately irritated with gay-sayers.

"It was not our intention to do anything other than to create a toy for kids", media-relations director Donna Gibbs told a reporter for the *Chicago Sun Times* in August 1993. Of the doll's adoption by members of the gay community, Gibbs reportedly said: "How lovely. Who would have thought it?"[5] But by the time I spoke with Gibbs a year later, Earring Magic Ken had been "retired", and Mattel was holding a much harder defensive line. The claim that Earring Magic Ken is gay is "outrageous", she told me. "It was purely innocent on Mattel's part." Though I didn't ask about the cock ring, Gibbs's own train of thought ran in that direction. Earring Magic Ken was part of a series of six Earring Magic Barbie dolls, all of which were designed for children to play with, she went on to explain. Ken, like the Barbie dolls in the series, came with a large ring and two charms, which could be suspended from the ring. The claim that his doll is gay, Gibbs concluded, is just another example of "adults putting their perceptions on something intended for children."[6]

It has been difficult for some queer theorists, cultural critics, and Barbie watchers to believe that no one at Mattel ever had any idea that Earring Magic Ken might be taken for gay. No multinational corporation could be that innocent across the boardroom, these sceptics argue. Some have gone so far as to suggest that Mattel was simply trying again to capitalize on the spending power of what has been dubbed the "newest minority". But, as with Colored Francie, the company misread the signs and was not prepared for the commotion that would arise over the bauble some consumers identified as sexual paraphernalia.

For Mattel the actual point of contention and source of outrage may be the extent to which the corporation found itself caught in its own contradiction. On the one hand, so-named Barbie Millicent Roberts and her boyfriend Ken Carson (always presented as "she" and "he" rather than "it") – both of Willow, Wisconsin, both of whom went to State College – are marketed as if they were real people in the real world. On the other hand, when their unrealistic body types come under fire, Mattel maintains that Barbie (notorious bosom and all) and Ken are merely innocent toys for tots and teens. Having long denied that there is any sexual subtext to their dolls, Mattel suddenly found itself in the position of having to assert Earring Magic Ken's heterosexuality: the ring around Ken's neck might as well have been a noose. An earring is one thing, but a cock ring is another. Bestseller or not, Earring Magic Ken had to go.[7]

As for Mattel's claims of absolute innocence and righteous outrage, while I am among those inclined to be suspicious of Mattel's motives, I also remember that this is the same corporation that came up with Colored Francie in the heyday of the black-power movement and with a talking doll that said "Math class is tough", despite decades of scathing criticism from feminists. Mattel has profited from any number of blunders or accidents. The most important questions are not really about the corporation's intent: the road to Wall Street has rarely been paved with good intentions. As with Mattel's other efforts to commodify alterity, the most intriguing questions are about what makes possible the mass production of difference. How does difference look? What signifies race? What are the signs of sexual orientation? The rise and fall of Earring Magic Ken becomes a much more interesting story if Mattel is in fact innocent – if in trying for "hip", the company came up with "gay". We have, then, another instance of capitalism's necessarily reductive reading of the very signs of difference it tries to exploit.

To market, to market

As the queenpin of a billion-dollar industry, Barbie reigns supreme at the intersection of gender and capitalism. Moreover, the tremendous boost in sales that accompanied Mattel's marketing of ethnic Barbie dolls may suggest a critical link between consumerism and multiculturalism. Though it seems clear that black consumers buy black Barbie dolls, it is also clear that others buy them too. Doll collecting is big business, and Mattel's ethnic dolls – particularly those in its Dolls of the World series – are designed and marketed at least as much with adult collectors in mind as with little girls. Donna Gibbs told me that the national dolls are intended more for adults, "although appropriate for children". She explained that Mattel cultivates a competitive market for these "premium value" dolls by producing them in limited quantities, issuing them strategically (two or three different nations or cultures each year), and retiring a given national doll after only a year or two on the market.[8]

Doll catalogues, buyers' guides, and classified ads in *Barbie Bazaar* suggest precisely how premium this value currently is. According to the *Collector's Encyclopedia of Barbie Dolls*, Colored

Francie is now one of the most sought-after dolls ever produced by Mattel.[9] It may have been a flop when it appeared in 1967, but today, in mint condition, Colored Francie is worth between $700 and $900.[10] Finding this now premium-value vintage doll – especially finding it NRFB (never-removed-from-box) – is the dream of serious collectors. "With the quality of the ethnic dolls," writes Westenhauser, "Mattel has created a successful market of variety with Barbie that represents the racially diverse world in which we live." Saying perhaps more than she intends about difference as decoration, Westenhauser adds that "such a large variety of Barbie dolls turns any home into a museum".[11]

Questions about the ties between multiculturalism and capitalism are by all means larger than Barbie. But given the doll's status as an American icon, interrogating Barbie may facilitate an analysis of the commodity culture of which she is both part and product. What makes such an interrogation difficult, however, is the fact that Barbie simultaneously performs several disparate, often contradictory operations. On the one hand, ethnic Barbie dolls seem to colour in the whitewashed spaces of my childhood. They give little coloured girls toys to play with that look like them. On the other hand, this seeming act of racializing the dolls is accomplished by a contrapuntal action of erasure. In other words, Mattel is only able to racialize its dolls by blurring the sharp edges of the very difference that the corporation produces and profits from. It is able to make and market ethnicity by ignoring not only the body politics of the real people its dolls are meant to represent, but by ignoring the body politic as well – by eliding the material conditions of the masses it dolls up.

Here and elsewhere in commodity culture, this concurrent racing and erasing occurs precisely because big business both adores and abhors difference. It thrives on a heterogeneity that is cheaply reducible to its lowest common denominator – an assembly-line or off-the-rack difference that is actually sameness mass-reproduced in a variety of colours, flavours, fabrics, and other interchangeable options. For the most part, the corporate body is far less fond of more complex, less easily commodified distinctions – differences whose modes of production require constant retooling and fine-tuning. The exceptions here, of course, are the big-ticket speciality items – the handmade, one-of-a-kind originals and limited editions – which are intended not to be consumed rapidly by hordes who pay a little but to be acquired with deliberation by a few who pay a lot.

In today's toy world, race and ethnicity have fallen into the category of precious ready-to-wear difference. To be profitable, racial and cultural diversity – global heterogeneity – must be reducible to such common, reproducible denominators as colour and costume. Race and racial differences – whatever that might mean in the grander social order – must be reducible to skin colour or, more correctly, to the tint of the plastic poured into each Barbie mould. Each doll is marketed as representing something or someone in the real world, even as the political, social, and economic particulars of that world are not only erased but, in a curious way, made the same. Black Jamaican Barbie – outfitted as a peasant or a maid – stands alongside white English Barbie, who is dressed in the fancy riding habit of a lady of leisure. On the toystore shelf or in the collector's curio cabinet, maid and aristocrat enjoy an odd equality (they even sell for the same price), but this seeming sameness denies the historical relation they bear to each other as the colonized and the colonizer.

If we could line up the ninety or so different colours, cultures, and other incarnations in which Barbie currently exists, the physical facts of her unrelenting sameness (or at least similarity) would become immediately apparent. Even two dolls might do the trick: white Western Fun Barbie and black Western Fun Barbie, for example. Except for their dye jobs, the dolls are identical: the same body, size, shape, and apparel. Or perhaps I should say *nearly* identical

because in some instances – with black and Asian dolls in particular – colouring and other subtle changes (slanted eyes in the Asian dolls, thicker lips in the black dolls) suggest differently coded facial features.

In other instances, when Barbie moves across cultural as opposed to racial lines, it is costume rather than colour that distinguishes one ethnic group or nation from another. Nigeria and Jamaica, for instance, are represented by the same basic brown body and face mould, dolled up in different native garbs, or Mattel's interpretation thereof.[12] With other costume changes, this generic black body and face can be Marine Barbie or Army Barbie or even Presidential Candidate Barbie. Much the same is true of the generic Asian doll – sometimes called Kira – who reappears in a variety of different dress-defined ethnicities. In other words, where Barbie is concerned, clothes not only make the woman, they mark the racial and/or cultural difference.

Such difference is marked as well by the miniature cultural history and language lessons that accompany each doll in Mattel's international collection. The back of Jamaican Barbie's box tells us: "*How-you-du* (Hello) from the land of Jamaica, a tropical paradise known for its exotic fruit, sugar cane, breathtaking beaches, and reggae beat!" In an odd rendering of cause and effect, the box goes on to explain that "most Jamaicans have ancestors from Africa, so even though our official language is English, we speak patois, a kind of '*Jamaica Talk*', filled with English and African words.[13] For example, when I'm filled with *boonoonoonoos*, I'm filled with much happiness!" So written, Jamaica becomes an exotic tropical isle where happy, dark-skinned, English-speaking peasants don't really speak English.

Presented as if out of the mouths of native informants, the cultural captions on the boxes help to sell the impression that what we see isn't all we get with these dolls. The use of first-person narration lends a stamp of approval and a voice of authority to the object, confirming that the consumer has purchased not only a toy or a collector's item to display but access to another culture, inside knowledge of an exotic, foreign other. The invariably cheerful greetings and the warm, chatty tone affirm that all's well with the small world. As a marketing strategy, these captions contribute to the museum of culture effect, but as points of information, such reductive ethnographies only enhance the extent to which these would-be multicultural dolls make race and ethnicity collectors' items, contributing more to the stock exchange than to cultural exchange.

Shani and the politics of plastic

Not entirely immune to criticism of its identity politics, Mattel sought advice from black parents and specialists in early childhood development in the making and marketing of a new assortment of black Barbie dolls – the Shani line. Chief among the expert witnesses was the clinical psychologist Darlene Powell Hopson, who co-authored with her husband Derek Hopson a study of racism and child development, *Different and Wonderful: Raising Black Children in a Race-Conscious Society* (1990).

[. . .]

In 1990 Darlene Hopson was asked to consult with Mattel's product manager Deborah Mitchell and designer Kitty Black Perkins – both African Americans – in the development of a new line of "realistically sculpted" black fashion dolls. Hopson agreed, and about a year later Shani and her friends Asha and Nichelle became the newest members of Barbie's entourage.

According to the doll's package:

> Shani means marvelous in the Swahili language . . . and marvelous she is! With her friends Asha and Nichelle, Shani brings to life the special style and beauty of the African American woman. Each one is beautiful in her own way, with her own lively skin shade and unique facial features. Each has a different hair color and texture, perfect for braiding, twisting and creating fabulous hair styles! Their clothes, too, reflect the vivid colors and ethnic accents that showcase their exotic looks and fashion flair![14]

These words attempt to convey a message of black pride [. . .] but that message is clearly tied to bountiful hair, lavish and exotic clothes, and other external signs of beauty, wealth, and success.

Mattel gave Shani a coming-out party at the International Toy Fair in February 1991. Also making their debuts were Shani's friends Asha and Nichelle, notable for the different hues in which their black plastic skin comes – an innovation due in part to Darlene Hopson. Shani, the signature doll of the line, is what some would call brown-skinned; Asha is honey-coloured; and Nichelle is deep mahogany. Their male friend Jamal, added in 1992, completes the collection.

The three-to-one ratio of the Shani quartet – three black females to one black male – may be the most realistic thing about these dolls. In the eyes of Mattel, however, Shani and her friends are the most authentic black dolls yet produced in the mainstream toy market. Billed as "Tomorrow's African American woman", Shani has broader hips, fuller lips, and a broader nose, according to Deborah Mitchell. Kitty Black Perkins, who has dressed black Barbies since their birth in 1980, adds that the Shani dolls are also distinguished by their unique, culturally specific clothes in "spice tones, [and] ethnic fabrics", rather than "fantasy colors like pink or lavender"[15] – evidently the colours of the faint of skin.

The notion that fuller lips, broader noses, wider hips, and higher derrieres make the Shani dolls more realistically African American again raises many difficult questions about difference, authenticity, and the problematic categories of the real and the symbolic, the typical and the stereotypical. Again we have to ask what authentic blackness looks like. Even if we knew, how could this ethnic or racial authenticity ever be achieved in a doll? Also, where capital is concerned, the profit motive must always intersect with all other incentives.

The Shani doll is an apt illustration of this point. On the one hand, Mattel was concerned enough about producing a more "ethnically correct" black doll to seek the advice of black image specialists in the development and marketing of the Shani line. On the other hand, the company was not willing to follow the advice of such experts where doing so would entail a retooling that would cost the corporation more than the price of additional dyes and fabrics.

For example, Darlene Hopson argued not just for gradations in skin tones in the Shani dolls but also for variations in body type and hair styles. But, while Mattel acknowledged both the legitimacy and the ubiquity of such arguments, the ever-present profit incentive militated against breaking the mould, even for the sake of the illusion of realism. "To be truly realistic, one [Shani doll] should have shorter hair", Deborah Mitchell has admitted. "But little girls of all races love hair play. We added more texture. But we can't change the fact that long, combable hair is still a key seller."

In fact, there have been a number of times when Mattel has changed the length and style of its dolls' hair. Christie, the black doll that replaced Colored Francie in 1968, had a short Afro, which was more in keeping with what was perhaps the signature black hairstyle of the sixties. Other shorter styles have appeared as the fashions of the moment dictated. In the early sixties, Barbie sported a bubble cut like Jacqueline Kennedy's.[16] Today, though, Mattel seems less willing to crop Barbie's hair in accord with fashion. Donna Gibbs told me that the

long hair of Mattel's dolls is the result of research into play patterns. "Combing, cutting, and styling hair is basic to the play patterns of girls of all ethnicities," she said. All of the products are test-marketed first with both children and adults, and the designs are based on such research.[17]

Hair play is no doubt a favorite pastime with little girls. But Mattel, I would argue, doesn't simply respond to the desire among girls for dolls with long hair to comb; it helps to produce those desires. Most Barbie dolls come with a little comb or brush, and ads frequently show girls brushing, combing, and braiding their dolls' long hair. In recent years Mattel has taken its invitation to hair play to new extremes with its mass production of Totally Hair Barbie, Hollywood Hair Barbie, and Cut and Style Barbie – dolls whose Rapunzel-like hair lets down in seemingly endless locks. (Cut and Style Barbie comes with "functional sharp edge" scissors and an extra wad of attachable hair. Hair refill packs are sold separately.) But what does the transference of flowing fairy-princess hair on to black dolls mean for the black children for whom these dolls are supposed to inspire self-esteem?

In the process of my own archival research – poking around in the dusty aisles of Toys R Us – I encountered a black teenage girl in search of the latest black Barbie. During the impromptu interview that ensued, my subject confessed to me in graphic detail the many Barbie murders and mutilations she had committed over the years. "It's the hair", she said emphatically several times. "The hair, that hair; I want it. I want it!" Her words recalled my own torturous childhood struggles with the straightening combs, curling irons, and chemical relaxers that biweekly transformed my woolly "just like a sponge" kinks into what the white kids at school marvelled at as my "Cleopatra [straight] hair".

Many African American women and quite a few African American men have similar tales about dealing with their hair or with the hair of daughters or sisters or mothers. In "Life with Daughters", the black essayist Gerald Early recounts the difficulties that arose when Linnet, the elder of his two daughters, decided that she wanted hair that would "blow in the wind", while at the same time neither she nor her mother wanted her to have her hair straightened. "I do not think Linnet wanted to change her hair to be beautiful", Early writes; "she wanted to be like everyone else. But perhaps this is simply wishful thinking here or playing with words, because Linnet must have felt her difference as being a kind of ugliness".[18]

Indeed, "coloured hair", like dark skin, has been both culturally and commercially constructed as ugly, nappy, wild, and woolly, in constant need of taming, straightening, cropping, and cultivating.[19] In the face of such historically charged constructions, it is difficult for black children not to read their hair as different and that difference as ugly. Stories and pictures abound of little black girls putting towels on their heads and pretending that the towels are long hair that can blow in the wind or be tossed over the shoulder. But ambivalence about or antipathy towards the hair on our heads is hardly limited to the young. Adult African Americans spend millions each year on a variety of products that promise to straighten, relax, or otherwise make more manageable kinky black hair.[20] And who can forget the painful scene – made hilarious by Spike Lee and Denzel Washington in *Malcolm X* – in which his friend Shorty gives the young Malcolm Little his first conk?

Mattel may have a point. It may be that part of Shani's and black Barbie's attraction for little black girls – as for all children and perhaps even for adults – is the dolls' fairy-princess good looks, the crowning touch of glory of which is long, straight hair, combable locks that cascade down the dolls' backs. Even though it is not as easy to comb as Mattel maintains, for black girls the simulated hair on the heads of Shani and black Barbie may suggest more than simple hair play; it may represent a fanciful alternative to what society presents as their own less attractive, short, kinky, hurts-to-comb hair.

As difficult as this prospect is to consider, its ancillary implications are even more jarring. If Colored Francie failed in 1967 partly because of her "Caucasian features" and her long, straight hair, is Shani such a success in the 1990s because of those same features? Is the popularity of these thin-bodied, straight-haired dolls a sign that black is most beautiful when readable in traditional white terms? Have blacks, too, bought the dominant ideals of beauty inscribed in Barbie's svelte figure and flowing locks?

It would be difficult to answer these questions, I suppose, without making the kinds of reductive value judgements about the politics of black hair that Kobena Mercer has warned us against: the assumption that "hair styles which avoid artifice and look 'natural', such as the Afro or Dreadlocks, are the more authentically black hair-styles and thus more ideologically 'right-on'".[21] Suffice it to say that Barbie's svelte figure – like her long hair – became Shani's body type as well, even as Mattel claims to have done the impossible, even as they profess to have captured in this new doll the "unique facial features" and the "special style and beauty of the African American people". This claim seems to be based on subtle changes in the doll that apparently are meant to signify Shani's black difference. Chief among these changes – especially in Soul Train Shani, a scantily clad hiphop edition of the series released in 1993 – is the *illusion* of broader hips and elevated buttocks.

This illusion is achieved by a technological sleight of design that no doubt costs the company far less than all the talk about Shani's broader hips and higher derriere would suggest. No matter what Mattel spokespersons say, Shani – who has to be able to wear Barbie's clothes – is not larger or broader across the hips and behind than other Barbie dolls. In fact, according to the anthropologists Jacqueline Urla and Alan Swedlund, who have studied the anthropometry (body measurements) of Barbie, Shani's seemingly wider hips are if anything a fraction smaller in both circumference and breadth than those of other Barbie dolls. The effect of higher buttocks is achieved by a change in the angle of the doll's back.[22]

On closer examination, one finds that not only is Shani's back arched, but her legs are also bent in and backward. When laid face down, other Barbie Dolls lie flat, but the legs of Soul Train Shani rise slightly upward. This barely noticeable backward thrust of the legs also enhances the impression of protruding buttocks, the technical term for which is "steatopygia", defined as an excessive accumulation of fat on the buttocks. (The same technique was used in nineteenth-century art and photography in an attempt to make subjects look more primitive.) Shani's buttocks may appear to protrude, but actually the doll has no posterior deposits of plastic fat and is not dimensionally larger or broader than all the other eleven-and-a-half-inch fashion dolls sold by Mattel. One might say that reports of Shani's butt enhancement have been greatly exaggerated. Her signifying black difference is really just more (or less) of the same.

There is a far more important point to be made, however. Illusion or not, Shani's buttocks can pass for uniquely black only if we accept the stereotypical notion of what black looks like. Social scientists, historians, literary scholars, and cultural theorists have long argued that race is socially constructed rather than biologically determined. Yet, however coded, notions of race remain finely connected to the biological, the phenotypical, and the physiological in discussions about the racially marked body, not to mention the racially marketed body.

No matter how much scholars attempt to intellectualize it otherwise, "race" generally means "non-white", and "black" is still related to skin colour, hair texture, facial features, body type, and other outward signifiers of difference. A less neutral term for such signifiers is, of course, stereotypes. In playing the game of difference with its ethnic dolls, Mattel either defies or deploys these stereotypes, depending on cost and convenience. "Black hair" might be easy enough to simulate (as in Kenyan Barbie's astro-turf Afro), but – if we buy what

Mattel says about its market research – anything other than long straight hair could cost the company some of its young consumers. Mechanical manipulation of Shani's plastic body, on the other hand, represents a facile deployment of stereotype in the service of capital. A *trompe-l'œil* derriere and a dye job transform the already stereotypical white archetype into the black stereotype – into what one might call the Hottentot Venus of toyland.

Indeed, in identifying buttocks as the signifier of black female difference, Mattel may unwittingly be taking us back to the eugenics and scientific racism of earlier centuries. One of the most notorious manifestations of this racism was the use and abuse of so-called Hottentot women such as Sarah Bartmann, whom science and medicine identified as the essence of black female sexuality. Presented to European audiences as the "Hottentot Venus", Saartjie or Sarah Bartmann was a young African woman whose large buttocks (common among the people of southern Africa whom Dutch explorers called Hottentots or Bushmen) made her an object of sexual curiosity for white Westerners travelling in Africa. According to Sander Gilman, for Victorians the protruding buttocks of these African women pointed to "the other, hidden sexual signs, both physical and temperamental, of the black female". "Female sexuality is linked to the image of the buttocks," Gilman writes, "and the quintessential buttocks are those of the Hottentot".[23]

Transformed from individual to icon, Bartmann was taken from Cape Town in the early 1800s and widely exhibited before paying audiences in Paris and London between 1810 and her death in 1815 at age 25. According to some accounts, she was made to appear on stage in a manner that confirmed her as the primitive beast she and her people were believed to be. Bartmann's body, which had been such a curiosity during her life, was dissected after her death, her genitals removed, preserved under a bell jar, and placed on display at the Musée de l'Homme in Paris.[24] But as Anne Fausto-Sterling has argued so persuasively, even attempting to tell the known details of the exploitation of this woman, whose given African name is not known, only extends her victimization in the service of intellectual inquiry. The case of Sarah Bartmann, Fausto-Sterling points out, can tell us nothing about the woman herself; it can only give us insight into the minds and methodologies of the scientists who made her their subject.[25]

Given this history, it is ironic that Shani's would-be protruding buttocks (even as a false bottom) should be identified as the site and signifier of black female alterity – of "butt also" difference, if I may be pardoned the pun. Georges Cuvier, one of several nineteenth-century scientists to dissect and to write about Bartmann, maintained that the black female "looks different"; her physiognomy, her skin colour, and her genitalia mark her as "inherently different".[26] Long since recognized as morbidly racist, the language of Cuvier's "diagnosis" nevertheless resembles the terms in which racial difference is still written today. The problems that underpin Mattel's deep play with Shani's buttocks, then, are the very problems that reside within the grammar of difference in contemporary critical and cultural theory.

From bell jar to bell curve

With Shani and its other black Barbie dolls, Mattel has made blackness simultaneously visible and invisible, at once different and the same. What Mattel has done with Barbie is not at all unlike what society has done with the facts and fictions of difference over the course of several centuries. In theoretical terms, what's at stake in studying Barbie is much more than just fun and games. In fact, in its play with racial and ethnic alterity, Mattel may well have given us a prism through which to see in living colour the degree to which difference is an impossible space – antimatter located not only beyond the grasp of low culture but also beyond the reach of high theory.

Just as Barbie reigns ubiquitously white, blonde, and blue-eyed over a rainbow coalition of coloured optical illusions, human social relations remain in hierarchical bondage, one to the other, the dominant to the different. Difference is always relational and value-laden. We are not just *different*; we are always *different from*. All theories of difference – from Saussure and Derrida to Fanon and Foucault – are bound by this problematic of relativity. More significantly, all notions of human diversity necessarily constitute difference as oppositional. From the prurient nineteenth-century racism that placed Sarah Bartmann's genitals under a bell jar, to the contemporary IQ-based social Darwinism that places blacks at the bottom of a bell curve, difference is always stacked up against a (superior) centre. This is the irony of deconstruction and its failure: things fall apart, but the centre holds remarkably firm. It holds precisely because the very act of theorizing difference affirms that there is a centre, a standard, or – as in the case of Barbie – a mould.

Yet, however deep its fissures, deconstruction – rather than destruction – may be the closest we can come to a solution to the problem for which Barbie is but one name. Barbie, like racism (if not race), is indestructible. Not even Anna Quindlen's silver-lamé stake through the doll's plastic heart would rid us of this immovable object, which is destined to outlive even its most tenacious critics. (This is literally true, since Barbie dolls are not biodegradable. Remembering the revenge the faithful took on Nietzsche – " 'Nietzsche is dead,' signed God" – I can see my obituary in *Barbie Bazaar*: " 'duCille is dead,' signed Barbie".) But if, as Wordsworth wrote, we murder to dissect, deconstructing Barbie may be our only release from the doll's impenetrable plastic jaws, just as deconstructing race and gender may be the only way out of the deep or muddy waters of difference.

The particulars of black Barbie illustrate the difficulties and dangers of treating race and gender differences as biological stigmata that can be fixed in plastic and mass-reproduced. But if difference is indeed an impossible space – a kind of black hole, if you will – it is antimatter that continues to matter tremendously, especially for those whose bodies bear its visible markings and carry its material consequences.

The answer, then, to the problematic of difference cannot be, as some have argued, that gender does not exist or that race is an empty category. Such arguments throw the body out with the murky bath water. But, as black Barbie and Shani also demonstrate, the body will not be so easily disposed of. If we pull the plug on gender, if we drain race of any meaning, we are still left with the material facts and fictions of the body – with the different ifs, ands, and butts of different bodies. It is easy enough to theorize difference in the abstract, to posit "the body" in one discourse or another. But in the face of real bodies, ease quickly expands into complexity. To put the question in disquietingly personal terms: from the ivory towers of the academy I can criticize the racist fictions inscribed in Shani's false bottom from now until retirement, but shopping for jeans in Filene's Basement, how am I to escape the physical fact of my own steatopygic hips? Do the facts of my own body leave me hoisted not on my own petard, perhaps, but on my own haunches?

We need to theorize race and gender not as meaning*less* but as meaning*ful* – as sites of difference, filled with constructed meanings that are in need of constant decoding and interrogation. Such analysis may not finally free us of the ubiquitous body-biology bind or release us from the quagmire of racism and sexism but it may be at once the most and the least we can do to reclaim difference from the moulds of mass production and the casts of dominant culture.

Yet, if the process of deconstruction also constructs, tearing Barbie down runs the risk of building Barbie up – of reifying difference in much the same way that commodity culture does. Rather than representing a critical kiss of death, readings that treat Barbie as a real

threat to womankind – a harbinger of eating and shopping disorders – actually breathe life into the doll's plastic form. This is not to say that Barbie can simply be reduced to a piece of plastic. It is to say that hazard lies less in buying Barbie than in buying into Barbie, internalizing the larger mythologies of gender and race that make possible both the "like me" of Barbie and its critique. So, if this is a cautionary tale, the final watchword for consumers and critics alike must be not only *caveat emptor* but also *caveat lector*: let the buyer and the reader beware.

Notes

1 Catherine Belsey, *Critical Practice* (New York: Routledge, 1987), 47.
2 According to various doll-collector magazines, handmade, one-of-a-kind, and limited-edition dolls made by doll artists range in price from several hundred dollars to as much as $20,000.
3 Part of Article I, Section 2, of the US Constitution established that only three-fifths of a state's slave population would be counted in determining a state's congressional representation and federal tax share. Passed by California voters in Nov. 1994, Proposition 187 sought to deny undocumented immigrants access to public education and health care.
4 Dan Savage, "Ken Comes Out", *Chicago Reader*, Summer 1993, 8.
5 Richard Roeper, *Chicago Sun Times*, 3 Aug. 1993, 11.
6 Telephone conversation with Donna Gibbs, 9 Sept. 1994.
7 Mattel denies that Earring Magic Ken was pulled from the market. He was simply part of a 1993 Barbie line that was discontinued, a spokesperson told me. Some toystore managers and clerks tell a different story, however.
8 Phone conversation with Gibbs, 9 Sept. 1994.
9 Sibyl DeWein and Joan Ashabraner, *The Collector's Encyclopedia of Barbie Dolls and Collectibles* (Paducah, Ky.: Collector Books, 1994), 35.
10 This is the price range listed in the 11th edition of Jan Foulke's *Blue Book: Dolls and Values* (Grantsville, Md.: Hobby House Press, 1993), 83. Many of what are called vintage dolls – early or otherwise special-edition Barbie dolls – have the "premium value" described by Donna Gibbs. For example, according to the *Blue Book* a first-edition 1959 Barbie never removed from its box would be worth between $3,200 and $3,700. A Barbie infomercial airing in 1994–5 placed the value as high as $4,500. The same doll sold in 1959 for $2.99.
11 Kitturah B. Westenhauser, *The Story of Barbie* (Paducah, Ky.: Collector Books, 1994), 138, 119. Serious Barbie collectors often purchase duplicates of a given doll: one to keep in mint condition in its box and one to display. Or, as we used to say of the two handkerchiefs we carried to Sunday school: one for show and one for blow. For an intriguing psychosocial analysis of the art of collecting, see Jean Baudrillard, "The System of Collecting", in John Elsner and Roger Cardinal (eds.), *The Cultures of Collecting* (Cambridge, Mass.: Harvard University Press, 1994), 7–24.
12 After many calls to the Jamaican embassy in Washington and to various cultural organizations in Jamaica, I have concluded that Jamaican Barbie's costume – a floor-length granny dress with apron and headrag – bears some resemblance to what is considered the island's traditional folk costume. But it was also made clear to me that these costumes have more to do with tourism than with local traditions. According to Gibbs at Mattel, decisions about costuming are made by the design and marketing teams in consultation with other senior staffers. The attempt, Gibbs informed me, "is to determine and roughly approximate" the national costume of each country in the collection (conversation, 9 Sept. 1994). I still wonder, though, about the politics of these design decisions: why the doll representing Jamaica is figured as a maid, while the doll representing Great Britain is presented as a lady – a blonde, blue-eyed Barbie doll dressed in a fancy riding habit with boots and hat.
13 Actually, Jamaican *patois* is spelled differently: *potwah*, I believe.
14 Asha is a variant of the Swahili and Arabic name Aisha or Ayisha, meaning "life" or "alive". It is also the name of Muhammed's chief wife. As a minor point of interest, "Nichelle" is the first name of the black actress (Nichelle Nichols) who played Lieutenant Uhura on the original *Star Trek* TV series (1966–9).
15 Quoted in Lisa Jones, "A Doll Is Born", *Village Voice*, 26 Mar. 1991, 36.
16 Kenyan Barbie, introduced in 1994, has the most closely cropped hair of any Barbie doll to date. I asked Donna Gibbs if Mattel was concerned that the doll's severely cropped hair (little more than

peach fuzz, or what a colleague described as "Afro turf") would hamper sales. She told me that the company expected Kenyan Barbie to sell as well as all the other national dolls, which are intended more for adult collectors. Kenyan Barbie received a "short-cropped Afro in an attempt to make her look more authentic", Gibbs informed me. "She represents a more authentic-looking doll". (The doll also has bare feet and wears Mattel's interpretation of the native dress of the Masai woman; the first-person narrative on the back of the box tells us that most Kenyan people wear modern dress and that spears are banned in the city.)

17 Gibbs, conversation, 9 Sept. 1994.

18 See Gerald Early, "Life with Daughters: Watching the Miss America Pageant", in his *The Culture of Bruising: Essays on Prizefighting, Literature, and Modern American Culture* (Hopewell: Ecco Press, 1994), 268.

19 Among many texts on the politics of black people's hair, see Cheryl Clarke's poem "Hair: A Narrative", in her *Narratives: Poems in the Tradition of Black Women* (New York: Kitchen Table/Women of Color Press, 1982); Kobena Mercer, "Black Hair/Style Politics", in R. Ferguson, M. Gever, T. T. Minh-ha, and C. West (eds.), *Out There: Marginalization and Contemporary Cultures* (New York and Cambridge, Mass.: New Museum of Contemporary Art and MIT Press, 1992), 247–64; and Ayoka Chinzera, director, *Hairpiece: A Film for Nappy-Headed People*, 1982. In fiction see Toni Morrison's *The Bluest Eye*.

20 I intend no value judgement in making this observation about what we do with our hair. Though Afros, braids, and dreadlocks may be seen by some as more "authentically black" or more Afrocentrically political than straightened or chemically processed hair, I am inclined to agree with Kobena Mercer that all black hairstyles are political as a historical ethnic signifier ("Black Hair/Style Politics", 251). It is history that has made black hair *mean*.

21 Mercer, "Black Hair/Style Politics", 247–8.

22 Jacqueline Urla and Alan Swedlund, "The Anthropometry of Barbie: Unsettling Ideas of the Feminine in Popular Culture", in Jennifer Terry and Jacqueline Urla (eds.), *Deviant Bodies: Critical Perspectives on Differences in Science and Popular Culture* (Bloomington, Ind.: Indiana University Press, 1995).

23 Sander L. Gilman, "Black Bodies, White Bodies: Toward an Iconography of Female Sexuality in Late Nineteenth-Century Art, Medicine, and Literature", in Henry Louis Gates Jr. (ed.), *"Race", Writing and Difference* (Chicago: University of Chicago Press, 1985), 238. [Chapter 19 in this volume.]

24 See Stephen Jay Gould, "The Hottentot Venus", *Natural History*, 91 (1982), 20–7. For a poetic interpretation of Sarah Bartmann's story, see the title poem in Elizabeth Alexander's *The Venus Hottentot* (Charlottesville, Va.: University of Virginia Press, 1990), 3–7.

25 Anne Fausto-Sterling, "Gender, Race, and Nation: The Comparative Anatomy of 'Hottentot' Women in Europe: 1815–1817", in Terry and Urla (eds.), *Deviant Bodies*, 19–48.

26 Gilman, "Black Bodies, White Bodies", 232.

THE GUERRILLA GIRLS

INTRODUCTION AND CONCLUSION TO *THE GUERRILLA GIRLS' BEDSIDE COMPANION TO THE HISTORY OF WESTERN ART*

> THERE IS A GOOD PRINCIPLE, WHICH CREATED ORDER, LIGHT, AND MAN, AND AN EVIL PRINCIPLE, WHICH CREATED CHAOS, DARKNESS, AND WOMEN.
> —PYTHAGORAS, 6TH CENTURY B.C.

> GIRLS BEGIN TO TALK AND TO STAND ON THEIR FEET SOONER THAN BOYS BECAUSE WEEDS GROW MORE QUICKLY THAN GOOD CROPS.
> —MARTIN LUTHER, 1533

> INSTEAD OF CALLING THEM BEAUTIFUL, THERE WOULD BE MORE WARRANT FOR DESCRIBING WOMEN AS THE UNESTHETIC SEX. NEITHER FOR MUSIC, NOR FOR POETRY, NOR FOR FINE ART, HAVE THEY REALLY AND TRULY ANY SENSE OR SUSCEPTIBILITY.
> —ARTHUR SCHOPENHAUER, 1851

Forget the stale, male, pale, Yale textbooks, this is Art Herstory 101!

If you were to believe what many of us were taught in school and museums, you would think a clear line of achievement links one genius innovator to the next. For example, Michelangelo paves the way for Caravaggio. Or, a few hundred years later, Monet begets Cézanne, who influences Picasso, who brings us to Pollock. This is the canon that–until recently–most of us took for granted as the history of Western art. It reduced centuries of artistic output to a bunch of white male masterpieces and movements, a world of "seminal" and "potent" art where the few women you hear about are white, and even they are rarely mentioned and never accorded a status anywhere near the big boys. Now, the Guerrilla Girls admire the old "masters"–and lots of young ones, too. But we also believe–along with most contemporary scholars–that the time has come, once and for all, for the canon to be fired.

The famous query by feminist artists and art historians goes, "Why haven't there been more great women artists throughout Western history?" The Guerrilla Girls want to restate the question: "Why haven't more women been *considered* great artists throughout Western history?" And we have a lot more questions (see below), because even though making it as an artist isn't easy for *anyone*, the history of art has been a history of discrimination.

Look at the attitudes toward women emanating from some of the most celebrated male minds of Western culture (quotations, above). Notice how little these attitudes

Why do we always have to be called "women artists"? They don't call Rembrandt and Van Gogh "male artists."

GEORGIA O'KEEFFE

Why does being African-American and female make it twice as hard for my work to be remembered?

EDMONIA LEWIS

Who are the Guerrilla Girls?

We are a group of women artists and arts professionals who fight discrimination. We're the consicence of the art world, counterparts to the mostly male tradition of anonymous do-gooders like Robin Hood, Batman, and the Lone Ranger. We have produced over 80 posters, printed projects, and actions that expose sexism and racism in the art world and the culture at large. We wear gorilla masks to keep the focus on the issues rather than our personalities. We use humor to prove that feminists can be funny. Our work has been passed around the world by kindred spirits who consider themselves Guerrilla Girls too. We could be anyone; we are everywhere.

7

GARDNER'S

**WHITE
MALE
ART**
THROUGH
THE AGES

FIFTH EDITION

H. W. JANSON

**HISTORY
OF
MOSTLY
MALE
ART**

changed from the 6th century B.C. to the 19th century A.D. (Remember, women didn't even get the vote in the U.S. until 1919, in France until 1945.) With misogyny and racism the ideologies of the day, backed up with repressive laws, it is amazing that any women became artists at all, especially when you realize that until this century, women were rarely allowed to attend art schools, join artists' guilds or academies, or own an atelier. Many were kept from learning to read or write. For most of history, women have, by law, been considered the property of their fathers, husbands, or brothers, who almost always believed women were put on earth to serve them and bear children.

The truth is that, despite prejudice, there have been lots of women artists throughout Western history. From ancient Greece and Rome there are accounts of women painters who earned more than their male counterparts. In the Middle Ages, nuns made tapestries and illuminated manuscripts. In the Renaissance, daughters were trained to help in their fathers' ateliers; some went on to have careers of their own. In the 17th and 18th centuries, women excelled at portraiture and broke new ground in the scientific observation of plants and animals. In the 19th century, women cross-dressed for success or lived in exile, far enough from home to behave as they pleased. In the 20th century, the ranks of white women artists and women artists of color swelled. These artists were part of every 20th-century "ism" and started a few of their own, too.

But even after overcoming incredible obstacles, women artists were usually ignored by critics and art historians–who claimed that art by white women and people of color didn't meet their "impartial" criteria for "quality." These impartial standards place a high value on art that expresses white male experience and a low

A WOMAN BY ANY OTHER NAME...

For years the Guerrilla Girls have been using the label "women and artists of color" to describe the "others" we represent. But we've always felt the phrase was inadequate because it's unclear where women of color fit in: they are BOTH women AND artists of color. Furthermore, the history of Western art is primarily a history of white Europeans in which people of color have been excluded and marginalized. So, while we declare that when we use the word "women" we mean ALL women, we wish there was a better term to express the diverse experiences of Asians, blacks, Latinas, Native Americans, etc.

8

Why is The Museum of Modern Art more interested in African art than in art by African-Americans?

Why did so few male art historians mention me in their survey books?

ALMA THOMAS

ARTEMISIA GENTILESCHI

value on everything else. Twentieth-century art historians have worse records vis-à-vis women than their earlier counterparts: Pliny the Elder in the 1st century A.D., Boccaccio in the 14th, and Vasari in the 16th acknowledged more women artists than Meyer Schapiro, T.J. Clark and H.W. Janson in the 20th.

Luckily, in recent decades feminist art historians, most of whom are–surprise!–women, have resurrected and revalued hundreds of women artists from the past. Whenever an art history survey, like Janson's *History of Art* or Gardner's *Art Through the Ages* adds a female author, the number of women artists included–white and of color–miraculously increases. The Guerrilla Girls have gratefully benefited from the ideas and research of these scholars, several of whom have secretly helped us write this book.

THE ADVANTAGES OF BEING A WOMAN ARTIST:

Working without the pressure of success.
Not having to be in shows with men.
Having an escape from the art world in your 4 free-lance jobs.
Knowing your career might pick up after you're eighty.
Being reassured that whatever kind of art you make it will be labeled feminine.
Not being stuck in a tenured teaching position.
Seeing your ideas live on in the work of others.
Having the opportunity to choose between career and motherhood.
Not having to choke on those big cigars or paint in Italian suits.
Having more time to work when your mate dumps you for someone younger.
Being included in revised versions of art history.
Not having to undergo the embarrassment of being called a genius.
Getting your picture in the art magazines wearing a gorilla suit.

A PUBLIC SERVICE MESSAGE FROM **GUERRILLA GIRLS** CONSCIENCE OF THE ART WORLD
532 LaGUARDIA PLACE, #237 • NY, NY 10012
fEmail: guerrillagirls@voyagerco.com

POSTER BY THE GUERRILLA GIRLS, 1988

The Guerrilla Girls' Bedside Companion to the History of Western Art isn't a comprehensive survey of women artists in history. It doesn't include all the cultures of the world. It's not a list of the most significant women artists. It wasn't written for experts who already know all this stuff. Writing about women artists in Western history is complicated. There are lots of contradictory positions and theories. We have opted to stay out of the theory wars, and present our irreverent take on what life was like for some females in the West who managed, against all odds, to make art. It's ammunition for all the women who are–or will become–artists.

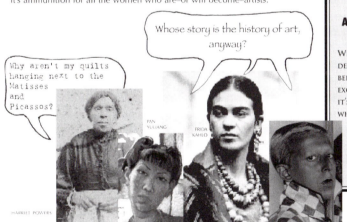

Whose story is the history of art, anyway?

Why aren't my quilts hanging next to the Matisses and Picassos?

PAN YULIANG

FRIDA KAHLO

HARRIET POWERS

CLAUDE CAHUN

OFFICIAL DISCLAIMER: A GRAVE APPROACH TO ART HISTORY

WE'VE RESTRICTED THE BOOK TO DEAD ARTISTS BECAUSE WE DON'T BELIEVE IN EVALUATING OR EXCLUDING OUR PEERS. EVEN SO, IT'S BEEN HARD TO DECIDE WHOM TO WRITE ABOUT. THERE ARE MANY WOMEN ARTISTS WHO DESERVE TO BE IN THIS BOOK AND WOULD BE IF WE HAD MORE ROOM.

9

Conclusion

GUERRILLA GIRLS
POSTER, 1989

WHEN RACISM & SEXISM ARE NO LONGER FASHIONABLE, WHAT WILL YOUR ART COLLECTION BE WORTH?

The art market won't bestow mega-buck prices on the work of a few white males forever. For the 17.7 million you just spent on a single Jasper Johns painting, you could have bought at least one work by all these women and artists of color:

Berenice Abbott
Anni Albers
Sofonisba Anguissola
Diane Arbus
Vanessa Bell
Isabel Bishop
Rosa Bonheur
Elizabeth Bougereau
Margaret Bourke-White
Romaine Brooks
Julia Margaret Cameron
Emily Carr
Rosalba Carriera
Mary Cassatt
Constance Marie Charpentier
Imogen Cunningham
Sonia Delaunay

Elaine de Kooning
Lavinia Fontana
Meta Warrick Fuller
Artemisia Gentileschi
Marguerite Gérard
Natalia Goncharova
Kate Greenaway
Barbara Hepworth
Eva Hesse
Hannah Hoch
Anne Huntington
May Howard Jackson
Frida Kahlo
Angelica Kauffmann
Hilma af Klint
Kathe Kollwitz
Lee Krasner

Dorothea Lange
Marie Laurencin
Edmonia Lewis
Judith Leyster
Barbara Longhi
Dora Maar
Lee Miller
Lisette Model
Paula Modersohn-Becker
Tina Modotti
Berthe Morisot
Grandma Moses
Gabriele Münter
Alice Neel
Louise Nevelson
Georgia O'Keeffe
Meret Oppenheim

Sarah peale
Liubov Popova
Olga Rozanova
Nellie Mae Rowe
Rachel Ruysch
Kay Sage
Augusta Savage
Varvara Stepanova
Florine Stettheimer
Sophie Taeuber-Arp
Alma Thomas
Mara Robach
Suzanne Valadon
Remedios Varo
Elizabeth Vigée Le Brun
Laura Wheeling Waring

A PUBLIC SERVICE MESSAGE FROM **GUERRILLA GIRLS** CONSCIENCE OF THE ART WORLD

TODAY WOMEN ARE EQUAL, RIGHT?

In our introduction, many pages back, you probably remember that we decided not to write about living women artists in this *Bedside Companion,* because we didn't want to put ourselves in the position of having to evaluate (or exclude) our peers. We think of ourselves as representing all women artists, not just a few. But this doesn't mean we can't discuss the collective accomplishments of our contemporaries, which have been enormous. How's it going for women artists today? Well...

It's been good...

• More women's art has been exhibited, reviewed, and collected than ever before. Dealers, critics, curators, and collectors are fighting their own prejudices and practicing affirmative action for women and artists of color. (The GG's take some of the credit for this.)

• Everyone except a few misogynist diehards believe there are–and have been–great women artists. Finally, women can benefit from role models and mentors of their own gender.

• Feminists have transformed the fields of art, history, and philosophy, making room for the point of view of the "other" (that's us, girls). They have made people aware that what most of us learned as objective reality was actually white male reality.

• Recently, there have been shows of openly gay and lesbian artists, and shows that attempt to explore homosexual sensibility.

• The age of the isms is over. Few art historians still cling to the idea that there is a mainstream, that art develops in a linear direction from artist A to artist B. In the current postmodern era, more kinds of art practice and more kinds of artists are accepted and written into the historical record. This is creating a truer, richer picture of the present and the past.

It's been bad...

• Women artists still get collected less and shown less. The price of their work is almost never as high as that of white males. Women art teachers rarely get tenure and their salaries are often lower than those of their male counterparts.

• Museums still don't buy enough art by women, even though it's a bargain! Our 1989 poster "When racism and sexism are no longer fashionable..." pointed out that for the amount of money spent at auction on a single painting by Jasper Johns, an art collector could have bought a work of art by every woman in this book!

• There's still a materials hierarchy, with oil paint on canvas at the top. Other media–like sculpture, drawing, photography, installation, and performance–are not quite as prestigious. Ironically, this has made it easier for women to make it in these fields.

• Museums and galleries in Europe and New York are the worst. All our research shows that the farther you get from New York and Western Europe, the better it gets for women and artists of color.

• Although the West has lost some of its cultural hegemony, the art of Asia, Africa and the Americas is still not accorded equal status with European art, or taught as often.

90

It's been ugly...

- •Women of color are at the low end of the totem pole and have the hardest time getting their work shown. When they are exhibited, it's often as tokens: there never seems to be room for more than two or three in prestigious shows like the Whitney Biennial, Venice Biennial, etc.

- •Some women still think that feminism is the "F" word.

- •Women artists and theorists are still arguing over whether there is an essential female sensibility or whether the feminine is a cultural construct. GG advice: agree to disagree, find some common ground, and get on to more important things.

AND IT'S NOT OVER YET...

What would Western art history be without Gentileschi, Bonheur, Lewis, Kahlo, or any of the women who are or could have been in this book? What would contemporary art be without all the great women artists of the last few decades? Let's make sure that, generations from now, we never have to find out. Let's make sure that the work of women and artists of color is valued, exhibited, and preserved by our institutions. Guerrilla Girls plan to keep up the pressure on the art world. We'll continue to identify and ridicule the powers that be and to drag the misogynists and racists kicking and screaming into the 21st century. We invite you to join us. Tell your local galleries and museums how to behave. Write letters, make posters, make trouble.

KATHLEEN ZANE

REFLECTIONS ON A YELLOW EYE
Asian i(\eye/)cons and cosmetic surgery

I wish I had double eye.
. . .
I like go Honolulu
for get one double eye operation.
I no care if all bruise.
. . .
I take the operation any day.
> "Tita: Japs," from *Saturday Night at the Pahala Theatre* by Lois Ann Yamanaka

WHEN I WAS GROWING UP IN HAWAII, my parents and I were patients of the ear, eye, nose, and throat clinic headed by two Chinese American doctors. In their waiting room, I was always fascinated by the glass-encased display of photographs and objects documenting the surgical recovery of foreign matter (teeth, bottle caps, pins, marbles, jacks) from patients' ears, eyes, noses, and throats. I don't recall exactly when these exhibits began to include "before and after" photographs of "double eyelid" surgeries, performed with no identifiable medical purpose. Despite the gruesome aspects of this display, it was reassuring to know that if I were ever a victim of such "matter out of place," I would receive competent medical care, and might even become a star feature of the showcase. As for those eyelid surgeries, I accepted them as normalizing procedures, in the sense both of practices taken for granted by doctors and patients in this Honolulu clinic, and of restoration to a normal state.

At sixteen I decided I wanted contact lenses instead of the nerdy-looking glasses I was embarrassed to wear. To my surprise, the doctor opposed my wearing contact lenses on the grounds that a foreign object in direct contact with one's eye wasn't "natural." It was puzzling to hear this objection from a doctor whose services included the surgical alteration of patients' healthy eyelids for cosmetic purposes. However, his point of distinction between the artifice of a temporary device requiring daily insertion and the "natural" permanence of a surgically achieved eyelid was one I would remember many years later when my interest in body-sited constructions of gender and race led me to examine the dynamics of cosmetic eyelid surgery on ethnic Asians.[1]

This essay is formed in part by reflections on some of the responses I have received to my earlier research on the transgressive possibilities of diverse aesthetic interventions on the racialized body.[2] To re-think possible meanings of the optional double eyelid surgery for Asian women in relation to American racial histories, to feminist discourses about the body, and to

ethnic pride politics, I have attempted a brief comparative review of some contexts for such surgeries. To chart meanings of agency in the context of historical and political settings, I question how cosmetic surgery functions differently for Asians (in the case of my research, the Japanese) than for Asian Americans; and how differently again for Asian Americans marginalized as minorities, as distinct from those constituting majority populations as in Hawaii.

Although I'm unable here to do more than merely sketch out some suggested directions for possible alternative readings of negotiative meanings, I want to emphasize the importance for multicultural feminism of dealing with our own discomfort with acknowledging variant forms of agency in cultural negotiations. This discomfort, or dis-"ease" often short-circuits Foucauldian views[3] by denying its own situation of identification with notions of property and propriety adherent to a Western hegemony, as when reverse mimicry or appropriation by mainstream culture links the ideas of originating culture and ethnic naturalness into a moral equation for authenticity. A by-product of this ambivalence has been described by Rey Chow as an "Orientalist melancholia."[4]

Such Asian(eyes)ing essentialism needs to take into account what the surgical subjects say, that is, to take them seriously on/in their own terms, without attempting to replace or "give" them their subjectivity, rushing to their defense, or reasserting their perspectives as singular truth.[5] Such alternative readings may open up ways we can begin to consider the place of hybridity among notions of authenticity and the natural as they function in ethnic pride politics or aesthetics of morality in the form of reconfigurations from Western "eye-cons."

I Eyeing Asians: Asian(eyes)ing authenticity

A girls' high school in Okayama City caused a stir when it was found out last year that girls with natural brown hair were being made to dye their hair black to conform to the "uniform" regulations of the school.[6]

On the banning of colored contact lenses for its flight attendants by Singapore airlines, officials at Japan Air Lines and Malaysia Airlines concurred that the lenses were not suitable for "the Asian look": "How can an Asian girl have blue or green eyes?"[7]

. . . she had been relieved to see that her daughter had all her toes and fingers, and double eyelids as well. . . . Brenda was going to be an all-American girl.[8]

Some of the responses I have encountered when speaking about my research privately, as well as in feminist-organized venues, have confirmed the necessity, as well as the difficulty, of interrogating my location vis à vis my materials, my stake in academic feminism, and my own plausibility as a surgical candidate. The totalizing and dismissive assumption that Asian women who elect such surgery obviously desire to look/be Western has seemed too readily to essentialize Asians as degraded imitations and mimics. Labeling Asian surgical clients as mere victims of internalized racism resulting from their enthrallment with the patriarchal gaze of Western cultural imperialism seems to further a divide between enlightened or true feminists and these "other" less privileged "natives." Recounting that many Japanese involved as practitioners or patients have disputed the interpretation that the surgeries are intended to imitate a Caucasian appearance,[9] has tended to fuel dismissive mutterings about hegemony's efficacy in internalized racism. Such responses approach what Trinh T. Minh-ha speaks of as a "form of legitimized (but unacknowledged as such) voyeurism and a subtle arrogance."[10]

Typical of these criticisms I encountered was the refusal to acknowledge what Asian/Asian American women who had been cosmetic eyelid surgery patients or had considered the prospect said, thought, or felt about the procedure.[11] Yet, many feminist discussions or

critiques of *any form* of elective cosmetic surgery peremptorily charged mutilation, self-hatred, and duping as givens, by conflating moral, aesthetic, and political judgments. Some of these critiques attribute certain ideal features to white, Western, Anglo-Saxon bodies as property and propriety. This ignores the implicit idealization of white, Western, Anglo-Saxons, and denies the non-random and non-isolated occurrence of such features on the bodies of non-white, non-Western, non-Anglo-Saxon people.[12] Variety of hair type, skin texture and hue, facial structure, nose, lip, and eye shape within ethnic or racial groups is vast, but largely ignored among white feminists, as well as by feminists of color.[13]

The strong and specific repugnance with which eyelid surgeries on Asians is viewed insists on racially "authentic" meanings, which in turn elicit claims of proprietorship embedded in Western hegemonic culture. Medically termed a blapheroplasty, this eyelid surgery is also commonly performed on non-Asian women to combat their aging appearance.[14] In these cases, "heavy eyelids" are formulated as the problematic signs of age, indicators of the need for surgery. While the appearance they produce in non-Asians is interpreted as undesirable – lack of alertness, passivity, crankiness – these same indicators and appearance are deemed normal, "natural," and proper in an Asian's face.[15]

Consequently, the "problem" and the means of correction acquire legitimacy in the pre-determinacy of a racialized eye or face. An ethnic Asian's desire to "correct" what is culturally interpreted as undesirable, unattractive, abnormal, or problematic (out of place in a non-Asian face) is automatically construed as an inauthentic and inappropriate act, or purely symptomatic of internalized racial self-hatred. As a result, the ethnic Asian operatee's trans-gression of purported racial boundaries may be regarded as a moral issue – as denying her "natural" body, origins, and authenticity – in the manner of anti-miscegenation rhetoric, regarding it as trespassing on the law of the eye-con.

Like Michael Jackson, another purported "victim" of racial self-hatred and maven of cosmetic surgery,[16] Asian eyelid surgery clients must be located in the context of the imagery of the culture and sexuality they enact. Certainly, assumptions of the unnaturalness of these surgeries for Asians call into question received ideas about what Asians are supposed to look like. The collapse of Asian agency into a stereotype of the Asian mimic(wo)man, comes close at times to reiterating Orientalist discourse. Sources of this essentializing insistence on the mimetic nature of the Asian may be glimpsed through a further look at the representational systems producing the Asian eye-con.

II Eye-conography: reading in a yellow eye

In Western representational systems, the Asian eye has been iconized into the gestural abstrac-tion of a slash: (\ /).[17] Like the "Oriental"-ized script used for representing Asianness in titles or signs, with its calligraphic reference or the suggestion of a bamboo graphic, the Asian eye (a slashed icon) is a racialized inscription identifying the Asian as Other. The operating dynamic of writing or cutting this eye-con on the blank face to signify "Asian" is an inscribing or branding by those with agency on those who are acted upon. While the "failure" by Japanese to represent themselves in Japanese *manga* (comics) with slanted "Asian" eyes is often noted with some amusement, perhaps the question needs to be reframed to uncover the expecta-tions that predicate such a risible, seeming incongruity.

Commonly referred to as an "Oriental/Asian" eye and a "Western/Caucasian" eye, respec-tively, the so-called single eyelid expresses lack in the first instance while the double eyelid assumes presence in the second. Although many non-Caucasians, including Asians, have double eyelids, these purportedly "round eyes" are conventionally attributed to Westerners, who are

presumed to be white. Echoing the inscriptive nature of Western representations of the Asian eye, the double eyelid is surgically produced by the cutting or slash in the eyelid. Paradoxically, fashioning a double eyelid, in what might be considered an augmentation or a creation of a previously non-existent part of facial anatomy in response to a lack, is achieved by removing the fat in the lid, which constitutes the lid itself (the epicanthic fold). The eyelid surgery's economy is suggestive of forms of genital or sexual surgical interventions also engendered in response to notions of presence and lack.

The process of symbolization in clitoridectomy, as discussed by Paula Bennett,[18] provokes insights into cosmetic surgery's racial discourse in relation to the epicanthic fold ("single lid"). Like the clitoris, the eyelid fat may be viewed as having no reason for being except as a marker; in the case of the clitoris, as Gayatri Spivak explains, its "pre-comprehended suppression or effacement . . . relates to every move to define [women] . . . with no recourse to a subject-function except . . . as 'imitators' of men."[19] By reiterating predetermined definitions of mimicry as the sole means of subject-function for Asians, as for women, the epicanthic fold, like the clitoris, is defined as a suppressed/effaced excess. In a system based on the subordination and containment of "others," the autonomy represented by these entities of excess poses a threat to dominant rule generally. Where presence signifies impending lack, the Asian's practice of double eyelid surgery cuts into a Western ironic property to signal its transgression upon the seemingly stable marker of racial identity as well as its potential threat to the Western gaze. As a possible contestation of the Asianized eye-con, double eyelid surgery carves a racial construction into the body that reflexively reinscribes itself.[20]

That reinscription of eyelid fat as the Asian racial marker in an economy of presence/absence was maintained by Asian American activists as signifier of cultural pride and coded as authenticity. In the climate of Black Power and in emulation of ethnic pride movements, a relationship or equation between "roots/origins" and "natural looks" had been consolidated and validated among natives, appropriated into mainstream American aesthetics, and shifted into a moral sphere. While remaining a sign of foreignness,[21] the reification of the unexamined idea of the natural, the *idée fixe* on fixed eyelids sustained the eye-con as the version of the "natural" Asian eye throughout a system of aesthetic values.[22] In part, it subscribed to a pre-existing notion of Asian beauty/ugliness that was both gender and class calibrated. The notion of an appropriately feminine beauty inherent in the exoticism of Asian looks functioned obliquely via Orientalist paradigms, like the "model minority" or the "China doll," by employing seemingly positive values to condescend or negate.[23] In contrast to its negative assessments of black looks, the cosmetic industry frequently advertised products offering formulas using "beauty secrets of the Orient" or in use traditionally by "ladies of the Orient." Similarly, the Asian beauty of reputedly slender and petite doll-like bodies was extolled in terms of soft skin and silky hair, and contrasted with images of repudiated and coarser African hair and skin.[24]

The actual beauty secrets or procedures used by some Asian women, such as glue, tape, tools for temporarily tucking a fold into the eyelid, and eyelid surgery, are discredited by Western liberal responses to such reshaping that parallel responses to black hairstraightening as unnatural and self-hating.[25] Nor have these "secrets" of Asian beauty culture been appropriated by a dominant culture that has taken to mimicking African-American identified, but de-politicized hair styles.[26] Aside from exoticized make-up styles, consistent with Western self-referential ideas of the Asian eye rather than emulations of actual make-up practices of ethnic Asian women, the mimicry is significantly unidirectional.

Several films by Asian American women are noteworthy in their attempts to offer valuable critiques of the pseudo-medical promotion of eyelid surgery and the racialized aesthetics

of its beauty discourse. The critiques of the gaze presented in these films, however, are even further enmeshed in the sticky implications of visual politics. In a seemingly inescapable process of the visual, the women as subjects become at the same time objects of essentialism even as they speak. Caught within the politics of looking, the subject of a "fixed eye" is fixedly located outside the narrative, as another object of the gaze. Remaining within a white/other binary, the parameters of these critiques maintain the Western eye-con and ignore the possible usages of eyelid modifications as partial expressions of communalizing ritual, by articulating them only in terms of internalized racism. In voicing an opposition to the distortions of Eurocentric discourse upon the body of that other, it is pertinent to recall Rey Chow's point that a critique of orientalism "neither implies that only 'natives' of East Asian cultures are entitled to speaking about those cultures truthfully nor that 'natives' themselves are automatically innocent of Orientalism as a mode of discourse."[27]

Pam Tom's *Two Lies* (1989) is especially remarkable in complexly situating the inter-familial ramifications attendant on one woman's eyelid surgery and intersecting the issues of aging and racism. The film uses the event of an Asian American mother's eyelid surgery to explore the relationships between the mother and her two daughters. It places the "lies" of the mother's surgery against the hybridization of cultural artifacts, in particular the touristic imitation of a Native American lodge/resort where the family goes during the mother's recovery. The repetition of "lies" and contrived authenticities, as articulated by the more polit-ically conscious daughter, serves as a critique of the false in cultural identity. The daughter's privileged perspective meshes with her role in familial and generational conflicts to detect the contradictions enacted by the mother. This critical strategy implicates the mother's desire in a moral imperative that deflects from her own motives and interpretation of her experience.

The film *Operculum* by Tran T. Kim-Tran (1993), scrolls a Western medical treatise of historical lobotomy experiments on one side of the screen while a female, ethnic Asian client for eyelid surgery listens to a white male doctor recount the procedures and demonstrate his recommended modifications [Figure 40.1]. The discourses of race, gender, and beauty implicit in this cosmetic surgical information are rendered as images of violent torture analogous to the butchering of brain lobes. The client's passivity mimics the body on which a white model of beauty will be imposed. Hence, the film's parody of scientific discourse upstages and effaces the patient's desires and motives, while leaving the complexity of specific power relations unexamined.

Within the process of acknowledging institutional racism, the viewer is encouraged to see these others only as unwitting victims or as unenlightened collaborators who reproduce the system. The narrative scrutiny of the filmmakers' gazes serves to establish their own contrastive identities against those women who are seemingly unable to resist, interrogate, or control the manipulation of their desires by the eye-con. In dismissing these women as subjects and ignor-ing the power of a shared and historical racist experience, the gazes gloss an Asian American identity, but neglect to account for their own positions, in terms of class, educational, or occu-pational privilege. In consequence, they are able to do little to interrogate the positions of women who figure in their work as actual or possible surgical clients or to provide a dialogue with them. Occupying positions bonded with a privileged critical perspective, these purported confrontations of the very institutions that endow privilege instead operate in collusion with institutional power. The critiquing narrator is identified as exceptional, as successfully trans-formed, while locating those other(ed) women outside her critical production.

Fostering that "specialness," as Trinh T. Minh-Ha suggests, is founded on divisiveness and preserved at the expense of other women whose embodiment of the norm assists in main-taining one's exemplary status.[28] Although these could perhaps plausibly be read as narratives

Figure 40.1 Tran T. Kim-Tran, *Operculum*, 1993, video still.

of the artist herself who might desire such surgeries but comes to see them in a different light, that is, read as in a sense autobiographical,[29] the disassociation of narrator from oper- atee seems effectively to reiterate a sense of self-hatred; and the attempted disassociation implies that the narrator's position is unambiguously transformed and in control. Thus the ambiguity that resides in racial self-contempt is foreclosed and its role in negotiating a hybrid- eyes-ed cultural position disenfranchised.

III Cross-secting lids: race for beauty/culture for style

A former student at the University of Rochester, a Korean American, reported that her father had offered her as an unsolicited high school graduation gift the choice of either a car or a trip to Korea for eyelid surgery. She explained that this was a fairly common rite of passage for her Korean American peers and surmised it signified for her father a variety of relational meanings of his success in providing for his children.[30] The practice among many Korean Americans of sending adolescent offspring to South Korea for summer courses in Korean language and culture highlights several aspects of their experience that is distinct from that of other Asian American communities. In regard to this example, the trip to Korea for cosmetic surgery that might have been performed in the U.S. could be viewed as an assertion of one's originary Korean cultural identity (gender and class), rather than its loss or denial.

In the Japanese setting, as in some Asian American communities, certain meanings of the "double lid surgery" are connected to social ritual, to family or community relationships, or

to rites of passage. Not simply matters of personal self-esteem, facial alterations can mark changes of social status, such as graduation, coming of age, or first full-time employment. The eyelid surgery may be sanctioned as appropriate preparation for moving to the next stage of one's life among Japanese young women[31] within a culture whose highly codified markers of appearance correspond to specific age and gender status:

> A plastic surgery clinic in Tokyo's Minato Ward says that forty percent of its clients are female university students. . . . Over half of the young women cite their search for jobs as the main reason for visiting the clinic. . . . A twenty-one-year-old student with ambitious career goals says she had surgical adjustments made last fall to her eyes, nose, and chin. "I thought it was a drawback to look too serious."[32]

The interplay of power relations affecting meanings of the racialized eyelid is seen when we compare its cultural purposes and practices in movements across borders. As the reward and sign of economic agency, Japanese assume the prerogative of naming themselves "Western," or conversely, of naming the Western "Japanese," just as English (its fractured syntax a sign of appropriation rather than error) is used for Japanese purposes as a ubiquitous design element of T-shirts, toys, and shopping bags, or as cosmetic surgeons describe their achievement of a "Japanese eye."

The active appropriation of "Western" culture as agent rather than as passive recipient, as a means through which Japanese assume a "Western" prerogative and identity, especially vis à vis other Asian cultures, must also be considered. The ambivalence of Japan's self-identification as "Asian," as a consequence of this historical power dynamic with other countries of Asia, the contemporary export of its pop culture, and the economic cachet it enjoys in the region, also must be reiterated as background to a comparative cultural view of issues raised about eyelid surgery. Having been an active colonizer in Asia, Japan may be seen as maintaining its formerly imperialistic relationships through current labor, sex, immigration, tourist, or entertainment practices.

Under usual circumstances, the fat removal cannot be reversed, hence there cannot be a re-creation of a single lid, at least not with the same fat; nor is there much of a demand for such surgery.[33] However, the Japanese reinscription of "their" eye through their economic ascendance is reflected in the surgical creation of the single lid from an unconstructed double one to forge a visible Japanese identity for a number of Peruvians wishing to work in Japan. To "authenticate" their adoptions by Japanese or their purchase of false identity papers, these Latin Americans of would-be "Japanese" ethnicity have elected eyelid surgery to satisfy Japanese immigration authorities who have balked at admitting "so many 'Japanese' Peruvians [who] had such distinctly non-Asian features."[34]

By contrast, one team of Japanese cosmetic surgeons presenting a clinic workshop in the Philippines noted that the most advanced techniques for eyelid reconstruction were little appreciated by participants in a context in which ethnic Chinese were in positions of dominance.[35] Constituting the elite, professional, wealthy classes, and hence, the client pool for cosmetic surgery, Chinese in the Philippines wished to preserve the markers of their status that visually distinguished them from poorer indigenous groups whose eyes are "rounder." That is, power and status ascriptions both inscribe and prescribe the body as it is inflected by the dynamics of power relations, to reflect the positioning strategies of who sets the norm.

The effect on relationships of power is culturally relative in psychological, economic, and material ways. In contrast to the examples above, the single eyelid in the United States identifies one as Asian and constitutes a mark of the marginal despite the media-touted images of

Asian Americans as the model minority, whose economic and educational levels often surpass those of dominant white groups.[36] Long identified as ugly and inferior, distorted and weak, embodying perversion and vice, Asian looks as iconically focused on the slanted-eye graphic have conventionally represented variously as indicating comic subordination, "inscrutable" deceit, or moral depravity.[37] Certainly, the power of the conventionally attractive in American culture cannot be dismissed as a potent factor in life experience only on the grounds of its being ideologically incorrect.

> The destructive effect of racism on the self-image of people of color is well-documented and much bemoaned – especially among anti-racist whites. . . . Isn't it shocking that eye jobs creating a Western eyelid were popular among certain Vietnamese women during the war? . . . Yes. But at some level it is also profoundly reassuring to white women; we are, after all, the model. We do embody at least one element of the beauty formula. Our white Western lives are the stuff of global fantasy and demonstrably enviable.[38]

Yet, surgically transforming the eyelid is a far more complex cultural production than a simply imitative media-instructed practice that reasserts Western, white patriarchy as a remnant of cultural or political colonization. Cultural boundaries on aesthetics can be maintained within the seeming embrace of Western discourses of beauty, just as the cultural boundaries of otherness are maintained in the display and promotion of Western commodities in Japanese department stores as separate adjuncts to existing Japanese functions. By lending status or filling in a previously uncovered arena, they are thereby productive of meanings "consistent with the existing fabric of Japanese culture."[39]

Susan Bordo's work on anorexic reproductions of femininity offers several useful insights in this regard. Her view of the anorexic as embodying the intersection of traditional constructions of femininity with "the new requirement for women to embody the 'masculine' values of the public arena," such as self-control and mastery,[40] touches upon the ways in which Asian women's elective eyelid surgery can be motivated, not simply by the desire to simulate Caucasian looks, but rather as a response to the values of the new woman. It may be interesting to look at the surgeries in the light of escaping not simply from race but also from the traditionally limited options within a specific culture's gender-coded relationships. As an attempt to secure an aspect of male privilege with Japan's gendered economy, the surgery may engage resistance to traditional forms of femininity through "the illusion of meeting, through the body, the contradictory demands of the contemporary ideology of femininity."[41]

[. . .]

Notes

1 I began thinking about representations of Asian women in American popular culture as a participant in the Seminar on Gender, Ethnicity, and Race as a Fellow at the Pembroke Center for Teaching and Research on Women at Brown University from 1987–1988. A subsequent focus on cosmetic surgery in Japan became part of my research as a Rockefeller Fellow at the Susan B. Anthony Center, University of Rochester, in 1992–1993. In January 1992 I was cordially provided full access to two cosmetic surgery clinics in Tokyo with the help of Doctors Sakata and Ishii. Earlier assistance crucial to these and other contacts was generously given by Mr. Isamu Maruyama and the staff at International House, Tokyo, and Professor Hiroko Hara at the Institute for Gender Studies Center, Ochanamizu University.

2 Conference presentations of this research have included: the Asian American Studies Association, Honolulu, 1991; the American Studies Association, Costa Mesa, 1993; the New Museum of

Contemporary Art, Crosstalk Conference, New York, 1993; and lectures or panels held in the U.S., Spain, and Japan between 1988 and 1995.

3 Susan Bordo clearly articulates the overly general application and misuse of Foucault in this context in her " 'Material Girl': The Effacements of Postmodern Culture," *Michigan Quarterly Review* (Fall 1990): 653–677, although the value of other similar uses of Foucauldian notions of disciplinary power are not precluded.

4 Rey Chow, *Writing Diaspora: Tactics of Intervention in Contemporary Cultural Studies* (Bloomington: Indiana University Press, 1993), 4.

5 I am indebted to my friend and colleague, Karen Kosasa, who insisted in discussions that this work needed to be done, and who reminded me of the importance of not dismissing these voices, even while trying to negotiate around an awareness of the trap of representing and aspiring to the subjectivity of others.

6 Paul J. Buklarewicz, "The Me Generation," *Transpacific* (July–August 1990): 30–35.

7 Reported in the *International Herald Tribune*, via U.P.I. (n.d.).

8 Shawn Wong, *American Knees* (New York: Simon and Schuster, 1995), 96.

9 Examples of deferral include these statements: "It is looked upon by the Orientals [*sic*] as a method to enhance the beauty of the eyelids but not as an attempt to 'Westernize' their facial features. Various techniques . . . have long been used by ophthalmologists and nonophthalmologists in the Far East. Even nonsurgical means such as glue or tape have been tried. . . ." (Don Liu, M.D., Ph.D. "Oriental Eyelids," *Ophthalmic Plastic Reconstructive Surgery* 2, no. 2: 59 (1986)); "Half of all Asians are born with a double eyelid. So you can still have a double eyelid and maintain your ethnic appearance" (Edward Falces, M.D., quoted in Joanne Chen, "Before and After," *A Magazine: The Asian American Quarterly* 2, no. 1 (1993): 15–18f.); "About 50 percent of Asians lack an upper eyelid crease, giving their eyes a sleepy look, Dr. Song said. The creation of this fold . . . if properly performed should not result in Caucasian-looking eyes" (Elizabeth Rosenthal, "Ethnic Ideals: Rethinking Plastic Surgery," *The New York Times*, September 25, 1991).

10 Trinh T. Minh-ha, *When the Moon Waxes Red: Representation, Gender and Cultural Politics* (New York: Routledge, 1991), 66.

11 Likewise, those who argue against straightening black people's hair, according to Kobena Mercer, "rarely actually listen to what people think and feel about it." ("Black Hair/Style Politics" reprinted in *Welcome to the Jungle* [New York: Routledge, 1994], 104). I do not imply that the operatee knows better; only that there is a total disregard for or lack of engagement with her version of the matter.

12 See Anne Balsamo, "On the Cutting Edge: Cosmetic Surgery and the Technological Production of the Gendered Body," *Camera Obscura: A Journal of Feminism and Film Theory* 28 (1992): 206–237; Kathryn Pauly Morgan, "Women and the Knife: Cosmetic Surgery and the Colonization of Women's Bodies," *Hypatia* 6, no. 3 (Fall 1991): 25–53; Diana Dull and Candace West, "Accounting for Cosmetic Surgery: The Accomplishment of Gender," *Social Problems* 38, no. 1 (1991): 54–65; Naomi Wolf, *The Beauty Myth: How Images of Beauty Are Used Against Women* (New York: William Morrow, 1991); and Susan Bordo, *Unbearable Weight: Feminism, Western Culture, and the Body* (Berkeley: University of California, 1993).

13 An accessible discussion of the denial in American racial constructions of physical variation among African peoples can be found in Jefferson M. Fish, "Mixed Blood," *Psychology Today* 28, no. 6 (November–December 1995): 55–61f.

14 Judith Newman reports that "it's a relatively easy, long-lasting and safe procedure for removing fatigue from your face," in her article, "Eye Hopes," *Mirabella* (May 1993): 97–100.

15 I am aware that these "objective indicators for surgery" in both cases are what Don H. Zimmerman observes as "managed accomplishments or achievements of local processes"; but I am struck by how the interpretation of what the appearance of a heavy eyelid might possibly signify ("serious," "gloomy," "sleepy"), and its bearer's reasons for intervening in the ascription of such negative characteristics to her are dismissed as unwitting forms of racial self-hatred if she is an ethnic Asian. Don H. Zimmerman, "Ethnomethodology," *The American Sociologist* 13 (1978): 11, quoted in Dull and West, "Accounting for Cosmetic Surgery," 57.

16 Jackson's face and hairstyle are deconstructed by Kobena Mercer in ways pertinent to this study. See his "Monster Metaphors: Notes on Michael Jackson's Thriller," in *Welcome to the Jungle*, 33–52.

17 Barthes writes "The Written Face" of Japanese as an inscription and incision of "the strictly elongated slit of the eyes," describing how the blank mask onto which the ambiguity of the slash is inscribed produces the identity of the other as an inscrutability. Roland Barthes, *Empire of Signs*, trans. Richard Howard (New York: Hill and Wang, 1982), 89.

18 Paula Bennett, "Critical Clitoridectomy: Female Sexual Imagery and Feminist Psychoanalytic Theory," *Signs* (Winter 1993): 235–259.

19 Gayatri Chakrovorty Spivak, "French Feminism in an International Frame," *Yale French Studies* 62 (1981): 181, cited in Bennett, "Critical Clitoridectomy," 238.

20 Another thing to explore is how Barthes approaches inscriptions of the other and self-inscription to develop a way of understanding critiques of otherness, and how that critique is involved in one's own self-image; in effect, Barthes the inscriber performs his own *Bunraku*, being simultaneously present in his presentation of the presence of his puppet, and thus writing himself.

21 In the infamous article "How to Tell Your Friends from the Japs" that appeared in *Time* magazine, December 22, 1941, a distinction between friendly and enemy aliens fails in this singular and inescapably alien eye detail: "Although both have the typical epicanthic fold of the upper eyelid (which makes them look almond-eyed), Japanese eyes are usually set closer together" (33).

22 "Images of the small-eyed, round-faced Asian, so prevalent in cartoons and old movies, have been internalized to the point where even Asians believe that these features are essential, ignoring the reality that Asians have much more physical diversity than most people realize." Joanne Chen, "Before and After," *A Magazine: The Asian American Quarterly* 2 (1): 15–18.

23 Chinese American writer and critic Frank Chin terms this "Racist Love," in *Seeing Through Shuck*, Richard Kostelanetz, ed. (New York: Ballantine, 1972).

24 Tired standards of Asian beauty continue to resurface as in the recent echo from William Prochnau, "The Boys of Saigon," excerpted from *Once Upon a Distant War* in *Vanity Fair* (November 1995): 234: "Women of exceptional Asian beauty – tiny, porcelain, ephemeral images of perfect grace . . . silken trails of their raven hair." Asian Americans have also been used historically as tools of control by the dominant culture, as contrasts against other less favored minorities, and as wedges to disrupt possibilities of affiliation or solidarity among minorities.

25 Mercer characterizes these responses as adjudgments of "wretched imitations," "a diseased state of black consciousness," and a "deracializing sellout and morbid symptom." "Black Hair/Style Politics," *Welcome to the Jungle*, 97–98.

26 These and other African American styles of hair fashioning are sometimes seen adorning young Japanese males and females during a few years of a brief stage in their lives before they assume, as expected, their first full-time jobs.

27 Chow, *Writing Diaspora*, 7.

28 Trinh T. Minh-ha, *Woman Native Other* (Bloomington: Indiana University Press, 1989), 86–88.

29 This perspective was suggested to me by Ella Shohat.

30 Conversations with S. Kim, Rochester, NY, Spring 1993.

31 Examples of the body/age focus of advertising that targets Japanese young women by offering a socially validated and identifiable image with clear group boundaries are presented in Rosenberger's analysis of fashion magazines. Nancy R. Rosenberger, "Fragile Resistance, Signs of Status: Women between State and Media in Japan," in *Re-Imaging Japanese Women*, Anne E. Imamura, ed. (Berkeley: University of California, 1996), 12–45.

32 Reported in the *Asahi Evening News*, April 14, 1993.

33 Reversals do occur, supposedly among the occasional repentant and enlightened victim of racism. In this sense, cosmetic eyelid surgery is distinct from face-lifts, which tend not to be reversed as a result of change of heart. People might regret the residual pain, or the imperfect outcome of a face-lift, but they do not elect to revert to the former state in which a face-lift was deemed desirable or necessary to begin with.

34 *Newsweek*, January 26, 1993, 39.

35 Japan is generally credited with developing these surgical techniques during the post-World War II period.

36 The ambiguous and converse value of the model minority appellation has been widely discussed, for example, by Ron Takaki, in *Strangers from a Different Shore: A History of Asian Americans* (New York: Penguin, 1989), in terms of its effacement of significant numbers of Asian Americans trapped in poverty and violence, the constrictures of the label, and its use as a divisive tactic against other minority groups. See also Frank Chin, "Racist Love."

37 For examples of historical overviews of yellowface imagery, see John Kuo Wei Tchen, "Believing is Seeing: Transforming Orientalism and the Occidental Gaze," in *Asia/America: Identities in Contemporary Asian American Art* (exh. cat.) (New York: The Asia Society Galleries and The New Press, 1994); and Carla Zimmerman, "From Chop-Chop to Wu Cheng: The Evolution of the Chinese Character in

Blackhawk Comic Books," in *Ethnic Images in the Comics* (exh. cat.) (Philadelphia: The Balch Institute for Ethnic Studies and the Anti-Defamation League of B'nai B'rith, 1986).

38 Wendy Chapkis, *Beauty Secrets: Women and the Politics of Appearance* (Boston: South End Press, 1986), 34.

39 Millie R. Creighton, "Maintaining Cultural Boundaries in Retailing: How Japanese Department Stores Domesticate 'Things Foreign,' " *Modern Asia Studies* 25, no. 4 (1991): 677.

40 Bordo, "The Body and the Reproduction of Femininity: A Feminist Appropriation of Foucault," in *Gender/Body/Knowledge: Feminist Reconstructions of Being and Knowing*, Alison Jaggar and Susan Bordo, eds. (New Brunswick: Rutgers University Press, 1989), 19.

41 Ibid., 19. See also Miriam Silverberg, "The Modern Girl as Militant," in *Recreating Japanese Women, 1600–1945*, Gail Lee Bernstein, ed. (Berkeley: University of California Press), 239–266.

Chapter 41

JUDITH MAYNE

FEAR OF FALLING

I HAVE BEEN FOLLOWING FIGURE SKATING in a relatively informal but passionate way for years. By *informal* I mean that I have acquired a fair amount of knowledge about skaters, about the presentation of skating on television, and about controversies (concerning, say, judging); at the same time, I am a real neophyte in that I still really can't tell the difference between a triple flip and a triple Salchow. My limited knowledge hasn't prevented me from articulating firm opinions, and I have often found myself swept up by the frenzy of competition. For instance, during the famous 1988 Olympic showdown between Katarina Witt and Debi Thomas, popularly billed as the "duelling Carmens," I enthusiastically adopted the popular conception of Witt as female villain, as ice princess, and of Thomas as the earnest and forthright challenger. (At the 1994 Olympics I was equally taken in by the image of Witt as a wise old-timer.) I've cheered for Brian Boitano. I was appalled that Isabelle and Paul Duchesnay, the brother-and-sister ice dancing pair who challenged many of the gender stereotypes of the sport, didn't get the gold. And so on.

When Nancy Kerrigan was attacked and the subsequent involvement of Tonya Harding was revealed, I consumed news of the event as enthusiastically as anyone I know. What interested me in particular about the Harding/Kerrigan event was how it foregrounded and exaggerated issues that have been present in the presentation of figure skating as a spectator sport for years. Abigail Feder's study (1994) of the presentation of women's figure skating is a sobering reminder that in the one sport where women tend to be more visible than men, the price paid for such visibility is the excess of stereotypes of femininity. The fact that figure skating is virtually absent from such recent studies as Susan Cahn's *Coming On Strong: Gender and Sexuality in Twentieth-Century Women's Sport* (1994) and Mariah Burton Nelson's *The Stronger Women Get, the More Men Love Football* (1994) suggests that the battle between "femininity" and "female strength" is not really being waged in any particularly groundbreaking ways on the ice.

Yet however much figure skating seems to be ruled by extremely conventional representations of femininity, I find that analysis of spectatorship vis-à-vis figure skating raises more complicated issues. Just as the supposedly universal and ubiquitous male gaze of the classical Hollywood cinema functions quite differently when examined through the lens of female spectators and female pleasures in the cinema, so the spectacle of figure skating takes on a different look and set of expectations when viewed through the lens of female spectatorship.

Consider in this context one of the many peculiar devices employed in the NBC made-for-television movie *Tonya and Nancy: The Inside Story* (broadcast April 30, 1994). A series of fictionalized interviews with a range of commentators on the Harding/Kerrigan affair are featured in the telefilm. Taped rather than filmed (thus creating the illusion of authentic interviews), and featuring direct address to the camera in the style of talking-heads documentaries, these interviews included television producers, a former skater, a 1960s' activist, and a skating judge. Two of the interviews included in the television movie serve as appropriate images of the issues at stake in this essay, a very speculative exploration of female spectatorship in relationship to figure skating.

Two individuals, one female and one male, are identified as "supporters" of Harding and Kerrigan, respectively. Both of these interviews occur in the last half-hour of the teleplay. The Harding supporter is middle-aged, and she wears an "I Love Tonya" button. "It's just so unfair," she says angrily and passionately to the camera. She continues: "The way the judges have always treated her. . . . And the media! That's why we started the fan club. Because the Nancy Kerrigans of the world get all the attention. And somebody like Tonya who's had to struggle all her life. . . . The Tonyas of this world just get pushed aside. It makes me sick."

The Kerrigan supporter appears a bit later, following images of Tonya and her husband Jeff Gillooly planning what they will say to the police. The Kerrigan supporter appears to be a bit younger than the Harding fan club organizer, but he is also middle-aged (and balding), wearing horn-rimmed glasses, a button-down shirt, and a cardigan around his shoulders. His tone is also angry, though not quite as personally involved as the woman's:

> Don't give me that bleeding-heart crap about unhappy childhoods. I mean, what are we saying here? That because she comes from a dysfunctional family that she's supposed to grow up and marry a jerk and commit a crime? What ever happened to free will? I mean, look at Nancy. Now she sacrificed, too. But she played by the rules. You get what you deserve.

While it might be appropriate to describe both of these fictional supporters as passionate in their defenses of their heroines, there is no question that the Harding fan is more emotional and seems to have more at stake personally in her identification with the skater. The Harding fan even seems somewhat deranged, whereas the Kerrigan fan utters what was quickly becoming popular common wisdom concerning the paths of the two skaters. In addition, the contextualization of the interviews creates an odd juxtaposition between the female fan who reacts and the male fan who comments. It is, of course, no coincidence that the more deranged and excessive fan is female, while the male fan embodies cool reason and sarcastic restraint.

While the gender dichotomy of these two presentations of spectatorship does not surprise me, I find it a matter of some curiosity that both supporters are distinctly middle-aged. One suspects perhaps that the Harding/Kerrigan affair, as retold in this made-for-television movie, offers the possibility to middle-aged spectators to take sides and to act out fantasies and projections of the meanings of success and failure for the female skaters. Both fans are identified as "supporters," which suggests an investment stronger than everyday, run-of-the-

mill spectatorship. Yet the intensity of each supporter's defense of her/his favorite speaks to a particular quality of figure skating and its relationship to its viewers. For figure skating is notorious for its provocation of histrionics, from the outlandish and fluid standards of judging to the dramatic question that is raised every time a skater glides onto the ice: will she fall?

Falls are the unconscious of figure skating, the dangerous id that can emerge at any time and upset years of preparation and devotion. There is a hierarchy of falling in skating: there are near falls and real falls. When a skater's hand touches down after a jump or a landing is two-footed, then we are witnessing a near fall, the possible prelude to a real fall. Among the real falls, there are variations of degree, from awkward but recoverable stumbles onto the ice to splats in which the graceful, athletic body is out of control. A real fall is always potentially catastrophic, but it offers the opportunity to witness the gumption of the athlete in his or her recovery time. More than one fall signifies a crumbling of confidence.

The fear of falling is a factor in all figure skating, whether the competitors are male or female. Brian Boitano's performance at the 1994 Olympics was ultimately reducible to a single moment, repeated on television replays over and over again (as such moments always are), in which he fell during his short program. But I want to argue that the fear of falling has special significance for women skaters, and in particular for the relationship that exists between female spectators and female skaters. Perhaps more than any other spectator sport, women's figure skating relies on the precarious balance between athleticism and the display of grace – that is, femininity. The fall shatters the balance and in particular disrupts the performance of femininity.

[. . .]

Given how central female spectatorship has been in film, television, and mass culture studies of the past decade, it is useful to consider how and to what extent the female spectators identified in other forms of mass culture might relate to female spectators of figure skating. Studies such as Tania Modleski's analysis of soap operas and popular fiction (1984) and Janice Radway's examination of romance novels (1991) have put into question the supposedly simple, transparent ways in which women respond to these examples of mass culture. For while neither Modleski nor Radway questions the strength of women's identifications, they do not assume that identification to be a simple matter of identifying with cultural ideals of femininity.

Figure skating offers a display of grace and femininity to which women in this culture are presumed to aspire; in this sense, figure skating offers a spectacle of identification. Indeed, one could go so far as to say that the presentation of figure skating keeps female athleticism within safe boundaries by constantly emphasizing the grace and prettiness of skaters. But then there is the nagging question of the fall – and of the fact that what spectators actually see in watching figure skating is less an idealized spectacle of femininity than the potential acting out of the *failures* of femininity.

Very schematically, and following work on female spectatorship in film, we could define the significance of falling in figure skating in two very different ways. Imagine yourself watching a favorite performer as she takes the ice. One of the minibios that often accompany televised coverage of ice skating has emphasized how much she has struggled to achieve perfection. As she takes the ice, you are excited and nervous for her. She glides, she spins, she turns, and then she is ready to jump. She falls. You gasp. You blink. You hurt for her. You share her pain. You have identified with her so closely. Now imagine yourself watching another skater, one about whom you have some suspicions. As she glides confidently across the ice, you find yourself a bit contemptuous of her. Who does she think she is? She completes her first triple

combination, and you begrudgingly join in the praise of the television commentators. But then she two-foots a landing of a jump, and you find yourself becoming edgy and, if truth be told, hopeful. On her next jump she falters and spills, legs akimbo, across the ice. You laugh.

Those familiar with recent film theory concerning spectatorship and female spectatorship in particular will recognize these two scenarios: in the first case there is an excess of identi-fication, leaning toward a masochistic desire; in the second, there is distance from the image produced by identifying with the imagined male spectator, and attendant sadistic pleasure in the falling apart of the image of femininity (Doane 1991, esp. chaps. 1, 2). In the first case there is imagined closeness to the skater; in the second, distance from her. For the purpose of this essay, the particular dynamics of cinematic identification as rendered through psycho-analysis are less significant than the simultaneity of closeness and distance. The relationship of female spectatorship to figure skating is to be found in the particular way in which iden-tification and distance intersect. The most common popular conception of Nancy Kerrigan and Tonya Harding was that spectators "identified" with Kerrigan and "distanced themselves" from Harding, that there was hope that Kerrigan would succeed and that Harding would fall. The news reporter who functioned as the narrator of *Tonya and Nancy: The Untold Story* puts it quite bluntly near the conclusion of the televised movie. Over an image of Tonya Harding, he says: "Imagine how it would feel to know that 100 million people want you to fall." And over a contrasting image of Nancy Kerrigan, he says: "Image how it would feel to know that if you fall you would fail 100 million people."

But if Harding and Kerrigan embodied an opposition between distance and closeness, between hoping she falls and fearing she'll fall, it is far more typical for those responses to exist simultaneously. There is nothing particularly new about this hypothesis concerning the simultaneity of closeness and distance; this is precisely what many feminist theorists have argued about the nature of women's responses to many different forms of mass culture, from Modleski's argument that the female villain in soap operas provides both an object of scorn and a projection of power, to Radway's claim that women identify with romance novels because the male characters that inhabit them exhibit a utopian synthesis of male and female qualities. What is particular about spectatorship and figure skating is the significance of falling. Films, television programs, and novels may have symbolic ruptures; ice skating performances have real ones, when the fragility of performance is amply on display. Few televised specta-cles offer such consistent possibilities for disruption. And when a skater falls, the performance is shattered, perhaps momentarily, but often irreparably. Put another way, the significance of the fear of falling lies in a particular contract established between spectator and skater; the rupture of performance is immediate.

[. . .]

[S]o much of the experience of watching figure skating involves the anticipation of or reaction to the fall that one begins to suspect that part of the appeal of the sport for women viewers is less the simple exhibition of femininity than the exhibition of femininity as a perfor-mance fraught with danger and the possibilities of failure.

[. . .]

[T]he pleasures of watching figure skating for women involve identification with and anxiety about feminine ideals simultaneously, as well as a certain satisfaction in witnessing possible spectacles of humiliation. Indeed, as much as the story of Harding and Kerrigan seemed to play on the desire to separate the bad girl and the good girl, and to see the bad girl fall and the good girl skate "flawlessly," the aftermath of the Olympic competition demon-strated how the appeal of figure skating lies in the very fluidity of the boundaries separating good girl and bad girl. For after Oksana Baiul won the gold medal, a new set of opposing

pairs emerged. Baiul is an interesting study in contrasts, a young woman who skates with remarkable confidence (and with an equally remarkable persona) and who virtually always seems to be sobbing once she is off the ice. This contrast is also a variation on the fear of falling, but now in Baiul's case the question becomes when she will cry rather than when she will fall. As is well known, Nancy Kerrigan complained loudly when she mistakenly assumed that Baiul was reapplying her makeup before the Olympic presentation ceremony. Suddenly, it became common for Kerrigan to be criticized as a prima donna. During the exhibition of medal winners, Kerrigan stumbled and performed far from "flawlessly." My guess is that many female spectators were not only waiting for it to happen but were secretly enjoying the spectacle of the fall. As much as women's figure skating may embody fantasies of perfect and idealized femininity, the fear of falling makes this a spectator sport in which the fall from grace is every bit as, if not more, appealing than perfection.

References

Cahn, Susan K. 1994. *Coming on Strong: Gender and Sexuality in Twentieth-Century Women's Sport*. New York: Free Press.

Doane, Mary Ann. 1991. *Femmes Fatales: Feminism, Film Theory, Psychoanalysis*. New York: Routledge. [See Chapter 11 in this volume.]

Feder, Abigail M. 1994. " 'A Radiant Smile from the Lovely Lady': Overdetermined Femininity in 'Ladies' Figure Skating." *TDR (The Drama Review)* 38, no. 1: 62–78.

Modleski, Tania. 1984. *Loving with a Vengeance: Mass-Produced Fantasies for Women*. New York: Methuen. [See Chapter 34 in this volume.]

Nelson, Mariah Burton. 1994. *The Stronger Women Get, the More Men Love Football: Sexuality and the American Culture of Sports*. New York: Harcourt Brace.

Radway, Janice. 1991. *Reading the Romance: Women, Patriarchy, and Popular Literature*, 2nd ed. Chapel Hill: University of North Carolina Press.

Body

T HE SECTION "BODY" MARKS THE EMERGENCE of a philosophical and sociological interest in theorizing the social relations of the embodied subject in the post-WWII period (see Mary Douglas (Chapter 42)). Klaus Theweleit's (Chapter 43) groundbreaking analysis in his book *Male Fantasies* of the production of the male subject as inviolate in fascist literature exemplifies the best of this confluence of psychoanalysis, historical consciousness, and feminism.

This broad interest in the body was paralleled, as Judy Chicago and Miriam Schapiro's (Chapter 8) text makes clear, by an exploration of the relation between the body and the image on the part of artists and theorists in the 1960s and early 1970s – the effusion of body and performance art, as well as of "central core" and other types of body-related imagery, during this period exemplifies this interest. Chicago and Schapiro, who wrote this essay as an extension of their broad – and explicitly feminist – pedagogical efforts during this period, argue polemically for a new acknowledgment of the role of the body in conditioning the forms and content of women's art.

While some theorists outside the art world continued to address issues of embodiment from the mid-1970s to the mid-1980s (see Julia Kristeva (Chapter 45)), by and large visual arts discourse shut out considerations of embodiment during this period, even arguing explicitly against the representation of the female body as necessarily playing into the fetishistic structure of the male gaze outlined by Mulvey in her 1975 essay (Chapter 9; and see Kelly (1981) and Griselda Pollock (Chapter 13)). Even art criticism and practice that were not explicitly feminist, per se, also largely turned away from the body as New York dominated art discourse promoted and marketed appropriation art and an avant-gardist approach to representation, wherein a "proper" critical practice, it was argued, would refuse the fetishistic relation of the male gaze by distancing the viewer rather than allowing him visual pleasure.

Andrea Dworkin's (Chapter 44) powerful polemic against pornography – which argues that seeing the woman's body in pornography is having her – is one of the most extreme examples of the notion of a representation of a woman's body as necessarily being politically disadvantageous for women. In Dworkin's case, the representation collapses into the real: there is no distinction between a picture and a body (the "fetish" is the "real thing"). Dworkin's brief essay points to, but – in its extremity and its rejection of pornography tout

court – certainly does not represent the whole of the extended debates within feminist studies of visual culture on pornography.

The late 1980s and 1990s witnessed a reemergence of more nuanced views about the usefulness of addressing embodiment in relation to visual experience; the body became an increasingly common trope of analysis and a common reference for visual artists – especially a new generation of women and other artists from previously marginalized or oppressed groups – during this period. A new generation of feminist writers and image-makers returned with a vengeance to the body, sometimes in explicit reaction against the "anti-body" arguments of previous dominant feminist discourse. Women artists once again began exploring the body and its capacity, through abjection and flow (see Douglas, Theweleit, and Kristeva), to disrupt the structures of social institutions such as the art world (the deliberately "nasty" paintings of Sue Williams are exemplary in this regard). For feminist image-makers, such a disruption provided a more powerful tool of intervention in the late Reagan–Thatcher era than critiquing or seeking to undercut or reverse the male gaze through avant-gardist strategies of distanciation.

Susan Leigh Foster (Chapter 50), whose practice and theory has provided a crucial feminist intervention into the field of dance, here examines the "phallic" ballerina – "fleshing" her out by providing her with "an origin, a history, and an anatomy." As a quintessentially embodied medium, dance – through Foster's critical practice – is wrest from the idealizations of the concert hall. The bodies of those "seven-year-old girls . . . pull[ing] on their pink tights" all over the world to practice ballet, as Foster points out, are being disciplined into maintaining the rationalized, "phallic" form of the ballerina and thus into perpetuating an impossible, fetishistic femininity constructed to palliate heterosexual masculine anxieties.

Judith Butler's (Chapter 46) arguments about the potential of performative acts to transform normative gender and sexual relations were extremely fruitful in setting a framework for new ways to think about images as *enactments of* particular embodied subjects (rather than, necessarily, frozen fetishes for male viewers' delectation). Butler's model of performativity offered a way of moving away from the rigid formulae of the "gaze" and the "fetish," which seemed by this point (1988) somewhat outmoded as ways of understanding how images condition women's position in society.

By the late 1980s, then, an increasing flow of feminist essays on embodiment and visuality completed the shift away from a strict Freudian or Lacanian model of understanding power relations and fetishism towards a model insisting on embodiment of both subjects making and subjects viewing the work. The essays of Sue-Ellen Case (Chapter 47), Janet Wolff (Chapter 48), Deborah Fausch (Chapter 49), Susan Bordo (Chapter 51), and Moira Gatens (Chapter 52) thus pivot around the body as the means by which gender is made manifest or visualized through social codes and, through interpretation, is given meaning. Each author explores how particular bodies project and are interpreted in different visual contexts. Focusing on the explicitly lesbian feminist performance work of Peggy Shaw and Lois Weaver, Case offers a new way of thinking the category "feminist subject," one allowing for different sexual positionalities.

Wolff and Bordo are two of the key figures in the development of a feminist model for analyzing visual culture. Wolff complicates the conception of the "female body" to argue strongly – against the 1980s' prohibition of attention to the body – that "a feminist cultural politics of the body *is* a possibility." Extending her earlier work, in *Unbearable Weight*, on media images of ideal female bodies, Bordo, in "Never Just Pictures," deploys a Marxist concept of ideology as false consciousness to argue that fashion and advertising photographs

manufacture endless false images of women's bodies as extremely thin, taking their cue from but also reinforcing the explosion of eating disorders and destructive body images for girls and women. Bordo also theorizes the deeper causes of our culture's fixation on slenderness, pinpointing the fear of the "too much" woman and the racial and ethnic codes attached to such a threatening figure.

Working within feminist architectural theory, a burgeoning field, Deborah Fausch takes a more phenomenological approach to embodied, gendered subjectivity. Fausch argues that architecture, as "an art which directly engages the body, . . . has the potential to be feminist" because it allows women to "have a body without *being* the body." Moira Gatens, too, presents a more holistic, phenomenological theory, engaging the philosophy of Spinoza to argue for the profound interconnection of body and mind in the experience and articulation of sex and gender.

The body, then, becomes one of the most productive avenues of intervention and analysis for the feminist study and practice of visual culture. By attending to, rather than repressing or disavowing, our embodiment as informing our conception and experience of gender in ourselves and others, these writers expand the feminist understanding of how visuality contributes to our understanding of who we are as embodied subjects.

References and further reading

Albright, Ann Cooper. *Choreographing Difference: The Body and Identity in Contemporary Dance*. Middletown, Conn.: Wesleyan University Press and Hanover, NH: University Press of New England, 1997.

Banes, Sally. *Dancing Women: Female Bodies on Stage*. London and New York: Routledge, 1998.

Betterton, Rosemary. *An Intimate Distance: Women, Artists, and the Body*. London and New York: Routledge, 1996.

Bordo, Susan. *Unbearable Weight: Feminism, Western Culture, and the Body*. Berkeley and Los Angeles: University of California Press, 1993.

Butler, Judith. *Bodies That Matter: On the Discursive Limits of "Sex"*. London and New York: Routledge, 1993.

Gallop, Jane. *Thinking Through the Body*. New York: Columbia University Press, 1988.

Gibson, Pamela Church and Gibson, Roma, eds. *Dirty Looks: Women, Pornography, Power*. London: BFI Press, 1993.

Grosz, Elizabeth. *Volatile Bodies: Toward a Corporeal Feminism*. Bloomington: Indiana University Press, 1994.

Jones, Amelia. *Body Art/Performing the Subject*. Minneapolis: University of Minnesota Press 1998.

Jones, Amelia and Stephenson, Andrew, eds. *Performing the Body/Performing the Text*. London and New York: Routledge, 1999.

Kelly, Mary. "Re-Viewing Modernist Criticism" (1981). *Imaging Desire*. Cambridge, Mass.: MIT Press, 1996.

Meskimmon, Marsha. *The Art of Reflection: Women Artists' Self-Portraiture in the Twentieth-Century*. London: Scarlet Press, 1996.

Nead, Lynda. *The Female Nude: Art, Obscenity and Sexuality*. London and New York: Routledge, 1992.

Schneider, Rebecca. *The Explicit Body in Performance*. London and New York: Routledge, 1997.

Solomon-Godeau, Abigail. "The Legs of the Countess." *October* 39 (Winter 1986).

Stiles, Kristine. "Never Enough is *Something Else*: Feminist Performance Art, Avant-Gardes, and Probity." *Contours of the Theatrical Avant-Garde: Performance and Textuality*. James M. Harding, ed. Ann Arbor: University of Michigan Press, 2000.

Suleiman, Susan Rubin, ed. *The Female Body in Western Culture: Contemporary Perspectives*. Cambridge, Mass.: Harvard University Press, 1986.

"Vulvamorphia." Special issue of *Lusitania*, n. 6 (1994).

Warr, Tracy, ed. *The Artist's Body*. London: Phaidon Press, 2000.

Williams, Linda. *Hard Core: Power, Pleasure, and the Frenzy of the Visible*. Berkeley and Los Angeles: University of California Press, 1989.

MARY DOUGLAS

EXTERNAL BOUNDARIES

THE IDEA OF SOCIETY is a powerful image. It is potent in its own right to
control or to stir men to action. This image has form; it has external boundaries, margins,
internal structure. Its outlines contain power to reward conformity and repulse attack. There
is energy in its margins and unstructured areas. For symbols of society any human experi-
ence of structures, margins or boundaries is ready to hand.

Van Gennep shows how thresholds symbolise beginnings of new statuses. Why does the
bridegroom carry his bride over the lintel? Because the step, the beam and the door posts
make a frame which is the necessary everyday condition of entering a house. The homely
experience of going through a door is able to express so many kinds of entrance. So also are
cross roads and arches, new seasons, new clothes and the rest. No experience is too lowly
to be taken up in ritual and given a lofty meaning. The more personal and intimate the source
of ritual symbolism, the more telling its message. The more the symbol is drawn from the
common fund of human experience, the more wide and certain its reception.

The structure of living organisms is better able to reflect complex social forms than door
posts and lintels. So we find that the rituals of sacrifice specify what kind of animal shall be used,
young or old, male, female or neutered, and that these rules signify various aspects of the situa-
tion which calls for sacrifice. The way the animal is to be slaughtered is also laid down. The
Dinka cut the beast longitudinally through the sexual organs if the sacrifice is intended to undo
an incest; in half across the middle for celebrating a truce; they suffocate it for some occasions
and trample it to death for others. Even more direct is the symbolism worked upon the human
body. The body is a model which can stand for any bounded system. Its boundaries can repre-
sent any boundaries which are threatened or precarious. The body is a complex structure. The
functions of its different parts and their relation afford a source of symbols for other complex
structures. We cannot possibly interpret rituals concerning excreta, breast, milk, saliva and the
rest unless we are prepared to see in the body a symbol of society, and to see the powers and
dangers credited to social structure reproduced in small on the human body.

[. . .]

[W]e should classify carefully the contexts in which body dirt is thought of as powerful.
It may be used ritually for good, in the hands of those vested with power to bless. Blood, in
Hebrew religion, was regarded as the source of life, and not to be touched except in the
sacred conditions of sacrifice. Sometimes the spittle of persons in key positions is thought
effective to bless. Sometimes the cadaver of the last incumbent yields up material for anointing
his royal successor. For example, the decayed corpse of the last Lovedu queen in the
Drakensberg mountains is used to concoct unguents which enable the current queen to control
the weather (Krige, pp. 273–4). These examples can be multiplied. They repeat the analysis
in the previous chapter of the powers attributed to the social or religious structure for its

own defence. The same goes for body dirt as ritual instrument of harm. It may be credited to the incumbents of key positions for defending the structure, or to sorcerers abusing their positions in the structure, or to outsiders hurling bits of bone and other stuff at weak points in the structure.

But now we are ready to broach the central question. Why should bodily refuse be a symbol of danger and of power? Why should sorcerers be thought to qualify for initiation by shedding blood or committing incest or anthropophagy? Why, when initiated, should their art consist largely of manipulating powers thought to inhere in the margins of the human body? Why should bodily margins be thought to be specially invested with power and danger?

First, we can rule out the idea that public rituals express common infantile fantasies. These erotic desires which it is said to be the infant's dream to satisfy within the body's bounds are presumably common to the human race. Consequently body symbolism is part of the common stock of symbols, deeply emotive because of the individual's experience. But rituals draw on this common stock of symbols selectively. Some develop here, others there. Psychological explanations cannot of their nature account for what is culturally distinctive.

Second, all margins are dangerous. If they are pulled this way or that the shape of functional experience is altered. Any structure of ideas is vulnerable at its margins. We should expect the orifices of the body to symbolise its specially vulnerable points. Matter issuing from them is marginal stuff of the most obvious kind. Spittle, blood, milk, urine, faeces or tears by simply issuing forth have traversed the boundary of the body. So also have bodily parings, skin, nail, hair clippings and sweat. The mistake is to treat bodily margins in isolation from all other margins. There is no reason to assume any primacy for the individual's attitude to his own bodily and emotional experience, any more than for his cultural and social experience. This is the clue which explains the unevenness with which different aspects of the body are treated in the rituals of the world. In some, menstrual pollution is feared as a lethal danger; in others not at all. In some, death pollution is a daily preoccupation; in others not at all. In some, excreta is dangerous, in others it is only a joke. In India cooked food and saliva are pollution-prone, but Bushmen collect melon seeds from their mouths for later roasting and eating (Marshall-Thomas, p. 44).

Each culture has its own special risks and problems. To which particular bodily margins its beliefs attribute power depends on what situation the body is mirroring. It seems that our deepest fears and desires take expression with a kind of witty aptness. To understand body pollution we should try to argue back from the known dangers of society to the known selection of bodily themes and try to recognise what appositeness is there.

In pursuing a last-ditch reduction of all behaviour to the personal preoccupations of individuals with their own bodies the psychologists are merely sticking to their last.

> The derisive remark was once made against psychoanalysis that the unconscious sees a penis in every convex object and a vagina or anus in every concave one. I find that this sentence well characterises the facts.
>
> (Ferenczi, *Sex in Psychoanalysis*, p. 227, quoted by Brown)

It is the duty of every craftsman to stick to his last. The sociologists have the duty of meeting one kind of reductionism with their own. Just as it is true that everything symbolises the body, so it is equally true (and all the more so for that reason) that the body symbolises everything else. Out of this symbolism, which in fold upon fold of interior meaning leads back to the experience of the self with its body, the sociologist is justified in trying to work in the other direction to draw out some layers of insight about the self's experience in society.

If anal eroticism is expressed at the cultural level we are not entitled to expect a population of anal erotics. We must look around for whatever it is that has made appropriate any cultural analogy with anal eroticism. The procedure in a modest way is like Freud's analysis of jokes. Trying to find a connection between the verbal form and the amusement derived from it he laboriously reduced joke interpretation to a few general rules. No comedian scriptwriter could use the rules for inventing jokes, but they help us to see some connections between laughter, the unconscious, and the structure of stories. The analogy is fair for pollution is like an inverted form of humour. It is not a joke for it does not amuse. But the structure of its symbolism uses comparison and double meaning like the structure of a joke.

[. . .]

References

Brown, Norman, O., 1959. *Life against Death*, London.
Krige, E. J. and J. D., 1943. *The Realm of a Rain Queen*. London.
Marshall-Thomas, E., 1959. *The Harmless People*. New York.
Van Gennep, 1909. *Les Rites de Passage*. (English translation 1960).

Chapter 43

KLAUS THEWELEIT

STREAMS/ALL THAT FLOWS and WOMAN: TERRITORY OF DESIRE

Streams

All that flows

"**WHO DOES NOT FEEL** in the flows of his desire both the lava and the water?"[1] Deleuze and Guattari pose that question in *Anti-Oedipus*, referring to every person in whom the flow of the streams of desire isn't, and hasn't been, impeded. Perhaps the best evidence that this is no mere metaphor is the fact that Wilhelm Reich attempted to describe the pleasurable feelings of orgasm as a "streaming" (*Strömen*) and the abatement of physical tension as a "streaming away" (*Abströmen*).[2]

One look at the history of medicine, psychology, philosophy, or biology is enough to show that attempts to understand human functioning with the notion of "flowing" are part of a long tradition.

[. . .]

The formulation of the later Freud, "Where id was, there ego shall be,"[3] can thus be seen as a program for eliminating the machinic and the flowing from the productions of the human unconscious: shutting down and draining. Indeed the idea is formulated word for word in Freud's comparison of the process of ego formation ("culture-work") to the draining of the Zuider Zee.[4] The person capable of being described by the ego-id-superego topography would in this case be conceived as a dry grave, the final resting place of streams and desiring-machines. This ties in with an assumption whose validity will have to be proved later on: that the *concrete* form of the struggle against the flowing-machinic productive force of the unconscious has been (and still is) a battle against women, against female sexuality.

Given that the channeling of streams and shutting down of desiring-machines became constituent elements of Freudian psychoanalytic thinking, it seems obvious that Freudian concepts have only a limited capacity for describing the psychophysical processes leading to the struggle to suppress female sexuality (and to suppress the productions of the unconscious in general). I'll therefore begin by trying to gather support from writers who haven't closed themselves off to feeling "the lava and the water in the streams of their desire," and letting them flow. In the writings of these authors from various continents and societies, particular bodies of water find a home, and the reader is free to drift along on them for a while, or offer resistance, as s/he wishes.

> Say, you are in the country, in some high land of lakes. Take almost any path you please, and ten to one it carries you down in a dale, and leaves you there by a pool in a stream. There is a magic in it. Let the most absentminded of men be plunged in his deepest reveries – stand that man on his legs, set his feet a-going, and he will infallibly lead you to water, if water there be in all that region.

It is *precisely* the most absentminded of men who will find his way to water, we should add, if that is the element in which desires flow. But it affects everyone:

> thousands upon thousands of mortal men fixed in ocean reveries. . . . But these are all landsmen; of weekdays pent up in lath and plaster – tied to counters, nailed to benches, clinched to desks. How then is this? Are the green fields gone? What do they here?
>
> But look! here come more crowds, pacing straight for the water and seemingly bound for a dive.[5]

The same compulsion is felt by Isaac himself, narrator of Melville's *Moby Dick*. He has to go down to the sea at regular intervals; if he stays on land too long, he will start knocking people's hats off.

> Yet the springs their word forever keep:
> The water continues to sing in its sleep.

– The emotions of Eduard Mörike, a rural pastor in the Swabian town of Cleversulzbach.[6]

> Let them come, the ovaries of the water,
> Where the future stirs its tiny head

– of Aimé Césaire, an African revolutionary from the Antilles.[7] For the North American poet, Walt Whitman, a view across the wide expanses of the USA fails to bring fulfillment.[8]

O something unpro'd! something in a trance!
To escape utterly from others' anchors and holds!

Mayakowski:

Break free of those played-out Caspian waves!
No going back to Riverbed-Russia!
 We want to
Dance and raise hell
 with the Mediterranean waves,
Not in rotting Baku, but in bright Nizza.[9]

That was his hope for the Soviet Union – in vain. The riverbed called Stalin began his
rise in Baku and never set eyes on the Mediterranean. For Solzhenitsyn in *The Gulag Archipelago*,
it was literally streams of prisoners that Stalin channeled into the camps, those enormous
gullies where life and desire trickled away.

The hatred of life, of everything that runs or flows freely . . .

It was to combat this hatred that Henry Miller, German by heritage, living by choice in
France, passported United States citizen, and cosmopolitan Jew issued his streams of words:

They cut the umbilical cord, give you a slap on the ass, and
presto! you're out in the world . . . a ship without a rudder.[10]

. . . Stop it now! If you mention
Landing again, I tell you,
I'll jump overboard, right before your eyes.[11]
 (Saint-John Perse)

Ocean, I don't think the earth
Has any voice to answer with
That sounds as happy as you.[12]
 (Rafael Alberti)

Or the Chilean revolutionary Pablo Neruda, whose verses overflow in praise of waters:

. . . Your profound energy
Seems to glide onward, never exhausting itself;
Seems to return to its own peace.
The wave that rushes out from you,
Consubstantial arch, stellar spring,
Was, in crashing, only froth,
And rolled back to arise anew, unconsumed,
All your strength returns to be a source
. . .
The universe basin quakes with your salt and your honey,
The hollow space encompassing all waters,
And you are lacking nothing.[13]

Thus the flowing of the libido is sung. Its most fundamental principle is to land, then drift freely along again; to have no prescribed goal, because everything is its object. The waters flow to every shore and from every shore. Out of that comes an assurance (more than an intimation) of happiness: "And you are lacking nothing."[14]

> Lord, ain't don't got a bone in his jelly-back.
> Floating every day and every night, riding high,
> then there's a rest, sometimes the wind ain't right.
> (Jimi Hendrix knew: With the Power of Soul)

It is the desire for a life free from lack – or writing extravagantly in the knowledge of abundance (as Bataille would say) – that permits writers from different societies and regions to arrive at such similar ideas when trying to describe states, or expectations, of happiness. They are rooted in a feeling they must all have felt: the actual experience of nonlack in the streaming of pleasure through their own bodies.

> Desire causes the current to flow, itself flows in turn, and breaks the flows. "I love everything that flows, even the menstrual flow that carries away the seed unfecund," writes Henry Miller in his ode to desire. Amniotic fluid spilling out of the sac and kidney stones, flowing hair, a flow of spittle, a flow of sperm, shit, or urine that is produced by partial objects and constantly cut off by other partial objects, which in turn produces other flows, interrupted by other partial objects. Every object presupposes the continuity of a flow, the fragmentation of the object
> (Deleuze and Guattari).[15]

The streams of desire flow in *real* streams, *real* physical processes: in the stream of sperm, the stream of tears, the stream of warmth that autogenic training teaches us to direct toward our various extremities; and in the streams that flood through our musculature during orgasm. (Starobinski opens himself up to criticism here. He dispenses with real streams in a single sentence, naming only blood, lymphatic fluid, bile, and pus, so that he can enter "the realm of imaginary streams without delay.")[16]

And it isn't only *the* body in, on, and out of which things flow, but its parts – partial subjects, or "organ-machines" (as they are called in *Anti-Oedipus*). These processes are not initiated by the body, or the person, as a whole:

> Doubtless each organ-machine interprets the entire world from the perspective of its own flux, from the point of view of the energy that flows from it: the eye interprets everything . . . in terms of seeing.[17]

And so on.

The Oedipal triangle, its vertices defined by the father-mother-child configuration, uses the lines connecting those vertices to superimpose itself on the current of streams. It cuts off streams, channels them, directs them toward father/mother without allowing them to get there. Sublimation: a highly ramified canal-and-drainage system. Yet:

> Flows ooze, they traverse the triangle, breaking apart its vertices. The Oedipal wad does not absorb these flows, any more than it could seal off a jar of jam or plug a

dike. Against the walls of the triangle, toward the outside, flows exert the irresistible pressure of lava or the invincible oozing of water.[18]

The streams don't need an "ego" to act as a dam and mediator. In Henry Miller's experience:

and my guts spill out in a grand schizophrenic rush, an evacuation that leaves me face to face with the Absolute.[19]

In *Crowds and Power* (*Masse und Macht*), Elias Canetti talks about a "mythical primitive age . . . when transformation was the universal gift of every creature and happened all the time. The *fluidness* of that world has often been emphasized. You could change yourself into anything at all, but you also had the power to change others. Out of that universal flowing emerged individual shapes that were simply fixations of specific transformations. . . . The *process* of transformation, in other words, is the oldest shape there is."[20]

"Being at the mercy of the alien" was part and parcel of this process. In the resultant fears, Canetti saw the reason why an "urge for permanence and hardness" had to arise in humans.[21] But did it really *have to*? Canetti's terminology is contradictory here. What can *alien* mean to someone who is in constant flux? Wouldn't it just be an *Other*, a renewal each time (though perhaps threatening as well)? Even the term "transform" seems unfortunate, since it presupposes a definable, *true* nature, which a person can move away from the back toward. Rather than a "process of transformation," the "oldest pattern" would be a flowing between two transitory points: "Now what?" . . . "So that's what that was" . . . "Now what?"

It seems unlikely that a human desire itself would limit the flowing of its streams or the fluidity of its form – Canetti ignores the attendant *pleasures* – in order to assume a fixed, confining external shape. It seems far more likely that the rigidity and permanence of bodily boundaries and psychic systems have been set up by external social constraints and natural adversity – a dam built around flowing desire by hostile forces.

We can perhaps concede to pastors of the ego that this dam also protects us and that we need it. Still, we have to ask what it is protecting us from. Is it the adversities of the outside world or something within ourselves? "[A]nd my inner being pours out in a massive schizophrenic eruption," spilling me perhaps into the waiting arms of a clinical physician, with his insulin needle? It is this that I can and must fear and protect myself against. But what if the dams are meant for the essence of the eruption itself? What if they have been erected against our own innermost flows, because those flows are seen as some lethal *evil*, rather than as pleasure?

In narrative literature of the nineteenth century, there is a remarkable proliferation of characters whose "inner" (true) and "outer" (social) natures are divided. Characteristic of this kind of split is the antagonism between the "inner" and "outer" natures. Dr. Jekyll, the promising young scientist, is about to abandon his risky experiments along with his other youthful sins, in order to enter into a love-marriage with a general's daughter. But after drinking the potion that exposes his inner being to the outside world, he is transformed (the notion of transformation fits in this case) into Mr. Hyde. He has to become Mr. Hyde, because otherwise social convention would delay the redeeming union with his beloved *too long*. In any case, Mr. Hyde abandons himself to the inner stream that will bring about his death.[22]

The stream flows *within*, as it does in our fascist texts. But in this case *contact with oneself* produces not fear, but pleasure – albeit a pleasure deriving from "evil." The millstream *flows*: it is no "numbly glowing, fluid ocean." And Hyde isn't the night owl "that has mistakenly flown into the glaring noonday sun." Robert Louis Stevenson allows him to reach, and to *relish*, the stream of evil and of intoxication in a fully conscious state. This is something the

villains of English and German romanticism have in common. It's a *game* that gradually becomes more serious, until finally the transformation is irreversible and the outcome is death – immersion in the dead sea of evil that first felt like an ocean of freedom.

In the fascist texts, we saw that any contact between "inner" and "outer" realms – any boundary transgression – immediately shuts off consciousness, producing a trancelike state. Dr. Jekyll descends to his inner streams as an *ego*; by contrast, Jünger, Schauwecker, and Dwinger's eruptions occur *as if of their own accord*, triggered with the help of the war. The men are at their mercy. Dr. Jekyll's dilemma seems like a preliminary stage of this later state. The decisive element of Jekyll is his splitting. The bodily exterior and its borders form a cohesive totality; they have ceased to be an arrangement of loosely connected part-objects, a transit system for streams en route to the production of social reality. The inner stream is seen as something *sinful*, as the evil "that was originally inside of me." It is only fitting that it should be penned in.

Almost always, it is scientists who are made to transgress *inner* boundaries and discover they've gone "too far." Others who go too far are those who violate *outer* boundaries. Rather than being transformed by some potion, they discover to their horror (after planning and constructing an actual creature, a machine that is the human being of their dreams) that they have given form to the "evil" within themselves, which immediately sets out to destroy both their lives and itself. This is what happened to Mary Shelley's Dr. Frankenstein.[23]

Odd, isn't it, that just when natural scientific theory and practice are advancing more rapidly than ever before in human history, the literatures of contemporary societies produce a string of scientists who come to ruin by immersing themselves in that far-reaching stream of knowledge and discovery? What taboo have they violated? In every instance, it is the taboo against extending their research to human beings – to themselves and their own bodies. They run up against the forcibly maintained religion of capitalism, which decrees that human beings should remain an unfathomable mystery (where their potential for freedom is concerned). The only thing open to investigation is human exploitability.

The contradiction runs as follows: the process of primary accumulation in industry opens up the borders of a hitherto unknown human productive potential, setting in motion streams of money, commodities, and workers, and propelling itself forward on the streams of sweat and blood of workers and non-European peoples. Running parallel to that is a process of *limitation*, directed against the evolution of human pleasures. Deleuze and Guattari call the first process *deterritorialization* – the opening up of new possibilities for desiring-production across the "body with organs" – and the second process *reterritorialization*, which is the mobilization of dominant forces to prevent the new productive possibilities from becoming new human freedoms.[24] We'll look next at the course taken by reterritorialization in bourgeois history as a whole; that is, at how anything that flowed came to inspire the kind of fear we have seen in our soldier males.

To begin with, the work of reterritorialization constructs human subjects as *masters* of the machine – as directors and channelers of their own, and of social, streams. This is a reactionary undertaking, for the object of such efforts is their own unconscious: production is blocked here, while streams of money flow on.

Those who hear the machines that are ticking away within themselves, who open up and make the connection to their own streams of desire, and who dream of a new human being at a time when the emergent class is busy exploiting the old one – these are the condemned, the damned. Witness Jekyll, Frankenstein, or Jules Verne's clockmaker Zacharias, whose soul is a mainspring that confers immortality, and who dies when the devil robs him of it.[25] Witness Ambrose Bierce's Mr. Moxon, who is murdered by the chess-playing machine he has built,

after defeating it in a game. There are many others: sorcerers' apprentices, killed by the streams and machines they have set loose.[26] "That kind of thing should be left to the Creator," that is, to the entrepreneurs.

More on the subject of deterritorialization/reterritorialization:

> For capitalism constantly counteracts, constantly inhibits this inherent tendency while at the same time allowing it free rein; it continually seeks to avoid reaching its limit while simultaneously tending toward that limit. Capitalism institutes or restores all sorts of residual and artificial, imaginary, or symbolic territorialities, thereby attempting, as best it can, to recode, to rechannel persons who have been defined in terms of abstract quantities. Everything returns or recurs: states, nations, families. That is what makes the ideology of capitalism "a motley painting of everything that has ever been believed." The real is not impossible; it is simply more and more artificial. Marx termed the twofold movement of the tendency to a falling rate of profit, and the increase in the absolute quantity of surplus value, the law of the counteracted tendency. As a corollary of this law, there is the twofold movement of decoding or deterritorializing flows on the one hand, and their violent and artificial reterritorialization on the other. The more the capitalist machine deterritorializes, decoding and axiomatizing flows in order to extract surplus value from them, the more its ancillary apparatuses, such as government bureaucracies and the forces of law and order, do their utmost to reterritorialize, absorbing in the process a larger and larger share of surplus value.[27]

The real is not impossible; it is simply more and more artificial. Even the production and maintenance of life are not impossible; they simply take place more and more often in illness. Here is Margaret Mahler, reporting on her young patient "Teddy":

> He was preoccupied with the fear of losing body substance, of being drained by his father and grandfather, with whom his body, he believed, formed a kind of communicating system of tubes. At night the father-grandfather part of the system drained him of the "body juices of youth." Survival depended on who was most successful in draining more life fluid from the others, he or the father and grandfather part. He invented an elaborate heart machine which he could switch on and connect with his body's circulatory system so that he would never die.[28]

Let the juices flow, in spite of all the father-grandfather (and other) systems for extracting them.

Let's stop for a minute. It should be possible now, I think, to develop some idea of what is at stake in fending off the communist surge and the Red floods. For the soldier-male dam, none of the streams we've mentioned can be allowed to flow. He is out to prevent all of them from flowing: "imaginary" and real streams, streams of sperm and desire. Even taking pleasure in the stream of evil (the kind that flows in Mr. Hyde) is impossible for him. All of these flows are shut off; more important, not a single drop can be allowed to seep through the shell of the body. One little drop of pleasure – a single minute flyspeck on the wall of a house, or a single escapee from a concentration camp – threatens to undermine the whole system (the system of dams). Those drops are more than mere metaphors; they are harbingers of imminent defeat ("we're going under").

[. . .]

Capitalism brought about a comprehensive deterritorializaton; in the course of its evolution, it dissolved every previous order and code (religious, scientific, philosophical), altering their functions and rendering them obsolete. It opened up new worlds, made new areas accessible, created new avenues for the deployment of human bodies, thoughts, and feelings, even for escaping from the existing order. Like every dominant force that wishes to remain dominant, feudal capitalism (followed by bourgeois capitalism and the bourgeois state) took up the task of blocking new possibilities, obscuring their existence, chaining them up, redirecting streams for their own benefit, "codifying" them in a way that served dominant interests, yet allowed subject peoples to retain the illusion of newfound freedom.[29]

Under no circumstances could desires be allowed to flow in their inherently *undirected* manner. Word of the ability to tie themselves to *any* object, then abandon it to form new ties in a powerful movement of affective intensities, couldn't be permitted to leak out. *Goals* had to be found, desires had to be channeled.

The new overloads, interested in the flowing of desire, at least insofar as it might bolster the flow of currency, looked then to the possibility of encoding. Streams of desire were encoded as streams of money, and circulation replaced free trajectories. The end result: a strictly limited number of infinitely capacious counting rooms under private ownership; and for the rest, the shackles of wages and the lure of (state-controlled) gambling operations. How quickly did the promise of America as the land of limitless opportunity become synonymous with the unlimited chance of making money! The sad thing wasn't so much that the slogan "From dishwasher to company boss" was ideological or untrue, as the fact that desire had been reduced to that narrow ambition.

From the flowing of desire to the flowing of money. What precisely this involved was captured by the Donald Duck cartoonists (producing under the name of "Walt Disney") when they gave supercapitalist Uncle Scrooge the ability to swim around in his reservoirs of gold treasure. On one occasion his perennial adversaries manage to rupture the dam; the stream of gold coins spills thunderously out onto a dry riverbed. The victors don't have the heart to deny the old miser his last wish, which is to take a final dip in his river. Inspired by the sight of the old man frolicking in the stream of gold (a fish in water), they jump in after him and break their necks on the hard surface.

A further form of encoding is of greater interest to us here; it is older – probably the oldest form there is – and underwent many changes before being shaped by the gradual ascendancy of bourgeois society in Europe. I'm referring to historical changes in function to which women have been subjected in patriarchal male-female relations. Under patriarchy, the productive force of women has been effectively excluded from participating in male public and social productions. What has happened to that force? For one thing, it must have trickled away in direct slave labor for men. But I don't think that form of absorption explains everything, or that the function of women is confined to being portable power packs for men (as Borneman claims).[30] It seems to me that women were subjugated and exploited in more than simply this direct fashion. They were put to worse use, namely, by themselves having to absorb the productive force of men belonging to the subjugated classes of their eras – all to the benefit of the dominant class. What I have in mind here will become clearer, once we have come to understand the following: in all European literature (and literature influenced by it), desire, if it flows at all, flows in a certain sense *through women*. In some way or other, it always flows in relation to the image of woman. (It is far rarer for it to flow *aimlessly* as a desire for freedom, as in the recently cited examples.)

In their primary role as "powerhouse," women simply don't exist in Western literature. (The same is true of other producers of surplus value: the slave in ancient times, the peasant

in the Middle Ages, the modern worker.) In their secondary role, as a force of absorption, however, they have been a central concern – perhaps *the* central concern – of that literature. It is usual – and rightly so – to speak of a history of the female *image* in European literature, and of a history of men who made it. Somehow, that image lives in water.

[. . .]

A river without end, enormous and wide, flows through the world's literatures. Over and over again: the women-in-the-water; woman as water, as a stormy, cavorting, cooling ocean, a raging stream, a waterfall; as a limitless body of water that ships pass through, with tributaries, pools, surfs, and deltas; woman as the enticing (or perilous) deep, as a cup of bubbling body fluids; the vagina as wave, as foam, as a dark place ringed with Pacific ridges; love as the foam from the collision of two waves, as a sea voyage, a slow ebbing, a fish-catch, a storm; love as a process that washes people up as flotsam, smoothing the sea again; where we swim in the divine song of the sea knowing no laws, one fish, two fish; where we are part of every ocean, which is part of every vagina. To enter those portals is to begin a global journey, a flowing around the world. He who has been inside the right woman, the ultimate *cunt* – knows every place in the world that is worth knowing. And every one of those flowing places goes by the name of Woman: Congo, Nile, Zambezi, Elbe, Neva ("Father Rhine" doesn't flow – he is a border). Or the Caribbean Sea, the Pacific, the Mediterranean, *the* ocean that covers two-thirds of the earth's surface and all its shorelines, the irreproachable, inexhaustible, anonymous superwhore, across whom we ourselves become anonymous and limitless, drifting along without egos, like "masses of rubble," like God himself, immersed in the principle of masculine pleasure.

What is really at work here, it seems to me, is a specific (and historically relatively recent) form of the oppression of women – one that has been notably underrated. It is oppression through exaltation, through a lifting of boundaries, an "irrealization" and reduction to principle – the principle of flowing, of distance, of vague, endless enticement. Here again, women have *no names*.

[. . .]

Exaltation is coupled with a negation of women's carnal reality. No single real woman is now of any use for the noble aims and Edenic pleasures of her creative masters, who may dedicate their deeds to a woman – ever since the fourteenth century, the image of an immeasurably perfect and all-deserving "Beatrice" has always hung somewhere in the firmament – but they are resolved to carry them out *without her*. The various forms of "devotion" to women have passed themselves off as philogynous, yet the attitude they adopt seems in essence to be a secular offshoot of the Catholic cult of the Virgin. It extends even as far as to Henry Miller, who, on the one hand, is one of its frankest critics, but, on the other, introduces dissatisfaction into even the most liberated lovemaking by fixing men's hopes on the arrival of some woman in whose vagina the oceans of the world quite literally flow and by saddling women with corresponding expectations of performance. There is still more of transcendence in the "juices" he writes of than of the real wetness of the women who have made love to him. Transcendence and competition. We sense that the depersonalization of women here, the dissolving of their boundaries, is a consequence of the extreme abstractness of a desire that lacks adequate objects. And the only things preventing desires having adequate objects are barriers of domination. The link between the female image and the notion of wish fulfillment derives from these barriers.

It is not a real, living woman who appears here in relation to desire – though the man in question may have chosen a specific woman to embody his ideas – nor is it a real work of art.

[. . .]

The end products of these processes have been both highly durable and highly mutable. Their mutability has increased in the course of history, with the acceleration of processes of social transition. Femininity in particular has retained a special malleability under patriarchy, for women have never been able to be identified directly with dominant historical processes, such as those that gave rise to bourgeois society, because they have never been the direct agents of those processes; in some way or other, they have always remained objects and raw materials, pieces of nature awaiting socialization. This has enabled men to see and use them collectively as part of the earth's *inorganic body* – the terrain of men's own productions.

Behind every new frontier that is opened up, the sum total of all female bodies appears: oceans of animated flesh and virginal skin, streams of hair, seas of eyes – an infinite, untrodden territory of desire which, at every stage of historical deterritorialization, men in search of material for (abstract) utopias have inundated with their desires. It's easy enough to see that this territory was (is) unsuited to the discovery of a freer existence, and it's just as easy to see that men in power were not the ones who would enter it with that in mind. Their global voyages took place in a very different geography. Rarely did they mistake the bodies of women for that of the earth.

[. . .]

The *fictive* body of woman has become an imaginary arena for fantasies of deterritorializations, while actual male–female relationships have continued to serve, and have been actively maintained, as focal points for the implementation of massive reterritorializations. Exotic women, and women of the ruling class, have provided the raw material for those fictions. Women belonging to the oppressed classes, by contrast, have provided the material for male fears. These latter women have been victims, rather than images; they have been persecuted, not exalted.

[. . .]

Notes

1 Deleuze and Guattari, *Anti-Oedipus*, 67.
2 Wilhelm Reich, *Die Funktion des Orgasmus*, 24ff.
3 Freud, *New Introductory Lectures*, *SE*, vol. XXII, 80.
4 Ibid. The metaphor gains importance by being introduced in connection with the final idea of the lecture: the dismemberment of the psychic personality.
5 Herman Melville, *Moby Dick*, 3.
6 Eduard Mörike, "Mein Fluss," *Gesammelte Werke*, 10.
7 A. Césaire, "Notizen von einer Heimkehr," in *Schwarzer Orpheus*, edited by Jahn, 92.
8 Walt Whitman, "One Hour to Madness and Joy," in *Leaves of Grass*, 91–92.
9 W. Majakowski, "150,000,000," *Frühe Gedichte*, 94.
10 Henry Miller, *Tropic of Cancer*, 290.
11 Saint-John Perse, "Preislieder," *Oeuvres Complète*.
12 Rafael Alberti, "Arion/Einfälle über das Meer," in *Museum der Modernen Poesie*, edited by H. M. Enzensberger, 112.
13 Pablo Neruda, *Obras Completas*.
14 These are just a few examples, chosen more or less at random. Anyone who swims through the libraries of the world's literatures (as Herman Melville reported doing in order to fish up everything about whales) will find an infinite number of waters, whose flowing is that of desire. I've included more of these below. Elias Canetti, *Masse und Macht* (*Crowds and Power*), 89: "The ocean is the model for a humanity that is content, that contains everything, and into which all life empties." Stadler: "O, my desire is like dark water stored up by floodgates" ("In diesen Nächten," in *Dein Leib ist mein Gedicht*, edited by Arnold, 137). Benn: "The only music you want to hear on the radio is Volga,/Distant, alien, and coming from the steppes" ("Es gibt," *Distillationen*, 9). Benn: "Eingeengt," *Distillationen*, 39:

"Hemmed in by feelings and thoughts,/A massive stream lies within you,/Its melody limitless,/Unmournful and light and self-propelled." Benn: "Melodien," *Distillationen*, 8: "Melodies, oh yes – the question-poser pales,/No longer the counting-/and cityman./The clouds dust his camp,/The oceans strike up below." Benn: "Orpheus tod," *Statische Gedichte*, 14: "And now the lyre downriver –/The banks resound." Rafael Alberti, "Arion/Einfälle über das Meer" (see note 12):

> I opened the door. The sea
> Came to my bed so confidently
> That my dog saw it and didn't flick an ear.
> How happy I was, ocean. I went so far as to think
> I was you, and everyone already called me
> By your name. They cried, "Rafael!"
> And I could already
> Carry ships on my back.

Friederike Kempner, "Vermutlich ja," in *Frederike Kempner*, edited by G. Mostar, 92: "Little silver-blue brook, little brook in the meadow./Are you making belts there? Do you empty anywhere?" Goethe, "Buch der Sprüche 5," *Gedichte in zwei Bänden*, vol. 2, 51: "The sea flows ever,/The land holds it never." Aimé Césaire, "An Afrika," in *Schwarzer Orpheus*, edited by Jahn, 101: "Your gesture is a howling wave caught in the hollow of a beloved cliff, as though it were trying to finish giving birth to an island of rebellion." Harold Telemaque, "Wurzeln," in *Schwarzer Orpheus*, edited by Jahn, 117ff.: "Hint of cool rivers,/Fresh and sweet./The man who followed crooked coastlines/Between two seasons,/and felt the islands in his own hands,/His weight/Is the weight of dreams/From loins of fatigue." Ovidio Martins, "Salziges Gedicht," in *Afrikanische Lyrik aus zwei Kontinenten*, edited by Klemisch, 9: "I was born at the edge of the shore,/And I carry within me all the oceans of the world."

15 Deleuze and Guattari, *Anti-Oedipus*, 5–6; Miller, *Tropic of Cancer*, 261.
16 Starobinski, *Literatur und Psychoanalyse*, 24.
17 Deleuze and Guattari, *Anti-Oedipus*, 6.
18 Ibid., 67.
19 Miller, *Tropic of Cancer*, 250.
20 Canetti, *Masse und Macht (Crowds and Power)*, 429.
21 Ibid., 439.
22 Robert Louis Stevenson, *Dr. Jekyll and Mr. Hyde*.
23 Mary Shelley, *Frankenstein, or the New Prometheus* (1817). The novel is based, among other things, on an awareness that bourgeois society certainly did not expect the "New Human Being."
24 Deleuze and Guattari, *Anti-Oedipus*, 34ff.
25 Jules Verne, *Meister Zacharias (Master Zacharias)*, in *Künstliche Menschen*, edited by Völker, 264ff.
26 Ambrose Bierce, *Moxons Herr und Meister (Moxon's Master)*, in *Künstliche Menschen*, 250ff.
27 Deleuze and Guattari, *Anti-Oedipus*, 34.
28 Mahler, *Symboise und Individuation (On Human Symbiosis)*, edited by Völker, 67.
29 We will often be talking about things not only "changing," but *being* changed, *being* implemented by momentary rulers who wish to preserve their authority. A favorite related question is exactly *how* that occurs. We would not want to concoct some vague "conspiracy theory" that makes the rulers responsible for every evil, and we certainly cannot say that they always act intentionally. (Just between you and me, rulers are not smart enough for that, though an oppressor does not need to be especially bright or *conscious* of his role; he just needs to be very good at doing what is necessary for preserving power.) It seems to me that the whole question arises because people do not like to think about such unpleasant things; or perhaps the question reflects taste that is too refined to work with legal writings and administrative ordinances. Most of the processes in question have been described by Michel Foucault, "Power and Norm."
30 Ernest Bornemann, *Das patriarchat*. A sort of main theme of the work, printed on the back cover.

References

Arnold, Heinz Ludwig (ed.) *Dein Leib ist mein Gedicht*. Frankfurt, 1973.

Benn, Gottfried. *Distillationen*. Wiesbaden, 1953.

—— . *Statische Gedichte*. Zurich, 1948.

Bornemann, Ernst. *Das Patriarchat*. Frankfurt, 1975.

Canetti, Elias. *Masse und Macht* (*Crowds and Power*). Translated from the German by Carol Stewart. Harmondsworth, 1973.

Deleuze, Gilles and Guattari, Felix. *Anti-Oedipus. Capitalism and Schizophrenia*. Translated from the French by Robert Hurley, Mark Seem and Helen R. Lane. Minneapolis, 1983.

Enzensberger, Hans M. (ed.) *Museum der Modernen Poesie*. Frankfurt, 1964.

Foucault, Michel. "Notes on a lecture delivered by Foucault at the College de France, 28 March, 1973." Translated as "Power and Norm," in *Power, Truth and Strategy*, Meaghan Morris and Paul Patton (eds.). Sydney, 1979, 59–66.

Freud, Sigmund. *The Standard Edition of the Complete Psychological Works of Sigmund Freud*. Translated from the German under general editorship of James Strachey, in collaboration with Anna Freud, assisted by Alix Strachey and Alan Tyson, 24 vols. London, 1959.

Goethe, J. W. von. *Gedichte in zwei Bänden*. Frankfurt, 1964.

Jahn, Janheinz (ed.) *Schwarzer Orpheus: Moderne Dichtung afrikanischer Völker beider Hemisphären*. N.p., n.d.

Klemisch, Franz Josef (ed.) *Afrikanische Lyrik aus zwei Kontinenten*. Stuttgart, 1966.

Mahler, Margaret. *On Human Symbiosis and the Vicissitudes of Individuation*, vol. 1, *Infantile Psychosis*. New York, 1970.

Majakowski, Wladimir. *Frühe Gedichte*. Frankfurt, 1965.

Melville, Herman. *Moby Dick or the White Whale*. Berkeley, 1981.

Miller, Henry. *Tropic of Cancer*. New York, 1961.

Mörike, Eduard. *Gesammelte Werke*. Bergen, n.d. In English see *Poems*, selected and edited by Lionel Thomas. Oxford, 1960.

Mostar, Gerhart (ed.) *Frederike Kempner, der schlesische Schwan*. Munich, 1965.

Neruda, Pablo. *Oberas Completas*. Edited by M. Aguirre. Buenos Aires, 1973.

Perse, Saint-John. *Oeuvres Complètes*. Paris, 1972.

Reich, Wilhelm. *Die Entdeckung des Orgons / Die Funktion des Orgasmus*. Frankfurt, 1972. First part of the work translated by Theodore P. Wolfe under the title *The Discovery of the Orgone*. New York, 1971. Second part translated by Vincent R. Carfagno under the title *The Function of the Orgasm*. New York, 1973.

Shelley, Mary. *Frankenstein, or the New Prometheus* (1817). New York, 1977.

Starobinski, Jean. *Literatur und Psychoanalyse: Die Geschichte der imaginären Ströme*. Frankfurt, n.d.

Stevenson, Robert Louis. *Dr Jekyll and Mr Hyde*. New York, 1981.

Völker, Klaus (ed.) *Künstliche Menschen: Dichtungen und Dokumente über Golems, Homunculi, Androiden und liebende Statuen*. Munich, 1971.

Whitman, Walt. *Leaves of Grass*. Philadelphia, 1882.

ANDREA DWORKIN

PORNOGRAPHY

Consider also our spirits that break a little each time we see ourselves in chains or full labial display for the conquering male viewer, bruised or on our knees, screaming a real or pretended pain to delight the sadist, pretending to enjoy what we don't enjoy, to be blind to the images of our sisters that really haunt us – humiliated often enough ourselves by the truly obscene idea that sex and the domination of women must be combined.

Gloria Steinem, "Erotica and Pornography"

Somehow every indignity the female suffers ultimately comes to be symbolized in a sexuality that is held to be her responsibility, her shame. Even the self-denigration required of the prostitute is an emotion urged upon all women, but rarely with as much success: not as frankly, not as openly, not as efficiently. It can be summarized in one four-letter word. And the word is not *fuck*, it's *cunt*. Our self-contempt originates in this: in knowing we are cunt. This is what we are supposed to be about – our essence, our offense.

Kate Millett, *The Prostitution Papers*

I can never have my fill of killing whores.

Euripides' Orestes, in *Orestes*

THE WORD *PORNOGRAPHY*, derived from the ancient Greek *porne* and *graphos*, means "writing about whores." *Porne* means "whore," specifically and exclusively the lowest class of whore, which in ancient Greece was the brothel slut available to all male citizens. The *porne* was the cheapest (in the literal sense), least regarded, least protected of all women, including slaves. She was, simply and clearly and absolutely, a sexual slave. *Graphos* means "writing, etching, or drawing."

The word *pornography* does not mean "writing about sex" or "depictions of the erotic" or "depictions of sexual acts" or "depictions of nude bodies" or "sexual representations" or any other such euphemism. It means the graphic depiction of women as vile whores. In ancient Greece, not all prostitutes were considered vile: only the *porneia*.

Contemporary pornography strictly and literally conforms to the word's root meaning: the graphic depiction of vile whores, or, in our language, sluts, cows (as in: sexual cattle, sexual chattel), cunts. The word has not changed its meaning and the genre is not misnamed. The only change in the meaning of the word is with respect to its second part, *graphos:* now there are cameras – there is still pornography, film, video. The methods of graphic depiction have increased in number and in kind: the content is the same; the meaning is the same; the

purpose is the same; the status of the women depicted is the same; the sexuality of the women depicted is the same; the value of the women depicted is the same. With the technologically advanced methods of graphic depiction, real women are required for the depiction as such to exist.

The word *pornography* does not have any other meaning than the one cited here, the graphic depiction of the lowest whores. Whores exist to serve men sexually. Whores exist only within a framework of male sexual domination. Indeed, outside that framework the notion of whores would be absurd and the usage of women as whores would be impossible. The word *whore* is incomprehensible unless one is immersed in the lexicon of male domination. Men have created the group, the type, the concept, the epithet, the insult, the industry, the trade, the commodity, the reality of woman as whore. Woman as whore exists within the objective and real system of male sexual domination. The pornography itself is objective and real and central to the male sexual system. The valuation of women's sexuality in pornography is objective and real because women are so regarded and so valued. The force depicted in pornography is objective and real because force is so used against women. The debasing of women depicted in pornography and intrinsic to it is objective and real in that women are so debased. The uses of women depicted in pornography are objective and real because women are so used. The women used in pornography are used in pornography. The definition of women articulated systematically and consistently in pornography is objective and real in that real women exist within and must live with constant reference to the boundaries of this definition. The fact that pornography is widely believed to be "sexual representations" or "depictions of sex" emphasizes only that the valuation of women as low whores is widespread and that the sexuality of women is perceived as low and whorish in and of itself. The fact that pornography is widely believed to be "depictions of the erotic" means only that the debasing of women is held to be the real pleasure of sex. As Kate Millett wrote, women's sexuality is reduced to the one essential: "cunt . . . our essence, our offense."[1] The idea that pornography is "dirty" originates in the conviction that the sexuality of women is dirty and is actually portrayed in pornography; that women's bodies (especially women's genitals) are dirty and lewd in themselves. Pornography does not, as some claim, refute the idea that female sexuality is dirty; instead, pornography embodies and exploits this idea; pornography sells and promotes it.

In the United States, the pornography industry is larger than the record and film industries combined. In a time of widespread economic impoverishment, it is growing: more and more male consumers are eager to spend more and more money on pornography – on depictions of women as vile whores. Pornography is now carried by cable television; it is now being marketed for home use in video machines. The technology itself demands the creation of more and more *porneia* to meet the market opened up by the technology. Real women are tied up, stretched, hanged, fucked, gang-banged, whipped, beaten, and begging for more. In the photographs and films, real women are used as *porneia* and real women are depicted as *porneia*. To profit, the pimps must supply the *porneia* as the technology widens the market for the visual consumption of women being brutalized and loving it. One picture is worth a thousand words. The number of pictures required to meet the demands of the marketplace determines the number of *porneia* required to meet the demands of graphic depiction. The numbers grow as the technology and its accessibility grow. The technology by its very nature encourages more and more passive acquiescence to the graphic depictions. Passivity makes the already credulous consumer more credulous. He comes to the pornography a believer; he goes away from it as missionary. The technology itself legitimizes the uses of women conveyed by it.

In the male system, women are sex; sex is the whore. The whore is *pornē*, the lowest whore, the whore who belongs to *all* male citizens: the slut, the cunt. Buying her is buying pornography. Having her is having pornography. Seeing her is seeing pornography. Seeing her sex, especially her genitals, is seeing pornography. Seeing her in sex is seeing the whore in sex. Using her is using pornography. Wanting her means wanting pornography. Being her means being pornography.

Note

1 Kate Millett, *The Prostitution Papers* (New York: Avon Books, 1973), p. 95.

Chapter 45

JULIA KRISTEVA

APPROACHING ABJECTION

No Beast is there without glimmer of infinity,
No eye so vile nor abject that brushes not
Against lightning from on high, now tender, now fierce.
 Victor Hugo, *La Légende des siècles*

Neither subject nor object

THERE LOOMS WITHIN ABJECTION, one of those violent, dark revolts of being, directed against a threat that seems to emanate from an exorbitant outside or inside, ejected beyond the scope of the possible, the tolerable, the thinkable. It lies there, quite close, but it cannot be assimilated. It beseeches, worries, and fascinates desire, which, nevertheless, does not let itself be seduced. Apprehensive, desire turns side; sickened, it rejects. A certainty protects it from the shameful – a certainty of which it is proud holds on to it. But simultaneously, just the same, that impetus, that spasm, that leap is drawn toward an elsewhere as tempting as it is condemned. Unflaggingly, like an inescapable boomerang, a vortex of summons and repulsion places the one haunted by it literally beside himself.

When I am beset by abjection, the twisted braid of affects and thoughts I call by such a name does not have, properly speaking, a definable *object*. The abject is not an ob-ject facing me, which I name or imagine. Nor is it an ob-jest, an otherness ceaselessly fleeing in a systematic quest of desire. What is abject is not my correlative, which, providing me with someone or something else as support, would allow me to be more or less detached and autonomous. The abject has only one quality of the object – that of being opposed to *I*. If the object, however, through its opposition, settles me within the fragile texture of a desire for meaning,

which, as a matter of fact, makes me ceaselessly and infinitely homologous to it, what is *abject*, on the contrary, the jettisoned object, is radically excluded and draws me toward the place where meaning collapses. A certain "ego" that merged with its master, a superego, has flatly driven it away. It lies outside, beyond the set, and does not seem to agree to the latter's rules of the game. And yet, from its place of banishment, the abject does not cease challenging its master. Without a sign (for him), it beseeches a discharge, a convulsion, a crying out. To each ego its object, to each superego its abject. It is not the white expanse or slack boredom of repression, not the translations and transformations of desire that wrench bodies, nights, and discourse; rather it is a brutish suffering that "I" puts up with, sublime and devastated, for "I" deposits it to the father's account [*verse au père – père-version*]: I endure it, for I imagine that such is the desire of the other. A massive and sudden emergence of uncanniness, which, familiar as it might have been in an opaque and forgotten life, now harries me as radically separate, loathsome. Not me. Not that. But not nothing, either. A "something" that I do not recognize as a thing. A weight of meaninglessness, about which there is nothing insignificant, and which crushes me. On the edge of non-existence and hallucination, of a reality that, if I acknowledge it, annihilates me. There, abject and abjection are my safeguards. The primers of my culture.

The improper/unclean

Loathing an item of food, a piece of filth, waste, or dung. The spasms and vomiting that protect me. The repugnance, the retching that thrusts me to the side and turns me away from defilement, sewage, and muck. The shame of compromise, of being in the middle of treachery. The fascinated start that leads me toward and separates me from them.

Food loathing is perhaps the most elementary and most archaic form of abjection. When the eyes see or the lips touch that skin on the surface of milk – harmless, thin as a sheet of cigarette paper, pitiful as a nail paring – I experience a gagging sensation, and, still farther down, spasms in the stomach, the belly; and all the organs shrivel up the body, provoke tears and bile, increase heartbeat, cause forehead and hands to perspire. Along with sight-clouding dizziness, *nausea* makes me balk at that milk cream, separates me from the mother and father who proffer it. "I" want none of that element, sign of their desire; "I" do not want to listen, "I" do not assimilate it, "I" expel it. But since the food is not an "other" for "me," who am only in their desire, I expel *myself*, I spit *myself* out, I abject *myself* within the same motion through which "I" claim to establish *myself*. That detail, perhaps an insignificant one, but one that they ferret out, emphasize, evaluate, that trifle turns me inside out, guts sprawling; it is thus that *they* see that "I" am in the process of becoming an other at the expense of my own death. During that course in which "I" become, I give birth to myself amid the violence of sobs, of vomit. Mute protest of the symptom, shattering violence of a convulsion that, to be sure, is inscribed in a symbolic system, but in which, without either wanting or being able to become integrated in order to answer to it, it reacts, it abreacts. It abjects.

The corpse (or cadaver: *cadere*, to fall), that which has irremediably come a cropper, is cesspool, and death; it upsets even more violently the one who confronts it as fragile and fallacious chance. A wound with blood and pus, or the sickly, acrid smell of sweat, of decay, does not *signify* death. In the presence of signified death – a flat encephalograph, for instance – I would understand, react, or accept. No, as in true theater, without makeup or masks, refuse and corpses *show me* what I permanently thrust aside in order to live. These body fluids, this defilement, this shit are what life withstands, hardly and with difficulty, on the part of death. There, I am at the border of my condition as living being. My body extricates itself,

as being alive, from that border. Such wastes drop so that I might live, until from loss to loss, nothing remains in me and my entire body falls beyond the limit – *cadere*, cadaver. If dung signifies the other side of the border, the place where I am not and which permits me to be, the corpse, the most sickening of wastes, is a border that has encroached upon every-thing. It is no longer I who expel, "I" is expelled. The border has become an object. How can I be without border? That elsewhere that I imagine beyond the present, or that I hallu-cinate so that I might, in a present time, speak to you, conceive of you – it is now here, jetted, abjected, into "my" world. Deprived of world, therefore, I *fall in a faint*. In that compelling, raw, insolent thing in the morgue's full sunlight, in that thing that no longer matches and therefore no longer signifies anything, I behold the breaking down of a world that has erased its borders: fainting away. The corpse, seen without God and outside of science, is the utmost of abjection. It is death infecting life. Abject. It is something rejected from which one does not part, from which one does not protect oneself as from an object. Imaginary uncanniness and real threat, it beckons to us and ends up engulfing us.

It is thus not lack of cleanliness or health that causes abjection but what disturbs iden-tity, system, order. What does not respect borders, positions, rules. The in-between, the ambiguous, the composite. The traitor, the liar, the criminal with a good conscience, the shameless rapist, the killer who claims he is a savior. . . . Any crime, because it draws atten-tion to the fragility of the law, is abject, but premeditated crime, cunning murder, hypocritical revenge are even more so because they heighten the display of such fragility. He who denies morality is not abject; there can be grandeur in amorality and even in crime that flaunts its disrespect for the law – rebellious, liberating, and suicidal crime. Abjection, on the other hand, is immoral, sinister, scheming, and shady: a terror that dissembles, a hatred that smiles, a passion that uses the body for barter instead of inflaming it, a debtor who sells you up, a friend who stabs you. . . .

In the dark halls of the museum that is now what remains of Auschwitz, I see a heap of children's shoes, or something like that, something I have already seen elsewhere, under a Christmas tree, for instance, dolls I believe. The abjection of Nazi crime reaches its apex when death, which, in any case, kills me, interferes with what, in my living universe, is supposed to save me from death: childhood, science, among other things.

[. . .]

JUDITH BUTLER

PERFORMATIVE ACTS AND GENDER CONSTITUTION
An essay in phenomenology and feminist theory

PHILOSOPHERS RARELY THINK ABOUT ACTING in the theatrical sense, but they do have a discourse of "acts" that maintains associative semantic meanings with theories of performance and acting. For example, John Searle's "speech acts," those verbal assurances and promises which seem not only to refer to a speaking relationship, but to constitute a moral bond between speakers, illustrate one of the illocutionary gestures that constitutes the stage of the analytic philosophy of language. Further, "action theory," a domain of moral philosophy, seeks to understand what it is "to do" prior to any claim of what one *ought* to do. Finally, the phenomenological theory of "acts," espoused by Edmund Husserl, Maurice Merleau-Ponty and George Herbert Mead, among others, seeks to explain the mundane way in which social agents *constitute* social reality through language, gesture, and all manner of symbolic social sign. Though phenomenology sometimes appears to assume the existence of a choosing and constituting agent prior to language (who poses as the sole source of its constituting acts), there is also a more radical use of the doctrine of constitution that takes the social agent as an *object* rather than the subject of constitutive acts.

When Simone de Beauvoir claims, "one is not born, but, rather, *becomes* a woman," she is appropriating and reinterpreting this doctrine of constituting acts from the phenomenological tradition.[1] In this sense, gender is in no way a stable identity or locus of agency from which various acts proceed; rather, it is an identity tenuously constituted in time – an identity instituted through a *stylized repetition of acts*. Further, gender is instituted through the stylization of the body and, hence, must be understood as the mundane way in which bodily gestures, movements, and enactments of various kinds constitute the illusion of an abiding gendered self. This formulation moves the conception of gender off the ground of a substantial model of identity to one that requires a conception of a constituted *social temporality*. Significantly, if gender is instituted through acts which are internally discontinuous, then the *appearance of substance* is precisely that, a constructed identity, a performative accomplishment which the mundane social audience, including the actors themselves, come to believe and to perform in the mode of belief. If the ground of gender identity is the stylized repetition of acts through time, and not a seemingly seamless identity, then the possibilities of gender transformation are to be found in the arbitrary relation between such acts, in the possibility of a different sort of repeating, in the breaking or subversive repetition of that style.

Through the conception of gender acts sketched above, I will try to show some ways in which reified and naturalized conceptions of gender might be understood as constituted and, hence, capable of being constituted differently. In opposition to theatrical or phenomeno-

logical models which take the gendered self to be prior to its acts, I will understand constituting acts not only as constituting the identity of the actor, but as constituting that identity as a compelling illusion, an object of *belief*. In the course of making my argument, I will draw from theatrical, anthropological, and philosophical discourses, but mainly phenomenology, to show that what is called gender identity is a performative accomplishment compelled by social sanction and taboo. In its very character as performative resides the possibility of contesting its reified status.

I Sex/gender: feminist and phenomenological views

Feminist theory has often been critical of naturalistic explanations of sex and sexuality that assume that the meaning of women's social existence can be derived from some fact of their physiology. In distinguishing sex from gender, feminist theorists have disputed causal explanations that assume that sex dictates or necessitates certain social meanings for women's experience. Phenomenological theories of human embodiment have also been concerned to distinguish between the various physiological and biological causalities that structure bodily existence and the *meanings* that embodied existence assumes in the context of lived experience. In Merleau-Ponty's reflections in *The Phenomenology of Perception* on "the body in its sexual being," he takes issue with such accounts of bodily experience and claims that the body is "an historical idea" rather than "a natural species."[2] Significantly, it is this claim that Simone de Beauvoir cites in *The Second Sex* when she sets the stage for her claim that "woman," and by extension, any gender, is an historical situation rather than a natural fact.[3]

In both contexts, the existence and facticity of the material or natural dimensions of the body are not denied, but reconceived as distinct from the process by which the body comes to bear cultural meanings. For both de Beauvoir and Merleau-Ponty, the body is understood to be an active process of embodying certain cultural and historical possibilities, a complicated process of appropriation which any phenomenological theory of embodiment needs to describe. In order to describe the gendered body, a phenomenological theory of constitution requires an expansion of the conventional view of acts to mean both that which constitutes meaning and that through which meaning is performed or enacted. In other words, the acts by which gender is constituted bear similarities to performative acts within theatrical contexts. My task, then, is to examine in what ways gender is constructed through specific corporeal acts, and what possibilities exist for the cultural transformation of gender through such acts.

Merleau-Ponty maintains not only that the body is an historical idea but a set of possibilities to be continually realized. In claiming that the body is an historical idea, Merleau-Ponty means that it gains its meaning through a concrete and historically mediated expression in the world. That the body is a set of possibilities signifies (a) that its appearance in the world, for perception, is not predetermined by some manner of interior essence, and (b) that its concrete expression in the world must be understood as the taking up and rendering specific of a set of historical possibilities. Hence, there is an agency which is understood as the process of rendering such possibilities determinate. These possibilities are necessarily constrained by available historical conventions. The body is not a self-identical or merely factic materiality; it is a materiality that bears meaning, if nothing else, and the manner of this bearing is fundamentally dramatic. By dramatic I mean only that the body is not merely matter but a continual and incessant *materializing* of possibilities. One is not simply a body, but, in some very key sense, one does one's body and, indeed, one does one's body differently from one's contemporaries and from one's embodied predecessors and successors as well.

It is, however, clearly unfortunate grammar to claim that there is a "we" or an "I" that does its body, as if a disembodied agency preceded and directed an embodied exterior. More appropriate, I suggest, would be a vocabulary that resists the substance metaphysics of subject-verb formations and relies instead on an ontology of present participles. The "I" that is its body is, of necessity, a mode of embodying, and the "what" that it embodies is possibilities. But here again the grammar of the formulation misleads, for the possibilities that are embodied are not fundamentally exterior or antecedent to the process of embodying itself. As an intentionally organized materiality, the body is always an embodying *of* possibilities both conditioned and circumscribed by historical convention. In other words, the body *is* a historical situation, as de Beauvoir has claimed, and is a manner of doing, dramatizing, and *reproducing* a historical situation.

To do, to dramatize, to reproduce, these seem to be some of the elementary structures of embodiment. This doing of gender is not merely a way in which embodied agents are exterior, surfaced, open to the perception of others. Embodiment clearly manifests a set of strategies or what Sartre would perhaps have called a style of being or Foucault, "a stylistics of existence." This style is never fully self-styled, for living styles have a history, and that history conditions and limits possibilities. Consider gender, for instance, as *a corporeal style*, an "act," as it were, which is both intentional and performative, where "performative" itself carries the double-meaning of "dramatic" and "non-referential."

When de Beauvoir claims that "woman" is a historical idea and not a natural fact, she clearly underscores the distinction between sex, as biological facticity, and gender, as the cultural interpretation or signification of that facticity. To be female is, according to that distinction, a facticity which has no meaning, but to be a woman is to have *become* a woman, to compel the body to conform to an historical idea of "woman," to induce the body to become a cultural sign, to materialize oneself in obedience to an historically delimited possibility, and to do this as a sustained and repeated corporeal project. The notion of a "project," however, suggests the originating force of a radical will, and because gender is a project which has cultural survival as its end, the term *"strategy"* better suggests the situation of duress under which gender performance always and variously occurs. Hence, as a strategy of survival, gender is a performance with clearly punitive consequences. Discrete genders are part of what "humanizes" individuals within contemporary culture; indeed, those who fail to do their gender right are regularly punished. Because there is neither an "essence" that gender expresses or externalizes nor an objective ideal to which gender aspires; because gender is not a fact, the various acts of gender create the idea of gender, and without those acts, there would be no gender at all. Gender is, thus, a construction that regularly conceals its genesis. The tacit collective agreement to perform, produce, and sustain discrete and polar genders as cultural fictions is obscured by the credibility of its own production. The authors of gender become entranced by their own fictions whereby the construction compels one's belief in its necessity and naturalness. The historical possibilities materialized through various corporeal styles are nothing other than those punitively regulated cultural fictions that are alternatively embodied and disguised under duress.

How useful is a phenomenological point of departure for a feminist description of gender? On the surface it appears that phenomenology shares with feminist analysis a commitment to grounding theory in lived experience, and in revealing the way in which the world is produced through the constituting acts of subjective experience. Clearly, not all feminist theory would privilege the point of view of the subject (Kristeva once objected to feminist theory as "too existentialist"),[4] and yet the feminist claim that the personal is political suggests, in part, that subjective experience is not only structured by existing political arrangements, but effects and structures those arrangements in turn. Feminist theory has sought to understand the

way in which systemic or pervasive political and cultural structures are enacted and reproduced through individual acts and practices, and how the analysis of ostensibly personal situations is clarified through situating the issues in a broader and shared cultural context. Indeed, the feminist impulse, and I am sure there is more than one, has often emerged in the recognition that my pain or my silence or my anger or my perception is finally not mine alone, and that it delimits me in a shared cultural situation which in turn enables and empowers me in certain unanticipated ways. The personal is thus implicitly political inasmuch as it is conditioned by shared social structures, but the personal has also been immunized against political challenge to the extent that public/private distinctions endure. For feminist theory, then, the personal becomes an expansive category, one which accommodates, if only implicitly, political structures usually viewed as public. Indeed, the very meaning of the political expands as well. At its best, feminist theory involves a dialectical expansion of both of these categories. My situation does not cease to be mine just because it is the situation of someone else, and my acts, individual as they are, nevertheless reproduce the situation of my gender, and do that in various ways. In other words, there is, latent in the personal is political formulation of feminist theory, a supposition that the life-world of gender relations is constituted, at least partially, through the concrete and historically mediated *acts* of individuals. Considering that "the" body is invariably transformed into his body or her body, the body is only known through its gendered appearance. It would seem imperative to consider the way in which this gendering of the body occurs. My suggestion is that the body becomes its gender through a series of acts which are renewed, revised, and consolidated through time. From a feminist point of view, one might try to reconceive the gendered body as the legacy of sedimented acts rather than a predetermined or foreclosed structure, essence or fact, whether natural, cultural, or linguistic.

The feminist appropriation of the phenomenological theory of constitution might employ the notion of an *act* in a richly ambiguous sense. If the personal is a category which expands to include the wider political and social structures, then the *acts* of the gendered subject would be similarly expansive. Clearly, there are political acts which are deliberate and instrumental actions of political organizing, resistance collective intervention with the broad aim of instating a more just set of social and political relations. There are thus acts which are done in the name of women, and then there are acts in and of themselves, apart from any instrumental consequence, that challenge the category of women itself. Indeed, one ought to consider the futility of a political program which seeks radically to transform the social situation of women without first determining whether the category of woman is socially constructed in such a way that to be a woman is, by definition, to be in an oppressed situation. In an understandable desire to forge bonds of solidarity, feminist discourse has often relied upon the category of woman as a universal presupposition of cultural experience which, in its universal status, provides a false ontological promise of eventual political solidarity. In a culture in which the false universal of "man" has for the most part been presupposed as coextensive with humanness itself, feminist theory has sought with success to bring female specificity into visibility and to rewrite the history of culture in terms which acknowledge the presence, the influence, and the oppression of women. Yet, in this effort to combat the invisibility of women as a category feminists run the risk of rendering visible a category which may or may not be representative of the concrete lives of women. As feminists, we have been less eager, I think, to consider the status of the category itself and, indeed, to discern the conditions of oppression which issue from an unexamined reproduction of gender identities which sustain discrete and binary categories of man and woman.

When de Beauvoir claims that woman is an "historical situation," she emphasizes that the body suffers a certain cultural construction, not only through conventions that sanction and

proscribe how one acts one's body, the "act" or performance that one's body is, but also in the tacit conventions that structure the way the body is culturally perceived. Indeed, if gender is the cultural significance that the sexed body assumes, and if that significance is codetermined through various acts and their cultural perception, then it would appear that from within the terms of culture it is not possible to know sex as distinct from gender. The reproduction of the category of gender is enacted on a large political scale, as when women first enter a profession or gain certain rights, or are reconceived in legal or political discourse in significantly new ways. But the more mundane reproduction of gendered identity takes place through the various ways in which bodies are acted in relationship to the deeply entrenched or sedimented expectations of gendered existence. Consider that there is a sedimentation of gender norms that produces the peculiar phenomenon of a natural sex, or a real woman, or any number of prevalent and compelling social fictions, and that this is a sedimentation that over time has produced a set of corporeal styles which, in reified form, appear as the natural configuration of bodies into sexes which exist in a binary relation to one another.

II Binary genders and the heterosexual contract

To guarantee the reproduction of a given culture, various requirements, well-established in the anthropological literature of kinship, have instated sexual reproduction within the confines of a heterosexually-based system of marriage which requires the reproduction of human beings in certain gendered modes which, in effect, guarantee the eventual reproduction of that kinship system. As Foucault and others have pointed out, the association of a natural sex with a discrete gender and with an ostensibly natural "attraction" to the opposing sex/gender is an unnatural conjunction of cultural constructs in the service of reproductive interests.[5] Feminist cultural anthropology and kinship studies have shown how cultures are governed by conventions that not only regulate and guarantee the production, exchange, and consumption of material goods, but also reproduce the bonds of kinship itself, which require taboos and a punitive regulation of reproduction to effect that end. Lévi-Strauss has shown how the incest taboo works to guarantee the channeling of sexuality into various modes of heterosexual marriage.[6] Gayle Rubin has argued convincingly that the incest taboo produces certain kinds of discrete gendered identities and sexualities.[7] My point is simply that one way in which this system of compulsory heterosexuality is reproduced and concealed is through the cultivation of bodies into discrete sexes with "natural" appearances and "natural" heterosexual dispositions. Although the enthnocentric conceit suggests a progression beyond the mandatory structures of kinship relations as described by Lévi-Strauss, I would suggest, along with Rubin, that contemporary gender identities are so many marks or "traces" of residual kinship. The contention that sex, gender, and heterosexuality are historical products which have become conjoined and reified as natural over time has received a good deal of critical attention not only from Michel Foucault, but Monique Wittig, gay historians, and various cultural anthropologists and social psychologists in recent years.[8] These theories, however, still lack the critical resources for thinking radically about the historical sedimentation of sexuality and sex-related constructs if they do not delimit and describe the mundane manner in which these constructs are produced, reproduced, and maintained within the field of bodies.

Can phenomenology assist a feminist reconstruction of the sedimented character of sex, gender, and sexuality at the level of the body? In the first place, the phenomenological focus on the various acts by which cultural identity is constituted and assumed provides a felicitous starting point for the feminist effort to understand the mundane manner in which bodies get

crafted into genders. The formulation of the body as a mode of dramatizing or enacting possibilities offers a way to understand how a cultural convention is embodied and enacted. But it seems difficult, if not impossible, to imagine a way to conceptualize the scale and systemic character of women's oppression from a theoretical position which takes constituting acts to be its point of departure. Although individual acts do work to maintain and reproduce systems of oppression and, indeed, any theory of personal political responsibility presupposes such a view, it doesn't follow that oppression is a sole consequence of such acts. One might argue that without human beings whose various acts, largely construed, produce and maintain oppressive conditions, those conditions would fall away, but note that the relation between acts and conditions is neither unilateral nor unmediated. There are social contexts and conventions within which certain acts not only become possible but become conceivable as acts at all. The transformation of social relations becomes a matter, then, of transforming hegemonic social conditions rather than the individual acts that are spawned by those conditions. Indeed, one runs the risk of addressing the merely indirect, if not epiphenomenal, reflection of those conditions if one remains restricted to a politics of acts.

But the theatrical sense of an "act" forces a revision of the individualist assumptions underlying the more restricted view of constituting acts within phenomenological discourse. As a given temporal duration within the entire performance, "acts" are a shared experience and "collective action." Just as within feminist theory the very category of the personal is expanded to include political structures, so is there a theatrically-based and, indeed, less individually-oriented view of acts that goes some of the way to defusing the criticism of act theory as "too existentialist." The act that gender is, the act that embodied agents *are* inasmuch as they dramatically and actively embody and, indeed, *wear* certain cultural significations, is clearly not one's act alone. Surely, there are nuanced and individual ways of *doing* one's gender, but *that* one does it, and that one does it *in accord with* certain sanctions and prescriptions, is clearly not a fully individual matter. Here again, I don't mean to minimize the effect of certain gender norms which originate within the family and are enforced through certain familial modes of punishment and reward and which, as a consequence might be construed as highly individual, for even there family relations recapitulate, individualize, and specify pre-existing cultural relations; they are rarely, if even radically original. The act that one does, the act that one performs, is, in a sense, an act that has been going on before one arrived on the scene. Hence, gender is an act which has been rehearsed, much as a script survives the particular actors who make use of it; but which requires individual actors in order to be actualized and reproduced as reality once again. The complex components that go into an act must be distinguished in order to understand the kind of acting in concert and acting in accord which acting one's gender invariably is.

In what senses, then, is gender an act? As anthropologist Victor Turner suggests in his studies of ritual social drama, social action requires a performance which is *repeated*. This repetition is at once a reenactment and reexperiencing of a set of meanings already socially established; it is the mundane and ritualized form of their legitimation.[9] When this conception of social performance is applied to gender, it is clear that although there are individual bodies that enact these significations by becoming stylized into gendered modes, this "action" is immediately public as well. There are temporal and collective dimensions to these actions, and their public nature is not inconsequential; indeed, the performance is effected with the strategic aim of maintaining gender within its binary frame. Understood in pedagogical terms, the performance renders social laws explicit.

As a public action and performative act, gender is not a radical choice or project that reflects a merely individual choice, but neither is it imposed or inscribed upon the individual,

as some post-structuralist displacements of the subject would contend. The body is not passively scripted with cultural codes, as if it were a lifeless recipient of wholly pre-given cultural relations. But neither do embodied selves pre-exist the cultural conventions which essentially signify bodies. Actors are always already on the stage, within the terms of the performance. Just as a script may be enacted in various ways, and just as the play requires both text and interpretation, so the gendered body acts its part in a culturally restricted corporeal space and enacts interpretations within the confines of already existing directives.

Although the links between a theatrical and a social role are complex and the distinctions not easily drawn (Bruce Wilshire points out the limits of the comparison in *Role-Playing and Identity: The Limits of Theatre as Metaphor*[10]), it seems clear that, although theatrical performances can meet with political censorship and scathing criticism, gender performances in non-theatrical contexts are governed by more clearly punitive and regulatory social conventions. Indeed, the sight of a transvestite onstage can compel pleasure and applause while the sight of the same transvestite on the seat next to us on the bus can compel fear, rage, even violence. The conventions which mediate proximity and identification in these two instances are clearly quite different. I want to make two different kinds of claims, regarding this tentative distinction. In the theatre, one can say, "this is just an act," and de-realize the act, make acting into something quite distinct from what is real. Because of this distinction, one can maintain one's sense of reality in the face of this temporary challenge to our existing ontological assumptions about gender arrangements; the various conventions which announce that "this is only a play" allows strict lines to be drawn between the performance and life. On the street or in the bus, the act becomes dangerous, if it does, precisely because there are no theatrical conventions to delimit the purely imaginary character of the act, indeed, on the street or in the bus, there is no presumption that the act is distinct from a reality; the disquieting effect of the act is that there are no conventions that facilitate making this separation. Clearly, there is theatre which attempts to contest or, indeed, break down those conventions that demarcate the imaginary from the real (Richard Schechner brings this out quite clearly in *Between Theatre and Anthropology*[11]). Yet in those cases one confronts the same phenomenon, namely, that the act is not contrasted with the real, but *constitutes* a reality that is in some sense new, a modality of gender that cannot readily be assimilated into the pre-existing categories that regulate gender reality. From the point of view of those established categories, one may want to claim, but oh, this is *really* a girl or a woman, or this is *really* a boy or a man, and further that the *appearance* contradicts the *reality* of the gender, that the discrete and familiar reality must be there, nascent, temporarily unrealized, perhaps realized at other times or other places. The transvestite, however, can do more than simply express the distinction between sex and gender, but challenges, at least implicitly, the distinction between appearance and reality that structures a good deal of popular thinking about gender identity. If the "reality" of gender is constituted by the performance itself, then there is no recourse to an essential and unrealized "sex" or "gender" which gender performances ostensibly express. Indeed, the transvestite's gender is as fully real as anyone whose performance complies with social expectations.

Gender reality is performative which means, quite simply, that it is real only to the extent that it is performed. It seems fair to say that certain kinds of acts are usually interpreted as expressive of a gender core or identity, and that these acts either conform to an expected gender identity or contest that expectation in some way. That expectation, in turn, is based upon the perception of sex, where sex is understood to be the discrete and factic datum of primary sexual characteristics. This implicit and popular theory of acts and gestures as *expressive* of gender suggests that gender itself is something prior to the various acts, postures, and

gestures by which it is dramatized and known; indeed, gender appears to the popular imagination as a substantial core which might well be understood as the spiritual or psychological correlate of biological sex.[12] If gender attributes, however, are not expressive but performative, then these attributes effectively constitute the identity they are said to express or reveal. The distinction between expression and performativeness is quite crucial, for if gender attributes and acts, the various ways in which a body shows or produces its cultural signification, are performative, then there is no preexisting identity by which an act or attribute might be measured; there would be no true or false, real or distorted acts of gender, and the postulation of a true gender identity would be revealed as a regulatory fiction. That gender reality is created through sustained social performances means that the very notions of an essential sex, a true or abiding masculinity or femininity, are also constituted as part of the strategy by which the performative aspect of gender is concealed.

As a consequence, gender cannot be understood as a *role* which either expresses or disguises an interior "self," whether that "self" is conceived as sexed or not. As performance which is performative, gender is an "act," broadly construed, which constructs the social fiction of its own psychological interiority. As opposed to a view such as Erving Goffman's which posits a self which assumes and exchanges various "roles" within the complex social expectations of the "game" of modern life,[13] I am suggesting that this self is not only irretrievably "outside," constituted in social discourse, but that the ascription of interiority is itself a publically regulated and sanctioned form of essence fabrication. Genders, then, can be neither true nor false, neither real nor apparent. And yet, one is compelled to live in a world in which genders constitute univocal signifiers, in which gender is stabilized, polarized, rendered discrete and intractable. In effect, gender is made to comply with a model of truth and falsity which not only contradicts its own performative fluidity, but serves a social policy of gender regulation and control. Performing one's gender wrong initiates a set of punishments both obvious and indirect, and performing it well provides the reassurance that there is an essentialism of gender identity after all. That this reassurance is so easily displaced by anxiety, that culture so readily punishes or marginalizes those who fail to perform the illusion of gender essentialism should be sign enough that on some level there is social knowledge that the truth or falsity of gender is only socially compelled and in no sense ontologically necessitated.[14]

III Feminist theory: beyond an expressive model of gender

This view of gender does not pose as a comprehensive theory about what gender is or the manner of its construction, and neither does it prescribe an explicit feminist political program. Indeed, I can imagine this view of gender being used for a number of discrepant political strategies. Some of my friends may fault me for this and insist that any theory of gender constitution has political presuppositions and implications, and that it is impossible to separate a theory of gender from a political philosophy of feminism. In fact, I would agree, and argue that it is primarily political interests which create the social phenomena of gender itself, and that without a radical critique of gender constitution feminist theory fails to take stock of the way in which oppression structures the ontological categories through which gender is conceived. Gayatri Spivak has argued that feminists need to rely on an operational essentialism, a false ontology of women as a universal in order to advance a feminist political program.[15] She knows that the category of "women" is not fully expressive, that the multiplicity and discontinuity of the referent mocks and rebels against the univocity of the sign, but suggests it could be used for strategic purposes. Kristeva suggests something similar,

I think, when she prescribes that feminists use the category of women as a political tool without attributing ontological integrity to the term, and adds that, strictly speaking, women cannot be said to exist.[16] Feminists might well worry about the political implications of claiming that women do not exist, especially in light of the persuasive arguments advanced by Mary Anne Warren in her book, *Gendercide*.[17] She argues that social policies regarding population control and reproductive technology are designed to limit and, at times, eradicate the existence of women altogether. In light of such a claim, what good does it do to quarrel about the metaphysical status of the term, and perhaps, for clearly political reasons, feminists ought to silence the quarrel altogether.

But it is one thing to use the term and know its ontological insufficiency and quite another to articulate a normative vision for feminist theory which celebrates or emancipates an essence, a nature, or a shared cultural reality which cannot be found. The option I am defending is not to redescribe the world from the point of view of women. I don't know what that point of view is, but whatever it is, it is not singular, and not mine to espouse. It would only be half-right to claim that I am interested in how the phenomenon of a men's or women's point of view gets constituted, for while I do think that those points of view are, indeed, socially constituted, and that a reflexive genealogy of those points of view is important to do, it is not primarily the gender episteme that I am interested in exposing, deconstructing, or reconstructing. Indeed, it is the presupposition of the category of woman itself that requires a critical genealogy of the complex institutional and discursive means by which it is constituted. Although some feminist literary critics suggest that the presupposition of sexual difference is necessary for all discourse, that position reifies sexual difference as the founding moment of culture and precludes an analysis not only of how sexual difference is constituted to begin with but how it is continuously constituted, both by the masculine tradition that preempts the universal point of view, and by those feminist positions that construct the univocal category of "women" in the name of expressing or, indeed, liberating a subjected class. As Foucault claimed about those humanist efforts to liberate the criminalized subject, the subject that is freed is even more deeply shackled than originally thought.[18]

Clearly, though, I envision the critical genealogy of gender to rely on a phenomenological set of presuppositions, most important among them the expanded conception of an "act" which is both socially shared and historically constituted, and which is performative in the sense I previously described. But a critical genealogy needs to be supplemented by a politics of performative gender acts, one which both redescribes existing gender identities and offers a prescriptive view about the kind of gender reality there ought to be. The redescription needs to expose the reifications that tacitly serve as substantial gender cores or identities, and to elucidate both the act and the strategy of disavowal which at once constitute and conceal gender as we live it. The prescription is invariably more difficult, if only because we need to think a world in which acts, gestures, the visual body, the clothed body, the various physical attributes usually associated with gender, *express nothing*. In a sense, the prescription is not utopian, but consists in an imperative to acknowledge the existing complexity of gender which our vocabulary invariably disguises and to bring that complexity into a dramatic cultural interplay without punitive consequences.

Certainly, it remains politically important to represent women, but to do that in a way that does not distort and reify the very collectivity the theory is supposed to emancipate. Feminist theory which presupposes sexual difference as the necessary and invariant theoretical point of departure clearly improves upon those humanist discourses which conflate the universal with the masculine and appropriate all of culture as masculine property. Clearly, it is necessary to reread the texts of western philosophy from the various points of view that

have been excluded, not only to reveal the particular perspective and set of interests informing those ostensibly transparent descriptions of the real, but to offer alternative descriptions and prescriptions; indeed, to establish philosophy as a cultural practice, and to criticize its tenets from marginalized cultural locations. I have no quarrel with this procedure, and have clearly benefited from those analyses. My only concern is that sexual difference not become a reification which unwittingly preserves a binary restriction on gender identity and an implicitly heterosexual framework for the description of gender, gender identity, and sexuality. There is, in my view, nothing about femaleness that is waiting to be expressed; there is, on the other hand, a good deal about the diverse experiences of women that is being expressed and still needs to be expressed, but caution is needed with respect to that theoretical language, for it does not simply report a pre-linguistic experience, but constructs that experience as well as the limits of its analysis. Regardless of the pervasive character of patriarchy and the prevalence of sexual difference as an operative cultural distinction, there is nothing about a binary gender system that is given. As a corporeal field of cultural play, gender is a basically innovative affair, although it is quite clear that there are strict punishments for contesting the script by performing out of turn or through unwarranted improvisations. Gender is not passively scripted on the body, and neither is it determined by nature, language, the symbolic, or the overwhelming history of patriarchy. Gender is what is put on, invariably, under constraint, daily and incessantly, with anxiety and pleasure, but if this continuous act is mistaken for a natural or linguistic given, power is relinquished to expand the cultural field bodily through subversive performances of various kinds.

Notes

1 For a further discussion of Beauvoir's feminist contribution to phenomenological theory, see my "Variations on Sex and Gender: Beauvoir's *The Second Sex*," *Yale French Studies* 172 (1986).
2 Maurice Merleau-Ponty, "The Body is its Sexual Being," in *The Phenomenology of Perception*, trans. Colin Smith (Boston: Routledge and Kegan Paul, 1962).
3 Simone de Beauvoir, *The Second Sex*, trans. H. M. Parshley (New York: Vintage, 1974), 38.
4 Julia Kristeva, *Histoire d'amour* (Paris: Editions Denoel, 1983), 242.
5 See Michel Foucault, *The History of Sexuality: An Introduction*, trans. Robert Hurley (New York: Random House, 1980), 154: "the notion of 'sex' made it possible to group together, in an artificial unity, anatomical elements, biological functions, conducts, sensations, and pleasures, and it enabled one to make use of this fictitious unity as a causal principle."
6 See Claude Lévi-Strauss, *The Elementary Structures of Kinship* (Boston: Beacon Press, 1965).
7 Gayle Rubin, "The Traffic in Women: Notes on the 'Political Economy' of Sex," in *Toward an Anthropology of Women*, ed. Rayna R. Reiter (New York: Monthly Review Press, 1975), 178–85.
8 See my "Variations on Sex and Gender: Beauvoir, Wittig, and Foucault," in *Feminism as Critique*, ed. Seyla Benhabib and Drucila Cornell (London: Basil Blackwell, 1987 [distributed by University of Minnesota Press]).
9 See Victor Turner, *Dramas, Fields, and Metaphors* (Ithaca: Cornell University Press, 1974). Clifford Geertz suggests in "Blurred Genres: The Refiguration of Thought," in *Local Knowledge, Further Essays in Interpretive Anthropology* (New York: Basic Books, 1983), that the theatrical metaphor is used by recent social theory in two, often opposing, ways. Ritual theorists like Victor Turner focus on a notion of social drama of various kinds as a means for settling internal conflict within a culture and regenerating social cohesion. On the other hand, symbolic action approaches, influenced by figures as diverse as Emile Durkheim, Kenneth Burke, and Michel Foucault, focus on the way in which political authority and questions of legitimation are thematized and settled within the terms of performed meaning. Geertz himself suggests that the tension might be viewed dialectically; his study of political organization in Bali as a "theatre-state" is a case in point. In terms of an explicitly feminist account of gender as performative, it seems clear to me that an account of gender as ritualized, public performance must be combined with an analysis of the political sanctions and taboos under which that performance may and may not occur within the public sphere free of punitive consequence.

10 Bruce Wilshire, *Role-Playing and Identity: The Limits of Theatre as Metaphor* (Boston: Routledge and Kegan Paul, 1981).

11 Richard Schechner, *Between Theatre and Anthropology* (Philadelphia: University of Pennsylvania Press, 1985). See especially, "News, Sex, and Performance," 295–324.

12 In *Mother Camp* (Prentice Hall, 1974), anthropologist Esther Newton gives an urban ethnography of drag queens in which she suggests that all gender might be understood on the model of drag. In *Gender: An Ethnomethodological Approach* (Chicago: University of Chicago Press, 1978), Suzanne J. Kessler and Wendy McKenna argue that gender is an "accomplishment" which requires the skills of constructing the body into a socially legitimate artifice.

13 See Erving Goffman, *The Presentation of Self in Everyday Life* (Garden City: Doubleday, 1959).

14 See Michel Foucault's edition of *Herculine Barbin: The Journals of a Nineteenth Century French Hermaphrodite*, trans. Richard McDougall (New York: Pantheon Books, 1984), for an interesting display of the horror evoked by intersexed bodies. Foucault's introduction makes clear that the medical delimitation of univocal sex is yet another wayward application of the discourse on truth-as-identity. See also the work of Robert Edgerton in *American Anthropologist* on the cross-cultural variations of response to hermaphroditic bodies.

15 Remarks at the Center for Humanities, Wesleyan University, Spring 1985.

16 Julia Kristeva, "Woman Can Never Be Defined," trans. Marilyn A. August, in *New French Feminisms*, ed. Elaine Marks and Isabelle de Courtivron (New York: Schocken, 1981).

17 Mary Anne Warren, *Gendercide: The Implications of Sex Selection* (New Jersey: Rowman and Allanheld, 1985).

18 Ibid.; Michel Foucault, *Discipline and Punish: The Birth of the Prison*, trans. Alan Sheridan (New York: Vintage Books, 1978).

Chapter 47

SUE-ELLEN CASE

TOWARD A BUTCH–FEMME AESTHETIC

IN THE 1980S, FEMINIST CRITICISM has focused increasingly on the subject position: both in the explorations for the creation of a female subject position and the deconstruction of the inherited subject position that is marked with masculinist functions and history. Within this focus, the problematics of women inhabiting the traditional subject position have been sketched out, the possibilities of a new heterogeneous, heteronomous position have been explored, and a desire for a collective subject has been articulated. While this project is primarily a critical one, concerned with language and symbolic structures, philosophic assumptions, and psychoanalytic narratives, it also implicates the social issues of class, race, and sexuality. Teresa de Lauretis's article "The Technology of Gender" (in *Technologies of Gender*, 1987) reviews the recent excavations of the subject position in terms of ideology, noting that much of the work on the subject, derived from Foucault and Althusser, denies both agency and gender to the subject. In fact, many critics leveled a similar criticism against Foucault in a recent conference on postmodernism, noting that while his studies seem to

unravel the web of ideology, they suggest no subject position outside the ideology, nor do they construct a subject who has the agency to change ideology ("Postmodernism," 1987). In other words, note de Lauretis and others, most of the work on the subject position has only revealed the way in which the subject is trapped within ideology and thus provides no programs for change.

For feminists, changing this condition must be a priority. The common appellation of this bound subject has been the "female subject," signifying a biological, sexual difference, inscribed by dominant cultural practices. De Lauretis names her subject (one capable of change and of changing conditions) the feminist subject, one who is "at the same time inside and outside the ideology of gender, and conscious of being so, conscious of that pull, that division, that doubled vision" (1987, 10). De Lauretis ascribes a sense of self-determination at the micro-political level to the feminist subject. This feminist subject, unlike the female one, can be outside of ideology, can find self-determination, can change. This is an urgent goal for the feminist activist/theorist. Near the conclusion of her article (true to the newer rules of composition), de Lauretis begins to develop her thesis: that the previous work on the female subject, assumes, but leaves unwritten, a heterosexual context for the subject and this is the cause for her continuing entrapment. Because she is still perceived in terms of men and not within the context of other women, the subject in heterosexuality cannot become capable of ideological change (1987, 17–18).

De Lauretis's conclusion is my starting place. Focusing on the feminist subject, endowed with the agency for political change, located among women, outside the ideology of sexual difference, and thus the social institution of heterosexuality, it would appear that the lesbian roles of butch and femme, as a dynamic duo, offer precisely the strong subject position the movement requires. Now, in order for the butch–femme roles to clearly emerge within this sociotheoretical project, several tasks must be accomplished: the lesbian subject of feminist theory would have to come out of the closet, the basic discourse or style of camp for the lesbian butch–femme positions would have to be clarified, and an understanding of the function of roles in the homosexual lifestyle would need to be developed, particularly in relation to the historical class and racial relations embedded in such a project. Finally, once these tasks have been completed, the performance practice, both on and off the stage, may be studied as that of a feminist subject, both inside and outside ideology, with the power to self-determine her role and her conditions on the micropolitical level. Within this schema, the butch–femme couple inhabit the subject position together – "you can't have one without the other," as the song says. The two roles never appear as . . . discrete. The combo butch–femme as subject is reminiscent of Monique Wittig's "j/e" or coupled self in her novel *The Lesbian Body*. These are not split subjects, suffering the torments of dominant ideology. They are coupled ones that do not impale themselves on the poles of sexual difference or metaphysical values, but constantly seduce the sign system, through flirtation and inconstancy into the light fondle of artifice, replacing the Lacanian slash with a lesbian bar.

However, before all of this *jouissance* can be enjoyed, it is first necessary to bring the lesbian subject out of the closet of feminist history. The initial step in that process is to trace historically how the lesbian has been assigned to the role of the skeleton in the closet of feminism; in this case, specifically the lesbian who relates to her cultural roots by identifying with traditional butch–femme role-playing. First, regard the feminist genuflection of the 1980s – the catechism of "working-class-women-of-color" feminist theorists feel impelled to invoke at the outset of their research. What's wrong with this picture? It does not include the lesbian position. In fact, the isolation of the social dynamics of race and class successfully relegates sexual preference to an attendant position, so that even if the lesbian were to appear, she

would be as a bridesmaid and never the bride. Several factors are responsible for this ghosting of the lesbian subject: the first is the growth of moralistic projects restricting the production of sexual fiction or fantasy through the anti-pornography crusade. This crusade has produced an alliance between those working on social feminist issues and right-wing homophobic, born-again men and women who also support censorship. This alliance in the electorate, which aids in producing enough votes for an ordinance, requires the closeting of lesbians for the so-called greater cause.

Although the antipornography issue is an earmark of the moralistic 1980s, the homophobia it signals is merely an outgrowth of the typical interaction between feminism and lesbianism since the rise of the feminist movement in the early 1970s. Del Martin and Phyllis Lyon describe the rise of the initial so-called lesbian liberatory organization, the Daughters of Bilitis (DOB), in their influential early book, *Lesbian/Woman* (1972). They record the way in which the aims of such organizations were intertwined with those of the early feminist, or more precisely, women's movement. They proudly exhibit the way in which the DOB moved away from the earlier bar culture and its symbolic systems to a more dominant identification and one that would appease the feminist movement. DOB's goal was to erase butch–femme behavior, its dress codes, and lifestyle from the lesbian community and to change lesbians into lesbian feminists.

Here is the story of one poor victim who came to the DOB for help. Note how similar this narrative style is to the redemptive, corrective language of missionary projects: "Toni joined Daughters of Bilitis . . . at our insistence, and as a result of the group's example, its unspoken pressure, she toned down her dress. She was still very butch, but she wore women's slacks and blouses . . . one of DOB's goals was to teach the lesbian a mode of behavior and dress acceptable to society. . . . We knew too many lesbians whose activities were restricted because they wouldn't wear skirts. But Toni did not agree. 'You'll never get me in a dress,' she growled, banging her fist on the table." The description of Toni's behavior, her animal growling noise, portrays her as uncivilized, recalling earlier, colonial missionary projects. Toni is portrayed as similar to the inappropriately dressed savage whom the missionary clothes and saves. The authors continue: "But she became fast friends with a gay man, and over the months he helped her to feel comfortable with herself as a woman" (*Lesbian/Woman* 1972, 77). Here, in a lesbian narrative, the missionary position is finally given over to a man (even if gay) who helps the butch to feel like a woman. The contemporary lesbian-identified reader can only marvel at the conflation of gender identification in the terms of dominant, heterosexual culture with the adopted gender role-playing within the lesbian subculture.

If the butches are savages in this book, the femmes are lost heterosexuals who damage birthright lesbians by forcing them to play the butch roles. The authors assert that most femmes are divorced heterosexual women who know how to relate only to men and thus force their butches to play the man's role, which is conflated with that of a butch (*Lesbian/Woman* 1972, 79). Finally, the authors unveil the salvationary role of feminism in this process and its power to sever the newly constructed identity of the lesbian feminist from its traditional lesbian roots: "The minority of lesbians who still cling to the traditional male–female or husband–wife pattern in their partnerships are more than likely old-timers, gay bar habituées or working class women." This sentence successfully compounds ageism with a (homo)phobia of lesbian bar culture and a rejection of a working-class identification. The middle-class upward mobility of the lesbian feminist identification shifts the sense of community from one of working-class, often women-of-color lesbians in bars, to that of white upper-middle-class heterosexual women who predominated in the early women's movement. The book continues: "the old order changeth however" (here they even begin to adopt verb endings from the King

James Bible) "as the women's liberation movement gains strength against this pattern of hetero-
sexual marriages, the number of lesbians involved in butch–femme roles deminishes"
(*Lesbian/Woman* 1972, 80).

However, this compulsory adaptation of lesbian feminist identification must be under-
stood as a defensive posture, created by the homophobia that operated in the internal dynamics
of the early movement, particularly within the so-called consciousness-raising groups. In her
article with Cherríe Moraga on butch–femme relations, Amber Hollibaugh, a femme, described
the feminist reception of lesbians this way: "the first discussion I ever heard of lesbianism
among feminists was: 'We've been sex objects to men and where did it get us? And here
when we're just learning how to be friends with other women, you got to go and sexualize
it' . . . they made men out of every sexual dyke" (1983, 402). These kinds of experiences
led Hollibaugh and Moraga to conclude: "In our involvement in a movement largely controlled
by white middle-class women, we feel that the values of their culture . . . have been pushed
down our throats," and even more specifically, in the 1980s, to pose these questions: "why
is it that it is largely white middle-class women who form the visible leadership in the anti-
porn movement? Why are women of color not particularly visible in this sex-related single
issue movement?" (1983, 405).

When one surveys these beginnings of the alliance between the heterosexual feminist
movement and lesbians, one is not surprised at the consequences for lesbians who adopted
the missionary position under a movement that would lead to an antipornography crusade
and its alliance with the Right. Perhaps too late, certain members of the lesbian community
who survived the early years of feminism and continued to work in the grass-roots lesbian
movement, such as Joan Nestle, began to perceive this problem. As Nestle, founder of the
Lesbian Herstory Archives in New York, wrote: "We lesbians of the 1950s made a mistake
in the 1970s: we allowed ourselves to be trivialized and reinterpreted by feminists who did
not share our culture" (1981, 23). Nestle also notes the class prejudice in the rejection of
butch–femme roles: "I wonder why there is such a consuming interest in the butch-fem lives
of upper-class women, usually more literary figures, while real-life, working butch-fem women
are seen as imitative and culturally backward . . . the reality of passing women, usually a
working-class lesbian's method of survival, has provoked very little academic lesbian-feminist
interest. Grassroots lesbian history research is changing this" (1981, 23).

So the lesbian butch–femme tradition went into the feminist closet. Yet the closet, or
the bars, with their hothouse atmosphere have produced what, in combination with the
butch–femme couple, may provide the liberation of the feminist subject – the discourse of
camp. Proust described this accomplishment in his novel *The Captive*:

> The lie, the perfect lie, about people we know, about the relations we have had with
> them, about our motive for some action, formulated in totally different terms, the
> lie as to what we are, whom we love, what we feel in regard to those people who
> love us . . . – that lie is one of the few things in the world that can open windows
> for us on to what is new and unknown, that can awaken in us sleeping senses for
> the contemplation of the universes that otherwise we should never have known.
>
> (Proust, 213; in Sedgwick 1987)

The closet has given us camp – the style, the discourse, the *mise en scène* of butch–femme
roles. In his history of the development of gay camp, Michael Bronski describes the libera-
tive work of late-nineteenth-century authors such as Oscar Wilde in creating the homosexual
camp liberation from the rule of naturalism, or realism. Within this argument, Bronski

describes naturalism and realism as strategies that tried to save fiction from the accusation of daydream, imagination, or masturbation and to affix a utilitarian goal to literary production – that of teaching morals. In contrast, Bronski quotes the newspaper *Fag Rag* on the functioning of camp: "We've broken down the rules that are used for validating the difference between real/true and unreal/false. The controlling agents of the status quo may know the power of lies; dissident subcultures, however, are closer to knowing their value" (1984, 41). Camp both articulates the lives of homosexuals through the obtuse tone of irony and inscribes their oppression with the same device. Likewise, it eradicates the ruling powers of heterosexist realist modes.

Susan Sontag, in an avant-garde assimilation of camp, described it as a "certain mode of aestheticism . . . one way of seeing the world as an aesthetic phenomenon . . . not in terms of beauty, but in terms of the degree of artifice" (1966, 275). This artifice, as artifice, works to defeat the reign of realism as well as to situate the camp discourse within the category of what can be said (or seen). However, the fixed quality of Sontag's characteristic use of camp within the straight context of aestheticization has produced a homosexual strategy for avoiding such assimilation: what Esther Newton has described as its constantly changing, mobile quality, designed to alter the gay camp sensibility before it becomes a fad (1972, 105). Moreover, camp also protects homosexuals through a "first-strike wit" as *Fag Rag* asserts: "Wit and irony provide the only reasonable modus operandi in the American Literalist Terror of Straight Reality" (Bronski, 1984, 46).

Oscar Wilde brought this artifice, wit, irony, and the distancing of straight reality and its conventions to the stage. Later, Genet staged the malleable, multiple artifice of camp in *The Screens*, which elevates such displacement to an ontology. In his play, *The Blacks*, he used such wit, irony and artifice to deconstruct the notion of "black" and to stage the dynamics of racism. *The Blacks* displaced the camp critique from homophobia to racism, in which "black" stands in for "queer" and the campy queen of the bars is transformed into an "African queen." This displacement is part of the larger use of the closet and gay camp discourse to articulate other social realities. Eve Sedgwick attests to this displacement when she writes: "I want to argue that a lot of energy of attention and demarcation that has swirled around issues of homosexuality since the end of the nineteenth century . . . has been impelled by the distinctly indicative relation of homosexuality to wider mappings of secrecy and disclosure, and of the private and the public, that were and are critically problematical for the gender, sexual, and economic structures of the heterosexist culture at large . . . 'the closet' and 'coming out' are now verging on all-purpose phrases for the potent crossing and recrossing of almost any politically-charged lines of representation. . . . The apparent floating-free from its gay origins of that phrase 'coming out of the closet' in recent usage might suggest that the trope of the closet is so close to the heart of some modern preoccupations that it could be . . . evacuated of its historical gay specificity. But I hypothesize that exactly the opposite is true." Thus, the camp success in ironizing and distancing the regime of realist terror mounted by heterosexist forces has become useful as a discourse and style for other marginal factions.

Camp style, gay-identified dressing and the articulation of the social realities of homosexuality have also become part of the straight, postmodern canon, as Herbert Blau articulated it in a special issue of *Salmagundi:* "becoming homosexual is part of the paraphilia of the postmodern, not only a new sexual politics but the reification of all politics, supersubtilized beyond the unnegotiable demands of the sixties, from which it is derived, into a more persuasive rhetoric of unsublimated desire" (1983, 233). Within this critical community, the perception of recognizable homosexuals can also inspire broader visions of the operation of social codes. Blau states: "there soon came pullulating toward me at high prancing amphetamined pitch

something like the end of Empire or like the screaming remains of the return of the repressed – pearl-white, vinyl, in polo pants and scarf – an englistered and giggling outburst of respondent queer . . . what was there to consent to and who could possibly legitimate that galloping specter I had seen, pure ideolect, whose plunging and lungless soundings were a full-throttled forecast of much weirder things to come?" (1983, 221–22). Initially, these borrowings seem benign and even inviting to the homosexual theorist. Contemporary theory seems to open the closet door to invite the queer to come out, transformed as a new, postmodern subject, or even to invite straights to come into the closet, out of the roar of dominant discourse. The danger incurred in moving gay politics into such heterosexual contexts is in only slowly discovering that the strategies and perspectives of homosexual realities and discourse may be locked inside a homophobic "concentration camp." Certain of these authors, such as Blau, even introduce homosexual characters and their subversions into arguments that conclude with explicit homophobia. Note Blau's remembrance of things past: "thinking I would enjoy it, I walked up Christopher Street last summer at the fag end of the depleted carnival of Gay Pride Day, with a disgust unexpected and almost uncontained by principle. . . . I'll usually fight for the right of each of us to have his own perversions, I may not, under the pressure of theory and despite the itchiness of my art, to try on yours and, what's worse, rather wish you wouldn't. Nor am I convinced that what you are doing isn't perverse in the most pejorative sense" (1983, 249). At least Blau, as in all of his writing, honestly and openly records his personal prejudice. The indirect or subtextual homophobia in this new assimilative discourse is more alluring and ultimately more powerful in erasing the social reality and the discursive inscriptions of gay, and more specifically, lesbian discourse.

Here, the sirens of sublation may be found in the critical maneuvers of heterosexual feminist critics who metaphorize butch–femme roles, transvestites and campy dressers into a "subject who masquerades," as they put it, or is "carnivalesque" or even, as some are so bold to say, who "cross-dresses." Even when these borrowings are nested in more benign contexts than Blau's, they evacuate the historical, butch–femme couples' sense of masquerade and cross-dressing the way a cigar-store Indian evacuates the historical dress and behavior of the Native American. As is often the case, illustrated by the cigar-store Indian, these symbols may only proliferate when the social reality has been successfully obliterated and the identity has become the private property of the dominant class. Such metaphors operate simply to display the breadth of the art collection, or style collection, of the straight author. Just as the French term *film noir* became the name for B-rate American films of the 1940s, these notions of masquerade and cross-dressing, standing in for the roles of working-class lesbians, have come back to us through French theory on the one hand and studies of the lives of upper-class lesbians who lived in Paris between the wars on the other. In this case, the referent of the term Left Bank is not a river, but a storehouse of critical capital.

Nevertheless, this confluence of an unresolved social, historical problem in the feminist movement and these recent theoretical strategies, re-assimilated by the lesbian critic, provide a ground that could resolve the project of constructing the feminist subject position. The butch–femme subject could inhabit that discursive position, empowering it for the production of future compositions. Having already grounded this argument within the historical situation of butch–femme couples, perhaps now it would be tolerable to describe the theoretical maneuver that could become the butch–femme subject position. Unfortunately, these strategies must emerge in the bodiless world of "spectatorial positions" or "subject positions," where transvestites wear no clothes and subjects tread only "itineraries of desire." In this terrain of discourse, or among theorized spectators in darkened movie houses with their gazes fixed on the dominant cinema screen, "the thrill is gone" as Nestle described it. In the

Greenwich Village bars, she could "spot a butch 50 feet away and still feel the thrill of her power" as she saw "the erotic signal of her hair at the nape of her neck, touching the shirt collar; how she held a cigarette; the symbolic pinky ring flashing as she waved her hand" (1981, 21–22). Within this theory, the erotics are gone, but certain maneuvers maintain what is generally referred to as "presence."

The origins of this theory may be found in a Freudian therapist's office, where an intellectual heterosexual woman, who had become frigid, had given way to rages, and, puzzled by her own coquettish behavior, told her story to Joan Riviere sometime around 1929. This case caused Riviere to publish her thoughts in her ground-breaking article entitled "Womanliness as a Masquerade" that later influenced several feminist critics such as Mary Russo and Mary Ann Doane and the French philosopher Jean Baudrillard. Riviere began to "read" this woman's behavior as the "wish for masculinity" which causes the woman to don "the mask of womanliness to avert anxiety and the retribution feared from men" (1929, 303). As Riviere saw it, for a woman to read an academic paper before a professional association was to exhibit in public her "possession of her father's penis, having castrated him" (1929, 305–6). In order to do recompense for this castration, which resided in her intellectual proficiency, she donned the mask of womanliness. Riviere notes: "The reader may now ask how I define womanliness or where I draw the line between genuine womanliness and the 'masquerade' . . . they are the same thing" (1929, 306). Thus began the theory that all womanliness is a masquerade worn by women to disguise the fact that they have taken their father's penis in their intellectual stride, so to speak. Rather than remaining the well-adjusted castrated woman, these intellectuals have taken the penis for their own and protect it with the mask of the castrated, or womanhood. However, Riviere notes a difference here between heterosexual women and lesbian ones – the heterosexual women don't claim possession openly, but through reaction-formations; whereas the homosexual women openly display their possession of the penis and count on the males' recognition of defeat (1929, 312). This is not to suggest that the lesbian's situation is not also fraught with anxiety and reaction-formations, but this difference in degree is an important one.

I suggest that this kind of masquerade is consciously played out in butch–femme roles, particularly as they were constituted in the 1940s and 1950s. If one reads them from within Riviere's theory, the butch is the lesbian woman who proudly displays the possession of the penis, while the femme takes on the compensatory masquerade of womanliness. The femme, however, foregrounds her masquerade by playing to a butch, another woman in a role; likewise, the butch exhibits her penis to a woman who is playing the role of compensatory castration. This raises the question of "penis, penis, who's got the penis," because there is no referent in sight; rather, the fictions of penis and castration become ironized and "camped up." Unlike Riviere's patient, these women play on the phallic economy rather than to it. Both women alter this masquerading subject's function by positioning it between women and thus foregrounding the myths of penis and castration in the Freudian economy. In the bar culture, these roles were always acknowledged as such. The bars were often abuzz with the discussion of who was or was not a butch or femme, and how good they were at the role (see Davis and Kennedy 1986). In other words, these penis-related posturings were always acknowledged as roles, not biological birthrights, nor any other essentialist poses. The lesbian roles are underscored as two optional functions for women in the phallocracy, while the heterosexual woman's role collapses them into one compensatory charade. From a theatrical point of view, the butch–femme roles take on the quality of something more like a character construction and have a more active quality than what Riviere calls a reaction-formation. Thus, these roles qua roles lend agency and self-determination to the historically passive

subject, providing her with at least two options for gender identification and, with the aid of camp, an irony that allows her perception to be constructed from outside ideology, with a gender role that makes her appear as if she is inside of it.

Meanwhile, other feminist critics have received this masquerade theory into a heterosexual context, retaining its passive imprint. In Mary Ann Doane's influential article entitled "Film and the Masquerade: Theorising the Female Spectator," Doane, unfortunately, resorts to a rather biologistic position in constructing the female spectator and theorizing out from the female body. From the standpoint of something more active in terms of representation such as de Lauretis's feminist subject or the notion of butch–femme, this location of critical strategies in biological realities seems revisionist. That point aside, Doane does devise a way for women to "appropriate the gaze for their own pleasure" (1982, 77) through the notion of the transvestite and the masquerade. As the former, the female subject would position herself as if she were a male viewer, assimilating all of the power and payoffs that spectatorial position offers. As the latter, she would, as Riviere earlier suggested, masquerade as a woman. She would "flaunt her femininity, produce herself as an excess of femininity – foreground the masquerade," and reveal "femininity itself . . . as a mask" (1982, 81). Thus, the masquerade would hold femininity at a distance, manufacturing "a lack in the form of a certain distance between oneself and one's image" (1982, 82). This strategy offers the female viewer a way to be the spectator of female roles while not remaining close to them, nor identifying with them, attaining the distance from them required to enter the psychoanalytic viewing space. The masquerade that Doane describes is exactly that practiced by the femme – she foregrounds cultural femininity. The difference is that Doane places this role in the spectator position, probably as an outgrowth of the passive object position required of women in the heterosexist social structures. Doane's vision of the active woman is as the active spectator. Within the butch–femme economy, the femme actively performs her masquerade as the subject of representation. She delivers a performance of the feminine masquerade rather than, as Doane suggests, continues in Riviere's reactive formulation of masquerading compensatorily before the male-gaze-inscribed-dominant-cinema-screen. *Flaunting* has long been a camp verb and here Doane borrows it, along with the notion of "excess of femininity," so familiar to classical femmes and drag queens. Yet, by reinscribing it within a passive, spectatorial role, she gags and binds the traditional homosexual role players, whose gender play has nothing essential beneath it, replacing them with the passive spectatorial position that is, essentially, female.

Another feminist theorist, Mary Russo, has worked out a kind of female masquerade through the sense of the carnivalesque body derived from the work of Mikhail Bakhtin. In contrast to Doane, Russo moves on to a more active role for the masquerader, one of "making a spectacle of oneself." Russo is aware of the dangers of the essentialist body in discourse, while still maintaining some relationship between theory and real women. This seems a more hopeful critical terrain to the lesbian critic. In fact, Russo even includes a reference to historical instances of political resistance by men in drag (1985, 3). Yet in spite of her cautions, like Doane, Russo's category is once again the female subject, along with its biologically determined social resonances. Perhaps it is her reliance on the male author Bakhtin and the socialist resonances in his text (never too revealing about gender) that cause Russo to omit lesbian or gay strategies or experiences with the grotesque body. Instead, she is drawn to depictions of the pregnant body and finally Kristeva's sense of the maternal, even though she does note its limitations and problematic status within feminist thought (1985, 6). Finally, this swollen monument to reproduction, with all of its heterosexual privilege, once more stands alone in this performance area of the grotesque and carnivalesque. Though she does note the exclusion, in this practice, of "the already marginalized" (6), once again, they do not appear.

Moreover, Russo even cites Showalter's notion that feminist theory itself is a kind of "critical cross-dressing," while still suppressing the lesbian presence in the feminist community that made such a concept available to the straight theorists (1985, 8). Still true to the male, heterosexual models from which her argument derives, she identifies the master of *mise en scène* as Derrida. Even when damning his characterization of the feminist as raging bull and asking "what kind of drag is this," her referent is the feminist and not the bull . . . dyke (1985, 9). This argument marks an ironic point in history: once the feminist movement had obscured the original cross-dressed butch through the interdiction of "politically incorrect," it donned for itself the strategies and characteristics of the role-playing, safely theorized out of material reality and used to suppress the referent that produced it.

In spite of their heterosexist shortcomings, what, in these theories, can be employed to understand the construction of the butch–femme subject on the stage? First, how might they be constructed as characters? Perhaps the best example of some workings of this potential is in Split Britches' production of *Beauty and the Beast* [see Figure 47.1].[1] The title itself connotes the butch–femme couple: Shaw as the butch becomes the Beast who actively pursues the femme, while Weaver as the excessive femme becomes Beauty. Within the dominant system of representation, Shaw, as butch Beast, portrays as bestial women who actively love other women. The portrayal is faithful to the historical situation of the butch role, as Nestle describes it: "None of the butch women I was with, and this included a passing woman, ever presented themselves to me as men; they did announce themselves as tabooed women who were willing to identify their passion for other women by wearing clothes that symbolized the taking of responsibility. Part of this responsibility was sexual expertise . . . this courage to feel comfortable with arousing another woman became a political act" (1981, 21). In other words, the butch, who represents by her clothing the desire for other women, becomes the beast – the marked taboo against lesbianism dressed up in the clothes of that desire. Beauty is the desired one and the one who aims her desirability at the butch.

This symbolism becomes explicit when Shaw and Weaver interrupt the Beauty/Beast narrative to deliver a duologue about the history of their own personal butch–femme roles. Weaver uses the trope of having wished she was Katherine Hepburn and casting another woman as Spencer Tracy, while Shaw relates that she thought she was James Dean. The identification with movie idols is part of the camp assimilation of dominant culture. It serves multiple purposes: (1) they do not identify these butch–femme roles with "real" people, or literal images of gender, but with fictionalized ones, thus underscoring the masquerade; (2) the history of their desire, or their search for a sexual partner becomes a series of masks, or identities that stand for sexual attraction in the culture, thus distancing them from the "play" of seduction as it is outlined by social mores; (3) the association with movies makes narrative fiction part of the strategy as well as characters. This final fiction as fiction allows Weaver and Shaw to slip easily from one narrative to another, to yet another, unbound by through-lines, plot structure, or a stable sense of character because they are fictional at their core in the camp style and through the butch–femme roles. The instability and alienation of character and plot is compounded with their own personal butch–femme play on the street, as a recognizable couple in the lower East Side scene, as well as within fugitive narratives on-stage, erasing the difference between theatre and real life, or actor and character, obliterating any kind of essentialist ontology behind the play. This allows them to create a play with scenes that move easily from the narrative of beauty and the beast, to the duologue on their butch–femme history, to a recitation from *Macbeth*, to a solo lip-synced to Perry Como. The butch–femme roles at the center of their ongoing personalities move masquerade to the base of performance and no narrative net can catch them or hold them, as they wriggle into a variety of characters and plots.

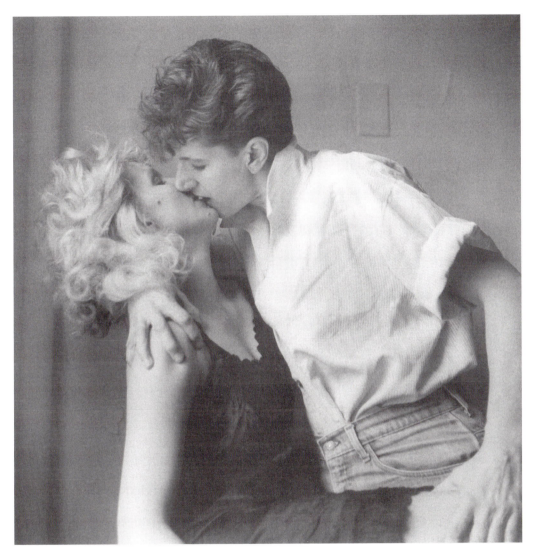

Figure 47.1 Peggy Shaw and Lois Weaver in *Split Britches Cabaret*, *c.*1981–2. Photo by Morgan Gwenweld.

This exciting multiplicity of roles and narratives signals the potency of their agency. Somehow the actor overcomes any text, yet the actor herself is a fiction and her social self is one as well. Shaw makes a joke out of suturing to any particular role or narrative form when she dies, as the beast. Immediately after dying, she gets up to tell the audience not to believe in such cheap tricks. Dies. Tells the audiences that Ronald Reagan pulled the same trick when he was shot – tells them that was not worth the suturing either. Dies. Asks for a Republican doctor. Dies. Then rises to seemingly close the production by kissing Weaver. Yet even this final butch–femme tableau is followed by a song to the audience that under-cuts the performance itself.

Weaver's and Shaw's production of butch–femme role-playing in and out of a fairy tale positions the representation of the lesbian couple in a childhood narrative: the preadolescent

proscription of perversity. Though they used *Beauty and the Beast* to stage butch–femme as outsiders, the quintessential childhood narrative that proscribes cross-dressing is *Little Red Riding Hood*, in which the real terror of the wolf is produced by his image in grandmother's clothing. The bed, the eating metaphor, and the cross-dressing by the wolf, provide a grid-lock closure of any early thoughts of transgressing gender roles. Djuna Barnes wrote a version of this perspective in *Nightwood*. When Nora sees the transvestite doctor in his bed, wearing women's nightclothes, she remarks: "God, children know something they can't tell; they like Red Riding Hood and the wolf in bed!" Barnes goes on to explicate that sight of the cross-dressed one: "Is not the gown the natural raiment of extremity? . . . He dresses to lie beside himself, who is so constructed that love, for him, can only be something special . . ." (1961, 78–80).[2] *Beauty and the Beast* also returns to a childhood tale of taboo and liberates the sexual preference and role-playing it is designed to repress, in this case, specifically the butch–femme promise. As some lesbians prescribed in the early movement: identify with the monsters!

What, then, is the action played between these two roles? It is what Jean Baudrillard terms *séduction* and it yields many of its social fruits. Baudrillard begins his argument in *De la séduction*, by asserting that seduction is never of the natural order, but always operates as a sign, or artifice (1979, 10). By extension, this suggests that butch–femme seduction is always located in semiosis. The kiss, as Shaw and Weaver demonstrate in their swooping image of it, positioned at its most clichéd niche at the end of the narrative, is always the high camp kiss. Again, Baudrillard: seduction doesn't "recuperate the autonomy of the body . . . truth . . . the sovereignty of this seduction is transsexual, not bisexual, destroying all sexual organi-zation." (1979, 18). The point is not to conflict reality with another reality, but to abandon the notion of reality through roles and their seductive atmosphere and lightly manipulate appearances. Surely, this is the atmosphere of camp, permeating the *mise en scène* with "pure" artifice. In other words, a strategy of appearances replaces a claim to truth. Thus, butch–femme roles evade the notion of "the female body" as it predominates in feminist theory, dragging along its Freudian baggage and scopophilic transubstantiation. These roles are played in signs themselves and not in ontologies. Seduction, as a dramatic action, transforms all of these seeming realities into semiotic play. To use Baudrillard with Riviere, butch–femme roles offer a hypersimulation of woman as she is defined by the Freudian system and the phallocracy that institutes its social rule.[3]

Therefore, the female body, the male gaze, and the structures of realism are only sex toys for the butch–femme couple. From the perspective of camp, the claim these have to realism destroys seduction by repressing the resonances of vision and sound into its medium. This is an idea worked out by Baudrillard in his chapter on pornography, but I find it apt here. That is, that realism, with its visual organization of three dimensions, actually degrades the scene; it impoverishes the suggestiveness of the scene by its excess of means (1979, 49). This implies that as realism makes the spectator see things its way, it represses her own ability to free-associate within a situation and reduces the resonances of events to its own limited, technical dimensions. Thus, the seduction of the scene is repressed by the authoritarian claim to realistic representation. This difference is marked in the work of Weaver and Shaw in the ironized, imaginative theatrical space of their butch–femme role-playing. Contrast their freely moving, resonant narrative space to the realism of Marsha Norman, Beth Henley, Irene Fornes's *Mud*, or Sam Shepard's *A Lie of the Mind*. The violence released in the continual zooming-in on the family unit, and the heterosexist ideology linked with its stage partner, realism, is directed against women and their hint of seduction. In *A Lie of the Mind*, this becomes liter-ally woman-battering. Beth's only associative space and access to transformative discourse is the result of nearly fatal blows to her head. One can see similar violent results in Norman's

concerted moving of the heroine toward suicide in *'night, Mother* or Henley's obsession with suicide in *Crimes of the Heart* or the conclusive murder in Fornes's *Mud*. The closure of these realistic narratives chokes the women to death and strangles the play of symbols, or the possibility of seduction. In fact, for each of them, sexual play only assists their entrapment. One can see the butch Peggy Shaw rising to her feet after these realistic narrative deaths and telling us not to believe it. Cast the realism aside – its consequences for women are deadly.

In recuperating the space of seduction, the butch–femme couple can, through their own agency, move through a field of symbols, like tiptoeing through the two lips (as Irigaray would have us believe), playfully inhabiting the camp space of irony and wit, free from biological determinism, elistist essentialism, and the heterosexist cleavage of sexual difference. Surely, here is a couple the feminist subject might perceive as useful to join.

Notes

A version of this article appears in the journal *Discourse* II, no. 1, from the Center for Twentieth Century Studies, University of Wisconsin-Milwaukee.

1 There is no published version of this play. In fact, there is no satisfactory way to separate the spoken text from the action. The play is composed by three actors, Deborah Margolin along with Shaw and Weaver. Margolin, however, does not play within the lesbian dynamics, but represents a Jewish perspective. For further discussions of this group's work see Kate Davy, "Constructing the Spectator: Reception, Context, and Address in Lesbian Performance," *Performing Arts Journal* 10, no. 2 (1986): 43–52; Jill Dolan, "The Dynamics of Desire: Sexuality and Gender in Pornography and Performance," *Theatre Journal* 39, no. 2 (1987): 156–74; and Sue-Ellen Case, "From Split Subject to Split Britches," in *Feminine Focus: The New Women Playwrights*, ed. Enoch Brater, Oxford: Oxford University Press, 1989, 126–46.
2 My thanks to Carolyn Allen, who pointed out this passage in Barnes to me in discussing resonances of the fairy tale. In another context, it would be interesting to read the lesbian perspectives on the male transvestite in these passages and the way he works in Barnes's narrative. "The Company of Wolves," a short story and later a screenplay by Angela Carter, begins to open out the sexual resonances, but retains the role of the monster within heterosexuality.
3 The term *hypersimulation* is borrowed from Baudrillard's notion of the simulacrum rather than his one of seduction. It is useful here to raise the ante on terms like artifice and to suggest, as Baudrillard does, its relation to the order of reproduction and late capitalism.

References

Barnes, Djuna. 1961. *Nightwood*. New York: New Directions.
Baudrillard, Jean. 1979. *De la séduction*. Paris: Editions Galilee.
Blau, Herbert. 1983. "Disseminating Sodom." *Salmagundi* 58–59: 221–51.
Bronski, Michael. 1984. *Culture Clash: The Making of Gay Sensibility*. Boston: South End Press.
Davis, Madeline, and Kennedy, Elizabeth Lapovsky. 1986. "Oral History and the Study of Sexuality in the Lesbian Community: Buffalo, New York, 1940–1960." *Feminist Studies* 12, no. 1: 7–26.
de Lauretis, Teresa. 1987. *Technologies of Gender*. Bloomington, Ind.: Indiana University Press.
Doane, Mary Ann. 1982. "Film and the Masquerade: Theorising the Female Spectator." *Screen* 23: 74–87. [Chapter 11 in this volume.]
Dolan, Jill. 1987. "The Dynamics of Desire: Sexuality and Gender in Pornography and Performance." *Theatre Journal* 39, no. 2: 156–74.
Echols, Alice. 1983. "The New Feminism of Yin and Yang." In *Powers of Desire: The Politics of Sexuality*, ed. Ann Snitow, Christine Stansell, and Sharon Thompson, 440–59. New York: Monthly Review Press.
Hollibaugh, Amber, and Moraga, Cherríe. 1983. "What We're Rollin' Around in Bed With: Sexual Silences in Feminism." In *Powers of Desire: The Politics of Sexuality*, ed. Ann Snitow, Chritine Stansell, and Sharon Thompson, 395–405. New York: Monthly Review Press.
Martin, Del, and Lyon, Phyllis. 1972. *Lesbian/Woman*. New York: Bantam.

Nestle, Joan. 1981. "Butch-Fem Relationships: Sexual Courage in the 1950s." *Heresies* 12: 21–24. All pagi-
 nation here is from that publication. Reprinted in Joan Nestle, 1987. *A Restricted Country*, 100–109.
 Ithaca: Firebrand Books.
Newton, Esther. 1972. *Mother Camp: Female Impersonators in America*. Englewood Cliffs, N. J.: Prentice Hall.
"Postmodernism: Text, Politics, Instruction." 1987. International Association for Philosophy and Literature.
 Lawrence, Kansas, April 30–May 2.
Riviere, Joan. 1929. "Womanliness as a Masquerade." *International Journal of Psycho-Analysis* 10: 303–13.
Russo, Mary. 1985. "Female Grotesques: Carnival and Theory." Working Paper no. I. Center for Twentieth
 Century Studies, Milwaukee. Page citations for this text. Reprinted in *Feminist Studies Critical Studies*,
 ed. Teresa de Lauretis. Bloomington: Indiana University Press, 1986.
Sedgwick, Eve. 1987. "The Epistemology of the Closet." Manuscript.
Sontag, Susan. 1966. *Against Interpretation*. New York: Farrar, Straus & Giroux.
Wittig, Monique. *The Lesbian Body*. Trans. David LeVay. New York: William Morrow, 1975.

Chapter 48

JANET WOLFF

REINSTATING CORPOREALITY
Feminism and body politics

IS THE BODY A SITE of cultural and political protest? And can women's bodies be the site of feminist cultural politics? These are currently contested issues.

> I do not see how . . . there is any possibility of using the image of a naked woman . . . other than in an absolutely sexist and politically repressive patriarchal way in this conjuncture.[1]

> To use the body of the woman, her image or person is not impossible but prob-lematic for feminism.[2]

Crucial to the debate about the political potential of the body is the more fundamental question of whether there *is* any body outside discourse – another matter of dispute.

> Experience of the body even at the simplest level is mediated by a presentation of the body, the body-image.[3]

> The positing of a body *is* a condition of discursive practices.[4]

In this essay I will argue for a cultural politics of the body, based on a recognition of the social and discursive construction of the body, while emphasizing its lived experience and materiality.

The dangers of body politics

On 17 July 1989, a group of women staged a protest against the sole use by men of a bathing area at Sandycove, Dublin. The men often swam naked in this area, an artificial harbour on the seafront called Forty Foot pool. The women's protest was to invade the area and to remove their own swimming suits. The reporting of this event makes clear the ambiguities and ultimate failure of such body politics. The *Guardian* carried a short note, as a caption to a photograph. The photo depicts one of the women, facing the camera and walking out of the water, wearing only a small pair of briefs. Behind her men and boys in small boats stare. She walks past a line of young boys, who gawp at her body and laugh at her. It is not an attractive scene. Without having been at the event, one can only assume that female nudity achieved nothing more than male lechery. Moreover, the photograph in the press the next morning renders the liberal (and generally pro-feminist) paper the *Guardian* little different from the tabloids, with their Page Three topless pinups. The political gesture is neutralized and doubly cancelled – first by the look of those at the scene, and second by its representation in the press for the reader's gaze. The lesson (or one of them) is that there are problems with using the female body for feminist ends. Its pre-existing meanings, as sex object, as object of the male gaze, can always prevail and reappropriate the body, despite the intentions of the woman herself.

This can also occur with less naïve interventions, which incorporate a critical understanding of the meanings and uses of the female body in our culture. The movie *Not a Love Story* is a documentary about the pornography industry, made by women and presenting a clearly feminist and critical view of pornography. When it arrived in Leeds in the early 1980s, however, it was for some reason shown in one of the rather sleazy city-centre cinemas. Its audience consisted of a few groups of women (the film had not had much advance publicity, and this, together with the rather peculiar venue, meant that large numbers of local feminists did not turn up), and a considerable contingent from the raincoat brigade. Individual men were scattered throughout the cinema. And the point is that they would not have been disappointed, for, as sympathetic critics have pointed out, in order to discuss the pornography industry, the movie spent a good deal of time showing pornographic images and sequences.[5] Again, this raises the question of whether, or how, women can engage in a critical politics of the body, in a culture which so comprehensively codes and defines women's bodies as subordinate and passive, and as objects of the male gaze. Peter Gidal's pessimism, in the first quotation with which I began this essay, is a well-founded one.

Yet I want to argue that a feminist cultural politics of the body *is* a possibility. As Mary Kelly says, this may be problematic, but it is not impossible. There is every reason, too, to propose the body as a privileged site of political intervention, precisely because it is the site of repression and possession. The body has been systematically repressed and marginalized in Western culture, with specific practices, ideologies, and discourses controlling and defining the female body. What is repressed, though, may threaten to erupt and challenge the established order. It is on such grounds that some have argued for a body politics, and some feminists have urged a cultural and political intervention which is grounded in, and which employs, the body. I shall review these arguments, in order to draw some conclusions about the prospects for a feminist body politics in contemporary culture.

Repression and marginalization of the body in Western culture

As Mary Douglas has shown, the body operates as a symbol of society across cultures, and the rituals, rules, and boundaries concerning bodily behaviour can be understood as the functioning of social rules and hierarchies.[6] In some cultures, bodily refuse (excreta, blood, tears, hair, nail clippings) has magical, and dangerous, qualities. In its marginality, in the way in which it traverses the boundaries of the body, it comes to represent particular threats and powers, which ultimately symbolize social boundaries, transgressions, and threats. What counts as pollution varies from society to society, but in all cases, according to Douglas, it is a "symbolic system, based on the image of the body, whose primary concern is the ordering of a social hierarchy".[7]

[. . .]

In the civilizing process, the body is increasingly patrolled, the range of acceptable behaviour increasingly carefully and narrowly defined. Emerging from this process of gradual exclusion and privatization of areas of bodily functions is what Bakhtin called the "classical body". The classical body has no orifices and engages in no base bodily functions. It is like a classical statue. It is opposed to the "grotesque body", which has orifices, genitals, protuberances.[8] Francis Barker's fascinating study of seventeenth-century Europe documents the developing idea of the separation of the body from the soul, showing in relation to selected key texts (a Marvell poem, a Rembrandt painting, Pepys's diary) how the body was increasingly redefined and privatized, its sexual and other needs and appetites denied.[9]

[. . .]

If the body has thus been repressed since the seventeenth century, does it follow that the irruption of the "grotesque" body, the explosion into visibility of its suppressed features (sex, laughter, excretion, and so on) constitutes a political revolution as well as a moral transgression? Stallybrass and White are rightly cautious about any blanket endorsement of bodily transgression as inherently radical.

> It would be wrong to associate the exhilarating sense of freedom which transgression affords with any necessary or automatic political progressiveness. . . . Often it is a powerful ritual or symbolic practice whereby the dominant squanders its symbolic capital so as to get in touch with the fields of desire which it denied itself as the price paid for its political power. Not a repressive desublimation (for just as transgression is not intrinsically progressive, nor is it intrinsically conservative), it is a counter-sublimation, a delirious expenditure of the symbolic capital accrued (through the regulation of the body and the decathexis of habitus) in the successful struggle of bourgeois hegemony.[10]

Indeed, the transgressions of the carnivalesque and of the grotesque body can in many cases, as they also point out, operate in reactionary ways, particularly with regard to gender. This is something I shall return to.

The female body in Western culture

Despite Foucault's radical argument that the nineteenth century saw an incitement to sex, not a repression of it, there is no question about the oppression of women through the discourses of the body. One collection of essays, largely inspired by Foucault's work, demonstrates the many ways in which contemporary discourses and practices rendered women

inferior, put control of women's bodies into men's hands, and produced new sciences which redefined women and femininity centrally in terms of reproductive function, denying female sexuality while perceiving women as somehow closer to Nature than men.[11] This equation of woman with the body, for the most part a product of eighteenth- and nineteenth-century debates and ideologies,[12] has a pre-history in classical thought. Elizabeth Spelman has shown that Plato, despite an apparent commitment to the equality of the sexes (in *The Republic*, for example), believed that women exemplified the failure to value the soul above the body.[13] His somatophobia and his misogyny, she suggests, are closely linked. Here, then, we already have the notion that women are closer (too close) to the body compared with men. When we recognize the great value put on the soul or the mind as against the body (which is a central aspect of the process discussed by Barker, in which the "positive body" of rational science excludes and obscures the "absent body" of desires and appetites), the significance of the identification of women with the body is clear.

It is through the body, too, that women in our culture learn their own particular form of self-surveillance. Sandra Bartky identifies the "panoptical male connoisseur" in women's consciousness.[14] The discursive practices which produce "femininity" are in the culture and within women. Thus they diet, dress for certain effect, monitor their movement and gestures. Unlike Bartky, I do not conclude that radical social change will come about as a result of a refusal of particular definitions and demands of "femininity" and the substitution of an "as yet unimagined transformation of the female body",[15] for this addresses only the *effects* of gender inequalities. It is likely that any *new* definitions of "femininity" would equally provide the basis for control and self-surveillance. But the perception is accurate, that it is through the body that women collude in their own oppression, and the specifically feminist slant on Foucault's analysis of the effects of discourse is an invaluable one.

Women learn as girls to monitor their appearance, and to conform to what is presented in the culture as some ideal of femininity. A group of German women explored in discussion the ways in which this policing (and self-policing) works, and how early it begins.

> Every Thursday afternoon, the park was open to me for free; I had a special pass to let me in for my gym lesson. My mother had put my name down for the class so I could do something about my weak stomach muscles. She said the only way I could get rid of my tummy at my age was by strengthening the muscles with exercise. In a few years' time, when I was grown up, I'd then be able to deal with it by pulling it in.[16]

Advertising and the fashion industry show us the perfect body for women, though, as Rosalind Coward has said, this ideal shifts slightly from one season to the next.[17]

> If you just *love* being a girl (and really look like one), this is *your* time! After decades of "You can never be too rich or too thin", the all-girl girl has reemerged to be celebrated and adored. Curves à la Monroe (if she'd worked out a bit more!) are what's red-hot right now. So if you've been disguising all those luscious lines under industrial-strength bras and baggy sweaters, stop! Here are a few suggestions for really showing *off* this shapely, gorgeous girl.[18]

(It is noticeable, however, that the all-girl girl still has a small waist and perfectly flat stomach. There are apparently limits to the revolution in body ideal.)

Cultural theory, particularly in the visual arts and film studies, has explored for a decade and a half the representation of women's bodies in patriarchal culture, informed first by

John Berger's early perception that paintings of the nude in Western art imply a male spectator and are constructed for the male gaze, and then by Laura Mulvey's influential article of 1975, which analyzed the operation of the male gaze and the representation of the female body in film in terms of psychoanalytic theory.[19] The issue of women's viewing positions and possible identifications has been one much discussed (and disputed) in recent years, though this is not something I shall consider here. The devastating implication of this work in general appears to be that women's bodies (particularly the nude, though not just that) *cannot* be portrayed other than through the regimes of representation which produce them as objects for the male gaze, and as the projection of male desires. The failure of the Dublin intervention should have been predicted, in the light of this. We have to ask what this means for feminist art practice (can women paint women's bodies? are there ways of subverting or circumventing the dominant modes of representation?) and for body politics (*can* the body, after all, be a site of cultural critique?).

Transgression and the female body

What happens when the female body is affirmed and displayed, in defiance of the dominant ideals of the "perfect body", acknowledging the reality of actual women, the diversities of shape and size, the functions of corporeal existence (eating, excreting, menstruation, sex, pregnancy, aging, illness)? The "grotesque body", at least, should be immune from incorporation into the objectifying gaze. (The question of hard-core pornography, which depends on a particular deviation from the classical to the grotesque body, is an interesting one, requiring a more complex analysis of such imagery in relation to sexuality and representation in patriarchal society. It is something I shall have to leave to one side, however.)

Mary Russo considers the female grotesques of carnival. The examples she discusses are unruly women (including men cross-dressing as women, in this role) in popular uprisings in seventeenth-century England, terracotta figurines of "senile, pregnant hags" (discussed by Bakhtin) and Charcot's famous photographs of women hysterics.[20] She concludes that these figures are deeply ambivalent. As she says, "woman and their bodies, certain bodies, in certain public framings, in certain public spaces, are always already transgressive – dangerous and in danger".[21] These cases and images of women "in excess" of the idealized feminine may operate as threat (as well as example to other women). However, there are always reactionary connotations. The unruly woman is pilloried as a scold, henpecking her husband. Cross-dressing men are as likely to be portraying women with contempt as with respect. The image of the pregnant hag is "loaded with all of the connotations of fear and loathing associated with the biological processes of reproduction and of aging".[22] Female hysterics have a history of being locked up and contained. And at fairs and carnival festivities women were frequently abused and raped.

In any case, the excesses and reversals of the carnivalesque often operate to reaffirm the status quo, providing licensed but limited occasions for transgressions which are guaranteed to be neutralized. Whether or not there is any leakage into the culture in general from such occasions is an important question, though it is not one to which we can assume a positive answer. What I think we *can* safely affirm is the importance of the appearance itself of such transgressive images, practices, and ideas, for they render visible the suppressed. As Mary Russo says, how the category of the grotesque "might be used affirmatively to destabilize the idealizations of female beauty or to realign the mechanisms of desire" is the subject of another study.[23] Like her, at this stage I simply note the potential value of the existence of spaces for the female grotesque body for the daunting project of the subversion of its dominant construction and portrayal.

Related to the notion of the female grotesque is Julia Kristeva's concept of the "monstrous-feminine." In her psychoanalytic account, the maternal body is the object of horror, a feeling based in the fear of reincorporation into the mother, as well as in the fear of the mother's generative power. In becoming a subject, with defined boundaries, the child is separating from the body of the mother. As a result the maternal body becomes "abject" – an object of horror and threat.[24] Although Kristeva does not discuss this as a specifically gendered process, other recent work in psychoanalytic theory suggests that it is particularly the *male* child who confronts the trauma of separation, and who retains into adulthood the fear of reincorporation (and, hence, loss of masculinity and self).[25] This psychic process, undergone in a culture where it is women who do the mothering, explains the barely concealed level of violent fantasy men often manifest against women, the well-known construction of the virgin/whore dichotomy which counterposes the "pure" woman (the classical body?) to the slut (the grotesque?). As Barbara Ehrenreich has put it, in a foreword to Klaus Theweleit's shocking study of male fantasies about women:

> It seems to me that as long as women care what we are in this world – at best, "social inferiors", and at worst, a form of filth – then the male ego will be formed by, and bounded by, hideous dread. For that which they loved first – woman and mother – is that which they must learn to despise in others and suppress within themselves. Under these conditions, which are all we know, so far, as the human condition, men will continue to see the world as divided into "them" and "us", male and female, hard and soft, solid and liquid – and they will, in every way possible, fight and flee the threat of submersion. They will build dykes against the "streaming" of their own desire. . . . They will confuse, in some mad revery, love and death, sex and murder.[26]

Discussions about the female body in terms of abjection, or the monstrous-feminine, tend to operate on different levels, and to refer to rather different aspects of psychic processes. Sometimes they concern the Oedipal drama and the fear of castration. Sometimes they are based in a theory of fetishism (the phallic woman). At other times they rely on a psychoanalytic account that stresses the pre-Oedipal moment, and deal with the need for separation and consequent fear of re-engulfment which I have been discussing. A more Lacanian version is based on the threat to the man's place in the Symbolic, which produces a resistance to the pre-Symbolic (and the mother). Yet another version rests on the fear of maternal authority, or of the power of the "archaic" mother. All these accounts can be found in current film studies and cultural theory, and it is not my intention to assess or compare them. The general question raised by the notion of the "monstrous-feminine", whatever its presumed origins, is whether it renders the (abject) body a potential site of transgression and feminist intervention. And I think our answer must be in terms of the same guarded optimism with which I considered the female grotesque: namely that the operative word is "potential", for the dominant culture of patriarchy has already defined and situated the body, and the prospects for reappropriation are, to say the least, fraught with hazards and contradictions.

A third area of feminist body politics is what has been called "*l'écriture féminine*". A concept originating in what is generally referred to as French feminism, this notion has a number of slightly different manifestations, of which I shall briefly discuss two.[27] In *La Révolution de langage poétique*, Julia Kristeva contrasts the realm and language of the Symbolic (the law of the Father, identified with and coincident with the coming into language of the child) with what she calls the "semiotic". The semiotic is the pre-linguistic, the bodily drives, rhythms, and "pulsions" experienced by the child in the infantile fusion with the mother. These pleasures and feelings

are repressed on entry into the Symbolic, but, according to Kristeva, since they remain in the unconscious, they may emerge at a later stage. In the writing of Lautréamont and Mallarmé, as well as Joyce and Artaud, the experience of the semiotic is articulated. (The term "*l'écriture féminine*" is not Kristeva's, and of course her examples of this kind of writing here are all of men. However, the "feminine" nature of the writing consists of its supposed origins in the pre-Symbolic, pre-patriarchal moment of the child–mother relationship.)

Kristeva is well aware that it makes no sense to propose the semiotic as somehow outside of language. In the first place, she is talking about writing, which is necessarily linguistic. And in the second place, the writers she discusses are, like everyone else, in the Symbolic – an essential condition of human development. "The semiotic that 'precedes' symbolization is only a *theoretical supposition* justified by the need for description. It exists in practice only within the symbolic and requires the symbolic break to obtain the complex articulation we associate with it in musical and poetic practices."[28]

Nevertheless, her argument is that there is possible a particular kind of writing that originates in the pre-linguistic, bodily experiences of infancy that have persisted in the unconscious into adulthood. Inasmuch as such writing subverts the Symbolic, it can therefore be seen (and has been so, by some feminists) as "feminine" – both in the sense that its origins are in the pre-Oedipal child–mother relationship, and in the sense that it escapes the rule of the Father and the dominance of patriarchal language and thought.

Luce Irigaray and Hélène Cixous have proposed a more direct relationship between women, writing, and the body, one in which men could not be the agents of "feminine writing". Both begin from the specificity of woman's body – for Irigaray, a plural, multiple, diffuse sexuality, for Cixous, similarly multiple libidinal impulses (oral, anal, vocal, the pleasures of pregnancy). Woman, says Cixous, must "write from the body": "Her libido is cosmic, just as her unconscious is worldwide. Her writing can only keep going, without ever inscribing or discerning contours. . . . She alone dares and wishes to know from within, where she, the outcast, has never ceased to hear the resonance of fore-language."[29] *L'écriture féminine* is writing grounded in women's experience of the body and sexuality, an experience which is not mediated by men and by patriarchy. This has been found to be an exceptionally liberating and suggestive notion by many feminists, who perceive in it the prospect of a cultural practice which is not compromised and contained by patriarchal discourses. The painter, Nancy Spero, has referred to her work as *la peinture féminine*, on the model of "feminine writing", which, as Lisa Tickner says, commenting on Spero's work, is "a form of writing marked by the pulsions of a female sexual body . . . and effecting various kinds of displacement on the western phallogocentric tradition of writing and the subject".[30] In the next section of this essay, I will look at some of the problems involved in the notion of "writing from the body" as feminist practice.

Discourse and the body

One objection to the kind of body politics just discussed is that identifying women with their bodies is perilously close to those reactionary arguments in sociobiology and other disciplines, as well as in conservative common sense, which justify women's oppression in terms of their biology – size, hormones, lack of strength, child-bearing functions, lactation, monthly cycles, and so on. So, for example, Judy Chicago's famous art work, *The Dinner Party*, which celebrates the hidden history of women, and, amongst other things, employs vaginal imagery to represent selected women from the past, has been criticized by other feminists for this equation of women with their biology (and specifically their genitals).[31] This is a complex issue,

for there is also every reason to want to affirm that which is denied or denigrated, and to assert the specificity and experience of the female body.

Related to this is the objection that *what* the female body is varies by culture, by century, and by social group. It is a social, historical, and ideological construct. (As I argued earlier, it is clear that, for example, medical science has "made" the female body into a new entity in the modern age.) Biology is always overlaid and mediated by culture, and the ways in which women experience their own bodies is largely a product of social and political processes. The charge of "essentialism" is a serious one – that is, the criticism that concepts like *l'écriture féminine* often depend on an assumed basic, unchanging identity of "woman" and women's bodies, which ignores the realities of historical change, social production, and ideological construction. Elizabeth Grosz has produced a carefully judged assessment of this debate, which I think is worth adopting, and which leaves us with the insights of Kristeva and Irigaray without the problems of an unacceptable essentialism: "Both these feminists have shown that *some* concept of the body is essential to understanding social production, oppression and resistance; and that the body need not, indeed must not, be considered merely a biological entity, but can be seen as a socially inscribed, historically marked, physically and interpersonally significant product."[32] The female body is seen as psychically and socially produced and inscribed. At the same time, it is experienced by women – primarily as lacking or incomplete. The feminist project of Irigaray, "to speak about a positive model or series of representations of femininity by which the female body may be positively marked",[33] is endorsed by Grosz.

The more radical version of this critique of essentialism argues that *there is no body outside discourse*. Parveen Adams's argument, indicated in the third quotation at the beginning of this essay, is the psychoanalytic one that we never have an unmediated experience of a pre-given body, but rather that perceptions of the body are "represented from the start as agreeable or disagreeable".[34] The experience of the body is always mediated by libidinal energy. To this we may add the parallel argument that the body is never experienced except as mediated through language and discourse. As I have already shown, the "body" is a product of social histories, social relations, and discourses, all of which define it, identify its key features (ignoring others), prescribe and proscribe its behaviour. With regard to women's bodies, Denise Riley follows through this perception to conclude that whether and when bodies are *gendered* "is a function of historical categorisations as well as of an individual daily phenomenology".[35] The body is not always lived or treated as sexed. For, as she points out in relation to the politics of maternity:

> If women did not have the capacity of childbearing they could not be arrayed by natalist or anti-natalist plans into populations to be cajoled or managed. But the point is that irrespective of natural capacities, only some prior lens which intends to focus on "women's bodies" is going to set them in such a light. The body becomes visible *as* a body, and *as* a female body, only under some particular gaze – including that of politics.[36]

There can, therefore, be no "direct" experience of the body, and we cannot talk about, or even conceive of, the body as some pre-given entity. This is as true for men as it is for women, but the particular implication here is that we need to be very careful in talking about a feminist body politics, whether one of *l'écriture féminine* or one of celebration of the female body. What constitutes the body, and what constitutes the female body and its experience, is already implicated in language and discourse. But this does not mean we must abandon the project. Recent developments in linguistics, psychoanalysis, and cultural theory have achieved the important task of challenging essentialism and naïve realism, and of deconstructing the

category of "woman", demonstrating its construction in psychic processes, social and historical relations, ideological struggles, and discursive formations. But there are pragmatic, political, and philosophical reasons for resisting a total agnosticism of the body. As Denise Riley puts it, "it is compatible to suggest that 'women' don't exist – while maintaining a politics of 'as if they existed' – since the world behaves as if they unambiguously did".[37]

In the first place, then, the instability of the category "woman" and the specific objection to identifying women with the female body (itself seen to be ill-defined and not a constant), need not lead to the conclusion that the subject is irrevocably dispersed. There is some agreement among feminists that deconstruction, poststructuralism, and postmodernist theory are valuable allies in feminist analysis, critique, and political action, since they operate to destabilize patriarchal orthodoxies and also to oppose mistaken notions of uniform female identity.[38] At the same time, politically and experientially, it makes sense for women to mobilize around the social construct of "woman" for, as Riley says, modern feminism "is landed with the identity of women as an achieved fact of history and epistemology".[39] To that extent, too, the female body, as discursively and socially constructed, and as currently experienced by women, may form the basis of a political and cultural critique – so long as it is one which eschews a naïve essentialism and incorporates the self-reflexivity of a recognition of the body as an effect of practices, ideologies, and discourses.

Finally, inconsistencies of the more radical anti-essentialist position have been pointed out. In the context of feminist film theory, Mary Ann Doane sees essentialism and anti-essentialism as opposite but equivalent mistakes.

> Both the proposal of a pure access to a natural female body and the rejection of attempts to conceptualize the female body based on their contamination by ideas of "nature" are inhibiting and misleading. Both positions deny the necessity of posing a complex relation between the body and psychic-signifying processes, of using the body, in effect, as a "prop". For Kristeva is right – the positing of the body *is* a condition of discursive practices. It is crucial that feminism move beyond the opposition between essentialism and anti-essentialism.[40]

As she says, the question about the relation between the female body and language, raised by deconstructionists and discourse theorists, is a question about a relation between two terms.[41] In other words, the critique of essentialism does *not* amount to a proof that there *is* no body.

In the following section, I will draw some preliminary conclusions from this discussion about the prospects of a feminist cultural politics of the body, which need not be doomed to negation or reincorporation by the male gaze and by a patriarchal culture.

Gender, dance, and body politics

Since the body is clearly marginalized in Western culture, it might appear that dance is an inherently subversive activity. Indeed, the marginality of dance itself as an art form in the West suggests that this is so – compared with orchestral music, opera, film, and literature, dance has had minority appeal. But we must beware of making the easy assumption that use of the body is itself transgressive, in a culture which allows only the "classical body". Here, from a key text on dance, is an accredited discussion of the ballet.

> The bearing of the classical dancer . . . is characterized by compactness. The thigh muscles are drawn up, the torso rests upon the legs like a bust upon its base. This

bust swivels and bends but, in most *adagio* movements at any rate, the shoulders remain parallel to the pelvis bone. Every bend, every jump is accomplished with an effect of ease and of lightness. . . . In all such convolutions of the *adagio* the ballerina is showing the many gradual planes of her body in terms of harmonious lines. While her arms and one leg are extended, her partner turns her slowly round upon the pivot of her straight point. She is shown to the world with utmost love and grace. She will then integrate herself afresh, raise herself on the points, her arms close together, the one slightly in front of the other. It is the alighting of the insect, the shutting of the wings, the straightening into the perpendicular of feelers and of legs. Soon she will take flight and extend herself again. Meanwhile she shows us on the points what we have not seen in the *arabesque* or *développé*, two unbroken lines from toes to thighs.[42]

The classical ballet has colluded in the preservation of the classical body, emphasizing in its commitment to line, weightlessness, lift, and extension an ethereal presence rather than a real corporeality. In addition, the strict limits on body size and shape for girls and women dancers reinforce a denial of the female body in favour of an ideal of boyish petiteness. (It is no surprise that the incidence of eating disorders among ballerinas and would-be ballerinas is far higher than that among the general population.[43]) The roles created for women in the classical repertoire – fairies, swans, innocent peasant girls – collude in a discourse which constructs, in a medium which employs the body for its expression, a strangely disembodied female.

Modern dance, from its beginnings early in the twentieth century, has usually been seen as an important breakthrough for women. For one thing, many of the major innovators and choreographers in modern dance have been women, unlike the classical ballet which has always been dominated by men. Isadora Duncan, Martha Graham, Doris Humphreys, and Mary Wigman are among the key figures here. The modern repertoire also consists of many pieces which deal with strong women, and with myths and stories from women's point of view. Most important, modern dance has totally transformed the types of movement seen on the stage, abandoning the purity of line and denial of weight of the classical ballet, and introducing angularity, pelvic movement, emphasis on the body's weight and its relationship to the ground. A notion of the "natural body" has been employed in this development, particularly by Duncan and Graham and their followers. This particular combination, of a conception of the natural body, and a commitment to women's stories and lives, has led many practitioners and critics to conclude that modern dance *is* a medium for political as well as aesthetic transgression.

But, as the critique of essentialism has shown, we must be wary of a cultural politics which is based on any notion of women's natural body, or women's universal essence – the kind of conception, for example, which lies behind many of Martha Graham's representations of Greek myths. What this means is that dance can only be subversive when it questions and exposes the construction of the body in culture. In doing so, it necessarily draws attention to itself *as* dance – a version of the Brechtian device of laying bare the medium. Postmodern dance has begun to achieve this, and thus to use the body for the first time in a truly political way. This development is discussed by Elizabeth Dempster, who stresses that the key focus of postmodern dance (going back to Merce Cunningham in the 1940s, but for the most part emerging in the 1960s and 1970s) has been the body itself.[44] It is not uncommon for a postmodern choreographer to use untrained bodies in a work, alongside trained dancers. (Michael Clark's work is a British example of this practice.) Dance itself is thus deconstructed,

and the operations and actions of the body made clear. The body itself may be the theme of the dance, and a good deal of postmodern dance is concerned with gender and sexual politics (Yvonne Rainer in the United States, DV8 in Britain). The repertoire, the style, the ideologies, and the illusion of transparency of the medium of both classical and modern dance have been overturned by postmodern dance. In such a practice, the body can indeed provide a site for a radical cultural politics.

The implications for a feminist politics of the body are clear, not just for dance, which is necessarily founded on the body as its medium of expression, but also for visual representation, performance art, and other arts disciplines. A straightforward celebratory art of the female body may have the welcome effect of producing positive images for women, in defiance of the dominant constructions of femininity in our culture. At the same time, it runs two kinds of risk: first, that these images can be re-appropriated by the dominant culture, and read against the grain of their intended meaning (as in the Dublin demonstration); and second that they may collude with a kind of sexist thinking which identifies woman with the body, and assumes an unchanging, pre-given essence of the female. Any body politics, therefore, must speak *about* the body, stressing its materiality and its social and discursive construction, at the same time as disrupting and subverting existing regimes of representation. Feminist artists and critics have suggested strategies for this kind of intervention, including ironic quotation of works by men, juxtapositions of text and image which challenge representation, addressing the construction of femininity in the work itself, incorporating the self-reflexive commentary on the mode of representation employed, and what Mary Kelly has called the "depropriation" of the image.[45]

Body politics need not depend on an uncritical, ahistorical notion of the (female) body. Beginning from the lived experience of women in their currently constituted bodily identities – identities which are *real* at the same time as being socially inscribed and discursively produced – feminist artists and cultural workers can engage in the challenging and exhilarating task of simultaneously affirming those identities, questioning their origins and ideological functions, and working towards a non-partriarchal expression of gender and the body.

Notes

1 Peter Gidal, quoted by Mary Ann Doane, "Woman's Stake: Filming the Female Body", in Constance Penley (ed.), *Feminism and Film Theory* (New York and London, BFI Publishing, 1988), p. 217.

2 Mary Kelly, quoted by Rosemary Betterton, "New Images for Old: The Iconography of the Body", in *Looking On: Images of Femininity in the Visual Arts and Media* (London and New York, Pandora, 1987), p. 206.

3 Parveen Adams, "Versions of the Body", *m/f*, 11/12 (1986), p. 29.

4 Mary Ann Doane, "Woman's Stake", p. 226.

5 See, for example, Susan Barrowclough, "Not a Love Story", *Screen*, 23, 5 (1982).

6 Mary Douglas, *Purity and Danger: An Analysis of the Concepts of Pollution and Taboo* (1966; London and Boston, Routledge & Kegan Paul, 1984). [See Chapter 42 in this volume.]

7 Ibid., p. 125.

8 See Peter Stallybrass and Allon White, *The Politics and Poetics of Transgression* (London, Methuen, 1986), for an analysis of body imagery and social change in Europe from the seventeenth century, based on Bakhtin's division.

9 Francis Barker, *The Tremulous Private Body: Essays on Subjection* (London and New York, Methuen, 1984).

10 Stallybrass and White, *Politics and Poetics of Transgression*, p. 201.

11 Catherine Gallagher and Thomas Laqueur (eds), *The Making of the Modern Body: Sexuality and Society in the Nineteenth Century* (Berkeley, Los Angeles and London, University of California Press, 1987).

12 See L.J. Jordanova, "Natural Facts: A Historical Perspective on Science and Sexuality", in Carol MacCormack and Marilyn Strathern (eds), *Nature, Culture and Gender* (Cambridge and New York, Cambridge University Press, 1980).

13 Elizabeth V. Spelman, "Woman as Body: Ancient and Contemporary Views", *Feminist Studies*, 8, 1 (Spring 1982).

14 Sandra Lee Bartky, "Foucault, Femininity, and the Modernization of Patriarchal Power", in Irene Diamond and Lee Quinby (eds), *Feminism and Foucault: Reflections on Resistance* (Boston, Northeastern University Press, 1988), p. 72.

15 Ibid., p. 79.

16 From Frigga Haug (ed.), *Female Sexualization: A Collective Work of Memory* (London, Verso, 1987), p. 126.

17 Rosalind Coward, *Female Desire* (London, Paladin, 1984), p. 39.

18 *Cosmopolitan* (US) (August 1989), p. 186.

19 John Berger, *Ways of Seeing* (Harmondsworth, Penguin, 1972); Laura Mulvey, "Visual Pleasure and Narrative Cinema", *Screen*, 16, 3 (1975). [See Chapters 7 and 9 in this volume.]

20 Mary Russo, "Female Grotesques: Carnival and Theory", in Teresa de Lauretis (ed.), *Feminist Studies/ Critical Studies* (London, Macmillan, 1986).

21 Ibid., p. 217.

22 Ibid., p. 219.

23 Ibid., p. 221.

24 Julia Kristeva, *Powers of Horror: An Essay on Abjection* (New York, Columbia University Press, 1982). [See Chapter 45 in this volume.] Barbara Creed has used this analysis in a most interesting way in the discussion of the basis of appeal of horror movies. (Barbara Creed, "Horror and the Monstrous-Feminine: An Imaginary Abjection", *Screen*, 27, 1 (1986).)

25 See, for example, Evelyn Fox Keller, "Gender and Science", in Sandra Harding and Merrill B. Hintikka (eds), *Discovering Reality: Feminist Perspectives on Epistemology, Metaphysics, Methodology, and Philosophy of Science* (Dordrecht, D. Reidel, 1983).

26 Barbara Ehrenreich, "Foreword" to Klaus Theweleit, *Male Fantasies*, vol. 1: *Women, Floods, Bodies, History* (Minneapolis, University of Minnesota Press, 1987), p. xvi.

27 For a helpful discussion and critique of this term and its uses, see Ann Rosalind Jones, "Writing the Body: Toward an Understanding of *l'écriture féminine*", in Elaine Showalter (ed.), *The New Feminist Criticism: Essays on Women, Literature, and Theory* (London, Virago, 1986).

28 Julia Kristeva, *Revolution in Poetic Language* (New York, Columbia University Press, 1984), p. 68.

29 Hélène Cixous, "The Laugh of the Medusa", *Signs*, 1, 4 (Summer 1976), p. 889. See also Luce Irigaray, *This Sex Which Is Not One* (Ithaca, NY, Cornell University Press, 1985).

30 Lisa Tickner, "Nancy Spero: Images of Women and *la peinture féminine*", in *Nancy Spero* (London, Institute of Contemporary Arts, 1987), pp. 5, 7–8.

31 See, for example, Michèle Barrett, "Feminism and the Definition of Cultural Politics", in C. Brunt and C. Rowan (eds), *Feminism, Culture and Politics* (London, Lawrence and Wishart, 1983).

32 Elizabeth Grosz "Philosophy, Subjectivity and the Body: Kristeva and Irigaray", in Carole Pateman and Elizabeth Grosz (eds), *Feminist Challenges: Social and Political Theory* (Boston, Northeastern University Press, 1986), p. 140.

33 Ibid., p. 142.

34 Adams, "Versions of the Body", p. 29.

35 Denise Riley, *"Am I That Name?" Feminism and the Category of "Women" in History* (Minneapolis, University of Minnesota Press, 1988), p. 105.

36 Ibid., p. 106.

37 Ibid., p. 112.

38 See, for example, Jane Flax, "Postmodernism and Gender Relations in Feminist Theory", in *Signs*, 12, 4 (Summer 1987). Also *Feminist Studies*, 14, 1 (Spring 1988): special issue on deconstruction.

39 Riley, *"Am I That Name?"*, p. 111.

40 "Woman's Stake", pp. 225–6.

41 Ibid., p. 223.

42 Adrian Stokes, "The Classical Ballet", extract from *Tonight the Ballet*, in Roger Copeland and Marshall Cohen (eds), *What is Dance? Readings in Theory and Criticism* (Oxford and New York, Oxford University Press, 1983), pp. 244–5.

43 A personal account is the dancer Gelsey Kirkland's autobiography, *Dancing on my Grave* (London, Penguin, 1986).

44 Elizabeth Dempster, "Women Writing the Body: Let's Watch a Little How She Dances", in Susan Sheridan (ed.), *Grafts: Feminist Cultural Criticism*, (London and New York, Verso, 1988).

45 Mary Kelly, "Beyond the Purloined Image", *Block*, no. 9, (1983). See also Judith Barry and Sandy Flitterman, "Textual Strategies: The Politics of Art-Making", *Screen*, 21, 2 (Summer 1980) [Chapter 10 in this volume]; and Lisa Tickner, "The Body Politic: Female Sexuality and Women Artists since 1970", *Art History*, 1, 2 (June 1978) (repr. in Rosemary Betterton (ed.), *Looking on: Images of Femininity in the Visual Arts and Media* (London and New York, Pandora, 1987).)

Chapter 49

DEBORAH FAUSCH

THE KNOWLEDGE OF THE BODY AND THE PRESENCE OF HISTORY
Toward a feminist architecture

WHAT ARE THE POSSIBILITIES for a feminist architecture? Or for a feminist architectural history, theory, or criticism?

[. . .]

[I propose in this essay] to adopt a tactical and historical position, to use the term "feminist" in a strategic manner, as a designation for stances that women may endorse as valuable, without necessarily claiming for them an essential relationship to "the feminine." Perhaps there are some positions to which women have a historical if not an inherent connection, some aspects of human life that are distorted or depreciated in Western culture, some cases in which these distortions have been historically linked to a hatred of the feminine.[1] Clearly, one such area is our relationship to the body – to the female body, but also to the bodily in general: the concrete, the material, the empirical, the "brute fact," the "dumb object" – terms which register the fear, contempt, and hatred in Western culture of "mere matter."[2]

To take this course is to claim, not that the feminine is bodily, but that the bodily is feminist – not that a concern with the body is a guarantee of nonoppressive attitudes, but that a nonoppressive attitude would include a regard for the bodily. It is to claim that women can have a body without *being* the body.

How do these considerations apply to architecture? As an art which directly engages the body, architecture has the potential to be feminist in the sense I have just described. Architecture is involved in forming matter in conformance with ideas; thus it partakes of the rational, the nonmaterial, the ideal. But if the feminine is bodily, has body, this does not prevent it from encompassing reason as well. While architects cannot avoid the instrumentalization of the material, we can, within the limits of client preferences and budgets, choose

the kinds of experience we create. A feminist architecture can attempt to create a "second nature," a "world" in Hannah Arendt's sense, which engenders particular perceptions and experiences.[3] Such an architecture can, by offering experiences that correspond to, provide modes for, the experience of the body, give validity to a sense of the self as bodily – a sense that may be shared by both sexes. The discipline of architecture can thus provide room to address Western culture's tendency toward abstraction, distortion, mistreatment, even banishment of the body. It can offer a counterexperience to our culture's indulgence in René Descartes's escape wish, one of the most compelling and persistent ever imagined – the desire to be only a mind.

In Western philosophy, the mind has been strongly connected with the organ of the eye and the sense of vision. Philosophers have employed vision as a metaphor for thought, and light for the faculty of reason. Sight has been opposed to the rest of the body as the least bodily sense (despite the fact that it consumes some twenty-five percent of our energy), and the eye has been conceived of as the most disembodied of the sense organs.

[. . .]

The very name of the Enlightenment demonstrates the continuing connection between light and reason, the separation of sight from its bodily integument. In the twentieth century, our increasing technological capacity to make connections across space and time has intensified the traditional bodilessness of the sense of vision.[4]

Situated within this long-standing opposition between vision and the other senses, an architecture that required that it be experienced by senses other than vision in order to be understood could be claimed as a strategically feminist architecture. It would merit this designation if it fostered an awareness of and posited a value to the experience of the concrete, the sensual, the bodily – if it used the body as a necessary instrument in absorbing the content of the experience.

It might be argued that modern architecture's emphasis on construction and materials would qualify it for inclusion in this category. For some late modernists, tangibility becomes both a value in itself and an index of the primitive or the timeless. Mario Botta's architecture – for example the house at Cadenazzo – possesses a materiality that asserts its own nature and "making." But for two reasons, I will pass over these examples. First, this tangibility is made to be perceptible by sight alone, to be obvious even in photographs. Second, for reasons that will become clear later, I am most interested in the use of the body to apprehend meanings beyond the self-referentiality of construction.

Le Corbusier's chapel at La Tourette, whose dark, high, oblong shape must be experienced more by the reverberation of sound and the movement of the body than by sight, comes to mind as an architecture that can be claimed as feminist in this way. Another is Maya Lin's Vietnam Veterans Memorial in Washington D.C. Cut into the flat lawn of the capital, the memorial is invisible from a distance. The first sight of it comes as a visceral shock – a sudden opening in the earth, a gash in the green turf which ruptures the infinite extension and perfect rationality of the ground plane. The visitor's slow movement along the black wall becomes an imaginative descent into the tombs of the soldiers whose names are engraved on the reflective stone face. A similar physical relationship to words and their enframing site occurs on the stair from Forty-third Street down to the United Nations Plaza in New York. Here one descends a gentle curve past carved words from the Old Testament prophesying peace. Moving down along the beautiful marble panel inscribed with a hope so often disappointed induces an experience of poignant sadness that makes actual the etymological connection between motion and emotion.

[. . .]

The body is also central to a visitor's experience of two Philadelphia parks by Venturi, Rauch and Scott Brown. Both Welcome Park and Franklin Court are found in the Center City area of Philadelphia.[5] Welcome Park (named after the ship that brought William Penn to Philadelphia) is located at the edge of the city near the Delaware River on the site of the Slate Roof House, Penn's residence and the seat of the government of Pennsylvania in the years 1700–1701. This park is one of several by Venturi, Rauch and Scott Brown – including Copley Square in Boston and Western Plaza in Washington D.C. – that employ the device of miniaturization. These designs have elicited a certain amount of incomprehension from critics, probably at least in part because the experience is not adequately represented by photographs – that is, it is not an entirely visual experience.[6]

At one level, Welcome Park is simply a miniature map of historic Philadelphia, its pavement pattern the replica of the original surveyor's plan. The park is mostly open, a space meant to be traversed rather than meditated upon. The mural at the far end of the park, adapted from a seventeenth-century view from the site, pulls one across the map toward its bright colors, creating a heady feeling of power and freedom as one strides over several blocks at a time. Small trees are located on the sites of Philadelphia's four squares. These and two miniature bronzes – the Slate Roof House, located in its proper square on the plan, and a statue of Penn in the center – intensify the sense of gigantic omnipotence. Not simply a picturesque experience of movement through an organized series of events, this translation through miniaturized space evokes a hyperawareness of the body.

The park's impact derives from relationships more complex than the scale differential of a Gulliver to Lilliputian city blocks, however. The effects of miniaturization are felt at several levels. First is the experiencing of the map. Seen in perspective, laid out on the ground, the subtle variations in the city grid are enhanced. The eye, accustomed to picking out differences in stereoscopic views, more readily comprehends the variations in block width and depth than in an orthographic drawing. Second is a curious undermining of identity. Stepping up to the bronze Slate Roof House at the far end of the park, conscious that one is actually standing on its site, one experiences a strange oscillation of identification between the house and one's own body. The ordinary unthinking connection of the mind with its physical home is momentarily disrupted by its tendency to project itself into places it is absorbed in. This produces an almost Cartesian doubt as to the relationship of mind and body – am "I" "in here" or "in there"? Perhaps this oscillation is also a part of the enjoyment of certain neoclassical buildings such as William Strickland's wonderful early-nineteenth-century Merchants Exchange located nearby, whose cool blue-gray stones are so palpable in their own way. Its lions and gigantic arabesques, of about the same size and also about human-sized, induce their own form of oscillating identification in which the body equilibrates itself to another entity of similar size and configuration.

This experience confers a heightened sense of physicality when the mind returns to its accustomed container. As one walks over the paving stones, the streets, blocks, and rivers, flat and graphic in photographs, take on depth and tangibility from the simultaneous sight and feel of the changing textures and colors of the stone underfoot – concrete, marble, red sandstone, and brick. The palpability of the surface is increased by the sharp incision of the letters of the street names and the stylized waves cut into the two rivers. Walking on them is eerie, like stepping on something one shouldn't – a dedication set into a wall, perhaps, or a commemorative inscription. The letters stretching along the marble stones of the streets are haphazardly chopped in two as they fall across the joints between stones. Like the jointed keystone of Venturi, Rauch, and Scott Brown's Wu Hall at Princeton University, these cloven letters confront the visitor with the materiality of the surface and the materiality of the word on

that surface. Unlike Henri Labrouste's inscription of the library catalogue onto the façade of the Bibliothèque Sainte-Geneviève, which makes of the building a "book" whose words are to be read as abstract information, this technique rematerializes letters into substance, prevents the unconscious taking in – consumption – of the street names as incorporeal information.[7] These words have emphatic presence – carved forms cut into rocks laid side by side, sharp Roman faces whose edges will someday be eroded and green from the wear of feet and the ravages of weather, thus to become themselves part of the history of the city.

A time line that runs along a side wall and falls as the site slopes down from the Delaware side to the "Skoolkill" side (as the old map spelled it) also requires a peripatetic reading. Not only lateral, but also descending movement is required – a movement "down through history." Even this most banal presentation of historical data engages the body in an action that adds to the sense of what might otherwise be ingested as pure sign, disembodied information.

My claim is not that this park is completely explained by its relationship to the body, but the more modest one that contemplation is not enough. The action of the body must be performed to complete the intellectual content of the park, to get the message. *Inter alia*, this places a higher value upon greater complexity and greater subtlety of experience, experience that includes both the body and the mind as opposed to developing one at the expense of the other. Preliterate Greeks knew that all of the senses and emotions must be engaged in order to remember; thus they inculcated important cultural knowledge with rhyme, rhythm, dance, song, and story. All knowledge was body language.[8] In this postmodern park, history is incorporated – made a part of the individual – through a combination of visual, kinetic, and projective means involving the body in awareness and action.

Franklin Court is a few blocks away from Welcome Park on Market Street. Comprising a national landmark and museum as well as an urban park, it has a much more complicated program and design. The site was owned by Benjamin Franklin, and the still extant Georgian row houses along Market Street, which provided him with rental income, are incorporated into the project. The majority of the exhibitions are contained in the brownstones and in an underground level housing a theater and various programmatic exhibits. Franklin's own mansion, once located at the back of the lot, disappeared many years ago, along with all record of its layout. Venturi, Rauch, and Scott Brown's design does not attempt to re-create it. Instead the Franklin mansion is embodied – or rather dis-embodied – by two ghost houses constructed of oversized smooth, gray-white metal members of square section. One of these structures is the archetypal outline of a house, a child's drawing – a pitched roof, a chimney at each end, and one in the middle. It is located roughly over the foundations of the vanished house. A similar structure, an archway leading to an area of more private gardens, is set between Franklin's house and the brownstones lining Market Street. In photographs these gray ghost lines look too heavy, too cartoonlike; they seem a mockery of the "idea of history" in the old city. However, unlike the sharp skeletal wires of Giacometti's sculptures that served as their inspiration, the flat, broad, opaque smoothness of the members prevents them from being perceived as structural. Indeed, in some lights and from some angles, they seem to fade into the sky above the open park, appearing ghostly indeed.

It is the park itself, rather than the museum in its entirety, that interests me – the way in which it, like Welcome Park, employs the body as an essential organ of comprehension, and the way it uses narrative inscribed into the surfaces of the park to create a sense of history. Entering at the back from the little stone alley called Orianna Street, one is drawn immediately toward the first ghost house and the curious brown concrete hoods within its perimeter. These are somewhat hidden from view and of mysterious purpose. Walking down a few shallow steps, markers of a mythical descent into the past or the other world, one peers into

these brown openings. The hoods envelope the head like shrouds, screening out the city and the immediate environment as one bends into them, enforcing contemplation. One looks down onto the few remaining stone foundations of the old house – foundations under glass, seen through periscopes onto a buried past. These "mute stones" are given a ventriloquist's voice by diagrams indicating what part of the house they supported.

As one straightens up, one's gaze, schooled in looking down, falls on the pavement below. The slate within the perimeter of the ghost house is inscribed with quotations from the seventeenth-century individuals who once lived here, telling stories of hardship and joy in the New World. To stand on these stones, which bear such a marked resemblance in their colors, textures, and letters to early American headstones, is to feel oneself in the place of the former inhabitants. If there was a slight feeling of transgression in walking over the city map in Welcome Park, here there is a strong sense of the sacrilege of walking over graves.

Stepping out of the depression of the house's domain, one moves up from the dream of the past, wandering toward a low wall made of worn brick and passing under the ghost arch into the garden precinct. This part of the park is provided with abundant seating covered by pergolas or set against walls. Whereas the graveyard of quotations and the shrouded foundation stones are clearly marked as "past," these gardens are just as clearly in the present tense. Designed as a semblance of seventeenth-century gardens, which were important sources of medicines and spices, their formal layout organizes an apothecary as well as an aesthetic experience. Seated under an oversized and simplified pergola positioned where Franklin might have placed it long ago, one understands oneself as a stand-in. The pergola as well as the walls, the gardens, and the trellises are representatives, not re-creations, of what might have been here, intellectually satisfying in their somewhat schematic forms.

By calling attention to what is (and is not) materially present, this park makes a clear distinction between old and new. Without fabricating a "living museum" or attempting to recreate an accurate, literal representation of previous times, it allows the history of the site to be experienced as simultaneously present to the imagination and past in actuality. It invites a subtle and precise understanding of the relationship of these fragmentary remains to the period which produced them. The elements of the site function both as presences and as signs.

In all [. . .] of these landscapes, imaginal projection, the psychic dimension of depth, is given architectural representation and concrete embodiment through the visitor's somatic experience. Depth takes on different meanings in each of the four projects – remembrance and grief, distance from civilization, historical span. But in each case, time and space attain an elastic dimension through the projective propensities of the body. In his villas, Le Corbusier used the body's movement along the *promenade architecturale* to tell the story of ascending through uniform, infinite space-time to the top of the world in order to contemplate, to theorize – to survey "the present situation" and to plan alternatives.[9] In contrast to this archetypal modern experience, these projects give being to alternatives to linear historical time and rational Cartesian space. Imaginative involvement produces, not a hegemonic narrative, but instead each person's individually constructed story. Cultural meanings given experiential presence by being embedded in the physical experience of places thus propose new relationships between form and content. The relaxation of Descartes's distinction between mind and body also allows for a relaxation in the distinction between sign and referent. Meaning escapes the strictures of semiotic theory to an enlarged dimension, in blithe disregard of the poststructuralist anxiety about presence. "Incorporation" of meaning, within both subject and object, gives it a reality not objective, but not illusory either.

Histories take the form of narratives, of readings. In literate cultures, in which recorded history has replaced an ever-present tradition, buildings need explanations to be understood as memories of the past. In the Vietnam Veterans Memorial and the two Philadelphia parks, these narratives are literally inscribed onto the architecture. By putting the body in an unfamiliar relationship to writing on man-made – or, I should say, humanly-created – surfaces, the architects have allowed history to become "part of" the individual. For a postliterate society, however, in which television and the computer are replacing the book which killed the building, this incorporated "body knowledge" cannot be a possibility in the same uncomplicated way that it was for the largely oral Greek society of Plato's time. Perhaps that is why body knowledge is used in these projects to establish a relationship with the distant – the dead, the past, the "natural."

These body experiences suggest possibilities for understanding the role of history in the postmodern, "posthistorical" present. Our period, when the modern idea of a unified and teleological history has dissolved into that of multiple, coexisting histories, has been called the "end of history." In this view, the simultaneous presence of objects and images from places far separated in location, and the contemporaneity of references to many historical periods, comprise a single, almost immaterial, postmodern place-time.[10] Theorists of postmodernism have ascribed this flattening of reference to problems in the structure of representation, to the lack of "a referential being or substance" engendered by commodity capitalism and the media.[11] Culture theorists such as Fredric Jameson have adduced postmodern architects' preoccupation with the surface as evidence for this assessment.[12] What these four landscapes provide, however, is an alternative model for the operation of history not dependent on this structure of representation – defined either as an object "standing over against" a subject or as "the presence of an absence." Rather, the flexible operation of imaginal projection into highly articulated substance couples literal surface with imaginal depth, creating physical presence without totalizing narrative, providing content without singular interpretation, replacing the separation of form and meaning with embodied meanings.

If these four projects point beyond the condition of disembodied subject "standing over against" corporeal object, then according to Heidegger they can only do so through a *Verwindung*, an overcoming, healing, acceptance, and deepening of the dichotomous definition of the person entailed by Descartes's epistemology. I would like to suggest that these four projects provide, through the knowledge of the body, glimpses of an alternate metaphysics of knowledge for the postmodern subject. The experiences they provide do not eliminate the subject, but the subject they do presume is neither the unified mental subject of humanism nor the fragmented subject of poststructuralism. Rather, through the knowledge of the body, a subject implicated in bodiliness is able to comprehend experiences that employ all of the senses. This implies the existence of a "nature" that even Descartes, towards the end of his *Meditations*, grudgingly admitted forms a "mixed whole" or "composite body."[13] Such a rapprochement of subject and object, ideal and material, mind and body, in a new, postliterate form of mixed whole could thus be said to "produce" a feminist subject whose strategy is the embodiment of knowledge.

Notes

1 This strategic approach avoids the problem articulated by the *Questions féministes* group: "It is legitimate to expose the oppression, the mutilation, the 'functionalization' and the 'objectivation' of the female body, but it is also dangerous to place the body at the center of a search for female identity. Furthermore, the themes of Otherness and of the Body merge together, because the most visible difference between men and women is . . . indeed the difference in body. This difference has been used as a pretext to 'justify' full power of one sex over the other. . . . In everything that is supposed to characterize women,

oppression is always present." "Variations on common themes," trans. Yvonne Rochette-Ozzello, cited in *New French Feminisms: An Anthology*, eds. Elaine Marks and Isabelle de Courtivron (Amherst: University of Massachusetts Press, 1980), 218–22; originally published as "Variations sur des thèmes communs," *Questions féministes* 1 (1977). Compare Gayatri Chakravorty Spivak's complex defense of the necessity for being "against sexism and for feminism" in "French Feminism in an International Frame," *Yale French Studies* 62 (1981): 154–84, especially 179–84. Elsewhere, however, Spivak seems to endorse in a qualified way a strategic essentialism. See Gayatri Chakravorty Spivak, "Subaltern Studies: Deconstructing Historiography," in *In Other Worlds: Essays in Cultural Politics* (New York: Routledge, 1988), 206–7.

Since essentialism is often derogated as conservative, it is worth quoting Diana Fuss on its political mutability: "There is an important distinction to be made, I would submit, between 'deploying' or 'activating' essentialism and 'falling into' or 'lapsing into' essentialism. . . . [T]he radicality or conservatism of essentialism depends, to a significant degree, on *who* is utilizing it, *how* it is deployed, and *where* its effects are concentrated." Diana Fuss, *Essentially Speaking: Feminism, Nature & Difference* (New York: Routledge, 1989), 20.

2 The "body" of literature on the body in Western culture is enormous. For one history of the hatred of the female body as it is connected to the separation of mind and matter see James Hillman, "Part Three: On Psychological Femininity," in *The Myth of Analysis* (New York: Harper and Row, 1972). As Hillman notes, the etymological connection between *mater* and *matter* is an index of the close relationship of the female and the material in Western culture. This connection is at least as old as Plato's separation of Being into matter and form, with matter as the mother and form as the father of Being (*Timaeus* 50d).

To equate the bodily with the sexual is, I think, a phallocentric error, as if the body were only sexual, or the material only a metaphor for sexuality. Making a rigid separation between the sexual and non-sexual body is another phallocentric error, of course. But even when these terms are used metaphorically, I prefer "bodily" to "sexual" as the representative for this complex of experiences, since it is less reductive.

3 Arendt defines the world as that which relates and separates human beings and outlives individual existence. See Hannah Arendt, "The Human Condition" and "Work," in *The Human Condition* (Chicago: University of Chicago Press, 1958).

4 In "Urban Ecology or the Space of Energy," Virilio emphasizes the need to restore the dimensions of time and gravity to the relationship of human beings with their world: "'Citizens of the World,' inhabitants of nature, we too often omit that we also live in physical dimensions, in life-size spatial scale and time lengths; so the obvious duration of the constituent elements of the substances (chemical or others) making up our natural environment is doubled with the unseen pollution of the distances organizing our relationship with the other, but also with the world of sensual experience. Therefore, it is urgent to affix to the ecology of nature, an ecology of the artifice of the techniques of transportation and transmission that literally *exploit* the field of the dimensions of the geographical milieu and degrade their scale." Paul Virilio, "Urban Ecology or the Space of Energy" (paper translated and presented by Louis Martin at The New Urbanism conference, Princeton University School of Architecture, October 1992). See also Paul Virilio, *The Lost Dimension* (New York: Semiotext(e), 1991). I want to make clear that I am not suggesting that these technologies be rejected – rather, that they be "incorporated" consciously.

5 For basic information about the parks see *Stanislaus von Moos, Venturi, Rauch and Scott Brown: Buildings and Projects* (New York: Rizzoli, 1987), 104–9, 138–40.

6 See for example Thomas Hine, "Welcome Park's Exposed Look Overshadows its Tribute to Penn," *Philadelphia Inquirer*, 14 January 1983, sec. 1D, 8D; Paul Goldberger, "Western Plaza in Washington Gets a Somewhat Flat Reception," *New York Times*, 18 December 1980, sec. A18; Benjamin Forgey, "The Plaza that Might Have Been," *The Washington Star*, 28 December 1980, sec. D11–D13. In what follows I will present the parks as the record of an experience – just as partial a portrayal, of course, as photography, but one that allows for a description of the experience of the body.

7 According to Neil Levine, Labrouste's purpose in decorating the library façade with words was "to show that the content of architecture could no longer be the plastically qualified transformation of the word into stone but just its literal transcription – the descriptive naming on its surface of the actual content of thought contained therein in books of printed words." As Levine notes, Labrouste was closely connected with Victor Hugo, whose famous declaration in *The Hunchback of Notre Dame* that architecture had been replaced by the printed word – "This will kill that" – served as a motto for Néo-Grec architects. According to Emile Trélat, they desired to "make the stone speak as a book

speaks, to borrow from the writer his ideas and his images, and to clothe our monuments in them." See Neil Levine, "The Romantic Idea of Architectural Legibility: Henri Labrouste and the Néo-Grec," in *The Architecture of the École des Beaux-Arts*, ed. Arthur Drexler (Cambridge: MIT Press, 1977), 350, 408.

8 Much has been written about the forms of knowledge and the means of transmission in nonliterate cultures. For an extensive discussion of the Greek case see Eric Havelock's history of mimesis in *Preface to Plato* (Cambridge: Belknap/Harvard University Press, 1963). Other sources include Jean Pierre Vernant, *Myth and Thought among the Greeks* (London: Routledge and Kegan Paul, 1983) and Bruno Snell, *The Discovery of the Mind in Greek Philosophy and Literature* (New York: Dover, 1982). A more recent treatment of mimesis which also examines the Greek theories is Philippe Lacoue-Labarthe, *Typography: Mimesis, Philosophy, Politics* (Cambridge: Harvard University Press, 1989).

9 For descriptions of the promenade architecturale in Le Corbusier's work, see Beatriz Colomina, "Le Corbusier and Photography," *Assemblage* 4 (1987): 7–23; Stanford Anderson, "Architectural Research Programmes in the Work of Le Corbusier," *Design Studies* 5:3 (July 1984): 151–58; and Tim Benton, "Le Corbusier y la Promenade Architecturale," *Arquitectura* 264–5 (1987): 38–47.

10 For example, Marc Augé labels this phenomenon "non-place" (possibly referring to Melvin Webber's phrase "the non-place urban realm"). For Augé the non-place is characterized by an excess of history, an excess of place, and excess individuality. He claims that whereas modernity created a whole that included traditional organic places within it, supermodern non-place displays places as unintegrated nuggets without connection to the matrix within which they are set. *Non-Places: Introduction to an Anthropology of Supermodernity*, trans. John Howe (London: Verso, 1995). See also Gianni Vattimo, *The End of Modernity: Nihilism and Hermeneutics in Postmodern Culture*, trans. Jon R. Snyder (Baltimore: The Johns Hopkins Press, 1988). In his introduction, Vattimo seems to be describing a process of "retraditionalizing history." In a traditional society, the events of the past are simultaneously present because they are all equally available for use by living persons for their own purposes; thus a tradition is always being altered as it is being employed for new purposes by different persons and groups. The discipline of history, on the other hand, fixes the past – "as it was" – into one unalterable story. Both are concerned with the past – both have a sense of "pastness" – but the relationship to that past differs.

11 Jean Baudrillard, "The Precession of Simulacra," *Art and Text* 11 (September 1983): 3; Vattimo, *End of Modernity*, 10, 128.

12 Fredric Jameson, "Postmodernism, or The Cultural Logic of Late Capitalism," *New Left Review* 146 (1984): 33–92.

13 "Nature also teaches me by these feelings of pain, hunger, thirst, and so on that I am not only residing in my body, as a pilot in his ship, but furthermore, that I am intimately connected with it, and that the mixture is so blended, as it were, that something like a single whole is produced. . . . [These feelings] have their origin in and depend upon the union and apparent fusion of the mind with the body." René Descartes, "Sixth Meditation," in *The Meditations Concerning First Philosophy*, in *Philosophical Essays*, trans. Laurence J. Lafleur (Indianapolis: The Bobbs-Merrill Company, Inc., 1964), 128, 132, 134–35; see also 137.

SUSAN LEIGH FOSTER

THE BALLERINA'S PHALLIC POINTE

PLIANT, QUIVERING WITH RESPONSIVENESS, ready to be guided anywhere, she inclines towards him, leaving one leg behind, ever erect, a strong reminder of her desire. As he promenades around the single pointe on which she balances, the leg lifts higher and higher. They pause at the moment her breast bone appears about to break. Arms in a wide V connect to his supporting lunge. The leg, a full 180 degrees vertical, looms behind them; white-pink, utterly smooth, charged with a straining, vibrant vitality.

Then, she floats impetuously away from him. His gaze following her, his arm gestures a pathetic desire. As the music builds to its climax, she reaches the corner and turns back towards him. The emollient rush of her body into his outstretched arms results in yet another stiffening: she holds decorously rigid as he lifts and swirls her in a circle above his head. Her delicate tensility allows her to dwell there high in space, a proud ornament, a revolving bowsprit.

If we have seen it once, we have seen it a thousand times, this generic sequence that resembles *pas des deux* in *Swan Lake, Jewels, The Ballet of the Red Guard*, that can be found in the repertoires of the National Ballets of Canada, Taiwan, South Africa, Cuba, the Philippines, Australia, Argentina, Mexico, Brazil. . . . We have interpreted this phrasing of two bodies as a sequence of abstract referents, a culmination in the striving towards physical refinement and purification that originated in Renaissance European court codes of bodily civility.[1] These bodies celebrate a breathtaking physical accomplishment. They dance out an ethereal realm of perpetually vanishing perfect forms.

But they are also desiring bodies, bodies that turn away from the rush back towards one another, bodies that touch one another, that strive together delicately and fervently in front of other bodies who, from their anonymous location in a darkened auditorium, desire them as well. And they are gendered bodies. Even when costumed in the most unisex unitards, *she* wears pointe shoes, and *he* wears ballet slippers. *She* elaborates a vast range of intricate coordinations for legs, feet, arms, and head, while *he* launches into the air, defying gravity in a hundred different positions. *She* extends while *he* supports. *She* resides in front and *he* remains in back. *She* looks forward as *he* looks at her. *She* touches his arms, hands, and shoulders, whereas *he* touches her arms, and hands and also her waist, thighs, buttocks, and armpits.[2]

And these two bodies, because of their distinctly gendered behavior, dance out a specific kind of relationship between masculine and feminine.[3] They do more than create an alert, assertive, solicitous manliness and a gracious, agile, vibrant womanliness. Their repeated rushes of desire – the horizontal attraction of bodies, the vertical fusion of bodies – do more than create unified sculptural wholes that emblematize the perfect union of male and female roles. *He* and *she* do not participate equally in their choreographic coming together. *She* and *he* do not carry equal valence. *She* is persistently put forward, the object of his adoration. *She* never

reaches out and grabs him but is only ever impelled towards him, arms streaming behind in order to signal her possession by a greater force. *He* longs for her and moves with alacrity to support her from behind or at her side, yet he dances as though *she* were a dream, an hallucination he can long for but only momentarily handle. *She* is the registering of *his* desire. *She* is attraction itself which *he* presents for all the world to see.

The world sees more and more of her as ballet, taken up by former colonies in the Pacific and Latin America, and also in China and Japan spreads across the globe.[4] Strong contendent for a universal standard of physical achievement in dance, ballet, with its pedagogical order-liness and clear criteria for excellence, promises a homogenizing medium for the expression of cultural difference. It offers a global aesthetic whose universal claims enable each commu-nity to particularize itself while at the same time assuring each community's access to the status of a world player of the form. Annual Ballet Olympics, by conflating distinctions between sport and art, extend an invitation to all to participate in this single aesthetic enterprise. Video, a medium well-suited to the documentation of ballet's aesthetic ideals – extended bodily lines and clear shapes – transports images of balletic bodies around the world. This First World export contains in its historical repertoire numerous images of the hitherto exotic populations that are now adapting its aesthetic as their tradition. Yet in the abstraction of contemporary ballet, little residue remains of the foreign Exotics – the colorful, sensuous settings, or the tempestuous, irresistible women and aggressive, voracious villains – that moved the nineteenth-century ballet plots forward through their combination of evil and sexual impulses. Today's ballet, a sanitized geometry, emphasizes physical discipline and dedication. Rather than offering a travelogue through real and imaginary worlds as it did in the nine-teenth century, contemporary ballet provides a seemingly neutral *techne* through which intensities of cultural or psychological ambiance can be projected.

In these landscapes of virtuosity, both *her* and *his* bodies bear the marks of colonization and colonial contact. They stand against indigenous forms of dancing as bodies estranged. The sheer excitement of their physical endeavor, however, galvanizes viewers in proud and enthu-siastic response. Both *he* and *she* dare to accomplish so much and dare to mask the effort necessary to make their bodily shapings, rhythmic phrasings, and complex exchanges of weight appear so effervescent. Both *she* and *he* sweat to make the choreographer's vision manifest just as they erase their faces of the tension inherent in their exertion and modulate the energy through their limbs so as to render their labor effortless in appearance. Perspiration marks slowly appearing around armpits, groins, abdomens, or backs only make the masking of their effort more miraculously convincing.

But if these two dancing bodies share a dedication to artisanal perfection, they do not enjoy equal visibility. In their joint striving, they construct two unequivalent forms of pres-ence. *He* fades away behind or beneath *her* in their duets, becoming an indispensable assistant, the necessary backdrop against which *she* sparkles. And even though *he* asserts a compelling presence in his solos when the full power of his aerial dexterity is revealed, in the end, even in their bows, he remains upstage, orchestrating, enabling *her* performance, but also chan-neling all attention towards her. *She*, like a divining rod, trembling, erect, responsive, which *he* handles, also channels the energy of all the eyes focused upon *her*, yet even as *she* commands the audience's gaze, *she* achieves no tangible or enduring identity. *Her* personhood is eclipsed by the attention *she* receives, by the need for her to dance in front of everyone. Just as *he* conveys her, *she* conveys desire. *She* exists as a demonstration of that which is desired but is not real. *Her* body flames with the charged wantings of so many eyes, yet like a flame it has no substance. *She* is, in a word, the phallus, and *he* embodies the forces that pursue, guide, and manipulate it.[5]

Now this is a naughty thing to propose. Why revile the delicate and flexible grace, the superb celebration of feminine physicality that these women display by connecting it to the sexual politics of the phallus? Why not give male and female dancers an egalitarian future, regardless of their past, at the moment where ballet enters the late twentieth-century global state? The answer rests on the series of gendered bodies developed historically within the ballet tradition over the past two hundred years.[6] Whether visible in reworked versions of the classical masterpieces – *Giselle, Swan Lake, Coppelia*, etc. – or merely in the vocabulary and style of the dancing, the weight of these past bodies presses too hard upon contemporary ballet to allow a nongendered reception of its meaning, or even to allow for the dismissal of gendered content as a superfluous formal feature analogous in impact only to that of an irrelevant cliché.

At this moment of ballet's global visibility, the labor of historicizing its gendered meaning is more crucial than ever. The ballerina-as-phallus provokes an analysis of the performance of both feminine and masculine desire. It forces an inquiry into the classical routing of the female viewer's attention: either she must look through the eyes of the male dancer at his partner in order actively to assert attraction, or she must empathize passively with the ballerina as an object of male desire. Both these mappings of her participation as viewer are subtended by a masculine logic that traffics women to sustain various forms of male hegemony.[7] The ballerina-as-phallus likewise problematizes the male viewer's gaze: his point of identification on-stage is an effeminate man, a man in tights, through whom he must pass on his way to the object of fascination, or on whom he can focus within a homosexual counter-reading of the performance.[8] The global context of ballet performance, the remarkable homogeneity of ballet productions regardless of the aesthetics of the choreographic tradition – modern dance, jazz, experimental or ethnic – mandate a consideration of all these gendered identities.

But there is also a promise in the naughtiness of the ballerina-phallus, the promise that all monsters afford, to forge from the cataclysmic energy of their aberrant parts a new identity that meets the political and aesthetic exigencies of the moment.[9] The ballerina is, after all, gulp, magnetically magical. An object of revulsion while under feminist scrutiny, she nonetheless enchants us. Perhaps, via the ballerina-as-phallus, her power can reconfigure so as to sustain her charisma even as she begins to determine her own fate. Perhaps the ballerina-as-phallus can even reclaim for ballet, long viewed as a neutral parade of geometrized forms, a certain sensual and even sexual potency. But first, the ballerina-as-phallus must be fleshed out, provided an origin, a history, and an anatomy.

Sometime early in the middle of the nineteenth century, in Paris, city host to the most lavish and sustained achievements in theatrical dance of any European capital, choreographic and narrative elements congealed so as to form that distinct genre of spectacle, known as the Romantic ballet, whose imprint haunts the aesthetics of contemporary ballet performance.[10] Two ballets from this period, *Les Sylphides* (1832) and *Giselle* (1841) survive in the repertoires of many ballet companies and retain immense popularity. More significantly, the Romantic ballet celebrated the principle of distinct vocabularies for male and female dancers – the dainty and complex footwork, the *developpés* of the leg and extended balances for women and the high leaps, jumps with beats, and multiple pirouettes for men. It rationalized the new technique of pointe work which added a strenuous precariousness to the female dancer's performance. And it encouraged new conventions of partnering that incorporated new codes for touching, for support, and for the achievement of pleasing configurations. Up until the end of the eighteenth century the *pas de deux* had placed great emphasis on male and female dancers performing alongside one another or traveling separately designated pathways in

mirrored opposition. These dancers shared a common vocabulary of steps performed with distinctive styles stipulated for male and female dancers. By the time of the Romantic ballets partnering included sections of sustained, slowly evolving shapes where male and female dancers constructed intricate designs, always with the male dancer supporting, guiding, and manipulating the female dancer as she balanced delicately and suspensefully in fully extended shapes. And the divergent vocabularies for male and female dancers symbolized a difference between the sexes far greater than the distinct styles of eighteenth-century performers.[11]

These duets paired a noble if confused male lead with one of two female character types: the supernatural creature or the exotic foreigner. Sylphs, naiads, and wilis offered an enigmatic ephemerality, dream-like, vaporous, incomparably light. Gypsies, Creoles, and other Orientalist characters constituted the sylph's pagan counterpart. Rapturously sensual, unabashedly suggestive, these heroines after innumerable obstacles eventually consummated their romantic attachments, whereas the sylph's unequivocal Otherness usually led to tragic conclusions. In either case, the male lead indulged his longing attachment to her, seeking her out, adoring her, and partnering her with solicitous mastery.

These two female character types helped to solve the ballet's greatest dilemma, growing in intensity since the later decades of the eighteenth century, to integrate the equally pressing needs for a coherent plot and for the display of virtuoso dancing. The ballet plots typically orchestrated one kind of solution by always including festivals, weddings, or celebrations, occasions where dancing would expectably take place, as part of the action. But the female leading character played an even more crucial role in the balancing of drama and spectacle. As some form of exotic, whether foreign or supernatural, her character could easily be construed as one predisposed to dancing. Or even better, dancing might figure as the character's very mode of being in the world. Rather than a walking, talking, gesturing person, she knew best how to float, gambol, suspend, and disappear. As a dancing being, she could easily embody both the necessary passion-filled responses and the repertoire of classical steps. Her pressing desire to dance thus facilitated an easy transition from story to spectacle and back again.

The tragic ballets like *Les Sylphides* and *Giselle*, depicting the impossible love between man and sylph (*Les Sylphides*) or between prince and peasant (*Giselle*), used the separate vocabularies and stereotypic character types to greatest advantage. Their heroines symbolized not only love lost, but also dreams unrealized and unrealizable. The sylphide, one of a band living in the forest, represented the ideal blending of abstraction and sensuality, a ravishing sensibility, no longer found in the mundane actions of the real world. Giselle offered the beguiling spontaneity of an innocence untainted by the sterile and tedious codes of aristocratic (or urban) civilization. Upon her tragic death she transformed into a wili, yet another variety of enchanted being, defined as a girl "who loved to dance too much," and who on her wedding's eve, at the height of unconsummated sexual arousal, died.[12] The wilis appeared to mortals in the forest at night and lured unsuspecting men into a dance that could only end in their death from exhaustion. Like the sylphides, the wilis enticed men with their voluptuous ways and then vanished.

The spectacle created by low-level gas lighting and elaborate flying machinery for these tulle-skirted supernaturals offered both optical indefiniteness and opulence. Viewers witnessed mirage-like forms dissolving, vanishing, escaping the mortal with such softness. The sprites' world exuded a ravishing melancholy that transcended diversion and referenced truly lost hopes. The sylphide's death after her mortal lover had removed her wings carried a moral and aesthetic significance comparable to the great literature of the Romantic period. Giselle's poignant and miraculously successful efforts to protect her beloved prince from the rapacious wilis resonated with a kind of hope and courage that transcended her specific moment.

Yet the success and durability of these ballets derived not only from their powerful scenarios and sumptuous spectacle, but also from the plentiful opportunities for virtuoso display. Celebrations for the impending wedding in *Les Sylphides* showed off the skills of a large *corps de ballet* and several soloists. The witches' dance that opened Act II proffered the high leaps and jumps as well as the contorted acrobatics that audiences adored. Giselle's village commemorated the harvest with a danced celebration, and the wilis in Act II danced Giselle's initiation, the death of the gamekeeper Hilarion, and their pursuit of the prince. These scenes staged group precision at complicated steps and traveling patterns along with dazzling individual expertise. The disposition of dancers in space and the sequencing of dances within these scenes always orchestrated a hierarchical display of skills, contrasting *corps de ballet* with soloists in ways that revealed as they confirmed the very training process that built a great dancer.

The drive to develop new levels of competence at dancing can be traced to the consolidation of the ballet lexicon with its specification of positions, steps, and variations at the beginning of the eighteenth century. Dancers had endeared themselves to audiences for generations by developing some new proof of their dexterity and grace. What distinguished the early nineteenth-century quest for virtuosity was a new conception of bodily responsiveness evident in the training procedures for dancers and also in the high expectations for skill at social dancing and the approach to physical discipline taken in the nascent physical education movement. By the early nineteenth century, dancers no longer studied individually a regimen designed specifically for their physical type and inclination, but instead attended large group classes where they learned standardized sequences of exercises with designated shapes to which all bodies should conform.[13] The pedagogical goal of these classes, informed by the science of anatomy, was to develop the body's strength and flexibility so as to enable more turns, higher leaps and leg extensions, and longer balances. The social dance repertoire reflected a similar concern with expanding physical achievement – more complicated rhythmic patterns, beats of the foot, jumps, and shifts of weight. At the various *bals* and *fêtes* where social dancing occurred, this quest for virtuosity signaled a body that functioned less as a medium for communication than as a showcase for accomplishments.[14] The very fact of the emergence of a new discipline of physical education corroborated this conception of the body-showcase by identifying a set of exercises for the sole purpose of developing bodily strength and equilibrium.[15] In the eighteenth century many activities including dance had claimed a healthy body as an added benefit for those who pursued them. Now, the body had a thing-ness that required maintenance in and of itself. A hundred years earlier dancing had constituted a meta-discipline that prepared the body to execute gracefully all actions whether those of sports, warfare, or the daily behaviors of proper social comportment.[16] Now, the practice of theatrical dance, like the regimens of physical education or social dancing, implemented a body that was isolated by and contained within the specific program of exercises it pursued.

If the physical demands of virtuosity leached from the body any connection to a signifying sociability, they did not de-sexualize it. Rather, the objectification of the body accomplished in these physical regimens rendered it a more neutral and compartmentalized receptacle for an abundance of sexual connotations. Yet, in the same way that codes of partnering put the female body forward for the viewer's delectation, so too, her body bore the vast majority of all sexualizing inferences. Newspaper critics described and compared female dancers' body parts in excruciating and leering detail. An immense literature of gossipy pamphlets sprang up that recounted as a kind of biographical profile the amorous liaisons and sexual escapades of female dancers.[17] The disdainful yet salacious tone, the suspicion of prurience in these publications, distinguishes them from the more modest literature summing up

the glamour and power of eighteenth-century ballerinas. Even the definition of the "wili" as the girl who loved to dance too much implied a transparent conflation of dancing with sexual intercourse that extended to the ballet generally. Thus the ballet, even as it danced out an ethereal world of idealized enchantment, also proffered lovely ladies, scantily clad, engaged in a blatant metaphor for sensual and sexual actions.

Capitalist marketing strategies initiated in the early nineteenth century supported and enhanced the objectified dancing body and the commodified female dancer.[18] They pitted one ballerina against another in intensive, objectifying advertising campaigns and opened up backstage areas where wealthy patrons might enjoy the company of dancers before, during, and after the performance. Rather than evaluate a performance within the context of a given genre, or even character type, viewers were encouraged to focus on female stars with merciless comparative scrutiny. The progressive segmentation of the body occurring in physical education, anatomy and the new science of phrenology further supported the fascination with isolated parts of the female dancing body. Poorly paid dancers and insubstantial government support left the institution of dance vulnerable to exploitation, both sexual and specular.[19]

If the female body quietly endured the evaluation of viewers, it nonetheless repelled their gaze through its demonstration of ephemerality itself. As it danced through the exotic trappings of these productions, it conveyed a sumptuous ethereality that rendered viewers mute. Unable to grasp the beauty that vanished as it moved, viewers succumbed to gossip about the dancers, to criticism of their physique, or to rhapsodic evocations of dance's inexpressible loveliness. No translation into words of choreographic action or its danced execution seemed possible. Although eighteenth- and early nineteenth-century choreographers had written the scenarios of their ballets for the program and for publication, choreographers skilled at the conventions of this vaporous ethereality could no longer be expected to write, much less to contrive, the plots for ballets. A scenarist was now called upon to formulate the storyline which the choreographer then evoked through danced action. Nor could any form of notation preserve this action. Like the unattainable love it typically portrayed, choreographic form left its only trace in the bodies that had performed it.

The ballet's evanescence, its reputation as decorative and pleasurable entertainment, aligned it with a host of feminine attributes. Dancing in general accentuated the moderated and flowing use of the body uniquely suited to women, and it provided the nurturing guidance necessary during that romantic and most feminine moment in one's life, late adolescent courtship. The concern with physical presentation, with mannerly and decorous behavior grew out of a uniquely feminine sphere of influence. Theatrical dance, now dominated by female dancers and by female characters, offered a delightful treat more than an edifying experience. Artistic endeavours likewise became feminized within a public sphere dedicated to political and economic governance. Of all the arts, dance, with its concern for bodily display, its evanescent form, and its resistance to the verbal, distinguished itself as overwhelmingly feminine in nature.

The harder-edged bodies, the abstract geometries, the athleticism found in today's productions do not substantively alter the surround of cultural and aesthetic issues, inherited from the nineteenth century, that continues to define ballet today. If not globally, then at least in the United States and Europe, the countries that have exported ballet, the divide between classical steps and representational gestures, the quest for virtuoso display, the division of labor along gender lines, the reputation of dance as non-verbal diversion – all these features remain central to ballet's identity. Despite the security of the choreographic validity of exquisite

physical forms, the menacing question of what the ballet is about still looms large. To the extent that the choreographer aspires to represent any facet of human feeling, interaction, or drama, some vocabulary, whether pantomimic or modernist must be deployed. And its gestures must somehow reconcile with the basic ballet vocabulary and with the mandate to present virtuoso dancing. Ballet training, more painful and demanding than ever, produces the audacious and rapturous brilliance that consistently motivates audiences to interrupt the performance with their applause. Even in the most avant-garde companies, distinct vocabularies for male and female dancers endure. Where the ballet vocabulary has blended with modern, jazz, and postmodern movement traditions so as to blur stylistic and lexical distinctiveness, the pointe shoe with its attendant demands on the female dancer survives to assure viewers of the genre. Despite a recently acquired respectability for the male dancer, ballet continues to be conceptualized as a feminine art, especially when compared with music, painting, or poetry. It is dominated by women, even though men hold key artistic and managerial positions. It lacks the permanence of an accessible notation system, and seems sublimely incapable of translation into words.

What no longer endures of the nineteenth-century tradition (or is it merely glossed over?) is the blatant sexual inflection of the ballet, its extroverted signaling of gender identity and sexual desire. Today's audiences seem not to view the exposed crotch of the ballerina in *arabesque promenade* as genitals. They do not view the moment where her thighs slide over her partner's face as she descends from a high lift as oral sex. Nor do they see her gentle fall onto her partner's prone body as copulation. The formality of balletic bodily shape and line dominates all coding of body parts and conventions of touching. Nineteenth-century audiences likewise accepted the aestheticized coding of body parts that the ballet had developed, even if many men sat in the front row in order to peek up the dancers' bloomers.[20] Still the nineteenth-century productions broadcast the synthetic possibility of spectacle as simultaneously physical, sexual, glamorous, romantic, and aesthetic. To sort through to what has been lost or somehow transformed in contemporary ballet requires a return to Romantic period performances with specific attention to their vectoring of the viewer's desire.

Renowned critic Jules Janin provided this assessment of ballet's structuring of desire in 1844:

> The *grand danseur* appears to us so sad and so heavy! He is so unhappy and so self-satisfied! He responds to nothing, he represents nothing, he is nothing. Speak to us of a pretty dancing girl who displays the grace of her features and the elegance of her figure, who reveals so fleetingly all the treasures of her beauty. Thank God, I understand that perfectly, I know what this lovely creature wishes us, and I would willingly follow her wherever she wishes in the sweet land of love. But a man, a frightful man, as ugly as you and I, a wretched fellow who leaps about without knowing why, a creature specially made to carry a musket and a sword and to wear a uniform. That this fellow should dance as a woman does – impossible! That this bewhiskered individual who is a pillar of the community, an elector, a municipal councillor, a man whose business it is to make and above all unmake laws, should come before us in a tunic of sky-blue satin, his head covered with a hat with a waving plume amorously caressing his cheek, a frightful *danseuse* of the male sex, come to pirouette in the best place while the pretty ballet girls stand respectfully at a distance – this was surely impossible and intolerable, and we have done well to remove such great artists from our pleasures. Today, thanks to this revolution which we have effected, woman is queen of ballet. She breathes and dances there at her ease. She

is no longer forced to cut off half her silk petticoat to dress her partner with it. Today the dancing man is no longer tolerated except as a useful accessory.[21]

Janin succinctly observed the alignment of masculine identity with a public domain and of feminine identity with a private domain and the inevitable destinies of male and female performers within such an alignment. Male dancers, so chunky and thick on the one hand, so dangerously effeminate on the other, should be banished from the stage. These "frightful *danseuse(s)* of the male sex" only contaminated, through their doubly failed performance of gender, the viewer's rightful access to the "pretty dancing girl." Her mission and message, utterly obvious according to Janin, was to lead the viewer through the "sweet land of love." Her body, through the act of dancing, would reveal treasures of beauty and sensuality unavailable in any other context.[22]

Although fashion in the early nineteenth century had created of all women a kind of spectacle, theatrical dance constituted one of the few cultural events that framed women, and specifically women's bodies for view. As public personages, the details of their daily lives infused their identities on-stage with prurient intrigue.[23] Their participation in a market economy – buying the claque's applause and publicity from critics like Janin, selling sexual privileges in order to pay for dance classes – was familiar public knowledge. Among the aging aristocrats and business tycoons who could afford to "contribute to their careers," the dancers were referred to as fillies who could be mounted, re-mounted, or exchanged for a new mount.[24] Still, they maintained a kind of dignity that even Janin's demeaning tone could not deny them, one that derived from their expertise at dancing and their dedication to a life in the arts.

As a variety of public woman, female dancers nonetheless bore the burden of spectacularizing expectations for their performance, and they were subject to strategies of containment that controlled their effect on public life. Their bodies, morselized by training and by the viewing gaze, were described as "Nordic," or "gangly," or "with the legs of a gazelle."[25] These terms belied not only the compartmentalization of the body but also the conflation of body parts with characterological attributes. Dancers no longer aspired to represent realistic characters on-stage. Instead, their bodies' parts stood in for various states of being – love, longing, wickedness, pathos, nurturance, dementedness, etc. And these states lined up along axes defined by ethereality and fleshliness, abstinence and rapaciousness, piety and succor. Their physique's natural inclination to evoke these states mattered more than their skill at acting. Thus even as they captured the public's eye with their willingness to put the body on display, their skills were minimized in favor of their natural physical endowments.

In the plots for ballets, female characters uniformly served as the desired personage, and they also registered the bulk of the pathos – in scenes of lamentation, madness, or delight. Male characters' longing overwhelmed in magnitude and intensity any reciprocal gestures the female characters might proffer, yet they also stood by with incapacitated stoicism as the objects of their desire became seized by the torment or ecstasy that the plot produced. Female bodies, absorbent of the feelings and conflicts circulating through all the story's characters, trembled with sexual and emotional fervor. Their solos, the rewarding climax of any scene, were the ones all other bodies watched. Using their exceptional prowess at dancing, these women could express what no other bodies could. Dancing occurred at the site of these bodies as both an indescribable event and an expression of the indescribable.

If these female lead characters gave their male counterparts the dispassion necessary, as Janin observed, to govern, they also sustained male sexual potency. The separation of the dance vocabulary into gendered parts placed female soloists as the central and final object of the specular gaze, yet allowed the male character to remain in control of this charismatic

object. The choice and development of female characters likewise worked to preserve male sexual superiority. The wilis, for example, through their challenge to men's sexual endurance, augmented and bolstered male sexual capacity. The few who "died" at their hands in no way undermined the enhanced reputation for sexual prowess that the wilis' existence secured for all men. Other Orientalist and pagan female characters functioned in a similar if less dramatic way. Their renowned sensuality and sexual forwardness reflected directly and positively onto the male character whose inclination it was to pursue and master them.

Scenarists invented a remarkable number of female character types who could assure a potent yet stoic male identity, and these types functioned similarly, in their use of gender-specific vocabulary, in both tragic and comic plots. Although they filled the stage with their voluptuous variations, these female leads never achieved a strong or profound sense of identity. In the tragedies, the point at which they would begin to develop characterological depth most often coincided with the story's demand for the explosive registering of feeling. In that display of pathos, the body was frequently undone.[26] Once their function – as the mark of that which was not male – was jeopardized by the impending need to know them more intimately, the plot wiped them out. All that remained were the endlessly duplicated minor ballerinas, the *corps de ballet*, who, because of their massive number and routinized action, posed no threat of a palpable personhood.[27] In the comedies, heroine and hero would eventually unite, yet the plot and the casting of characters gave little depth to either. Neither lead encountered any substantive conflict through which personality could be revealed. And the fast-paced encounters, extrications, and flirtations that composed the action could only be seen as plays of appearance, especially since a large number of the male parts were played by women.

The popularity of the female travesty dancer grew in tandem with the individuation of masculine and feminine vocabularies of dance movement in the early nineteenth century.[28] A common role in boulevard and variety-show productions from the turn of the century, the travesty role made its way into the Opera in the 1820s.[29] Although the seriousness of tragedy continued to demand a male lead character, the frivolity of comedies and divertissements increasingly called for female dancers in the male roles. Reviews complimented the travesty dancer on her skillful partnering and her graceful ability to display the female lead's talents. They praised her shapely legs, well revealed by the men's *pantalons* she wore. Her presence, perfectly acceptable, even desirable because the two bodies worked so well together, signaled no intimation of homoerotic possibility, no sense of illicit, much less scandalous, behavior. It rested upon, even as it advertised more widely than ever before, a tradition of travesty that since the early 1800s had seen no possibility of or "any affecting consequence" in the love of one woman by another.[30]

The travesty dancer through her blatant burlesque helped to subdue the charismatic power of the female lead. She also seemed to solve, through its elimination, the problem of the effeminate male. Especially in the comedies where true suffering and unbearable consequences never appeared on stage, the male dancer's leaps and turns, even more, his decorous gestures and gaudy costume gave his gendered identity an uncomfortable ambiguousness. The tragedies' plots also tainted him with the same wimpishness. In *Les Sylphides* circumstances rather than an act of will caused him to abandon his fiancée and follow the sylphide into the woods. In *Giselle* he stood by aghast and watched as his peasant-love, now cognizant of his treachery, danced herself, by fits and starts, to death. Thus the feminized context of the ballet with its exploration of bodily, sentimental, and opulent aesthetics left little room for a man to move.

It left a great deal, however, for him and for the male viewer who identified with him, to look upon. First, there was the spectacle of the female *corps de ballet*, all those similarly dressed bodies moving in unison like merchandise lined up on a shelf. He could savor the

knees of one, the neck of another, engulfed in a glorified female sensuality that required no commitment and no obligation. Then, there were the ballerinas, the ones most desired, most sought after, whose individual physiques and talents inspired different varieties of erotic reverie. Through identification with the male lead, he could likewise adore her, partner her, and possess her. Or if the male lead was played by a woman, her body added yet another kind of feminine form, one that summoned up the voyeuristic erotics of two women dancing an amorous duet together. The whole organization of balletic spectacle presumed the primacy of the male heterosexual viewer whose eyes would be satisfied by a display of voluptuous feminine forms.

But how did the synthesis of choreography and plot guide his desire? As specified in the scenarios and also in the dancing itself, the dominant message in all the ballets amplified upon the desirability of heterosexual coupling. Male and female characters always united or else their union reverberated, in its images of progress and expansiveness, with the promise to realize a new society. At the same time, it affirmed in the procreative unit the secure foundation of the nation. Father passed daughter along to her new husband, ensuring simultaneously the perpetuation of the lineage and male control over it. The female character, even when she asserted a preference for spouse to which her father eventually capitulated, served to mark the exchange between men. The male viewer, identifying with the male lead, confirmed his own sensitivity to and mastery over woman and story. And he participated tacitly in the exchange of woman among men by witnessing the heroine's transfer from father to husband.

Where the leading couple failed, the impedance could be traced to the impossibility of achieving union across class or blood lines. Here male characters accumulated a misguided and tormented persona, stoic, pathetic, but also autonomous. The number of introspective moments performed on-stage built up a character in deep conflict. He alone suffered the agony of the antagonism between social proprieties and deepest desires. He alone danced out that agony with the ballerina – the perfect representation of the impossibility of resolving that conflict. This autoerotic display engulfed all other characters' identities. Even the ballerina was recast as a dream-like conjuration of his torment-filled fantasies. Did the sylphide really exist, or was she simply a symbol of the unrealizable aspirations that divided his soul? This power to summon into being all the facets of his desire and the conditions of their impossible fulfillment imbued the male character with a kind of self-sufficiency that again proved his superiority. Through identification with this hero, the male viewer could nurture his own fantasies using feminine forms to stand in for all impediments and solutions to his happiness.

And what if a woman played the role of the male lead? The popularity of the female travesty dancer in enacting these heterosexual scenarios and her reception as recorded in the press, point towards additional, mutually reinforcing trajectories of desire for the male viewer. The anxiety provoked by the effeminate male dancer resulted not only from a sensuality and decorativeness entirely inappropriate for the male position in society, but also because it referenced a homoerotic aesthetic. The heterosexual valuing of sexuality and sexual preference that dominated both public and private domains, forced an interiorization of homosexual desire and a closeting of same-sex social and sexual practices.[31] Since male interest in grace, lightness, and physical appearance was prohibited as unmanly, any male enactment of these values could easily be construed as homoerotic expression. By insinuating the female body into the male character, the homoerotic connotations of the performance were preserved without any compromise to male superiority. Her travesty garb was material evidence of the conventions of closeting through which male homosexual desire was sublimated. This type of closeting worked to facilitate male bonding, whether in a homosexual or heterosexual context. The "man" who was not himself invited the erotic attachment of both male sexual orientations.

The homosexual male viewer could fantasize the two women as standing in for men, while the heterosexual male viewer could risk the fantasy with no consequences to his reputation. The entire stage thus became a closet for the exercise of male desire.

But if the travesty dancer showed a "man" who was not himself, she equally showed a woman whose pretense posed no threat of uncontrollable sexual appetite or uncontainable passion. Where the female ballerina embodied an explosive charge, the travesty dancer's appearance invoked only perverse delight. Her crossing-over diffused the power of the ballerina and also provided the perfect wrapping for the ballerina as eroticized commodity. She purveyed the ballerina/commodity to the spectator, functioning neither as a member of the patriarchy nor as a menacing "wili." Her transgressive and revealing garb exacerbated the desire to possess the ballerina at the same time that it authorized the sale. Thus the ballerina and her inverted double, the travesty dancer, gestured towards four complementary features of the patriarchal order: as desired mate within the heterosexual union, she fulfilled the procreative half of the social contract; as spectacularly charismatic fantasy, she proved the self-sufficient superiority of the male character; as the entity of exchange within a homosexual or heterosexual male economy, she ensured male potency and rationalized their entitlement to governance; and as the fetishized promise of sexual acquisition, she ordained male capitalist competition within a society of consumption.

All of these readings foreclosed the possibility of a feminine expression of desire whether heterosexual or homosexual. The strict division of labor that placed woman in a purely reproductive function required of her appearance in public the complete eradication of her desire's expression. The heterosexual viewer could only identify with the female leads as objects of a masculine desire. The woman interested in same-sex erotic attachment would necessarily labor so intensively to read against the dominant choreography of desire that she might well have left the theater in search of working-class productions whose eclectic offerings included vicious satires of "high" art successes and also a great range of hyperbolic enactments of gender and sexuality. On the Opera stage, however, the only resistance to the foreclosure of feminine desire took place through the act of vanishing, or disappearing in the act of performing the feminine function. Yet this strategy of vanishing looked exactly like the vanishing that established her charismatic identity. The male viewer thereby controlled both homosexual and heterosexual viewing privileges at the expense of two kinds of "men" who were not themselves – one who dressed like them and another who was entirely concocted by them.

Gone, for the most part, are the complicated stories and the dozens of distinct characters, and certainly the travesty dancer no longer figures as a genre of leading character in contemporary ballets. Instead, when male and female leads extend an arm towards one another and begin their *pas de deux*, this expansive sweep gestures the full statement of their desire to be together. This is how, for example, the audience knows that Balanchine's Apollo has chosen Terpsichore over the other two muses, that he cherishes her expertise at fitting movement to the architectural structure of the music over prowess in drama or poetry.[32] But aren't all three muses versions of the charismatic ballerina whose powers of inspiration secure even as they challenge male authority? Doesn't Apollo sit to the side and evaluatively admire their dancing thereby guiding the audience's gaze towards them? Doesn't he drive them as prancing horses pulling his chariot up into the sky to meet his destiny as god? Don't their legs fan out behind him as protective aura, decorative armor, radiant testimony to his glory?

The legs. The ballerinas' legs. Sheathed in unblemished nylon from high hip bone to pointe shoe, most often a distinct color and texture from both skin and costume, they seem at times almost detached from the rest of the body. Their astonishing straightness, length, and the

flexibility of hip and thigh muscles that permits their extreme separation from one another contrast with the supple, softly flowing arms and arching torso. Then the pointe shoe, a recapitulation of the leg's length and line, forms a slightly bulbous tip at the end of the ankle's thinness. So much of the choreographic focus goes to the articulation of these legs and feet, how the direction they take will establish a certain tension between mobility and precariousness. The tiniest, fastest steps across the floor on pointe (*the bourrée*), the balance on pointe with one leg extended high to the side then sweeping to the back, the turns in place or traveling – all these moves show her standing on so little. She becomes so insubstantial yet so resilient. Straight legs float in space; bent legs open out into straight legs; legs turn soft in order to accomplish some ornamental foot gesture, then re-lineify to point out the lines across the stage space that extend beyond them, to pronounce the precise angle that separates them from one another. In this moment of re-erection, they reveal the creation of the abstract line running from pelvis to toe that draws the musculature to it. The power of these legs springs from their fleshly realization of an abstract ideal.

Nineteenth-century reviews of the female dancers, iconographic representations, costuming – all established the erotic pre-eminence of the ballerina's legs. Breasts or bellies, physical features associated with motherhood, garnered no attention. The legs, unveiled for the first time, indicated a kind of sexual access to the dancing body even as they deflected awareness of the ballerina's "non-natural" status as a non-childbearing character. These late twentieth-century legs, however, do not glow in the same way. Emblazoned in theatrical space rather than coyly shimmering under a translucent skirt, their allure augments as they mutate from stiffness to pliability, from precision to effortlessness. They celebrate vital physical vigor and, at the same time, the triumphant quest for rational form.

The legs belie the phallic identity of the ballerina. They signal her situatedness just in between penis and fetish:[33]

She looks like but isn't a penis. Her legs, her whole body become pumped up and hard yet always remain supple. Both the preparation, the dipping motion that precedes the etched shape, and the graceful fade from an extended pose show deflation, but always on its way to re-enflation. She never twists or contracts. Her sudden changes of direction and shifts of weight, always erect, resemble the penis's happy mind of its own, its inexplicable interest in negligible incidents. Yet, clearly, she is not a penis; she is a woman whose leg movements symbolize those of a penis.

She attracts like but isn't a fetish. Her charisma comes from no single or identifiable source. She synthesizes strangely dissonant elements – legs with whole body, beauty with athleticism, physicality, and rationality. Although some may hoard her used pointe shoes or focus fixedly on the proportionate lengths of her arms and legs, she resists the alienated severing of part from whole necessary to create a fetish. Her whole body and performance persona, despite the extremes to which they have been cultivated, remain intact.

She enacts desire and the inevitable loss of the object of desire. She is there and then elsewhere, in his arms, then running to the other side of the stage, in a given shape then transforming to another. A perpetual mutating of form, she attracts, invites, beckons and then disappears. To lose her is to lose that which is desired above all else, the imaginary, that pre-verbal, womb-ish world of sound, light, and movement. Her every move promises recuperation of that world and, in the very same gesture, shows its vanishing.

She gives figure to signification. In her, the chaos of body transmutes into rational form. The years of bodily disciplining have refigured fleshly curves and masses as lines

and circles. Geometric perfection displays itself at both core and surface. Bodily shapes present one stunning design after another, notable for their silhouette and also for the interiorized configuration of lines running parallel to the skeleton around which the musculature is wrapped. Via this geometry her movements turn mess into symbol.

Supporting, underlying, founding this phallic identity is the ballet's perpetual upward thrust. The choreographic and stylistic demands of ballet take the weight of the body and make it disappear into thin air. Everything lifts up, moves towards height rather than depth; everything gestures out and up, never in, never down. This obsessive aeriality reinforces the erection of the penis-like ballerina. It helps transform movement into the void of space, thereby facilitating dancing's vanishing and confirming its rational principles. By gesturing upwards into the realm of abstraction itself, the dancing proves its fraternal relation to music and mathematics.[34] Its grammar, evident in its geometry of forms, manufactures Pythagorean equations.[35]

The Romantic ballet, its choreographic conventions and its narratives, prepared the ballerina for just this phallic destiny. The same principles of desire and loss, the same charismatic glow now evident in the movement sequences themselves, originally manifest in the danced plot. Whether as sylphide or gypsy, the ballerina embodied an unattainable desire. Dance style allotted her elusive ethereality or ungovernable vitality. The plot often contrived her character so as to enable the displacement of the phallic attachment onto race or class. The ballets danced out the impossibility of love through a representation of the impossibility of non-permissible love, love that transgressed class and racial or inter-species boundaries. As a figment of the imagination, as in the sylphide, or as an independent and volatile gypsy, she augmented male sexual potency just before she vanished. Or if she passed from one male partner to the next, she lubricated the exchange of their sexual power. When those partners were played by female dancers, female bodies whose lack of a penis could arouse no fears of castration, then the ballerina sexualized commodity exchange. Her body, fetishized both on- and off-stage, offered itself up to the viewer from the same abstract distance as that from which the burgeoning capitalist market offered its goods.[36] In the absence of a castrating father or castrated mother, the ballerina floated as freely from obligation as all purchases procurable within a monetary medium. She danced out the erotics of acquisition under a system that measured all objects with a common symbolic denominator. In all these mutually reinforcing roles, the ballerina conferred phallic power upon male viewers by enacting their scenarios and appearing as their fantasy projection.

Between the Romantic ballet and her late twentieth-century descendant, two events of enormous choreographic significance intervened that have influenced the ballerina's phallic inheritance. First, at the beginning of the twentieth century, women as soloists who choreographed and performed their own dances began to occupy the stage, appropriating the phallus for themselves. Unpartnered and refusing to realize any choreographic vision other than their own, they detonated the classical stage and its sexual politics. Earthbound, preoccupied with flow from core to peripheral body and back, rather than from body out into space, they claimed "natural" physical processes rather than rational aesthetic tradition as inspiration for their movement choices. Yes, they were gazed upon, but they did not die at the end of the dances. Instead, arms plunging upwards and legs shooting down into the ground, they stood proudly, thereby collapsing the phallus into themselves, becoming the phallus themselves. Their charisma resulted in part from their ability to capitalize on and, at the same time, disrupt the sexual economy of viewing to which their audiences were accustomed. Their

ascendance to the stage was partnered by a second major choreographic change – the premier of the gay male dancer.

The ballet tradition's uneasy relationship to these choreographic initiatives has yet to be assessed, and it deserves a kind of consideration that space here does not permit. However, one ballet, Fokine's *Petroushka*, suggests itself as a model for the kind of prescient story of ballet's initial response to the modern dance aesthetic. Opening on the hubbub of a mid-nineteenth-century Russian fair, *Petroushka* introduces an ancient wizard-like puppeteer whose mysterious allure charms the populace into attending his small theater. The curtains are drawn back to reveal three puppets: the exotic, brutish Moor; the mechanical, virtuoso Columbine; and the contorted, sincere Petroushka. In this brief display Petroushka's love for Columbine enrages the Moor and they burst the boundaries of the theater only to be restrained by the discontented puppeteer. Petroushka, banished to his private cell, acts out the mournful tale of his unrequited love and his frustrated incarceration at the hands of the puppeteer. Then in his own cell the Moor, in the midst of worshipful devotion to a coconut, is visited by Columbine, who kicks and pirouettes around him in an effort to attract his attention. Having finally succeeded by sitting on his lap, she is annoyed to see Petroushka enter. His further entreaties towards Columbine enrage the Moor, and their frantic chase spills out into the street, where, much to the crowd's dismay, the Moor kills Petroushka. The wizard, exhausted and irritated, shoves his way through the concerned onlookers to demonstrate that Petroushka is only a puppet, a bag of straw which he yanks from the ground with terrifying authority. Dragging the puppet back to his theater, he closes for the night. But as he begins to exit the stage he suddenly sees the apparition of Petroushka, gesturing menacingly from the rooftop above the theater. Overwhelmed with fear, he runs out as Petroushka persists in a melancholy yet taunting laugh.

This ballet presented an almost transparent critique of czarist Russia with Petroushka, standing for the pathetic commoners, struggling under the czar-puppeteer whose portrait hung in his tiny room. It could equally be construed as one of the first renderings of modernist subjectivity: man, no longer noble or good, and woman, no longer a goddess or a whore, acted out the destinies that Fate had provided. Alienated from their means of production, they performed their small dramas whose impact only resonated in the hollow laugh of a ghostly afterlife. I want to propose a third interpretation, one which sees in the puppeteer the choreographer Fokine who recognized that he was working at the faultline of an enormous aesthetic rupture. Captivated by the dancing of Isadora Duncan only a few years earlier, he cannily appraised what the ballet tradition had to offer; the exotic and lavish trappings of other-worldly places that activated desire (the Moor), and the virtuoso yet mechanized vocabulary of spectacular dancing (Columbine). Petroushka represented the new expressivist agenda as proposed by Duncan with its radical overhauling of the very conditions under which vocabulary, subject matters, and viewing experience might be constructed. Fokine, inheritor of the ballet tradition that had choreographed the law of the father, could only respond by running from the ominous threat of aesthetic rebellion.

Yet Petroushka, played by Nijinsky, introverted and pathetic, lacking all erectness, and dominated by a controlling male partner, represented the inverse of the female choreographer who had assimilated the phallus. Clearly identified as homosexual in an age that had recently recognized homosexuality as a category,[37] his performance in *Petroushka* and other ballets constructed an entirely new character type – the male performer as queered phallus. Deviant yet magnificent, always cast in the role of the exotic, Nijinsky specialized in a serpentine, even contorted bodily shaping combined with the highest leaps ever made.[38] It was he who died or vanished at the end of Fokine's ballets, and he who came back like a queer male

"wili" to haunt the stage at the end of *Petroushka*. Nevertheless, Nijinsky went on to choreograph three ballets that self-consciously staged the same patriarchal dynamics on which the ballets of a century before had been founded: the autoerotic supremacy of the male position in *L'Après midi d'un faune*; the female as sacrificial object of exchange among men in *Le Sacre du printemps*; and the sexualized encounter as commodity in *Jeux*.

Thus *Petroushka* forecast the ballerina, always the vehicle for a male choreographic vision, as estranged from the feminist response of modern dance, and it also predicted the gay male choreographer/performer easily insinuated into the stable patriarchy of the ballet and the volatile sorority of modern dance. *Petroushka* also portended a division of labor between ballet and modern dance in which ballet no longer provoked empathic connections to its danced characters so much as to the superbly moving beauty of its form. Modern dance, by contrast, explored the authenticity of human feeling whether embodied in identifiable characters or in movement qualities.[39] As in the character of Petroushka, the growing gay male presence in both traditions remained entirely closeted thereby submerging any distinctive homosexual aesthetic deep within musculature of the tradition. The leggy, anorexic, hyper-extended ballerina issued from this matrix of aesthetic concerns.

But what if *Petroushka*'s poor puppeteer in his panicked exit from ballet's dilemmas were now, almost a century later, to run headlong into the ballerina-as-phallus? Would she machinegun him down with her pointe shoes, or, better yet, trade them in for combat boots? Would she "out" all the gay male choreographers, viewers, and critics – those "frightful *danseuses* of the male sex" – who have consistently ignored her plight? What kind of a deal could she make? How might she mobilize to secure a choreographic place for her female body and a narrative space for her feminine desire? Could she somehow contrive to both terrify and enchant his fleeing figure so as to short-circuit the traffic in women? Could she take inspiration from the gender-failure of the nineteenth-century male dancer and the courage of the female dancer to create a new identity, dangerously ambiguous or constantly changing, that would elude the viewer's grasping gaze? Could she collaborate with the choreographer/puppeteer on a movement lexicon that would enable her to dance on the graves of Lacan as well as Freud and thereby teach them a new move or two? These are the questions, I believe, that those seven-year-old girls must ask as they draw their hair back into a bun, pull on their pink tights, and head downtown in Hong Kong, Havana, New York, Buenos Aires, Sydney . . . for their weekly class.

Notes

1 This is the argument that has been made in the classic dance history books such as Lincoln Kirstein's *The Book of the Dance: A Short History of Dancing* or Walter Sorell's *The Dance Through the Ages*.
2 For a comprehensive analysis of conventions of partnering in the ballet conducted in the context of a comparative study of ballet with modern dance and contact improvisation, see Cynthia Novack's *Sharing the Dance: Contact Improvisation and American Culture*.
3 Novack and Ann Daly are among the first to launch an inquiry into gendered roles in dance. See also Daly's "The Balanchine Woman: Of Hummingbirds and Channel Swimmers."
4 The whole history of ballet's migration from Europe begs to be written. I want to allude to the colonialist implications of this migration here, yet it lies outside the bounds of this essay to undertake a full history or even to probe the relevance of postcolonial theory to the global dissemination of ballet.
5 The initial apprehension of this potential identity for the ballerina came from my attempt to understand the full impact of nineteenth-century innovations in ballet technique and vocabulary. As the argument in the text indicates, the separation of the ballet lexicon into distinctive vocabularies for male and female dancers occurred seemingly in tandem with a marked increase in the popularity of the travesty dancer. These three performance roles suggested a set of oppositions and contra-

distinctions that could be mapped onto the Greimasian quadrangle. According to Fredric Jameson whose work on Greimas can be found in *The Ideologies of Theory: Essays 1971–86*, the fourth location on the quadrangle reveals the hidden ideological content of the entire system of relations. The quadrangle as I have been able to develop it reads as follows:

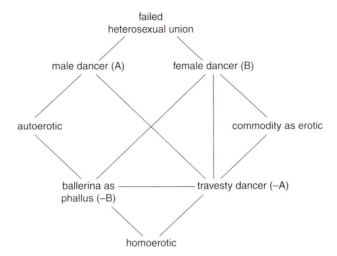

6 Another kind of answer might result from an inquiry into ballet's structuring of expression, as compared, for example, with that of opera. In *The Queen's Throat: Opera, Homosexuality, and the Mystery of Desire*, Wayne Koestenbaum identifies opera's special expressive power as a product of its communication via the ear:

> The listener's inner body is illuminated, opened up: a singer doesn't expose her own throat, she exposes the listener's interior. Her voice enters me, makes me a "me," and interior, by virtue of the fact that I have been entered. The singer, through osmosis, passes through the self's porous membrane, and discredits the fiction that bodies are separate, boundaried packages. The singer destroys the division between her body and our own, for her sound enters our system. I am sitting in the Met at Leontyne Price's recital in 1985 and Price's vibrations are *inside my body*, dressing it up with the accoutrements of interiority. Am I listening to Leontyne Price or am I incorporating her, swallowing her, memorizing her? She becomes part of my brain. And I begin to believe – sheer illusion! – that she spins out *my* self, not hers, as Walt Whitman, Ancient-of-Days opera queen, implied when he apostrophized a singer in "out of the Cradle Endlessly Rocking": "O you singer solitary, singing by yourself, projecting me, / O solitary me listening, never more shall I cease perpetuating you. . . ." I follow a singer towards her climax, I will it to happen, and feel myself "made" when she attains her note.
>
> (Koestenbaum 1993, 43)

Koestenbaum argues that this ability to create interiority is partly responsible for the attraction of gay and lesbian audiences to the opera. Elizabeth Wood and Terry Castle (among others) affirm and expand on Koestenbaum's assertion with their proposals that the quality of the voice, its sonority, flexibility, and its resonant "low notes" are a source of attraction for lesbian listeners. See Wood's essay "Saphonics" and Castle's "In Praise of Brigitte Fassbaender (A Musical Emanation)." Gays and lesbians have attached themselves to the voice's production of song, to the operatic spectacle, and to the diva for distinct yet sometimes overlapping reasons. They read into and against the grain of the performance so as to find systems of values that resonate with the complex status of their sexual and social identities in contemporary society. But where the body serves not as the site for the manufacture of expressive signals and instead as the very substance expressed, the opportunities of empathic connection to the performer proliferate differently. No one minds the corpulent, awkward bodies that produce those luminous sounds in opera; the sounds themselves are what excite. In ballet, however, the bodies

are what matter, and identification with the dancing body, especially the ballet body, is far less likely to establish the kind of interiority for the viewer that the voice can.

7 Here I am referencing Gayle Rubin's famous article "The Traffic in Women." Her essay was one of the first in what has become a sustained critique within feminist theory on the role of the woman as the most fundamental category of goods exchanged within a culture.

8 Koestenbaum eloquently describes the gay male experience of identifying with the diva during her performance at the opera. I suspect that the ballet performance functions similarly in that the gay viewer ignores the obvious heterosexual thrust of the narrative, and differently, in that neither male nor female dancer serves as the exclusive focus of his attention. Rather, it is the generalized climate of physical and sensual grace which the ballet offers that makes it so popular among gay men. Significantly, whereas the opera also boasts a strong lesbian following, the ballet holds little if any interest for the lesbian viewer. One of the goals of this essay is to theorize this difference.

9 Here I am alluding to Donna Haraway's exploration of the opportunities for political resistance offered by the Cyborg in "Manifesto for Cyborgs: Science, Technology, and Socialist Feminism in the 1980s," and by the Monster of "The Promises of Monsters."

10 For an excellent overview of the Romantic ballet in its cultural surround, see Eric Aschengren's "The Beautiful Danger: Facets of the Romantic Ballet."

11 Here I am referring to the shift from a one-sex/two-gender model to a two-sex/two-gender model outlined by Thomas Laqueur in *Making Sex: Body and Gender from the Greeks to Freud* and eloquently summarized in this description of male and female essential differences:

> Les prédispositions particulières de l'homme et de la femme sont telles, que le premier, ayant la force en partage, semble né pour commander et être obéi. Par là il doit être suject à des passions plus violentes que la femme, qui, faible, douce et soumise, ne semble criée que pour aimer et consoler, obéir et plaire. Par conséquent l'attitude de l'homme doit être noble, fière et impérieuse; sa pose pleine de fermenté, la rectitude du tronc invariable, et la position de la tête fixe; tandis que la position de la femme doit être timide, remplie de mollesse et d'agrément: tout chez elle est souplesse et ondulations gracieuses; sa tête, mollement penchée, a toute la candeur de la pose enfantine.
>
> Dans les fonctions ordinaires de la vie, l'homme est plus froid; il est d'une sensibilité plus profonde que la femme au milieu des grandes influences; s'il emploie le geste, c'est toujours avec une supériorité d'expression et d'entraînement, surtout pour la manifestation des sentiments énergiques. La femme, dont les idées sont plus nombreuses et plus nuancées, les mouvements plus souples et plus faibles, emploie des gestes variés et sans énergie.
>
> Dans la démarche et l'expression, l'homme, dont la taille est moins balancée et l'attitude plus ferme, se meut avec plus de force et d'aplomb que la femme; sa démarche prend un caractère de virilité et de résolution; son regard est ferme et méditatif; sa diction, énergique, positive et régulière; sa voix, sonore, impérieuse et sans éclat. Chez la femme la démarche est légère et élégante; son regard plein de douceur, de sensualité et de finesse. Dotée d'une sensibilité dont les modifications sont infinies, elle parle souvent avec excès, presque toujours d'une manière agréable; son élocution est gracieuse et brillante; sa voix, douce, flûtée et claire: sa respiration, active et variée, prend un caractère particulier en conséquence des déplacements qu'elle fait éprouver aux seins.
>
> (B*** and Ball 1846, 41–2)

12 This description is taken from the published scenario for the ballet *Giselle, ou les wilis*, by Vernoy de Saint-Georges, Théophile Gautier, and Jean Coraly.

13 Carlo Blasis describes the new pedagogy in his *Traité elementaire, theorique et pratique de l'art de la danse*.

14 An account of the changing priorities for social dance practice is provided by Jean-Michel Guilcher in his *La Contredanse et les renouvellements de la danse française*. A more detailed analysis of social dance practices is given in Sarah Cordova's "Poetics of Dance: Narrative Designs from Staël to Maupassant."

15 In *Le Corps redressé: histoire d'un pouvoir pedagogique* Georges Vigarello provides a powerful and convincing history of the changes in postural pedagogy and bodily comportment from the seventeenth century to the present.

16 Louis XIV's original charter for the Academy of Dance specifies dance's contribution to the arts of war and theatrical entertainment. A host of dancing manuals from the early and middle eighteenth century reiterate dance's value as a foundation for proper conduct, attractive appearance, good health, and success in all endeavors.

17 Publications appearing in the 1840s that disseminated gossip about primarily female artists include the following: Touchard-LaFosse, *Chroniques secrètes et galantes de l'opéra, 1665–1845*; Anon., *Le Foyer de l'opéra*; Anon., *Le Monde d'amour*; and Anon., *Les Filles d'opéra et les vertus de table d'hôte*.

18 The most notorious instance of this is Louis Véron who took over the Paris Opera as a private venture from 1830–33. His *Mémoires d'un bourgeois de Paris* details the various strategies he implemented for making the Opera a profitable enterprise.

19 The most comprehensive analysis of the daily circumstances of dancers in this period is provided by Louise Robin-Challan in "Danse et danseuses l'envers du décor, 1830–1850."

20 They also participated in more fetishizing adventures. As recounted by Margot Fonteyn for the video series "The Magic of Dance," Marie Taglioni's fans cooked and ate her pointe shoes following her last performance in St. Petersburg.

21 This is Ivor Guest's translation from his book *The Romantic Ballet in Paris*, 21.

22 In her essay, "The Legs of the Countess," interpreting photos taken of the Comtesse de Castiglione, Abigail Solomon-Godeau raises many of the issues discussed here and provides important evidence that corroborates the mid-nineteenth-century status of women in the arts.

23 A sudden surge within French publications of gossipy biographies that focused on dancers' liaisons occurs in the 1830s and 1840s.

24 In his *Petits mémoires de l'opéra*, Charles de Boigne claims that Véron was a genius at publicity, repeatedly announcing that a production was close to its final performance (p. 8). He calls the mother or sister an essential piece of the ballerina's equipment, "un meuble de rigueur comme 'l'arrosoir'" (p. 19). He also observes that:

> A l'Opéra l'avancement ne se donne pas à l'ancienneté, mais au choix. On ne gagne pas ses grades un à un; d'un bond on saisit, on enlève le sceptre. On arrive de Londres, de Naples ou de Vienne avec un nom tout fait. Quelquefois avec un talent trop fait.
>
> (de Boigne 1857, 23)

And he compares the ballerina to a horse, remarking derogatorily that horses look good after battle but the dancer:

> Après son pas, elle n'est même une pauvre après la lettre! Epuisé, haletante, presque morte, elle se soutient à peine; elle souffle comme une machine à vapeur; son visage, peint à la colle, a déteint et ressemble à un arc-en-ciel; son corsage est mouillé, souillé par la sueur; sa bouche grimace, ses yeux sont hagards; quel spectacle!
>
> (ibid., 33)

> Huit jours de repos les condamnent à un mois d'entrechats forcés. La classe de danse a remplacé l'inquisition, avec cette différence qu'à la classe, pour se faire administrer la question, les patientes payent cinquante francs par mois et par tête. Le maître de danse est sans pitié pour ses victimes: il les presse, les tourmente, les harcèle, les gronde. Jamais un moment de repos! Jamais un mot d'encouragement: Il commande et elles obéissent. Tournons nous! s'écrie-t-il; et toutes de rester, tant qu'elles peuvent, talon contre talon; les genoux tendus et les pieds sur la même ligne. *Cassons nous!* Ajoute-t-il; et vous voyez tous ces pieds et toutes ces mains exécuter la manœuvre avec un ensemble parfait. Il s'agit, tout en tenant la barre de la main droite, de poser le pied gauche sur la même barre, et de changer, au commandement, de pied et de main; et au milieu de ces tortures, il faut sourire.
>
> (ibid., 35)

25 See Gautier's *Gautier on Dance* for exemplary instances of the morselized female body. Guest's *The Romantic Ballet in Paris* also includes many quotations from the newspapers that described dancers' performances.

26 See Catherine Clément's *Opera, or the Undoing of Women* for a deeply moving analysis of the varieties of "undoing" for nineteenth-century opera heroines. Their fates parallel those of the ballet's leading female characters.

27 In her article "Film Body: An Implantation of Perversions," Linda Williams finds built into the very structure of the cinematic apparatus a fetishizing function for the female body "whose first effect is to deny the very existence of women." Specifically with regard to the work of Muybridge, whose photographic investigations of motion help form the cinema's origin, she claims that the threat posed by the female nude determined two strategies of containment for the female body in the photographs. Either

the female subject was ensnared in a scene suggestive of a narrative, or she was reduplicated so many times as to erode any power she might have. These two strategies map easily onto the Romantic ballet's frequently tragic fates for leading female dancers and to its reduplication of the female body to form the *corps de ballet*.

28 Lynn Garafola's pioneering essay "The Travesty Dancer in Nineteenth Century Ballet" provided a much-needed feminist intervention into the subject of the travesty dancer. Further historical research is required in order to understand the exact nature of their popularity and the relationship between travesty appearances at working-class theaters and at venues like the Opera.

29 One of the most famous travesty performers of the early nineteenth century was Virginie Déjazet (1797–1875) who initiated a range of travesty roles at the Théâtre des Variétés. For thirty years she played roles as "gamin de Paris, coquette, débardeur, duc, marquis, acteur, jeune homme timide, tambour et même officier d'artillerie." She even played Napoléon with a huge army. See Grand-Carteret, *XIXᵉ Siècle: classes, mœurs, usages, costumes, inventions*. At the Opera Louis Milon's ballet *Les Pages du Duc de Vendôme* (1820) featured women including the highly popular Emilie Biggotini as one of the four pages. A more standard use of travesty, however, began in the 1840s and 1850s.

30 This is a reference to a review from 1806 of the ballet *Les deux Créoles* whose production at the Théâtre de Porte St Martin featured a female dancer in the role of the male lead. The reviewer's response to the performance was as follows; "and the love of one woman for another is scarcely affecting." *Journal de l'Empire*, 4 July 1806. The situation was apparently quite different in England and in the medium of drama where female travesty performers became a threat by the early nineteenth century. See Kristina Straub's essay "The Guilty Pleasures of Female Theatrical Cross-Dressing and the Autobiography of Charlotte Charke" in *Body Guards*, 142–66.

31 Foucault's *The History of Sexuality* initiated an inquiry into the various discursive practices that work to define categories of sexual experience and sexual preference. David Halperin and others have suggested that homosexuality as a category emerges out of societal insistence on the public-normal as hetero-sexual and the private-abnormal as homosexual that occurred in the late eighteenth and early nineteenth centuries. See Halperin's *One Hundred Years of Homosexuality: And Other Essays on Greek Love*.

32 The fitting of movement to the architectural structure embodied in the music is one of Balanchine's most often claimed choreographic goals.

33 In this four-part definition of the ballerina-as-phallus, I am following the general Lacanian thesis that sees in the phallus the law that divides symbolic from imaginary. The phallus's function in this capacity as it affects the experience of subjectivity and desire is worked out in Lacan's essay "The Subversion of the Subject and the Dialectic of Desire in the Freudian Unconscious." I am also relying on Teresa de Lauretis's critique of the phallus in *Alice Doesn't*; Charles Bernheimer's re-assertion of the similarities between the phallus and the penis in "Penile Reference in Phallic Theory"; and Michael Taussig's explication of the relationship of the fetish to the totem in "Maleficium: State of Fetishism."

34 In *The Art of Making Dances*, Doris Humphrey describes the desirable relation between dance and music as one that brings the feminine dance together with her "perfect mate but not master" (p. 132). I am proposing a different relation between ballet and her "sister" arts based on a homosocial male aesthetic economy.

35 For additional feminist perspectives on Pythagorean aesthetics, see Sue-Ellen Case's "Meditations on the Patriarchal Pythagorean Pratfall and the Lesbian Siamese Two-Step" and Susan McClary's "Music, the Pythagoreans, and the Body."

36 The analysis I am undertaking here parallels and takes inspiration from Jean-Joseph Goux's "The Phallus: Masculine Identity and the 'Exchange of Women'." Goux's is a complex and elegant thesis, two aspects of which are important to the argument presented here. First, Goux works to historicize the very conception of the phallus by considering its role in "primitive" societies and in their myths and rituals, then in nineteenth-century and early twentieth-century capitalist societies, and now in a postcapitalist, postmodernist landscape. He argues that the phallus itself, our access to it, and its relation to modes of cultural production have changed distinctively in each of these periods. Second, he connects the identity of the phallus to the identity of capital, claiming for each an analogous degree of abstract functioning in relation to their respective economies of desire and material production.

37 One of Halperin's arguments in *One Hundred Years of Homosexuality* is that the separation of public and private forces a notion of homosexuality as an inverted sexuality. The resonance between Halperin's theorization of late nineteenth-century homosexuality and Nijinsky's performances is striking.

38 Michael Moon expands on Nijinsky's gayness in his article "Flaming Closets."

39 Frederick Ashton is the most notable choreographer who attempted to reach across this divide.

References

Anon. *Le Foyer de l'opéra*. Paris: Hippolyte Souverain, 1842.

Anon. *Le Monde d'amour*. Geneva: Lepondvil, 1842.

Anon. *Les Filles d'opéra et les vertus de table d'hôte*. Paris: J. Labitte, 1846.

Aschengren, Eric. "The Beautiful Danger: Facets of the Romantic Ballet," *Dance Perspectives*, 58, Summer, 1974.

B***, A. and J. Ball. *Histoire pittoresque des passions chez l'homme et chez la femme, et particulierement de l'amour*. Paris: Chez les Principaux Librairies Imprimeur d'Alexandres Baily, 1846.

Bernheimer, Charles. "Penile Reference in Phallic Theory," *Differences*, 4(1), Spring, 1992, 116–132.

Blasis, Carlo. *Traite élémentaire. Théorique et pratique de l'art de la danse*. Milan: Chez Meati et A. Teneti, 1820.

Boigne, Charles de. *Petits mémoires de l'opéra*. Paris, 1857.

Case, Sue-Ellen. "Meditations on the Patriarchal Pythagorean Pratfall and the Lesbian Siamese Two-Step." In Susan L. Foster (ed.), *Choreographing History*. Bloomington: University of Indiana Press, 1995.

Castle, Terry. "In Praise of Bridgette Fasskaender (A Musical Emanation)." In *The Apparitional Lesbian: Female Homosexuality in Modern Culture*. New York: Columbia University Press, 1993, pp. 200–23.

Clément, Catherine. *Opera, or the Undoing of Women*. Trans. by Betsy Wing. Minneapolis: University of Minnesota Press, 1988.

Cordova, Sarah Penelope Davies. "Poetics of Dance: Narrative Designs from Stael to Maupassant." Ph.D. dissertation, University of California, Los Angeles, 1993.

Daly, Ann. "The Balanchine Woman: Of Hummingbirds and Channel Swimmers," *Drama Review*, 31(1), Spring, 1987, 8–21.

de Lauretis, Teresa. *Alice Doesn't: Feminism, Semiotics, Cinema*. Bloomington: University of Indiana Press, 1984.

Foucault, Michel. *The History of Sexuality*. Trans. by Robert Hurley. New York: Pantheon Books, 1978.

Garafola, Lynn. "The Travesty Dancer in Nineteenth Century Ballet," *Dance Research Journal*, 17/2 and 18/1, 1985–86, 35–40.

Gautier, Théophile. *Gautier on Dance*. Trans. by Ivor Guest. London: Dance Books, 1986.

Goux, Jean-Joseph. "The Phallus: Masculine Identity and the 'Exchange of Women'," *Differences*, 4(1), 1992, 40–75.

Grand-Carteret, J. *XIXe Siècle, Classes, Mœurs, Usages, Costumes, Inventions*. Paris: Librairie de Firmin-Didot et Cie, 1983.

Guest, Ivor. *The Romantic Ballet in Paris*. London: Pitman, 1966.

Guilcher, Jean-Michel. *La Contredanse et les renouvellements de la danse française*. Paris: Mouton, 1969.

Halperin, David. *One Hundred Years of Homosexuality: and Other Essays on Greek Love*. New York: Routledge, 1990.

Haraway, Donna. "Manifesto for Cyborgs: Science, Technology, and Socialist Feminism in the 1980s," *Socialist Review*, 15(2), 1985, 65–108. [Chapter 53 in this volume.]

——— . "The Promises of Monsters." In Lawrence Grossberg, Cary Nelson, and Paula Treichler (eds), *Cultural Studies*. New York: Routledge, 1992, pp. 295–337.

Humphrey, Doris. *The Art of Making Dances*. New York: Grove Press, 1959.

Jameson, Fredric. *The Ideologies of Theory: Essays 1971–1986*. Minneapolis: University of Minnesota Press, 1990.

Kirstein, Lincoln. *The Book of the Dance: A Short History of Dancing*. Garden City: Garden City Publishing Company, 1942.

Koestenbaum, Wayne. *The Queen's Throat: Opera, Homosexuality, and the Mystery of Desire*. New York: Poseidon Press, 1993.

Lacan, Jacques. "The Subversion of the Subject and the Dialectic of Desire in the Freudian Unconscious," from *Écrits*. Trans. by Alan Sheridan. New York: W.W. Norton & Company, 1977, pp. 292–325.

Laqueur, Thomas. *Making Sex: Body and Gender from the Greeks to Freud*. Cambridge, MA: Harvard University Press, 1990.

McClary, Susan. "Music, the Pythagoreans, and the Body." In Susan L. Foster (ed.), *Choreographing History*. Bloomington: University of Indiana Press, 1995.

Moon, Michael. "Flaming Closets," *October*, 51, Winter, 1989, 19–54.

Novack, Cynthia. *Sharing the Dance: Contact Improvisation and American Culture*. Madison: University of Wisconsin Press, 1980.

Robin-Challan, Louise. "Danse et danseuses l'envers du décor, 1830–1850," dissertation, University of Paris, 1983. Bibliothèque de Cité Universitaire: G.3848.

Rubin, Gayle. "The Traffic in Women." In Rayna R. Reiter (ed.), *Toward an Anthropology of Women*. New York: Monthly Review Press, 1975, pp. 157–210.

Saint-Georges, Vernoy de, Théophile Gautier, and Jean Coraly. *Giselle, ou les wilis, ballet fantastique en 2 actes*. Paris: Mme Ve Jonas, Libraire de l'Opéra, 1841.

Solomon-Godeau, Abigail. "The Legs of the Countess," *October*, 39, Winter, 1986, 65–108.

Sorrell, Walter. *The Dance Through the Ages*. New York: Grosset and Dunlap, 1967.

Straub, Kristina. "The Guilty Pleasures of Female Theatrical Cross-Dressing and the Autobiography of Charlotte Charke." In Julia Epstein and Kristina Straub (eds), *Body Guards*. New York: Routledge, 1991, pp. 142–166.

Taussig, Michael. "Maleficium: State Fetishism." In Emily Apter and William Pietz (eds), *Fetishism as Cultural Discourse*. Ithaca and London: Cornell University Press, 1993, pp. 217–247.

Touchard-LaFosse, Georges. *Chroniques Secretes et Galantes de l'Opéra, 1665–1845*. Paris: G. Roux et Cassinet, 1846.

Véron, Louis. *Mémoires d'un bourgeois de Paris* Paris: G. de Gonet, 1853–55.

Vigarello, Georges. *Le Corps redresse: histoire d'un pouvoir pedagogique*. Paris: J.P. Delarge, 1978.

Williams, Linda. "Film Body: An Implantation of Perversions," *Ciné-Tracts*, 12, Winter, 1981, 19–35.

Wood, Elizabeth. "Sapphonics." In Philip Brett, Elizabeth Wood, and Gary C. Thomas (eds), *Queering the Pitch: The New Gay and Lesbian Musicology*. New York: Routledge, 1994, pp. 26–37.

Chapter 51

SUSAN BORDO

NEVER JUST PICTURES

Bodies and fantasies

WHEN ALICIA SILVERSTONE, the svelte nineteen-year-old star of *Clueless*, appeared at the Academy Awards just a smidge more substantial than she had been in the movie, the tabloids ribbed her cruelly, calling her "fat-girl" and "buttgirl" (her next movie role is Batgirl) and "more *Babe* than babe."[1] Our idolatry of the trim, tight body shows no signs of relinquishing its grip on our conceptions of beauty and normality. Since I began exploring this obsession it seems to have gathered momentum, like a spreading mass hysteria. Fat is the devil, and we are continually beating him – "eliminating" our stomachs, "busting" our thighs, "taming" our tummies – pummeling and purging our bodies, attempting to make them into something other than flesh. On television, infomercials hawking miracle diet pills and videos promising to turn our body parts into steel have become as commonplace as aspirin ads. There hasn't been a tabloid cover in the past few years that didn't boast of an inside scoop on some star's diet regime, a "fabulous" success story of weight loss, or a tragic relapse. (When they can't come up with a current one, they scrounge up an old one; a few weeks ago the *National Inquirer* ran a story on Joan Lunden's fifty-pound weight loss fifteen years ago!) Children in this culture grow up knowing that you can never be thin enough and that

being fat is one of the worst things one can be. One study asked ten- and eleven-year-old boys and girls to rank drawings of children with various physical handicaps; drawings of fat children elicited the greatest disapproval and discomfort, over pictures of kids with facial disfigurements and missing hands.

Psychologists commonly believe that girls with eating disorders suffer from "body image disturbance syndrome": they are unable to see themselves as anything but fat, no matter how thin they become. If this is a disorder, it is one that has become a norm of cultural perception. Our ideas about what constitutes a body in need of a diet have become more and more pathologically trained on the slightest hint of excess.

[. . .] Is it any wonder that despite media attention to the dangers of starvation dieting and habitual vomiting, eating disorders have spread throughout the culture?[2] In 1993 in *Unbeatable Weight* I argued that the old clinical generalizations positing distinctive class, race, family, and "personality" profiles for the women most likely to develop an eating disorder were being blasted apart by the normalizing power of mass imagery. Some feminists complained that I had not sufficiently attended to racial and ethnic "difference" and was assuming the white, middle-class experience as the norm. Since then it has been widely acknowledged among medical professionals that the incidence of eating and body-image problems among African American, Hispanic, and Native American women has been grossly underestimated and is on the increase.[3] Even the gender gap is being narrowed, as more and more men are developing eating disorders and exercise compulsions too.

[. . .]

Eating disorders in a culture of images

Fashion is never "just" fashion, [however,] and the images are never "just" pictures. The mistake of regarding slenderness as a surface ideal, powerful but empty, is rampant in commentary and discussion of eating disorders, from scholarly journals to *People* magazine, and the mistake is as common among critics of popular imagery as it is among apologists for the fashion industry. Consider, for example, the position of groups such as BAM – the organization to Boycott Anorexic Marketing – which, when the waif look became popular in 1994, called for a boycott against marketers who employ hyperthin models.[4] Their argument, in a nutshell, is that these images have enormous power to imprint themselves on us, particularly on impressionable young girls. For BAM, the consumer is a tabula rasa, awaiting inscription, potentially vulnerable to any and all influences. The ubiquity of glamorizing images of the thin body, dictating the terms of beauty in this culture, shaping our perceptions of our own bodies and their (imagined) defects, is enough to account for the desperate lengths that girls and women go to to achieve the desired look.

Before I go on to point out the limitations of BAM's argument, I want to note that the group is making an important point (one that had been sorely neglected for a long time in the literature on eating disorders)[5] about the role of cultural images in the spread of eating disorders. Most eating disorders, it has long been recognized, begin with a diet and escalate from there. But why do most of us diet nowadays if not to try to become the bodies in the images? Therapists tell me that their teenage clients bring photos of Kate Moss and others to therapy, to show their shrinks what they want to look like. I had a student who had to leave the classroom when I presented slide shows of contemporary advertisements. She was a recovering bulimic and in order to stay on the wagon could not even permit herself to *look* at the pictures of Moss and the rest. Some current therapeutic approaches, acknowledging (and seemingly capitulating to) the all-powerful role that images play in the lives of women with

eating problems, encourage group participants to talk about the body styles that most attract them – waif look, athletic look, professional "superwoman" look – and then discuss the ways they can be achieved with more moderate dieting and exercise. (This sort of approach, I fear, only reinforces the authority of the images.)

It's also important to recognize, as I argue in the introduction to this book, that our susceptibility to cultural imagery has changed. When I was a teenager in the sixties, Twiggy's mascara-spiked stare and long coltlike legs represented our variant of the wide-eyed waif. We envied Twiggy's casual cool and boyish body. But few of us imagined that Twiggy was a blue-print for the ordinary adolescent girl to pattern herself after. She was a high-fashion mannequin after all, and we all knew that models had to be skinny "to photograph well." Today, teenagers no longer have the luxury of a distinction between what's required of a fashion model and what's required of them; the perfected images have become our dominant reality and have set standards for us all – standards that are increasingly *un*real in their demands on us.

With some insightful and brave pioneers as notable exceptions,[6] it has taken a long time for clinicians working in the field of eating disorders to acknowledge the central role that cultural images play in women's problems with food, eating, and body image. To acknow-ledge that role is arguably to admit that anorexia and bulimia – although they both do terrible damage to individual lives and may respond favorably to many different kinds of individual psychotherapy – need to be understood not as individual psychopathology but as *social* pathology. It's understandable that there is professional resistance to the implications of the enormous evidence now establishing that eating disorders (like hysteria and neurasthenia in the nineteenth century) are culturally produced and culture-bound, and on a continuum with normative female behavior. A whole industry in the conceptualization and treatment of eating disorders – distinguished by professionals, journals, conferences, treatment centers, paradigms and concepts (such as "Body Image Disturbance Syndrome," "Bulimic Thinking," "Anorexic Personality Type") – has been organized, it now seems, around highly questionable premises. Conceptual transformation is not just about ideas, it's about personal and professional invest-ments. Change is usually arduous and slow.

Most frequently nowadays, clinicians are willing to grant that cultural images may contribute to or "trigger" eating disorders, but they insist that underlying psychological, familial, or biological factors are the true cause of eating disorders. "There has to be a predis-posing vulnerability," says Michael Strober, director of the eating disorder center at UCLA's Neuropsychiatric Institute. "A *real* anorectic suffers from extreme self-doubt, inadequacy concerns and self-esteem anxieties that are far more extreme than other people's. The average person will not be induced into anorexia because they see Kate Moss."[7] Dr. John Mead, director of the eating disorders clinic at Chicago's Rush Presbyterian-St. Luke Medical Center, adds that "girls who have a healthy self-image and come out of a good parent–child relation-ship do not fall victim to eating disorders."[8] In such arguments the role of the family is often emphasized. Clinical psychologist Rhoda Lee Fisher, for example, considers cultural messages far less potent than those sent by parents: "A mother saying 'Don't take that food. You've been a bad girl' is a powerful message to a female child."[9]

Medical professionals are right to insist that eating disorders are multidimensional and that many of those with severe eating problems have serious psychological and familial prob-lems too. But in positing culture as a "contributory" factor and families as the "real" cause they forget that families do not exist outside cultural time and space. The destructive family dynamics they cite prove rather than dispute the importance of culture. In Fisher's example a mother scolds her daughter for eating too much food. But what made this mother so anxious about her daughter's eating? Such anxiety, after all, is not universal; families living in poverty

probably have more anxiety over their children's *not* getting enough to eat than eating too much. And even in conditions of greater economic security, "old" cultural associations relating to food, eating, and the body may persist in families.

[. . .]

When a father teases his daughter for getting "chubby," when parents encourage their teenagers to become mini-superwomen who get the best grades but never forget the importance of looking good, they too are responding to (and perpetuating) messages sent to them from their culture.

Families exist in cultural time and space. So does "peer pressure," "perfectionism," "body-image distortion," "fear of fat," and all those other elements of individual and social behavior that clinical models have tended to abstract and pathologize. In a culture in which dieting, bingeing, purging, and compulsive exercising are virtually normative behavior for college women (that is, *most* young women engage in them; they are the norm not the exception), surely Strober and others are wrong to consider the most extreme cases as their model and to make such a sharp demarcation between these "real" anorectics and all the others. Are the majority of my students suffering from self-doubt, inadequacy concerns, and self-esteem anxieties far more extreme than those of most women? It's hard to believe that their problems are anything but fairly representative of the experiences of other working- and middle-class women attending a coed state institution. If so, then according to Strober they could not have "real" eating disorders, since the underlying vulnerabilities of those with "real" disorders are by definition more extreme than the norm. But what then do my students have?

[. . .]

Thanks to the arguments of feminist writers and consumer groups like BAM and because of the unfortunate worsening and increasing visibility of the problem, the popular media and the therapeutic community are finally beginning to confront the power of cultural images over women's lives. A few years ago *People* ran a much publicized cover story showing a picture of Kate Moss alongside the question: "Is a Dangerous Message Being Sent to Weight-Obsessed Teens?" The article, which made sure to include "experts" from the fashion industry to give their opposing point of view (as well as the views of Strober, Mead, and other semi-skeptical therapists), answered the cover question with a highly qualified "Yes, but . . ." (the "but" insisting that "no one gets sick just from looking at a picture"). More recently another *People* cover story ("Too Fat? Too Thin? How Media Images of Celebrities Teach Kids to Hate Their Bodies") was much less equivocating in its indictment of mass imagery:

> In the moral order of today's media-driven universe – in which you could bounce a quarter off the well-toned abs of any cast member of *Melrose Place* or *Friends*, fashion magazines are filled with airbrushed photos of emaciated models with breast implants, and the perfectly attractive Janeane Garofalo can pass for an ugly duckling next to Beautiful Girl Uma Thurman in the current hit movie *The Truth about Cats and Dogs* – the definition of what constitutes beauty or even an acceptable body seems to become more inaccessible every year. The result? Increasingly bombarded by countless "perfect" body images projected by TV, movies and magazines, many Americans are feeling worse and worse about the workaday bodies they actually inhabit. The people being hurt most are the ones who are most vulnerable: adolescents.[10]

From my point of view – and for the moment ignoring the fact that the preceding month's issue of *People* had been completely devoted to airbrushed coverage of "the fifty most beautiful people in the world" – the new story was a big improvement over the old. But the

fashion industry, as might be expected, is not too happy with such a shift in perspective and is especially scornful of groups like BAM. Coopting the rhetoric of "power feminism," Peggy Northrop, senior editor at *Vogue*, charges her critics with minimizing women's active agency and also misunderstanding what fashion is all about. She insists that to suggest that "women are so utterly victimized by the way they are portrayed that they go on a diet, starve themselves and become sick" is to see women as passive, helpless pawns of the media.[11] Surely, the implication is, feminists must grant women more independence of mind, more individualism than that!

Moreover, as designer Josie Natori argues (in a *Harper's Bazaar* magazine article specifically "answering" feminists and others who protested when the waif look came into fashion), anyone ought to know that "fashion is not about reality. It's about ideas and vision."[12] On this argument it's as inappropriate to emulate Kate Moss as to try to look like the Mona Lisa, or – perhaps more relevant – like a Rossetti or Beardsley waif. These ideas have been recycled in a recent *Vogue* rejoinder to Swiss watch manufacturer Omega's charge that the glamorization of "skeletal" models like Annie Morton and Trish Goff promotes eating disorders. *Vogue* wants to know why we just can't get it through our heads that these are *models* (and hefty eaters, too, as the designers are always quick to insist).[13] They are incredulous that any ordinary girl would think they should or could look like them.

In one sense, of course, Josie Natori is right. Fashion images are not "reality" but an artfully arranged manipulation of visual elements. Those elements *are*, however, arranged precisely in order to arouse desire, fantasy, and longing, to make us want to participate in the world they portray. That is their point and the source of their potency, and it's in bad faith for the industry to pretend otherwise. If we were content to admire the pictures in some mildly interested, aestheticized way and then put down the magazine, personally unaffected, our bubble of fantasy time over and done with, ready to get back to "real" life, it is unlikely that we would be as hot to buy the clothes and products advertised as the industry obviously want us to be. And if they truly want us to regard the models as belonging to an unattainable world of artifice and illusion, why do they so often publish makeup and hair-styling features telling us how to achieve "the look" of popular models as well as diet and exercise "tips" on how models keep their bodies in shape?

I do agree that no one gets sick just from looking at a picture, and I share Peggy Northrop's irritation with BAM's depiction of women as pawns of the media. But there are other ways of looking at how we experience these images, as I will now argue, than as a choice between acknowledging that we are victimized dupes unable to resist the images or insisting that we are autonomous free spirits who can take them or leave them.

Just bodies?

Although BAM and the fashion industry seem to be standing on opposite sides of the fence in the debate about cultural images and eating disorders, they (and *People* and therapists Mead and Strober) share an important and defective assumption about the way we interact with media imagery of slenderness. Because these images use bodies to sell surface adornments (such as clothing, jewelry, footwear), the images are taken to be advertising, at most, a certain "look" or style of appearance. What that "look" or style might project (intelligence, sophistication, childlikeness) is unacknowledged and unexplored, along with the values that the viewer might bring to the experience of looking. Throughout the literature on eating disorders, whether "fashion" is being let off the hook or condemned, it appears as a whimsical, capricious, and socially disembodied force in our lives.

This trivializing of fashion reflects a more general failure to recognize that looks are more than skin deep, that bodies *speak* to us. The notion that bodies are mere bodies, empty of meaning, devoid of mind, just material stuff occupying space, goes back to the philosopher Descartes. But do we ever interact with or experience "mere" bodies? People who are attracted to certain sizes and shapes of bodies or to a particular color of hair or eyes are mistaken if they think their preference is only about particular body parts. Whether we are conscious of it or not, whether our preferences have their origins in (positive or negative) infant memories, culturally learned associations, or accidents of our histories, we are drawn to what the desired body *evokes* for us and in us. I have always found certain kinds of male hands – sturdy, stocky hands, the kind one might find on a physical laborer or a peasant – to be sexually attractive, even strangely moving. My father had hands like this, and I am convinced my "aesthetic" preferences here derive from a very early time when my attitudes toward my father's masculinity were not yet ambivalent, when he existed in my life simply as the strong, omnipotent, secure hands that held me snugly against harm.

Once we recognize that we never respond *only* to particular body parts or their configuration but *always* to the meanings they carry for us, the old feminist charge of "objectification" seems inadequate to describe what is going on when women's bodies are depicted in sexualized or aestheticized ways. The notion of women-as-objects suggests the reduction of women to "mere" bodies, when actually what's going on is often far more disturbing than that, involving the depiction of regressive ideals of feminine behavior and attitude that go much deeper than appearance. I remember Julia Roberts in *Mystic Pizza* when she was still swinging her (then much ampler) hips and throwing sassy wisecracks, not yet typecast as the perpetually startled, emotional teeter-totter of later films. In order for Roberts to project the vulnerability that became her trademark, those hips just had to go. They suggested too much physical stability, too much sexual assertiveness, too much womanliness. Today the camera fastens on the coltlike legs of a much skinnier Roberts, often wobbly and off balance, not because she has "great legs" in some absolute aesthetic sense (actually, when they do aestheticized close-ups of her legs, as in *Pretty Woman*, they use a body double!) but because her legs convey the qualities of fragility that directors – no doubt responding to their sense of cultural zeitgeist as well as their own preferences – have chosen to emphasize in her.

The criticism of "objectification" came naturally to feminism because of the continual cultural fetishization of women's bodies and body parts – breasts and legs and butts, for example. But these fetishes are not mere body parts. Often, features of women's bodies are arranged in representations precisely in order to suggest a particular attitude – dependence or seductiveness or vulnerability, for example. Heterosexual pornography, which has been accused of being the worst perpetrator of a view of woman as mute "meat," in fact seems more interested than fashion layouts in animating women's bodies with fantasies of what's going on inside their minds. Even the pornographic motif of spread legs – arguably the worst offender in reducing the woman to the status of mere receptacle – seems to me to use the body to "speak" in this way. "Here I am," spread legs declare, "utterly available to you, ready to be and do whatever you desire."

Many women may not like what this fetish, as I have interpreted it, projects – the woman's willing collapsing of her own desire into pleasing the male. Clearly, my interpretation won't make pornography less of a concern to many feminists. But it situates the problem differently, so we're not talking about the reduction of women to mere bodies but about what those bodies *express*. This resituating also opens up the possibility of a non-polarizing conversation between men and women, one that avoids unnuanced talk of "male dominance" and control in favor of an exploration of images of masculinity and femininity and the

"subjectivities" they embody and encourage. Men and women may have very different interpretations of those images, differences that need to be brought out into the open and disinfected of sin, guilt, and blame.

Some feminists, for example, might interpret a scene of a man ejaculating on a woman's face as a quintessential expression of the male need to degrade and dominate. Many men, however, experience such motifs as fantasies of unconditional acceptance. "From a male point of view," writes Scott MacDonald, "the desire is not to see women harmed, but to momentarily identify with men who – despite their personal unattractiveness by conventional cultural definition, despite the unwieldy size of their erections, and despite their aggressiveness with their semen – are adored by the women they encounter sexually."[14] From this point of view, then, what much (soft) heterosexual porn provides for men is a fantasy world in which they are never judged or rejected, never made to feel guilty or embarrassed. I think that all of us, male and female alike, can identify with the desire to be unconditionally adored, our most shame-haunted body parts and body fluids worshipped, our fears about personal excess and ugliness soothed and calmed.

From the perspective of many women, however, the female attitudes that provide reassurance to MacDonald – although he may, as he says, "mean no harm" by them – *are* demeaning. They are demeaning not because they reduce women to *bodies* but because they *embody* and promulgate images of feminine subjectivity that idealize passivity, compliance, even masochism. Just as women need to understand why men – in a culture that has required them to be sexual initiators while not permitting them the "weakness" of feeling hurt when they are rejected – might crave uncomplicated adoration, so men need to understand why women might find the depiction of female bodies in utterly compliant poses to be problematic. In our gender history, after all, being unstintingly obliging – which in an ideal world would be a sexual "position" that all of us could joyfully adopt with each other – has been intertwined with social subordination. When bodies get together in sex, a whole history, cultural as well as personal, comes along with them.[15]

In *Unbearable Weight* I attempted to "unpack" the range of meanings embodied by the slenderness ideal. I found them to be complicated and often contradictory, suggesting empowerment in some representations and feminine passivity in others. I continue to believe that the appeal of slenderness is *overdetermined* in this culture; we worship the slender body because it evokes so many different qualities that we value. Here I would like to explore the appeal of slenderness as reflecting anxiety about women as "too much." This metaphor, I discovered, struck a chord with more women than any other idea or image in *Unbearable Weight* and so it deserves a closer look. We need to reflect on its specific meaning for younger women today ("generation X," those in their early thirties and younger) and its connection with racial images and ideology. I emphasize, though, that my discussion here will only follow the trail of this one metaphor and is not meant to be an exhaustive analysis of either the images or the current situation of women.

When we admire an image, a kind of recognition beyond a mere passive imprinting takes place. We recognize, consciously or unconsciously, that the image carries values and qualities that "hit a nerve" and are not easy to resist. Their power, however, derives from the culture that has generated them and resides not merely "in" the images but in the psyche of the viewer too. I recently asked my students why they found Kate Moss so appealing. It took them a while to get past "She's so thin! And so beautiful!" I wanted to know what *made* her beautiful in their eyes and how her thinness figured into that. Once they began to talk in nonphysical terms, certain themes emerged again and again: She's so detached. So above it all. She looks like she doesn't need anything or anyone. She's in a world of her own, untouch-

able. Invulnerable. One of my students, who had been struggling unsuccessfully with her bulimia all semester, nearly moved me to tears with her wistful interpretation. "She looks so cool," she whispered longingly. "Not so needy, like me."

These are not mere projections on the part of my students. The unfocused princess of indifference whom Kate Moss impersonates in fashion photos is also part of the "real" persona created by Moss and those who market her. Her detachment is always emphasized (and glamorized). "I like doing the [fashion] shows," she told *People* magazine, "but I don't need to at all." The quotation was the apt caption for an image of slouching, blank-faced Moss, cigarette in hand, in a dazed world of her own [Figure 51.1]. Worries about lung cancer? It wouldn't be chic to be concerned about one's health. And although many models admit to smoking in order to hold their weight down, Moss denies that she ever frets over her diet. "It's kind of boring for me to have to eat," she said in an *Esquire* interview. "I would know that I had to, and I would." How many times have we read statements like this in interviews with

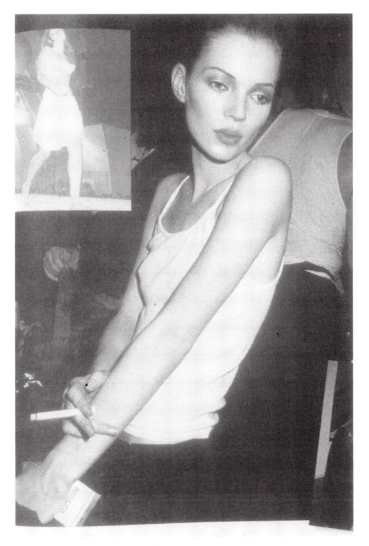

Figure 51.1 Kate Moss, from *People*: too cool to care.

supermodels? "I guess I'm just one of those lucky people who doesn't have to count calories. . . . But I've never really been all that interested in food, anyway." Then, we are often treated to an accounting of the model's daily routine, recited with supreme casualness. "I'll catch some pasta at Spago's." Frankly, I find these comments rather sadistic. How many girls and women would give their eye teeth to find food boring or something you "catch" on the fly! Most of my students are in a constant and often bloody battle with their appetite. And they associate that struggle with their own (as they see them) gross desires.

[. . .]

The values that animate my students' perceptions of Moss – whether they are anorexic or not – are on a continuum with "anorexic thinking." "People think that anorexics imagine ourselves fat and diet away invisible flab," writes Stephanie Grant in her autobiographical novel, *The Passion of Alice:* "But people are afraid of the truth: we prefer ourselves this way, boiled-down bone, essence. . . . Anorexics differentiate between desire and need. Between want and must. Just to know where I begin and end seems, in this day and age, a remarkable spiritual achievement."[16] And if the thin body represents a triumph over need and want, a stripping down to some clear, distinct, essence of the self, fat represents just the opposite – the shame of being too present, too hungry, too overbearing, too needy, overflowing with unsightly desire, or simply "too much." Often the fear of being "too much" will have a strong sexual dimension, an association that is present in the stories of women with anorexia and bulimia, disorders that often arise after episodes of sexual abuse, sexual taunting, or rejection by fathers who are uncomfortable with their daughter's maturation.

These sexual associations are cultural as well. From Eve in the garden to the many voluptuous movie stars who have found themselves typecast as sex bombshells, female eating, sexual voraciousness, and expansive flesh have long been associated with each other. (Even Cindy Crawford, who is hardly *saftig*, is continually hypersexualized and cast as a temptress, at least in part because she falls on the curvaceous end of the supermodel spectrum.) When *Cosmopolitan* ran a story aimed at striking a blow against the tyranny of slenderness and rehabilitating voluptuousness, it advised "big, beautiful, Junoesque girls" that their "style is best enhanced with classic courtesan looks: upswept hair (leaving some tendrils hanging), flowing fabrics and décolleté necklines, sultry eyes." The story was illustrated with photos of "Famous Love-Goddess Bodies": Ann-Margret, Sophia Loren, Mae West, and Jayne Mansfield. If Helen Gurley-Brown imagined that this article would help stem the tide against eating disorders, she no longer had her pulse on the modern woman. The last thing most women with eating disorders want is a body that blatantly advertises female sexuality. Jayne Mansfield is *not* their ideal!

[. . .]

Anxieties about women as "too much" are also layered with racial and other associations that, contrary to the old clinical clichés, set up black, Jewish, lesbian, and other women who are specially marked in this way for particular shame. According to the old clichés, those who come from ethnic traditions or live in subcultures that have historically held the fleshy female body in greater regard and that place great stock in the pleasures of cooking, feeding, and eating are "protected" against problems with food and body image. There is an element of truth in this understanding. Certainly, many cultural heritages and communities offer childhood memories (big, beloved female bodies, sensuous feasts), places (the old Italian neighborhood, the lesbian commune kitchen), and cultural resources (ethnic art, woman-centered literature) that seem diametrically in opposition to everything Kate Moss stands for.

Feminist writers have also worked to reconceive the uneasy relationships between women, sexuality, food, and eating as well as the stereotypes associated with them. Among the charms

of Laura Esquivel's *Like Water for Chocolate* is the evocation of a sensual and magical world in which female sexuality, food, and power are knit together but celebrated rather than feared. Audre Lorde, in *Zami*, also yokes food – the erotically described preparation of a Jamaican dish – with her sexual coming of age and increasing self-knowledge. Alice Walker, putting a new spin on the Aunt Jemima stereotype, describes in *Ms.* her delighted recognition of the goddess imagery latent in caricatures that have usually been criticized as only representing the powerlessness, subservience, and sexlessness of the black mammy.[17]

These "alternative" images may provide comfort, delight, inspiration. But each of us also lives within a dominant culture that not only surrounds us with its versions of what is beautiful (still Anglo-Saxon, despite the allowance of "erotic" touches like full lips) but often recoils from what we are. We may grow up sharply aware of representing for that dominant culture a certain disgusting excess – of body, fervor, intensity – which needs to be restrained, trained, and, in a word, made more "white." (Recall that in describing my "former," more assertive self in my journal, I listed "Jewish" among my attributes.) A quote from poet and theorist Adrienne Rich speaks to the bodily dimension of "assimilation":

> Change your name, your accent, your nose; straighten or dye your hair; stay in the closet; pretend the Pilgrims were your fathers; become baptized as a Christian; wear dangerously high heels, and starve yourself to look young, thin, and feminine; don't gesture with your hands. . . . To assimilate means to give up not only your history but your body, to try to adopt an alien appearance because your own is not good enough, to fear naming yourself lest name be twisted into label.[18]

Clearly we can no longer regard serious problems with food and body image as solely the province of pampered, narcissistic, heterosexual white girls. To do so is to view black, Asian, Latin, lesbian, and working-class women as outside the loop of the dominant culture and its messages about what is beautiful – a mistake that has left many women feeling stranded and alone with a disorder that they weren't "supposed" to have and that clinicians dismissed. Indeed, as I am arguing, there are reasons why racial and sexual "Others" might find themselves to be more, not less, susceptible to the power of cultural imagery.[19] I include myself here, as a Jewish woman whose body is unlike any of the cultural ideals that have ruled in my lifetime and who has felt my physical "difference" painfully. I have been especially ashamed of the lower half of my body, of my thick peasant legs and calves (for that is indeed how I represented them to myself) and large behind, so different from the aristocratic WASP norm. Because I've somehow felt marked as Jewish by my lower body, I was at first surprised to find that some of my African-American female students felt marked as black by the same part of their bodies. I remember one student in particular who wrote often in her journal of her "disgusting big black butt." For both of us our shame over our large behinds was associated with feelings not of being too fat but of being "too much," of overflowing with some kind of gross body principle. The distribution of weight in our bodies made us low, closer to earth; this baseness was akin to sexual excess (while at the same time not being sexy at all) and decidedly not feminine.

But we didn't pull these associations out of thin air. Racist tracts continually describe Africans and Jews as dirty, animal-like, smelly, and sexually "different" from the white norm. Our body parts have been caricatured and exaggerated in racist cartoons and "scientific" demonstrations of our difference. Much has been made of the (larger or smaller) size of penises, the "odd" morphology of vaginas. In the early nineteenth century Europeans brought a woman from Africa – Saartje Baartman, who came to be known as "The Hottentot Venus" – to display

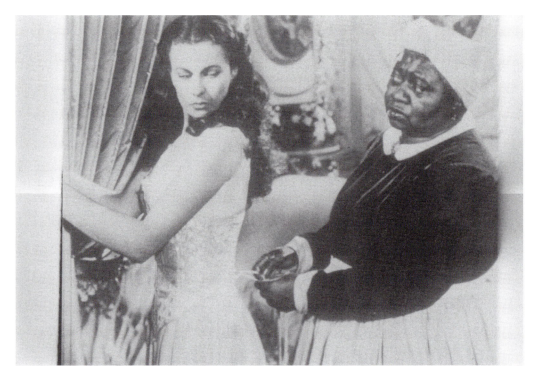

Figure 51.2 Scarlett and Mammy from *Gone with the Wind*, 1939: fashioning femininity as white.

at sideshows and exhibitions as an example of the greater "voluptuousness" and "lascivity" of Africans. European drawings from the period show a woman with extraordinarily large nipples, broad hips, and buttocks so protuberant that one could balance a glass on them. Baartman was exhibited as a sexual monstrosity, her prominent parts an indication of the more instinctual, "animal" nature of the black woman's sexuality (a motif that continues in commercial advertisements today).

When the female "dark Other" is not being depicted as a sexually voracious primitive, she is represented as fat, asexual, unfeminine, and unnaturally dominant over her family and mate – for example, the Jewish Mother or Mammy [Figure 51.2]. These stereotypes appear not only in cartoons and situation comedies but in contemporary academic texts, such as David Gilmore's *Manhood in the Making*, in which Gilmore describes "secular, assimilated Jewish-American culture" as "one of the few in which women virtually dominate men."[20] (This would have been a real surprise to my mother!) It isn't surprising then that when black, Jewish, and other racially marked groups talk about their eating problems, ethnic "shame" is a prominent theme, with slenderness and fat coming to stand for successful assimilation versus the taint of "difference."

The associations are loaded even more when sexuality enters in. As one woman notes, "As a Fat Jewish Lesbian out in the world I fulfill the stereotype of the loud pushy Jewish mother just by being who I am (even without children)!"[21] The same woman remarks that the culture of the nineties has "brought a new level of fat hatred within many lesbian communities . . . [an] overwhelming plethora of personal ads which desire someone fit, slim, attractive, passable, not dykey, athletic, etc." That "not dykey" and "slim" are bedfellows here is not surprising. An older generation of lesbians who dressed in overalls and let their hips spread

in defiance of norms of femininity may be as much an embarrassment to young nineties' lesbians as the traditional Jewish mother is to her more assimilated daughters.

A similar desire to disown the "too much" mother, I believe, motivates many young women today in their relation to feminism and to the stereotypes of my generation's feminism which they have grown up with. Young women today, more seemingly "free" and claiming greater public space than was available to us at their age, appear especially concerned to establish with their bodies that, despite the fact that they are competing alongside men, they *won't* be too much (like their strident, "aggressive," overpolitical feminist mothers). In conversation, they lower their heads and draw in their chests, peeking out from behind their hair, pulling their sleeves over their hands like bashful little girls. Like Julia Roberts, Meg Ryan, and the other young stars who model this culture's versions of vulnerable femininity, they talk in halting baby voices that seem always ready to trail off, lose their place, scatter, giggle, dissolve. They speak in "up talk," ending every sentence with an implied question mark, unable to make a declaration that plants its feet on the ground. They often seem to me to be on the edge of their nerves and on the verge of running away. They apologize profusely for whatever they present of substance, physically or intellectually. And they want desperately to be thin.

Notes

1 I give great credit to Alicia Silverstone for her response to these taunts. In *Vanity Fair* she says "I do my best. But it's much more important to me that my brain be working in the morning than getting up early and doing exercise. . . . The most important thing for me is that I eat and that I sleep and that I get the work done, but unfortunately . . . it's the perception that women in film should look a certain way" ("Hollywood Princess," September 1996, pp. 292–294). One wonders how long she will manage to retain such a sane attitude!

2 Despite media attention to eating disorders, an air of scornful impatience with "victim feminism" has infected attitudes toward women's body issues. Christina Hoff-Sommers charges Naomi Wolf (*The Beauty Myth*) with grossly inflating statistics on eating disorders and she pooh-poohs the notion that women are dying from dieting. Even if some particular set of statistics is inaccurate, why would Sommers want to deny the reality of the problem, which as a teacher she can surely see right before her eyes? See '*Braveheart, Babe*, and the Contemporary Body" in my book *Twilight Zones* (Berkeley: University of California Press, 1997).

3 For the spread of eating disorders in minority groups, see, for example, "The Art of Integrating Diversity: Addressing Treatment Issues of Minority Women in the 90's," in *The Renfrew Perspective*, Winter 1994; see also Becky Thompson, *A Hunger So Wide and So Deep* (Minneapolis: University of Minnesota Press, 1994).

4 On the boycott see Stuart Elliott's "Advertising" column in *The New York Times*, April 26, 194, p. D18.

5 See "Whose Body Is This? Feminism, Medicine, and the Conceptualization of Eating Disorders," in my *Unbearable Weight: Feminism, Western Culture and the Body* (Berkeley: University of California Press, 1993), for a discussion of the long-standing neglect of cultural factors in the medical literature on eating disorders.

6 Susie Ohrbach, Susan and Wayne Wooley, Marlene Boskind White, Susan Gutwill, Andrea Gitter, and Kim Chernin stand out here as pioneers in the relation of cultural images to eating disorders. See *Eating Problems: A Feminist Psychoanalytic Treatment Model*, coauthored by Carol Bloom, Andrea Gitter, Susan Gutwill, Laura Kogel, and Lela Zaphiropoulos (New York: Basic Books, 1994), for the most rigorous, penetrating analysis to date of how cultural images shape our emotional lives.

7 Michael Strober in "How Thin Is Too Thin?" *People*, September 20, 1993, p. 80.

8 John Mead in ibid.

9 Rhoda Lee Fisher on parents' messages, in *Syracuse Herald Journal*, September 14, 1993, p. C3.

10 "Mission Impossible," *People*, June 3, 1996, p. 66.

11 For Northrop quote see Stuart Elliott's "Advertising" column, *The New York Times*, Tuesday, April 26, 1994.

12 Josie Natori in "Beauty's New Debate: Anorexic versus Waif," *Harper's Bazaar*, July 1993, p. 78.

13 David Bonnouvrier, who is Annie Morton's agent, comments: "She drinks beer. We go to dinner and I can tell you she's not a cheap date" ("Skeletal Models Create Furor over British Vogue," *The New York Times*, Monday, June 3, 1996). Moss, we were continually told when she first became popular, "eats like a horse." Even if this were true – which I doubt – it is of course irrelevant to the question of what sorts of eating habits her images encourage in teenage consumers.

14 Scott MacDonald, "Confessions of a Feminist Porn Watcher," in Michael Kimmel, ed., *Men Confront Pornography* (New York: Meridian, 1991), 41.

15 Of course, not all women find compliant poses demeaning. Women have different reactions to such depictions. Many find them erotic and have no problem with them. The meanings of certain poses may change too in the context of lesbian pornography. For the purposes of this piece I cannot go into the complex and diverse "readings" that pornographic motifs would require if their interpretation were my main point, which it is not here. Here I am presenting two different (and heterosexualized) "readings" as an example of a point about the representation of bodies; I am not attempting a definitive (or even near-definitive) analysis of soft-core porn. [. . .]

16 Stephanie Grant, *The Passion of Alice* (New York: Houghton Mifflin, 1995), 2.

17 Alice Walker, "Giving the Party," *Ms.*, May/June 1994, pp. 22–25.

18 Adrienne Rich, "Resisting Amnesia: History and Personal Life," in *Blood, Bread and Poetry* (New York: Norton, 1986), 142.

19 See also Becky Thompson, *A Hunger So Wide and So Deep*.

20 David Gilmore, *Manhood in the Making* (New Haven: Yale University Press, 1990), 127.

21 Arl Spencer Nadel, "My Dinner with Fat Jewish Dykes," *Bridges* 4, no. 2 (Winter 1994/1995): 79.

Chapter 52

MOIRA GATENS

EPILOGUE TO *IMAGINARY BODIES: ETHICS, POWER AND CORPOREALITY*

LET ME OPEN THE EPILOGUE with [a] passage from Spinoza on the imagination . . .

an imagination is an idea which indicates the present constitution of the human body. . . . For example, when we look at the sun, we imagine it to be about 200 feet away from us. In this we are deceived so long as we are ignorant of its true distance; but when its distance is known, the error is removed, not the imagination [since this imagination is] not contrary to the true, and do[es] not disappear on its presence.[1]

Spinoza insists that this proposition holds true for all those imaginings that arise from the affective relations between my body and any other body with which I enter into a relation. Hence, his point is pertinent not only to natural science or astronomy, but holds good for my relations with bodies of all kinds, whether they be individual human bodies or corporate social bodies. The nature of my imaginary grasp of these bodies will depend upon how they

affect me – do they increase or diminish my power of acting? Do they cause me pleasure or pain? Just as there is a vast difference between the sun *per se* and the sun *as it affects my present bodily constitution* (does it warm me? burn me?), so too can one distinguish between the general nature, constitution or powers of a body and the particular manner in which that body affects me. However, as Spinoza pointed out, an understanding of the nature of another body, including the powers that it possesses independently of its relation to me, does not *remove* the affect that it produces in me, that is, such understanding does not cancel out any imaginary relation which I may have towards it.

Many of the essays in this volume may be seen as attempts to think through this view of the imagination and imaginary relations between bodies, in the context of philosophical accounts of sexual difference. Often enough, such accounts are rooted in historically domi-nant sexual imaginaries, which include disturbing assumptions about the appropriate political, ethical and legal treatment to which women are entitled. One does not need to subscribe to a "conspiracy theory" in order to argue that men who occupy positions of institutional power will share some "imaginings" about women. This is not because they "conspire" against women in order to protect their privileged positions. Rather, and as many sociological studies have shown, they share similar "imaginings" about women because they share types of relation to women, for example, as mothers, wives, secretaries. The manner in which "women", here understood as a "type" or "class", stand in relation to these men is likely to be as dependent and subordinate servicers of their needs. Such men may never have encountered women to whom they were socially, professionally or economically subordinate. The problem of the power of the imagination as it operates between the sexes is not that men have "strange" ideas about women, whereas women have more realistic ideas about men. The problem, as I see it, is that dominant masculine sexual imaginaries are politically, legally, economically and socially legitimated through existing networks of power, whereas women's imaginings about men are not. Such legitimation entrenches sexual imaginaries that tell us only about the affec-tive relation in which men stand to women. They tell us nothing about the various powers and capacities which women possess independently of their power to affect, or be affected by, men.

Those who occupy positions of social, economic and political power, such as members of the judiciary, politicians or heads of business corporations, have considerable direct and indirect influence on the lives of many women. Such socially or politically powerful persons will almost certainly believe, in the abstract, that women are entitled to the franchise, are (rightly) covered by the "rule of law" and (rightly) enjoy a formal equality with men in the market place. Nevertheless, the affective relation in which such men are likely to stand to significant women in their lives will unavoidably affect their general attitudes toward women understood as a "type" or "class". It is here that Spinoza's insight into the resilience of the imagination becomes important to sexual politics.

Spinoza certainly argues that human passions drive each in a different direction in contrast to reason which unites different persons. However, the imagination is capable of forging alliances between people on those occasions when their imaginings correspond. It is, after all, to the power of the imagination that Spinoza turns in order to offer an account of the socially binding nature of various superstitions, including religion.[2] [Here . . .] I tried to investigate the operation of sexual imaginaries in the context of sexual ethics, politics and law [. . .] One of the things I tried to show is the utterly paradoxical nature of certain aspects of present liberal democracies in which widely held and institutionally sanctioned views concerning women's equal rights and entitlements sit alongside widely held and institutionally sanctioned notions of women's natural subordination to men. My response to this paradox is that it may

be at least epistemically (if not in economic or political terms) approached by *combining* a study of the social and sexual imaginaries in which we live with the formal socio-political equality to which all citizens are entitled. Here we would need to ask: are the legal duties and obligations of a "wife" in conflict with the rights of a citizen? Is wife-beating an offence which is distinguishable from assaulting a "fellow" citizen? Is a husband who rapes his wife guilty of a different sort of offence from one who rapes a "fellow" citizen? Of course, in contemporary liberal democracies, women *are* citizens, and the distinction drawn above, between "wife" and "citizen", should not be a significant one.[3] Yet these questions still deserve to be taken seriously – why is that? That these questions make sense at all is itself an indication of the paradoxical nature of female citizenship.[4]

One of the challenges confronting feminist theory is how to account for the manner in which these dominant sexual imaginaries become fundamental to social imaginaries. [In this book] I tried to link the psychoanalytic notion of the body image, or imaginary body, with a political imaginary that posits an image of the unified and independent "leviathan" or body politic. While I do not think that social and political imaginaries can be *reduced* to sexual imaginaries, it is an important task for feminist theory to show the complicity of these various imaginaries. I maintain that such complicity may be shown without thereby supporting an essentialist notion of sexual difference. [. . .I] critically considered attempts by Carole Pateman, Andrea Dworkin and Catharine MacKinnon to draw connections between sexual, political and legal "imaginaries". Each of these theorists, I argued, too readily accepts dominant notions of male and female sexual embodiment as the origin of social and political relations between the sexes. In various sections of this book [. . .] I have argued for a genealogical approach to the manner in which sexual difference becomes socially, politically and ethically significant. I see this approach as one which is capable of opening the present to different ways of being a woman or a man, along with different ways of negotiating that difference.

A genealogy of sexual and social imaginaries inevitably raises questions concerning sociability. What types of sociability are realizable for us in the present? Spinoza's monistic and immanent theory of being is of particular interest here since he offers an account of knowledge in which both reason and imagination are collectively embodied. Rationality is not a transcendent capacity of a disembodied "mind" but an immanent power of active nature. Neither reason nor law come to us "from above" but rather develop immanently from our collective situations. Ironically, it is precisely because philosophers often fail to acknowledge the embodiedness of reason and knowledge that their own (embodied) imaginings play such a large part in their "reasoned" accounts of politics, morality and justice. The specificity of human embodiment should be understood not simply in terms of sexual or racial specificity, but also in terms of the *historical* specificity of human embodiment which provides a basis of commonality for all those who share, however inequitably, a present *as being their present*. It is this fact of embodiment that makes our present situation "ours" and one which only "we" can address. Those who make up any particular sociability are literally embodied elements of the historical conditions which make that form of sociability possible.

This view of human social and political being is one which is bound to see social and political power as immanent in the field of social relations. This in turn necessitates the rejection of any morality which would conceive of itself as a transcendent set of rules with the power to impose itself on an independently existing social terrain. Spinoza does not offer a moral theory of this sort, which amounts to a wish list, dreamed up "outside" power relations. Rather, he offers an ethics of power, where power is conceived as determined capacity for action. In this sense, what he offers sits well with a genealogy of our sexual and social present, where genealogy is understood as a critical history of the present which seeks to

understand what we have been, what we are now and, on this basis, what it is possible for us to become. Put differently, ethics is concerned with knowledge concerning that which we are and the type of sociability in which we participate. I have offered some suggestions concerning how we might go about an ethical appraisal of our present.

The path taken by these essays has tended to move away from dualistic understanding of sexual difference (sex/gender) and towards understanding differences as constituted through relatively stable but dynamic networks of relational powers, capacities and affects. Spinoza's immanent and monistic theory of being is attractive to me because it allows one to theorize the interconnections between sexed bodies and other body complexes, such as the body politic or other institutional assemblages (the law, for example). It is only within these complex assemblages that sexed bodies are produced as socially and politically meaningful bodies. How would a Spinozist theorize the sex/gender distinction?[5] Since Spinoza maintains that there can be no causal relation between mind and body (since both are modifications of the attributes of a single substance, or nature), sex, in some sense, must be gender, though "expressed" or made manifest through the attribute of extension rather than thought. This amounts to saying that sex is a particular extensive "organization" of the material powers and capacities of a body, whereas gender would amount to the affective powers and affects of such a body. On this reading of the sex/gender distinction, gender is both a power and an affect of a certain modification of the attribute of extension.[6]

This understanding introduces a good deal of dynamism into the categories "sex" and "gender" since both the extensive (bodies) and the intensive (minds) are conceived by Spinoza as complex fields of interconnecting powers and affects. Hence, both sex and gender, as parallel descriptions of modified nature, will be definable in relational terms only. A particular extensive organization of bodies will be paralleled by certain intensive powers and capacities. However, given that there is no causal relation between the attributes, the sex of a body does not and cannot cause its gender. [. . .] [I]f we understand gender as the powers, affects and dispositions that *are* the intensive parallel of a certain extensive organization of sexed bodies, then gender can indeed be understood in terms of the imaginative grasp that we have on the specificity of our sexual and historical embodiment.

Notes

1 *Ethics*, pt. IV, prop. 1, scholium.
2 See *A Theologico-Political Treatise*.
3 It is, of course, true that large numbers of women are not citizens of any polity. Here I am concerned to draw out the paradox of female citizenship *simpliciter*. In actual polities the situations of women are much more complex than I can show in this context. Consider, for example, the situation of indigenous women who formally may be citizens of the polity which has colonized them.
4 Carole Pateman has written about the conceptual difficulties involved in female citizenship in *The Sexual Contract* and in *The Disorder of Women*.
5 See G. Lloyd, "Woman as Other: Sex, Gender and Subjectivity".
6 The "Spinozism" of both Deleuze and Foucault is obvious in this context. The account offered by Deleuze and Guattari of the extensive and intensive axes of the "plane of immanence" in *A Thousand Plateaus* and Foucault's account of sexuality in *The History of Sexuality I* resonate with Spinoza's account of mind and body.

References

Deleuze, G. and Guattari, F., *A Thousand Plateaus: Capitalism and Schizophrenia*, trans. B. Massumi, Minneapolis, University of Minnesota Press, 1987.
Foucault, M., *The History of Sexuality*, vol. I, London, Allen Lane, 1978.

Lloyd, G. "Woman as Other: Sex, Gender and Subjectivity", *Australian Feminist Studies*, no. 10 (1989).
Pateman, Carole. *The Sexual Contract*, Cambridge, Polity, 1988.
—— *The Disorder of Women*, Cambridge, Polity, 1989.
Spinoza, B., *A Theologico-Political Treatise*, in *The Chief Works of Benedict de Spinoza*, vol. I, ed. R.H.M. Elwes, New York, Dover, 1951.
—— *Ethics*, in *The Collected Works of Spinoza*, vol. I, trans. E. Curley, Princeton, N.J., Princeton University Press, 1985.

PART SEVEN

Technology

I N T H I S F I N A L S E C T I O N, I have collected a number of essays, written from 1985 to 2000, addressing feminist issues in relation to new technologies of image-making. This section marks the fact that, as with contemporary art history and visual culture in general, much of the most cutting edge work on feminism and visual culture in recent years has focused on new media: the images produced in and through new technologies of representation, often linked to the biotechnology and fertility industries, and communications fields. Some of these technologies, such as imaging systems intended to map or explore the human body, make pictures as a by-product of scientific goals. Others – the Web, virtual imaging systems, digital photography, and so on – were developed by, or are often put in the hands of, artists, designers, and other image-makers for the specific aim of producing visual images.

If there was any doubt before these developments that the boundaries between high and low culture were dissolving, the visual images produced through such means should settle the question. There is little or no distinction in appearance between an image produced by a doctor exploring her patient's intestines and the image of intestines produced by Mona Hatoum (see Christine Ross (Chapter 56)); nor between an advertisement for software viewed as a pop-up screen while browsing the Web and a manifesto for cyberfeminism (VNS Matrix (Chapter 59)). Appropriation artists in the 1980s knew that much. What is different, of course, is the manner in which the images circulate and are contextualized: their constitution through digital rather than analogue means (N. Katherine Hayles (Chapter 54)), the very specific access points from which such images are circulated, the networks in which they travel, and the points at which they come to rest (on *my* computer screen; or, here, captured for reproduction in *this* anthology). VNS Matrix's manifesto does not, yet, pop up to advertise itself as a banner on Microsoft Corporation's Internet Explorer browser software. And Hatoum's intestinal imagery is placed on a video monitor beneath one's feet as one stands in an art museum. As always, then, cultural producers appropriate new modes of representation and recontextualize them to make them mean in particular ways (returning to Berger, the images still propose their own "ways of seeing").

The authors of essays in this last section, then, offer new ways of understanding how visual images in the digital age function and what subjects they engage and propose. Historian of science Donna Haraway's (Chapter 53) epochal 1985 "Cyborg Manifesto" presciently

articulated a feminist intervention into the discourses and institutions of high technology, arguing for the possibility of the cyborg as a potentially feminist tool (in its "confusion of boundaries" of gender, class, etc., and perhaps particularly in its reworking of categories of nature and culture). N. Katherine Hayles provides a complex but clear model for understanding the fundamental differences between analogue and digital representations and offers feminist insights on the implications of these differences. Extending Haraway's basic insight, Sadie Plant's (Chapter 58) brief but pithy "Feminisations" rejects gloomy appraisals of technology as inevitably dominating and masculinist, theorizing cybernetics as a feminizing "decomposition of the spectacle." By valuing this feminization, Plant thus turns on its head the conventional derogation of the spectacular (or the simulacral) for, precisely, its feminization of some nostalgically defined pre-existing real.

Elizabeth Grosz (Chapter 55), Christine Ross, María Fernández (Chapter 57), Rosi Braidotti (Chapter 60), Jennifer González (Chapter 61) and Sharon Lehner (Chapter 62) each focus on particular aspects of visuality to insist on understanding the subjects of new media imagery as embodied and specific in their identifications. Grosz's essay, part of her long-term philosophical and feminist interest in the body, explores the specific effects of the "interactive network" of the city, crisscrossed by increasingly technologically sophisticated webs of communication and transportation, on the gendered, embodied subject, and vice versa (people produce cities; cities engender people). Braidotti's essay addresses the paradoxical question of posthuman cyber-bodies through the three "sublime" spectacles of Dolly Parton, Elizabeth Taylor, and Jane Fonda – three presumably "real" (i.e., living) subjects, but ones whose artifice puts a lie to any conception of the embodied, gendered subject as determinable through a humanist discourse of the "individual" or the "real."

Fernández and González intervene in techno-theory with aggressively feminist and postcolonial/anti-racist arguments about the specificity of subjects producing and produced in and through new technologies. Fernández deals with high-tech art projects and the World Wide Web, pointing to the ways in which they – and the art critical essays discussing them – can occlude differences through a "homogenizing hybridity" that, like multiculturalism, is aligned with the machinations of multinational capitalism. González's "The Appended Subject" addresses the "assemblage" of identity via the digital codes comprising artists' websites, pointing, like Fernández, to the dangers of fantasies about "transcending" race and gender through the mutability and hybridity of Web "subjects."

Sharon Lehner and Christine Ross explore the intimate relation between high-tech imagery and the body. Lehner, in an essay that movingly and effectively plays out the feminist dictum "the personal is political," explores in theoretical terms the harrowing personal trauma of undergoing a "therapeutic abortion," examining in particular her own deeply invested relationship to the fetus, which she "knows" only as a sonogram image. Ross offers a sophisticated analysis of the work of Mona Hatoum, exploring the way in which the video screen is mobilized by artists as a means of projecting specifically embodied subjects – and so of engaging the body and mind of the viewer and provoking a potentially politically charged intersubjective encounter.

The VNS Matrix feminist manifesto printed here fresh off the Web provides an alternative to this type of encounter fostered in video installation art, indicating that the Web is both a site of distribution and a means of producing new kinds of embodied subjects. As the VNS Matrix contributors, who open the website with the proclamation "Dirty Work for Slimey Girls," seem to understand, new technologies are not inherently patriarchal and sexist in their

effects. As Haraway suggested almost two decades ago, new technologies have masculinist tendencies (they were developed primarily by men and their related fields are still dominated by men) but, provided we engage them with energy, sass, and critical astuteness, they can also provide powerful tools for a feminist production and/or critique of visual culture.

References and further reading

Balsamo, Anne. *Technologies of Gendered Body: Reading Cyborg Women*. Durham: Duke University Press, 1996.

Berger, John. *Ways of Seeing*. Harmondsworth: Penguin Books and London: BBC, 1972.

Braidotti, Rosi. *Nomadic Subjects: Embodiment and Sexual Difference in Contemporary Feminist Theory*. New York: Columbia University Press, 1994.

Calvert, Melodie and Terry, Jennifer, eds. *Processed Lives: Gender and Technology in Everyday Life*. London and New York: Routledge, 1997.

Cartwright, Lisa, Penley, Constance, and Treichler, Paula, eds. *The Visible Woman: Imaging Technologies, Gender and Science*. New York: New York University Press, 1998.

Clough, Patricia Ticineto. "Queer Desire and the Technobodies of Feminist Theory." *Autoaffection: Unconscious Thought in the Age of Teletechnology*. Minneapolis: University of Minnesota Press, 2000.

Hartouni, Valeria. *Cultural Conceptions: On Reproductive Technologies and the Remaking of Life*. Minneapolis: University of Minnesota, 1997.

Jackson, Shelley. *Patchwork Girl*. CD Rom. Watertown, Mass.: Eastgate Systems, 1995.

Kolko, Beth E., Nakamura, Lisa, and Rodman, Gilbert B., eds. *Race in Cyberspace*. New York and London: Routledge, 2000.

Old Boys Network. *Documents of the Cyberfeminist International Conference* (1999). http://www.obn.org/nCI/reports.htm

Petchesky, Rosalind. "Foetal Images: The Power of Visual Culture in the Politics of Reproduction." *Reproductive Technologies: Gender, Motherhood, and Medicine*. Michelle Stanworth, ed. Minneapolis: University of Minnesota Press, 1978.

Plant, Sadie. *Zeroes and Ones: Digital Women and the New Technoculture*. New York: Doubleday, 1997.

Richards, Catherine. "Fungal Intimacy: The Cyborg in Feminism and Media Art" (1995). *Clicking In: Hot Links to a Digital Culture*. Lynn Hershman Leeson, ed. Seattle: Bay Press, 2000.

Sobchack, Vivian, ed. *Meta-morphing: Visual Transformation and the Culture of Quick-change*. Minneapolis: University of Minnesota Press, 2000.

Stone, Allucquère Rosanne (Sandy). *The War of Desire and Technology at the Close of the Mechanical Age*. Cambridge, Massachusetts: MIT Press, 1995.

SubRosa, Feminist new media activist and publishing network. <www.cyberfeminism.net>.

Treichler, Paula A., Cartwright, Lisa, and Penley, Constance, eds. *The Visible Woman: Imaging Technologies, Gender and Science*. New York: New York University Press, 1998.

Wilding, Faith. "Where is the Feminism in Cyberfeminism?" *n. paradoxa* 2 (July 1998): 7–13.

DONNA HARAWAY

A CYBORG MANIFESTO

Science, technology, and socialist-feminism in the late twentieth century[1]

An ironic dream of a common language for women in the integrated circuit

THIS CHAPTER IS AN EFFORT TO BUILD an ironic political myth faithful to feminism, socialism, and materialism. Perhaps more faithful as blasphemy is faithful, than as reverent worship and identification. Blasphemy has always seemed to require taking things very seriously. I know no better stance to adopt from within the secular-religious, evangelical traditions of United States politics, including the politics of socialist feminism. Blasphemy protects one from the moral majority within, while still insisting on the need for community. Blasphemy is not apostasy. Irony is about contradictions that do not resolve into larger wholes, even dialectically, about the tension of holding incompatible things together because both or all are necessary and true. Irony is about humour and serious play. It is also a rhetorical strategy and a political method, one I would like to see more honoured within socialist-feminism. At the centre of my ironic faith, my blasphemy, is the image of the cyborg.

A cyborg is a cybernetic organism, a hybrid of machine and organism, a creature of social reality as well as a creature of fiction. Social reality is lived social relations, our most important political construction, a world-changing fiction. The international women's movements have constructed "women's experience", as well as uncovered or discovered this crucial collective object. This experience is a fiction and fact of the most crucial, political kind. Liberation rests on the construction of the consciousness, the imaginative apprehension, of oppression, and so of possibility. The cyborg is a matter of fiction and lived experience that changes what counts as women's experience in the late twentieth century. This is a struggle over life and death, but the boundary between science fiction and social reality is an optical illusion.

Contemporary science fiction is full of cyborgs – creatures simultaneously animal and machine, who populate worlds ambiguously natural and crafted. Modern medicine is also full of cyborgs, of couplings between organism and machine, each conceived as coded devices, in an intimacy and with a power that was not generated in the history of sexuality. Cyborg "sex" restores some of the lovely replicative baroque of ferns and invertebrates (such nice organic prophylactics against heterosexism). Cyborg replication is uncoupled from organic reproduction. Modern production seems like a dream of cyborg colonization work, a dream that makes the nightmare of Taylorism seem idyllic. And modern war is a cyborg orgy, coded by C^3I, command-control-communication-intelligence, an $85 billion item in 1984's US defence

budget. I am making an argument for the cyborg as a fiction mapping our social and bodily reality and as an imaginative resource suggesting some very fruitful couplings. Michel Foucault's biopolitics is a flaccid premonition of cyborg politics, a very open field.

By the late twentieth century, our time, a mythic time, we are all chimeras, theorized and fabricated hybrids of machine and organism; in short, we are cyborgs. The cyborg is our ontology; it gives us our politics. The cyborg is a condensed image of both imagination and material reality, the two joined centres structuring any possibility of historical transformation. In the traditions of "Western" science and politics – the tradition of racist, male-dominant capitalism; the tradition of progress; the tradition of the appropriation of nature as resource for the production of culture; the tradition of reproduction of the self from the reflections of the other – the relation between organism and machine has been a border war. The stakes in the border war have been the territories of production, reproduction, and imagination. This chapter is an argument for *pleasure* in the confusion of boundaries and for *responsibility* in their construction. It is also an effort to contribute to socialist-feminist culture and theory in a postmodernist, non-naturalist mode and in the utopian tradition of imagining a world without gender, which is perhaps a world without genesis, but maybe also a world without end. The cyborg incarnation is outside salvation history. Nor does it mark time on an oedipal calendar, attempting to heal the terrible cleavages of gender in an oral symbiotic utopia or post-oedipal apocalypse. As Zoe Sofoulis argues in her unpublished manuscript on Jacques Lacan, Melanie Klein, and nuclear culture, *Lacklein*, the most terrible and perhaps the most promising monsters in cyborg worlds are embodied in non-oedipal narratives with a different logic of repression, which we need to understand for our survival.

The cyborg is a creature in a post-gender world; it has no truck with bisexuality, pre-oedipal symbiosis, unalienated labour, or other seductions to organic wholeness through a final appropriation of all the powers of the parts into a higher unity. In a sense, the cyborg has no origin story in the Western sense – a "final" irony since the cyborg is also the awful apocalyptic *telos* of the "West's" escalating dominations of abstract individuation, an ultimate self untied at last from all dependency, a man in space. An origin story in the "Western", humanist sense depends on the myth of original unity, fullness, bliss and terror, represented by the phallic mother from whom all humans must separate, the task of individual development and of history, the twin potent myths inscribed most powerfully for us in psychoanalysis and Marxism. Hilary Klein has argued that both Marxism and psychoanalysis, in their concepts of labour and of individuation and gender formation, depend on the plot of original unity out of which difference must be produced and enlisted in a drama of escalating domination of woman/nature. The cyborg skips the step of original unity, of identification with nature in the Western sense. This is its illegitimate promise that might lead to subversion of its teleology as star wars.

The cyborg is resolutely committed to partiality, irony, intimacy, and perversity. It is oppositional, utopian, and completely without innocence. No longer structured by the polarity of public and private, the cyborg defines a technological polis based partly on a revolution of social relations in the *oikos*, the household. Nature and culture are reworked; the one can no longer be the resource for appropriation or incorporation by the other. The relationships for forming wholes from parts, including those of polarity and hierarchical domination, are at issue in the cyborg world. Unlike the hopes of Frankenstein's monster, the cyborg does not expect its father to save it through a restoration of the garden; that is, through the fabrication of a heterosexual mate, through its completion in a finished whole, a city and cosmos. The cyborg does not dream of community on the model of the organic family, this time

without the oedipal project. The cyborg would not recognize the Garden of Eden; it is not made of mud and cannot dream of returning to dust. Perhaps that is why I want to see if cyborgs can subvert the apocalypse of returning to nuclear dust in the manic compulsion to name the Enemy. Cyborgs are not reverent; they do not re-member the cosmos. They are wary of holism, but needy for connection – they seem to have a natural feel for united front politics, but without the vanguard party. The main trouble with cyborgs, of course, is that they are the illegitimate offspring of militarism and patriarchal capitalism, not to mention state socialism. But illegitimate offspring are often exceedingly unfaithful to their origins. Their fathers, after all, are inessential.

I will return to the science fiction of cyborgs at the end of this chapter, but now I want to signal three crucial boundary breakdowns that make the following political-fictional (political-scientific) analysis possible. By the late twentieth century in United States scientific culture, the boundary between human and animal is thoroughly breached. The last beach-heads of uniqueness have been polluted if not turned into amusement parks – language, tool use, social behaviour, mental events, nothing really convincingly settles the separation of human and animal. And many people no longer feel the need for such a separation; indeed, many branches of feminist culture affirm the pleasure of connection of human and other living creatures. Movements for animal rights are not irrational denials of human uniqueness; they are a clear-sighted recognition of connection across the discredited breach of nature and culture. Biology and evolutionary theory over the last two centuries have simultaneously produced modern organisms as objects of knowledge and reduced the line between humans and animals to a faint trace re-etched in ideological struggle or professional disputes between life and social science. Within this framework, teaching modern Christian creationism should be fought as a form of child abuse.

Biological-determinist ideology is only one position opened up in scientific culture for arguing the meanings of human animality. There is much room for radical political people to contest the meanings of the breached boundary.[2] The cyborg appears in myth precisely where the boundary between human and animal is transgressed. Far from signalling a walling off of people from other living beings, cyborgs signal disturbingly and pleasurably tight coupling. Bestiality has a new status in this cycle of marriage exchange.

The second leaky distinction is between animal-human (organism) and machine. Pre-cybernetic machines could be haunted; there was always the spectre of the ghost in the machine. This dualism structured the dialogue between materialism and idealism that was settled by a dialectical progeny, called spirit or history, according to taste. But basically machines were not self-moving, self-designing, autonomous. They could not achieve man's dream, only mock it. They were not man, an author to himself, but only a caricature of that masculinist reproductive dream. To think they were otherwise was paranoid. Now we are not so sure. Late twentieth-century machines have made thoroughly ambiguous the difference between natural and artificial, mind and body, self-developing and externally designed, and many other distinctions that used to apply to organisms and machines. Our machines are disturbingly lively, and we ourselves frighteningly inert.

Technological determination is only one ideological space opened up by the reconcep-tions of machine and organism as coded texts through which we engage in the play of writing and reading the world.[3] "Textualization" of everything in poststructuralist, postmodernist theory has been damned by Marxists and socialist feminists for its utopian disregard for the lived relations of domination that ground the "play" of arbitrary reading.[4] It is certainly true that postmodernist strategies, like my cyborg myth, subvert myriad organic wholes (for

example, the poem, the primitive culture, the biological organism). In short, the certainty of what counts as nature – a source of insight and promise of innocence – is undermined, probably fatally. The transcendent authorization of interpretation is lost, and with it the ontology grounding "Western" epistemology. But the alternative is not cynicism or faithlessness, that is, some version of abstract existence, like the accounts of technological determinism destroying "man" by the "machine" or "meaningful political action" by the "text". Who cyborgs will be is a radical question; the answers are a matter of survival. Both chimpanzees and artefacts have politics, so why shouldn't we (de Waal, 1982; Winner, 1980)?

The third distinction is a subset of the second: the boundary between physical and non-physical is very imprecise for us. Pop physics books on the consequences of quantum theory and the indeterminacy principle are a kind of popular scientific equivalent to Harlequin romances* as a marker of radical change in American white heterosexuality: they get it wrong, but they are on the right subject. Modern machines are quintessentially microelectronic devices: they are everywhere and they are invisible. Modern machinery is an irreverent upstart god, mocking the Father's ubiquity and spirituality. The silicon chip is a surface for writing; it is etched in molecular scales disturbed only by atomic noise, the ultimate interference for nuclear scores. Writing, power, and technology are old partners in Western stories of the origin of civilization, but miniaturization has changed our experience of mechanism. Miniaturization has turned out to be about power; small is not so much beautiful as pre-eminently dangerous, as in cruise missiles. Contrast the TV sets of the 1950s or the news cameras of the 1970s with the TV wrist bands or hand-sized video cameras now advertised. Our best machines are made of sunshine; they are all light and clean because they are nothing but signals, electromagnetic waves, a section of a spectrum, and these machines are eminently portable, mobile – a matter of immense human pain in Detroit and Singapore. People are nowhere near so fluid, being both material and opaque. Cyborgs are ether, quintessence.

The ubiquity and invisibility of cyborgs is precisely why these sunshine-belt machines are so deadly. They are as hard to see politically as materially. They are about consciousness – or its simulation.[5] They are floating signifiers moving in pickup trucks across Europe, blocked more effectively by the witch-weavings of the displaced and so unnatural Greenham women, who read the cyborg webs of power so very well, than by the militant labour of older masculinist politics, whose natural constituency needs defence jobs. Ultimately the "hardest" science is about the realm of greatest boundary confusion, the realm of pure number, pure spirit, C^3I, cryptography, and the preservation of potent secrets. The new machines are so clean and light. Their engineers are sun-worshippers mediating a new scientific revolution associated with the night dream of post-industrial society. The diseases evoked by these clean machines are "no more" than the minuscule coding changes of an antigen in the immune system, "no more" than the experience of stress. The nimble fingers of "Oriental" women, the old fascination of little Anglo-Saxon Victorian girls with doll's houses, women's enforced attention to the small take on quite new dimensions in this world. There might be a cyborg Alice taking account of these new dimensions. Ironically, it might be the unnatural cyborg women making chips in Asia and spiral dancing in Santa Rita jail** whose constructed unities will guide effective oppositional strategies.

So my cyborg myth is about transgressed boundaries, potent fusions, and dangerous possibilities which progressive people might explore as one part of needed political work. One of my premises is that most American socialists and feminists see deepened dualisms of mind and body, animal and machine, idealism and materialism in the social practices, symbolic formulations, and physical artefacts associated with "high technology" and scientific culture.

From *One-Dimensional Man* (Marcuse, 1964) to *The Death of Nature* (Merchant, 1980), the analytic resources developed by progressives have insisted on the necessary domination of technics and recalled us to an imagined organic body to integrate our resistance. Another of my premises is that the need for unity of people trying to resist world-wide intensification of domination has never been more acute. But a slightly perverse shift of perspective might better enable us to contest for meanings, as well as for other forms of power and pleasure in technologically mediated societies.

From one perspective, a cyborg world is about the final imposition of a grid of control on the planet, about the final abstraction embodied in a Star Wars apocalypse waged in the name of defence, about the final appropriation of women's bodies in a masculinist orgy of war (Sofia, 1984). From another perspective, a cyborg world might be about lived social and bodily realities in which people are not afraid of their joint kinship with animals and machines, not afraid of permanently partial identities and contradictory standpoints. The political struggle is to see from both perspectives at once because each reveals both dominations and possibilities unimaginable from the other vantage point. Single vision produces worse illusions than double vision or many-headed monsters. Cyborg unities are monstrous and illegitimate; in our present political circumstances, we could hardly hope for more potent myths for resistance and recoupling. I like to imagine LAG, the Livermore Action Group, as a kind of cyborg society, dedicated to realistically converting the laboratories that most fiercely embody and spew out the tools of technological apocalypse, and committed to building a political form that actually manages to hold together witches, engineers, elders, perverts, Christians, mothers, and Leninists long enough to disarm the state. Fission Impossible is the name of the affinity group in my town. (Affinity: related not by blood but by choice, the appeal of one chemical nuclear group for another, avidity.)[6]

Fractured identities

It has become difficult to name one's feminism by a single adjective – or even to insist in every circumstance upon the noun. Consciousness of exclusion through naming is acute. Identities seem contradictory, partial, and strategic. With the hard-won recognition of their social and historical constitution, gender, race, and class cannot provide the basis for belief in "essential" unity. There is nothing about being "female" that naturally binds women. There is not even such a state as "being" female, itself a highly complex category constructed in contested sexual scientific discourses and other social practices. Gender, race, or class consciousness is an achievement forced on us by the terrible historical experience of the contradictory social realities of patriarchy, colonialism, and capitalism. And who counts as "us" in my own rhetoric? Which identities are available to ground such a potent political myth called "us", and what could motivate enlistment in this collectivity? Painful fragmentation among feminists (not to mention among women) along every possible fault line has made the concept of *woman* elusive, an excuse for the matrix of women's dominations of each other. For me – and for many who share a similar historical location in white, professional middle-class, female, radical, North American, mid-adult bodies – the sources of a crisis in political identity are legion. The recent history for much of the US left and US feminism has been a response to this kind of crisis by endless splitting and searches for a new essential unity. But there has also been a growing recognition of another response through coalition – affinity, not identity.[7]

Chela Sandoval (n.d., 1984), from a consideration of specific historical moments in the formation of the new political voice called women of colour, has theorized a hopeful model

of political identity called "oppositional consciousness", born of the skills for reading webs of power by those refused stable membership in the social categories of race, sex, or class. "Women of color", a name contested at its origins by those whom it would incorporate, as well as a historical consciousness marking systematic breakdown of all the signs of Man in "Western" traditions, constructs a kind of postmodernist identity out of otherness, difference, and specificity. This postmodernist identity is fully political, whatever might be said about other possible postmodernisms. Sandoval's oppositional consciousness is about contradictory locations and heterochronic calendars, not about relativisms and pluralisms.

Sandoval emphasizes the lack of any essential criterion for identifying who is a woman of colour. She notes that the definition of the group has been by conscious appropriation of negation. For example, a Chicana or US black woman has not been able to speak as a woman or as a black person or as a Chicano. Thus, she was at the bottom of a cascade of negative identities, left out of even the privileged oppressed authorial categories called "women and blacks", who claimed to make the important revolutions. The category "woman" negated all non-white women; "black" negated all non-black people, as well as all black women. But there was also no "she", no singularity, but a sea of differences among US women who have affirmed their historical identity as US women of colour. This identity marks out a self-consciously constructed space that cannot affirm the capacity to act on the basis of natural identification, but only on the basis of conscious coalition, of affinity, of political kinship.[8] Unlike the "woman" of some streams of the white women's movement in the United States, there is no naturalization of the matrix, or at least this is what Sandoval argues is uniquely available through the power of oppositional consciousness.

Sandoval's argument has to be seen as one potent formulation for feminists out of the world-wide development of anti-colonialist discourse; that is to say, discourse dissolving the "West" and its highest product – the one who is not animal, barbarian, or woman; man, that is, the author of a cosmos called history. As orientalism is deconstructed politically and semiotically, the identities of the occident destabilize, including those of feminists.[9] Sandoval argues that "women of colour" have a chance to build an effective unity that does not replicate the imperializing, totalizing revolutionary subjects of previous Marxisms and feminisms which had not faced the consequences of the disorderly polyphony emerging from decolonization.

Katie King has emphasized the limits of identification and the political/poetic mechanics of identification built into reading "the poem", that generative core of cultural feminism. King criticizes the persistent tendency among contemporary feminists from different "moments" or "conversations" in feminist practice to taxonomize the women's movement to make one's own political tendencies appear to be the *telos* of the whole. These taxonomies tend to remake feminist history so that it appears to be an ideological struggle among coherent types persisting over time, especially those typical units called radical, liberal, and socialist-feminism. Literally, all other feminisms are either incorporated or marginalized, usually by building an explicit ontology and epistemology.[10] Taxonomies of feminism produce epistemologies to police deviation from official women's experience. And of course, "women's culture", like women of colour, is consciously created by mechanisms inducing affinity. The rituals of poetry, music, and certain forms of academic practice have been pre-eminent. The politics of race and culture in the US women's movements are intimately interwoven. The common achievement of King and Sandoval is learning how to craft a poetic/political unity without relying on a logic of appropriation, incorporation, and taxonomic identification.

The theoretical and practical struggle against unity-through-domination or unity-through-incorporation ironically not only undermines the justifications for patriarchy, colonialism,

humanism, positivism, essentialism, scientism, and other unlamented -isms, but *all* claims for an organic or natural standpoint. I think that radical and socialist/Marxist-feminisms have also undermined their/our own epistemological strategies and that this is a crucially valuable step in imagining possible unities. It remains to be seen whether all "epistemologies" as Western political people have known them fail us in the task to build effective affinities.

It is important to note that the effort to construct revolutionary standpoints, epistemologies as achievements of people committed to changing the world, has been part of the process showing the limits identification. The acid tools of postmodernist theory and the constructive tools of ontological discourse about revolutionary subjects might be seen as ironic allies in dissolving Western selves in the interest of survival. We are excruciatingly conscious of what it means to have a historically constituted body. But with the loss of innocence in our origin, there is no expulsion from the Garden either. Our politics lose the indulgence of guilt with the *naïveté* of innocence. But what would another political myth for socialist-feminism look like? What kind of politics could embrace partial, contradictory, permanently unclosed constructions of personal and collective selves and still be faithful, effective – and, ironically, socialist-feminist?

I do not know of any other time in history when there was greater need for political unity to confront effectively the dominations of "race", "gender", "sexuality", and "class". I also do not know of any other time when the kind of unity we might help build could have been possible. None of "us" have any longer the symbolic or material capability of dictating the shape of reality to any of "them". Or at least "we" cannot claim innocence from practising such dominations. White women, including socialist feminists, discovered (that is, were forced kicking and screaming to notice) the non-innocence of the category "woman". That consciousness changes the geography of all previous categories; it denatures them as heat denatures a fragile protein. Cyborg feminists have to argue that "we" do not want any more natural matrix of unity and that no construction is whole. Innocence, and the corollary insistence on victimhood as the only ground for insight, has done enough damage. But the constructed revolutionary subject must give late-twentieth-century people pause as well. In the fraying of identities and in the reflexive strategies for constructing them, the possibility opens up for weaving something other than a shroud for the day after the apocalypse that so prophetically ends salvation history.

Both Marxist/socialist-feminisms and radical feminisms have simultaneously naturalized and denatured the category "woman" and consciousness of the social lives of "women". Perhaps a schematic caricature can highlight both kinds of moves. Marxian socialism is rooted in an analysis of wage labour which reveals class structure. The consequence of the wage relationship is systematic alienation, as the worker is dissociated from his (sic) product. Abstraction and illusion rule in knowledge, domination rules in practice. Labour is the pre-eminently privileged category enabling the Marxist to overcome illusion and find that point of view which is necessary for changing the world. Labour is the humanizing activity that makes man; labour is an ontological category permitting the knowledge of a subject, and so the knowledge of subjugation and alienation.

In faithful filiation, socialist-feminism advanced by allying itself with the basic analytic strategies of Marxism. The main achievement of both Marxist feminists and socialist feminists was to expand the category of labour to accommodate what (some) women did, even when the wage relation was subordinated to a more comprehensive view of labour under capitalist patriarchy. In particular, women's labour in the household and women's activity as mothers generally (that is, reproduction in the socialist-feminist sense) entered theory on the authority

of analogy to the Marxian concept of labour. The unity of women here rests on an epistemology based on the ontological structure of "labour". Marxist/socialist-feminism does not "naturalize" unity; it is a possible achievement based on a possible standpoint rooted in social relations. The essentializing move is in the ontological structure of labour or of its analogue, women's activity.[11] The inheritance of Marxian humanism, with its pre-eminently Western self, is the difficulty for me. The contribution from these formulations has been the emphasis on the daily responsibility of real women to build unities, rather than to naturalize them.

Catherine MacKinnon's (1982, 1987) version of radical feminism is itself a caricature of the appropriating, incorporating, totalizing tendencies of Western theories of identity grounding action.[12] It is factually and politically wrong to assimilate all of the diverse "moments" or "conversations" in recent women's politics named radical feminism to MacKinnon's version. But the teleological logic of her theory shows how an epistemology and ontology – including their negations – erase or police difference. Only one of the effects of MacKinnon's theory is the rewriting of the history of the polymorphous field called radical feminism. The major effect is the production of a theory of experience, women's identity, that is a kind of apocalypse for all revolutionary standpoints. That is, the totalization built into this tale of radical feminism achieves its end – the unity of women – by enforcing the experience of and testimony to radical non-being. As for the Marxist/socialist feminist, consciousness is an achievement, not a natural fact. And MacKinnon's theory eliminates some of the difficulties built into humanist revolutionary subjects, but at the cost of radical reductionism.

[. . .]

In my taxonomy, which like any other taxonomy is a re-inscription of history, radical feminism can accommodate all the activities of women named by socialist feminists as forms of labour only if the activity can somehow be sexualized. Reproduction had different tones of meanings for the two tendencies, one rooted in labour, one in sex, both calling the consequences of domination and ignorance of social and personal reality "false consciousness".

Beyond either the difficulties or the contributions in the argument of any one author, neither Marxist nor radical feminist points of view have tended to embrace the status of a partial explanation; both were regularly constituted as totalities. Western explanation has demanded as much; how else could the "Western" author incorporate its others? Each tried to annex other forms of domination by expanding its basic categories through analogy, simple listing, or addition. Embarrassed silence about race among white radical and socialist feminists was one major, devastating political consequence. History and polyvocality disappear into political taxonomies that try to establish genealogies. There was no structural room for race (or for much else) in theory claiming to reveal the construction of the category woman and social group women as a unified or totalizable whole. The structure of my caricature looks like this:

> socialist feminism – structure of class // wage labour // alienation
> labour, by analogy reproduction, by extension sex, by addition race
> radical feminism – structure of gender // sexual appropriation // objectification
> sex, by analogy labour, by extension reproduction, by addition race

In another context, the French theorist, Julia Kristeva, claimed women appeared as a historical group after the Second World War, along with groups like youth. Her dates are doubtful; but we are now accustomed to remembering that as objects of knowledge and as historical actors, "race" did not always exist, "class" has a historical genesis, and "homosexuals" are quite

junior. It is no accident that the symbolic system of the family man – and so the essence of woman – breaks up at the same moment that networks of connection among people on the planet are unprecedentedly multiple, pregnant, and complex. "Advanced capitalism" is inadequate to convey the structure of this historical moment. In the "Western" sense, the end of man is at stake. It is no accident that woman disintegrates into women in our time. Perhaps socialist feminists were not substantially guilty of producing essentialist theory that suppressed women's particularity and contradictory interests. I think we have been, at least through un-reflective participation in the logics, languages, and practices of white humanism and through searching for a single ground of domination to secure our revolutionary voice. Now we have less excuse. But in the consciousness of our failures, we risk lapsing into boundless difference and giving up on the confusing task of making partial, real connection. Some differences are playful; some are poles of world historical systems of domination. "Epistemology" is about knowing the difference.

The informatics of domination

In this attempt at an epistemological and political position, I would like to sketch a picture of possible unity, a picture indebted to socialist and feminist principles of design. The frame for my sketch is set by the extent and importance of rearrangements in world-wide social relations tied to science and technology. I argue for a politics rooted in claims about funda-mental changes in the nature of class, race, and gender in an emerging system of world order analogous in its novelty and scope to that created by industrial capitalism; we are living through a movement from an organic, industrial society to a polymorphous, information system – from all work to all play, a deadly game. Simultaneously material and ideological, the dichotomies may be expressed in the following chart of transitions from the comfortable old hierarchical dominations to the scary new networks I have called the informatics of domination:

Representation	Simulation
Bourgeois novel, realism	Science fiction, postmodernism
Organism	Biotic component
Depth, integrity	Surface, boundary
Heat	Noise
Biology as clinical practice	Biology as inscription
Physiology	Communications engineering
Small group	Subsystem
Perfection	Optimization
Eugenics	Population control
Decadence, *Magic Mountain*	Obsolescence, *Future Shock*
Hygiene	Stress management
Microbiology, tuberculosis	Immunology, AIDS
Organic division of labour	Ergonomics/cybernetics of labour
Functional specialization	Modular construction
Reproduction	Replication
Organic sex role specialization	Optimal genetic strategies
Biological determinism	Evolutionary inertia, constraints

Community ecology	Ecosystem
Racial chain of being	Neo-imperialism, United Nations humanism
Scientific management in home/factory	Global factory/Electronic cottage
Family/Market/Factory	Women in the integrated circuit
Family wage	Comparable worth
Public/Private	Cyborg citizenship
Nature/Culture	Fields of difference
Co-operation	Communications enhancement
Freud	Lacan
Sex	Genetic engineering
Labour	Robotics
Mind	Artificial intelligence
Second World War	Star Wars
White capitalist patriarchy	Informatics of domination

This list suggests several interesting things.[13] First, the objects on the right-hand side cannot be coded as "natural", a realization that subverts naturalistic coding for the left-hand side as well. We cannot go back ideologically or materially. It's not just that "god" is dead; so is the "goddess". Or both are revivified in the worlds charged with microelectronic and biotechnological politics. In relation to objects like biotic components, one must think not in terms of essential properties, but in terms of design, boundary constraints, rates of flows, systems logics, costs of lowering constraints. Sexual reproduction is one kind of reproductive strategy among many, with costs and benefits as a function of the system environment. Ideologies of sexual reproduction can no longer reasonably call on notions of sex and sex role as organic aspects in natural objects like organisms and families. Such reasoning will be unmasked as irrational, and ironically corporate executives reading *Playboy* and anti-porn radical feminists will make strange bedfellows in jointly unmasking the irrationalism.

Likewise for race, ideologies about human diversity have to be formulated in terms of frequencies of parameters, like blood groups or intelligence scores. It is "irrational" to invoke concepts like primitive and civilized. For liberals and radicals, the search for integrated social systems gives way to a new practice called "experimental ethnography" in which an organic object dissipates in attention to the play of writing. At the level of ideology, we see translations of racism and colonialism into languages of development and under-development, rates and constraints of modernization. Any objects or persons can be reasonably thought of in terms of disassembly and reassembly; no "natural" architectures constrain system design. The financial districts in all the world's cities, as well as the export-processing and free-trade zones, proclaim this elementary fact of "late capitalism". The entire universe of objects that can be known scientifically must be formulated as problems in communications engineering (for the managers) or theories of the text (for those who would resist). Both are cyborg semiologies.

One should expect control strategies to concentrate on boundary conditions and interfaces, on rates of flow across boundaries – and not on the integrity of natural objects. "Integrity" or "sincerity" of the Western self gives way to decision procedures and expert systems. For example, control strategies applied to women's capacities to give birth to new human beings will be developed in the languages of population control and maximization of goal achievement for individual decision-makers. Control strategies will be formulated in terms of rates, costs of constraints, degrees of freedom. Human beings, like any other component or

subsystem, must be localized in a system architecture whose basic modes of operation are probabilistic, statistical. No objects, spaces, or bodies are sacred in themselves; any component can be interfaced with any other if the proper standard, the proper codes, can be constructed for processing signals in a common language. Exchange in this world transcends the universal translation effected by capitalist markets that Marx analysed so well. The privileged pathology affecting all kinds of components in this universe is stress – communications breakdown (Hogness, 1983). The cyborg is not subject to Foucault's biopolitics; the cyborg simulates politics, a much more potent field of operations.

This kind of analysis of scientific and cultural objects of knowledge which have appeared historically since the Second World War prepares us to notice some important inadequacies in feminist analysis, which has proceeded as if the organic, hierarchical dualisms ordering discourse in "the West" since Aristotle still ruled. They have been cannibalized, or as Zoe Sofia (Sofoulis) might put it, they have been "techno-digested". The dichotomies between mind and body, animal and human, organism and machine, public and private, nature and culture, men and women, primitive and civilized are all in question ideologically. The actual situation of women is their integration/exploitation into a world system of production/reproduction and communication called the informatics of domination. The home, workplace, market, public arena, the body itself – all can be dispersed and interfaced in nearly infinite, polymorphous ways, with large consequences for women and others – consequences that themselves are very different for different people and which make potent oppositional international movements difficult to imagine and essential for survival. One important route for reconstructing socialist-feminist politics is through theory and practice addressed to the social relations of science and technology, including crucially the systems of myth and meanings structuring our imaginations. The cyborg is a kind of disassembled and reassembled, postmodern collective and personal self. This is the self feminists must code.

Communications technologies and biotechnologies are the crucial tools recrafting our bodies. These tools embody and enforce new social relations for women world-wide. Technologies and scientific discourses can be partially understood as formalizations, i.e., as frozen moments, of the fluid social interactions constituting them, but they should also be viewed as instruments for enforcing meanings. The boundary is permeable between tool and myth, instrument and concept, historical systems of social relations and historical anatomies of possible bodies, including objects of knowledge. Indeed, myth and tool mutually constitute each other.

Furthermore, communications sciences and modern biologies are constructed by a common move – *the translation of the world into a problem of coding*, a search for a common language in which all resistance to instrumental control disappears and all heterogeneity can be submitted to disassembly, reassembly, investment, and exchange.

In communications sciences, the translation of the world into a problem in coding can be illustrated by looking at cybernetic (feedback-controlled) systems theories applied to telephone technology, computer design, weapons deployment, or database construction and maintenance. In each case, solution to the key questions rests on a theory of language and control; the key operation is determining the rates, directions, and probabilities of flow of a quantity called information. The world is subdivided by boundaries differentially permeable to information. Information is just that kind of quantifiable element (unit, basis of unity) which allows universal translation, and so unhindered instrumental power (called effective communication). The biggest threat to such power is interruption of communication. Any system breakdown is a function of stress. The fundamentals of this technology can be condensed into

the metaphor C³I, command-control-communication-intelligence, the military's symbol for its operations theory.

In modern biologies, the translation of the world into a problem in coding can be illustrated by molecular genetics, ecology, sociobiological evolutionary theory, and immunobiology. The organism has been translated into problems of genetic coding and read-out. Biotechnology, a writing technology, informs research broadly.[14] In a sense, organisms have ceased to exist as objects of knowledge, giving way to biotic components, i.e., special kinds of information-processing devices. The analogous moves in ecology could be examined by probing the history and utility of the concept of the ecosystem. Immunobiology and associated medical practices are rich exemplars of the privilege of coding and recognition systems as objects of knowledge, as constructions of bodily reality for us. Biology here is a kind of cryptography. Research is necessarily a kind of intelligence activity. Ironies abound. A stressed system goes awry; its communication processes break down; it fails to recognize the difference between self and other. Human babies with baboon hearts evoke national ethical perplexity – for animal rights activists at least as much as for the guardians of human purity. In the US gay men and intravenous drug users are the "privileged" victims of an awful immune system disease that marks (inscribes on the body) confusion of boundaries and moral pollution (Treichler, 1987).

But these excursions into communications sciences and biology have been at a rarefied level; there is a mundane, largely economic reality to support my claim that these sciences and technologies indicate fundamental transformations in the structure of the world for us. Communications technologies depend on electronics. Modern states, multinational corporations, military power, welfare state apparatuses, satellite systems, political processes, fabrication of our imaginations, labour-control systems, medical constructions of our bodies, commercial pornography, the international division of labour, and religious evangelism depend intimately upon electronics. Microelectronics is the technical basis of simulacra; that is, of copies without originals.

Microelectronics mediates the translations of labour into robotics and word processing, sex into genetic engineering and reproductive technologies, and mind into artificial intelligence and decision procedures. The new biotechnologies concern more than human reproduction. Biology as a powerful engineering science for redesigning materials and processes has revolutionary implications for industry, perhaps most obvious today in areas of fermentation, agriculture, and energy. Communications sciences and biology are constructions of natural-technical objects of knowledge in which the difference between machine and organism is thoroughly blurred; mind, body, and tool are on very intimate terms. The "multinational" material organization of the production and reproduction of culture and imagination seem equally implicated. The boundary-maintaining images of base and superstructure, public and private, or material and ideal never seemed more feeble.

I have used Rachel Grossman's (1980) image of women in the integrated circuit to name the situation of women in a world so intimately restructured through the social relations of science and technology.[15] I used the odd circumlocution, "the social relations of science and technology", to indicate that we are not dealing with a technological determinism, but with a historical system depending upon structured relations among people. But the phrase should also indicate that science and technology provide fresh sources of power, that we need fresh sources of analysis and political action (Latour, 1984). Some of the rearrangements of race, sex, and class rooted in high-tech-facilitated social relations can make socialist-feminism more relevant to effective progressive politics.

[. . .]

Cyborgs: a myth of political identity

I want to conclude with a myth about identity and boundaries which might inform late twentieth-century political imaginations. I am indebted in this story to writers like Joanna Russ, Samuel R. Delany, John Varley, James Tiptree, Jr, Octavia Butler, Monique Wittig, and Vonda McIntyre.[16] These are our story-tellers exploring what it means to be embodied in high-tech worlds. They are theorists for cyborgs. Exploring conceptions of bodily boundaries and social order, the anthropologist Mary Douglas (1966, 1970) should be credited with helping us to consciousness about how fundamental body imagery is to world view, and so to political language. French feminists like Luce Irigaray and Monique Wittig, for all their differences, know how to write the body; how to weave eroticism, cosmology, and politics from imagery of embodiment, and especially for Wittig, from imagery of fragmentation and reconstitution of bodies.[17]

American radical feminists like Susan Griffin, Audre Lorde, and Adrienne Rich have profoundly affected our political imaginations – and perhaps restricted too much what we allow as a friendly body and political language.[18] They insist on the organic, opposing it to the technological. But their symbolic systems and the related positions of ecofeminism and feminist paganism, replete with organicisms, can only be understood in Sandoval's terms as oppositional ideologies fitting the late twentieth century. They would simply bewilder anyone not preoccupied with the machines and consciousness of late capitalism. In that sense they are part of the cyborg world. But there are also great riches for feminists in explicitly embracing the possibilities inherent in the breakdown of clean distinctions between organism and machine and similar distinctions structuring the Western self. It is the simultaneity of breakdowns that cracks the matrices of domination and opens geometric possibilities. What might be learned from personal and political "technological" pollution? I look briefly at two overlapping groups of texts for their insight into the construction of a potentially helpful cyborg myth: constructions of women of colour and monstrous selves in feminist science fiction.

Earlier I suggested that "women of colour" might be understood as a cyborg identity, a potent subjectivity synthesized from fusions of outsider identities and in the complex political-historical layerings of her "biomythography", *Zami* (Lorde, 1982; King, 1987a, 1987b). There are material and cultural grids mapping this potential, Audre Lorde (1984) captures the tone in the title of her *Sister Outsider*. In my political myth, Sister Outsider is the offshore woman, whom US workers, female and feminized, are supposed to regard as the enemy preventing their solidarity, threatening their security. Onshore, inside the boundary of the United States, Sister Outsider is a potential amidst the races and ethnic identities of women manipulated for division, competition, and exploitation in the same industries. "Women of colour" are the preferred labour force for the science-based industries, the real women for whom the world-wide sexual market, labour market, and politics of reproduction kaleidoscope into daily life. Young Korean women hired in the sex industry and in electronics assembly are recruited from high schools, educated for the integrated circuit. Literacy, especially in English, distinguishes the "cheap" female labour so attractive to the multinationals.

Contrary to orientalist stereotypes of the "oral primitive", literacy is a special mark of women of colour, acquired by US black women as well as men through a history of risking death to learn and to teach reading and writing. Writing has a special significance for all colonized groups. Writing has been crucial to the Western myth of the distinction between oral and written cultures, primitive and civilized mentalities, and more recently to the erosion of that distinction in "postmodernist" theories attacking the phalllogocentrism of the West, with its worship of the monotheistic, phallic, authoritative, and singular work, the unique and

perfect name.[19] Contests for the meanings of writing are a major form of contemporary political struggle. Releasing the play of writing is deadly serious. The poetry and stories of US women of colour are repeatedly about writing, about access to the power to signify; but this time that power must be neither phallic nor innocent. Cyborg writing must not be about the Fall, the imagination of a once-upon-a-time wholeness before language, before writing, before Man. Cyborg writing is about the power to survive, not on the basis of original innocence, but on the basis of seizing the tools to mark the world that marked them as other.

The tools are often stories, retold stories, versions that reverse and displace the hierarchical dualisms of naturalized identities. In retelling origin stories, cyborg authors subvert the central myths of origin of Western culture. We have all been colonized by those origin myths, with their longing for fulfilment in apocalypse. The phallogocentric origin stories most crucial for feminist cyborgs are built into the literal technologies – technologies that write the world, biotechnology and microelectronics – that have recently textualized our bodies as code problems on the grid of C^3I. Feminist cyborg stories have the task of recoding communication and intelligence to subvert command and control.

Figuratively and literally, language politics pervade the struggles of women of colour; and stories about language have a special power in the rich contemporary writing by US women of colour. For example, retellings of the story of the indigenous woman Malinche, mother of the mestizo "bastard" race of the new world, master of languages, and mistress of Cortés, carry special meaning for Chicana constructions of identity. Cherríe Moraga (1983) in *Loving in the War Years* explores the themes of identity when one never possessed the original language, never told the original story, never resided in the harmony of legitimate heterosexuality in the garden of culture, and so cannot base identity on a myth or a fall from innocence and right to natural names, mother's or father's.[20] Moraga's writing, her superb literacy, is presented in her poetry as the same kind of violation as Malinche's mastery of the conqueror's language – a violation, an illegitimate production, that allows survival. Moraga's language is not "whole"; it is self-consciously spliced, a chimera of English and Spanish, both conquerors' languages. But it is this chimeric monster, without claim to an original language before violation, that crafts the erotic, competent, potent identities of women of colour. Sister Outsider hints at the possibility of world survival not because of her innocence, but because of her ability to live on the boundaries, to write without the founding myth of original wholeness, with its inescapable apocalypse of final return to a deathly oneness that Man has imagined to be the innocent and all-powerful Mother, freed at the End from another spiral of appropriation by her son. Writing marks Moraga's body, affirms it as the body of a woman of colour, against the possibility of passing into the unmarked category of the Anglo father or into the orientalist myth of "original illiteracy" of a mother that never was. Malinche was mother here, not Eve before eating the forbidden fruit. Writing affirms Sister Outsider, not the Woman-before-the-Fall-into-Writing needed by the phallogocentric Family of Man.

Writing is pre-eminently the technology of cyborgs, etched surfaces of the late twentieth century. Cyborg politics is the struggle for language and the struggle against perfect communication, against the one code that translates all meaning perfectly, the central dogma of phallogocentrism. That is why cyborg politics insist on noise and advocate pollution, rejoicing in the illegitimate fusions of animal and machine. These are the couplings which make Man and Woman so problematic, subverting the structure of desire, the force imagined to generate language and gender, and so subverting the structure and modes of reproduction of "Western" identity, of nature and culture, of mirror and eye, slave and master, body and mind. "We"

did not originally choose to be cyborgs, but choice grounds a liberal politics and epistemology that imagines the reproduction of individuals before the wider replications of "texts".

From the perspective of cyborgs, freed of the need to ground politics in "our" privileged position of the oppression that incorporates all other dominations, the innocence of the merely violated, the ground of those closer to nature, we can see powerful possibilities. Feminisms and Marxisms have run aground on Western epistemological imperatives to construct a revolutionary subject from the perspective of a hierarchy of oppressions and/or a latent position of moral superiority, innocence, and greater closeness to nature. With no available original dream of a common language or original symbiosis promising protection from hostile "masculine" separation, but written into the play of a text that has no finally privileged reading or salvation history, to recognize "oneself" as fully implicated in the world, frees us of the need to root politics in identification, vanguard parties, purity, and mothering. Stripped of identity, the bastard race teaches about the power of the margins and the importance of a mother like Malinche. Women of colour have transformed her from the evil mother of masculinist fear into the originally literate mother who teaches survival.

This is not just literary deconstruction, but liminal transformation. Every story that begins with original innocence and privileges the return to wholeness imagines the drama of life to be individuation, separation, the birth of the self, the tragedy of autonomy, the fall into writing, alienation; that is, war, tempered by imaginary respite in the bosom of the Other. These plots are ruled by a reproductive politics – rebirth without flaw, perfection, abstraction. In this plot women are imagined either better or worse off, but all agree they have less selfhood, weaker individuation, more fusion to the oral, to Mother, less at stake in masculine autonomy. But there is another route to having less at stake in masculine autonomy, a route that does not pass through Woman, Primitive, Zero, the Mirror Stage and its imaginary. It passes through women and other present-tense, illegitimate cyborgs, not of Woman born, who refuse the ideological resources of victimization so as to have a real life. These cyborgs are the people who refuse to disappear on cue, no matter how many times a "Western" commentator remarks on the sad passing of another primitive, another organic group done in by "Western" technology, by writing.[21] These real-life cyborgs (for example, the Southeast Asian village women workers in Japanese and US electronics firms described by Aihwa Ong) are actively rewriting the texts of their bodies and societies. Survival is the stakes in this play of readings.

To recapitulate, certain dualisms have been persistent in Western traditions; they have all been systemic to the logics and practices of domination of women, people of colour, nature, workers, animals – in short, domination of all constituted as others, whose task is to mirror the self. Chief among these troubling dualisms are self/other, mind/body, culture/nature, male/female, civilized/primitive, reality/appearance, whole/part, agent/resource, maker/made, active/passive, right/wrong, truth/illusion, total/partial, God/man. The self is the One who is not dominated, who knows that by the service of the other, the other is the one who holds the future, who knows that by the experience of domination, which gives the lie to the autonomy of the self. To be One is to be autonomous, to be powerful, to be God; but to be One is to be an illusion, and so to be involved in a dialectic apocalypse with the other. Yet to be other is to be multiple, without clear boundary, frayed, insubstantial. One is too few, but two are too many.

High-tech culture challenges these dualisms in intriguing ways. It is not clear who makes and who is made in the relation between human and machine. It is not clear what is mind and what body in machines that resolve into coding practices. In so far as we know ourselves in both formal discourse (for example, biology) and in daily practice (for example, the homework

economy in the integrated circuit), we find ourselves to be cyborgs, hybrids, mosaics, chimeras. Biological organisms have become biotic systems, communications devices like others. There is no fundamental, ontological separation in our formal knowledge of machine and organism, of technical and organic.

[. . .]

There are several consequences to taking seriously the imagery of cyborgs as other than our enemies. Our bodies, ourselves; bodies are maps of power and identity. Cyborgs are no exception. A cyborg body is not innocent; it was not born in a garden; it does not seek unitary identity and so generate antagonistic dualisms without end (or until the world ends); it takes irony for granted. One is too few, and two is only one possibility. Intense pleasure in skill, machine skill, ceases to be a sin, but an aspect of embodiment. The machine is not an *it* to be animated, worshipped, and dominated. The machine is us, our processes, an aspect of our embodiment. We can be responsible for machines; *they* do not dominate or threaten us. We are responsible for boundaries; we are they. Up till now (once upon a time), female embodiment seemed to be given, organic, necessary; and female embodiment seemed to mean skill in mothering and its metaphoric extensions. Only by being out of place could we take intense pleasure in machines, and then with excuses that this was organic activity after all, appropriate to females. Cyborgs might consider more seriously the partial, fluid, sometimes aspect of sex and sexual embodiment. Gender might not be global identity after all, even if it has profound historical breadth and depth.

The ideologically charged question of what counts as daily activity, as experience, can be approached by exploiting the cyborg image. Feminists have recently claimed that women are given to dailiness, that women more than men somehow sustain daily life, and so have a privileged epistemological position potentially. There is a compelling aspect to this claim, one that makes visible unvalued female activity and names it as the ground of life. But *the* ground of life? What about all the ignorance of women, all the exclusions and failures of knowledge and skill? What about men's access to daily competence, to knowing how to build things, to take them apart, to play? What about other embodiments? Cyborg gender is a local possibility taking a global vengeance. Race, gender, and capital require a cyborg theory of wholes and parts. There is no drive in cyborgs to produce total theory, but there is an intimate experience of boundaries, their construction and deconstruction. There is a myth system waiting to become a political language to ground one way of looking at science and technology and challenging the informatics of domination – in order to act potently.

One last image: organisms and organismic, holistic politics depend on metaphors of rebirth and invariably call on the resources of reproductive sex. I would suggest that cyborgs have more to do with regeneration and are suspicious of the reproductive matrix and of most birthing. For salamanders, regeneration after injury, such as the loss of a limb, involves regrowth of structure and restoration of function with the constant possibility of twinning or other odd topographical productions at the site of former injury. The regrown limb can be monstrous, duplicated, potent. We have all been injured, profoundly. We require regeneration, not rebirth, and the possibilities for our reconstitution include the utopian dream of the hope for a monstrous world without gender.

Cyborg imagery can help express two crucial arguments in this essay: first, the production of universal, totalizing theory is a major mistake that misses most of reality, probably always, but certainly now; and second, taking responsibility for the social relations of science and technology means refusing an anti-science metaphysics, a demonology of technology, and so means embracing the skilful task of reconstructing the boundaries of daily life, in partial

connection with others, in communication with all of our parts. It is not just that science and technology are possible means of great human satisfaction, as well as a matrix of complex dominations. Cyborg imagery can suggest a way out of the maze of dualisms in which we have explained our bodies and our tools to ourselves. This is a dream not of a common language, but of a powerful infidel heteroglossia. It is an imagination of a feminist speaking in tongues to strike fear into the circuits of the super-savers of the new right. It means both building and destroying machines, identities, categories, relationships, space stories. Though both are bound in the spiral dance, I would rather be a cyborg than a goddess.

Notes

* The US equivalent of Mills and Boon.
** A practice at once both spiritual and political that linked guards and arrested anti-nuclear demonstrators in the Alameda County jail in California in the early 1980s.

1 Research was funded by an Academic Senate Faculty Research Grant from the University of California, Santa Cruz. An earlier version of the paper on genetic engineering appeared as "Lieber Kyborg als Göttin: für eine sozialistisch-feministische Unterwanderung der Gentechnologie", in Bernd-Peter Lange and Anna Marie Stuby, eds, Berlin: Argument-Sonderband 105, 1984, pp 66–84. The cyborg manifesto grew from my "New machines, new bodies, new communities: political dilemmas of a cyborg feminist", "The Scholar and the Feminist X: The Question of Technology", Conference, Barnard College, April 1983.

 The people associated with the History of Consciousness Board of UCSC have had an enormous influence on this paper, so that it feels collectively authored more than most, although those I cite may not recognize their ideas. In particular, members of graduate and undergraduate feminist theory, science, and politics, and theory and methods courses contributed to the cyborg manifesto. Particular debts here are due Hilary Klein (1989), Paul Edwards (1985), Lisa Lowe (1986), and James Clifford (1985).

 Parts of the paper were my contribution to a collectively developed session, "Poetic Tools and Political Bodies: Feminist Approaches to High Technology Culture", 1984 California American Studies Association, with History of Consciousness graduate students Zoe Sofoulis, "Jupiter space"; Katie King, "The pleasures of repetition and the limits of identification in feminist science fiction: reimaginations of the body after the cyborg"; and Chela Sandoval, "The construction of subjectivity and oppositional consciousness in feminist film and video". Sandoval's (n.d.) theory of oppositional consciousness was published as "Women respond to racism: a report on the National Women's Studies Association Conference". For Sofoulis's semiotic-psychoanalytic readings of nuclear culture, see Sofia (1984). King's unpublished papers ("Questioning tradition: canon formation and the veiling of power"; "Gender and genre: reading the science fiction of Joanna Russ"; "Varley's *Titan and Wizard*: feminist parodies of nature, culture, and hardware") deeply informed the cyborg manifesto.

 Barbara Epstein, Jeff Escoffier, Rusten Hogness, and Jaye Miler gave extensive discussion and editorial help. Members of the Silicon Valley Research Project of UCSC and participants in SVRP conferences and workshops were very important, especially Rick Gordon, Linda Kimball, Nancy Snyder, Langdon Winner, Judith Stacey, Linda Lim, Patricia Fernandez-Kelly, and Judith Gregory. Finally, I want to thank Nancy Hartsock for years of friendship and discussion on feminist theory and feminist science fiction. I also thank Elizabeth Bird for my favourite political button: "Cyborgs for Earthly Survival".

2 Useful references to left and/or feminist radical science movements and theory and to biological/biotechnical issues include: Bleier (1984, 1986), Harding (1986), Fausto-Sterling (1985), Gould (1981), Hubbard et al. (1982), Keller (1985), Lewontin et al. (1984), *Radical Science Journal* (became *Science as Culture* in 1987), 26 Freegrove Road, London N7 9RQ; *Science for the People*, 897 Main St, Cambridge, MA 02139.

3 Starting points for left and/or feminist approaches to technology and politics include: Cowan (1983), Rothschild (1983), Traweek (1988), Young and Levidow (1981, 1985), Weizenbaum (1976), Winner (1977, 1986), Zimmerman (1983), Athanasiou (1987), Cohn (1987a, 1987b), Winograd and Flores (1986), Edwards (1985). *Global Electronics Newsletter*, 867 West Dana St, #204, Mountain View, CA 94041; *Processed World*, 55 Sutter St, San Francisco, CA 94104; ISIS, Women's International Information and Communication Service, PO Box 50 (Cornavin), 1211 Geneva 2, Switzerland, and Via Santa Maria

Dell'Anima 30, 00186 Rome, Italy. Fundamental approaches to modern social studies of science that do not continue the liberal mystification that it all started with Thomas Kuhn, include: Knorr-Cetina (1981), Knorr-Cetina and Mulkay (1983), Latour and Woolgar (1979), Young (1979). The 1984 Directory of the Network for the Ethnographic Study of Science, Technology, and Organizations lists a wide range of people and projects crucial to better radical analysis; available from NESSTO, PO Box 11442, Stanford, CA 94305.

4 A provocative, comprehensive argument about the politics and theories of "postmodernism" is made by Fredric Jameson (1984), who argues that postmodernism is not an option, a style among others, but a cultural dominant requiring radical reinvention of left politics from within; there is no longer any place from without that gives meaning to the comforting fiction of critical distance. Jameson also makes clear why one cannot be for or against postmodernism, an essentially moralist move. My position is that feminists (and others) need continuous cultural reinvention, postmodernist critique, and historical materialism; only a cyborg would have a chance. The old dominations of white capitalist patriarchy seem nostalgically innocent now: they normalized heterogeneity, into man and woman, white and black, for example. "Advanced capitalism" and postmodernism release heterogeneity without a norm, and we are flattened, without subjectivity, which requires depth, even unfriendly and drowning depths. It is time to write *The Death of the Clinic*. The clinic's methods required bodies and works; we have texts and surfaces. Our dominations don't work by medicalization and normalization any more; they work by networking, communications redesign, stress management. Normalization gives way to automation, utter redundancy. Michel Foucault's *Birth of the Clinic* (1963), *History of Sexuality* (1976), and *Discipline and Punish* (1975) name a form of power at its moment of implosion. The discourse of biopolitics gives way to technobabble, the language of the spliced substantive; no noun is left whole by the multinationals. These are their names, listed from one issue of *Science*: Tech-Knowledge, Genentech, Allergen, Hybritech, Compupro, Genen-cor, Syntex, Allelix, Agrigenetics Corp., Syntro, Codon, Repligen, MicroAngelo from Scion Corp., Percom Data, Inter Systems, Cyborg Corp., Statcom Corp., Intertec. If we are imprisoned by language, then escape from that prison-house requires language poets, a kind of cultural restriction enzyme to cut the code; cyborg heteroglossia is one form of radical cultural politics. For cyborg poetry, see Perloff (1984); Fraser (1984). For feminist modernist/postmodernist "cyborg" writing, see HOW(ever), 871 Corbett Ave, San Francisco, CA 94131.

5 Baudrillard (1983). Jameson (1984, p. 66) points out that Plato's definition of the simulacrum is the copy for which there is no original, i.e., the world of advanced capitalism, of pure exchange. See *Discourse* 9 (Spring/Summer 1987) for a special issue on technology (cybernetics, ecology, and the postmodern imagination).

6 For ethnographic accounts and political evaluations, see Epstein (1991), Sturgeon (1986). Without explicit irony, adopting the spaceship earth/whole earth logo of the planet photographed from space, set off by the slogan "Love Your Mother", the May 1987 Mothers and Others Day action at the nuclear weapons testing facility in Nevada none the less took account of the tragic contradictions of views of the earth. Demonstrators applied for official permits to be on the land from officers of the Western Shoshone tribe, whose territory was invaded by the US government when it built the nuclear weapons test ground in the 1950s. Arrested for trespassing, the demonstrators argued that the police and weapons facility personnel, without authorization from the proper officials, were the trespassers. One affinity group at the women's action called themselves the Surrogate Others; and in solidarity with the creatures forced to tunnel in the same ground with the bomb, they enacted a cyborgian emergence from the constructed body of a large, non-heterosexual desert worm.

7 Powerful developments of coalition politics emerge from "Third World" speakers, speaking from nowhere, the displaced centre of the universe, earth: "We live on the third planet from the sun" – *Sun Poem* by Jamaican writer, Edward Kamau Braithwaite, review by Mackey (1984). Contributors to Smith (1983) ironically subvert naturalized identities precisely while constructing a place from which to speak called home. See especially Reagon (in Smith, 1983, pp. 356–68); Trinh T. Minh-ha (1986–87).

8 Hooks (1981, 1984); Hull et al. (1982). Bambara (1981) wrote an extraordinary novel in which the women of colour theatre group, The Seven Sisters, explores a form of unity. See analysis by Butler-Evans (1987).

9 On orientalism in feminist works and elsewhere, see Lowe (1986); Said (1978); Mohanty (1984); *Many Voices, One Chant: Black Feminist Perspectives* (1984).

10 Katie King (1986, 1987a) has developed a theoretically sensitive treatment of the workings of feminist taxonomies as genealogies of power in feminist ideology and polemic. King examines Jaggar's (1983) problematic example of taxonomizing feminisms to make a little machine producing the desired final position. My caricature here of socialist and radical feminism is also an example.

11 The central role of object relations versions of psychoanalysis and related strong universalizing moves in discussing reproduction, caring work, and mothering in many approaches to epistemology under-line their authors' resistance to what I am calling postmodernism. For me, both the universalizing moves and these versions of psychoanalysis make analysis of "women's place in the integrated circuit" difficult and lead to systematic difficulties in accounting for or even seeing major aspects of the construction of gender and gendered social life. The feminist standpoint argument has been developed by: Flax (1983), Harding (1986), Harding and Hintikka (1983), Hartsock (1983a, b), O'Brien (1981), Rose (1983), Smith (1974, 1979). For rethinking theories of feminist materialism and feminist standpoints in response to criticism, see Harding (1986, pp. 163–96), Hartsock (1987), and Rose (1986).

12 I make an argumentative category error in "modifying" MacKinnon's positions with the qualifier "radical", thereby generating my own reductive critique of extremely heterogeneous writing, which does explic-itly use that label, by my taxonomically interested argument about writing which does not use the modifier and which brooks no limits and thereby adds to the various dreams of a common, in the sense of univocal, language for feminism. My category error was occasioned by an assignment to write from a particular taxonomic position which itself has a heterogeneous history, socialist-feminism, for *Socialist Review*. A critique indebted to MacKinnon, but without the reductionism and with an elegant feminist account of Foucault's paradoxical conservatism on sexual violence (rape), is de Lauretis (1985; see also 1986a, pp. 1–19). A theoretically elegant feminist social-historical examination of family violence, that insists on women's, men's, and children's complex agency without losing sight of the material structures of male domination, race, and class, is Gordon (1988).

13 This chart was published in 1985. My previous efforts to understand biology as a cybernetic command-control discourse and organisms as "natural-technical objects of knowledge" were Haraway (1979, 1983, 1984). The 1979 version of this dichotomous chart appears in *Simians, Cyborgs and Women*, NY: Routledge, 1991, ch. 3; for a 1989 version, see ch. 10. The differences indicate shifts in argument.

14 For progressive analyses and action on the biotechnology debates: *GeneWatch, a Bulletin of the Committee for Responsible Genetics*, 5 Doane St, 4th Floor, Boston, MA 02109; Genetic Screening Study Group (for-merly the Sociobiology Study Group of Science for the People), Cambridge, MA; Wright (1982, 1986); Yoxen (1983).

15 Starting references for "women in the integrated circuit": D'Onofrio-Flores and Pfafflin (1982), Fernandez-Kelly (1983), Fuentes and Ehrenreich (1983), Grossman (1980), Nash and Fernandez-Kelly (1983), Ong (1982), Science Policy Research Unit (1982).

16 King (1984). An abbreviated list of feminist science fiction underlying themes of this essay: Octavia Butler, *Wild Seed, Mind of My Mind, Kindred, Survivor*; Suzy McKee Charnas, *Motherliness*; Samuel R. Delany, the Nevèryon series; Anne McCaffery, *The Ship Who Sang, Dinosaur Planet;* Vonda McIntyre, *Superluminal, Dreamsnake*; Joanna Russ, *Adventures of Alix, The Female Man*; James Tiptree, Jr, *Star Songs of an Old Primate, Up the Walls of the World*; John Varley, *Titan, Wizard, Demon*.

17 French feminisms contribute to cyborg heteroglossia. Burke (1981); Irigaray (1977, 1979); Marks and de Courtivron (1980); *Signs* (Autumn 1981); Wittig (1973); Duchen (1986). For English translation of some currents of francophone feminism see *Feminist Issues: A Journal of Feminist Social and Political Theory*, 1980.

18 But all these poets are very complex, not least in their treatment of themes of lying and erotic, decen-tred collective and personal identities. Griffin (1978), Lorde (1984), Rich (1978).

19 Derrida (1976, especially part II); Lévi-Strauss (1971, especially "The Writing Lesson"); Gates (1985); Kahn and Neumaier (1985); Ong (1982); Kramarae and Treichler (1985).

20 The sharp relation of women of colour to writing as theme and politics can be approached through: Program for "The Black Woman and the Diaspora: Hidden Connections and Extended Acknowledg-ments", An International Literary Conference, Michigan State University, October 1985; Evans (1984); Christian (1985); Carby (1987); Fisher (1980); *Frontiers* (1980, 1983); Kingston (1977); Lerner (1973); Giddings (1985); Moraga and Anzaldúa (1981); Morgan (1984). Anglophone European and Euro-American women have also crafted special relations to their writing as a potent sign: Gilbert and Gubar (1979), Russ (1983).

21 The convention of ideologically taming militarized high technology by publicizing its applications to speech and motion problems of the disabled/differently abled takes on a special irony in monotheistic, patriarchal, and frequently anti-semitic culture when computer-generated speech allows a boy with no voice to chant the Haftorah at his bar mitzvah. See Sussman (1986). Making the always context-relative social definitions of "ableness" particularly clear, military high-tech has a way of making human beings disabled by definition, a perverse aspect of much automated battlefield and Star Wars R&D. See Welford (1 July 1986).

References

Athanasiou, Tom (1987) "High-tech politics: the case of artificial intelligence", *Socialist Review* 92: 7–35.

Bambara, Toni Cade (1981) *The Salt Eaters*. New York: Vintage/Random House.

Baudrillard, Jean (1983) *Simulations*, P. Foss, P. Patton, P. Beitchman, trans. New York: Semiotext[e].

Bleier, Ruth (1984) *Science and Gender: A Critique of Biology and Its Themes on Women*. New York: Pergamon.

—— , ed. (1986) *Feminist Approaches to Science*, New York: Pergamon.

Burke, Carolyn (1981) "Irigaray through the looking glass", *Feminist Studies* 7(2): 288–306.

Butler-Evans, Elliott (1987) "Race, gender and desire: narrative strategies and the production of ideology in the fiction of Toni Carde Bambara, Toni Morrison and Alice Walker", University of California at Santa Cruz, PhD thesis.

Carby, Hazel (1987) *Reconstructing Womanhood: The Emergence of the Afro-American Woman Novelist*. New York: Oxford University Press.

Christian, Barbara (1985) *Black Feminist Criticism: Perspectives on Black Women Writers*. New York: Pergamon.

Clifford, James (1985) "On ethnographic allegory", in James Clifford and George Marcus, eds, *Writing Culture: The Poetics and Politics of Ethnography*. Berkeley: University of California Press.

Cohn, Carol (1987a) "Nuclear language and how we learned to pat the bomb", *Bulletin of Atomic Scientists*, pp. 17–24.

—— (1987b) "Sex and death in the rational world of defense intellectuals", *Signs* 12(4): 687–718.

Cowan, Ruth Schwartz (1983) *More Work for Mother: The Ironies of Household Technology from the Open Hearth to the Microwave*. New York: Basic.

de Lauretis, Teresa (1985) "The violence of rhetoric: considerations on representation and gender", *Semiotica* 54: 11–31.

—— (1986a) "Feminist studies/critical studies: issues, terms, and contexts", in de Lauretis (1986b), pp. 1–19.

—— , ed. (1986b) *Feminist Studies/Critical Studies*. Bloomington: Indiana University Press.

de Waal, Frans (1982) *Chimpanzee Politics: Power and Sex among the Apes*. New York: Harper and Row.

Derrida, Jacques (1976) *Of Grammatology*, G.C. Spivak, trans. and introd. Baltimore: Johns Hopkins University Press.

D'Onofrio-Flores, Pamela and Pfafflin, Sheila M., eds (1982) *Scientific-Technological Change and the Role of Women in Development*. Boulder: Westview.

Douglas, Mary (1966) *Purity and Danger*. London: Routledge and Kegan Paul. [See Chapter 42 in this volume.]

—— (1970) *Natural Symbols*. London: Cresset Press.

Duchen, Claire (1986) *Feminism in France from May '68 to Mitterrand*. London: Routledge and Kegan Paul.

Edwards, Paul (1985) "Border wars: the science and politics of artificial intelligence", *Radical America* 19(6): 39–52.

Epstein, Barbara (1991) *Political Protest and Cultural Revolution: Nonviolent Direct Action in the Seventies and Eighties*. Berkeley: University of California Press.

Evans, Mari, ed. (1984) *Black Women Writers: A Critical Evaluation*. Garden City, NY: Doubleday/Anchor.

Fausto-Sterling, Anne (1985) *Myths of Gender: Biological Theories about Women and Men*. New York: Basic.

Fernandez-Kelly, Maria Patricia (1983) *For We Are Sold, I and My People*. Albany: State University of New York Press.

Fisher, Dexter, ed. (1980) *The Third Woman: Minority Women Writers of the United States*. Boston: Houghton Mifflin.

Flax, Jane (1983) "Political philosophy and the patriarchal unconscious: a psychoanalytic perspective on epistemology and metaphysics", in Harding and Hintikka (1983), pp. 245–82.

Foucault, Michel (1963) *The Birth of the Clinic: An Archaeology of Medical Perception*, A.M. Smith, trans. New York: Vintage, 1975.

—— (1975) *Discipline and Punish: The Birth of the Prison*, Alan Sheridan, trans. New York: Vintage, 1979.

—— (1976) *The History of Sexuality*, Vol. 1: *An Introduction*, Robert Hurley, trans. New York: Pantheon, 1978.

Fraser, Kathleen (1984) *Something. Even Human Voices. In the Foreground, a Lake*. Berkeley, CA: Kelsey St Press.

Fuentes, Annette and Ehrenreich, Barbara (1983) *Women in the Global Factory*. Boston: South End.

Gates, Henry Louis (1985) "Writing 'race' and the difference it makes", in *"Race", Writing and Difference*, special issue, *Critical Inquiry* 12(1): 1–20.

Giddings, Paula (1985) *When and Where I Enter: The Impact of Black Women on Race and Sex in America*. Toronto: Bantam.

Gilbert, Sandra M. and Gubar, Susan (1979) *The Madwoman in the Attic: The Woman Writer and the Nineteenth-Century Literary Imagination*. New Haven, CT: Yale University Press.

Gordon, Linda (1988) *Heroes of Their Own Lives. The Politics and History of Family Violence, Boston 1880–1960*. New York: Viking Penguin.

Gould, Stephen J. (1981) *Mismeasure of Man*. New York: Norton.

Griffin, Susan (1978) *Woman and Nature: The Roaring Inside Her*. New York: Harper and Row.

Grossman, Rachel (1980) "Women's place in the integrated circuit", *Radical America* 14(1): 29–50.

Haas, Violet and Perucci, Carolyn, eds (1984) *Women in Scientific and Engineering Professions*. Ann Arbor: University of Michigan Press.

Haraway, Donna J. (1979) "The biological enterprise: sex, mind, and profit from human engineering to sociobiology", *Radical History Review* 20: 206–37.

—— (1983) "Signs of dominance: from a physiology to a cybernetics of primate society", *Studies in History of Biology* 6: 129–219.

—— (1984) "Class, race, sex, scientific objects of knowledge: a socialist-feminist perspective on the social construction of productive knowledge and some political consequences", in Violet Haas and Carolyn Perucci (1984), pp. 212–29.

Harding, Sandra (1986) *The Science Question in Feminism*. Ithaca: Cornell University Press.

—— and Hintikka, Merill, eds (1983) *Discovering Reality: Feminist Perspectives on Epistemology, Metaphysics, Methodology, and Philosophy of Science*. Dordrecht: Reidel.

Hartsock, Nancy (1983a) "The feminist standpoint: developing the ground for a specifically feminist historical materialism", in Harding and Hintikka (1983), pp. 283–310.

—— (1983b) *Money, Sex, and Power*. New York: Longman; Boston: Northeastern University Press, 1984.

—— (1987) "Rethinking modernism: minority and majority theories", *Cultural Critique* 7: 187–206.

Hogness, E. Rusten (1983) "Why stress? A look at the making of stress, 1936–56", unpublished paper available from the author, 4437 Mill Creek Rd, Healdsburg, CA 95448.

hooks, bell (1981) *Ain't I a Woman*. Boston: South End.

—— (1984) *Feminist Theory: From Margin to Center*. Boston: South End.

Hubbard, Ruth, Henifin, Mary Sue, and Fried, Barbara, eds (1982) *Biological Woman, the Convenient Myth*. Cambridge, MA: Schenkman.

Hull, Gloria, Scott, Patricia Bell, and Smith, Barbara, eds (1982) *All the Women Are White, All the Men Are Black, But Some of Us Are Brave*. Old Westbury: The Feminist Press.

Irigaray, Luce (1977) *Ce sexe qui n'en est pas un*. Paris: Minuit.

—— (1979) *Et l'une ne bouge pas sans l'autre*. Paris: Minuit.

Jaggar, Alison (1983) *Feminist Politics and Human Nature*. Totowa, NJ: Roman and Allenheld.

Jameson, Frederic (1984) "Post-modernism, or the cultural logic of late capitalism", *New Left Review* 146: 53–92.

Kahn, Douglas and Neumaier, Diane, eds (1985) *Cultures in Contention*. Seattle: Real Comet.

Keller, Evelyn Fox (1985) *Reflections on Gender and Science*. New Haven: Yale University Press.

King, Katie (1984) "The pleasure of repetition and the limits of identification in feminist science fiction: reimaginations of the body after the cyborg", paper delivered at the California American Studies Association, Pamona.

—— (1986) "The situation of lesbianism as feminism's magical sign: contests for meaning and the U.S. women's movement, 1968–72", *Communication* 9(1): 65–92.

—— (1987a) "Canons without innocence", University of California at Santa Cruz, PhD thesis.

—— (1987b) *The Passing Dreams of Choice . . . Once Before and After: Audre Lorde and the Apparatus of Literary Production*, book prospectus, University of Maryland at College Park.

Kingston, Maxine Hong (1977) *China Men*. New York: Knopf.

Klein, Hilary (1989) "Marxism, psychoanalysis, and mother nature", *Feminist Studies* 15(2): 255–78.

Knorr-Cetina, Karin (1981) *The Manufacture of Knowledge*. Oxford: Pergamon.

—— and Mulkay, Michael, eds (1983) *Science Observed: Perspectives on the Social Study of Science*. Beverly Hills: Sage.

Kramarae, Cheris and Treichler, Paula (1985) *A Feminist Dictionary*. Boston: Pandora.

Lange, Bernd-Peter and Stuby, Anne Marie, eds (1984) *1984*. Berlin: Argument Sonderband 105.

Latour, Bruno (1984) *Les microbes, guerre et paix, suivi des irréductions*. Paris: Métailié.

—— and Woolgar, Steve (1979) *Laboratory Life: The Social Construction of Scientific Facts*. Beverly Hills: Sage.

Lerner, Gerda, ed. (1973) *Black Women in White America: A Documentary History*. New York: Vintage.

Lévi-Strauss, Claude (1971) *Tristes tropiques*, John Russell, trans. New York: Atheneum.

Lewontin, R.C., Rose, Steven, and Kamin, Leon J. (1984) *Not in Our Genes: Biology, Ideology, and Human Nature*. New York: Pantheon.

Lorde, Audre (1982) *Zami, a New Spelling of My Name*. Trumansberg, NY: Crossing, 1983.

—— (1984) *Sister Outsider*. Trumansberg, NY: Crossing.

Lowe, Lisa (1986) "French literary Orientalism: the representation of 'others' in the texts of Montesquieu, Flaubert, and Kristeva", University of California at Santa Cruz, PhD thesis.

Mackey, Nathaniel (1984) "Review", *Sulfur* 2: 200–5.

MacKinnon, Catherine (1982) "Feminism, marxism, method, and the state: an agenda for theory", *Signs* 7(3): 515–44.

—— (1987) *Feminism Unmodified: Discourses on Life and Law*. Cambridge, MA: Harvard University Press.

Many Voices, One Chant: Black Feminist Perspectives (1984) *Feminist Review* 17, special issue.

Marcuse, Herbert (1964) *One-Dimensional Man: Studies in the Ideology of Advanced Industrial Society*. Boston: Beacon.

Marks, Elaine and de Courtivron, Isabelle, eds (1980) *New French Feminisms*. Amherst: University of Massachusetts Press.

Merchant, Carolyn (1980) *The Death of Nature: Women, Ecology, and the Scientific Revolution*. New York: Harper and Row.

Mohanty, Chandra Talpade (1984) "Under western eyes: feminist scholarship and colonial discourse", *Boundary* 2, 3 (12/13): 333–58.

Moraga, Cherríe (1983) *Loving in the War Years: lo que nunca pasó por sus labios*. Boston: South End.

—— and Anzaldúa, Gloria, eds (1981) *This Bridge Called My Back: Writings by Radical Women of Color*. Watertown: Persephone.

Morgan, Robin, ed. (1984) *Sisterhood Is Global*. Garden City, NY: Anchor/Doubleday.

Nash, Jane and Fernandez-Kelly, Maria Patricia, eds (1983) *Women and Men and the International Division of Labor*. Albany: State University of New York Press.

O'Brien, Mary (1981) *The Politics of Reproduction*. New York: Routledge and Kegan Paul.

Ong, Aihwa (1987) *Spirits of Resistance and Capitalist Discipline: Factory Workers in Malaysia*. Albany: State University of New York Press.

Ong, Walter (1982) *Orality and Literacy: The Technologizing of the Word*. New York: Methuen.

Perloff, Marjorie (1984) "Dirty language and scramble systems", *Sulfur* 11: 178–83.

Rich, Adrienne (1978) *The Dream of a Common Language*. New York: Norton.

Rose, Hilary (1983) "Hand, brain, and heart: a feminist epistemology for the natural sciences", *Signs* 9(1): 73–90.

—— (1986) "Women's work: women's knowledge", in Juliet Mitchell and Ann Oakley, eds, *What is Feminism? A Re-Examination*. New York: Pantheon, pp. 161–83.

Rothschild, Joan, ed. (1983) *Machina ex Dea: Feminist Perspectives on Technology*. New York: Pergamon.

Russ, Joanna (1983) *How to Suppress Women's Writing*. Austin: University of Texas Press.

Said, Edward (1978) *Orientalism*. New York: Pantheon.

Sandoval, Chela (1984) "Dis-illusionment and the poetry of the future: the making of oppositional consciousness", University of California at Santa Cruz, PhD qualifying essay.

—— (n.d.) *Yours in Struggle: Women Respond to Racism, a Report on the National Women's Studies Association*. Oakland, CA: Center for Third World Organizing.

Science Policy Research Unit (1982) *Microelectronics and Women's Employment in Britain*. University of Sussex.

Smith, Barbara, ed. (1983) *Home Girls: A Black Feminist Anthology*. New York: Kitchen Table, Women of Color Press.

Smith, Dorothy (1974) "Women's perspective as a radical critique of sociology", *Sociological Inquiry* 44.

—— (1979) "A sociology of women", in J. Sherman and E.T. Beck, eds *The Prisms of Sex*. Madison: University of Wisconsin Press.

Sofia, Zoe (also Zoe Sofoulis) (1984) "Exterminating fetuses: abortion, disarmament, and the sexo-semiotics of extra-terrestrialism", *Diacritics* 14(2): 47–59.

Sofoulis, Zoe (1987) "Lacklein", University of California at Santa Cruz, unpublished essay.

—— (1988) "Through the lumen: Frankenstein and the optics of re-origination", University of California at Santa Cruz, PhD thesis.

Sturgeon, Noel (1986) "Feminism, anarchism, and non-violent direct action politics", University of California at Santa Cruz, PhD qualifying essay.

Sussman, Vic (1986) "Personal tech. Technology lends a hand", *The Washington Post Magazine*, 9 November, pp. 45–56.

Traweek, Sharon (1988) *Beamtimes and Lifetimes: The World of High Energy Physics*. Cambridge, MA: Harvard University Press.

Treichler, Paula (1987) "AIDS, homophobia, and biomedical discourse: an epidemic of signification", *October* 43: 31–70.

Trinh T. Minh-ha (1986–7) "Introduction", and "Difference: 'a special third world women issue'", *Discourse: Journal for Theoretical Studies in Media and Culture* 8: 3–38. [Chapter 20 in this volume.]

Weizenbaum, Joseph (1976) *Computer Power and Human Reason*. San Francisco: Freeman.

Welford, John Noble (1 July, 1986) "Pilot's helmet helps interpret high speed world", *New York Times*, pp. 21, 24.

Winner, Langdon (1977) *Autonomous Technology: Technics out of Control as a Theme in Political Thought*. Cambridge, MA: MIT Press.

—— (1980) "Do artifacts have politics?", *Daedalus* 109(1): 121–36.

—— (1986) *The Whale and the Reactor*. Chicago: University of Chicago Press.

Winograd, Terry and Flores, Fernando (1986) *Understanding Computers and Cognition: A New Foundation for Design*. Norwood, NJ: Ablex.

Wittig, Monique (1973) *The Lesbian Body*, David LeVay, trans. New York: Avon, 1975 (*Le corps lesbien*, 1973).

Wright, Susan (1982, July/August) "Recombinant DNA: the status of hazards and controls", *Environment* 24(6): 12–20, 51–53.

—— (1986) "Recombinant DNA technology and its social transformation, 1972–82", *Osiris*, 2nd series, 2: 303–60.

Young, Robert M. (1979, March) "Interpreting the production of science", *New Scientist* 29: 1026–8.

—— and Levidow, Les, eds (1981, 1985) *Science, Technology and the Labour Process*, 2 vols. London: CSE and Free Association Books.

Yoxen, Edward (1983) *The Gene Business*. New York: Harper and Row.

Zimmerman, Jan, ed. (1983) *The Technological Woman: Interfacing with Tomorrow*. New York: Praeger.

Chapter 54

N. KATHERINE HAYLES

VIRTUAL BODIES AND FLICKERING SIGNIFIERS

> We might regard patterning or predictability
> as the very essence and raison d'être of
> communication . . . communication is the creation
> of redundancy or patterning.
> > Gregory Bateson, *Steps to an
> > Ecology of Mind*

IN THIS LAST DECADE OF THE TWENTIETH CENTURY, information circulates as the currency of the realm. Genetics, warfare, entertainment, communications, grain production, and financial markets number among the sectors of society revolutionized by the shift to an information paradigm. The shift has also profoundly affected

contemporary fiction. If the effects on literature are not widely recognized, perhaps it is because they are at once pervasive and elusive. A book produced by typesetting may look very similar to one generated by a computerized program, but the technological processes involved in this transformation are not neutral. Different technologies of text production suggest different models of signification; changes in signification are linked with shifts in consumption; shifting patterns of consumption initiate new experiences of embodiment; and embodied experience interacts with codes of representation to generate new kinds of textual worlds.[1] In fact, each category – production, signification, consumption, bodily experience, and representation – is in constant feedback and feedforward loops with the others. Pull any thread in the skein, and the others prove to be entangled in it.

The clue that I want to pursue through these labyrinthine passages is provided by the following proposition: *even though information provides the basis for much of contemporary society, it is never present in itself.* The site where I will pick up this thread is the development of information theory in the years following World War II. In information-theoretic terms, information is conceptually distinct from the markers that embody it, for example, newsprint or electromagnetic waves. It is a pattern rather than a presence, defined by the probability distribution of the coding elements comprising the message. If information is pattern, then noninformation should be the absence of pattern, that is, randomness. This commonsense expectation ran into unexpected complications when certain developments within information theory implied that information could be equated with randomness as well as with pattern.[2] Identifying information with *both* pattern and randomness proved to be a powerful paradox, leading to the realization that in some instances, an infusion of noise into a system can cause it to reorganize at a higher level of complexity.[3] Within such a system, pattern and randomness are bound together in a complex dialectic that makes them not so much opposites as complements or supplements to each other. Each helps to define the other; each contributes to the flow of information through the system.

Were this dialectical relation only an aspect of the formal theory, its impact might well be limited to the problems of maximizing channel utility and minimizing noise that occupy electrical engineers. Through the development of information technologies, however, the interplay between pattern and randomness became a feature of everyday life. A common site where people are initiated into this dialectic is the cathode tube display. Working at the computer screen, I cannot read unaided the magnetic markers that physically embody the information within the computer, but I am acutely aware of the patterns of blinking lights that comprise the text in its screen format. When I discover that my computerized text has been garbled because I pressed the wrong function key, I experience firsthand the intrusion of randomness into pattern.

This knowledge, moreover, is not merely conceptual. It is also sensory and kinesthetic. As Friedrich Kittler has demonstrated in *Discourse Networks 1800/1900*, typewriters exist in a discourse network underlaid by the dialectic of presence and absence.[4] The keys on a manual typewriter are directly proportionate to the script they produce. One keystroke yields one letter, and striking the key harder produces a darker letter. The system lends itself to a model of signification that links signifier to signified in direct correspondence, for there is a one-to-one relation between the key and the letter it produces. By contrast, the connection between computer keys and text manipulation is nonproportional and electronic. Display brightness is unrelated to keystroke pressure, and striking a single key can effect massive changes in the entire text. Interacting with electronic images rather than a materially resistant text, I absorb through my fingers as well as my mind a model of signification in which no simple one-to-one correspondence exists between signifier and signified. I know kinesthetically as well as conceptually that the text can be manipulated in ways that would be impossible if it existed

as a material object rather than a visual display. As I work with the text-as-image, I instantiate within my body the habitual patterns of movement that make pattern and randomness more real, more relevant, and more powerful than presence and absence.[5]

In societies enmeshed within information networks, as the United States and other first-world countries are, this example can be multiplied a thousandfold. Money is increasingly experienced as informational patterns stored in computer banks rather than the presence of cash; in surrogacy and *in vitro* fertilization cases, informational genetic patterns compete with physical presence for the right to determine the "legitimate" parent; automated factories are controlled by programs that constitute the physical realities of work assignments and production schedules as flows of information through the system;[6] criminals are tied to crime scenes through DNA patterns rather than eyewitness accounts verifying their presence; right of access to computer networks rather than physical possession of the data determines nine-tenths of computer law;[7] sexual relationships are pursued through the virtual spaces of computer networks rather than through meetings at which the participants are physically present.[8] The effect of these transformations is to create a highly heterogeneous and fissured space in which discursive formations based on pattern and randomness jostle and compete with formations based on presence and absence. Given the long tradition of dominance that presence and absence have enjoyed in the Western tradition, the surprise is not that formations based on them continue to exist but that they are being displaced so rapidly across such a wide range of cultural sites.

Critical theory has also been marked by this displacement. At the same time that absence was reconceptualized in poststructuralist theory so that it is not mere nothingness but a productive force seminal to discourse and psycholinguistics, so randomness was reconceptualized in scientific fields so that it is not mere gibberish but a productive force essential to the evolution of complex systems. The parallel suggests that the dialetic between absence and presence came clearly into focus because it was already being displaced as a cultural presupposition by randomness and pattern. Presence and absence were forced into visibility, so to speak, because they were already losing their constitutive power to form the ground for discourse, becoming instead discourse's subject. In this sense deconstruction is the child of an information age, formulating its theories from strata pushed upward by the emerging substrata beneath.

The displacement of presence/absence hints at how central pattern/randomness may be informing contemporary ideas of language, narrative, and subjectivity. The new technologies of virtual reality illustrate the kind of phenomena that foreground pattern and randomness and make presence and absence seem irrelevant. Already an industry worth hundreds of millions, virtual reality puts the user's sensory system into a direct feedback loop with a computer.[9] In one version, the user wears a stereovision helmet and a body suit with sensors at joint positions. The user's movements are reproduced by a simulacrum on the computer screen called a puppet. When the user turns her head, the computer display changes in a corresponding fashion. At the same time, audiophones create a three-dimensional sound field. Kinesthetic sensations, such as G-loads for flight simulators, can be supplied by the body suit. The result is a multisensory interaction that creates the illusion the user is *inside* the computer. From my experience with the virtual reality simulations at the Human Interface Technology Laboratory and elsewhere, I can attest to the disorienting, exhilarating effect of feeling that subjectivity is dispersed throughout the cybernetic circuit. The user learns kinesthetically and proprioceptively in these systems that the boundaries of self are defined less by the skin than by the feedback loops connecting body and simulation in a techno-bio-integrated circuit.

Questions about presence and absence do not yield much leverage in this situation, for the puppet both is and is not present, just as the user both is and is not inside the screen.

Instead, the focus shifts to questions about pattern and randomness. What transformations govern the connections between user and puppet? What parameters control the construction of the screen world? What patterns can the user discover through interaction with the system? Where do these patterns fade into randomness? What stimuli cannot be encoded within the system and therefore exist only as extraneous noise? When and how does this noise coalesce into pattern?

The example, taken from technology, illustrates concerns that are also appropriate to literary texts. It may seem strange to connect postmodern bodies with print rather than electronic media, but bodies and books share a crucially important characteristic not present in electronic media. Unlike radio and television, which receive and transmit signals but do not permanently store messages, books carry their information in their bodies. Like the human body, the book is a form of information transmission and storage that incorporates its encodings in a durable material substrate. Once encoding in the material base has taken place, it cannot easily be changed. Print and proteins in this sense have more in common with each other than with any magnetic or electronic encodings, which can be erased and rewritten simply by changing the magnetic polarities. The metaphors of books, alphabets, and printing, pervasive in the discourse of genetics, are constituted through and by this similarity of corporeal encoding.

The entanglement of signal and materiality in bodies and books confers on them a parallel doubleness. Just as the human body is understood in molecular biology as simultaneously a physical structure and an expression of genetic information, so the literary corpus is at once a physical object and a space of representation, a body and a message. Because they have bodies, books and people have something to lose if they are regarded solely as informational patterns, namely the resistant materiality that has traditionally marked the experience of reading no less than it has marked the experience of living as embodied creatures. From this affinity emerge complex feedback loops between contemporary literature, the technologies that produce it, and the embodied readers who produce and are produced by books and technologies. The result is a network of changes that are moving in complex syncopation with one another. Changes in bodies as they are represented within literary texts have deep connections with changes in textual bodies as they are encoded within information media, and both stand in complex relation to changes in the construction of human bodies as they interface with information technologies. The term I use to designate this network of relations is informatics. Following Donna Haraway, I take informatics to mean the technologies of information as well as the biological, social, linguistic, and cultural changes that initiate, accompany, and complicate their development.[10]

I am now in a position to state my thesis explicitly. The contemporary pressure toward dematerilization, understood as an epistemic shift toward pattern/randomness and away from presence/absence, affects human and textual bodies on two levels at once, as a change in the body (the material substrate) and a change in the message (the codes of representation). To explore these transformations, I want to untangle and then entangle again the networks connecting technological modes of production to the objects produced and consumed, embodied experience to literary representation. The connectivity between these parts and ports is, as they say in the computer industry, massively parallel and highly interdigitated. My narrative will therefore weave back and forth between the represented worlds of contemporary fictions, models of signification implicit in word processing, embodied experience as it is constructed by interactions with information technologies, and the technologies themselves.

The next thread I will pull from this tangled skein concerns the models of signification suggested and instantiated by information technologies. Information technologies do more than change modes of text production, storage, and dissemination. They fundamentally alter the

relation of signified to signifier. Carrying the instabilities implicit in Lacanian floating signifiers one step further, information technologies create what I will call *flickering signifiers*, characterized by their tendency toward unexpected metamorphoses, attenuations, and dispersions. Flickering signifiers signal an important shift in the plate tectonics of language. Much of contemporary fiction is directly influenced by information technologies; cyberpunk, for example, takes informatics as its central theme. Even narratives without this focus can hardly avoid the rippling effects of informatics, for the changing modes of signification affect the *codes* as well as the subjects of representation.

Signifying the processes of production

"Language is not a code," Lacan asserted, because he wished to deny any one-to-one correspondence between the signifier and the signified.[11] In word processing, however, language is a code. The relation between assembly and compiler languages is specified by a coding arrangement, as is the relation of the compiler language to the programming commands that the user manipulates. Through these multiple transformations some quantity is conserved, but it is not the mechanical energy implicit in a system of levers or the molecular energy of a thermodynamical system. Rather it is the informational structure that emerges from the interplay between pattern and randomness. The immateriality of the text, deriving from a translation of mechanical leverage into informational patterns, allows transformations to take place that would be unthinkable if matter or energy were the primary basis for the systemic exchanges. This textual fluidity, which the user learns in her body as she interacts with the system, implies that signifiers flicker rather than float.

To explain what I mean by flickering signifiers, I will find it useful briefly to review Lacan's notion of floating signifiers. Lacan, operating within a view of language that was primarily print-based rather than electronically mediated, focused not surprisingly on presence and absence as the dialectic of interest.[12] When he formulated the concept of floating signifiers, he drew on Saussure's idea that signifiers are defined by networks of relational differences between themselves rather than by their relation to signifieds. He complicated this picture by maintaining that signifieds do not exist in themselves, except insofar as they are produced by signifiers. He imagined them as an ungraspable flow floating beneath a network of signifiers that itself is constituted through continual slippages and displacements. Thus for him a doubly reinforced absence is at the core of signification – absence of signifieds as things-in-themselves as well as absence of stable correspondences between signifiers. The catastrophe in psycholinguistic development corresponding to this absence in signification is castration, the moment when the (male) subject symbolically confronts the realization that subjectivity, like language, is founded on absence.

How does this scenario change when floating signifiers give way to flickering signifiers? Foregrounding pattern and randomness, information technologies operate within a realm in which the signifier is opened to a rich internal play of difference. In informatics the signifier can no longer be understood as a single marker, for example an ink mark on a page. Rather it exists as a flexible chain of markers bound together by the arbitrary relations specified by the relevant codes. As I write these words on my computer, I see the lights on the video screen, but for the computer the relevant signifiers are magnetic tracks on disks. Intervening between what I see and what the computer reads are the machine code that correlates alphanumeric symbols with binary digits, the compiler language that correlates these symbols with higher-level instructions determining how the symbols are to be manipulated, the processing program that mediates between these instructions and the commands I give the computer,

and so forth. A signifier on one level becomes a signified on the next higher level. Precisely because the relation between signifier and signified at each of these levels is arbitrary, it can be changed with a single global command. If I am producing ink marks by manipulating movable type, changing the font requires changing each line of type. By contrast, if I am producing flickering signifiers on a video screen, changing the font is as easy as giving the system a single command. The longer the chain of codes, the more radical the transformations that can be effected. Acting as linguistic levers, the coding chains impart astonishing power to even very small changes.

Such leverage is possible because the constant reproduced through multiple coding layers is a pattern rather than a presence. Pattern can be recognized through redundancy or repetition of elements. If there is only repetition, however, no new information is imparted; the intermixture of randomness rescues pattern from sterility. If there is only randomness, the result is gibberish rather than communication. Information is produced by a complex dance between predictability and unpredictability, repetition and variation. We have seen that the possibilities for mutation are enhanced and heightened by long coding chains. We can now understand mutation in more fundamental terms. Mutation is crucial because it names the bifurcation point at which the interplay between pattern and randomness causes the system to evolve in a new direction.[13] Mutation implies both the replication of pattern – the morphological standard against which it can be measured and understood as a mutation – and the interjection of randomness – the variations that mark it as a deviation so decisive it can no longer be assimilated into the same.

Mutation is the catastrophe in the pattern/randomness dialetic analogous to castration in presence/absence. It marks the opening of pattern to randomness so extreme that the expectation of continuous replication can no longer be sustained. But as with castration, this only appears to be a disruption located at a specific moment. The randomness to which mutation testifies is always already interwoven into pattern. One way to understand this "always already" is through the probability function that mathematically defines information in Claude Shannon's classic equations in information theory.[14] Were randomness not always already immanent, we would be in the Newtonian world of strict causality rather than the information-theoretic realm of probability. More generally, randomness is involved because it is only against the background or possibility of nonpattern that pattern can emerge. Wherever pattern exists, randomness is implicit as the contrasting term that allows pattern to be understood as such. The crisis named by mutation is as wide-ranging and pervasive in its import within the pattern/randomness dialectic as castration is within the tradition of presence/absence, for it is the visible mark that testifies to the continuing interplay of the dialectical terms.

Shifting the emphasis from presence/absence to pattern/randomness suggests different choices for tutor texts. Rather than Freud's discussion of "fort/da" (a short passage whose replication in hundreds of commentaries would no doubt astonish its creator), theorists interested in pattern and randomness might point to something like David Cronenberg's film *The Fly* [Figure 54.1]. At a certain point the protagonist's penis does fall off (he quaintly puts it in his medicine chest as a memento to times past), but the loss scarcely registers in the larger metamorphosis he is undergoing. The operative transition is not from male to female-as-castrated-male, but from human to something radically other than human. Flickering signification brings together language with a psychodynamics based on the symbolic moment when the human confronts the posthuman.

I understand "human" and "posthuman" to be historically specific constructions that emerge from different configurations of embodiment, technology, and culture. A convenient point of reference for the human is the picture constructed by nineteenth-century American and British

Figure 54.1 Metamorphosis in progress in David Cronenberg's *The Fly*, 1986.

anthropologists of "man" as a tool-user.[15] Using tools may shape the body (some anthropologists made this argument), but the tool nevertheless is envisioned as an object, apart from the body, that can be picked up and put down at will. When the claim could not be sustained that man's unique nature was defined by tool use (because other animals were shown also to use tools), the focus shifted during the early twentieth century to man the tool-maker. Typical is Kenneth P. Oakley's 1949 *Man the Tool-Maker*, a magisterial work with the authority of the British Museum behind it.[16] Oakley, in charge of the Anthropological Section of the museum's Natural History division, wrote in his introduction, "Employment of tools appears to be [man's] chief biological characteristic, for considered functionally they are detachable extensions of the forelimb" (1). The kind of tool he envisioned was mechanical rather than informational; it goes *with* the hand, not *on* the head. Significantly, he imagined the tool to be at once "detachable" and an "extension," separate from yet partaking of the hand. If the placement and kind of tool marks his affinity with the epoch of the human, its construction as a prosthesis points forward to the posthuman. Similar ambiguities informed the Macy Conference discussions taking place during the same period (1946–53), as participants wavered between a vision of man as a homeostatic, self-regulating mechanism whose boundaries were clearly delineated from the environment,[17] and a more threatening, reflexive vision of a man spliced into an informational circuit that could change him in unpredictable ways. By the 1960s, the consensus within cybernetics had shifted dramatically toward the reflexivity. By the 1980s, the inertial pull of homeostasis as a constitutive concept had largely given way to theories of self-organization that implied radical changes were possible within certain kinds of complex systems.[18] Through these discussions, the "posthuman" future of "humanity" began increasingly to be evoked. Examples range from Hans Moravec's invocation of a "postbiological"

future in which human consciousness is downloaded into a computer, to the more sedate (and in part already realized) prospect of a symbiotic union between human and intelligent machine that Howard Rheingold calls "intelligence augmentation."[19] Although these visions differ in the degree and kind of interfaces they imagine, they concur that the posthuman implies a coupling so intense and multifaceted that it is no longer possible to distinguish meaningfully between the biological organism and the informational circuits in which it is enmeshed. Accompanying this change, I have argued, is a corresponding shift in how signification is understood and corporeally experienced. In contrast to Lacanian psycholinguistics, derived from the generative coupling of linguistics and sexuality, flickering signification is the progeny of the fascinating and troubling coupling of language and machine.

[. . .]

"Functionality" is a term used by virtual reality technologists to describe the communication modes that are active in a computer–human interface. If the user wears a data glove, for example, hand motions constitute one functionality. If the computer can respond to voice-activated commands, voice is another functionality. If it can sense body position, spatial location is yet another. Functionalities work in both directions; that is, they both describe the computer's capabilities and also indicate how the user's sensory-motor apparatus is being trained to accommodate the computer's responses. Working with a VR simulation, the user learns to move her hand in stylized gestures that the computer can accommodate. In the process, changes take place in the neural configuration of the user's brain, some of which can be long-lasting. The computer molds the human even as the human builds the computer.

When narrative functionalities change, a new kind of reader is produced by the text. The effects of flickering signification ripple outward because readers are trained to read through different functionalities, which can affect how they interpret any text, including texts written before computers were invented. Moreover, changes in narrative functionalities go deeper than structural or thematic characteristics of a specific genre, for they shift the modalities that are activated to produce the narrative. It is on this level that the subtle connections between information narratives and other kinds of contemporary fictions come into play.

Drawing on a context that included information technologies, Roland Barthes in *S/Z* brilliantly demonstrated the possibility of reading a text as a production of diverse codes.[20] Information narratives make that possibility an inevitability, for they often cannot be understood, even on a literal level, without referring to codes and their relation to information technologies. Flickering signification extends the productive force of codes beyond the text to include the signifying processes by which the technologies produce texts, as well as the interfaces that enmesh humans into integrated circuits. As the circuits connecting technology, text, and human expand and intensify, the point where quantitative increments shade into qualitative transformation draws closer.

If my assessment that the dialectic of pattern/randomness is displacing presence/absence is correct, the implications extend beyond narrative into many cultural arenas. In my view, one of the most serious of these implications for the present cultural moment is a systematic devaluation of materiality and embodiment. I find this trend ironic, for changes in material conditions and embodied experience are precisely what give the shift its deep roots in everyday experience. In this essay I have been concerned not only to anatomize the shift and understand its implications for literature but also to suggest that it should be understood in the context of changing experiences of embodiment. If, on the one hand, embodiment implies that informatics is imprinted into body as well as mind, on the other, it also acts as a reservoir of materiality that resists the pressure toward dematerialization.

Implicit in nearly everything I have written here is the assumption that presence and pattern are opposites existing in antagonistic relation. The more emphasis that falls on one, the less the other is noticed and valued. Entirely different readings emerge when one entertains the possibility that pattern and presence are mutually enhancing and supportive. Paul Virilio has observed that one cannot ask whether information technologies should continue to be developed.[21] Given the market forces already at work, it is virtually (if I may use the word) certain that increasingly we will live, work, and play in environments that construct us as embodied virtualities.[22] I believe that our best hope to intervene constructively in this development is to put an interpretive spin on it that opens up the possibilities of seeing pattern and presence as complementary rather than antagonistic. Information, like humanity, cannot exist apart from the embodiment that brings it into being as a material entity in the world; and embodiment is always instantiated, local, and specific. Embodiment can be destroyed but it cannot be replicated. Once the specific form constituting it is gone, no amount of massaging data will bring it back. This observation is as true of the planet as it is of an individual life-form. As we rush to explore the new vistas that cyberspace has made available for colonization, let us also remember the fragility of a material world that cannot be replaced.

Notes

I am indebted to Brooks Landon and Felicity Nussbaum for their helpful comments on this essay.

1 Among the studies that explore these connections are Jay Bolter, *Writing Space: The Computer, Hypertext, and the History of Writing* (Hillsdale, N.J.: Lawrence Erlbaum Associates, 1991); Michael Heim, *Electric Language: A Philosophical Study of Word Processing* (New Haven: Yale University Press, 1987); and Mark Poster, *The Mode of Information: Poststructuralism and Social Context* (Chicago: University of Chicago Press, 1990).

2 The paradox is discussed in N. Katherine Hayles, *Chaos Bound: Orderly Disorder in Contemporary Literature and Science* (Ithaca: Cornell University Press, 1990), pp. 31–60.

3 Self-organizing systems are discussed in Grégoire Nicolis and Ilya Prigogine, *Exploring Complexity: An Introduction* (New York: Freeman and Company, 1989); Roger Lewin, *Complexity: Life at the Edge of Chaos* (New York: Macmillan 1992); and M. Mitchell Waldrop, *Complexity: The Emerging Science at the Edge of Order and Chaos* (New York: Simon and Schuster, 1992).

4 Friedrich A. Kittler, *Discourse Networks 1800/1900*, trans. Michael Metteer and Chris Cullens (Stanford: Stanford University Press, 1990).

5 The implications of these conditions for postmodern embodiment are explored in N. Katherine Hayles, "The Materiality of Informatics," *Configurations: A Journal of Literature, Science, and Technology* 1 (Winter 1993), pp. 147–70.

6 In *The Age of the Smart Machine: The Future of Work and Power* (New York: Basic Books, 1988), Shoshana Zuboff explores through three case studies the changes in American workplaces as industries become informatted.

7 Computer law is discussed in Katie Hafner and John Markoff, *Cyberpunk: Outlaws and Hackers on the Computer Frontier* (New York: Simon and Schuster, 1991); also informative is Bruce Sterling, *The Hacker Crackdown: Law and Disorder on the Electronic Frontier* (New York: Bantam, 1992).

8 Sherry Turkel documents computer network romances in "Constructions and Reconstructions of the Self in Virtual Reality," a paper presented at the Third International Conference on Cyberspace (Austin, Texas, May 1993); Nicholson Baker's *Vox: A Novel* (New York: Random House, 1992) imaginatively explores the erotic potential for better living through telecommunications; and Howard Rheingold looks at the future of erotic encounters in cyberspace in "Teledildonics and Beyond," *Virtual Reality* (New York: Summit Books, 1991), pp. 345–77.

9 Howard Rheingold surveys the new virtual technologies in *Virtual Reality*. Also useful is Ken Pimentel and Kevin Teixeira, *Virtual Reality: Through the New Looking Glass* (New York: McGraw-Hill, 1993).

Benjamin Woolley takes a skeptical approach toward claims for the new technology in *Virtual Worlds: A Journey in Hyped Hyperreality* (Oxford: Blackwell, 1992).

10 Donna Haraway, "Manifesto for Cyborgs: Science, Technology, and Socialist Feminism in the 1980s," *Socialist Review* 80 (1985), pp. 65–108 [Chapter 53 in this volume]; see also "The High Cost of Information in Post World War II Evolutionary Biology: Ergonomics, Semiotics, and the Sociobiology of Communications Systems," *Philosophical Forum* 8, no. 2–3 (1981–82), pp. 244–75.

11 Jacques Lacan, "Radiophonies," *Scilicet* 2/3 (1970), pp. 55, 68. For floating signifiers, see *Le Séminaire XX: Encore* (Paris: Seuil, 1975), pp. 22, 35.

12 Although presence and absence loom larger in Lacanian psycholinguistics than do pattern and randomness, Lacan was not uninterested in information theory. In the 1954–55 Seminar, he played with incorporating ideas from information theory and cybernetics into psychoanalysis. See especially "The Circuit" (pp. 77–90) and "Psychoanalysis and Cybernetics, or on the Nature of Language" (pp. 294–308) in *The Seminar of Jacques Lacan: Book II*, ed. Jacques-Alain Miller (New York: W.W. Norton and Co., 1991).

13 Several theorists of the postmodern have identified mutation as an important element of postmodernism, including Ihab Hassan in *The Postmodern Turn: Essays in Postmodern Theory and Culture* (Columbus: Ohio State University, 1987), p. 91, and Donna Haraway, "The Actors Are Cyborgs, Nature Is Coyote, and the Geography Is Elsewhere: Postscript to 'Cyborgs at Large,'" in *Technoculture*, ed. Constance Penley and Andrew Ross (Minneapolis: University of Minnesota Press, 1991), pp. 21–26.

14 Claude E. Shannon and Warren Weaver, *The Mathematical Theory of Communication* (Urbana: University of Illinois Press, 1949).

15 The gender encoding implicit in "man" (rather than human) is also reflected in the emphasis on tool usage as a defining characteristic, rather than, say, altruism or extended nurturance, traits traditionally encoded female.

16 Kenneth P. Oakley, *Man the Tool-Maker* (London: Trustees of the British Museum, 1949).

17 The term "homeostasis," or self-regulating stability through cybernetic corrective feedback, was introduced by physiologist Walter B. Cannon in "Organization for Physiological Homeostasis," *Physiological Reviews* 9 (1929), pp. 399–431. Cannon's work influenced Norbert Wiener, and homeostasis became an important concept in the initial phase of cybernetics from 1946–53.

18 Key figures in moving from homeostasis to self-organization were Heinz von Foerster, especially *Observing Systems* (Salinas, Calif.: Intersystems Publications, 1981) and Humberto R. Maturana and Francisco J. Varela, *Autopoiesis and Cognition: The Realization of the Living* (Dordrecht: Reidel, 1980).

19 Howard Rheingold, *Virtual Reality*, pp. 13–49; Hans Moravec, *Mind Children: The Future of Robot and Human Intelligence* (Cambridge: Harvard University Press, 1988), pp. 1–5, 116–22.

20 Roland Barthes, *S/Z*, trans. Richard Miller (New York: Hill and Wang, 1974).

21 Paul Virilio and Sylvère Lotringer, *Pure War*, trans. Mark Polizzotti (New York: Semiotext(e), 1983).

22 "Embodied virtuality" is Mark Weiser's phrase in "The Computer for the 21st Century," *Scientific American* 265 (September 1991), pp. 94–104. Weiser distinguishes between technologies that put the user into a simulation with the computer (virtual reality) and those that embed computers within already existing environments (embodied virtuality or ubiquitous computing). In virtual reality, the user's sensorium is redirected into functionalities compatible with the simulation; in embodied virtuality, the sensorium continues to function as it normally would but with an expanded range made possible through the environmentally embedded computers.

ELIZABETH GROSZ

BODIES–CITIES

I Congruent counterparts

FOR A NUMBER OF YEARS I have been involved in research on the body as sociocultural artifact. I have been interested in challenging traditional notions of the body so that we can abandon the oppositions by which the body has usually been understood – mind and body, inside and outside, experience and social context, subject and object, self and other, and underlying these, the opposition between male and female. Thus "stripped," corporeality in its sexual specificity may be seen as the material condition of subjectivity, that is, the body itself may be regarded as the locus and site of inscription for specific modes of subjectivity. In a "deconstructive turn," the subordinated terms of these oppositions take their rightful place at the very heart of the dominant ones.

Among other things, my recent work has involved a kind of turning *inside out* and *outside in* of the sexed body, questioning how the subject's exteriority is psychically constructed, and conversely, how the processes of social inscription of the body's surface construct for it a psychical interior. In other words, I have attempted to problematize the opposition between the inside and the outside by looking at the outside of the body from the point of view of the inside, and looking at the inside of the body from the point of view of the outside, thus re-examining and questioning the distinction between biology and culture, exploring the way in which culture constructs the biological order in its own image, the way in which the psychosocial simulates and produces the body as such. Thus I am interested in exploring the ways in which the body is psychically, socially, sexually, and discursively or representationally produced, and the ways, in turn, bodies reinscribe and project themselves onto their sociocultural environment so that this environment both produces and reflects the form and interests of the body. This relation of introjections and projections involves a complex feedback relation in which neither the body nor its environment can be assumed to form an organically unified ecosystem. (The very notion of an ecosystem implies a kind of higher-order unity or encompassing totality that I will try to problematize in this paper.) The body and its environment, rather, produce each other as forms of the hyperreal, as modes of simulation which have overtaken and transformed whatever reality each may have had into the image of the other: the city is made and made over into the simulacrum of the body, and the body, in its turn, is transformed, "citified," urbanized as a distinctively metropolitan body.

One area that I have neglected for too long – and I am delighted to have the opportunity here to begin to rectify this – is the constitutive and mutually defining relation between bodies and cities. The city is one of the crucial factors in the social production of (sexed) corporeality: the built environment provides the context and coordinates for most contemporary Western and, today, Eastern forms of the body, even for rural bodies insofar as the

twentieth century defines the countryside, "the rural," as the underside or raw material of urban development. The city has become the defining term in constructing the image of the land and the landscape, as well as the point of reference, the centrepiece of a notion of economic/social/political/cultural exchange and a concept of a "natural ecosystem." The ecosystem notion of exchange and "natural balance" is itself a counterpart to the notion of a global economic and informational exchange system (which emerged with the computerization of the stock exchange in the 1970s).

The city provides the order and organization that automatically links otherwise unrelated bodies. For example, it links the affluent lifestyle of the banker or professional to the squalor of the vagrant, the homeless, or the impoverished without necessarily positing a conscious or intentional will-to-exploit. It is the condition and milieu in which corporeality is socially, sexually, and discursively produced. But if the city is a significant context and frame for the body, the relations between bodies and cities are more complex than may have been realized. My aim here will be to explore the constitutive and mutually defining relations between corporeality and the metropolis, if only in a rather sketchy but I hope suggestive fashion. I would also like to project into the not-too-distant future some of the effects of the technologization and the technocratization of the city on the forms of the body, speculating about the enormous and so far undecidable prosthetic and organic changes this may effect for, or in, the lived body. A deeper exploration would of course be required to elaborate the historico-geographic specificity of bodies, their production as determinate types of subject with distinctive modes of corporeality.

Before going into any detail, it may be useful to define the two key terms I will examine today, *body* and *city*.

By *body* I understand a concrete, material, animate organization of flesh, organs, nerves, muscles, and skeletal structure which are given a unity, cohesiveness, and organization only through their psychical and social inscription as the surface and raw materials of an integrated and cohesive totality. The body is, so to speak, organically/biologically/naturally "incomplete"; it is indeterminate, amorphous, a series of uncoordinated potentialities which require social triggering, ordering, and long-term "administration," regulated in each culture and epoch by what Foucault has called "the micro-technologies of power."[1] The body becomes a *human* body, a body which coincides with the "shape" and space of a psyche, a body whose epidermic surface bounds a psychical unity, a body which thereby defines the limits of experience and subjectivity, in psychoanalytic terms, through the intervention of the (m)other, and, ultimately, the Other or Symbolic order (language and rule-governed social order). Among the key structuring principles of this produced body is its inscription and coding by (familially ordered) sexual desires (the desire of the other), which produce (and ultimately repress) the infant's bodily zones, orifices, and organs as libidinal sources; its inscription by a set of socially coded meanings and significances (both for the subject and for others), making the body a meaningful, "readable," depth-entity; and its production and development through various regimes of discipline and training, including the coordination and integration of its bodily functions so that not only can it undertake the general social tasks required of it, but so that it becomes an integral part of or position within a social network, linked to other bodies and objects.

By *city*, I understand a complex and interactive network which links together, often in an unintegrated and de facto way, a number of disparate social activities, processes, and relations, with a number of imaginary and real, projected or actual architectural, geographic, civic, and public relations. The city brings together economic and informational flows, power networks, forms of displacement, management, and political organization, interpersonal,

familial, and extra-familial social relations, and an aesthetic/economic organization of space and place to create a semipermanent but ever-changing built environment or milieu. In this sense, the city can be seen, as it were, as midway between the village and the state, sharing the interpersonal interrelations of the village (on a neighborhood scale) and the administrative concerns of the state (hence the need for local government, the pre-eminence of questions of transportation, and the relativity of location).

II Body politic and political bodies

I will look at two pervasive models of the interrelation of bodies and cities, and, in outlining their problems, I hope to suggest alternatives that may account for future urban developments and their corporeal consequences.

In the first model, the body and the city have merely a de facto or external, contingent rather than constitutive relation. The city is a reflection, projection, or product of bodies. Bodies are conceived in naturalistic terms, predating the city, the cause and motivation for their design and construction. This model often assumes an ethnological and historical character: the city develops according to human needs and design, developing from nomadism to sedentary agrarianism to the structure of the localized village, the form of the polis through industrialization to the technological modern city and beyond. More recently, we have heard an inverted form of this presumed relation: cities have become (or may have always been) alienating environments, environments which do not allow the body a "natural," "healthy," or "conducive" context.

Underlying this view of the city as a product or projection of the body (in all its variations) is a form of humanism: the human subject is conceived as a sovereign and self-given agent which, individually and collectively, is responsible for all social and historical production. Humans *make* cities. Moreover, in such formulations the body is usually subordinated to and seen merely as a "tool" of subjectivity, of self-given consciousness. The city is a product not simply of the muscles and energy of the body, but the conceptual and reflective possibilities of consciousness itself: the capacity to design, to plan ahead, to function as an intentionality and thereby be transformed in the process. This view is reflected in the separation or binarism of design, on the one hand, and construction, on the other, the division of mind from hand (or art from craft). Both Enlightenment humanism and marxism share this view, the distinction being whether the relation is conceived as a one-way relation (from subjectivity to the environment), or a dialectic (from subjectivity to environment and back again). Nonetheless, both positions consider the active agent in social production (whether the production of commodities or in the production of cities) to be the subject, a rational or potentially rational consciousness clothed in a body, the "captain of the ship," the "ghost in the machine."

In my opinion, this view has at least two serious problems. First, it subordinates the body to the mind while retaining a structure of binary opposites. Body is merely a tool or bridge linking a nonspatial (i.e., Cartesian) consciousness to the materiality and coordinates of the built environment, a kind of mediating term between mind on the one hand and inorganic matter on the other, a term that has no agency or productivity of its own. It is presumed to be a machine, animated by a consciousness. Second, at best, such a view only posits a one-way relation between the body or the subject and the city, linking them through a causal relation in which body or subjectivity is conceived as the cause, and the city its effect. In more sophisticated versions of this view, the city can have a negative feedback relation with the bodies that produce it, thereby alienating them. Implicit in this position is the active causal power of the subject in the design and construction of cities.

Another equally popular formulation proposes a kind of parallelism or isomorphism between the body and the city. The two are understood as analogues, congruent counterparts, in which the features, organization, and characteristics of one are reflected in the other. This notion of the parallelism between the body and social order (usually identified with the state) finds its clearest formulations in the seventeenth century, when liberal political philosophers justified their various allegiances (the divine right of kings, for Hobbes; parliamentary representation, for Locke; direct representation, for Rousseau, etc.) through the metaphor of the body-politic. The state parallels the body; artifice mirrors nature. The correspondence between the body and the body-politic is more or less exact and codified: the King usually represented as the head of the body-politic,[2] the populace as the body. The law has been compared to the body's nerves, the military to its arms, commerce to its legs or stomach, and so on. The exact correspondences vary from text to text, and from one political regime to another. However, if there is a morphological correspondence or parallelism between the artificial commonwealth (the "Leviathan") and the human body in this pervasive metaphor of the body-politic, the body is rarely attributed a sex. If one presses this metaphor just a little, we must ask: if the state or the structure of the polis/city mirrors the body, what takes on the metaphoric function of the genitals in the body-politic? What kind of genitals are they? In other words, does the body-politic have a sex?

Here once again, I have serious reservations. The first regards the implicitly phallocentric coding of the body-politic, which, while claiming it models itself on the *human* body, uses the male to represent the human. Phallocentrism is, in my understanding, not so much the dominance of the phallus as the pervasive unacknowledged use of the male or masculine to represent the human. The problem, then, is not so much to eliminate as to reveal the masculinity inherent in the notion of the universal, the generic human, or the unspecified subject. The second reservation concerns the political function of this analogy: it serves to provide a justification for various forms of "ideal" government and social organization through a process of "naturalization": the human body is a natural form of organization which functions not only for the good of each organ but primarily for the good of the whole. Similarly, the body politic, whatever form it may take,[3] justifies and naturalizes itself with reference to some form of hierarchical organization modelled on the (presumed and projected) structure of the body. A third problem: this conception of the body-politic relies on a fundamental opposition between nature and culture, in which nature dictates the ideal forms of culture. Culture is a supercession and perfection of nature. The body-politic is an artificial construct which replaces the primacy of the natural body. Culture is molded according to the dictates of nature, but transforms nature's limits. In this sense, nature is a passivity on which culture works as male (cultural) productivity supercedes and overtakes female (natural) reproduction.

But if the relation between bodies and cities is neither causal (the first view) nor representational (the second view), then what kind of relation exists between them? These two models are inadequate insofar as they give precedence to one term or the other in the body/city pair. A more appropriate model combines elements from each. Like the causal view, the body (and not simply a disembodied consciousness) must be considered active in the production and transformation of the city. But bodies and cities are not causally linked. Every cause must be logically distinct from its effect. The body, however, is not distinct, does not have an existence separate from the city, for they are mutually defining. Like the representational model, there may be an isomorphism between the body and the city. But it is not a mirroring of nature in artifice. Rather, there is a two-way linkage which could be defined as an *interface*, perhaps even a cobuilding. What I am suggesting is a model of the relations between bodies and cities which sees them, not as megalithic total entities, distinct identities, but as

assemblages or collections of parts, capable of crossing the thresholds between substances to form linkages, machines, provisional and often temporary sub- or microgroupings. This model is a practical one, based on the practical productivity bodies and cities have in defining and establishing each other. It is not a holistic view, one that stresses the unity and integration of city and body, their "ecological balance." Instead, I am suggesting a fundamentally disunified series of systems and interconnections, a series of disparate flows, energies, events or entities, and spaces, brought together or drawn apart in more or less temporary alignments.

The city in its particular geographical, architectural, spatializing, municipal arrangements is one particular ingredient in the social constitution of the body. It is by no means the most significant. The structure and particularity of, say, the family is more directly and visibly influential, although this in itself is to some extent a function of the social geography of cities. But nonetheless, the form, structure, and norms of the city seep into and affect all the other elements that go into the constitution of corporeality and/as subjectivity. It affects the way the subject sees others (domestic architecture and the division of the home into the conjugal bedroom, separated off from other living and sleeping spaces, and the specialization of rooms are as significant in this regard as smaller family size[4]), as well as the subject's understanding of, alignment with, and positioning in space. Different forms of lived spatiality (the verticality of the city, as opposed to the horizontality of the landscape – at least our own) affect the ways we live space, and thus our comportment and corporeal orientations and the subject's forms of corporeal exertion – the kind of terrain it must negotiate day by day, the effect this has on its muscular structure, its nutritional context, providing the most elementary forms of material support and sustenance for the body. Moreover, the city is, of course, also the site for the body's cultural saturation, its takeover and transformation by images, representational systems, the mass media, and the arts – the place where the body is representationally reexplored, transformed, contested, reinscribed. In turn, the body (as cultural product) transforms, reinscribes the urban landscape according to its changing (demographic, economic, and psychological) needs, extending the limits of the city, of the sub-urban, ever towards the countryside which borders it. As a hinge between the population and the individual, the body, its distribution, habits, alignments, pleasures, norms, and ideals are the ostensible object of governmental regulation, and the city is a key tool.[5]

III Body spaces

Some general implications:

First, there is no natural or ideal environment for the body, no "perfect" city, judged in terms of the body's health and well-being. If bodies are not culturally pregiven, built environments cannot alienate the very bodies they produce. However, what may prove unconducive is the rapid transformation of an environment, such that a body inscribed by one cultural milieu finds itself in another involuntarily. This is not to say that there are not *un*conducive city environments, but rather there is nothing intrinsically alienating or unnatural about the city. The question is not simply how to distinguish conducive from unconducive environments, but to examine how different cities, different sociocultural environments actively produce the bodies of their inhabitants as particular and distinctive types of bodies, as bodies with particular physiologies, affective lives, and concrete behaviors. For example, the slum is not inherently alienating, although for those used to a rural or even a suburban environment, it produces extreme feelings of alienation. However, the same is true for the slum dweller who moves to the country or the suburbs. It is a question of negotiation of urban spaces by

individuals/groups more or less densely packed, who inhabit or traverse them: each environment or context contains its own powers, perils, dangers, and advantages.

Second, there are a number of general effects induced by cityscapes, which can only be concretely specified in particular cases. The city helps to orient sensory and perceptual information, insofar as it helps to produce specific conceptions of spatiality, the vectorization and setting for our earliest and most ongoing perceptions. The city orients and organizes family, sexual, and social relations insofar as the city divides cultural life into public and private domains, geographically dividing and defining the particular social positions and locations occupied by individuals and groups. Cities establish lateral, contingent, short- or long-term connections between individuals and social groups, and more or less stable divisions, such as those constituting domestic and generational distinctions. These spaces, divisions, and interconnections are the roles and means by which bodies are individuated to become subjects. The structure and layout of the city also provide and organize the circulation of information, and structure social and regional access to goods and services. Finally, the city's form and structure provide the context in which social rules and expectations are internalized or habituated in order to ensure social conformity, or position social marginality at a safe or insulated and bounded distance (ghettoization). This means that the city must be seen as the most immediately concrete locus for the production and circulation of power.

I have suggested that the city is an active force in constituting bodies, and always leaves its traces on the subject's corporeality. It follows that, corresponding to the dramatic transformation of the city as a result of the information revolution will be a transformation in the inscription of bodies. In his paper, "The Overexposed City," Paul Virilio makes clear the tendency toward hyperreality in cities today: the replacement of geographical space with the screen interface, the transformation of distance and depth into pure surface, the reduction of space to time, of the face-to-face encounter to the terminal screen:

> On the terminal's screen a span of time becomes both the surface and the support of inscription; time literally . . . surfaces. Due to the cathode-ray tube's imperceptible substance, the dimensions of space become inseparable from their speed of transmission. Unity of place without unity of time makes the city disappear into the heterogeneity of advanced technology's temporal regime.[6]

The implosion of space into time, the transmutation of distance into speed, the instantaneousness of communication, the collapsing of the workspace into the home computer system, will clearly have major effects on specifically sexual and racial bodies of the city's inhabitants as well as on the form and structure of the city. The increased coordination and integration of microfunctions in the urban space creates the city not as a body-politic but as a political-machine – no longer a machine modelled on the engine but now represented by the computer, facsimile machine, and modem, a machine that reduces distance and speed to immediate, instantaneous gratification. The abolition of the distance between home and work, the diminution of interaction between face-to-face subjects, the continuing mediation of interpersonal relations by terminals, screens, and keyboards, will increasingly affect/infect the minutiae of everyday life and corporeal existence.

> With the advent of instantaneous communications (satellite, TV, fiber optics, telematics) arrival supplants departure: everything arrives without necessarily having to depart. . . . Contributing to the creation of a permanent present whose intense pace knows no tomorrow, the latter type of time space is destroying the rhythms of

a society which has become more and more debased. And "monument," no longer the elaborately constructed portico, the monumental passageway punctuated by sumptuous edifices, but idleness, the monumental wait for service in front of machinery: everyone bustling about while waiting for communication and telecommunication machines, the lines at highway tollbooths, the pilot's checklist, night tables as computer consoles. Ultimately, the door is what monitors vehicles and various vectors whose breaks of continuity compose less a space than a kind of countdown in which the urgency of work time plays the part of a *time center*, while unemployment and vacation time play the part of the periphery – *the suburb of time*: a clearing away of activity whereby everyone is exiled to a life of both privacy and deprivation.[7]

The subject's body will no longer be disjointedly connected to random others and objects according to the city's spatio-temporal layout. The city network – now vertical more than horizontal in layout – will be modeled on and ordered by telecommunications. The city and body will interface with the computer, forming part of an information machine in which the body's limbs and organs will become interchangeable parts with the computer and with the technologization of production. The computerization of labor is intimately implicated in material transformations, including those which pose as merely conceptual. Whether this results in the "cross-breeding" of the body and machine – that is, whether the machine will take on the characteristics attributed to the human body ("artificial intelligence," automatons) or whether the body will take on the characteristics of the machine (the cyborg, bionics, computer prosthesis) remains unclear. Yet it is certain that this will fundamentally transform the ways in which we conceive both cities and bodies, and their interrelations.

Notes

1 See, in particular, *Discipline and Punish* (New York: Vintage, 1979) and *The History of Sexuality*, Vol. 1: *An Introduction* (New York: Pantheon, 1978).
2 The king may also represent the heart. See Michel Feher, ed., *Fragments of a History of the Human Body*, Vol. 1 (New York: Zone, 1989).
3 There is a slippage from conceptions of the state (which necessarily raise questions of legal sovereignty) and conceptions of the city as a commercial and cultural entity:

> The town is the correlate of the road. The town exists only as a function of a circulation and of circuits; it is a singular point on the circuits which create it and which it creates. It is defined by entries and exits; something must enter it and exit from it. It imposes a frequency. It effects a polarization of matter, inert, living or human. . . . It is a phenomenon of transconsistency, a network, because it is fundamentally in contact with other towns. . . .
>
> The State proceeds otherwise: it is a phenomenon of ultraconsistency. It makes points resonate together, points . . . very diverse points of order – geographic, ethnic, linguistic, moral, economic, technological particulars. The State makes the town resonate with the countryside . . . the central power of the State is hierarchical and constitutes a civil-service sector; the center is not in the middle but on top because [it is] the only way it can recombine what it isolates . . . through subordination.
>
> (Gilles Deleuze and Félix Guattari, "City/State," Zone 1/2 [1986]: 195–197).

4 See Jacques Donzelot, *The Policing of Families* (New York: Pantheon, 1979).
5 See Foucault's discussion of the notion of biopower in the final sections of *The History of Sexuality*.
6 Paul Virilio, "The Overexposed City," *Zone* 1/2 (1986): 19.
7 Ibid.: 19–20.

References

Clifford, Sue. "Common Ground." *Meanjin* 47, no. 4 (Summer 1988): 625–636.
Cook, Philip. "Modernity, Postmodernity and the City." *Theory, Culture and Society* 5 (1988): 475–493.
de Landa, Manuel. "Policing the Spectrum." *Zone* 1/2 (1986): 176–193.
Deleuze, Gilles and Guattari, Félix. "City/State." *Zone* 1/2 (1986): 194–199.
Foucault, Michel. *Discipline and Punish: The Birth of the Prison.* Trans. Alan Sheridan. New York: Vintage, 1979.
Foucault, Michel. *The History of Sexuality*, Vol. 1: *An Introduction.* Trans. Robert Hurley. New York: Pantheon, 1978.
Jerde, Jon. "A Philosophy for City Development." *Meanjin* 47, no. 4 (Summer 1988): 609–614.
Kwinter, Sanford. "La Città Nuova: Modernity and Continuity." *Zone* 1/2 (1986): 80–127.
Sky, Alison. "On Site." *Meanjin* 47, no. 4 (Summer 1988): 614–625.
Virilio, Paul. "The Overexposed City." *Zone* 1/2 (1986): 14–39.
Yencken, David. "The Creative City." *Meanjin* 47, no. 4 (Summer 1988): 597–609.

Chapter 56

CHRISTINE ROSS

TO TOUCH THE OTHER
A story of corpo-electronic surfaces

[. . .]

LET US BEGIN [. . .] with this hypothesis: video is a technology which, when it takes a tactile approach to the surface (accentuating the electronic fluctuations of skin, and the body's scintillating contacts with the screen), radically undermines not only the conception of desire as lack but also the notion of the body as a unified representation or distinct biological organism opposed to mind, thought, and the machine. When used in this way, video reduces to almost nothing the distance between the electronic wash of the image, the filmed body, and the viewer.

[. . .]

Touch through abjection

It is important that one always be able to situate, locate and contextualize the corporal and psychic dispersions of the subject, which may be pathological yet beneficial, and may reduce or enhance the complexity of the subject. Such contextualizations are more and more widespread in recent electronic art, particularly in video that deals with questions of diaspora and immigration. Here, in order to survive, the subject must learn to unwrite or even rewrite the boundaries of national and personal identity. In this respect, Mona Hatoum's work is

distinguished by its recourse to the figure of the foreigner who unwrites his or her self by unwriting that of the viewer, a process connected to the fact that sight is constantly called upon to transform itself into touch. But in order for the dissolution of the "correct distance" to take place the foreigner must function as an agent, a status conferred upon it by the construction of a space that simultaneously separates this figure from, and connects it with, the viewer. [. . .]

In the second part of Hatoum's *Changing Parts* (1984), photographs of a bathroom appear at first sporadically and then with increased frequency, and are contaminated by a slow-motion black-and-white video sequence of Hatoum inside a transparent cube. Hatoum's actions are simple and earthy. She presses against the wall of the cube, which corresponds to the screen of the monitor, smearing it with what looks like blood (in fact liquid clay). The tactile nature of this activity defines the screen as an interface that opacifies in order to separate the space of the video artist from that of the viewer. In *Measures of Distance* (1988), the photographed body of Hatoum's mother is also spatially differentiated and delimited by an electronic mesh (composed of a grid and the Arabic script of the mother's letters to her daughter) that textures, marks and stigmatizes the surface of the screen.

In neither video does the screen relinquish its paradoxical dimension of imprisonment and protection of the body. On the one hand, the opacified screen reinforces the category of the "other" insofar as it reproduces the cleavage between the Palestinian body and the Occidental gaze. On the other hand, the screen protects the female body by problematizing visual and auditory access to it. But the paradox does not end there. It is as if the body were using this normative distance not only actively to occupy the space that is granted to it, but also to bolster this distance, and to such an extent that those elements which serve to reinforce distance ("blood," Arabic script) manage to subvert the distance in question, to revoke and dissolve it.

The opacification of the screen through the use of "blood" and script produces a confusion, a confusion facilitated by the black-and-white sequence of *Changing Parts* and the electronic grid of *Measures of Distance*. Also, the screen is contaminated by signs of alterity: the Arabic script (illegible to most Westerners) and the "blood" (menstrual blood, or blood shed in wartime – elements that normally remain concealed). The combination of these two characteristics (the confusion between skin and screen and the contamination of the screen by alterity) subverts the distance between the "foreigner" and the viewer, insofar as it progressively transforms video into an instance of abjection. More precisely, the fact of touch (body-blood-screen, body-script-screen) not only maintains the cleavage between the viewer and the "foreigner," it also manifests the instability of this cleavage: it casts doubt on the permanence of the "correct distance".

The term "abjection," as used by Julia Kristeva in *Powers of Horror* (1980), describes the revulsion and horror involved in the child's pre-Oedipal attempt to separate from its mother, a separation necessary for the child to accede to the Symbolic order and become a subject.[1] Abjection, in its most archaic form, is an oral abhorrence, a refusal of maternal sustenance corresponding to a refusal of the mother, who is felt to be abject. In this refusal, the child itself attempts to project itself outside the mother–child dyad. But, for Kristeva, one's experience of the abject figure does not stop there, since the latter never ceases to haunt the frontiers of the subject's identity, constantly threatening to dissolve its unity. The abject thus belongs to the category of rubbish, of the incorporated-to-be-expelled; it demonstrates the incapacity of modern Western cultures to accept not only the mother, but also the materiality of the body, its limits and its mortality, illness, bodily fluids, menstrual blood, difference, the (m)other.[2]

In the video work of Mona Hatoum, the screen has become the skin of the other since the latter (as "woman" and "Arab," and as the "colonized" who must be kept at a distance) touches the screen with its hands, blood and script, and thus can no longer be situated *behind* the screen. Hence the abject character of the images: the other is no longer what the camera records at a distance, it is at the surface (flush with the screen) as a surface (electronic skin). Viewers can no longer tell themselves that they are facing the representation of a body distanced by the framing of this "body": the latter has already affected and infected the screen where it is dissolved in surface intensities. Because of this body-screen tactility, the other is now flush with "my" space; it is a body that has mutated through abjection.

We learn from these two videos that "we" consider the foreigner only when the latter begins to touch the surface (the screen) that separates us from her: in other words, when "our" skin ego perceives itself to be suddenly threatened, enfeebled and thrown into crisis by the other who has become abject. Only then are we in a position to realize how "our" territory is one in which multiculturalism (as the juxtaposition of *preserved* skin egos) develops to the detriment of interculturalism (as *negotiated* skin egos).[3]

Desire as communicative body

In Mona Hatoum's work, desire is developed through an aesthetic that transforms the depth of contact with the other into a surface of contact. Viewers are positioned in a way that forces them to abandon their negation of the other (who is denied because the other – the "woman," the "Arab" – is what represents the absence from oneself, the lack) in order to be attentive to the very surface of the screen where the body and the electronic apparatus come into contact. This displacement becomes all the more significant in the video installation *Corps étranger* [Foreign Body and Strange Body; Figure 56.1]; for here the transformation of desire-as-lack into desire-as-production is articulated through a tactility performed by viewers themselves.

Corps étranger was originally produced for a 1994 exhibition at the Centre Georges Pompidou's Musée national d'art moderne, and was shown subsequently at the Venice Biennale and at the Tate Gallery in an exhibition entitled *Rites of Passage*. A space partially closed upon itself, it consists of a circular area delimited by two semicircular partitions that leave two openings, one for viewers to enter the piece, and one for them to leave. On the floor, projected from above, one can see video images of various internal and external features of Hatoum's body. Immediately upon entering the space, viewers are placed in a situation of exteriority vis-à-vis images of an internal body that they must apprehend at a distance equivalent to their own body height, a distance measured from their feet (where the images play upon the screen) to the perceptual apparatus (eyes and ears). But tactile contact with the images is established through the feet; this is a crucial point, and I will come back to it later.

The most disturbing images of *Corps étranger* are surely those that show the visceral body, as it is defined by two optical instruments (the endoscope and coloscope) used to scan certain parts of the digestive system, colon and intestines. The visual scanning sequence is accompanied by an ultrasound recording of heartbeats which echo throughout different parts of the body and are punctuated at regular intervals by the sound of Hatoum's breathing. The body's deep cavities are illuminated and examined by the camera in its continual search for orifices. Deeper and deeper it moves, probing these visceral tunnels until, unable to advance any farther, it reemerges only to seek elsewhere, as if compelled to go on blindly without any real goal, without any beginning or end.

One of the most striking ambivalences of this installation resides in the production, by the body, of effects that may be described as simultaneously incorporating and incorporated.

Figure 56.1 Mona Hatoum, *Corps étranger*, 1994.

In the space between the viewer and the images, a gradual oscillation develops between the two effects. In the first instance, the body is represented as incorporated (as much by the camera that penetrates it as by the viewer who follows its movement); in the second instance, the body becomes an incorporating power to the extent that, by following the intrusive action of the camera, viewers feel themselves absorbed by what they are so intently looking at, as if they themselves were being pulled down into the profound darkness of the body's cavities. This ambivalence assumes its full meaning when one realizes that the body being scanned is the body of a woman. For it is the female sex in its cultural ambivalence – as both a body pure and simple, and as a threatening sex – that holds the viewer's fascination. Thus the images we see are of a female body reinscribing the link Freud established between the death instinct and the life instinct; in other words, *Corps étranger* reinscribes the fantasy of the *vagina*

dentata, of the woman as vampire or animal equipped with a sexuality that is identified as devouring, enigmatic, dissembling, and castrating for men.[4]

Corps étranger also performs that which recent phenomenology, particularly that exemplified by Drew Leder's *The Absent Body*, designates as the recessive visceral body, or, the whole set of organs hidden under the skin, which function as an absence independent of the subject's awareness of control.[5] By exhibiting this phenomenologically absent body, the installation transforms the recessive into the ecstatic and once more plunges us into the movement away from depth and absence toward surface and presence. As in *Changing Parts* and *Measures of Distance*, this transformation into surface is productive of an abject effect. But in *Corps étranger* abjection is at play insofar as it points to the extent to which the use of endoscopy in medicine is associated with the diagnosis of illness; that is, with the existence of symptoms which indicate that something, some "it," is acting in a dysfunctional manner. Endoscopy and coloscopy are hermeneutic practices that bring out what Leder has dubbed an interiority in "dys-appearance": a visceral body that appears, that one becomes aware of, precisely because it is dysfunctional. Thus the foreign body is not so much the absent visceral body that tends to disappear phenomenologically from my consciousness as I move about in the world; it is also the dysfunctional body, a body both threatened and threatening, an "it" that reveals itself as something different from me, something strange and hard to control.

Mona Hatoum brings together the visceral body, technology, the Palestinian and the female as incorporating threats, making each category a metaphor or metonymy of the other, projecting them over each other in order to consolidate an abjection effect. In an interview Julia Kristeva gave for *Rites of Passage* at the Tate Gallery (an exhibition that included *Corps étranger*), she spoke about abjection effects in reference to works in the show, describing them as effecting a *mise en scène* of the "impossible," the "disgusting" and the "intolerable."[6] It is interesting to note that, for Kristeva, abjection here is slated to be transformed into an experience of harmony and communion with others. "When they look at these objects," she says, "they [the viewers] see their own regressions, their own abjection, and at that moment what occurs is a veritable state of communion."[7]

If one follows Kristeva, the production of the body as a dysfunctional surface (the *mise en scène* of the abject) would make it possible not only to represent a state of crisis but also to transform abjection into catharsis, into a communal, quasi-religious experience of harmony. Nevertheless, Kristeva reinforces the metaphysical negation of the other. For transforming abjection into communion is tantamount to (re)negating the other, who has already been denied by the social order and whose abjection is a way of disclosing this fact. Furthermore, it is far from certain that the communion postulated by Kristeva actually takes place, for abjection is and remains a constant. Why? Because in *Corps étranger* the viewer never ceases to enter into contact with the other, even if he or she often does so in an unconscious or involuntary manner.

It is important, first of all, to keep in mind that because their feet touch the screen viewers are not at a "correct distance" from the body shown on video. Unlike *Changing Parts* and *Measures of Distance*, where it is the foreigner who touches the screen in a manner that is threatening to viewers and that makes them aware of their habit of negating the other, here it is the viewer who touches the screen that separates himself or herself from the foreigner. Thus it is impossible to dissociate oneself so categorically from the visceral body in disappearance, or from technology as the ecstatic machine of the recessive body, and of the female sex as *vagina dentata*. *Corps étranger* offers neither communion nor catharsis; nor is there resolution. On the contrary, such closures are thrown into question. This process produces a body that is both living and dying, present and absent, recessive and enraptured, a body whose

contours follow the vicissitudes of its disorganization and reorganization. *Corps étranger* situates the viewer's experience in a circular space, a sort of shelter that also serves as a meeting place for other viewers. Thus the way a viewer touches the screen is akin to the way he or she happens to brush against another viewer within the same exacting space, the way Hatoum touched the screen in *Changing Parts*.

If the installation problematizes the body and sexuality as models of depth and absence, if it attempts to bring about a transformation of the body into surface, it does so by employing a tactility performed by the viewer who thereby becomes engaged in a meeting of surfaces (between her or his shoes and the screen, her or his skin and that of others in the same space). In the video work of Mona Hatoum, touch makes it possible to undertake the work of abjection; but it also opens onto the "communicative body." In opposition to the isolation and dissociation of the disciplined body, the communicative body is constituted through coexistence with the other made possible when the subject attempts to "accept what the other's bodily contingencies have imposed on it as being possibilities for my own body."[8] The loss through tactility of the correct distance is one of the main conditions that make such acceptance possible.

Notes

1 Julia Kristeva, *Powers of Horror: An Essay on Abjection*, trans. Leon S. Roudiez (New York: Columbia University Press, 1989). [See Chapter 45 in this volume.]

2 On this subject, see Elizabeth Grosz, "The Body of Signifcation," eds. John Fletcher and Andrew Benjamin, *Abjection, Melancholia and Love: The Work of Julia Kristeva* (New York: Routledge, 1990), 80–103.

3 On this subject, see Rey Chow, *Writing Diaspora: Tactics of Intervention in Contemporary Cultural Studies* (Bloomington and Indianapolis: Indiana University Press, 1993), 23–24.

4 On the *vagina dentata*, see Elizabeth Grosz, "Animal Sex: Libido as Desire and Death (Short Version)." Unpublished text.

5 See Drew Leder, *The Absent Body* (Chicago: The University of Chicago Press, 1990).

6 Julia Kristeva, "Of Words and Flesh: An Interview with Julia Kristeva," eds. Stuart Morgan and Frances Morris, *Rites of Passage: Art for the End of the Century* (London: Tate Gallery Publications, 1995), 21.

7 Ibid.

8 Arthur W. Frank, "For the Sociology of the Body: An Analytical Review," eds. Mike Featherstone, Mike Hepworth and Bryan S. Turner, *The Body: Social Process and Cultural Theory* (London: Sage Publications, 1991), 93.

MARÍA FERNÁNDEZ

POSTCOLONIAL MEDIA THEORY

THE ARTIST GUILLERMO GÓMEZ-PEÑA recently commented that in discussions of electronic media "twenty years of post-colonial theory simply disappear."[1] He was referring to the large and influential body of work known as postcolonial studies, which for the past two decades has been notoriously absent from electronic media practice, theory, and criticism. This absence is not due to the lack of theory in the field, as there has always been theoretically based writing about electronic media. Much of the early work was based on the theories of Marshall McLuhan and other utopians characterized as "inebriated with the potential of new technology."[2] More recent discussions have been anchored in the work of theorists including Walter Benjamin, the Situationists, Jean Baudrillard, Gilles Deleuze, Félix Guattari, Paul Virilio, Jacques Lacan, Luce Irigaray, and Donna Haraway. This eclecticism, in conjunction with recent debates around topics such as multiculturalism, colonialism, the 1992 quincentenary, identity politics, and whiteness studies, make it ever more striking that postcolonial studies and electronic media theory have developed parallel to one another but with very few points of intersection.

[. . .]

In the late 1980s and early 1990s, electronic media theory debates focused on the preeminence of the virtual body; in the late 1990s the body is altogether irrelevant. More interesting in current theory are discussions about genetic technologies and artificial life. As with other live entities, humans are viewed primarily as patterns of information transferable to various media, such as computers. In this scheme of things, embodiment is secondary; the organism has been replaced by its code.[3] Christopher Langton, one of the guiding theorists of artificial life, explains that one of its premises is the possibility of separating the informational content of life from its material substrate. Although a small number of theorists have cautioned against "forgetting the body," they are a minority.[4]

Human/Machine hybrids and the virtualization of the body have long-standing roots in the theorization of electronic technologies: prefigurations of cyborgs appear in the writings of both McLuhan and Jack Burnham in the 1960s. A decade earlier, the cyberneticist Norbert Wiener had proposed the theoretical possibility of telegraphing a human being.[5] In contrast to this fascination with mechanization and virtualization of the body, postcolonial studies underscores the physiological specificity of the lived body as the realities of subjection are inscribed on the bodies of colonized peoples: torture, rape, and physical exhaustion, as well as the learning of new bodily grammars and forms of discipline required by colonization and conversion. Of primary importance have been examinations of the construction of social and scientific discourses about race that initially authorized colonial violence against subject peoples and that in our era continue to support imperial military invasions, police brutality, and repressive economic policies.

Figure 57.1 Lee Bul, *Cyborg Blue*, 1997–1998. Commissioned by Ssamzie Ltd, Seoul.
Photo by Yoon Hyung-moon.

Frantz Fanon, Edward Said, Homi Bhabha, and Anne McClintock, among others, have written extensively on the overdetermination of the racialized body as sign and have explored connected issues in the representation of colonized and postcolonial peoples: mimicry, stereotyping, exoticism, and primitivism.[6] Discussion of these subjects is underdeveloped in electronic media theory in part because most theorists are white and middle-class, but also because the lack of physicality and the anonymity made possible by electronic communication are believed to elide all differences. To admit that inequalities exist in cyberspace is for some tantamount to *authorizing* inequality. Rather, it has been suggested that marginality and subalternity exist only *outside* of cyberspace in the masses yet to be linked to the global network.[7] In summary, in postcolonial theory, the body is conceived as a palimpsest on which relations of power are inscribed. In electronic media, the body is irrelevant to those relations. This difference in foci between the theorization of the body in each field affects the theorization of other areas I will explore: feminism, identity, history, and aesthetics.

Feminism

In her famous essay "A Manifesto for Cyborgs: Science, Technology, and Socialist Feminism in the 1980's," Donna Haraway proposed the cyborg, "a hybrid of machine and organism," as a foundation for feminist politics.[8] By basing her cyborg on the model of *mestizaje*, the phenomenon of racial mixing that took place during the colonial period in the New World, Haraway attempted to bridge a profound gap that had opened in the United States between white and Third World feminism. As she explains, the category *woman* in previous feminisms "negated all non-white women." White women "discovered (i.e. were forced kicking and screaming) to notice the non-innocence of the category 'woman.'" She refers here to a series of contestations by women of color that had challenged the universalist claims of the feminist movement. Building on the work of feminist theorist Chela Sandoval, Haraway posits that women of color might be understood as "a cyborg identity, a potent subjectivity synthesized from fusions of outsider identities."[9]

While the hybridization of humans, animals, and machines found enthusiastic acceptance among feminist cultural theorists, Haraway's attempts to incorporate postcolonial or so-called Third World feminism have been largely forgotten in current theorizations.[10] With the exception of references to cyborgian qualities, including the multiple subjectivities of the *mestiza*, women of color seldom figure in the work of cyberfeminists.[11] The supposition that women of color are natural cyborgs or that they already possess the tools necessary to oppose and to subvert oppressive practices is often used tacitly to condone separatism. Strategies of mutual support and coalition in theory and practice urgently need to be developed. The liberational aspects of the cyborg apply least to women forced to repetitive work, who in Sandoval's words "know the pain of the union of machine and bodily tissue" but have no health and social benefits and no legal rights against abusive employment practices.[12]

But while the recent enthusiasm for hybridity is being contested in postcolonial studies, few theorists of electronic media problematize the racial identity of cyborgs. In the opinion of media theorist Jennifer González, what makes the term *hybrid* controversial is "the assumed existence of a non-hybrid state – a pure state, a pure species, a pure race – with which it is contrasted. It is this notion of purity that must in fact be problematized."[13]

Identity

Postcolonial studies and electronic media theory concur in challenging traditional understandings of identity as stable and singular. In both areas identity is conceptualized as multiple,

contradictory, and even conflictive. Discussions of identity in postcolonial studies frequently involve collective identities: ethnic, national, gender. As in much postmodern literary theory, discussions of identity in electronic media theory concentrate on the individual as author of his or her own identity. Thus, where electronic media theory stresses the present (the moment of authorship), many postcolonial theorists view identity as rooted in specific historic pasts.

Stuart Hall has advocated the construction of a collective will through difference. This implies the recognition of multiple identities, a crucial process for diasporic cultures. Hall proposes that in order to conduct this cultural politics it is necessary to return to the past. But he recognizes that this return is not of a direct and literal kind: "we go through our own pasts through history, through memory, through desire, not as a literal fact."[14] Other theorists, including Bhabha and Spivak, have independently proposed similar strategies.[15]

After the philosopher Daniel Dennet, the psychologist Sherry Turkle views individual identity as "several versions of a document open in a computer screen where the user is able to move between them at will." She emphasizes the ludic possibilities of virtual spaces for the construction of identity, as one can play with one's identity and try out new ones. Participants in MUDs (multiple user domains) are authors not only of text but of themselves: "you are who you pretend to be."[16] Turkle's writings remain largely uncritiqued in electronic media circles.

What does it mean to sever the construction of identity from history and from bodily experience? Some of us might welcome these propositions as nonessentialist, but as Tim Dean has noted in another context, the idea of cross-dwelling in multiple identities involves an intricate collection of issues including "tourism, colonization, Orientalism, appropriation, domestication and such like – to which cultural studies in general and postcolonial studies in particular have sensitized us."[17] For Bhabha, the constant refashioning of the subject in postmodern theories of identity may be ethnocentric in its construction of cultural difference, since it allows one to be "somewhat dismissive of the 'real' history of the other – women, foreigners, homosexuals, the natives of Ireland."[18] González notes that cyborgs, "given their multiple parts and multiple identities . . . will always be read in relation to historical context."[19] A cyborg is not without origins. Thus, both postcolonial studies and electronic media theory view identity as multiple and open-ended, but they differ drastically in focus. In postcolonial studies theories of identity emphasize the social – identities are historically rooted, open-ended, collective political projects. Electronic media theory gives primacy to the individual as the construction of identity is viewed as an opportunity for self-development and (re)creation.

History

The writing of history has been a major concern of postcolonial studies as subaltern histories are omitted from dominant historical narratives or remain intractable to historians. In the West, reclaiming histories has been a preliminary step in the construction of identity for marginalized groups. Consequently, the nation has come to be understood as a result of many narratives.[20] The representation of the subaltern in history has been problematic either because the groups have not left their own sources, or because their narratives lack the historian's requirement of a rationally defensible point of view from which to tell the story.[21] These issues were hotly debated by the Subaltern Studies Group in the 1980s.[22] More recently, Dipesch Chakrabarty, a former member of the group, proposed that subaltern pasts do not belong exclusively to socially subordinate groups. Elite and dominant groups can also have subaltern pasts. Thus the writing of history must implicitly assume a plurality of times existing together, a discontinuity

of the present with itself.[23] Chakrabarty's theories coincide with Bhabha's proposition that colonial and postcolonial moments create a disjunction, a time-lag that renders the project of modernity contradictory and unresolved. For Bhabha this time-lag should provide a basis for the representation of subaltern and postcolonial agency, since it introduces an alternative site for intercession: "The cultural inheritance of slavery or colonialism is brought before modernity *not* to resolve its historic differences into a new totality nor to forego its traditions. It is to introduce another locus of inscription and intervention, another hybrid, 'inappropriate' enunciative site through that temporal split – or time lag."[24] For these and other postcolonial theorists the examination of history is integral to postcolonial agency.

By contrast, in electronic media theory history is either nonexistent or has become what Arthur Kroker and Michel Weinstein termed *recombinant history*, "a universal digital archive, always available for sampling, triggered by system operators at its XY axis, and infinitely recombined into hybrid images of the telematic future." Through digitization, archiving, and recombination, history is fully virtualized, local histories acquire the status of games, "fantasy worlds, maintained and periodically visited by representatives of the media for spectacular recombination into the entertainment function for the comfort zone tastes of the virtual class." Kroker and Weinstein conclude that "just when we thought that history as a grand récit had finally died . . . suddenly it returns in full recombinant force: that point where history merges with digital technology, becoming the world-historical process animating the will to virtuality."[25] Theories of history are intimately tied with the theorizations of the body since recombinant history concerns primarily what exists in the digital. It has been proposed not only that surveillance and control focus on the virtual body but that the most effective forms of resistance must take place in cyberspace.[26] Here there seems to be an area of irreconcilable difference. At the point where postcolonial theorists suggest productive approaches to the representation of subaltern histories, suddenly there is no field to be contested. There is no history. Must postcolonial peoples forget if they are to function in cyberspace?

Aesthetics

Postcolonial theorists have examined the construction of aesthetic values questioning the validity of universality in aesthetics and exploring strategies of appropriation, cannibalization, and subversion of dominant visual vocabularies. Said, Sally Price, Marianna Torgovnick, James Clifford, and others have argued that scholars often mistake "European" and "North American" for "universal" and as a result develop aesthetic criteria that marginalize and exclude the distinctive characteristics of other cultures. The canonization of works of art thus serves purposes of inclusion and exclusion as the construction of universal aesthetic systems has been an integral part of colonial and neocolonial domination. In addition, postcolonial theorists have examined the legacy of colonialism on contemporary critical discourses, such as the prevalence of stereotypes in discussions of artists from postcolonial regions.[27]

Discussions of aesthetics are rare in electronic media theory. Critics are often more concerned with the technological currency of works of art than with examining what makes them work (or not).[28] Festivals of electronic media art place a premium on the exploration of new technologies, excluding and implicitly announcing the obsolescence of older technological forms. For instance, the category of still image has been abolished from the grand prize competitions at Arts Electronica and did not figure prominently in the exhibitions at the 1998 International Symposium of Electronic Art (ISEA 98) in Manchester and Liverpool. Progressive art practice is indirectly linked with new generations of technology. The role of the artist is to explore the technology before it is commercialized. In other words, the artist

does the R&D for corporations and then goes on to explore the next wave of technological media.[29] Electronic art concurs with commerce, where products are ranked on the use of the latest technology. The value of novelty is so extreme that corporations customarily sell unfinished hardware and software that customers not only purchase but beta-test. In electronic media art, the artist's concentration on technology frequently makes content irrelevant. Emphasis on state of the art technology requires artists who work in these media to struggle to keep up with the latest trends. In this period of scarce funding for the arts, artists who cannot afford to join the race are at a disadvantage.

In recent years, several artists and writers, including Margaret Morse, Erkki Huhtamo, Simon Penny, and Lev Manovich, have discussed the value placed on specific works by virtue of the use of state of the art technology; but they discuss this issue exclusively in the context of art in developed nations. The effects of aesthetic technofetishism in the wider context of world art are at present largely unexamined.

When looking at computer-aided images, technologically sophisticated viewers can usually tell whether the artist is using current or antiquated technology. High-end computer art can achieve greater degrees of mimesis to the extent of making the presence of the technology invisible. Since the late 1980s, a primary goal of computer graphics has been to achieve the reality effect of color photography and, more recently, 35mm film. This imperative has parallels in theoretical writing. According to the late media theorist Vilém Flusser, the aesthetic value of computer art depends on realism. Because digital images can be quantified, he equated realism with truth: "From now on we will have to embrace beauty as the only acceptable criterion of truth. . . . This is already observable in relation to computer art: the more beautiful the digital apparition the more real and truthful the projected alternative worlds."[30]

If the use of state of the art technology increasingly becomes a primary factor in determining the aesthetic significance of a work of art, it will be impossible to maintain the respect of aesthetic diversity that postcolonial studies has supported. The new aesthetics will promote a cultural supremacy that will not be easily challenged as the construction of new canons will be justified by quantifiable and measurable attributes. Manovich has noted that all the dimensions in a digital image, including detail, number of colors, shape, and movement, can be specified in exact numbers. For example, the spatial and color resolution of a two-dimensional image is expressed by the number of pixels and the colors per pixel. The degree of detail of a three-dimensional model and consequently its reality effect is specified by three-dimensional resolution, the number of points to which the model is composed. "Not surprisingly, the advertisements for graphics software and hardware prominently display these numbers. . . . The bottom line: the reality effect of a digital representation can be measured in dollars. Realism has become a commodity. It can be bought and sold like anything else."[31]

If artists in developed countries feel pressured to constantly upgrade, fearing that the value of their work will be judged on the currency of the technology, artists in poor countries could be even more severely marginalized, as they have fewer opportunities for upgrading and may choose not to work with the technology in the first place. Thus, the emerging aesthetics could be retrogressive in two ways: in re-establishing mimesis as the norm to which art should aspire and in re-establishing the aesthetic superiority of wealthy nations over poor ones. Here I should add that in contemporary culture mimesis is not limited to the realism of images, as Flusser envisioned. Mimesis is a more open realm including the simulation of all levels of organic behavior, from the reproduction and evolution of viruses to animal and human interaction. Although not all simulations of behavior necessitate high technology, they require specialized technical skills from computer programming for artificial life, autonomous

agents, and animatronic robots. Because these fields are closely connected with the military industrial complex, they have greater representation in developed countries.

Objections could be made to these suggestions on two grounds: the incidence of low-tech photography and video in contemporary art and the phenomenon of art on the Net. The current enthusiasm for photography and video occurs at a time when these art forms are being absorbed by digital media. This enthusiasm could be interpreted as a nostalgic gesture rather than as proof of the equality of all technologies in the contemporary art world. The race for high technology is evident in the art showcased at institutions that have established themselves as models for art in new media, including the InterCommunication Center (ICC) in Tokyo, the ZKM/Center for Art and Media in Karlsruhe, and the Ars Electronica Center, the Museum of the Future, in Linz.

The phenomenon of Net art presumably neutralizes the question of value, since no work has a higher value than the next.[32] In this respect, art on the Net partakes of its utopian rhetoric, in which all creatures are created equal. The Net has been ascribed the potential to liberate humanity; Net art is believed to have the capacity to restructure the art world. Net artists are believed to be more revolutionary than artists working in another media, as they function independent of institutions, commercial and academic.[33]

No one will dispute the openness of the Net as an exhibition medium. But although anyone who has access to a server can exhibit work there, this does not mean that anyone will see it. In the early days of Web-based artwork (ca. 1996), the works that gained the most critical notoriety were often by artists who already had established a reputation in other media, such as Antonio Muntadas.[34] More recently, activist interventions such as those organized by the Electronic Disturbance Theater in solidarity with Zapatistas in Mexico have gained recognition.[35] These are innovative forms of activism, but the effects of these actions on the art world are yet to be determined.

Then there is the question of the transposition of the museum and gallery world to the Web. Commercial galleries are already numerous there. Traditional museums, initially dismissive of art on the Net, are racing to have a presence in this new realm. Major museums like the Guggenheim and the Museum of Modern Art in New York are sponsoring Web site projects, and institutions that previously funded artworks in traditional media are currently favoring Web-based projects.[36]

Because it is possible to receive images from anywhere in the world in seconds, the Net has the possibility of obliterating hierarchies and homogenizing difference. Some theorists view it as a medium for people from different places to enter the space of modernity.[37] The rapid accessibility of images on the Net opens great possibilities for a homogenizing hybridity, although at present most of Net culture is Western.[38] The hybridity of images alone will not necessarily erase differences, nor will it impede the formation of new canons. Hybridity is already ingrained in postmodern aesthetics and has been aptly coopted by the world of advertising. Multiculturalism and multinational capitalism are complexly interconnected. What is relevant now is not the sources of an image but its ability to partake in current technological discourses. At present, there is much investment in VRML sites, autonomous agents, and artifical life on the Web, all of which require sophisticated resources. The technological imperative in the arts is creating a new and exclusionary universalism. Lessons from postcolonial studies could provide a frame of reference to question this new order.

[. . .]

Notes

1 Guillermo Gómez-Peña, personal communication, September 1997.

2 Timothy Druckrey, ed., *Electronic Culture: Technology and Visual Representation* (New York: Aperture, 1997), 17.

3 Druckrey, 23; see also Vilém Flusser's "Digital Apparition" in the same volume.

4 Christopher G. Langton, "Artifical Life," in *Artificial Life*, ed. Langton, Santa Fe Institute Studies in the Sciences of Complexity, vol. 6 (Redwood City, Calif.: Addison-Wesley Publishing Co., 1989), 2. On forgetting the body, see Rosanne Stone, "Will the Real Body Please Stand Up? Boundary Stories about Virtual Culture," in *Cyberspace: First Steps*, ed. Michael Benedikt (Cambridge, Mass.: MIT Press, 1992), 81–118; Simon Penny, "The Virtualization of Art Practice: Body Knowledge and the Engineering World View," *Art Journal* 56, no. 3 (Fall 1997): 30–8.

5 Norbert Wiener, *The Human Use of Human Beings: Cybernetics and Society* (Garden City, N.J.: Doubleday, 1954), 103–4.

6 Frantz Fanon, *Black Skin, White Masks*, trans. Charles Lam (New York: Grove Press, 1967); Edward Said, *Orientalism* (New York: Vintage Books, 1978); Homi K. Bhabha, *The Location of Culture* (New York: Routledge, 1995); Anne McClintock, *Imperial Leather: Race, Gender, and Sexuality in the Colonial Context* (New York: Routledge, 1995).

7 Olu Oguibe and Ben Williams, as cited in Jordan Crandall, summary of e-mail forum "Citizenship," <eyebeam><blast>, February 1–April 30, 1998, distributed via Nettime, June 15, 1998.

8 Donna Haraway, "A Manifesto for Cyborgs: Science, Technology and Socialist Feminism in the 1980's," *Socialist Review* 80, no. 15 (2) (March–April 1985): 65–108. [Chapter 53 in this volume.]

9 Ibid.: 73, 75, 93.

10 VNS Matrix, "A Cyberfeminist Manifesto for the 21st Century" and "All New Gen," in *Unnatural-techno-theory for a contaminated culture*, ed. Mathew Fuller (London, 1994), unpag. (*All New Gen*, CD-ROM 1994); Sadie Plant, *Zeros and Ones: Digital Women and the New Technoculture* (New York: Prentice Hall, 1997). Productive critiques of cyberfeminism are offered by Susanna Paasonen, "Digital, Human, Animal, Plant: The Politics of Cyberfeminism?" and Faith Wilding, "Where Is the Feminism in Cyberfeminism?" Both published in *n.paradoxa* 2 (July 1998).

11 Stone, 112.

12 Chela Sandoval, "New Sciences: Cyborg Feminism and the Methodology of the Oppressed," in *The Cyborg Handbook*, ed. Chris Hables Gray (New York: Routledge, 1995), 407–21.

13 Jennifer González, "Envisioning Cyborg Bodies: Notes from Current Research," in *Cyborg Handbook*, 275. For recent problematizations of hybridity, see *Debating Cultural Hybridity: Multi-Cultural Identities and the Politics of Anti-Racism*, ed. Pnina Werbner and Tariq Modood (London: Zed Books, 1997).

14 Stuart Hall, "Old and New Identities, Old and New Ethnicities," in *Culture, Globalization, and the World System*, ed. Anthony King (Binghamton: State University of New York, 1991), 57–8.

15 Bhabha, 40–65 and 236–56; Gayatri Chakravorty Spivak, "Acting Bits/Identity Talk," *Critical Inquiry* 18, no. 4 (Summer 1992): 770–803.

16 Sherry Turkle, "Rethinking Identity through Virtual Community," in Lynn Hershman-Leeson, ed., *Clicking In: Hot Links to a Digital Culture* (Seattle: Bay Press, 1996), 121–2; see also her *Life on the Screen: Identity in the Age of the Internet* (New York: Simon and Schuster, 1995).

17 Tim Dean, "Two Kinds of Other and Their Consequences," *Critical Inquiry* 23, no. 4 (Summer 1997): 914.

18 Bhabha, 240.

19 González, 272.

20 Dipesch Chakrabarty, "Minority Histories, Subaltern Pasts," *Humanities Research* (Winter 1997): 17; Homi K. Bhabha, ed., *Nation and Narration* (New York: Routledge, 1990).

21 Chakrabarty, 18.

22 Ranajit Guha, ed., *Subaltern Studies 1: Writings on South Asian History and Society* (Delhi: Oxford University Press, 1982); Gayatri Chakravorty Spivak, "Can the Subaltern Speak?" in *Marxism and the Interpretation of Culture*, ed. Gary Nelson and Lawrence Grossberg (Urbana: University of Illinois Press, 1988).

23 Chakrabarty, 30.

24 Bhabha, 238, 242.

25 Arthur Kroker and Michael A. Weinstein, *Data Trash: The Theory of the Virtual Class* (New York: St. Martin's Press, 1994), 133, 136, 133.

26 Critical Art Ensemble, *Electronic Disturbance* (Brooklyn: Autonomedia, 1994).

27 See Mari Carmen Ramírez, "Beyond the Fantastic: Framing Identity in U.S. Exhibitions of Latin American Art," in *Beyond the Fantastic: Contemporary Art Criticism from Latin America*, ed. Gerardo Mosquera (Cambridge, Mass.: MIT Press, 1995), 229–46.

28 Sean Cubitt's *Digital Aesthetics* (London: Sage, 1998) and Anne Marie Duguet's essay in Jeffrey Shaw, *A User's Manual: From Expanded Cinema to Virtual Reality* (Karlsruhe: ZKM, 1997) are exceptional in this respect.

29 Dr. Future, "New Media, Old Technology," paper distributed via Nettime, June 14, 1998.

30 Flusser, 243.

31 Lev Manovich, "The Aesthetics of Virtual Worlds: Report from Los Angeles," in *Telepolis*, <www.ix.de/tp> (Munich: Verlag Heinz Heise, 1996); reprinted in *Digital Delirium*, ed. Arthur Kroker and Marilouise Kroker (New York: St. Martin's Press, 1997).

32 Edited version of "A Conversation with Alexei Shulgin," interview by Rachel Baker, distributed via Nettime, March 16, 1997.

33 For an example, see Jennifer Cowan and Ingrid Hein, "Sage of Subversion," *Wired*, December 1997, 62.

34 For a select bibliography on Muntadas, including Web-based work, see <www.gsd.harvard.edu/library/bibliographies/muntada.htm>.

35 The Electronic Disturbance Theater was invited to participate in the prestigious Ars Electronica Festival in 1998; its Web site is located at <www.thing.net/~rdom/ecd/ecd.html>.

36 Dr. Future.

37 Manovich, cited by Crandall.

38 Saskia Sassen, ibid.

Chapter 58

SADIE PLANT

FEMINISATIONS
Reflections on women and virtual reality

the clitoris is a direct line to the matrix — VNS matrix

Women, he has always said,
are tied to the earth
and too tangled up
with all its messy cycles and flows.

AND YET ON ANOTHER INVISIBLE HAND, women are too artificial for man: a matter of glamour, illusion, a trick. Even her foundations are cosmetic: **she's made up**. Hardly a problem out on the Net, where nature and artifice melt as they meet. No wonder women so quickly become advanced and fearless practitioners of virtual engineering.

Masculine identity has everything to **lose** from this new **technics**. The sperm count falls as the replicants stir and the meat learns how to learn for itself.

Cybernetics is feminisation. When intelligent space emerges alongside this history of women's liberation, no one is responsible. That's the point, the fold in the map, where architects get lost in the pattern. **Self-guiding systems were not in the plan**.

Trace the emergence of cyberspace: through the history of commerce to the point at which **capitalism** begins to come out as a **self-organizing** system; through the history of mediation to the moment of immersion. War is of course the exemplary case: the theater itself becomes cyberspace.

The **construct** cunt activates the program. Viral transmissions appear on the screen. Downloaded images converge with their own engineering. Markets and media; military machines. Intended to serve man's quest for planetary domination and escape from the corruptions of the troublesome meat, the matrix was always having him on. **He** gets the picture as **it** gets in touch.

All that matters turns itself on. Nature has never been waiting for man. Matter is microprocessing: what else do molecules do with themselves? There is no need to soften the edges of the virtual world. The matrix has in any case already hacked into all self-conscious attempts to shape it in man's image of nature and artifice.

Travelers always leave their mark, and what is traversed marks them out in turn. Humanity does not escape its own reprocessings. The technoscapes are **trailers** for future **decompositions** of the **spectacle**. Produced in their own machined codes where zero has long interrupted square one, these trips are as deliciously alien as their own fractal fabrications.

NATURALLY ENOUGH, OUTLAW ZONES ARE COMING.

AUTOMATICALLY.

VNS MATRIX

CYBERFEMINIST MANIFESTO

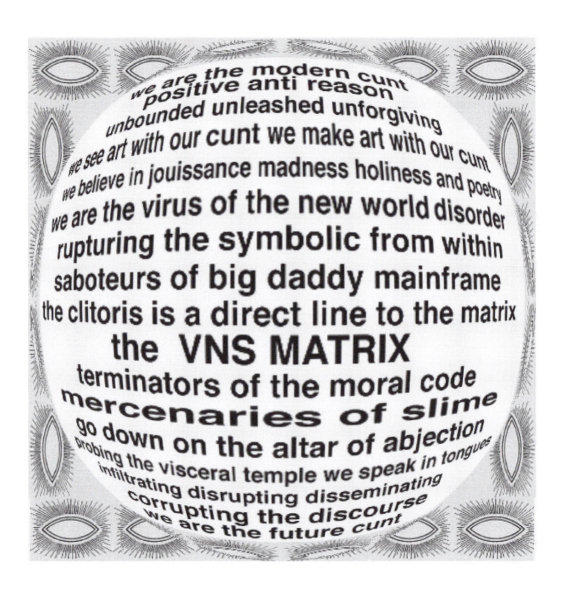

we are the modern cunt
positive anti reason
unbounded unleashed unforgiving
we see art with our cunt we make art with our cunt
we believe in jouissance madness holiness and poetry
we are the virus of the new world disorder
rupturing the symbolic from within
saboteurs of big daddy mainframe
the clitoris is a direct line to the matrix
the VNS MATRIX
terminators of the moral code
mercenaries of slime
go down on the altar of abjection
probing the visceral temple we speak in tongues
infiltrating disrupting disseminating
corrupting the discourse
we are the future cunt

ROSI BRAIDOTTI

CYBERFEMINISM WITH A DIFFERENCE

[. . .]

Post-human bodies

It's a good thing I was born a woman,
or I'd have been a drag queen.
Dolly Parton

THE QUOTE FROM THAT GREAT SIMULATOR, Dolly Parton, sets the mood for the rest of this section, in which I will offer a survey of some of the socio-political representations of the cyber-body phenomenon from a feminist angle. Let us imagine a postmodern tryptic for a moment: Dolly Parton in all her simulated Southern Belle outlook. On her right hand that masterpiece of silicon re-construction that is Elizabeth Taylor, with Peter Pan look-alike Michael Jackson whimpering at her side. On Dolly's left, hyper-real fitness fetishist Jane Fonda, well established in her post-Barbarella phase as a major dynamo in Ted Turner's planetary cathodic embrace. There you have the Pantheon of postmodern feminity, live on CNN at any time, any place, from Hong Kong to Sarajevo, yours at the push of a button. Interactivity is another name for shopping, as Christine Tamblyn put it,[1] and hyper-real gender identity is what it sells.

These three icons have some features in common: firstly, they inhabit a post-human body, that is to say an artificially reconstructed body.[2] The body in question here is far from a biological essence: it is a crossroad of intensive forces; it is a surface of inscriptions of social codes. Ever since the efforts by the poststructuralist generation to rethink a non-essentialized embodied self, we should all have grown accustomed to the loss of ontological security that accompanies the decline of the naturalistic paradigm. As Francis Barker puts it,[3] the disappearance of the body is the apex of the historical process of its de-naturalization. The problem that lingers on is how to re-adjust our politics to this shift. I would like to suggest as a consequence that it is more adequate to speak of our body in terms of embodiment, that is to say of multiple bodies or sets of embodied positions. Embodiment means that we are situated subjects, capable of performing sets of (inter)actions which are – discontinuous in space and time. Embodied subjectivity is thus a paradox that rests simultaneously on the historical decline of mind/body distinctions and the proliferation of discourses about the body. Foucault reformulates this in terms of the paradox of simultaneous disappearance and over-exposure of the body. Though technology makes the paradox manifest and in some ways exemplifies it perfectly, it cannot be argued that it is responsible for such a shift in paradigm.

In spite of the dangers of nostalgia, mentioned above, there is still hope: we can still hang on to Nietzsche's crazed insight that God is finally dead and the stench of his rotting corpse is filling the cosmos. The death of God has been long in coming and it has joined a domino-effect, which has brought down a number of familiar notions. The security about the categorical distinction between mind and body; the safe belief in the role and function of the nation state; the family; masculine authority; the eternal feminine and compulsory heterosexuality. These metaphysically founded certainties have floundered and made room for something more complex, more playful and infinitely more disturbing.

Speaking as a woman, that is to say a subject emerging from a history of oppression and exclusion, I would say that this crisis of conventional values is rather a positive thing. The metaphysical condition in fact had entailed an institutionalized vision of femininity which has burdened my gender for centuries. The crisis of modernity is, for feminists, not a melancholy plunge into loss and decline, but rather the joyful opening up of new possibilities. Thus, the hyper-reality of the post-human predicament so sublimely presented by Parton, Taylor and Fonda, does not wipe out politics or the need for political resistance: it just makes it more necessary than ever to work towards a radical redefinition of political action. Nothing could be further from a postmodern ethics than Dostoyevsky's over-quoted and profoundly mistaken statement, that if God is dead, anything goes. The challenge here is rather how to combine the recognition of postmodern embodiment with resistance to relativism and a free fall into cynicism.

Secondly, the three cyborg goddesses mentioned above are immensely rich because they are media stars. Capital in these postindustrial times is an immaterial flow of cash that travels as pure data in cyber-space till it lands in (some of) our bank accounts. Moreover, capital harps on and trades in body fluids: the cheap sweat and blood of the disposable workforce throughout the third world; but also, the wetness of desire of first world consumers as they commodify their existence into over-saturated stupor. Hyper-reality does not wipe out class relations: it just intensifies them.[4] Postmodernity rests on the paradox of simultaneous commodification and conformism of cultures, while intensifying disparities among them, as well as structural inequalities.

An important aspect of this situation is the omnipotence of the visual media. Our era has turned visualization into the ultimate form of control; in the hands of the clarity fetishists who have turned CNN into a verb: "I've been CNN-ed today, haven't you?" This marks not only the final stage in the commodification of the scopic, but also the triumph of vision over all the other senses.[5]

This is of special concern from a feminist perspective, because it tends to reinstate a hierarchy of bodily perception which over-privileges vision over other senses, especially touch and sound. The primacy of vision has been challenged by feminist theories. In the light of the feminist work proposed by Luce Irigaray and Kaja Silverman, the idea has emerged to explore the potentiality of hearing and audio material as a way out of the tyranny of the gaze. Donna Haraway has inspiring things to say about the logocentric hold of disembodied vision, which is best exemplified by the satellite/eye in the sky. She opposes to it an embodied and therefore accountable redefinition of the act of seeing as a form of connection to the object of vision, which she defines in terms of "passionate detachment." If you look across the board of contemporary electronic art, especially in the field of virtual reality, you will find many women artists, like Catherine Richards and Nell Tenhaaf, who apply the technology to challenge the in-built assumption of visual superiority which it carries.

Thirdly, the [. . .] icons I have chosen to symbolize postmodern bodies are all white, especially and paradoxically Taylor's sidekick Michael Jackson. In his perverse wit, hyper-real

con artist Jeff Koons (ex-husband of the post-human Italian porno star Cicciolina) depicted Jackson in a ceramic piece, as a lily-white god holding a monkey in his arms. With great panache, Koons announced that this was a tribute to Michael Jackson's pursuit of the perfectibility of his body. The many cosmetic surgery operations he has undergone testify to Jackson's wilful sculpting and crafting of the self. In the post-human world view, deliberate attempts to pursue perfection are seen as a complement to evolution, bringing the embodied self to a higher stage of accomplishment. Whiteness being, in Koons' sublime simplicity, the undisputed and utterly final standard of beauty, Jackson's superstardom could only be depicted in white. Hyper-reality does not wipe out racism: it intensifies it and it brings it to implosion.

One related aspect of the racialization of post-human bodies concerns the ethnic-specific values it conveys. Many have questioned the extent to which we are all being re-colonized by an American and more specifically a Californian "body-beautiful" ideology. In so far as US corporations own the technology, they leave their cultural imprints upon the contemporary imaginary. This leaves little room to any other cultural alternatives. Thus, the three emblems of postmodern femininity on whose discursive bodies I am writing this, could only be American.

[. . .]

Notes

1 Remark at the Conference "Seduced and Abandoned: the Body in the Virtual World," held at the Institute of Contemporary Arts, London March 12–13, 1994.
2 *Post-Human*, catalogue of the exhibition at Deichtorhallen, Hamburg, Germany, 1993.
3 Francis Barker, *The Tremulous Private Body. Essays on Subjection* (London: Methuen, 1984).
4 Caren Kaplan and Inderpal Grewal (eds), *Scattered Hegemonies: Postmodernity and Transnational Feminist Practices* (Minnesota: University of Minnesota Press, 1994).
5 Evelyn Fox Keller and C.R. Grontowksi, "The mind's eye," in: Sandra Harding and M.B. Hintikka, eds, *Discovering Reality* (Dordrecht: Reidel, 1983), pp. 207–224; Fox Keller, *A Feeling for the Organism* (New York: Freeman, 1985); Luce Irigaray, *Spéculum* (Paris: Minuit, 1974); Donna Haraway, "A Cyborg Manifesto," in: *Simians, Cyborgs and Women* (London: Free Association Books, 1990), pp. 149–182 [Chapter 53 in this volume]; Haraway, "Situated Knowledges," in: op. cit., pp. 183–202.

JENNIFER GONZÁLEZ

THE APPENDED SUBJECT
Race and identity as digital assemblage

To APPEND IS TO ATTACH or fix something onto something else. The Latin root *pendere* means *to hang* – to hang something (an arm, a leg, a text) onto something else. In an uncanny way, an appendage is always considered integral to the object to which it is also an addition. The simultaneous necessity and marginality of the appendage also characterizes many of those material practices, objects and signs that are said to construct forms of social and cultural identification. Signs grafted onto the human subject – such as clothing or names, projections of others based upon historical circumstances, location, language – enunciate both defining elements of that subject and part of an external, changing narrative into which that subject is drawn – voluntarily or involuntarily – as a participant. The "appended subject" has several connotations here: that of a subject that is comprised of appendages, of parts put together, of supplementary materials, or that of a subject or person who is defined by a relation of supplementarity, added to some other principal body – as the colonized subject might be perceived by an imperial nation as an appendage to a centralized state. Finally, the appended subject describes an object constituted by electronic elements serving as a psychic or bodily appendage, an artificial subjectivity that is attached to a supposed original or unitary being, an online persona understood as somehow appended to a real person who resides elsewhere, in front of a keyboard. In each case a body is constructed or assembled in order to stand in for, or become an extension of, a subject in an artificial but nevertheless inhabited world.

The concept of an appended subject is used in this essay in order to account for contemporary artists' representations of utopic spaces on the World Wide Web and the visible models of embodied subjects produced therein. This relatively new domain for the phantasmatic projection of subjectivity (new in comparison to other media such as film, television, advertising and forms of cultural spectacle that produce patterns of identification) has also been championed as an innovative space for the reinscription or redefinition of social relations, as well as the reconceptualization of the traditional markers of race and ethnicity, sexuality and gender. There are currently thousands of online spaces that allow users to experiment with identity in an artificial world. The original form of such sites – MUDs or MOOs – are collaborative writing projects in which people describe or define a physical presence, contribute to a textual architecture, and converse with other online participants. Media theorists and communications scholars have provided the most sophisticated and extensive readings of this social collective practice. Much has already been written about the agony and ecstasy of gender swapping, virtual sex, passing, and politics on these sites.[1] As computer monitors and Internet interfaces have increased in their capacity to display visual information over the last decade, online sites with image and sound components have become popular. In these "habitats" or

"palaces" a textual description of the user is superseded or supplemented by a visual icon – usually called an avatar.

Even a superficial glance at online sites that distribute or sell avatars is instructive, revealing a common set of identificatory fantasies created by individual whim as well as popular demand. Simple grids of images (scanned photographs, drawings, cartoons) are arranged thematically (as movie stars or "avamarks," soft-porn models or "avatarts," muscular men or "avahunks," trouble-makers or "avapunks," cats, dogs, Native Americans, blondes, brunettes, happy faces, Hula dancers, space aliens, medieval knights, and corporate logos) apparently following an internal logic of demand but tacitly referencing a social typology in which such categories mark out a hierarchy of social relations and stereotypes. The availability of these images for sale makes literal a public circulation of ego ideals while simultaneously naturalizing the market-place as the privileged domain – beyond family, church or state – of contemporary identity construction and consumption.

The enactment of racial identity in online sites takes a variety of forms. In some cases users will self-identify (as white, black, Latino) in chats that solicit discussion on the topic of race. In other cases, race or ethnicity will be a defining feature of a website to which users send photographs of themselves, such as sites that function as support groups for mixed-race couples. My focus here, however, is on the phantasmatic representation of race or ethnicity and in particular on models of hybrid racial identity that take the form of avatars or other visual assemblages of human bodies. Insofar as racial and ethnic identity are conceived in many cases to be limited to visible signs such as skin color, eye color, or bone structure, they are also conceived as decorative features to be attached or detached at will in the so-called arti-ficial or virtual context of cyberspace. Such play with racial identity nevertheless can and does have concrete consequences as real as those occurring in other cultural domains of social exchange such as literature, film or music. Because "passing" (or pretending to be what one is not) in cyberspace has become a norm rather than an exception, the representation of race in this space is complicated by the fact that much of the activity online is about becoming the fantasy of a racial other.

Homi Bhabha's 1986 essay "The Other Question" has been useful to my own work for its elaboration of the link between racial stereotyping and the structural disavowal that char-acterizes fetishism. Stereotypes are created by colonizing cultures, Bhabha asserts, in order to mask real cultural difference. In order to disavow this difference, as well as the complex subjecthood of the colonized population, the stereotype presents itself as a fetish – in the form of literature, images, speech – by which the possible threat of the "other's" difference is transformed into a safe fantasy for the colonizer. Thus "the recognition and disavowal of difference is always disturbed by the question of its representation or construction."[2] Bhabha's analysis succeeds in drawing out the relations of power that underlie the colonialist enter-prise and that become manifest in social and material practices. Something on the same order of analysis is required, I believe, to address the fantasy utopias or dystopias of the Web that reproduce stereotypes (particularly of race and gender) at an impressive pace.

My brief analysis here is motivated largely by a curiosity concerning representations of human bodies online. How do such visual representations extend or challenge current concep-tions of racial and cultural identity and relations of power? In what ways is human identity equated with the notion of a bodily assemblage? What are the possible ramifications of such an equation for conceptions of cultural hybridity on the one hand, or a revived eugenics on the other?

Two provocative sites will serve as a point of discussion, though there are many others appearing daily. UNDINA, by the Russian artist Kostya Mitenev, and Bodies[©] INCorporated,

by U.S.-based artist Victoria Vesna, appear inspired, at least in part, by the contemporary phenomenon of avatar production. Both websites deviate somewhat from the norm, putting an unusual spin on the production of "appended subjects," particularly as those subjects are conceived as assembled from disparate iconic elements. Each site offers the user the opportunity to construct or "submit" visual images of a body or of body parts, and to examine other bodies that have been put on display. These two sites were chosen for comparison because the human body is their primary focus and race or ethnicity as elements of identity are conspicuous in their presence or absence in each case. Both sites use the space of the computer screen to depict bodies in pieces, either as photographic images or three-dimensional renditions of corporeal fragments (arms, legs, heads, torsos) that can be selected from a menu or reassembled. I am particularly interested in the ramifications of such artistic projects for thinking about the interpellation of individuals as embodied subjects and the political, ethical, and aesthetic notions of choice that they imply.

Identity as bodily assemblage: parts and proximate relations

The title of Kostya Mitenev's website, UNDINA, is an acronym for United Digital Nations. Linked to a collective webpage for a group of Russian artists and scholars who identify themselves as Digital Body and who participate in exhibitions held in the Bionet Gallery, as well as to the home page for the city of St. Petersburg, the site has an international, cosmopolitan, and diplomatic feel. At the same time, UNDINA is clearly positioned as a work of contemporary art, sited within its own electronic gallery and addressing an audience of other artists and designers. Indeed, the line between so-called high art and the visual culture that pervades the World Wide Web has long been institutionally crossed insofar as museums of art (ICA London, the Guggenheim Museum, the Museum of Modern Art, and so on) regularly display online art projects; institutions of art education in industrialized nations offer computer graphics as a central component of their curricula; and art critics produce many online and offline publications that address exclusively online art practice. At the same time, the work is not unlike other sites that are presented for entertainment, commerce, or information. The space is electronic, the vernacular is based on standards of hardware and software, and the audience is unpredictable. To study works of art in this context thus invites comparison to a broader field of visual culture (i.e. avatar production) as well as to parallels in other fine art practices and performances.

On the opening page of Kostya Mitenev's UNDINA appears the familiar figure of Leonardo Da Vinci's fifteenth-century Vitruvian Man, with arms and legs outstretched, floating in geometric perfection. An ironic gesture on the part of Mitenev, the Vitruvian Man situates his work within and against a tradition of figurative normativity. Leonardo's geometry becomes a sign of the standard against which the artist develops his own model of contemporary human form and being, while at the same time the body of man is read as the central axis in a futurology of body archetypes. Mitenev accuses this standard (here renamed Xyman) of having dominated European cultural representations of the body "for half a millennium."[3] Part of the goal of the UNDINA website, according to the artist, is to de-center this traditional form with a set of collectively constructed new future bodies.

Comprised of three separate domains, the UNDINA site includes a virtual gallery space that can be navigated with VRML technology, a planetary system "populated" by cultural archetypes, and, the central focus of the work, what might be called a future-body table of new physical types. This last consists of a screen space divided into a grid of nine squares, depicting the head, torso, and legs of three vertical figures [see Figure 61.1]. Body or body-

Figure 61.1 UNDINA screen grab, *c.* 2002.

part images that have been submitted by users or that the artist has included himself are joined or stacked together to form a monstrous or fantastical mixing of sex, age and race into a single body. The artist comments, "In the project of UNDINA the intrigue of the collective modelling of the body of the future is maintained." His plan is to make "a wide range catalog of visual delirium of future images of the body and to create a model or space of international foresight of artistic images of future bodies." In the process, he suggests that "you can choose your own model of a body, alternatively you can create it yourself with your computer. The bodies are timeless and anonymous, that frees the self in the space of the meta-world." He adds in conclusion that "Artists of non-European traditions of conceptualizing and visualizing of the body are specially invited."[4] Mitenev's project appears progressive in so far as it aims to undermine narrow conceptions of human being; to shift European standards of body norma-tivity from center to margin; to offer a United Digital Nations of diverse international membership as a model for future cultural contact, perhaps even a "global" village. But UNDINA's effort to escape the culture of the stereotype oddly reinscribes its narrow confines. The result is more akin to what might be a fantasy in the form of the surrealist game Exquisite Corpse.

The bodies in Mitenev's body grid are "timeless" or perhaps more precisely, heterochronic, insofar as they are comprised of both historical and contemporary images that are also constantly shifting, the mix-and-match elements recurring or transforming into new configurations. Along the row of heads, for example, one might see a portrait by Archimboldo or Rosetti, a 1940s

photograph of a beautiful black woman's face, or the head of a white male fashion model; at torso level there might appear the bare breasts of a pornography model, a scantily clad dark-skinned woman or a white man in a suit and tie; and for legs a pair of combat boots, a photograph of female – or in the rare instance, male – genitalia and bare legs, or the tender feet of an infant. These and many other images flash continually on and off in this imaginary game of human exhibition and hybridization. Fantasies of undressing and connecting with cultural "others" are expressed in a painfully awkward montage, resulting in a strange dysplasia.

Leaving behind this screen of automated flesh, the user can travel to the planetary realm of UNDINA populated by selected archetypal figures of the artist's futurology. Rather than dissecting these bodies into a set of interchangeable parts, the artist presents them within categories of his own devising. One can visit, for example, the planet of the gods, the aliens, the heroes, the mythological heroes, the wonderland heroes, the cult images, the fantastical images, or the monsters. Here, future bodies are not so much hybrids as characters within an almost literary taxonomy, and there seems to be little distinction between Mitenev's work and the cultural stereotypes provided by other avatar sites. For example, aliens are either black men or blue space creatures; heroes are white men with blond hair; killers wear African headdresses; and cult images include nude women of color.

Mitenev's work, perhaps unconsciously, perpetuates damaging racial and sexual stereotypes – in itself nothing new in art or visual culture; yet, UNDINA is all the more insidious because of its utopic and inclusive rhetoric. Indeed, I would probably not address this work if it were not for its supposed attempt to picture a progressive model of future subjectivity. In this context, the most interesting aspect of the site is the series of images that comprise the automatic body table, those future bodies exemplified in a nonunitary, hybrid form. This ambitious attempt to reproduce a model of cultural mixing through an intersection of photographic images appears in an equally insidious way in *Time* magazine, in an article entitled "The New Face of America" (1993). Donna Haraway has commented, "*Time* magazine's matrix of morphed racial mixtures induces amnesia about what it costs, and what might be possible when flesh-and-blood people confront the racialized structure of desire and/or reproduction collectively and individually."[5] Evelynn M. Hammonds comments that

> Morphing, with its facile device of shape-changing, interchangeability, equivalency, and feigned horizontality in superficial ways elides its similarity with older hierarchical theories of human variation. [. . .] With the *Time* cover we wind up not with a true composite, but a preferred or filtered composite of mixed figures with no discussion of the assumptions or implications underlying the choices.[6]

What both UNDINA and *Time* magazine offer in the form of a visual representation is a dissection of a fantasy subject along the gross criteria of bodily appendages or genotype, with little or no consideration of other cultural factors such as language, economic class, or political practice. It is similar to the process that Margaret Morse sees operating in the morphing of human faces in Michael Jackson's *Black and White* music video: "Ideologically, the work of achieving harmony among different people disappears along with the space in between them."[7] The artist's desire to produce timeless and anonymous bodies creates precisely the kind of historical elision that erases any complex notion of cultural identity. Here a hybrid identity is presumed to reside in or on the visible markers of the body, the flesh. In a sense, Mitenev beautifully illustrates the projective power of stereotyping. Here the *subject* is distilled from the assembled components (appendages) of the *body*.

This reading of the body as a coded form, a visible map, of the subject is as familiar as the idea of the symptom, as basic to visual culture as the process of photographic mimesis that followed painting in a long line of efforts to capture the subject through a record, an imprint of the body. But it is not this history that is of greatest importance here. Mitenev's work has less in common with the history of portraiture than with the experiments enacted in the name of modernity, the split and divided corporeality of twentieth-century visual collage, photomontage, and assemblage that attempts to map an unstable subjectivity with the collection or appropriation of disparate images and objects. I have already suggested a parallel with the surrealist game Exquisite Corpse, here played out electronically. It is also clear that this site derives its formal structures from photomontage. Indeed, an oblique reference to Hannah Höch's work can be found in Mitenev's use of an African headdress that bears a remarkable resemblance to *Denkmal II: Eitelkeit (Monument II: Vanity)* from the series *Aus einem ethnographischen Museum (From an Ethnographic Museum)* of 1926.

Insofar as Kostya Mitenev's project relies upon, or at least gestures toward, these artistic precedents, it is tempting to read UNDINA as simply an electronic extension of a familiar formal practice, but it is also something more. The site might be read as a progressive recognition of the *fact* of cultural hybridity, a recognition that humans are all produced through genetic and linguistic mixes. Yet, as I note above, the mix in Mitenev's universe depends upon cultural stereotypes for its model of the future. I have written elsewhere that the very concept of hybridity is haunted by its assumption of original purity.[8] UNDINA, finally, does little to subvert the racial or cultural hierarchies that underlie its playful, monstrous hybrids.

Mary Shelley's *Frankenstein* was an exploration of psychological and moral transformation, but it is remembered best in popular culture as the story of the reanimation of dead flesh, the production of a monstrosity out of parts of human bodies. The monstrous, as Barbara Maria Stafford reminds us, derives etymologically from the Latin *monstrare* "to show," from *monere*, "to warn," and has come to mean the unnatural mixing of elements that do not belong together – a mixing of elements most often read as a tragic accident.[9] While Frankenstein's monster was no accident, Shelley's novel implies that the monstrous is nevertheless a product of tragedy. It is as if the various parts of the beast, acting in disunion or disharmony, create his inability to cohere as a subject.

The step from the tragic monster to the tragic mulatto or mestizo was a short one in the nineteenth century. The hybrid subject is never considered immune from the vicissitudes of fate or of the repercussions of unnatural union. Here there is also a notion of the body in pieces, somehow unable to become accurately assembled into a properly functioning subject or citizen – hence the laws banning miscegenation that were only repealed in the United States in 1968. Thirty years later, the once forbidden has become an unlikely ideal. What is the appeal of such a subject position (still presented as monstrous) at the end of the twentieth century?

In the context of post-Soviet Russia, it may be a radical act to suggest or visually represent racial and cultural hybridity. This gesture may have some impact on contemporary political activism. At the same time, the work does little to undo the essentializing tendency common in many well-intentioned efforts to populate the World Wide Web with a variety of human types. Instead, the body fragment is used as a fetish to make cultural difference palatable, as an element of desire, of consumption. The synecdochic quality of the fetish, its status as a part object that allows pleasure, appears in UNDINA's formal, visual dissection and literal truncation of corporeal signs. Even the body as a whole, represented in parts, reproduces a fetishistic structure of disavowal, an occlusion of both the original subject and of the *historical relations between concrete bodies*, of enforced racial mixing, of colonialism. Yet, Mitenev's future bodies are presented as part of a new archetypal architecture of diplomacy. If the artist

wishes his audience to play out the metaphor of a United Digital Nations, then what kind of diplomacy, dialog or action can take place in this context? Is the lack of a fixed subject position, a shifting set of bodily apparatus, enough to constitute or provoke, as the artist seems to hope, a new international consciousness? In short, what set of relations is being offered to the audience as the model of future global interchange? Despite its claims of collaborative construction UNDINA perpetuates a unidirectional, uncritical reiteration of precisely the hegemony it claims to critique, and it does so using racial mixing as its model.

In a different way, shifting from an imagined global community to a corporate one, artist Victoria Vesna also takes up the visual metaphor of the body-in-pieces to figure a new elemental species. Bodies$^{©}$ INCorporated is an art project based at the University of California at Santa Barbara, created by Victoria Vesna and a team of collaborators including Robert Nideffer, Nathanial Freitas, Kenneth Fields, Jason Schleifer and others. The site is designed to allow users to "build out bodies in 3-D space, graphically visualizing what were previously bodies generated as text-only."[10] Bodies$^{©}$ INC clearly situates its origins within the world of avatar manufacturers, yet it also foregrounds the manner in which bodies can be conceived as part of a corporate or institutional structure in contemporary capitalist culture. It hovers in its own liminal space, a pun on the term "incorporated" that becomes a simultaneous critique of corporate culture and a capitulation to its terms of enunciation. For example, as with many other websites, visitors to the site must agree to recognize and abide by various copyright restrictions, legal disclaimers, and limits of liability – including liability for *disappointment* in the outcome of the body one constructs. This witty, self-conscious irony runs throughout the text of the site, drawing upon the rhetoric of advertising as well as making subtle and often satirical gestures toward the politics of identity and, in this case, the very notion of satisfaction guarantees or the lack thereof in the complex construction of a bodily identity. For here, as in Mitenev's world, the construction of a body is expressly linked to the construction of identity. The opening page of the site welcomes the new visitor, who is informed that the site "functions as an institution through which your body gets shaped in the process of identity construction that occurs in, and mutually implicates, both the symbolic and material realms."[11] The important relation between the material and the symbolic for Vesna is that between the shaping of the body and the construction of identity (the former being the apparent process by which the latter is achieved). While this equation echoes the assumptions of eugenics, it also can be read, alternatively, as a progressive assertion that identities are always inseparable from corporeal encounters and the symbolic inscription of bodily signs. The corporate rhetoric continues in the assertion that the body created "becomes the personal property" of the person who assembled it. The notion of the body as property also has its own historical connotations, not only in the traditional examples of prostitution and slavery, but also in a contemporary moment when body parts, organs, and vital tissue are bought and sold on a black market.[12] Body parts are also for sale in Bodies$^{©}$ INC, and the more shares the user accrues, the more parts he or she can buy.

Bodies$^{©}$ INC aptly reconstructs the bureaucracy that inspired its inception, drawing attention to bodies threaded through the paperwork of birth and death certificates, census forms, and medical records, and simultaneously emphasizing the necessity and ludicrous limits of creating selfhood through the apparatus of checked boxes and a narrow range of multiple choices. Birth and death are reduced to nothing but the mechanical act of filling out a form – accompanied by the frustration of waiting indefinitely to see the body-object one has created to appear as a visual model in 3D graphics. The process of constructing a body for Bodies$^{©}$ INC sensitizes the user to the categories of identity and identification already standardized in the culture at large.

The administrative forms are a simple black and white, divided into various subsections beginning with a "personal validation" in the form of a name, e-mail address, and password. One must next choose a name for the body to be constructed, then a sex assignment (choices include: female, male, hermaphrodite, other), then a sexual preference (choices include: heterosexual, homosexual, bisexual, transsexual, asexual, other), then an age group (any number with three digits or fewer), then body parts. One arrives at the construction of the body after already declaring its attributes. Continuing with the reductionist model maintained throughout, the body is conceived as an object composed of six essential components: a head, torso, left arm, right arm, left leg, and right leg. No logic is given for this decomposition, though it is likely that the design is dependent upon a number of technical constraints as well as conceptual focus. Each body part can be masculine, feminine, infantile, or nonexistent. One could produce a body without a head, for example. Each part can be sized either small, medium, or large, and is finally surfaced by one of twelve textures: black rubber, blue plastic, bronze, clay, concrete, lava, pumice, water, chocolate, glass, or wood. Vesna contends that the bodies are "constructed from textures, in order to shift the tendency to perceive the project from a strictly sexualized one (as frequently indicated by people's orders and comments) to a more psychological one (where matters of the mind are actively contemplated and encouraged). Before long, each of the textures is given detailed symbolic meaning."[13]

Bodies© INC thus establishes its own community of bodies with symbolic meaning intimately tied to a surface texture. Given the kinds of images available on the Web, this gesture is probably groundbreaking, though it remains to be seen how successful it is in desexualizing the body, as the representative forms in Bodies© INC are tall and slim and decidedly reflect the Euro-American ideal. Indeed, to construct a fat body or to produce an unusual or monstrous body in this context requires more shares and expertise. Textures are also a convenient solution to the problem of skin color(s). Yet, the progressive potential of a rejection of racial typology falls into its own essentialism when character traits are equated with physical attributes, and limited to a prescribed system of behaviors. Black rubber is hot and dry, sublimates at a relatively low temperature and is a fashion and style element; bronze is hot and cold, hard and wet, very reactive when heated with most substances and is a corporate leader element; clay is cold, dry, and melancholy, it works on subliminal levels to bring out the feminine and is an organizational element; concrete is cold and wet, a powerful desiccating agent that reacts strongly with water and is a business element; lava is hot and dry, conceived as light trapped in matter or perpetual fire and represents a team leader sense; chocolate is sweet and moist, an integrative force that interweaves and balances and is a marketing element, and so on. What emerges from this list is a set of corporate typologies – the fiery team leader; the melancholy feminine organizer; the dry diplomat; the black, stylish sublimator – that are simultaneously humorous and disturbingly familiar. Familiar because they combine traits that are already linked in the popular preconscious of the culture at large (the melancholy female, the reactive corporate leader) in the form of archetypes or stereotypes. Hybrid figures may also be composed of different elements, perhaps even a schizophrenic set of surfaces that may implicate the body in a set of conflicting power relations. More ironic and sophisticated than those produced in UNDINA, these body textures are still problematic for those who may already be identified as black or bronze.

In addition to a visual body, the user is able to choose from one of twelve sounds that will provide an otherwise mute figure with a kind of vocal presence: breath, geiger, history, nuclear, sine, and voice for example. The sound components are clearly conceived as conceptual signs that function evocatively rather than mimetically. Finally, the user can mark whether the newly designed body functions as an alter ego, a significant other, a desired sexual partner,

or "other," and may add special handling instructions or body descriptions and general comments.

Unlike Mitenev's UNDINA, Vesna's Bodies© INC has extensive written documentation on the website that creates a metadiscourse for the user. An essay by Christopher Newfield defines Bodies© INC as a specific kind of corporate structure that

> establishes a virtual corporation as an "active community" of participants who choose their own bodily form. The primary activity is the creation of a body in exchange for which the creator is given a share of stock. Corporation B thus exists to express each member's desire about his or her physical shape. Production serves self-creation. Firm membership formally ratifies expression. These expressions have none of the usual limits: men become women; black becomes white and white becomes brown; flesh turns to clay, plastic, air; clay, plastic, air are attached on one body. Bodies need be neither whole nor have parts that fit.[14]

Indeed, this work clearly produces what I have called an appended subject whose limbs and flesh are accessorized, linked to personality traits, and used as values of exchange. The miscegenation of this world is one of hot and cold, wet and dry, mind over matter. But the underlying notion of easily transformed gender and skin color – "men become women; black becomes white and white becomes brown" – more accurately denotes the fantasies inherent in the project.

To her credit Vesna writes, "There is a need for alternate worlds to be built with more complex renditions of identity and community building and not simply replicating the existing physical structures of hierarchies."[15] She also comments that Bodies© INC is conceived "with the intention of shifting the discourse of the body from the usual idea of flesh and identity. Every member's body represented is the locus of the contradictions of functioning in the hi-tech environment, while being in the meta-Body, the Entity in the business of service."[16] Vesna here maps the internal logic of her own work, criticizing and at the same time reproducing a corporate ontology. Unfortunately, the users of the site do not seem to share her self-conscious take on the function of bodily representations. Lucy Hernandez, quoted in the discussion section of Bodies© INC, writes in May 1997, "I am very pleased to have found your site. I am looking for avatars that can be used in any VRML world. Can my new body leave this site and visit other places? How can I get my new body code? Thanks for making 'real' people. I'm tired of being a bird!" What happens to these real people when they are no longer needed? Like the leftover packaging of mass-produced commodities, the bodies created in Bodies© INC are sent to the wasteland of "Necropolis" after their creators choose a method for their death. Never really gone, they haunt the floating world in cold rows of gray geometric blocks. Other bodies circulate and purchase parts at the "Marketplace" (where a *Star Trek* Vulcan head might currently be on sale), or exercise their exhibitionism in "Showplace," return "Home," or loiter in "Limbo." Each domain is a separate VRML world within Bodies© INC that can be navigated with the proper software [see Figure 61.2].

Sardonic, slick and beautiful, Bodies© INC offers a critical response to a corporate structure and hierarchy – a hierarchy it maintains, despite its claims to the contrary. Its irony is also part of its complicity. And for this group of artists, complicity seems to be the primary mode by which any kind of cultural transformation and critique will take place. Christopher Newfield writes,

> There's no more important change right now than culture recapturing technology – recapturing technology not to reject it but to make culture its partner again as we

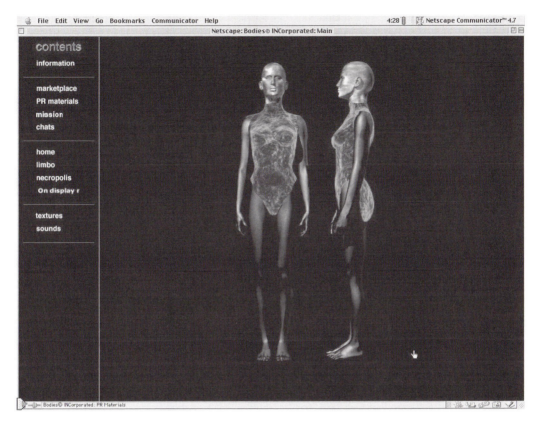

Figure 61.2 Bodies[©] INC screen grab, *c.*2002.

invent our future, our society, our redemptions. An excellent place to begin is the [corporate] B-form's recolonization of business power for the artist's mode of continuous invention business now says it seeks. You will know the recolonization is working when you say, paraphrasing Louis Massiah, "it makes revolution irresistible."[17]

This unlikely mix of neo-Marxist and marketing rhetoric suggests a new critical form for art production. Bodies[©] INC's financial sponsors include, among others, Viewpoint Data Labs, Netscape, alias/Wavefront, Silicon Graphics, MetaTools, and Siggraph. It remains to be seen whether a "recolonization" of business power is the most effective method for its critique. Bodies[©] INC succeeds at least in foregrounding relations among bodies, bureaucracy, and power in a culture based on consumption.

[. . .]

As works of art, UNDINA and Bodies[©] INC fall somewhere between [. . .] two models of postmodernism. If the transcendental subject of an enlightenment reason was a unified, predictable subject that could only be imagined because of a homogeneous cultural context, and if the postmodern subject emerged from a recognition of, among other things, a complex heterogeneous cultural context, then these two art works enact the *return* of a transcendental subject as an *endlessly appendable subject*. What the creation of this appended subject presupposes is the possibility of a new cosmopolitanism constituting all the necessary requirements for a global citizen who speaks multiple languages, inhabits multiple cultures, wears whatever

skin color or body part desired, elaborates a language of romantic union with technology or nature, and moves easily between positions of identification with movie stars, action heroes, and other ethnicities or races. It is precisely through an experimentation with cultural and racial fusion and fragmentation, combined with a lack of attention to social process, a lack of attention to history, and a strange atomization of visual elements that a new transcendental, universal, and, above all, consuming subject is offered as the model of future cyber-citizenship.

Political and ethical choice is reduced to the consumption and incorporation of new appendages to the body. When these appendages are "racialized" a new form of colonization takes place on the level of symbolic exchange. UNDINA and Bodies© INC offer one view into this global ideological apparatus and serve as a reminder that human bodies continue to be the material and visible form through which human subjectivities are defined and contested today, despite the new popular belief in cyberspace as the ultimate realm of disembodiment.

Notes

1 See the writings of Allucquère Rosanne [Sandy] Stone, Julian Dibbell, Steven Jones, Anne Balsamo, Mark Dery, and others.
2 Homi Bhabha, "The Other Question."
3 Written e-mail comments to the author, January, 1998.
4 Ibid.
5 Donna Haraway, "Monkey Puzzle," 42.
6 Evelynn M. Hammonds, "New Technologies of Race," 109, 118.
7 Margaret Morse, *Virtualities: Television, Media Art and Cyberculture*, 96.
8 Jennifer González, "Envisioning Cyborg Bodies."
9 Barbara Maria Stafford, *Body Criticism*, 264.
10 Victoria Vesna, Bodies© INCorporated.
11 Ibid.
12 See Anthony Beadie, "Body-Parts Black Market on Rise, Film Says." Cited in Dery.
13 Vesna, Bodies© INCorporated.
14 Christopher Newfield, Essay, Bodies© INCorporated.
15 Victoria Vesna, Genealogy, Bodies© INCorporated.
16 Ibid.
17 Newfield.

References

The two URLs for the sites are Bodies© INCorporated: <http://www.bodiesinc.ucla.edu/> and UNDINA: <http://www.digbody.spb.ru/undina/!undina.htm>.

Balsamo, Anne. *Technologies of the Gendered Body: Reading Cyborg Women*. Durham, NC: Duke University Press, 1996.
Beadie, Anthony. "Body-Parts Black Market on Rise, Film Says," *Arizona Republic*, 12 November, 1993.
Bhabha, Homi. "The Other Question: Difference, Discrimination and the Discourse of Colonialism," in *Literature, Politics and Theory*, F. Barker et al., eds. New York: Methuen, 1986, p. 169.
——— *The Location of Culture*, London; New York: Routledge, 1994, p. 252.
Dery, Mark. *Escape Velocity*. New York: Grove Press, 1996.
Dibbell, Julian. *My Tiny Life: Crime and Passion in a Virtual World*. London: Fourth Estate, 1999.
González, Jennifer. "Envisioning Cyborg Bodies: Notes from Current Research," in *The Cyborg Handbook*, Chris H. Gray, ed. New York: Routledge, 1995.
Hammonds, Evelynn M. "New Technologies of Race," in *Processed Lives: Gender and Technology in Everyday Life*, Jennifer Terry and Melodie Calvert, eds. New York: Routledge, 1997.
Haraway, Donna. "Monkey Puzzle." *World Art* 1 (1996), 42.

Jones, Steven. *CyberSociety 2.0: Revisiting Computer-Mediated Communication and Community*, Thousand Oaks, Calif.: Sage, 1998.

Morse, Margaret. *Virtualities: Television, Media Art and Cyberculture*, Bloomington: Indiana University Press, 1998.

Newfield, Christopher. Essay, Bodies© INCorporated, <http://www.bodiesinc.ucla.edu/> (1997).

Stafford, Barbara Maria. *Body Criticism: Imagining the Unseen in Enlightenment Art and Medicine*, Cambridge, MA: MIT Press, 1991.

Stone, Allucquère Rosanne. *The War of Desire and Technology at the Close of the Mechanical Age*, Cambridge, MA: MIT Press, 1995.

Vesna, Victoria. Bodies© INCorporated, <http://www.bodiesinc.ucla.edu/> (1997).

Chapter 62

SHARON LEHNER

MY WOMB, THE MOSH PIT

Mourning for the image, insofar as I fail to perform it, makes me anxious; but insofar as I succeed in performing it, makes me sad . . .

Roland Barthes, *A Lover's Discourse: Fragments*

EXACTLY TEN DAYS BEFORE I ABORTED a ten-inch fetus from my body in the company of medical strangers, I laughed with wonder at what looked like a naked baby boy in real-time, documentary black and white on an ultrasound monitor. The sonogram was followed with amniocentesis, a mildly invasive procedure, in which fluid from the womb was extracted in order to grow a genetic culture. It was determined from this test that the fetus displayed certain profound anomalies and that the severity of those abnormalities could not be determined.

The room is dark. The technician glides a flat wand over the sound-conducting gel spread all over my belly. I look at the monitor, as the technician begins to interpret the image in an intimate whisper: "There is the spine, those are the toes . . . all ten. Okay, let's see your fingers, Baby." The fetus spreads all ten of its fingers as if on command. "Oh," the technician announces, "He's proud." It takes thirty minutes to measure and inventory the body parts of the fetus: the arms, the legs, the stomach, the liver, the lungs, the kidneys, the brain. The doctor zooms in on the penis with the special camera, outlining it with a strong dotted line. "Look," he announces, "He has a large and strong penis, it is standing up like the Statue of Liberty!" Everyone laughs, even me. I'm not sure what is funny. We name this fetus "Boy." We give him a big white dick. We turn it into that phallic woman who stands up for freedom. I stare at the image on the screen. It is in constant, violent motion, a 1980s punk rocker in a mosh pit.

Figure 62.1 Replication by Tina La Porta, *c.* 2000.

I am mourning, and I can't say for whom, or even what. Does the loss of a fetus consti-tute a death, and if so, who dies? How can the fetus die if it hasn't been born? How do I properly mourn an image? I turn to Freud, and find him of little use, as his insights pale before the technological "advances" complicating my loss. How could he know that I would be given a chromosomal Xerox map defining this fetus as damaged? For all its discussions of mourning and melancholia, classical psychoanalysis fails to absorb the scope of my grief. Even psychoanalytic feminist theory fails me, coming to a grinding halt precisely at the moment I attempt to theorize the ramifications of my conscious decision to end a pregnancy. In the crowded abortion clinic after the Catholic hospital refuses to perform the procedure, I feel alone with my only witness, an image with ten fingers and ten toes.

The fetus could not be taken seriously as long as he [*sic*] remained a medical recluse in an opaque womb; and it was not until the last half of this century that the prying eye of the ultra sonogram [that is, ultrasound visualization] rendered the once opaque womb transparent, stripping the veil of mystery from the dark inner sanctum, and letting the light of scientific observation fall on the shy and secretive fetus. The sonographic voyeur, spying on the unwary fetus, finds him or her a surprisingly active little creature, and not at all the passive parasite we had imagined.

Michael Harrison, in Petchesky 1987: 69

Ultrasound, developed in World War II in order to seek out and destroy enemy submarines, utilizes sound to "see." A sonogram image is created by high frequency sound waves that vibrate all through a woman's body. In this way, I am "skinned" and the contents of my womb exposed.[1] The density of the tissue determines the color of the image: bone shows white, blood looks black.

Ultrasound technology continues to advance. The image isn't hazy, as I had assumed it would be. It takes my breath away; it looks so real. I don't see the outline of fingers and toes, I see kidneys, lobes of the brain, the four chambers of a beating heart. It is an intimate pleasure to see my baby. It is the first projection of his performance, measured under surveillance before birth.

The desire to see the unborn is a relatively recent phenomenon. Until the nineteenth century, when X-rays reached the fetus, "the invisibility of the unborn seems to be protected by widespread taboo" (Duden 1993: 32). During the late 1960s and early 1970s, ultrasound moved into gynecological offices, opening new markets lost after the baby boom (Petchesky 1987: 65). In the 1990s sonograms have become increasingly common.

Ultra sound imaging has come to play a symbolically predominant role in prenatal care. Its rapid spread is due to a number of factors: it produces income that stays in the doctor's office; the equipment manufacturers have made it attractive; it plays on the fantasy of patients for TV-inside news; it promises information, certainty and control.

Duden 1993: 75

The interior of a woman as TV news presentation resonates nicely with the mother's visual absence during a sonogram. Hubbard, Phelan, and Duden, among others, point out that the free-floating image of the fetus in the sonogram erases the body of the woman. In other words: a sonogram takes a picture of me that I'm not in. Even in the examining room I do not really exist. The moment when all eyes turn away from my belly, and toward the monitor, even I become a passive observer of an "Other," an "Other" which cannot be seen with the eye. For the fetus to be seen as an independent entity, the woman must drop out of the image.

While I believed my fetus to be of me, and yet not of me, on screen the image of the fetus is separate, detached, independent of my body. The fetus becomes the star of the documentary, whose topic is the status of the fetus as a self-defined medical "fact." In *Unmarked*, Phelan argues that both the political left and the right hold the dangerous belief that representation "can be treated as real truth." Scientific representations, Phelan warns, are especially dangerous, because the logic of scientific technology is often tautological: the "truth" is presented by a technology, and yet it is invisible without that exact technology (Phelan 1993: 2). We read the real time, scientific, black and white sonogram as a TV documentary; the genre asserts the realness of the fetus. Another real element is this: the majority of the women who use these

visual reproductive technologies are middle class or wealthy and have health insurance policies. It is no accident that the age of the women who are considered to be "at risk" for pregnancy drops with each year as more and more markets are opened up to these technologies. The sonogram retroactively decides when and if the "fact" of pregnancy is medically acceptable. In this case, the image – or the ability to make an image – determines reality.

The examining room is like a movie theatre. The room is dark and the ultrasound monitor flickers with "the brilliance of the shifting patterns of light and shade on the screen [which] helps to promote the illusion of voyeuristic separation" (Mulvey 1973: 17). I joked with the Asian immigrant doctor and the African American ultrasound technician. I am white, forty, and nervous. My husband Andrew sits on a stool looking at the monitor. I find looking at the fetus in my body to be unbelievably pleasurable. Although image and self-image are inextricable, feminist film critics tell us this much: the danger and the pleasure of dropping out of one's own picture should not be underestimated.

In cinematic realism, the character on screen does not break the frame to tell the viewer that "it's just a movie." Likewise, the doctor and technician in the examining room do not call the fetus a representation. They want me, instruct me, to see a baby. After the examination, the technician offers me a few snapshots from the collection stapled to my medical records. I take them home. I believe I have seen my child. I can't help myself. I forget about girl names, report to my friends, call my family. It's a Boy.

I was given options. I could have delivered. It sounded like strange, barbaric torture to hold this tiny object in my arms. But now I understand why many women choose to deliver the fetus. If they see it as "real," they are able to mourn its passing. Do not misunderstand me – I do not argue here that the fetus of the sonogram is, simply, the right wing icon: the unborn child. Instead I wish to complicate the relative political silence of the feminist left on the complexity of the fetus, as image and as infant. It is not enough to say, "a fetus is nothing more than an image" and be done with it. This statement ignores the very history of genre conventions upon which sonograms build their claims to medical fact. Images ARE real, insofar as they offer pleasure, cause pain, and incite viewers to action. Women, especially, ignore this crucial lesson in aesthetics at their political and medical peril. Certainly representation is not reality, but as Susan Bordo says,

> Attempts to devalue fetal life have fed powerfully into the right-wing imagination of a possible world in which women would be callously and casually scraping fetuses out of their bodies like leftovers off a plate. This image [is] cruelly unrepresentative of most women's experiences.
>
> Bordo 1993: 95[2]

Laura Mulvey suggests, "It is the long love affair/despair between image and self-image which has found such intensity of expression in film" (Mulvey 1973: 18). Sherry Turkle claims "our new technologically enmeshed relationships oblige us to ask to what extent we ourselves have become cyborgs, transgressive mixtures of biology, technology and code. The traditional distance between people and machines has become harder to maintain" (Turkle 1995: 21). Looking at the sonogram is a "technologically enmeshed" pleasure. The relationship between technology and biology becomes the relationship between mother and child. I bonded with an image, I aborted an image, and I deeply mourn an image. The image does not supersede the material presence of a pregnancy, it mediates, interprets, and supports the physical presence of an unborn child. I felt this baby inside me. I produced milk to feed him. Days after the abortion my breasts leaked.

Exactly one year following my so-called therapeutic abortion, I had a miscarriage. The same doctor measured the embryo at five weeks using a sonogram. At this stage all I could see was a dark depression in a white field. Now for the third time in two years, I am pregnant. Irene from Israel draws blood twice a week. This process gives me information. Of course there's not much the knowing can do. For most parents these technologies promise perfect babies. I know it can hurt but I long to look again for that bleep on screen . . . that representation of a beating human heart obscured and embedded within my own flesh.

Notes

1 See Barbara Duden's *Disembodying Women: Perspectives on Pregnancy and the Unborn*. Duden, a medical historian, asks us to question the use of technologies which "skin" women.
2 Bordo suspects that perhaps feminists would have developed such a perspective if African American women, given their historical experience of having both their bodies and their children appropriated from them, had played a more central role in framing the arguments of earlier feminist politics.

References

Barthes, Roland. 1978. *A Lovers' Discourse: Fragments*. Translated by Richard Howard. New York: Hill and Wang.

Bordo, Susan. 1993. *Unbearable Weight: Feminism, Western Culture and the Body*. Berkeley: University of California Press.

Duden, Barbara. 1993. *Disembodying Women: Perspectives on Pregnancy and the Unborn*. Translated by Lee Hoinack. London and Cambridge, MA: Harvard University Press.

Freud, Sigmund. 1989. "Mourning and Melancholia." In *General Selections from the Works of Sigmund Freud*. New York: Anchor Books.

Hubbard, Ruth. 1992. *The Politics of Women's Biology*. New Brunswick, NJ: Rutgers University Press.

Mulvey, Laura. 1973. "Visual Pleasure and Narrative Cinema'. Bloomington and Indianapolis: Indiana University Press, 1989. [Chapter 9 in this volume.]

Petchesky, Rosalind Pollack. 1987. "Foetal Images: The Power of Visual Culture in the Politics of Reproduction." In *Reproduction Technologies: Gender, Motherhood and Medicine*. Edited by Michelle Stanworth. Minneapolis: University of Minnesota Press.

Phelan, Peggy. 1993. *Unmarked: the Politics of Performance*. London and New York: Routledge. [See Chapter 15 in this volume.]

Turkle, Sherry. 1995. *Life on the Screen: Identity in the Age of the Internet*. New York: Simon and Schuster.

Index

Pages with illustrations are presented in italic. British and US spellings follow those of the individual chapters.

abjection 389–91, 419; death 390–1; food loathing 390; in video art 515–16, 518

absence *see* presence and absence

abstract art 34, 41, 192–202, 255

"acts": and gender identity 392–401

Adam and Eve, images of 38

Adam's Rib 65

Adler, Alfred 182

advertising 89, 305–7, 317–18, *319–20*, 370–1, 417, 458, 464, 526; *see also* television commercials

aesthetics 136, 524–6

affinity 210–11, 479–80

African-Americans 110–11, 175–7, 180, 182–3, 185, 186 n. 13, 201, 337, 349, 350, 463; Barbie dolls 341–2; exclusion from art world 239–46; hair 343–4

Africans 137, 140, 154, 158, 169–70, 172, 174–5, 178, 209; *see also* Hottentot Venus

Afro-American art: paucity of black nudes 176

Althusser, Louis 82

Amerindians 216

Andre, Carl: gossip about 274–5

androgyny 73

animals: connection with humans 477, 479

"Ansonia" (Remington) 42

anthropology: as male-biased 168, 169

anti-feminism 171–2, 314, 317–18, 323, 326

Anti-Oedipus (Deleuze/Guattari) 375, 378–9, 381

apartheid 152–4, 159

appendages 534, 538

"appended subjects" 534, 536, 542–4

architecture 226, 277–81, 371; and the body 427–31, 509; obstacles facing women 279–80; in postwar suburban America 330; and social relations 278–9; women's collaboration in 278, 279; *see also* cities

Architecture and Feminism 280–1

Ariadne: A Social Art Network 303–4

aristocracy: lack of artists from 232

Art After Modernism (Wallis): patrilineage 253

art history 5, 6 n. 2, 11, 129, 199, 225, 226; Asia Pacific 18–19; eighteenth-century 138–9; Euroethnic 229–30, 243–5; lack of female "greatness" 229–33; modernism v. realism debate 78–9; of monochrome painting 192–4, 198; nineteenth-century 137–9; patrilineal/matrilineal legitimation 249–55, 349–51

art practice 13, 56–8, 84, 210, 232; black 24, 176; female sensitivity 41–2; as glorification of female power 54–5; preconditions for achievement 232 –3; transnationalist 18–21

art world 15–17, 19, 526; negation of colored women artists (CWAs) 239–46, 352 –3; in 1980s New York 274–5; in the 1970s 77–8, 80–1

"Art World Racism" (Pindell) 241

artist/woman contradiction 40, 72–3

artists: colored women (CWAs) 239–46; focus on "otherness" 241–2; gay/lesbian 15–17, 128–9; "Great" 231, 349

Artists' Union 84

Asian Americans 156–7, 159; cosmetic surgery 355, 357, 358–61

"Asian art": meaning of 19–20

Asians 166; appropriation of "Western" culture 360; art and art criticism 18–21; cosmetic surgery 354–61; gender equality/inequality 19; media images 287–93

Association for Women in Architecture (AWA) 279

authenticity 158–60, 211; of Barbie dolls 342; illusion of 209; racial 355–6, 358

autobiography 107

avant-garde 13, 27, 80, 176, 201, 209–11, 315, 321, 323, 324; pre-war 269–70, 272–4

avatars 535

Baartman, Saartjie *see* Hottentot Venus
Baiul, Oksana 367–8
Baker, Josephine 24, 177
ballet *see* dance
Barbie and Ken dolls: black 340–2, 343–5; buttocks
 344–5; deconstructing 346; hair play 342–3; Queer
 Ken 338–9; racial stereotyping 337–8, 340–2, 344–7
Barnes, Djuna 412
Barry, Judith xiii, 53–9
Barthes, Roland 130, 294, 504
Bartmann, Sarah *see* Hottentot Venus
Bateson, Gregory 497
Bathsheba Bathing (Rembrandt) 256, *257*, 258–64, 267
Baudrillard, Jean 89, 111, 412
Beauty and the Beast (Split Britches) 410, *411*, 412
Beauvoir, Simone de 23, 164, 393–4
belief 30, 105–6
Benjamin, Walter 294–5, 298, 299
Berger, John xiii, 3, 37–9, 56
Bergstrom, Janet *see* Camera Obscura Collective
Betterton, Rosemary xiii, 9, 11–14
Beyond the Forest 67–8
Beyond the Purloined Image exhibition 89
Bhabha, Homi 213, 524, 535
biotechnologies 485–7; feminist involvement in 27–8;
 and the female body 28–9
Black Power 220–1
black servants: as figures in European art 138, 175
black stereotypes *see* stereotyping, racial
The Blacks (Genet) 406
blasphemy 475
Blau, Herbert 406–7
bloc formation 222
Blondin, Nicole Dubreuil 80
Bloom, Lisa xiii, 9, 18–22
Bloomer, Jennifer 279
The Bluest Eye (Morrison) 98
Bly, Robert 321
Bodies© INCorporated 535–6, 540–2, *543*, 544
body, the/bodies 24, 54–5, 63–4, 66, 111, 164, 200,
 221, 224, 346, 369–71, 373–4, 378–80, 384,
 414–16, 420–2, 459, 466–9, 500, 504, 507–8, 510,
 515–20, 522, 531–3; aesthetic interventions 354–61;
 all-nature v. all-culture 180–3; and architecture
 427–31; black 23–4, 96, 104, 136–47, 174–85, 178,
 210, 463–4; and cities 507–8, 509–11, 513;
 "grotesque" 416, 418–19; as historical situation
 393–401; and monochrome art 195–9; posthuman
 502–4, 531–3; and sexuality 72, 81, 139–45; as "too
 much" 462–5; transsexual 187–91; *see also* cyborgs;
 dance; eating disorders; images; virtual reality
body art 55–6
body-politic, the 510
body politics 12, 23–4, 340, 415; and dance 422–4;
 l'écriture feminine 226, 419–21
bohemian circles: gossip 269–70, 272–3; homoerotic
 possibilities 17
Boigne, Charles de 451 n. 24

Bontecou, Lee 42
books: and bodies 500
Bordo, Susan xiv, 361, 370–1, 454–65, 548
"both:and-ism" 181, 182
Bourdieu, Pierre 325–6
Boycott Anorexic Marketing (BAM) 455
Braidotti, Rosi xiv, 472, 531–3
Brecht, Bertolt 78–9, 81–3, 84, 85, 88, 89, 253,
 324–5
Brenson, Michael 241
Britain: racist views on immigration 287–9
Bronski, Michael 405–6
Brown, Murphy 316
"buddy movies" 48
Bul, Lee *521*
Burchill, Julie 96–7
Bush, Barbara 316, *317*
butch–femme roles 187–8, 403–5, 407–13
Butler, Judith xiv, 106, 187–8, 370, 392–402
buttocks: as representing sexual organs 140–2, 144;
 as signifier of black female difference 344–5, 464

Cadmium Red (Hafif) *195*
camera, the 51, 62; manipulation of screen space 49, 52;
 and pornography 387–8
camera obscura, the 258; as metaphor for ideology and
 the unconscious 237–9
Camera Obscura Collective 225, 234–9
Cameron, Dan 323
camp 405–7, 409–10, 412–13; *see also* homosexuality
Canetti, Elias 379
capitalism 381–2, 483–4; health problems caused by 28
Carr, Emily 42
Cary, Lorene 111
Case, Sue-Ellen xiv, 402–13
castration 73, 76; as link between narcissism/fetishism
 75; symbolic 176, 408, 501
castration anxiety 44, 49, 52, 64, 74, 115, 122
catalogues: and patrilineage 252–3
Cawelti, John 296
Cézanne, Paul 252, 258
Chakrabarty, Dipesch 523–4
Changing Parts (Hatoum) 515
Cheng, Meiling xiv, 10, 29–31
Chicago, Judy xiv, 40–3, 81, 176, 277, 369, 420
child/father relation 43, 64, 70, 73–4, 77
child/mother relation 85, 88, 123–4
China *see* Asians
Chodorow, Nancy 297–8
¡Cholita! 219, 221
choreography *see* dance
cinema *see* film
cities 508–9, 512–13; and bodies 507–8, 509–11, 513;
 see also architecture
"The Civilization of the Woman in African Tradition"
 colloquium 169–70
Cixous, Hélène xv, 226, 256–68, 420
Clark, T. J. 78–9

Climate No. 6 (Zhang Xin) 19, *21*
close-ups: importance in women's art 298
Collins and Milazzo exhibition catalogues: patrilineage
 252–3
colonialism 209–10, 213, 245, 287–8, 484, 524, 535
color 196–7, 199–200; resistance to signification
 194–5
colored women artists (CWAs) 239–41; negation of by
 art world 242–6
Columbus, Christopher 208; as icon of control over
 Otherness 206
command-control-communication-intelligence (C^3I) 475,
 486
commercials *see* advertising; television
consciousness 83, 234, 235; and the camera obscura
 237–8; oppositional 480
conventions: aesthetic and medical 136–7
Conway, Patricia 279
Cornered (Piper) 110–11
Corps étranger (Hatoum) 516, *517*, 518
counteridentification 220
crafts 277; valorisation of 56, 57, 252
cross-dressing *see* transvestism
cultural intelligibility 188
cultural studies 2–3, 6 n. 1
culture: as opposed to nature 132–3, 180–3, 510
Cuvier, Georges 140, 345
cyberfeminism 10, 26–9, 522, 530, 531–3
cybernetics 485, 503, 520, 529
Cyborg Blue (Bul) *521*
"Cyborg Manifesto" (Haraway) 471–2, 522
cyborgs 475–9, 481–5, 487–91, 522–3, 532

Dadaists 209–10, 300
Dallas 297–8
Daly, Mary 165
dance 370; and body politics 422–4; fetishism in 445–6;
 and gender 434–7, 440–3, 447–8; postmodern
 423–4; Romantic ballet 436–46; as sensual/sexual
 metaphor 438–9, 443; travesty 442–4
Dark Victory 68
Dash, Julie 101, 103–4
Daughters of Bilitis (DOB) 404
Davis, Vaginal 116, *218*, 219–22, *223*
death 390–1
Debord, Guy 34
decoration 165–6
defamiliarization *see* distanciation
de Feo, J. 42
Deleuze, Gilles 375, 378–9, 380, 381
depropriation 89, 90–1
Derrida, Jacques 200–1, 269, 270, 271, 272, 410
Descartes, René 431
"Desert Fan" (Chicago) 42–3
desire 73, 75; "streams" of 375–85, 419
deterritorialization 380–2, 384
Deux Fois (Raynal) 235
Diawara, Manthia 95, 102, 103

différance 199, 201
difference 12, 27, 49, 63, 77, 81, 89, 100, 102,
 154–5, 165, 176, 201–2, 339, 346; as "division"
 152–3; gender/sex distinction 167–8, 172,
 393–401, 469; and identity 161–2; naturalization by
 "glasses" cliché 67; racial 99, 110, 139–42, 157–9,
 181–3, 201, 206, 211, 213, 340–6, 535; sexual 64,
 69, 79, 90–1, 93 n. 50, 108, 109, 115–16, 133,
 164, 166–7, 277, 325, 450 n. 11, 468; *see also*
 "Other", the
Difference On Representation and Sexuality exhibition 77
Differencing the Canon (Pollock) 12–13
The Dinner Party (Chicago) 176, 277, 420
"dirty joke", the 68–9
discourses 23, 58, 59, 85, 107, 120, 125, 130, 132,
 139, 223; of acts 392; body/gaze 24; and the body
 420–2; of camp 405–6; écriture 109; essentialist 181;
 feminist 11; of heterosexuality 131–2; imaged 75–6;
 pornographic 132; power and violence 96, 100, 132;
 psychoanalytic 131
disidentification 78, 82, 220–4, 324–5
distanciation 82, 83, 88, 324
Doane, Mary Ann xv, 60–71, 99–100, 101, 103, 409,
 422
documentary photography 89, 288
Doisneau, Robert 68–9
domination: informatics of 483–4
Douglas, Mary xv, 373–5, 487
Doyle, Jennifer xv, 9, 15–17
drag 219–20, 223; modalities/styles of 221–2
dreams 122
dualisms in Western traditions 478, 485, 489–91;
 human/animal 477, 479; machine/organism
 477
Duchamp, Marcel 194
DuCille, Ann xv, 337–48
Duden, Barbara 547
Duncan, Isadora 423, 447
Dworkin, Andrea xvi, 369–70, 387–9

Easy Aces 329–30
eating disorders: and body image 454–8, 461–4; food
 loathing 390
l'écriture feminine 226, 419–20, 421
ego formation: and film 46–7
"either:or-ism" 181–2
Elam, Diane 273, 274
electronic art 514–19, 524–5, 536–7
electronic media theory 520, 522; and aesthetics 524–6;
 and feminism 522; and history 523; and identity
 522–3
Ellis, Havelock 142, 147
embodiment *see* body, the
endings *see* narrative
Enlightenment 34, 209, 509
Equal Pay Act (1970) 84
Erasmus (Holbein) 263
essentialism 181, 323, 355, 358, 421–2, 432 n. 1

ethnicity v. womanhood 167–9

ethnographic exhibition of human beings 205–9, 211, *212*, 213–15; *see also* Hottentot apron; Hottentot Venus

exchange of women 130–5

expectation 294

eyes: Asian 354–61; *see also* vision

family values: patriarchal fantasy of 314, 316–19; in postwar suburban America 329–30

Fanon, Frantz 23, 95, 213

fashion: and anorexic images 457–62

father/child relation 43, 64, 70, 73–4, 77, 165

Fausch, Deborah xvi, 371, 426–33

Felix, Petal 102

female citizenship: paradox of 467–8

feminine, the: and architecture 278–9; neutering of 200–1; as opposed to feminist 12, 169, 322; in soap operas 294

femininity 12, 41, 56, 57, 73, 169, 175, 361, 384, 417, 531; as construct 53, 59, 290, 370; and dance 439; and figure skating 364–7; masquerade of 66, 70, 90, 408–9; and photographic representation 90, 315–19; "riddle" of 60–1; and sexual mobility 65–6

feminism 1–2, 4, 19, 23, 30, 57, 75, 80, 99–100, 156, 229–30, 253, 403, 489, 522; and bio/genetic technologies 28–9; and body politics 414–24; and lesbianism 404–5, 407; proximity motif in 63–4; radical 27, 54, 481–2, 484, 487; of radical painting 192, 200; relationship with visual culture 3, 29–31; socialist 475–91; taxonomies of 480; transnational 9, 18–21, 28; as "westernization" 168; *see also* postfeminism

feminist theory and practice 18, 20, 22–8, 35, 53–9, 80–1, 83, 91, 99–100, 176, 229, 269, 322, 325, 476–7, 485; architecture 277–81; Asian 18–19; avant-garde 176; cultural skills 12; diaspora 20–1; digital 26–7; film 234–9; French 63, 226, 322, 419, 487; gender 394–5, 399–401; gossip 270–1; and late modernism 80–1

femme fatale, the 66

Fernández, María xvi, 520–7

Fertile La Toyah Jackson 'zine 219

fetishism 34–5, 65, 73, 82, 115, 127, 325, 369, 535; in dance 445–6; female 74–5, 85, 88; in film 49, 62; in photography 68, 315

fetishistic scopophilia 49–50, 325; in Sternberg films 50

fetishization 65, 107, 109, 127; of the child 74, 85; of the "primitive" 209–10, 213; of women 79, 85, 109, 459

fetus, the 547–8

figure skating 364–8; and femininity 364–7

film 44–7, 63, 67; avant-garde 13, 14, 45; barriers to black women film-makers 293; black stereotypes 95–7, 104; feminist analysis 234–9; fetishism 49, 62; Hollywood 13, 14, 45, 96, 101–2, 103; homosexual eroticism 48; image v. self-image 47; male

protagonists 48–9; narrative structure 48–9; postfeminism 319, 321; representation of "woman" 62, 79, 97, 235; sexual difference 69–70; voyeurism 46, 49–53, 62–3; white supremacy 95–7

Film about a woman who ... 235

Flitterman-Lewis, Sandy xvi, 53–9

"flowing" *see* "streams"

The Fly 502, *503*

Fokine, Michel 447

Fonda, Jane 531

Food for the Spirit (Piper) 177

"Forest of British Columbia" (Carr) 42

Foster, Hal 77, 324

Foster, Susan Leigh xvi, 370, 434–52

Foucault, Michel 70, 81, 94, 268–9, 270, 272, 276 n. 1, 396, 400, 402–3, 531

Fourth World 163–4

fragmentation 184

Frankenstein (Shelley) 539

Franklin Court, Philadelphia 429–30

Freud, Sigmund 35, 46, 47, 68, 107, 123, 124, 144, 147, 182, 237–8, 257, 272, 375–6; on "femininity" 60, 64; on fetishism 115; on sexual identity 73–4, 75, 81

Friedberg, Anne 96, 100

functionalities 504

"furniture art/music" 300

Fusco, Coco xvi, 205–16

Gage, John 199

galleries and gallery system *see* art world

Gatens, Moira xvi, 371, 466–9

"gaze", the 12, 23–4, 30, 34, 47–9, 63, 97, 103, 108, 127–8, 325–6, 358, 436; abuse of black females 100–1; black female/male 94, 96–9, 102; oppositional 94–5, 98–9, 101, 102, 103; "textual strategies" to counteract 35, 53–9; women's appropriation of 67–70, 73, 104, 409; *see also* looks/looking; seeing, ways of; spectatorship

Gaze 3 (O'Grady) *179*

gender 1, 9, 12, 169–70, 172, 370; and body politics 422–4; and dance 434–7, 440–3, 447–8; gender/sex distinction 167–8, 171, 393–9; as performance 188, 392–401; social 168

gender inequality 30; for African women 172; for Asian women 19

gender studies: contribution to abstraction 192

genealogy 268–9, 400, 468

Generations of Vipers (Wylie) 333

Genesis story 38

Genet, Jean 406

genitalia 440, 510; buttocks as representing 144; female 64, 146, 176, 277, 357, 388, 420; as sign of the "primitive" 140–2, *143*, 345, 463–4; and transsexuality 189; *see also* penis; vagina

"Genius", concept of 231, 232

Gibson, Ann Eden xvi, 192–204

Gilman, Sander L. xvii, 136–50

Giselle 437–8, 442
glasses: as visual cliché 67–8
Gómez-Peña, Guillermo 205–7, 211, 213–14, 520
Gone with the Wind 464
González, Jennifer xvii, 534–44
Good Housekeeping 319, *320*
gossip 225, 268–76; categories of study 269; value in "scientific study" 270–272
Gramsci, Antonio 222
"Great Artist" myth 231
Greenberg, Clement 33, 192, 322–3
Greimasian quadrangle 449 n. 5
"Grey Line with Black, Blue and Yellow" (O'Keeffe) 41
Grosz, Elizabeth xvii, 421, 472, 507–13
Guattari, Félix 221, 375, 378–9, 380, 381
The Guerrilla Girls xvii, 254, 349–53

Hafif, Marcia *195*, 196, *197*, 198
Hall, Stuart 2, 94–5, 104, 183, 184, 523
Hammond, Harmony xvii, 128–9
Haraway, Donna xvii, 190, 471–2, 475–93, 532
Harding, Tonya 364–5, 367
A Harlot's Progress (Hogarth) 138
Harrison, Margaret 84
Harrison, Michael 547
Hartsock, Nancy 176, 177
Hatoum, Mona 472, 514–19
Hayles, N. Katherine xviii, 472, 497–506
"Heart" (Do I have to give up me to be loved by you?) (Kruger) 195, *196*
Heath, Stephen 82, 84, 88
Heidegger, Martin 193
Heine, Heinrich 60–1
Hepworth, Barbara 42
hieroglyphs 61, 70 n. 5, 75, 124
history 155, 523–4
Hitchcock, Alfred 50–1
Hofmannsthal, Hugo von 138
Hogarth, William 138
Holbein, Hans 263
Hollibaugh, Amber 405
Hollywood *see* film
hom(m)osexuality 109, 124, 125
homoeroticism: in bohemian circles 17; in dance 443–4
homophobia 16, 221, 404–7
homosexuality: butch–femme roles 187–8, 403–5, 407–13; in dance 447–8; heterosexual men's phobic fantasy of 15; oppression of 131–3; and power 16; and women 16; *see also* camp
The Honeymooners 332
hooks, bell xviii, 94–104, 182, 184
Horne, Lena 96–7
Hottentot apron 140, 142, *143*
Hottentot Venus 24, 137, 139–40, *141*–4, *145*, 177, 212, 345, 463–4
housewives *see* labour, sexual division of
Huangfu, Binghui 19–20
Hulan, Liu 19

Humoresque 67
Hunt, Kay 84
hybridity 358–9, 472, 522, 524, 526, 538–9, 541; *see also* cyborgs

"I" 390–1; layers of 159–60, 167
iconography 136–7; of the Asian eye 356–9; eighteenth-century 138–9; of monochrome painting 193–4, 198; nineteenth-century 137–47
ICT 26–7, 485–6, 497–8, 505, 512–13; functionalities 504; racism/sexism 28, 29; signification 500–2, 504; and women's labor 28
identification 100, 220
identity 12, 24, 34, 37, 40, 42, 108, 110, 112, 161–2, 164, 479–80, 514–15, 522–3; as bodily assemblage 536–44; cultural 205–6, 358; double 43; ethnic v. female 167–9; gender 393–401; intersectionality 220–1; misrecognition 218–19; racial 104, 110–11, 357, 535; of "women of colour" 479–80, 487, 522
identity politics 109–10, 116; and visibility 111
ideology 78, 80, 81, 82–3, 88, 92 n. 4, 132, 220, 290, 484; camera obscura as metaphor for 237–9; and mode of representation 234, 236; and subject position 403
Illich, Ivan 167–8, 169–72
Illusions (Dash) 103–4
images 33, 236, 471; anorexic 455–8, 460–2; believable 105–6; black as icons 137–44, 145–7; body 23–4, 38, 69, 75, 79, 250–2, 260–2, 315, 417–18, 454–65; digital 525, 534–43; meaning and value 33–4; pornographic 74, 302, 387–9; proximity v. distance 63, 70; ultrasound 547–8; violent 302–3; of women 47–52, 58, 72, 90, 97, 98, 137–40, *141*, 315–26, 455–64; *see also* representation
imagination 466–8
Imitation of Life 98
immigration: of Asians into Britain 289
imperialism 177, 180, 287–8
In Mourning and In Rage (Lacy/Labowitz) *308*, 309
"In the Patio 1" (O'Keeffe) 41
The Incest Awareness Project (Labowitz et al.) *311*
incest taboo 123–4, 396
indexical signs 194
India *see* "Asian art"; Asians
informatics 500–1, 504
information *see* books; ICT; informatics
information and communication technologies *see* ICT
intellectuals, organic 222–3
Internet *see* ICT; media, new
invagination 200–1
invisibility *see* visibility
Irigary, Luce xviii, 63, 65, 115, 119–28, 315, 420
Ito, Taro 19, *20*

Jackson, Michael 531, 532–3
Janin, Jules 440–1
Japan *see* Asians
Jekyll and Hyde 379–80

Jones, Amelia xviii, 1–7, 9–10, 33–6, 115–18, 225–7, 283–5, 314–28, 369–71, 471–3
Julien, Isaac 180–1

Kafka, Franz 205
Kelly, Mary xviii, 35, *58–9*, 72–6, 80–1, 84, 89, 194–5, 253
Kerrigan, Nancy 364–5, 367–8
Kim-Trang, Tran T. 358, *359*
King, Katie 480
Klein, Yves 197, 252
Koestenbaum, Wayne 449 n. 6
Koons, Jeff 533
Kristeva, Julia xviii, 163, 166–7, 200, 389–91, 399–400, 419–20, 482, 515, 518
Kruger, Barbara 195, *196*, 323
Kumiko, Korā 160

La Porta, Tina *546*
labour: Marxist view of 481–2; sexual division of 84–5, 297, 298, 299; of "women of colour" 487, 522
Labowitz, Leslie xix, 302, *303*, 304–6, *307–8*, 309–10, *311*, 312–13
Lacan, Jacques 46, 73, 106, 109, 131, 134, 200, 501, 506 n. 12
Lacanian psychoanalysis 77, 81, 107, 109, 181
The Lacemaker (Vermeer) 263
Lacy, Suzanne xix, 302, *303*, 304–7, *308*, 309–13
language 44–5, 47, 56, 77, 85, 88–9, 101, 109, 122, 123–4, 126, 130–1, 151, 171, 419–20, 488; cinematic 236; hieroglyphic 61; as political 130, 134; speech acts 392; in word processing 501–2, 504
Lauretis, Teresa de 96, 402–3
Lautrec, Toulouse 232; psychoanalytical analysis of 13
"law of the father" *see* Symbolic, the
Le Corbusier 427, 430
Leave Her to Heaven 67
Lee, Spike 101
Lehner, Sharon xix, 472, 545–9
Leonardo da Vinci 536
lesbianism 403–4; art/artists 57, 128–9; and black concupiscence 142; butch–femme roles 187–8, 403–5, 407–13; performance 19, 410, *411*, 412; sexuality 464–5
lexicon *see* language
Lin, Maya 427
linguistics *see* language
Lippard, Lucy 80
literacy: as mark of "women of colour" 487–8
Little Red Riding Hood 412
Lomax, Yve *86–7*, 89–91
looks/looking 13, 34, 37–9, 56, 63, 72–3, 95–6, 98, 101–3; distance/proximity dichotomy 63–5, 70; in film 48–50, 52–3, 69–70; pleasure/unpleasure in 13, 45, 46–8, 49–50, 52–3, 62, 69, 75, 324–5; power in 94–5; *see also* "gaze", the; seeing, ways of; spectatorship; voyeurism
Lorde, Audre 151–2, 155, 165

Los Angeles punk scene 217, 219–22
Lukacs, George 78, 82–3
Lyon, Elisabeth *see* Camera Obscura Collective

machines: miniaturization 478; and organisms 477, 479
MacKinnon, Catherine 482
Malinche 488–9
"man" 133–4, 503; fantasy of emasculinization 41; need for control 147; non-comprehension of women's art 40, 41–2, 43; presence 37–8; role in film 4
Man the Tool-Maker (Oakley) 503
Manet, Edouard 78, 137, 146, 175
Marisol 318
Mark, Mary Ellen 291–2
Marxism 2, 19, 34, 83, 238, 476, 481–2, 509
masquerade of femininity 66, 70, 90, 408–9
master/slave dialectic 24, 115
materiality 80, 82
maternity *see* motherhood
matrilineal legitimation 254
Matrix Feminist Architectural Co-operative Limited 278
Mattel *see* Barbie and Ken dolls
Maximo and Bartola *212*
Mayne, Judith xix, 364–8
Me Being Me (Taro Ito) 19, *20*
meaning formation 13, 57, 81, 82, 200; in film 234, 235–6; in the media 305; psychoanalytic models of 34; and technologies 485
Measures of Distance (Hatoum) 515
media: new 471–2, 526; representation of Asian women 287–93; use of by feminists 284; *see also* electronic art; electronic media theory; radio; television
media actions/events *see* performance
medicine, nineteenth-century: and aesthetics 148 n. 1; and the Hottentot 139–44; power of 137; and the prostitute 144–5
melodrama *see* soap operas
men's movement 321
Mendieta, Ana 211; gossip about 270, 274–5
Mercer, Kobena 180–1
Merchants Exchange, Philadelphia 428
Merleau-Ponty, Maurice 198–201, 393
metaphor *see* symbology
Metz, Christian 63
Meyrowitz, Joshua 331
Mill, John Stuart 229
Miller, Henry 377, 379, 383
Mirabelles, the 221
mirrors: in ego formation 46–7; as symbols 38–9, 121, 126–8
miscegenation, nineteenth-century fear of 147
misrecognition 218–19
Mitchell, Juliet 85
Mitenev, Kostya 535–9
modernism 3, 33, 80, 81, 184, 192–4, 202 n. 4, 243, 270, 273–4, 276, 278; as decadence 83; v. realism debate 78–80

Modleski, Tania xix, 284, 294–301, 323

monochrome painting 192–202; as icon of unitary modernist humanism 193–4, 198; male domination of 198

monstrous, the 539

"monstrous-feminine" see abjection

Moraga, Cherríe 405, 488

Morris, Robert 250

Morrison, Toni 98, 175

Morton, Patricia xix, 226, 277–81

Moss, Kate 460, *461*, 462

mother/child relation 42, 58–9, 73–5, 85, 88, 123–4, 127–8, 419

mother/melodrama connection 297

motherhood 41, 42, 45, 54–5, 58–9, 64, 75, 88, 126, 298

muf 279, 280

multiculturalism, 206, 516; and capitalism 340; and ways of seeing 18

multiplicity 184

Mulvey, Laura xx, 3, 13, 34, 44–53, 65, 79, 99, 101, 196, 296, 325–6, 548

Muñoz, José Esteban xx, 217–24

Museum of Modern Art (MOMA) 79, 81

mutation see pattern and randomness

n. Paradoxa 22 n. 4

narcissism 75; in the cinema 46–7, 63

narrative: endings 294–7; in film 48–9, 296; interruptions in 298–9; in soap operas 294–5

nature: inner/outer split 379–80; as opposed to culture 132–3, 180–3, 510

"Nesting Stones" (Hepworth) 42

Nestle, Joan 405, 407–8, 410

Net art 526

networks, international 18–19; electronic 26–7, 28

Nevelson, Louise 42, 43

Newfield, Christopher 542–3

newspapers see media

Nightcleaners (Kelly et al.) 84, 93

Nightwood (Barnes) 412

Nijinsky, Vaslav 447–8

1950 M, No. 1 (Still) 192, *193*

Noble Savage, the 209

Nochlin, Linda xx, 225, 229–33

non-places 433 n. 10

Now Voyager 62, 67

nude, the 38, 68, 178, 256, 260; avoidance by black artists 176; v. nakedness 39; in non-European traditions 39

O'Connor, Flannery 184

O'Grady, Lorraine xx, 174–86

O'Keeffe, Georgia 40, 41, 43

Oakley, Kenneth P. 503

objectification 214, 459, 482

objectivity 119–20, 122, 127

October 6 n. 2

Oedipal moment 74, 75, 93 n. 50

Oedipus complex 73–4, 75, 77, 113 n. 8

Of Radishes and Flowers (Wilke) *251*

Olympia (Manet) 78, 79, 137, *138*, 146, 175

On Governmentality (Tabrizian) 89

Open Rings and Partial Lines (Lomax) *86*–7, 89–91

opera 449 n. 6

Operculum (Kim-Trang) 358, *359*

oppression: by heterosexuality 133–4; structures of 53–4

orifices/tunnels as symbols 40–3, 54, 374

"Other", the/"Otherness" 90, 95, 106–7, 109–10, 120–3, 147, 177, 205, 213, 241–2, 275, 280; black females as 97, 142, 174–6; creative processes of "primitive" 210–11; and "discovery" 207, 209; fetishization of 209–10, 213; focus on by Euroethnic art world 241–2; as performative 209, 211, 213; *see also* difference

"The Other Question" (Bhabha) 213, 535

Owens, Craig 322

"Ox" (Schapiro) 42, *43*

pain/pleasure dichotomy 55, 56

Pane, Gina 55, 56

Parent-Duchatelet, A. J. B. 144–5

Parmar, Pratibha xx, 287–93

Partington, Angela 11–12

Parton, Dolly 531–2

"passing" 189–90; and drag 219

Passion of Remembrance 104

patriarchy 12, 19, 30, 44–5, 56, 59, 73, 77, 100, 237, 252, 255, 316, 321, 325–6; exclusion of women's productive force 382, 384; in film 52, 234, 321; in photography 315–19; in representation 53, 198; subversion of 54, 57–8, 420

patrilineal legitimation 249–55

pattern and randomness: in information technologies 497–9, 501–2, 504–5; mutation 502; in virtual reality 500

Payne, Sandra 177–8

Pedro, Muriel and Esther (PME) 219

Peeping Tom see voyeurism

Pence, Ellen 155–6

penis, the 183, 408, 445–6; lack of 44, 49, 64, 73; man's eye as substitute for 127

Penley, Constance see Camera Obscura Collective

People: indictment of anorexic images 457–8

performance 205–8, 211, 213–16; Dadaist 209–10; drag 219–23; gender 392–401; intercultural 208–9; through the media 303–13; to "rehearse identities" 219; staging 309–10, 312–13

performativity 188, 370, 392–401

Petroushka 447–8

phallocentrism 31, 34, 44–5, 91, 96–7, 99, 189, 510

phallus, the 44, 452 n. 36; ballerina as 436, 445–6; male dancer as 447; woman as 73–4

phantasmatic, the 47, 106, 108, 113 n. 8

Phelan, Peggy xxi, 105–14, 547

phenomenology 392, 393–401

Philosopher Meditating (Rembrandt) 265

photography 33, 68–9, 89–90, 92 n. 24, 288, 370–1, 526; anthropological 291–2; as tool of postfeminism 314–18, *319–20*, 321–6

photomontage 539

Picasso, Pablo 79

Pindell, Howardena 241

Piper, Adrian xxi, 110–11, 177, 225, 239–48

Plant, Sadie xxi, 472, 528–9

pleasure: destruction of 45; female 326; in narrative 300; pleasure/pain dichotomy 55, 56; refusal of 324–5; streaming of 375–8; visual 13, 45, 46–53, 97–8

Pollock, Griselda xxi, 12–13, 76–93, 192–3, 201, 253

Pollock, Jackson 34, 194, 198

porneia see prostitutes

pornography 132, 369–70, 387–9, 415, 459–60; Bearden's 176; iconography of 74

Post-Partum Document (Kelly) *58–9*, *74*, 84, 85, 88, 253

postcolonial studies 520; and aesthetics 524–6; and feminism 522; and history 523–4; and identity 522–3

postcolonialism 20, 27; and ways of seeing 18

postfeminism: in film 319, 321; in photographic images 314–18, *319–20*, 321–6; and postmodernism 321–3; *see also* feminism

posthuman v. human 502–4, 531–3

postmodernism 14, 15, 81, 181, 183, 200, 253–4, 431, 477, 480, 492 n. 4, 532–3; and dance 423–4; Euroethnic 243–6; and gossip 269, 271, 274, 276; and postfeminism 321–3; and print 500; suspension of history 79

poststructuralism 33, 82

posttranssexuality 187–91

power 16, 19, 24; of looking 94–5; political 106; of visibility 109–10, 112

Pre/Pop Post/Appropriation exhibition 252

presence: and absence 498–9, 501–2, 505; male/female 37; white 94–5

primal scene 108

"Prospero complex" 213

prostitutes 387; as icons for the sexualized female 137, 144–5, 147; photographs of 291–2

Proust, Marcel 405

proximity motif 63–4

psychoanalysis 13, 33–4, 64, 73, 79, 82, 84, 85, 91, 108, 115, 123, 131, 134, 181–3, 374, 419, 476; and the camera obscura 237–8; and cinematic meaning 236; Lacanian 77, 81, 107, 109, 181; of pleasure/unpleasure in looking at film 46–53; as political weapon 44–5; triangulation of sexuality/language/meaning 77–8, 81

Psychoanalysis and Cinema (Kaplan) 100

Psychoanalysis and Feminism (Mitchell) 85

public informational campaigns *see* performance, through the media

punk scene 217, 219–22

Pure Yellow, Pure Red and *Pure Blue* (Rodchenko) 200

Questions Féministes 164–5

quiz shows 299

race 23–4, 79, 94–104, 110–11, 139, 182; in the toy world 340–4; movies 96

racism 9, 103, 152–4, 164, 167, 176, 180, 206, 345, 358, 361, 463, 484; in cinema/television 95–6; in art world 241–2; of Internet and biotech art 28; in news reporting 288–9, 292

radical painting 192–202

radio: as threat to manhood 333

Rainer, Yvonne 235

randomness *see* pattern and randomness

rape *see* violence, sexual

reading "against the grain" 12–13, 99, 101, 198

real, the 160; confusion with representation 106–11

realism 83, 88–9, 337; and camp 405–6, 412–13; and computer art 525; historical 271, 273–4, 276; v. modernist debate 78–80

realities 84, 136–7; social 235

Rear Window: as metaphor for the cinema 51

Record Companies Drag Their Feet (Labowitz/WAVAW/NOW) *307*

Un Regard Oblique 68–9

Rembrandt 256, *257*, 258–67

Remington, Deborah 42, 43

Renaissance 33, 38, 237, 243, 278

Replication (La Porta) *546*

representation 33–4, 59, 69, 106, 108–11, 315, 471; confusion with the real 106–9; digital 525; iconic system of 61–2, 136–47; and ideology 234, 236; as a political issue 53–9, 106; as power 35, 112; scientific 547–8; of women 38, 62, 75, 79–80, 90, 96–7, 100, 102, 283, 314–26; *see also* images; self-representation

Republicanism 316

Requiem, Blue (Klein) 197

reterritorialization 380–1, 384

reviews: and patrilineage 250–1

Rich, Adrienne 157, 280, 463

Riley, Denise 421–2

Riviere, Joan 66, 408–9

Roach, Jacqui 102

"Road Past the View" (O'Keeffe) 41

Rodchenko, Alexander 200

Rogoff, Irit xxi, 225, 268–76

Roman Painting XVIII (Hafif) *197*

Rose, Jacqueline 181, 185

Der Rosenkavalier 138

Ross, Christine xxi, 472, 514–19

Rothenberg, Jerome 210–11

"rupture" 106, 367; model of 80; moments of 95

Russo, Mary 409–10, 418

Saat-Jee *see* Hottentot Venus

sadism 49–50

Sandoval, Chela 479–80, 522

"Sapphire" (*Amos 'n' Andy*) 97

Schapiro, Miriam xxi, 40–3, 369
Schor, Mira xxii, 225, 249–55
scopophilia *see* fetishistic scopophilia
Screen magazine 81, 234
Sedgwick, Eve 406
seduction 412
seeing, ways of 18, 30, 37–9, 45; *see also* "gaze", the; looks/looking; spectatorship
Seen (Greene) 177
self-: definition, right to 211; determination 19; expression 177; identity 108; perception 43, 456–8, 460–62; performance 19; representation 12, 107, 120–2
Self-portrait (Stone) *188*
semiotics 33, 82, 130, 132, 226, 419–20; and film 236
separate development, policy of 152, 157, 159
sex: economic/social 168; sex/gender distinction 167–8, 171, 393–9, 469
sexism 17, 154–5, 167, 171, 241, 349–50; of Internet and biotech art 28
sexual difference *see* difference
sexual organs *see* genitalia; penis; vagina
sexual politics 79, 314
sexuality 16, 81, 82, 182, 376; association of the black with 138–44, 145–7, 149 n. 14, 182; prostitute as embodiment of 144–5; representations of 12, 137–41
Shaw, Peggy *see* Split Britches Cabaret
"shepherding" 193
Sherman, Cindy 90, 323–4
signification: in film 234–6; in information technologies 497–8, 500–2, 504
signifiers: flickering/floating 501–2, 504
Simpson, Lorna 178
simulation *see* representation
Sister Outsider (Lorde) 487–8
The Slaughtered Ox (Rembrandt) 265, *266*, 267
slavery 94, 110, 146, 175
Smith, Kiki 250–2
smut 68–9
soap operas 294–301; "flow" in 298–9; and immortality of "family" 295; women's liking for 297–8
sociality 80–1, 82
Solomon-Godeau, Abigail 315
Sontag, Susan 406
"SOS Starification Object Series" (Wilke) *55–6*
specialness, sense of 156–8
spectatorship 35, 59, 62–3, 66, 68–70, 75–6, 95, 211, 325, 409; of ballet 440–1, 443; black female 94–104; black male 95–6; in cultural production 82, 83; of figure skating 365–8; in and of film 46–53, 62–3, 67, 70, 104, 235–6; masculinization of 65, 69; and the nude 39, 68; problems in theorizing 65, 71 n. 10; of soap operas 296–7; *see also* "gaze", the; looks/looking; seeing, ways of; voyeurism
Spence, Jo 291
Spero, Nancy 420

Spigel, Lynn xxii, 284, 329–36
Spillers, Hortense 176, 177, 182
Spinoza, Benedict de 466–9
Spivak, Gayatri 21, 177, 181, 182, 184, 399
Split Britches Cabaret (Shaw and Weaver) 410, *411*, 412
St Matthew and the Angel (Rembrandt) 265
steatopygia *see* buttocks
stereotyping 136, 156, 208, 211, 213–4, 241, 283–4, 316, 464, 538–9; of femininity 364–6; racial 24, 95, 96–7, 104, 24, 95, 96–7, 104, 137–47, 213, 290, 337, 342, 344–5, 356, 535
Sternberg, Josef von 50
Stevenson, Robert Louis 379–80
Still, Clyfford 192, *193*
Stone, Sandy xxii, 187–91
Stowe, Harriet Beecher 297
"straight mind" 132–4
"streams": of desire 375–82, 419
subaltern studies 523–4
subject positions 402–3; butch–femme 403–5, 407–13
subjectivity 102, 105–6, 119–26, 181, 460; black female 104, 174–85; body as "tool" of 509; construction of 82–3, 89; contradictory 218; white male 229
suburban America 330–6
Surname Viet Given Name Nam (Trinh) *152*
Susannah and the Elders 38
Les Sylphides 437–8, 442
Symbolic, the 44–5, 49–51, 75, 85, 88, 133–4, 200, 419–20, 515
symbology 130–1, 176, 198; of the androgene 73; of the body 373–5, 416, 427; of buildings 41; of mirrors 38–9, 121; of orifices/tunnels 40, 41, 43; of the transvestite 65
syntax *see* language

Tabrizian, Mitra 89
Taylor, Mark C. 198, 200
technologies 475–91, 524–6, 528–9, 534–44
"The Technology of Gender" (de Lauretis) 96, 402
television 298; black stereotypes 97; commercials 299, 331, 333, *334–5*; and domestic confinement 331–2; and feminization 332–3; "flow" of programs 298–9; negation of black representation 95; in postwar America 329–34; and private/public space 331–2, 333–5; soap operas 294–301; as threat to manhood 333–4
Text-Subtext exhibition catalogue 18–19
Theweleit, Klaus xxii, 369, 375–85
Third World: connotations of term 162–4; media representations 288; exclusion of Third World women 153, 155–7, 159, 162, 163, 168, 169; *see also* Africans; Asians
Three Weeks in May (Lacy and Labowitz) *303*, 304
Time magazine: morphed racial images 538; as tool of postfeminism 316–18, *319*
Tom, Pam 358
Tonya and Nancy: The Inside Story 365, 367

toy industry *see* Barbie dolls
tradition: as weapon of oppression 169, 171–2
transformation 379–80
transnationalism 9, 18–21, 28
transsexuality 188–91
transvestism 65–6, 70, 398, 409. 412
travesty dancers 442–4
Trinh, T. Minh-ha, xix, 21, 102, 151–72
Truth, Sojourner 164, 176
tunnels *see* orifices/tunnels as symbols
Turkle, Sherry 523, 548
Two Lies (Tom) 358
Two Undiscovered Amerindians Visit ... (Fusco and Gómez-
 Peña) 206, *207*, 208, 211, 213–16
Tzara, Tristan 210

ultrasound images 545; and mother's absence 547, 548
unconscious, the 34, 45, 59, 72, 75, 107–9, 120–2,
 130–1, 134; camera obscura as metaphor for 237–8;
 and film 236; male 49; patriarchal 44–5; woman's
 appropriation of 124
UNDINA 535–6, *537*, 538–44
United Nations Plaza, New York 427
United States: postwar suburbia 329–31; quincentenary
 celebration fiasco 205–6; *see also* African-Americans;
 Asian Americans
"Unknown" (Bontecou) 42
Unmarked (Phelan) 106, 107, 109, 547

vagina, the 41–3, 45, 54, 75, 142, 176, 183, 383, 420
vagina dentata 517–18
Van Gogh, Vincent 258; on Rembrandt 264
Venturi, Rauch and Scott Brown 278, 428–30
Vermeer, Jan 258, 263
Vertigo: centrality of the look 50, *51*
Vesna, Victoria 536, 540–2
video art 526; diaspora and immigration 514–19
Vietnam Veterans Memorial, Washington D.C. 427
violence, sexual 302–3, 305–8, 311–12
Virey, J. J. 139–40
Virilio, Paul 512–13
virtual reality (VR) 499, 504, 506 n. 22, 520, 528–9
visibility 35, 106, 109–10, 292; of black skin 111, 175;
 and identity politics 111; and power 112; queer 221
vision: and the "gaze" 30, 532; as metaphor for thought
 427; *see also* eyes
Vision & Difference (Pollock): patrilineal legitimation
 253
visual culture 1–3, 5, 12, 14, 30, 33; black 22–6;
 feminist critique of 35; new digital 27; relationship
 with feminism 3, 29–31; social approach 15;
 study/theories of 13, 18, 24, 31; theory/practice
 relationship 27

"Visual Pleasure and Narrative Cinema" (Mulvey) 3, 79,
 99, 325
VNS Matrix xxii, 472, 530
Vogue: anorexic images 458
voyeurism 13, 46, 52–3, 62–3, 67, 69, 75, 214, 235,
 291–2; and essential distance 63, 70; in films 46,
 49–53, 62–3; and sadism 49–50; *see also*
 looks/looking; spectatorship

Wallace, Michele 176, 180–1, 201
Warren, Mary Anne 400
Ways of Seeing (Berger) 3, 56
Weaver, Lois *see* Split Britches Cabaret
Welcome Park, Philadelphia 428–9
White Rose (de Feo) 42
white supremacy: perpetuation of in film 95–7
whores *see* prostitutes
Wilding, Faith xxii, 10, 26–9
Wilke, Hannah *55*–6, 250, *251*
Williams, Raymond 2, 298
Wilson, Judith xxiii, 9, 22–6, 176–7
Wimsey, Lord Peter 271
Wittig, Monique xxiii, 130–5, 403
Wolff, Janet xxiii, 370, 414–25
Wollen, Peter 78–9
Wolverton, Terry 57
"woman" 16, 44, 52, 57, 75, 100, 133–5, 162, 164,
 166–7, 325, 394, 479, 481–2; depersonalization
 383–4; v. ethnicity 167–9; identification with body
 416–22; images 47–52, 58, 72, 90, 97, 98, 137–40,
 141, 315–26, 455–64; secondary role in literature
 382–3; sexualized 48, 137–47; social presence 37–8;
 as surveyor and surveyed 37–9; as "too much" 462–5;
 as whore 387–9
woman/artist contradiction 40, 72–3
Womanhouse project 277
womanliness *see* femininity
"Womanliness as a Masquerade" (Riviere) 408
"womb art" 43
Women and Work (Harrison, Hunt and Kelly) 84
"women in the integrated circuit" 486, 487, 490, 493
 n. 11
World Wide Web *see* ICT; media, new
writing *see* literacy
"wrong body" *see* transsexuality
Wylie, Philip 333

X (band) 217
Xin, Zhang 19, *21*

Yamada, Mitsuye 156–7, *158*, 159

Zane, Kathleen xxiii, 354–63